2006

Artist's & Graphic Designer's Market

Mary Cox, Editor

Assistant Editors:
Lauren Mosko & Alice Pope

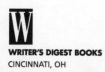
WRITER'S DIGEST BOOKS
CINCINNATI, OH

If you are an editor, art director, creative director, art publisher or gallery director and would like to be considered for a listing in the next edition of *Artist's & Graphic Designer's Market*, send your request for a questionnaire to *Artist's & Graphic Designer's Market*—QR, 4700 East Galbraith Road, Cincinnati OH 45236, or e-mail artdesign@fwpubs.com.

Managing Editor, Writer's Digest Annual Books: Alice Pope
Supervisory Editor, Writer's Digest Market Books: Donna Poehner
Writer's Market website: www.writersmarket.com
Writer's Digest Books website: www.writersdigest.com

International Standard Serial Number 1075-0894
International Standard Book Number 1-58297-396-2

Cover design by Kelly Kofron
Interior design by Clare Finney
Production coordinated by Robin Richie

Attention Booksellers: This is an annual directory of F+W Publications. Return deadline for this edition is December 31, 2006.

Contents

THE MARKERS

Murray's Law® / ® Design Design, Inc.

© Glenn Olson, courtesy of Clearwater Publishing, www.clearwater-publishing.com

RESOURCES

INDEXES

© Michele Amatrula

From the Editor
The Five Stages of Accomplishment

It is really fun putting this book together every year. Not only do I get to learn about the different markets but I get to see a lot of great art—much of it from readers like you. I have a huge box I go through to choose prints, paintings, promotional cards, cartoons, greeting card designs, magazine and book illustrations and place them throughout this book. Each year I spend a couple of days working my way through the art box, trying to pick the best work for the book.

This year as I looked through the images, one greeting card by DCI Studios really hit home. It wasn't a sentimental one, or a sarcastic one. It was clearly meant to be funny, but the theme of the card seemed to fit this book so perfectly. Check out the card on page 96 and see if you don't agree with me.

At the top of the card is the heading **5 Stages of Accomplishment**. Followed by a simple list of each stage. According to this card,

- First comes Denial ("I can't do it!")
- Next comes Uncertainty ("Maybe I can do it!")
- Followed by Resistance ("There's no way I can do it!")
- Then Panic sets in ("Aargh! What if I can't do it!") Sound familiar so far?
- The fifth and final stage is my favorite: Acceptance, ("All right! I did it! Let's Party!").

Sounds good to me! Why not just skip right to "party"?

I've decided that as much as you'd like, it's virtually impossible to reach the final phase without at least passing through the first four. But that glorious fifth stage is just around the corner waiting for you *if* you know how to get to it.

Visualize *your* fifth stage of accomplishment as you begin this year's work of researching listings and mailing out samples. Sure it's going to be a lot of work, and sometimes you'll think you don't have enough energy to do it. And that celebration will feel light years away!

But it will happen! And when it does, please e-mail me and tell me about your success. And you know what my reply will be?

"All Right! You Did it! Let's Party!"

Mary Cox

Mary Cox
artdesign@fwpubs.com

P.S. Have fun this year making and selling your art, and don't forget to enter our annual drawing on page 585 to win a free copy of our next edition!

How to Use This Book

To Sell Your Work

I f you are picking up this book for the first time, you might not know quite how to start using it. Your first impulse might be to flip through and quickly make a mailing list, submitting to everyone with hopes that someone might like your work. Resist that urge.

First you have to narrow down the names in this book to those who need your particular art style. That's what this book is all about. We provide the names and addresses of art buyers along with plenty of marketing tips. You provide the hard work, creativity and patience necessary to hang in there until work starts coming your way.

What you'll find in this book

The book is divided into five parts:

1. Business articles and interviews
2. Section introductions
3. Listings of companies and galleries
4. Insider Reports
5. Indexes

Listings: the heart of this book

This book is divided into market sections, from Greeting Card companies to Record Labels. (See Table of Contents for complete list.) Each section begins with an introduction containing information and advice to help you break into the specific market.

Listings are the life's blood of this book. In a nutshell listings are names, addresses and contact information for places that buy or commission artwork, along with a description of the type of art they need and their submission preferences.

Articles and Interviews

Throughout this book you will find helpful articles and interviews with working artists and experts from the art world. These articles give you a richer understanding of the marketplace by sharing the featured artists' personal experiences and insights. Their stories, and the lessons you can learn from other artists' feats and follies, give you an important edge over artists who skip the articles.

HOW *AGDM* WORKS

Following the instructions in the listings, we suggest you send samples of your work (not originals) to a dozen (or more) targeted listings. The more listings you send to, the greater

your chances. Establish a tracking system to keep track of who you submit your work to and send follow-up mailings to your target markets at least twice a year.

How to read listings

Each listing contains a description of the artwork and/or services it prefers. The information often reveals how much freelance artwork they use, whether computer skills are needed and which software programs are preferred.

In some sections, additional subheads help you identify potential markets. Magazine listings specify needs for cartoons and illustrations. Galleries specify media and style.

Editorial comments, denoted by bullets (•), give you extra information about markets, such as company awards, mergers and insight into a listing's staff or procedures.

It takes a while to get accustomed to the layout and language in the listings. In the beginning, you will encounter some terms and symbols that might be unfamiliar to you. Refer to the Glossary on page 580 to help you with terms you don't understand.

Listings are often preceded by symbols, which help lead the way to new listings **N**, mailing address or contact name changes ☑ and other information. When you encounter these symbols, refer to the inside covers of this book for a complete list of their meanings.

Working with listings

1. Read the entire listing to decide whether to submit your samples. Do *not* use this book simply as a mailing list of names and addresses. Reading listings helps you narrow your mailing list and submit appropriate material.

2. Read the description of the company or gallery in the first paragraph of the listing. Then jump to the **Needs** heading to find out what type of artwork the listing prefers. Is it the type of artwork you create? This is the first step to narrowing your target market. You should only send your samples to listings that need the kind of work you create.

3. Send appropriate submissions. It seems like common sense to research what kind of samples a listing wants before sending off just any artwork you have on hand. But believe it or not, some artists skip this step. Many art directors have pulled their listings from *AGDM* because they've received too many inappropriate submissions. Look under the **First Contact & Terms** heading to find out how to contact the listing. Some companies and publishers are very picky about what kind of samples they like to see; others are more flexible.

What's an inappropriate submission? I'll give you an example. Suppose you want to be a children's book illustrator. Don't send your sample of puppies and kittens to *Business Law Today* magazine—they would rather see law-related subjects. Instead use the Niche Marketing Index on page 587 to find listings that take children's illustrations. You'd be surprised how many illustrators waste their postage sending the wrong samples. And boy, does that alienate art directors. Make sure all your mailings are *appropriate* ones.

4. Consider your competition. Under the **Needs** heading, compare the number of freelancers who contact the listing with the number they actually work with. You'll have a better chance with listings that use a lot of artwork or work with many artists.

5. Look for what they pay. In most sections, you can find this information under **First Contact & Terms**. Book publishers list pay rates under headings pertaining to the type of work you do, such as **Text Illustration** or **Book Design**.

At first, try not to be too picky about how much a listing pays. After you have a couple of assignments under your belt, you might decide to only send samples to medium- or high-paying markets.

6. Be sure to read the Tips! Artists say the information within the **Tips** helps them get a feel for what a company might be like to work for.

These steps are just the beginning. As you become accustomed to reading listings, you

will think of more ways to mine this book for your potential clients. Some of our readers tell us they peruse listings to find the speed at which a magazine pays its freelancers. In publishing, it's often a long wait until an edition or book is actually published, but if you are paid "on acceptance" you'll get a check soon after you complete the assignment and it is approved by the Art Director.

When looking for galleries, savvy artists often check to see how many square feet of space is available and what hours the gallery is open. These details all factor in when narrowing down your search for target markets.

Pay attention to copyright information

It's also important to consider what **rights** listings buy. It is preferable to work with listings that buy first or one-time rights. If you see a listing that buys "all rights," be aware you may be giving up the right to sell that particular artwork in the future. See Copyright Basics on page 20.

Look for specialties and niche markets

Read listings closely. Most describe their specialties, clients and products within the first paragraph of the listing. If you hope to design restaurant menus, for example, target agencies that have restaurants for clients. But if you don't like to draw food-related illustration and prefer illustrating people, you might target ad agencies whose clients are hospitals or financial institutions. If you like to draw cars, look for agencies with clients in the automotive industry, and so on. Many book publishers specialize, too. Look for a publisher who specializes in children's books if that's the type of work you'd like to do. The Niche Marketing Index on page 587 lists possible opportunities for specialization.

Read listings for ideas

You'd be surprised how many artists found new niches they hadn't thought of by browsing the listings. One greeting card artist read about a company that produces mugs. Inspiration struck. Now this artist has added mugs to her repertoire, along with paper plates, figurines and rubber stamps—all because she browsed the listings for ideas!

Sending out samples

Once you narrow down some target markets, the next step is sending them samples of your work. As you create your samples and submission packets, be aware your package or postcard has to look professional. It must be up to the standards art directors and gallery dealers expect. See Promotional Mailings: Let Your Artwork Work for You, on page 14 for a look at some great samples sent out by other artists. Make sure your samples rise to that standard of professionalism.

See you next year!

Use this book for one year. Highlight listings, make notes in the margins, fill it full of Post-it notes. In November of 2006, our next edition—the 2007 *Artist's & Graphic Designer's Market*—starts arriving in bookstores. By then, we'll have collected hundreds of new listings and changes in contact information. It is a career investment to buy the new edition every year. (And it's deductible! See The Business of Art on page 6.)

Join a professional organization

Artists who have the most success using this book are those who take the time to read the articles to learn about the bigger picture. In our interviews and Insider Reports, you'll learn

Getting Started

ICONS FOR
EASY
REFERENCE

WHERE TO
SEND
SUBMISSIONS

WHAT TO
SEND

TIPS STRAIGHT
FROM ART
DIRECTORS

E-MAIL AND
WEBSITE

WHO TO
CONTACT

WHAT
THEY PAY

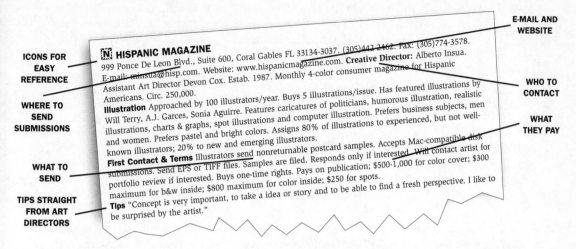

N **HISPANIC MAGAZINE**
999 Ponce De Leon Blvd., Suite 600, Coral Gables FL 33134-3037. (305)442-2462. Fax: (305)774-3578.
E-mail: ainsua@hisp.com. Website: www.hispanicmagazine.com. **Creative Director:** Alberto Insua.
Assistant Art Director Devon Cox. Estab. 1987. Monthly 4-color consumer magazine for Hispanic
Americans. Circ. 250,000.
Illustration Approached by 100 illustrators/year. Buys 5 illustrations/issue. Has featured illustrations by
Will Terry, A.J. Garces, Sonia Aguirre. Features caricatures of politicians, humorous illustration, realistic
illustrations, charts & graphs, spot illustrations and computer illustration. Prefers business subjects, men
and women. Prefers pastel and bright colors. Assigns 80% of illustrations to experienced, but not well-
known illustrators; 20% to new and emerging illustrators.
First Contact & Terms Illustrators send nonreturnable postcard samples. Accepts Mac-compatible disk
submissions. Send EPS or TIFF files. Samples are filed. Responds only if interested. Will contact artist for
portfolio review if interested. Buys one-time rights. Pays on publication; $500-1,000 for color cover; $300
maximum for b&w inside; $800 maximum for color inside; $250 for spots.
Tips "Concept is very important, to take a idea or story and to be able to find a fresh perspective. I like to
be surprised by the artist."

what has worked for other artists and what kind of work impresses art directors and gallery
dealers.

You'll find out how joining professional organizations such as the Graphic Artists Guild
(www.gag.org) or the American Institute of Graphic Arts (www.aiga.org) and the Society of
Children's Writers and Illustrators (www.scbwi.org) can jump start your career. You'll find
out the importance of reading trade magazines such as *HOW* (www.howdesign.com), *Print*
and *Greetings etc.* to learn more about the industries you hope to approach. You'll learn about
trade shows, portfolio days, Web sites, art reps, shipping, billing, working with vendors,
networking, self-promotion and hundreds of other details it would take years to find out about
on your own. Perhaps most importantly, you'll read about how successful artists overcame
rejection through persistence.

Hang in there!

Being professional doesn't happen overnight. It's a gradual process. I would venture to say
that only after two or three years of using each successive year's edition of this book will
you have garnered enough information and experience to be a true professional in your field.
So if you really want to be a professional artist, hang in there. Before long, you'll feel that
heady feeling that comes from selling your work or seeing your illustrations on a greeting
card or in a magazine. If you really want it and you're willing to work for it, it *will* happen.

The Business of Art

How to Stay on Track and Get Paid

As you launch your artistic career, be aware that you are actually starting a small business. It is crucial that you keep track of the details, or your business will not last very long. The most important rule of all is to find a system to keep your business organized and stick with it.

YOUR DAILY RECORD-KEEPING SYSTEM

Every artist needs to keep a daily record of art-making and marketing activities. Before you do anything else, visit an office supply store and pick out the following items (or your own variations of these items). Keep it simple so you can remember your system and use it on automatic pilot whenever you make a business transaction.

What you'll need:

- A packet of colorful file folders or a basic Personal Information Manager on your computer or Palm Pilot.
- A notebook or legal pads to serve as a log or journal to keep track of your daily art-making and art marketing activities.
- A small pocket notebook to keep in your car to track mileage and gas expenses.

How to start your system

- Designate a permanent location in your studio or home office for two file folders and your notebook.
- Label one red file folder "Expenses."
- Label one green file folder "Income."
- Write in your daily log book each and every day.

Every time you purchase anything for your business, such as envelopes or art supplies, place the receipt in your red Expenses folder. When you receive payment for an assignment or painting, photocopy the check or place the receipt in your green Income folder.

That's all there is to it. By the way, if you purchase any of the suggested supplies at the store, place your receipt in the "Expenses" folder. Congratulations! You've already begun to use your record-keeping system!

Job jackets keep assignments on track

Whether you are an illustrator or fine artist, you should devise a system for keeping track of assignments and artworks. Most illustrators assign job numbers to each assignment they receive and create job jacket or file folders for each job. Some file these folders by client

name; others keep them in numerical order. The important thing is to keep all correspondence for each assignment in a spot where you can easily find it.

Pricing illustration and design

One of the hardest things to master is what to charge for your work. It's difficult to make blanket statements on this topic. Every slice of the market is somewhat different. Nevertheless, there is one recurring pattern: Hourly rates are generally only paid to designers working

Pricing Your Fine Art

Tips

There are no hard-and-fast rules for pricing your fine artwork. Most artists and galleries base prices on market value—what the buying public is currently paying for similar work. Learn the market value by visiting galleries and checking prices of works similar to yours. When you are starting out, don't compare your prices to established artists but to emerging talent in your region. Consider these when determining price:

- **Medium.** Oils and acrylics cost more than watercolors by the same artist. Price paintings higher than drawings.

- **Expense of materials.** Charge more for work done on expensive paper than for work of a similar size on a lesser grade paper.

- **Size.** Though a large work isn't necessarily better than a small one, as a rule of thumb you can charge more for the larger work.

- **Scarcity.** Charge more for one-of-a-kind works like paintings and drawings, than for limited editions such as lithographs and woodcuts.

- **Status of artist.** Established artists can charge more than lesser-known artists.

- **Status of gallery.** Prestigious galleries can charge higher prices.

- **Region.** Works usually sell for more in larger cities like New York and Chicago.

- **Gallery commission.** The gallery will charge from 30 to 50 percent commission. Your cut must cover the cost of materials, studio space, taxes and perhaps shipping and insurance, and enough extra to make a profit. If materials for a painting cost $25, matting and framing cost $37 and you spent five hours working on it, make sure you get at least the cost of material and labor back before the gallery takes their share. Once you set your price, stick to the same price structure wherever you show your work. A $500 painting by you should cost $500 whether it is bought in a gallery or directly from you. To do otherwise is not fair to the gallery and devalues your work.

As you establish a reputation, begin to raise your prices—but do so cautiously. Each time you graduate to a new price level, it becomes more difficult to come back down.

in house on a client's equipment. Freelance illustrators working out of their own studios are almost always paid a flat fee or an advance against royalties.

If you don't know what to charge, begin by devising an hourly rate, taking into consideration the cost of materials and overhead and what you think your time is worth. If you are a designer, determine what the average salary would be for a full-time employee doing the same job. Then estimate how many hours the job will take and quote a flat fee based on these calculations.

There is a distinct difference between giving the client a job estimate and a job quote. An estimate is a ballpark figure of what the job will cost but is subject to change. A quote is a set fee which, once agreed upon, is pretty much carved in stone. Make sure the client understands which you are negotiating. Estimates are often used as a preliminary step in itemizing costs for a combination of design services such as concepting, typesetting and printing. Flat quotes are usually used by illustrators, as there are fewer factors involved in arriving at fees.

For recommended fees for different services, refer to *Graphic Designer's Guide to Pricing, Estimating & Budgeting,* by Theo Stephan Williams and the *Graphic Artist's Guild's Handbook of Pricing & Ethical Guidelines,* 11th edition. Many artists' organizations have hotlines you can call to find out standard payment for the job you're doing.

As you set fees, certain stipulations call for higher rates. Consider these bargaining points:

- **Usage (rights).** The more rights purchased, the more you can charge. For example, if the client asks for a "buyout" (to buy all rights), you can charge more, because by relinquishing all rights to future use of your work, you will be losing out on resale potential.
- **Turnaround time.** If you are asked to turn the job around quickly, charge more.
- **Budget.** Don't be afraid to ask a project's budget before offering a quote. You won't want to charge $500 for a print ad illustration if the ad agency has a budget of $40,000 for that ad. If the budget is that big, ask for higher payment.
- **Reputation.** The more well known you are, the more you can charge. As you become established, periodically raise your rates (in small steps) and see what happens.

What goes in a contract?

Contracts are simply business tools to make sure everyone is in agreement. Ask for one any time you enter into a business agreement. Be sure to arrange for the specifics in writing or provide your own. A letter stating the terms of agreement signed by both parties can serve as an informal contract. Several excellent books, such as *Legal Guide for the Visual Artist* (Fourth Edition) and *Business and Legal Forms for Illustrators,* both by Tad Crawford (Allworth Press), contain negotiation checklists and tear-out forms and provide sample contracts you can copy. The sample contracts in these books cover practically any situation you might run into.

The items specified in your contract will vary according to the market you are dealing with and the complexity of the project. Nevertheless, here are some basic points you'll want to cover:

Commercial contracts
- **A description of the service you are providing.**
- **Deadlines for finished work.**
- **Rights sold.**
- **Your fee.** Hourly rate, flat fee or royalty.
- **Kill fee.** Compensatory payment received by you if the project is cancelled.
- **Changes fees.** Penalty fees to be paid by the client for last-minute changes.
- **Advances.** Any funds paid to you before you begin working on the project.

- **Payment schedule.** When and how often you will be paid for the assignment.
- **Statement regarding return of original art.** Unless you are doing work for hire, your artwork should always be returned to you.

Gallery contracts

- **Terms of acquisition or representation.** Will the work be handled on consignment? What is the gallery's commission?
- **Nature of the show(s).** Will the work be exhibited in group or solo shows or both?
- **Time frames.** At what point will the gallery return unsold works to you? When will the contract cease to be in effect? If a work is sold, when will you be paid?
- **Promotion.** Who will coordinate and pay for promotion? What does promotion entail? Who pays for printing and mailing of invitations? If costs are shared, what is the breakdown?
- **Insurance.** Will the gallery insure the work while it is being exhibited?
- **Shipping.** Who will pay for shipping costs to and from the gallery?
- **Geographic restrictions.** If you sign with this gallery, will you relinquish the rights to show your work elsewhere in a specified area? If so, what are the boundaries of this area?

How to send invoices

If you are a designer or illustrator, you will be responsible for sending invoices for your services. Clients generally will not issue checks without them, so mail or fax an invoice as soon as you've completed the assignment. Illustrators are generally paid in full either upon receipt of illustration or on publication. Most graphic designers arrange to be paid in thirds, billing the first third before starting the project, the second after the client approves the initial roughs and the third upon completion of the project.

Standard invoice forms allow you to itemize your services. The more you spell out the charges, the easier it will be for your clients to understand what they are paying for. Most freelancers charge extra for changes made after approval of the initial layout. Keep a separate form for change orders and attach it to your invoice.

If you are an illustrator, your invoice can be much simpler, as you'll generally be charging a flat fee. It's helpful, in determining your quoted fee, to itemize charges according to time, materials and expenses. (The client need not see this itemization; it is for your own purposes.)

Most businesses require your social security number or tax ID number before they can cut a check, so include this information in your bill. Be sure to put a due date on each invoice; include the phrase "payable within 30 days" (or other preferred time frame) directly on your invoice. Most freelancers ask for payment within 10-30 days.

Sample invoices are featured in *Business and Legal Forms for Illustrators* and *Business and Legal Forms for Graphic Designers*, by Tad Crawford (Allworth Press).

If you are working with a gallery, you will not need to send invoices. The gallery should send you a check each time one of your pieces is sold (generally within 30 days). To ensure that you are paid promptly, call the gallery periodically to touch base. Let the director or business manager know that you are keeping an eye on your work. When selling work independently of a gallery, give receipts to buyers and keep copies for your records.

Take advantage of tax deductions

You have the right to deduct legitimate business expenses from your taxable income. Art supplies, studio rent, printing costs and other business expenses are deductible against your gross art-related income. It is imperative to seek the help of an accountant or tax preparation service in filing your return. In the event your deductions exceed profits, the loss will lower your taxable income from other sources.

The Art of Business

Can I Deduct My Home Studio?

Important

If you freelance full time from your home and devote a separate area to your business, you may qualify for a home office deduction. If eligible, you can deduct a percentage of your rent or mortgage and utilities and expenses like office supplies and business-related telephone calls.

The IRS does not allow deductions if the space is used for reasons other than business. A studio or office in your home must meet three criteria:

- The space must be used exclusively for your business.

- The space must be used regularly as a place of business.

- The space must be your principle place of business.

The IRS might question a home office deduction if you are employed full time elsewhere and freelance from home. If you do claim a home office, the area must be clearly divided from your living area. A desk in your bedroom will not qualify. To figure out the percentage of your home used for business, divide the total square footage of your home by the total square footage of your office. This will give you a percentage to work with when figuring deductions. If the home office is 10% of the square footage of your home, deduct 10% of expenses such as rent, heat and air conditioning.

The total home office deduction cannot exceed the gross income you derive from its business use. You cannot take a net business loss resulting from a home office deduction. Your business must be profitable three out of five years. Otherwise, you will be classified as a hobbyist and will not be entitled to this deduction.

Consult a tax advisor before attempting to take this deduction, since its interpretations frequently change.

For additional information, refer to IRS Publication 587, Business Use of Your Home, which can be downloaded at www.irs.gov or ordered by calling (800)829-3676.

To guard against taxpayers fraudulently claiming hobby expenses as business losses, the IRS requires taxpayers demonstrate a "profit motive." As a general rule, you must show a profit three out of five years to retain a business status. If you are audited, the burden of proof will be on you to demonstrate your work is a business and not a hobby.

The nine criteria the IRS uses to distinguish a business from a hobby are:

- the manner in which you conduct your business
- expertise
- amount of time and effort put into your work
- expectation of future profits
- success in similar ventures
- history of profit and losses
- amount of occasional profits

- financial status
- element of personal pleasure or recreation

If the IRS rules that you paint for pure enjoyment rather than profit, they will consider you a hobbyist. Complete and accurate records will demonstrate to the IRS that you take your business seriously.

Even if you are a "hobbyist," you can deduct expenses such as supplies on a Schedule A, but you can only take art-related deductions equal to art-related income. If you sold two $500 paintings, you can deduct expenses such as art supplies, art books and seminars only up to $1,000. Itemize deductions only if your total itemized deductions exceed your standard deduction. You will not be allowed to deduct a loss from other sources of income.

How to fill out a Schedule C

To deduct business expenses, you or your accountant will fill out a 1040 tax form (not 1040EZ) and prepare a Schedule C. Schedule C is a separate form used to calculate profit or loss from your business. The income (or loss) from Schedule C is then reported on the 1040 form. In regard to business expenses, the standard deduction does not come into play as it would for a hobbyist. The total of your business expenses need not exceed the standard deduction.

There is a shorter form called Schedule C-EZ for self-employed people in service industries. It can be applicable to illustrators and designers who have receipts of $25,000 or less and deductible expenses of $2,000 or less. Check with your accountant to see if you qualify.

Deductible expenses include advertising costs, brochures, business cards, professional group dues, subscriptions to trade journals and arts magazines, legal and professional services, leased office equipment, office supplies, business travel expenses, etc. Your accountant can give you a list of all 100 percent and 50 percent deductible expenses (such as entertainment). And don't forget to deduct the cost of this book.

As a self-employed "sole proprieter," there is no employer regularly taking tax out of your paycheck. Your accountant will help you put money away to meet your tax obligations and may advise you to estimate your tax and file quarterly returns.

Your accountant also will be knowledgeable about another annual tax called the Social Security Self-Employment tax. You must pay this tax if your net freelance income is $400 or more.

The fees of tax professionals are relatively low, and they are deductible. To find a good accountant, ask colleagues for recommendations, look for advertisements in trade publications or ask your local Small Business Association.

Whenever possible, retain your independent contractor status

Some clients automatically classify freelancers as employees and require them to file Form W-4. If you are placed on employee status, you may be entitled to certain benefits but a portion of your earnings will be withheld by the client until the end of the tax year and you could forfeit certain deductions. In short, you may end up taking home less than you would if you were classified as an independent contractor.

The IRS uses a list of 20 factors to determine whether a person should be classified as an independent contractor or an employee. This list can be found in the IRS Publication 937. Note, however, that your client will be the first to decide how you will be classified.

Report all income to Uncle Sam

Don't be tempted to sell artwork without reporting it on your income tax. You may think this saves money, but it can do real damage to your career and credibility—even if you are

never audited by the IRS. Unless you report your income, the IRS will not categorize you as a professional, and you won't be able to deduct expenses. And don't think you won't get caught if you neglect to report income. If you bill any client in excess of $600, the IRS requires the client to provide you with a form 1099 at the end of the year. Your client must send one copy to the IRS and a copy to you to attach to your income tax return. Likewise, if you pay a freelancer over $600, you must issue a 1099 form. This procedure is one way the IRS cuts down on unreported income.

Register with the state sales tax department

Most states require a two to seven percent sales tax on artwork you sell directly from your studio or at art fairs or on work created for a client. You must register with the state sales tax department, which will issue you a sales permit or a resale number and send you appropriate forms and instructions for collecting the tax. Getting a sales permit usually involves filling out a form and paying a small fee. Reporting sales tax is a relatively simple procedure. Record all sales taxes on invoices and in your sales journal. Every three months, total the taxes collected and send it to the state sales tax department.

In most states, if you sell to a customer outside of your sales tax area, you do not have to collect sales tax. However, this may not hold true for your state. You may also need a business license or permit. Call your state tax office to find out what is required.

Save money on art supply sales tax

As long as you have the above sales permit number, you can buy art supplies without paying sales tax. You will probably have to fill out a tax-exempt form with your permit number at the sales desk where you buy materials. The reason you do not have to pay sales tax on art supplies is that sales tax is only charged on the final product. However, you must then add the cost of materials into the cost of your finished painting or the final artwork for your client. Keep all receipts in case of a tax audit. If the state discovers that you have not collected sales tax, you will be liable for tax and penalties.

If you sell all your work through galleries, they will charge sales tax, but you still need a tax exempt number to get a tax exemption on supplies.

Some states claim "creativity" is a non-taxable service, while others view it as a product and therefore taxable. Be certain you understand the sales tax laws to avoid being held liable for uncollected money at tax time. Write to your state auditor for sales tax information.

Save money on postage

When you send out postcard samples or invitations to openings, you can save big bucks by mailing bulk. Fine artists should send submissions via first class mail for quicker service and better handling. Package flat work between heavy cardboard or foam core, or roll it in a cardboard tube. Include your business card or a label with your name and address on the outside of the packaging material in case the outer wrapper becomes separated from the inner packing in transit.

Protect larger works—particularly those that are matted or framed—with a strong outer surface, such as laminated cardboard, masonite or light plywood. Wrap the work in polyfoam, heavy cloth or bubble wrap and cushion it against the outer container with spacers to keep from moving. Whenever possible, ship work before it is glassed. If the glass breaks en route, it may destroy your original image. If you are shipping large framed work, contact a museum in your area for more suggestions on packaging.

The U.S. Postal Service will not automatically insure your work, but you can purchase up to $600 worth of coverage. Artworks exceeding this value should be sent by registered mail. Certified packages travel a little slower but are easier to track.

Helpful Resources

For More Info

Most IRS offices have walk-in centers open year-round and offer over 90 free IRS publications to help taxpayers. Some helpful booklets include Publication 334—Tax Guide for Small Business; Publication 505—Tax Withholding and Estimated Tax; and Publication 533—Self Employment Tax. Order by phone at (800)829-3676.

There's plenty of great advice on the Internet, too. Check out the official IRS website: www.irs.gov. Fun graphics lead you to information, and you can even download tax forms.

If you don't have access to the Web, the booklet that comes with your tax return forms contains addresses of regional Forms Distribution Centers you can write to for information.

The U.S. Small Business Administration offers seminars and publications to help you launch your business. Check out their extensive website at www.sba.gov.

Arts organizations hold many workshops covering business management, often including detailed tax information. Inquire at your local arts council, arts organization or university to see if a workshop is scheduled.

The Service Corp of Retired Executives (SCORE) offers free business counseling via e-mail at their website at www.score.org.

The Art of Business

Consider special services offered by the post office, such as Priority Mail, Express Mail Next Day Service and Special Delivery. For overnight delivery, check to see which air freight services are available in your area. Federal Express automatically insures packages for $100 and will ship art valued up to $500. Their 24-hour computer tracking system enables you to locate your package at any time.

UPS automatically insures work for $100, but you can purchase additional insurance for work valued as high as $25,000 for items shipped by air (there is no limit for items sent on the ground). UPS cannot guarantee arrival dates but will track lost packages. It also offers Two-Day Blue Label Air Service within the U.S. and Next Day Service in specific zip code zones.

Before sending any original work, make sure you have a copy (photocopy, slide or transparency) in your files. Always make a quick address check by phone before putting your package in the mail.

Send us your business tips!

If you've discovered a business strategy we've missed, please write to *Artist's & Graphic Designer's Market*, 4700 East Galbraith Road, Cincinnati OH 45236 or e-mail us at artdesign@f wpubs.com. A free copy of the 2007 edition goes to the best five suggestions.

Promotional Mailings

Let Your Artwork Work for You

So you're ready to launch your freelance art or gallery career. How do you let people know about your talent? One way is by introducing yourself to them by sending promotional samples. Samples are your most important sales tool so put a lot of thought into what you send. Your ultimate success depends largely on the impression they make.

We divided this article into three sections, so whether you are a fine artist, illustrator or designer, check the appropriate heading for guidelines. Read individual listings and section introductions thoroughly for more specific instructions.

As you read the listings, you'll see the term SASE, short for self-addressed, stamped envelope. Enclose a SASE with your submissions if you want your material returned. If you send postcards or tearsheets, no return envelope is necessary. Many art directors only want nonreturnable samples. More and more, busy art directors do not have time to return samples, even with SASEs. So read listings carefully and save stamps!

ILLUSTRATORS AND CARTOONISTS

You will have several choices when submitting to magazines, book publishers and other illustration and cartoon markets. Many freelancers send a cover letter and one or two samples in initial mailings. Others prefer a simple postcard showing their illustrations. Here are a few of your options:

Postcard. Choose one (or more) of your illustrations or cartoons that is representative of your style, then have the image printed on postcards. Have your name, address and phone number printed on the front of the postcard or in the return address corner. Somewhere on the card should be printed the word "Illustrator" or "Cartoonist." If you use one or two colors, you can keep the cost below $200. Art directors like postcards because they are easy to file or tack on a bulletin board. If the art director likes what she sees, she can always call you for more samples.

Promotional sheet. If you want to show more of your work, you can opt for an 8½×11 color or black and white photocopy of your work. No matter what size sample you send, never fold the page. It is more professional to send them flat, in a 9×12 envelope, along with a typed query letter, preferably on your own professional stationery.

Tearsheets. After you complete assignments, acquire copies of any printed pages on which your illustrations appear. Tearsheets impress art directors because they are proof that you are experienced and have met deadlines on previous projects.

Photographs. Some illustrators have been successful sending photographs, but printed or photocopied samples are preferred by most art directors. It is probably not practical or effective to send slides.

© Aaron Meshon

Aaron Meshon's goals for sending promotional postcards were to broaden his client base, remind former clients he is "still alive" and direct people to his website www.aaronmeshon.com. His plan worked. His mailing of the postcards pictured above garnered 10 assignments from new clients and 15 from old clients. Meshon does not send promotional e-mails, because he has an affinity for holding the concrete art in his hands and has talked to art directors who feel the same way. "Sometimes the personal touch of a hand written greeting makes all the difference." For inspiration, Aaron Meshon tries to see life through the eyes of a child or as though he were a tourist, transforming the mundane into something extraordinary. Meshon also travels quite a bit, and thinks exploring new places, whether foreign country or a new neighborhood, can work as an exceptional muse. "Le Petit Parisian" was inspired by a trip to Paris where Meshon learned you definitely have to "watch your step." In addition to sending postcards, Meshon recommends keeping an updated website and listing on a few portfolio websites like www.altpick.com and www.theispot.com.

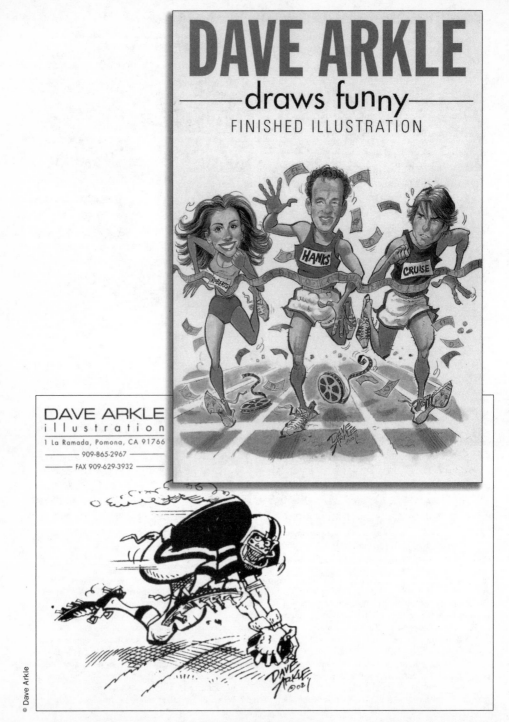

"Dave Arkle draws funny" is a tagline this busy illustrator prints on his promotional postcards and promo sheets. He mails twice a year to past and potential clients, always updating images to something current. Whether it is Cruise, Leno, Letterman, Julia or Gwyneth, this artist knows just how to draw them in funny situations to catch the art director's eye. See more of his work at davearkledrawsfunny.com.

Query or cover letter. A query letter is a nice way to introduce yourself to an art director for the first time. One or two paragraphs stating you are available for freelance work is all you need. Include your phone number, samples or tearsheets.

E-mail submissions. E-mail is another great way to introduce your work to potential clients. When sending e-mails, provide a link to your website or JPEGs of your best work.

DESIGNERS AND COMPUTER ARTISTS

Plan and create your submission package as if it were a paying assignment from a client. Your submission piece should show your skill as a designer. Include one or both of the following:

Cover letter. This is your opportunity to show you can design a beautiful, simple logo or letterhead for your own business card, stationery and envelopes. Have these all-important pieces printed on excellent quality bond paper. Then write a simple cover letter stating your experience and skills.

Sample. Your sample can be a copy of an assignment you have done for another client or a clever self-promotional piece. Design a great piece to show off your capabilities. For ideas and inspiration, browse through *Designers' Self-Promotion: How Designers and Design Companies Attract Attention to Themselves*, by Roger Walton (HBI).

STAND OUT FROM THE CROWD

You may only have a few seconds to grab art directors' attention as they make their way through the "slush" pile (an industry term for unsolicited submissions). Make yourself stand out in simple, effective ways:

Tie in your cover letter with your sample. When sending an initial mailing to a potential client, include a cover letter of introduction with your sample. Type it on a great-looking letterhead of your own design. Make your sample tie in with your cover letter by repeating a design element from your sample onto your letterhead. List some of your past clients within your letter.

Send artful invoices. After you complete assignments, a well-designed invoice (with one of your illustrations or designs strategically placed on it, of course) will make you look professional and help art directors remember you—and hopefully, think of you for another assignment!

Follow up with seasonal promotions. Many illustrators regularly send out holiday-themed promo cards. Holiday promotions build relationships while reminding past and potential clients of your services. It's a good idea to get out your calendar at the beginning of each year and plan some special promos for the year's holidays.

ARE PORTFOLIOS NECESSARY?

You do not need to send a portfolio when you first contact a market. But after buyers see your samples they may want to see more, so have a portfolio ready to show.

Many successful illustrators started their careers by making appointments to show their portfolios. But it is often enough for art directors to see your samples.

Some markets in this book have drop-off policies, accepting portfolios one or two days a week. You will not be present for the review and can pick up the work a few days later, after they've had a chance to look at it. Since things can get lost, include only duplicates that can be insured at a reasonable cost. Only show originals when you can be present for the review. Label your portfolio with your name, address and phone number.

PORTFOLIO POINTERS

The overall appearance of your portfolio affects your professional presentation. It need not be made of high-grade leather to leave a good impression. Neatness and careful organization are

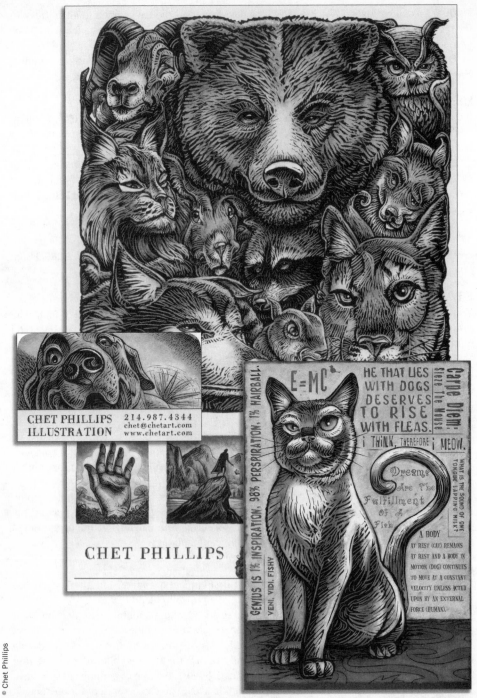

© Chet Phillips

One of the most striking aspects of Chet Phillips' work is its unified style, achieved using digital scratch board in Corel Painter. Phillips sends these self-promotional pieces to remind clients that he's ''out here in the world, ready to concoct as much visual foolishness as the law allows.'' In addition to promotional mailings, Phillips also launched an online portfolio at www.chetart.com and sells stock art, magnets and calendars at www.cafepress.com/chetstore. Why spend so much time and energy on self-promotion? It helps him ''attract enough business to keep our two cats, Lily and Brodie, whisker high in deluxe kitty treats.''

essential whether you are using a three-ring binder or a leather case. The most popular portfolios are simulated leather with puncture-proof sides that allow the inclusion of loose samples. Choose a size that can be handled easily. Avoid the large, "student" size books which are too big to fit easily on an art director's desk. Most artists choose 11×14 or 18×24. If you are a fine artist and your work is too large for a portfolio, bring your slides and a few small samples.

- **Don't include everything you've done in your portfolio.** Select only your best work and choose pieces germane to the company or gallery you are approaching. If you're showing your book to an ad agency, for example, don't include greeting card illustrations.
- **Show progressives.** In reviewing portfolios, art directors look for consistency of style and skill. They sometimes like to see work in different stages (roughs, comps and finished pieces) to see the progression of ideas and how you handle certain problems.
- **Allow your work to speak for itself when presenting your portfolio.** It's best to keep explanations to a minimum and be available for questions if asked. Prepare for the review by taking along notes on each piece. If the buyer asks a question, take the opportunity to talk a little bit about the piece in question. Mention the budget, time frame and any problems you faced and solved. If you are a fine artist, talk about how the piece fits into the evolution of a concept and how it relates to other pieces you've shown.
- **Leave a business card.** Don't ever walk out of a portfolio review without leaving the buyer a sample to remember you by. A few weeks after your review, follow up by sending a small promo postcard or other sample as a reminder.

Print & Mail Through the USPS

Tip

If you're looking for a convenient, timesaving and versatile service for printing and mailing promotional postcards consider the U.S. Postal Service. USPS offers a postcard service through their website. You can have promotional postcards printed either on 4×6 or 6×9 glossy cardstock and buy as many or as little as you need. Postcards cost 79 cents for 4×6 and $1.30 for 6×9—which includes the cost of postage.

One drawback of going through the USPS is that you can't order a certain amount of postcards to keep on hand—cards must be addressed through the website and are mailed out for you automatically. But you can essentially create a personal database and simply click on an address and mail a promo card whenever needed. You can upload different images to the site, www.usps.com, and create postcards that are geared to specific companies. (When you visit the site, click on "Send Cards & Letters" in the "Send Mail & Packages" box.)

GUIDELINES FOR FINE ARTISTS

Send a 9×12 envelope containing material galleries request in their listings. Usually that means a query letter, slides and résumé, but check each listing. Some galleries like to see more. Here's an overview of the various components you can include:

- **Slides.** Send 8-12 slides of similar work in a plastic slide sleeve (available at art supply stores). To protect slides from being damaged, insert slide sheets between two pieces of cardboard. Ideally, slides should be taken by a professional photographer, but if you

The Art of Business

© Robert Carter

www.crackedhat.com
rob@crackedhat.com
905.333.9209

ROBERT CARTER'S
CRACKED HAT ILLUSTRATION

When designing this promotional piece, Robert Carter was artistic, as well as *strategic* in the placement of his name and contact information directly in the center of his artwork, so that it could also serve as a mailer. This allows Carter to not only put his talent front and center, but also his name at the forefront which is essential in self-promotion. To establish an identity, Carter chose the name "Cracked Hat Illustration" as a moniker that derives from a strange self-portrait he drew that his friend entitled, "Musings from a Cracked Head."

© 2003 Mark Bieber

Mark Bieber
Illustration / Portraits

© Mark Bieber

Mark Bieber had a light bulb moment when he read about promotional postcards in *Artist's & Graphic Designer's Market*: ''Here's an example of your art, instantly viewable to the recipient, equipped with contact information.'' Bieber's cards have landed him quite a bit of work and ignited a fire under his career.

must take your own slides, refer to *The Quick & Easy Guide to Photographing Your Artwork,* by Roger Saddington (North Light Books), or *Photographing Your Artwork,* by Russell Hart and Nan Star (Amherst Media). Label each slide with your name, the title of the work, media and dimensions of the work and an arrow indicating the top of the slide. Include a list of titles and suggested prices they can refer to as they review slides. Make sure the list is in the same order as the slides. Type your name, address and phone number at the top of the list. Don't send a variety of unrelated work. Send work that shows one style or direction.

- **Query letter or cover letter.** Type one or two paragraphs expressing your interest in showing at the gallery, and include a date and time when you will follow up.
- **Résumé or bio.** Your résumé should concentrate on your art-related experience. List any shows your work has been included in and the dates. A bio is a paragraph describing where you were born, your education, the work you do and where you have shown in the past.
- **Artist's statement.** Some galleries require a short statement about your work and the themes you are exploring. Your statement should show you have a sense of vision. It should also explain what you hope to convey in your work.
- **Portfolios.** Gallery directors sometimes ask to see your portfolio, but they can usually judge from your slides whether your work would be appropriate for their galleries. Never visit a gallery to show your portfolio without first setting up an appointment.
- **SASE.** If you need material back, don't forget to include a SASE.

Reach Out to New Clients

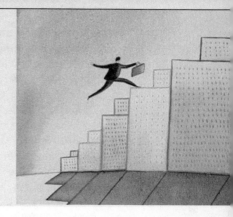

by Maria Piscopo

Today's competitive marketplace has most freelancers asking what clients really want when they are buying services. The key is to look at the client you don't have yet, not necessarily your regular clients! Regular clients are already giving you work. *Do* keep selling to them but devise a second plan to reach out to prospective clients in a new way. This article will give you some self-promotion tips as well as some testimonials from clients. Please remember these tips and testimonials are for prospective clients. How do they want to be sold to? Ask them!

- **Clients will categorize your services** in order to find you when they need you. Photography, illustration and design are very broad catchall categories. Have separate promotions when you sell different styles or types of freelance work.
- **Sourcebook ads** are especially important for illustrators and photographers with a strong visual style. The ads allow you to "broadcast" your message and let clients call you. Always be able to support that style with a complete portfolio of similar visuals.
- **Use direct mail with really strong images.** Show the purest work, show what you *can* do not necessarily what your current client did with the work. Often, clients don't know what was your work and what was post-production.
- **Plan a manageable portfolio,** not too many pieces, something clients can simply and quickly categorize. It does put you in a pigeonhole, but at least it puts you somewhere!
- **Don't make wasted calls!** It's hard for clients to take "Hey, how's it going?" calls. Have a good strong verbal script before you pick up the phone.
- **Clients need to be reminded of your work very consistently.** What stops most freelancers is the lack of a plan for sending promos and for having enough promos to send. For prospective clients you have been in constant touch with and not worked with yet, it is time to get creative. Send interesting article clippings, notices of gallery openings, congratulations on a new business pitch or product they are working on even invitations to join you at industry association meetings! Contact your local chapters of American Society of Media Photographers, American Institute of Graphic Arts, The Graphic Artists Guild or The Ad Club to name just a few to attend with your clients.
- **Bottom line is that a lot of this is timing.** The more follow-up you send, the more likely your promo arrives when the perfect project for you comes in.

For more information on **MARIA PISCOPO** and her book, *Graphic Designer's and Illustrator's Guide to Marketing and Promotion*, published by Allworth Press and co-published with the Graphic Artists Guild, visit www.mpiscopo.com.

Now, let's hear from some clients

From **Michelle Gauthier**, Marketing and Communications Manager at Waterloo Maple, Inc. "To me, an impressive portfolio that always gets my attention contains freelance work relating to my own industry, information technology."

Tracy Smith, Art Director at Spring Industries, tells us "First send your promotional pieces, call to follow-up to get your foot in the door and setup a time we can meet face-to-face. This is hard to do but *don't* give up."

Meredith Brison, Creative Department Manager for Ha*lo Advertising agrees, "Do your follow-up! I have a particular freelance illustrator who sends me samples of his most current work as updates. It is a subtle yet effective way to keep his name in my mind. It is one of the best examples of being creative and knowing how to do business I have seen."

Rob O'Reilly, Senior Art Director at Access Advertising, "Send something completely unexpected. Most promos are boring. The more weird and off-center, the better!"

The Art of Business

Copyright Basics

What You Need to Know

As creator of your artwork, you have certain inherent rights over your work and can control how each one of your artworks is used, until you sell your rights to someone else.

The legal term for these rights is called **copyright**. Technically, any original artwork you produce is automatically copyrighted as soon as you put it in tangible form.

To be automatically copyrighted, your artwork must fall within these guidelines:

- **It must be your *original* creation.** It cannot be a *copy* of somebody else's work.
- **It must be "pictorial, graphic, or sculptural."** Utilitarian objects, such as lamps or toasters, are not covered, although you can copyright an illustration featured on a lamp or toaster.
- **It must be fixed in "any tangible medium, now known or later developed."** Your work, or at least a representation of a planned work, must be created in or on a medium you can see or touch, such as paper, canvas, clay, a sketch pad or even a website. It can't just be an idea in your head. An idea cannot be copyrighted.

Copyright lasts for your lifetime plus seventy years

Copyright is *exclusive*. When you create a work, the rights automatically belong to you and nobody else but you until you sell those rights to someone else.

Works of art created on or after January 1978 are protected for your lifetime plus 70 years.

The artist's bundle of rights

One of the most important things you need to know about copyright is that it is not just a *singular* right. It is a *bundle* of rights you enjoy as creator of your artwork. Let's take a look at the five major categories in your bundle of rights and examine them individually:

- **Reproduction right.** You have the right to make copies of the original work.
- **Modification right.** You have the right to create derivative works based on the original work.
- **Distribution rights.** You have the right to sell, rent or lease copies of your work.
- **Public performance right.** The right to play, recite or otherwise perform a work. (This right is more applicable to written or musical art forms than visual art.)
- **Public display right.** You have the right to display your work in a public place.

This bundle of rights can be divided up in a number of ways, so that you can sell all or part of any of those exclusive rights to one or more parties. The system of selling parts of your copyright bundle is sometimes referred to as **"divisible" copyright**. Just as a land

owner could divide up his property and sell it to many different people, the artist can divide up his rights to an artwork and sell portions of those rights to different buyers.

Divisible copyright: Divide and conquer

Why is this so important? Because dividing up your bundle and selling parts of it to different buyers will help you get the most payment from each of your artworks. For any one of your artworks, you can sell your entire bundle of rights at one time (not advisable!) or divide and sell each bundle pertaining to that work into smaller portions and make more money as a result. You can grant one party the right to use your work on a greeting card and sell another party the right to print that same work on T-shirts.

Clients tend to use legal jargon to specify the rights they want to buy. The terms below are commonly used in contracts to specify portions of your bundle of rights. Some terms are vague or general, such as "all rights"; others are more specific, such as "first North American rights." Make sure you know what each term means.

Divisible copyright terms

- **One-time rights.** Your client buys the right to use or publish your artwork or illustration on a one-time basis. One fee is paid for one use. Most magazine and bookcover assignments fall under this category.
- **First rights.** This is almost the same as purchase of one-time rights, except that the buyer is also paying for the privilege of being the first to use your image. He may use it only once unless the other rights are negotiated.

 Sometimes first rights can be further broken down geographically when a contract is drawn up. The buyer might ask to buy **first North American rights,** meaning he would have the right to be the first to publish the work in North America.
- **Exclusive rights.** This guarantees the buyer's exclusive right to use the artwork in his particular market or for a particular product. Exclusive rights are frequently negotiated by greeting card and gift companies. One company might purchase the exclusive right to use your work as a greeting card, leaving you free to sell the exclusive rights to produce the image on a mug to another company.
- **Promotion rights.** These rights allow a publisher to use an artwork for promotion of a publication in which the artwork appeared. For example, if *The New Yorker* bought promotional rights to your cartoon, they could also use it in a direct mail promotion.
- **Electronic rights.** These rights allow a buyer to place your work on electronic media such as websites. Often these rights are requested with print rights.
- **Work for hire.** Under the Copyright Act of 1976, section 101, a "work for hire" is defined as "(1) a work prepared by an employee within the scope of his or her employment; or (2) a work . . . specially ordered or commissioned for use as a contribution to a collective, as part of a motion picture or audiovisual work or as a supplementary work . . . if the parties expressly agree in a written instrument signed by them that the work shall be considered a work made for hire." When the agreement is "work for hire," you surrender all rights to the image and can never resell that particular image again. If you agree to the terms, make sure the money you receive makes it well worth the arrangement.
- **All rights.** Again, be very aware that this phrase means you will relinquish your right to a specific artwork. Before agreeing to the terms, make sure this is an arrangement you can live with. At the very least, arrange for the contract to expire after a specified date. Terms for all rights—including time period for usage and compensation—should be confirmed in a written agreement with the client.

Since legally your artwork is your property, when you create an illustration for a magazine you are, in effect, temporarily "leasing" your work to the client for publication. Chances are you'll never hear an art director ask to lease or license your illustration, and he may not even realize he is leasing, not buying, your work. But most art directors know that once the magazine is published, the art director has no further claims to your work and the rights revert back to you. If the art director wants to use your work a second or third time, he must ask permission and negotiate with you to determine any additional fees you want to charge. You are free to take that same artwork and sell it to another buyer.

However, had the art director bought "all rights," you could not legally offer that same image to another client. If you agreed to create the artwork as "work for hire," you relinquished your rights entirely.

What licensing agents know

The practice of leasing parts or groups of an artist's bundle of rights is often referred to as **"licensing,"** because (legally) the artist is granting someone a "license" to use his work for a limited time for a specific reason. As licensing agents have come to realize, it is the exclusivity of the rights and the ability to divide and sell them that make them valuable. Knowing exactly what rights you own, which you can sell, and in what combinations will help you negotiate with your clients.

Don't sell conflicting rights to different clients

You also have to make sure the rights you sell to one client don't conflict with any of the rights sold to other clients. For example, you can't sell the exclusive right to use your image on greeting cards to two separate greeting card companies. You *can* sell the exclusive greeting card rights to one card company and the exclusive rights to use your artwork on mugs to a separate gift company. It's always good to get such agreements in writing and to let both companies know your work will appear on other products.

When to use the Copyright © and credit lines

A copyright notice consists of the word "Copyright" or its symbol ©, the year the work was created or first published and the full name of the copyright owner. It should be placed where it can easily be seen, on the front or back of an illustration or artwork. It's also common to print your copyright notice on slide mounts or onto labels on the back of photographs.

Under today's laws, placing the copyright symbol on your work isn't absolutely necessary to claim copyright infringement and take a plagiarist to court if he steals your work. If you browse through magazines, you will often see the illustrator's name in small print near the illustration, *without* the Copyright ©. This is common practice in the magazine industry. Even though the © is not printed, the illustrator still owns the copyright unless the magazine purchased all rights to the work. Just make sure the art director gives you a credit line near the illustration.

Usually you will not see the artist's name or credit line alongside advertisements for products. Advertising agencies often purchase all rights to the work for a specified time. They usually pay the artist generously for this privilege and spell out the terms clearly in the artist's contract.

How to register a copyright

To register your work with the U.S. Copyright Office, call the Copyright Form Hotline at (202) 707-9100 and ask for package 115 and circulars 40 and 40A. Cartoonists should ask for package 111 and circular 44. You can also write to the Copyright Office, Library of Congress,

The Art of Business

101 Independence Ave. SE, Washington DC 20559, Attn: Information Publications, Section LM0455.

You can also download forms from the Copyright Office website at www.copyright.gov. Whether you call or write, they will send you a package containing Form VA (for visual artists). Registering your work costs $30.

After you fill out the form, return it to the Copyright Office with a check or money order for $30, a deposit copy or copies of the work and a cover letter explaining your request. For almost all artistic work, deposits consist of transparencies (35mm or $2\frac{1}{4} \times 2\frac{1}{4}$) or photographic prints (preferably $8\frac{1}{2} \times 10$). Send one copy for unpublished works; two copies for published works.

You can register an entire collection of your work rather than one work at a time. That way you will only have to pay one $30 fee for an unlimited number of works. For example if you have created a hundred works between 2003 and 2004, you can send a copyright form VA to register "the collected work of Jane Smith, 2003-2004." But you will have to send either slides or photocopies of each of those works.

Why register?

It seems like a lot of time and trouble to send in the paperwork to register copyrights for all your artworks. It may not be necessary or worth it to you to register every artwork you create. After all, a work is copyrighted the moment it's created anyway, right?

The benefits of registering are basically to give you additional clout in case an infringement occurs and you decide to take the offender to court. Without a copyright registration, it probably wouldn't be economically feasible to file suit, because you'd be only entitled to your damages and the infringer's profits, which might not equal the cost of litigating the case. Had the works been registered with the U.S. Copyright office, it would be easier to prove your case and get reimbursed for your court costs.

Likewise, the big advantage of using the copyright © also comes when and if you ever have to take an infringer to court. Since the copyright © is the most clear warning to potential plagiarizers, it is easier to collect damages if the © is in plain sight.

Register with the U.S. Copyright Office those works you fear are likely to be plagiarized before or shortly after they have been exhibited or published. That way, if anyone uses your work without permission, you can take action.

Deal swiftly with plagiarists

If you suspect your work has been plagiarized and you have not already registered it with the Copyright Office, register it immediately. You have to wait until it is registered before you can take legal action against the infringer.

Before taking the matter to court, however, your first course of action might be a well-phrased letter from your lawyer telling the offender to "cease and desist" using your work, because you have a registered copyright. Such a warning (especially if printed on your lawyer's letterhead) is often enough to get the offender to stop using your work.

Don't sell your rights too cheaply

Recently a controversy has been raging about whether or not artists should sell the rights to their work to stock illustration agencies. Many illustrators strongly believe selling rights to stock agencies hurts the illustration profession. They say artists who deal with stock agencies, especially those who sell royalty-free art, are giving up the rights to their work too cheaply.

Another pressing copyright concern is the issue of electronic rights. As technology makes it easier to download images, it is more important than ever for artists to protect their work against infringement.

Copyright Resources

For More Info

The U.S. Copyright Website (www.copyright.gov), the official site of the U.S. Copyright Office, is very helpful and will answer just about any question you can think of. Information is also available by phone at (202)707-3000. Another great site, called The Copyright Website, is located at http://benedict.com.

A few great books on the subject are *Legal Guide for the Visual Artist*, by Tad Crawford (Allworth Press); *The Rights of Authors, Artists, and other Creative People*, by Kenneth P. Norwick and Jerry Simon Chasen (Southern Illinois University Press); *Electronic Highway Robbery: An Artist's Guide to Copyrights in the Digital Era*, by Mary E. Carter (Peachpit Press). *The Business of Being an Artist*, by Daniel Grant (Allworth Press), contains a section on obtaining copyright/trademark protection on the Internet.

Log on to www.theispot.com and discuss copyright issues with your fellow artists. Join organizations that crusade for artists' rights, such as the Graphic Artist's Guild (www.gag.org) or The American Institute of Graphic Arts (www.aiga.org). Volunteer Lawyers for the Arts (www.vlany.org) is a national network of lawyers who volunteer free legal services to artists who can't afford legal advice. A quick search of the Web will help you locate a branch in your state. Most branches offer workshops and consultations.

10 Secrets to Success in Art Licensing

by Lance J. Klass

As president of Porterfield's Fine Art Licensing, I see thousands of pieces of art each year. So much of the art that is submitted to us for review is just beautiful—and yet much of it is completely unsuitable for licensing. I know that sounds like a contradiction. How can beautiful art not appeal to potential licensees? Isn't that what print and card and giftware and home decor companies really want to put on their products? In most cases the answer is a qualified "no"—it just isn't that simple.

Over the years I've learned that there are basic rules or "secrets" to art licensing that will make some talented artists winners in licensing their art and reaping the potential financial rewards of doing so, while other artists who are perhaps equally talented will lose out completely because they just didn't know the secrets of successful art licensing.

It all comes down to how you paint, what you paint, and how you present your art. Here I'll offer you some basic guidelines that will help you succeed in a very competitive business.

I call these guidelines "secrets" because they're generally not known by most artists. I make no claim that they're completely infallible because they're not. And I don't claim that they will always work, or that every successfully licensed artist has used them. In fact, there are many exceptions to these rules in which artists have achieved great success simply by breaking them.

But for the rest of us mortals, they're sensible guidelines to what tends to work, and what doesn't tend to work, in art licensing.

One final point before we dig into them: if you disagree with any of these rules—if they don't suit what you do, what you want to do, and where you want to go with your art—that's fine. After all, the very first rule in art is always to seek out your own path. While it may not lead you to financial success in licensing, doing what you most want to do can bring you enormous personal and emotional satisfaction as an artist and lead to a happy and fulfilling life.

But if you want to be successful in licensing your art to companies that need really good art for their products, then let's get into it.

LANCE J. KLASS, President of Porterfield's Fine Art Licensing, has many years of experience in the licensing field and expertise in promoting the works of artists seeking to increase their income and establish their names in the world of commercial, licensed art. For more information see www.porterfieldsfineart.com.

Secret #1: The winning format

By survey, the most acceptable format for artwork is a ratio of 3:4 in overall rectangular dimensions. That means working on a flat surface (canvas, board, paper) that is 9×12 or 18×24 or some other multiple of the basic 3:4 ratio.

Yes, collector plates are round and there are lots of tall, skinny prints on the market. But most round uses of art (plates, coasters, and the like) are cropped out of square or rectangular pieces of art. And for every set of tall, skinny prints there are 50 sets of prints in standard dimensions. If you paint round or in some specialized shape, you're limiting the uses of the art and also limiting the possibility of licensing your art.

Paint in standard format and your work can cropped for specific uses. Paint in round or in odd shapes and there's no way it can be expanded by the licensee to fit other uses. It's safe to say that using a standard 3:4 ratio will increase your chances of licensing art by a factor of 10.

Secret #2: Work flat

You may like to sculpt or to create mixed-media three-dimensional pieces of art but if you do so, don't expect them to be licensable. The vast majority of businesses that sell products with featuring art want two-dimensional images. That means oil, acrylic, gouache or water-color on canvas, paper or board, and increasingly it means digital art as well.

Secret #3: Work in color

I'm regularly approached by artists who have created superb pen and ink or pencil drawings. While these may have been popular back in the days of fine art prints and etchings a hundred years ago, they are almost impossible to license nowadays. People want color, the more the better. They want density of color, good color saturation, pleasing color, rich color. Not black and white, no matter what your art instructor may have told you.

Secret #4: Paint to the edges

Yes, there are a ton of specialized uses for free-floating art that have no backgrounds. These include heat transfers for T-shirts and clothing, stickers, mugs, decorative borders on dinnerware, even jigsaw puzzles, but stand-alone images with no backgrounds are definitely in the minority and such design work is often handled by in-house design teams or by hired design studios.

What can be most appealing about a piece of art is its overall composition, how everything fits together into a compelling artistic statement. You may be the world's best painter of dogs but if you paint them without backgrounds, you're seriously limiting the potential uses of your art.

Some good examples of the use of overall design are obvious: Thomas Kinkade, who specializes in creating a mood all the way to the edges of an image, and Mary Engelbreit, who creates each piece of art as a total design unit. Each artist is fantastically successful, and one of the most basic reasons for their success is their ability to design an overall and complete setting for the focus of their art. So remember, plan out your composition and take it all the way out to the edges of that 3:4 rectangle.

Secret #5: Have a clear and compelling focal point

Studies in the advertising industry have shown that you have about one-eighth of a second to attract the eye of a viewer. Then the viewer looks elsewhere, only looking back if there is something compelling, some visual focal point, that draws the viewer's eye back to the art. That isn't much time to create interest in your art. It has to have immediate impact.

What happens once you've grabbed the person's attention and brought it back to your

art? The viewer's eye tends to focus on a key unit of your piece of art, then the eye flits very quickly around the image, coming back to the key focus of the art repeatedly. Studies of eye movement have shown that a viewer's eyes can move half a dozen times a second as the viewer scans your painting and is drawn into it.

Studies have also shown that the best location for that key focal point is slightly above the dead center of the image. It's less effective and compelling to have the focus of the image out on the side, or to have several major focal points in the image.

What do you do if you're creating a landscape? The answer is simple: have an easy entryway for the eye. Use a road, a path, a street, a lawn, an open space—anything that will allow the viewer to go into the scene and become interested and involved in it.

Remember, your focal point is your eye-grabber. Don't finish a piece of art without it.

Secret #6: Create art in sets of four

Artists often come to me with a broad smorgasbord of images, each one different in style, subject, size, format, design. That eclectic approach may work for selling originals in art galleries but it doesn't work for most art licensees.

Print companies in particular want to see sets of four or more images that obviously "fit" together. The same is true of many stationary, giftware, wall decor and home decor companies. They simply can't design their products around one image, and if an image sells well they want to have depth to their collection. Plus, many people want to decorate their homes with sets of images rather than with single images.

Yes, calendar companies need 12 images for a calendar (some will want a 13th image for the cover) and card and needlework companies will occasionally pick up a stray image here and there, but most often companies want that set of four matching images.

If you have many different ideas for different types of art or subject material, then do different sets of four images each. But remember to think in terms of four images that obviously fit together and your chances at licensing your art will be greatly improved.

Secret #7: Be wary of "niche" markets

The other day I received some wonderful images of horses that an artist in the midwest had painted. It was obvious to me from looking at her work that she loves horses and loves painting them. That's fine, as far as it goes.

You see, her chosen subject matter falls in what we call a "niche" market because there's a very limited number of consumers in America who buy products with images of horses. True, there is a small and vital market for this type of art and there are some wonderful artists who specialize in horses, but they're in the minority and not at the heart of the consumer art market.

It's sort of like going to a party to meet potential guys to date and deciding beforehand that you only want to date guys who are exactly 5′7″, have brown hair, and wear loafers. Yes, they're out there, but why limit your range of options if you don't have to?

I happen to be a devotee of fantasy and science fiction art and there are some wonderful artists in this field. But that said, I have a devil of a time licensing such art to consumer-oriented companies because it just doesn't appeal to the broad spectrum of American consumers.

Secret #8: Paint what people want to look at again and again

It makes sense that if you want to license your art, then you improve your chances if you paint something that people want to look at not just once, but again and again. That means finding winning subject matter that will appeal to the great majority of art buyers.

How do you do that? One way is to go to your local mall, the bigger the better, and

walk into every giftware store, every collectibles store, every store that sells prints, posters, calendars, home decor, wall decor, stationary, cards—anything that sells because it carries compelling art.

Look carefully around you at the major displays of products that carry art. A lot of it will be junk and you'll want nothing to do with it. But a lot of the art will be pretty good—not art gallery or museum quality perhaps, but still pretty good. This research will give you an idea of what people are buying, or at least what licensees think people will buy. And that will give you some direction on subject matter, colors, style, format and a hundred other details that you can use as guides when next you put brush to canvas.

Is this "selling out"? That all depends on your viewpoint. If you want to paint in your barn and hope that someday the world will come to you, that's fine. It's worked for many great artists. But if you're interested in producing art to license and hopefully make a good living at it, then give people images that they want to see again and again. How will you know? Show your art to a lot of people and look at their faces as they take their first look at your art.

Secret #9: Stay generic

As much as you may like to paint your new grandson, your dog, or your house, don't be surprised if no one outside your immediate family or circle of friends wants to look at your paintings, much less buy your art or license your work. After all, who wants a painting of your Uncle Harry on their wall? Would you want a painting of my Uncle Harry on your wall?

Stay generic. Animals, children, people, and pretty places seem to do best when they could be anyone or anywhere.

Secret #10: Representational art sells better than abstract

There a lot of abstract art out there that is quite beautiful but most commercial art licensees want representational art. Remember that shopping mall survey I recommended above? See how many abstracts you come upon versus images that are clearly recognizable as something.

I've had to turn down a whole lot of artists who do beautiful abstracts just because they're so very difficult to license. If I got very lucky I might find a print company that would want them but even so, would the prints sell?

A few years back my wife and I were at the famous Tate Gallery in London, at the same time they were running a huge exhibit of abstract works. Walking through the halls of that exhibit we had plenty of time to look at the paintings because the exhibit was deserted. Leaving that "important" exhibition we walked twenty feet to another hall that was crowded with people. On the walls were the extremely realistic and beautiful works of English pre-Rafaelite painters. More people entered the room in the half hour we were there; few left. I learned something that day at the Tate, and you should learn it too.

What to Send to Galleries & Why

by Alyson B. Stanfield

Y ou send your portfolio to galleries because you are looking for possible exhibitions and/or representation by that gallery. The reasons to seek gallery representation are many, but among them are: increased exposure (critics review galleries, curators visit them), prestige, and the knowledge that someone else is working to help sell your art.

You are ready to approach galleries when you have:

- a recognizable style
- a large body of work (at least two exhibitions' worth)
- done your homework and understand the artist-gallery relationship
- researched appropriate galleries where your work might fit in
- completed some sales on your own
- built up a résumé you are proud of

Before you send your presentation materials to a gallery, do your homework. Make sure you are sending it to a gallery in which you can envision your work. It is best if you can visit the gallery in person and check things out. It is rarely, if ever, a good idea to pop in without an appointment and ask a dealer to review your portfolio. Like anyone else, they do not appreciate being hoodwinked and have a schedule to maintain.

Do not send your materials to anyone and everyone. Dealers have a lot of packets to wade through. They will only become annoyed with you if your materials clearly do not fit into their gallery. After you decide on appropriate galleries for your work, call them and ask for their guidelines for reviewing portfolios. Introduce yourself and begin the process of name recognition. Your professionalism and courtesy will impress them! The gallery's guidelines should help your organize your materials in the best format for that specific gallery. *Never* send unsolicited digital images as attachments to your e-mail.

The contents of your portfolio for gallery dealers will differ depending on your reason for sending. This is a generic checklist:

- ☑ Cover Letter
- ☑ Business Card
- ☑ Artist Statement
- ☑ Résumé
- ☑ Biography

ALYSON B. STANFIELD, drawing on her experience as a curator, educator and consultant in the art field, founded ArtBizCoach.com to help artists promote themselves and build their businesses through workshops, publications, online classes and a free weekly e-newsletter.

Gallery Cover Letter

Make your letter short and to the point. Only a few paragraphs.

ARTHUR JACKSON
894 N.E. 29th Street • Oklahoma City, OK 73162 • (405) 555-3850
info@arthurjacksonart.art • www.arthurjacksonart.art

March 26, 2002

Caroline Hanna
Caroline Hanna Fine Art
2788 Success Way
Dallas, TX 75512

Show the dealer you know her gallery and are not sending your portfolio blindly.

Dear Ms. Hanna,

Introduce your art. You could go into more detail in an additional paragraph.

It was a nice surprise when I came upon your gallery during my last visit to Dallas. I very much enjoyed your current exhibit of regional artists and thought that my work might be of interest. Like your other artists, I come from the abstract tradition. Specifically, my paintings are an exploration of the formal elements of art.

State your purpose for writing and sending your materials.

I am not seeking exclusive representation, but I thought perhaps you might be able to fit my work into future exhibitions. I am also available for commissions.

Clarify what material you would like to have returned in the SASE.

I have enclosed a brochure, visuals, and background information. Other images are available upon request or you may visit my website at www.arthurjacksonart.art. When you are finished with the materials, I would appreciate the return of my slides in the enclosed self-addressed, stamped envelope. Otherwise, I would be happy for you to keep everything on file for your future use.

Mention that you will be following up. More importantly, do what you say! Dealers like to know that artists follow through.

Thank you, in advance, for taking the time to look at my portfolio. I will call you in three weeks to see if you need anything else from me.

Sincerely,

Arthur Jackson

Enclosures

Gallery dealers receive lots of portfolios. Don't be surprised if, when you call, she doesn't recognize your name right away. By calling when you say you will, you are giving her one more contact with you and helping to establish name recognition. Also, it is probable that it will taker her longer than those three weeks to review.

The Art of Business

☑ Slides & Other Images (only art that is for sale and represents a cohesive body of work)
☑ Image & Price List
☑ Brochure (if available; not included here)
☑ Articles & Press (if available)
☑ SASE for the Return of Your Materials (not included here)

I suggest some version of this for a two-pocket folder or a three-ring binder, with your cover letter on top of the closed packet. The illustration below is an example of what to include in your folder.

The Art of Business

RÉSUMÉS

The need to have a good, accurate, up-to-date résumé is the number one reason for keeping excellent records of your career. When your career becomes so full that you need to edit out less important exhibits, articles, or awards, you can break them into two different documents.

The first is a **master résumé** or **curriculum vitae (CV)**, on which you will keep every detail of your career: from perfect exhibition titles down to the smallest award. You want this information complete and in one place so that you will have it when you are famous and some fancy curator wants to write a book about you. Make a habit of updating it constantly. Curriculum vitae are most often used in academic situations and are usually more than three pages long. People might erroneously request a CV from you when what they really want is a résumé. A CV is what a curator would be interested in if you were donating a work or having a one-person museum exhibition at their institution.

The second is an **abbreviated résumé**, which shows only the highlights, what you are most proud of. It is no more than two pages long and is what you will send out most of the time. I am sure that many galleries would even prefer résumé of no more than a single page.

Rules for putting together your résumé

- Your résumé should reveal that you are making progress in your career and working toward a professional goal.
- Make it easy for someone to read.
- No funky fonts!
- No funky paper! Print on good quality résumé paper, preferably in white to match your other materials.
- Don't forget dates. You might say "duh!", but I have seen résumé without dates!
- Everything should be in reverse chronological order, emphasizing that your most recent accomplishments are your most important ones.
- Have accurate exhibit titles—the same titles that would have been used on publicity materials. Do not file press, invitations, or anything else from your exhibit until you have added the information to your résumé.
- Yours is a professional artist's résumé. Do not add any extraneous information such as marriage status, children, or other employment.
- As I noted earlier, do not use the title "Artist" after your name. Your résumé will say that for you.

The résumé template included here is an example only. You should not get discouraged if you don't have all of these headings on yours. I only show the various categories so that you will know where to put the information when you do have it.

The Art of Business

Résumé

ARTHUR JACKSON
894 N.E. 29th Street • Oklahoma City, OK 73162 • (405) 555-3850
info@arthurjacksonart.art • www.arthurjacksonart.art

Selected Solo Exhibitions
2001 "New Works by Arthur Jackson," Contemporary Fine Arts, Tulsa, OK
2000 "Arthur Jackson," Center for the Arts, Oklahoma City, OK
1998 "Muse-ings: Recent Sculpture by Arthur Jackson," Wright Conservatory, Wichita, KS

Selected Group Exhibitions
2000 "Off the Wall!," group exhibition, Dallas Arts Association, TX
1997 "Five-State Invitational," invitational group exhibition, Fort Worth Visual Artists, TX
1993 "Oklahoma Biennial," juried exhibition, Oklahoma Artists Consortium, Oklahoma City, OK
1991 "Oklahoma Biennial," juried exhibition, Oklahoma Artists Consortium, Oklahoma City, OK

Public Collections
Fred Jones Jr. Museum of Art, The University of Oklahoma, Norman, OK

Oklahoma City Museum of Art, OK

Mabee-Gerrer Art Museum, Shawnee, OK

Corporate Collections
Bank of Oklahoma City, OK

Sandy Leitbeck Financial Services, Ardmore, OK

Red Canyon Energy, Tulsa, OK

Central Regional Physicians Group, Oklahoma City, OK

Selected Publications
2001 J.D. Martin, "New Works by Arthur Jackson," review, *Tulsa People* (May)
2000 Katherine T. Walker, "Artists for Action Founding Director Relinquishes Post," article, *Oklahoma City News* (October 17)

Maya Flynn, "An Artist of Action: Arthur Jackson," article, *Seen* (November-December)

Arthur Jackson, catalogue, essay by Jason Harvey, Center for the Arts, Oklahoma City
1998 Robin Frazier, "A-mused by Muse-ings," review, *Downtown Wichita* (March)
1994 Katherine T. Walker, "Artists for Action Celebrates Five Years," article, *Oklahoma City News* (August 28)
1993 "Oklahoma Biennial," catalogue, Oklahoma Artists Consortium

Grants & Awards
2002 National Prize for Artistic Excellence, The Foundation for the Arts, Washington, D.C.
2000 Art Educator of the Year, National Art Education Association
1997 Artist in Residence, Museum of Fine Arts, San Antonio, TX

Lectures & Public Speaking
2002 "Update: The State of the Arts in our Public Schools," Oklahoma Art Education Association, Lawton, OK
2001 "New Works by Arthur Jackson," gallery talk, Contemporary Fine Arts, Tulsa, OK
2000 "Arthur Jackson," gallery talk, Center for the Arts, Oklahoma City, OK
1998 "The State of the Arts in our Public Schools," Oklahoma Art Education Association, Norman, OK
1996 "Three Abstract Artists," Oklahoma Conference of Art Historians, Stillwater, OK

Related Activities
Artists for Action, Oklahoma City, OK, Founding Director, 1989-2000

Oklahoma Art Education Association, Chair 1994-95

Oklahoma Artists Consortium, Board member, 2000-present

National Endowment for the Arts, grant reviewer 1999-2001

Education
Master of Fine Arts, The University of Oklahoma, 1979

Bachelor of Fine Arts, Central Oklahoma College, 1976

Born
February 17, 1954 in Houston, TX

If your portfolio didn't wow them, persevere! If you are convinced your work is a good fit for a certain gallery, keep them on your mailing list. Continue sending new images (postcards, annual portfolio) without becoming an annoyance.

Self-promo Q&A

*Is It Bragging to Talk About
My Artwork?*

by Tera Leigh

We are taught as children that talking about our accomplishments in a positive light is "bragging." There is a line between bragging and self-promotion. Promotion is a professional necessity. We have to put together press kits, press releases, and promotional materials to get our name out in front of editors, art directors and gallery owners. It is not bragging to talk about what you do and how you are unique. There is no need to be pushy, but there is a need to be professional and consistent.

If talking about your art in a positive light has been an issue for you, you are not alone. To follow are some of the many questions I've received on this important topic, gleaned from my workshops and Web site www.teras-wish.com.

I really struggle with talking about my work. I know my art is as good as my friend's work, but she has the gift of gab. When she talks about her accomplishments, it doesn't come off as being pushy, but when I do it I feel like I'm bragging. I know I need to get over this. Any suggestions?

Congratulations on being wise enough to understand that you do need to be able to talk about your work to get ahead. One of the challenges we face is that our society does tell us that talking about our accomplishments (especially women) is bragging. The truth is, sometimes it is bragging—what matters is the context.

If you are asked about what you are doing, answering honestly is *not* bragging. If you are talking to an industry peer or an Editor, it is not bragging to say "I'd like to tell you about my latest project".

Bragging often involves exaggeration, or talking to make yourself feel more important. It is not bragging to talk about one's accomplishments in a professional setting-especially not when the purpose of the event is to network!

Is there a way I can get the word out about my work without having to talk about myself directly?

Yes, but you should also learn to feel comfortable talking about what you have done. For heavens sake, you should be proud of yourself! Every new thing you do represents a risk you took, a challenge you conquered. Other people will be interested.

However, if you don't feel like you can do that, or if you need something to get the

Award-winning designer and author **TERA LEIGH** runs the motivational artist's Web site, *Tera's Wish* at www.teras-wish.com. She is also the author of *How to Be Creative if You Never Thought You Could* (North Light Books).

conversation started, consider a) press releases each time you have a new project or accomplishment (there are many books on marketing that can outline the basics of a good, and simple, press release.) and b) a press kit. A press kit should include a photo, photos of your work, tear sheets of and articles about you, or articles you have written, a biography, etc. This can give an art buyer a reason to contact you.

But if I do a press release, or a press kit, I still have to talk about myself— just on paper! That might even be harder!

I think that many artists have a Cinderella complex. No offense intended. It's just that often artists tell me that if they just had someone willing to go out and sell their work (the proverbial fairy godmother), they could do great things. Well, we'd all love that, but most people don't get it. Doing PR for yourself is part of getting yourself established, just like joining trade groups, purchasing supplies, and the many other tasks you must do. Once you become established, you may be able to convince an agent to carry your work for you so that you can stay in your studio and work, but until then, you have to learn to tell people who you are and what you do.

Just because you are talking, doesn't mean someone is listening. If people aren't interested, they will let you know. In most cases, people will be happy for your success, so joyfully share your good news—and be willing to ask questions and listen with a glad heart to the successes of those around you!

An Illustrator's Journal

Launching a Dream Career Day by Day

by Holli Conger

After the birth of my daughter, I was inundated with cute little clothes, books, pictures—you name it—with incredible designs and illustrations. Time after time the same thought would fill my head: "I wish I could do that!" I'd been dreaming about an illustration career for years. And there was absolutely no reason why I couldn't have one! Sure, I had a full time design job and a new bundle of joy to take care of, but why not just go for it? Here I share experts from my monthly journal entries. Read my complete journal on my website, www.holliconger.com. This journal covers the first year of the journey I took to launch my illustration career with entries dedicated to my process of self-promotion.

I decided to keep a monthly journal for two reasons. First, to encourage others and let them know successful promotion can be done and how one person was able to do it. I am always on the lookout to see what other illustrators are doing. I've found a few illustrators' sites with blogs that sometimes mention their promotional endeavors but never seem to give updates on their progress.

My second reason was to keep myself accountable and to follow through with my dream. Keeping a personal deadline has always been hard for me. With this commitment of documenting my process online, I knew I could keep myself accountable not only to myself, but to all the people who followed my series. My goal in all this? To become a full-time illustrator while being a stay-at-home Mom.

Month 1: June 2004

I have had a website dedicated to my illustration work for a couple of years now, but have done little to promote it. One thing I have done is link exchanges. By linking to other designers' and illustrators' sites (and them linking to me), my name comes up more times in search engines. You'll be surprised just how many hits you'll get from another person's site. Just this week I received two e-mails from people who had seen my site listed on another designer's site.

Last year I had 1,000 postcards printed with plans to mail them out to potential clients. Today I have about 990 of those cards still left in the box. Why? I over-critique my work, as I'm sure most people do. I started not to like the image I had produced specifically for the card. This time I am approaching it differently. I realized I need to pick one of my best pieces for the promo card and not try to think of something specifically for it.

HOLLI CONGER is a designer/illustrator working in Nashville, Tennessee. She has been able to balance being a stay-at-home-mom without compromising her career.

So, I have my Web site up, I have an illustration to use for my postcard, and I have a growing list of names to send them to (thanks to the *Artist & Graphic Designer's Market*, *Children's Writers & Illustrators Market*, people e-mailing me to be on my mailing list, as well as companies I've found by using keywords on Yahoo! and Google). I am now officially ready to move forward!

Month 2: July 2004

I have totally surprised myself. I've made so much progress this month but, near the beginning, I thought I'd get nothing accomplished. I couldn't concentrate on what to do next or get motivated to do anything. Part of it probably had to do with the fact that I was missing my daughter horribly while working my full-time design job all week. But I worked out my schedule with my boss so I am able to work from home three days a week which made me a much happier and more pleasant person to be around.

At the end of last month I mailed out a press release announcing my new dimensional illustrations, as well as announcing some illustrations I had completed for a magazine. After mailing those out to my list of 30 people (boy, I really need to add some names!) I got three responses back, one of which said they had some upcoming projects they would contact me about them.

I did one very important thing this week. Since people constantly misspell my name (which is understandable), I purchased hollyconger.com and redirected it to holliconger.com. It's just a little something to make sure people find me, but I think it was smart to do. I also revised my logo to emphasize the ''i.''

I updated my site (again) with more work, better meta tags, a ''How I Work'' section and a downloadable PDF sample sheet. I've had several comments on it already.

Month 3: August 2004

Ideas. Can you ever have too many? I'm finding out that you can. I have a long list of them on my desk. They all consist of creative things to make. Most, if not all, have been on the list for several months. Why haven't they gotten done? Time, motivation and inspiration. Things I feel I've had very little of this month. I've spent most of the month on promotion, which has left me no time to be creative.

My site traffic has been amazing this month. I can really tell that my promotional efforts are paying off. Last month I received 511 hits, this month I received 2,800. One thing I am surprised about is that no one, not a single soul, has signed up for my mailing list. Not that I want any average Joe to sign up, but I figured I'd get some potential clients signing up with all those hits. So that was a little disheartening.

I've updated my free listing on Folioplanet, my free listing on Creative Hotlist, my free portfolio on Portfolios.com, and added a free portfolio listing to Coroflot.com, as well as adding myself to the free Google illustration directory. Do you notice a trend? I'm trying to spend as little money as I can right now on promotion since I'm just starting out. Just today I received an inquiry from someone who had seen my listing on Coroflot. These listings have added to my site traffic and my search engine results. I'm constantly on the lookout for more exposure.

Month 4: September 2004

This month has been full of interruptions and delays. I didn't get done what I wanted and began doubting my illustration style. Do people even like my work? I've had a few freelance design projects absorb my time as well as some projects around the house.

I had one person sign up for my mailing list after seeing my last article. I added a link on every page of my site for people to sign-up. I realized that I really didn't specify to sign-up

for my mailing list and people may not know to go to my contact page. Hopefully I'll get some more names and hopefully I'll get some work so I can send out a press release to them. I'm about due for one.

Promoting myself as an illustrator has been hard. I've never really promoted my freelance design business and I've had steady freelance work (by word of mouth) for six years. I guess every business needs a designer and few need illustrators. Especially if your style is geared for one audience—children. I've been thinking about offering some pro-bono illustration work. I've "budgeted" it for this year but I don't know exactly how to go about it. I need to get my name and work out there but I'm struggling with how. Maybe I'll look through my *Children's Writers & Illustrators Market* and see if a particular magazine strikes my fancy.

Month 5: October 2004

This month has been one of the busiest months I've probably ever had, and I can see all future months being busier. No new illustration jobs, hopefuls or leads, but a slew of design work, and my husband and I purchased a business. So, now I'm the marketing coordinator and designer for the business. Let's see, I am a full time wife, mom, designer, freelance designer, illustrator and now a marketing coordinator. Whew! No wonder I'm so tired. But, I'm happy. Even though I'm not getting much (well, any) response from my illustration promotion from prospective clients, I have been creative with my design work, so I'm feeling creatively fulfilled and not as discouraged as I would normally be.

This month I mailed out a few more postcards to some people I found by word of mouth

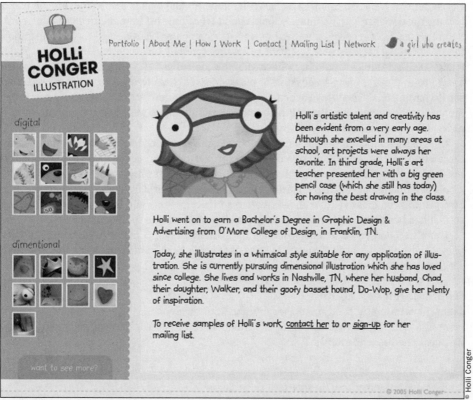

Holli Conger's website www.holliconger.com showcases her art and also features a blog where she recorded the ups and downs of her career launch. The blog also has been featured at www.CreativeLatitudes.com.

on the Internet and mailed out two promo packs to people who have shown interest in my work before. But I still haven't received any of my SAS reply cards I included in the promo packs. I also set up a paid (yes, I spent some money) account on Portfolios.com. It's for a four-month trial and it was super cheap, so I thought I'd try it out. I don't know how many people have looked at my section since they don't supply stats, but I've only gotten about five hits on my site from there. The key to having a portfolio on Portfolios.com is to update your info whenever you can since the search feature pushes newly revised sections to the top.

Month 6: November 2004

Well, I finally got an illustration job this month. It was my first job that came directly through my promotional efforts. A local company saw my work on Portfolios.com and hired me to do a set of illustrations that will potentially be used for stickers and window clings. This one job more than paid for my four-month trial on Portfolios.com! Not bad considering my portfolio has only been up for about a month-and-a-half. I know we've all heard this before, but the company was interested in working with me on future projects. I'm not getting my hopes up, but it does feel good to know that someone likes your work. Then, another company contacted me after seeing my listing on Portfolios.com They want to license some of my work for cell phone wallpaper. I still need to go through the contract they sent and see if it's something I'd want to do.

Month 7: December 2004

December was a slacker month for me. With all the holiday hustle and bustle, I just haven't had the time or energy to do much. I took a good bit of time off from my freelance ''career.'' Before Christmas I received another job from the company I had done a digital illustration for last month. They hired me to create a Christmas money holder in my dimensional style. It was a tight deadline, but I got it finished and it looked great! Now I have another project to add to my press release! Speaking of press releases, I really need to send one out. I've somewhat made a schedule of when I need to send them out. My plan is to do one every month. I don't know what I'm going to do if I have nothing to announce one month but I'll have to find something.

One big step I took at the end of December (New Year's Eve actually) was to start a blog. I'm an introvert so this is kind of a challenge for me to let people know what's going on in my life. I really want to network with other illustrators and force myself to be creative. Having a blog will do that for me. I'll be participating in Illustration Friday (www.illustrationfriday.com) just to keep creative. I've already gotten some comments and feedback about the blog so that has been a big encourager plus I've added some people to my mailing list.

I've also jotted down a general marketing plan for myself. I find it hard to stick to with personal deadlines, but I've convinced myself that I *have* to in order to reach the goals I've set for myself.

Month 8: January 2005

January was a pretty good month for my illustration career. At the beginning of January I went into ''full'' client acquisition mode. I made out a to-do list that will help keep me on my toes. The list is as follows:

Daily

Find 3 new addresses for promo
Sketch
Do blog entry (at least a few days a week)

Weekly
Update Portfolios.com listing
Participate in Illustration Friday
Create one clay or digital illustration (portfolio quality)
Look at freelance job listing sites

Monthly
Send press release
Update portfolio
Write Creative Latitude article

Believe it or not I have really stuck to it and it's been fairly easy.

With my quota of three addresses a day to meet, I have been scouring the Internet and am amazed at the children's publishers and product makers out there. I haven't had any trouble finding new and obscure little places to send my postcards. I am still toying with the idea of doing a postcard mailer. I need to send something out, but I just don't know what. I don't know if I should do digital or dimensional focus if I do go the postcard route. I do have some promo/sample packets to put together and mail to some publishers I'd really like to work for.

Having a blog has helped my creative and motivational efforts greatly. I have already met so many people who are in the same boat as me or are already successful illustrators. Before I really knew no other illustrators with my same focus, but now I know several I feel I can call on for advice. Also participating in Illustration Friday has really helped me be creative and build my portfolio. Plus it feels good to get all those compliments about my work. I am just super motivated now that I have a network of illustrators and feel like I belong.

Month 9: February 2005

Wow! This has been the best month so far in my illustration ventures. The biggest thing was joining a critique group. The Picture Book Junkies (www.pbjunkies.com) were kind enough to let me join their group and it has been a wonderful experience. I have felt like I've been going though my daily struggles by myself, but this group has really taken me under their wing and has been a huge support system. It feels so good to know others who face the same struggles I do.

One large step I took this month was to e-mail a few Illustrator Reps. It would be a dream to just draw all day and not have to worry about all the contracts and negotiations. I do love the promotion part of it but not so much the business side. I heard back from some who said they weren't taking on new talent but to keep in touch, and then some that my style didn't jive with. I did get two nibbles though. One sent me a contract and I have e-mailed her with several questions but haven't heard back yet. The other likes my work but isn't taking on new talent but was interested in helping me strengthen my work. She gave me great advice and I have been plugging away and doing more work.

My style has also made a transition this month. My wide-eyed style is no more. I've had a few comments on my big-eyes and the more I look at then, the scarier they look to me. So, I have modified them to smaller eyes and some with dots. I am really digging my dots eyes and how they bring personality to each character. I am also experimenting with a painterly digital style. I've done a pieces and really love the look of it.

Months 10 and 11: March/April 2005

I have finally switched my freelance work over to more illustration than design work (it has been the opposite for several years). Illustration jobs have been very steady with some exist-

ing clients and a few new. This is exactly where I want to be freelance wise. I am still holding onto the full time job, but am in negotiations for going part time. Once I know a little more on their end, I'll be able to make the decision: "Do I stay or do I go?" Hopefully by next month's entry, a decision will have been reached.

I sent out a press release last month announcing my new painterly technique and also updated my portfolio to reflect the new work. I feel I have grown leaps and bounds from when I first started promoting myself. The more work I do in this technique, to more I begin to dislike my vector work. I am slowly phasing that look out of my portfolio.

I had mentioned before about working with a rep on building my portfolio. She was extremely nice and helpful by taking me under her wing and showing me how I can grow my style. Well, in April, she signed me. I was (and still am) so excited. It feels like a huge weight has been lifted off of me. There is still a need for me to do my own promotion, but it feels good to know I have my own cheerleader out there rooting for me and helping find me work. She has already gotten me a nice project that I am currently working on.

My critique group continues to give me much needed support and gets me excited about being creative. Having a critique group has been the most beneficial thing in my career thus far.

Month 12: May/June 2005

Well, it's been a year since I started to "actively" pursue my dream. I am proud to say I have done it. I have reached my goal of becoming a professional illustrator and being a stay-at-home mom. May 31st was my last day as an employee and now I'm out on my own.

I have learned so much over the past year. The main thing has been the evolution of my style. I was happy with what I had going when I first started out, but as I got more feedback I decided I needed to work on some things.

I am very comfortable with my style and technique now but I know there is room to grow. I'm starting to experiment with paper and surface textures and things I need to work on are my noses and gestures. It will all come together in time and I'm enjoying the process.

I've mentioned my self-promotion process throughout the year and have narrowed down the things that have helped me the most.

Things that worked for me marketing-wise:

My website
Link exchanges
Detailed meta tags
Portfolios.com
Coroflot.com
Folioplanet.com

Things that helped me grow as an illustrator:

Researching other illustrators
Looking at picture books
Starting a blog
Illustration Friday
Networking with other illustrators
Joining a critique group
Sketching daily
And believe it or not, just spending time with my daughter to see facial features and body language.

All the things above cost no money (except portfolios.com since I sprung for the titanium portfolio and it has more than paid for itself). Although I had a full time design job in all this and did freelance design work on the side, I still didn't want to spend any money. I wanted to prove that promotion could be done without spending gobs of money on flashy mailers or sample packets. Without doing those things, I got my work out to potiential clients, landed an agent and have gotten enough work so I could quit my full time job.

Getting here has not been easy. I have worked on my goal one way or another every day for a year. There have been (and still are) many late nights working on projects, slowly building my client base. But now I have more freedom and am not bogged down with a full time job, but I do have my hands full chasing a giggly one-year-old around, so having a huge project with a short deadline sometimes has to wait until naptime or bedtime. I wouldn't have it any other way though. Being home with my daughter is the most important thing for my family and me, but I still want a career. I need to accomplish goals and have something to show for it. I want to be successful. As I starting out being completely self-employed, I still have to market myself heavily and keep doing what I've been doing.

Editor's Note: *Holli Conger's month-by-month account of her marketing efforts helped her stay on track as she launched her career. If you've written a journal or blog tracking your journey, and think you'd like to share it with other artists, please e-mail artdesign@fwpubs.c om. We'd love to read your diary and share your adventures.*

The Art of Business

Illustrators Share Networking Tips

by Maria Piscopo

Creative professionals seem to have a love/hate relationship with networking. Joining and participating in professional associations does advance and enhance your career and business. It can also be a living nightmare when you walk in to a room full of people you don't know or find yourself serving on 17 committees with no time to do your own work. In my seminars and books, I often refer to networking as marketing by association. This term is less worn-out and more understandable in its intent. It means identifying and seeking out associations to aid in your self-promotion and marketing efforts.

Networking is always a very effective business and marketing tool. Networks are groups of your peers, your clients or even groups in your community. The benefits are many and range from personal development to job leads from referrals. Here are a few recommendations from three creative professionals for more effective networking:

Tay R. McClellan: I am a member of the Association of Medical Illustrators, the Graphics Artist Guild, and the Society for Technology in Anesthesia, the Society for Airway Management, and the American Society of Anesthesiologists. I joined the AMI because I am a medical illustrator and wanted to become board certified through the association. The AMI has enabled me to meet a number of well-known medical illustrators. Since I lecture yearly on Copyright Law on the Internet for Physicians, I joined the STA, SAM and the ASA.

Joining business organizations has broadened my business substantially. These anesthesia societies have made my business and my advancement intellectually and educationally possible. GAG has provided me with untold business savvy, contractual assistance, and timely and monthly meetings. GAG is by far the best association for business support. I would never have made it in business save for the consistent and professional help of GAG, both through their books and their national standing on issues for artists and illustrators.

David Veal: In the 1980s I was just out of college and bought the *Graphic Artist's Guild's Handbook: Pricing and Ethical Guidelines*. I was hooked by the relevant content. It just happened that there was a Colorado Chapter to join. In the 1990s, I helped to create a local illustration organization, Colorado Alliance of Illustrators, to promote illustration to local art buyers and to present industry concerns and business practices through educational programs. I joined Art Directors Club of Denver in the 1990s for networking purposes. An AIGA chapter just opened up in Colorado recently and I felt it was important to network with, and learn from, the design community both locally and nationally.

I have benefited from the business programs of these groups. They inspire me to try new administrative and marketing methods. Secondly, the networking is great for marketing and building a nest of friendships. I think the main reason for joining is to elevate your reputation.

When you join a board or committee you are giving back to the industry while enhancing your market exposure and networking capabilities. Truth be told, once you get into the swing of active membership it becomes its own reward. It is addictive, inspiring, educational and a lot of fun.

Rob Bynder: I am a member of the AIGA because I felt that the AIGA most accurately reflects my personal interests in the design industry. The organization provides events and publications that offer a good combination of intellectual dialogue with practical application. I also attend the AIGA Design Conference and the AIGA Business and Design Conference. They have enlightened and inspired me in a way that I feel I many times don't get at my place of employment. My AIGA chapter in Los Angeles has provided me with a good sense of community and has given me the opportunity to meet and converse with others in my field.

One way experienced professionals can benefit from membership in these associations is by taking advantage of the networking opportunities they provide. These relationships can often manifest in business and job opportunities as well as satisfying personal relationships due to inherent common interests. When looking for work, we all live by the old adage that it's not what you know; it's whom you know. One is more likely to be hired for a job or project, or at least given the opportunity to interview for it, when one has contacts within the organization doing the hiring.

The Art of Business

15 Tips to Grow Your Creativity

by Eric Maisel

People come from far and wide in search of inspiration from Eric Maisel, psychotherapist, America's foremost creativity coach, and the author of more than twenty books, including *Coaching the Artist Within*.

Not surprisingly, he has a lot to say to artists. Consider this your first workout with your very own artist's coach. Follow through on just one tip, and watch your attitude (and career) take off in new directions.

1. Grow creative by fostering self-relationship. Start a journal you call "creative solutions." Every time a problem or issue arises, turn to your journal and ask yourself, "How can I handle this creatively?" Begin to see yourself as an everyday creative problem-solver.

2. Grow creative by manifesting your artist nature. Name some creative project that you would like to tackle. Then write down the qualities in you that will help bring this project to fruition, qualities like imagination, spunk, discipline, a sense of humor. These qualities are your artist nature.

3. Grow creative by embracing mystery. What do you find really mysterious? In that direction is the potential for excellent work. Prepare a list you call "Mysteries" and read over your list. Circle the mysteries that stir your soul and repeat each one out loud, like an incantation.

4. Grow creative through genuine silence. Pick a quiet hour of the day. Turn off the television, close your book, eliminate all stimuli. Quiet your mind by saying "Hush!" Let silence reign. When you are fully quiet, say to yourself, "Come, creative work!" Pursue what arrives.

5. Grow creative through concentration and surrender. Find a brain teaser, puzzle, or conundrum. Concentrate very hard for five minutes on solving it. Then let it go completely. Experience total surrender to "not knowing." Repeat this process three or four times.

6. Grow creative through simple effort. Select a creative project. Prepare and commit to a "creative work" schedule. Work on your project for a month without second-guessing your choice or bad-mouthing your progress.

7. Grow creative by regularly and routinely creating. Take the following pledge: "I

ERIC MAISEL is a psychotherapist, creativity coach, and the author of more than twenty books, among them *Fearless Creating, The Van Gogh Blues*, and the forthcoming *A Writer's Paris*. You can learn more about Eric's work, including his creativity coaching trainings, at ericmaisel.com or you can contact Eric at ericmaisel@hotmail.com. Portions of this article appeared in *The Creativity Deck* (Red Wheel/Weiser), available online and at bookstores everywhere.

will do some creative work every day, if only for fifteen or twenty minutes." Honor your pledge for the next two weeks and spend fourteen consecutive days creating.

8. Grow creative through endless exploration. Pick a subject that fascinates you, one that you've always wanted to study. Avoid saying "It's too late to start" or "There's too much to learn." Enter the unexplored territory of your new subject like an intrepid explorer.

9. Grow creative through powerful intention. Confirm your intention to work on a given creative project and to live a creative life by posting that intention on signs that you put up around your house: on the refrigerator door, above your desk, on the bathroom mirror.

10. Grow creative by returning to your creative work. Have you abandoned some creative projects in the past? Most of us have abandoned quite a few! Pick a project dear to your heart that you abandoned and return to it with optimism, an open heart, and a firm belief in renewed possibility.

11. Grow creative through anxiety awareness. Learn one or two anxiety management strategies from the following list: breath awareness, meditation, guided imagery, yoga, tai-chi, self-relaxation, affirmations. Learn them and use them on a regular basis.

12. Grow creative by risking and committing. Picture yourself separated from your creative work by a chasm a thousand feet deep but only a foot wide. That chasm represents our fear. Its narrowness is the truth about how easy it is to cross over. In your mind's eye—and then in reality—cross right over.

13. Grow creative through measured wildness. Pick a time today to create. When that time arrives, say to yourself, "I am a wild, passionate, energetic creature!" Shout it out, if you dare. Work in a frenzy of creative energy. At the same time keep a measured eye on the work's progress.

14. Grow creative by demanding excellence. Choose a new creative project to work on. As you begin it, say to yourself, "I want to raise the bar and do my best work." Calmly and confidently launch into your project. As you work, remind yourself that you are a serious, committed artist.

15. Grow creative by putting creating first. Tomorrow morning, create first thing. If you can't manage it tomorrow, aim for the day after. Or the day after that. Keep putting "I will create first thing!" on your agenda until the idea takes hold and you begin each day creating.

The Art of Business

Greeting Cards, Gifts & Products

The companies listed here contain some great potential clients for you. Although greeting card publishers make up the bulk of the listings, you'll also find hundreds of other opportunities. The businesses in this section need images for all kinds of other products: paper plates, napkins, banners, shopping bags, T-shirts, school supplies, personal checks, calendars—you name it. We've included manufacturers of everyday items, like mugs, as well as companies looking for fine art for limited edition collectibles.

THE BEST WAY TO ENTER THE MARKET

1. Read the listings carefully to learn exactly what products each company makes and the specific styles and subject matter they use.

2. Visit stores. Browse store shelves to see what's out there. Take a notebook and jot down the types of cards and products you see. If you want to illustrate greeting cards, familiarize yourself with the various categories of cards and note which images tend to appear again and again in each category.

3. Track down trends. Pay attention to the larger trends in society. Society's move toward diversity, openness and acceptance is reflected in the cards we buy. There has also been a return to patriotism. Fads such as reality TV, as well as popular celebrities, often show up in images on cards and gifts. Trends can also be spotted in movies, national magazines and on Web sites.

WHAT TO SUBMIT

- Do NOT send originals. Companies want to see photographs, photocopies, printed samples, computer printouts, slides or tearsheets.
- Before you make copies of your sample, render the original artwork in watercolor or gouache in the standard industry size, $4^5/_8 \times 7^1/_2$ inches.
- Artwork should be upbeat, brightly colored and appropriate to one of the major categories or niches popular in the industry.
- When creating greeting card art, leave some space at the top or bottom of the artwork, because cards often feature lettering there. Check stores to see how much space to leave. It is not necessary to add lettering, because companies often prefer to use staff artists to create lettering.
- Have color photocopies or slides made of your completed artwork. (See listings for specific instructions.)
- Make sure each sample is labeled with your name, address and phone number.
- Send three to five appropriate samples of your work to the contact person named in the

Insider Tips You Can Use

Tips

Linda King Davey spent 10 years at Paramount Cards as a creative planner, humor manager and creative director and served as creative vice president at Marian Heath for five years. Now she's working as a freelance illustrator, editor and art director. Here, she gives her observations on how to increase your salability in a changing market.

1. Due to increased belt tightening, greeting card companies have fewer in-house artists, or else they've eliminated them entirely. This is good news for freelancers. More companies are buying freelance versus internally generated art.

2. Art directors want to identify an artist with one specific look. The ability to do various styles of illustration was once thought to increase an artist's marketability, but having multiple styles in your portfolio is not as highly regarded these days and can possibly be a drawback.

3. In recent years, consumer acceptance of contemporary looks has grown. The demand for creative, unique and innovative techniques is great.

4. Art directors typically have difficulty finding designs for specific categories, such as Wedding Congratulations, First Communion, Graduation and so on. You may want to consider doing speculative designs in these areas.

5. Create designs that utilize popular greeting card finishes like foil, emboss, glitter and virko (raised, plastic coating). Art directors will appreciate having these processes considered as an integral part of the design.

6. When sending a portfolio, make it clear what you want returned and what the art director can keep on file. Always include samples or photocopies that can be kept on file with your name, phone and e-mail address on each piece.

—Cindy Duesing

listing. Include a brief (one to two paragraph) cover letter with your initial mailing.

- Enclose a self-addressed stamped envelope if you need your samples back.
- Within six months, follow up with another mailing to the same listings and additional companies you have researched.

Submitting to gift & product companies

Send samples similar to those you would send to greeting card companies, only don't be concerned with leaving room at the top of the artwork for a greeting. Some companies prefer you send postcard samples or color photocopies. Check the listings for specifics.

Greeting Card Basics

Important

- **Approximately 7 billion** greeting cards are purchased annually, generating more than $7.5 billion in retail sales.

- **Women** buy 85 to 90% of all cards.

- **The average person** receives eight birthday cards a year.

- **Seasonal cards** express greetings for more than 20 different holidays, including Christmas, Easter and Valentine's Day.

- **Everyday cards** express nonholiday sentiments. The "everyday" category includes get well cards, thank you cards, sympathy cards, and a growing number of person-to-person greetings. There are cards of encouragement that say "Hang in there!" and cards to congratulate couples on staying together, or even getting divorced! There are cards from "the gang at the office" and cards to beloved pets. Check the rows and rows of cards in store racks to note the many "everyday" occasions.

- **Birthday cards** are the most popular everyday cards, accounting for 60% of sales of everyday cards.

- **Categories** are further broken down into the following areas: **traditional, humorous** and "**alternative**" cards. "Alternative" cards feature quirky, sophisticated or offbeat humor.

- **The most popular card-sending holidays,** according to the Greeting Card Association, are (in order):

 1. Christmas
 2. Valentine's Day
 3. Mother's Day
 4. Easter
 5. Father's Day
 6. Thanksgiving
 7. Halloween
 8. St. Patrick's Day
 9. Jewish New Year
 10. Hannukkah
 11. Grandparent's Day
 12. Sweetest Day
 13. Passover
 14. Secretary's Day
 15. National Boss's Day
 16. April Fool's Day
 17. Nurses' Day

Payment and royalties

Most card and product companies pay set fees or royalty rates for design and illustration. Card companies almost always purchase full rights to work, but some are willing to negotiate for other arrangements, such as greeting card rights only. If the company has ancillary plans in mind for your work (calendars, stationery, party supplies or toys), they will probably want to buy all rights. In such cases, you may be able to bargain for higher payment. For more tips, see Copyright Basics on page 25.

Don't overlook the collectibles market

Limited edition collectibles—everything from Dale Earnhardt collector plates to *Wizard of Oz* ornaments—appeal to a wide audience and are a lucrative niche for artists. To do well in this field, you have to be flexible enough to take suggestions. Companies test market to find

out which images will sell the best, so they will guide you in the creative process. For a collectible plate, for example, your work must fit into a circular format or you'll be asked to extend the painting out to the edge of the plate.

Popular themes for collectibles include patriotic images, Native American, wildlife, animals (especially kittens and puppies), children, religious (including madonnas and angels), stuffed animals, dolls, TV nostalgia, gardening, culinary and sports images.

E-cards

If you are at all familiar with the Internet, you know that electronic greeting cards are everywhere. Many can be sent for free, but they drive people to Web sites so they are a big bonus for Web sites to offer visitors. The most popular e-cards are animated, and there is an increasing need for artists who can animate their own designs for the Web, using Flash animation. To look at the range in electronic greeting cards, visit a few sites, such as www.amazon.com; www.bluemountain.com; www.barnesandnoble.com, and do a few Web searches. Companies often post their design needs on their Web sites.

Helpful Resources

For More Info

Greetings etc. (www.greetingsmagazine.com) is the official publication of the Greeting Card Association (www.greetingcard.org). Subscriptions are reasonably priced. To subscribe call (973)252-0100.
Party & Paper is a trade magazine focusing on the party niche. Visit their website at www.partypaper.com for industry news and subscription information.
The National Stationery Show, the "main event" of the greeting card industry, is held each May at New York City's Jacob K. Javits Center. Visit www.nationalstationeryshow.com to learn more about that important event. Other industry events are held across the country each year. For upcoming trade show dates, check *Greetings Etc.* or *Party & Paper.*

ACME GRAPHICS, INC.

P.O. Box 1348, 201 Third Ave. SW, Cedar Rapids IA 52406. (319)364-0233. Fax: (319)363-6437. E-mail: info@ac megraphicsinc.com. Website: www.regalline.com. **President:** Jeff Scherrman. Estab. 1913. Produces printed merchandise used by funeral directors, such as acknowledgments, register books and prayer cards. Art guidelines free for SASE.

● Acme Graphics manufactures a line of merchandise for funeral directors. Floral subjects, religious subjects and scenes are their most popular products.

Needs Approached by 30 freelancers/year. Considers pen & ink, watercolor and acrylic. "We will send a copy of our catalog to show type of work we do." Art guidelines available for SASE with first-class postage. Looking for religious, inspirational, church window, floral and nature art. Also uses freelancers for calligraphy and lettering.

First Contact & Terms Designers should send query letter with résumé, photocopies, photographs, slides and transparencies. Illustrators: Send postcard sample or query letter with brochure, photocopies, photographs, slides and tearsheets. Accepts submissions on disk. Samples are not filed and are returned by SASE. Responds in 10 days. Call or write for appointment to show portfolio of roughs. Originals are returned. Requests work on spec before assigning a job. Pays by the project, $50 minimum or flat fee. Buys all rights.

Tips "Send samples or prints of work from other companies. No modern art. Some designs are too expensive to print. Learn all you can about printing production. Please refer to website for examples of appropriate images!"

KURT S. ADLER INC.

1107 Broadway, New York NY 10010. (212)924-0900. Fax: (212)807-0575. Website: Kurtadler.com. **President:** Howard Adler. Estab. 1946. Produces collectible figurines, decorations, gifts, ornaments. Manufacturer and importer of Christmas ornaments and giftware products.

Needs Prefers freelancers with experience in giftware. Considers all media. Will consider all styles appropriate for Christmas ornaments and giftware. Produces material for Christmas, Easter, Halloween.

First Contact & Terms Send query letter with brochure, photocopies, photographs. Responds within 1 month. Will contact for portfolio review if interested. Payment negotiable.

Tips "We rely on freelance designers to give our line a fresh, new approach and innovative new ideas."

ALLPORT EDITIONS

2337 NW York, Portland OR 97210-2112. (503)223-7268. Fax: (503)223-9182. E-mail: info@allport.com. Website: www.allport.com. **Contact:** Creative Director. Estab. 1983. Produces greeting cards and stationery. Specializes in greeting cards fine art, humor, contemporary illustration, florals, animals and collage.

Needs Approached by 300 freelancers/year. Works with 10 freelancers/year. Buys 60 freelance designs and illustrations/year. Art guidelines available on website. Uses freelancers mainly for art for cards. Also for final art. Prefers art scaleable to card size. Produces material for all holidays and seasons, birthdays and everyday. Submit seasonal material 1 year in advance.

First Contact & Terms Illustrators/Artists: Send query letter with photocopies or photographs and SASE. Accepts submissions on disk compatible with PC-formatted TIFF or JPEG files with Illustrator, Photoshop or Quark document. Samples are filed or returned by SASE. Responds in 3 months. Portfolio review not required. Rights purchased vary according to project. Pays for illustration by the project. Finds freelancers through artists' submissions and stationery show in New York.

Tips "Submit enough samples for us to get a feel for your style/collection. Two is probably too few, 40 is too many."

AMCAL, INC., MeadWestvaco Consumer and Office Products

Courthouse Plaza NE, Dayton OH 45463. (937)495-3046 or (800)798-6323. Fax: (937)495-3192. E-mail: calendars@meadwestvaco.com. Website: www.amcalart.com or www.meadwestvaco.com. Publishes calendars, note cards, Christmas cards and other books and stationery items. "Markets to a broad distribution channel, including better gifts, books, department stores and larger chains throughout U.S. Some sales to Europe, Canada and Japan. We look for illustration and design that can be used many ways: calendars, note cards, address books and more, so we can develop a collection. We license art that appeals to a widely female audience." No gag humor or cartoons.

Needs Prefers work in horizontal format. Art guidelines for SASE with first-class postage, on our website or "you can call and request."

First Contact & Terms Illustrators: Send query letter with brochure, résumé, photographs, SASE, slides, tearsheets and transparencies. Include a SASE for return of submission. Responds within 6 weeks. Will contact artist for portfolio review if interested. Pays for illustration by the project, advance against royalty.

Tips "Research what is selling and what's not. Go to gift shows and visit lots of stationery stores. Read all the trade magazines. Talk to store owners."

AMERICAN GREETINGS CORPORATION

One American Rd., Cleveland OH 44144. (216)252-7300. E-mail: jim.hicks@amgreetings.com. Website: www.a mgreetings.com. **Director of Creative Recruitment:** James E. Hicks. Estab. 1906. Produces greeting cards, stationery, calendars, paper tableware products, giftwrap and ornaments "a complete line of social expressions products." Also recruiting for AGInteractive. Also looking for skills in Flash, Photoshop, strong drawing skills and animation.

Needs Prefers artists with experience in illustration, decorative design and calligraphy. Usually works from a list of 100 active freelancers. Guidelines available for SASE.

First Contact & Terms Send query letter with résumé. "Do not send samples." Pays $200 and up based on complexity of design. Does not offer royalties.

Tips "Get a BFA in Graphic Design with a strong emphasis on typography."

AMSCAN INC.

80 Grasslands Rd., Elmsford NY 10523. (914)345-2020. Fax: (914)345-8431. **Contact:** Erika Pozzuto. Estab. 1954. Designs and manufactures paper party goods. Extensive line includes paper tableware, invitations, giftwrap and bags, decorations. Complete range of party themes for all ages, all seasons and all holidays. Features a gift line which includes baby hard and soft goods, wedding giftware, and home decorative and tabletop products. Seasonal giftware also included.

Needs "Ever-expanding department with incredible appetite for fresh design and illustration. Subject matter varies from baby, juvenile, floral, type-driven and graphics. Designing is accomplished both in the traditional way by hand (i.e., painting) or on the computer using a variety of programs like FreeHand, Illustrator, Painter and Photoshop."

First Contact & Terms "Send samples or copies of artwork to show us range of illustration styles. If artwork is appropriate, we will pursue." Pays by the project $300-3,500 for illustration and design.

☑ ANW CRESTWOOD/THE PAPER COMPANY/PAPER ADVENTURES

(formerly Leader Paper Products/Paper Adventures), 501 Ryerson Road, Lincoln Park NJ 07035. (973)406-5000. (973)709-9494. E-mail: katey@anwcrestwood.com. Website: www.anwcrestwood.com. **Creative Department:** Katey Franceschini. Estab. 1901. Company produces stationery, scrapbook and paper crafting. Specializes in stationery, patterned papers, stickers and related paper products.

Needs Approached by 100 freelancers/year. Works with 20 freelancers/year. Buys or licenses 150 freelance illustrations and design pieces/year. Prefers freelancers with experience in illustration/fine art, stationery design/surface design. Works on assignment only. Considers any medium that can be scanned.

First Contact & Terms Freelancers send or e-mail nonreturnable color samples. Company will call if there is a current or future project that is relative. Accepts Mac-compatible disk and e-mail submissions. Samples are filed for future projects. Will contact artist for more samples and to discuss project. Pays for illustration by the project, $100 and up. Also considers licensing for complete product collections. Finds freelancers through tradeshows and *Artist's & Graphic Designer's Market.*

Tips "Research the craft and stationery market and send only appropriate samples for scrapbooking, cardcrafting and stationery applications. Send lots of samples, showing your best, neatest and cleanest work with a clear concept."

APPLEJACK ART PARTNERS

(formerly Applejack Licensing International), Box 1527, Historic Route 7A, Manchester Center VT 05255. (802)362-3662. Fax: (802)362-3286. E-mail: tino@applejackart.com. Website: www.applejackart.com. **Contact:** Tino Barbarossa, Artist Liason. Licenses art for balloons, bookmarks, calendars, CD-ROMs, collectible figurines, decorative housewares, decorations, games, giftbags, gifts, giftwrap, greeting cards, limited edition plates, mugs, ornaments, paper tableware, party supplies, personal checks, posters, prints, school supplies, stationery, T-shirts, textiles, toys, wallpaper, etc.

Needs Extensive artwork for use on wide cross section of product categories. Looking for variety of styles and subject matter. Art guidelines free for SASE with first class postage. Considers all media and all styles. Prefers final art under 24×36, but not required. Produces material for all holidays. Submit seasonal material 6 months in advance.

First Contact & Terms Artists: Send brochure, photocopies, photographs, slides, tearsheets, transparencies, CD-ROM and SASE. Illustrators: Send query letter with photocopies, photographs, photostats, transparencies, tearsheets, résumé and SASE. No e-mail submissions. Accepts disk submissions compatible with Photoshop, Quark or Illustrator. Samples are filed or returned by SASE. Responds in 1 month. Will contact artist for portfolio

review if interested. Portfolio should include color final art, photographs, photostats, roughs, slides, tearsheets.

AR-EN PARTY PRINTERS, INC.

8225 N. Christiana Ave., Skokie IL 60076. (847)673-7390. Fax: (847)673-7379. E-mail: info@ar-en.net. Website: ar-en.com. **Owner:** Gary Morrison. Estab. 1978. Produces stationery and paper tableware products. Makes personalized party accessories for weddings and all other affairs and special events.

Needs Works with 1-2 freelancers/year. Buys 10 freelance designs and illustrations/year. Art guidelines not available. Works on assignment only. Uses freelancers mainly for new designs. Also for calligraphy. Looking for contemporary and stylish designs, especially b&w line art, no gray scale, to use for hot stamping dyes. Prefers small (2×2) format.

First Contact & Terms Send query letter with brochure, résumé and SASE. Samples are filed or returned by SASE if requested by artist. Responds in 2 weeks. Company will contact artist for portfolio review if interested. Rights purchased vary according to project. Pays by the hour, $40 minimum; by the project, $750 minimum.

Tips "My best new ideas always evolve from something I see that turns me on. Do you have an idea/style that you love? Market it. Someone out there needs it."

ART LICENSING INTERNATIONAL INC.

7350 So. Tamiami Trail #227, Sarasota FL 34231. (941)966-8912. Fax: (941)966-8914. E-mail: artlicensing@comcast.net. Website: www.artlicensinginc.com. **Contact:** Michael Woodward, president. Licenses art and photography for calendars, decorative housewares, gifts, greeting cards, jigsaw puzzles, party supplies, stationery and textiles.

- Please see listing in Artists' Reps section.

ARTFUL GREETINGS

P.O. Box 52428, Durham NC 27717. (919)598-7599. Fax: (919)598-8909. E-mail: myw@artfulgreetings.com. Website: www.artfulgreetings.com. **Vice President of Operations:** Marian Whittedalderman. Estab. 1990. Produces bookmarks, greeting cards, T-shirts and magnetic notepads. Specializes in multicultural subject matter, all ages.

Needs Approached by 200 freelancers/year. Works with 10 freelancers/year. Buys 20 freelance designs and illustrations/year. No b&w art. Pastel chalk media does not reproduce as bright enough color for us. Uses freelancers mainly for cards. Considers bright color art, no photographs. Looking for art depicting people of all races. Prefers a multiple of 2 sizes 5×7 and 5½×8. Produces material for Christmas, Mother's Day, Father's Day, graduation, Kwanzaa, Valentine's Day, birthdays, everyday, sympathy, get well, romantic, thank you, woman-to-woman and multicultural. Submit seasonal material 1 year in advance.

First Contact & Terms Designers: Send photocopies, SASE, slides, transparencies (call first). Illustrators: Send photocopies (call first). May send samples and queries by e-mail. Samples are filed. Artist should follow up with call or letter after initial query. Will contact for portfolio review of color slides and transparencies if interested. Negotiates rights purchased. Pays for illustration by the project $50-100. Finds freelancers through word of mouth, NY Stationery Show.

Tips "Don't sell your one, recognizable style to all the multicultural card companies."

ARTVISIONS

12117 SE 26th St., Bellevue WA 98005-4118. (425)746-2201. Website: www.artvisions.com. **Owner:** Neil Miller. Estab. 1993. Markets include publishers of limited edition prints, calendars, home decor, stationary, note cards and greeting cards, posters, and manufacturers of giftware, home furnishings, textiles, puzzles and games. Artists must have 4×5 transparencies or high resolution scans of artwork.

Handles Fine art licensing for listed markets. See extensive listing in Artists' Reps section.

THE ASHTON-DRAKE GALLERIES

9200 N. Maryland Ave., Niles IL 60714. E-mail: adartist@ashtondrake.com. Website: www.collectiblestoday.com. Estab. 1985. Direct response marketer of collectible dolls, ornaments and figurines. Clients consumers, mostly women of all age groups.

Needs Approached by 300 freelance artists/year. Works with 250 freelance doll artists, sculptors, costume designers and illustrators/year. Works on assignment only. Uses freelancers for illustration, wigmaking, porcelain decorating, shoemaking, costuming and prop making. Prior experience in giftware design and doll design a plus. Subject matter includes babies, toddlers, children, brides and fashion. Prefers "cute, realistic and natural human features."

First Contact & Terms Send or e-mail query letter with résumé and copies of samples to be kept on file. Prefers photographs, tearsheets or photostats as samples. Samples not filed are returned. Responds in 1 month.

Compensation by project varies. Concept illustrations are done "on spec." Sculptors receive contract for length of series on royalty basis with guaranteed advances.

Tips "Please make sure we're appropriate for you. Visit our website before sending samples!"

N BARTON-COTTON INC.

1405 Parker Rd., Baltimore MD 21227. (410)247-4800. Fax: (410)247-3681. E-mail: carol.bell@bartoncotton.com. **Contact:** Carol Bell, art buyer. Produces religious greeting cards, commercial all-occasion, Christmas cards, wildlife designs and spring note cards. Licenses wildlife art, photography, traditional Christmas art for note cards, Christmas cards, calendars and all-occasion cards.

Needs Buys 150-200 freelance illustrations/year. Submit seasonal work any time. Free art guidelines for SASE with first-class postage and sample cards; specify area of interest (religious, Christmas, spring, etc.).

First Contact & Terms Send query letter with résumé, tearsheets, photocopies or slides. Submit full-color work only (watercolor, gouache, pastel, oil and acrylic). Previously published work and simultaneous submissions accepted. Responds in 1 month. Pays by the project. Pays on acceptance.

Tips "Good draftsmanship is a must. Spend some time studying current market trends in the greeting-card industry. There is an increased need for creative ways to paint traditional Christmas scenes with up-to-date styles and techniques."

N FREDERICK BECK ORIGINALS

51 Bartlett Ave., Pittsfield MA 01201. (413)443-0973. Fax: (413)445-5014. **Art Director:** Mark Brown. Estab. 1953. Produces silk screen printed Christmas cards, traditional to contemporary.

● This company is under the same umbrella as Editions Limited and Gene Bliley Stationery. One submission will be seen by all companies, so there is no need to send three mailings. Frederick Beck and Editions Limited designs are a little more high end than Gene Bliley designs. The cards are sold through stationery and party stores, where the customer browses through thick binders to order cards, stationery or invitations imprinted with customer's name. Though some of the same cards are repeated or rotated each year, all companies are always looking for fresh images. Frederick Beck and Gene Bliley's sales offices are still in North Hollywood, CA, but art director works from Pittsfield office.

N BEISTLE COMPANY

1 Beistle Plaza, Shippensburg PA 17257-9623. (717)532-2131. Fax: (717)532-7789. E-mail: beistle@cvn.net. Website: www.beistle.com. **Product Manager:** C. Luhrs-Wiest. Art Director: Rick Buterbaugh. Estab. 1900. Manufacturer of paper and plastic decorations, party goods, gift items, tableware and greeting cards. Targets general public, home consumers through P-O-P displays, specialty advertising, school market and other party good suppliers.

Needs Approached by 250-300 freelancers/year. Works with 50 freelancers/year. Prefers artists with experience in designer gouache illustration. Also needs digital art (Macintosh platform or compatible). Art guidelines available. Looks for full-color, camera-ready artwork for separation and offset reproduction. Works on assignment only. Uses freelance artists mainly for product rendering and brochure design and layout. Prefers designer gouache and airbrush technique for poster style artwork. 50% of freelance design and 50% of illustration demand knowledge of QuarkXPress, Illustrator, Photoshop or Painter.

First Contact & Terms Send query letter with résumé and color reproductions with SASE. Samples are filed or returned by SASE. Art director will contact artist for portfolio review if interested. Sometimes requests work on spec before assigning a job. Pays by the project. Considers buying second rights (reprint rights) to previously published work. Finds artists through word of mouth, magazines, submissions/self-promotions, sourcebooks, agents, visiting artists' exhibitions, art fairs and artists' reps.

Tips "Our primary interest is in illustration; often we receive freelance propositions for graphic designbrochures, logos, catalogs, etc. These are not of interest to us as we are manufacturers of printed decorations. Send color samples rather than b&w."

BERGQUIST IMPORTS, INC.

1412 Hwy. 33 S., Cloquet MN 55720. (218)879-3343. Fax: (218)879-0010. E-mail: bbergqu106@aol.com. Website: www.bergquistimports.com. **President:** Barry Bergquist. Estab. 1948. Produces paper napkins, mugs and tile. Wholesaler of mugs, decorator tile, plates and dinnerware.

Needs Approached by 25 freelancers/year. Works with 5 freelancers/year. Buys 50 designs and illustrations/year. Prefers freelancers with experience in Scandinavian designs. Works on assignment only. Also uses freelancers for calligraphy. Produces material for Christmas, Valentine's Day and everyday. Submit seasonal material 6-8 months in advance.

First Contact & Terms Send query letter with brochure, tearsheets and photographs. Samples are not filed and are returned. Responds in 2 months. Request portfolio review in original query. Artist should follow up with a

letter after initial query. Portfolio should include roughs, color tearsheets and photographs. Rights purchased vary according to project. Originals are returned at job's completion. Requests work on spec before assigning a job. Pays by the project, $50-300; average flat fee of $100 for illustration/design; or royalties of 5%. Finds artists through word of mouth, submissions/self-promotions and art fairs.

N GENE BLILEY STATIONERY

51 Bartlett Ave., Pittsfield MA 01201-0989. (413)443-0973. Fax: (413)445-5014. **Art Director:** Mark Brown. General Manager: Gary Lainer. Sales Manager: Ron Pardo. Estab. 1967. Produces stationery, family-oriented birth announcements and invitations for most events and Christmas cards.

- This company also owns Editions Limited and Frederick Beck Originals. One submission will be seen by both companies. See listing for Editions Limited/Frederick Beck.

BLOOMIN' FLOWER CARDS

4734 Pearl St., Boulder CO 80301. (800)894-9185. Fax: (303)545-5273. E-mail: don@bloomin.com. Website: http//bloomin.com. **President:** Don Martin. Estab. 1995. Produces greeting cards, stationery and gift tags—all embedded with seeds.

Needs Approached by 100 freelancers/year. Works with 5-8 freelancers/year. Buys 5-8 freelance designs and illustrations/year. Art guidelines available. Uses freelancers mainly for card images. Considers all media. Looking for florals, garden scenes, holiday florals, birds, and butterflies—bright colors, no photography. Produces material for Christmas, Easter, Mother's Day, Father's Day, Valentine's Day, Earth Day, birthdays, everyday, get well, romantic and thank you. Submit seasonal material 8 months in advance.

First Contact & Terms Designers: Send query letter with color photocopies and SASE or electronic files. Illustrators: Send postcard sample of work, color photocopies or e-mail. Samples are filed or returned with letter if not interested. Responds if interested. Portfolio review not required. Rights purchased vary according to project. Pays royalties for design. Pays by the project or royalties for illustration. Finds freelancers through word of mouth, submissions, and local artists' guild.

Tips "All submissions MUST be relevant to flowers and gardening."

BLUE MOUNTAIN ARTS

P.O. Box 1007, Boulder CO 80306. (303)417-6513. Fax: (303)447-0939. E-mail: jkauflin@sps.com. Website: www.sps.com. **Contact:** Jody Kauflin, art director. Estab. 1970. Produces books, bookmarks, calendars, greeting cards, mugs and prints. Specializes in handmade looking greeting cards, calendars and books with inspirational or whimsical messages accompanied by colorful hand-painted illustrations.

Needs Art guidelines free with SASE and first-class postage or on website. Uses freelancers mainly for hand-painted illustrations. Considers all media. Product categories include alternative cards, alternative/humor, conventional, cute, inspirational and teen. Submit seasonal material 10 months in advance. Art size should be 5×7 vertical format for greeting cards.

First Contact & Terms Send query letter with photocopies, photographs, SASE and tearsheets. Send no more than 5 illustrations initially. No phone calls, faxes or e-mails. Samples are filed or are returned by SASE. Responds in 1 month. Portfolio not required. Buys all rights. Pays freelancers flat rate; $150-250/illustration if chosen. Finds freelancers through artists' submissions and word of mouth.

Tips "We are an innovative company, always looking for fresh and unique art styles to accompany our sensitive or whimsical messages. We strive for a hand-made look. We love color! We don't want photography! We don't want slick computer art! Do in-store research to get a feel for the look and content of our products. We want illustrations for printed cards, NOT E-CARDS! We want to see illustrations that fit with our existing looks and we also want fresh, new and exciting styles. Remember that people buy cards for what they say. The illustration is a beautiful backdrop for the message."

N BLUE SHEET MARKETING

1710 Roe Crest Dr., North Mankato MN 56003. (972)641-4911. Fax: (817)545-6235. E-mail: dknutson@blueshee tmarketing.com. Website: www.executive-greetings.com. **Creative Director:** Deb Knutson. Produces calendars, greeting cards, stationery, posters, memo pads, advertising specialties. Specializes in Christmas, everyday, dental, healthcare greeting cards and postcards, and calendars for businesses and professionals.

Needs Art guidelines available free for SASE. Works with 20-30 freelancers/year. Buys approximately 300 freelance designs and illustrations/year. Prefers freelancers with experience in greeting cards. Works on assignment only. Uses freelancers mainly for illustration, calligraphy, lettering, humorous writing, cartoons. Prefers traditional Christmas and contemporary and conservative cartoons. Some design work demands knowledge of Photoshop, Illustrator, QuarkXPress. Produces material for Christmas, Thanksgiving, birthdays, everyday.

First Contact & Terms Designers: Send brochure, résumé, tearsheets. Illustrators and cartoonists: Send tearsheets. After introductory mailing, send follow-up postcard sample every 6 months. Calligraphers: Send photo-

copies of their work. Accepts Mac-compatible disk submissions. Samples are filed or returned. Buys one-time or all rights. Pays for illustration by the project, $250-500. Finds freelancers through agents, other professional contacts, submissions and recommendations.

BLUE SKY PUBLISHING

6595 Odell Place, Suite C, Boulder CO 80301. (303)530-4654. E-mail: bspinfo@blueskypublishing.net. Website: www.blueskypublishing.net. **Contact:** Helen McRae. Estab. 1989. Produces greeting cards. "At Blue Sky Publishing, we are committed to producing contemporary fine art greeting cards that communicate reverence for nature and all creatures of the earth, that express the powerful life-affirming themes of love, nurturing and healing, and that share different cultural perspectives and traditions, while maintaining the integrity of our artists' work. Our mainstay is our photographic card line of Winter in the West and other breathtaking natural scenes. We use well known landmarks in Arizona, New Mexico, Colorado and Utah that businesses in the West purchase as their corporate holiday greeting cards."
Needs Approached by 500 freelancers/year. Works with 3 freelancers/year. Licenses 10 fine art pieces/year. Works with freelancers from all over US. Prefers freelancers with experience in fine art media oils, oil pastels, acrylics, calligraphy, vibrant watercolor and fine art photography. Art guidelines available for SASE. "We primarily license existing pieces of art or photography. We rarely commission work." Looking for colorful, contemporary images with strong emotional impact. Art guidelines for SASE with first-class postage. Produces cards for all occasions. Submit seasonal material 1 year in advance.
First Contact & Terms Send query letter with SASE, slides or transparencies. Samples are filed or returned if SASE is provided. Responds in 4 months if interested. Transparencies are returned at job's completion. Pays royalties of 3% with a $150 advance against royalties. Buys greeting-card rights for 5 years (standard contract; sometimes negotiated).
Tips "We're interested in seeing artwork with strong emotional impact. Holiday cards are what we produce in biggest volume. We are looking for joyful images, cards dealing with relationships, especially between men and women, with pets, with Mother Nature and folk art. Vibrant colors are important."

THE BRADFORD EXCHANGE

9333 Milwaukee Ave., Niles IL 60714. (847)581-8217. Fax: (847)581-8221. E-mail: squigley@bradfordexchange.com. Website: www.collectiblestoday.com. **Artist Relations:** Suzanne Quigley. Estab. 1973. Produces and markets collectible products, including collector plates, ornaments, music boxes, cottages and figurines.
Needs Approached by thousands of freelancers/year. "We're seeking talented freelance designers, illustrators and artists to work with our product development teams." Prefers artists with experience in rendering painterly, realistic, "finished" scenes. Uses freelancers for all work including concept sketching, border designs, sculpture. Traditional representational style is best, depicting children, pets, wildlife, homes, religious subjects, fantasy art, animation, celebrities, florals or songbirds in idealized settings.
First Contact & Terms Prefers designers send color references or samples of work you have done or a CD, along with a résumé and additional information. Please do not send original work or items that are one of a kind. Samples are filed in our Artist Resource file and are reviewed by product development team members as concepts are created that would be appropriate for your work. Art Director will contact artist only if interested. "We offer competitive compensation."

BRILLIANT ENTERPRISES

117 W. Valerio St., Santa Barbara CA 93101. **Art Director:** Ashleigh Brilliant. Publishes postcards.
Needs Buys up to 300 designs/year. Freelancers may submit designs for word-and-picture postcards, illustrated with line drawings.
First Contact & Terms Submit $5\frac{1}{2} \times 3\frac{1}{2}$ horizontal b&w line drawings and SASE. Responds in 2 weeks. Buys all rights. "Since our approach is very offbeat, it is essential that freelancers first study our line. Ashleigh Brilliant's books include *I May Not Be Totally Perfect, But Parts of Me Are Excellent*; *Appreciate Me Now and Avoid the Rush*; and *I Want to Reach Your Mind, Where Is It Currently Located?* "We supply a catalog and sample set of cards for $2 plus SASE." Pays $60 minimum, depending on "the going rate" for camera-ready word-and-picture design.
Tips "Since our product is highly unusual, familiarize yourself with it by sending for our catalog. Otherwise, you will just be wasting our time and yours."

N BRISTOL GIFT CO., INC.

P.O. Box 425, 6 North St., Washingtonville NY 10992. (845)496-2821. Fax: (845)496-2859. E-mail: bristol6@frontiernet.net. Website: www.bristolgift.net. **President:** Matt Ropiecki. Estab. 1988. Produces framed pictures for inspiration and religious markets.
Needs Approached by 5-10 freelancers/year. Art guidelines available for SASE. Works with 2 freelancers/year.

Buys 15-30 freelance designs and illustrations/year. Works on assignment only. Uses freelancers mainly for design. Also for calligraphy, P-O-P displays, Web design and mechanicals. Prefers 16×20 or smaller. 10% of design and 60% of illustration require knowledge of PageMaker or Illustrator. Produces material for Christmas, Mother's Day, Father's Day and graduation. Submit seasonal material 6 months in advance.

First Contact & Terms Send query letter with brochure and photocopies. Samples are filed or are returned. Responds in 2 weeks. Company will contact artist for portfolio review if interested. Portfolio should include roughs. Requests work on spec before assigning a job. Originals are not returned. Pays by the project $30-50 or royalties of 5-10%. Rights purchased vary according to project. Interested in buying second rights (reprint rights) to previously published artwork.

BRUSH DANCE INC.

165 N. Redwood Dr., San Rafael CA 94903. (800)531-7445. Fax: (415)259-0905. E-mail: lkalloch@brushdance.com. Website: www.brushdance.com. **Contact:** Liz Kalloch, art director. Estab. 1989. Produces greeting cards, blank journals, illustrated journals, gift books, boxed notes, calendars and magnets. ''The line of Brush Dance products is inspired by the interplay of art and words. We develop products that combine powerful and playful words and images that act as daily reminders that inspire, connect, challenge and support.''

Needs Approached by 200 freelancers/year. Works with 5-7 freelancers/year. Uses freelancers for illustration and calligraphy. Looking for nontraditional work conveying emotion or message. We are also interested in artists who are using both images and original words in their work.

First Contact & Terms Check our website for artist guidelines. Send query letter and tearsheets or color copies of your work. *Please don't send us transparencies, and never send originals.* Samples are filed or returned by SASE. Pays on a royalty basis with percentage depending on product. Finds artists through word of mouth, submissions, art shows.

Tips ''*Please* do your research, and look at our website to be sure your work will fit into our line of products.''

CAMPAGNA FURNITURE

7500 E. Pinnacle Peak Rd. H221, Scottsdale AZ 85255. (480)563-2577. Fax: (480)563-7459. E-mail: laurajmorse @hotmail.com. Website: campagnafurniture.com. **Vice President:** Laura Morse. Estab. 1994. Produces furniture. Specializes in powder room vanities and entertainment units.

Needs Approached by 80 freelancers/year. Works with 12 freelancers/year. Buys 100 freelance designs and/ or illustrations/year. Uses freelancers mainly for decoupage. Considers all media. Product categories include floral, Trompe L'Oeil.

First Contact & Terms Send query letter with tearsheets, photocopies and photographs. Accepts e-mail submissions with link to website and submissions with image file. Prefers Windows-compatible, JPEG files. Samples are not filed and returned by SASE. Responds only if interested. Portfolio not required but should include finished art. Buys rights for furniture. Pays freelancers by the project $100 minimum-$200 maximum. Finds freelancers through word of mouth and artists' submissions.

Tips ''We will consider new themes which individual artists might think appropriate for our cabinetry.''

☑ CAN CREATIONS, INC.

Box 848576, Pembroke Pines FL 33084. (954)581-3312. E-mail: judy@cancreations.com. Website: www.cancreations.com. **President:** Judy Rappoport. Estab. 1984. Manufacturer of Cello wrap.

Needs Approached by 8-10 freelance artists/year. Works with 2-3 freelance designers/year. Assigns 5 freelance jobs/year. Prefers local artists only. Works on assignment only. Uses freelance artists mainly for ''design work for cello wrap.'' Also uses artists for advertising design, illustration and layout; brochure design; posters; signage; magazine illustration and layout. ''We are not looking for illustrators at the present time. Most designs we need are graphic and we also need designs which are geared toward trends in the gift industry. Looking for a graphic website designer for graphics on website only.''

First Contact & Terms Send query letter with tearsheets and photostats. Samples are not filed and are returned by SASE only if requested by artist. Responds in 2 weeks. Call or write to schedule an appointment to show a portfolio, which should include roughs and b&w tearsheets and photostats. Pays for design by the project, $75 minimum. Pays for illustration by the project, $150 minimum. Considers client's budget and how work will be used when establishing payment. Negotiates rights purchased.

Tips ''We are looking for simple designs geared to a high-end market.''

☒ CANETTI DESIGN GROUP INC.

P.O. Box 57, Pleasantville NY 10570. (914)238-3159. Fax: (914)238-0106. E-mail: info@canettidesigngroup.com. **Marketing Vice President:** M. Berger. Estab. 1982. Produces photo frames, writing instruments, kitchen accessories and product design.

Needs Approached by 50 freelancers/year. Works with 10 freelancers/year. Works on assignment only. Uses

freelancers mainly for illustration/computer. Also for calligraphy and mechanicals. Considers all media. Looking for contemporary style. Needs computer-literate freelancers for illustration and production. 80% of freelance work demands knowledge of Illustrator, Photoshop, Quark.

First Contact & Terms Send postcard-size sample of work and query letter with brochure. Samples are not filed. Portfolio review not required. Buys all rights. Originals are not returned. Pays by the hour. Finds artists through agents, sourcebooks, magazines, word of mouth and artists' submissions.

CAPE SHORE, INC.

Division of Downeast Concepts, 86 Downeast Dr., Yarmouth ME 04096. (207)846-3726. Fax: (207)846-1019. E-mail: capeshore@downeastconcepts.com. Website: www.downeastconcepts.com. **Contact:** Melody Martin-Robie, creative director. Estab. 1947. "Cape Shore is concerned with seeking, manufacturing and distributing a quality line of gifts and stationery for the souvenir and gift market." Licenses art by noted illustrators with a track record for paper products and giftware. Guidelines available on website.

Needs Approached by 100 freelancers/year. Works with 50 freelancers/year. Buys 400 freelance designs and illustrations/year. Prefers artists and product designers with experience in gift product, hanging ornament and stationery markets. Art guidelines available free for SASE. Uses freelance illustration for boxed note cards, Christmas cards, ornaments, home accessories, ceramics and other paper products. Considers all media. Looking for skilled wood carvers with a warm, endearing folk art style for holiday gift products.

First Contact & Terms "Do not telephone; no exceptions." Send query letter with color copies. Samples are filed or are returned by SASE. Art director will contact artist for portfolio review if interested. Portfolio should include finished samples, printed samples. Pays for design by the project, advance on royalties or negotiable flat fee. Buys varying rights according to project.

Tips "Cape Shore is looking for realistic detail, good technique, and traditional themes or very high quality contemporary looks for coastal as well as inland markets. We will sometimes buy art for a full line of products, or we may buy art for a single note or gift item. Proven success in the giftware field a plus, but will consider new talent and exceptional unpublished illustrators."

CARDMAKERS

Box 236, High Bridge Rd., Lyme NH 03768. Phone/fax: (603)795-4422. E-mail: info@cardmakers.com. Website: www.cardmakers.com. **Principal:** Peter Diebold. Estab. 1978. Produces greeting cards. "We produce special cards for special interests and greeting cards for businesses—primarily Christmas. We also publish everyday cards for stockbrokers and boaters."

● Cardmakers requests if you send submissions via e-mail, please keep files small. When sending snail mail, please be aware they will only respond if SASE is included.

Needs Approached by more than 300 freelancers/year. Works with 5-10 freelancers/year. Buys 20-40 designs and illustrations/year. Prefers professional-caliber artists. Art guidelines available on website only. Please do not e-mail us for same. Works on assignment only. Uses freelancers mainly for greeting card design and calligraphy. Considers all media. "We market 5×7 cards designed to appeal to individual's specific interest—boating, building, cycling, stocks and bonds, etc." Prefers an upscale look. Submit seasonal ideas 6-9 months in advance.

First Contact & Terms Designers: Send brief sample of work. Illustrators: Send postcard sample or query letter with brief sample of work. "One good sample of work is enough for us. A return postcard with boxes to check off is wonderful. Phone calls are out; fax is a bad idea." Samples are filed. Responds only if interested. Portfolio review not required. Pays flat fee of $100-300 depending on many variables. Rights purchased vary according to project. Interested in buying second rights (reprint rights) to previously published work, if not previously used for greeting cards. Finds artists through word of mouth, exhibitions and *Artist's & Graphic Designer's Market* submissions.

Tips "We like to see new work in the early part of the year. It's important that you show us samples *before* requesting submission requirements. Getting published and gaining experience should be the main objective of freelancers entering the field. We favor fresh talent (but do also feature seasoned talent). PLEASE be patient waiting to hear from us! Make sure your work is equal to or better than that which is commonly found in use presently. Go to a large greeting card store. If you think you're as good or better than the artists there, continue!"

CAROLE JOY CREATIONS, INC.

1087 Federal Road, Unit #8, Brookfield CT 06804. Fax: (203)740-4495. Website: www.carolejoy.com. **President:** Carole Gellineau. Estab. 1986. Produces greeting cards. Specializes in cards, notes and invitations for people who share an African heritage.

Needs Approached by 200 freelancers/year. Works with 5-10 freelancers/year. Buys 100 freelance designs, illustrations and calligraphy/year. Prefers artists "who are thoroughly familiar with, educated in and sensitive to the African-American culture." Works on assignment only. Uses freelancers mainly for greeting card art. Also for calligraphy. Considers full color only. Looking for realistic, traditional, Afrocentric, colorful and upbeat

style. Prefers 11×14. 20% freelance design work demands knowledge of Illustrator, Photoshop and QuarkX-Press. Also produces material for Christmas, Easter, Mother's Day, Father's Day, graduation, Kwanzaa, Valentine's Day, birthdays and everyday. Also for sympathy, get well, romantic, thank you, serious illness and multicultural cards. Submit seasonal material 1 year in advance.

First Contact & Terms Send query letter with brochure, photocopies, photographs and SASE. No phone calls or slides. No e-mail addresses. Responds to street address only. Calligraphers send samples and compensation requirements. Samples are not filed and are returned with SASE only within 6 months. Responds only if interested. Portfolio review not required. Buys all rights. Pays for illustration by the project. Does not pay royalties; will license at one-time flat rate.

Tips "Excellent illustration skills are necessary and designs should be appropriate for African-American social expression. Writers should send verse that is appropriate for greeting cards and avoid lengthy, personal experiences. Verse and art should be uplifting. We need coordinated themes for calendars."

Ⓝ CASE STATIONERY CO., INC.

179 Saw Mill River Rd., Yonkers NY 10701-6616. (914)965-5100. Fax: (914)965-2362. E-mail: case@casestationery.com. Website: www.casestationery.com. **President:** Jerome Sudnow. Vice President: Joyce Blackwood. Estab. 1954. Produces stationery, notes, memo pads and tins for mass merchandisers in stationery and housewares departments.

Needs Approached by 10 freelancers/year. Buys 50 designs from freelancers/year. Works on assignment only. Buys design and/or illustration mainly for stationery products. Uses freelancers for mechanicals and ideas. Produces materials for Christmas; submit 6 months in advance. Likes to see youthful and traditional styles, as well as English and French country themes. 10% of freelance work requires computer skills.

First Contact & Terms Send query letter with résumé and tearsheets, photostats, photocopies, slides and photographs. Samples not filed are returned. Responds ASAP. Call or write for appointment to show a portfolio. Original artwork is not returned. Pays by the project. Buys first rights or one-time rights.

Tips "Find out what we do. Get to know us. We are creative and know how to sell a product."

CASPARI, INC.

116 E. 27th St., New York NY 10016. (212)685-9798. Fax: (212)685-9401. E-mail: info@hgcaspari.com. Website: www.hgcaspari.com. **Contact:** Lucille Andriola. Publishes greeting cards, Christmas cards, invitations, giftwrap and paper napkins. "The line maintains a very traditional theme."

Needs Buys 80-100 illustrations/year. Prefers watercolor, gouache, acrylics and other color media. Produces seasonal material for Christmas, Mother's Day, Father's Day, Easter and Valentine's Day. Also for life events such as moving, new house, wedding, birthday, graduation, baby, get well, sympathy.

First Contact & Terms Send samples to Lucille Andriola to review. Prefers unpublished original illustrations, slides or transparencies. Art director will contact artist for portfolio review if interested. **Pays on acceptance**; negotiable. Pays flat fee of $400 for design. Finds artists through word of mouth, magazines, submissions/self-promotions, sourcebooks, agents, visiting artist's exhibitions, art fairs and artists' reps.

Tips "Caspari and many other small companies rely on freelance artists to give the line a fresh, overall style rather than relying on one artist. We feel this is a strong point of our company. Please do not send verses."

CATCH PUBLISHING, INC.

456 Penn St., Yeadon PA 19050. (484)521-0132. Fax: (610)626-2778. **Contact:** Michael Markowicz. Produces greeting cards, stationery, giftwrap, blank books, posters and calendars.

Needs Approached by 200 freelancers/year. Works with 5-10 freelancers/year. Buys 25-50 freelance designs and illustrations/year. Art guidelines for SASE with first-class postage. Uses freelancers mainly for design. Considers all media. Produces material for Christmas, New Year and everyday. Submit seasonal material 1 year in advance.

First Contact & Terms Send query letter with brochure, tearsheets, résumé, slides, computer disks and SASE. Samples are not filed and are returned by SASE if requested by artist. Responds in 6 months. Company will contact artist for portfolio review if interested. Portfolio should include final art, slides or large format transparencies. Rights purchased vary according to project. Originals are returned at job's completion. Pays royalties of 10-12% (may vary according to job).

CEDCO PUBLISHING CO.

100 Pelican Way, San Rafael CA 94901. E-mail: licensingadministrator@cedco.com. Website: www.cedco.com. **Contact:** Licensing Department. Estab. 1982. Produces 200 upscale calendars and books.

Needs Approached by 500 freelancers/year. Art guidelines on website. "We never give assignment work." Uses freelancers mainly for stock material and ideas. "We use either 35mm slides or 4×5s of the work."

First Contact & Terms "No phone calls accepted." Send query letter with nonreturnable photocopies and

tearsheets. Samples are filed. Also send list of places where your work has been published. Responds only if interested. To show portfolio, mail thumbnails and b&w photostats, tearsheets and photographs or e-mail JPEG file. Original artwork is returned at the job's completion. Pays by the project. Buys one-time rights. Interested in buying second rights (reprint rights) to previously published work. Finds artists through art fairs and licensing agents.

Tips ''Full calendar ideas encouraged!''

CENTRIC CORP.

6712 Melrose Ave., Los Angeles CA 90038. (323)936-2100. Fax: (323)936-2101. E-mail: centric@juno.com. Website: www.centriccorp.com. **President:** Sammy Okdot. Estab. 1986. Produces fashion watches, clocks, mugs, frames, pens and T-shirts for ages 13-60.

Needs Approached by 40 freelancers/year. Works with 6-7 freelancers/year. Buys approximately 100 designs and illustrations/year. Prefers local freelancers only. Works on assignment only. Uses freelancers mainly for watch and clock dials, frames and mug designs, T-shirts, pens and packaging. Also for mechanicals and Web design. Considers mainly graphics, computer graphics, cartoons, pen & ink, photography. 95% of freelance work demands knowledge of QuarkXPress, Illustrator, Photoshop.

First Contact & Terms Send postcard sample or query letter with appropriate samples. Accepts submissions on disk. Samples are filed if interested. Responds only if interested. Originals are returned at job's completion. Also needs package/product designers, pay rate negotiable. Requests work on spec before assigning a job. Pays by the project. Pays royalties of 1-10% for design. Rights purchased vary according to project. Finds artists through submissions/self-promotions, sourcebooks, agents and artists' reps.

Tips ''Show your range on a postcard addressed personally to the target person. Be flexible, easy to work with. The World Wide Web is making it easier to work with artists in other locations.''

CHARTPAK/FRANCES MEYER, INC.

1 River Road, Leeds MA 01053. (800)628-1910. Fax: (800)762-7918. E-mail: info@chartpak.com. Website: www.chartpak.com. **Contact:** Robin Campion, creative director. Estab. 1979. Produces scrapbooking products, stickers and stationery.

- Frances Meyer was acquired by Chartpak in 2003. Product lines will retain the Frances Meyer look, but company moved from Savannah, Georgia to Leeds, Massachusetts.

Needs Works with 5-6 freelance artists/year. Art guidelines available free for SASE. Commissions 100 freelance illustrations and designs/year. Works on assignment only. ''Most of our artists work in either watercolor or acrylic. We are open, however, to artists who work in other media.'' Looking for ''everything from upscale and sophisticated adult theme-oriented paper items, to fun, youthful designs for birth announcements, baby and youth products. Diversity of style, originality of work, as well as technical skills are a few of our basic needs.'' Produces material for Christmas, graduation, Thanksgiving (fall), New Year's, Halloween, birthdays, everyday, weddings, showers, new baby, etc. Submit seasonal material 6-12 months in advance.

First Contact & Terms Send query letter with tearsheets, SASE, photocopies, transparencies (no originals) and ''as much information as is necessary to show diversity of style and creativity. No response or return of samples by Frances Meyer, Inc. *without SASE*!'' Responds in 2-3 months. Company will contact artist for portfolio review if interested. Originals are returned at job's completion. Pays royalty (varies).

Tips ''Generally, we are looking to work with a few talented and committed artists for an extended period of time. We do not 'clean out' our line on an annual basis just to introduce new product. If an item sells, it will remain in the line. Punctuality concerning deadlines is a necessity.''

N CITY MERCHANDISE INC.

241 41st St., P.O. Box 320081, Brooklyn NY 11232. (718)832-2931. Fax: (718)832-2939. E-mail: citymdse@aol.c om. **Executive Assistant:** Martina Santoli. Produces calendars, collectible figurines, gifts, mugs, souvenirs of New York.

Needs Works with 6-10 freelancers/year. Buys 50-100 freelance designs and illustrations/year. ''We buy sculptures for our casting business.'' Prefers freelancers with experience in graphic design. Works on assignment only. Uses freelancers for most projects. Considers all media. 50% of design and 80% of illustration demand knowledge of Photoshop, QuarkXPress, Illustrator. Does not produce holiday material.

First Contact & Terms Designers: Send query letter with brochure, photocopies, résumé. Illustrators and/or cartoonists: Send postcard sample of work only. Sculptors send résumé and slides, photos or photocopies of their work. Samples are filed. Include SASE for return of samples. Responds in 2 weeks. Portfolios required for sculptors only if interested in artist's work. Buys all rights. Pays by project.

N CLARKE AMERICAN

P.O. Box 460, San Antonio TX 78292-0460. (210)697-1375. Fax: (210)558-7045. E-mail: linda_m_roothame@clar keamerican.com. Website: www.clarkeamerican.com. **Senior Product Development Manager:** Linda Roo-

thame. Estab. 1874. Produces checks and other products and services sold through financial institutions. "We're a national printer seeking original works for check series, consisting of five, three, or one scene. Looking for a variety of themes, media, and subjects for a wide market appeal."

Needs Uses freelancers mainly for illustration and design of personal checks. Considers all media and a range of styles. Prefers art twice standard check size.

First Contact & Terms Send postcard sample or query letter with brochure and résumé. "Indicate whether the work is available; do not send original art." Samples are filed and are not returned. Responds only if interested. Rights purchased vary according to project. Payment for illustration varies by the project.

Tips "Keep red and black in the illustration to a minimum for image processing."

⚏ CLAY ART

239 Utah Ave., South San Francisco CA 94080-6802. (650)244-4970. Fax: (650)244-4979. **Art Director:** Jenny McClain Doores. Estab. 1979. Produces giftware and home accessory products cookie jars, salt & peppers, mugs, pitchers, platters and canisters. Line features innovative, contemporary or European tableware and hand-painted designs.

Needs Approached by 70 freelancers/year. Prefers freelancers with experience in 3-D design of giftware and home accessory items. Works on assignment only. Uses freelancers mainly for illustrations and 3-D design. Seeks humorous, whimsical, innovative work.

First Contact & Terms Send query letter with résumé, SASE, tearsheets and photocopies. Samples are filed. Responds only if interested. Call for appointment to show portfolio of thumbnails, roughs, final art, color photostats, tearsheets, slides and dummies. Negotiates rights purchased. Originals are returned at job's completion. Pays by project. Prefers buying artwork outright.

CLEO, INC.

4025 Viscount Ave., Memphis TN 38118. (901)369-6657 or (800)289-2536. Fax: (901)369-6376. E-mail: cpatat@cleowrap.com. Website: www.cleowrap.com. **Senior Director of Creative Resources:** Claude Patat. Estab. 1953. Produces giftwrap and gift bags. "Cleo is the world's largest Christmas giftwrap manufacturer. Other product categories include some seasonal product. Mass market for all age groups."

Needs Approached by 25 freelancers/year. Works with 40-50 freelancers/year. Buys more than 200 freelance designs and illustrations/year. Uses freelancers mainly for giftwrap and gift bags (designs). Also for calligraphy. Considers most any media. Looking for fresh, imaginative as well as classic quality designs for Christmas. 30″ repeat for giftwrap. Art guidelines available. Submit seasonal material at least a year in advance.

First Contact & Terms Send query letter with slides, SASE, photocopies, transparencies and speculative art. Accepts submissions on disk. Samples are filed if interested or returned by SASE if requested by artist. Responds only if interested. Rights purchased vary according to project; usually buys all rights. Pays flat fee. Also needs package/product designers, pay rate negotiable. Finds artists through agents, sourcebooks, magazines, word of mouth and submissions.

Tips "Understand the needs of the particular market to which you submit your work."

⚏ COMSTOCK CARDS, INC.

600 S. Rock Blvd., Suite 15, Reno NV 89502. (775)856-9400. Fax: (775)856-9406. E-mail: submissions@comstockcards.com. Website: www.comstockcards.com. **Production Manager:** Cindy Thomas. Estab. 1987. Produces greeting cards, giftbags and invitations. Styles include alternative and adult humor, outrageous and shocking themes; specializes in fat, age and funny situations. No animals or landscapes. Target market predominately professional females, ages 25-55.

Needs Approached by 250-350 freelancers/year. Works with 30-35 freelancers/year. "Especially seeking artists able to produce outrageous adult-oriented cartoons." Uses freelancers mainly for cartoon greeting cards. Art guidelines for SASE with first-class postage. No verse or prose. Gaglines must be brief. Prefers 5×7 final art. Produces material for all occasions. Submit holiday concepts 6 months in advance.

First Contact & Terms Send query letter with SASE, tearsheets or photocopies. Samples are not usually filed and are returned by SASE if requested. Responds only if interested. Portfolio review not required. Originals are not returned. Pays royalties of 5%. Pays by project, $50-150 minimum; may negotiate other arrangements. Buys all rights.

Tips "Make submissions outrageous and funny prose. Outrageous humor is what we look for—risqué OK, mild risqué best."

⚏ CONCORD LITHO

92 Old Turnpike Rd., Concord NH 03301. (603)225-3328. Fax: (603)225-6120. E-mail: brockwell@concordlitho.com. Website: www.concordlitho.com. **Creative Director:** Brian Rockwell. Estab. 1958. Produces greeting cards, stationery, posters, giftwrap, specialty paper products for direct marketing. "We provide a range of print goods

for commercial markets but also supply high-quality paper products used for fundraising purposes.''

Needs Buys 200 freelance designs and illustrations/year. Works on assignment only but will consider available work also. Uses freelancers mainly for greeting cards, wrap and calendars. Also for calligraphy and computer-generated art. Considers all media but prefers watercolor. Art guidelines available for SASE with first-class postage. ''Our needs range from generic seasonal and holiday greeting cards to religious subjects, florals, nature, scenics, ''cutesies,'' whimsical art and inspirational vignettes. We prefer more traditional designs with occasional contemporary needs. Always looking for traditional religious art.'' Prefers original art no larger than 10×14. Produces material for all holidays and seasons Christmas, Valentine's Day, Mother's Day, Father's Day, Easter, Thanksgiving, New Year, birthdays, everyday and other religious dates. Submit seasonal material 6 months in advance.

First Contact & Terms Send introductory letter with résumé or brochure, along with nonreturnable photographs, samples, or photocopies of work. Indicate whether work is for style only and if it is available. Accepts submissions on disk. Responds in 3 months. Portfolio review not required. Rights purchased vary according to project. Pays by the project, $200-800. ''We will exceed this amount depending on project.'' No phone calls, please.

Tips ''Keep sending samples or color photocopies of work to update our reference library. Be patient. Send quality samples or copies.''

COURAGE CENTER

3915 Golden Valley Road, Minneapolis, MN 55422. (888)413-3323. E-mail: artsearch@courage.org. Website: www.couragecards.org. **Art and Production Manager:** Laura Brooks. Estab. 1970. ''Courage Cards are holiday cards that are produced to support the programs of Courage Center, a nonprofit provider of rehabilitation services that helps people with disabilities live more independently.''

Needs Holiday art appropriate for greeting cards: including traditional, winter, nostalgic, religious, ethnic and world peace designs. Features artists with disabilities, but all artists are encouraged to enter the annual Courage Card Art Search. Art guidelines available on company's website.

First Contact & Terms Call or e-mail name and address to receive Art Search guidelines, which are mailed in January for the March 31 entry deadline. Artist retains ownership of the art. Pays $400 licensing fee in addition to nationwide recognition through distribution of more than 500,000 catalogs and promotional pieces, Internet, TV, radio and print advertising.

Tips ''Do not send originals. Entries should arrive as a result of the Art Search. The Selection Committee chooses art that will reproduce well as a card. We need colorful contemporary and traditional images for holiday greetings. Participation in the Courage Cards Art Search is a wonderful way to share your talents and help people live more independently.''

CREATIF LICENSING

31 Old Town Crossing, Mt. Kisco NY 10549. (914)241-6211. E-mail: info@creatifusa.com. Website: www.creatif usa.com. **Licensing Contact:** Marcie Silverman. Estab. 1975. ''Creatif is a licensing agency that represents artists and brands.'' Licensing art for commercial applications on consumer products in the gift, stationery and home furnishings industries.

Needs Looking for unique art styles and/or concepts that are applicable to multiple products and categories.

First Contact & Terms Send query letter with brochure, photocopies, photographs, SASE and tearsheets. Does not accept e-mail attachments but will review website links. Responds in 2 months. Samples are returned with SASE. Creatif will obtain licensing agreements on behalf of the artists, negotiate and manage the licensing programs and pay royalties. Artists are responsible for filing all copyright and trademark. Requires exclusive representation of artists.

Tips ''We are looking to license talented and committed artists. It is important to understand current trends, and design with specific products in mind.''

[N] [T] CREEGAN CO., INC.

The Creegan Animation Factory, 510 Washington St., Steubenville OH 43952. (740)283-3708. Fax: (740)283-4117. E-mail: creegans@weir.net. Website: www.creegans.com. **President:** Dr. G. Creegan. Estab. 1961. ''The Creegan Company designs and manufactures animated characters, costume characters and life-size audio animatronic air-driven characters. All products are custom made from beginning to end.''

● Recently seen on the Travel Channel and Made in America with John Ratzenberger.

Needs Approached by 10-30 freelance artists/year. Works with 3 freelancers/year. Prefers local artists with experience in sculpting, latex, oil paint, molding, etc. Artists sometimes work on assignment basis. Uses freelancers mainly for design comps. Also for mechanicals. Produces material for all holidays and seasons, Christmas, Valentine's Day, Easter, Thanksgiving, Halloween and everyday. Submit seasonal material 3 months in advance.

First Contact & Terms Send query letter with résumé and nonreturnable photos or other samples. Samples are

filed. Responds. Write for appointment to show portfolio of final art, photographs. Originals returned. Rights purchased vary according to project.

SUZANNE CRUISE CREATIVE SERVICES, INC.

7199 W. 98th Terrace, #110, Overland Park KS 66212. (913)648-2190. Fax: (913)648-2110. E-mail: artagent@crui secreative.com. Website: www.cruisecreative.com. **President:** Suzanne Cruise. Estab. 1990. "Sells and licenses art for calendars, craft papers, decorative housewares, fabric giftbags, gifts, giftwrap, greeting cards, home decor, keychains, mugs, ornaments, prints, rubber stamps, stickers, tabletop, and textiles. "We are a full-service licensing agency, as well as a full-service creative agency representing licensed artists and freelance artists. Our services include, but are not limited to, screening manufacturers for quality and distribution, negotiating rights, overseeing contracts and payments, sending artists' samples to manufacturers for review, and exhibiting artists' work at major trade shows annually." Art guidelines on website.

Needs Seeks established and emerging artists with distinctive styles suitable for the ever-changing consumer market. Looking for artists that manufacturers cannot find in their own art staff or in the freelance market, or who have a style that has the potential to become a classic license. "We represent a wide variety of freelance artists, and a few select licensed artists, offering their work to manufacturers of goods such as gifts, textiles, home furnishings, bedding, book publishing, social expression, puzzles, rubber stamps, etc. We look for art that has popular appeal. It can be traditional, whimsical, cute, humorous, seasonal or everyday, as long as it is not 'dated'."

First Contact & Terms Send query letter with color photocopies, tearsheets or samples. No originals. Samples are returned only if accompanied by SASE. Responds only if interested. Portfolio required. Request portfolio review in original query.

Tips "Walk a few trade shows and familiarize yourself with the industries you want your work to be in. Attend a few of the panel discussions that are put on during the shows to get to know the business a little better."

CURRENT, INC.

1005 E. Woodmen Rd., Colorado Springs CO 80920. (719)594-4100. Fax: (719)531-2564. Website: www.currentc atalog.com. **Creative Business Manager:** Dana Grignano. Estab. 1950. Produces bookmarks, calendars, collectible plates, decorative housewares, decorations, giftbags, gifts, giftwrap, greeting cards, mugs, ornaments, school supplies, stationery, T-shirts. Specializes in seasonal and everyday social expressions products.

Needs Works with hundreds of freelancers/year. Buys 700 freelance designs and illustrations/year. Prefers freelancers with experience in greeting cards and textile industries. Uses freelancers mainly for cards, wraps, calendars, gifts, calligraphy. Considers all media. Product categories include business, conventional, cute, cute/religious, juvenile, religious, teen. Freelancers should be familiar with Photoshop, Illustrator and FreeHand. Produces material for all holidays and seasons and everyday. Submit seasonal material year-round.

First Contact & Terms Send query letter with photocopies, tearsheets, brochure and photographs. Samples are filed. Responds only if interested. Will contact artist for portfolio review if interested. Buys all rights. Pays by the project; $50-500. Finds freelancers through agents, artists' submissions, sourcebooks.

Tips "Review website or catalog prior to sending work."

✔ CUSTOM STUDIOS INC.

4353 N. Lincoln Ave., Chicago IL 60618. (773)665-2226. Fax: (773)665-2228. E-mail: customstudios123@yahoo. com. Website: www.custom-studios.com. **President:** Gary Wing. Estab. 1966. "We specialize in designing and screen printing custom T-shirts for schools, business promotions, fundraising and for our own line of stock." Also manufacture coffee mugs, bumper stickers, balloons and over 1,000 other products.

Needs Works with 10 freelance illustrators/year. Assigns 12 freelance jobs/year. Needs b&w illustrations (some original and some from customer's sketch). Uses artists for direct mail and brochures/fliers, but mostly for custom and stock T-shirt designs.

First Contact & Terms Send query letter with résumé, photostats, photocopies or tearsheets. "We will not return originals or samples." Responds in 1 month. Mail b&w or color tearsheets or photostats to be kept on file. Pays for design and illustration by the hour, $28-35; by the project, $50-150. Considers turnaround time and rights purchased when establishing payment. For designs submitted to be used as stock T-shirt designs, pays 5-10% royalty. Rights purchased vary according to project.

Tips "Send 5-10 good copies of your best work. We would like to see more illustrations or copies, not originals. Do not get discouraged if your first designs sent are not accepted."

DESIGN DESIGN, INC.

P.O. Box 2266, Grand Rapids MI 49501. (616)774-2448. Fax: (616)774-4020. **Creative Director:** Tom Vituj. Produces humorous and traditional fine art greeting cards, stationery, magnets, sticky notes, giftwrap/tissue and paper plates/napkins.

Needs Uses freelancers for all of the above products. Considers most media. Produces cards for everyday and all holidays. Submit seasonal material 1 year in advance.

First Contact & Terms Send query letter with appropriate samples and SASE. Samples are not filed and are returned by SASE if requested by artist. To show portfolio, send color copies, photographs or slides. Do not send originals. Pays various royalties per product development.

DESIGNER GREETINGS, INC.

Box 140729, Staten Island NY 10314. (718)981-7700. Fax: (718)981-0151. E-mail: info@designergreetings.com. Website: www.designergreetings.com. **Art Director:** Fern Gimbelman. Produces all types of greeting cards. Produces alternative, general, informal, inspirational, contemporary, juvenile and studio cards and giftwrap.

Needs Works with 16 freelancers/year. Buys 250-300 designs and illustrations/year. Art guidelines free for SAE with first-class postage or on website. Works on assignment only both traditionally and digitally. Also uses artists for airbrushing and pen & ink. No specific size required. Produces material for all seasons; submit seasonal material 6 months in advance. Also needs package/product design and web design.

First Contact & Terms Send query letter with tearsheets, photocopies or other samples. Samples are filed or are returned only if requested. Responds in 2 months. Appointments to show portfolio are only made after seeing style of artwork. Originals are not returned. Pays flat fee. Buys all greeting card rights. Artist guidelines on website. Do not send electronic submissions.

Tips "We are willing to look at any work through traditional mail (photocopies, etc.). Appointments are given after I personally speak with the artist (by phone)."

DIMENSIONS, INC.

1801 N 12th St., Reading PA 19604. (610)939-9900. Fax: (610)939-9666. E-mail: pam.keller@dimensions-crafts. com. Website: www.dimensions-crafts.com. **Designer Relations Coordinator:** Pamela Keller. Produces craft kits including but not limited to needlework, stained glass, paint-by-number, kids bead crafts and memory products. "We are a craft manufacturer with emphasis on sophisticated artwork and talented designers. Products include needlecraft kits, paint-by-number, and baby products. Primary market is anyone who does crafts."

Needs Approached by 50-100 freelancers/year. Works with 200 freelancers/year. Develops more than 400 freelance designs and illustrations/year. Uses freelancers mainly for the original artwork for each product. Art guidelines for SASE with first-class postage. In-house art staff adapts for needlecraft. Considers all media. Looking for fine art, realistic representation, good composition, more complex designs than some greeting card art; fairly tight illustration with good definition; also whimsical, fun characters. Produces material for Christmas, everyday birth, wedding and anniversary records. Majority of products are everyday decorative designs for the home.

First Contact & Terms Send cover letter with color brochure, tearsheets, photographs or photocopies. Samples are filed "if artwork has potential for our market." Samples are returned by SASE only if requested by artist. Responds in 1 month. Portfolio review not required. Originals are returned at job's completion. Pays by project, royalties of 2-5%; sometimes purchases outright. Finds artists through magazines, trade shows, word of mouth, licensors/reps.

Tips "Current popular subjects in our industry florals, wildlife, garden themes, ocean themes, celestial, cats, birds, Southwest/Native American, juvenile/baby and whimsical."

DLM STUDIO

2563 Princeton Rd., Cleveland Heights OH 44118. (216)881-8888. Fax: (216)274-9308. E-mail: pat@dlmstudio.com. Website: www.dlmstudio.com. **Vice President:** Pat Walker. Estab. 1984. Produces fabrics/packaging/wallpaper. Specializes in wallcovering, border and mural design, entire package with fabrics, also ultra-wide "mural" borders. Also licenses artwork for wall murals.

Needs Approached by 40-80 freelancers/year. Works with 20-40 freelancers/year. Buys hundreds of freelance designs and illustrations/year. Art guidelines free for SASE with first-class postage. Works on assignment and some licensing. Uses freelancers mainly for designs, color work. Looking for traditional, country, floral, texture, woven, menswear, children's and novelty styles. 50% of freelance design work demands computer skills. Wallcovering CAD experience a plus. Produces material for everyday.

First Contact & Terms Illustrators: Send query letter with photocopies, examples of work, résumé and SASE. Accepts disk submissions compatible with Illustrator or Photoshop files (Mac), SyQuest, Jaz or Zip. Samples are filed or returned by SASE on request. Responds in 1 month. Request portfolio review of color photographs and slides in original query, follow-up with letter after initial query. Rights purchased vary according to project. Pays by the project, $500-1,500, "but it varies." Finds freelancers through agents and local ads, word of mouth.

Tips "Send great samples, especially traditional patterns. Novelty and special interest also strong, and digital files are very helpful. Study the market closely; do very detailed artwork."

Leslie Murray

*Greeting card artist
finds happy place*

Leslie Murray has been drawing ever since she can remember. At the age of two, she took down every book that her little arms could reach from her parents' bookshelves and drew on all of the blank white pages. She even recalls scribbling on the dry cleaning cardboards that she pulled out of her father's newly pressed shirts. "Every blank space cried out to be filled!" If these stunts didn't clue her parents into their daughter's artistic aspirations, they must have had some inclination after young Murray drew what she describes as, "an attractive mural of stick figures" on the walls of her parents' bedroom. The mural reached only about two or three feet high, her eye-level at the time, and extended *all* around the room. "I assumed my mother would have been pleased," Murray says. Clearly her sense of humor began developing at a young age as well.

Greeting card artist and writer Leslie Murray has made her mark on the artistic world, not only with her clever illustrations and quirky characters like Madame Laverne, the less than gifted fortune-teller, but also with her colorful humor—and the comedy doesn't stop with her drawings. In addition to her identifiable illustrations, Murray also writes all of her own cards, delivering the kind of uncensored punch-lines that let her audience, women ages 25 to 55, know at a quick glance that this has Murray's Law written all over it.

Although her style has evolved over her twenty-one years in this profession, Murray does have some early characters who reappear throughout her work, including Ginger, a large woman with curly red hair and invincible self-esteem, Madame LaVerne, the fortune teller who tends to predict the obvious (telling a pregnant woman, "I see a baby in your future"), and Lill, another redhead who is very well-endowed with skinny legs and bad taste in clothes. Although none of these characters are based on real people, Murray feels she knows each one personally and just what they would say in any situation.

A Chicago-native, Murray's life before leaping into the greeting card industry definitely gives her a wide range of interesting experiences from which to draw. She started out in college studying art, but thinking that this major would not lead to many job prospects, she graduated with a degree in French, which she later learned to be equally or less marketable than her original pursuit. After dabbling in the modeling world for a few years, Murray went to work for Air France, making homemade Christmas cards for friends and family as a hobby. She had no idea this hobby of hers would turn into such a successful career. In fact, it was her former husband, Jim Murray, who recognized her talent and suggested she try to sell some of her cards.

Murray's career began with printing a little line of only 14 Christmas cards with gouache and marker on Strathmore watercolor paper. Having no idea what to do next, she read some trade publications, such as *Gifts & Decorative Accessories*, and traveled to New

York for the 1984 National Stationery Show, which she recommends *all* aspiring artists to attend. Murray showed her small line to countless booths and signed contacts with a handful of different sales representatives at the show from all over the United States. She recalls carrying around the 14 pieces of original art, not having thought to make duplicates. "You'd think I'd have heard of color photocopies. Sometimes when I look back, I am amazed I ever had a career," Murray admits.

Once Murray returned home from the show, she and her ex-husband searched for a printer in Chicago and took a "wild optimistic guess" at the quantities to print. Then, the pair chose a name that they could both work under as freelance designers. Living near the north side of Chicago, they decided on the name Near North Graphics, then met with a lawyer to get their company incorporated, and printed their newly designed company logo on generic invoices and commission report forms. But the work didn't stop there.

Murray acted as her own publisher for four years, storing her inventory in the bathtub and using grocery store saran wrap to "shrink wrap" her orders. Still working 9 to 5 jobs, both Murray and her ex-husband began boxing up orders at night when calls came from their NY contacts, and driving them over to UPS themselves to be shipped. "I don't recommend being your own publisher for any length of time. I paid huge printing costs, for one thing," says Murray. Plus, marketing your own work is very time-consuming, requiring you to "keep a finger on the pulse of America at all times" and listen to what store owners want.

In 1988, Murray teamed up with Design Design Inc., a small, new greeting card company, after receiving a phone call from its founder and publisher, Don Kalil who had seen her cards in a local store in Grand Rapids, Michigan. Having served as her own publisher for a few years, Murray had used this time to expand her card line beyond Christmas and holidays and therefore was *ready* when approached by Design Design. Kalil bought out Murray's existing inventory and gave her design advice in all areas from resizing her cards to fit store racks, as well as artistic direction like using more color and backgrounds. Since all of Kalil's artists had names for their lines, Murray decided to create a play-on-words and came up with the name Murray's Law. "We still get people asking for 'Murphy's Law' cards."

With the Design Design team working hard to market her work, Murray has been able to focus her energy on creating thousands of new greeting cards, as well as a four-panel syndicate comic strip. In the late 1990's, Kalil developed a new company called, cleverly enough, The Syndicate, and Murray was his only client. Kalil created sales kits when pre-

Murray's Law®/© Design Design, Inc.

Leslie Murray doesn't limit her humor to just birthdays and Christmas greetings. She believes the trend is veering away from the usual card giving occasions. She images her audience to be women between the ages of 25 and 55 who don't need an excuse to give each other a laugh or poke fun at their own lives for sanity's sake.

Greeting Cards & Gifts

Murray's Law®/© Design Design, Inc.

Although Murray can create a hilarious Boss's Day card, she knows from experience how difficult it is to be your own boss/publisher in the greeting card industry. Remembering how inventory spilled out of her bathtub like "the last scene from *Raiders of the Lost Ark*," she is grateful to Design Design for handling all marketing and helping turn her career into a huge success.

senting the strip to newspapers, and Murray's comic ran for a few months. Most recently, Murray invented a line of cocktail napkins, allowing her to capitalize on the wide possibilities of "drinking and alcohol jokes." Murray also credits Design Design for creating her Web site located at www.murrayslaw.com, showing her illustrations in flash animation. However, Murray can't completely forget marketing when designing new cards.

"Sendability is the hardest part. You don't send a new mom a card that calls kids rug-rats. This sometimes gets in the way of the artist's *vision*. You can come up with a really funny joke, but it can be completely *un*sendable. Trying to contort it into an occasion for sending a card can be very frustrating. That's why I loved doing the comic strip. Who cared if anybody liked it but me or if they would want to send it to their Aunt Betty!"

Murray finds ideas for cards everywhere, from the mall and grocery store, to watching TV and overhearing other people's conversations. "Anybody who goes out in public wearing stretch pants or white vinyl with pantyhose is going to be on a Murray's Law product, *fair warning*." Her colleagues have also offered inspiration, particularly her Creative Director, Tom Vituj, who helped Murray create her most recent character, Arabella, a self-involved young "fashionista."

Although very prolific, Murray admits that she only writes and draws feverishly when a deadline is looming. With about five deadlines per year, Murray tries to prepare herself and get into what she calls "the zone" where she brainstorms as many jokes as she can. "I usually write the joke first and then illustrate it." Throughout the year, Murray will keep spiral notebooks that she fills with funny thoughts or ideas to keep inspiration flowing. She is no stranger to writer's block.

"As deadlines approach, I usually spend a day just sitting there staring at a blank piece of notebook paper hoping something will come to be. About six hours later when nothing has, my forehead breaks out in a sweat and I think, 'Oh God. I will never have another idea again. I am washed up and I will lose my house and wind up in the gutter living on cat food! I am not in my Happy Place." And then Murray thought, "Hey, that might be kind of funny on a notepad, so she created a notepad, sticky notes, and magnet all that read, "I am not in my Happy Place."

That is just one of the hilarious jokes Murray has delivered that doesn't necessarily match your typical card-giving occasion. "I don't match my style to the occasion, rather I make the occasion fit my style." And what a beloved unique style it is.

Her primary advice to new artists is to develop a number of samples that show style and consistency. Developing your own identifiable line is helpful, even if you are starting with as few as 14 cards, like she did. In her usual humor, Murray wants to emphasize one last pearl of wisdom to all of those who are looking to enter this industry: "Don't be funnier than me. I will find you."

—*Rebecca Chrysler*

EDITIONS LIMITED/FREDERICK BECK

51 Bartlett Ave., Pittsfield MA 01201. (413)443-0973. Fax: (413)445-5014. E-mail: mark@chatsworthcollection.com. Website: www.chatsworthcollection.com. **Art Director:** Mark Brown. Estab. 1958. Produces holiday greeting cards, personalized and box stock and stationery.

• Editions Limited joined forces with Frederick Beck Originals. The company also runs Gene Bliley Stationery. See editorial comment under Frederick Beck Originals for further information. Mark Brown is the art director for all three divisions.

Needs Approached by 100 freelancers/year. Works with 20 freelancers/year. Buys 50-100 freelance designs and illustrations/year. Prefers freelancers with experience in silkscreen. Art guidelines available. Uses freelancers mainly for silkscreen greeting cards. Also for separations and design. Considers offset, silkscreen, thermography, foil stamp. Looking for traditional holiday, a little whimsy, contemporary designs. Size varies. Produces material for Christmas, graduation, Hannukah, New Year, Rosh Hashanah and Valentine's Day. Submit seasonal material 15 months in advance.

First Contact & Terms Designers send query letter with brochure, photocopies, photographs, résumé, tearsheets. Samples are filed. Responds in 1 month. Will contact artist for portfolio review of b&w, color, final art, photographs, photostats, roughs if interested. Buys all rights. Pays $150-300/design. Finds freelancers through word of mouth, past history.

EISENHART WALLCOVERINGS CO.

400 Pine St., Hanover PA 17331. (717)632-5918. Fax: (717)632-2321. Website: www.eisenhartwallcoverings.com. **Co-Design Center Administrators:** Gen Huston and Teresa Schnetzka. Licensing: Joanne Berwager. Estab. 1940. Produces custom and residential wallpaper, borders, murals and coordinating fabrics. Licenses various types of artwork for wall coverings. Manufactures and imports residential and architectural wallcovering under the Ashford House®, Eisenhart® and Color Tree® collections.

Needs Works with 10-20 freelancers/year. Buys 25-50 freelance designs and illustrations/year. Prefers freelancers with experience in wallcovering design, experience with Photoshop helpful. Uses freelancers mainly for wallpaper design/color. Also for P-O-P. Looking for traditional as well as novelty designs.

First Contact & Terms Designers should contact by e-mail. Illustrators: Send query letter with color copies. Samples are filed. Samples are returned by SASE if requested. Responds in 2 weeks. Artist should contact after 2 weeks. Will contact for portfolio review if interested. Buys all rights. Pays by design, varies. Finds freelancers through artists' submissions.

KRISTIN ELLIOTT, INC.

10 Industrial Way, Amesbury, MA 01913. (978)526-7126. Fax: (978)465-6522. E-mail: kedesignstudio@verizon.net. Website: www.kristinelliott.com. **Creative Director:** Barbara Elliott. Publishes greeting cards and stationery products.

Needs Works with 25 freelance artists/year. Uses illustrations and graphic design. Prefers watercolor and gouache. Produces Christmas and everyday stationery products, including boxed notes, imprintables and photo cards.

First Contact & Terms Send published samples, color copies, slides, tearsheets or photos. Include SASE for return of materials. Payment negotiable.

Tips Crisp, clean colors preferred. "Show prospective clients a full range of art styles in a professional presentation."

ENESCO GROUP INC.

225 Windsor Dr., Itasca IL 60143-1225. (630)875-5300. Fax: (630)875-5350. Website: www.enesco.com. **Contact:** New Submissions/Licensing. Producer and importer of fine gifts, home decor and collectibles, such as resin, porcelain bisque and earthenware figurines, plates, hanging ornaments, bells, picture frames, decorative housewares. Clients gift stores, card shops and department stores.

Needs Works with multiple freelance artists/year. Prefers artists with experience in gift product and packaging development. Uses freelancers for rendering, illustration and sculpture. 50% of freelance work demands knowledge of Photoshop, QuarkXPress or Illustrator.

First Contact & Terms Send query letter with résumé, tearsheets and/or photographs. Samples are filed or are returned. Responds in 2 weeks. Pays by the project. Submittor may be required to sign a submission agreement.

Tips "Contact by mail only. It is better to send samples and/or photocopies of work instead of original art. All will be reviewed by Senior Creative Director, Executive Vice President and Licensing Director. If your talent is a good match to Enesco's product development, we will contact you to discuss further arrangements. Please do not send slides. Have a well-thought-out concept that relates to gift products before mailing your submissions."

ⓝ EQUITY MARKETING, INC.

6330 San Vicente, Los Angeles CA 90048. (323)932-4300. Website: www.equity-marketing.com. **President, Chief Creative Director:** Kim Thomsen. Specializes in design, development and production of promotional, toy and gift items, especially licensed properties from the entertainment industry. Clients include Tyco, Applause, Avanti and Ringling Bros. and worldwide licensing relationships with Disney, Warner Bros., 20th Century Fox and Lucas Film.

Needs Needs product designers, sculptors, packaging and display designers, graphic designers and illustrators. Prefers local freelancers only with whimsical and cartoon styles. Products are typically targeted at children. Works on assignment only.

First Contact & Terms Send résumé and nonreturnable samples. Will contact for portfolio review if interested. Rights purchased vary according to project. Pays for design by the project, $50-1,200. Pays for illustration by the project, $75-3,000. Finds artists through word of mouth, network of design community, agents/reps.

Tips ''Gift items will need to be simply made, priced right and of quality design to compete with low prices at discount houses.''

EVERYTHING METAL IMAGINABLE, INC. (E.M.I.)

401 E. Cypress, Visalia CA 93277. (559)732-8126 or (800)777-8126. Fax: (559)732-5961. Website: www.artbronze.com. **Artists' Liaison:** Renee Robbins. Estab. 1967. Wholesale manufacturer. ''We manufacture lost wax bronze sculpture.'' Clients: wholesalers, premium incentive consumers, retailers, auctioneers, corporations.

Needs Approached by 10 freelance artists/year. Works with 20 freelance designers/year. Assigns 5-10 jobs to freelance artists/year. Prefers artists that understand centrifugal casting, bronze casting and the principles of mold-making. Uses artists for figurine sculpture and model-making.

First Contact & Terms Send query letter with brochure or résumé, tearsheets, photostats, photocopies and slides. Samples not filed are returned only if requested. Responds only if interested. Call for appointment to show portfolio of original/final art and photographs ''or any samples.'' Pays for design by the project, $500-20,000. Buys all rights.

Tips ''Artists must be conscious of detail in their work, be able to work expediently and under time pressure and be able to accept criticism of work from client. Price of program must include completing work to satisfaction of customers. Trends include children at play.''

ⓝ FANTAZIA MARKETING CORP.

65 N. Chicopee St., Chicopee MA 01020. (413)534-7323. Fax: (413)534-4572. E-mail: fantazia@charter.net. Website: www.fantaziamarketing.com. **President:** Joel Nulman. Estab. 1979. Produces toys and high-end novelty products. Produces novelty, lamps, banks and stationery items in over-sized form.

Needs Not limited. Will review anything. Prefers artists with experience in product development. ''We're looking to increase our molded products.'' Uses freelancers for P-O-P displays, paste-up, mechanicals, product concepts. 50% of design requires computer skills.

First Contact & Terms Send query letter with résumé. Samples are filed. Responds in 2 weeks. Call for appointment to show portfolio. Portfolio should include roughs and dummies. Rights purchased vary according to project. Originals not returned. Pays by project. Royalties negotiable.

ⓝ FENTON ART GLASS COMPANY

700 Elizabeth St., Williamstown WV 26187. (304)375-6122. Fax: (304)375-7833. E-mail: AskFenton@FentonArtGlass.com. Website: www.Fentonartglass.com. **Design Director:** Nancy Fenton. Estab. 1905. Produces collectible figurines, gifts. Largest manufacturer of handmade colored glass in the US.

- Design Director Nancy Fenton says this company rarely uses freelancers because they have their own staff of artisans. ''Glass molds aren't very forgiving,'' says Fenton. Consequently it's a difficult medium to work with. There have been exceptions. ''We were really taken with Linda Higdon's work,'' says Fenton, who worked with Higdon on a line of historical dresses.

Needs Uses freelancers mainly for sculpture and ceramic projects that can be translated into glass collectibles. Considers clay, ceramics, porcelain figurines. Looking for traditional artwork appealing to collectibles market.

First Contact & Terms Send query letter with brochure, photocopies, photographs, résumé and SASE. Samples are filed. Responds only if interested. Negotiates rights purchased. Pays for design by the project; negotiable.

FISHER-PRICE

636 Girard Ave., E. Aurora NY 14052. (716)687-3983. Fax: (716)687-5281. Website: www.fisher-price.com. **Director of Product Art:** Henry Schmidt. Estab. 1931. Manufacturer of toys and other children's products.

Needs Approached by 10-15 freelance artists/year. Works with 25-30 freelance illustrators and sculptors and 15-20 freelance graphic designers/year. Assigns 100-150 jobs to freelancers/year. Prefers artists with experience in children's style illustration and graphics. Works on assignment only. Uses freelancers mainly for product

decoration (label art). Prefers all media and styles except loose watercolor. Also uses sculptors. 25% of work demands knowledge of FreeHand, Illustrator, Photoshop and FreeForm (sculptors).

• This company has two separate art departments Advertising and Packaging, which does catalogs and promotional materials, and Product Art, which designs decorations for actual toys. Be sure to specify your intent when submitting material for consideration. Art director told *AGDM* he has been receiving more e-mail and disk samples. He says it's a convenient way for him or his staff to look at work.

First Contact & Terms Send query letter with nonreturnable samples showing art style or photographs. Samples are filed. Responds only if interested. Call to schedule an appointment to show a portfolio. Portfolio should include original, final art and color photographs and transparencies. Pays for design and illustration by the hour, $25-50. Buys all rights.

GAGNÉ WALLCOVERING, INC.

1771 N. Hercules Ave., Clearwater FL 33765. (727)461-1812. Fax: (727)447-6277. **Contact:** Linda Vierk, studio director. Estab. 1977. Produces wall murals and wallpaper. Specializes in residential and commercial wallcoverings, borders and murals encompassing a broad range of styles and themes for all age groups.

Needs Approached by 12-20 freelancers/year. Works with 20 freelancers/year. Buys 150 freelance designs and/or illustrations/year. Considers oils, watercolors, pastels, colored pencil, gouache, acrylic—just about anything two dimensional. Artists should check current wallcovering collections to see the most common techniques and media used.

First Contact & Terms Send brochure, color photocopies, photographs, slides, tearsheets, actual painted or printed sample of artist's hand if possible. Samples are filed. Responds only if interested. Portfolio not required. "We usually buy all rights to a design, but occasionally consider other arrangements." Pays freelancers by the project $500-1,200. Finds freelancers through magazines, licensing agencies, trade shows and word of mouth.

Tips "We are usually looking for traditional florals, country/folkart, juvenile and novelty designs. We do many borders and are always interested in fine representational art. Panoramic borders and murals are also a special interest. Be aware of interior design trends, both in style and color. Visit a wallcovering store and see what is currently being sold. Send us a few samples of your best quality, well-painted, detailed work.

GALISON BOOKS/MUDPUPPY PRESS

28 W. 44th St., New York NY 10036. (212)354-8840. Fax: (212)391-4037. E-mail: Lorena@galison.com. Website: www.galison.com. **Creative Director:** Lorena Siminovich. Estab. 1978. Produces boxed greeting cards, puzzles, address books and specialty journals. Many projects are done in collaboration with museums around the world.

Needs Works with 10-15 freelancers/year. Buys 20 designs and illustrations/year. Works on assignment only. Uses freelancers mainly for illustration. Considers all media. Also produces material for Christmas and New Year. Submit seasonal material 1 year in advance. 100% of design and 5% of illustration demand knowledge of QuarkXPress.

First Contact & Terms Send postcard sample, photocopies, résumé and tearsheets (no unsolicited original artwork) and SASE. Accepts submissions on disk compatible with Photoshop, Illustrator or QuarkXPress (but not preferred). Samples are filed. Responds only if interested. Request portfolio review in original query. Creative Director will contact artist for portfolio review if interested. Portfolio should include color photostats, slides, tearsheets and dummies. Originals are returned at job's completion. Pays by project. Rights purchased vary according to project. Finds artists through word of mouth, magazines and artists' reps.

Tips "Looking for great presentation and artwork we think will sell and be competitive within the gift market."

GALLANT GREETINGS CORP.

P.O. Box 308, Franklin Park IL 60131. (847)671-6500. Fax: (847)233-2499. E-mail: joanlackouitz@gallantgreetings.com. Website: www.gallantgreetings.com. **Vice President Product Development:** Joan Lackouitz. Estab. 1966. Creator and publisher of seasonal and everyday greeting cards, gift wrap and gift bags as well as stationery products.

First Contact & Terms Samples are filed or returned. Will respond within 3 weeks if interested. Do not send originals.

C.R. GIBSON, CREATIVE PAPERS

404 BNA Drive, Building 200, Suite 600, Nashville TN 37217. (615)724-2900. Fax: (615)391-3166. Website: www.crgibson.com. **Vice President of Creative:** Ann Cummings. Producer of stationery and gift products, baby, kitchen and wedding collections. Specializes in baby, children, feminine, floral, wedding and kitchen-related subjects, as well as holiday designs. 80% require freelance illustration; 15% require freelance design. Gift catalog free by request.

Needs Approached by 200-300 freelance artists/year. Works with 30-50 illustrators and 10-30 designers/year. Assigns 30-50 design and 30-50 illustration jobs/year. Uses freelancers mainly for covers, borders and cards. 50% of freelance work demands knowledge of QuarkXPress, FreeHand and Illustrator. Works on assignment only.

First Contact & Terms Send query letter with brochure, résumé, tearsheets and photocopies. Samples are filed or are returned. Responds only if interested. Request portfolio review in original query. Portfolio should include thumbnails, finished art samples, color tearsheets and photographs. Return of original artwork contingent on contract. Sometimes requests work on spec before assigning a job. Interested in buying second rights (reprint rights) to previously published work. "Payment varies due to complexity and deadlines." Finds artists through word of mouth, magazines, artists' submissions/self-promotion, sourcebooks, agents, visiting artist's exhibitions, art fairs and artists' reps.

Tips "The majority of our mechanical art is executed on the computer with discs and laser runouts given to the engraver. Please give a professional presentation of your work."

N̄ GLITTERWRAP, INC.

701 Ford Rd., Rockaway NJ 07866. (973)625-4200, ext. 265. Fax: (973)625-0399. **Creative Director:** Melissa Camacho. Estab. 1987. Produces giftwrap, gift totes and allied accessories. Also photo albums, diaries and stationery items for all ages—party and special occasion market.

Needs Approached by 50-100 freelance artists/year. Works with 10-15 artists/year. Buys 10-30 designs and illustrations/year. Art guidelines available. Prefers artists with experience in textile design who are knowledgeable in repeat patterns or surface, or designers who have experience with the gift industry. Uses freelancers mainly for occasional on-site Mac production at hourly rate of $15-25. Freelance work demands knowledge of QuarkXPress, Illustrator and Photoshop. Considers many styles and mediums. Style varies with season and year. Consider trends and designs already in line, as well as up and coming motifs in gift market. Produces material for baby, wedding and shower, florals, masculine, Christmas, graduation, birthdays, Valentine's Day, Hanukkah and everyday. Submit seasonal material 6-8 months in advance.

First Contact & Terms Send query letter with brochure, tearsheets, or color copies of work. Do not send original art, photographs, transparencies or oversized samples. Samples are not returned. Responds in 3 weeks. "To request our submission guidelines send SASE with request letter. To request catalogs send 11×14 SASE with $3.50 postage. Catalogs are given out on a limited basis." Rights purchased vary according to project.

Tips "Giftwrap generally follows the fashion industry lead with respect to color and design. Adult birthday and baby shower/birth are fast-growing categories. There is a need for good/fresh/fun typographic birthday general designs in both adult and juvenile categories."

GLOBAL GRAPHICS & GIFTS LLC.

16781 Chagrin Blvd. #333, Shaker Heights OH 44120. E-mail: fredw@globalgraphics-gifts.com. Website: www.globalgraphics-gifts.com. President: Fred Willingham. Estab. 1995. Produces calendars, e-cards, giftbags, giftwrap/wrapping paper, greeting cards, party supplies and stationery. Specializes in all types of cards including traditional, humorous, inspirational, juvenile and whimsical.

Needs Works with 5-10 freelancers/year. Buys 50-100 freelance designs and/or illustrations/year. Uses freelancers mainly for illustration and photography. Product categories include African American, alternative/humor, conventional, cute, cute/religious, Hispanic, inspirational, juvenile, religious and teen. Produces material for baby congrats, birthday, Christmas, congratulations, Easter, everyday, Father's Day, First Communion/Confirmation, get-well/sympathy, graduation, Mother's Day, Valentine's Day and wedding/anniversary. Submit seasonal material 1 year in advance. Art size should be 12×18 or less. 5% of freelance digital art and design work demands knowledge of FreeHand, Illustrator, InDesign, Photoshop.

First Contact & Terms Send postcard sample with brochure, photocopies and tearsheets. Send follow-up postcard every 3 months. Samples are filed. Responds only if interested. Portfolio not required. Buys all rights. Pays freelancers by the project $150 minimum-$400 maximum. Finds freelancers through agents, artists' submissions and word of mouth.

Tips "Make sure artwork is clean. Our standards for art are very high. Only send upbeat themes, nothing depressing. Only interested in wholesome images."

GRAHAM & BROWN

3 Corporate Dr., Cranbury NJ 08512. (609)395-9200. Fax: (609)395-9676. E-mail: atopper@grahambrownusa.com. Website: www.grahambrown.com. Estab. 1946. Produces residential wall coverings and home decor products.

Needs Prefers freelancers for designs. Also for artwork. Produces material for everyday.

First Contact & Terms Designers: Send query letter with photographs. Illustrators: Send postcard sample of work only to the attention of Andrea Topper. Samples are filed or returned. Responds only if interested. Buys all rights. For illustration pays a variable flat fee. Finds freelancers through shows (Surtex, etc.).

GREAT AMERICAN PUZZLE FACTORY INC.

16 S. Main St., South Norwalk CT 06854. (203)838-4240. Fax: (203)838-2065. E-mail: pduncan@greatamericanpuzzle.com. Website: www.greatamericanpuzzle.com. **President:** Pat Duncan. Licensing: Patricia Duncan. Es-

tab. 1975. Produces jigsaw puzzles and games for adults and children. Licenses various illustrations for puzzles (children's and adults').

Needs Approached by 150 freelancers/year. Works with 80 freelancers/year. Buys 70 designs and illustrations/year. Uses freelancers mainly for puzzle material. Looking for "fun, busy and colorful" work. 100% of graphic design requires knowledge of QuarkXPress, Illustrator or Photoshop.

First Contact & Terms Send postcard sample and/or 3 representative samples via e-mail. Do not send seasonal material. Also accepts e-mail submissions. Do not send originals or transparencies. Samples are filed or are returned. Art director will contact artist for portfolio review if interested. Original artwork is returned at job's completion. Pays flat fee of $600-1,000, work for hire. Royalties of 5-6% for licensed art (existing art only). Interested in buying second rights (reprint rights) to previously published work.

Tips "All artwork should be *bright*, cheerful and eye-catching. 'Subtle' is not an appropriate look for our market. Go to a toy store and look at what is out there. Do your homework! Send a professional-looking package to appropriate potential clients. Presentation means a lot. We get a lot of totally inappropriate submissions."

N GREAT ARROW GRAPHICS

2495 Main St., Suite 457, Buffalo NY 14214. (716)836-0408. Fax: (716)836-0702. E-mail: design@greatarrow.com. Website: www.greatarrow.com. **Art Director:** Lisa Samar. Estab. 1981. Produces greeting cards and stationery. "We produce silkscreened greeting cards—seasonal and everyday—to a high-end design-conscious market."

Needs Approached by 150 freelancers/year. Works with 75 freelancers/year. Buys 350-500 images/year. Send or call for art guidelines. Prefers freelancers with experience in hand-separated art. Uses freelancers mainly for greeting card design. Considers all 2-dimensional media. Looking for sophisticated, classic, contemporary or cutting edge styles. Requires knowledge of QuarkXPress, Illustrator or Photoshop. Produces material for all holidays and seasons. Submit seasonal material 1 year in advance.

First Contact & Terms Send query letter with photocopies. Accepts submissions on disk compatible with QuarkXPress, Illustrator or Photoshop. Samples are filed or returned if requested. Responds in 1 month. Art director will contact artist for portfolio review if interested. Portfolio should include color roughs, final art, photographs and transparencies. Originals are returned at job's completion. Pays royalties of 5% of net sales. Rights purchased vary according to project.

Tips "We are interested in artists familiar with the assets and limitations of screenprinting, but we are always looking for fun new ideas and are willing to give help and guidance in the silkscreen process. Be original—be complete with ideas—don't be afraid to be different . . . forget the trends . . . do what you want. Make your work as complete as possible at first submission. The National Stationery Show in New York City is a great place to make contacts."

HALLMARK CARDS, INC.

P.O. Box 419580, Kansas City MO 64141-6580. www.hallmark.com. Estab. 1931.

- Because of Hallmark's large creative staff of full-time employees and their established base of freelance talent capable of fulfilling their product needs, they do not accept unsolicited freelance submissions.

N ✠ HAMPSHIRE PEWTER COMPANY

43 Mill St., Wolfeboro NH 03894-1570. (603)569-4944. Fax: (603)569-4524. E-mail: gifts@hampshirepewter.com. Website: www.hampshirepewter.com. **President:** Bob Steele. Estab. 1974. Manufacturer of handcast pewter tableware, accessories and Christmas ornaments. Clients jewelry stores, department stores, executive gift buyers, tabletop and pewter specialty stores, churches and private consumers.

Needs Works with 3-4 freelance artists/year. "Prefers New-England based artists." Works on assignment only. Uses freelancers mainly for illustration and models. Also for brochure and catalog design, product design, illustration on product and model-making.

First Contact & Terms Send query letter with photocopies. Samples are not filed and are returned only if requested. Call for appointment to show portfolio, or mail b&w roughs and photographs. Pays for design and sculpture by the hour or project. Considers complexity of project, client's budget and rights purchased when determining payment. Buys all rights.

Tips "Inform us of your capabilities. For artists who are seeking a manufacturing source, we will be happy to bid on manufacturing of designs under private license to the artists, all of whose design rights are protected. If we commission a project, we intend to have exclusive rights to the designs by contract as defined in the Copyright Law, and we intend to protect those rights."

N HANNAH-PRESSLEY PUBLISHING

1232 Schenectady Ave., Brooklyn NY 11203-5828. (718)451-1852. Fax: (718)629-2014. **President:** Melissa Pressley. Estab. 1993. Produces calendars, giftwrap, greeting cards, stationery, murals. "We offer design, illustration,

writing and printing services for advertising, social and commercial purposes. We are greeting card specialists."

Needs Approached by 10 freelancers/year. Works on assignment only. Uses freelancers mainly for pattern design, invitations, advertising, cards. Also for calligraphy, mechanicals, murals. Considers primarily acrylic and watercolor, but will consider others. Looking for upscale, classic; rich and brilliant colors; traditional or maybe Victorian; also adult humor. Produces material for Christmas, Mother's Day, Father's Day, graduation, Kwanzaa, Valentine's Day, birthdays, everyday, ethnic cards (black, Hispanic, Caribbean), get well, thank you, sympathy, Secretary's Day.

First Contact & Terms Send query letter with slides, color photocopies, résumé, SASE. Samples are filed or returned by SASE. Responds only if interested. Company will contact artist for portfolio review if interested. Portfolio should include b&w, color, final art, slides. Rights purchased vary according to project. Payment varies according to project. Finds freelancers through submissions, *Creative Black Book.*

Tips "Please be honest about your expertise and experience."

Ⓝ HEART STEPS INC.

E. 502 Highway 54, Waupaca WI 54981. (715)258-8141. Fax: (715)256-9170. **Contact:** Debra McCormick. Estab. 1993. Produces greeting cards, marble and bronze plaques, photo frames, gift boxes, framed art, scrapbooking items and stationery. Specializes in inspirational items.

Needs Prefers freelancers with experience in watercolor. Works on assignment only. Uses freelancers mainly for completing the final watercolor images. Considers original art. Looking for watercolor fine art, floral, juvenile and still life. Prefers 10×14. Produces material for Christmas, Mother's Day, Father's Day, graduation, birthday, everyday, inspirational, encouragement, woman-to-woman. Submit seasonal material 8 months in advance.

First Contact & Terms Designers: Send query letter with brochure, photocopies, photographs, résumé and SASE. Illustrators: Send query letter with photocopies and résumé. Samples are filed. Responds in 2 months. Request portfolio review in original query. Rights purchased vary according to project. Pays by the project for design; $100-300 for illustration. Finds freelancers through gift shows and word of mouth.

Tips "Don't overlook opportunities with new, small companies!"

MARIAN HEATH GREETING CARDS, LCC

9 Kendrick Rd., Wareham MA 02571. (508)291-0766. Fax: (508)295-5992. E-mail: marianheath@marianheath.com. Website: www.marianheath.com. **Creative Director:** Molly DelMastro. Estab. 1950. Produces greeting cards, giftbags, giftwrap, stationery and ancillary products. Greeting card company supporting independent card and gift shop retailers.

Needs Approached by 100 freelancers/year. Works with 35-45 freelancers/year. Buys 1,200 freelance designs and illustrations/year. Prefers freelancers with experience in social expression. Art guidelines free for SASE with first-class postage or e-mail requesting guidelines. Uses freelancers mainly for greeting cards. Considers all media and styles. Generally $5\frac{1}{4} \times 7\frac{1}{4}$ unless otherwise directed. Will accept various sizes due to digital production, manipulation. 30% of freelance design and illustration work demands knowledge of Photoshop, Illustrator, QuarkXPress. Produces material for all holidays and seasons and everyday. Submit seasonal material 1 year in advance.

First Contact & Terms Designers: Send query letter with photocopies, résumé and SASE. OK to send slides, tearsheets and transparencies if necessary. Illustrators: Send query letter with photocopies, résumé, tearsheets and SASE. Accepts Mac-formatted JPEG disk submissions. Samples are filed or returned by SASE. Responds within 1-3 month. Will contact artist for portfolio review of color, final art, slides, tearsheets and transparencies. Pays for illustration by the project; flat fee; varies per project. Finds freelancers through agents, artists' rep, artist's submission, licensing and design houses.

Ⓝ HIGH RANGE DESIGNS

P.O. Box 346, Victor ID 83455-0346. (208)787-2277. E-mail: hmiller@highrangedesigns.com. **President:** Hondo Miller. Estab. 1989. Produces T-shirts. "We produce screen-printed garments for recreational sport-oriented markets and resort markets, which includes national parks. Subject matter includes, but is not limited to, skiing, climbing, hiking, biking, fly fishing, mountains, out-of-doors, nature, canoeing and river rafting, Native American, wildlife and humorous sayings that are text only or a combination of text and art. Our resort market customers are men, women and kids looking to buy a souvenir of their vacation experience or activity. People want to identify with the message and/or the art on the T-shirt."

• According to High Range Graphics' art guidelines, it is easiest to break into HRG with designs related to fly fishing, downhill skiing, snowboarding or river rafting. The guidelines suggest that your first submission cover one or more of these topics. The art guidelines for this company are detailed and include suggestions on where to place design on the garment.

Needs Approached by 20 freelancers/year. Works with 3-8 freelancers/year. Buys 10-20 designs and illustra-

tion/year. Prefers artists with experience in screen printing. Uses freelancers mainly for T-shirt ideas, artwork and color separations.

First Contact & Terms Send query letter with résumé, SASE and photocopies. Accepts submissions on disk compatible with FreeHand 8.0 and Illustrator 8.0. Samples are filed or are returned by SASE if requested by artist. Responds in 6 months. Company will contact artist for portfolio review if interested. Portfolio should include b&w thumbnails, roughs and final art. Originals are returned at job's completion. Pays by the project, royalties of 5% based on actual sales. Buys garment rights.

Tips "Familiarize yourself with screen printing and T-shirt art that sells. Must have knowledge of color separations process. We look for creative design styles and interesting color applications. Artists need to be able to incorporate the colors of the garments as part of their design thinking, as well as utilize the screen-printing medium to produce interesting effects and textures. However, sometimes simple is best. Four-color process will be considered if highly marketable. Be willing to work with us on design changes to get the most marketable product. Know the industry. Art that works on paper will not necessarily work on garments. No cartoons please."

HOFFMASTER SOLO CUP COMPANY

2920 N. Main St., Oshkosh WI 54903. (920)235-9330. Fax: (920)235-1642. **Art and Marketing Services Manager:** Paul Zuehlke. Produces decorative paper tableware, placemats, plates, tablecloths and napkins for institutional and consumer markets. Printing includes up to 6-color flexographic napkin printing.

Needs Approached by 20-30 freelancers/year. Works with 5-10 freelancers/year. Prefers freelancers with experience in paper tableware products. Art guidelines and specific design needs based on current market are available from Creative Managers. Looking for trends and traditional styles. Prefers 9″ round artwork with coodinating 6½″ square image. Produces material for all holidays and seasons and everyday. Special need for seasonal material.

First Contact & Terms Send query letter with photocopies, résumé, appropriate samples by mail or fax only. Ideas may be sent in a color rough sketch. Accepts disk submissions compatible with Illustrator and FreeHand. Samples are filed or returned by SASE if requested by artist. Responds in 90 days only if interested. "Will provide feedback to artists whose designs could be adapted but are not currently acceptable for use without additional work and a resubmission." Creative Manager will contact artist for portfolio review if interested. Portfolio should include thumbnails, roughs, finished art samples, color photostats, tearsheets, photographs and dummies. Prefers to buy artwork outright. Rights purchased vary according to project. Pays by the project $350-1,500. Amounts vary according to project. May work on a royalty arrangement for recognized properties. Finds freelancers through art fairs and artists' reps.

Tips Looking for new trends and designs appropriate for plates and napkins.

ℕ HOME INTERIORS & GIFTS

1649 Frankford Rd. W., Carrollton TX 75007. (972)695-1000. Fax: (972)695-1062. **Art Director:** Robbin Allen. Estab. 1957. Produces decorative framed art in volume to public by way of shows in the home. "H.I.&G. is a direct sales company. We sell nationwide with over 71,000 consultants in our sales force. We work with artists to design products for our new product line yearly. We work with some publishers now, but wish to work with more artists on a direct basis."

Needs Approached by 75 freelance artists/year. Works with 25-30 freelancers/year. "We carry approximately 500-600 items in our line yearly." Prefers artists with knowledge of current colors and the decorative art market. "We give suggestions, but we do not dictate exacts. We would prefer the artists express themselves through their individual style. We will make correction changes that will enhance each piece for our line." Uses freelance artists mainly for artwork to be framed (oil and watercolor work mostly). Also for calligraphy. Considers oil, watercolor, acrylic, pen & ink, pastels, mixed media. "We sell to middle America for the most part."

First Contact & Terms Send query letter with résumé, SASE, photographs, slides and transparencies. Samples are filed or are returned by SASE. Art director will contact artist for portfolio review if interested. Portfolio should include color slides, photographs. Requests work on spec before assigning a job. Pays royalties. Royalties are discussed on an individual basis. Buys reprint rights. E-mail JPEGs to jberger@homeinteriors.com or acarter@homeinteriors.com.

Tips "This is a great opportunity for the artist who is willing to learn our market. The artist will work with our design department to stay current with our needs."

IGPC

460 W. 34th St., 10th Floor, New York NY 10001. (212)629-7979. Fax: (212)629-3350. E-mail: mordechaif@igpc. net. Website: www.igpc.net. **Art Director:** Mordechai Friedman. Agent to foreign governments. "We produce postage stamps and related items on behalf of 40 different foreign governments."

Needs Approached by 50 freelance artists/year. Works with 10 freelance illustrators and designers/year. Assigns several hundred jobs to freelancers/year. Prefers artists within metropolitan New York or tri-state area. Must have extremely sophisticated computer, design and composition skills and a working knowledge of graphic

design (mechanicals). Artist's research ability a plus. Artwork must be focused and alive (4-color) and reproducible to stamp size (usually 4 times up). Artist's pricing needs to be competitive. Works on assignment only. Uses artists for postage stamp art. Prefers airbrush, acrylic and gouache (some watercolor and oil OK). Must have reasonable knowledge of Photoshop and Quark.

First Contact & Terms Send samples showing illustrative skills. Doesn't need to be precious high quality. Color copies are fine. Responds in 5 weeks. Art Director will contact artist for portfolio review if interested. Portfolio should contain "4-color illustrations of realistic, tight flora, fauna, technical subjects, autos or ships. Also include reduced samples of original artwork." Sometimes requests work on spec before assigning a job. Pays by the project, $1,000-4,000. Consider government allowance per project when establishing payment.

Tips "Artists considering working with IGPC must have excellent drawing abilities in general or specific topics, i.e., flora, fauna, transport, famous people, etc.; sufficient design skills to arrange for and position type; the ability to create artwork that will reduce to postage stamp size and still hold up with clarity and perfection. Familiarity with printing process and print call-outs a plus. Generally, the work we require is realistic art. In some cases, we supply the basic layout and reference material; however, we appreciate an artist who knows where to find references and can present new and interesting concepts. Initial contact should be made by phone for appointment. Have fun!"

THE IMAGINATION ASSOCIATION
P.O. Box 1780, Lake Dallas TX 75065-1780. (940)498-3308. Fax: (940)498-1596. E-mail: ellice@funnyaprons.c om. Website: www.funnyaprons.com. **Creative Director:** Ellice Lovelady. Estab. 1992. Our primary focus is now on our subdivision, The Funny Apron Company, that manufactures humorous culinary-themed aprons and T-shirts for the gourmet marketplace.''

Needs Works with 12 freelancers/year. Artists must be fax/e-mail accessible and able to work on fast turnaround. Check website to determine if your style fits our art direction. 100% of freelance work DEMANDS knowledge of Illustrator, Corel Draw, or programs with ability to electronically send vector-based artwork. (Photoshop alone is not sufficient.)

First Contact & Terms Send query letter with brochure, photographs, SASE and photocopies. E-mail inquiries must include a LINK to a website to view artwork. We will NOT open unsolicited attachments. Samples are filed or returned by SASE if requested by artist. Company will contact artist if interested. Negotiates rights and payment terms. Finds artists via word of mouth from other freelancers or referrals from publishers.

Tips Looking for artist "with a style we feel we can work with and a professional attitude. Understand that sometimes we require several revisions before final art, and all under tight deadlines. Even if we can't use your style, be persistent! Stay true to your creative vision and don't give up!"

⛴ INCOLAY STUDIOS INCORPORATED
520 Library St., San Fernando CA 91344. (818)365-2521. Fax: (818)365-9599. **Art Director:** Louise Hartwell. Estab. 1966. Manufacturer. "Basically we reproduce antiques in Incolay Stone, all handcrafted here at the studio. There were marvelous sculptors in that era, but we believe we have the talent right here in the U.S. today and want to reproduce living American artists' work."

Needs Prefers local artists with experience in carving bas relief. Uses freelance artists mainly for carvings. Also uses artists for product design and model making.

First Contact & Terms Send query letter with résumé, or "call and discuss; 1-800-INCOLAY." Samples not filed are returned. Responds in 1 month. Call for appointment to show portfolio. Pays 5% of net. Negotiates rights purchased.

Tips "Let people know that you are available and want work. Do the best you can. Discuss the concept and see if it is right for 'your talent.' "

Ⓝ INKADINKADO, INC.
1801 North 12th St., Reading PA 19604. (610)939-9900 or (800)523-8452. Fax: (610)939-9666. E-mail: customer. service@inkadinkado.com. Website: www.inkadinkado.com. **Creative Director:** Mark Nelson, licensing contact. Pamela Keller, designer relations coordinator. Estab. 1978. Produces craft kits and nature, country, landscapes and holiday designs for art for rubber stamps. Also offers licenses to illustrators depending upon number of designs interested in producing and range of style by artist. Distributes to craft, gift and toy stores and specialty catalogs.

Needs Works with 12 illustrators and 6 designers/year. Uses freelancers mainly for illustration, lettering, line drawing, type design. Considers pen & ink. Themes include animals, education, holidays and nature. Prefers small; about 2×3. 50% of design and illustration work demands knowledge of Photoshop, QuarkXPress, Illustrator. Produces material for all holidays and seasons. Submit seasonal material 6-8 months in advance.

First Contact & Terms Designers and illustrators: Send query letter with 6 nonreturnable samples. Accepts submissions on disk. Samples are filed and not returned. Responds only if interested. Company will contact

artist for portfolio review of b&w and final art if interested. Pays for illustration by the project, $100-250/piece. Rights purchased vary according to project. Also needs calligraphers for greeting cards and stamps, pays $50-100/project.

Tips "Work small. The average size of an art rubber stamp is 3×3."

INSPIRATIONS UNLIMITED

P.O. Box 5097, Crestine CA 92325. (909)338-6758 or (800)337-6758. Fax: (909)338-2907. Website: www.inspirationalgreetingcards.org. **Owner:** John Wiedefeld. Estab. 1983. Produces greeting cards, gift enclosures, note cards and stationery.

Needs Approached by 15 freelancers/year. Works with 4 freelancers/year. Buys 48 freelance designs and illustrations/year. Uses freelancers mainly for greeting cards. Will consider all media, all styles. Prefers 5×7 vertical only. Produces material for Christmas, Mother's Day, graduation, Valentine's Day, birthdays, everyday, sympathy, get well, romantic, thank you, serious illness. Submit seasonal material 1 year in advance.

First Contact & Terms Designers and illustrators: Send photocopies and photographs. Samples are filed and are not returned. Responds in 1 week. Company will contact artist for portfolio review if interested. Buys reprint rights; rights purchased vary according to project. Pays $100/piece of art. Also needs calligraphers, pays $25/hour. Finds freelancers through artists' submissions, art galleries and shows.

Tips "Send color copies of your artwork for review with a self-addressed envelope."

INTERCONTINENTAL GREETINGS LTD.

176 Madison Ave., New York NY 10016. (212)683-5830. Fax: (212)779-8564. E-mail: intertg@intercontinental-ltd.com. **Creative Director:** Thea Groene. Estab. 1967. Sells reproduction rights of designs to manufacturers of multiple products around the world. Reps artists in 50 different countries, with clients specializing in greeting cards, giftware, giftwrap, calendars, postcards, prints, posters, stationery, paper goods, food tins, playing cards, tabletop, bath and service ware and much more. (Prefer artwork previously made with few or no rights pending.)

Needs Approached by several hundred artists/year. Seeking creative decorative art in traditional and computer media (Photoshop preferred; some Illustrator work accepted). Graphics, sports, occasions (i.e., Christmas, baby, birthday, wedding), humorous, "soft touch," romantic themes, animals. Accepts seasonal/holiday material any time. Prefer artists/designers experienced in greeting cards, paper products, tabletop and giftware.

First Contact & Terms Query with samples. Send unsolicited color copies or CDs by mail with return SASE for consideration. Upon request, submit portfolio for review. Provide résumé, business card, brochure, flier, tearsheets or slides to be kept on file for possible future assignments. "Once your art is accepted, we use" original color art; Photoshop files on disk, TIFF, Mac, 300 dpi; 4×5, 8×10 transparencies and 35mm slides. Responds only if interested (will send back nonaccepted in SASE if given). Pays on publication. No credit line given. Offers advance when appropriate. Sells one-time rights and exclusive product rights. Simultaneous submissions and previously published work OK. Please state reserved rights if any.

Tips Recommends the annual New York Surtex and Licensing shows. In portfolio samples, wants to see "a neat presentation, thematic in arrangement, a series of interrelated images (at least six). In addition to having good drawing/painting/designing skills, artists should be aware of market needs."

THE INTERMARKETING GROUP

29 Holt Rd., Amherst NH 03031. (603)672-0499. **President, licensing:** Linda L. Gerson. Estab. 1985. Licensing agent for all categories of consumer goods including greeting cards, stationery, calendars, posters, paper tableware products, tabletop, dinnerware, giftwrap, eurobags, giftware, toys, needle crafts. The Intermarketing Group is a full-service art licensing agency representing artists' works for licensing with companies in consumer goods products, including the home furnishings, paper product, greeting card, giftware, toy, housewares, needlecraft and apparel industries.

Needs Approached by 100 freelancers/year. Works with 6 freelancers/year. Licenses work as developed by clients. Prefers freelancers with experience in full-color illustration. Uses freelancers mainly for tabletop, cards, giftware, calendars, paper tableware, toys, bookmarks, needlecraft, apparel, housewares. Will consider all media forms. "My firm generally represents illustrated works and illustrations for direct product applications. All works are themed." Prefers 5×7 or 8×10 final art. Produces material for all holidays and seasons and everyday. Submit seasonal material 6 months in advance.

First Contact & Terms Send query letter with brochure, tearsheets, résumé, slides, SASE or color copies. Samples are not filed and are returned by SASE. Responds in 3 weeks. Originals are returned at job's completion. Requests work on spec before assigning a job. Pays royalties of 2-7% plus advance against royalties. Buys all rights. Considers buying second rights (reprint rights) to previously published work. Finds new artists "mostly by referrals and via artist submissions. I do review trade magazines, attend art shows and other exhibits to locate suitable clients."

Tips "Companies today seem to be leaning towards a fresh, trendy look in the art approach. Companies are

selective in their licenses. A well-organized presentation is very helpful. Be aware of the market. See what is selling in stores and focus on specific products that would incorporate your art well. Get educated on market conditions and trends."

JILLSON & ROBERTS

3300 W. Castor St., Santa Ana CA 92704. (714)424-0111. Fax: (714)424-0054. Website: www.jillsonroberts.com. **Art Director:** Shawn Doll. Estab. 1974. Produces giftwrap and giftbags using more recycled/recyclable products.

Needs Works with 10 freelance artists/year. Prefers artists with experience in giftwrap design. Considers all media. "We are looking for colorful graphic designs as well as humorous, sophisticated, elegant or contemporary styles." Produces material for Christmas, Valentine's Day, Hanukkah, Halloween, graduation, birthdays, baby announcements and everyday. Submit 3-6 months before holiday.

First Contact & Terms Send query letter with brochure showing art style, tearsheets and slides. Samples are filed or are returned. Responds in 3 weeks. To show a portfolio, mail thumbnails, roughs, final reproduction/product, color slides and photographs. Originals not returned. Pays average flat fee of $250 or pays royalties (percentage negotiable).

KALAN LP

97 S. Union Ave., Lansdowne PA 19050. (610)623-1900 ext. 341. Fax: (610)623-0366. E-mail: klangrock@kalanlp.com. Website: www.kalanlp.com. **Art Director:** Chris Wiemer. Copywriter: Katie Langrock. Estab. 1973. Produces giftbags, greeting cards, school supplies, stationery and novelty items such as keyrings, mouse pads, shot glasses and magnets.

Needs Approached by 50-80 freelancers/year. Buys 100 freelance designs and illustrations/year. Art guidelines are available. Uses freelancers mainly for fresh ideas, illustration and design. Considers all media and styles. Some illustration demands knowledge of Photoshop 7.0 and Illustrator 10. Produces material for major holidays such as Christmas, Mother's Day, Valentine's Day; plus birthdays and everyday. Submit seasonal material 9-10 months in advance.

First Contact & Terms Designers: Send query letter with photocopies, photostats and résumé. Illustrators and cartoonists: Send query letter with photocopies and résumé. Accepts disk submissions compatible with Illustrator 10 or Photoshop 7.0. Send EPS files. Samples are filed. Responds in 1 month if interested in artist's work. Will contact artist for portfolio review of final art if interested. Buys first rights. Pays by the project, $75 and up. Finds freelancers through submissions and newspaper ads.

N KEMSE AND COMPANY

P.O. Box 14334, Arlington TX 76094. (888)656-1452. Fax: (817)446-9986. E-mail: kim@kemseandcompany.com. Website: www.kemseandcompany.com. **Contact:** Kimberly See. Estab. 2003. Produces stationery. Specializes in multicultural stationery and invitations.

Needs Approached by 10-12 freelancers/year. Works with 5-6 freelancers/year. Buys 15-20 freelance designs and/or illustrations/year. Considers all media. Product categories include African American and Hispanic. Produces material for all holidays and seasons, birthday, graduation and woman-to-woman. Submit seasonal material 8 months in advance. Art size varies, please discuss with contact. 75% of freelance work demands knowledge of FreeHand, Illustrator, QuarkXPress and Photoshop.

First Contact & Terms Send query letter with photocopies, résumé and SASE. Accepts e-mail submissions with image file. Prefers Windows-compatible, JPEG files. Samples are filed. Responds only if interested. Company will contact artist for portfolio review if interested. Portfolio should include color, finished art, roughs and thumbnails. Buys all rights and reprint rights. Pays freelancers by the project. Finds freelancers through artists' submissions.

KENZIG KARDS, INC.

2300 Julia Goldbach Ave., Ronkonkoma NY 11779-6317. (631)737-1584. Fax: (631)737-8341. E-mail: kenzigkards@aol.com. **Contact:** Jerry Kenzig, president. Estab. 1999. Produces greeting cards and stationery. Specializes in greeting cards (seasonal and everyday) for a high-end, design-conscious market (all ages).

Needs Approached by 75 freelancers/year. Works with 3 freelancers/year. Prefers local designers/illustrators, however, we will consider freelancers working anywhere in US. Art guidelines free with SAE and first-class postage. Uses freelancers mainly for greeting cards/design and calligraphy. Considers watercolor, colored pencils; most media. Product categories include alternative/humor, business and cute. Produces material for baby congrats, birthday, cards for pets, Christmas, congratulations, everyday, get-well/sympathy, Valentine's Day and wedding/anniversary. Submit seasonal material 6 months in advance. Art size should be 5×7 or 5¾×5¾ square. 20% of freelance work demands knowledge of Illustrator, QuarkXPress and Photoshop.

First Contact & Terms Send query letter with brochure, résumé and tearsheets. After introductory mailing, send follow-up postcard sample every 6 months. Samples are filed. Responds in 2 weeks. Company will contact artist for portfolio review if interested. Portfolio should include color, original art, roughs and tearsheets. Buys

one-time rights and reprint rights for cards and mugs. Negotiates rights purchased. Pays freelancers by the project, $150-350; royalties (subject to negotiation). Finds freelancers through industry contacts (Kenzig Kards, Inc. is a regular member of the Greeting Card Association [GCA]), artist's submissions and word of mouth.

Tips ''We are open to new ideas and different approaches within our niche (i.e. dog- and cat-themed designs, watercolor florals, etc.) Looking for bright colors and cute, whimsical art. Floral designs require crisp colors.''

N KID STUFF

University Blvd. at Essex Entrance, Topeka KS 66619-0235. (785)862-3707. Fax: (785)862-1424. E-mail: michael @kidstuff.com. Website: www.kidstuff.com. **Contact:** Michael Oden, creative director. Estab. 1982. Produces collectible figurines, toys, kids' meal sacks and cartons for restaurants worldwide.

Needs Approached by 8 freelancers/year. Works with 6 freelancers/year. Buys 10 freelance designs and illustrations/year. Works on assignment only. Uses freelancers mainly for illustration and sculpting toys. Considers all media. Looking for humorous, child-related styles. Freelance illustrators should be familiar with Photoshop, Illustrator, FreeHand and QuarkXPress. Produces material for Christmas, Easter, Halloween, Thanksgiving, Valentine's Day and everyday. Submit seasonal material 3 months in advance.

First Contact & Terms Illustrators and cartoonists: Send query letter with photocopies or e-mail JPEG files. Sculptors, calligraphers: Send photocopies. Samples are filed or returned by SASE. Responds only if interested. Portfolio review not required. Pays by the project, $250-2,000 for illustration. Finds freelancers through word of mouth and artists' submissions.

KOEHLER COMPANIES

8758 Woodcliff Rd., Bloomington MN 55438. (952)942-5666. Fax: (952)942-5208. E-mail: bob@koehlercompani es.com. Website: www.koehlercompanies.com. **President:** Bob Koehler. Estab. 1988. Manufactures wall decor, plaques, clocks and mirrors; artprints laminated to wood. Clients gift-based and home decor mail order catalog companies. Clients include Signals, Paragon, Potpourri and others.

Needs Works with 10 established artists; 8 mid-career artists and 10 emerging artists/year. Considers oil, acrylic, watercolor, mixed media, pastels and pen & ink. Preferred themes and styles humorous, Celtic, inspirational, pet (cats and dogs), golf, fishing.

First Contact & Terms Send query letter with brochure, photocopies or photographs, résumé and tearsheets. Samples are not filed and are returned by SASE. Company will contact artist for portfolio review if interested. Pays royalties or negotiates payment. Does not offer an advance. Rights purchased vary according to project. Also works with freelance designers. Finds artists through word of mouth.

THE LANG COMPANIES, LCC.

514 Wells St., Delafield WI 53018. (262)646-3399. Website: www.lang.com. **Product Development Coordinator:** Yvonne Moroni (product development and art submissions). Estab. 1982. Produces high quality linen-embossed greeting cards, stationery, calendars, boxes, and gift items.

Needs Approached by 300 freelance artists/year. Art guidelines available, SASE. Works with 40 freelance artists/year. Uses freelancers mainly for card and calendar illustrations. Considers all media and styles. Looking for traditional and nonabstract country-inspired, folk, contemporary and fine art styles. Produces material for Christmas, birthdays and everyday. Submit seasonal material 6 months in advance.

First Contact & Terms Send query letter with SASE and brochure, tearsheets, photostats, photographs, slides, photocopies or transparencies. Samples are returned by SASE if requested by artist. Responds in 6 weeks. Pays royalties based on net wholesale sales. Rights purchased vary according to project.

Tips ''Research the company and submit compatible art. Be patient awaiting a response.''

N LEGACY PUBLISHING GROUP

P.O. Box 299, Clinton MA 01510. (800)322-3866 or (978)368-8711. Fax: (978)368-7867. Website: legacypublishi nggroup.com. **Contact:** Art Department. Produces bookmarks, calendars, gifts, Christmas and seasonal cards and stationery pads. Specializes in journals, note cards, address and recipe books, coasters, placemats, magnets, book marks, albums, calendars and grocery pads.

Needs Works with 8-10 freelancers/year. Buys 25-30 freelance designs and illustrations/year. Prefers traditional art. Art guidelines available for SASE. Works on assignment only. Uses freelancers mainly for original art for product line. Considers all color media. Looking for traditional, contemporary, garden themes and Christmas. Produces material for Christmas, everyday (note cards) and cards for teachers.

First Contact & Terms Illustrators: Send query letter with photocopies, photographs, résumé, tearsheets, SASE and any good reproduction or color copy. We accept work compatible with Adobe or QuarkXPress plus color copies. Samples are filed. Responds in 2 weeks. Company will contact artist for portfolio review if interested. Portfolio should include color photographs, slides, tearsheets and printed reproductions. Buys all rights. Pays for illustration by the project, $600-1,000. Finds freelancers through word of mouth and artists' submissions.

Tips "Get work out to as many potential buyers as possible. *Artist's & Graphic Designer's Market* is a good source. Initially, plan on spending 80% of your time on self-promotion."

THE LEMON TREE STATIONERY CORP.

95 Mahan St., West Babylon NY 11704. (631)253-2840. Fax: (631)253-3369. Website: www.lemontreestationery .com. **Contact:** Lucy Mlexzko. Estab. 1969. Produces birth announcements, Bar Mitzvah and Bat Mitzvah invitations and wedding invitations.

Needs Buys 100-200 pieces of calligraphy/year. Prefers local designers. Works on assignment only. Uses Mac designers. Also for calligraphy, mechanicals, paste-up, P-O-P. Looking for traditional, contemporary. 50% of freelance work demands knowledge of Photoshop, QuarkXPress, Illustrator.

First Contact & Terms Send query letter with résumé. Calligraphers send photocopies of work. Samples are not filed and are not returned. Responds only if interested. Company will contact artist for portfolio review of final art, photostats, thumbnails if interested. Pays for design by the project. Pays flat fee for calligraphy.

Tips "Look around at competitors' work to get a feeling of the type of art they use."

LIFE GREETINGS

P.O. Box 468, Little Compton RI 02837. (401)635-4918. **Editor:** Kathy Brennan. Estab. 1973. Produces greeting cards. Religious, inspirational greetings.

Needs Approached by 25 freelancers/year. Works with 5 freelancers/year. Uses freelancers mainly for greeting card illustration. Also for calligraphy. Considers all media but prefers pen & ink and pencil. Prefers $4\frac{1}{2} \times 6\frac{1}{4}$—no bleeds. Produces material for Christmas, religious/liturgical events, baptism, first communion, confirmation, ordination, etc.

First Contact & Terms Send query letter with photocopies. Samples are filed or returned by SASE if requested by artist. Responds only if interested. Portfolio review not required. Originals are not returned. Pays by the project. "**We pay on acceptance.**" Finds artists through submissions.

THE LOLO COMPANY

6755 Mira Mesa Blvd., Suite 123-410, San Diego, CA 92121. (800)760-9930. Fax: (800)234-6540. E-mail: products @lolofun.com. Website: www.lolofun.com. **Creative Director:** Robert C. Paul. Estab. 1995. Publishes board games. Prefers humorous work. Uses freelancers mainly for product design and packaging. Recent games include: "Bucket Blast," "It Dahgan," "Run Around Fractions" and "You're It."

Needs Approached by 1 illustrator and 1 designer/year. Works with 2 illustrator and 2 designer/year. 100% of freelance design and illustration demands knowledge of Illustrator, Photoshop and QuarkXPress.

First Contact & Terms Preferred submission package is self-promotional postcard sample. Send 5 printed samples or photographs. Accepts disk submissions in Windows format; send via Zip as EPS. Samples are filed. Will contact artist for portfolio review if interested. Portfolios should include artwork of characters in sequence, color photocopies, photographs, transparencies of final art and roughs. Rights purchased vary according to project. Finds freelancers through word of mouth and Internet.

LPG GREETINGS, INC.

4000 Porett Dr., Gurnee IL 60031. (847)244-4414. Fax: (847)244-0188. E-mail: judy@lpggreetings.com. Website: www.lpggreetings.com. **Creative Director:** Judy Cecchi. Estab. 1992. Produces greeting cards. Specializes in boxed Christmas cards.

Needs Approached by 50-100 freelancers/year. Works with 20 freelancers/year. Buys 70 freelance designs and illustrations/year. Art guidelines free for SASE with first-class postage. Uses freelancers mainly for original artwork for Christmas cards. Considers any media. Looking for traditional and humorous Christmas. Greeting cards can be vertical or horizontal; 5×7 or 6×8. Usually prefers 5×7. Submit seasonal material 1 year in advance.

First Contact & Terms Send query letter with photocopies. Samples are filed if interested or returned by SASE. Portfolio review not required. Will contact artist for portfolio if interested. Rights purchased vary according to project. Pays for design by the project. For illustration: pays flat fee. Finds freelancers through word of mouth and artists' submissions. Please do not send unsolicited samples via e-mail; they will not be considered.

Tips "Be creative with fresh new ideas."

LUNT SILVERSMITHS

298 Federal St., P.O. Box 1010, Greenfield MA 01302-1010. (413)774-2774. Fax: (413)774-4393. E-mail: crombole tti@luntsilver.com. Website: www.luntsilver.com. **Director of Design:** Carl F. Romboletti Jr. Estab. 1902. Produces collectibles, gifts, Christmas ornaments, babyware, tabletop products, sterling and steel flatware.

Needs Approached by 1-2 freelancers/year. Works with 1-2 freelancers/year. Contracts 35 product models/year. Prefers freelancers with experience in tabletop product, model-making. Uses freelancers mainly for model-making and prototypes. Also for mechanicals. Considers clay, plastaline, resins, hard models. Looking for traditional,

florals, sentimental, contemporary. 25% of freelance design work demands knowledge of Photoshop, Illustrator, AutoCad. Produces material for all holidays and seasons, Christmas, Valentine's Day, everyday.

First Contact & Terms Designers and sculptors should send query letter with brochure, photocopies, photographs, résumé. Sculptors should also send résumé and photos. Accepts disk submissions created in Photoshop. Samples are filed or returned by SASE. Responds in 1 week only if interested. Will contact for portfolio review if interested. Portfolio should include photographs, photostats, slides. Rights purchased vary according to project. Pays for design, illustration and sculpture according to project.

MADISON PARK GREETINGS

1407 11th Ave., Seattle WA 98122-3901. (206)324-5711. Fax: (206)324-5822. E-mail: info@madpark.com. Website: www.madisonparkgreetings.com. **Art Director:** Glen Biely. Estab. 1977. Produces greeting cards, stationery, notepads, frames.

Needs Approached by 250 freelancers/year. Works with 15 freelancers/year. Buys 200 freelance designs and illustrations/year. Art guidelines available free for SASE. Works on assignment only. Uses freelancers mainly for greeting cards. Also for calligraphy, reflective art. Considers all paper-related media. Produces material for Christmas, Easter, Mother's Day, Father's Day, graduation, New Year, Valentine's Day, birthdays, everyday, sympathy, get well, anniversary, baby congratulations, wedding, thank you, expecting, friendship. "We are interested in floral and whimsical imagery, as well as humor." Submit seasonal material 10 months in advance.

First Contact & Terms Designers: Send photocopies, slides, transparencies. Illustrators: Send postcard sample or photocopies. Accepts submissions on disk. Send EPS files. "Good samples are filed; rest are returned." Please enclose SASE. Company will contact artist for portfolio review of color, final art, roughs if interested. Rights purchased and royalty vary according to project.

MILLIMAC LICENSING CO.

188 Michael Way, Santa Clara CA 95051. (408)984-0700. Fax: (408)984-7456. E-mail: bruce@clamkinman.com or clamkinman@comcast.net. Website: www.clamkinman.com. **Owner:** Bruce Ingrassia. Estab. 1978. Produces collectible figurines, mugs, T-shirts and textiles. Produces a line of cartoon characters called the Clamkin® Family directed towards "children and adults young at heart."

Needs Approached by 10 freelancers/year. Works with 2-3 freelancers/year. Buys 30-40 freelance designs and illustrations/year. Prefers freelancers with experience in cartooning. Works on assignment only. Uses freelancers mainly for line art, color separation, Mac computer assignments. Considers computer, pen & ink. Looking for humorous, clever, "off the wall," cute animals. 50% of freelance design/illustration demands knowledge of Photoshop, Illustrator, FreeHand (pencil roughs OK). "Computer must be Mac." Produces material for everyday.

First Contact & Terms Designers/cartoonists: Send query letter with photocopies. Sculptors send photos of work. Accepts disk submissions compatible with Mac Adobe Illustrator files. Samples are filed. Will contact artist for portfolio review if interested. Rights purchased and pay rates vary according to project. Finds freelancers through submissions. "I also find a lot of talent around townat fairs, art shows, carnivals, students—I'm always on the lookout."

Tips "Get a computer—learn Adobe Illustrator, Photoshop. Be clever, creative, open minded and responsible and never give up. Quitters never get there."

MIXEDBLESSING

P.O. Box 97212, Raleigh NC 27624-7212. (919)847-7944. Fax: (919)847-6429. E-mail: mixedblessing@earthlink.com. Website: www.mixedblessing.com. **President:** Elise Okrend. Licensing: Philip Okrend. Estab. 1990. Produces interfaith greeting cards combining Jewish and Christian as well as multicultural images for all ages. Licenses holiday artwork for wrapping paper, tote bags, clothing, paper goods and greeting cards.

Needs Approached by 10 freelance artists/year. Works with 10 freelancers/year. Buys 20 designs and illustrations/year. Provides samples of preferred styles upon request. Works on assignment only. Uses freelancers mainly for card illustration. Considers watercolor, pen & ink and pastel. Prefers final art 5×7. Produces material for Christmas and Hanukkah. Submit seasonal material 10 months in advance.

First Contact & Terms Send nonreturnable samples for review. Samples are filed. Responds only if interested. Originals are returned at job's completion. Sometimes requests work on spec before assigning a job. Pays flat fee of $125-500 for illustration/design. Buys all rights. Finds artists through visiting art schools.

Tips "I see growth ahead for the industry. Go to and participate in the National Stationery Show."

J.T. MURPHY CO.

200 W. Fisher Ave., Philadelphia PA 19120. (215)329-6655. **President:** Jack Murphy. Estab. 1937. Produces greeting cards and stationery. "We produce a line of packaged invitations, thank-you notes and place cards for retail."

Needs Approached by 12 freelancers/year. Works with 4 freelancers/year. Buys 8 freelance designs and illustrations/year. Prefers local freelancers with experience in graphics and greeting cards. Uses freelancers mainly for

concept, design and finished artwork for invitations and thank-yous. Looking for graphic, contemporary or traditional designs. Prefers $4 \times 5\frac{1}{8}$ but can work double size. Produces material for graduation, birthdays and everyday. Submit seasonal material 9 months in advance.
First Contact & Terms Send nonreturnable samples. Responds in 1 month. Company will contact artist for portfolio review if interested. Rights purchased vary. Originals not returned. Payment negotiated.

N NALPAC, LTD.
1111 E. Eight Mile Rd., Ferndale MI 48220. (248)541-1140. Fax: (248)544-9126. E-mail: ralph@nalpac.com. **President, licensing:** Ralph Caplan. Estab. 1971. Produces coffee mugs and T-shirts for gift and mass merchandise markets. Licenses all kinds of artwork for T-shirts, mugs and gifts.
Needs Approached by 10-15 freelancers/year. Works with 2-3 freelancers/year. Buys 70 designs and illustrations/year. Works on assignment only. Considers all media. Needs computer-literate freelancers for design, illustration and production. 60% of freelance work demands computer skills.
First Contact & Terms Send query letter with brochure, résumé, SASE, photographs, photocopies, slides and transparencies. Samples are filed or are returned by SASE if requested by artist. Responds in 1 month. Call for appointment to show portfolio. Usually buys all rights, but rights purchased may vary according to project. Also needs package/product designers, pay rate varies. Pays for design and illustration by the hour $10-25; or by the project $40-500, or offers royalties of 4-10%.

NAPCO MARKETING
7800 Bayberry Rd., Jacksonville FL 32256-6893. (904)737-8500. Fax: (904)737-9526. E-mail: napco@leading.com. **Art Director:** Robert Keith. Estab. 1940. NAPCO Marketing supplies floral, garden and home interior markets with middle to high-end products. Clients wholesale.

- NAPCO Marketing has a higher-end look for their floral market products.

Needs Works with 15 freelance illustrators and designers/year. 50% of work done on a freelance basis. No restrictions on artists for design and concept. Art guidelines available for SASE with first-class postage. Works on assignment only. Uses freelancers mainly for mechanicals and product design. "Need artists that are highly skilled in illustration for three-dimensional products."
First Contact & Terms Designers: Send query letter with brochure, résumé, photocopies, photographs, SASE, tearsheets and "any samples we can keep on file." Illustrators send brochure, résumé, photocopies, photographs and SASE. If work is in clay, send photographs. Samples are filed or returned by SASE. Responds in 2 weeks. Artist should follow up with letter after initial query. Portfolio should include samples which show a full range of illustration style. Sometimes requests work on spec before assigning a job. Pays for design by the project, $50-500. Pays by the project for illustration, $50-2,000. Pays $15/hour for mechanicals. Buys all rights. Considers buying second rights (reprint rights) to previously published work. Finds artists through word of mouth and self-promotions.
Tips "We are very selective in choosing new people. We need artists that are familiar with three-dimensional giftware and floral containers."

N NATIONAL DESIGN CORP.
P.O. Box 509032, San Diego CA 92150-9032. (858)674-6040. Fax: (858)674-4120. Website: www.nationaldesign.com. **Creative Director:** Christopher Coats. Estab. 1985. Produces gifts, writing instruments and stationery accoutrements. Multi markets include gift/souvenir and premium markets.
Needs Works with 3-4 freelancers/year. Buys 3 freelance designs and illustrations/year. Prefers local freelancers only. Must be Macintosh proficient. Works on assignment only. Uses freelancers mainly for design illustration. Also for prepress production on Mac. Considers computer renderings to mimic traditional medias. Prefers children's and contemporary styles. 100% of freelance work demands knowledge of QuarkXPress, Freehand and Photoshop. Produces material for Christmas and everyday.
First Contact & Terms Send query letter with photocopies, résumé, SASE. Accepts submissions on disk. "Contact by phone for instructions." Samples are filed and are returned if requested. Company will contact artist for portfolio review of color, final art, tearsheets if interested. Rights purchased vary according to project. Payments depends on complexity, extent of project(s).
Tips "Must be well traveled to identify with gift/souvenir markets internationally. Fresh ideas always of interest."

N NCE, NEW CREATIVE ENTERPRISES, INC.
401 Milford Pkwy., Milford OH 45150. (800)435-1000. Fax: (513)248-3156. E-mail: bishee@ncegifts.com. Website: www.ncegifts.com. **Contact:** Mark Haas, creative director. Estab. 1979. Produces low-medium priced giftware and decorative accessories. "We sell a wide variety of items ranging from home decor to decorative flags. Our typical retail-level buyer is female, age 30-50."

Needs Approached by 5-10 freelancers/year. Works with 2-5 freelancers/year. Buys 10-50 designs and illustrations/year. Prefers freelancers with experience in textiles. Most often needs ink or marker illustration. Seeks heart-warming and whimsical designs and illustrations using popular (Santa, Easter Bunny, etc.) or unique characters. Final art must be mailable size. Needs computer-literate freelancers for design, illustration and production. 50% of freelance work demands knowledge of Illustrator. Produces material for Christmas, Valentine's Day, Easter, Thanksgiving and Halloween. Submit seasonal material 1 year in advance.

First Contact & Terms Send query letter with tearsheets, photographs, photocopies, photostats, slides and transparencies. Samples are filed and are returned by SASE if requested by artist. Responds in 1 week. Director will contact artists for portfolio review if interested. Portfolio should include thumbnails, roughs, finished art samples, b&w and color tearsheets, photographs, slides and dummies. Originals are returned at job's completion. Rights purchased vary according to project.

Tips "If you want the artwork back please send a SASE with it."

N NEW DECO, INC.

23123 Sunfield Dr., Boca Raton FL 33433. (800)543-3326. Fax: (561)488-9743. E-mail: newdeco@mindspring.com. Website: newdeco.com. **President:** Brad Hugh Morris. Estab. 1984. Produces greeting cards, posters, fine art prints and original paintings.

Needs Specializing in pool and billiard artwork only. Works with 5-10 freelancers/year. Buys 8-10 designs and 5-10 illustrations/year. Uses artwork for original paintings, limited edition graphics, greeting cards, giftwrap, calendars, paper tableware, poster prints, etc. Licenses artwork for posters and prints.

First Contact & Terms Send query letter with brochure, résumé, tearsheets, slides and SASE. Samples not filed are returned by SASE. Responds in 10 days only if interested. To show portfolio, send e-mail. Pays royalties of 5-10%. Negotiates rights purchased.

Tips "Do not send original art at first." Contact only if you have an original image relating to Pool and Billiards.

N NEW ENGLAND CARD CO.

Box 228, West Ossipee NH 03890. (603)539-5095. E-mail: GLP@nhland.com. Website: www.nhland.com. **Owner:** Harold Cook. Estab. 1980. Produces greeting cards and prints of New England scenes which can be viewed on our website.

Needs Approached by 75 freelancers/year. Works with 10 freelancers/year. Buys more than 24 designs and illustrations/year. Prefers freelancers with experience in New England art. Art guidelines available. Considers oil, acrylic and watercolor. Looking for realistic styles. Prefers art proportionate to 5×7. Produces material for all holidays and seasons. "Submit all year."

First Contact & Terms Send query letter with SASE, photocopies, slides and transparencies. Samples are filed or are returned. Responds in 2 months. Artist should follow up after initial query. Pays by project. Rights purchased vary according to project, but "we prefer to purchase all rights."

Tips "Once you have shown us samples, follow up with new art."

N NOBLE WORKS

123 Grand St., P.O. Box 1275, Hoboken NJ 07030. (201)420-0095. Fax: (201)420-0679. Website: www.noblewor ksinc.com. **Contact:** Art Department. Estab. 1981. Produces greeting cards, notepads, gift bags and gift products. Produces "modern cards for modern people." Trend oriented, hip urban greeting cards.

Needs Approached by 100-200 freelancers/year. Works with 50 freelancers/year. Buys 250 freelance designs and illustrations/year. Prefers freelancers with experience in illustration. Art guidelines on website or available for SASE with first-class postage. We purchase "secondary rights" to illustration. Considers illustration, electronic art. Looking for humorous, "off-the-wall" adult contemporary and editorial illustration. Produces material for Christmas, Mother's Day, Father's Day, graduation, Halloween, Valentine's Day, birthdays, thank you, anniversary, get well, astrology, sympathy, etc. Submit seasonal material 18 months in advance.

First Contact & Terms Designers send query letter with photocopies, SASE, tearsheets, transparencies. Illustrators and cartoonists send query letter with photocopies, tearsheets, SASE. After introductory mailing send follow-up postcard sample every 8 months. Responds in 1 month. Buys reprint rights. Pays for design and illustration by the project. Finds freelancers through sourcebooks, illustration annuals, referrals.

N NORTHERN CARDS

5694 Ambler Dr., Mississauga ON L4W 2K9 Canada. (905)625-4944. Fax: (905)625-5995. E-mail: ggarbacki@nor therncards.com. Website: northerncards.com. **Product Coordinator:** Greg Garbacki. Estab. 1992. Produces 3 brands of greeting cards.

Needs Approached by 200 freelancers/year. Works with 25 freelancers/year. Buys 75 freelance designs and illustrations/year. Uses freelancers for "camera-ready artwork and lettering." Art guidelines for SASE with first-class postage. Looking for traditional, sentimental, floral and humorous styles. Prefers 5½×7¾ or 5×7. Pro-

duces material for Christmas, Easter, Mother's Day, Father's Day, graduation, Valentine's Day, birthdays and everyday. Also sympathy, get well, someone special, thank you, friendship, new baby, good-bye and sorry. Submit seasonal material 6 months in advance.

First Contact & Terms Designers: Send query letter with brochure, photocopies, slides, résumé and SASE. Illustrators and cartoonists: Send photocopies, tearsheets, résumé and SASE. Lettering artists send samples. Samples are filed or returned by SASE. Responds only if interested. Pays flat fee, $200 (CDN). Finds freelancers through newspaper ads, gallery shows and Internet.

Tips "Research your field and the company you're submitting to. Send appropriate work only."

N NOTES & QUERIES

9003A Yellow Brick Rd., Baltimore MD 21237. (410)682-6102. Fax: (410)682-5397. E-mail: nandq@nandq.com. Website: www.nandq.com. **Sales Coordinator:** Vanessa Harnik. Estab. 1981. Produces greeting cards, stationery, journals, paper tableware products and giftwrap. Products feature contemporary art.

Needs Approached by 30-50 freelancers/year. Works with 3-10 freelancers/year. Art guidelines available "pending our interest." Produces material for special projects only.

First Contact & Terms Send query letter with photographs, slides, SASE, photocopies, transparencies, "whatever you prefer." Samples are filed or returned by SASE as requested by artist. Responds in 1 month. Artist should follow up with call and/or letter after initial query. Portfolio should include thumbnails, roughs, photostats or transparencies. Rights purchased or 5-7% royalties paid; varies according to project.

Tips "Review what we do before submitting. Make sure we're appropriate for you."

THE NOTEWORTHY COMPANY

100 Church St., Amsterdam NY 12010. (518)842-2660. Fax: (800)866-8317. Website: www.noteworthyphoto.com. **Contact:** Larry Rallo, vice president sales & marketing. Estab. 1954. Produces bags and coloring books. Advertising specialty manufacturer selling to distributors with clients in the health, real estate, banking and retail fields.

Needs Buys 25 illustrations/year. Prefers freelancers with experience in designing for flexographic printing. Works on assignment only. Uses freelancers mainly for stock bag art and coloring book themes.

First Contact & Terms Send query letter with brochure, résumé, samples and SASE. Samples are filed. Pays $200 for bag design.

N NOVO CARD PUBLISHERS INC.

3630 W. Pratt Ave., Lincolnwood IL 60712. (847)763-0077. Fax: (847)763-0022. E-mail: art@novocard.net. Website: www.novocard.net. Estab. 1927. Produces all categories of greeting cards.

Needs Approached by 200 freelancers/year. Works with 30 freelancers/year. Buys 300 or 400 pieces/year from freelance artists. Art guidelines free for SASE with first-class postage. Uses freelancers mainly for illustration and text. Also for calligraphy. Considers all media. Prefers crop size $5 \times 7^{3}/_{4}$, bleed $5^{1}/_{4} \times 8$. Knowledge of Photoshop, Illustrator and QuarkXPress helpful. Produces material for all holidays and seasons and everyday. Submit seasonal material 8 months in advance.

First Contact & Terms Designers send brochure, photocopies, photographs and SASE. Illustrators and cartoonists send photocopies, photographs, tearsheets and SASE. Calligraphers send b&w copies. Accepts disk submissions compatible with Macintosh QuarkXPress 4.0 and Windows 95. Art samples are not filed and are returned by SASE only. Written samples retained on file for future assignment with writer's permission. Responds in 2 months. Pays for design and illustration by the project, $75-200.

N NRN DESIGNS, INC.

5142 Argosy Ave., Huntington Beach CA 92649. (714)898-6363. Fax: (714)898-0015. Website: www.NRNDesigns.com. **Art Director:** Linda Braun. Scrapbooking Art Director: Mariza Mendoza. Estab. 1984. Produces calendars, high-end stationery and scrapbooking items including stickers.

• This company is no longer producing greeting cards.

Needs Looking for freelance artists with innovative ideas and formats for invitations and scrapbooking products. Works on assignment only. Produces stickers and other material for Christmas, Easter, graduation, Halloween, Hanukkah, New Year, Thanksgiving, Valentine's Day, birthdays, everyday, (sympathy, get well, etc.). Submit seasonal material 1 year in advance.

First Contact & Terms Send photocopies or other nonreturnable samples. Responds only if interested. Portfolios required from designers. Company will contact artist for portfolio review if interested. Rights purchased vary according to project. Pays for design by the project.

OATMEAL STUDIOS

Box 138, Rochester VT 05767. (802)767-3171. Fax: (802)767-9890. **Creative Director:** Helene Lehrer Siobhan. Estab. 1979. Publishes humorous greeting cards and notepads, creative ideas for everyday cards and holidays.

Needs Approached by approximately 300 freelancers/year. Buys 100-150 freelance designs and illustrations/year. Art guidelines for SASE with first-class postage. Considers all media. Produces seasonal material for Christmas, Mother's Day, Father's Day, Easter, Valentine's Day and Hanukkah. Submit art year-round for all major holidays.

First Contact & Terms Send query letter with slides, roughs, printed pieces or brochure/flyer to be kept on file; write for artists' guidelines. "If brochure/flyer is not available, we ask to keep one slide or printed piece; color or b&w photocopies also acceptable for our files." Samples returned by SASE. Responds in 6 weeks. No portfolio reviews. Negotiates payment.

Tips "We're looking for exciting and creative, humorous (not cutesy) illustrations and single panel cartoons. If you can write copy and have a humorous cartoon style all your own, send us your ideas! We do accept work without copy too. Our seasonal card line includes traditional illustrations, so we do have a need for non-humorous illustrations as well."

N OFFRAY

Rt. 24 Box 601, Chester NJ 07930. (908)879-3135. Fax: (908)879-8588. E-mail: pattijosmith@berwickoffray.com. **Contact:** Patti Jo Smith, business unit manager of design and new product. Estab. 1900. Produces ribbons. "We're a ribbon company—for ribbon designs we look to the textile design studios and textile-oriented people; children's designs, craft motifs, fabric trend designs, floral designs, Christmas designs, bridal ideas, etc. Our range of needs is wide, so we need various looks."

Needs Approached by 8-10 freelancers/year. Works with 5-6 freelancers/year. Buys 40-50 freelance designs and illustrations/year. Artists must be able to work from pencils to finish, various styleswork is small and tight. Works on assignment only. Uses freelancers mainly for printed artwork on ribbons. Looking for artists able to translate a trend or design idea into a 1½ to 2-inch space on a ribbon. Produces material for Christmas, everyday. Submit seasonal material 6 months in advance.

First Contact & Terms Send postcard sample or query letter with résumé or call. Samples are filed. Responds only if interested. Portfolio should include color final art. Rights purchased vary according to project. Pays by the project.

ONTARIO FEDERATION OF ANGLERS AND HUNTERS

P.O. Box 2800, Peterborough ON K9J 8L5 Canada. (705)748-6324. Fax: (705)748-9577. Website: www.ofah.org. **Graphic Designer:** Deborah Carew. Estab. 1928. Produces calendars, greeting cards, limited edition prints. "We are a nonprofit, conservation organization who publishes a high quality wildlife art calendar and a series of four Christmas cards each year. We also commission two paintings per year that we produce in limited edition prints."

Needs Approached by 60 freelancers/year. Works with 6-12 freelancers/year. Buys 12 freelance designs and illustrations/year. Prefers wildlife artists. Art guidelines free by mail, e-mail or on website. Uses freelancers mainly for calendar/cards. Considers any media that gives realistic style. "We find talent through a yearly wildlife art calendar contest. Our criteria is specific to the wildlife art market with a slant towards hunting and fishing activities. We can only consider North American species found in Ontario. We welcome scenes involving sportsmen and women in the outdoors. Also sporting dogs. All art must be fine art quality, realistic, full color, with backgrounds. Any medium that gives these results is acceptable. No illustrative or fantasy-type work please. Look to successful wildlife artists like Robert Bateman or Michael Dumas for the style we're seeking." Prefers minimum 9×12 final art. Produces material for Christmas, wildlife art cards, i.e. no wording required.

First Contact & Terms Contact through contest only please. Samples are filed or returned. Responds following contest. Portfolio review not required. Buys one-time rights. Pays $150/calendar piece plus extras.

OUT OF THE BLUE

7350 So. Tamiami Trial #227, Sarasota FL 34231. (941)966-4042. Fax: (941)966-8914. E-mail: outoftheblue.us@mac.com. Website: www.out-of-the-blue.us. **President:** Michael Woodward. Creative Director: Maureen May. "Out of the Blue is a new division of Art Licensing International Inc. This new division specializes in creating 'Art Brands.' We are looking for artwork, designs, photography or character concepts that we can license for product categories such as posters and prints, greeting cards, calendars, stationery, gift products and the home decor market."

Needs Collections of art, illustrations or photography which have wide consumer appeal. CD presentation preferred, but photocopies/flyers are acceptable. If submitting character concepts, include a style guide showing all the characters and a synopsis with storylines.

First Contact & Terms Send samples on CD (JPEG files), short bio, color photocopies and SASE. E-mail presentations also accepted. Terms 50/50 with no expense to artist as long as artist can provide high-res scans if we agree on representation.

Tips "Pay attention to trends and color palettes. Artists need to consider actual products when creating new

art. Look at products in retail outlets and get a feel for what is selling well. Get to know the markets you want to sell your work to.''

P.S. GREETINGS, INC.
5730 N. Tripp Ave., Chicago IL 60646. Website: www.psgreetings.com. **Contact:** Design Director. Manufacturer of boxed greeting and counter cards.

Needs Receives submissions from 300-400 freelance artists/year. Artists' guidelines are posted on website, or send SASE. Works with 50-100 artists/year on greeting card designs. Publishes greeting cards for everyday and holidays. 70% of work demands knowledge of QuarkXPress, Illustrator and Photoshop.

First Contact & Terms All requests as well as submissions must be accompanied by SASE. Samples will *not* be returned without SASE! Responds in 1 month. Pays flat fee. Buys exclusive worldwide rights for greeting cards and stationery.

Tips ''Our line includes a whole spectrum from everyday needs (florals, scenics, feminine, masculine, humorous, cute) to every major holiday (from New Year's to Thanksgiving) with a very extensive Christmas line. We continue to grow every year and are always looking for innovative talent.''

ⓝ PAINTED HEARTS
1222 N. Fair Oaks Ave., Pasadena CA 91103. (626)798-3633. Fax: (626)296-8890. E-mail: richard@paintedhearts .com. Website: www.paintedhearts.com. **Sales Manager:** Richard Crawford. President: Susan Kinney. Estab. 1988. Produces greeting cards, stationery, invitations and note cards.

Needs Approached by 75 freelance artists/year. Works with 6 freelancers/year. Art guidelines free for SASE with first-class postage or by e-mail. Works on assignment only. Uses freelancers mainly for design. Produces material for all holidays and seasons, birthdays and everyday. Submit seasonal material 1 year in advance.

First Contact & Terms Send art submissions Attn: David Mekelburg, send writer's submissions Attn: Richard Crawford or use e-mail. Send query letter with résumé, SASE and color photocopies. Samples are returned with SASE. Responds only if interested. Write for appointment to show portfolio, which should include original and published work. Rights purchased vary according to project. Originals returned at job's completion. Pays flat fee of $150-300 for illustration. Pays royalties of 5%.

Tips ''Familiarize yourself with our card line.'' This company is seeking ''young artists (in spirit!) looking to develop a line of cards. We're looking for work that is compatible but adds to our look, which is bright, clean watercolors. We need images that go beyond just florals to illustrate and express the occasion.''

PANDA INK
Woodland Hills CA 91367. (818)340-8061. Fax: (818)883-6193. E-mail: ruthluvph@socal.rr.com. **Art Director:** Ruth Ann Epstein. Estab. 1982. Produces greeting cards, stationery, calendars and magnets. Products are Judaic, general, everyday, anniversary, etc. Also has a metaphysical line of cards.

Needs Approached by 8-10 freelancers/year. Works with 1-2 freelancers/year. Buys 3-4 freelance designs and illustrations/year. Uses freelancers mainly for design, card ideas. Considers all media. Looking for bright, colorful artwork, no risque, more ethnic. Prefers 5 × 7. Produces material for all holidays and seasons, Christmas, Valentine's Day, Mother's Day, Father's Day, Easter, Hanukkah, Passover, Rosh Hashanah, graduation, Thanksgiving, New Year, Halloween, birthdays and everyday. Submit seasonal material 6 months in advance.

First Contact & Terms Send query letter with résumé, SASE, tearsheets and photocopies. Samples are filed. Responds in 1 month. Portfolio review not required. Rights purchased vary according to project. Originals are returned at job's completion. Pay is negotiable; pays flat fee of $20; royalties of 2% (negotiable). Finds artists through word of mouth and submissions. ''We have no guidelines available.''

Tips ''Looking for bright colors and cute, whimsical art. Be professional. Always send SASE. Make sure art fits company format.''

ⓝ PAPER MAGIC GROUP INC.
401 Adams Ave., Scranton PA 18510. (570)961-3863. Fax: (570)348-8389. **Creative Director for Winter Division:** Peg Cohan. Estab. 1984. Produces greeting cards, stickers, vinyl wall decorations, 3-D paper decorations. ''We publish seasonal cards and decorations for the mass market. We use a wide variety of design styles.''

Needs Works with 60 freelance artists/year. Prefers artists with experience in greeting cards. Work is by assignment or send submissions on spec. Designs products for Christmas and Valentine's Day. Also uses freelancers for lettering and art direction.

First Contact & Terms Send query letter with résumé, samples and SASE to the attention of Lisa Spencer. Color photocopies are acceptable samples. Samples are filed or are returned by SASE only if requested by artist. Responds in 2 months. Originals not returned. Pays by the project, $350-2,000 average. Buys all rights.

Tips ''Please, experienced illustrators only.''

ⓝ PAPER MOON GRAPHICS, INC.

Box 34672, Los Angeles CA 90034. (310)287-3949. Fax: (310)287-2588. E-mail: moonguys@aol.com. Website: www.papermoon.com. **Contact:** Creative Director. Estab. 1977. Produces greeting cards and stationery. "We publish greeting cards with a friendly, humorous approach—dealing with contemporary issues."

• Paper Moon is a contemporary, alternative card company. Traditional art is not appropriate for this company.

Needs Works with 40 artists/year. Buys 200 designs/illustrations/year. Buys illustrations mainly for greeting cards and stationery. Art guidelines for SASE with first-class postage. Produces material for everyday, holidays and birthdays. Submit seasonal material 6 months in advance.

First Contact & Terms Send query letter with brochure, tearsheets, photostats, photocopies, slides and SASE. Samples are filed or are returned only if requested by artist and accompanied by SASE. Responds in 10 weeks. To show a portfolio, mail color roughs, slides and tearsheets. Original artwork is returned to the artist after job's completion. Pays average flat fee of $350/design; $350/illustration. Negotiates rights purchased.

Tips "We're looking for bright, fun style with a contemporary look. Artwork should have a young 20s and 30s appeal." A mistake freelance artists make is that they "don't know our product. They send inappropriate submissions, not professionally presented and with no SASE."

ⓝ ⊡ PAPERPOTAMUS PAPER PRODUCTS INC.

Box 310, Delta BC V4K 3Y3 Canada. Alternative address for small packages or envelopes only: Box 966, Point Roberts WA 98281. (604)940-3370. Fax: (604)940-3380. E-mail: art@paperpotamus.com. **Director of Marketing:** George Jackson. Estab. 1988. Produces greeting cards bought mainly by women ages 16-60.

Needs Works with 8-10 freelancers/year. Buys 50-75 illustrations from freelancers/year. Also uses freelancers for P-O-P displays, paste-up and inside text. Prefers hand draw, computer colored art, but will look at all color media. No b&w except photographic. Only looking for detailed humorous cartoons with very funny captions. Nothing else at this time. Produces color notepads and t-shirts in both b&w and color. Produces material for Christmas. Submit seasonal work at least 10 months before holiday. Has worked with artists to produce entire lines of cards but is currently most interested in putting selected work into existing or future card lines. Prefers $5\frac{1}{4} \times 7\frac{1}{4}$ finished artwork.

First Contact & Terms Prefers all submission to be via e-mail but if necessary send brochure, roughs, color photos or photocopies with SASE. Do not send slides. Samples are not filed and are returned only if SASE is sent by artist. Reports back in 2-3 months on average but sometimes longer. Original artwork is not returned if purchased. Prefers to buy all rights. Purchases for average flat fee of $100-150 or 5-8% royalty on sales of all products on which artwork is used. Please DO NOT SEND POSTAL IRC's in place of SASE. Put enough postage on your SASE to cover return cost or artwork will not be returned. Do not phone or fax to enquire about your artwork. It will be returned if you send an SASE with it. If you have a Web page with your artwork online, send an e-mail giving Web address and it will be reviewed and e-mail sent in response.

Tips "Know who your market is! Who would buy your card? Why? Who would they send it to? Why? Birthdays are the most popular occasions to send humorous cards for. Specific age cards are especially needed, i.e. 40, 50, 60, 65, etc. Understand the time frame necessary to produce cards and do not expect your artwork to appear on a card in a store next month. Send only your best work, and we will show it to the world, with your name on it."

PAPERPRODUCTS DESIGN U.S. INC.

60 Galli Dr., Suite 1, Novato CA 94949. (415)883-1888. Fax: (415)883-1999. E-mail: carol@paperproductdesign.com. Website: www.paperproductsdesign.com. **President:** Carol Florsheim. Estab. 1990. Produces paper napkins, plates, designer tissue, giftbags and giftwrap, porcelain accessories. Specializes in high-end design, fashionable designs.

Needs Approached by 50-100 freelancers/year. Buys multiple freelance designs and illustrations/year. Artists do not need to write for guidelines. They may send samples to the attention of Carol Florsheim at any time. Uses freelancers mainly for designer paper napkins. Looking for very stylized/clean designs and illustrations. Prefers $6\frac{1}{2} \times 6\frac{1}{2}$. Produces seasonal and everyday material. Submit seasonal material 9 months in advance.

First Contact & Terms Designers: Send brochure, photocopies, photographs, tearsheets. Samples are not filed and are returned if requested with SASE. Responds in 6 weeks. Request portfolio review of color, final art, photostats in original query. Rights purchased vary according to project. Pays for design and illustration by the project in advances and royalties. Finds freelancers through agents, *Workbook*.

Tips "Shop the stores, study decorative accessories, fashion clothing. Read European magazines. We are a design house."

PARAMOUNT CARDS INC.

400 Pine St., Pawtucket RI 02860. (401)726-0800, ext. 2182. Fax: (401)727-3890. Website: www.paramountcards.com. **Contact:** Freelance Art Coordinator. Estab. 1906. Publishes greeting cards. "We produce an extensive

line of seasonal and everyday greeting cards which range from very traditional to whimsical to humorous. Almost all artwork is assigned." Art guidelines on website.

Needs Works with 50-80 freelancers/year. Uses freelancers mainly for finished art. Also for calligraphy. Considers watercolor, gouache, airbrush and acrylic. Prefers $5\frac{1}{2} \times 8\frac{5}{16}$. Produces material for all holidays and seasons. Submit seasonal holiday material 1 year in advance.

First Contact & Terms Send query letter, résumé, SASE (important), color photocopies, slides, photos, transparencies (35mm, 4×5 and 8×10), CDs (no zip disks please) and printed card samples. Label all your pieces with your name, address and telephone number. Send duplicates and copies only! "If you send originals, it is at your own risk. Paramount Cards will not be held responsible for lost and damaged submissions." Samples are filed only if interested or returned by SASE if requested by artist. Responds in up to 4 months if interested. If your style is of interest, company may contact you for a larger selection. Pays by the project, $200-450. Finds artists through word of mouth and submissions.

Tips "Send a complete, professional package. Only include your best work; you don't want us to remember you from one bad piece. Always include SASE with proper postage and *never* send original art; color photocopies are enough for us to see what you can do. Label all your pieces with your name, address and phone number. Limit your submission to no more than 25 images (10-12 editorial samples) that will best demonstrate the range and variety of your work. Allow up to 4 months for a response. No submission will be returned without an appropriate sized SASE. No phone calls please."

⚑ PICKARD CHINA
782 Pickard Ave., Antioch IL 60002. (847)395-3800. Website: www.pickardchina.com. **President:** Eben C. Morgan, Jr. Estab. 1893. Manufacturer of fine china dinnerware. Clients: Upscale specialty stores and department stores. Current clients include Gearys, Marshall Field's and Gump's.

Needs Assigns 2-3 jobs to freelance designers/year. Prefers designers for china pattern development with experience in home furnishings. Tabletop experience is a plus but not required.

First Contact & Terms Send query letter with résumé and color photographs, tearsheets, slides or transparencies showing art styles. Samples are filed or are returned if requested. Art Director will contact artist for portfolio review if interested. Negotiates rights purchased. May purchase designs outright, work on royalty basis (usually 2%) or negotiate nonrefundable advance against royalties.

⚑ MARC POLISH ASSOCIATES
P.O. Box 3434, Margate NJ 08402. (609)823-7661. E-mail: mpolish@verizon.net. Website: www.justtoiletpaper. com. **President:** Marc Polish. Estab. 1972. Produces T-shirts and sweatshirts. "We specialize in printed T-shirts, sweatshirts, printed bathroom tissue, paper towels and coasters. Our market is the gift and mail order industry, resort shops and college bookstores."

Needs Works with 6 freelancers/year. Designs must be convertible to screenprinting. Produces material for Christmas, Valentine's Day, Mother's Day, Father's Day, Hanukkah, graduation, Halloween, birthdays and everyday.

First Contact & Terms Send query letter with brochure, tearsheets, photographs, photocopies, photostats and slides. Samples are filed or are returned. Responds in 2 weeks. To show portfolio, mail anything to show concept. Originals returned at job's completion. Pays royalties of 6-10%. Negotiates rights purchased.

Tips "We like to laugh. Humor sells. See what is selling in the local mall or department store. Submit anything suitable for T-shirts. Do not give up. No idea is a bad idea. It sometimes might have to be changed slightly to fit into a marketplace."

⚑ THE POPCORN FACTORY
13970 W. Laurel Dr., Lake Forest IL 60045. E-mail: abromley@thepopcornfactory.com. Website: www.thepopco rnfactory.com. **Director of Merchandising:** Ann Bromley. Estab. 1979. Manufacturer of popcorn packed in exclusive designed cans and other gift items sold via catalog for Christmas, Halloween, Valentine's Day, Easter and year-round gift giving needs.

Needs Works with 6 freelance artists/year. Assigns up to 20 freelance jobs/year. Works on assignment only. Uses freelancers mainly for cover illustration and design. Occasionally uses artists for advertising, brochure and catalog design and illustration. 100% of freelance catalog work requires knowledge of QuarkXPress and Photoshop.

First Contact & Terms Send query letter with photocopies, photographs or tearsheets. Samples are filed. Responds in 1 month. Write for appointment to show portfolio, or mail finished art samples and photographs. Pays for design by the hour, $50 minimum. Pays for catalog design by the page. Pays for illustration by project, $250-2,000. Considers complexity of project, skill and experience of artist, and turnaround time when establishing payment. Buys all rights.

Tips "Send classic illustration, graphic designs or a mix of photography/illustration. We can work from b&w concepts—then develop to full 4-color when selected. *Do not send art samples via e-mail.*"

🅽 PORTAL PUBLICATIONS, LTD.

201 Alameda del Prado, Suite 200, Novato CA 94949. (415)884-6200. Fax: (415)382-3377. E-mail: artsub@portal pub.com. Website: www.portalpub.com. **Cards and Stationery:** Gary Higgins, creative director. Calendars, posters, prints (wall decor): Bette Trono, VP of Wall Decor. Estab. 1954. Produces calendars, cards, stationery, posters and prints and other decorative art. ''All Portal products are image-driven, with emphasis on unique styles of photography and illustration. All age groups are covered in each product category, although the prime market is female, ages 18 to 45.''

Needs Approached by more than 1,000 freelancers (includes photographers and illustrators)/year. Freelance designs and illustrations purchased per year varies, more than 12 calligraphy projects/year. Prefers freelancers with experience in ''our product categories.'' Art guidelines free for SASE with first-class postage or via website. Works on assignment only. Uses freelancers mainly for primary image, photoshop work and calligraphy. Considers any media. Looking for ''beautiful, charming, provocative, humorous images of all kinds.'' 90% of freelance design demands knowledge of the most recent versions of Illustrator, QuarkXPress and Photoshop. Submit seasonal material 12 months in advance.

First Contact & Terms Send query letter with photocopies and SASE and follow-up postcard every 6 months. Prefers color copies to disk submissions. Samples are filed and not returned. Responds only if interested. Will contact for portfolio review of b&w, color and final art if interested. Rights purchased vary according to project.

Tips ''Send color copies of your work that we can keep in our files—also, know our product lines.''

🅽 PORTERFIELD'S FINE ART LICENSING

5 Mountain Rd., Concord NH 03301-5479. (800)660-8345 or (603)228-1864. Fax: (603)228-1888. E-mail: informa tion@porterfieldsfineart.com. Website: www.porterfieldsfineart.com. **President:** Lance J. Klass. Licenses representational, holiday, seasonal, Americana, and many other subjects. ''We're a full-service licensing agency.'' Estab. 1994. Functions as a full-service licensing representative for individual artists wishing to license their work into a wide range of consumer-oriented products. ''We have one of the fastest growing art licensing agencies in North America, as well as the largest and best-known art licensing site on the Internet, rated #1 in art licensing by Google for over five years. Stop by our site for more information about how to become a Porterfield's artist and have us represent you and your work for licenses in wall and home decor, home fabrics, stationery and all paper products, crafts, giftware and many other fields.''

Needs Approached by more than 400 artists/year. Licenses many designs and illustrations/year. Prefers representational artists ''who can create beautiful pieces of art that people want to look at again and again, and that will help sell products to the core consumer, that is, women over 30 who purchase 85% of all consumer goods in America.'' Art guidelines listed on its Internet site. Considers existing works first. Considers any media—oil, pastel, watercolor, acrylics. ''We want artists who have exceptional talent and who would like to have their art and their talents introduced to the broad public. Artists must be willing to work hard to produce art for the market.''

First Contact & Terms E-mail JPEG files or your site address, or send query letter with tearsheets, photographs, photocopies. SASE required for return of materials. Responds in 1 month. Will contact for portfolio review if interested. Portfolio should include tearsheets or photographs. Licenses primarily on a royalty basis.

Tips ''We are impressed first and foremost by level of ability, even if the subject matter is not something we would use. Thus a demonstration of competence is the first step; hopefully the second would be that demonstration using subject matter that we believe would be commercially marketable. We work with artists to help them with the composition of their pieces for particular media. We treat artists well, and actively represent them to potential licensees. Instead of trying to reinvent the wheel yourself and contact everyone 'cold,' get a licensing agent or rep whose particular abilities complement your art. We specialize in the application of art to home decor and accessories, prints and wall decor, and also to print media such as cards, stationery, calendars, prints, lithographs and home fabrics. The trick is to find the right rep whom you feel you can work with, who really loves your art whatever it is, who is interested in investing financially in promoting your work, and whose specific contacts and abilities can help further your art in the marketplace.''

PRATT & AUSTIN COMPANY, INC.

1 Cabot St., Holyoke MA 01040. (800)848-8020, ext. 577. E-mail: bruce@specialtyll.com. **Contact:** Bruce Pratt. Estab. 1931. Produces envelopes, children's items, stationery and calendars. Does not produce greeting cards. ''Our market is the modern woman at all ages. Design must be bright, cute, busy and elicit a positive response.''
- Now a division of Specialty Loose Leaf Inc.

Needs Approached by 100-200 freelancers/year. Works with 10 freelancers/year. Buys 50-100 designs and illustrations/year. Art guidelines available. Uses freelancers mainly for concept and finished art. Also for calligraphy.

First Contact & Terms Send nonreturnable samples, such as postcard or color copies. Samples are filed or are returned by SASE if requested. Will contact for portfolio review if interested. Portfolio should include thumbnails, roughs, color tearsheets and slides. Pays flat fee. Rights purchased vary. Interested in buying second rights (reprint rights) to previously published work. Finds artists through submissions and agents.

THE PRINTERY HOUSE OF CONCEPTION ABBEY

P.O. Box 12, Conception MO 64433. (660)944-3110. Fax (660)944-3116. E-mail: art@printeryhouse.org. Website: www.printeryhouse.org. **Art Director:** Brother Michael Marcotte, O.S.B. Creative Director: Ms. Lee Coats. Estab. 1950. Publishes religious greeting cards. Licenses art for greeting cards and wall prints. Specializes in religious Christmas and all-occasion themes for people interested in religious, yet contemporary, expressions of faith. "Our card designs are meant to touch the heart. They feature strong graphics, calligraphy and other appropriate styles."

Needs Approached by 100 freelancers/year. Works with 40 freelancers/year. Art guidelines and technical specifications available on website. Uses freelancers for product illustration and lettering. Looking for dignified styles and solid religious themes. Produces seasonal material for Christmas and Easter as well as the religious birthday, get well, sympathy, thank you, etc. Digital work is accepted in Photoshop or Illustrator format.

First Contact & Terms Send query letter with résumé, photocopies, CDs, photographs, slides or tearsheets. Calligraphers send samples of printed or finished work. Nonreturnable samples preferred or else samples with SASE. Accepts disk submissions compatible with Photoshop or Illustrator. Send TIFF or EPS files. Usually responds within 3-4 weeks. To show portfolio, mail appropriate materials only after query has been answered. "In general, we continue to work with artists once we have accepted their work." Pays flat fee of $250-400 for illustration/design, and $50-150 for calligraphy. Usually buys exclusive reproduction rights for a specified format, but artist retains copyright for any other usage.

Tips "Remember that our greeting cards need to have a definite Christian/religious dimension but not overly sentimental. It must be good quality artwork. We sell mostly via catalogs so artwork has to reduce well for catalog."

PRISMATIX, INC.

324 Railroad Ave., Hackensack NJ 07601. (201)525-2800 or (800)222-9662. Fax: (201)525-2828. E-mail: prismatix@optonline.net. **Vice President:** Miriam Salomon. Estab. 1977. Produces novelty humor programs. "We manufacture screen-printed novelties to be sold in the retail market."

Needs Works with 3-4 freelancers/year. Buys 100 freelance designs and illustrations/year. Works on assignment only. 90% of freelance work demands computer skills.

First Contact & Terms Send query letter with brochure, résumé. Samples are filed. Responds only if interested. Portfolio should include color thumbnails, roughs, final art. Payment negotiable.

PRIZM INC.

P.O. Box 1106, Manhattan KS 66505-1106. (785)776-1613. Fax (785)776-6550. E-mail: michele@pipka.co. **President of Product Development:** Michele Johnson. Produces collectible figurines, decorative housewares, gifts, limited edition plates, ornaments. Manufacturer of exclusive collectible figurine line.

Needs Approached by 20 freelancers/year. Art guidelines free for SASE with first-class postage. Works on assignment only. Uses freelancers mainly for figurines, home decor items. Also for calligraphy. Considers all media. Looking for traditional, old world style, sentimental, folkart. Produces material for Christmas, Mother's Day, everyday. Submit seasonal material 1 year in advance.

First Contact & Terms Send query letter with photocopies, résumé, SASE, slides, tearsheets. Samples are filed. Responds in 2 months if SASE is included. Will contact for portfolio review of color, final art, slides. Rights purchased vary according to project. Pays royalties plus payment advance; negotiable. Finds freelancers through artist submissions, decorative painting industry.

Tips "People seem to be more family oriented—therefore more wholesome and positive images are important. We are interested in looking for new artists and lines to develop. Send a few copies of your work with a concept."

PRUDENT PUBLISHING

65 Challenger Rd., Ridgefield Park NJ 07660. (201)641-7900. Fax: (201)641-9356. Website: www.gallerycollection.com. **Marketing:** Marian Francesco. Estab. 1928. Produces greeting cards. Specializes in business/corporate all-occasion and holiday cards.

Needs Buys calligraphy. Art guidelines available. Uses freelancers mainly for card design, illustrations and calligraphy. Considers traditional media. Prefers no cartoons or cute illustrations. Prefers $5^{1}/_{2} \times 7^{7}/_{8}$ horizontal format (or proportionate to those numbers). Produces material for Christmas, Thanksgiving, birthdays, everyday, sympathy, get well and thank you.

First Contact & Terms Designers, illustrators and calligraphers send query letter with brochure, photostats, photocopies, tearsheets. Samples are filed or returned by SASE if requested. Responds ASAP. Portfolio review not required. Buys all rights. No royalty or licensing arrangements. Payment is negotiable. Finds freelancers through artist's submissions, magazines, sourcebooks, agents and word of mouth.

Tips "No cartoons."

RAINBOW CREATIONS, INC.

216 Industrial Dr., Ridgeland MS 39157. (601)856-2158. Fax: (601)856-5809. E-mail: phillip@rainbowcreations. net. Website: http/rainbowcreations.net. **President:** Steve Thomas. Art Director: Phillip McDaniel. Estab. 1976. Produces wallpaper.

Needs Approached by 10 freelancers/year. Works with 5 freelancers/year. Buys 45 freelance designs and illustrations/year. Prefers freelancers with experience in Illustrator and Photoshop. Art guidelines available on individual project basis. Works on assignment only. Uses freelancers mainly for images that are enlarged into murals. Also for setting designs in repeat. Considers Mac and hand-painted media. 50% of freelance design work demands knowledge of Photoshop and Illustrator. Produces material for everyday.

First Contact & Terms Designers: Send query letter with photocopies, photographs and résumé. "We will accept disk submissions if compatible with Illustrator 5.0." Samples are returned. Responds in 7 days. Buys all rights. Pays for design and illustration by the project. Payment based on the complexity of design.

Tips "Primarily designs wall coverings, boarders and murals for the contract wallcovering market."

ⓝ RECO INTERNATIONAL CORPORATION

706 Woodlawn Ave., Cambridge OH 43725. (740)432-8800. Fax: (740)432-8811. E-mail: hreich@reco.com. Website: www.reco.com. Manufacturer/distributor of limited editions, collector's plates, 3-dimensional plaques, lithographs and figurines. Sells through retail stores and direct marketing firms.

Needs Works with freelance and contract artists. Uses freelancers under contract for plate and figurine design, home decor and giftware. Prefers romantic and realistic styles.

First Contact & Terms Send query letter and brochure to be filed. Write for appointment to show portfolio. Art director will contact artist for portfolio review if interested. Negotiates payment. Considers buying second rights (reprint rights) to previously published work or royalties.

Tips "Have several portfolios available. We are very interested in new artists. We go to shows and galleries, and receive recommendations from artists we work with."

RECYCLED PAPER GREETINGS INC.

3636 N. Broadway, Chicago IL 60613. (773)348-6410. Fax: (773)281-1697. Website: www.recycled.com. **Art Directors:** Gretchen Hoffman, John LeMoine. Publishes greeting cards, adhesive notes and imprintable stationery.

Needs Buys 1,000-2,000 freelance designs and illustrations. Considers b&w line art and color—"no real restrictions." Looking for "great ideas done in your own style with messages that reflect your own slant on the world." Prefers 5×7 vertical format for cards. "Our primary interest is greeting cards." Produces seasonal material for all major and minor holidays including Jewish holidays. Submit seasonal material 18 months in advance; everyday cards are reviewed throughout the year.

First Contact & Terms Send SASE to the Art Department or view website for artist's guidelines. "Please do not send slides, CD's or tearsheets. We're looking for work done specifically for greeting cards."Responds in 2 months. Portfolio review not required. Originals returned at job's completion. Sometimes requests work on spec before assigning a job. Pays average flat fee of $250 for illustration/design with copy. Some royalty contracts. Buys card rights.

Tips "Remember that a greeting card is primarily a message sent from one person to another. The art must catch the customer's attention, and the words must deliver what the front promises. We are looking for unique points of view and manners of expression. Our artists must be able to work with a minimum of direction and meet deadlines. There is a renewed interest in the use of recycled paper; we have been the industry leader in this for over three decades."

ⓝ REEDPRODUCTIONS

100 Ebbtide Ave., Suite 100, Sausalito CA 94965. (415)331-2694. Fax: (415)331-3690. E-mail: reedpro@earthlink .net. **Owner/Art Director:** Susie Reed. Estab. 1978. Produces general stationery and gift items including greeting cards, magnets and address books. Special emphasis on nature.

Needs Approached by 20 freelancers/year. Works with few freelancers/year. Art guidelines are not available. Prefers local freelancers with experience. Works on assignment only. Artwork used for paper and gift novelty items. Also for computer graphics. Prefers color or b&w photo realist illustrations of nature images.

First Contact & Terms Send query letter with brochure or résumé, tearsheets, photocopies or slides and SASE. Samples are filed or are returned by SASE. Art Director will contact artist for portfolio review if interested. Portfolio should include color or b&w final art, final reproduction/product, slides, tearsheets and photographs. Originals are returned at job's completion. Payment negotiated at time of purchase. Considers buying second rights (reprint rights) to previously published work.

ⓝ RENAISSANCE GREETING CARDS

Box 845, Springvale ME 04083. (207)324-4153. Fax: (207)324-9564. E-mail: talktous@rencards.com. Website: www.rencards.com. **Art Director:** Jennifer Stockless. Estab. 1977. Publishes greeting cards; "current ap-

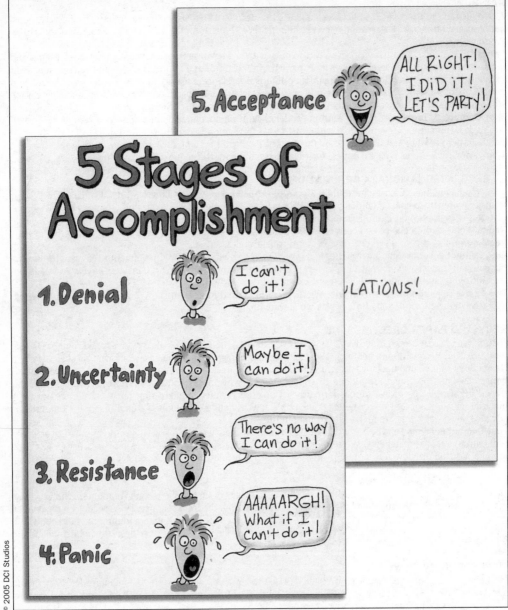

This card, created by DCI Studios, was distributed by Recycled Paper Greetings. The artist sought to portray the cycle each of us go through when working to achieve our goals. For more information visit www.dcistudios.com.

proaches'' to all-occasion cards and seasonal cards. ''We're an alternative card company with a unique variety of cards for all ages, situations and occasions.''

Needs Approached by 500-600 artists/year. Buys 300 illustrations/year. Occasionally buys calligraphy. Art guidelines on website, and available free for SASE with first-class postage. Full-color illustrations only. Produces materials for all holidays and seasons and everyday. Submit art 18 months in advance for fall and Christmas material; approximately 1 year in advance for other holidays.

First Contact & Terms Send query letter with SASE. To show portfolio, mail color copies, tearsheets, slides or

transparencies. Packaging with sufficient postage to return materials should be included in the submission. Responds in 2 months. Originals are returned to artist at job's completion. Sometimes requests work on spec before assigning a job. Pays for design by the project, $150-300 advance on royalties or flat fee, negotiable. Also needs calligraphers, pay rate negotiable. Finds artists mostly through submissions/self-promotions.

Tips "Do some 'in store' research first to get familiar with a company's product/look in order to decide if your work is a good fit. It can take a lot of patience to find the right company or situation. Especially interested in trendy styles as well as humorous and whimsical illustration. Start by requesting guidelines, and then send a small (10-12) sampling of 'best' work, preferably color copies or slides (with SASE for return). Indicate if the work shown is available or only samples. We're doing more designs with special effects like die-cutting and embossing. We're also starting to use more computer-generated art and electronic images."

RIGHTS INTERNATIONAL GROUP, LLC

453 First St., Hoboken NJ 07030. (201)239-8118. Fax: (201)222-0694. E-mail: rhazaga@rightsinternational.com. Website: www.rightsinternational.com. **Contact:** Robert Hazaga. Estab. 1996. Agency for cross licensing. Licenses images for manufacturers of giftware, stationery, posters, home furnishing.

• This company also has a listing in the Posters & Prints section.

Needs Approached by 50 freelancers/year. Uses freelancers mainly for creative, decorative art for the commercial and designer market. Also for textile art. Considers oil, acrylic, watercolor, mixed media, pastels and photography.

First Contact & Terms Send brochure, photocopies, photographs, SASE, slides, tearsheets or transparencies. Accepts disk submissions compatible with PC format. Responds in 1 month. Will contact for portfolio review if interested. Negotiates rights purchased and payment.

RITE LITE LTD./THE JACOB ROSENTHAL JUDAICA-COLLECTION

333 Stanley Ave., Brooklyn NY 11207. (718)498-1700. Fax: (718)498-1251. E-mail: alex@riteliteltd.com. Estab. 1948. Manufacturer and distributor of a full range of Judaica. Clients include department stores, galleries, gift shops, museum shops and jewelry stores.

• Company is looking for new menorahs, mezuzahs, children's Judaica, Passover and matza plates.

Needs Art guidelines not available. Works on assignment only. Must be familiar with Jewish ceremonial objects or design. Also uses artists for brochure and catalog design, illustration and layout mechanicals, and product design. Most of freelance work requires knowledge of Illustrator and Photoshop. Produces material for Hannukkah, Passover and other Jewish Holidays. Submit seasonal material 1 year in advance.

First Contact & Terms Designers: Send query letter with brochure or résumé and photographs. Illustrators: Send photocopies. Do not send originals. Samples are filed. Responds in 1 month only if interested. Portfolio review not required. Art Director will contact for portfolio review if interested. Portfolio should include color tearsheets, photographs and slides. Pays flat fee per design. Buys all rights. Finds artists through word of mouth.

Tips "Be open to the desires of the consumers. Don't force your preconceived notions on them through the manufacturers. Know that there is one retail price, one wholesale price and one distributor price."

ROCKSHOTS GREETING CARDS

20 Vandam St., 4th Floor, New York NY 10013-1274. (212)243-9661. Fax: (212)604-9060. **Editor:** Bob Vesce. Estab. 1979. Produces calendars, giftbags, giftwrap, greeting cards, mugs. "Rockshots is an outrageous, sometimes adult, always hilarious card company. Our themes are sex, birthdays, sex, holiday, sex, all occasion and sex. Our images are mainly photographic, but we also seek out cartoonists and illustrators."

Needs Approached by 10-20 freelancers/year. Works with 5-6 freelancers/year. Buys 10 freelance designs and illustrations/year. Art guidelines free for SASE with first-class postage. "We like a line that has many different facets to it, encompassing a wide range of looks and styles. We are outrageous, adult, witty, off-the-wall, contemporary and sometimes shocking." Prefers any size that can be scaled on a greeting card to 5 inches by 7 inches. 10% of freelance illustration demands computer skills. Produces material for Christmas, New Year, Valentine's Day, birthdays, everyday, get well, woman to woman ("some male bashing allowed") and all adult themes.

First Contact & Terms Illustrators and/or cartoonists send photocopies, photographs and photostats. Samples are filed. Responds only if interested. Portfolio review not required. Buys first rights. Pays per image.

Tips "As far as trends go in the greeting card industry, we've noticed that 'retro' refuses to die. Vintage looking cards and images still sell very well. People find comfort in the nostalgic look of yesterday. Sex also is a huge seller. Rockshots is looking for illustrators that can come up with something a little out of mainstream. Our look is outrageous, witty, adult and sometimes shocking. Our range of style starts at cute and whimsical and runs the gamut all the way to totally wacky and unbelievable. Rockshots cards definitely stand out from the competition. For our line of illustrations, we look for a style that can convey a message, whether through a detailed elaborate colorful piece of art or a simple 'gesture' drawing. Characters work well, such as the ever-present wisecracking granny to the nerdy 'everyman' guy. It's always good to mix sex and humor, as sex always

sells. As you can guess, we do not shy away from much. Be creative, be imaginative, be funny, but most of all, be different.''

☑ ROMAN, INC.

880 S. Rohlwing Rd., Addison IL 60101-4218. (630)705-4500. Fax: (630)705-4601. E-mail: dswetz@roman.com. Website: www.roman.com. **Vice President:** Julie Puntch. Estab. 1963. Produces collectible figurines, decorative housewares, decorations, gifts, limited edition plates, ornaments. Specializes in collectibles and giftware to celebrate special occasions.

Needs Approached by 25-30 freelancers/year. Works with 3-5 freelancers/year. Uses freelancers mainly for graphic packaging design, illustration. Also for a variety of services. Considers variety of media. Looking for traditional-based design. Roman also has an inspirational niche. 80% of freelance design and illustration demands knowledge of Photoshop, QuarkXPress, Illustrator. Produces material for Christmas, Mother's Day, graduation, Thanksgiving, birthdays, everyday. Submit seasonal material 1 year in advance.

First Contact & Terms Send query letter with photocopies. Samples are filed or returned by SASE. Responds in 2 months if artist requests a reply. Portfolio review not required. Pays by the project, varies. Finds freelancers through word of mouth, artists' submissions.

RUBBERSTAMPEDE

2550 Pellisier Place, Whittier CA 90601. (562)695-7969. Fax: (800)546-6888. E-mail: ochoa@dtccorp.com. Website: www.deltacrafts.com. **Senior Marketing Manager:** Olive Choa. Estab. 1978. Produces art and novelty rubber stamps, kits, glitter pens, ink pads, papers, stickers, scrapbooking products.

Needs Approached by 30 freelance artists/year. Works with 10-20 freelance artists/year. Buys 200-300 freelance designs and illustrations/year. Uses freelance artists for calligraphy, P-O-P displays, and original art for rubber stamps. Considers pen & ink. Looks for whimsical, feminine style and fashion trends. Produces seasonal material Christmas, Valentine's Day, Easter, Hanukkah, Thanskgiving, Halloween, birthdays and everyday (includes wedding, baby, travel, and other life events). Submit seasonal material 9 months in advance.

First Contact & Terms Send nonreturnable samples. Samples are filed. Responds only if interested. Pays by the hour, $15-50; by the project, $50-1,000. Rights purchased vary according to project. Originals are not returned.

RUSS BERRIE AND COMPANY

111 Bauer Dr., Oakland NJ 07436. (800)631-8465. **Director Paper Goods:** Penny Shaw. Produces greeting cards, bookmarks and calendars. Manufacturer of impulse gifts for all age groups.

● This company is no longer taking unsolicited submissions.

SANGRAY CORPORATION

2318 Lakeview Ave., Pueblo CO 81004. (719)564-3408. Fax: (719)564-0956. E-mail: lmusgrave@sangray.com. Website: www.sangray.com. **Licensing:** Vern Estes. Licenses art for gift and novelty. Estab. 1971. Produces refrigerator magnets, trivets, wall decor and other decorative accessories—all using full-color art. Art guidelines for SASE with first-class postage.

Needs Approached by 30-40 freelancers/year. Works indirectly with 6-7 freelancers/year. Buys 25-30 freelance designs and illustrations/year. Prefers florals, scenics, small animals and birds. Uses freelancers mainly for fine art for products. Considers all media. Prefers 7×7 or digital. Submit seasonal material 10 months in advance.

First Contact & Terms Send query letter with examples of work in any media. Samples are filed. Responds in 1 month. Company will contact artist for portfolio review if interested. Buys first rights. Originals are returned at job's completion. Pays by the project or royalty. Finds artists through submissions and design studios.

Tips "Try to get a catalog of the company products and send art that closely fits the style the company tends to use."

Ⓝ THE SARUT GROUP

P.O. Box 110495, Brooklyn NY 11211. (718)387-7484. Fax: (718)387-7467. E-mail: far@sarut.com. Website: www.thesarutgroup.com. **Vice President Marketing:** Frederic Rambaud. Estab. 1979. Produces museum quality science and nature gifts. "Marketing firm with 20 employees. 36 trade shows a year. No reps. All products are exclusive. Medium- to high-end market."

Needs Approached by 4-5 freelancers/year. Works with 4 freelancers/year. Uses freelancers mainly for new products. Seeks contemporary designs. Produces material for all holidays and seasons.

First Contact & Terms Samples are returned. Responds in 2 weeks. Write for appointment to show portfolio. Rights purchased vary according to project.

Tips "We are looking for concepts; products, not automatically graphics."

[N] SEABROOK WALLCOVERINGS, INC.

1325 Farmville Rd., Memphis TN 38122. (901)320-3500. Fax: (901)320-3675. Website: www.seabrookwallpaper .com. **Director of Product Development:** Suzanne Ashley. Estab. 1910. Developer and distributor of wallcovering, coordinating fabric and accessories for all age groups and styles.

Needs Approached by 10-15 freelancers/year. Works with approximately 6 freelancers/year. Buys approximately 200 freelance designs and illustrations/year. Prefers freelancers with experience in wall coverings. Works on assignment only. Uses freelancers mainly for designing and styling wallcovering collections. Considers gouache, oil, watercolor, etc. Prefers $20\frac{1}{2} \times 20\frac{1}{2}$. Produces material for everyday, residential.

First Contact & Terms Designers: Send query letter with color photocopies, photographs, résumé, slides, transparencies and sample of artists' "hand." Illustrators send query letter with color photocopies, photographs and résumé. Samples are filed or returned. Responds in 2 weeks. Company will contact artist for portfolio review of final art, roughs, transparencies and color copies if interested. Buys all rights. Pays for design by the project. Finds freelancers through word of mouth, submissions, trade shows.

Tips "Attend trade shows pertaining to trends in wall covering. Be familiar with wallcovering design repeats."

[globe] SECOND NATURE, LTD.

10 Malton Rd., London, W105UP England (020)8960-0212. Fax: (020)8960-8700. E-mail: contact@secondnature .co.uk. Website: www.secondnature.co.uk. **Contact:** Rod Schragger. Greeting card publisher specializing in unique 3-D/handmade cards and special finishes.

Needs Prefers interesting new contemporary but commercial styles. Also calligraphy and Web design. Art guidelines available. Produces material for Christmas, Valentine's Day, Mother's Day and Father's Day. Submit seasonal material 19 months in advance.

First Contact & Terms Send query letter with samples showing art style. Samples not filed are returned only if requested by artist. Responds in 2 months. Originals are not returned at job's completion. Pays flat fee.

Tips "We are interested in all forms of paper engineering or anything fresh and innovative."

[N] SIGNED, SEALED, DELIVERED

P.O. Box 70007, Pasadena CA 91117. (626)796-9107. Fax (626)564-1478. **Art Director:** Desi Adamson. Estab. 1998. Produces greeting cards, stationery. Specializes in Christmas cards and stationery featuring illustration, foil stamping and engraving. Supplier of all major department stores and fine card and gift stores.

Needs Approached by 20 freelancers/year. Works with 3-5 freelancers/year. Buys 10 freelance designs and illustrations/year. Also buys some calligraphy. Use freelancers mainly for Christmas cards. Considers all media except sculpture. Looking for traditional, humorous, cute animals and graphic designs. Prefers multiple size range. 30% of freelance work demands knowledge of Photoshop, QuarkXPress. Produces material for Christmas, Hannukkah and Valentine's Day. Submit seasonal material 8-12 months in advance.

First Contact & Terms Send query letter with photocopies. Samples are filed. Will contact artist for portfolio review of color photographs and slides if interested. Negotiates rights purchased. Pays flat fee by the project. Will also license with option to buy out after license is completed. Finds freelancers through word of mouth, submissions, Surtex show.

[N] PAULA SKENE DESIGNS

1250 45th St., Suite 240, Emeryville CA 94608. (510)654-3510. Fax: (510)654-3496. E-mail: paulaskenedesi@aol. com. **Contact:** Paula Skene, owner/president. Specializes in all types of cards and graphic design as well as foil stamping and embossing. "We do not use any cartoon art. We only use excellent illustration or fine art."

Needs Works with 1-2 freelancers/year. Works on assignment only. Produces material for all holidays and seasons, everyday.

First Contact & Terms Designers, Artists, and illustrators send tearsheets and photocopies. DO NOT SEND MORE THAN TWO EXAMPLES. Samples are returned. Responds in 1 week. Buys all rights. Pays for design and illustration by the project.

[checkmark] SOURIRE

P.O. Box 1659, Old Chelsea Station, New York NY 10013. (718)573-4624. Fax: (718)573-5150. E-mail: greetings@c ardsorbust.com. Website: www.cardsorbust.com. **Contact:** Submissions. Estab. 1998. Produces giftbags, giftwrap/wrapping paper, greeting cards, stationery, T-shirts. Specializes in exclusive designs for cultural holidays and occasions. Target market is Black American and multi-ethnic men and women between ages 20 and 60.

Needs Approached by 50 freelancers/year. Licenses up to 20 freelance designs and/or illustrations/year. Art guidelines free with SASE and first-class postage. Uses freelancers mainly for graphics, paintings, illustrations. Considers all media. Product categories include wedding, women, babies, historical, handcrafted. Produces material for all cultured holidays and occasions. Submit material 6 months in advance.

First Contact & Terms Send query letter with brochure, postcard sample, photocopies, SASE, tearsheets, URL.

Samples are returned by SASE or else discarded. Responds in 3 months. Portfolio not required. Rights purchased vary according to licensing contract. Pays freelancers by royalties or flat fee. Finds freelancers through artists' submissions and word of mouth.

SPARROW & JACOBS

6701 Concord Park Dr., Houston TX 77040. (713)329-9400. Fax: (713)744-8799. E-mail: sparrowart@gabp.com. **Contact:** Product Merchandiser. Estab. 1986. Produces calendars, greeting cards, postcards and other products for the real estate industry.

Needs Buys up to 100 freelance designs and illustrations/year including illustrations for postcards and greeting cards. Considers all media. Looking for new product ideas featuring residential front doors, flowers, landscapes, animals, holiday themes and much more. "Our products range from, but are not limited to, humourous illustrations and comical cartoons to classical drawings and unique paintings." Produces material for Christmas, Easter, Mother's Day, Father's Day, Halloween, New Year, Thanksgiving, Valentine's Day, birthdays, everyday, time change. Submit seasonal material 1 year in advance.

First Contact & Terms Send query letter with color photocopies, photographs or tearsheets. We also accept e-mail submissions of low-resolution images. If sending slides, do not send originals. We are not responsible for slides lost or damaged in the mail. Samples are filed or returned in your SASE.

N SPENCER GIFTS, LLC

6826 Black Horse Pike, Egg Harbor Twp. NJ 08234-4197. (609)645-5526. Fax: (609)645-5797. E-mail: james.stevenson@spencergifts.com. Website: wwwspencergifts.com. **Contact:** James Stevenson. Licensing: Carl Franke. Estab. 1965. Retail gift chain located in approximately 750 stores in 43 states including Hawaii and Canada. Includes new retail chain stores named Spirit Halloween Superstores.

- Products offered by store chain include posters, T-shirts, games, mugs, novelty items, cards, 14k jewelry, neon art, novelty stationery. Spencer's is moving into a lot of different product lines, such as custom lava lights and Halloween costumes and products. Visit a store if you can to get a sense of what they offer.

Needs Assigns 10-15 freelance jobs/year. Prefers artists with professional experience in advertising design. Uses artists for illustration (hard line art, fashion illustration, airbrush). Also needs product and fashion photography (primarily jewelry), as well as stock photography. Uses a lot of freelance computer art. 50% of freelance work demands knowledge of FreeHand, Illustrator, Photoshop and QuarkXPress. Also needs color separators, production and packaging people. "You don't necessarily have to be local for freelance production."

First Contact & Terms Send postcard sample or query letter with *nonreturnable* brochure, résumé and photocopies, including phone number where you can be reached during business hours. Accepts submissions on disk. James Stevenson will contact artist for portfolio review if interested. Will contact only upon job need. Considers buying second rights (reprint rights) to previously published work. Finds artists through sourcebooks.

Tips "Become proficient in as many computer programs as possible."

N ST. ARGOS CO., INC.

11040 W. Hondo Pkwy., Temple City CA 91780. (626)448-8886. Fax: (626)579-9133. **Manager:** Su-Chen Liang. Estab. 1987. Produces greeting cards, giftwrap, Christmas decorations, paper boxes, tin boxes, bags, puzzles, cards.

Needs Approached by 3 freelance artists/year. Works with 2 freelance artists/year. Buys 3 freelance designs and illustrations/year. Prefers artists with experience in Victorian or country style. Uses freelance artists mainly for design. Produces material for all holidays and seasons. Submit seasonal material 6 months in advance.

First Contact & Terms Send query letter with résumé and slides. Samples are filed. Art Director will contact artist for portfolio review if interested. Portfolio should include color samples. Originals are not returned. Pays royalties of 7.5%. Negotiates rights purchased.

N STANDARD CELLULOSE & NOV CO., INC.

90-02 Atlantic Ave., Ozone Park NY 11416. (718)845-3939. Fax: (718)641-1170. **President:** Stewart Sloane. Estab. 1932. Produces giftwrap and seasonal novelties and decorations.

Needs Approached by 10 freelance artists/year. Works with 1 freelance artist/year. Buys 3-4 freelance designs and illustrations/year. Prefers local artists only. Uses freelance artists mainly for design packaging. Also uses freelance artists for P-O-P displays, all media appropriate for display and P-O-P. Produces material for all holidays and seasons, Christmas, Easter, Halloween and everyday. Submit 6 months before holiday.

First Contact & Terms Send query letter or call for appointment. Samples are not filed and are returned. Responds only if interested. Call to schedule an appointment to show a portfolio. "We will then advise artist what we want to see in portfolio." Original artwork is not returned at the job's completion. Payment negotiated at time of purchase. Rights purchased vary according to project.

⃞Ⓝ STOTTER & NORSE

1000 S. Second St., Plainfield NJ 07063. (908)754-6330. Fax: (908)757-5241. E-mail: sales@stotternorse.com. Website: www.stotternorse.com. **V.P. of Sales:** Larry Speichler. Estab. 1979. Produces barware, serveware, placemats and a broad range of tabletop products.

Needs Buys 20 designs and illustrations/year. Art guidelines not available. Works on assignment only. Uses freelancers mainly for product design. Seeking trendy styles. Final art should be actual size. Produces material for all seasons. Submit seasonal material 6 months in advance.

First Contact and Terms Send query letter with brochure and résumé. Samples are filed. Responds in 1 month or does not reply, in which case the artist should call. Call for appointment to show portfolio. Negotiates rights purchased. Originals returned at job's completion if requested. Pays flat fee and royalties; negotiable.

⃞Ⓝ SUNSHINE ART STUDIOS, INC.

270 Main St., Agawan MA 01001. (413)82-8700. Fax: (413)821-8701. E-mail: aorsi@sunshinecards.com. Website: sunshinecards.com. **Contact:** Alicia Orsi, art director. Estab. 1921. Produces greeting cards, stationery and calendars that are sold in own catalog, appealing to all age groups.

Needs Works with 50 freelance artists/year. Buys 100 freelance designs and illustrations/year. Prefers artists with experience in greeting cards. Art guidelines available for SASE with first-class postage. Works on assignment only. Uses freelancers for greeting cards, stationery and gift items. Also for calligraphy. Considers all media. Looking for traditional or humorous look. Prefers art $4\frac{1}{2} \times 6\frac{1}{2}$ or 5×7. Produces material for Christmas, birthdays and everyday. Submit seasonal material 6-8 months in advance.

First Contact & Terms Send query letter with brochure, résumé, SASE, tearsheets and slides. Samples are filed or are returned by SASE if requested by artist. Responds only if interested. Portfolio should include finished art samples and color tearsheets and slides. Originals not returned. Pays by the project, $450-700. Pays $100-150/piece for calligraphy and lettering. Buys all rights.

A SWITCH IN ART, GERALD F. PRENDERVILLE, INC.

P.O. Box 246, Monmouth Beach NJ 07750. (732)389-4912. Fax (732)389-4913. E-mail: aswitchinart@aol.com. **President:** G. Prenderville. Estab. 1979. Produces decorative switch plates. "We produce decorative switch plates featuring all types of designs including cats, animals, flowers, kiddies/baby designs, birds, etc. We sell to better gift shops, museums, hospitals, specialty stores, with large following in mail order catalogs."

Needs Approached by 4-5 freelancers/year. Works with 2-3 freelancers/year. Buys 10-20 designs and illustrations/year. Prefers artists with experience in card industry and cat rendering. Seeks cats and wildlife art. Prefers 8×10 or 10×12. Submit seasonal material 6 months in advance.

First Contact & Terms Send query letter with brochure, tearsheets and photostats. Samples are filed and are returned. Responds in 3-5 weeks. Pays by the project, $75-150. Interested in buying second rights (reprint rights) to previously published artwork. Finds artists mostly through word of mouth.

Tips "Be willing to accept your work in a different and creative form that has been very successful. We seek to go vertical in our design offering to insure continuity. We are very easy to work with and flexible. Cats have a huge following among consumers, but designs must be realistic."

SYRACUSE CULTURAL WORKERS

Box 6367, Syracuse NY 13217. (315)474-1132. Fax: (877)265-5399. E-mail: scw@syrculturalworkers.com. Website: www.syrculturalworkers.com. **Art Director:** Karen Kerney. Estab. 1982. Syracuse Cultural Workers publishes and distributes peace and justice resources through their Tools For Change catalog. Produces posters, note cards, postcards, greeting cards, T-shirts and calendars that are feminist, progressive, radical, multicultural, lesbian/gay allied, racially inclusive and honoring of elders and children.

- SCW is specifically seeking artwork celebrating diverstiy, people's history and community building. Themes include environment, positive parenting, positive gay and lesbian images, multiculturalism and cross-cultural adoption.

Needs Approached by many freelancers/year. Works with 50 freelancers/year. Buys 40-50 freelance fine art images and illustrations/year. Considers all media (in slide form). Art guidelines available on website or free for SASE with first-class postage. Looking for progressive, feminist, liberating, vital, people- and earth-centered themes. "December and January are major art selection months."

First Contact & Terms Send query letter with slides, brochures, photocopies, photographs, SASE, tearsheets and transparencies. Samples are filed or returned by SASE. Responds in 1 month with SASE. Will contact for portfolio review if interested. Buys one-time rights. Pays flat fee of $85-450; royalties of 4-6% gross sales. Finds artists through word of mouth, our own artist list and submissions.

Tips "Please do NOT send original art or slides. Rather, send photocopies, printed samples or duplicate slides. Also, one postcard sample is not enough for us to judge whether your work is right for us. We'd like to see at least three or four different images. Include return postage if you would like your artwork/slides returned."

TALICOR, INC.

901 Lincoln Parkway, Plainwell MI 49080. (269)685-2345. E-mail: nikkih@talicor.com. Website: www.talicor.com. **President:** Nicole Hancock. Estab. 1971. Manufacturer and distributor of educational and entertainment games and toys. Clients chain toy stores, department stores, specialty stores and Christian bookstores.

Needs Works with 4-6 freelance illustrators and designers/year. Prefers local freelancers. Works on assignment only. Uses freelancers mainly for game design. Also for advertising, brochure and catalog design, illustration and layout; product design; illustration on product; P-O-P displays; posters and magazine design.

First Contact & Terms Send query letter with tearsheets, samples or postcards. Samples are not filed and are returned only if requested. Responds only if interested. Call or write for appointment to show portfolio. Pays for design and illustration by the project, $100-3,000. Negotiates rights purchased. Accepts digital submissions via e-mail.

TJ'S CHRISTMAS

14855 W. 95th St., Lenexa KS 66215. (913)888-8338. Fax: (913)888-8350. E-mail: mitch@imitchell.com. Website: www.imitchell.com. **Creative Coordinator:** Edward Mitchell. Estab. 1983. Produces figurines, decorative accessories, ornaments and other Christmas adornments. Primarily manufactures and imports Christmas ornaments, figurines and accessories. Also deals in some Halloween, Thanksgiving, gardening, 3-D art (woodcarving and sculptures) and everyday home decor items. Clients higher-end floral, garden, gift and department stores.

Needs Uses freelancers mainly for unique and innovative designs. Considers most media. "Our products are often nostalgic, bringing back childhood memories. They also should bring a smile to your face. We are looking for traditional designs that fit with our motto, 'Cherish the Memories.' " Produces material for Christmas, Halloween, Thanksgiving and everyday. Submit seasonal material 18 months in advance.

First Contact & Terms Send query letter with résumé, SASE and photographs. Will accept work on disk. Portfolios may be dropped off Monday-Friday. Samples are not filed and are returned by SASE. Responds in 1 month. Negotiates rights purchased. Pays advance on royalties of 5%. Terms are negotiated. Finds freelancers through magazines, word of mouth and artists' reps.

Tips "Continually search for new and creative ideas. Sometimes silly, cute ideas turn into the best sellers (i.e., sad melting snowmen with a sign saying 'I Miss Snow'). Watch for trends (such as increasing number of baby boomers that are retiring). Try to target the trends you see. Think from the viewpoint of a consumer walking around a small gift store."

N UNITED DESIGN

1600 N. Main St., Noble OK 73068. (405)872-4433. Fax: (405)360-4442. E-mail: ghaynes@united-design.com. Website: www.united-design.com. **Product Development Assistant:** Gayle Haynes. Produces collectible figurines, decorative housewares, garden. Specializes in giftware frames, animal sculpture, garden ornament, figurines.

Needs Approached by 300 freelancers/year. Works with 70 freelancers/year. Buys 300 freelance designs and illustrations/year. Also 500-1,000 sculptures/year. Prefers freelancers with experience in sculpting and/or design for sampling. Considers sculpy, plastilene, wood. Please familiarize yourself with our subject matter before submitting portfolio. Produces material for seasonal and everyday home decor.

First Contact & Terms Designers and sculptors: Send query letter with brochure, photocopies, photographs, résumé, SASE. No 3D samples or slides. Samples are filed (unless otherwise directed by submitter) or returned by SASE. Will contact within 3 weeks for portfolio review if interested. Rights purchased vary according to project. Pays by the project based on experience, expertise. Royalty arrangements vary. Finds freelancers through word of mouth, artists' submissions, websites.

Tips "You must possess creativity, high technical ability while meeting deadlines."

VAGABOND CREATIONS INC.

2560 Lance Dr., Dayton OH 45409. (937)298-1124. E-mail: vagabond@siscom.net. Website: www.vagabondcreations.com. **Art Director:** George F. Stanley, Jr. Publishes stationery and greeting cards with contemporary humor. 99% of artwork used in the line is provided by staff artists working with the company.

• Vagabond Creations Inc. now publishes a line of coloring books.

Needs Works with 3 freelancers/year. Buys 6 finished illustrations/year. Prefers local freelancers. Seeking line drawings, washes and color separations. Material should fit in standard-size envelope.

First Contact & Terms Query. Samples are returned by SASE. Responds in 2 weeks. Submit Christmas, Valentine's Day, everyday and graduation material at any time. Originals are returned only upon request. Payment negotiated.

Tips "Important! Currently we are *not* looking for additional freelance artists because we are very satisfied with the work submitted by those individuals working directly with us. We do not in any way wish to offer false hope to anyone, but it would be foolish on our part not to give consideration. Our current artists are very experienced and have been associated with us in some cases for over 30 years."

N VERMONT T'S

354 Elm St., Chester VT 05143. (802)875-2091. Fax: (802)875-4480. E-mail: vermontts@vermontel.net. **President:** Thomas Bock. Commercial screenprinter, specializing in T-shirts and sweatshirts. Vermont T's produces custom as well as tourist-oriented silkscreened sportswear. Does promotional work for businesses, ski-resorts, tourist attractions and events.

Needs Works with 3-5 freelance artists/year. Uses artists for graphic designs for T-shirt silkscreening. Prefers pen & ink, calligraphy and computer illustration.

First Contact & Terms Send query letter with brochure. Samples are filed or are returned only if requested. Responds in 10 days. To show portfolio, mail photostats. Pays for design by the project, $400-1,200. Negotiates rights purchased. Finds most artists through portfolio reviews and samples.

Tips "Have samples showing rough through completion. Understand the type of linework needed for silkscreening."

WANDA WALLACE ASSOCIATES

323 E. Plymouth, Suite 2, Inglewood CA 90302. (310)419-0376. Fax: (310)419-0382. E-mail: wandawallacefound ation@yahoo.com. Website: www.wandawallacefoundation.com. **President:** Wanda Wallace. Estab. 1980. Nonprofit organization produces greeting cards and posters for general public appeal. "We produce black art prints, posters, originals and other media."

- This publisher is doing more educational programs, touring schools nationally with artists.

Needs Approached by 10-12 freelance artists/year. Works with varying number of freelance artists/year. Buys varying number of designs and illustrations/year from freelance artists. Prefers artists with experience in black/ ethnic art subjects. Uses freelance artists mainly for production of originals and some guest appearances. Considers all media. Produces material for Christmas. Submit seasonal material 4-6 months in advance.

First Contact & Terms Send query letter with any visual aid. Some samples are filed. Policy varies regarding answering queries and submissions. Call or write to schedule an appointment to show a portfolio. Rights purchased vary according to project. Art education instruction is available. Pays by the project.

WHITEGATE FEATURES SYNDICATE

71 Faunce Dr., Providence RI 02906. (401)274-2149. **Contact:** Eve Green.

- This syndicate is looking for fine artists and illustrators. See their listing in Syndicates for more information about their needs.

N WILLITTS DESIGNS

1129 Industrial Ave., Petaluma CA 94952. (707)778-7211. Fax: (707)769-0304. E-mail: info@willitts.com. Website: http://willitts.com. **Marketing Coordinator:** Robin Richards. Produces collectible figurines, decorative housewares, limited edition plates, mugs, ornaments, jewelry. Specializes in Just the Right Shoe miniature shoe figurines; Ebony Products (Thomas Blackshear's ebony visions).

Needs Approached by about 40 freelancers/year. Works with about 25 freelancers/year. Buys 6 freelance designs and illustrations/year. Uses freelancers mainly for mechanicals, P-O-P. Considers all media. 50% of freelance design work demands knowledge of Photoshop, QuarkXPress. Also needs graphics for catalog/collateral production. Produces material for Mother's Day, Father's Day. Submit seasonal material 6 months in advance.

First Contact & Terms Designers: Send brochure, photocopies, photographs, résumé, slides, transparencies. Illustrators: Send query letter, photocopies, photographs, résumé. Sculptors send sample or photos with résumé/ letter. Accepts disk submissions (PC, JPEG or Mac TIFF); Prefers Photoshop and QuarkXPress. Samples are filed. Wishes to see portfolios for designers, illustrators and sculptors. Will contact for portfolio review if interested. Artist should request portfolio review in original query and follow up with phone call. Negotiates rights purchased. Payment varies depending on project. Finds freelancers through word of mouth, artists' submissions.

Tips "Attend collectible shows/subscribe to magazines. Be patient."

N CAROL WILSON FINE ARTS, INC.

Box 17394, Portland OR 97217. (503)261-1860. E-mail: info@carolwilsonfinearts.com. Website: www.carolwils onfinearts.com. **Contact:** Gary Spector. Estab. 1983. Produces greeting cards and fine stationery products.

Needs Romantic floral and nostalgic images. "We look for artists with high levels of training, creativity and ability."

First Contact & Terms Write or call for art guidelines. No original artwork on initial inquiry. Samples not filed are returned by SASE.

Tips "We are seeing an increased interest in romantic fine arts cards and very elegant products featuring foil, embossing and die-cuts."

Magazines

Magazines are a major market for freelance illustrators. The best proof of this fact is as close as your nearest newsstand. The colorful publications competing for your attention are chock-full of interesting illustrations, cartoons and caricatures. Since magazines are generally published on a monthly or bimonthly basis, art directors look for dependable artists who can deliver on deadline and produce quality artwork with a particular style and focus.

Art that illustrates a story in a magazine or newspaper is called editorial illustration. You'll notice that term as you browse through the listings. Art directors look for the best visual element to hook the reader into the story. In some cases this is a photograph, but often, especially in stories dealing with abstract ideas or difficult concepts, an illustration makes the story more compelling. A whimsical illustration can set the tone for a humorous article, for example, or an edgy caricature of movie stars in boxing gloves might work for an article describing conflicts within a film's cast. Flip through a dozen magazines in your local drugstore and you will quickly see that each illustration conveys the tone and content of articles while fitting in with the magazine's "personality."

The key to success in the magazine arena is matching your style to appropriate publications. Art directors work to achieve a synergy between art and text, making sure the artwork and editorial content complement each other.

TARGET YOUR MARKETS

Read each listing carefully. Within each listing are valuable clues. Knowing how many artists approach each magazine will help you understand how stiff your competition is. (At first, you might do better submitting to art directors who aren't swamped with submissions.) Look at the preferred subject matter to make sure your artwork fits the magazine's needs. Note the submission requirements and develop a mailing list of markets you want to approach.

Visit newsstands and bookstores. Look for magazines not listed in *Artist's & Graphic Designer's Market*. Check the cover and interior. If illustrations are used, flip to the masthead (usually a box in one of the beginning pages) and note the art director's name. The circulation figure is relevant too. As a rule of thumb, the higher the circulation, the higher the art director's budget. When art directors have a good budget, they tend to hire more illustrators and pay higher fees. Look at the illustrations and check the illustrator's name in the credit line in small print to the side of the illustration. Notice which illustrators are used often in the publications you wish to work with. You will notice that each illustrator they chose has a very definite style. After you have studied the illustrations in dozens of magazines, you will understand what types of illustrations are marketable.

Although many magazines can be found at a newsstand or library, some of your best markets may not be readily available on newsstands. If you can't find a magazine, check the listing in *Artist & Graphic Designer's Market* to see if sample copies are available. Keep in mind that many magazines also provide artists' guidelines on their Web sites.

CREATE A PROMO SAMPLE

Focus on one or two *consistent* styles to present to art directors in sample mailings. See if you can come up with a style that is different from every other illustrator's style, if only slightly. No matter how versatile you may be, limit styles you market to one or two. That way, you'll be more memorable to art directors. Pick a style or styles you enjoy and can work quickly in. Art directors don't like surprises. If your sample shows a line drawing, they expect you to work in that style when they give you an assignment. It's fairly standard practice to mail nonreturnable samples: either postcard-size reproductions of your work, photocopies or whatever is requested in the listing. Some art directors like to see a résumé; some don't. Look on pages 14-22 for some examples of good promotional pieces.

MORE MARKETING TIPS

- **Don't overlook trade magazines and regional publications.** While they may not be as glamorous as national consumer magazines, some trade and regional publications are just as lavishly produced. Most pay fairly well and the competition is not as fierce. Until you can get some of the higher circulation magazines to notice you, take assignments from smaller magazines, too. Alternative weeklies are great markets as well. Despite their modest payment, there are many advantages. You learn how to communicate with art directors, develop your signature style and learn how to work quickly to meet deadlines. Once the assignments are done, the tearsheets become valuable samples to send to other magazines.

- **Develop a spot illustration style in addition to your regular style.** "Spots"—illustrations that are half-page or smaller—are used in magazine layouts as interesting visual cues to lead readers through large articles or to make filler articles more appealing. Though the fee for one spot is less than for a full layout, art directors often assign five or six spots within the same issue to the same artist. Because spots are small in size, they must be all the more compelling. So send art directors a sample showing several power-packed small pieces along with your regular style.

- **Invest in a fax machine, e-mail and graphics software.** Art directors like to work with illustrators with fax machines and e-mail, because they can quickly fax or e-mail a layout with a suggestion. The artist can send back a preliminary sketch or "rough" the art director can OK. Also they will appreciate it if you can e-mail TIFF, EPS or JPEG files of your work.

- **Get your work into competition annuals and sourcebooks.** The term "sourcebook" refers to the creative directories published annually showcasing the work of freelancers. Art directors consult these publications when looking for new styles. If an art director uses creative directories, we often include that information in the listings to help you understand your competition. Some directories like *Black Book*, *The American Showcase* and *RSVP* carry paid advertisements costing several thousand dollars per page. Other annuals, like the *Print Regional Design Annual* or *Communication Art Illustration Annual* feature award winners of various competitions. An entry fee and some great work can put your work in a competition directory and in front of art directors across the country.

- **Consider hiring a rep.** If after working successfully on several assignments you decide to make magazine illustration your career, consider hiring an artists' representative to market your work for you. (See the Artists' Reps section, page 562.)

Helpful Resources

For More Info

- A great source for new magazine leads is in the business section of your local library. Ask the librarian to point out the business and consumer editions of the *Standard Rate and Data Service (SRDS)* and *Bacon's Magazine Directory*. These huge directories list thousands of magazines and will give you an idea of the magnitude of magazines published today. Another good source is a yearly directory called *Samir Husni's Guide to New Consumer Magazines* also available in the business section of the public library and online at www.mrmagazine.com. Also read *Folio* magazine to find out about new magazine launches and redesigns.

- Each year the Society of Publication Designers sponsors a juried competition called, appropriately, SPOTS. The winners are featured in a prestigious exhibition. For information about the annual competition, contact the Society of Publication Designers at (212)983-8585 or visit their Web site at www.spd.org.

- Networking with fellow artists and art directors will help you find additional success strategies. The Graphic Artist's Guild, The American Institute of Graphic Artists (AIGA), your city's Art Director's Club or branch of the Society of Illustrators holds lectures and networking functions. Attend one event sponsored by each organization in your city to find a group you are comfortable with. Then join and become an active member.

N A.T. JOURNEYS: The Magazine of the Appalachian Trail Conservancy

P.O. Box 807, Harpers Ferry WV 25425. (304)535-6331. Fax: (304)535-2667. **Editor:** Martin A. Bartels. Membership publication focuses on the stories of people who experience and support the Appalachian Trail, as well as conservation-oriented stories related to the Appalachian Mountain region. Circ. 37,000. Published 6 times/year. Sometimes accepts previously published material. Returns original artwork after publication. Sample copy and art guidelines available for legitimate queries.

Illustration Buys 8-12 illustrations/issue. Accepts all styles and media; computer generated (identified as such) or manual. Original artwork should be directly related to the Appalachian Trail.

First Contact & Terms Illustrators: Send query letter with samples to be kept on file. Prefers nonreturnable postcards, photocopies or tearsheets as samples. Samples not filed are returned by SASE. Responds in 2 months. Negotiates rights purchased. **Pays on acceptance;** $25-250 for b&w, color. Finds most artists through references, word of mouth and samples received through the mail.

AARP THE MAGAZINE

601 E Street NW, Washington DC 20049. (202)434-2277. Fax: (202)434-6451. Website: www.aarpmagazine.org. **Design Director:** Eric Seidman. Art Director: Courtney Murphy-Price. Estab. 2002. Bimonthly 4-color magazine emphasizing health, lifestyles, travel, sports, finance and contemporary activities for members 50 years and over. Circ. 21 million. Originals are returned after publication.

Illustration Approached by 200 illustrators/year. Buys 30 freelance illustrations/issue. Assigns 60% of illustrations to well-known or "name" illustrators; 30% to experienced but not well-known illustrators; 10% to new and emerging illustrators. Works on assignment only. Considers digital, watercolor, collage, oil, mixed media and pastel.

First Contact & Terms Samples are filed "if I can use the work." Do not send portfolio unless requested. Portfolio can include original/final art, tearsheets, slides and photocopies and samples to keep. Buys first rights. Pays on completion of project; $700-3,500.

Tips "We generally use people with strong conceptual abilities. I request samples when viewing portfolios."

N ACTIVE LIFE

LexiCon, 1st Floor, London EC1M 5PA. (020)7253 5775. Fax: (020)7253 5676. E-mail: activelife@lexicon-uk.com. Website: www.activelifemag.co.uk. **Managing Editor:** Helene Hodge. Editor's Assistant: Katy Morrison. Estab. 1990. Bimonthly lively lifestyle consumer magazine for the over 50s. Circ. 240,000.

Illustration Approached by 200 illustrators/year. Buys 12 illustration/issue. Features humorous illustration. Preferred subject families. Target group 50+. Prefers pastel and bright colors. Assigns 20% of illustration to well-known or "name" illustrators; 60% to experienced, but not well-known illustrators; 20% to new and emerging illustrators.

First Contact & Terms Illustrators: Send nonreturnable samples. Accepts Mac-compatible disk submissions. Samples are filed. Responds within 1 month. Will contact artist for portfolio review if interested. Buys all rights. Pays on publication. Finds illustrators through promotional samples.

Tips We use all styles, but more often "traditional" images.

ADVANSTAR MEDICAL ECONOMICS

Five Paragon Dr., 2nd Floor, Montvale NJ 07645. (973)944-7777. E-mail: mec.art@advanstar.com. Website: www.advanstar.com. **Art Coordinator:** Sindi Price. Estab. 1909. Publishes 8 health-related publications and special products. Interested in all media, including electronic and traditional illustrations. Accepts previously published material. Originals are returned at job's completion. Uses freelance artists for "most editorial illustration in the magazines."

Cartoons Prefers general humor topics workspace, family, seasonal; also medically related themes. Prefers single panel b&w drawings and washes with gagline.

Illustration Prefers all media including 3-D illustration. Needs editorial and medical illustration that varies "but is mostly on the conservative side." Works on assignment only.

First Contact & Terms Cartoonists: Submissions accepted twice a year—in January and July only. Send unpublished cartoons only with SASE to Jeanne Sabatie, cartoon editor. Pays $115. Buys first world publication rights. Illustrators: Send samples to Sindi Price. Samples are filed. Responds only if interested. Write for portfolio review. Buys nonexclusive worldwide rights. Pays $1,000-1,500 for color cover; $200-600 for b&w, $250-800 for color inside.

ADVENTURE CYCLIST

150 E. Pine St., Missoula MT 59802. (406)721-1776. Fax: (406)721-8754. E-mail: gsiple@adventurecycling.org. Website: www.adventurecycling.org. **Art Director:** Greg Siple. Estab. 1974. Published 9 times/year. A journal

of adventure travel by bicycle. Circ. 32,000. Originals returned at job's completion. Sample copies available.

Illustration Buys 1 illustration/issue. Has featured illustrations by Margie Fullmer, Ludmilla Tomova and Kelly Sutherland. Works on assignment only.

First Contact & Terms Illustrators: Send printed samples. Samples are filed. Publication will contact artist for portfolio review if interested. Pays on publication, $50-350. Buys one-time rights.

ℕ THE ADVOCATE

6922 Hollywood Blvd., Suite 1000, Los Angeles CA 90028. (323)871-1225. Fax: (323)467-6805. E-mail: gstoll@advocate.com. Website: www.advocate.com. **Art Director:** George Stoll. Estab. 1967. Frequency biweekly. National gay and lesbian 4-color consumer news magazine.

Illustration Approached by 20 illustrators/year. Buys 1-2 illustrations/issue. Has featured illustrations by Alexander Munn, Sylvie Bourbonniere and Tom Nick Cocotos. Features caricatures of celebrities and politicians, computer illustration, realistic illustration and medical illustration. Preferred subjects men, women, gay and lesbian topics. Considers all media. Assigns 90% of illustrations to experienced, but not well-known illustrators; 10% to new and emerging illustrators.

First Contact & Terms Send postcard sample or nonreturnable samples. Accepts Mac-compatible disk submissions. Art guidelines available on website. Samples are filed. Responds only if interested. Portfolio review not required. Buys one-time rights. Pays on publication.

Tips "We are happy to consider unsolicited illustration submissions to use as a reference for making possible assignments to you in the future. Before making any submissions to us, please familiarize yourself with our magazine. Keep in mind that *The Advocate* is a news magazine. As such, we publish items of interest to the gay and lesbian community based on their newsworthiness and timeliness. We do not publish unsolicited illustrations or portfolios of individual artists. Any illustration appearing in *The Advocate* was assigned by us to an artist to illustrate a specific article."

AGING TODAY

833 Market St., San Francisco CA 94103. (415)974-9619. Fax: (415)974-0300. Website: www.asaging.org. **Editor:** Paul Kleyman. Estab. 1979. "*Aging Today* is the bimonthly black & white newspaper of The American Society on Aging. It covers news, public policy issues, applied research and developments/trends in aging." Circ. 15,000. Accepts previously published artwork. Originals returned at job's completion if requested. Sample copies available for SASE with 77¢ postage.

Cartoons Approached by 50 cartoonists/year. Buys 1-2 cartoons/issue. Prefers political and social satire cartoons; single, double or multiple panel with or without gagline, b&w line drawings. Samples returned by SASE. Responds only if interested. Buys one-time rights.

Illustration Approached by 50 illustrators/year. Buys 1 illustration/issue. Works on assignment only. Prefers b&w line drawings and some washes. Considers pen & ink. Needs editorial illustration.

First Contact & Terms Cartoonists: Send query letter with brochure and roughs. Illustrators: Send query letter with brochure, SASE and photocopies. Pays cartoonists $15-25 for b&w. Samples are not filed and are returned by SASE. Responds only if interested. To show portfolio, artist should follow up with call and/or letter after initial query. Buys one-time rights. Pays on publication; pays illustrators $25 for b&w cover; $25 for b&w inside.

Tips "Send brief letter with two or three applicable samples. Don't send hackneyed cartoons that perpetuate ageist stereotypes."

ALASKA BUSINESS MONTHLY

P.O. Box 241288, Anchorage AK 99524-1288. (907)276-4373. Fax: (907)279-2900. E-mail: editor@akbizmag.com. **Editor:** Debbie Cutler. Estab. 1985. Monthly business magazine. "*Alaska Business Monthly* magazine is written, edited and published by Alaskans for Alaskans and other U.S. and international audiences interested in business affairs of the 49th state. Its goal is to promote economic growth in the state by providing thorough and objective discussion and analyses of the issues and trends affecting Alaska's business sector and by featuring stories on the individuals, organizations and companies that shape the Alaskan economy." Circ. 10,000. Accepts previously published artwork. Originals returned at job's completion if requested. Sample copies available for SASE with 3 first-class stamps.

First Contact & Terms Rights purchased vary according to project. Pays on publication; $300-500 for color cover; $50-250 for b&w inside and $75-300 for color inside.

Tips "We usually use local photographers for photos and employees for illustrations. Read the magazine before submitting anything."

ALASKA MAGAZINE

301 Arctic Slope Ave., Suite 300, Anchorage AK 99518-3035. (907)272-6070. Fax: (907)258-5360. E-mail: webmaster@alaskamagazine.com. Website: www.alaskamagazine.com. **Art Director:** Tim Blum. Estab. 1935.

Monthly 4-color regional consumer magazine featuring Alaskan issues, stories and profiles exclusively. Circ. 200,000.

Illustration Approached by 200 illustrators/year. Buys 1-4 illustration/issue. Has featured illustrations by Bob Crofut, Chris Ware, Victor Juhaz, Bob Parsons. Features humorous and realistic illustrations. On assignment only. Assigns 50% to new and emerging illustrators. 50% of freelance illustration demands knowledge of Illustrator, Photoshop and QuarkXPress.

First Contact & Terms Send postcard or other nonreturnable samples. Accepts Mac-compatible disk submissions. Samples are not returned. Responds only if interested. Will contact artist for portfolio review if interested. Buys first North American serial rights and electronic rights or rights purchased vary according to project. Pays on publication. Pays illustrators $125-300 for color inside; $400-600 for 2-page spreads; $125 for spots.

Tips "We work with illustrators who grasp the visual in a story quickly and can create quality pieces on tight deadlines."

ALTERNATIVE THERAPIES IN HEALTH AND MEDICINE

169 Saxony Rd., Suite 103, Encinitas CA 92024-6779. (760)633-3910. Fax: (760)633-3918. Website: www.alternative-therapies.com. **Creative Art Director:** Lee Dixson. Estab. 1995. Bimonthly trade journal. "*Alternative Therapies* is a peer-reviewed medical journal established to promote integration between alternative and cross-cultural medicine with conventional medical traditions." Circ. 20,000. Accepts previously published artwork. Originals returned at job's completion. Sample copies available.

Illustration Buys 6 illustrations/year. "We purchase fine art for the covers, not graphic art."

First Contact & Terms Illustrators: Send query letter with slides. Samples are filed. Responds in 10 days. Publication will contact artist for portfolio review if interested. Portfolio should include photographs and slides. Buys one-time and reprint rights. Pays on publication; negotiable. Finds artists through agents, sourcebooks and word of mouth.

AMERICA

106 W. 56th St., New York NY 10019. (212)581-4640. Fax: (212)399-3596. Website: www.americamagazine.org. **Associate Editor:** James Martin. Estab. 1904. Weekly Catholic national magazine published by US Jesuits. Circ. 46,000.

Illustration Buys 3-5 illustrations/issue. Has featured illustrations by Michael O'Neill McGrath, William Hart McNichols, Tim Foley, Stephanie Dalton Cowan. Features realistic illustration and spot illustration. Assigns 45% of illustrations to new and emerging illustrators. Considers all media.

First Contact & Terms Illustrators: Send printed samples and tearsheets. Buys first rights. Pays on publication; $300 for color cover; $150 for color inside.

Tips "We look for illustrators who can do imaginative work for religious, educational or topical articles. We will discuss the article with the artist and usually need finished work in two to three weeks. A fast turnaround is extremely valuable."

AMERICA WEST AIRLINES MAGAZINE

4636 E. Elwood St., Suite 5, Phoenix AZ 85040-1963. (602) 997-7200 Fax: (602) 9979-9875. Website: www.skyword.com. Estab. 1986. Monthly inflight magazine for national airline; 4-color, "conservative design. Appeals to an upscale audience of travelers reflecting a wide variety of interests and tastes." Circ. 130,000. Accepts previously published artwork. Original artwork is returned after publication. Sample copy $3. Art guidelines for SASE with first-class postage. Needs computer-literate illustrators familiar with Photoshop, Illustrator, QuarkXPress and FreeHand.

Illustration Approached by 100 illustrators/year. Buys 5 illustrations/issue from freelancers. Has featured illustrations by Pepper Tharp, John Nelson, Shelly Bartek, Tim Yearington. Assigns 95% of illustrations to experienced but not well-known illustrators. Buys illustrations mainly for spots, columns and feature spreads. Uses freelancers mainly for features and columns. Works on assignment only. Prefers editorial illustration in airbrush, mixed media, colored pencil, watercolor, acrylic, oil, pastel, collage and calligraphy.

First Contact & Terms Illustrators: Send query letter with color brochure showing art style and tearsheets. Looks for the "ability to intelligently grasp idea behind story and illustrate it. Likes crisp, clean colorful styles." Accepts disk submissions. Send EPS files. Samples are filed. Does not report back. Will contact for portfolio review if interested. Sometimes requests work on spec. Buys one-time rights. Pays on publication. "Send lots of good-looking color tearsheets that we can keep on hand for reference. If your work interests us we will contact you."

Tips "In your portfolio show examples of editorial illustration for other magazines, good conceptual illustrations and a variety of subject matter. Often artists don't send enough of a variety of illustrations; it's much easier to determine if an illustrator is right for an assignment if we have a complete grasp of the full range of abilities. Send high-quality illustrations and show specific interest in our publication."

THE AMERICAN ATHEIST

Box 5733, Parsippany NJ 07054-6733. (908)276-7300. Fax: (908)276-7402. Website: www.americanatheist.org. Editorial office (to which art and communications should be sent) 1352 Hunter Ave., Columbus OH 43201-2733. (614)299-1036. Fax: (614)299-3712. **Editor:** Frank Zindler. Estab. 1958. Monthly for atheists, agnostics, materialists and realists. Circ. 10,000. Simultaneous submissions OK. Sample copy for self-addressed 9×12 envelope or label.

Cartoons Buys 5 cartoons/issue.

Illustration Buys 1 illustration/issue. Especially needs 4-seasons art for covers and greeting cards. Prefers pen & ink, then airbrush, charcoal/pencil and calligraphy. Covers are in color.

First Contact & Terms Illustrators: "Send samples to be kept on file. We do commission artwork based on the samples received. All illustrations must have bite from the atheist point of view and hit hard." To show a portfolio, mail final reproduction/product and b&w photographs. **Pays on acceptance.** Pays cartoonists $30 each. Pays illustrators $75-100 for cover; $25 for inside.

Tips *"American Atheist* looks for clean lines, directness and originality. We are not interested in side-stepping cartoons and esoteric illustrations. Our writing is hard-punching and we want artwork to match. The American Atheist Press (parent company) buys book cover designs and card designs. Nearly all our printing is in black & white, but several color designs (i.e. for covers and cards) are acceptable if they do not require highly precise registration of separations for printing."

AMERICAN BANKER

1 State St. Plaza, 27th Floor, New York NY 10004. (212)803-8229. Fax: (212)843-9600. E-mail: deborah.fogel@sourcemedia.com. Website: www.americanbanker.com. **Art Director:** Debbie Fogel. Estab. 1865. Financial services daily newspaper specializing in banking, insurance/investments products, mortgages and credit. Circ. 14,000. Guidelines not available.

Illustration Approached by 250 illustrators/year. Buys 10 illustrations/year. Features spot illustrations. Prefers business. Prefers fine art with thick, heavy brush strokes and strong, vibrant colors. Assigns 1% to new and emerging illustrators.

First Contact & Terms Send postcard sample with additional printed samples. After introductory mailing, send follow-up postcard every 3 months. Samples are filed. Does not reply. Portfolio not required. **Pays on acceptance.** Buys electronic rights, one-time rights. Finds freelancers through word of mouth.

Tips "Please don't call, simply send in samples of your work and if we need you, we will contact you."

AMERICAN BANKERS ASSOCIATION-BANKING JOURNAL

345 Hudson St., 12th Floor, New York NY 10014-4502. (212)620-7256. Fax: (212)633-1165. E-mail: wwilliams@sbpub.com. Website: www.ababj.com. **Creative Director:** Wendy Williams. Associate Creative Director: Phil Desiere. Estab. 1908. 4-color; contemporary design. Emphasizes banking for middle and upper level banking executives and managers. Monthly. Circ. 31,440. Accepts previously published material. Returns original artwork after publication.

Illustration Buys 4-5 illustrations/issue from freelancers. Features charts & graphs, computer, humorous and spot illustration. Assigns 20% of illustrations to new and emerging illustrators. Themes relate to stories, primarily financial, from the banking industry's point of view; styles vary, realistic, surreal. Uses full-color illustrations. Works on assignment only.

First Contact & Terms Illustrators: Send finance-related postcard sample and follow-up samples every few months. To send a portfolio, send query letter with brochure and tearsheets, promotional samples or photographs. Negotiates rights purchased. **Pays on acceptance;** $250-950 for color cover; $250-450 for color inside; $250-450 for spots.

Tips Must have experience illustrating for business or financial publications.

AMERICAN DEMOGRAPHICS

249 W. 17th St. #8, New York NY 10011. (212)204-1513. Website: www.demographics.com. **Art Director:** Tammy Morton-Fernandez. Estab. 1979. Monthly trade journal covering consumer trends. Circ. 42,000. Sample copies available.

Illustration Approached by 300 illustrators/year. Buys 2-3 illustrations/issue. Considers all media. Knowledge of Photoshop 3, Illustrator 5.5 helpful but not required.

First Contact & Terms Illustrators: Send postcard sample. Designers: Send query letter with tearsheets. Accepts disk submissions. Samples are filed and not returned. Will contact for portfolio review if interested; portfolio should include color tearsheets. Buys one-time rights. **Pays on acceptance.**

AMERICAN FITNESS

15250 Ventura Blvd., Suite 200, Sherman Oaks CA 91403. (818)905-0040 ext. 200. Fax: (818)990-5468. E-mail: americanfitness@afaa.com. Website: www.afaa.com. **Editor-in Chief:** Meg Jordan. Bimonthly magazine for

fitness and health professionals. Circ. 42,900. Accepts previously published material. Original artwork returned after publication.

Illustration Approached by 12 illustrators/month. Assigns 2 illustrations/issue. Works on assignment only. Prefers "very sophisticated" 4-color line drawings.

First Contact & Terms Illustrators: Send postcard promotional sample. Acquires one-time rights.

Tips "Excellent source for never-before-published illustrators who are eager to supply full-page lead artwork."

THE AMERICAN GARDENER

7931 E. Boulevard Dr., Alexandria VA 22308. (703)768-5700. Fax: (703)768-7533. E-mail: editor@ahs.org. Website: www.ahs.org. **Editor:** David J. Ellis. Managing Editor: Mary Yee. Estab. 1922. Consumer magazine for advanced and amateur gardeners and horticultural professionals who are members of the American Horticultural Society. Bimonthly, 4-color magazine, "very clean and open, fairly long features." Circ. 35,000. Accepts previously published material. Original artwork is returned at job's completion. Sample copies for $5.

Illustration Buys 6-10 illustrations/year from freelancers. Works on assignment only. "Botanical accuracy is important for some assignments. All media used; digital media welcome."

First Contact & Terms Illustrators: Send query letter with résumé, tearsheets, slides and photocopies. Samples are filed. "We will call artist if their style matches our need." To show a portfolio, mail b&w and color tearsheets and slides. Buys one-time rights. Pays $150-300 color inside; on publication.

Tips "As a nonprofit we have a low budget, but we offer interesting subject matter, good display and we welcome input from artists."

AMERICAN LIBRARIES

50 E. Huron St., Chicago IL 60611-2795. (312)280-4216. Fax: (312)440-0901. E-mail: americanlibraries@ala.org. Website: www.ala.org/alonline. **Editor:** Leonard Kniffel. Estab. 1907. Monthly professional 4-color journal of the American Library Association for its members, providing independent coverage of news and major developments in and related to the library field. Circ. 58,000. Original artwork returned at job's completion if requested. Sample copy $6. Art guidelines available with SASE and first-class postage.

Cartoons Approached by 15 cartoonists/year. Buys no more than 1 cartoon/issue. Themes related to libraries only. Average payment $50.

Illustration Approached by 20 illustrators/year. Buys 1-2 illustrations/issue. Assigns 25% of illustrations to new and emerging illustrators. Works on assignment only.

First Contact & Terms Cartoonists: Send query letter with brochure and finished cartoons. Illustrators: Send query letter with brochure, tearsheets and résumé. Samples are filed. Does not respond to submissions. To show a portfolio, mail tearsheets, photographs and photocopies. Portfolio should include broad sampling of typical work with tearsheets of both b&w and color. Buys first rights. **Pays on acceptance.** Pays cartoonists $35-50 for b&w. Pays illustrators $75-150 for b&w and $250-300 for color cover; $150-250 for color inside.

Tips "I suggest inquirer go to a library and take a look at the magazine first." Sees trend toward "more contemporary look, simpler, more classical, returning to fewer elements."

AMERICAN MUSIC TEACHER

441 Vine St. Suite 505, Cincinnati OH 45202-2811. (513)421-1420. Fax: (513)421-2503. Website: www.mtna.org. **Art Director:** Brian Pieper. Estab. 1951. Bimonthly 4-color trade journal emphasizing music teaching. Features historical and how-to articles. "*AMT* promotes excellence in music teaching and keeps music teachers informed. It is the official journal of the Music Teachers National Association, an organization which includes concert artists, independent music teachers and faculty members of educational institutions." Circ. 26,424. Accepts previously published material. Original artwork returned after publication. Sample copies available.

Illustration Buys 1 illustration/issue. Uses freelancers mainly for diagrams and illustrations. Prefers musical theme. "No interest in cartoon illustration."

First Contact & Terms Illustrators: Send query letter with brochure or résumé, tearsheets, slides and photographs. Samples are filed or are returned only if requested with SASE. Responds in 3 months. To show a portfolio, mail printed samples, color and b&w tearsheets, photographs and slides. Buys one-time rights. Pays on publication; $50-150 for b&w and color, cover and inside.

AMERICAN SCHOOL BOARD JOURNAL

1680 Duke St., Alexandria VA 22314-3474. (703)838-6722. Fax: (703)549-6719. E-mail: msabatier@nsba.org. Website: www.asbj.com. **Production Manager/Art Director:** Michele Sabatier Mann. Estab. 1891. National monthly magazine for school board members and school administrators. Circ. 36,000. Sample copies available.

Illustration Buys 40-50 illustrations/year. Considers all media. Send postcard sample.

First Contact & Terms Illustrators: Send follow-up postcard sample every 3 months. Will not accept samples as e-mail attachment. Please send URL. Responds only if interested. Art director will contact artist for portfolio

review of tearsheets if interested. Buys one-time rights. **Pays on acceptance.** Pays $1,200 maximum for color cover; $250-350 for b&w, $300-600 for color inside. Finds illustrators through agents, sourcebooks, online services, magazines, word of mouth and artist's submissions.

Tips ''We're looking for new ways of seeing old subjects children, education, management. We also write a great deal about technology and love high-tech, very sophisticated mediums. We prefer concept over narrative styles.''

THE AMERICAN SPECTATOR

1611 N. Kent St., Suite 901, Arlington VA 22209-2111. (703)807-2011. Fax: (703)807-2013. Website: www.specta tor.org. Monthly political, conservative, newsworthy literary magazine.

First Contact & Terms Illustrators samples are filed or returned by SASE. No phone calls please.

ANALOG

475 Park Ave. S., New York NY 10016. (212)686-7188. Fax: (212)686-7414. **Senior Art Director:** Victoria Green. Associate Art Director June Levine. All submissions should be sent to June Levine, associate art director. Estab. 1930. Monthly consumer magazine. Circ. 80,000. Art guidelines free for #10 SASE with first-class postage.

Cartoons Prefers single panel cartoons.

Illustration Buys 4 illustrations/issue. Prefers science fiction, hardware, robots, aliens and creatures. Considers all media.

First Contact & Terms Cartoonists: Send query letter with photocopies and/or tearsheets and SASE. Samples are not filed and are returned by SASE. Illustrators: Send query letter with printed samples or tearsheets and SASE. Send follow-up postcard sample every 4 months. Accepts disk submissions compatible with QuarkXPress 7.5/version 3.3. Send EPS files. Files samples of interest, others are returned by SASE. Responds only if interested. ''No phone calls.'' Portfolios may be dropped off every Tuesday and should include b&w and color tearsheets and transparencies. ''No original art please, especially oversized.'' Buys one-time rights. **Pays on acceptance.** Pays cartoonists $35 minimum for b&w cartoons. Pays illustrators $1,200 for color cover; $125 minimum for b&w inside; $35-50 for spots. Finds illustrators through *Black Book, LA Workbook, American Showcase* and other reference books.

[N] ANGELS ON EARTH MAGAZINE

16 E. 34th St., New York NY 10016. (212)251-8126. Fax: (212)684-1311. Website: www.guideposts.org. **Director of Art & Design:** Francesca Messina. Associate Art Director Donald Partyka. Estab. 1995. Bimonthly magazine featuring true stories of angel encounters and angelic behavior. Circ. 1,000,000. Art guidelines posted on website.

● Also publishes *Guideposts*, a monthly magazine, which did not respond to our request for updated information this year. See listing in this section.

Illustration Approached by 500 illustrators/year. Buys 5-10 illustrations/issue. Has featured illustrations by Kinuko Craft, Gary Kelley, Rafal Olbinski. Features computer, whimsical, reportorial, humorous, conceptual, realistic and spot illustration. Assigns 40% of illustrations to well-known or ''name'' illustrators; 40% to experienced but not well-known illustrators; 20% to new and emerging illustrators. Prefers conceptual/realistic, ''soft'' styles. Considers all media.

First Contact & Terms Illustrators: Please send nonreturnable promotional materials, slides or tearsheets. Accepts disk submissions compatible with Photoshop, Illustrator. Samples are filed. Send *only* nonreturnable samples. Art director will contact artist for portfolio review of color slides and transparencies if interested. Rights purchased vary. **Pays on acceptance;** $500-2,500 for color cover; $500-2,000 2-page spreads; $300-500 for spots. For more informtion, see website. Finds artists through reps, *American Showcase, Society of Illustrators Annual*, submissions and artist's websites.

Tips ''Please study our magazine and be familiar with the content presented.''

[N] APPLICATION DEVELOPMENT TRENDS

9121 Oakdale Ave., Suite 101, Chatsworth CA 91311. (818)734-1520. Fax: (818)734-1526. E-mail: msingh@101c om.com. Website: www.adtmag.com. Estab. 1990. Monthly 4-color trade publication for corporate software managers. Circ. 50,000.

Illustration Approached by 20 illustrators/year. Features charts & graphs, informational graphics, spot illustrations and computer illustration of business subjects. Featured illustrations by Ryan Etter. Assigns 50% of illustrations to experienced, but not well-known illustrators; 50% to new and emerging illustrators.

First Contact & Terms E-mail submissions or PDF files. Samples are filed. Responds in 1 month. Portfolio review not required. Pays $400 for spots.

Tips Art director looks for ''illustrate technology concepts in a unique way.''

AQUARIUM FISH MAGAZINE

P.O. Box 6050, Mission Viejo CA 92690. (949)855-8822. Fax: (949)855-3045. E-mail: aquariumfish@fancypubs.com. Website: www.aquariumfish.com. **Editor:** Russ Case. Estab. 1988. Monthly magazine covering fresh and marine aquariums and garden ponds. Photo guidelines for SASE with first-class postage or on website.

Cartoons Approached by 30 cartoonists/year. Themes should relate to aquariums and ponds.

First Contact & Terms Cartoonists: Cartoon guidelines for SASE with first-class postage. Buys one-time rights. Pays $35 for b&w and color cartoons.

AREA DEVELOPMENT MAGAZINE

400 Post Ave., New York NY 11590-2267. (516)338-0900. Fax: (516)338-0100. E-mail: areadev@areadevelopment.com. Website: www.areadevelopment.com. **Art Directors:** Patricia Zedalis and Carole Ross. Estab. 1965. Monthly trade journal regarding economic development, relocation and site selection issues. Circ. 45,000.

Illustration Approached by 60 illustrators/year. Buys 3-4 illustrations/year. Features charts & graphs; informational graphics; realistic, biotechnology and computer illustration. Assigns 20% of illustration to experienced but not well-known illustrators. Prefers business/corporate themes with strong conceptual ideas. Considers all media. 50% of freelance illustration demands knowledge of Photoshop, Illustrator and QuarkXPress.

First Contact & Terms Illustrators: Send postcard sample. Accepts disk submissions compatible with QuarkXPress 4.0 for the Mac. Send EPS, TIFF files. Art director will contact artist for portfolio review of b&w, color tearsheets if interested. Rights purchased vary according to project. Pays on publication; $500-1,200 for color cover.

Tips "Must have corporate understanding and strong conceptual ideas. We address the decision-makers' needs by presenting their perspectives. Create a varied amount of subjects (business, retail, money concepts). Mail color self-promotions with more than one illustration."

ARMY MAGAZINE

2425 Wilson Blvd., Arlington VA 22201. (703)841-4300. Website: www.ausa.org. **Art Director:** Paul Bartels. Estab. 1950. Monthly trade journal dealing with current and historical military affairs. Also covers military doctrine, theory, technology and current affairs from a military perspective. Circ. 115,000. Originals returned at job's completion. Sample copies available for $3.00. Art guidelines available.

Cartoons Approached by 5 cartoonists/year. Buys 1 cartoon/issue. Prefers military, political and humorous cartoons; single or double panel, b&w washes and line drawings with gaglines.

Illustration Approached by 1 illustrator/year. Buys 1 illustration/issue. Works on assignment only. Prefers military, historical or political themes. Considers pen & ink, airbrush, acrylic, marker, charcoal and mixed media. "Can accept artwork done with Illustrator or Photoshop for Macintosh."

First Contact & Terms Cartoonists: Send query letter with brochure and finished cartoons. Responds to the artist only if interested. Illustrators: Send query letter with brochure, résumé, tearsheets, photocopies and photostats. Samples are filed or are returned by SASE if requested by artist. Publication will contact artist for portfolio review if interested. Portfolio should include b&w and color tearsheets, photocopies and photographs. Buys one-time rights. Pays on publication. Pays cartoonists $50 for b&w. Pays illustrators $300 minimum for b&w cover; $500 minimum for color cover; $50 for b&w inside; $75 for color inside; $35-50 for spots.

ART:MAG

P.O. Box 70896, Las Vegas NV 89170-0896. (702)734-8121. E-mail: magman@iopener.net. **Art Director:** Peter Magliocco. Contributing Artist-at-Large Bill Chown. Art Editor "The Mag Man." Estab. 1984. Yearly b&w small press literary arts zine. Circ. 100. Art guidelines for #10 SASE with first-class postage.

Cartoons Approached by 5-10 cartoonists/year. Buys 5 cartoons/year. Prefers single panel, political, humorous and satirical b&w line drawings.

Illustration Approached by 5-10 illustrators/year. Buys 3-5 illustrations/year. Has featured illustrations by Jon Bush and Dan Buck. Features caricatures of celebrities and politicians and spot illustrations. Preferred subjects art, literature and politics. Prefers realism, hip, culturally literate collages and b&w line drawings. Assigns 30% of illustrations to new and emerging illustrators.

First Contact & Terms Cartoonists: Send query letter with b&w photocopies, samples, tearsheets and SASE. Samples are filed. Rights purchased vary according to project. Illustrators: Send query letter with photocopies, SASE. Responds in 3 months. Portfolio review not required. Buys one-time rights. Pays on publication. Pays cartoonists/illustrators 1 contributor's copy. Finds illustrators through magazines, word of mouth.

Tips "*Art:Mag* is basically for new or amateur artists with unique vision and iconoclastic abilities whose work is unacceptable to slick mainstream magazines. Don't be conventional, be idea-oriented."

ARTHRITIS TODAY MAGAZINE

1330 W. Peachtree St., Atlanta GA 30309-2922. (404)872-7100. Fax: (404)872-9559. E-mail: atmail@arthritis.org. Website: www.arthritis.org. **Art Director:** Susan Siracusa. Estab. 1987. Bimonthly consumer magazine.

''*Arthritis Today* is the official magazine of the Arthritis Foundation. The award-winning publication is more than the most comprehensive and reliable source of information about arthritis research, care and treatment. It is a magazine for the whole person—from their lifestyles to their relationships. It is written both for people with arthritis and those who care about them.'' Circ. 700,000. Originals returned at job's completion. Sample copies available. 20% of freelance work demands knowledge of Illustrator, QuarkXPress or Photoshop.

Illustration Approached by over 100 illustrators/year. Buys 5-10 illustrations/issue. Works on assignment only; stock images used in addition to original art.

First Contact & Terms Illustrators: Send query letter with brochure, tearsheets, photostats, slides (optional) and transparencies (optional). Samples are filed. Publication will contact artist for portfolio review if interested. Portfolio should include color tearsheets, photostats, photocopies, final art and photographs. Buys first-time North American serial rights. Other usage negotiated. **Pays on acceptance.** Finds artists through sourcebooks, Internet, other publications, word of mouth, submissions.

Tips ''No limits on areas of the magazine open to freelancers. Two to three departments in each issue use spot illustrations. Submit tearsheets for consideration. No cartoons.''

THE ARTIST'S MAGAZINE

4700 E. Galbraith Rd., Cincinnati OH 45236. E-mail: tamedit@fwpubs.com. **Art Director:** Daniel Pessell. Monthly 4-color magazine emphasizing the techniques of working artists for the serious beginning, amateur and professional artist. Circ. 180,000. Occasionally accepts previously published material. Returns original artwork after publication. Sample copy $4.99 US, $7.99 Canadian or international; remit in US funds.

• Sponsors annual contest. Send SASE for more information. Also publishes a bimonthly magazine called *Artist's Sketchbook.*

Cartoons Buys 3-4 cartoons/year. Must be related to art and artists.

Illustration Buys 2-3 illustrations/year. Has featured illustrations by Susan Blubaugh, Sean Kane, Jamie Hogan, Steve Dininno, Kathryn Adams. Features humorous and realistic illustration. Works on assignment only.

First Contact & Terms Cartoonists: Contact Cartoon Editor. Send query letter with brochure, photocopies, photographs and tearsheets to be kept on file. Prefers photostats or tearsheets as samples. Samples not filed are returned by SASE. Buys first rights. **Pays on acceptance.** Pays cartoonists $65 on acceptance for first-time rights. Pays illustrators $350-1,000 for color inside; $100-500 for spots.

Tips ''Research past issues of publication and send samples that fit the subject matter and style of target publication.''

ISAAC ASIMOV'S SCIENCE FICTION MAGAZINE

475 Park Ave. S., New York NY 10016. (212)686-7188. Fax: (212)686-7414. **Senior Art Director:** Victoria Green. All submissions should be sent to June Levine, associate art director. Estab. 1977. Monthly b&w with 4-color cover magazine of science fiction and fantasy. Circ. 61,000. Accepts previously published artwork. Original artwork returned at job's completion. Art guidelines available for #10 SASE with first-class postage.

Cartoons Approached by 20 cartoonists/year. Buys 10 cartoons/year. Two covers commissioned/year. The rest are second-time rights or stock images. Prefers single panel, b&w washes or line drawings with and without gagline. Address cartoons to Brian Bieniowski, editor.

Illustration No longer buys interior illustration.

First Contact & Terms Cartoonists: Send query letter with printed samples, photocopies and/or tearsheets and SASE. Accepts disk submissions compatible with QuarkXPress version 3.3. Send EPS files. Accepts illustrations done with Illustrator and Photoshop. Samples are filed or returned by SASE. Responds only if interested. Portfolios may be dropped off every Tuesday and should include b&w and color tearsheets. Buys one-time and reprint rights. **Pays on acceptance.** Pays cartoonists $35 minimum. Pays illustrators $600-1,200 for color cover.

Tips No comic book artists. Realistic work only, with science fiction/fantasy themes. Show characters with a background environment.

ASPEN MAGAZINE

720 E. Durant Ave., Suite E8, Aspen CO 81611. (970)920-4040. Fax: (970)920-4044. E-mail: production@aspenm agazine.com. Website: www.aspenmagazine.com. **Art Director:** David Cook. Bimonthly 4-color city magazine with the emphasis on Aspen and the valley. Circ. 18,300. Accepts previously published artwork. Original artwork returned at job's completion. Sample copies and art guidelines available.

Illustration Approached by 15 illustrators/year. Buys 2 illustrations/issue. Themes and styles should be appropriate for editorial content. Considers all media. Send query letter with tearsheets, photostats, photographs, slides, photocopies and transparencies. Samples are filed. Responds only if interested. Call for appointment to show a portfolio, which should include thumbnails, roughs, tearsheets, slides and photographs. Buys first, one-time or reprint rights. Pays on publication.

ATLANTA MAGAZINE

260 W. Peachtree St. NW, Suite 300, Atlanta GA 30303-1202. (404)527-5500. Fax: (404)527-5575. E-mail: sbogle @atlantamag.emmis.com. Website: www.atlantamagazine.com. **Contact:** Susan L. Bogle, design director. Associate Art Director Alice Lynn McMichael. Estab. 1961. Monthly 4-color consumer magazine. Circ. 66,000.

Illustration Buys 3 illustrations/issue. Has featured illustrations by Fred Harper, Harry Campbell, Jane Sanders, various illustrators repped by Wanda Nowak, various illustrators repped by Gerald & Cullen Rapp, Inc. Features caricatures of celebrities, fashion illustration, humorous illustration and spot illustrations. Prefers a wide variety of subjects. Style and media depend on the story. Assigns 60% of illustrations to well-known or "name" illustrators; 30% to experienced but not well-known illustrators; 10% to new and emerging illustrators.

First Contact & Terms Illustrators: Send nonreturnable postcard sample. Samples are filed. Will contact artist for portfolio review if interested. Buys first rights. **Pays on acceptance.** Finds freelancers through promotional samples, artists' reps, *The Alternative Pick.*

AUTHORSHIP

10940 S. Parker Rd., Parker CO 80134-7440. (303)841-0246. Fax: (303)841-2607. Website: www.nationalwriters. com. **Executive Director:** Sandy Whelchel. Estab. 1937. Quarterly magazine. "Our publication is for our 3,000 members and is cover-to-cover about writing."

First Contact & Terms Cartoonists: Samples are returned. Responds in 4 months. Buys first North American serial and reprint rights. **Pays on acceptance.** Pays cartoonists $25 minimum for b&w. Illustrators: Accepts disk submissions. Send TIFF or JPEG files.

Tips "We only take cartoons slanted to writers."

BABYBUG

315 Fifth St., Peru IL 61354-0300. (815)223-2520. Fax: (815)224-6675. **Art Director:** Suzanne Beck. Estab. 1994. Magazine published every six weeks "for children six months to two years." Circ. 44,588. Sample copy for $4.95 plus 10% of total order ($4 minimum) for shipping and handling; art guidelines for SASE.

Illustration Approached by about 85 illustrators/month. Buys 23 illustrations/issue. Considers all media.

First Contact & Terms Illustrators: Send query letter with printed samples, photocopies and tearsheets. Samples are filed or returned if postage is sent. Responds in 45 days. Buys all rights. Pays 45 days after acceptance. Pays $500 minimum for color cover; $250 minimum per page inside. Finds illustrators through agents, *Creative Black Book*, magazines, word of mouth, artist's submissions and printed children's books.

BACKPACKER MAGAZINE

Rodale, 33 E. Minor St., Emmaus PA 18098-0001. (610)967-5171. Fax: (610)967-8181. E-mail: mbates@backpac ker.com. Website: www.backpacker.com. **Art Director:** Matthew Bates. Estab. 1973. Consumer magazine covering nonmotorized wilderness travel. Circ. 306,500.

Illustration Approached by 200-300 illustrators/year. Buys 10 illustrations/issue. Considers all media. 60% of freelance illustration demands knowledge of FreeHand, Photoshop, Illustrator, QuarkXPress.

First Contact & Terms Illustrators: Send query letter with printed samples, photocopies and/or tearsheets. Send follow-up postcard sample every 6 months. Accepts disk submissions compatible with QuarkXPress, Illustrator and Photoshop. Samples are filed and are not returned. Art director will contact artist for portfolio review of color photographs, slides, tearsheets and/or transparencies if interested. Buys first rights or reprint rights. Pays on publication. Finds artists through submissions and other printed media.

Tips *Backpacker* does not buy cartoons. "Know the subject matter, and know *Backpacker Magazine*."

BALTIMORE JEWISH TIMES

1040 Park Ave., Suite 200, Baltimore MD 21218. (410)752-3504. Fax: (443)451-0702. E-mail: artdirector@jewish times.com. Website: www.jewishtimes.com. **Art Director:** Tracie Restauro. Weekly b&w tabloid with 4-color cover emphasizing special interests to the Jewish community for largely local readership. Circ. 20,000. Accepts previously published artwork. Returns original artwork after publication, if requested. Sample copy available.

- This publisher also publishes *Style Magazine*, a Baltimore lifestyle magazine, and *Chesapeake Life*, covering lifestyle topics in southern Maryland and the Eastern Shore.

Illustration Approached by 50 illustrators/year. Buys 4-6 illustrations/year. Works on assignment only. Prefers high-contrast, b&w illustrations.

First Contact & Terms Illustrators: Send query letter with brochure showing art style or tearsheets and photocopies. Samples not filed are returned by SASE. Responds if interested. To show a portfolio, mail appropriate materials or write/call to schedule an appointment. Portfolio should include original/final art, final reproduction/product and color tearsheets and photostats. Buys first rights. Pays on publication; $200 for b&w cover and $300 for color cover; $50-100 for b&w inside.

Tips Finds artists through word of mouth, self-promotion and sourcebooks. Sees trend toward "more freedom of design integrating visual and verbal."

BALTIMORE MAGAZINE

1000 Lancaster St., Suite 400, Baltimore MD 21202-4382. (410)752-4200. Fax: (410)625-0280. E-mail: wamanda @baltimoremag.com. Website: www.baltimoremag.com. **Art Director:** Amanda White-Iseli. Production Assistant Michael Tranquillo. Estab. 1908. Monthly city magazine featuring news, profiles and service articles. Circ. 57,000. Originals returned at job's completion. Sample copies available for $2.05/copy. 10% of freelance work demands knowledge of QuarkXPress, FreeHand, Illustrator or Photoshop or any other program that is saved as a TIFF or PICT file.

Illustration Approached by 60 illustrators/year. Buys 4 illustrations/issue. Works on assignment only. Considers all media, depending on assignment.

First Contact & Terms Illustrators: Send postcard sample. Accepts disk submissions. Samples are filed. Will contact for portfolio review if interested. Buys one-time rights. Pays on publication; $100-400 for b&w, $150-600 for color insides; 60 days after invoice. Finds artists through sourcebooks, publications, word of mouth, submissions.

Tips All art is freelance—humorous front pieces, feature illustrations, etc. Does not use cartoons.

BARTENDER MAGAZINE

Box 158, Liberty Corner NJ 07938-0158. (908)766-6006. Fax: (908)766-6607. E-mail: barmag@aol.com. Website: www.bartender.com. **Editor:** Jackie Foley. Art Director: Todd Thomas. Estab. 1979. Quarterly 4-color trade journal emphasizing restaurants, taverns, bars, bartenders, bar managers, owners, etc. Circ. 150,000.

Cartoons Approached by 10 cartoonists/year. Buys 3 cartoons/issue. Prefers bar themes; single panel.

Illustration Approached by 5 illustrators/year. Buys 1 illustration/issue. Works on assignment only. Prefers bar themes. Considers any media.

First Contact & Terms Cartoonists: Send query letter with finished cartoons. Buys first rights. Illustrators: Send query letter with brochure. Samples are filed. Negotiates rights purchased. Pays on publication. Pays cartoonists $50 for b&w and $100 for color inside. Pays illustrators $500 for color cover.

☒ BC OUTDOORS, HUNTING AND SHOOTING

1080 Howe St., Suite 900, Vancouver BC V6Z-2T1 Canada (604)606-4644. Fax: (604)687-1925. E-mail: sswanson @oppublishing.com. Website: www.bcosportfishing.com. **Art Director:** Shannon Swanson. Biannual 4-color magazine, emphasizing fishing, hunting, camping, wildlife/conservation in British Columbia. Circ. 30,000. Original artwork returned after publication unless bought outright.

Illustration Approached by more than 10 illustrators/year. Has featured illustrations by Ian Forbes, Brad Nickason and Michael McKinell. Buys 4-6 illustrations/year. Prefers local artists. Interested in outdoors, wildlife (BC species only) and activities as stories require. Format b&w line drawings and washes for inside and color washes for inside.

First Contact & Terms Works on assignment only. Samples returned by SAE (nonresidents include IRC). Reports back on future assignment possibilities. Arrange personal appointment to show portfolio or send samples of style. Subject matter and the art's quality must fit with publication. Buys first North American serial rights or all rights on a work-for-hire basis. Pays on publication; $40 minimum for spots.

Tips "Send us material on fishing and hunting. We generally just send back nonrelated work."

THE BEAR DELUXE

P.O. Box 10342, Portland OR 97296. (503)242-1047. E-mail: bear@orlo.org. Website: www.orlo.org. **Contact:** Thomas Cobb, art director. Editor-in-Chief: Tom Webb. Estab. 1993. Quarterly 4-color, b&w consumer magazine emphasizing environmental writing and visual art. Circ. 20,000. Sample copies for $3. Art guidelines for SASE with first-class postage.

Cartoons Approached by 50 cartoonists/year. Buys 5 cartoons/issue. Prefers work related to environmental, outdoor, media, arts. Prefers single panel, political, humorous, b&w line drawings.

Illustration Approached by 50 illustrators/year. Has featured illustrations by Matt Wuerker, Ed Fella, Eunice Moyle and Ben Rosenberg. Caricature of politicians, charts & graphs, natural history and spot illustration. Assigns 30% of illustrations to new and emerging illustrators. 30% of freelance illustration demands knowledge of Illustrator, Photoshop and FreeHand.

First Contact & Terms Cartoonists: Send query letter with b&w photocopies and SASE. Samples are filed or returned by SASE. Responds in 4 months. Illustrators: Send postcard sample and nonreturnable samples. Accepts Mac-compatible disk submissions. Send EPS or Tiff files. Samples are filed or returned by SASE. Responds only if interested. Portfolios may be dropped off by appointment. Buys first rights. Pays on publication. Pays cartoonists $10-50 for b&w. Pays illustrators $200 b&w or color cover; $15-75 for b&w or color inside; $15-75

for 2-page spreads; $20 for spots. Finds illustrators through word of mouth, gallery visits and promotional samples.

Tips We are actively seeking new illustrators and visual artists, and we encourage people to send samples. Most of our work (besides cartoons) is assigned out as editorial illustration or independent art. Indicate whether an assignment is possible for you. Indicate your fastest turn-around time. We sometimes need people who can work with 2-3 week turn-around or faster.

BEVERAGE WORLD MAGAZINE

770 Broadway, New York NY 10003-9522. (646)545-4500. Fax: (646)654-7727. E-mail: pmoliver@beverageworl d.com. Website: www.beverageworld.com. **Art Director:** Patti Moliver. Editor Andrea Foote. Monthly magazine covering beverages (beers, wines, spirits, bottled waters, soft drinks, juices) for soft drink bottlers, breweries, bottled water/juice plants, wineries and distilleries. Circ. 34,000. Accepts simultaneous submissions. Original artwork returned after publication if requested. Sample copy $8.00. Art guidelines available.

Illustration Buys 2-3 illustrations/year. Has featured illustrations by Ned Shaw and Steven Morrell. Works on assignment only. Assigns 70% of illustrations to experienced but not well-known illustrators; 30% to new and emerging illustrators.

First Contact & Terms Illustrators: Send postcard sample, brochure, photocopies and photographs to be kept on file. Responds only if interested. Negotiates rights purchased. **Pays on acceptance.** Pays illustrators $500-$1,000 for color cover.

BIRD WATCHER'S DIGEST

149 Acme St., Marietta OH 45750. (740)373-5285. Fax: (740)373-8443. E-mail: editor@birdwatchersdigest.com. Website: www.birdwatchersdigest.com. **Editor:** William H. Thompson III. Bimonthly magazine covering birds and bird watching for "bird watchers and birders (backyard and field; veteran and novice)." Circ. 90,000. Art guidelines available on website or free for SASE. Previously published material OK. Original work returned after publication. Sample copy $3.99.

Illustration Buys 1-2 illustrations/issue. Has featured illustrations by Julie Zickefoose, Tom Hirata, Kevin Pope and Jim Turanchik. Assigns 15% of illustrations to new and emerging illustrators.

First Contact & Terms Illustrators: Send samples or tearsheets. Responds in 2 months. Buys one-time rights. Pays $50 minimum for b&w; $100 minimum for color.

[N] BIRMINGHAM PARENT, EVANS PUBLISHING LLC

3584 Hwy. 31 S. #324, Pelham AL 35124. (205)663-5070. Fax: (205)621-3983. E-mail: carol@birminghamparent. com. Website: www.birminghamparent.com. Estab. 2004. Monthly. We serve parents of families in Central Alabama/Birmingham with news pertinent to them. Circ. 35,000+. Art guidelines free with SASE or on website.

Cartoons Approached by 2-3 cartoonists/year. Buys 12 cartoons/year. Prefers fun, parenting issues, nothing controversial. Format: single panel. Humorous. Media: color washes.

Illustration Approached by 2 illustrators/year. Buys 0 illustrations/year. Has featured illustrations by only our art director at this time. Preferred color schemes, styles and/or media: see magazine. Assigns 5% of illustrations to new and emerging illustrators; 95% of freelance work demands computer skills. Freelancers should be familiar with InDesign, QuarkXPress, Photoshop. E-mail submissions accepted with link to website. Windows-compatible. Prefers JPEG, PDF. Samples are not filed. If not filed, samples are returned by SASE; not returned. Portfolio not required. Pays cartoonists $0-25 for b&w cartoons, $0-25 for color cartoons. Pays on publication. Buys electronic rights, first North American serial rights

Tips "We do very little freelance artwork. We are still a small publication and don't have space or funds for it. Our art director provides the bulk of our needs. It would have to be outstanding for us to consider purchasing such right now."

[N] BITCH FEMINIST RESPONSE TO POP CULTURE

1611 Telegraph Ave., Suite 515, Oakland CA 94612. (510)625-9390. Fax: (510)625-9717. E-mail: nicholas@bitch magazine.com. Website: www.bitchmagazine.com. **Art Director:** Nicholas Brawley. Estab. 1996. Four times yearly b&w magazine. "We examine popular culture in all its forms for women and feminists of all ages." Circ. 45,000.

Illustration Approached by 300 illustrators/year. Buys 3-7 illustrations/issue. Has featured illustrations by Andi Zeisler, Hugh D'Andrade, Pamela Hobbs, Isabel Samaras and Pam Purser. Features caricatures of celebrities, conceptual, fashion and humorous illustration. Work on assignment only. Prefers b&w ink drawings and photo collage. Assigns 90% of illustrations to experienced but not well-known illustrators; 8% to new and emerging illustrators; 2% to well-known or "name" illustrators.

First Contact & Terms Illustrators: Send postcard sample, nonreturnable samples. Accepts Mac-compatible disk submissions. Samples are filed and are not returned. Will contact artist for portfolio review if interested.

"We now are able to pay, but not much at all." Finds illustrators through magazines and word of mouth.

Tips "We have a couple of illustrators we work with generally but are open to others. Our circulation has been doubling annually, and we are distributed internationally. Read our magazine and send something we might like."

N BLACK ENTERPRISE

130 Fifth Ave., 10th Floor, New York NY 10011-4306. (212)242-8000. Website: www.blackenterprise.com. **Contact:** Terence K. Saulsby, art director. Estab. 1970. Monthly 4-color consumer magazine targeting African Americans and emphasizing personal finance, careers and entrepreneurship. Circ. 450,000.

Illustration Approached by over 100 illustrators/year. Buys 10 illustrations/issue. Has featured illustrations by Ray Alma, Cecil G. Rice, Peter Fasolino. Features humorous and spot illustrations, charts & graphs, computer illustration on business subjects. Assigns 10% of illustrations to new and emerging illustrators. 50% of freelance illustration demands knowledge of Illustrator and Photoshop.

First Contact & Terms Illustrators: Send postcard sample. Samples are filed. After introductory mailing, send follow-up postcard every 3 months. Responds only if interested. Portfolios may be dropped off Monday-Friday and should include color finished, original art and tearsheets. Buys first rights. **Pays on acceptance**; $200-800 for color inside; $800-1,000 for 2-page spreads. Finds illustrators through agents, artist's submissions and *Directory of Illustration.*

BOYS' QUEST

P.O. Box 227, Bluffton OH 45817. (419)358-4610. Fax: (419)358-5027. Website: www.boysquest.com. **Assistant Editor:** Diane Winebar. Estab. 1995. Bimonthly consumer magazine "geared for elementary boys." Circ. 10,000. Sample copies $5 each; art guidelines for SASE with first-class postage.

Cartoons Buys 1-3 cartoons/issue. Prefers wholesome children themes. Prefers single or double panel, humorous, b&w line drawings with gagline.

Illustration Approached by 100 illustrators/year. Buys 6 illustrations/issue. Has featured illustrations by Chris Sabatino, Gail Roth and Pamela Harden. Features humorous illustration; realistic and spot illustration. Assigns 40% of illustrations to new and emerging illustrators. Prefers childhood themes. Considers all media.

First Contact & Terms Cartoonists: Send finished cartoons. Illustrators: Send query letter with printed samples. Samples are filed or returned by SASE. Responds in 2 months. To arrange portfolio review of b&w work, artist should follow up with call or letter after initial query. Buys first rights. Pays on publication. Pays cartoonists $5-25 for b&w. Pays illustrators $200-250 for color cover; $25-35 for b&w inside; $50-70 for 2-page spreads; $10-25 for spots. Finds illustrators through artist's submissions.

Tips "Read our magazine. Send in a few samples of work in pen & ink. Everything revolves around a theme; the theme list is available with SASE."

BRIDE'S MAGAZINE

750 Third Ave., New York NY 10017. (212)630-3740. Fax: (212)630-5894. Website: www.brides.com. **Design Director:** Phyllis Cox. Estab. 1934. Bimonthly 4-color; "classic, clean, sophisticated design style." Circ. 440,511. Original artwork is returned after publication.

Illustration Buys illustrations mainly for spots and feature spreads. Buys 5-10 illustrations/issue. Works on assignment only. Considers pen & ink, airbrush, mixed media, colored pencil, watercolor, acrylic, collage and calligraphy. Needs editorial illustrations.

First Contact & Terms Illustrators: Send postcard sample. In samples or portfolio, looks for "graphic quality, conceptual skill, good 'people' style; lively, young but sophisticated work." Samples are filed. Will contact for portfolio review if interested. Portfolios may be dropped off every Monday-Thursday and should include color and b&w final art, tearsheets, slides, photostats, photographs and transparencies. Buys one-time rights or negotiates rights purchased. Pays on publication; $250-350 for b&w or color inside; $250 minimum for spots. Finds artists through word of mouth, magazines, submissions/self-promotions, sourcebooks, artists' agents and reps, attending art exhibitions.

BUCKMASTERS WHITETAIL MAGAZINE

10350 Hwy. 80 E., Montgomery AL 36117-6064. (334)215-3337. Fax: (334)215-3535. E-mail: lunger@buckmasters.com. Website: www.buckmasters.com. **Art Director:** Laura Unger. Estab. 1987. Magazine covering whitetail deer hunting. Seasonal—6 times/year. Circ. 400,000. Accepts previously published artwork. Originals are not returned. Sample copies and art guidelines available. 80% of freelance work demands knowledge of Illustrator, QuarkXPress, Photoshop or FreeHand.

• Also publishes *Rack* and *Young Bucks Outdoors* Tim Martin is art director for *Rack*; John Manfredi is art director for *Young Bucks Outdoors.*

Cartoons Approached by 5 cartoonists/year. Buys 1 cartoon/issue.

Illustrations Approached by 5 illustrators/year. Buys 1 illustration/issue. Works on assignment only. Considers all media.

Design Needs freelance designers for multimedia. 100% of freelance work requires knowledge of Photoshop, QuarkXPress or Illustrator.

First Contact & Terms Cartoonists: Send query letter with brochure and photos of originals. Illustrators: Send postcard sample. Accepts submissions on disk. Samples are filed. Responds in 3 months. Call or write for appointment to show portfolio. Portfolio should include final art, slides and photographs. Rights purchased vary. Pays on publication. Pays cartoonists $25 for b&w. Pays illustrators $500 for color cover; $150 for color inside. Pays designers by project.

Tips "Send samples related to whitetail deer or turkeys."

BUILDINGS MAGAZINE

615 Fifth St. SE, Cedar Rapids IA 52401-2158. (319)364-6167. Fax: (319)364-4278. E-mail: info@buildings.com. Website: www.buildings.com. **Art Director:** Elisa Geneser. Estab. 1906. Monthly trade magazine featuring "information related to current approaches, technologies and products involved in large commercial facilities." Circ. 72,000. Original artwork returned at job's completion.

Illustration Works on assignment only. Considers all media, themes and styles.

First Contact & Terms Illustrators: Send postcard sample. Designers: Send query letter with brochure, photocopies and tearsheets. Accepts submissions on disk compatible with Macintosh. Will contact for portfolio review if interested. Portfolio should include thumbnails, b&w/color tearsheets. Rights purchased vary. **Pays on acceptance.** Pays illustrators $250-500 for b&w, $500-1,500 for color cover; $50-200 for b&w inside; $100-350 for color inside; $30-100 for spots. Pays designers by the project. Finds artists through recommendations and submissions.

Tips "Send postcards with samples of your work printed on them. Show us a variety of work (styles), if available. Send only artwork that follows our subject matter commercial buildings, products and processes, and facility management."

BULLETIN OF THE ATOMIC SCIENTISTS

6042 S. Kimbark Ave., Chicago IL 60637-2898. (773)702-2555. Fax: (773)702-0725. E-mail: bulletin@thebulletin. org. Website: www.thebulletin.org. **Managing Editor:** Catherine Auer. Art Director: Joy Olivia Miller. Estab. 1945. Bimonthly magazine of international affairs and nuclear security. Circ. 15,000. Sample copies available.

Cartoons Approached by 15-30 cartoonists/year. Buys 3-5 cartoons/issue. Prefers single panel, humor related to global security, b&w/color washes and line drawings.

Illustration Approached by 30-40 illustrators/year. Buys 2-3 illustrations/issue.

First Contact & Terms Send postcard sample and photocopies. Buys one-time and digital rights. Responds only if interested. **Pays on acceptance.** Pays cartoonists $60 for b&w. Pays illustrators $300-500 for color cover; $100-300 for color inside. Publishes illustrators with a variety of experience.

Tips "We're eager to see cartoons that relate to our editorial content, so it's important to take a look at the magazine before submitting items."

BUSINESS & COMMERCIAL AVIATION

6 International Dr., Suite 310, Rye Brook NY 10573. (914)939-0300. Fax: (914)939-1283. E-mail: william_garvey @aviationnow.com. Website: www.aviationnow.com/bca. **Art Direction:** Ringston Media. **Editor-in-Chief:** William Garvey. Monthly technical publication for corporate pilots and owners of business aircraft. 4-color; "contemporary design." Circ. 55,000.

Illustration Works with 12 illustrators/year. Buys 12 editorial and technical illustrations/year. Uses artists mainly for editorials and some covers. Especially needs full-page and spot art of a business-aviation nature. "We generally only use artists with a fairly realistic style. This is a serious business publication and graphically conservative. Need artists who can work on short deadline time." 70% of freelance work demands knowledge of Photoshop, Illustrator, QuarkXPress and FreeHand.

First Contact & Terms Illustrators: Query with samples and SASE. Responds in 1 month. Photocopies OK. Buys all rights, but may reassign rights to artist after publication. Negotiates payment. **Pays on acceptance.** $400 for color; $175-250 for spots.

BUSINESS LAW TODAY

321 N. Clark St., 20th Floor, Chicago IL 60610. (312)988-5000. Fax: (312)988-5444. E-mail: tedhamsj@staff.aban et.org. Website: www.abanet.org/buslaw/blt. **Art Director:** Jill Tedhams. Estab. 1992. Bimonthly magazine covering business law. Circ. 60,291. Art guidelines not available.

Cartoons Buys 20-24 cartoons/year. Prefers business law and business lawyers themes. Prefers single panel, humorous, b&w line drawings with gaglines.

Illustration Buys 6-9 illustrations/issue. Has featured illustrations by Sean Kane, Max Licht and Jim Starr. Features whimsical, realistic and computer illustrations. Assigns 10% of illustrations to new and emerging illustrators. Prefers editorial illustration. Considers all media. 10% of freelance illustration demands knowledge of Photoshop, Illustrator and QuarkXPress.

First Contact & Terms Cartoonists: Send photocopies and SASE to the attention of Ray DeLong. Samples are not filed and are returned by SASE. Responds in several days. Illustrators: "We will accept work compatible with QuarkXPress version 4.04. Send EPS or TIFF files." Samples are filed and are not returned. Responds only if interested. Buys one-time rights. Pays on publication. Pays cartoonists $150 minimum for b&w. Pays illustrators $850 for color cover; $520 for b&w inside, $650 for color inside; $175 for b&w spots.

Tips "Although our payment may not be the highest, accepting jobs from us could lead to other projects, since we produce many publications at the ABA. Sending samples (three to four pieces) works best to get a sense of your style; that way I can keep them on file."

BUSINESS TENNESSEE

2817 West End Ave., Suite 216, Nashville TN 37203. (615)843-8000. Fax: (615)843-4300. E-mail: finney@busine sstn.com. Website: www.businesstn.com. **Creative Director:** Lauren Finney. Estab. 1993. Monthly statewide business magazine. Circ. 45,000.

• A publication of the Nashville Post Company (www.nashvillepost.com).

Cartoons Approached by 2 cartoonists/year. Buys 2-3 cartoons/year. Prefers whimsical single panel, political color washes and b&w line drawings. Responds only if interested.

Illustration Approached by 25 illustrators/year. Buys 2-3 illustrations/issue. Has featured illustrations by Lori Bilter, Pashur, Mike Harris, Dar Maleki, Kurt Lightner. Features caricatures of celebrities and politicians; charts & graphs; computer and spot illustrations of business subjects and country music celebs. Prefers bright colors and pastels, "all styles welcome except 'grunge.' " Assigns 50% of illustrations to experienced but not well-known illustrators; 50% to new and emerging illustrators. 10% of freelance illustration demands knowledge of Illustrator, Photoshop, FreeHand, QuarkXPress.

First Contact & Terms Send query letter with samples. Accepts Mac-compatible disk submissions. Send EPS files. Samples are filed and are not returned. Will contact artist for portfolio review if interested. Rights purchased vary according to project. **Pays on publication.** Pays cartoonists $50-150 for b&w; $60-200 for color cartoons. Pays illustrators $200-1,000 for color cover; $50-300 for b&w inside; $60-500 for color inside; $150-800 for 2-page spreads; $30 for spots. Finds freelancers through other publications.

N CALIFORNIA LAWYER

44 Montgomery St., Suite 250, San Francisco CA 94104. (415)296-2473. Fax: (415)296-2440. E-mail: jake_flahert y@dailyjournal.com. **Creative Director:** Jake Flaherty. Art Director: Marsh Sessa. Art guidelines available free with SASE or on website.

Illustration Approached by 5-8 illustrators/year. Buys 12-20 illustrations/year. Has featured illustrations by Dav Bordeleau, Grady McFerrin, Doug Fraser, Red Nose Studio, Richard Borge, Jack Black, Jonathan Carlson, Dan Page, Asaf Hanuka. Features caricatures of celebrities/politicians, realistic illustration, charts & graphs, humorous illustration, computer illustration, informational graphics, spot illustrations. Preferred subjects: business, politics, law. E-mail submissions accepted with link to website, accepted with image file at 72 dpi. Prefers JPEG. If not filed, samples are not returned. Request portfolio review in original query. Artist should follow up with call.

First Contact & Terms Cartoonists: Send postcard sample, URL. After introductory mailing, send follow-up postcard every 2 or 3 months.

N CAMPUS LIFE

465 Gundersen Dr., Carol Stream IL 60188. (630)260-6200. Fax: (630)260-0114. Website: www.campuslife.net. **Designer:** Doug Fleener. Bimonthly 4-color publication for high school and college students. "Though our readership is largely Christian, *Campus Life* reflects the interests of all kids—music, activities, photography and sports." Circ. 100,000. Original artwork returned after publication. "No phone calls, please. Send mailers." Uses freelance artists mainly for editorial illustration.

Cartoons Approached by 50 cartoonists/year. Buys 35 cartoons/year from freelancers.

Illustration Approached by 175 illustrators/year. Works with 5 illustrators/year. Buys 2 illustrations/issue, 10/year from freelancers. Styles vary from "contemporary realism to very conceptual." Works on assignment only. 10% of freelance work demands knowledge of FreeHand and Illustrator.

First Contact & Terms Cartoonists: Prefers to receive finished cartoons. Illustrators: Send promos or tearsheets. Please no original art transparencies or photographs. Samples returned by SASE. Responds in 1 month. Publication will contact artist for portfolio review if interested. Buys first North American serial rights; also considers

second rights. **Pays on acceptance.** Pays cartoonists $50 for b&w, $75 for color. Pays illustrators $75-350 for b&w; $300-500 for color inside.

Tips "I like to see a variety in styles and a flair for expressing the teen experience. Keep sending a mailer every couple of months."

CANADIAN BUSINESS

One Mount Pleasant Rd., 11th Floor, Toronto ON M4Y 2Y5 Canada. (416)596-5100. Fax: (416)596-5155. E-mail: tdavin@canadianbusiness.com. Website: www.canadianbusiness.com. **Art Director:** Tim Davin. Associate Art Director: John Montgomery. Biweekly 4-color business magazine focusing on Canadian management and entrepreneurs. Circ. 85,000.

Illustration Approached by 200 illustrators/year. Buys 5-10 illustrations/issue. Has featured illustrations by Gerard Dubois, Joe Morse, Seth, Gary Taxali, Dan Page. Features conceptual illustrations, portraits, caricatures and infographics of business subjects. Assigns 70% of illustrations to well-known or "name" illustrators; 30% to new and emerging illustrators. 50% of freelance illustration demands knowledge of Illustrator and Photoshop.

First Contact & Terms Illustrators: Send postcard sample, printed samples and photocopies. Accepts Mac-compatible disk submissions. Responds only if interested. Will contact artist for portfolio review if interested. **Pays on acceptance**; $1,000-2,000 for color cover; $300-1,500 for color inside; $300 for spots. Finds illustrators through magazines, word of mouth and samples.

CAREER FOCUS

7300 W. 110th St., 7th Floor, Overland Park KS 66210-2330. (913)317-2888. E-mail: editorial@careerfocusmagazine.net. Website: www.careerfocusmagazine.net. **Contact:** Executive Editor. Estab. 1985. Bimonthly educational, career development magazine. "A motivational periodical designed for Black and Hispanic college graduates who seek career development information." Circ. 250,000. Accepts previously published artwork. Originals are returned at job's completion.

• *Career Focus* is published by CPG Communications Inc. (Career Publishing Group) which also publishes *Direct Aim*, *College Preview*, *Focus Kansas City* and *First Opportunity*. These magazines have similar needs for illustration as *Career Focus*.

Illustration Buys 1 illustration/issue.

First Contact & Terms Illustrators: Send query letter with samples as attachments via e-mail. Any correspondence should be conducted via e-mail. Samples are filed. Responds only if interested. Buys one-time rights. Pays on publication; $20 for b&w, $25 for color.

THE CAROLINA QUARTERLY

Greenlaw Hall CB 3520, Chapel Hill NC 27599-3520. (919)962-0204. Fax: (919)962-3520. E-mail: cquarter@unc.edu. Website: www.unc.edu/depts/cqonline. **Contact:** Art Editor. Estab. 1948. Quarterly literary magazine featuring contemporary fiction, poetry, reviews, creative nonfiction, interviews and artwork by established and emerging artists. Circ. 800. Send only clear copies of artwork. Sample copy $6 (includes postage and handling). Art guidelines for SASE with first-class postage and on website.

Illustration Approached by 100 illustrators/year. Buys 3-5 illustrations/year. Assigns 70% of illustrations to new and emerging illustrators.

First Contact & Terms Cartoonists/Illustrators: After introductory mailing, send follow-up postcard sample every year. Samples are filed unless return is requested and SASE included. Does not review samples May-August. When response is requested, responds in 6 months. Company will contact artist for portfolio review if interested. Pays cartoonists/illustrators maximum $50 for any image or sequence of images. Pays on publication. Rights purchased vary according to project. Finds freelancers through word of mouth and artists' submissions.

Tips "We purchase art only for our covers and are open to interesting and innovative design. We generally do not consider caricatures or political cartoons."

CAT FANCY

Bowtie, Inc., 3 Burroughs, Irvine CA 92618. (949)855-8822. E-mail: query@catfancy.com. Website: www.catfancy.com. **Contact:** Tom Kimbell. Monthly 4-color magazine for cat owners, breeders and fanciers; contemporary, colorful and conservative. Readers are interested in all phases of cat ownership. Circ. 250,000. No simultaneous submissions. Check website for artist guidlines. Sample copy $5.50; artist's guidelines for SASE.

Cartoons Buys 4 cartoons/year. Seeks single, double and multipanel with gagline. Should be simple, upbeat and reflect love for and enjoyment of cats. Central character should be a cat.

Illustration Needs editorial, medical and technical illustration and images of cats.

First Contact & Terms Cartoonists: Send query letter with photostats or photocopies as samples and SASE. Illustrators: Send query letter with brochure, high-quality photocopies (preferably color), SASE and tearsheets. Article illustrations assigned. Portfolio review not required. Responds in 3 months. Buys first rights. Pays on

publication. Pays cartoonists $35 for b&w line drawings. Pays illustrators $20-35 for spots; $50-300 for color insides; more for packages of multiple illustrations.

Tips "Seeking creative and innovative illustrators that lend a modern feel to our magazine. Please review a sample copy of the magazine before submitting your work to us."

CATHOLIC FORESTER

Box 3012, Naperville IL 60566-7012. (630)983-4900. Fax: (630)983-4057. E-mail: magazine@catholicforester.c om. Website: www.catholicforester.com. **Contact:** Art Director. Estab. 1883. "We are a fraternal insurance company but use general-interest articles, art and photos. Audience is middle-class, many small-town as well as big-city readers, patriotic, Catholic and traditionally conservative." National quarterly 4-color magazine. Circ. under 100,000. Accepts previously published material. Sample copy for 9×12 SASE with 3 first-class stamps.

Cartoons Buys less than 2 cartoons/year from freelancers. Considers "anything *funny* but it must be clean." Prefers single panel with gagline or strip; b&w line drawings.

Illustration Buys and commissions editorial illustration.

First Contact & Terms Cartoonists: Material returned by SASE. Responds in about 2 months. Illustrators: Will contact for portfolio review if interested. Requests work on spec before assigning job. Buys one-time rights, North American serial rights or reprint rights. Pays on publication. Pays cartoonists $30 for b&w. Pays illustrators $30-100 for b&w, $75-300 for color inside.

Tips "Know the audience you're drawing for; always read the article and don't be afraid to ask questions. Pick the art director's brain for ideas and be timely."

CED

P.O. Box 266007, Highlands Ranch CO 80163-6007. (303)470-4800. Fax: (303)470-4890. E-mail: druth@reedbusi ness.com. Website: www.cedmagazine.com. **Art Director:** Don Ruth. Estab. 1978. Monthly trade journal dealing with "the engineering aspects of the technology in Cable TV. We try to publish both views on subjects." Circ. 22,815. Accepts previously published work. Original artwork not returned at job's completion. Sample copies and art guidelines available.

Illustration Buys 1 illustration/issue. Works on assignment only. Features caricatures of celebrities; realistic illustration; charts and graphs; informational graphics and computer illustrations. Assigns 10% of illustrations to new and emerging illustrators. Prefers cable TV-industry themes. Considers watercolor, airbrush, acrylic, colored pencil, oil, charcoal, mixed media, pastel, computer disk formatted in Photoshop, Illustrator or Free-Hand.

First Contact & Terms Contact only through artist rep. Samples are filed. Call for appointment to show portfolio. Portfolio should include final art, b&w/color tearsheets, photostats, photographs and slides. Rights purchased vary according to project. **Pays on acceptance.** Pays illustrators $400-800 for color cover; $125-400 for b&w and color inside; $250-500 for 2-page spreads; $75-175 for spots.

Tips "Be persistent; come in person if possible. Be willing to change in mid course; be willing to have finished work rejected. Make sure you can draw and work fast."

CHARLESTON MAGAZINE, CHARLESTON HOME, CHARLESTON WEDDINGS

782 Johnnie Dodds Blvd., Suite C, Mt. Pleasant SC 29464. (843)971-9811. Fax: (843)971-0121. E-mail: mmonk@ charlestonmag.com. Website: www.charlestonmag.com. **Art Director:** Melinda Smith Monk. Editor: Darcy Shankland. Estab. 1973. Monthly 4-color consumer magazine. *Charleston Home* is quarterly, *Charleston Weddings* is two times a year with a more regional and national distribution. "Indispensible resource for information about modern-day Charleston SC, addresses issues of relevance and appeals to both visitors and residents." Circ. 20,000. Art guidelines are free for #10 SASE with first-class postage.

Illustration Approached by 35 illustrators/year. Buys 1 illustration/issue. Has featured illustrations by Tate Nation, Nancy Rodden, Paige Johnson, Emily Thompson and local artists. Features realistic illustrations, informational graphics, spot illustrations, computer illustration. Prefers business subjects, children, families, men, pets, women and teens. Assigns 10% of illustrations to well-known or "name" illustrators; 30% to experienced but not well-known illustrators; 60% to new and emerging illustrators. 35% of freelance illustration demands knowledge of Illustrator, Photoshop, FreeHand, PageMaker, QuarkXPress.

First Contact & Terms Illustrators: Send postcard sample and follow-up postcard every month or send query letter with printed samples. Accepts Mac-compatible disk submissions. Samples are filed or returned by SASE. Responds only if interested. Will contact artist for portfolio review if interested. Rights purchased vary according to project. Pays 30 days after publication; $175 for b&w, $200 for color cover; $100-400 for 2-page spreads; $50 for spots. Finds illustrators through sourcebooks, artists' promo samples, word of mouth.

Tips "Our magazine has won several design awards and is a good place for artists to showcase their talent in print. We welcome letters of interest from artists interested in semester-long, unpaid internships-at-large. If

selected, artist would provide 4-5 illustrations for publication in return for masthead recognition and sample tearsheets. Staff internships (unpaid) also available on-site in Charleston SC. Send letter of interest and samples of work to Art Director.''

CHARLOTTE MAGAZINE

127 W. Worthington Ave., Suite 208, Charlotte NC 28203-4474. (704)335-7181. Fax: (704)335-3739. E-mail: erin.potter@charlottemagazine.com. Website: www.charlottemag.com. **Art Director:** Erin Potter. Estab. 1995. Monthly 4-color city-based consumer magazine for Charlotte and surrounding areas. Circ. 30,000. Sample copies free for #10 SAE with first-class postage.

Illustration Approached by many illustrators/year. Buys 1-5 illustrations/issue. Features caricatures of celebrities and politicians; computer illustration; humorous illustration; natural history, realistic and spot illustration. Prefers wide range of media/conceptual styles. Assigns 20% of illustrations to new and emerging illustrators.

First Contact & Terms Illustrators: Send postcard sample and follow-up postcard every 6 months. Send nonreturnable samples. Accepts e-mail submissions. Send EPS or TIFF files. Samples are filed. Responds only if interested. Portfolio review not required. Finds illustrators through artist promotional samples and sourcebooks.

Tips ''We are looking for diverse and unique approaches to illustration. Highly creative and conceptual styles are greatly needed. If you are trying to get your name out there, we are a great avenue for you.''

[N] CHEMICAL WEEK

110 William St., 11th Floor, New York NY 10038. (212)621-4900. Fax: (212)621-4950. E-mail: msotolongo@chemweek.com. Website: www.chemweek.com. **Director:** Mario Sotolongo. Assistant Art Director Gen Yee. Estab. 1998. Bimonthly, 4-color trade publication emphasizing commercial developments in specialty chemical markets. Circ. 23,000.

- This publisher also publishes other trade magazines, such as *Modern Paints & Coatings*, *Adhesives Age* and *Soap and Cosmetics*, which have similar needs for illustration and are produced by the same staff. Check out their websites www.modernpaintsandcoatings.com; www.adhesivesage.com. Art directors say these publications are open to submissions.

Illustration Features charts and graphs, computer illustration, informational graphics, natural history illustration, realistic illustrations, medical illustration of business subjects. Prefers bright colors and clean look. Assigns 100% of illustrations to experienced but not well-known illustrators. 100% of freelance illustration demands knowledge of Illustrator, Photoshop, QuarkXPress.

First Contact & Terms Illustrators: Send nonreturnable postcard sample and follow-up postcard every 6 months. Accepts Mac-compatible disk submissions. Send EPS or TIFF files. Samples are filed and are not returned. Responds only if interested. Portfolio review not required. Rights purchased vary according to project. Pays on publication; $500-800 for color.

Tips ''Freelancers should be reliable and produce quality work. Promptness and the ability to meet deadlines are most important.''

CHESAPEAKE BAY MAGAZINE

1819 Bay Ridge Ave., Annapolis MD 21403. (410)263-2662. Fax: (410)267-6924. E-mail: kashley@cbmmag.net. Website: www.cbmmag.net. **Art Director:** Karen Ashley. Estab. 1972. Monthly 4-color magazine focusing on the boating environment of the Chesapeake Bay—including its history, people, places and ecology. Circ. 45,000. Original artwork returned after publication upon request. Sample copies free for SASE with first-class postage. Art guidelines available.

Illustration Approached by 12 illustrators/year. Buys 2-3 technical and editorial illustrations/issue. Has featured illustrations by Jim Paterson, Kim Harroll, Jan Adkins, Tamzin C. Biles, Marcy Ramsey, Peter Bono and Stephanie Carter. Assigns 50% of illustrations to new and emerging illustrators. Considers pen & ink, watercolor, collage, acrylic, marker, colored pencil, oil, charcoal, mixed media and pastel. Usually prefers watercolor or acrylic for 4-color editorial illustration. ''Style and tone are determined by the artist after he/she reads the story.''

First Contact & Terms Illustrators: Send query letter with résumé, tearsheets and photographs. Samples are filed. Make sure to include contact information on each sample. Responds only if interested. Publication will contact artist for portfolio review if interested. Portfolio should include ''anything you've got.'' No b&w photocopies. Buys one-time rights. ''Price decided when contracted.'' Pays illustrators $100-300 for quarter-page or spot illustrations; up to $1,200 for spreads—four-color inside.

Tips ''Our magazine design is relaxed, fun, oriented toward people having fun on the water. Style seems to be loosening up. Boating interests remain the same. But for the Chesapeake Baywater, quality and the environment are more important to our readers now than in the past. Colors brighter. We like to see samples that show the artist can draw boats and understands our market environment. Send tearsheets or send website information.''

We're always looking. Artist should have some familiarity with the appearance of different types of boats, boating gear and equipment.''

⊠ CHESS LIFE

3068 US Rt. 9W, New Windsor NY 12553. (845)565-8687. Fax: (845)236-4852. Website: www.uschess.org. **Art Director:** Kathleen Merz. Estab. 1939. Official publication of the United States Chess Federation. Contains news of major chess events with special emphasis on American players, plus columns of instruction, general features, historical articles, personality profiles, tournament reports, cartoons, quizzes, humor and short stories. Monthly b&w with 4-color cover. Design is ''text-heavy with chess games.'' Circ. 70,000/month. Accepts previously published material and simultaneous submissions. Sample copy for SASE with 6 first-class stamps; art guidelines for SASE with first-class postage.

• Also publishes children's magazine, *School Mates* insert within *Chess Life* every other month. Same submission guidelines apply.

Cartoons Approached by 200-250 cartoonists/year. Buys 10-20 cartoons/year. All cartoons must be chess related. Prefers single panel with gagline; b&w line drawings.

Illustration Approached by 100-150 illustrators/year. Works with 4-5 illustrators/year from freelancers. Buys 8-10 illustrations/year. Uses artists mainly for cartoons and covers. All must have a chess motif. Works on assignment, but will also consider unsolicited work.

First Contact & Terms Cartoonists: Send query letter with brochure showing art style. Material kept on file or returned by SASE. Illustrators: Send query letter with samples. Responds in 2 months. Call to schedule an appointment to show a portfolio, which should include original/final art. Negotiates rights purchased. Pays on publication. Pays cartoonists $25, b&w; $40, color. Pays illustrators $150, b&w cover; $300, color cover; $25, b&w inside; $40, color inside.

Tips ''Include a wide range in your portfolio.''

▨ CHICKADEE

Bayard Press Canada, 49 Front St. E., 2nd Floor, Toronto M5E 1B3 Canada. (416)340-2700. Fax: (416)340-9769. E-mail: chickadee@owl.on.ca. Website: www.owlkids.com. **Creative Director:** Barb Kelly. Estab. 1979. 9 issues/year. Children's discovery magazine. Chickadee is a ''hands-on'' science, nature and discovery publication designed to entertain and educate 6-9 year-olds. Each issue contains photos, illustrations, an easy-to-read animal story, a craft project, fiction, puzzles, a science experiment and a pull-out poster. Circ. 150,000 in North America. Originals returned at job's completion. Sample copies available. Uses all types of conventional methods of illustration. Digital illustrators should be familiar with Illustrator or Photoshop.

• The same company that publishes *Chickadee* now also publishes *Chirp*, a science, nature and discovery magazine for pre-schoolers two to six years old, and *OWL*, a similar publication for children over eight years old.

Illustration Approached by 500-750 illustrators/year. Buys 3-7 illustrations/issue. Works on assignment only. Prefers animals, children, situations and fiction. All styles, loaded with humor but not cartoons. Realistic depictions of animals and nature. Considers all media and computer art. No b&w illustrations.

First Contact & Terms Illustrators: Send postcard sample, photocopies and tearsheets. Accepts disk submissions compatible with Illustrator 8.0. Send EPS files. Samples are filed or returned by SASE. Will contact for portfolio review if interested. Portfolio should include final art, tearsheets and photocopies. Buys all rights. Pays within 30 days of invoice; $500 for color cover; $100-750 for color/inside; $100-300 for spots. Finds artists through sourcebooks, word of mouth, submissions as well as looking in other magazines to see who's doing what.

Tips ''Please become familiar with the magazine before you submit. Ask yourself whether your style is appropriate before spending the money on your mailing. Magazines are ephemeral and topical. Ask yourself if your illustrations are editorial and contemporary. Some styles suit books or other forms better than magazines.'' Impress this art director by being ''fantastic, enthusiastic and unique.''

CHILD LIFE

Children's Better Health Institute, P.O. Box 567, Indianapolis IN 46206. (317)634-1100. Fax: (317)684-8094. Website: www.childlifemag.org. **Art Director:** Rob Falco. Estab. 1921. 4-color magazine for children 9-11. Bimonthly. Circ. 30,000. Sample copy $2.95. Art guidelines for SASE with first-class postage.

• *Child Life* is not accepting freelance illustrations at this time.

CHILDREN'S DIGEST

Children's Better Health Institute, P.O. Box 567, Indianapolis IN 46202. (317)636-8881. Fax: (317)684-8094. Website: www.childrensdigestmag.org. **Art Director:** Penny Rasdall. 4-color magazine with special emphasis on book reviews, health, nutrition, safety and exercise for preteens. Published 8 times/year. Circ. 106,000. Sample copy $1.25; art guidelines for SASE.

- Also publishes *Child Life, Children's Playmate, Humpty Dumpty's Magazine, Jack and Jill, Turtle Magazine* and *UKids Weekly Reader Magazine.*

Illustration Approached by 200 illustrators/year. Works with 2 illustrators/year. Buys 2 illustrations/year. Has featured illustrations by Len Ebert, Tim Ellis and Kathryn Mitter. Features humorous, realistic, medical, computer and spot illustrations. Assigns 90% of illustrations to experienced but not well-known illustrators; 10% to new and emerging illustrators. Uses freelance art mainly with stories, articles, poems and recipes. Works on assignment only.

First Contact & Terms Illustrators: Send query letter with brochure, résumé, samples and tearsheets to be kept on file. "Send samples with comment card and SASE." Portfolio review not required. Prefers photostats, slides and good photocopies as samples. Samples returned by SASE if not kept on file. Responds in 2 months. Buys all rights. Pays $275 for color cover; $35-90 for b&w inside; $60-120 for 2-color inside; $70-155 for 4-color inside; $35-70 for spots. Pays within 3 weeks prior to publication date. "All artwork is considered work for hire." Finds artists through submissions and sourcebooks.

Tips Likes to see situation and storytelling illustrations with more than 1 figure. When reviewing samples, especially looks for artist's ability to bring a story to life with illustrations and to draw well consistently. No advertising work, cartoon styles or portraits of children. Needs realistic styles and animals.

CHILDREN'S PLAYMATE

Children's Better Health Institute, P.O. Box 567, Indianapolis IN 46206. (317)636-8881. Fax: (317)684-8094. Website: www.childrensplaymatemag.org. **Art Director:** Rob Falco. 4-color magazine for ages 6-8. Special emphasis on entertaining fiction, games, activities, fitness, health, nutrition and sports. Published 8 times/year. Circ. 78,000. Original art becomes property of the magazine and will not be returned. Sample copy $1.25.

- Also publishes *Child Life, Children's Digest, UKids Weekly Reader Magazine, Humpty Dumpty's Magazine, Jack and Jill* and *Turtle Magazine.*

Illustration Uses 8-12 illustrations/issue; buys 6-8 from freelancers. Interested in editorial, medical, stylized, humorous or realistic themes; also food, nature and health. Considers pen & ink, airbrush, charcoal/pencil, colored pencil, watercolor, acrylic, oil, pastel, collage, multimedia and computer illustration. Works on assignment only.

First Contact & Terms Illustrators: Send sample of style; include illustrations of children, families, animals—targeted to children. Provide brochure, tearsheet, stats or good photocopies of sample art to be kept on file. Samples returned by SASE if not filed. Artist should follow up with call or letter. Also considers b&w camera-ready art for puzzles, such as dot-to-dot, hidden pictures, crosswords, etc. Buys all rights on a work-for-hire basis. Payment varies. Pays $275 for color cover; up to $155 for color and $90 for b&w inside, per page. Finds artists through artists' submissions/self-promotions.

Tips "Become familiar with our magazine before sending anything. Don't send just two or three samples. I need to see a minimum of eight pieces to determine that the artist fits our needs. Looking for samples displaying the artist's ability to interpret text, especially in fiction for ages 6-8. Illustrators must be able to do their own layout with a minimum of direction."

CHILE PEPPER MAGAZINE

River Plaza 1701 River Run, Suite 901, FtWorth TX 76107. (817)877-1048. Fax: (817)877-8870. E-mail: aglazener @chilepepper.com. Website: www.chilepepper.com. **Creative Director:** Alan Glazener. Bimonthly magazine covering hot and spicy food/cuisine. Circ. 100,000.

Illustration Approached by 6-12 illustrators/year. Buys 2-3 illustrations/issue. Prefers Southwestern art or just playful; colorful and classy. Considers all media. 90% of freelance illustration demands knowledge of Photoshop, Illustrator and QuarkXPress.

First Contact & Terms Illustrators: Send postcard sample or printed samples. Accepts disk submissions compatible with Macintosh Photoshop 3, Illustrator 5, or other EPS or TIFF files. Samples are not filed and are not returned. Does not report back. Artist should follow-up in writing. Art director will contact artist for portfolio review of final art and tearsheets if interested. Rights purchased vary according to project. Pays $300-500. Finds illustrators through word of mouth, submissions.

Tips "World travel is addressed often in *Chile Pepper* Ethnic art and photography or just local color images are regular fare, but must have a hot & spicy bent to them. While often associated with hot & spicy, sexually suggestive images are not considered."

CHRISTIAN HOME & SCHOOL

3350 E. Paris Ave. SE, Grand Rapids MI 49512. (616)957-1070. Fax: (616)957-5022. E-mail: rogers@csionline.o rg. Website: www.CSIonline.org. **Senior Editor:** Roger W. Schmurr. Emphasizes current, crucial issues affecting the Christian home for parents who support Christian education. 4-color magazine; 4-color cover; published 6

times/year. Circ. 66,000. Sample copy for 9×12 SASE with 4 first-class stamps; art guidelines for SASE with first-class postage.

Cartoons Prefers family and school themes.

Illustration Buys approximately 2 illustrations/issue. Has featured illustrations by Patrick Kelley, Rich Bishop and Pete Sutton. Features humorous, realistic and computer illustration. Assigns 75% of illustrations to experienced but not well-known illustrators; 25% to new and emerging illustrators. Prefers pen & ink, charcoal/pencil, colored pencil, watercolor, collage, marker and mixed media. Prefers family or school life themes. Works on assignment only.

First Contact & Terms Illustrators: Send query letter with résumé, tearsheets, photocopies or photographs. Show a representative sampling of work. Samples returned by SASE, or "send one or two samples art director can keep on file." Will contact if interested in portfolio review. Buys first rights. Pays on publication. Pays cartoonists $75 for b&w. Pays illustrators $300 for 4-color full-page inside. Finds most artists through references, portfolio reviews, samples received through the mail and artist reps.

CHRISTIAN PARENTING TODAY MAGAZINE

465 Gunderson Dr., Carol Stream IL 60188-2498. (630)260-6200. Fax: (630)260-0114. E-mail: jaardema@christianitytoday.com. Website: www.christianparenting.net. **Art Director:** John Aardema. Estab. 1988. Bimonthly 2-color and 4-color consumer magazine featuring advice for Christian parents raising kids. Circ. 90,000.

Illustration Approached by 100 illustrators/year. Buys 6 illustrations/issue (humorous and spot illustrations).

First Contact & Terms Illustrators: Send postcard or other nonreturnable samples or tearsheets. Samples are filed. Will contact artist for portfolio review if interested. Buys first rights and one-time rights. Pays on publication. Pay varies. Finds illustrators through agents, self promos and directories.

CHRISTIAN RESEARCH JOURNAL

30162 Tomas, Rancho Santa Margarita CA 92688-2124. (949)858-6100. Fax: (949)858-6111. E-mail: response@equip.org. Website: www.equip.org. **Contact:** Melanie Cogdil, managing editor. Estab. 1987. Quarterly religion and theology journal that probes "today's religious movements, promoting doctrinal discernment and critical thinking, and providing reason for Christian faith and ethics." Circ. 20,000. Art guidelines not available.

Illustration Has featured illustrations by Tom Fluharty, Phillip Burke, Tim O'Brian. Features caricatures of celebrities/politicians, realistic illustrations of men and women and related to subjects of articles. Assigns 20% of illustrations to new and emerging illustrators.

First Contact & Terms Cartoonists/Illustrators: Send postcard sample. Accepts e-mail submissions with link to website. Prefers JPEG files. Responds only if interested. Company will contact artist for portfolio review if interested. Pays on completion of assignment. Buys first rights. Finds freelancers through artists' submissions, word of mouth and sourcebooks.

ℕ THE CHRONICLE OF THE HORSE

Box 46, Middleburg VA 20118. **Editor:** John Strassburger. Estab. 1937. Weekly magazine emphasizing horses and English horse sports for dedicated competitors who ride, show and enjoy horses. Circ. 23,500. Sample copy and guidelines available for $2.

Cartoons Approached by 25 cartoonists/year. Buys 1-2 cartoons/issue. Considers anything about English riding and horses. Prefers single panel b&w line drawings or washes with or without gagline.

Illustration Approached by 25 illustrators/year. "We use a work of art on our cover every week. The work must feature horses, but the medium is unimportant. We do not pay for this art, but we always publish a short blurb on the artist and his or her equestrian involvement, if any."

First Contact & Terms Cartoonists: Send query letter with finished cartoons to be kept on file if accepted for publication. Buys first rights. Illustrators: Send query letter with samples to be kept on file until published. If accepted, insists on high-quality, b&w 8×10 photographs of the original artwork. Samples are returned. Responds in 6 weeks. Pays cartoonists on publication $20, b&w.

Tips Does not want to see "current horse show champions or current breeding stallions."

THE CHURCH HERALD

4500 60th St. SE, Grand Rapids MI 49512-9642. (616)698-7071. Fax: (616)698-6606. E-mail: herald@rca.org. Website: www.herald.rca.org. **Editor:** Christina Van Eyl. Estab. 1837. Monthly magazine. "The official denominational magazine of the Reformed Church in America." Circ. 110,000. Accepts previously published artwork. Originals returned at job's completion. Sample copies available for $2. Open to computer-literate freelancers for illustration.

Illustration Buys up to 2 illustrations/issue. Works on assignment only. Considers pen & ink, watercolor, collage, marker and pastel.

First Contact & Terms Illustrators: Send postcard sample with brochure. Accepts disk submissions compatible

with QuarkXPress, InDesign, Photoshop, Illustrator. Also may submit via e-mail. Samples are filed. Responds to the artist only if interested. Portfolio review not required. Buys one-time rights. Pays on publication; $300 for color cover; $200 for color inside.

Ⓝⓘ CICADA

Box 300, Peru IL 61354. Website: www.cricketmag.com. **Senior Art Editor:** Ron McCutchan. Estab. 1998. Bimonthly literary magazine for young adults (senior high-early college). Limited illustration (spots and frontis pieces). Black & white interior with full-color cover. Circ. 18,000. Original artwork returned after publication. Sample copy $7.95 plus 10% of total order ($4 minimum) for shipping and handling; art guidelines available on website or for SASE with first-class postage.

Illustration Works with 30-40 illustrators a year. Buys 120 illustrations/year. Has featured illustrations by Erik Blegvad, Victor Ambrus, Ted Rall and Whitney Sherman. Has a strong need for good figurative art with teen appeal, but also uses looser/more graphic/conceptual styles and photo illustrations. Works on assignment only.

First Contact & Terms Illustrators: Send query letter and 4-6 samples to be kept on file "if I like it." Prefers photocopies and tearsheets as samples. Samples not kept on file are returned by SASE only. Responds in 6 weeks. Pays 45 days from receipt of final art; $750 for color cover, $50-150 for b&w inside. Buys all rights.

CINCINNATI CITYBEAT

811 Race St., 5th Floor, Cincinnati OH 45202. (513)665-4700. Fax: (513)665-4369. Website: www.citybeat.com. **Art Director:** Sean Hughes. Estab. 1994. Weekly alternative newspaper emphasizing issues, arts and events. Circ. 50,000.

 • Please research alternative weeklies before contacting this art director. He reports receiving far too many inappropriate submissions.

Cartoons Approached by 30 cartoonists/year. Buys 1 cartoon/year.

Illustration Buys 1-3 illustrations/issue. Has featured illustrations by Ryan Greis, Woodrow J. Hinton III and Jerry Dowling. Features caricatures of celebrities and politicians, computer and humorous illustration. Prefers work with a lot of contrast. Assigns 40% of illustrations to new and emerging illustrators. 10% of freelance illustration demands knowledge of Illustrator, Photoshop, FreeHand, QuarkXPress.

First Contact & Terms Cartoonists: Send query letter with samples. Illustrators: Send postcard sample or query letter with printed samples and follow-up postcard every 4 months. Accepts Mac-compatible disk submissions. Send EPS, TIFF or PDF files. Samples are filed. Responds in 2 weeks only if interested. Buys one-time rights. Pays on publication. Pays cartoonists $10-100 for b&w, $30-100 for color cartoons, $10-35 for comic strips. Pays illustrators $75-150 for b&w cover, $150-250 for color cover; $10-50 for b&w inside, $50-75 for color inside, $75-150 for 2-page spreads. Finds illustrators through word of mouth and artist samples.

CINCINNATI MAGAZINE

705 Central Ave., Suite 175, Cincinnati OH 45202. (513)421-4300. Fax: (513)562-2746. E-mail: nstetler@cintima g.emmis.com. **Art Director:** Nancy Stetler. Estab. 1960. Monthly 4-color lifestyle magazine for the city of Cincinnati. Circ. 30,000. Accepts previously published artwork. Original artwork returned at job's completion.

Illustration Approached by 200 illustrators/year. Has featured illustrations by Robert de Michiel and C.F. Payne. Works on assignment only.

First Contact & Terms Send samples. Samples are filed or returned by SASE. Responds only if interested. Buys one-time rights or reprint rights. Pays on publication; $500-800 for features; $200-450 for spots.

Tips Prefers traditional media with an interpretive approach. No cartoons or mass-market computer art, please.

Ⓝⓘ CIRCLE K MAGAZINE

3636 Woodview Trace, Indianapolis IN 46268. (317)875-8755. Fax: (317)879-0204. E-mail: magazine@kiwanis. org. Website: www.circlek.org. **Art Director:** Maria Malandrakis. Estab. 1968. Kiwanis International's youth magazine for college-age students emphasizing service, leadership, etc. Published 3 times/year. Circ. 12,000. Originals and sample copies returned to artist at job's completion.

 • This organization also publishes *Kiwanis* magazine and *Keynoter.*

Illustration Approached by more than 30 illustrators/year. Buys 1-2 illustrations/issue. Works on assignment only. Needs editorial illustration. "We look for variety."

First Contact & Terms Send query letter with photocopies, photographs, tearsheets and SASE. Samples are filed. Will contact for portfolio review if interested. Portfolio should include tearsheets and slides. **Pays on acceptance;** $100 for b&w cover; $250 for color cover; $50 for b&w inside; $150 for color inside.

Ⓝⓘ CLARETIAN PUBLICATIONS

205 W. Monroe, Chicago IL 60606. (312)236-8682. Fax: (312)236-8207. E-mail: wrightt@uscatholic.org. **Art Director:** Tom Wright. Estab. 1960. Monthly magazine "covering the Catholic family experience and social justice." Circ. 40,000. Sample copies and art guidelines available.

Illustration Approached by 20 illustrators/year. Buys 6 illustrations/issue. Considers all media.

First Contact & Terms Illustrators: Send postcard sample or send query letter with printed samples and photocopies. Accepts disk submissions compatible with EPS or TIFF. Samples are filed. Responds only if interested. Art director will contact artist for portfolio review if interested. Negotiates rights purchased. **Pays on acceptance.** $100-400 for color inside.

Tips "We like to employ humor in our illustrations and often use clichés with a twist and appreciate getting art in digital form."

N CLEANING BUSINESS

Box 1273, Seattle WA 98111. (206)622-4241. Fax: (206)622-6876. E-mail: wgriffin@cleaningconsultants.com. Website: www.cleaningbusiness.com. **Publisher:** Bill Griffin. Submissions Editor: Bill S. Quarterly e-magazine with technical, management and human relations emphasis for self-employed cleaning and maintenance service contractors and workers. Internet publication. Prefers to purchase all rights. Simultaneous submissions OK "if sent to noncompeting publications." Original artwork returned after publication if requested by SASE.

Cartoons Buys 1-2 cartoons/issue. Must be relevant to magazine's readership. Prefers b&w line drawings.

Illustration Buys approximately 12 illustrations/year including some humorous and cartoon-style illustrations.

First Contact & Terms Illustrators: Send query letter with samples. *"Don't* send samples unless they relate specifically to our market." Samples returned by SASE. Buys first publication rights. Responds only if interested. Pays for illustration by project $3-15. Pays on publication.

Tips "Our budget is limited. Those who require high fees are wasting their time. We are interested in people with talent and ability who seek exposure and publication. Our readership is people who work for and own businesses in the cleaning industry, such as maid services; janitorial contractors; carpet, upholstery and drapery cleaners; fire, odor and water damage restoration contractors; etc. If you have material relevant to this specific audience, we would definitely be interested in hearing from you. We are also looking for books, games, videos, software, jokes and reports related to the cleaning industry."

THE CLERGY JOURNAL

6160 Carmen Ave. E., Inver Grove Heights MN 55076-4422. (800)328-0200. Fax: (888)852-5524. E-mail: sfirle@logostaff.com. Website: www.logosproductions.com. **Editor:** Sharon Firle. Magazine for professional clergy and church business administrators; 2-color with 4-color cover. Monthly (except June, August and December). Circ. 10,000. Original artwork returned after publication if requested.

● This publication is one of many published by Logos Productions and Woodlake Books.

Cartoons Buys 4 single panel cartoons/issue from freelancers on religious themes.

First Contact & Terms Cartoonists: Send SASE. Responds in 1 month. Pays $25 on publication.

CLEVELAND MAGAZINE

1422 Euclid Ave., Suite 730, Cleveland OH 44115. (216)771-2833. Fax: (216)781-6318. E-mail: sluzewski@clevelandmagazine.com. **Contact:** Gary Sluzewski. Monthly city magazine, b&w with 4-color cover, emphasizing local news and information. Circ. 45,000.

Illustration Approached by 100 illustrators/year. Buys 3-4 editorial illustrations/issue on assigned themes. Sometimes uses humorous illustrations. 40% of freelance work demands knowledge of QuarkXPress, FreeHand or Photoshop.

First Contact & Terms Illustrators: Send postcard sample with brochure or tearsheets. E-mail submissions must include sample. Accepts disk submissions. Please include application software. Call or write for appointment to show portfolio of printed samples, final reproduction/product, color tearsheets and photographs. Pays $100-700 for color cover; $75-300 for b&w inside; $150-400 for color inside; $75-350 for spots.

Tips "Artists are used on the basis of talent. We use many talented college graduates just starting out in the field. We do not publish gag cartoons but do print editorial illustrations with a humorous twist. Full-page editorial illustrations usually deal with local politics, personalities and stories of general interest. Generally, we are seeing more intelligent solutions to illustration problems and better techniques. The economy has drastically affected our budgets; we pick up existing work as well as commissioning illustrations."

COBBLESTONE, DISCOVER AMERICAN HISTORY

Cobblestone Publishing, Inc., 30 Grove St., Suite C, Peterborough NH 03458-1438. (603)924-7209. Fax: (603)924-7380. E-mail: anndillon@yahoo.com. Website: www.cobblestonepub.com. **Art Director:** Ann Dillon. Monthly magazine emphasizing American history; features nonfiction, supplemental nonfiction, fiction, biographies, plays, activities and poetry for children ages 8-14. Circ. 38,000. Accepts previously published material and simultaneous submissions. Sample copy $4.95 with $8 × 10$ SASE; art guidelines on website. Material must relate to theme of issue; subjects and topics published in guidelines for SASE. Freelance work demands knowledge of Illustrator, Photoshop and QuarkXPress.

• Other magazines published by Cobblestone include *Calliope* (world history), *Dig* (archaeology for kids), *Faces* (cultural anthropology), *Footsteps* (African-American history), *Odyssey* (science), all for kids ages 8-15, and *Appleseeds* (social studies), for ages 7-9.

Illustration Buys 2-5 illustrations/issue. Prefers historical theme as it pertains to a specific feature. Works on assignment only. Has featured illustrations by Annette Cate, Beth Stover, David Kooharian. Features caricatures of celebrities and politicians, humorous, realistic illustration, informational graphics, computer and spot illustration. Assigns 15% of illustrations to new and emerging illustrators.

First Contact & Terms Illustrators: Send query letter with brochure, résumé, business card and b&w photocopies or tearsheets to be kept on file or returned by SASE. Write for appointment to show portfolio. Buys all rights. Pays on publication; $20-125 for b&w inside; $40-225 for color inside. Artists should request illustration guidelines.

Tips "Study issues of the magazine for style used. Send update samples once or twice a year to help keep your name and work fresh in our minds. Send nonreturnable samples we can keep on file; we're always interested in widening our horizons."

◨ ✓ COMMON GROUND

#204-4381 Fraser St., Vancouver BC V5V 4G4 Canada. (604)733-2215. Fax: (604)733-4415. E-mail: admin@commonground.ca. Website: www.commonground.ca. **Contact:** Art Director. Estab. 1982. Monthly consumer magazine focusing on health and cultural activities and holistic personal resource directory. Circ. 70,000. Accepts previously published artwork and cartoons. Original artwork is returned at job's completion. Sample copies for SASE with first-class Canadian postage or International Postage Certificate.

Illustration Approached by 20-40 freelance illustrators/year. Buys 1-2 freelance illustrations/issue. Prefers all themes and styles. Considers cartoons, pen & ink, watercolor, collage and marker.

First Contact & Terms Illustrators: Send query letter with brochure, photographs, SASE and photocopies. Samples are filed or are returned by SASE if requested by artist. Responds only if interested. Buys one-time rights. Payment varies.

Tips "Send photocopies of your top one-three inspiring works in black & white or color. Can have all three on one sheet of $8\frac{1}{2} \times 11$ paper or all in one color copy. I can tell from that if I am interested."

COMMONWEAL

475 Riverside Dr., Suite 405, New York NY 10115-0433. (212)662-4200. Fax: (212)662-4183. E-mail: editors@commonwealmagazine.org. Website: www.commonwealmagazine.org. **Editor:** Paul Baumann. Estab. 1924. Public affairs journal. "Journal of opinion edited by Catholic lay people concerning public affairs, religion, literature and all the arts"; b&w with 4-color cover. Biweekly. Circ. 20,000. Original artwork is returned at the job's completion. Sample copies for SASE with first-class postage. Guidelines for SASE with first-class postage.

Cartoons Approached by 20-40 cartoonists/year. Buys 3-4 cartoons/issue from freelancers. Prefers simple lines and high-contrast styles. Prefers single panel, with or without gagline; b&w line drawings.

Illustration Approached by 20 illustrators/year. Buys 3-4 illustrations/issue, 60/year from freelancers. Has featured illustrations by Baloo. Assigns 10% of illustrations to new and emerging illustrators. Prefers high-contrast illustrations that "speak for themselves." Prefers pen & ink and marker.

First Contact & Terms Cartoonists: Send query letter with finished cartoons. Illustrators: Send query letter with tearsheets, photographs, SASE and photocopies. Samples are filed or returned by SASE if requested by artist. Responds in 2 weeks. To show a portfolio, mail b&w tearsheets, photographs and photocopies. Buys nonexclusive rights. Pays cartoonists $15 for b&w. Pays illustrators $15 for b&w inside. Pays on publication.

Tips "Be familiar with publication before mailing submissions."

◨ COMMUNICATION WORLD

One Hallidie Plaza, Suite 600, San Francisco CA 94102. (415)544-4700. E-mail: jburnette@iabc.com. Website: www.iabc.com/cw. **Contact:** Natasha Spring, senior editor. Emphasizes communication, public relations for members of International Association of Business Communicators corporate and nonprofit businesses, hospitals, government communicators, universities, etc. who produce internal and external publications, press releases, annual reports and customer magazines. Published 6 times/year. Circ. 18,000. Accepts previously published material. Original artwork returned after publication. Art guidelines available for SASE with first-class postage.

Cartoons Approached by 6-10 cartoonists/year. Buys 3 cartoons/year. Considers public relations, entrepreneurship, teleconference, editing, writing, international communication and publication themes. Prefers single panel with gagline; b&w line drawings or washes.

Illustration Approached by 20-30 illustrators/year. Buys 6-8 illustrations/issue. Features humorous and realistic illustration; informational graphics; computer and spot illustration. Assigns 35% to new and emerging illustrators. Theme and style are compatible to individual article.

First Contact & Terms Cartoonists/Illustrators: Send query letter with samples to be kept on file. To show a

portfolio, write or call for appointment. Accepts tearsheets, photocopies or photographs as samples. Samples not filed are returned only if requested. Responds in 1 year only if interested. Negotiates rights purchased. Pays on publication. Pays cartoonists $25-50, b&w. Pays illustrators $300 for b&w cover; $200-500 for color cover; $200 for b&w or color inside; $350 for 2-page spreads; $200 for spots.

Tips Sees trend toward ''more sophistication, better quality, less garish, glitzy—subdued, use of subtle humor.''

COMMUNITY BANKER

900 19th St. NW, Washington DC 20006. (202)857-3100. Fax: (202)857-5581. E-mail: jbock@acbankers.org. Website: www.americascommunitybankers.com. **Art Director:** Jon C. Bock. Estab. 1993. Monthly trade journal targeting senior executives of high tech community banks. Circ. 12,000. Accepts previously published artwork. Originals returned at job's completion.

Illustration Approached by 200 illustrators/year. Buys 2 illustrations/issue. Has featured illustrations by Michael Gibbs, Kevin Rechin, Jay Montgomery and Matthew Trueman. Features humorous illustration, informational graphics, spot illustrations, computer illustration. Preferred subjects business subjects. Prefers pen & ink with color wash, bright colors, painterly. Works on assignment only.

First Contact & Terms Illustrators: Send query letter, nonreturnable postcard samples and tearsheets. Accepts Mac-compatible disk submissions. Send TIFF files. Samples are filed. Responds only if interested. ''Artists should be patient and continue to update our files with future mailings. We will contact artist when the right story comes along.'' Publication will contact artist for portfolio review if interested. Portfolio should include mostly finished work, some sketches. Buys first North American serial rights. Pays on publication; $1,200-2,000 for color cover; $800-1,200 for color inside; $250-300 for spots. Finds artists primarily through word of mouth and sourcebooks—*Directory of Illustration* and *Illustration Work Book.*

Tips ''Looking for high tech/technology in banking; quick turnaround; and new approaches to illustration.''

COMPUTERWORLD

500 Old Connecticut Path, Framingham MA 01701-4573. (508)879-0700. Fax: (508)875-8931. E-mail: stephanie_faucher@computerworld.com. Website: www.computerworld.com. **Art Director:** Stephanie Faucher. Weekly newspaper for information technology leaders. Circ. 180,000. Sample copies and art guidelines available.

Illustration Approached 150 illustrators/year. Buys 2 illustrations/issue. Prefers business/professional. Considers all media. 30% of freelance illustration demands knowledge of Photoshop, FreeHand and QuarkXPress.

Design Needs freelancers for design. Prefers local design freelancers only. 100% of freelance work demands knowledge of Photoshop, FreeHand and QuarkXPress.

First Contact & Terms Send postcard sample or query letter with printed samples. Designers: Send query letter with printed samples and résumé. Accepts disk submissions; EPS files are the best. Samples are filed. Responds only if interested. Art director will contact artist for portfolio review of b&w, color, final art, photographs, tearsheets and transparencies. Buys one-time rights. Pays on publication. Pays $1,000-2,000 for color cover; $100-250 b&w inside; $400-500 for color inside; $300-400 for spots.

Tips ''Send a sample regularly. No phone calls please.''

CONFRONTATION: A LITERARY JOURNAL

English Department, C.W. Post, Brookville NY 11548. (516)299-2720. Fax: (516)299-2735. E-mail: martin.tucker @liu.edu. **Editor:** Martin Tucker. Estab. 1968. Semiannual literary magazine devoted to the short story and poem, for a literate audience open to all forms, new and traditional. Circ. 2,000. Sample copies available for $3. 20% of freelance work demands computer skills.

• *Confrontation* has won a long list of honors and awards from CCLM (now the Council of Literary Magazines and Presses) and NEA grants.

Illustration Approached by 10-15 illustrators/year. Buys 2-3 illustrations/issue. Works on assignment only. Considers pen & ink and collage.

First Contact & Terms Illustrators: Send query letter with SASE and photocopies. Samples are not filed and are returned by SASE. Responds in 2 months only if interested. Rights purchased vary according to project. Pays on publication; $50-100 for b&w, $100-250 for color cover; $25-50 for b&w, $50-75 for color inside; $25-75 for spots.

COOK COMMUNICATIONS MINISTRIES

4050 Lee Vance View, Colorado Springs CO 80918-7100. (719)536-0100. Website: www.cookministries.org. **Creative Director:** Randy Maid. Publisher of teaching booklets, books, take home papers for Christian market, ''all age groups.'' Art guidelines available for SASE with first-class postage only. No samples returned without SASE.

Illustration Buys about 10 full-color illustrations/month. Has featured illustrations by Richard Williams, Chuck

Hamrick, Ron Diciani. Assigns 5% of illustrations to new and emerging illustrators. Features realistic illustration; Bible illustration; computer and spot illustration.

First Contact & Terms Illustrators: Send tearsheets, color photocopies of previously published work; include self-promo pieces. No samples returned unless requested and accompanied by SASE. Work on assignment only. **Pays on acceptance**; $400-700 for color cover; $150-250 for b&w inside; $250-400 for color inside; $500-800 for 2-page spreads; $50-75 for spots. Considers complexity of project, skill and experience of artist and turn-around time when establishing payment. Buys all rights.

Tips "We do not buy illustrations or cartoons on speculation. Do *not* send book proposals. We welcome those just beginning their careers, but it helps if the samples are presented in a neat and professional manner. Our deadlines are generous but must be met. Fresh, dynamic, the highest of quality is our goal; art that appeals to everyone from preschoolers to senior citizens; realistic to humorous, all media."

COPING WITH CANCER

P.O. Box 682268, Franklin TN 37068. (615)790-2400. Fax: (615)794-0179. E-mail: editor@copingmag.com. Website: www.copingmag.com. **Editor:** Julie McKenna. Estab. 1987. "*Coping with Cancer* is a bimonthly, nationally-distributed consumer magazine dedicated to providing the latest oncology news and information of greatest interest and use to its readers. Readers are cancer survivors, their loved ones, support group leaders, oncologists, oncology nurses and other allied health professionals. The style is very conversational and, considering its sometimes technical subject matter, quite comprehensive to the layman. The tone is upbeat and generally positive, clever and even humorous when appropriate, and very credible." Circ. 80,000. Accepts previously published artwork. Originals returned at job's completion. Sample copy available for $3. Art guidelines for SASE with first-class postage.

COSMO GIRL

224 W. 57th St., 3rd Floor, New York NY 10019-3212. (212)649-3852. Fax: (212)489-9664. Website: www.cosmo girl.com. **Contact:** Art Department. Estab. 1996. Monthly 4-color consumer magazine designed as a cutting-edge lifestyle publication exclusively for teenage girls. Circ. 1.5 million.

Illustration Approached by 350 illustrators/year. Buys 6-10 illustrations/issue. Has featured illustrations by Annabelle Verhoye, Kareem Iliya, Balla Pilar, Berto Martinez, Marc Stuwe, Chuck Gonzales and Marie Perron. Features caricatures of celebrities and music groups, fashion, humorous and spot illustration. Preferred subjects teens. Assigns 10% of illustrations to well-known or "name" illustrators; 80% to experienced but not well-known illustrators; 10% to new and emerging illustrators.

First Contact & Terms Illustrators: Send postcard sample and follow-up postcard every 6 months. Samples are filed. Responds only if interested. Buys first rights. **Pays on acceptance.** Pay varies. Finds illustrators through sourcebooks and samples.

COSMOPOLITAN

The Hearst Corp., 224 W. 57th St., New York NY 10019-3299. (212)649-3570. Fax: (212)581-6792. E-mail: jlanuza@hearst.com. Website: www.cosmopolitan.com. **Art Director:** John Lanuza. Associate Art Director: Theresa Izzilo. Estab. 1886. Monthly 4-color consumer magazine for contemporary women covering a broad range of topics including beauty, health, fitness, fashion, relationships and careers. Circ. 3,021,720.

Illustration Approached by 300 illustrators/year. Buys 10-12 illustrations/issue. Has featured illustrations by Marcin Baranski and Aimee Levy. Features beauty, humorous and spot illustration. Preferred subjects women and couples. Prefers trendy fashion palette. Assigns 5% of illustrations to new and emerging illustrators.

First Contact & Terms Illustrators: Send postcard sample and follow-up postcard every 4 months. Samples are filed. Responds only if interested. Buys first North American serial rights. **Pays on acceptance**; $1,000 minimum for 2-page spreads; $450-650 for spots. Finds illustrators through sourcebooks and artists' promotional samples.

Ⓝ COUSTEAU KIDS

(formerly Dolphin Log), Weekly Reader Corp., 200 First Stamford Pl., Stamford CT 06902. (757)772-9300. Fax: (757)722-8185. E-mail: mnorkin@wrc-ccp.com. **Editor:** Melissa Norkin. Group Design Director: Richard Ciotti. Bimonthly 4-color educational magazine for children ages 8-12 covering "all areas of science, natural history, marine biology, ecology, and the environment as they relate to our global water system." 20-pages, 8×10 trim size. Circ. 80,000. Sample copy for $2.50 and 9×12 SASE with 3 first-class stamps; art guidelines for letter-sized SASE with first-class postage.

● Editor Melissa Norkin told AGDM that the Cousteau Society and Weekly Reader teamed up to relaunch the society's magazine. The redesign includes plenty of fresh and lively illustration styles to appeal to kids.

Illustration Buys approximately 4 illustrations/year. Uses simple, biologically and technically accurate line drawings and scientific illustrations. "*Never* uses art that depicts animals dressed or acting like people. Subjects should be carefully researched." Prefers pen & ink, airbrush and watercolor.

First Contact & Terms Illustrators: Send query letter with tearsheets and photocopies showing art style. ''No portfolios. We review only tearsheets and/or photocopies. No original artwork, please.'' Buys one-time rights and worldwide translation rights for inclusion in other Cousteau Society publications and the right to grant reprints for use in other publications. Pays on publication; $25-200 for color inside.

Tips ''We usually find artists through their submissions/promotional materials and in sourcebooks. Artists should first request a sample copy to familiarize themselves with our style. Send only art that is both water-oriented and suitable for children.''

CRAFTS 'N THINGS

2400 Devon, Suite 375, Des Plaines IL 60018-4618. (847)635-5800. Fax: (847)635-6311. Website: www.craftidea s.com. **President and Publisher:** Marie Clapper. Estab. 1975. General crafting magazine published 8 times yearly. Circ. 200,000. Sample copies available. Art guidelines for SASE with first-class postage.

- *Crafts 'n Things* is a ''how to'' magazine for crafters. The magazine is open to crafters submitting designs and step-by-step instruction for projects such as Christmas ornaments, cross-stitched pillows, knitted or crocheted items and quilts. They do not buy cartoons and illustrations. This publisher also publishes other craft titles including *Cross Stitcher* and *Pack-O-Fun*.

Design Needs freelancers for design.

First Contact & Terms Designers: Send query letter with photographs. Pays by project $50-300. Finds artists through submissions.

Tips ''Our designers work freelance. Send us photos of your *original* craft designs with clear instructions. Skill level should be beginning to intermediate. We concentrate on general crafts and needlework. Call or write for submission guidelines.''

CRICKET

Box 300, Peru IL 61354-0300. Website: www.cricketmag.com. **Senior Art Director:** Ron McCutchan. Estab. 1973. Monthly magazine emphasizes children's literature for children ages 10-14. Design is fairly basic and illustration-driven; full-color with 2 basic text styles. Circ. 65,000. Original artwork returned after publication. Sample copy $4.95 plus 10% of total order ($4 minimum) for shipping and handling; art guidelines available on website or for SASE with first-class postage.

Cartoons ''We rarely run cartoons.''

Illustration Approached by 800-1,000 illustrators/year. Works with 75 illustrators/year. Buys 600 illustrations/ year. Has featured illustrations by Trina Schart Hyman, Kevin Hawkes and Deborah Nourse Lattimore. Assigns 25% to new and emerging illustrators. Uses artists mainly for cover and interior illustration. Prefers realistic styles (animal or human figure), but ''we're also looking for humorous, folkloric and nontraditional styles.'' Works on assignment only.

First Contact & Terms Illustrators: Send query letter with SASE and samples to be kept on file, ''if I like it.'' Prefers photocopies and tearsheets as samples. Samples not kept on file are returned by SASE. Responds in 6 weeks. Does not want to see ''overly slick, cute commercial art (i.e., licensed characters and overly sentimental greeting cards).'' Buys all rights. Pays 45 days from receipt of final art; $750 for color cover; $50-150 for b&w inside; $75-250 for color inside; $250-350 for 2-page spreads; $50-75 for spots.

Tips ''We are trying to focus *Cricket* at a slightly older, preteen market. Therefore we are looking for art that is less sweet and more edgy and funky. Since a large proportion of the stories we publish involve people, particularly children, *please* try to include several samples with *faces* and full figures in an initial submission (that is, if you are an artist who can draw the human figure comfortably). It's also helpful to remember that most children's publishers need artists who can draw children from many different racial and ethnic backgrounds. Know how to draw the human figure from all angles, in every position. Send samples that tell a story (even if there is no story); art should be intriguing.''

DECORATIVE ARTIST'S WORKBOOK

4700 E. Galbraith Rd., Cincinnati OH 45236. E-mail: joan.heiob@fwpubs.com. **Contact:** Joan Heiob, art director. Estab. 1987. ''A step-by-step bimonthly decorative painting workbook. The audience is primarily female; slant is how-to.'' Circ. 89,000. Does not accept previously published artwork. Original artwork is returned at job's completion. Sample copy available for $4.65; art guidelines not available.

Illustration Buys occasional illustration; 1/year. Works on assignment only. Features humorous, realistic and spot illustration. Assigns 50% of illustrations to experienced but not well-known illustrators; 50% to new and emerging illustrators. Prefers realistic styles. Prefers pen & ink, watercolor, airbrush, acrylic, colored pencil, mixed media, pastel and digital art.

First Contact & Terms Send postcard sample or query letter with tearsheets. Accepts disk submissions compatible with the major programs. Send EPS or TIFF files. Samples are filed. Responds only if interested. Buys first or one-time rights. Pays on publication; $50-100 for b&w inside; $100-350 for color inside.

DELAWARE TODAY MAGAZINE

3301 Lancaster Pike, Suite 5C, Wilmington DE 19805-1436. (302)656-1809. Fax: (302)656-5843. E-mail: kcarter @delawaretoday.com. Website: www.delawaretoday.com. **Creative Director:** Kelly Carter. Monthly 4-color magazine emphasizing regional interest in and around Delaware. Features general interest, historical, humorous, interview/profile, personal experience and travel articles. "The stories we have are about people and happenings in and around Delaware. Our audience is middle-aged (40-45) people with incomes around $79,000, mostly educated. We try to be trendy in a conservative state." Circ. 25,000. Needs computer-literate freelancers for illustration.

Cartoons Works on assignment only.

Illustration Buys approximately 3-4 illustrations/issue. Has featured illustrations by Nancy Harrison, Tom Deja, Wendi Koontz, Craig LaRontonda and Jacqui Oakley. "I'm looking for different styles and techniques of editorial illustration!" Works on assignment only. Open to all styles.

First Contact & Terms Cartoonists: Do not send gaglines. Do not send folders of pre-drawn cartoons. Illustrators: Send postcard sample. "Will accept work compatible with QuarkXPress 7.5/version 4.0. Send EPS or TIFF files (RGB)." Send printed color promos. Samples are filed. Responds only if interested. Publication will contact artist for portfolio review if interested. Portfolio should include printed samples, color or b&w tearsheets and final reproduction/product. Pays on publication; $200-400 for cover; $100-150 for inside. Buys first rights or one-time rights. Finds artists through submissions and self-promotions.

Tips "Be conceptual, consistent and flexible."

DELICIOUS LIVING MAGAZINE

1401 Pearl St., Boulder CO 80302. (303)939-8440. Fax: (303)440-9020. E-mail: delicious@newhope.com. Website: www.deliciouslivingmag.com. **Art Director:** Vicki Hopewell. Estab. 1984. Monthly magazine distributed through natural food stores focusing on health, natural living, alternative healing. Circ. 400,000 guaranteed. Sample copies available.

Illustration Approached by hundreds of illustrators/year. Buys approximately 1 illustration/issue. Prefers positive, healing-related and organic themes. Considers acrylic, collage, color washed, mixed media, pastel. 30% of illustration demands knowledge of Photoshop and Illustrator.

Design Needs freelancers for design, production. Prefers local designers with experience in QuarkXPress, Illustrator, Photoshop and magazines/publishing. 100% of freelance work demands knowledge of Photoshop, Illustrator, QuarkXPress.

First Contact & Terms Illustrators: Send postcard sample, query letter with printed samples, tearsheets. Send follow-up postcard sample every 6 months. Designers: Send query letter with printed samples, photocopies, tearsheets and résumé. Accepts disk submissions compatible with QuarkXPress 3.32 (EPS or TIFF files). Samples are filed and are not returned. Art director will contact artist for portfolio review of color, final art, photographs, photostats, tearsheets, transparencies, color copies. Rights purchased vary according to project. **Pays on acceptance.** Pays illustrators $1,000 maximum for color cover; $250-700 for color inside; $250 for spots. Finds illustrators through *Showcase Illustration*, SIS, magazines and artist's submissions.

Tips "We like our people and designs to have a positive and upbeat outlook. Illustrators must be able to illustrate complex health articles well and have great concepts with single focus images."

DERMASCOPE

Geneva Corporation, 2611 N. Belt Line Rd., Suite 101, Sunnyvale TX 75182. (972)226-2309. Fax: (972)226-2339. E-mail: willstrunk@dermascope.com. Website: www.dermascope.com. **Production Manager:** Will Strunk. Estab. 1978. Monthly magazine/trade journal, 128-page magazine for aestheticians, plastic surgeons and stylists. Circ. 15,000. Sample copies and art guidelines available.

Illustration Approached by 5 illustrators/year. Prefers illustrations of "how-to" demonstrations. Considers all media. 100% of freelance illustration demands knowledge of Photoshop, Illustrator, QuarkXPress, Fractil Painter.

First Contact & Terms Accepts disk submissions. Samples are not filed. Responds only if interested. Rights purchased vary according to project. Pays on publication.

N DETROIT FREE PRESS MAGAZINE

600 W. Fort St., Detroit MI 48226. (313)222-6600. Fax: (313)222-5981. **Art Director:** Steve Dorsey. Weekly 4-color Sunday magazine of major metropolitan daily newspaper emphasizing general subjects. "The third largest newspaper magazine in the country." Circ. 1.1 million. Original artwork returned after publication. Sample copy available for SASE. 10% of freelance work demands knowledge of QuarkXPress, FreeHand or Illustrator.

Illustration Buys 2-3 illustrations/issue. Uses a variety of themes and styles, "but we emphasize fine art over cartoons." Works on assignment only.

First Contact & Terms Send query letter with samples to be kept on file unless not considered for assignment.

Send "whatever samples best show artwork and can fit into 8½×11 file folder." Samples not filed are not returned. Responds only if interested. Buys first rights. Pays on publication; fees vary, depending on size.

N DISCOVERIES

6401 The Paseo, Kansas City MO 64131. (816)333-7000. Fax: (816)333-4439. E-mail: sweatherwax@nazarene.o rg. **Editor:** Virginia L. Folsom. Estab. 1974. Weekly 4-color story paper; "for 8-10 year olds of the Church of the Nazarene and other holiness denominations. Material is based on everyday situations with Christian principles applied." Circ. 40,000. Originals are not returned at job's completion. Sample copies and guidelines for SASE with first-class postage.

Cartoons Approached by 15 cartoonists/year. Buys 52 cartoons/year. "Cartoons need to be humor for children—not about them." Spot cartoons only. Prefers artwork with children and animals; single panel.

First Contact & Terms Cartoonists: Send finished cartoons. Samples not filed are returned by SASE. Responds in 2 months. Buys all rights. Pays $15 for b&w.

Tips No "fantasy or science fiction situations or children in situations not normally associated with Christian attitudes or actions."

N DREAMS OF DECADENCE

P.O. Box 2988, Radford VA 24143-2988. (540)639-4288. Fax (540)639-4289. E-mail: customerservice@dnapublic ations.co. Website: www.dnapublications.com/dreams. **Art Director:** Angela Kessler. Estab. 1995. Quarterly, 4-color b&w interior literary gothic fiction zine. Circ. 3,000. Sample copies and art guidelines available.

Illustration Approached by 10 illustrators/year. Buys 15 illustrations/issue. Has featured illustrations by Lee Seed, Lori Albrech and Marianne Plumridge Eggleton. Features realistic and moody gothic illustrations for fiction pieces. Prefers bright colors for covers and pen & ink for interiors. Assigns 75% of illustrations to experienced, but not well-known illustrators; 25% to new and emerging illustrators.

First Contact & Terms Illustrators: Send query letter with photocopies or tearsheets. Samples are filed. Will contact artist for portfolio review if interested. Buys first rights and reprint rights. Pays $100-300 for color cover; $10-50 for b&w inside; $5 for spots. Finds illustrators through samples.

Tips "You are only as good as your weakest piece. We need quick turnaround and we do need new artists."

THE EAST BAY MONTHLY

1301 59th St., Emeryville CA 94608. (510)658-9811. Fax: (510)658-9902. E-mail: artdirector@themonthly.com. **Art Director:** Andreas Jones. Estab. 1970. Consumer monthly tabloid; b&w with 4-color cover. Editorial features are general interests (art, entertainment, business owner profiles) for an upscale audience. Circ. 80,000. Accepts previously published artwork. Originals returned at job's completion. Sample copy and guidelines for SASE with 5 oz. first-class postage. No nature or architectural illustrations.

Cartoons Approached by 75-100 cartoonists/year. Buys 3 cartoons/issue. Prefers single panel, b&w line drawings; "any style, extreme humor."

Illustration Approached by 150-200 illustrators/year. Buys 2 illustrations/issue. Prefers pen & ink, watercolor, acrylic, colored pencil, oil, charcoal, mixed media and pastel.

Design Occasionally needs freelancers for design and production. 100% of freelance design requires knowledge of PageMaker, Macromedia FreeHand, Photoshop, QuarkXPress, Illustrator and InDesign.

First Contact & Terms Cartoonists: Send query letter with finished cartoons. Illustrators: Send postcard sample or query letter with tearsheets and photocopies. Designers: Send query letter with résumé, photocopies or tearsheets. Accepts submissions on disk, Mac compatible with Macromedia FreeHand, Illustrator, Photoshop, PageMaker, QuarkXPress or InDesign. Samples are filed or returned by SASE. Responds only if interested. Write for appointment to show portfolio of thumbnails, roughs, b&w tearsheets and slides. Buys one-time rights. Pays cartoonists $35 for b&w. Pays illustrators $100-200 for b&w inside; $25-50 for spots. Pays 15 days after publication. Pays for design by project.

N ELECTRICAL APPARATUS

Barks Publications, Inc., Chicago IL 60611-4198. (312)321-9440. Fax: (312)321-1288. E-mail: eamagazine@aol.c om. Website: www.eamagazine.com. **Senior Editor:** Kevin Jones. Estab. 1948. Monthly 4-color trade journal emphasizing industrial electrical/mechanical maintenance. Circ. 16,000. Original artwork not returned at job's completion. Sample copy $4.

Cartoons Approached by several cartoonists/year. Buys 3-4 cartoons/issue. Has featured illustrations by Joe Buresch, Martin Filchock, James Estes, John Paine, Bernie White and Mark Ziemann. Prefers themes relevant to magazine content; with gagline. "Captions are edited in our style."

Illustration "We have staff artists, so there is little opportunity for freelance illustrators, but we are always glad to hear from anyone who believes he or she has something relevant to contribute."

First Contact & Terms Cartoonists: Send query letter with roughs and finished cartoons. "Anything we don't use is returned." Responds in 3 weeks. Buys all rights. Pays $15-20 for b&w and color.

Tips "We prefer single-panel cartoons that portray an industrial setting, ideally with an electrical bent. We also use cartoons with more generic settings and tailor the gaglines to our needs."

[N] EMERGENCY MEDICINE MAGAZINE

7 Century Dr., Suite 302, Parsippany NJ 07054-4603. (800)480-4851. Website: www.emedmag.com. **Art Director:** Karen Blackwood. Estab. 1969. Emphasizes emergency medicine for primary care physicians, emergency room personnel, medical students. Monthly. Circ. 140,000. Returns original artwork after publication. Art guidelines not available.

Illustration Works with 10 illustrators/year. Buys 1-2 illustrations/issue. Has featured illustrations by Brian Evans, Craig Zuckerman and Steve Oh. Features realistic, medical and spot illustration. Assigns 70% of illustrations to well-known or "name" illustrators; 30% to experienced, but not well-known illustrators. Works on assignment only.

First Contact & Terms Send postcard sample or query letter with brochure, photocopies, photographs, tearsheets to be kept on file. Samples not filed are not returned. Accepts disk submissions. To show a portfolio, mail appropriate materials. Responds only if interested. Buys first rights. Pays $1,000-1,500 for color cover; $200-500 for b&w inside; $500-1,000 for color inside; $250-600 for spots.

ENTREPRENEUR MAGAZINE

2445 McCabe Way, Suite 400, Irvine CA 92614-6244. (949)261-2325. Fax: (949)261-0234. Website: www.entrepreneur.com. **Creative Director:** Mark Kozak. Design Director: Richard Olson. Estab. 1978. Monthly 4-color magazine offers how-to information for starting a business, plus ongoing information and support to those already in business. Circ. 575,000.

Illustration Approached by 500 illustrators/year. Buys 15-20 illustrations/issue. Has featured illustrations by Peter Crowther, Adam McCauley, J.T. Morrow, Simone Tieber, Scott Menchin and Victor Gad. Features computer, humorous and spot illustration and charts and graphs. Themes are business, financial and legal. Needs editorial illustration, "some serious, some humorous depending on the article. Illustrations are used to grab readers' attention."

First Contact & Terms Send nonreturnable postcard samples and follow-up postcard every 4 months or query letter with printed samples and tearsheets. Accepts Mac-compatible disk submissions. Send EPS files. Samples are filed and not returned. Will contact artist for portfolio review if interested. Buys one-time rights. **Pays on acceptance**; $700 for full-page spread; $425-500 for spots. Finds freelancers through samples, mailers, *Work Book*, SIS and artist reps.

Tips "We want illustrators that are creative, clean and have knowledge of business concepts. We are always open to new talent."

ENVIRONMENT

1319 18th St. NW, Washington DC 20036-1802. (202)296-6267, ext. 237. Fax: (202)296-5149. E-mail: env@heldref.org. Website: www.heldref.org. **Editorial Assistant:** Melanie Papasian. Estab. 1958. Emphasizes national and international environmental and scientific issues. Readers range from "high school students and college undergrads to scientists, business and government leaders, and college and university professors." 4-color magazine with "relatively conservative" design. Published 10 times/year. Circ. 7,500. Original artwork returned after publication. Sample copy $10.90.

Cartoons Buys 1-2 cartoons/year. Receives 5 submissions/week. Interested in single panel line drawings or b&w washes with or without gagline.

First Contact & Terms Cartoonists: Send finished cartoons and SASE. Buys first North American serial rights. Pays on publication; $50 for b&w cartoon.

Tips "Regarding cartoons, we prefer witty or wry comments on the impact of humankind on the environment. Stay away from slapstick humor."

ESQUIRE

1790 Broadway, New York NY 10019. (212)649-4020. Fax: (212)977-3158. Website: www.esquire.com. **Contact:** Design Director. Contemporary culture magazine for men ages 28-40 focusing on current events, living trends, career, politics and the media. Estab. 1933. Circ. 750,000.

First Contact & Terms Illustrators: Send postcard mailers. Drop off portfolio on Wednesdays for review.

EXECUTIVE FEMALE

60 East 42nd St., Suit 2700, New York NY 10165. (212)351-6450. Fax: (212)351-6486. E-mail: nafe@nafe.com. Website: www.nafe.com. **Contact:** Art Director. Estab. 1972. Association magazine for National Association

for Female Executives, 4-color. "Get-ahead guide for women executives, which includes articles on managing employees, personal finance, starting and running a business." Circ. 125,000. Accepts previously published artwork. Original artwork is returned after publication.

Illustration Buys illustrations mainly for spots and feature spreads. Buys 7 illustrations/issue. Works on assignment only. Send samples (not returnable).

First Contact & Terms Samples are filed. Responds only if interested. Buys first or reprint rights. Pays on publication; $100-800.

N FAMILY CIRCLE

Dept. AGDM, 375 Lexington Ave., New York NY 10017-5514. (212)499-2000. Website: www.familycircle.com. **Art Director:** David Wolf. Circ. 7,000,000. Supermarket-distributed publication for women/homemakers covering areas of food, home, beauty, health, child care and careers. 17 issues/year. Does not accept previously published material. Original artwork returned after publication.

Illustration Buys 2-3 illustrations/issue. Works on assignment only.

First Contact & Terms Provide query letter with nonreturnable samples or postcard sample to be kept on file for future assignments. Do not send original work. Prefers transparencies, postcards or tearsheets as samples. Responds only if interested. Prefers to see finished art in portfolio. Submit portfolio by appointment. All art is commissioned for specific magazine articles. Negotiates rights. **Pays on acceptance.**

N FAMILY TIMES PUBLICATIONS

P.O. Box 16422, St. Louis Park MN 55416. (952)922-6186. Fax: (952)922-3637. E-mail: aobrien@familytimesinc. com. Website: www.familytimesinc.com. **Editor/Art Director:** Annie O-Brien. Estab. 1991. Bimonthly tabloid. Circ. 60,000. Sample copies available with SASE. Art guidelines available—call for guidelines.

• Publishes *Family, Senior, Grandparent* and *Baby Times.*

Illustration Approached by 6 illustrators/year. Buys 33 illustrations/year. Has featured illustrations by primarily local illustrators. Preferred subjects: children, families, teen. Preferred all media. Assigns 2% of illustrations to new and emerging illustrators. Freelancers should be familiar with Illustrator, Photoshop. E-mail submissions accepted with link to website, accepted with image file at 72 dpi. Mac-compatible. Prefers JPEG. Samples are filed. Responds only if interested. Portfolio not required. Company will contact artist for portfolio review if interested. Pays illustrators $300 for color cover, $100 for b&w inside, $225 for color inside. Pays on publication. Buys one-time rights, electronic rights. Finds freelancers through artists' submissions, sourcebooks, online.

First Contact & Terms Illustrators: Send query letter with b&w/color photocopies or e-mail.

Tips "Looking for fresh, family friendly styles and creative sense of interpretation of editorial."

FASHION ACCESSORIES

P.O. Box 859, Mahwah NJ 07430. (201)684-9222. Fax: (201)684-9228. **Publisher:** Sam Mendelson. Estab. 1951. Monthly trade journal; tabloid; emphasizing costume jewelry and accessories. Publishes both 4-color and b&w. Circ. 9,500. Accepts previously published artwork. Original artwork is returned to the artist at the job's completion. Sample copies for $3.

Illustration Works on assignment only. Needs editorial illustration. Prefers mixed media. Freelance work demands knowledge of QuarkXPress.

First Contact & Terms Illustrators: Send query letter with brochure and photocopies. Samples are filed. Responds in 1 month. Portfolio review not required. Rights purchased vary according to project. **Pays on acceptance**; $50-100 for b&w cover; $100-150 for color cover; $50-100 for b&w inside; $100-150 for color inside.

FAST COMPANY

375 Lexington Ave., 8th Floor, New York NY 10017-5644. (212)499-2000. Fax: (212)389-5496. E-mail: rrees@fas tcompany.com. Website: www.fastcompany.com. **Art Director:** Dean Markadakis. Deputy Art Director Lisa Kelsey. Estab. 1996. Monthly cutting edge business publication supplying readers with tools and strategies for business today. Circ. 734,500.

Illustration Approached by "tons" of illustrators/year. Buys approximately 20 illustrations/issue. Has used illustrations by Bill Mayer, Ward Sutton and David Cowles. Considers all media.

First Contact & Terms Illustrators: Send postcard sample or printed samples, photocopies. Accepts disk submissions compatible with QuarkXPress for Mac. Send EPS files. Send all samples to the attention of Julia Moburg. Samples are filed and not returned. Responds only if interested. Rights purchased vary according to project. **Pays on acceptance**, $300-1,000 for color inside; $300-500 for spots. Finds illustrators through submissions, illustration annuals, *Workbook* and *Alternative Pick*

⟦N⟧ FAULTLINE

Department of English and Comparative Literature, Irvine CA 92697-2650. E-mail: faultline@uci.edu. Website: www.humanities.uci.edu/faultline. **Creative Director:** Sara Joyce Robinson and Lisa P. Sutton (2004-05 rotating director).

● Even though this is not a paying market, this high-quality literary magazine would be an excellent place for fine artists to gain exposure. Postcard samples with a website address are the best way to show us your work.

FEDERAL COMPUTER WEEK

3141 Fairview Park Dr., Suite 777, Falls Church VA 22042. (703)876-5131. Fax: (703)876-5126. E-mail: jeffrey_langkau@fcw.com. Website: www.fcw.com. **Art Director:** Jeff Langkau. Estab. 1987. Four-color trade publication for federal, state and local government information technology professionals. Circ. 120,000.

Illustration Approached by 50-75 illustrators/year. Buys 5-6 illustrations/month. Features charts & graphs, computer illustrations, informational graphics, spot illustrations of business subjects. Assigns 5% of illustrations to well-known or "name" illustrators; 85% to experienced but not well-known illustrators; 10% to new and emerging illustrators.

First Contact & Terms Illustrators: Send postcard or other nonreturnable samples. Accepts Mac-compatible disk submissions. Samples are filed. Will contact artist for portfolio review if interested. Rights purchased vary according to project. Pays $800-1,200 for color cover; $600-800 for color inside; $200 for spots. Finds illustrators through samples and sourcebooks.

Tips "We look for people who understand 'concept' covers and inside art and very often have them talk directly to writers and editors."

FIFTY SOMETHING MAGAZINE

1168 Beachview, Willoughby OH 44094. (440)951-2468. Fax: (440)951-1015. **Editor:** Linda L. Lindeman-De-Carlo. Estab. 1990. Quarterly magazine; 4-color. "We cater to the fifty-plus age group with upbeat information, feature stories, travel, romance, finance and nostalgia." Circ. 25,000. Accepts previously published artwork. Original artwork is returned at the job's completion. Sample copies for SASE, 10×12, with $1.37 postage.

Cartoons Approached by 50 cartoonists/year. Buys 3 cartoons/issue. Prefers funny issues on aging. Prefers single panel b&w line drawings with gagline.

Illustration Approached by 50 illustrators/year. Buys 2 illustrations/issue. Prefers old-fashioned, nostalgia. Considers all media.

First Contact & Terms Cartoonists: Send query letter with brochure, roughs and finished cartoons. Illustrators: Send query letter with brochure, photographs, photostats, slides and transparencies. Samples are filed. Responds only if interested. To show a portfolio, mail thumbnails, printed samples, b&w photographs, slides and photocopies. Buys one-time rights. Pays on publication. Pays cartoonists $10, b&w and color. Pays illustrators $25 for b&w, $100 for color cover; $25 for b&w, $75 for color inside.

FILIPINAS MAGAZINE

1580 Bryant St., Daly City CA 94015. (650)985-2535. Fax: (650)985-2532. E-mail: r.virata@filipinasmag.com. Website: www.filipinasmag.com. **Art Director:** Raymond Virata. Estab. 1992. Monthly magazine "covering issues of interest to Filipino Americans and Filipino immigrants." Circ. 30,000. Sample copies free for 9×12 SASE and $1.70. Contact Art Director for information.

Cartoons Buys 1 cartoon/issue. Prefers work related to Filipino/Filipino-American experience. Prefers single panel, humorous, b&w washes and line drawings with or without gagline.

Illustration Approached by 5 illustrators/year. Buys 1-3 illustrations/issue. Considers all media.

First Contact & Terms Cartoonists/Illustrators: Send query letter with photocopies. Accepts disk submissions compatible with Mac, QuarkXPress 4.1, Photoshop 6, Illustrator 7; include any attached image files (TIFF or EPS) or fonts. Samples are filed. Responds only if interested. Pays on publication. Pays cartoonists $25 minimum. Pays illustrators $100 minimum for cover; $25 minimum for inside. Buys all rights.

Tips "Read our magazine."

⟦N⟧ FIRST FOR WOMEN

270 Sylvan Ave., Englewood Cliffs NJ 07632. (201)569-6699. Fax: (201)569-6264. Website: www.ffwmarket.com. **Art Director:** Lisa Vibronek. Estab. 1988. Mass market consumer magazine for the younger woman published every 3 weeks. Circ. 1.4 million. Originals returned at job's completion. Sample copies and art guidelines not available.

Cartoons Buys 10 cartoons/issue. Prefers women's issues. Prefers humorous cartoons; single panel b&w washes and line drawings.

Illustration Approached by 100 illustrators/year. Buys 1 illustration/issue. Works on assignment only. Preferred themes are humorous, sophisticated women's issues. Considers all media.

First Contact & Terms Cartoonists: Send query letter with photocopies. Illustrators: Send query letter with any sample or promo we can keep. Samples are filed. Responds only if interested. Publication will contact artist for portfolio review if interested. Buys one-time rights. **Pays on acceptance.** Pays cartoonists $150 for b&w. Pays illustrators $200 for b&w, $300 for color inside. Finds artists through promo mailers and sourcebooks.

Tips Uses humorous or conceptual illustration for articles where photography won't work. "Use the mail—no phone calls please."

N FITNESS MAGAZINE

375 Lexington Ave., New York NY 10017.212-499-2000. Website: www.fitnessmagazine.com. Monthly. Consumer magazine. For women in their twenties and thirties interested in fitness and living a healthy life. Circ. 1,003,133.

Cartoons Approached by 500 cartoonists/year. Buys 5 cartoons/year. Format: single panel.

Illustration Approached by 500 illustrators/year. Buys 5 illustrations/year. Features caricatures of celebrities/politicians. Preferred subjects: children, families, men, women, pets. E-mail submissions accepted with link to website, accepted with image file at 72 dpi. Prefers TIFF, JPEG. Samples are filed. If not filed, samples are not returned. Responds only if interested. Portfolio not required. Portfolio should include b&w, color. Pays cartoonists $200 for b&w cartoons. Pays illustrators $100-300 for color cover, $150-450 for color inside. Pays on publication. Buys first rights. Finds freelancers through sourcebooks, promotional samples.

First Contact & Terms Cartoonists: After introductory mailing, send follow-up postcard every 4 months. Illustrators: Send postcard sample. After introductory mailing, send follow-up postcard every 4 months.

N FOCUS ON THE FAMILY

8605 Explorer Dr., Colorado Springs CO 80920-1051. (719)531-3400. Fax: (719)531-3499. Website: www.family.org. **Senior Art Director:** Mike Harrigan. Estab. 1977. Publishes magazines. Specializes in religious-Christian. Circ. 2,700,000. Publishes 9 titles/year.

Needs Approached by 100 illustrators and 12 designers/year. Works with illustrators from around the US. Prefers designers experienced in Macintosh. Uses designers mainly for periodicals, publication design/production. 100% of design and 20% illustration demands knowledge of FreeHand, Photoshop, Illustrator and QuarkXPress.

First Contact & Terms Send query letter with photocopies, printed samples, résumé, SASE and tearsheets portraying family themes. Send follow-up postcard every year. Samples are filed. Responds in 2 weeks. Will contact artist for portfolio review of photocopies of artwork portraying family themes if interested. Buys first, one-time or reprint rights. Finds freelancers through agents, sourcebooks and submissions.

Text Illustration Assigns 150 illustration jobs/year. Pays by project. Prefers realistic, abstract, cartoony styles.

FOLIO MAGAZINE

Primedia, Inc., 249 W. 17th St., 3rd Floor, New York NY 10011. (212)462-3608. E-mail: bmoran@primediabusiness.com. Website: www.foliomag.com. **Art Director:** Brendan Moran. Trade magazine covering the magazine publishing industry. Circ. 9,380. Sample copies for SASE with first-class postage.

Illustration Approached by 200 illustrators/year. Buys 150-200 illustrations/year. Works on assignment only. Artists' online galleries welcome in lieu of portfolio.

First Contact & Terms Illustrators: Send postcard samples and/or photocopies or other appropriate samples. No originals. Samples are filed and returned by SASE if requested by artist. Responds only if interested. Call for appointment to show portfolio of tearsheets, slides, final art, photographs and transparencies. Buys one-time rights. Pays by the project.

Tips "Art director likes to see printed 4-color and b&w sample illustrations. Do not send originals unless requested. Computer-generated illustrations are used but not always necessary. Charts and graphs must be Macintosh-generated."

FORBES MAGAZINE

60 Fifth Ave., New York NY 10011. (212)620-2200. E-mail: bmansfield@forbes.com. **Art Director:** Robert Mansfield. Five associate art directors. Established 1917. Biweekly business magazine read by company executives and those who are interested in business and investing. Circ. 950,000. Art guidelines not available.

Illustration Assigns 20% of illustrations to new and emerging illustrators.

First Contact & Terms "Assignments are made by one of the art directors. We do not use, nor are we liable for, ideas or work that a Forbes art director didn't assign. We prefer contemporary illustrations that are lucid and convey an unmistakable idea with wit and intelligence. No cartoons please. Illustration art must be rendered on a material and size that can be separated on a drum scanner or submitted digitally. We are prepared to

receive art on zip, scitex, CD, floppy disk, or downloaded via e-mail. Discuss the specifications and the fee before you accept the assignment. **Pays on acceptance** whether reproduced or not. Pays up to $3,000 for a cover assignment and an average of $450 to $700 for an inside illustration depending on complexity, time and the printed space rate. Dropping a portfolio off is encouraged. Deliver portfolios by 11 a.m. and plan to leave your portfolio for a few hours or overnight. Call first to make sure an art director is available. Address the label to the attention of the Forbes Art Department and the individual you want to reach. Attach your name and local phone number to the outside of the portfolio. Include a note stating when you need it. Robin Regensberg, the art traffic coordinator, will make every effort to call you to arrange for your pickup. Samples: Do not mail original artwork. Send printed samples, scanned samples or photocopies of samples. Include enough samples as you can spare in a portfolio for each person on our staff. If interested, we'll file them. Otherwise they are discarded. Samples are returned only if requested.''

Tips "Look at the magazine to determine if your style and thinking are suitable. The art director and associate art directors are listed on the masthead, located within the first ten pages of an issue. The art directors make assignments for illustration. However, it is important that you include Robert Mansfield in your mailings and portfolio review. We get a large number of requests for portfolio reviews and many mailed promotions daily. This may explain why, when you follow up with a call, we may not be able to acknowledge receipt of your samples. If the work is memorable and we think we can use your style, we'll file samples for future consideration.''

N FOREIGN SERVICE JOURNAL

2101 E St. NW, Washington DC 20037. (202)338-4045. Fax: (202) 338-6820. E-mail: journal@afsa.org. Website: www.afsa.org/fs. **Art Director:** Caryn Suko. Estab. 1924. Monthly magazine emphasizing foreign policy for foreign service employees; 4-color with design in *''Harpers'* style.''* Circ. 13,000. Returns original artwork after publication. Art guidelines available.

Illustration Works with 10 illustrators/year. Buys 35 illustrations/year. Needs editorial illustration. Uses artists mainly for covers and article illustration. Works on assignment only.

First Contact & Terms Illustrators: Send postcard samples. Accepts disk submissions. ''Mail in samples for our files.'' Publication will contact artist for portfolio review if interested. Buys first rights. Pays on publication; $500 for color cover; $100 and up for color inside. Finds artists through sourcebooks.

N FUGUE LITERARY MAGAZINE

200 Brink Hall, University of Idaho, PO Box 441102, Moscow ID 83843. (208)885-6156. E-mail: fugue@uidaho.edu. Website: www.class.uidaho.edu/english/fugue. Estab. 1990. Biannual literary magazine. Circ. 500. Sample copies available for $6. Art guidelines available with SASE.

Illustration Approached by 10 illustrators/year. Buys 1-2 illustrations/year. Has featured illustrations by Sarah Wichlucz, Cori Flowers. Features graphic art. Prefers any color scheme; preferably paintings (in slide form). Freelance illustration demands knowledge of PageMaker and Photoshop.

First Contact & Terms Cartoonists/Illustrators: Send query letter with b&w photocopies, photographs, résumé, SASE and slides. Accepts e-mail submissions with link to website. Prefers Windows-compatible, TIFF or JPEG files. Samples are not filed but are returned by SASE. Responds in 4 months. Company will contact artist for portfolio review if interested. Portfolio should include b&w original art, photographs, slides and thumbnails. **Pays on acceptance.** Buys first North American serial rights.

FUTURIFIC MAGAZINE

Foundation for Optimism, 305 Madison Ave., Suite 1A, New York NY 10165. (212)297-0502. **Publisher:** B. Szent-Miklosy. Monthly b&w publication emphasizing future-related subjects for highly educated, upper income leaders of the community. Previously published material and simultaneous submissions OK. Original artwork returned after publication. Sample copy for SASE with $5 postage and handling.

Cartoons Buys 5 cartoons/year. Prefers positive, upbeat, futuristic themes; no ''doom and gloom.'' Prefers single, double or multiple panel with or without gagline, b&w line drawings.

Illustration Buys 5 illustrations/issue. Prefers positive, upbeat, futuristic themes; no ''doom and gloom.''

First Contact & Terms Cartoonists: Send finished cartoons. Illustrators: Send finished art. Samples returned by SASE. Responds in 1 month. To show a portfolio, walk in. Negotiates rights and payment. Pays on publication.

Tips ''Only optimists need apply. Looking for good, clean art. Interested in future development of current affairs, but not science fiction.''

THE FUTURIST

7910 Woodmont Ave., Suite 450, Bethesda MD 20814. (301)656-8274. Fax: (301)951-0394. Website: www.wfs.org. **Art Director:** Lisa Mathias. Managing Editor: Cynthia Wagner. Emphasizes all aspects of the future for a well-educated, general audience. Bimonthly b&w and color magazine with 4-color cover; ''fairly conservative

design with lots of text.'' Circ. 30,000. Accepts simultaneous submissions and previously published work. Return of original artwork following publication depends on individual agreement.

Illustration Approached by 50-100 illustrators/year. Buys fewer than 10 illustrations/year. Needs editorial illustration. Uses a variety of themes and styles ''usually b&w drawings. We like an artist who can read an article and deal with the concepts and ideas.'' Works on assignment only.

First Contact & Terms Illustrators: Send samples or tearsheets to be kept on file. Accepts disk submissions compatible with QuarkXPress or Photoshop on a Mac platform. Send EPS files. Will contact for portfolio review if interested. Rights purchased negotiable. **Pays on acceptance**; $500-750 for color cover; $75-350 for b&w, $200-400 for color inside; $100-125 for spots.

Tips ''Send samples that are strong conceptually with skilled execution. When a sample package is poorly organized, poorly presented—it says a lot about how the artists feel about their work.'' This publication does not use cartoons.

N̄ GAME & FISH

2250 Newmarket Pkwy., Suite 110, Marietta GA 30067. (770)953-9222. Fax: (770)933-9510. Website: www.gam eandfish.about.com. **Graphic Artist:** Allen Hansen. Estab. 1975. Monthly b&w with 4-color cover. Circ. 575,000 for 30 state-specific magazines. Original artwork is returned after publication. Sample copies available.

Illustration Approached by 50 illustrators/year. Buys illustrations mainly for spots and feature spreads. Buys 1-5 illustrations/issue. Considers pen & ink, watercolor, acrylic and oil.

First Contact & Terms Illustrators: Send query letter with photocopies. ''We look for an artist's ability to realistically depict North American game animals and game fish or hunting and fishing scenes.'' Samples are filed or returned only if requested. Responds only if interested. Portfolio review not required. Buys first rights. Pays 2½ months prior to publication; $25 minimum for b&w inside; $75-100 for color inside.

Tips ''We do not publish cartoons, but we do use some cartoon-like illustrations which we assign to artists to accompany specific humor stories. Send us some samples of your work, showing as broad a range as possible, and let us hold on to them for future reference. Being willing to complete an assigned illustration in a 4-6 week period and providing what we request will make you a candidate for working with us.''

GENTRY MAGAZINE

618 Santa Cruz Ave., Menlo Park CA 94025-4503. (650)324-1818. Fax: (650)324-1888. E-mail: info@18media.c om. Website: www.18media.com. **Art Director:** Lisa Duri. Estab. 1994. Monthly community publication for affluent audience of designers and interior designers. Circ. 35,000. Sample copies and art guidelines available for 9×10 SASE.

Cartoons Approached by 200 cartoonists/year. Buys 4 cartoon/issue. Prefers political and humorous b&w line drawings without gaglines.

Illustration Approached by 100 illustrators/year. Buys 6 illustrations/issue. Features informational graphics and computer and spot illustration. Assigns 50% of illustrations to experienced but not well-known illustrators; 50% to new and emerging illustrators. Prefers financial and fashion themes. Considers all media. Knowledge of Photoshop, Illustrator and QuarkXPress helpful.

Design Needs freelancers for design and production. Prefers local designers. 100% of freelance work demands knowledge of Photoshop, Illustrator and QuarkXPress.

First Contact & Terms Cartoonists: Send query letter with tearsheets. Illustrators: Send postcard sample or send query letter with printed samples, photocopies or tearsheets. Accepts disk submissions if Mac compatible. Send EPS files. Samples are filed. Art director will contact artist for portfolio review if interested. Buys one-time rights. Pays on publication. Pays cartoonists $50-100 for b&w; $75-200 for color. Pays illustrators $200-500 for color inside; $100-500 for spots. Finds illustrators through submissions.

Tips ''Read our magazine. Regional magazines have limited resources but are a great vehicle for getting your work printed and getting tearsheets. Ask people and friends (honest friends) to review your portfolio.''

GEORGIA MAGAZINE

P.O. Box 1707, Tucker GA 30085-1707. (770)270-6950. Fax: (770)270-6995. E-mail: ann.orowski@georgiaemc.c om. Website: www.georgiamagazine.org. **Editor:** Ann Orowski. Estab. 1945. Monthly consumer magazine promoting electric co-ops (largest read publication by Georgians for Georgians). Circ. 460,000 members.

Cartoons Approached by 10 cartoonists/year. Buys 2 cartoons/year. Prefers electric industry theme. Prefers single panel, humorous, b&w washes and line drawings.

Illustration Approached by 10 illustrators/year. Prefers electric industry theme. Considers all media. 50% of freelance illustration demands knowledge of Illustrator and QuarkXPress.

Design Uses freelancers for design and production. Prefers local designers with magazine experience. 80% of design demands knowledge of Photoshop, Illustrator, QuarkXPress and InDesign.

First Contact & Terms Cartoonists: Send query letter with photocopies. Samples are filed and not returned.

Illustrators: Send postcard sample or query letter with photocopies. Designers: Send query letter with printed samples and photocopies. Accepts disk submissions compatible with QuarkXPress 7.5. Samples are filed or returned by SASE. Responds in 2 months if interested. Rights purchased vary according to project. **Pays on acceptance.** Pays cartoonists $50 for b&w, $50-100 for color. Pays illustrators $50-100 for b&w, $50-200 for color. Finds illustrators through word of mouth and artist's submissions.

GLAMOUR

4 Times Square, 16th Floor, New York NY 10036. (212)286-2860. Fax: (212)286-8336. Website: www.glamour.com. **Art Director:** Cynthia Harris. Deputy Art Director: Peter Hemmel. Monthly magazine. Covers fashion and issues concerning working women (ages 20-35). Circ. 2 million. Originals returned at job's completion. Sample copies available on request. 5% of freelance work demands knowledge of Illustrator, QuarkXPress, Photoshop and FreeHand.

Cartoons Buys 1 cartoon/issue.

Illustration Buys 1 illustration/issue. Works on assignment only. Considers all media.

First Contact & Terms Illustrators: Send postcard-size sample. Samples are filed and not returned. Publication will contact artist for portfolio review if interested. Rights purchased vary according to project. Pays on publication.

[N] GLASS FACTORY DIRECTORY

Box 2267, Hempstead NY 11551. (516)481-2188. E-mail: manager@glassfactorydir.com. Website: www.glassfactorydir.com. **Manager:** Liz Scott. Annual listing of glass manufacturers in US, Canada and Mexico.

Cartoons Receives an average of 1 submission/week. Buys 5-10 cartoons/issue. Cartoons should pertain to glass manufacturing (flat glass, fiberglass, bottles and containers; no mirrors). Prefers single and multiple panel b&w line drawings with gagline. Prefers roughs or finished cartoons. "We do not assign illustrations. We buy from submissions only."

First Contact & Terms Send SASE. Responds in 3 months. Buys all rights. **Pays on acceptance**; $25.

Tips "Learn about making glass of all kinds. We rarely buy broken glass jokes. There *are* women working in glass plants. Glassblowing is overdone. What about flat glass, autoglass, bottles, fiberglass?"

GOLF ILLUSTRATED

15115 S. 76th East Ave., Bixby OK 74008-4114. (918)366-6191. Fax: (918)366-6512. Website: www.Golfillustrated.com. **Art Director:** Bert McCall. Estab. 1914. Golf lifestyle magazine published 4 times/year with instruction, travel, equipment reviews and more. Circ. 150,000. Sample copies free for 9×11 SASE and 6 first-class stamps. Art guidelines available for #10 SASE with first-class postage.

Cartoons Approached by 25 cartoonists/year. Prefers golf. Prefers single panel, b&w washes or line drawings.

Illustration Approached by 50 illustrators/year. Buys 10 illustrations/issue. Prefers instructional, detailed figures, course renderings. Considers all media. 30% of freelance illustration demands knowledge of Photoshop, Illustrator and QuarkXPress.

First Contact & Terms Cartoonists: Send photocopies. Illustrators: Send query letter with photocopies, SASE and tearsheets. Accepts disk submissions. Samples are filed. Responds in 1 month. Portfolios may be dropped off Monday-Friday. Buys first North American serial and reprint rights. **Pays on acceptance.** Pays cartoonists $50 minimum for b&w. Pays illustrators $100-200 for b&w, $250-400 for color inside. Finds illustrators through sourcebooks, magazines, word of mouth and submissions.

Tips "Read our magazine. We need fast workers with quick turnaround."

THE GOLFER

551 Fifth Ave., Suite 3010, New York NY 10176. (212)867-7070. Fax: (212)867-8550. E-mail: thegolfer@thegolfermag.com. Website: www.thegolfermag.com. **Contact:** Andrea Darif, art director. Estab. 1994. Published 6 times/year "sophisticated golf magazine with an emphasis on travel and lifestyle." Circ. 254,865.

Illustration Approached by 200 illustrators/year. Buys 6 illustrations/issue. Considers all media.

First Contact & Terms Illustrators: Send postcard sample. "We will accept work compatible with QuarkXPress 3.3. Send EPS files." Samples are not filed and are not returned. Responds only if interested. Rights purchased vary according to project. Pays on publication. Payment to be negotiated.

Tips "I like sophisticated, edgy, imaginative work. We're looking for people to interpret sport, not draw a picture of someone hitting a ball."

GOVERNING

1100 Connecticut Ave. NW, Suite 1300, Washington DC 20036-4109. (202)862-8802. Fax: (202)862-0032. E-mail: rsteadham@governing.com. Website: www.governing.com. **Art Director:** Richard Steadham. Estab.

1987. Monthly magazine. "Our readers are executives of state and local governments nationwide. They include governors, mayors, state legislators, county executives, etc." Circ. 86,284.

Illustration Approached by hundreds of illustrators/year. Buys 2-3 illustrations/issue. Prefers conceptual editorial illustration dealing with public policy issues. Considers all media. 10% of freelance illustration demands knowledge of Photoshop, Illustrator, FreeHand.

First Contact & Terms Send postcard sample with printed samples, photocopies and tearsheets. Send follow-up postcard sample every 3 months. "No phone calls please. We work in QuarkXPress, so we accept any format that can be imported into that program." Samples are filed. Responds only if interested. Art director will contact artist for portfolio review if interested. Buys one-time rights. Pays on publication; $700-1,200 for cover; $350-700 for inside; $350 for spots. Finds illustrators through *Blackbook*, *LA Workbook*, online services, magazines, word of mouth, submissions.

Tips "We are not interested in working with artists who can't take direction. If you can collaborate with us in communicating our words visually, then we can do business. Also, please don't call asking if we have any work for you. When I'm ready to use you, I'll call you."

GRAND RAPIDS MAGAZINE

Gemini Publications, 549 Ottawa Ave., Grand Rapids MI 49503. (616)459-4545. Fax: (616)459-4800. E-mail: info@geminipub.com. Website: www.geminipub.com. **Editor:** Carole Valade. Monthly for greater Grand Rapids residents. Circ. 20,000. Original artwork returned after publication. Local artists only.

Cartoons Buys 2-3 cartoons/issue. Prefers Michigan, Western Michigan, Lake Michigan, city, issue, consumer/household, fashion, lifestyle, fitness and travel themes.

Illustration Buys 2-3 illustrations/issue. Prefers Michigan, Western Michigan, Lake Michigan, city, issue, consumer/household, fashion, lifestyle, fitness and travel themes.

First Contact & Terms Cartoonists/Illustrators: Send query letter with samples. Samples not filed are returned by SASE. Responds in 1 month. To show a portfolio, mail printed samples and final reproduction/product or call for an appointment. Buys all rights. Pays on publication. Pays cartoonists $35-50 for b&w. Pays illustrators $200 minimum for color cover; $40 minimum for b&w inside; $40 minimum for color inside.

Tips "Particular interest in those who are able to capture the urban lifestyle."

☑ GRAPHIC ARTS MONTHLY

2000 Clearwater Drive, Oak Brook IL 60523. (630)288-8565. Fax: (630)288-8540. E-mail: tntovas@reedbusiness.com. Website: www.gammag.com/. **Creative Director:** Mr. Terry Ntovas. Estab. 1930. Monthly 4-color trade magazine for management and production personnel in commercial and specialty printing plants and allied crafts. Design is "direct, crisp and modern." Circ. 70,000. Accepts previously published artwork. Originals returned at job's completion. Needs computer-literate freelancers for illustration.

Illustration Approached by 150 illustrators/year. Buys 6 illustrations/issue. Works on assignment only. Considers all media, including computer.

First Contact & Terms Illustrators: Send postcard-sized sample to be filed. No phone calls please. Accepts disk submissions compatible with Photoshop, Illustrator or JPEG files. Will contact for portfolio review if interested. Portfolio should include final art, photographs, tearsheets. Buys one-time and reprint rights. **Pays on acceptance**; $750-1200 for color cover; $250-350 for color inside; $250 for spots. Finds artists through submissions.

GREENPRINTS

P.O. Box 1355, Fairview NC 28730. (828)628-1902. E-mail: patstone@atlantic.net. Website: www.greenprints.com. **Editor:** Pat Stone. Estab. 1990. Quarterly magazine "that covers the personal, not the how-to, side of gardening." Circ. 13,000. Sample copy for $5; art guidelines available on website or free for #10 SASE with first-class postage.

Illustration Approached by 46 illustrators/year. Works with 15 illustrators/issue. Has featured illustrations by Claudia McGehee, P. Savage, Marilynne Roach and Jean Jenkins. Assigns 30% of illustrations to emerging and 5% to new illustrators. Prefers plants and people. Considers b&w only.

First Contact & Terms Illustrators: Send query letter with photocopies, SASE and tearsheets. Samples accepted by US mail only. Accepts e-mail queries without attachments. Samples are filed or returned by SASE. Responds in 2 months. Buys first North American serial rights. Pays on publication; $250 maximum for color cover; $100-125 for b&w inside; $25 for spots. Finds illustrators through word of mouth, artist's submissions.

Tips "Read our magazine and study the style of art we use. Can you do both plants and people? Can you interpret as well as illustrate a story?"

GROUP PUBLISHING—MAGAZINE DIVISION

P.O. Box 481, Loveland CO 80539. (970)669-3836. Fax: (970)292-4372. E-mail: info@group.com. Website: www.group.com.Publishes *Group Magazine*, **Art Director:** Rebecca Parrott (6 issues/year; circ. 50,000; 4-color);

Children's Ministry Magazine, **Art Director:** RoseAnne Sather (6 issues/year; circ. 65,000; 4-color), for adult leaders who work with kids from birth to 6th grade; *Rev. Magazine*, **Art Director:** Jeff Spencer (6 issues; 4-color), an interdenominational magazine which provides innovative and practical ideas for pastors. Previously published, photocopied and simultaneous submissions OK. Original artwork returned after publication. Sample copy $2 with 9×12 SAE.

• This company also produces books. See listing in Book Publishers section.

Cartoons Generally buys one spot cartoon per issue that deals with youth or children ministry.

Illustration Buys 2-10 illustrations/issue. Has featured illustrations by Matt Wood, Chris Dean, Dave Klug and Otto Pfandschimdt.

First Contact & Terms Illustrators: Send postcard samples, SASE, slides or tearsheets to be kept on file for future assignments. Accepts disk submissions compatible with Mac. Send EPS files. Responds only if interested. **Pays on acceptance.** Pays cartoonists $50 minimum. Pays illustrators $125-1,000, from b&w/spot illustrations (line drawings and washes) to full-page color illustrations inside. Buys first publication rights and occasional reprint rights.

Tips "We prefer contemporary, nontraditional (not churchy), well-developed styles that are appropriate for our innovative, youth-oriented publications. We appreciate artists who can conceptualize well and approach difficult and sensitive subjects creatively."

N GUIDEPOSTS MAGAZINE

16 E. 34th St., New York NY 10016. (212)251-8127. Fax: (212)684-1311. Website: www.guideposts.org. **Art Director:** Kai-Ping Chao. Estab. 1945. Monthly nonprofit inspirational, consumer magazine. *Guideposts* articles "present tested methods for developing courage, strength and positive attitudes through faith in God." Circ. 4 million. Sample copies and guidelines are available.

• Also publishes *Angels on Earth*, a bimonthly magazine buying 7-10 illustrations/issue. They feature more eclectic and conceptual art, as well as realism. Considers watercolor, collage, airbrush, acrylic, colored pencil, oil, mixed media and pastel. Both magazines have been redesigned.

Illustration Buys 4-7 illustrations/issue. Works on assignment only. Features realistic, computer and spot illustration. Assigns 40% of illustrations to well-known or "name" illustrators; 40% to experienced, but not well-known illustrators; 20% to new and emerging illustrators. Prefers realistic, reportorial.

First Contact & Terms Send any promotional materials. Accepts disk submissions compatible with QuarkXPress, Illustrator, Photoshop (Mac based). Do not send nonreturnable work. To arrange portfolio review artist should follow up with call after initial query. Buys one-time rights. **Pays on acceptance**; $1,000-2,500 for color cover; $1,000-2,000 for 2-page spreads; $300-1,000 for spots. Finds artists through sourcebooks, other publications, word of mouth, artists' submissions and Society of Illustrators' shows.

Tips Sections most open to freelancers are illustrations for action/adventure stories. "Do your homework as to our needs and be familiar with the magazines. Tailor your portfolio or samples to each publication so our art director is not looking at one or two that fit her needs. Call me and tell me you've seen recent issues and how close your work is to some of the pieces in the magazine."

GUITAR PLAYER

2800 Campus Dr., San Mateo CA 94403. (650)513-4400. Fax: (650)513-4661. E-mail: azeigler@musicplayer.com. Website: www.guitarplayer.com. **Art Director:** Alexandra Zeigler. Estab. 1975. Monthly 4-color magazine focusing on technique, artist interviews, etc. Circ. 150,000. Original artwork is returned at job's completion. Sample copies and art guidelines not available.

Illustration Approached by 15-20 illustrators/week. Buys 5 illustrations/year. Works on assignment only. Features caricature of celebrities; realistic, computer and spot illustration. Assigns 33% of illustrations to new and emerging illustrators. Prefers conceptual, "outside, not safe" themes and styles. Considers pen & ink, watercolor, collage, airbrush, computer based, acrylic, mixed media and pastel.

First Contact & Terms Illustrators: Send query letter with brochure, tearsheets, photographs, photocopies, photostats, slides and transparencies. Accepts disk submissions compatible with Mac. Samples are filed. Responds only if interested. Will contact for portfolio review if interested. Buys first rights. Pays on publication; $200-400 for color inside; $400-600 for 2-page spreads; $200-300 for spots.

N GULF COAST MEDIA

886 110th Ave. N., Suite 5, Naples FL 34108. (239)591-3431. Fax: (239)591-3938. Website: www.gulfcoastmedia.com. **Art Director:** Tracy Gudgel. Estab. 1989. Publishes chamber's annuals promoting area tourism as well as books; 4-color and b&w; design varies. Accepts previously published artwork. Originals are returned at job's completion.

Illustration Works on assignment only; usage of illustration depends on client. Needs editorial illustration,

maps and charts. Preferred themes depend on subject; watercolor, collage, airbrush, acrylic, marker, color pencil, mixed media.

First Contact & Terms Illustrators: Send postcard or query letter with tearsheets, photographs and/or photocopies. Samples are filed. Responds only if interested. Publication will contact artist for portfolio review if interested. Portfolio should include roughs and original/final art. Buys first rights, one-time rights or reprint rights. Pays on publication; $250 for b&w, $250 for color, cover; $35 for b&w, $250 for color, inside; $50 for color spot art.

Tips "Our magazine publishing is restricted to contract publications, such as Chamber of Commerce publications, playbills, collateral materials. All of our work is located in Florida, mostly southwest Florida, therefore everything we use will have a local theme."

HADASSAH MAGAZINE

50 W. 58th St., New York NY 10019. (212)451-6289. Fax: (212)451-6257. E-mail: egoldberg@hadassah.org. Website: www.hadassah.org. **Art Director:** Jodie Rossi. Estab. 1914. Consumer magazine. *Hadassah Magazine* is a monthly magazine chiefly of and for Jewish interests—both here and in Israel. Circ. 270,000.

Cartoons Buys 3-5 freelance cartoons/year. Preferred themes include the Middle East/Israel, domestic Jewish themes and issues.

Illustration Approached by 50 freelance illustrators/year. Works on assignment only. Features humorous, realistic, computer and spot illustration. Prefers themes of news, Jewish/family, Israeli issues, holidays.

First Contact & Terms Cartoonists: Send postcard sample or query letter with tearsheets. Samples are filed or are returned by SASE. Write for appointment to show portfolio of original/final art, tearsheets and slides. Buys first rights. Pays on publication. Pays illustrators $400-600 for color cover; $100-200 for b&w inside; $200-250 for color inside; $75-100 for spots.

⚏ HARDWOOD MATTERS

National Hardwood Lumber Association, P.O. Box 34518, Memphis TN 38184-0518. (901)377-1818. Fax (901)382-6419. E-mail: t.bullard@nhla.com. Website: www.nhla.com. **Editor:** Tim Bullard. Estab. 1989. Bimonthly magazine for trade association. Publication covers "forest products industry, government affairs and environmental issues. Audience is forest products members, Congress, natural resource users. Our magazine is pro-resource use, *no preservationist slant* (we fight to be able to use our private property and natural resources)." Accepts previously published artwork. Art guidelines not available.

• This publication buys one cartoon/issue at $20 (b&w). Send query letter with finished cartoons (single, double or multi-panel).

Illustration Buys 6 illustrations/year. Prefers forestry, environment, legislative, legal themes. Considers pen & ink.

First Contact & Terms Illustrators: Send query letter with résumé, photocopies of pen & ink work. Rights purchased vary according to project. Pays up to $200 for b&w inside.

Tips "Our publication covers all aspects of the forest industry, and we consider ourselves good stewards of the land and manage our forestlands in a responsible, sustainable way—submissions should follow this guideline."

HARPER'S MAGAZINE

666 Broadway, 11th Floor, New York NY 10012. (212)420-5720. Fax: (212)228-5889. E-mail: stacey@harpers.org. **Art Director:** Stacey D. Clarkson. Estab. 1850. Monthly 4-color literary magazine covering fiction, criticism, essays, social commentary and humor.

Illustration Approached by 250 illustrators/year. Buys 5-10 illustrations/issue. Has featured illustrations by Ray Bartkus, Steve Brodner, Tavis Coburn, Hadley Hooper, Ralph Steadman, Raymond Verdaguer, Andrew Zbihlyj, Danijel Zezelj. Features intelligent concept-oriented illustration. Preferred subjects literary, artistic, social, fiction-related. Prefers intelligent, original thought and imagery in any media. Assigns 25% of illustrations to new and emerging illustrators. 10% of freelance illustration demands knowledge of Photoshop.

First Contact & Terms Illustrators: Send nonreturnable samples. Accepts Mac-compatible disk submissions. Samples are filed and are not returned. Will contact artist for portfolio review if interested. Portfolios may be dropped off for review the last Wednesday of any month. Buys first North American serial rights. Pays on publication; $250-400 for b&w inside; $450-1,000 for color inside; $450 for spots. Finds illustrators through samples, annuals, reps, other publications.

Tips "Intelligence, originality and beauty in execution are what we seek. A wide range of styles is appropriate; what counts most is content."

⚏ HEALTHCARE FINANCIAL MANAGEMENT

2 Westbrook Corp. Center, Suite 700, Westchester IL 60154-5723. (708)531-9600. Fax: (708)531-0032. E-mail: cstachura@hfma.org. Website: www.hfma.org. **Publisher:** Cheryl Stachura. Estab. 1946. Monthly association

magazine for chief financial officers in healthcare, managers of patient accounts, healthcare administrators. Circ. 33,220. Sample copies available; art guidelines not available.

Cartoons Buys 1 cartoon/issue. Prefers single panel, humorous b&w line drawings with gaglines.

Illustration Considers acrylic, airbrush, color washed, colored pencil, marker, mixed media, oil, pastel, watercolor.

First Contact & Terms Cartoonists: Send query letter to the publisher with photocopies. Send query letter with printed samples, photocopies and tearsheets. Samples are filed. Will contact artist for portfolio review if interested. Responds only if interested. Pays on publication.

HEAVY METAL MAGAZINE

100 N. Village Rd., Suite 12, Rookville Center NY 11570. Website: www.metaltv.com. **Contact:** Submissions. Estab. 1977. Consumer magazine. *"Heavy Metal* is the oldest illustrated fantasy magazine in U.S. history.*"*
 ● See listing in Book Publishers section.

N HIGH COUNTRY NEWS

119 Grand Ave., P.O. Box 1090, Paonia CO 81428-1090. (970)527-4898. Fax: (970)527-4897. E-mail: cindy@hcn. org. Website: www.hcn.org. **Art Director:** Cindy Wehling. Estab. 1970. Biweekly newspaper published by the nonprofit High Country Foundation. High Country News covers environmental, public lands and community issues in the 10 western states. Circ. 23,000. Art guidelines at www.hcn.org/about/guidelines.jep.

Cartoons Buys 1 editorial cartoon/issue. Only issues affecting Western environment. Prefers single panel, political, humorous b&w washes and line drawings with or without gagline. "Prefer attention to detail. Professional quality only.*"*

Illustration Considers all media if reproducible in b&w.

First Contact & Terms Cartoonists: Send query letter with finished cartoons and photocopies. Illustrators: Send query letter with printed samples and photocopies. Accepts e-mail and disk submissions compatible with QuarkXPress and Photoshop. Samples are filed or returned by SASE. Responds only if interested. Rights purchsed vary according to project. Pays on publication. Pays cartoonists $35-100 for b&w. Pays illustrators $100-200 for color cover; $35-75 for b&w inside. Finds illustrators through magazines, newspapers and artist's submissions.

HIGHLIGHTS FOR CHILDREN

803 Church St., Honesdale PA 18431. (570)253-1080. Fax: (570)253-0179. Website: www.highlights.com. **Art Director:** Cynthia Faber Smith. Editor: Christine French Clark. Monthly 4-color magazine for ages 2-12. Circ. 2 million plus. Art guidelines for SASE with first-class postage.

Cartoons Receives 20 submissions/week. Buys 2-4 cartoons/issue. Interested in upbeat, positive cartoons involving children, family life or animals; single or multiple panel. "One flaw in many submissions is that the concept or vocabulary is too adult or that the experience necessary for its appreciation is beyond our readers. Frequently, a wordless self-explanatory cartoon is best.*"*

Illustration Buys 30 illustrations/issue. Works on assignment only. Prefers "realistic and stylized work; upbeat, fun, more graphic than cartoon." Pen & ink, colored pencil, watercolor, marker, cut paper and mixed media are all acceptable. Discourages work in fluorescent colors.

First Contact & Terms Cartoonists: Send roughs or finished cartoons and SASE. Illustrators: Send query letter with photocopies, SASE and tearsheets. Samples to be kept on file. Responds in 10 weeks. Buys all rights on a work-for-hire basis. **Pays on acceptance.** Pays cartoonists $20-40 for line drawings. Pays illustrators $1,025 for color front and back covers; $50-600 for color inside. "We are always looking for good hidden pictures. We require a picture that is interesting in itself and has the objects well-hidden. Usually an artist submits pencil sketches. In no case do we pay for any preliminaries to the final hidden pictures." Hidden pictures should be submitted to Jody Taylor.

Tips "We have a wide variety of needs, so I would prefer to see a representative sample of an illustrator's style.*"*

N HISPANIC MAGAZINE

999 Ponce De Leon Blvd., Suite 600, Coral Gables FL 33134-3037. (305)442-2462. Fax: (305)774-3578. E-mail: minsua@hisp.com. Website: www.hispanicmagazine.com. **Creative Director:** Alberto Insua. Assistant Art Director Devon Cox. Estab. 1987. Monthly 4-color consumer magazine for Hispanic Americans. Circ. 250,000.

Illustration Approached by 100 illustrators/year. Buys 5 illustrations/issue. Has featured illustrations by Will Terry, A.J. Garces, Sonia Aguirre. Features caricatures of politicians, humorous illustration, realistic illustrations, charts & graphs, spot illustrations and computer illustration. Prefers business subjects, men and women. Prefers pastel and bright colors. Assigns 80% of illustrations to experienced, but not well-known illustrators; 20% to new and emerging illustrators.

First Contact & Terms Illustrators: Send nonreturnable postcard samples. Accepts Mac-compatible disk submissions. Send EPS or TIFF files. Samples are filed. Responds only if interested. Will contact artist for portfolio review if interested. Buys one-time rights. Pays on publication; $500-1,000 for color cover; $300 maximum for b&w inside; $800 maximum for color inside; $250 for spots.

Tips "Concept is very important, to take a idea or story and to be able to find a fresh perspective. I like to be surprised by the artist."

ALFRED HITCHCOCK MAGAZINE

475 Park Ave. S., 11th Floor, New York NY 10016. (212)686-7188. Fax: (212)686-7414. **Contact:** June Levine, associate art director. Estab. 1956. Monthly b&w magazine with 4-color cover emphasizing mystery fiction. Circ. 202,470. Accepts previously published artwork. Original artwork returned at job's completion. Art guidelines available for #10 SASE with first-class postage.

Illustration Approached by 300 illustrators/year. Buys 2-3 illustrations/issue. Prefers semi-realistic, realistic style. Works on assignment only. Considers pen & ink. Send query letter with printed samples, photocopies and/or tearsheets and SASE.

First Contact & Terms Illustrators: Send follow-up postcard sample every 3 months. Samples are filed or returned by SASE. Responds only if interested. "No phone calls." Portfolios may be dropped off every Tuesday and should include b&w and color tearsheets. "No original art please." Rights purchased vary according to project. **Pays on acceptance**; $1,000-1,200 for color cover; $100 for b&w inside; $35-50 for spots. Finds artists through submissions drop-offs, RSVP.

Tips "No close-up or montages. Show characters within a background environment."

HOME BUSINESS MAGAZINE

PMB 368, 9582 Hamilton, Suite 368, Huntington Beach CA 92646. (714)968-0331. Fax: (714)962-7722. E-mail: henderso@ix.netcom.com. Website: www.homebusinessmag.com. **Contact:** Creative Director. Estab. 1992. Bimonthly consumer magazine. Circ. 100,000. Sample copies free for 10×13 SASE and $2.21 in first-class postage.

Illustration Approached by 100 illustrators/year. Buys several illustrations/issue. Features natural history illustration, realistic illustrations, charts & graphs, informational graphics, spot illustrations and computer illustration of business subjects, families, men and women. Prefers pastel and bright colors. Assigns 40% of illustrations to well-known or "name" illustrators; 40% to experienced but not well-known illustrators; 20% to new and emerging illustrators. 100% of freelance illustration demands knowledge of Illustrator and QuarkXPress.

First Contact & Terms Illustrators: Send query letter with printed samples, photocopies and SASE. Send electronically as JPEG or TIFF files. Samples are filed or returned if requested. Responds only if interested. Will contact artist for portfolio review if interested. Buys reprint rights. Negotiates rights purchased. Pays on publication. Finds illustrators through magazines, word of mouth or via Internet.

N HOME EDUCATION MAGAZINE

P.O. Box 1083, Tonasket WA 98855. (509)486-1351. Fax: (509)486-2753. E-mail: edchief@homeedmag.com. Website: www.homeedmag.com. **Managing Editor:** Helen Hegener. Estab. 1983. "We publish one of the largest magazines available for homeschooling families." Desktop bimonthly published in full color; 4-color glossy cover. Circ. 82,500. Original artwork is returned after publication upon request. Sample copy $6.50. Guidelines available via e-mail.

Cartoons Approached by 15-20 cartoonists/year. Buys 1-2/year. Style preferred is open, but theme must relate to home schooling. Prefers single, double or multiple panel b&w line drawings and washes with or without gagline.

Illustration Staff handles illustration.

Design Staff handles design.

First Contact & Terms Cartoonists: Send query letter with samples of style, roughs and finished cartoons, "any format is fine with us." Accepts disk submissions. "We're looking for originality, clarity, warmth. Children, families and parent-child situations are what we need." Samples are filed or are returned by SASE. Responds in 3 weeks. Will contact for portfolio review if interested. Buys one-time rights, reprint rights or negotiates rights purchased. **Pays on acceptance.** Pays cartoonists $10-20 for b&w. Finds artists primarily through submissions and self-promotions.

Tips "Most of our artwork is produced by staff artists. We receive very few good cartoons. Study what we've done in the past, suggest how we might update or improve it."

HOPSCOTCH, The Magazine for Girls

P.O. Box 164, Bluffton OH 45817. (419)358-4610. Fax: (419)358-5027. Website: www.hopscotchmagazine.com. **Contact:** Marilyn Edwards. Estab. 1989. A bimonthly magazine for girls between the ages of 6 and 12; 2-color

with 4-color cover; 52 pp.; 7×9 saddle-stapled. Circ. 15,000. Original artwork returned at job's completion. Sample copies available for $4. Art guidelines for SASE with first-class postage. 20% of freelance work demands computer skills.

• Also publishes *Boys' Quest* (www.boysquest.com) and *Fun For Kidz* (www.funforkidz.com).

Illustration Approached by 200-300 illustrators/year. Buys 6-7 freelance illustrations/issue. Has featured illustrations by Chris Sabatino, Pamela Harden and Donna Catanese. Features humorous, realistic and spot illustration. Assigns 40% of illustrations to new and emerging illustrators. Artists work mostly on assignment. Needs story illustration. Prefers traditional and humor; pen & ink.

First Contact & Terms Illustrators: Send query letter with photocopies of pen & ink samples. Samples are filed. Responds in 2 months. Buys first rights and reprint rights. **Pays on acceptance**; $200-250 for color cover; $25-35 for b&w inside; $50-70 for 2-page spreads; $10-25 for spots.

Tips "Read our magazine. Send a few samples of work in pen and ink. Everything revolves around a theme. Our theme list is available with SASE."

N: HORSE ILLUSTRATED

Bowtie, Inc., 3 Burroughs, Irvine CA 92618. (949)855-8822. E-mail: horseillustrated@fancypubs.com. Website: www.horseillustratedmagazine.com. **Managing Editor:** Elizabeth Moyer. Editor Moira C. Harris. Estab. 1976. Monthly consumer magazine providing "information for responsible horse owners." Circ. 220,000. Originals are returned after job's completion. Art guidelines on website.

Cartoons Approached by 200 cartoonists/year. Buys 1 or 2 cartoons/issue. Prefers satire on horse ownership ("without the trite cliches"); single panel b&w line drawings with gagline.

Illustration Approached by 60 illustrators/year. Buys 1 illustration/issue. Prefers realistic, mature line art, pen & ink spot illustrations of horses. Assigns 10% of illustrations to new and emerging illustrators. Considers pen & ink.

First Contact & Terms Cartoonists: Send query letter with brochure, roughs and finished cartoons. Illustrators: Send query letter with SASE and photographs. Samples are not filed and are returned by SASE. Responds in 6 weeks. Portfolio review not required. Buys first rights or one-time rights. Pays on publication. Pays cartoonists $40 for b&w. Finds artists through submissions.

Tips "We only use spot illustrations for breed directory and classified sections. We do not use much, but if your artwork is within our guidelines, we usually do repeat business. *Horse Illustrated* needs illustrators who know equine anatomy, as well as human anatomy with insight into the horse world."

HORTICULTURE MAGAZINE

98 N. Washington St., Boston MA 02114. (617)742-5600. Fax: (617)367-6364. E-mail: edit@hortmag.com. Website: www.hortmag.com. **Contact:** Linda Golon, art director. Estab. 1904. Monthly magazine for all levels of gardeners (beginners, intermediate, highly skilled). "*Horticulture* strives to inspire and instruct avid gardeners of every level." Circ. 300,000. Originals are returned at job's completion. Art guidelines are available.

Illustration Approached by 75 freelance illustrators/year. Buys 10 illustrations/issue. Works on assignment only. Features realistic illustration; informational graphics; spot illustration. Assigns 20% of illustrations to new and emerging illustrators. Prefers tight botanicals; garden scenes with a natural sense to the clustering of plants; people; hands and "how-to" illustrations. Considers all media.

First Contact & Terms Illustrators: Send query letter with brochure, résumé, SASE, tearsheets, slides. Samples are filed or returned by SASE. Publication will contact artist for portfolio review if interested. Buys one-time rights. Pays 1 month after project completed. Payment depends on complexity of piece; $800-1,200 for 2-page spreads; $150-250 for spots. Finds artists through word of mouth, magazines, artists' submissions/self-promotions, sourcebooks, artists' agents and reps, attending art exhibitions.

Tips "I always go through sourcebooks and request portfolio materials if a person's work seems appropriate and is impressive."

N: HOUSE BEAUTIFUL

1700 Broadway, 29th Floor, New York NY 10019. (212)903-5233. Fax: (212)765-8292. Website: www.housebeautiful.com. **Art Director:** Howard Greenberg. Estab. 1896. Monthly consumer magazine. *House Beautiful* is a magazine about interior decorating—emphasis is on classic and contemporary trends in decorating, architecture and gardening. The magazine is aimed at both the professional and nonprofessional interior decorator. Circ. 1.3 million. Originals returned at job's completion. Sample copies available.

Illustration Approached by 75-100 illustrators/year. Buys 2-3 illustrations/issue. Works on assignment only. Prefers contemporary, conceptual, interesting use of media and styles. Considers all media.

First Contact & Terms Illustrators: Send postcard-size sample. Samples are filed only if interested and are not returned. Portfolios may be dropped off every Monday-Friday. Publication will contact artist for portfolio review of final art, photographs, slides, tearsheets and good quality photocopies if interested. Buys one-time rights.

Pays on publication; $600-700 for color inside; $600-700 for spots (99% of illustrations are done as spots).
Tips "We find most of our artists through artist submissions of either portfolios or postcards. Sometimes we will contact an artist whose work we have seen in another publication. Some of our artists are found through artist reps and annuals."

HOW, Design Ideas at Work
4700 E. Galbraith Rd., Cincinnati OH 45236. E-mail: triciab@fwpubs.com. Website: www.howdesign.com. **Art Director:** Tricia Bateman. Estab. 1985. Bimonthly trade journal covering "how-to and business techniques for graphic design professionals." Circ. 40,000. Original artwork returned at job's completion. Sample copy $8.50.
• Sponsors annual conference for graphic artists. Send SASE for more information.
Illustration Approached by 100 illustrators/year. Buys 4-8 illustrations/issue. Works on assignment only. Considers all media, including photography and computer illustration.
First Contact & Terms Illustrators: Send nonreturnable samples. Accepts disk submissions. Responds only if interested. Buys first rights or reprint rights. Pays on publication; $350-1,000 for color inside.
Tips "Send good samples that apply to the work I use. Be patient, art directors get a lot of samples."

ℕ HR MAGAZINE
1800 Duke St., Alexandria VA 22314. (703)535-6860. Fax: (703)548-9140. E-mail: janderson@shrm.org. Website: www.shrm.org. **Art Director:** John Anderson Jr. Estab. 1948. Monthly trade journal dedicated to the field of human resource management. Circ. 165,000.
Illustration Approached by 70 illustrators/year. Buys 6-8 illustrations/issue. Prefers people, management and stylized art. Considers all media.
First Contact & Terms Illustrators: Send query letter with printed samples. Accepts disk submissions. Illustrations can be attached to e-mails. *HR Magazine* is Macintosh based. Samples are filed. Art director will contact artist for portfolio review if interested. Rights purchased vary according to project. Requires artist to send invoice. Pays within 30 days. Pays $700-2,500 for color cover; $200-1,800 for color inside. Finds illustrators through sourcebooks, magazines, word of mouth and artist's submissions.

ℕ H6K MAGAZINE (HOMBRE 6000)
475 Elm Street, Suite 1C, Kearny NJ 07032. (201)246-4006. E-mail: hr@h6k.com. **Creative Director/Editor-in-Chief:** Marvin Valladares. Art guidelines available free with SASE or on website.
Illustration Approached by 100s illustrators/year. Buys 5 illustrations/year. Features caricatures of celebrities/politicians, fashion illustration, realistic illustration, charts & graphs, humorous illustration, medical illustration, computer illustration, informational graphics, spot illustrations, natural history illustration. Preferred subjects: business, families, men, women, politics. 80% of freelance work demands computer skills. Freelancers should be familiar with Illustrator, QuarkXPress, Photoshop. E-mail submissions accepted with link to website, accepted with image file at 72 dpi. Prefers JPEG, EPS. If not filed, samples are returned by SASE not returned. Artist should follow up with letter after inital query. Company will contact artist for portfolio review if interested.
First Contact & Terms Cartoonists: Send query letter, b&w photocopies, roughs, transparencies. Send postcard sample, brochure, sample, URL, photocopies, SASE. Send photographs. After introductory mailing, send follow-up postcard every 6 months. Illustrators: Send query letter, b&w photocopies, roughs, transparencies. Send postcard sample, brochure, samples, URL, photocopies, SASE. Send photographs. After introductory mailing, send follow-up postcard every 6 months.

ℕ HUMPTY DUMPTY'S MAGAZINE
Children's Better Health Institute, Box 567, Indianapolis IN 46206. (317)636-8881. Fax: (317)684-8094. Website: www.humptydumptymag.org. **Art Director:** Rob Falco. A health-oriented children's magazine for ages 4-7; 4-color; simple and direct design. Published 6 times/year. Circ. 264,000. Originals are not returned at job's completion. Sample copies available for $1.25; art guidelines for SASE with first-class postage.
• Also publishes *Child Life, Children's Digest, Children's Playmate, Jack and Jill, Turtle Magazine* and *U. Kids, A Weekly Reader Magazine*.
Illustration Approached by 300-400 illustrators/year. Buys 10-15 illustrations/issue. Has featured illustrations by John Nez, Kathryn Mitter, Alan MacBain, David Helton and Patti Goodnow. Features humorous, realistic, medical, computer and spot illustration. Assigns 10% of illustrations to new and emerging illustrators. Works on assignment only. Preferred styles are mostly cartoon and some realism. Considers any media as long as finish is done on scannable (bendable) surface.
First Contact & Terms Illustrators: Send query letter with photocopies, tearsheets and SASE. Samples are filed and are not returned. Responds only if interested. To show a portfolio, mail color tearsheets, digital files (Mac), photostats, photographs and photocopies. Buys all rights. Pays on publication; $275 for color cover; $35-90 for

b&w inside; $70-155 for color inside; $210-310 for 2-page spreads; $35-80 for spots; additional payment for digital pre-separated imagery $35 full; $15 half; $10 spot.

Tips "Please review our publications to see if your style is a match for our needs. Then you may send us very consistent styles of your abilities, along with a comment card and SASE for return."

N HUSTLER LEG WORLD

8484 Wilshire Blvd., Suite 900, Beverly Hills CA 90211. (323)651-5400. E-mail: legworld@lfp.com. **Art Director:** Ed Donato. Estab. 1997. Monthy magazine "which contains fiction and nonfiction; sometimes serious, often humorous. Sex is the main topic but any sensational subject is possible." Circ. 90,000. Originals returned at job's completion. Sample copies available for $12.

Illustration Approached by 15 illustrators/year. Buys 2 illustrations/issue. Works on assignment only. Prefers foot, leg and stocking fetishes as themes. Considers all media.

First Contact & Terms Illustrators: Send query letter with tearsheets, photographs and photocopies. Samples are filed. Artist should follow up with call and/or letter after initial query. Publication will contact artist for portfolio review if interested. Porfolio should include b&w and color slides and final art. Buys all rights. **Pays on acceptance**; $500 for full page color inside. Finds artists through word of mouth, mailers and submissions.

Tips "We use artists from all over the country, with diverse styles, from realistic to abstract. Must be able to deal with adult subject matter and have no reservations concerning explicit sexual images. We want to show these subjects in new and interesting ways."

N HUSTLER'S BARELY LEGAL

8484 Wilshire Blvd., Suite 900, Beverly Hills CA 90211. (323)651-5400. **Art Director:** Elizabeth Keating. Estab. 1993. Monthy magazine "which contains fiction and nonfiction; sometimes serious, often humorous. Sex is the main topic but any sensational subject is possible." Circ. 90,000. Originals returned at job's completion. Sample copies available for $6.

Illustration Approached by 15 illustrators/year. Buys 3 illustrations/issue. Works on assignment only. Prefers sex/eroticism as themes. Considers all media.

First Contact & Terms Illustrators: Send query letter with tearsheets, photographs and photocopies. Samples are filed. Artist should follow up with call and/or letter after initial query. Publication will contact artist for portfolio review if interested. Porfolio should include b&w and color slides and final art. Buys all rights. **Pays on acceptance**; $500 for full page color inside. Finds artists through word of mouth, mailers and submissions.

Tips "We use artists from all over the country, with diverse styles, from realistic to abstract. Must be able to deal with adult subject matter and have no reservations concerning explicit sexual images. We want to show these subjects in new and interesting ways."

N HX MAGAZINE

230 W. 17th St., 8th Floor, New York NY 10011. (212)352-3535. Fax: (212)252-3596. E-mail: hx@hx.com. Website: www.hx.com. **Art Director:** Chris Hawkins. Weekly magazine "covering gay and lesbian general interest, entertainment and nightlife in New York City." Circ. 40,000.

Cartoons Approached by 5 cartoonists/year. Buys 1 cartoon/issue. Prefers gay and/or lesbian themes. Prefers multiple panel, humorous b&w line drawings with gagline.

Illustration Approached by 10 illustrators/year. Number of illustrations purchased/issue varies. Prefers gay and/or lesbian themes. Considers all media.

First Contact & Terms Cartoonists: Send query letter with photocopies. Illustrators: Send query letter with photocopies. Samples are filed and are not returned. Responds only if interested. Art director will contact artist for portfolio review of b&w and color if interested. Rights purchased vary according to project. Pays on publication. Payment varies. Finds illustrators through submissions.

Tips "Read and be familiar with our magazine. Our style is very specific."

IDEALS MAGAZINE

A division of Guideposts, 535 Metroplex Dr., Suite 250, Nashville TN 37211. (615)333-0478. Fax: (888)815-2759. Website: www.idealspublications.com. **Editor:** Marjorie Lloyd. Estab. 1944. 4-color bimonthly seasonal general interest magazine featuring poetry and family articles. Circ. 200,000. Sample copy $4. Art guidelines free with #10 SASE with first-class postage or view on website.

Illustration Approached by 100 freelancers/year. Buys 4 illustrations/issue. Uses freelancers mainly for flowers, plant life, wildlife, realistic people illustrations and botanical (flower) spot art. Prefers seasonal themes. Prefers watercolors. Assigns 90% of illustrations to experienced illustrators; 10% to new and emerging illustrators. "We are not interested in computer generated art. No electronic submissions."

First Contact & Terms Illustrators: Send nonreturnable samples or tearsheets. Samples are filed. Responds only if interested. Do not send originals. Buys artwork "for hire." Pays on publication; payment negotiable.

Tips "In submissions, target our needs as far as style is concerned, but show representative subject matter. Artists should be familiar with our magazine before submitting samples of work."

⊕ IEEE SPECTRUM

3 Park Ave., 17th Floor, New York NY 10016-5902. (212)419-7555. Fax: (212)419-7570. Website: www.spectrum .ieee.org. **Contact:** Mark Montgomery, senior art director. Estab. 1964. Monthly nonprofit trade magazine serving electrical and electronics engineers worldwide. Circ. 380,000.

Illustration Buys 5 illustrations/issue. Has featured illustrations by John Hersey, David Plunkert, Gene Grief, Mick Wiggins. Features charts, graphs, computer illustration, informational graphics, realistic illustration and spot illustration. Preferred subjects business, technology, science. Assigns 25% to new and emerging illustrators. Considers all media.

First Contact & Terms Illustrators: Send postcard sample or query letter with printed samples and tearsheets. Samples are filed and are not returned. Responds only if interested. Art director will contact artist for portfolio review if interested. Do *not* send samples via e-mail. Portfolio should include color, final art and tearsheets. Buys first rights and one year's use on website. **Pays on acceptance**; $1,500 minimum for cover; $400 minimum for inside. Finds illustrators through *American Showcase, Workbook.*.

Tips "Please visit our website and review *Spectrum* before submitting samples. Most of our illustration needs are with 3-D technical diagrams and a few editorial illustrations."

N IN TOUCH FOR MEN

3230 East Flamingo Rd., Suite 8-17, Las Vegas NV 89121-4320. (877)446-8682. Fax: (702)974-0585. Website: www.gowestmediagroup.com. **Editor:** Michael Jimenez. Art Director Glen Bassett. Estab. 1973. *"In Touch* is a monthly erotic magazine for gay men that explores all aspects of the gay community (sex, art, music, film, etc.)." Circ. 60,000. Accepts previously published work (very seldom). Originals returned after job's completion. Sample copies available. Art guidelines available at website. Needs computer-literate freelancers for illustration.

• This magazine is open to working with illustrators who create work on computers and transfer it via modem. Final art must be saved in a Macintosh-readable format.

Cartoons Approached by 10 cartoonists/year. Buys 1-2 cartoons/issue. Prefers humorous, gay lifestyle related (not necessarily sexually explicit in nature); single and multiple panel b&w washes and line drawings with gagline. Responds in 1 month.

Illustration Approached by 10 illustrators/year. Buys 3-5 illustrations/issue. Assigns 95% of illustrations to well-known or "name" illustrators; 5% to new and emerging illustrators. Works on assignment only. Prefers open-minded, lighthearted style. Considers all types.

First Contact & Terms Cartoonists: Send query letter with finished cartoons. Send query letter with photocopies and SASE. Accepts disk submissions. Samples are filed. Will contact for portfolio review if interested. Portfolio should include b&w and color final art. Rights vary. **Pays on acceptance.** Pays cartoonists $50 for b&w, $100 for color. Pays illustrators $35-75 for b&w inside, $100 for color inside.

Tips "Most artists in this genre will contact us directly, but we get some through word of mouth, and occasionally we will look up an artist whose work we've seen and interests us. Areas most open to freelancers are 4-color illustrations for erotic fiction stories, humorous illustrations and stand-alone comic strips/panels depicting segments of gay lifestyle. Querying is like applying for a job because artwork is commissioned. Review our publication and submit samples that suit our needs. It's pointless to send your best work if it doesn't look like what we use. Understanding of gay community and lifestyle a plus."

THE INDEPENDENT WEEKLY

P.O. Box 2690, Durham NC 27715. (919)286-1972. Fax (919)286-4274. E-mail: lholm@indyweek.com. Website: www.indyweek.com. **Art Director:** Liz Holm. Estab. 1982. Weekly b&w with 4-color cover tabloid; general interest alternative. Circ. 50,000. Original artwork is returned if requested. Sample copies and art guidelines for SASE with first-class postage.

Illustration Buys 10-15 illustrations/year. Prefers local (North Carolina) illustrators. Has featured illustrations by Shelton Bryant, V. Cullum Rogers, Nathan Golub. Works on assignment only. Considers pen & ink; b&w, computer generated art and color.

First Contact & Terms Samples are filed or are returned by SASE if requested. Responds only if interested. Call for appointment to show portfolio or mail tearsheets. Pays on publication; $100-250 for cover; $50 for b&w inside and spots.

Tips "Have a political and alternative 'point of view.' Understand the peculiarities of newsprint. Be easy to work with. No prima donnas."

N INFORMATION WEEK

INFORMATION WEEK, 600 Community Dr., Manhasset NY 11030. (516)562-5000. Fax: (516)562-5036. E-mail: rbundi@cmp.com. Website: www.informationweek.com. **Art Director:** Mary Ellen Forte. Weekly 4-color trade

publication for business and technology managers, combining business and technology issues. Circ. 400,000.

- CMP Media publishes more than 40 magazines.

Illustration Approached by 200 illustrators/year. Buys 400 illustrations/year. Has featured illustrations by David Peters, Bill Mayer, Rapheal Lopez, Matsu, D.S. Stevens, Wendy Grossman. Features computer, humorous, realistic and spot illustrations of business subjects. Prefers many different media, styles. Assigns 33% of illustrations to well-known or "name" illustrators; 33% to experienced, but not well-known illustrators; 33% to new and emerging illustrators. 30% of freelance illustration demands knowledge of Illustrator, Photoshop.

First Contact & Terms Illustrators: Send postcard sample or query letter with nonreturnable printed samples, tearsheets. Send follow-up postcard every 6 months. Accepts Mac-compatible disk submissions. Send EPS files. Samples are filed. Will contact artist for portfolio review if interested. Buys first rights, reprint rights or rights vary according to project. Pays on publication; $700-1,200 for color cover; $500-1,000 for color inside; $800-1,500 for 2-page spreads; $300 for spots. Finds illustrators through mailers, sourcebooks *Showcase*, *Work Book*, *The Alternative Pick*, *Black Book*, *New Media Showcase*.

Tips "We look for a variety of styles and media. To illustrate, sometimes very abstract concepts. Quick turnaround is very important for a weekly magazine."

N INGRAMS MAGAZINE

306 E. 12th, #1014, Kansas City MO 64106. (816)842-9994. Fax: (816)474-1111. E-mail: msweeney@ingramsonli ne.com. Website: www.ingramsonline.com. **Contact:** Michelle Sweeney. Monthly magazine covering business. Circ. 25,000. Sample copies free for #10 SASE with first-class postage; art guidelines not available.

Illustration Buys 2 illustrations/issue. Features realistic illustration; charts & graphs and computer and spot illustration. Assigns 20% of illustrations to experienced, but not well-known illustrators; 80% to new and emerging illustrators. Considers all media. 50% of freelance illustration demands knowledge of Photoshop and QuarkXPress.

First Contact & Terms Illustrators: Send query letter with printed samples. Samples are filed. Responds only if interested. Art director will contact artist for portfolio review of b&w and color photographs and tearsheets if interested. Rights purchased include reprint rights and Web posting rights. Pays $100/image. Finds illustrators through magazines and artist's submissions.

Tips "Look through our magazine. If you're interested, send some samples or give me a call."

INSIDE

2100 Arch St., Philadelphia PA 19103. (215)832-0797. E-mail: bleiter@jewishexponent.com. **Editor:** Robert Leiter. Estab. 1979. Quarterly. Circ. 75,000.

Illustration Buys several illustrations/issue from freelancers. Has featured illustrations by Sam Maitin, David Noyes, Robert Grossman. Assigns 10% of work to new and emerging illustrators. Prefers color and drawings. Works on assignment only.

First Contact & Terms Illustrators: Send samples and tearsheets to be kept on file. Samples not kept on file are not returned. Call for appointment to show portfolio. Responds only if interested. Buys first rights. Pays on publication; minimum $500 for color cover; $350 for color inside. Prefers to see sketches.

Tips Finds artists through artists' promotional pieces, attending art exhibitions, artists' requests to show portfolio. "We like illustrations that are bold, edgy and hip. We have redesigned the magazine for a younger market (25-40 year olds)."

JACK AND JILL

Children's Better Health Institute, 1100 Waterway Blvd., Box 567, Indianapolis IN 46202. (317)636-8881. Fax: (317)684-8094. Website: www.jackandjillmag.org. **Art Director:** Greg Vanzo. Emphasizes educational and entertaining articles focusing on health and fitness as well as developing the reading skills of the reader. For ages 7-10. Monthly except bimonthly January/February, April/May, July/August and October/November. Circ. 200,000. Magazine is 36 pages, 30 pages 4-color and 6 pages b&w. The editorial content is 50% artwork. Original artwork not returned after publication (except in case where artist wishes to exhibit the art; art must be available to us on request). Sample copy $1.25; art guidelines for SASE with first-class postage.

- Also publishes *Child Life*, *Children's Digest*, *Children's Playmate*, *Humpty Dumpty's Magazine* and *Turtle*.

Illustration Approached by more than 100 illustrators/year. Buys 25 illustrations/issue. Has featured illustrations by Alan MacBain, Phyllis Pollema-Cahill, George Sears and Mary Kurnick Maass. Features humorous, realistic, medical, computer and spot illustration. Assigns 15% of illustrations to well-known or "name" illustrators; 70% to experienced but not well-known illustrators; 15% to new and emerging illustrators. Uses freelance artists mainly for cover art, story illustrations and activity pages. Interested in "stylized, realistic, humorous illustrations for mystery, adventure, science fiction, historical and also nature and health subjects. Works on assignment only. "Freelancers can work in FreeHand, Photoshop or Quark programs."

First Contact & Terms Illustrators: Send postcard sample to be kept on file. Accepts disk submissions. Publica-

tion will contact artist for portfolio review if interested. Portfolio should include printed samples, tearsheets, b&w and 2-color pre-separated art. Pays $275-335 for color cover; $90 maximum for b&w inside; $155-190 for color inside; $310-380 for 2-page spreads; $35-80 for spots. Company pays higher rates to artists who can provide color-separated art. Buys all rights on a work-for-hire basis. On publication date, each contributor is sent several copies of the issue containing his or her work. Finds artists through artists' submissions and self-promotion pieces.

Tips Portfolio should include "illustrations composed in a situation or storytelling way, to enhance the text matter. Send samples of published story for which you did illustration work, samples of puzzles, hidden pictures, mazes and self-promotion art. Art should appeal to children first. Artwork should reflect the artist's skill regardless of techniques used. Fresh, inventive colors and characters a strong point. Research publications to find ones that produce the kind of work you can produce. Send several samples (published as well as self-promotion art). The style can vary if there is a consistent quality in the work."

JACKSONVILLE

534 Lancaster St., Jacksonville FL 32204. (904)358-8330. Fax: (904)358-8668. E-mail: info@jacksonvillemag.com. Website: www.jacksonvillemag.com. **Creative Director:** Bronie Massey. Estab. 1983. City/regional lifestyle magazine covering Florida's First Coast. 12 times/yearly with 2 supplements. Circ. 25,000. Originals returned at job's completion. Sample copies available for $5 (includes postage).

Illustration Approached by 50 illustrators/year. Buys 1 illustration every 6 months. Has featured illustrations by Robert McMullen, Jennifer Kalis and Liz Burns. Assigns 75% of illustrations to local experienced but not well-known illustrators; 25% to new and emerging illustrators. Prefers editorial illustration with topical themes and sophisticated style.

First Contact & Terms Illustrators: Send tearsheets. Will accept computer-generated illustrations compatible with Macintosh programs Illustrator and Photoshop. Samples are filed and are returned by SASE if requested. Publication will contact artist for portfolio review if interested. Portfolio should include b&w and color tearsheets and slides. Buys one-time rights. Pays on publication; $600 for color cover; $150-400 for inside depending on scope.

☷ JEWISH ACTION

11 Broadway, New York NY 10004. (212)613-8146. Fax: (212)613-0646. E-mail: ja@ou.org. Website: www.ou.org. **Editor:** Nechama Carmel. Art Director Ed Hamway. Estab. 1986. Quarterly magazine "published by Orthodox Union for members and subscribers. Orthodox Jewish contemporary issues." Circ. 25,000. Sample copies available for 9×12 SASE and $1.75 postage or can be seen on website.

Cartoons Approached by 2 cartoonists/year. Prefers themes relevant to Jewish issues. Prefers single, double or multiple panel, political, humorous b&w washes and line drawings with or without gaglines.

Illustration Approached by 4-5 illustrators. Considers all media. Assigns 50% of illustrations to experienced but not well-known illustrators; 50% to new and emerging illustrators. Knowledge of Photoshop, Illustrator and QuarkXPress "not absolutely necessary, but preferred."

Design Needs freelancers for design and production. Prefers local design freelancers only.

First Contact & Terms Send query letter with photocopies and SASE. Accepts disk submissions. Prefer QuarkXPress TIFF or EPS files. Can send ZIP disk. Samples are not filed and are not returned. Responds only if interested. Art director will contact artist for portfolio review of photographs if interested. Buys one-time rights. Pays within 6 weeks of publication. Pays cartoonists $20-50 for b&w. Pays illustrators $25-75 for b&w, $50-300 for color cover; $50-200 for b&w, $25-150 for color inside. Finds illustrators through submissions.

Tips Looking for "sensitivity to Orthodox Jewish traditions and symbols."

JOURNAL OF ACCOUNTANCY

AICPA, Harborside 201 Plaza III, Jersey City NJ 07311. (201)938-3450. E-mail: jcostello@aicpa.org. **Art Director:** Jeryl Ann Costello. Monthly 4-color magazine emphasizing accounting for certified public accountants; corporate/business format. Circ. 360,000. Accepts previously published artwork. Original artwork returned after publication.

Illustration Approached by 200 illustrators/year. Buys 2-6 illustrations/issue. Prefers business, finance and law themes. Accepts mixed media, then pen & ink, airbrush, colored pencil, watercolor, acrylic, oil, pastel and digital. Works on assignment only. 35% of freelance work demands knowledge of Illustrator, QuarkXPress and FreeHand.

First Contact & Terms Illustrators: Send query letter with brochure showing art style. Samples not filed are returned by SASE. Portfolio should include printed samples, color and b&w tearsheets. Buys first rights. Pays on publication; $1,200 for color cover; $200-600 for color (depending on size) inside. Finds artists through submissions/self-promotions, sourcebooks and magazines.

Tips "I look for indications that an artist can turn the ordinary into something extraordinary, whether it be

through concept or style. In addition to illustrators, I also hire freelancers to do charts and graphs. In portfolios, I like to see tearsheets showing how the art and editorial worked together.''

JOURNAL OF ASIAN MARTIAL ARTS

821 W. 24th St., Erie PA 16502-2523. (814)455-9517. Fax: (814)455-2726. E-mail: info@goviamedia.com. Website: www.goviamedia.com. **Publisher:** Michael A. DeMarco. Estab. 1991. Quarterly journal covering all historical and cultural aspects of Asian martial arts. Interdisciplinary approach. College-level audience. Circ. 10,000. Accepts previously published artwork. Sample copies available for $10. Art guidelines for SASE with first-class postage.

Illustration Buys 60 illustrations/issue. Has featured illustrations by Oscar Ratti, Tony LaMotta and Michael Lane. Features realistic and medical illustration. Assigns 10% of illustrations to new and emerging illustrators. Prefers b&w wash; brush-like Oriental style; line. Considers pen & ink, watercolor, collage, airbrush, marker and charcoal.

First Contact & Terms Illustrators: Send query letter with brochure, résumé, SASE and photocopies. Accepts disk submissions compatible with PageMaker, QuarkXPress and Illustrator. Samples are filed. Responds in 6 weeks. Publication will contact artist for portfolio review if interested. Portfolio should include b&w roughs, photocopies and final art. Buys first rights and reprint rights. Pays on publication; $100-300 for color cover; $10-100 for b&w inside; $100-150 for 2-page spreads.

Tips ''Usually artists hear about or see our journal. We can be found in bookstores, libraries or in listings of publications. Areas most open to freelancers are illustrations of historic warriors, weapons, castles, battles—any subject dealing with the martial arts of Asia. If artists appreciate aspects of Asian martial arts and/or Asian culture, we would appreciate seeing their work and discuss the possibilities of collaboration.''

JOURNAL OF LIGHT CONSTRUCTION

186 Allen Brook Lane, Williston VT 05495-9222. (802)879-3335. Fax: (802)879-9384. E-mail: jlc-editorial@hanley_wood.com. Website: www.jlconline.com. **Art Director:** Barbara Nevins. Monthly magazine emphasizing residential and light commercial building and remodeling. Focuses on the practical aspects of building technology and small-business management. Circ. 72,000. Accepts previously published material. Original artwork is returned after publication. Sample copy free.

JUDICATURE

2700 University Ave., Des Moines IA 50311. E-mail: drichert@ajs.org. Website: www.ajs.org. **Contact:** David Richert. Estab. 1917. Journal of the American Judicature Society. 4-color bimonthly publication. Circ. 6,000. Accepts previously published material and computer illustration. Original artwork returned after publication. Sample copy for SASE with $1.52 postage; art guidelines not available.

Cartoons Approached by 10 cartoonists/year. Buys 1-2 cartoons/issue. Interested in ''sophisticated humor revealing a familiarity with legal issues, the courts and the administration of justice.''

Illustration Approached by 20 illustrators/year. Buys 1-2 illustrations/issue. Has featured illustrations by Estelle Carol, Mary Chaney, Jerry Warshaw and Richard Laurent. Features humorous and realistic illustration; charts & graphs; computer and spot illustration. Works on assignment only. Interested in styles from ''realism to light humor.'' Prefers subjects related to court organization, operations and personnel. Freelance work demands knowledge of PageMaker and FreeHand.

Design Needs freelancers for design. 100% of freelance work demands knowledge of PageMaker and FreeHand.

First Contact & Terms Cartoonists: Send query letter or e-mail with samples of style and SASE. Responds in 2 weeks. Illustrators: Send query letter, SASE, photocopies, tearsheets or brochure showing art style (can be sent electronically). Publication will contact artist for portfolio review if interested. Portfolio should include roughs and printed samples. Wants to see ''black & white and color, along with the title and synopsis of editorial material the illustration accompanied.'' Buys one-time rights. Negotiates payment. Pays cartoonists $35 for unsolicited b&w cartoons. Pays illustrators $250-375 for 2-, 3- or 4-color cover; $250 for b&w full page, $175 for b&w half page inside; $75-100 for spots. Pays designers by the project.

Tips ''Show a variety of samples, including printed pieces and roughs.''

KALEIDOSCOPE: Exploring the Experience of Disability Through Literature and the Fine Arts

701 S. Main St., Akron OH 44311-1019. (330)762-9755. E-mail: mshiplett@udsakron.org. Website: www.udsakron.org. **Editor-in-Chief:** Gail Willmott. Estab. 1979. Black & white with 4-color cover. Semiannual. ''Elegant, straightforward design. Explores the experiences of disability through lens of the creative arts. Specifically seeking work by artists with disabilities. Work by artists without disabilities must have a disability focus.'' Circ. 1,500. Accepts previously published artwork. Sample copy $6; art guidelines for SASE with first-class postage.

Illustration Freelance art occasionally used with fiction pieces. More interested in publishing art that stands on its own as the focal point of an article. Approached by 15-20 artists/year. Has featured illustrations by Dennis

J. Brizendine, Deborah Vidaver Cohen and Sandy Palmer. Features humorous, realistic and spot illustration.
First Contact & Terms Illustrators: Send query letter with résumé, photocopies, photographs, SASE and slides. Do not send originals. Prefers high contrast, b&w glossy photos, but will also review color photos or 35mm slides. Include sufficient postage for return of work. Samples are not filed. Publication will contact artist for portfolio review if interested. Acceptance or rejection may take up to a year. Pays $25-100 for color covers; $10-25 for b&w or color insides. Rights revert to artist upon publication. Finds artists through submissions/self-promotions and word of mouth.
Tips "Inquire about future themes of upcoming issues. Considers all mediums, from pastels to acrylics to sculpture. Must be high-quality art."

KALLIOPE, a journal of women's literature and art
11901 Beach Blvd., Jacksonville FL 32246. (904)646-2346. Website: www.fccj.org/kalliope. **Editor:** Mary Sue Koeppel. Estab. 1978. Literary b&w biannual which publishes an average of 27 pages of art by women in each issue. "Publishes poetry, fiction, reviews, and visual art by women and about women's concerns; high-quality art reproductions; visually interesting design." Circ. 1,600. Accepts previously published "fine" artwork. Original artwork is returned at the job's completion. Sample copy for $7. Art guidelines available for SASE with first-class postage.
Cartoons Approached by 1 cartoonist/year. Has featured art by Aimee Young Jackson, Kathy Keler, Lise Metzger, Joyce Tenneson. Topics should relate to women's issues.
Illustration Approached by 35 fine artists/year. Buys 27 photos of fine art/issue. Looking for "excellence in fine visual art by women (nothing pornographic)."
First Contact & Terms Cartoonists: Send query letter with roughs. Illustrators: Send query letter with résumé, SASE, photographs (b&w glossies) and artist's statement (50-75 words). Samples are not filed and are returned by SASE. Responds in 2 months. Rights acquired vary according to project. Pays 1 year subscription or 2 complimentary copies for b&w cover or inside.
Tips "Please study recent issues of *Kalliope.*"

⚜ KANSAS CITY MAGAZINE
118 Southwest Blvd., 3rd Floor, Kansas City MO 64108. (816)421-4111. Fax: (816)221-8350. E-mail: akingsolver @abartapub.com. Website: www.kcmag.com. **Contact:** Alice Kingsolver, art director. Estab. 1994. Monthly lifestyle-oriented magazine, celebrating living in Kansas City. "We try to look at things from a little different angle (for added interest) and show the city through the eyes of the people." Circ. 27,000. Sample copies available for #10 SASE with first-class postage. Art guidelines not available.
Illustration Approached by 100-200 illustrators/year. Buys 3-5 illustrations/issue. Works on assignment only. Prefers conceptual editorial style. Considers all media. 25% of freelance illustration demands knowledge of Illustrator and Photoshop.
Design Needs freelancers for design and production. Prefers local freelancers only. 100% of freelance work demands knowledge of Photoshop, Illustrator and QuarkXPress.
First Contact & Terms Illustrators: Send postcard-size sample or query letter with tearsheets, photocopies and printed samples. Designers: Send query letter with printed samples, photocopies, SASE and tearsheets. Accepts disk submissions compatible with Macintosh files (EPS, TIFF, Photoshop, etc.). Samples are filed. Will contact artist for portfolio review if interested. Portfolio should include final art, photographs, tearsheets, photocopies and photostats. Buys reprint rights. **Pays on acceptance**; $500-800 for color cover; $50-200 for b&w, $150-300 for color inside. Pays $50-150 for spots. Finds artists through sourcebooks, word of mouth, submissions.
Tips "We have a high quality, clean, cultural, creative format. Look at magazine before you submit."

KASHRUS MAGAZINE—The Periodical for the Kosher Consumer
Box 204, Brooklyn NY 11204. (718)336-8544. Fax: (718)336-8550. E-mail: info@kashrusmagazine.com. Website: www.kashrusmagazine.com. **Editor:** Rabbi Yosef Wikler. Estab. 1980. Bimonthly magazine with 4-color cover which updates consumer and trade on issues involving the kosher food industry, especially mislabeling, new products and food technology. Circ. 10,000. Accepts previously published artwork. Original artwork is returned after publication. Sample copy $2; art guidelines not available.
Cartoons Buys 2 cartoons/issue. Accepts color for cover or special pages. Seeks "kosher food and Jewish humor."
Illustration Buys illustrations mainly for covers. Works on assignment only. Has featured illustrations by R. Keith Rugg and Theresa McCracken. Features humorous, realistic and spot illustration. Assigns 30% of illustrations to new and emerging illustrators. Prefers pen & ink.
First Contact & Terms Send query letter with photocopies. Request portfolio review in original query. Portfolio should include tearsheets. Pays cartoonists $25-35 for b&w; payment is negotiated by project. Pays illustrators

$100-200 for color cover; $25-75 for b&w inside; $75-150 for color inside; $25-35 for spots. Finds artists through submissions and self-promotions.

Tips "Send general food or Jewish food- and travel-related material. Do not send off-color material."

KENTUCKY LIVING

Box 32170, Louisville KY 40232. (502)451-2430. Fax: (502)459-1611. E-mail: E-mail:@kentuckyliving.com. Website: www.kentuckyliving.com. **Editor:** Paul Wesslund. 4-color monthly emphasizing Kentucky-related and general feature material for Kentuckians living outside metropolitan areas. Circ. 500,000. Accepts previously published material. Original artwork returned after publication if requested. Sample copy available.

Cartoons Approached by 10-12 cartoonists/year.

Illustration Buys occasional illustrations/issue. Works on assignment only. Prefers b&w line art.

First Contact & Terms Illustrators: Send query letter with résumé and samples. Samples not filed are returned only if requested. Buys one-time rights. **Pays on acceptance.** Pays cartoonists $30 for b&w. Pays illustrators $50 for b&w inside.

KEYNOTER

3636 Woodview Trace, Indianapolis IN 46268. (317)875-8755. Website: www.keyclub.org. **Executive Editor:** Shanna Mooney. Art Director Maria Malandrakis. Official publication of Key Club International, nonprofit high school service organization. 4-color; "contemporary design for mature teenage audience." Published 4 times/ year. Circ. 170,000. Previously published, photocopied and simultaneous submissions OK. Original artwork is returned after publication only upon request. Free sample copy with SASE and 83¢ postage.

Illustration Buys 3 editorial illustrations/issue. Works on assignment only.

First Contact & Terms Include SASE. Responds in 2 weeks. "Freelancers should call our Production and Art Department for interview." Buys first rights. **Pays on receipt of invoice:** $100 for b&w, $250 for color cover; $50 for b&w, $150 for color, inside.

KIPLINGER'S PERSONAL FINANCE

1729 H St. NW, Washington DC 20006. (202)887-6416. Fax: (202)331-1206. E-mail: ccurrie@kiplinger.com. Website: www.kiplinger.com. **Art Director:** Cynthia L. Currie. Estab. 1947. A monthly 4-color magazine covering personal finance issues including investing, saving, housing, cars, health, retirement, taxes and insurance. Circ. 800,000. Originals are returned at job's completion.

Illustration Approached by 350 illustrators/year. Buys 4-6 illustrations/issue. Works on assignment only. Has featured illustrations by Dan Adel, Tim Bower, Edwin Fotheringham. Features computer, conceptual editorial and spot illustration. Assigns 5% of illustrations to new and emerging illustrators. Interested in editorial illustration in new styles, including computer illustration.

First Contact & Terms Illustration: Send postcard samples. Accepts Mac-compatible CD submissions. Samples are filed or returned by SASE if requested by artist. Publication will contact artist for portfolio review if interested. Buys one-time rights. Pays on publication; $400-1,200 for color inside; $250-500 for spots. Finds illustrators through reps, online, magazines, *Workbook* and award books.

KIWANIS

3636 Woodview Trace, Indianapolis IN 46268. (317)875-8755. Fax: (317)879-0204. E-mail: magazine@kiwanis. org. Website: www.kiwanis.org. **Art Director:** Maria Malandrakis. Estab. 1918. 4-color magazine emphasizing civic and social betterment, business, education and domestic affairs for business and professional persons. Published 6 times/year. Original artwork returned after publication by request. Circ. 240,000. Art guidelines available for SASE with first-class postage.

Illustration Buys 1-2 illustrations/issue. Assigns themes that correspond to themes of articles. Works on assignment only. Keeps material on file after in-person contact with artist.

First Contact & Terms Illustration: Include SASE. Responds in 2 weeks. To show a portfolio, mail appropriate materials (out of town/state) or call or write for appointment. Portfolio should include roughs, printed samples, final reproduction/product, color and b&w tearsheets, photostats and photographs. Buys first rights. **Pays on acceptance**; $600-1,000 for cover; $400-800 for inside; $50-75 for spots. Finds artists through talent sourcebooks, references/word of mouth and portfolio reviews.

Tips "We deal direct—no reps. Have plenty of samples, particularly those that can be left with us. Too many student or unassigned illustrations in many portfolios."

L.A. PARENT MAGAZINE

443 E. Irving Dr., Suite A, Burbank CA 91504-2447. (818)846-0400. Fax: (818)841-4964. E-mail: carolyn.graham @parenthood.com. Website: www.laparent.com. **Editor:** Carolyn Graham. Estab. 1979. Magazine. A monthly regional magazine for parents. 4-color throughout; "bold graphics and lots of photos of kids and families."

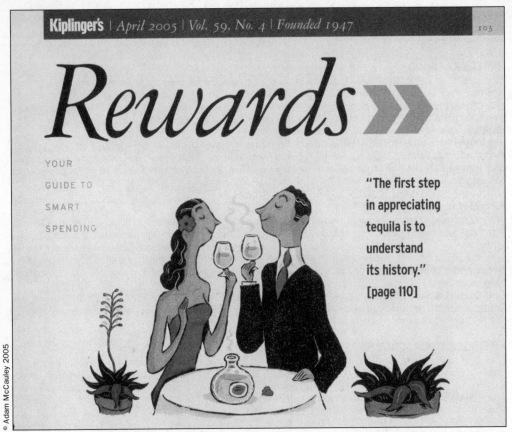

Kiplinger's | *April 2005* | *Vol. 59, No. 4* | *Founded 1947* 103

Rewards »

YOUR
GUIDE TO
SMART
SPENDING

"The first step in appreciating tequila is to understand its history." [page 110]

© Adam McCauley 2005

Adam McCauley's illustrations have appeared in *Time*, *National Geographic*, *HOW*, *Salon* and many more books and magazines. He has several styles which are showcased on his website at www.adammccauley.com. The style above, which appeared in Kiplinger's, conveys a light-hearted yet sophisticated mood that sets the tone for the article.

Circ. 120,000. Accepts previously published artwork. Originals are returned at job's completion.

Illustration Buys 2 freelance illustrations/issue. Assigns 50% of illustrations to experienced but not well-known illustrators; 50% to new and emerging illustrators. Works on assignment only. Send postcard sample. Accepts disk submissions compatible with Illustrator 5.0 and Photoshop 3.0. Samples are filed or returned by SASE. Responds in 2 months. To show a portfolio, mail thumbnails, tearsheets and photostats. Buys one-time rights or reprint rights. **Pays on publication**; $300 color cover; $75 for b&w inside; $50 for spots.

Tips "Show an understanding of our publication. Since we deal with parent/child relationships, we tend to use fairly straightforward work. Also looking for images and photographs that capture an L.A. feel. Read our magazine and find out what we're all about."

L.A. WEEKLY

6715 Sunset Blvd., Los Angeles CA 90028. (323)465-9909. Fax: (323)465-1550. E-mail: weeklyart@aol.com. Website: www.laweekly.com. **Assistant Art Director:** Laura Steele. Estab. 1978. Weekly alternative arts and news tabloid. Circ. 220,000. Art guidelines available.

Cartoons Approached by over 100 cartoonists/year. "We contract about 1 new cartoonist per year." Prefers Los Angeles, alternative lifestyle themes. Prefers b&w line drawings without gagline.

Illustration Approached by over 200 illustrators/year. Buys 4 illustrations/issue. Themes vary according to editorial needs. Considers all media.

First Contact & Terms Cartoonists: Send query letter with photocopies. Rights purchased vary according to project. Illustrators: Send postcard sample or query letter with photocopies of cartoons. "Can also e-mail final artwork." Samples are filed or returned by SASE. Responds only if interested. Portfolio may be dropped off

Monday-Friday and should include any samples except original art. Artist should follow up with call and/or letter after initial query. Buys first rights. Pays on publication. Pays cartoonists $120-200 for b&w. Pays illustrators $400-1,000 for cover; $120-400 for inside; $120-200 for spots. Prefers submissions but will also find illustrations through illustrators' websites, *Black Book*, *American Illustration*, various Los Angeles and New York publications.

Tips Wants ''less polish and more content. Gritty is good, quick turnaround and ease of contact a must.''

LADYBUG, the Magazine for Young Children

P.O. Box 300, Peru IL 61354. **Art Director:** Suzanne Beck. Estab. 1990. Monthly 4-color magazine emphasizing children's literature and activities for children, ages 2-6. Design is ''geared toward maximum legibility of text and basically art-driven.'' Circ. 140,000. Accepts previously published material. Original artwork returned after publication. Sample copy $4.95 plus 10% of total order ($4 minimum) for shipping and handling; art guidelines for SASE with first-class postage.

Illustration Approached by 600-700 illustrators/year. Works with 40 illustrators/year. Buys 200 illustrations/year. Has featured illustrations by Rosemary Wells, Tomie de Paola and Diane de Groat. Uses artists mainly for cover and interior illustration. Prefers realistic styles (animal, wildlife or human figure); occasionally accepts caricature. Works on assignment only.

First Contact & Terms Illustrators: Send query letter with photocopies, photographs and tearsheets to be kept on file, ''if I like it.'' Prefers photocopies and tearsheets as samples. Samples are returned by SASE if requested. Publication will contact artist for portfolio review if interested. Portfolio should show a strong personal style and include ''several pieces that show an ability to tell a continuing story or narrative.'' Does not want to see ''overly slick, cute commercial art (i.e., licensed characters and overly sentimental greeting cards).'' Buys all rights. **Pays 45 days after acceptance**; $750 for color cover; $250 for color full page; $100 for color, $50 for b&w spots.

Tips ''Has a need for artists who can accurately and attractively illustrate the movements for finger-rhymes and songs and basic informative features on nature and 'the world around you.' Multi-ethnic portrayal is also a *very* important factor in the art for *Ladybug*.''

LAW PRACTICE MANAGEMENT

24476 N. Echo Lake Rd., Hawthorn Woods IL 60047-9039. (847)550-9790. Fax: (847)550-9794. E-mail: mark@feldcomm.com. Website: www.abanet.org/lpm. **Art Director:** Mark Feldman, Feldman Communications, Inc. 4-color trade journal for the practicing lawyer about ''the business of practicing law.'' Estab. 1975. Published 8 times/year. Circ. 20,833.

Illustration Uses cover and inside feature illustrations. Uses all media, including computer graphics. Mostly 4-color artwork.

First Contact & Terms Illustrators: Send postcard sample or query letter with samples. Pays on publication. Very interested in high quality, previously published works. Pay rates $200-350/illustration. Original works negotiable. Cartoons very rarely used.

Tips ''Topics focus on management, marketing, communications and technology.''

LISTEN MAGAZINE

55 W. Oak Ridge Dr., Hagerstown MD 21740. (301)393-4010. E-mail: listen@healthconnection.org. **Editor:** Celeste Perrino Walker. Monthly magazine (September-May) for teens with specific aim to educate against alcohol, tobacco and other drugs and to encourage positive life choices. Circ. 30,000. Accepts previously published artwork. Originals returned at job's completion. Sample copies available for $1.

Cartoons Buys occasional cartoons. Prefers single panel b&w washes and line drawings.

Illustration Buys 6 illustrations/issue. Works on assignment only. Considers all media.

First Contact & Terms Cartoonists: Send query letter with brochure and roughs. Illustrators: Send postcard sample or query letter with brochure, résumé and tearsheets. Samples are filed or are returned by SASE. Responds only if interested. Publication will contact artist for portfolio review if interested. Buys reprint rights. **Pays on acceptance.** No longer uses illustrations for covers.

LOG HOME LIVING

4125 Lafayette Center Dr., Suite 100, Chantilly VA 20151. (800)826-3893 or (703)222-9411. Fax: (703)222-3209. E-mail: sgashi@homebuyerpubs.com. Website: www.loghomeliving.com. **Design Director:** Sylvia Gashi. Estab. 1989. Monthly 4-color magazine ''dealing with the aspects of buying, building and living in a log home. We emphasize upscale living (decorating, furniture, etc.).'' Circ. 108,000. Accepts previously published artwork. Sample copies not available. Art guidelines for SASE with first-class postage. 20% of freelance work demands knowledge of QuarkXPress, Illustrator and Photoshop.

● Also publishes *Timber Home Living, Log Home Design Ideas* and *Building Systems*.

Illustration Buys 2-4 illustrations/issue. Works on assignment only. Prefers editoral illustration with "a strong style—ability to show creative flair with not-so-creative a subject." Considers watercolor, airbrush, colored pencil, pastel and digital illustration.

Design Needs freelancers for design and production occasionally. 100% of freelance work demands knowledge of Photoshop, Illustrator, QuarkXPress and InDesign.

First Contact & Terms Illustrators: Send postcard sample. Designers: Send query letter with brochure, résumé, and samples. Accepts disk submissions compatible with Illustrator, Photoshop and QuarkXPress. Samples are filed. Publication will contact artist for portfolio review if interested. Portfolio should include thumbnails, roughs, printed samples or color tearsheets. Buys all rights. **Pays on acceptance**. Pays illustrators $100-200 for b&w inside; $250-800 for color inside; $100-250 for spots. Pays designers by the project. Finds artists through submissions/self-promotions, sourcebooks.

THE LOOKOUT

8121 Hamilton Ave., Cincinnati OH 45231. (513)728-6866. Fax: (513)931-0950. E-mail: lookout@standardpub.com. Website: www.lookoutmag.com. **Administrative Assistant:** Sheryl Overstreet. Weekly 4-color magazine for conservative Christian adults and young adults. Circ. 85,000. Sample copy available for $1.

Illustration Prefers both humorous and serious, stylish illustrations featuring Christian families.

First Contact & Terms Illustrators: Send postcard or other nonreturnable samples.

Tips Do not send e-mail submissions.

LOS ANGELES MAGAZINE

5900 Wilshire Blvd., 10th Floor, Los Angeles CA 90036. (323)801-0075. Fax: (323)801-0106. Website: www.losangelesmagazine.com. **Art Director:** Joe Kimberling. Monthly 4-color magazine with a contemporary, modern design, emphasizing lifestyles, cultural attractions, pleasures, problems and personalities of Los Angeles and the surrounding area. Circ. 170,000. Especially needs very localized contributors—custom projects needing person-to-person concepting and implementation. Previously published work OK. Sample copy $3. 10% of freelance work demands knowledge of QuarkXPress, Illustrator and Photoshop.

Illustration Buys 10 illustrations/issue on assigned themes. Prefers general interest/lifestyle illustrations with urbane and contemporary tone. To show a portfolio, send or drop off samples showing art style (tearsheets, photostats, photocopies and dupe slides).

First Contact & Terms Pays on publication; negotiable.

Tips "Show work similar to that used in the magazine. Study a particular publication's content, style and format. Then proceed accordingly in submitting sample work. We initiate contact of new people per *Showcase* reference books or promo fliers sent to us. Portfolio viewing is all local."

🅽 MACADDICT MAGAZINE

150 N. Hill Dr., Brisbane CA 94005-1000. (415)468-4684. Fax: (415)656-2483. Website: www.macaddict.com. **Art Director:** Christopher Imlay. Monthly 4-color consumer magazine for people who are passionate about their Macintosh computers. Circ. 180,159. Sample copies available with SASE. Art guidelines available free with SASE.

MAD MAGAZINE

1700 Broadway, New York NY 10019. (212)506-4850. Fax: (212)506-4848. Website: www.madmag.com. **Art Director:** Sam Viviano. Associate Art Director: Nadina Simon. Assistant Art Director: Patricia Dwyer. Monthly irreverent humor, parody and satire magazine. Estab. 1952. Circ. 250,000.

Illustration Approached by 300 illustrators/year. Works with 50 illustrators/year. Has featured illustrations by Mort Drucker, Al Jaffe, Sergio Aragones, Tom Richmond and Hermann Mejia. Features humor, realism, caricature.

First Contact & Terms Illustrators: Send query letter with tearsheets and SASE. Samples are filed. Buys all rights. Pays $2,500-3,200 for color cover; $400-725 for inside. Finds illustrators through direct mail, sourcebooks (all).

Design Uses local freelancers for design infrequently. 100% of freelance design demands knowledge of Illustrator, Photoshop and QuarkXPress.

Tips "Know what we do! *MAD* is very specific. Everyone wants to work for *MAD*, but few are right for what *MAD* needs! Understand reproduction process, as well as 'give-and-take' between artist and client."

MAIN LINE TODAY

4699 W. Chester Pike, Newtown Square PA 19703. (610)325-4630. Fax: (610)325-5215. Website: www.mainlinetoday.com. **Art Director:** Ingrid Hansen-Lynch. Estab. 1996. Monthly consumer magazine providing quality

information to the Main Line and western surburbs of Philadelphia. Circ. 40,000. Sample copies for #10 SASE with first-class postage.

Illustration Approached by 100 illustrators/year. Buys 3-5 illustrations/issue. Considers acrylic, charcoal, collage, color washed, mixed media, oil, pastel and watercolor.

First Contact & Terms Send postcard sample or query letter with printed samples and tearsheets. Send followup postcard sample every 3-4 months. Samples are filed and are not returned. Responds only if interested. Buys one-time and reprint rights. Pays on publication; $400 maximum for color cover; $125-250 for b&w inside; $125-250 for color inside. Pays $125 for spots. Finds illustrators by word of mouth and submissions.

N MANAGED CARE

780 Township Line Rd., Yardley PA 19067. (267)685-2788. Fax: (267)685-2966. Website: www.managedcarema g.com. **Art Director:** Philip Denlinger. Estab. 1992. Monthly trade publication for healthcare executives. Circ. 60,000.

Illustration Approached by 50 illustrators/year. Buys 3 illustrations/issue. Has featured illustrations by Theo Rudnak, David Wilcox, Gary Overacre, Roger Hill. Features informational graphics, realistic and spot illustration. Prefers business subjects. Assignments for illustrations divided equally between well-known or name illustrators; experienced, but not well-known, illustrators; and new and emerging illustrators.

First Contact & Terms Send postcard sample. Samples are filed. Will contact artist for portfolio review if interested. Rights purchased vary according to project. **Pays on acceptance**; $1,500-2,000 for color cover; $250-750 for color inside; $450 for spots. Finds illustrators through *American Showcase* and postcards.

N MEETINGS IN THE WEST

550 Montgomery St., Suite 750, San Francisco CA 94111. (415)788-2005. Fax: (415)788-0301. Website: www.me eting411.com. **Art Director:** Scott Kambic. Graphic Artist Mort Malison. Jr. Designer Stephanie Groom. Monthly 4-color tabloid/trade publication for meeting planners covering the 14 western United States, plus western Canada and Mexico. Circ. 25,000.

Illustration Approached by 5 illustrators/year. Buys more than 1 illustration/issue. Features computer illustration, humorous and spot illustration. Prefers subjects portraying business and business travel subjects. Prefers colorful, fun computer illustration. Assigns 20% of illustration to experienced, but not well-known illustrators; 80% to new and emerging illustrators.

First Contact & Terms Illustrators: Send postcard sample. Accepts Mac-compatible disk submissions. Samples are filed or returned by SASE. Will contact artist for portfolio review if interested. Buys first rights. Pays on publication; $700-1,000 for color cover; $50-300 for color inside. Finds illustrators through word of mouth, recommendations by colleagues, promo samples.

Tips "We are always open to new interpretations. All must be able to work fast and have a flexible style."

N MEN'S HEALTH

733 Third Ave., 15th Floor, New York NY 10017.(212)697-2040. Fax: (212)682-2273. Website: www.menshealth .com. **Art Director:** George Karabotsos. Art guidelines not available.

Cartoons Buys 10 cartoons/year.

Illustration Buys 100 illustrations/year. Has featured illustrations by Daniel Adel, Gary Taxali, Eboy, Mirkoilic, Jonathon Carlson. Features caricatures of celebrities/politicians, realistic illustration, charts & graphs, humorous illustration, medical illustration, computer illustration, informational graphics, spot illustrations. Prefer subjects about men. 100% of freelance work demands computer skills. Freelancers should be familiar with InDesign, Illustrator, Photoshop. E-mail submissions accepted with link to website. Samples are not filed and are not returned. Portfolio not required.

N MICHIGAN LIVING

2865 Waterloo, Troy MI 48084. (248)816-9265. Fax: (248)816-2251. E-mail: michliving@aol.com. **Editor:** Ron Garbinski. Estab. 1918. Monthly magazine emphasizing travel and lifestyle. Circ. 1.1 million. Sample copies and art guidelines for SASE with first-class postage.

Illustration Approached by 20 illustrators/year. Features natural history illustrations; realistic illustration; charts & graphs; and informational graphics. Assigns 50% of illustrations to experienced, but not well-known illustrators; 50% to new and emerging illustrators. Prefers travel related illustrations. Considers all media.

First Contact & Terms Illustrators: Send query letter with printed samples, photocopies, tearsheets and include e-mail address. Samples are not filed and are not returned. Art director will contact artist for portfolio review of b&w and color final art, photographs, photostats, roughs, slides, tearsheets, thumbnails, transparencies if interested. Buys first North American serial rights or reprint rights. Pays $450 maximum for cover and inside; $400 maximum for spots. Finds illustrators through sourcebooks, such as *Creative Black Book*, word of mouth, submissions.

Tips "Read our magazine, we need fast workers with quick turnaround."

MICHIGAN OUT OF DOORS

P.O. Box 30235, Lansing MI 48909. (517)371-1041. Fax: (517)371-1505. E-mail: magazine@mucc.org. Website: www.mucc.org. **Contact:** Dennis C. Knickerbocker. 4-color magazine emphasizing outdoor recreation, especially hunting and fishing, conservation and environmental affairs. Circ. 80,000. "Conventional" design. Art guidelines available free for SASE. Sample copy $3.50.

Illustration "Following the various hunting and fishing seasons, we have a limited need for illustration material; we consider submissions 6-8 months in advance." Has featured illustrations by Ed Sutton and Nick Van Frankenhuyzen. Assigns 10% of illustrations to new and emerging illustrators.

First Contact & Terms Responds as soon as possible. **Pays on acceptance**; $30 for pen & ink illustrations in a vertical treatment.

MID-AMERICAN REVIEW

English Dept., Bowling Green State University, Bowling Green OH 43403. (419)372-2725. Website: www.bgsu.edu/midamericanreview. **Contact:** Editor-in-Chief. Estab. 1980. Semiannual literary magazine publishing "the best contemporary poetry, fiction, essays, and work in translation we can find. Each issue includes poems in their original language and in English." Circ. 700. Originals are returned at job's completion. Sample copies available for $5.

Illustration Approached by 10-20 illustrators/year. Buys 1 illustration/issue.

First Contact & Terms Send query letter with brochure, SASE, tearsheets, photographs and photocopies. Samples are filed or are returned by SASE if requested by artist. Responds in 3 months. Buys first rights. Pays on publication. Pays $50 when funding permits. Also pays in copies, up to 20.

Tips "*MAR* only publishes artwork on its cover. We like to use the same artist for one volume (two issues). We are looking for full-color artwork for a front-to-back, full bleed effect. Visit our website!"

N MOBILE BEAT

P.O. Box 309, East Rochester NY 14445. (716)385-9920. Fax (716)385-3637. E-mail: info@mobilebeat.com. Website: www.mobilebeat.com. **Editor:** Robert Lindquist. Estab. 1991. Bimonthly magazine "of professional sound, lighting and karaoke." Circ. 18,000.

Cartoons Buys 1 cartoon/issue. Prefers single panel with gagline.

Illustration Approached by 10-12 illustrators. Buys 0-1 illustrations/issue. Has featured illustrations by Robert Burger, Jeff Marinelli, Dan Sipple. Assigns 50% of illustrations to experienced but not well-known illustrators; 50% to new and emerging illustrators. 100% of freelance illustration demands knowledge of PageMaker, Photoshop, Illustrator and MacroMedia FreeHand.

First Contact & Terms Cartoonists: Send query lettery with finished cartoons. Illustrators: Send query letter with photocopies. Accepts disk submissions compatible with PageMaker, Photoshop, Illustrator and MacroMedia FreeHand. Samples are filed. Responds in 1 month if interested. Buys one-time rights. Pays on publication. Pays cartoonists $100 minimum for b&w. Pays illustrators $200-400 for b&w cover; $100 for b&w inside. Finds illustrators through agents, sourcebooks and submissions.

Tips "Read our magazine."

MODERN DRUMMER

12 Old Bridge Rd., Cedar Grove NJ 07009. (973)239-4140. E-mail: scottb@moderndrummer.com. Website: www.moderndrummer.com. **Art Director:** Scott Bienstock. Monthly magazine for drummers, "all ages and levels of playing ability with varied interests within the field of drumming." Circ. 103,000. Previously published work OK. Original artwork returned after publication. Sample copy for $4.99.

Cartoons Buys 10-12 cartoons/year. Interested in drumming themes; single and double panel. Prefers finished cartoons or roughs.

First Contact & Terms "Send nonreturnable samples only!" Responds in 3 weeks. Buys first North American serial rights. Pays on publication; $100.

Tips "We want strictly drummer-oriented gags."

MODERN HEALTHCARE MAGAZINE

360 N. Michigan, 5th Floor, Chicago IL 60601. (312)649-5346. Fax: (312)280-3183. E-mail: khorist@crain.com. Website: www.modernhealthcare.com. **Assistant Managing Editor Graphics:** Keith Horist. Estab. 1976. Weekly 4-color trade magazine on healthcare topics, geared to CEO's, CFO's, COO's etc. Circ. 90,000.

Illustration Approached by 50 illustrators/year. Features caricatures of politicians, humorous illustration, charts & graphs, informational graphics, medical illustration, spot illustrations and computer illustration. Assigns 60%

of illustrations to well-known or "name" illustrators; 40% to experienced but not well-known illustrators. 100% of freelance illustration demands knowledge of Illustrator, Photoshop, FreeHand.

First Contact & Terms Illustrators: Send postcard sample and nonreturnable printed samples. Accepts Mac or Windows-compatible disk submissions. Samples are filed. Responds only if interested. Will contact artist for portfolio review if interested. Buys all rights. "Usually buy all rights for cover art. If it is a generic illustration not geared directly to our magazine, then we might buy only first rights in that case." **Pays on acceptance**; $400-450 for color cover; $50-150 for color inside. Finds illustrators through word of mouth and staff members.

Tips "Keep sending out samples, someone will need your style. Don't give up!"

N MODERN PLASTICS

110 William St., 11th Floor, New York NY 10038. (212)621-4653. Fax: (212)621-4685. Website: www.modplas.com. **Art Director:** Larry E. Matthews. Monthly trade journal emphasizing technical articles for manufacturers of plastic parts and machinery; 4-color with contemporary design. Circ. 65,000 domestic, 35,000 international. 20% of freelance work demands knowledge of Illustrator, QuarkXPress or FreeHand.

Illustration Works with 4 illustrators/year. Buys 6 illustrations/year. Prefers airbrush, computer and conceptual art. Works on assignment only.

First Contact & Terms Illustrators: Send brochure. Samples are filed. Does not reply. Call for appointment to show a portfolio of tearsheets, photographs, slides, color and b&w. Buys all rights. **Pays on acceptance**; $800-1,000 for color cover; $200-250 for color inside.

Tips "I get a lot of stuff that is way off track—aliens, guys with heads cut off, etc. We need technical and computer graphics that's appropriate."

N MOMENT

4710 41st St. NW, Washington DC 20016-1706. (202)364-3300. Fax: (202)364-2636. Website: www.momentmag.com. **Art Directors:** Ron Mele and Daryl Wakeley. Contact Josh Rolnick, associate editor. Estab. 1973. Bi-monthly Jewish magazine, featuring articles on religion, politics, culture and Israel. Circ. 65,000. Accepts previously published artwork. Originals returned at job's completion. Sample copies available for $4.50.

Cartoons Uses reprints and originals. Prefers political themes relating to Middle East, Israel and contemporary Jewish life.

Illustration Buys 5-10 illustrations/year. Works on assignment only.

First Contact & Terms Send query letter. Samples are filed. Responds only if interested. Rights purchased vary according to project. Pays cartoonists minimum of $30 for ¼ page, b&w and color. Pays illustrators $30 for b&w, $225 for color cover; $30 for color inside (¼ page or less).

Tips "We look for specific work or style to illustrate themes in our articles. Please know the magazine—read back issues!"

MONEY

Time & Life Bldg. Rockefeller Cntr., New York NY 10020-1393. (212)522-0930. Fax: (212)522-1796. Website: www.money.com. **Contact:** Syndi Becker, art director. Deputy Art Director Mary Ann Salvato Jones. Estab. 1972. Monthly 4-color consumer magazine. Circ. 1,000,000.

Illustration Approached by tons of illustrators/year. Buys 34 illustrations/issue. Features caricatures of business people, CEOs of visible companies, charts & graphs, humorous and spot illustrations of men and women. Assigns 10% of illustrations to well-known or "name" illustrators; 90% to experienced but not well-known illustrators.

First Contact & Terms Illustrators: Send query letter with 5 or 6 printed samples. Samples are not returned. Responds only if interested. Will contact artist for portfolio review if interested. Buys one-time rights. Pays $250-750 for spots. Finds illustrators through *Creative Black Book*, *LA Workbook*, artists' promotional samples.

Tips Because our publication is photo-driven, we don't use as much illustration as we'd like—but we love illustration. The trouble with some beginning illustrators is that they do not yet have the consistency of style that's so important in editorial work. I'll get a sample I love, ask to see more, and the illustrator shows work that's all over the place in terms of style. And I'll think "Oh, this isn't anything like the sample I liked," and won't hire that illustrator. Make sure your samples show that there is consistency in your work.

N MONTANA MAGAZINE

P.O. Box 5630, Helena MT 59604. (406)443-2842. Fax: (406)443-5480. Website: www.montanamagazine.com. **Editor:** Beverly R. Magley. Estab. 1970. Bimonthly magazine covering Montana recreation, history, people, wildlife. Geared to Montanans. Circ. 40,000.

Illustration Approached by 15-20 illustrators/year. Buys 1-2 illustrations/year. Prefers outdoors. Considers all media. Knowledge of Quark, Photoshop, Illustrator helpful but not required. Send query letter with photocopies. Accepts disk submissions combatible with Quark.

First Contact & Terms Illustrators: Send EPS files. Samples are filed and are not returned. Buys one-time rights. Pays on publication; $35-50 for b&w; $50-125 for color. Pays $35-50 for spots. Finds illustrators through submissions, word of mouth.

Tips "We work with local artists usually because of convenience and turnaround." No cartoons.

MOTHER JONES

731 Market St., Suite 600, San Francisco CA 94103. (415)665-6637. Fax: (415)665-6696. Website: www.motherjones.com. **Design Director:** Jane Palecek. Estab. 1976. Bimonthly magazine. Focuses on investigative journalism, progressive politics and exposes. Circ. 201,233. Accepts previously published artwork. Originals returned at job's completion. Sample copies available.

Cartoons Approached by 25 cartoonists/year. Prints one cartoon/issue (6/year). Prefers full page, multiple-frame color drawings. Works on assignment only.

Illustration Approached by hundreds of illustrators/year. Has featured illustrations by Gary Baseman, Chris Ware, Juliette Borda and Gary Panter. Assigns 90% of illustrations to well-known or "name" illustrators; 5% to experienced but not well-known illustrators; 5% to new and emerging illustrators. Works on assignment only. Considers all media.

First Contact & Terms Cartoonists: Send query letter with postcard-size sample or finished cartoons. Illustrators: Send postcard-size sample or query letter with samples. Samples are filed or returned by SASE. Responds to the artist only if interested. Portfolio should include photographs, slides and tearsheets. Buys first rights. Pays on publication; payment varies widely. Finds artists through illustration books, other magazines, word of mouth.

MOTHERING MAGAZINE

P.O. Box 1690, Santa Fe NM 85504. (505)984-6287. E-mail: laurat@mothering.com. Website: www.mothering.com. **Contact:** Laura Egley Taylor, art director. Estab. 1976. Consumer magazine focusing on natural family living and natural/alternative practices in parenting. Circ. 80,000. Sample copies and art guidelines available.

Illustration Send query letter and/or postcard sample. Works on assignment only. Media and styles vary.

First Contact & Terms Illustrators: Send query with postcard samples or send EPS, JPEG or PDF files. Director will contact for portfolio review if interested. Portfolio should include color tearsheets, photostats, photographs, slides and color photocopies. Samples are filed. Responds only if interested. Buys first rights. Pays on publication; $500 maximum for cover; $275-450 for inside. Payment for spots depends on size. Finds illustrators through submissions, sourcebooks, magazines, word of mouth.

Tips "Become familiar with tone and subject matter (mothers and babies) of our magazine."

MOTORING ROAD℠

P.O. Box M, Franklin MA 02038. Phone/fax (508)528-6211. **Contact:** Jay Kruza, editor. Estab. 2001. Bimonthly trade publication of automotive news affecting New England dealers, bodyshops, garages, mechanics and gas stations. Circ. 11,000. Sample copies available with SASE.

Cartoons Buys 12 cartoons/year. Prefers positive or corrective styles/themes. Prefers single panel, humorous, b&w washes and drawings.

Illustration Buys 6-12 illustrations/year. Features caricatures of celebrities/politicians, charts & graphs, computer illustration and informational graphics. Assigns 50% to new and emerging illustrators.

▣ ☑ MUSCLEMAG INTERNATIONAL

5775 McLaughlin Rd., Mississauga ON L5R 3P7 Canada. (905)507-3545. E-mail: editorial@emusclemag.com. Website: www.emusclemag.com. **Contact:** Robert Kennedy. Estab. 1974. Monthly consumer magazine. Magazine emphasizes bodybuilding for men and women. Circ. 300,000. Originals not returned at job's completion. Sample copies available for $5; art guidelines not available.

Illustration Approached by 200 illustrators/year. Buys 130 illustrations/year. Has featured illustrations by Eric Blais and Gino Edwards. Features caricatures of celebrities; charts & graphs; humorous, medical and computer illustrations. Assigns 20% of illustrations to new and emerging illustrators. Prefers bodybuilding themes. Considers all media.

First Contact & Terms Cartoonists: Send photocopy of your work. Illustrators: Send query letter with photocopies. Samples are filed. Responds in 1 month. Portfolio review not required. Buys all rights. **Pays on acceptance.** Pays cartoonists $50-100. Pays illustrators $100-150 for b&w inside; $250-1,000 for color inside. "Higher pay for high-quality work." Finds artists through "submissions from artists who see our magazine."

Tips Needs line drawings of bodybuilders exercising. "Study the publication. Work to improve by studying others. Don't send out poor quality stuff. It wastes editor's time."

ℕ MUSHING

P.O. Box 149, Ester AK 99725-0149. (907)479-0454. Fax (907)479-3137. E-mail: editor@mushing.com. Website: www.mushing.com. **Publisher:** Todd Hoener. Estab. 1988. Bimonthly "year-round, international magazine for all dog-powered sports, from sledding to skijoring to weight pulling to carting to packing. We seek to educate and entertain." Circ. 10,000. Photo/art originals are returned at job's completion. Sample copies available for $5. Art guidelines available upon request.

Cartoons Approached by 20 cartoonists/year. Buys up to 1 cartoon/issue. Prefers humorous cartoons; single panel b&w line drawings with gagline.

Illustration Approached by 20 illustrators/year. Buys 0-1 illustrations/issue. Prefers simple; healthy, happy sled dogs; some silhouettes. Considers pen & ink and charcoal. Send query letter with SASE and photocopies. Accepts disk submissions if Mac compatible.

First Contact & Terms Cartoonists: Send query letter with roughs. Illustrators: Send EPS or TIFF files with hardcopy. Samples are returned by SASE if requested by artist. Prefers to keep copies of possibilities on file and use as needed. Responds in 6 months. Portfolio review not required. Buys first rights and reprint rights. Pays on publication. Pays cartoonists $25 for b&w and color. Pays illustrators $150 for color cover; $25 for b&w and color inside; $25 for spots. Finds artists through submissions.

Tips "Be familiar with sled dogs and sled dog sports. We're most open to using freelance illustrations with articles on dog behavior, adventure stories, health and nutrition. Illustrations should be faithful and/or accurate to the sport. Cartoons should be faithful and tasteful (e.g., not inhumane to dogs)."

MY FRIEND: The Catholic Magazine for Kids

50 Saint Pauls Avenue, Boston MA 02130-3491. (617)522-8911. Fax: (617)541-9805. E-mail: myfriend@pauline media.org. Website: www.myfriendmagazine. org. **Contact:** Sister Maria Grace Dateno, editor. Estab. 1979. Monthly Catholic magazine for kids, 4-color cover, containing information, entertainment and Christian information for young people ages 7-12. Circ. 8,000. Art guidelines available for SASE with $1.29 postage.

Illustration Approached by 150 illustrators/year. Buys 6 illustrations/issue; 60/year. Works on assignment only. Has featured illustrations by Mary Rojas, Chris Ware, Larry Nolte and Virginia Esquinaldo. Features realistic illustration; spot illustration. Assigns 10% of illustrations to new and emerging illustrators. Prefers humorous, realistic portrayals of children. Considers pen & ink, watercolor, airbrush, acrylic, marker, colored pencil, oil, charcoal, mixed media, pastel and computer-generated art.

Design Done in-house.

First Contact & Terms Illustrators: Send query letter with résumé, SASE, tearsheets, photocopies. Designers: Send query letter with résumé, photocopies and tearsheets. Accepts disk submissions compatible with Windows/Mac OS, PageMaker 6.5, Illustrator, Photoshop. Send TIFF or EPS files. Samples are filed. Responds within 2 months only if interested. Portfolio review not required. Rights purchased vary according to project. Pays on publication; $250 for color 3-page spread; $200 for color single-page spread.

NA'AMAT WOMAN

350 Fifth Ave., Suite 4700, New York NY 10118. (212)563-5222. Fax: (212)563-5710. E-mail: judith@naamat.o rg. **Editor:** Judith Sokoloff. Estab. 1926. Jewish women's magazine published 4 times yearly, covering a wide variety of topics that are of interest to the Jewish community, affiliated with NA'AMAT USA (a nonprofit organization). Originals are returned at job's completion. Sample copies available for $1.

Illustration Approached by 30 illustrators/year. Buys 2-3 illustrations/issue (b&w for inside; color cover). Has featured illustrations by Julie Delton, Ilene Winn-Lederer and Avi Katz.

First Contact & Terms Illustrators: Send query letter with tearsheets. Samples are filed or are returned by SASE if requested by artist. Responds to the artist only if interested. Publication will contact artist for portfolio review if interested. Portfolio should include b&w tearsheets and final art. Rights purchased vary according to project. Pays on publication. Pays illustrators $150-200 for b&w cover; $150-250 for inside. Finds artists through sourcebooks, publications, word of mouth, submissions.

Tips "Give us a try! We're small, but nice."

NAILPRO

7628 Densmore Ave., Van Nuys CA 91406. (818)782-7328. Fax: (818)782-7450. E-mail: nailpro@creativeage.c om. Website: www.nailpro.com. **Art Director:** Dawn Clegman. Monthly trade magazine for the nail and beauty industry audience nail technicians. Circ. 58,000. Sample copies available.

Cartoons Prefers subject matter related to nail industry. Prefers humorous color washes and b&w line drawings with or without gagline.

Illustration Approached by tons of illustrators. Buys 3-4 illustrations/issue. Has featured illustrations by Kelley Kennedy, Nick Bruel and Kathryn Adams. Assigns 20% of illustrations to well-known or "name" illustrators; 70% to experienced but not well-known illustrators; 10% to new and emerging illustrators. Prefers whimsical

computer illustrations. Considers all media. 85% of freelance illustration demands knowledge of Photoshop 5.5, Illustrator 8.0 and QuarkXPress 4.04.

Design Needs freelancers for design, production and multimedia projects. Prefers local design freelancers only. 100% of freelance work demands knowledge of Photoshop 5.5, Illustrator 8.0 and QuarkXPress 4.04.

First Contact & Terms Cartoonists: Send query letter with samples. Responds only if interested. Rights purchased vary according to project. Illustrators: Send postcard sample. Designers: Send query letter with printed samples and tearsheets. Accepts disk submissions compatible with QuarkXPress 4.04, TIFFs, EPS files submitted on Zip, JAZ or CD (Mac format only). Send samples to Attn: Art Director. Samples are filed. Responds only if interested. Art director will contact artist for portfolio review of b&w, color, final art and tearsheets if interested. Buys first rights. Payment to cartoonists varies with projects. Pays on publication. Pays illustrators $350-400 for 2-page, full-color feature spread; $300 for 1-page; $250 for ½ page. Pays $50 for spots. Finds illustrators through *Workbook*, samples sent in the mail, magazines.

THE NATION

33 Irving Pl., 8th Floor, New York NY 10003. (212)209-5400. Fax: (212)982-9000. E-mail: studio@stevenbrowerdesign.com. Website: www.thenation.com. **Art Director:** Steven Brower. Estab. 1865. A weekly journal of "left/liberal political opinion, covering national and international affairs, literature and culture." Circ. 100,000. Originals are returned after publication upon request. Sample copies available. Art guidelines not available.

- *The Nation*'s art director works out of his design studio at Steven Brower Design. You can send samples to *The Nation* and they will be forwarded. Brower is also A.D. for *Print*.

Illustration Approached by 50 illustrators/year. Buys 3-4 illustrations/issue. Works with 25 illustrators/year. Has featured illustrations by Robert Grossman, Luba Lukora, Igor Kopelnitsky and Karen Caldecott. Buys illustrations mainly for spots and feature spreads. Works on assignment only. Considers pen & ink, airbrush, mixed media and charcoal pencil; b&w only.

First Contact & Terms Illustrators: Send query letter with tearsheets and photocopies. "On top of a defined style, artist must have a strong and original political sensibility." Samples are filed or are returned by SASE. Responds only if interested. Buys first rights. Pays $100-150 for b&w inside; $175 for color inside.

NATIONAL BUS TRADER

9698 W. Judson Rd., Polo IL 61064. (815)946-2341. **Editor:** Larry Plachno. Monthly magazine focusing on new and used transit and inter-city busses. Circ. 62,000.

- Also publishes books. See listing for Transportation Trails in Book Publishers section. Editor is looking for artists to commission oil paintings for magazine covers. He is also looking for artists who can render historic locomotives. He uses mostly paintings or drawings. He also considers silhouettes of locomotives and other historic transportation. He is open to artists who work on Illustrator and QuarkXPress.

NATIONAL ENQUIRER

1000 American Media Way, Boca Raton FL 33464. (561)997-7733. Fax: (561)989-1373. E-mail: jcannatafox@nationalenquirer.com. **Editor:** Joan Cannata-Fox. A weekly tabloid. Circ. 2 million (readership 14 million). Originals are returned at job's completion.

Cartoons "We get 1,000-1,500 cartoons weekly." Buys 200 cartoons/year. Has featured cartoons by Norm Rockwell, Glenn Bernhardt, Earl Engelman, George Crenshaw, Mark Parisi, Marty Bucella and Yahan Shirvanian. Prefers animal, family, husband/wife and general themes. Nothing political or off-color. Prefers single panel b&w line drawings and washes with or without gagline. Computer-generated cartoons are not accepted. Prefers to do own coloration.

First Contact & Terms Cartoonists: Send query letter with good, clean, clear copies of finished cartoons. Samples are not returned. Buys first and one-time rights. Pays $200 for b&w plus $20 each additional panel. Editor will notify if cartoon is accepted.

Tips "Study several issues to get a solid grasp of what we buy. Gear your work accordingly."

NATIONAL GEOGRAPHIC

17th and M Streets NW, Washington DC 20036. (202)857-7000. Website: www.nationalgeographic.com. **Art Director:** Chris Sloan. Estab. 1888. Monthly. Circ. 9 million. Original artwork returned 1 year after publication, but *National Geographic* owns the copyright.

- *National Geographic* receives up to 30 inquiries a day from freelancers. They report most are not appropriate to their needs. Please make sure you have studied several issues before you submit. They have a roster of artists they work with on a regular basis, and it's difficult to break in, but if they like your samples they will file them for consideration for future assignments.

Illustration Works with 20 illustrators/year. Contracts 50 illustrations/year. Interested in "full-color renderings of historical and scientific subjects. Nothing that can be photographed is illustrated by artwork. No decorative,

design material. We want scientific geological cut-aways, maps, historical paintings, prehistoric scenes.'' Works on assignment only.

First Contact & Terms Illustrators: Send color copies, postcards, tearsheets, proofs or other appropriate samples. Art director will contact for portfolio review if interested. Samples are returned by SASE. **Pays on acceptance**: varies according to project.

Tips ''Do your homework before submitting to any magazine. We only use historical and scientific illustrations, ones that are very informative and very accurate. No decorative, abstract or portraits.''

NATIONAL REVIEW

215 Lexington Ave., New York NY 10016. (212)679-7330. Website: www.nationalreview.com. **Art Director:** Luba Myts. Emphasizes world events from a conservative viewpoint; bimonthly b&w with 4-color cover, design is ''straight forward—the creativity comes out in the illustrations used.'' Originals are returned after publication. Uses freelancers mainly for illustrations of articles and book reviews, also covers. Circ. 150,000+.

Cartoons Buys 6 cartoons/issue. Interested in ''light political, social commentary on the conservative side.''

Illustration Buys 6-7 illustrations/issue. Especially needs b&w ink illustration, portraits of political figures and conceptual editorial art (b&w line plus halftone work). ''I look for a strong graphic style; well-developed ideas and well-executed drawings.'' Style of Tim Bower, Jennifer Lawson, Janet Hamlin, Alan Nahigian. Works on assignment only.

First Contact & Terms Cartoonists: Send appropriate samples and SASE. Responds in 2 weeks. Illustrators: Send query letter with brochure showing art style or tearsheets and photocopies. No samples returned. Responds to future assignment possibilities. Call for an appointment to show portfolio of final art, final reproduction/ product and b&w tearsheets. Include SASE. Buys first North American serial rights. Pays on publication. Pays cartoonists $50 for b&w. Pays illustrators $100 for b&w inside; $750 for color cover.

Tips ''Tearsheets and mailers are helpful in remembering an artist's work. Artists ought to make sure their work is professional in quality, idea and execution. Recent printed samples alongside originals help. Changes in art and design in our field include fine art influence and use of more halftone illustration.'' A common mistake freelancers make in presenting their work is ''not having a distinct style, i.e., they have a cross sample of too many different approaches to rendering their work. This leaves me questioning what kind of artwork I am going to get when I assign a piece.''

NATURAL HISTORY

36 W. 25th St., 5th Floor, New York NY 10010. (646)356-6500. Fax: (646)356-6511. Website: www.nhmag.com. **Editor-in-Chief:** Peter Brown. Art Director: Steve Black. Emphasizes social and natural sciences. For well-educated professionals interested in the natural sciences. Monthly. Circ. 250,000.

Illustration Buys 10-12 illustrations/year; 15-20 maps or diagrams/year. Works on assignment only.

First Contact & Terms Query with samples. Samples returned by SASE. Provide ''any pertinent information'' to be kept on file for future assignments. Buys one-time rights. Pays on publication; $200 and up for color inside.

Tips ''Be familiar with the publication. Always looking for accurate and creative scientific illustrations, good diagrams and maps.''

▢ Ⓝ NATURAL LIFE

508-264 Queens Quay W, Toronto ON M5J 1B5 Canada. **Editor:** Wendy Priesnitz. Estab. 1976. Bimonthly magazine covering environment, sustainability, voluntary simplicity. Circ. 5,000. Sample copy for $ 4.95.

• *Natural Life* is not currently buying cartoons or other illustrations.

Tips ''Read us first!''

NERVE COWBOY

P.O. Box 4973, Austin TX 78765-4973. **Editors:** Joseph Shields and Jerry Hagins. Website: www.onr.com/ user/jwhagins/nervecowboy.html. Estab. 1995. Biannual b&w literary journal of poetry, short fiction and b&w artwork. Sample copies for $5 postpaid. Art guidelines free for #10 SASE with first-class postage.

Illustration Approached by 400 illustrators/year. Buys work from 20 illustrators/issue. Has featured illustrations by Amanda Rehagen, Jennifer Stanley and Greta Shields. Features unusual illustration and creative b&w images. Strongly prefers b&w. ''Color will be considered if a b&w half-tone can reasonably be created from the piece.'' Assigns 60% of illustrations to new and emerging illustrators.

First Contact & Terms Illustrators: Send printed samples, photocopies with a SASE. Samples are returned by SASE. Responds in 3 months. Portfolio review not required. Buys first North American serial rights. Pays on publication; 3 copies of issue in which art appears on cover; or 1 copy if art appears inside.

Tips ''We are always looking for new artists with an unusual view of the world.''

NETWORK COMPUTING

600 Community Dr., Manhasset NY 11030-3847. (516)562-5000. Fax: (516)562-7293. E-mail: editor@nwc.com. Website: www.networkcomputing.com. **Art Director:** David Yamada. Monthly trade magazine for those who professionally practice the art and business of networkology (a technology driver of networks). Circ. 220,000. Sample copies available.

Illustration Approached by 30-50 illustrators/year. Buys 6-7 illustrations/issue. Considers all media. 60% of freelance illustration demands knowledge of FreeHand, Photoshop, Illustrator.

First Contact & Terms Illustrators: Send postcard sample with follow-up sample every 3-6 months. Contact through artists' rep. Accepts disk submissions compatible with QuarkXPress 7.5/version 3.3. Send EPS files. Samples are returned. Responds only if interested. Art director will contact artist for portfolio review of tearsheets if interested. Buys one-time rights. **Pays on acceptance**; $700-1,000 for b&w, $1,500-2,000 for color cover; $300 minimum for b&w, $350-500 for color inside. Pays $350-500 for spots. Finds illustrators through agents, sourcebooks, word of mouth, submissions.

NETWORK MAGAZINE

600 Harrison St., San Francisco CA 94107-1387. (415)947-6000. Fax: (415)947-6022. Website: www.networkmagazine.com. **Contact:** Rob Kirby. Estab. 1986. Monthly magazine covers local and wide area computer networks. Circ. 200,500.

Illustration Approached by 50 illustrators/year. Buys 5-7 illustrations/issue. "Half freelancers work electronically, half by hand. Themes are technology-oriented, but artwork doesn't have to be." Considers all media, color. 50% of freelance illustration demands knowledge of Photoshop.

First Contact & Terms Illustrators: Send postcard sample. Accepts disk submissions compatible with Photoshop files on Mac-formatted disks; "would recommend saving as JPEG (compressed) if you're sending a disk." Samples are filed. Responds only if interested. "Will look at portfolios if artists are local (Bay area), but portfolio review is not necessary." **Pays on acceptance;** $400 minimum for inside. Finds illustrators through postcards in the mail, agencies, word of mouth, artist's submissions.

Tips "Take a look at the magazine (on our website); all work is color; prefer contrast, not monochrome. Usually give freelancer a week to turn art around. The magazine's subject matter is highly technical, but the art doesn't have to be. (We use a lot of collage and hand-done work in addition to computer-assisted art.)"

NEVADA

401 N. Carson St., #100, Carson City NV 89701-4291. (775)687-5416. Fax: (775)687-6159. E-mail: denise@nevadamagazine.com. Website: www.nevadamagazine.com. **Art Director:** Denise Barr. Estab. 1936. Bimonthly magazine "founded to promote tourism in Nevada." Features Nevada artists, history, recreation, photography, gaming. Traditional, 3-column layout with large 4-color photos. Circ. 80,000. Accepts previously published artwork. Originals are returned to artist at job's completion. Sample copies for $3.50. Art guidelines available.

Illustration Approached by 25 illustrators/year. Buys 2 illustrations/issue. Works on assignment only.

First Contact & Terms Illustrators: Send query letter with brochure, résumé and slides. Samples are filed. Responds in 2 months. To show portfolio, mail 20 slides and bio. Buys one-time rights. Pays $35 minimum for inside illustrations.

NEW HAMPSHIRE MAGAZINE

150 Dow St., Manchester NH 03101. (603)624-1442. Fax: (603)624-1310. E-mail: slaughlin@nh.com. Website: www.nhmagazine.com. **Creative Director:** Susan Laughlin. Estab. 1990. Monthly 4-color magazine emphasizing New Hampshire lifestyle and related content. Circ. 26,000. Monthly topics: Health & senior living

Illustration Approached by 12 illustrators/year. Has featured illustrations by Brian Hubble and Stephen Sauer. Features lifestyle illustration, charts & graphs and spot illustration. Prefers illustrating concept of story. Assigns 50% to experienced but not well-known illustrators; 50% to new and emerging illustrators.

First Contact & Terms Cartoonists: Send query letter with b&w photocopies. Illustrators: Send postcard sample and follow-up postcard every 3 months. Samples are filed. Portfolio review not required. Negotiates rights purchased. Pays on publication. Pays illustrators $75-250 for color inside; $150-500 for 2-page spreads; $125 for spots.

Tips "Lifestyle magazines want 'uplifting' lifestyle messages, not dark or disturbing images."

NEW MOON: THE MAGAZINE FOR GIRLS AND THEIR DREAMS

34 E. Superior St., #200, Duluth MN 55802. (218)728-5507. Fax: (218)728-0314. E-mail: girl@newmoon.org. Website: www.newmoon.org. **Managing Editor:** Kate Freeborn. Estab. 1992. Bimonthly 4-color cover, 4-color inside consumer magazine. Circ. 30,000. Sample copies are $6.75.

Illustration Buys 3-4 illustrations/issue. Has featured illustrations by Andrea Good, Liza Ferneyhough, Liza

Wright. Features realistic illustrations, informational graphics and spot illustrations of children, women and girls. Prefers b&w, ink. Assigns 30% of illustrations to new and emerging illustrators.

First Contact & Terms Illustrators: Send postcard sample or other nonreturnable samples. Final work can be submitted electronically or as original artwork. Send EPS files at 300 dpi or greater, hi-res. Samples are filed. Responds only if interested. Portfolio review not required. Buys one-time rights. Pays on publication; $400 maximum for color cover; $200 maximum for inside.

Tips "Be very familiar with the magazine and our mission. We are a magazine for girls ages 8-14 and look for illustrators who portray people of all different shapes, sizes and ethnicities in their work. Women and girl artists only. See cover art guidelines at www.newmoon.org.

NEW MYSTERY MAGAZINE

101 W. 23rd St., Penthouse 1, New York NY 10011. (212)353-3495. E-mail: mail@newmystery.org. Website: newmystery.org. **Art Director:** Dana Irwin. Estab. 1989. Quarterly literary magazine—a collection of mystery, crime and suspense stories with b&w drawings, prints and various graphics. Circ. 100,000. Accepts previously published artwork. Originals are returned at job's completion. Sample copies available for $7 plus $1.24 postage and SASE; art guidelines for SASE with first-class postage.

Cartoons Approached by 100 cartoonists/year. Buys 1-3 cartoons/issue. Prefers themes relating to murder, heists, guns, knives, assault and various crimes; single or multiple panel, b&w line drawings.

Illustration Approached by 100 illustrators/year. Buys 12 illustrations/issue. Prefers themes surrounding crime, murder, suspense, noir. Considers pen & ink, watercolor and charcoal. Needs computer-literate freelancers for illustration.

Design Needs freelancers for multimedia. Freelance work demands knowledge of Photoshop and QuarkXPress.

First Contact & Terms Cartoonists: Send query letter with finished cartoon samples. Illustrators: Send postcard sample with SASE. Designers: Send query letter with SASE and tearsheets. Accepts disk submissions compatible with IBM. Send TIFF and GIF files. Samples are filed. Responds in 2 months. To show a portfolio, mail appropriate materials b&w photocopies and photographs. Rights purchased vary according to project. Pays on publication. Pays cartoonists $20-50 for b&w, $20-100 for color. Pays illustrators $100-200 for covers; $25-50 for insides; $10-25 for spots. Pays by the project, $100-200.

Tips "Study an issue and send right-on illustrations. Do not send originals. Keep copies of your work. *NMM* is not responsible for unsolicited materials."

THE NEW REPUBLIC

1331 H St. NW, Suite 700, Washington DC 20005. (202)508-4444. E-mail: jheroun@tnr.com. Website: www.tnr. com. **Art Director:** Joe Heroun. Estab. 1914. Weekly political/literary magazine; political journalism, current events in the front section, book reviews and literary essays in the back; b&w with 4-color cover. Circ. 100,000. Original artwork returned after publication. Sample copy for $3.50. 50% of freelance work demands computer skills.

Illustration Approached by 400 illustrators/year. Buys up to 5 illustrations/issue. Uses freelancers mainly for cover art. Works on assignment only. Prefers caricatures, portraits, 4-color, "no cartoons." Style of Vint Lawrence.

First Contact & Terms Illustrators: Send query letter with tearsheets or postcard samples. Samples returned by SASE if requested. Publication will contact artist for portfolio review if interested. Portfolio should include color photocopies. Rights purchased vary according to project. Pays on publication; up to $600 for color cover; $250 for b&w and color inside.

NEW WRITER'S MAGAZINE

P.O. Box 5976, Sarasota FL 34277. Phone/fax: (941)953-7903. E-mail: newriters@aol.com. **Editor/Publisher:** George J. Haborak. Estab. 1986. Bimonthly b&w magazine. Forum "where all writers can exchange thoughts, ideas and their own writing. It is focused on the needs of the aspiring or new writer." Circ. 5,000. Rarely accepts previously published artwork. Original artwork returned after publication if requested. Sample copies for $3; art guidelines for SASE with first-class postage.

Cartoons Approached by 15 cartoonists/year. Buys 1-3 cartoons/issue. Features spot illustration. Assigns 80% of illustrations to new and emerging illustrators. Prefers cartoons "that reflect the joys or frustrations of being a writer/author"; single panel b&w line drawings with gagline.

Illustration Buys 1 illustration/issue. Works on assignment only. Prefers line drawings. Considers watercolor, mixed media, colored pencil and pastel.

First Contact & Terms Cartoonists: Send query letter with samples of style. Illustrators: Send postcard sample. Samples are filed or returned by SASE if requested. Responds in 1 month. To show portfolio, mail tearsheets. Buys first rights or negotiates rights purchased. Pays on publication. Payment negotiated.

NEW YORK MAGAZINE

444 Madison Ave., 14th Floor, New York NY 10022. (212)508-0700. **Design Director:** Luke Hayman. Art Director Chris Dixon. Emphasizes New York City life; also covers all boroughs for New Yorkers with upper-middle income and business people interested in what's happening in the city. Weekly. Original artwork returned after publication.

Illustration Works on assignment only.

First Contact & Terms Illustrators: Send query letter with tearsheets to be kept on file. Prefers photostats as samples. Samples returned if requested. Call or write for appointment to show portfolio (drop-offs). Buys first rights. Pays $1,000 for b&w and color cover; $800 for 4-color, $400 for b&w full page inside; $225 for 4-color, $150 for b&w spot inside.

THE NEW YORKER

4 Times Square, New York NY 10036. (212)286-5400. Fax: (212)286-5735. E-mail: (cartoons) toon@cartoonbank.com. Website: www.cartoonbank.com. Emphasizes news analysis and lifestyle features. Circ. 938,600.

Cartoons Buys b&w cartoons. Receives 3,000 cartoons/week. Cartoon editor is Bob Mankoff, who also runs Cartoon Bank, a stock cartoon agency that features *New Yorker* cartoons.

Illustration All illustrations are commissioned. Portfolios may be dropped off Wednesdays between 10-6 and picked up on Thursdays. Art director is Caroline Mailhot.

First Contact & Terms Cartoonists: Accepts unsolicited submissions only by mail. Reviews unsolicited submissions every 1-2 weeks. Photocopies only. Strict standards regarding style, technique, plausibility of drawing. Especially looks for originality. Pays $575 minimum for cartoons. Contact cartoon editor. Illustrators: Mail samples, no originals. "Because of volume of submissions we are unable to respond to all submissions." No calls please. Emphasis on portraiture. Contact illustration department.

Tips "Familiarize yourself with *The New Yorker*."

NEWSWEEK

251 W. 57th St., 15th Floor, New York NY 10019. (212)445-4000. Website: www.newsweek.com. **Art Director:** Alexander Ha. Assistant Managing Editor/Design: Lynn Staley. Weekly news magazine. Circ. 3,180,000. Has featured illustrations by Daniel Adel and Zohar Lozar.

Illustration Prefers illustrations or situations in national and international news.

First Contact & Terms Illustrators: Send postcard samples or other nonreturnable samples. Portfolios may be dropped off at front desk Tuesday or Wednesday from 9 to 5. Call ahead.

NORTH AMERICAN WHITETAIL MAGAZINE

2250 Newmarket Pkwy., Suite 110, Marietta GA 30067. (770)953-9222. Fax: (770)933-9510. Website: www.northamericanwhitetail.com. **Editorial Director:** Ken Dunwoody. Estab. 1982. Consumer magazine "designed for serious hunters who pursue whitetailed deer." 8 issues/year. Circ. 130,000. Accepts previously published artwork. Original artwork is returned at job's completion. Sample copies available for $3; art guidelines not available.

Illustration Approached by 30 freelance illustrators/year. Buys 6-8 freelance illustrations/year. Works on assignment only. Considers pen & ink, watercolor, acrylic and oil.

First Contact & Terms Illustrators: Send postcard sample and/or query letter with brochure and photocopies. Samples are filed or are returned by SASE if requested by artist. Responds only if interested. To show a portfolio, mail appropriate materials. Rights purchased vary according to project. Pays 10 weeks prior to publication; $25 minimum for b&w inside; $75 minimum for color inside.

N NORTH CAROLINA LITERARY REVIEW

English Dept., Greenville NC 27858-4353. E-mail: bauerm@mail.ecu.edu. **Editor:** Margaret Bauer. Estab. 1992. Annual literary magazine of art, literature, culture having to do with NC. Circ. 500. Samples available for $10 and $15; art guidelines for SASE with first-class postage or e-mail address. NC artists/art only.

Illustration Considers all media.

First Contact & Terms Illustrators: Send postcard sample or send query letter with printed samples, SASE and tearsheets. Send follow-up postcard sample every 2 months. Samples are not filed and are returned by SASE. Responds in 2 months. Art director will contact artist for portfolio review of b&w, color slides and transparencies if interested. Rights purchased vary according to projects. Pays on publication; $100-250 for cover; $50-250 for inside. Pays $25 for spots. Finds illustrators through magazines and word of mouth.

Tips "Read our magazine."

THE NORTHERN LOGGER & TIMBER PROCESSOR

Northeastern Loggers Association, Inc., Old Forge NY 13420. (315)369-3078. **Editor:** Eric A. Johnson. Trade publication with an emphasis on education. Focuses on methods, machinery and manufacturing as related to

forestry. For loggers, timberland managers and processors of primary forest products. Monthly b&w with 4-color cover. Circ. 13,000. Previously published material OK. Free sample copy and guidelines available.

Cartoons Buys 1 cartoon/issue. Receives 1 submission/week. Interested in "any cartoons involving forest industry situations."

First Contact & Terms Cartoonists: Send finished cartoons with SASE. Responds in 1 week. **Pays on acceptance.** Pays cartoonists $25 for b&w line drawings. Pays $25 for b&w cover.

Tips "Keep it simple and pertinent to the subjects we cover. Also, keep in mind that on-the-job safety is an issue we like to promote."

NOTRE DAME MAGAZINE

535 Grace Hall, Notre Dame IN 46556. (574)631-4630. Website: www.ND.EDU/~NDMAG. **Art Director:** Don Nelson. Estab. 1971. Quarterly 4-color university magazine that publishes essays on cultural, spiritual and ethical topics, as well as news of the university for Notre Dame alumni and friends. Circ. 155,000. Accepts previously published artwork. Original artwork returned after publication.

Illustration Buys 5-8 illustrations/issue. Has featured illustrations by Ken Orvidas, Earl Keleny, Vivienne Fleshner, Darren Thompson and James O' Brien. Works on assignment only. Tearsheets, photographs, brochures and photocopies OK for samples. Samples are returned by SASE if requested. "Don't send submissionsonly tearsheets or samples." Buys first rights.

Tips "Create images that can communicate ideas. Looking for noncommercial style editorial art by accomplished, experienced editorial artists. Conceptual imagery that reflects the artist's awareness of fine art ideas and methods is the kind of thing we use. Sports action illustrations not used. Cartoons not used."

NOW AND THEN

CASS/ETSU, Box 70556, Johnson City TN 37614-1707. (423)439-7865. Fax: (423)439-7870. E-mail: fischman@etsu.edu. Website: cass.etsu.edu/n&t/. **Managing Editor:** Nancy Fischman. Estab. 1984. Magazine covering Appalachian issues and arts, published twice a year. Circ. 1,000. Accepts previously published artwork. Originals are returned at job's completion. Sample copies available for $7. Art guidelines free for SASE with first class postage or on website.

Cartoons Approached by 5 cartoonists/year. Prefers Appalachia issues, political and humorous cartoons; b&w washes and line drawings.

Illustration Approached by 3 illustrators/year. Buys 1-2 illustrations/issue. Has featured illustrations by Nancy Jane Earnest, David M. Simon and Anthony Feathers. Features natural history; humorous, realistic, computer and spot illustration. Assigns 100% of illustrations to experienced but not well-known illustrators. Prefers Appalachia, any style. Considers b&w or 2- or 4-color pen & ink, collage, airbrush, marker and charcoal. Freelancers should be familiar with FreeHand, PageMaker or Photoshop.

First Contact & Terms Cartoonists: Send query letter with brochure, roughs and finished cartoons. Illustrators: Send query letter with brochure, SASE and photocopies. Samples are filed or will be returned by SASE if requested by artist. Responds in 6 months. Publication will contact artist for portfolio review if interested. Portfolio should include b&w tearsheets, slides, final art and photographs. Buys one-time rights. Pays on publication. Pays cartoonists $25 for b&w. Pays illustrators $50-100 for color cover; $25 maximum for b&w inside.

Tips "We have special theme issues. Illustrations have to have something to do with theme. Write for guidelines, see the website, enclose SASE."

NURSEWEEK

6860 Santa Teresa Blvd., San Jose, CA 95119. (408)249-5877. Fax: (408)574-1207. E-mail: youngk@nurseweek.com. Website: www.nurseweek.com. **Art Director:** Young Kim. "*Nurseweek* is a biweekly 4-color tabloid mailed free to registered nurses nationwide. Combined circulation of all publications is over 1 million. *Nurseweek* provides readers with nursing-related news and features that encourage and enable them to excel in their work and that enhance the profession's image by highlighting the many diverse contributions nurses make. In order to provide a complete and useful package, the publication's article mix includes late-breaking news stories, news features with analysis (including in-depth bimonthly special reports), interviews with industry leaders and achievers, continuing education articles, career option pieces (Spotlight, Entrepreneur) and reader dialogue (Letters, Commentary, First Person)." Sample copy $3. Art guidelines not available. Needs computer-literate freelancers for production. 90% of freelance work demands knowledge of Quark, PhotoShop, Illustrator, Adobe Acrobat.

Illustration Approached by 10 illustrators/year. Buys 1 illustration/year. Prefers pen & ink, watercolor, airbrush, marker, colored pencil, mixed media and pastel. Needs medical illustration.

Design Needs freelancers for design. 90% of design demands knowledge of Photoshop CS, QuarkXPress 6.0. Prefers local freelancers. Send query letter with brochure, résumé, SASE and tearsheets.

First Contact & Terms Illustrators: Send query letter with brochure, tearsheets, photographs, photocopies,

photostats, slides and transparencies. Samples are not filed and are returned by SASE if requested by artist. Publication will contact artist for portfolio review if interested. Portfolio should include final art samples, photographs. Buys all rights. Pays on publication; $150 for b&w, $250 for color cover; $100 for b&w, $175 for color inside. Finds artists through sourcebooks.

NUTRITION HEALTH REVIEW

Box #406, Haverford PA 19041. (610)896-1853. Fax: (610)896-1857. **Contact:** A. Rifkin, publisher. Estab. 1975. Quarterly newspaper covering nutrition, health and medical information for the consumer. Circ. 285,000. Sample copies available for $3. Art guidelines available.

Cartoons Prefers single panel, humorous, b&w drawings.

Illustration Features b&w humorous, medical and spot illustrations pertaining to health.

First Contact & Terms Cartoonists/Illustrators: Send query letter with b&w photocopies. After introductory mailing, send follow-up postcard every 3-6 months. Samples are filed or returned by SASE. Responds in 6 months. Company will contact artist for portfolio review if interested. Pays cartoonists $20 maximum for b&w. Pays illustrators $200 maximum for b&w cover; $30 maximum for b&w inside. **Pays on acceptance.** Buys first rights, one-time rights, reprint rights. Finds freelancers through agents, artists' submissions, sourcebooks.

O&A MARKETING NEWS

Kal Publications, 559 S. Harbor Blvd., Suite A, Anaheim CA 92805-4525. (714)563-9300. Fax: (714)563-9310. Website: www.kalpub.com. **Editor:** Kathy Laderman. Estab. 1966. Bimonthly b&w trade publication about the service station/petroleum marketing industry. Circ. 8,000. Sample copies for 11×17 SASE with 10 first-class stamps.

- This publisher also published *Automotive Booster*.

Cartoons Approached by 10 cartoonists/year. Buys 1-2 cartoons/issue. Prefers humor that relates to service station industry. Prefers single panel, humorous, b&w line drawings.

First Contact & Terms Cartoonists: Send b&w photocopies, roughs or samples and SASE. Samples are returned by SASE. Responds in 1 month. Buys one-time rights. **Pays on acceptance**; $12 for b&w.

Tips "We run a cartoon (at least one) in each issue of our trade magazine. We're looking for a humorous take on business—specifically the service station/petroleum marketing/carwash/quick lube industry that we cover."

OFF OUR BACKS, a woman's news journal

2337B 18th St., NW, Washington DC 20009. (202)234-8072. Fax: (202)234-8092. E-mail: offourbacks@cs.com. Website: www.offourbacks.org. **Managing Editors:** Jennie Ruby and Karla Mantilla. Estab. 1970. Bimonthly feminist news journal; magazine format; covers women's issues and the feminist movement. Circ. 15,000. Accepts previously published artwork. Original artwork is returned at the job's completion. Sample copies available; art guidelines free for SASE with first-class postage.

Cartoons Approached by 6 freelance cartoonists/year. Buys 2 freelance cartoons/issue. Prefers political, feminist themes.

Illustration Approached by 20 freelance illustrators/year. Prefers feminist, political themes. Considers pen & ink.

First Contact & Terms Cartoonists: Send query letter with roughs. Responds to the artist if interested within 2 months. Illustrators: Send query letter with photocopies. Samples are filed. Responds to the artist only if interested. To show a portfolio, mail appropriate materials.

Tips "Ask for a sample copy. Preference given to feminist, woman-centered, multicultural line drawings."

OFFICEPRO

5501 Backlick Rd., Suite 240, Springfield VA 22151-3940. (703)914-9200. Fax: (703)914-6777. E-mail: abrady@st rattonpub.com. Website: www.iaap-hq.org. **Editor:** Angela Hickman Brady. Estab. 1945. Trade journal published 9 times/year. Publication directed to the office support professional. Emphasis is on workplace issues, trends and technology. Readership is 98% female. Circ. 40,000. Accepts previously published artwork. Originals returned at job's completion upon request only. Sample copies available (contact subscription office at (816)891-6600, ext. 235).

Illustration Approached by 50 illustrators/year. Buys 20 or fewer illustrations/year. Works on assignment and purchases stock art. Prefers communication, travel, meetings and international business themes. Considers pen & ink, airbrush, colored pencil, mixed media, collage, charcoal, watercolor, acrylic, oil, pastel, marker and computer.

First Contact & Terms Illustrators: Send postcard-size sample or send query letter with brochure, tearsheets and photocopies. Samples are filed. Responds to the artist only if interested. Publication will contact artist for portfolio review if interested. Portfolio should include final art and tearsheets. Buys one-time rights usually,

but rights purchased vary according to project. Pays $500-600 for color cover; $60-150 for b&w, $200-400 for color inside; $60 for b&w spots. Finds artists through word of mouth and artists' samples.

OKLAHOMA TODAY MAGAZINE

15 N. Robinson, Suite 100, Oklahoma City OK 73102-5403. (405)521-2496. Fax: (405)522-4588. Website: www.o klahomatoday.com. **Editor:** Louisa McCune. Associate Editor: Brooke Adcox. Estab. 1956. Bimonthly regional, upscale consumer magazine focusing on all things that define Oklahoma and interest Oklahomans. Circ. 50,000. Accepts previously published artwork. Originals are returned at job's completion. Sample copies available with a SASE.

Illustration Approached by 24 illustrators/year. Buys 5-10 illustrations/year. Has featured illustrations by Rob Silvers, Tim Jossel, Steven Walker and Cecil Adams. Features caricatures of celebrities; natural history; realistic and spot illustration. Assigns 10% of illustrations to new and emerging illustrators. Considers pen & ink, watercolor, collage, airbrush, acrylic, marker, colored pencil, oil, charcoal and pastel. 20% of freelance work demands knowledge of PageMaker, Illustrator and Photoshop.

First Contact & Terms Illustrators: Send query letter with brochure, résumé, SASE, tearsheets and slides. Samples are filed. Responds in days if interested; months if not. Portfolio review required if interested in artist's work. Portfolio should include b&w and color thumbnails, tearsheets and slides. Buys one-time rights. Pays $200-500 for b&w cover; $200-750 for color cover; $50-500 for b&w inside; $75-750 for color inside. Finds artists through sourcebooks, other publications, word of mouth, submissions and artist reps.

Tips Illustrations to accompany short stories and features are most open to freelancers. "Read the magazine. Be willing to accept low fees at the beginning. We enjoy working with local artists or those with Oklahoma connections."

ON EARTH

40 W. 20th St., New York NY 10011. (212)727-2700. Fax: (212)727-1773. E-mail: onearthart@nrdc.org. Website: www.nrdc.org. **Art Director:** Gail Ghezzi. Associate Art Director: Irene Huang. Estab. 1979. Quarterly "award-winning environmental magazine exploring politics, nature, wildlife, science and solutions to problems." Circ. 140,000.

Illustration Buys 4 illustrations/issue.

First Contact & Terms Illustrators: Send postcard sample. "We will accept work compatible with QuarkXPress, Illustrator 8.0, Photoshop 5.5 and below." Responds only if interested. Buys one-time rights. Also may ask for electronic rights. Pays $100-300 for b&w inside. Payment for spots varies. Finds artists through sourcebooks and submissions.

Tips "We prefer 4-color. Our illustrations are often conceptual, thought-provoking, challenging. We enjoy thinking artists, and we encourage ideas and exchange."

THE OPTIMIST

4494 Lindell Blvd., St. Louis MO 63108-2404. (314)371-6000. Fax: (314)371-6006. E-mail: walkera@optimist.o rg. Website: www.optimist.org. **Graphic Designer:** Andrea Walker. 4-color magazine with 4-color cover that emphasizes activities relating to Optimist clubs in US and Canada (civic-service clubs). "Magazine is mailed to all members of Optimist clubs. Average age is 42; most are management level with some college education." Circ. 120,000. Sample copy for SASE; art guidelines not available.

Cartoons Buys 2 cartoons/issue. Has featured cartoons by Martin Bucella, Randy Glasbergen, Randy Bisson. Prefers themes of general interest family-orientation, sports, kids, civic clubs. Prefers color single panel with gagline. No washes.

First Contact & Terms Illustrators: Send query letter with samples. Send art on a disk if possible (Macintosh compatible). Submissions returned by SASE. Buys one-time rights. **Pays on acceptance:** $30 for b&w or color.

Tips "Send clear cartoon submissions, not poorly photocopied copies."

ORANGE COAST MAGAZINE

3701 Birch St., Suite 100, Newport Beach CA 92660. (949)862-1133. Fax: (949)862-0133. E-mail: editorial@orang ecoastmag.com. Website: www.orangecoast.com. **Art Director:** Stacy Nunley. Estab. 1970. Monthly 4-color local consumer magazine with celebrity covers. Circ. 50,000.

Illustration Approached by 100 illustrators/year. Has featured illustrations by Cathi Mingus, Gweyn Wong, Scott Lauman, Santiago Veeda, John Westmark, Robert Rose, Nancy Harrison. Features computer, fashion and editorial illustrations featuring children and families. Prefers serious subjects; some humorous subjects. Assigns 10% of illustrations to well-known or "name" illustrators; 40% to experienced but not well-known illustrators; 50% to new and emerging illustrators. 40% of freelance illustration demands knowledge of Illustrator or Photoshop.

First Contact & Terms Illustrators: Send postcard or other nonreturnable samples. Accepts Mac-compatible

Magazines

disk submissions. Send EPS files. Samples are filed. Responds in 1 month. Will contact artist for portfolio review if interested. **Pays on acceptance**; $175 for b&w or color inside; $75 for spots. Finds illustrators through artist promotional samples.

Tips "Looking for fresh and unique styles. We feature approximately four illustrators per publication. I've developed great relationships with all of them."

OREGON CATHOLIC PRESS

5536 NE Hassalo, Portland OR 97213-3638. (503)281-1191. Fax: (503)282-3486. E-mail: jeang@ocp.org. Website: www.ocp.org/. **Art Director:** Jean Germano. Estab. 1988. Quarterly liturgical music planner in both Spanish and English with articles, photos and illustrations specifically for but not exclusive to the Roman Catholic market.

• See *OCP*'s listing in the Book Publishers section to learn about this publisher's products and needs.

Illustration Approached by 10 illustrators/year. Buys 20 illustrations/issue. Has featured illustrations by John August Swanson and Steve Erspamer. Assigns 50% of illustrations to new and emerging illustrators.

First Contact & Terms Illustrators: Send query letter with printed samples, photocopies, SASE. Samples are filed or returned by SASE. Responds in 2 weeks. Portfolio review not required. Rights purchased vary according to project. **Pays on acceptance.** $100-250 for color cover; $30-50 for b&w spot art or photo.

N ORLANDO MAGAZINE

801 N. Magnolia Ave., 201, Orlando FL 32803. (407)423-0618. Fax: (407)237-6258. E-mail: jason.jones@orlando magazine.com. Website: www.orlandomagazine.com. **Art Director:** Jason Jones. Estab. 1946. "We are a 4-color monthly city/regional magazine covering the Central Florida area—local issues, sports, home and garden, business, entertainment and dining." Circ. 30,000. Accepts previously published artwork. Originals are returned at job's completion. Sample copies available.

Illustration Buys 2-3 illustrations/issue. Has featured illustrations by T. Sirell, Rick Martin, Mike Wright, Jon Krause. Assigns 100% of illustrations to experienced, but not necessarily well-known illustrators. Works on assignment only. Needs editorial illustration.

Design Needs freelancers for design and production.

First Contact & Terms Illustrators: Send postcard, brochure or tearsheets. Samples are filed and are not returned. Responds only if interested with a specific job. Portfolio review not required. Buys first rights, one-time rights or all rights (rarely). Pays on publication; $400 for color cover; $200-250 for color inside. Pays for design by the project.

Tips "Send appropriate samples. Most of my illustration hiring is via direct mail. The magazine field is still a great place for illustration. Have several ideas ready after reading editorial to add to or enhance our initial concept."

N ▢ OUTDOOR CANADA MAGAZINE

25 Sheppard Ave. W, Suite 100, Toronto ON M2N 6S7 Canada. E-mail: editorial@outdoorCanada.ca. Website: www.outdoorcanada.ca. **Art Director:** Robert Biron. 4-color magazine for Canadian anglers and hunters. enthusiasts and their families. Stories on fishing, hunting and wildlife. Readers are 81% male. Publishes 8 regular issues/year. Circ. 95,000. Art guidelines are available.

Illustration Approached by 12-15 illustrators/year. Buys approximately 10 drawings/issue. Has featured illustrations by Malcolm Cullen, Stephen MacEachren and Jerzy Kolatch. Features humorous, computer and spot illustration. Assigns 90% to experienced, but not well-known illustrators; 10% to new and emerging illustrators. Uses freelancers mainly for illustrating features and columns. Uses pen & ink, acrylic, oil and pastel.

Design Needs freelancers for multimedia. 20% of freelance work demands knowledge of Photoshop, Illustrator and QuarkXPress.

First Contact & Terms Illustrators: Send postcard sample or tearsheets. Designers: Send brochure, tearsheets and postcards. Accepts disk submissions compatible with Illustrator 7.0. Send EPS, TIFF and PICT files. Buys first rights. Pays illustrators $100-200 for small icon or diagram; $250-350 for maps; $350 for column spots and $750 for full page. Pays designers by the project. Artists should show a representative sampling of their work. Finds most artists through references/word of mouth.

Tips "Meet our deadlines and our budget. Know our product. Fishing and hunting knowledge an asset."

OUTER DARKNESS

1312 N. Delaware Place, Tulsa OK 74110. E-mail: odmagazine@aol.com. **Editor:** Dennis Kirk. Estab. 1994. Quarterly digest/zine of horror and science fiction, poetry and art. Circ. 500. Sample copy for $3.95 plus $1.00 postage. Sample illustrations free for 6×9 SASE and 2 first-class stamps. Art guidelines free for #10 SASE with first-class postage.

Cartoons Approached by 15-20 cartoonists/year. Buys 3-5 cartoons/year. Prefers horror/science fiction slant, but not necessary. Prefers single panel, humorous, b&w line drawings.

Illustration Approached by 60-70 illustrators/year. Buys 5-7 illustrations/issue. Has featured illustrations by Allen Koszowski, William Johns, Erika McGinnis, and Steve Rader. Features realistic science fiction and horror illustrations, b&w, pencil or ink. Assigns 20% of illustrations to new and emerging illustrators.

First Contact & Terms Cartoonists: Send query letter with b&w photocopies, samples, SASE. Samples are returned. Illustrators: Send query letter with photocopies, SASE. Responds in 2 weeks. Buys one-time rights. Pays on publication in contributor's copies. Finds illustrators through magazines and submissions.

Tips "Send samples of your work, along with a cover letter. Let me know a little about yourself. I enjoy learning about artists interested in *Outer Darkness*. *Outer Darkness* is continuing to grow at an incredible rate; it's presently available through both Project Pulp and Shocklines. It's also available in two out-of-state bookstores, and I'm working to get it in more."

OVER THE BACK FENCE

P.O. Box 756, Chillicothe OH 45601. (740)772-2165. Fax: (740)773-7626. E-mail: backfenc@bright.net. Website: www.pantherpublishing.com. **Creative Director:** Rocky Alten. Estab. 1994. Quarterly consumer magazine emphasizing southern Ohio topics. Circ. 15,000. Sample copies for $4; art guidelines free for #10 SASE with first-class postage.

Illustration Features humorous and realistic illustration; informational graphics and spot illustration. Assigns 50% of illustration to experienced but not well-known illustrators; 50% to new and emerging illustrators.

First Contact & Terms Illustrators: Send query letter with photocopies, SASE and tearsheets. Ask for guidelines. Samples are occasionally filed or returned by SASE. Responds in 3 months. Creative director will contact artist for portfolio review if interested. Buys one-time rights. Pays $100 for b&w and color covers; $25-100 for b&w and color inside; $25-200 for 2-page spreads; $25-100 for spots. Finds illustrators through word of mouth and submissions.

Tips "Our readership enjoys our warm, friendly approach. The artwork we select will possess the same qualities."

⚡ OXYGEN

5775 Mclaughlin Rd., Mississauga ON L5R P37. (905)507-3545. Fax: (905)507-2372. E-mail: editorial@oxygenmag.com. Website: www.oxygenmag.com. **Art Director:** Robert Kennedy. Estab. 1997. Monthly consumer magazine. "Oxygen is a magazine devoted entirely to women's fitness, health and physique." Circ. 250,000.

Illustration Buys 6-10 illustrations/issue. Has featured illustrations by Erik Blais, Ted Hammond and Marvin Hearld. Features caricatures of celebrities; charts & graphs; computer and realistic illustrations. Assigns 15% of illustrations to new and emerging illustrators. Prefers loose illustration, full color. Considers acrylic, airbrush, charcoal, collage, color washed, colored pencil, mixed media, pastel and watercolor. 50% of freelance illustration demands knowledge of Photoshop and QuarkXPress.

First Contact & Terms Illustrators: Send query letter with photocopies and tearsheets. Samples are filed and are not returned. Responds in 21 days. Buys all rights. **Pays on acceptance**; $50-500 for b&w and color inside; $100-1,000 for 2-page spreads. Finds illustrators through word of mouth and submissions.

Tips "Artists should have a working knowledge of women's fitness. Study the magazine. It is incredible the amount of work that is sent that doesn't begin to relate to the magazine."

PACIFIC PRESS PUBLISHING ASSOCIATION

1350 North Kings Rd., Nampa ID 83687. (208)465-2500. **Contact:** Dennis Ferree, graphic designer. Art Designer, Textbooks: Eucaris Galicia. Art Designer, Spanish and French Magazines: Ariel Fuentealba. Art Designer, *Signs of the Times:* Merwin Stewart. Estab. 1875. Book and magazine publisher. Specializes in Christian lifestyles and Christian outreach.

• This association publishes magazines and books. Also see *Signs of the Times* listing for needs.

PAINT HORSE JOURNAL

Box 961023, Fort Worth TX 76161-0023. (817)834-2742. Fax: (817)222-8466. E-mail: pzinn@apha.com. Website: www.painthorsejournal.com. **Art Director:** Paul Zinn. Monthly 4-color official publication of breed registry of Paint horses for people who raise, breed and show Paint horses. Circ. 30,000. Original artwork returned after publication if requested. Sample copy for $4.50; artist's guidelines for SASE.

Illustration Buys a few illustrations each year.

First Contact & Terms Illustrators: Send business card and samples to be kept on file. Prefers snapshots of original art or photostats as samples. Samples returned by SASE if not filed. Responds in 1 month. Buys first rights but may wish to use small, filler art many times. Payment varies by project.

Tips "No matter what style of art you use, you must include Paint Horses with conformation acceptable (to

the APHA). Horses of Arabian-type conformation or with markings not appropriate for Paint Horses will not be considered.''

PALO ALTO WEEKLY

703 High St., Palo Alto CA 94302. (650)326-8210. Fax: (650)326-3928. E-mail: chubenthal@paweekly.com. Website: www.paloaltoonline.com/weekly/index2.shtml. **Design Director:** Carol Hubenthal. Estab. 1979. Semiweekly newspaper. Circ. 45,000. Accepts previously published artwork. Originals returned at job's completion. Sample copies available.

Illustration Buys 20-30 illustrations/year. Works on assignment only. Considers all media.

First Contact & Terms Illustrators: Send query letter with brochure, résumé, SASE, tearsheets, photographs and photocopies. Samples are filed. Publication will contact artist for portfolio review if interested. Pays on publication; $200 for color cover; $100 for b&w inside, $125 for color inside.

Tips Most often uses freelance illustration for covers and cover story, especially special section covers such as restaurant guides. ''We call for artists' work in our classified ad section when we need some fresh work to look at. We work exclusively with local artists.''

PARADE MAGAZINE

711 Third Ave., New York NY 10017-4014. (212)450-7000. Fax: (212)450-7284. E-mail: ira_yoffe@parade.com. Website: www.parade.com. **Creative Director:** Ira Yoffe. Photo Editor: Miriam White-Lorentzen. Art Director: Nick Torello. Weekly emphasizing general-interest subjects. Circ. 36 million (readership is 75 million). Original artwork returned after publication. Sample copy available. Art guidelines for SASE with first-class postage.

Illustration Uses varied number of illustrations/issue. Works on assignment only.

Design Needs freelancers for design. 100% of freelance work demands knowledge of Photoshop, Illustrator and QuarkXPress. Prefers local freelancers.

First Contact & Terms Illustrators: Send query letter with brochure, résumé, business card, postcard and/or tearsheets to be kept on file. Designers: Send query letter with résumé. Call or write for appointment to show portfolio. Responds only if interested. Buys first rights, occasionally all rights. Pays for design by the project, by the day or by the hour depending on assignment.

Tips ''Provide a good balance of work.''

PARENTS' PRESS

1454 Sixth St., Berkeley CA 94710-1431. (510)524-1602. Fax: (510)524-0912. E-mail: parentsprs@aol.com. **Art Director:** Ann Skram. Estab. 1980. Monthly tabloid-size newspaper ''for parents in the San Francisco Bay area.'' Circ. 75,000.

Illustration Buys occasional 4-color cover illustrations. Prefers parenting and child related. Considers all media, must be suitable for reproduction on newsprint. Send query letter with photocopies and SASE or URL for online samples; no e-mail attachments.

First Contact & Terms ''We will accept work compatible with QuarkXPress 4.1, Photoshop and Illustrator. Responds only if interested. Art director will contact artist for portfolio review of b&w and color slides if interested. Buys one-time rights. Pays on publication; negotiable. Payment for spots negotiable.

PC MAGAZINE

Ziff-Davis Media, 28 E. 28th St., 11th Floor, New York NY 10016. (212)503-3500. Fax: (212)503-5580. Website: www.pcmag.com. **Art Director:** Richard Demler. Senior Associate Art Director: Michael St. George. Estab. 1983. Bimonthly consumer magazine featuring comparative lab-based reviews of current PC hardware and software. Circ. 750,000. Sample copies available.

Illustration Approached by 100 illustrators/year. Buys 5-10 illustrations/issue. Considers all media.

First Contact & Terms Illustrators: Send postcard sample and/or printed samples, photocopies, tearsheets. Accepts CD or e-mail submissions. Samples are filed. Portfolios may be dropped off and should include tearsheets and transparencies; art department keeps for one week to review. **Pays on acceptance.** Payment negotiable for cover and inside; $350 for spots.

PENNSYLVANIA LAWYER

Pennsylvania Bar Association, 100 South St., Harrisburg PA 17108-0186. (717)238-6715. E-mail: editor@pabar.org. Website: www.pabar.org. **Editor:** Geoff Yuda. Bimonthly association magazine ''featuring nuts and bolts articles and features of interest to lawyers.'' Circ. 30,000. Sample copies for #10 SASE with first-class postage. Art guidelines available.

Illustration Approached by 30 illustrators/year. Buys 12 illustrations/year. Considers all media.

First Contact & Terms Illustrators: Send query letter with samples. Samples are filed or returned by SASE. Art director will contact artist for portfolio review if interested. Negotiates rights purchased. **Pays on acceptance;**

$300-500 for color cover; $100 for inside. Pays $25-50 for spots. Finds illustrators through word of mouth and artists' submissions.

Tips "Artists must be able to interpret legal subjects. Art must have fresh, contemporary look. Read articles you are illustrating, provide three or more roughs in timely fashion."

PET BUSINESS

333 Seventh Ave., 11th Floor, New York NY 10001-5004. (212)979-4800. Fax: (646)674-0102. Website: www.pet business.com. **Art Director:** Jennifer Bumgardner. Managing Editor: Mark Kalaygian. A monthly 4-color news magazine for the pet industry (retailers, distributors, manufacturers, breeders, groomers). Circ. 24,500. Accepts previously published artwork.

Illustration Occasionally needs illustration for business-oriented cover stories. Features realistic illustrations. Prefers watercolor, pen & ink, acrylics and color pencil.

First Contact & Terms Accepts Windows-compatible disk submissions. Send EPS files, 266 dpi. Portfolio review not required. Pays on publication; $100.

Tips "Send two or three samples and a brief bio, only."

PHI DELTA KAPPAN

P.O. Box 789, Bloomington IN 47402. (812)339-1156. Fax: (812)339-0018. Website: www.pdkintl.org/kappan/kappan.htm. **Design Director:** Carol Bucheri. Emphasizes issues, policy, research findings and opinions in the field of education. For members of the educational organization Phi Delta Kappa and subscribers. Black & white with 4-color cover and "conservative, classic design." Published 10 times/year. Circ. 100,000. Include SASE. Responds in 2 months. "We return illustrations and cartoons after publication." Sample copy for $7 plus $5 S&H. "The journal is available in most public and college libraries."

Cartoons Approached by over 100 cartoonists/year. Looks for "finely drawn cartoons, with attention to the fact that we live in a multi-racial, multi-ethnic world."

Illustration Approached by over 100 illustrators/year. Uses one 4-color cover and spread/issue. Features serious conceptual art; humorous, realistic, computer and spot illustraion. Prefers style of John Berry, Brenda Grannan and Jem Sullivan. Most illustrations depict some aspect of the education process (from pre-kindergarten to university level), often including human figures.

First Contact & Terms Illustrators: Send postcard sample and include Web address to online portfolio. "We can accept computer illustrations that are Mac formatted (EPS or TIFF files; Photoshop 6.0 or Illustrator 9.0)." Buys one-time print and electronic rights. Payment varies.

Tips "We look for artists who can create a finely crafted image that holds up when translated onto the printed page. Our journal is edited for readers with master's or doctoral degrees, so we look for illustrators who can take abstract concepts and make them visual, often through the use of metaphor. Submission specifications online."

PHILADELPHIA WEEKLY

1500 Sansom St., 3rd Floor, Philadelphia PA 19102-2800. (215)563-7400. Fax: (215)563-0620. E-mail: jcox@phil adelphiaweekly.com. Website: www.philadelphiaweekly.com. **Art Director:** Jeffrey Cox. Estab. 1971. Alternative weekly, 4-color, tabloid focusing on news and opinion and arts and culture. Circ. 105,500.

Cartoons Approached by 25 cartoonists/year. Buys 0-1 cartoon/issue. Prefers single panel, multiple panel, political, humorous, b&w washes, b&w line drawings.

Illustration Approached by scores of illustrators/year. Buys 3-5 illustrations/issue. Has featured illustrations by Brian Biggs, Jay Bevenour, James McHugh. Features caricatures of celebrities and politicians; humorous, realistic and spot illustrations. Considers a wide range of styles.

First Contact & Terms Cartoonists: Send query letter with b&w photocopies. Illustrators: Send postcard sample or query letter with printed samples and photocopies. Send nonreturnable samples. Samples are filed and are not returned. Responds only if interested. Buys one-time rights. Pays on publication; $300 for color cover; $75-150 for b&w inside; $100-250 for color inside; $75 for spots. Finds illustrators through promotional samples.

PHYSICAL MAGAZINE

11050 Santa Monica Blvd., 3rd Floor, Los Angeles CA 90025. (310)445-7528. Fax: (310)445-7587. E-mail: TPREIS S@Physicalmag.com. Website: www.physicalmag.com. **Contact:** Tamar Preiss, Art Director. Estab. 1998. Monthly fitness consumer magazine "with readers who enjoy working out and eating healthy. Supplements are a must!" Sample copies available on request. Art guidelines available when artist is hired.

● *Physical* is published by Basic Media Group which also publishes *Let's Live* and *Great Life* magazines.

Cartoons Buys 3-5 cartoons/year. Prefers clean but edgey. Prefers single or double panel, humorous, color washes.

Illustration Buys 8-10 illustrations/year. Features computer illustration, humorous illustration, realistic illustra-

tion, medical illustration and spot illustrations involving fitness and sports. Assigns 75% to new and emerging illustrators. 90% of freelance illustration demands knowledge of Illustrator, QuarkXPress and Photoshop.
First Contact & Terms Cartoonists/Illustrators: Send postcard sample. After introductory mailing, send follow-up postcard every 6-9 months. Responds only if interested. Company will contact artist for portfolio review if interested. Portfolio should include finished art. Pays cartoonists $800-1,200 for b&w and color cartoons. Pays illustrators $800-1,200 for color inside, $1,000-1,300 for 2-page spreads. **Pays on acceptance.** Buys one-time rights and first North American serial rights. Finds freelancers through sourcebooks.
Tips "Don't waste your cards and postage if your style does not match the magazine."

PLANNING

American Planning Association, 122 S. Michigan Ave., Suite 1600, Chicago IL 60603. (312)431-9100. Fax: (312)431-9985. Website: www.planning.org. **Editor and Publisher:** Sylvia Lewis. Art Director: Richard Sessions. Monthly 4-color magazine for urban and regional planners interested in land use, housing, transportation and the environment. Circ. 38,000. Previously published work OK. Original artwork returned after publication, upon request. Free sample copy and artist's guidelines available. "Enclose $1 in postage for sample magazines-tamps only, no cash or checks, please."
Cartoons Buys 2 cartoons/year on the environment, city/regional planning, energy, garbage, transportation, housing, power plants, agriculture and land use. Prefers single panel with gaglines ("provide outside of cartoon body if possible").
Illustration Buys 20 illustrations/year on the environment, city/regional planning, energy, garbage, transportation, housing, power plants, agriculture and land use.
First Contact & Terms Cartoonists: Include SASE. Illustrators: Send samples of style we can keep on file. If you want a response, enclose SASE. Responds in 2 weeks. Buys all rights. Pays on publication. Pays cartoonists $50 minimum for b&w line drawings. Pays illustrators $250 maximum for b&w cover drawings; $100 minimum for b&w line drawings inside.
Tips "Don't send portfolio. No corny cartoons. Don't try to figure out what's funny to planners. All attempts seen so far are way off base. Your best chance is to send samples of any type of illustration—cartoons or other—that we can keep on file. If we like your style we will commission work from you."

PLAYBOY MAGAZINE

680 N. Lakeshore Dr., Chicago IL 60611. (312)751-8000. Website: www.playboy.com. **Art Director:** Tom Staebler. Estab. 1952. Monthly magazine. Circ. 3.5 million.
Cartoons Playboy Enterprises Inc., Cartoon Dept., 730 Fifth Ave., New York NY 10019.
Illustration Approached by 700 illustrators/year. Prefers "uncommercial looking" artwork. Considers all media.
First Contact & Terms Illustrators: Send postcard sample or query letter with slides and photocopies or other appropriate sample. Does not accept originals. Samples are filed or returned. Responds in 2 weeks. Buys all rights. **Pays on acceptance.**
Tips "No phone calls, only formal submissions of five pieces."

PN/PARAPLEGIA NEWS

2111 E. Highland Ave., Suite 180, Phoenix AZ 85016-4702. (602)224-0500. Fax: (602)224-0507. E-mail: susan@p nnews.com. Website: www.pn-magazine.com. **Art Director:** Susan Robbins. Estab. 1947. Monthly 4-color magazine emphasizing wheelchair living for wheelchair users, rehabilitation specialists. Circ. 30,000. Accepts previously published artwork. Original artwork not returned after publication. Sample copy free for large-size SASE with $3 postage.
Cartoons Buys 3 cartoons/issue. Prefers line art with wheelchair theme. Prefers single panel b&w line drawings with or without gagline.
Illustration Prefers wheelchair living or medical and financial topics as themes. 50% of freelance work demands knowledge of QuarkXPress, Photoshop or Illustrator.
First Contact & Terms Cartoonists: Send query letter with finished cartoons to be kept on file. Responds only if interested. Buys all rights. **Pays on acceptance.** Illustrators: Send postcard sample. Accepts disk submissions compatible with Illustrator 10.0 or Photoshop 7.0. Send EPS, TIFF or JPEG files. Samples not filed are returned by SASE. Publication will contact artist for portfolio review if interested. Portfolio should include final reproduction/product, color and b&w tearsheets, photostats, photographs. Pays on publication. Pays cartoonists $10 for b&w. Pays illustrators $250 for color cover; $25 for b&w inside, $50 for color inside.
Tips "When sending samples, include something that shows a wheelchair user. We regularly purchase cartoons that depict wheelchair users."

☑ POCKETS

Box 340004, 1908 Grand Ave., Nashville TN 37203-0004. (615)340-7333. Fax: (615)340-7267. E-mail: pockets@ upperroom.org. Website: www.pockets.org. **Editor:** Lynn W. Gilliam. Devotional magazine for children 6-12.

4-color. Monthly except January/February. Circ. 100,000. Accepts one-time previously published material. Original artwork returned after publication. Sample copy for 9×12 or larger SASE with 4 first-class stamps.

Illustration Approached by 50-60 illustrators/year. Features humorous, realistic and spot illustration. Assigns 15% of illustrations to new and emerging illustrators. Uses variety of styles; 4-color, flapped art appropriate for children. Realistic, fable and cartoon styles.

First Contact & Terms Illustrators: Send postcard sample, brochure, photocopies, SASE and tearsheets. No fax submissions accepted. Also open to more unusual art forms cut paper, embroidery, etc. Samples not filed are returned by SASE. ''No response without SASE.'' Responds only if interested. Buys one-time or reprint rights.

Pays on acceptance; $600 flat fee for 4-color covers; $75-350 for color inside.

Tips ''Decisions made in consultation with out-of-house designer. Send samples to our designer Chris Schechner, 408 Inglewood Dr., Richardson, TX 75080.''

Ⓝ THE PORTLAND REVIEW

P.O. Box 347, Portland OR 97207. (503)725-4533. Fax: (503)725-5860. E-mail: review@vanguard.vg.pdx.edu. Website: www.portlandreview.org. **Contact:** Rebecca Rich Goldweber, editor. Estab. 1954. Quarterly student-run arts journal. Circ. 1,000. Sample copies available for $6. Art guidelines available free with SASE or on website.

Illustration Approached by 50 illustrators/year. We don't pay contributors. Features humorous and natural history illustration.

First Contact & Terms Cartoonists/Illustrators: Send postcard sample or query letter with b&w photocopies and SASE. Accepts e-mail submissions with link to website or with image file. Prefers Mac-compatible. Samples are not filed and not returned. Responds in 2 months. Portfolio not required.

POWDER MAGAZINE

33046 Calle Aviador, San Juan Capistrano CA 92675. (949)496-5922. Fax: (949)496-7849. E-mail: sonny.sisto@primedia.com. Website: www.powdermag.com. **Art Director:** Sonny Sisto. Estab. 1972. Monthly consumer magazine ''for core skiers who live, eat and breathe skiing and the lifestyle that goes along with it.'' Circ. 110,000. Samples are available; art guidelines not available.

Illustration Approached by 20-30 illustrators/year. Buys 5-10 illustrations/year. Has featured illustrations by Peter Spacek, Dan Ball and Santiago Uceda. Features humorous and spot illustration. Assigns 10% of illustrations to well-known or ''name'' illustrators; 70% to experienced but not well-known illustrators; 20% to new and emerging illustrators. ''Illustrators have to know a little about skiing.'' Considers all media. 10% of freelance illustration demands knowledge of Photoshop 3.0, Illustrator 5.0 and QuarkXPress 3.3.

Design Needs freelancers for design and multimedia projects. Prefers local design freelancers. 100% of freelance work demands knowledge of Photoshop 3.0, Illustrator 5.0 and QuarkXPress 3.3.

First Contact & Terms Illustrators: Send postcard sample or tearsheets. Designers: Send query letter with printed samples and photocopies. Accepts Macintosh EPS files compatible with QuarkXPress 3.3. Samples are filed. Responds only if interested. Buys one-time rights. **Pays on acceptance;** $100-300 for b&w inside; $200-400 for color inside; $400-1000 for 2-page spreads; 100-300 for spots. Finds illustrators through sourcebooks and submissions.

Tips ''We like cutting-edge illustration, photography and design. We need it to be innovative and done quickly. We give illustrators a lot of freedom. Send sample or promo and do a follow-up call.''

Ⓦ PRAIRIE JOURNAL OF CANADIAN LITERATURE

P.O. Box 61203 Brentwood Postal Services, Calgary AB T2L 2K6 Canada. E-mail: prairiejournal@yahoo.com. Website: www.geocities.com/prairiejournal. **Contact:** Editor (by mail). Estab. 1983. Biannual literary magazine. Circ. 600. Sample copies available for $6; art guidelines on website.

Illustration Approached by 25 illustrators/year. Buys 6 illustrations/year. Has featured illustrations by Hubert Lacey, Rita Diebolt, Lucie Chan. Considers artistic/experimental b&w line drawings or screened print.

First Contact & Terms Illustrators: Send postcard sample or query letter with b&w photocopies. Samples are filed. Responds only if interested. Portfolio review not required. Acquires one-time rights. Pays $50 maximum (Canadian) for b&w cover and $25 maximum for inside drawings. Pays on publication. Finds freelancers through unsolicited submissions and queries.

Tips ''We are looking for black & white line drawings easily reproducable and camera-ready copy. Never send originals through the mail.''

PRAIRIE SCHOONER

University of Nebraska, 201 Andrews Hall, Lincoln NE 68588-0334. (402)472-0911. Fax: (402)472-9771. E-mail: kgrey2@unlnotes.unl.edu. Website: www.unl.edu/schooner/psmain.htm. **Contact:** Kelly Grey Carlisle, managing editor. Estab. 1926. Quarterly b&w literary magazine with full-color cover. ''*Prairie Schooner*, now

in its 79th year of continuous publication, is called 'one of the top literary magazines in America' by *Literary Magazine Review*. Each of the four issues contains short stories, poetry, book reviews, personal essays, interviews or some mix of these genres. Contributors are both established and beginning writers. Readers live in all states in the U.S. and in most countries outside the U.S." Circ. 3,200. Original artwork is returned after publication. "We rarely have the space or funds to reproduce artwork in the magazine but hope to do more in the future." Sample copies for $6.

Illustration Approached by 5-10 illustrators/year. Uses freelancers mainly for cover art.

First Contact & Terms "Before submitting, artist should be familiar with our cover and format, 6×9, vertical images work best; artist should look at previous issues of *Prairie Schooner*. Portfolio review not required. We are rarely able to pay for artwork; have paid $50 to $100."

Tips Finds artists through word of mouth.

PREMIERE MAGAZINE

1633 Broadway, 41st Floor, New York NY 10019. (212)767-6000. Fax: (212)767-5450. Website: www.premieremag.com. **Art Director:** Richard Baker. Estab. 1987. "Monthly popular culture magazine about movies and the movie industry in the U.S. and the world. Of interest to both a general audience and people involved in the film business." Circ. 612,952. Original artwork is returned after publication.

Illustration Approached by 250 illustrators/year. Works with 150 illustrators/year. Buys 3-4 spot illustrations/issue. Buys illustrations mainly for spots. Has featured illustrations by Dan Adel, Brian Briggs, Anita Kunz and Roberto Parada. Works on assignment only. Considers all styles depending on needs.

First Contact & Terms Illustrators: Send query letter with tearsheets, photostats and photocopies. Samples are filed. Samples not filed are returned by SASE. Reports back about queries/submissions only if interested. Drop-offs Monday through Friday, and pick-ups the following day. Buys first rights or one-time rights. Pays $350 for b&w, $375-1,200 for color inside.

PRESBYTERIANS TODAY

100 Witherspoon St., Louisville KY 40202. (502)569-5637. Fax: (502)569-8632. E-mail: today@pcusa.org. Website: www.pcusa.org/today. **Art Director:** Linda Crittenden. Estab. 1830. 4-color; official church magazine emphasizing Presbyterian news and informative and inspirational features. Publishes 10 issues year. Circ. 58,000. Originals are returned after publication if requested. Some feature illustrations may appear on website. Sample copies for SASE with first-class postage.

Cartoons Approached by 20-30 cartoonists/year. Buys 1-2 freelance cartoons/issue. Prefers general religious material; single panel.

Illustration Approached by more than 50 illustrators/year. Buys 2-3 illustrations/issue, 30 illustrations/year from freelancers. Works on assignment only. Media varies according to need.

First Contact & Terms Cartoonists: Send roughs and/or finished cartoons. Responds in 1 month. Rights purchased vary according to project. Illustrators: Send query letter with tearsheets. Samples are filed and not returned. Responds only if interested. Buys one-time rights. Pays cartoonists $25, b&w. Pays illustrators $150-350, cover; $80-250, inside.

Ⓝ PREVENTION

400 S. 10th St., Emmaus PA 18098. (610)967-7548. Fax: (610)967-7654. E-mail: laura.baer@rodale.com. Website: www.prevention.com. **Art Director:** Laura Baer. Estab. 1950. Monthly consumer magazine covering health and fitness, women readership. Circ. 3 million. Art guidelines available.

Illustration Approached by 500-750 illustrators/year. Considers all media.

First Contact & Terms Illustrators: Send postcard sample or query letter with photocopies, tearsheets, URL. Accepts submissions on disk. Samples are filed. Responds only if interested. Art director will contact artist for portfolio review of b&w, color, photographs, tearsheets, transparencies if interested. Finds illustrators through iSpot, magazines, submissions.

PRINT MAGAZINE

38 E. 29th St., 3rd Floor, New York NY 10016. (212)447-1400. Fax: (212)447-5231. E-mail: steven.brower@printmag.com. Website: www.printmag.com. **Art Director:** Steven Brower. Estab. 1940. Bimonthly professional magazine for "art directors, designers and anybody else interested in graphic design." Circ. 55,000. Art guidelines available.

First Contact & Terms Illustrators/Designers: Send postcard sample, printed samples and tearsheets. Samples are filed. Responds only if interested. Art director will contact artist for portfolio review if interested. Portfolios may be dropped off every Monday, Tuesday, Wednesday, Thursday and Friday. Buys first rights. Pays on publication. Finds illustrators through agents, sourcebooks, word of mouth and artist's submissions.

Tips "Read the magazine: We show art and design and don't buy and commission much, but it does happen."

◱ PRISM INTERNATIONAL

Buch E4621866 Main Mall, Vancouver BC V6T 1Z1 Canada. (604)822-2514. Fax: (604)822-3616. E-mail: prism@ interchange.ubc.ca. Website: www.prism.arts.ubc.ca. Estab. 1959. Quarterly literary magazine. "We use cover art for each issue." Circ. 1,200. Original artwork is returned to the artist at the job's completion. Sample copies for $10, art guidelines for SASE with first-class postage.

Illustration Approached by 20 illustrators/year. Buys 1 cover illustration/issue. Has featured illustrations by Mark Ryden, Mark Mothersbaugh, Annette Allwood, The Clayton Brothers, Maria Capolongo, Mark Korn, Scott Bakal, Chris Woods, Kate Collie and Angela Grossman. Features representational and nonrepresentational fine art. Assigns 50% of illustrations to experienced but not well-known illustrators; 50% to new and emerging illustrators. "Most of our covers are full color artwork and sometimes photography; on occasion we feature black & white cover/year."

First Contact & Terms Illustrators: Send postcard sample. Accepts submissions on disk compatible with Corel-Draw 5.0 (or lower) or other standard graphical formats. Most samples are filed. Those not filed are returned by SASE if requested by artist. Responds in 6 months. Portfolio review not required. Buys first rights. Pays on publication; $250 (Canadian) for b&w and color cover; $40 (Canadian) for b&w and color inside and 3 copies. Finds artists through word of mouth and going to local exhibits.

Tips "We are looking for fine art suitable for the cover of a literary magazine. Your work should be polished, confident, cohesive and original. Please send postcard samples of your work. As with our literary contest, we will choose work which is exciting and which reflects the contemporary nature of the magazine."

◱ PROFIT MAGAZINE

One Mount Pleasant Rd., 11th Floor, Toronto M4Y 2Y5. (416)764-1402. Fax: (416)764-1404. E-mail: jhull@profit mag.ca. Website: www.profitguide.com. **Art Director:** John Hull. Estab. 1982. 4-color business magazine for Canadian entrepreneurs published 6 times/year. Circ. 102,000.

Illustration Buys 3-5 illustrations/issue. Has featured illustrations by Jerzy Kolacz, Jason Schneider, Ian Phillips. Features charts & graphs, computer, realistic and humorous illustration, informational graphics and spot illustrations of business subjects. Assigns 50% of illustrations to well-known or "name" illustrations; 50% to experienced but not well-known illustrators.

First Contact & Terms Illustrators: Send postcard or other nonreturnable samples. Accepts Mac-compatible disk submissions. Samples are not returned. Will contact artist for portfolio review if interested. Buys first rights. **Pays on acceptance**; $500-750 for color inside; $750-1,000 for 2-page spreads; $350 for spots. Pays in Canadian funds. Finds illustrators through promo pieces, other magazines.

PROGRESSIVE RENTALS

1504 Robin Hood Trail, Austin TX 78703. (512)794-0095. Fax: (512)794-0097. E-mail: nferguson@aprovision.o rg. Website: www.aprovision.org. **Art Director:** Neil Ferguson. Estab. 1983. Bimonthly association publication for members of the Association of Progressive Rental Organizations, the national association of the rental-purchase industry. Circ. 6,000. Sample copies free for catalog-size SASE with first-class postage.

Illustration Buys 2-3 illustrations/issue. Has featured illustrations by Barry Fitzgerald, Aletha St. Romain, A.J. Garces, Edd Patton and Jane Marinsky. Features conceptual illustration. Assigns 15% of illustrations to new and emerging illustrators. Prefers cutting edge; nothing realistic; strong editorial qualities. Considers all media. "Accepts computer-based illustrations (Photoshop, Illustrator)."

First Contact & Terms Illustrators: Send postcard sample, query letter with printed samples, photocopies or tearsheets. Accepts disk submissions. (Must be Photoshop-accessible EPS high-resolution [300 dpi] files or Illustrator files.) Samples are filed or returned by SASE. Responds in 1 month if interested. Rights purchased vary according to project. Pays on publication; $300-450 for color cover; $250-350 for color inside. Finds illustrators mostly through artist's submissions; some from other magazines.

Tips "Illustrators who work for us must have a strong conceptual ability—that is, they must be able to illustrate for editorial articles dealing with business/management issues. We are looking for cutting-edge styles and unique approaches to illustration. I am willing to work with new, lesser-known illustrators."

THE PROGRESSIVE

409 E. Main St., Madison WI 53703. (608)257-4626. Fax: (608)257-3373. Website: www.progressive.org. **Art Director:** Nick Jehlen. Estab. 1909. Monthly b&w plus 4-color cover. Circ. 65,000. Originals returned at job's completion. Free sample copy and art guidelines.

Illustration Works with 50 illustrators/year. Buys 10 b&w illustrations/issue. Features humorous and political illustration. Has featured illustrations by Luba Lukova, Alex Nabaum and Seymour Chwast. Assigns 30% of illustrations to new and emerging illustrators. Needs editorial illustration that is "original, smart and bold." Works on assignment only.

First Contact & Terms Illustrators: Send query letter with tearsheets and/or photocopies. Samples returned by

SASE. Responds in 6 weeks. Portfolio review not required. Pays $1,000 for b&w and color cover; $300 for b&w line or tone drawings/paintings/collage inside. Buys first rights. Do not send original art. Send samples, post-cards or photocopies and appropriate postage for materials to be returned.

Tips Check out a copy of the magazine to see what kinds of art we've published in the past. A free sample copy is available by visiting our website.

PROTOONER

P.O. Box 2270, Daly City CA 94017-2270. Phone/fax: (650)755-4827. E-mail: protooner@earthlink.ne. Website: www.protooner.lookscool.com. **Editor:** Joyce Miller. Art Director: Ladd A. Miller. Estab. 1995. Monthly trade journal for the professional cartoonist and gagwriter. Circ. 1,300. Sample copy $6 US, $10 foreign. Art guidelines for #10 SASE with first-class postage.

Cartoons Approached by tons of cartoonists/year. Buys 5-6 cartoons plus cover cartoon/issue. Prefers good visual humorous impact. Prefers single panel, humorous, b&w line drawings, with or without gaglines.

Illustration Approached by 6-12 illustrators/year. Buys 3 illustrations/issue. Has featured illustrations by Brewster Allison, Thom Bluemel, Murray Mann, Bob Vojtko, and Earl Engleman. Assigns 20% of illustrations to new and emerging illustrators. Features humorous illustration; informational graphics; spot illustration. Prefers humorous, original. Avoid vulgarity. Considers pen & ink. 50% of freelance illustration demands computer knowledge. Query for programs.

First Contact & Terms Cartoonists: Send query letter with roughs, SASE, tearsheets. Illustrators: Send query letter with printed samples and SASE. Samples are filed. Responds in 1 month. Buys reprint rights. **Pays on acceptance.** "Pays cartoonists and illustrators $25/b&w front cover and $15/inside spot drawings. We assign illustrations to accompany articles, choosing from filed samples."

Tips "Pay attention to the magazine slant and SASE a must! Study sample copy before submitting. Request guidelines. Don't mail artwork not properly slanted!"

PSYCHOLOGY TODAY

115 E. 23rd St., 9th Floor, New York NY 10010. (212)260-7210. Fax: (212)260-7566. Website: www.psychologytoday.com. **Art Director:** Philippe Garnier. Estab. 1991. Bimonthly consumer magazine for professionals and academics, men and women. Circ. 350,000. Accepts previously published artwork. Originals returned at job's completion.

Illustration Approached by 500 illustrators/year. Buys 5 illustrations/issue. Works on assignment only. Prefers psychological, humorous, interpersonal studies. Considers all media. Needs editorial, technical and medical illustration. 20% of freelance work demands knowledge of QuarkXPress or Photoshop.

First Contact & Terms Illustrators: Send query letter with brochure, photostats and photocopies. Samples are filed and are not returned. Responds only if interested. Buys one-time rights. Pays on publication; $200-500 for color inside; $50-350 for spots; cover negotiable.

PUBLIC CITIZEN NEWS

1600 20th St., NW, Washington DC 20009. (202)588-1000. Fax: (202)588-7799. E-mail: bguldin@citizen.org. Website: www.citizen.org. **Editor:** Bob Guldin. Bimonthly magazine emphasizing consumer issues for the membership of Public Citizen, a group founded by Ralph Nader in 1971. Circ. 90,000. Accepts previously published material. Sample copy available for 9×12 SASE with first-class postage.

Illustration Buys up to 2 illustrations/issue. Assigns 15% of illustrations to new and emerging illustrators. Prefers contemporary styles in pen & ink.

First Contact & Terms Illustrators: Send query letter with samples to be kept on file. Buys first rights or one-time rights. Pays on publication. Payment negotiable.

Tips "Send several keepable samples that show a range of styles and the ability to conceptualize. Want cartoons that lampoon policies and politicians, especially the Bush adminstration and on the far right of the political spectrum. Magazine was redesigned into a newspaper format in 1998."

PUBLISHERS WEEKLY

360 Park Avenue S., New York NY 10010. (646)746-6758. Fax: (646)746-6631. Website: www.publishersweekly.com. **Art Director:** Clive Chiu. Weekly magazine emphasizing book publishing for "people involved in the creative or the technical side of publishing." Circ. 50,000. Original artwork is returned to the artist after publication.

Illustration Buys 75 illustrations/year. Works on assignment only. "Open to all styles."

First Contact & Terms Illustrators: Send postcard sample or query letter with brochure, tearsheets, photocopies. Samples are not returned. Responds only if interested. **Pays on acceptance;** $350-500 for color inside.

Ⓝ QECE (QUESTION EVERYTHING CHALLENGE EVERYTHING)

P.O. Box 122, Royersford PA 19468-0122. E-mail: qece@yahoo.com. Website: www.geocities.com/qece/. **Creative Director:** Larry Nocella. Estab. 1996. Twice yearly b&w zine "encouraging a more questioning mentality." Circ. 450. Visit our website first to see what we publish.

Cartoons Prefers subversive and bizarre single, double or multiple panel humorous, b&w line drawings.

Illustration Approached by 12 illustrators/year. Has featured illustrations by Walter M. Rivera, Linda Chido, Colin Develin. Features charts & graphs, humorous and realistic illustrations; "anything that jolts the imagination." Prefers "intelligent rebellion." Prefers b&w line art. Assigns 100% of illustrations to new and emerging illustrators.

Tips "Be free and Question Everything. Challenge Everything."

QUEEN OF ALL HEARTS

26 S. Saxon Ave., Bay Shore NY 11706-8993. (631)665-0726. Fax: (631)665-4349. E-mail: montfort@optonline.net. Website: www.montfortmissionaries.com. **Managing Editor:** Rev. Roger Charest. Estab. 1950. Bimonthly Roman Catholic magazine on Marian theology and spirituality. Circ. 2,000. Accepts previously published artwork. Sample copy available.

Illustration Buys 1 or 2 illustrations/issue. Works on assignment only. Prefers religious. Considers pen & ink and charcoal.

First Contact & Terms Illustrators: Send postcard samples. Samples are not filed and are returned by SASE if requested by artist. Buys one-time rights. **Pays on acceptance.** $50 minimum for b&w inside.

Tips Area most open to freelancers is illustration for short stories. "Be familiar with our publication."

ELLERY QUEEN'S MYSTERY MAGAZINE

475 Park Ave. S., New York NY 10016. (212)686-7188. Fax: (212)686-7414. **Senior Art Director:** Victoria Green. Associate Art Director June Levine. All submissions should be sent to June Levine, associate art director. Emphasizes mystery stories and reviews of mystery books. Art guidelines for SASE with first-class postage.

• Also publishes *Alfred Hitchcock Mystery Magazine, Analog* and *Isaac Asimov's Science Fiction Magazine.*

Cartoons "We are looking for cartoons with an emphasis on mystery, crime and suspense."

Illustration Prefers line drawings. All other artwork is done in house.

First Contact & Terms Cartoonists: Cartoons should be addressed to Lauren Kuczala, editor. Illustrators: Send SASE and tearsheets or transparencies. Accepts disk submissions. Responds in 3 months. **Pays on acceptance**; $1,200 for color covers; $125 for b&w interior art. Considers all media in b&w and halftones. Send SASE with tearsheets or photocopies and printed samples. Accepts finished art on disc.

Tips "Please see our magazine before submitting samples."

RANGER RICK

1100 Wildlife Center Dr., Reston VA 20190. (703)438-6000. Fax: (703)438-6094. Website: www.nwf.org. **Art Director:** Donna D. Miller. Monthly 4-color children's magazine focusing on wildlife and conservation. Circ. 500,000. Art guidelines are free for #10 SASE with first-class postage.

Illustration Approached by 100-200 illustrators/year. Buys 4-6 illustrations/issue. Has featured illustrations by Danielle Jones, Jack Desrocher, John Dawson and Dave Clegg. Features computer, humorous, natural science and realistic illustrations. Preferred subjects children, wildlife and natural world. Assigns 1% of illustrations to new and emerging illustrators. 50% of freelance illustration demands knowledge of Illustrator, Photoshop.

First Contact & Terms Illustrators: Send query letter with printed samples, photocopies and SASE. Accepts Mac-compatible disk submissions. Samples are filed or returned by SASE. Responds in 3 months. Will contact artist for portfolio review if interested. Buys one-time rights. Pays on publication; $50-250 for b&w inside; $150-800 for color inside; $1,000-2,000 for 2-page spreads; $350-450 for full-color spots. Finds illustrators through promotional samples, books and other magazines.

Tips "Looking for new artists to draw animals using Illustrator, Photoshop and other computer drawing programs. Please read our magazine before submitting."

REDBOOK MAGAZINE

Redbook Art Dept., 224 W. 57th St., 6th Floor, New York NY 10019-3212. (212)649-2000. Website: www.redbookmag.com. **Contact:** Michele Tessler, deputy design director. Monthly magazine "geared to married women ages 24-39 with young children and busy lives interested in fashion, food, beauty, health, etc." Circ. 7 million. Accepts previously published artwork. Original artwork returned after publication with additional tearsheet if requested.

Illustration Buys 3-7 illustrations/issue. Illustrations can be in any medium. Accepts fashion illustrations for fashion page.

First Contact & Terms Send quarterly postcard. Art director will contact for more samples if interested. Portfolio drop off any day, pick up 2 days later. Buys reprint rights or negotiates rights.

Tips "We are absolutely open to seeing new stuff, but look at the magazine before you send anything, we might not be right for you. Generally, illustrations should look new, of the moment, fresh, intelligent and feminine. Keep in mind that our average reader is 30 years old, pretty, stylish (but not too 'fashion-y'). We do a lot of health pieces and many times artists don't think of health when sending samples to usso keep that in mind too."

REFORM JUDAISM

633 Third Ave., 7th Floor, New York NY 10017-6778. (212)650-4240. Fax: (212)650-4249. E-mail: rjmagazine@urj.org. Website: www.reformjudaismmag.org. **Managing Editor:** Joy Weinberg. Estab. 1972. Quarterly magazine. "The official magazine of the Reform Jewish movement. It covers developments within the movement and interprets world events and Jewish tradition from a Reform perspective." Circ. 310,000. Accepts previously published artwork. Originals returned at job's completion. Sample copies available for $3.50.

Cartoons Prefers political themes tying into editorial coverage.

Illustration Buys 8-10 illustrations/issue. Works on assignment. 10% of freelance work demands computer skills.

First Contact & Terms Cartoonists: Send query letter with finished cartoons. Illustrators: Send query letter with brochure, résumé, SASE and tearsheets. Samples are filed. Responds in 1 month. Publication will contact artist for portfolio review if interested. Portfolio should include tearsheets, slides and final art. Rights purchased vary according to project. **Pays on acceptance**; varies according to project. Finds artists through sourcebooks and artists' submissions.

N RELIX MAGAZINE

180 Varick St., Suite 410, New York NY 10014. (646)230-0100. Fax: (646)230-0200. E-mail: aeve@relix.com. Website: www.relix.com. **Contact:** Publisher. Estab. 1974. Bimonthly consumer magazine emphasizing independent music and the jamband scene. Circ. 100,000.

Cartoons Approached by 50 cartoonists/year. Prefers music-related humorous cartoons, single or multiple panel b&w line drawings.

Illustration Approached by 100 illustrators/year. Buys multiple illustrations/issue. Prefers color illustrations about alternative lifestyle, concerts, touring, hippies, and the jamband scene. Considers pen & ink, airbrush and marker.

First Contact & Terms Cartoonists: Send query letter with finished cartoons. Illustrators: Send query letter with SASE and photocopies. Samples are not filed and are returned by SASE if requested by artist. Responds to the artist only if interested. Portfolio review not required. Buys first-time rights. Pays on publication. Finds artists through word of mouth.

Tips "Not looking for any skeleton artwork. Artwork should be happy, trippy, humorous, and not dark or gory."

THE REPORTER

Women's American ORT, New York NY 10003. (212)505-7700. Fax: (212)674-3057. E-mail: dasher@waort.org. Website: www.waort.org. **Contact:** Dana Asher. Estab. 1966. Biannual organization magazine for Jewish women emphasizing Jewish and women's issues, lifestyle, education. *The Reporter* is the magazine of Women's American ORT, a membership organization supporting a worldwide network of technical and vocational schools. Circ. 50,000. Original artwork returned at job's completion. Sample copies for SASE with first-class postage.

Illustration Buys 4-8 illustrations/issue. Works on assignment only. Prefers contemporary art. Considers pen & ink, mixed media, watercolor, acrylic, oil, charcoal, airbrush, collage and marker.

First Contact & Terms Illustrators: Send postcard sample or query letter with brochure, SASE and photographs. Samples are filed. Responds to the artist only if interested. Rights purchased vary according to project. Pays on publication; $150 and up, depending on work.

RESIDENT AND STAFF PHYSICIAN

241 Forsgate Dr., Jamesburg NJ 08831-1385. (732)656-1140. Fax: (732)656-1955. E-mail: dbuffery@mwc.com. Website: www.mwc.com. **Editor:** Dalia Buffery. Monthly publication emphasizing hospital medical practice from clinical, educational, economic and human standpoints. For hospital physicians, interns and residents. Circ. 100,000.

Illustration "We commission qualified freelance medical illustrators to do covers and inside material. Artists should send sample work."

First Contact & Terms Illustrators: Send query letter with brochure showing art style or résumé, tearsheets,

photostats, photocopies, slides and photographs. Call or write for appointment to show portfolio of color and b&w final reproduction/product and tearsheets. **Pays on acceptance**; $800 for color cover; payment varies for inside work.

Tips "We like to look at previous work to give us an idea of the artist's style. Since our publication is clinical, we require highly qualified technical artists who are very familiar with medical illustration. Sometimes we have use for nontechnical work. We like to look at everything. We need material from the *doctor's* point of view, *not* the patient's."

RESTAURANT HOSPITALITY

1300 E. Ninth St., Cleveland OH 44114. (216)931-9942. Fax: (216)696-0836. E-mail: croberto@penton.com. **Group Creative Director:** Christopher Roberto. Circ. 123,000. Estab. 1919. Monthly trade publication emphasizing restaurant management ideas, business strategies and industry trends. Readers are independent and chain restaurant operators, executives and chefs.

Illustration Approached by 150 illustrators/year. Buys 3-5 illustrations per issue (combined assigned and stock). Prefers food- and business-related illustration in a variety of styles. Has featured illustrations by Mark Shaver, Paul Watson and Brian Raszka. Assigns 10% of illustrations to well-known or "name" illustrators; 60% to experienced but not well-known illustrators; and 30% to new and emerging illustrators. Welcomes stock submissions.

First Contact & Terms Illustrators: Send postcard samples and follow-up card every 3-6 months. Buys one-time rights. **Pays on acceptance.** Payment range varies for full page or covers; $300-350 quarter-page; $250-350 for spots.

Tips "I like to work with illustrators who are trying new techniques—contemporary styles that work well to connect business ideas with restaurant and foodservice visuals. Please include a web address on your sample so I can view more of your work online."

RHODE ISLAND MONTHLY

280 Kinsley Ave., Providence RI 02903-4161. (401)277-8280. Fax: (401)277-8080. **Art Director:** Ellen Dessloch. Estab. 1988. Monthly 4-color magazine which focuses on life in Rhode Island. Provides the reader with in-depth reporting, service and entertainment features and dining and calendar listings. Circ. 40,000. Accepts previously published artwork. Art guidelines not available.

• Also publishes a bride magazine and tourism-related publications.

Illustration Approached by 200 freelance illustrators/year. Buys 2-4 illustrations/issue. Works on assignment. Considers all media.

First Contact & Terms Illustrators: Send self-promotion postcards or samples. Samples are filed and not returned. Buys one-time rights. Pays on publication; $300 minimum for color inside, depending on the job. Pays $600-1,000 for features. Finds artists through submissions/self-promotions and sourcebooks.

Tips "Although we use a lot of photography, we are using more illustration, especially smaller, spot or quarter-page illustrations for our columns in the front of the magazine. If we see a postcard we like, we'll log on to the illustrator's website to see more work."

Ⓝ ROCKFORD REVIEW

P.O. Box 858, Rockford IL 61105. E-mail: dragonldy@prodigy.net. E-mail: daveconnieross@aol.com. Website: http://writersguild1.tripod.com. **Editor:** David Ross. Estab. 1971. Association publication of Rockford Writers' Guild. Twice a year literary magazine emphasizing literature and art which contain fresh insights into the human condition. Circ. 750.

Illustration Approached by 8-10 illustrators/year. Buys 1-2 illustrations/issue. Has featured illustrations by Sompith Maladouangork, Phil B. Welcome, Louis Netter. Features humorous, computer and satirical illustration. Prefers satire/human condition. Considers pen & ink and marker. Needs computer-literate freelancers for illustration.

First Contact & Terms Illustrators: Send query letter with photographs, SASE and photocopies. Samples are not filed and are returned by SASE. Responds in 2 months. Publication will contact artist for portfolio review if interested. Buys first rights. Pays on publication; 1 copy plus eligibility for $25 Editor's Choice Prize (6 each year)and guest of honor at summer party. Finds artists through word of mouth and submissions.

Tips "If something people do makes you smile, go 'hmph' or shake your head, draw it and send it to us. We are starving for satire on the human condition."

ROLLING STONE MAGAZINE

1290 Avenue of the Americas, 2nd Floor, New York NY 10104-0298. (212)484-1616. Fax: (212)484-1664. Website: www.rollingstone.com. **Art Director:** Amid Capeci. Deputy Art Director: Matthew Cooley. Associate Art Director: Martin Hoops. Estab. 1967. Bimonthly magazine. Circ. 1.4 million. Originals returned at job's comple-

tion. 100% of freelance design work demands knowledge of Illustrator, QuarkXPress and Photoshop. (Computer skills not necessary for illustrators). Art guidelines on website.

Illustration Approached by "tons" of illustrators/year. Buys approximately 4 illustrations/issue. Works on assignment only. Considers all media.

First Contact & Terms Illustrators: Send postcard sample and/or query letter with tearsheets, photocopies or any appropriate sample. Samples are filed. Does not reply. Portfolios may be dropped off every Tuesday before 3 p.m. and should include final art and tearsheets. Portfolios may be picked back up on Friday after 3 p.m. "Please make sure to include your name and address on the outside of your portfolio." Publication will contact artist for portfolio review if interested. Buys first and one-time rights. **Pays on acceptance**; payment for cover and inside illustration varies; pays $300-500 for spots. Finds artists through word of mouth, *American Illustration*, *Communication Arts*, mailed samples and drop-offs.

THE ROTARIAN

1560 Sherman Ave., Evanston IL 60201-4818. (847)866-3000. Fax: (847)866-9732. E-mail: rotarian@rotaryintl.org. Website: www.rotary.org. **Contact:** DLawrence, creative director. Estab. 1911. Monthly 4-color publication emphasizing general interest, business and management articles. The official magazine of Rotary International, a service organization for business and professional men and women, their families and other subscribers. Circ. 510,000. Accepts previously published artwork.

 • This creative director told *ADGM* that although she accepts hardcopy submissions, she no longer has time to reply (even with SASE). She will, however, keep the samples she likes on file. She only responds directly to e-mail submissions.

Cartoons Buys 5-8 cartoons/year. Interested in general themes with emphasis on business and sports. Avoid topics of sex, national origin, politics.

Illustration "Rarely purchase illustrations. Primarily purchase photography."

First Contact & Terms Prefers digital submissions. Cartoonists: Send query letter to Cartoon Editor, with brochure showing art style. Illustrators: Send query letter to art director with photocopies or brochure showing art style. To show portfolio, artist should follow up with a call or letter after initial query. Buys all rights. **Pays on acceptance.** Pays cartoonists $100. Illustrator payment negotiable, depending on size, medium, etc.; $800-1,000 for color cover; $75-150 for b&w inside; $200-700 for color inside.

RUNNER'S WORLD

135 N. 6th St., Emmaus PA 18098. (610)967-5171. Fax: (610)967-8883. E-mail: rwedit@runnersworld.com. Website: www.runnersworld.com. **Art Director:** Robert Festino. Director of Special Editorial Projects Ken Kleppert. Estab. 1965. Monthly 4-color with a "contemporary, clean" design emphasizing serious, recreational running. Circ. 530,511. Accepts previously published artwork "if appropriate." Returns original artwork after publication. Art guidelines not available.

Illustration Approached by hundreds of illustrators/year. Works with 50 illustrators/year. Buys average of 10 illustrations/issue. Has featured illustrations by Sam Hundley, Gil Eisner, Randall Enos and Katherine Adams. Features humorous and realistic illustration; charts & graphics; informational graphics; computer and spot illustration. Assigns 40% of illustrations to well-known or "name" illustrators; 40% to experienced but not well-known illustrators; 20% to new and emerging illustrators. Needs editorial, technical and medical illustrations. "Styles include tightly rendered human athletes, graphic and cerebral interpretations of running themes. Also, *RW* uses medical illustration for features on biomechanics." No special preference regarding media but appreciates electronic transmission. "No cartoons or originals larger than 11×14." Works on assignment only. 30% of freelance work demands knowledge of Illustrator, Photoshop or FreeHand.

First Contact & Terms Illustrators: Send postcard samples to be kept on file. Accepts submissions on disk compatible with Illustrator 5.0. Send EPS files. Publication will contact artist for portfolio review if interested. Buys one-time international rights. Pays $1,800 maximum for 2-page spreads; $400 maximum for spots. Finds artists through word of mouth, magazines, submissions/self-promotions, sourcebooks, artists' agents and reps and attending art exhibitions.

Tips Portfolio should include "a maximum of 12 images. Show a clean presentation, lots of ideas and few samples. Don't show disorganized thinking. Portfolio samples should be uniform in size. Be patient!"

RUNNING TIMES

15 River Rd., Wilton CT 06897. (203)761-1113. Fax: (203)761-9933. E-mail: editor@runningtimes.com. Website: www.runningtimes.com. **Art Director:** Troy Santi. Estab. 1977. Monthly consumer magazine covers sports, running. Circ. 80,098. Originals returned at job's completion. Sample copies available; art guidelines available.

Cartoons Used occasionally.

Illustration Buys 2-3 illustrations/issue. Works on assignment only. Has featured illustrations by Ben Fishman, Peter Hoex and Paul Cox. Features humorous, medical, computer and spot illustration. Considers pen & ink,

colored pencil, mixed media, collage, charcoal, acrylic, oil. 100% of freelance work demands knowledge of QuarkXPress, Photoshop, FreeHand and Illustrator.

Design Needs freelancers for design and production. 100% of design demands knowledge of Photoshop CS, QuarkXPress 6 and Illustrator CS.

First Contact & Terms Illustrators: Send postcard sample or query letter with tearsheets. Designers: Send query letter with résumé and tearsheets. Accepts disk submissions compatible with Photoshop, FreeHand or Illustrator. Samples are filed. Publication will contact artist for portfolio review of roughs, final art and tearsheets if interested. Buys one-time rights. Pays illustrators on publication; $400-600 for color inside; $250 maximum for b&w inside; $350 maximum for color inside; $500 maximum for 2-page spreads; $300 maximum for spots. Pays designers by the hour, $20. Finds artists through illustration annuals, mailed samples, published work in other magazines.

Tips "Look at previous issues to see that your style is appropriate. Send multiple samples and send samples regularly. I don't usually give an assignment based on one sample. Send out cards to as many publications as you can and make phone calls to set up appointments with the ones you are close enough to get to."

ℕ RURAL HERITAGE

281 Dean Ridge Lane, Gainesboro TN 38562-5039. (931)268-0655. Fax: (931)268-5884. E-mail: editor@ruralherit age.com. Website: www.ruralheritage.com. **Editor:** Gail Damerow. Estab. 1976. Bimonthly farm magazine "published in support of modern-day farming and logging with draft animals (horses, mules, oxen)." Circ. 8,000. Sample copy for $8 postpaid; art guidelines not available.

- Editor stresses the importance of submitting cartoons that deal only with farming and logging using draft animals.

Cartoons Approached by "not nearly enough" cartoonists who understand our subject. Buys 2 or more cartoons/issue. Prefers bold, clean, minimalistic draft animals and their relationship with the teamster. "No unrelated cartoons!" Prefers single panel, humorous, b&w line drawings with or without gagline.

First Contact & Terms Cartoonists: Send query letter with finished cartoons and SASE. Samples accepted by US mail only. Samples are not filed (unless we plan to use them—then we keep them on file until used) and are returned by SASE. Responds in 2 months. Buys first North American serial rights or all rights rarely. Pays on publication; $10 for one-time rights; $20 for all rights.

Tips "Know draft animals (horses, mules, oxen, etc.) well enough to recognize humorous situations intrinsic to their use or that arise in their relationship to the teamster. Our best contributors read *Rural Heritage* and get their ideas from the publication's content."

SACRAMENTO NEWS & REVIEW

1015 20th St., Sacramento CA 95814. (916)498-1234. Fax: (916)498-7920. E-mail: donb@newsreview.com. Website: www.newsreview.com. **Art Director:** Don Button. Estab. 1989. "An award-winning black & white with 4-color cover alternative newsweekly for the Sacramento area. We combine a commitment to investigative and interpretive journalism with coverage of our area's growing arts and entertainment scene." Circ. 90,000. Occasionally accepts previously published artwork. Originals returned at job's completion. Art guidelines not available.

- Also publishes issues in Chico, CA and Reno, NV.

Illustration Approached by 50 illustrators/year. Buys 1 illustration/issue. Works on assignment only. Features caricatures of celebrities and politicans; humorous, realistic, computer and spot illustrations. Assigns 50% of illustrations to new and emerging illustrators. For cover art, needs themes that reflect content.

First Contact & Terms Illustrators: Contact via e-mail with link to portfolio website or PDF samples. Send postcard sample or query letter with photocopies, photographs, SASE, slides and tearsheets. Samples are filed. Publication will contact artist for portfolio review if interested. Buys first rights. **Pays on acceptance.** $75-150 for b&w cover; $150-300 for color cover; $20-75 for b&w inside; $10-40 for spots. Finds artists through submissions.

Tips "Looking for colorful, progressive styles that jump off the page. Have a dramatic and unique style—not conventional or common."

SAILING MAGAZINE

P.O. Box 249, Port Washington WI 53074-0249. (262)284-3494. Fax (262)284-7764. E-mail: sailingmag@amerite ch.net. Website: www.sailingonline.com. **Editor:** Greta Schanen. Estab. 1966. Monthly 4-color literary magazine featuring sailing with a photography-oriented large format. Circ. 43,223.

Illustration Has featured illustrations by Marc Castelli. Features realistic illustrations, spot illustrations, map art and technical illustrations (sailboat plans). Preferred subjects nautical. Prefers pen & ink with color wash.

First Contact & Terms Illustrators: Send query letter with photocopies. Accepts Mac-compatible disk submissions. Send EPS, PDF or TIFF files. Samples are filed or returned by SASE. Responds within 2 months. Will

contact artist for portfolio review if interested. Rights purchased vary according to project. Pays on publication; $25-100 for b&w inside, $25-100 for color inside, $200-500 for 2-page spreads, $25 for spots. "Freelancers find us; we have no need to look for them."

Tips "Freelance art very rarely used."

SALES & MARKETING MANAGEMENT MAGAZINE

770 Broadway, New York NY 10003. (646)654-7608. Fax: (646)654-7616. E-mail: abass@salesandmarketing.c om. Website: www.salesandmarketing.com. **Contact:** Andrew Bass, art director. Monthly trade magazine providing a much needed community for sales and marketing executives to get information on how to do their jobs with colleagues and receive exclusive research and tools that will help advance their careers. Circ. 65,000.

Illustration Approached by 250-350 illustrators/year. Buys over 1,200 illustrations/year. Has featured illustrations by Douglas Fraser, Murray Kimber, Chris Sickels. Illustration style ranges from realistic to humorous but not cartoonish. Prefers business subjects. 65% of freelance illustration demands knowledge of Illustrator or Photoshop.

First Contact & Terms Illustrators: Send promotional sample or postcard. Accepts Mac-compatible JPEG or EPS files, or link to website. Samples are filed. Will contact artist for portfolio review if interested. Portfolio should include tearsheets. Buys first North American serial rights or one-time rights. Finds illustrators through agents, artists' submissions, *WorkBook*, *Art Pick*, *American Showcase* and word of mouth.

SAN FRANCISCO BAY GUARDIAN

135 Mississippi St., San Francisco CA 94103. (415)255-3100. Website: www.sfbg.com. **Art Director:** Victor Krummenacher. For "a young, liberal, well-educated audience." Circ. 157,000. Weekly newspaper; tabloid format, b&w with 4-color cover, "progressive design." Art guidelines not available.

Illustration Has featured illustrations by Mark Matcho, John Veland, Barbara Pollack, Gabrielle Drinard and Gus D'Angelo. Features caricatures of politicans; humorous, realistic and spot illustration. Assigns 30% of illustrations to new and emerging illustrators. Weekly assignments given to local artists. Subjects include political and feature subjects. Preferred styles include contemporary, painterly and graphic linepen and woodcut. "We like intense and we like fun." Artists who exemplify desired style include Tom Tommorow and George Rieman.

Design 100% of freelance work demands knowledge of Photoshop, Illustrator, QuarkXPress. Prefers diversified talent.

First Contact & Terms Designers: Send query letter with photocopies, photographs and tearsheets. Pays illustrators on publication; $300-315 for b&w and color cover; $34-100 for b&w inside; $75-150 for color inside; $100-250 for 2-page spreads; $34-100 for spots. Pays for design by the project.

Tips "Please submit samples and letter before calling. Turnaround time is generally short, so long-distance artists generally will not work out." Advises freelancers to "have awesome work—but be modest."

SANTA BARBARA MAGAZINE

25 E. De La Guerra St., Santa Barbara CA 93101-2217. (805)965-5999. Fax: (805)965-7627. E-mail: editor@sbmag .com. Website: www.sbmag.com. **Art Director:** Alisa Baur. Estab. 1975. Bimonthly 4-color magazine with classic design emphasizing Santa Barbara culture and community. Circ. 32,500. Original artwork returned after publication if requested. Sample copy for $3.50.

Illustration Approached by 20 illustrators/year. Works with 2-3 illustrators/year. Buys about 1-3 illustrations/ year. Uses freelance artwork mainly for departments. Works on assignment only.

First Contact & Terms Send postcard, tearsheets or photocopies. To show a portfolio, mail b&w and color art, final reproduction/product and tearsheets; will contact if interested. Buys first rights. **Pays on acceptance**; approximately $275 for color cover; $175 for color inside. "Payment varies."

Tips "Be familiar with our magazine."

THE SATURDAY EVENING POST

1100 Waterway Blvd., Indianapolis IN 46202. (317)634-1100. Fax: (317)637-0126. E-mail: Satevepst@aol.com. Website: www.satevepost.org. Cartoon Editor: Steven Pettinga. Mail cartoon submissions to Post Toons, Box 567, Indianapolis IN 46202. Buys about 30 cartoons/issue. Uses freelance artwork mainly for humorous fiction. Prefers single panel with gaglines. Receives 100 batches of cartoons/week. "We look for cartoons with neat line or tone art. The content should be in good taste, suitable for a general-interest, family magazine. It must not be offensive while remaining entertaining. Review our guidelines online and then review recent issues. Political, violent or sexist cartoons are not used. Need all topics, but particularly medical, health, travel and financial."

Illustration Art Director Chris Wilhoite. Uses average of 3 illustrations/issue. Send query letter with brochure showing art style or résumé and samples. To show a portfolio, mail final art. Buys all rights, "generally. All

ideas, sketchwork and illustrative art are handled through commissions only and thereby controlled by art direction. Do not send original material (drawings, paintings, etc.) or 'facsimiles of' that you wish returned." Cannot assume any responsibility for loss or damage.

First Contact & Terms Cartoonists: SASE. Illustrators: "If you wish to show your artistic capabilities, please send nonreturnable, expendable/sampler material (slides, tearsheets, photocopies, etc.)." Responds in 2 months. Pays on publication. Pays cartoonists $125 for b&w line drawings and washes, no pre-screened art. Pays illustrators $1,000 for color cover; $175 for b&w, $450 for color inside.

Tips "Send samples of work published in other publications. Do not send racy or too new-wave looks. Have a look at the magazine. It's clear that 50% of the new artists submitting material have not looked at the magazine."

THE SCHOOL ADMINISTRATOR

801 N. Quincy St., Suite 700, Arlington VA 22203-1730. (703)875-0753. Fax: (703)528-2146. E-mail: lgriffin@aasa.org. Website: www .aasa.org. **Managing Editor:** Liz Griffin. Monthly association magazine focusing on education. Circ. 22,000.

Cartoons Approached by 75 editorial cartoonists/year. Buys 11 cartoons/year. Prefers editorial/humorous, b&w/color washes or b&w line drawings. "Humor should be appropriate to a CEO of a school system, not a classroom teacher."

Illustration Approached by 60 illustrators/year. Buys 2-3 illustrations/issue. Has featured illustrations by Ralph Butler, Paul Zwolak, Heidi Younger and Claudia Newell. Features spot and computer illustrations. Preferred subjects education K-12. Assigns 50% of illustrations to experienced but not well-known illustrators; 50% to well-known or "name" illustrators. Considers all media. "Prefers illustrators who can take a concept and translate it into a simple powerful image and who can deliver art in digital form."

First Contact & Terms Cartoonists: Send photocopies and SASE. Buys one-time rights. **Pays on acceptance.** Send nonreturnable samples. Samples are filed and not returned. Responds only if interested. Rights purchased vary according to project. Pays on publication. Pays illustrators $ 800 for color cover. Finds illustrators through word of mouth, stock illustration source and Creative Sourcebook.

Tips "Read our magazine. I like work that takes a concept and translates it into a simple, powerful image. Check out our website."

SCIENTIFIC AMERICAN

415 Madison Ave., New York NY 10017-1111. (212)754-0550. Fax: (212)755-1976. Website: www.sciam.com. Contact: Jana Brenning, senior associate art director. Monthly 4-color consumer magazine emphasizing scientific information for educated readers, covering geology, astronomy, medicine, technology and innovations. Circ. 650,000.

Illustration Approached by 100 illustrators/year. Buys 5-6 illustrations/issue. Has featured illustrations by John McFaul, Dave Cutler, Jo Sloan, George Retseck, Matt Mahurin, Brian Cronin and Roz Chast. Features science related charts & graphs, natural history and spot illustrations and humorous spot illustration. Assigns 100% of illustrations to experienced but not well-known illustrators.

First Contact & Terms Illustrators: Send postcard sample and follow-up postcard every 3-4 months. Samples are filed. Responds only if interested. Will contact artist for portfolio review if interested. Buys one-time rights. **Pays on acceptance**; $750-1,000 for color inside; $350-750 for spots.

Tips "Illustrators should look at target markets more closely. Don't assume what a magazine wants, in terms of illustration, by its title. We're *Scientific American*, and we do use science illustration but we use a lot of other types of illustration as well, such as work by Roz Chast, which you might not think would fit with out publication. Many not-so-well-known publications have large budgets for illustration."

SEATTLE MAGAZINE

1505 Western Ave., Suite 500, Seattle WA 98101. Phone/fax: (206)284-1750. E-mail: sue.boylan@seattlemag.com. Website: www.seattlemag.com. **Art Director:** Sue Boylan. Estab. 1992. Monthly urban lifestyle magazine covering Seattle. Circ. 48,000. E-mail art director directly for art guidelines.

Illustration Approached by hundreds of illustrators/year. Buys 2 illustrations/issue. Considers all media. "We can scan any type of illustration."

First Contact & Terms Illustrators: Prefers e-mail submissions. Samples are filed. Responds only if interested. Art director will contact artist for portfolio review of color, final art and transparencies if interested. Buys one-time rights. Sends payment on 25th of month of publication. Pays on publication; $150-1,100 for color cover; $50-400 for b&w; $50-1,100 for color inside; $50-400 for spots. Finds illustrators through agents, sourcebooks such as *Creative Black Book, LA Workbook*, online services, magazines, word of mouth, artist's submissions, etc.

Tips "Good conceptual skills are the most important quality that I look for in an illustrator as well as unique skills."

SEATTLE WEEKLY

1008 Western Ave., Suite 300, Seattle WA 98104. (206)623-0500. Fax: (206)467-4338. E-mail: ksteichen@seattle weekly.com. Website: www.seattleweekly.com. **Contact:** Art Director. Estab. 1975. Weekly consumer magazine; tabloid format; news with emphasis on local and national issues and arts events. Circ. 102,000. Accepts previously published artwork. Original artwork can be returned at job's completion if requested, "but you can come and get them if you're local." Sample copies available for SASE with first-class postage. Art guidelines not available.

Illustration Approached by 30-50 freelance illustrators/year. Buys 3 freelance illustrations/issue. Works on assignment only. Prefers "sophisticated themes and styles."

First Contact & Terms Illustrators: Send query letter with tearsheets and photocopies. Samples are filed and are not returned. Does not reply, in which case the artists should "revise work and try again." To show a portfolio, mail b&w and color photocopies; "always leave us something to file." Buys first rights. Pays on publication; $200-250 for color cover; $60-75 for b&w inside.

Tips "Give us a sample we won't forget. A really beautiful mailer might even end up on our wall, and when we assign an illustration, you won't be forgotten. All artists used must sign contract. Feel free to e-mail for a copy."

SIERRA MAGAZINE

85 Second St., 2nd Floor, San Francisco CA 94105-3441. (415)977-5572. Fax: (415)977-5794. E-mail: sierra.letters @sierraclub.org. Website: www.sierraclub.org. **Art Director:** Martha Geering. Bimonthly consumer magazine featuring environmental and general interest articles. Circ. 500,000.

Illustration Buys 8 illustrations/issue. Considers all media. 10% of freelance illustration demands computer skills.

First Contact & Terms Illustrators: Send postcard samples or printed samples, SASE and tearsheets. Samples are filed and are not returned. Responds only if interested. Call for specific time for drop off. Art director will contact artist for portfolio review if interested. Buys one-time rights. Finds illustrators through illustration and design annuals, illustration websites, sourcebooks, submissions, magazines, word of mouth.

SIGNS OF THE TIMES

1350 N. King's Rd., Nampa ID 83687. (208)465-2592. E-mail: merste@pacificpress.com. Website: www.pacificp ress.com. **Art Director:** Merwin Stewart. A monthly Seventh-day Adventist 4-color publication that examines contemporary issues such as health, finances, diet, family issues, exercise, child development, spiritual growth and end-time events. "We attempt to show that Biblical principles are relevant to everyone." Circ. 200,000. Art guidelines available for SASE with first-class postage.

- They accept illustrations in electronic form provided to their ftp site by prior arrangement or sent as e-mail attachments.

Illustration Buys 6-10 illustrations/issue. Works on assignment only. Has featured illustrations by Ron Bell, Darren Thompson, Consuelo Udave and Lars Justinen. Features realistic illustration. Assigns 10% of illustrations to new and emerging illustrators. Prefers contemporary "realistic, stylistic, or humorous styles (but not cartoons)." Considers any media.

First Contact & Terms Send postcard sample, brochure, photographs, tearsheets or transparencies. Samples are not returned. "Tearsheets or color photos (prints) are best, although color slides are acceptable." Publication will contact artist for more samples of work if interested. Buys first-time North American publication rights. **Pays on acceptance** (30 days); $800 for color cover; $100-300 for b&w inside; $300-700 for color inside. Fees negotiable depending on needs and placement, size, etc. in magazine. Finds artists through submissions, sourcebooks and sometimes by referral from other art directors.

Tips "Most of the magazine illustrations feature people. Approximately 20 visual images (photography as well as artwork) are acquired for the production of each issue, half in black & white, half in color, and the customary working time frame is 3 weeks. Quality artwork and timely delivery are mandatory for continued assignments. It is customary for us to work with highly skilled and dependable illustrators for many years." Advice for artists "Invest in a good art school education, learn from working professionals within an internship, and draw from your surroundings at every opportunity. Get to know lots of people in the field where you want to market your work, and consistently provide samples of your work so they'll remember you. Then relax and enjoy the adventure of being creative."

SKILLSUSA CHAMPIONS

14001 James Monroe Hwy., Box 3000, Leesburg VA 20177. (703)777-8810. Fax: (703)777-8999. E-mail: tomhall @skillsusa. Website: www.skillsusa.org. **Editor:** Tom Hall. Estab. 1965. Four-color quarterly magazine. "*SkillsUSA Champions* is primarily a features magazine that provides motivational content by focusing on successful members. SkillsUSA is an organization of 279,000 students and teachers in technical, skilled and service careers.

Circ. 289,000. Accepts previously published artwork. Originals returned at job's completion (if requested). Sample copies available.

Illustration Approached by 4 illustrators/year. Works on assignment only. Prefers positive, youthful, innovative, action-oriented images. Considers pen & ink, watercolor, collage, airbrush and acrylic.

Design Needs freelancers for design. 100% freelance work demands knowledge of InDesign CS and FreeHand 5.0.

First Contact & Terms Illustrators: Send postcard sample. Designers: Send query letter with brochure. Accepts disks compatible with FreeHand 5.0, Illustrator 10, PageMaker 7.0 and InDesign CS. Send Illustrator, FreeHand and EPS files. Samples are filed. Portfolio should include printed samples, b&w and color tearsheets and photographs. Rights purchased vary according to project. **Pays on acceptance.** Pays illustrators $200-300 for color; $100-300 for spots. Pays designers by the project.

Tips "Send samples or a brochure. These will be kept on file until illustrations are needed. Don't call! Fast turnaround helpful. Due to the unique nature of our audience, most illustrations are not re-usable; we prefer to keep art."

SKIPPING STONES

P.O. Box 3939, Eugene OR 97403-0939. (541)342-4956. E-mail: editor@SkippingStones.org. Website: www.Skip pingStones.org. **Editor:** Arun Toke. Estab. 1988. Bimonthly b&w (with 4-color cover) consumer magazine. International nonprofit multicultural and nature education magazine for today's youth. Circ. 2,500. Art guidelines are free for SASE with first-class postage. Sample copy available for $5.

Cartoons Prefers multicultural, social issues, nature/ecology themes. Requests b&w washes and line drawings. Featured cartoons by Lindy Wojcicki of Florida. Prefers cartoons by youth under age 19.

Illustration Approached by 100 illustrators/year. Buys 10-20 illustrations/year. Has featured illustrations by Greg Acuna, India; Elizabeth Wilkinson, Vermont; Inna Svjatova, Russia; Jon Bush, Massachusetts. Features humorous illustration, informational graphics, natural history and realistic, authentic illustrations. Preferred subjects children and teens. Prefers pen & ink. Assigns 80% of work to new and emerging illustrators.

First Contact & Terms Cartoonists: Send b&w photocopies and SASE. Illustrators: Send nonreturnable photocopies and SASE. Samples are filed or returned by SASE. Responds in 3 months if interested. Portfolio review not required. Buys first rights, reprint rights. Pays on publication 1-5 copies, NO $$s. Finds illustrators through word of mouth, artists' promo samples.

Tips "We are a gentle, nonglossy, ad-free magazine not afraid to tackle hard issues. We are looking for work that challenges the mind, charms the spirit, warms the heart; handmade, nonviolent, global, for youth 8-15 with multicultural/nature content. Please, no aliens or unicorns. We are especially seeking work by young artists under 19 years of age! People of color and international artists are especially encouraged."

SLACK PUBLICATIONS

6900 Grove Rd., Thorofare NJ 08086-9447. (856)848-1000. Fax: (856)853-5991. E-mail: lbaker@slackinc.com. Website: www.slackinc.com. **Creative Director:** Linda Baker. Estab. 1960. Publishes 22 medical publications dealing with clinical and lifestyle issues for people in the medical professions. Accepts previously published artwork. Originals returned at job's completion. Art guidelines not available.

Illustration Approached by 50 illustrators/year. Buys 2 illustrations/issue. Works on assignment only. Features stylized and realistic illustration; charts & graphs; informational graphics; medical, computer and spot illustration. NO CARTOONS. Assigns 5% of illustrations to well-known or "name" illustrators; 90% to experienced but not well-known illustrators; 5% to new and emerging illustrators. Prefers digital submissions.

First Contact & Terms Send query letter with tearsheets, photographs, photocopies, slides and transparencies. Samples are filed and are returned by SASE if requested by artist. Responds to the artist only if interested. To show a portfolio, mail b&w and color tearsheets, slides, photostats, photocopies and photographs. Negotiates rights purchased. Pays on publication; $400-600 for color cover; $100-200 for b&w inside; $100-350 for color inside; $50-150 for spots.

Tips "Send samples."

SMALL BUSINESS TIMES

1123 N. Water St., Milwaukee WI 53202. (414)277-8181. Fax: (414)277-8191. Website: www.biztimes.com. **Art Director:** Shelly Paul. Estab. 1995. Biweekly newspaper/magazine business-to-business publication for southeast Wisconsin. Circ. 14,000.

Illustration Approached by 80 illustrators/year. Uses 3-5 illustrations/issue. Has featured illustrations by Jennifer Ingram, Marla Campbell, Dave Crosland, Brad Hamann, Fedrico Jordan, Michael Waraska. Features charts & graphs, computer, humorous illustration, informational graphics, realistic and b&w spot illustrations. Prefers business subjects in simpler styles that reproduce well on newsprint. Assigns 75% of work to new and emerging illustrators.

First Contact & Terms Illustrators: Send postcard sample and follow-up postcard every year. Accepts Mac-compatible disk submissions. Send EPS or TIFF files. Will contact artist for portfolio review if interested. Buys one-time rights. Pays illustrators $200-400 for color cover; $80-100 for inside. **Pays on acceptance**.

Tips "Conceptual work wanted! Audience is business men and women in southeast Wisconsin. Need ideas relative to today's business issues/concerns (insurance, law, banking, commercial, real estate, health care, manufacturing, finance, education, technology, retirement). One- to two-week turnaround."

N SMART MONEY

1755 Broadway, 2nd Floor, New York NY 10019. (212)830-9200. Fax: (212)830-9245. Website: www.smartmoney.com. **Art Director:** Gretchen Smelter. Estab. 1992. Monthly consumer magazine. Circ. 760,369. Originals returned at job's completion. Sample copies available.

Illustration Approached by 200-300 illustrators/year. Buys 10 illustrations/issue. Works on assignment only. Considers pen & ink, airbrush, colored pencil, mixed media, collage, charcoal, watercolor, acrylic, oil, pastel and digital.

First Contact & Terms Illustrators: Send postcard-size sample. Samples are filed. Publication will contact artist for portfolio review if interested. Portfolio should include tearsheets and photocopies. Buys first and one-time rights. Pays 30 days from invoice; $1,500 for color cover; $400-700 for spots. Finds artists through sourcebooks and submissions.

SMITHSONIAN MAGAZINE

750 Ninth St. NW, Suite 7100, Washington DC 20560-0001. (202)275-2000. Fax: (202)275-1986. Website: www.smithsonianmag.com. **Art Director:** Brian Noyes. Associate Art Director Erik K. Washam. Monthly consumer magazine exploring lifestyles, cultures, environment, travel and the arts. Circ. 2,088,000.

Illustration Approached by hundreds of illustrators/year. Buys 1-3 illustrations/issue. Has featured illustrations by Elizabeth Wolf. Features charts & graphs, informational graphics, humorous, natural history, realistic and spot illustration.

First Contact & Terms Samples are filed. Responds only if interested. Will contact artist for portfolio review if interested. Buys first rights. **Pays on acceptance**; $200-1,000 for color inside. Finds illustrators through agents and word of mouth.

SOAP OPERA DIGEST

261 Madison Ave., 10th Floor, New York NY 10016-2303. (212)716-2700. **Design Creative** Virginia Bassett. Estab. 1976. Emphasizes soap opera and prime-time drama synopses and news. Weekly. Circ. 2 million. Accepts previously published material. Returns original artwork after publication upon request. Sample copy available for SASE.

Tips "Review the magazine before submitting work."

N SOAP OPERA UPDATE MAGAZINE

270 Sylvan Ave., Englewood Cliffs NJ 07632. (201)569-6699, ext. 226. Fax: (201)569-2510. **Art Director:** Eric Savage. Estab. 1988. Biweekly consumer magazine geared toward fans of soap operas and the actors who work in soaps. It is "the only full-size, all color soap magazine in the industry." Circ. 700,000. Originals are not returned.

Illustration Approached by 100 illustrators/year. Works on assignment only. Prefers illustrations showing a likeness of an actor/actress in soap operas. Considers any and all media.

First Contact & Terms Illustrators: Send postcard sample. Samples are filed. Publication will contact artist for portfolio review if interested. Portfolio should include color tearsheets and final art. Buys all rights usually. Pays on publication; $50-200 maximum for color inside and/or spots. Finds artists through promo pieces.

Tips Needs caricatures of actors in storyline-related illustration. "Please send self-promotion cards along with a letter if you feel your work is consistent with what we publish."

SOAP OPERA WEEKLY

261 Madison Ave., New York NY 10016. (212)716-8400. **Art Director:** Susan Ryan. Estab. 1989. Weekly 4-color consumer magazine; tabloid format. Circ. 600,000-700,000. Original artwork returned at job's completion.

Illustration Approached by 50 freelance illustrators/year. Works on assignment only.

First Contact & Terms Illustrators: Send query letter with brochure and soap-related samples. Samples are filed. Request portfolio review in original query. Publication will contact artist for portfolio review if interested. Portfolio should include original/final art. Buys first rights. **Pays on acceptance**; $2,000 for color cover; $750 for color, full page.

N SOLDIERS MAGAZINE

9325 Gunston Rd., Suite S108, Ft. Belvoir VA 22060-5581. (703)806-4486. Fax: (703)806-4566. E-mail: soldiers@ belvoir.army.mil. Website: www.soldiers.com. **Editor-in-Chief:** Gil High. Art Director: Helen Hall Van Hoose. Monthly 4-color magazine that provides "timely and factual information on topics of interest to members of the Active Army, Army National Guard, Army Reserve and Department of Army civilian employees and Army family members." Circ. 155,000. Previously published material and simultaneous submissions OK. Samples available upon request.

Illustration Buys 5-10 illustrations/year. Considers all media.

First Contact & Terms Illustrators: Send query letter with photocopies of samples. Responds only if interested. Illustrations should have a military or general interest theme. No portfolio review necessary. Buys all rights. **Pays on acceptance.** Payment varies by project.

Tips "We are actively seeking new ideas and fresh humor, and are looking for new contributors. However, we require professional-quality material, professionally presented. We will not use anti-Army, sexist or racist material. We suggest you review recent back issues before submitting."

SOLIDARITY MAGAZINE

Published by United Auto Workers, 8000 E. Jefferson, Detroit MI 48214. (313)926-5291. Fax: (313)331-1520. E-mail: uawsolidarity@uaw.net. Website: www.uaw.org. **Editor:** Larry Gabriel. Four-color magazine for "1.3 million member trade union representing U.S., Canadian and Puerto Rican workers in auto, aerospace, agricultural-implement, public employment and other areas." Contemporary design.

Cartoons Carries "labor/political" cartoons. Payment varies.

Illustration Works with 10-12 illustrators/year for posters and magazine illustrations. Interested in graphic designs of publications, topical art for magazine covers with liberal-labor political slant. Looks for "ability to grasp our editorial slant."

First Contact & Terms Illustrators: Send postcard sample or tearsheets and SASE. Samples are filed. Pays $500-600 for color cover; $200-300 for b&w inside; $300-450 for color inside. Graphic Artists Guild members only.

N SOUTHERN ACCENTS MAGAZINE

2100 Lakeshore Dr., Birmingham AL 35209. (205)445-6000. Fax: (445)877-6990. Website: www.southernaccent s.com. **Art Director:** Ann M. Carothers. Estab. 1977. Bimonthly consumer magazine emphasizing fine Southern interiors and gardens. Circ. 400,000.

Ilustration Buys 25 illustrations/year. Considers color washes, colored pencil and watercolor.

First Contact & Terms Illustrators: Send postcard sample. Samples are returned. Responds only if interested. Art director will contact artist for portfolio of final art, photographs, slides and tearsheets if interested. Rights purchased vary according to project. Pays on publication; $100-800 for color inside. Finds artists through magazines, sourcebooks and submissions.

SPIDER

Carus Publishing Company, P.O. Box 300, Peru IL 61354. 815-224-5803. Website: www.cricketmag.com **Art Director:** Suzanne Beck. Monthly magazine. Estab. 1994. Circ. 70,000. *Spider* publishes high-quality literature for beginning readers, primarily ages 6-9.

Illustration Buys 20 illustrations/issue; 240 illustrations/year. Uses color artwork only. "Any medium—preferably one that can wrap on a laser scanner—no larger than 20×24. We use more realism than cartoon-style art." Works on assignment only. Reviews ms/illustration packages from artists. Illustrations only: Send promo sheet and tearsheets. Responds in 6 weeks. Samples returned with SASE; samples filed. Credit line given.

First Contact & Terms Send query letter with printed samples, photocopies, SASE and tearsheets. Send follow-up every 4 months. Samples are filed or are returned by SASE. Original artwork returned at job's completion. Responds in 6 weeks. Buys all rights. Pays 45 days after acceptance; $750 minimum for cover; $200-300 for color inside. Pays $50-150 for spots. Finds illustrators through artists who've published work in the children's field (books/magazines); artist's submissions.

Tips "Read our magazine; include samples showing children and animals; and put your name, address and phone number on every sample. It's helpful to include pieces that take the same character(s) through several actions/emotional states. It's also helpful to remember that most children's publishers need artists who can draw children from many different racial and ethnic backgrounds."

SPITBALL, the Literary Baseball Magazine

5560 Fox Rd., Cincinnati OH 45239. (513)385-2268. E-mail: spitball5@hotmail.com. Website: www.angelfire. com/oh5/spitball. **Editor:** Mike Shannon. Quarterly 2-color magazine emphasizing baseball exclusively, for "well-educated, literate baseball fans." Sometimes prints color material in b&w on cover. Returns original artwork after publication if the work is donated; does not return if purchases work. Sample copy for $6.

• *Spitball* has a regular column called "Brushes with Baseball" that features one artist and his work. Chooses artists for whom baseball is a major theme/subject. Prefers to buy at least one work from the artist to keep in its collection. *Spitball*'s editor, Mike Shannon, is organizing a national trading art show devoted to all-time baseball great Willie Mays. The show will celebrate Willie's 75th birthday, which occurs in May 2006. Artists interested in participating in the show should send Shannon a photo of baseball work of art completed by the artist and a SASE for more information. (This is not connected to *Spitball*.)

Cartoons Prefers single panel b&w line drawings with or without gagline. Prefers "old fashioned *Sport Magazine/New Yorker* type. Please, cartoonists . . . make them funny, or what's the point?"

Illustration "We need two types of art illustration (for a story, essay or poem) and filler. All work must be baseball-related; prefers pen & ink, airbrush, charcoal/pencil and collage. Interested artists should write to find out needs for specific illustration." Buys 3 or 4 illustrations/issue.

First Contact & Terms Cartoonists: Query with samples of style, roughs and finished cartoons. Illustrators: Send query letter with b&w illustrations or slides. Target samples to magazine's needs. Samples not filed are returned by SASE. Responds in 1 week. Negotiates rights purchased. **Pays on acceptance.** Pays cartoonists $10, minimum. Pays illustrators $20-40 b&w inside. Needs short story illustration.

Tips "Usually artists contact us and if we hit it off, we form a long-lasting mutual admiration society. Please, you cartoonists out there, drag your bats up to the *Spitball* plate! We like to use a variety of artists."

SPORTS 'N SPOKES

2111 E. Highland Ave., Suite 180, Phoenix AZ 85016-4702. (602)224-0500. Fax: (602)224-0507. E-mail: susan@pnnews.com. Website: www.sportsnspokes.com. **Art and Production Director:** Susan Robbins. Published 6 times a year. Consumer magazine with emphasis on sports and recreation for the wheelchair user. Circ. 15,000. Accepts previously published artwork. Sample copies for large SASE and $3.00 postage.

Cartoons Buys 3-5 cartoons/issue. Prefers humorous cartoons; single panel b&w line drawings with or without gagline. Must depict some aspect of wheelchair sport and/or recreation.

Illustration Works on assignment only. Considers pen & ink, watercolor and computer-generated art. 50% of freelance work demands knowledge of Illustrator, QuarkXPress or Photoshop.

First Contact & Terms Cartoonists: Send query letter with finished cartoons. Responds in 3 months. Buys all rights. **Pays on acceptance**; $10 for b&w. Illustrators: Send postcard sample or query letter with résumé and tearsheets. Accepts CD submissions compatible with Illustrator 10.0 or Photoshop 7.0. Send EPS, TIFF or JPEG files. Samples are filed or returned by SASE if requested by artist. Responds to the artist only if interested. Publication will contact artist for portfolio review if interested. Portfolio should include color tearsheets. Buys one-time rights and reprint rights. Pays on publication; $250 for color cover; $25 for b&w inside; $50 for color inside.

Tips "We have not purchased an illustration or used a freelance designer for many years. We regularly purchase cartoons with wheelchair sports/recreation theme."

SPORTS AFIELD

15621 Chemical Lane, Huntington Beach CA 92649. (714)373-4910. Fax: (714)894-4949. E-mail: art@sportsafield.com. Website: www.sportsafield.com. **Creative Director:** Peter Pawlyschyn. Estab. 1887. Monthly magazine. "*SA* is edited for outdoor enthusiasts with special interests in fishing and hunting. We are the oldest outdoor magazine and continue as the authority on all traditional sporting activities including camping, boating, hiking, fishing, mountain biking, rock climbing, canoeing, kayaking, rafting, shooting and wilderness travel." Circ. 459,396.

Illustration Buys 2-3 illustrations/issue. Prefers outdoor themes. Considers all media. Freelancers should be familiar with Photoshop, Illustrator, InDesign.

First Contact & Terms Illustrators: Send postcard sample or query letter with photocopies and tearsheets. Accepts disk submissions. Samples are filed. Responds only if interested. Will contact for portfolio of b&w or color photographs, slides, tearsheets and transparencies if interested. Buys first North American serial rights. Pays on publication; negotiable. Finds illustrators through *Black Book*, magazines, submissions.

N SPRING HILL REVIEW

P.O. Box 621, Brush Prairie WA 98606. (360)892-1178. E-mail: springhillreview@aol.com. **Contact:** Lucy S. R. Austen, editor. Estab. 2001. Monthly alternative newspaper/literary magazine of Northwest culture, a mixture of art, poetry, fiction, essays, book and movie reviews, and current regional issues. Circ. 6,100. Sample copies available for $2. Art guidelines free with SASE or by e-mail.

Cartoons Buys 10-12 cartoons/year. Prefers cartoons without sexist or ethnic humor. Prefers single panel, political, humorous, b&w washes, drawings.

Illustration "We buy artwork, preferably b&w drawings, paintings, photographs, prints, photos of sculpture/collage/etc. Often used as cover art and run with a note on the artist and the work (occasionally with a full

article on or interview with the artist). May be submitted in JPEG by e-mail, or hard copy with SASE.''

First Contact & Terms Cartoonists: Send postcard sample or samples with SASE. Artists: Send query letter with photographs, SASE, URL. Accepts e-mail submissions with link to website or image file. Prefers Windows-compatible, JPEG files. Samples are filed. Responds in 2 months (SASE required if hard copy). Request portfolio review in original query. Artist should follow up with letter or e-mail after initial query. Portfolio should include b&w, finished art, original art, photographs; no slides, please. Pays cartoonists $5. Pays artists $15 for b&w cover; $30 maximum for 2-page spreads. Pays within 2 weeks of publication. Buys first rights, reprint rights. Finds freelancers through artists' submissions, galleries, word of mouth.

Tips ''Artists: no cute small animal or cute angel pictures. We use a wide variety of media and styles, both representational and abstract. Cartoonists: No humor perpetrating sexist or racist stereotypes.''

STONE SOUP, The Magazine by Young Writers and Artists

P.O. Box 83, Santa Cruz CA 95063. (831)426-5557. E-mail: editor@stonesoup.co. Website: www.stonesoup.com. **Editor:** Gerry Mandel. Quarterly 4-color magazine with ''simple and conservative design'' emphasizing writing and art by children. Features adventure, ethnic, experimental, fantasy, humorous and science fiction articles. ''We only publish writing and art by children through age 13. We look for artwork that reveals that the artist is closely observing his or her world.'' Circ. 20,000. Sample copies available for $4. Art guidelines for SASE with first-class postage.

Illustration Buys 12 illustrations/issue. Prefers complete and detailed scenes from real life. All art must be by children ages 8-13.

First Contact & Terms Illustrators: Send query letter with photocopies. Samples are filed or are returned by SASE. Responds in 1 month. Buys all rights. Pays on publication; $75 for color cover; $25 for color inside; $25 for spots.

N STRANG COMMUNICATIONS COMPANY

600 Rinehart Rd., Lake Mary FL 32746. (407)333-0600. Fax: (407)333-7100. E-mail: bill.johnson@strang.com. Website: www.strang.com. **Contact:** Bill Johnson, marketing design director, or Joe Deleon, magazine design director. Estab. 1975. Publishes religious magazines and books for general readership. Illustrations used for text illustrations, promotional materials, book covers, children and gift books, dust jackets. Examples of recently published titles: *Charisma Magazine*; *New Man Magazine*; *Ministries Today Magazine*; Vida Cristiana (all editorial, cover). Illustration guidelines free with SASE.

Needs Works with 5-50 freelance illustrators annually. Needs illustrations of people, families, environmental portraits, situations. Model/property release preferred for all subjects.

First Contact & Terms Illustrators: Send nonreturnable promotional postcard, tearsheets, color copies or other appropriate promotional material. Accepts digital submissions. Send query letter with samples. Provide résumé, business card, brochure, flier or tearsheets to be kept on file for possible future assignments. Works with freelancers on assignment only. Keeps samples on file. Simultaneous submissions and previously published work OK. Pays $5-75 for b&w; $50-550 for color spots; $100-550 for color covers. Payment negotiable. Pays on publication. Credit line given. Buys one-time, first-time, book, electronic and all rights; negotiable.

STRATEGIC FINANCE

10 Paragon Dr., Montvale NJ 07645. (800)638-4427. Fax: (201)474-1603. E-mail: sfmag@imanet.org. Website: www.imanet.org and www.strategicfinancemag.com. **Editorial Director:** Kathy Williams. Art Director: Mary Zisk. Production Manager: Lisa Taylor. Estab. 1919. Monthly 4-color with a 3-column design emphasizing management accounting for management accountants, controllers, chief financial officers, chief accountants and treasurers. Circ. 65,000. Accepts simultaneous submissions. Originals are returned after publication.

Illustration Approached by 6 illustrators/year. Buys 10 illustrations/issue.

First Contact & Terms Illustrators: Send nonreturnable postcard samples. Prefers financial accounting themes.

N STRATTON MAGAZINE

P.O. Box 85, Dorset VT 05251. (802)362-7200. Fax (802)362-7222. Website: www.strattonmagazine.com. **Art Director:** Irene Cole. Estab. 1964. Quarterly 4-color free lifestyle magazine for the Southern Vermont resort area. Circ. 25,000.

Illustration Approached by 2-4 illustrators/year. Buys 0-6 illustrations/issue. Has featured illustrations by Matthew Perry, John D'Alliard. Features humorous illustration, natural history illustration and realistic illustrations. Preferred subjects nature. Assigns 85% to experienced, but not well-known illustrators; 15% to new and emerging illustrators. ''We will do traditional separations from reflective art but if supplied electronically, should be in Illustrator or Photoshop.''

First Contact & Terms Illustrators: Send postcard samples. Send nonreturnable samples. Accepts Mac-compatible disk submissions. Send EPS or TIFF files. Samples are filed. Responds only if interested. Will contact artist

for portfolio review if interested. Buys one-time rights. Rights purchased vary according to project. Pays on publication; $250-500 for color cover; $25-100 for b&w, $100-250 for color inside.

Tips "We have an outstanding nationally known staff photographer who provides most of our visuals, but we turn to illustration when the subject requires it and budget allows. I would like to have more artists available who are willing to accept our small payment in order to build their books! We are fairly traditional so please do not send way-out samples."

STUDENT LAWYER

321 N. Clark St., Chicago IL 60610. (312)988-6042. E-mail: kulcm@staff.abanet.org. **Art Director:** Mary Anne Kulchawik. Estab. 1972. Trade journal, 4-color, emphasizing legal education and social/legal issues. "*Student Lawyer* is a legal affairs magazine published by the Law Student Division of the American Bar Association. It is not a legal journal. It is a features magazine, competing for a share of law students' limited spare time—so the articles we publish must be informative, lively, good reads. We have no interest whatsoever in anything that resembles a footnoted, academic article. We are interested in professional and legal education issues, sociolegal phenomena, legal career features, and profiles of lawyers who are making an impact on the profession." Monthly (September-May). Circ. 35,000. Original artwork is returned to the artist after publication.

Illustration Approached by 20 illustrators/year. Buys 8 illustrations/issue. Has featured illustrations by Sean Kane and Jim Starr. Features realistic, computer and spot illustration. Assigns 50% of illustrations to experienced but not well-known illustrators; 50% to new and emerging illustrators. Needs editorial illustration with an 'innovative, intelligent style.' Works on assignment only. Needs computer-literate freelancers for illustration. No cartoons please.

First Contact & Terms Send postcard sample, brochure, tearsheets and printed sheet with a variety of art images (include name and phone number). Samples are filed. Call for appointment to show portfolio of final art and tearsheets. Buys one-time rights. **Pays on acceptance.** $500-800 for color cover; $450-650 for color inside; $150-350 for spots.

Tips "In your samples, show a variety of styles with an emphasis on editorial work."

[N] STUDENT LEADER MAGAZINE

P.O. Box 14081, Gainesville FL 32604-2081. (352)373-6907. Fax (352)373-8120. E-mail: jeff@studentleader.com. Website: www.studentleader.com. **Art Director:** Jeff Riemersma. Estab. 1993. National college leadership magazine published 3 times/year. Circ. 100,000. Sample copies for 8½×11 SASE and 4 first-class stamps. Art guidelines for #10 SASE with 1 first-class stamp.

 • Oxendine Publishing also publishes *Florida Leader Magazine* and *Florida Leader Magazine for High School Students*.

Illustration Approached by hundreds of illustrators/year. Buys 6 illustrations/issue. Has featured illustrations by Tim Foley, Jackie Pittman, Greta Buchart, Dan Miller. Assigns 33% of illustrations to well-known or "name" illustrators; 33% to experienced, but not well-known illustrators; 33% to new and emerging illustrators. Considers all media. 50% of freelance illustration demands computer skills.

First Contact & Terms Illustrators: Disk submissions must be PC-based, TIFF or EPS files. Samples are filed and are not returned. Responds only if interested. Rights purchased vary according to project. Pays on publication; $150 for color inside. Finds illustrators through sourcebook and artist's submissions.

Tips "We need responsible artists who complete projects on time and have a great imagination. Also must work within budget."

[✻] [✓] SUB-TERRAIN MAGAZINE

P.O. Box 3008, MPO, Vancouver BC V6B 3X5 Canada. (604)876-8710. Fax (604)879-2667. E-mail: subter@portal .c. Website: www.subterrain.ca. **Managing Editor:** Brian Kaufman. Estab. 1988. Quarterly b&w literary magazine featuring contemporary literature of all genres. Art guidelines for SASE with first-class postage.

Cartoons Prefers single panel cartoons.

Illustration Assigns 50% of illustrations to new and emerging illustrators.

First Contact & Terms Send query letter with photocopies. Samples are filed. Responds if interested. Portfolio review not required. Buys first rights, first North American serial rights, one-time rights or reprint rights. Pays $35-100 (Canadian), plus contributor copies.

Tips "Take the time to look at an issue of the magazine to get an idea of what work we use."

[N] SUN VALLEY MAGAZINE

12 E. Bullion St., Suite B, Hailey ID 83333-8409. (208)788-0770. Fax: (208)788-3881. E-mail: art@sunvalleymag. com. Website: www.sunvalleymag.com. **Art Director:** Mike Stevens. Estab. 1971. Consumer magazine published 3 times/year "highlighting the activities and lifestyles of people of the Wood River Valley." Circ. 17,000. Sample copies available. Art guidelines free for #10 SASE with first-class postage.

Illustration Approached by 10 illustrators/year. Buys 3 illustrations/issue. Prefers forward, cutting edge styles. Considers all media. 50% of freelance illustration demands knowledge of QuarkXPress.

First Contact & Terms Illustrators: Send query letter with SASE. Accepts disk submissions compatible with Macintosh, QuarkXPress 5.0. Send EPS files. Samples are filed. Does not report back. Artist should call. Art director will contact artist for portfolio review of b&w, color, final art, photostats, roughs, slides, tearsheets and thumbnails if interested. Buys first rights. **Pays on publication**; $350 cover; $80-240 inside.

Tips "Read our magazine. Send ideas for illustrations and examples."

ⓝ SWEET 16

(formerly Guideposts for Teens), 1050 Broadway, Chesterton IN 46304. (219) 929-4429. Fax: (219)926-3839. Website: www.guidepostssweet16mag.com. **Art Director:** Megan McPhail. Bimonthly magazine for teens 13-17 focusing on true teen stories, value centered. Estab. 1998. Circ. 200,000.

Illustration Approached by 100 illustrators per year. Buys 10 illustrations per issue. Considers all media but prefers electronic. Has featured illustrations by Cliff Nielsen, Jaques Barby, Donna Nelson, Sally Comport. Assigns 40% of illustrations to well-known or "name" illustrators; 70% to experienced, but not well-known illustrators; 50% to new and emerging illustrators.

First Contact & Terms Illustrators: Send postcard or tearsheets; "no large bundles, please. Disks welcome. Websites will be visited." Samples are filed or returned by SASE if requested by artist. Responds only if interested. Art director will contact if more information is desired. Buys mostly first and reprint rights. Pays on invoice, net 30 days. Pays $700-900 single page; $1,200-1,800 per spread; $150-400 per color spot. Finds illustrators through submissions, reps and Internet.

Tips This art director loves "on the edge, funky, stylized nonadult, alternative styles. Traditional styles are sometimes used." Freelance graphic designers are used in 2 stories/issue.

TALCOTT PUBLISHING

20 W. Kinzie, 12th Floor, Chicago IL 60610. (312)849-2220. Fax: (312)849-2174. E-mail: tgregorski@talcott.com. Website: www.talcott.com. **Art Director:** Traci Gregorski. Monthly trade magazines. Sample copies available.

- Talcott Publishing houses the following trade magazines *Giftware News*, *Giftware News Baby*, *Chef Magazine*, *Chef Educator Today*, *Fancy Food & Culinary Products*, *Equipment Solutions*, and *Home Fashions & Furniture Trends*.

Design Needs freelancers for design, production, multimedia projects and Internet. Prefers Adobe suite, QuarkXPress and Macromedia Suite.

First Contact & Terms Designers: Send query letter with printed samples.

TAMPA BAY MAGAZINE

2531 Landmark Dr., Clearwater FL 33761. (727)791-4800. **Editor:** Aaron Fodiman. Estab. 1986. Bimonthly local lifestyle magazine with upscale readership. Circ. 40,000. Accepts previously published artwork. Sample copy available for $4.50. Art guidelines not available.

Cartoons Approached by 30 cartoonists/year. Buys 6 cartoons/issue. Prefers single-panel color washes with gagline.

Illustration Approached by 100 illustrators/year. Buys 5 illustrations/issue. Prefers happy, stylish themes. Considers watercolor, collage, airbrush, acrylic, marker, colored pencil, oil and mixed media.

First Contact & Terms Cartoonists: Send query letter with finished cartoon samples. Illustrators: Send query letter with photographs and transparencies. Samples are not filed and are returned by SASE if requested. To show a portfolio, mail color tearsheets, slides, photocopies, finished samples and photographs. Buys one-time rights. Pays on publication. Pays cartoonists $15 for b&w, $20 for color. Pays illustrators $150 for color cover; $75 for color inside.

ⓝ TECHNICAL ANALYSIS OF STOCKS & COMMODITIES

4757 California Ave. SW, Seattle WA 98116-4499. (206)938-0570. Fax: (206)938-1307. E-mail: cmorrison@traders.com. Website: www.Traders.com. **Art Director:** Christine Morrison. Estab. 1982. Monthly traders' magazine for stocks, bonds, futures, commodities, options, mutual funds. Circ. 66,000. Accepts previously published artwork. Sample copies available for $5. Art guidelines on website.

- This magazine has received several awards including the Step by Step Design Annual, American Illustration IX, XXIII, Society of American Illustration, New York. They also publish *Working Money*, a general interest financial magazine (has similar cartoon and illustration needs).

Cartoons Approached by 10 cartoonists/year. Buys 1-4 cartoons/issue. Prefers humorous cartoons, single panel b&w line drawings with gagline.

Illustration Approached by 100 illustrators/year. Buys 6 illustrations/issue. Works on assignment only. Features humorous, realistic, computer (occasionally) and spot illustrations.

First Contact & Terms Cartoonists: Send query letter with finished (nonreturnable xeroxes only) cartoons. Illustrators: Send brochure, tearsheets, photographs, photocopies, photostats, slides. Accepts disk submissions compatible with any Adobe products on TIFF or EPS files. Samples are filed and are not returned. Publication will contact artist for portfolio review if interested. Portfolio should include b&w and color tearsheets, slides, photostats, photocopies, final art and photographs. Buys one-time rights and reprint rights. Pays on publication. Pays cartoonists $35 for b&w. Pays illustrators $135-350 for color cover; $165-213 for color inside; $105-133 for b&w inside.

Tips "Looking for creative, imaginative and conceptual types of illustration that relate to the article's concepts. Also caricatures with market charts and computers. Send a few copies of black & white and color work with cover letter. If I'm interested I will call."

N TECHNIQUES

1410 King St., Alexandria VA 22314-2749. (703)683-3111. Fax: (703)683-7424. E-mail: mjones@acteonline.org or jwelch@acteonline.org. Website: www.acteonline.org. **Art Director:** Mitchell Jones. Estab. 1924. Monthly 4-color technical and career education magazine. Circ. 45,000. Accepts previously published artwork. Originals returned at job's completion. Sample copies with 9×11 SASE and first-class postage. Art guidelines not available.

Illustration Approached by 50 illustrators/year. Buys 8 illustrations/year. Works on assignment only. Has featured illustrations by John Berry, Valerie Spain, Eric Westbrook, Becky Heavner and Bryan Leister. Features informational graphics; computer and spot illustrations. Assigns 60% of illustrations to well-known or "name" illustrators; 20% to experienced, but not well-known illustrators; 20% to new and emerging illustrators. Considers pen & ink, watercolor, colored pencil, oil and pastel. Needs computer-literate freelancers for illustration.

First Contact & Terms Illustrators: Send query letter with samples. Samples are filed. Portfolio review not required. Rights purchased vary according to project. Sometimes requests work on spec before assigning job. Pays on publication; $600-1,000 for color cover; $275-500 for color inside.

N TENNIS

79 Madison Ave., 8th Floor, New York NY 10016. (212)636-2700. Fax: (212)636-2730. Website: www.tennis.com. **Art Director:** Gary Stewart. For affluent tennis players. Monthly. Circ. 800,000.

Illustration Works with 15-20 illustrators/year. Buys 50 illustrations/year. Uses artists mainly for spots and openers. Works on assignment only.

First Contact & Terms Illustrators: Send postcard sample or query letter with tearsheets. Mail printed samples of work. **Pays on acceptance:** $400-800 for color.

TEXAS MONTHLY

P.O. Box 1569, Austin TX 78767-1569. (512)320-6900. Fax (512)476-9007. Website: www.texasmonthly.com. **Art Director:** Scott Dadich. Estab. 1973. Monthly general interest magazine about Texas. Circ. 350,000. Accepts previously published artwork. Originals are returned to artist at job's completion.

Illustrations Approached by hundreds of illustrators/year. Works on assignment only. Considers all media.

First Contact & Terms Illustrators: Send postcard sample of work or send query letter with tearsheets, photographs, photocopies. Samples are filed "if I like them" or returned by SASE if requested by artist. Publication will contact artist for portfolio review if interested. Portfolio should include tearsheets, photographs, photocopies. Buys one-time rights. Pays on publication; $1,000 for color cover; $800-2,000 for color inside; $150-400 for spots.

N ⊞ THE TEXAS OBSERVER

307 W. Seventh, Austin TX 78701. (512)477-0746. Fax: (512)474-1175. E-mail: editors@texasobserver.org. **Contact:** Matt Omohundro, Art Director. Estab. 1954. Biweekly magazine emphasizing Texas political, social and literary topics. Circ. 10,000. Accepts previously published material. Returns original artwork after publication. Sample copy for SASE with postage for 2 ounces; art guidelines for SASE with first-class postage.

● This magazine likes to feature Texas illustrators exclusively.

Cartoons "Our style varies; content is political/satirical or feature illustrations." Also uses caricatures.

Illustration Buys 4 illustrations/issue. Has featured illustrations by Matt Weurker and Sam Hurt. Assigns 10% of work to new and emerging illustrators. Needs editorial illustration with political content. "We only print b&w, so pen & ink is best; washes are fine."

First Contact & Terms Illustrators: Send photostats, tearsheets, photocopies, slides or photographs to be kept on file. Samples not filed are returned by SASE. Responds in 1 month. Request portfolio review in original query. Buys one-time rights. Pays on publication; $200 for cover; $50 for inside.

Tips "No color. We use mainly local artists usually to illustrate features. We also require a fast turnaround. Humor scores points with us."

N TEXAS PARKS & WILDLIFE

3000 S. IH 35, Suite 120, Austin TX 78704-6536. (512)912-7000. Fax: (512)707-1913. E-mail: magazine@tpwd.st ate.tx.us. Website: www.tpwmagazine.com. **Art Director:** Mark Mahorsky. Estab. 1942. Monthly magazine "containing information on state parks, wildlife conservation, hunting and fishing, environmental awareness." Circ. 180,000. Sample copies for #10 SASE with first-class postage.

Illustration 100% of freelance illustration demands knowledge of QuarkXPress.

First Contact & Terms Illustrators: Send postcard sample. Samples are not filed and are not returned. Responds only if interested. Buys one-time rights. Pays on publication; negotiable. Finds illustrators through magazines, word of mouth, artist's submissions.

Tips "Read our magazine."

N THEDAMU ARTS MAGAZINE

30 Josephine, 3rd Floor, Detroit MI 48202-1810. (313)871-3333. E-mail: davidrambeau@hotmail.com. Website: www.projectbait.blakgold.net. **Publisher:** David Rambeau. Estab. 1970. Quarterly b&w "general adult multi-disciplinary afro-centric urban arts magazine." Circ. 1,000. Accepts previously published graphic artwork "for our covers and our website." Send copies only. Sample copies and art guidelines available via e-mail.

Cartoons Approached by 5-10 cartoonists/year. "We do special cartoon issues featuring a single artist like a comic book (40-80, 8×11 horizontal drawings) with adult, urban, contemporary themes with a storyline that can be used or transferred to video and would fill seven tab pages and a cover." Prefers b&w graphics or color and b&w line drawings.

Design Needs freelancers for design, production and multimedia projects.

First Contact & Terms "Prefers correspondence be made by e-mail." Cartoonists: Send query letter with 3-6 story cartoons. Illustrators: Send résumé, photocopies, SASE; "whatever the illustrator is happy with." Prefers e-mail submissions. Payment negotiable; usually copies. Designers: Send query letter with photocopies and SASE. Pays by the project; negotiable. Responds in 2 weeks only if interested. Buys one-time rights usually, but rights purchased sometimes vary according to project. Payment for cartoons is negotiable. Finds artists through word of mouth and other magazines.

Tips "We're the first or second step on the publishing ladder for artists and writers. Submit same work to others also. Be ready to negotiate. I see even more computer-based magazines ahead. More small (500-1,000 copies) magazines given computer advances, linkages with video, particularly with respect to cartoons. Be ready to accept copies to distribute. Do cover graphics and story cartoons. Be computer literate. Be persistent. Be self-critical. Be ready to fit the format."

N THRASHER

1303 Underwood Ave., San Francisco CA 94124-3308. (415)822-3083. Fax: (415)822-8359. Website: www.thras hermagazine.com. **Managing Editor:** Ryan Henry. Estab. 1981. Monthly 4-color magazine. "*Thrasher* is the dominant publication devoted to the latest in extreme youth lifestyle, focusing on skateboarding, snowboarding, new music, videogames, etc." Circ. 200,000. Accepts previously published artwork. Originals returned at job's completion. Sample copies for SASE with first-class postage. Art guidelines not available. Needs computer-literate freelancers for illustration. Freelancers should be familiar with Illustrator or Photoshop.

Cartoons Approached by 100 cartoonists/year. Buys 2-5 cartoons/issue. Has featured illustrations by Mark Gonzales. Prefers skateboard, snowboard, music, youth-oriented themes. Assigns 100% of illustrations to new and emerging illustrators.

Illustrations Approached by 100 illustrators/year. Buys 2-3 illustrations/issue. Prefers themes surrounding skateboarding/skateboarders, snowboard/music (rap, hip hop, metal) and characters and commentary of an extreme nature. Prefers pen & ink, collage, airbrush, marker, charcoal, mixed media and computer media (Mac format).

First Contact & Terms Cartoonists: Send query letter with brochure and roughs. Illustrators: Send query letter with brochure, résumé, SASE, tearsheets, photographs and photocopies. Samples are filed. Publication will contact artist for portfolio review if interested. Portfolio should include b&w and color tearsheets, photocopies and photographs. Rights purchased vary according to project. Negotiates payment for covers. Sometimes requests work on spec before assigning job. Pays on publication. Pays cartoonists $50 for b&w, $75 for color. Pays illustrators $75 for b&w, $100 for color inside.

Tips "Send finished quality examples of relevant work with a bio/intro/résumé that we can keep on file and update contact info. Artists sometimes make the mistake of submitting examples of work inappropriate to the content of the magazine. Buy/borrow/steal an issue and do a little research. Read it. Desktop publishing is now sophisticated enough to replace all high-end prepress systems. Buy a Mac. Use it. Live it."

N TIKKUN MAGAZINE

2342 Shattuck Ave., #1200, Berkeley CA 94704. (510)644-1200. Fax: (510)644-1255. E-mail: magazine@tikkun.o rg. Website: www.tikkun.org. **Managing Editor:** Liz Winer. Estab. 1986. "A bimonthly Jewish critique of

politics, culture and society. Includes articles regarding Jewish and non-Jewish issues, left-of-center politically.'' Circ. 70,000. Accepts previously published material. Original artwork returned after publication. Sample copies for $6 plus $2 postage.

Illustration Approached by 50-100 illustrators/year. Buys 10-12 illustrations/issue. Has featured illustrations by Julie Delton, David Ball, Jim Flynn. Features symbolic and realistic illustration. Assigns 90% of illustrations to experienced, but not well-known illustrators; 10% to new and emerging illustrators. Prefers line drawings.

First Contact & Terms Illustrators: Send brochure, résumé, tearsheets, photostats, photocopies. Slides and photographs for color artwork only. Buys one-time rights. Do not send originals; unsolicited artwork will not be returned. ''Often we hold onto line drawings for last-minute use.'' Pays on publication; $150 for color cover; $50 for b&w inside.

Tips No ''sculpture, heavy religious content. Read the magazine—send us a sample illustration of an article we've printed, showing how you would have illustrated it.''

TIME

Attn: Art Dept., 1271 Avenue of the Americas, Rockefeller Center, New York NY 10020-1393. (212)522-4769. Fax: (212)522-0637. Website: www.time.com. **Art Director:** Arthur Hochstein. Deputy Art Directors Cynthia Hoffman and D.W. Pine. Estab. 1923. Weekly magazine covering breaking news, national and world affairs, business news, societal and lifestyle issues, culture and entertainment. Circ. 5,000,000.

Illustration Considers all media. Send postcard sample, printed samples, photocopies or other appropriate samples.

First Contact & Terms Illustrators: Accepts disk submissions. Samples are filed. Responds only if interested. Portfolios may be dropped off every Wednesday between 11 and 1. They are kept for one week and may be picked up the following Wednesday, between 11 and 1. Buys first North American serial rights. Payment is negotiable. Finds artists through sourcebooks and illustration annuals.

ℕ THE TOASTMASTER

23182 Arroyo Vista, Rancho Santa Margarita CA 92688-2699. (949)858-8255. Fax: (949)858-1207. Website: www.toastmasters.org. **Art Director:** Susan Campbell. Estab. 1924. Monthly trade journal for association members. ''Language, public speaking, communication are our topics.'' Circ. 200,000. Accepts previously published artwork. Originals returned at job's completion. Sample copies available.

Illustration Buys 6 illustrations/issue. Works on assignment only. Prefers communications themes. Considers watercolor and collage.

First Contact & Terms Illustrators: Send postcard sample. Accepts disk submissions. Samples are filed or returned by SASE if requested by artist. Responds to the artist only if interested. Portfolio should include tearsheets and photocopies. Negotiates rights purchased. **Pays on acceptance**; $500 for color cover; $50-200 for b&w, $100-250 for color inside.

TODAY'S CHRISTIAN

(formerly Christian Reader), 465 Gundersen Dr., Carol Stream IL 60188. (630)260-6200. Fax: (630)480-2004. Website: www.todays-christian.com. **Contact:** Phil Marcelo, senior designer. Estab. 1963. Bimonthly general interest magazine. ''People of Faith. Stories of Hope.'' Circ. 145,000. Accepts previously published artwork. Originals returned at job's completion.

Illustration Works on assignment only. Has featured illustrations by Mary Chambers, Alain Massicotte, Rex Bohn, Ron Mazellan and Donna Kae Nelson. Features humorous, realistic and spot illustration. Prefers family, home and church life. Considers all media. Digital delivery preferred.

First Contact & Terms Illustrators: Samples are filed. Responds only if interested. To show a portfolio, mail appropriate materials. Buys one-time rights.

Tips ''Send samples of your best work, in your best subject and best medium. We're interested in fresh and new approaches to traditional subjects and values.''

TODAY'S CHRISTIAN WOMAN

465 Gundersen Dr., Carol Stream IL 60188. (630)260-6200. Fax: (630)260-0114. **Design Director:** Douglas A. Johnson. Estab. 1978. Bimonthly consumer magazine ''for Christian women, covering all aspects of family, faith, church, marriage, friendship, career and physical, mental and emotional development from a Christian perspective.'' Circ. 250,000.

• This magazine is published by Christianity Today, Intl. which also publishes 11 other magazines.

Illustration Buys 6 illustrations/issue. Considers all media.

First Contact & Terms Illustrators: Send postcard sample or query letter with printed samples, photocopies, SASE and tearsheets. Samples are filed. Responds only if interested. Buys first rights. Pays $200-1,000 for color inside.

ℕ TRAINING MAGAZINE: Helping People and Business Succeed

50 S. Ninth St., Minneapolis MN 55402-3118. (612)333-0471. Fax: (612)333-6526. Website: www.trainingmag.c om. **Art Director:** Michele Schmidt. Estab. 1964. Monthly 4-color trade journal covering job-related training and education in business and industry, both theory and practice. Audience training directors, personnel managers, sales and data processing managers, general managers, etc. Circ. 51,000. Sample copies for SASE with first-class postage.

Illustration Buys a few illustrations/year. Works on assignment only. Prefers themes that relate directly to business and training. Styles are varied. Considers pen & ink, airbrush, mixed media, watercolor, acrylic, oil, pastel and collage.

First Contact & Terms Illustrators: Send postcard sample, tearsheets or photocopies. Accepts disk submissions. Samples are filed. Responds to the artist only if interested. Buys first rights or one-time rights. **Pays on acceptance.** Pays illustrators $1,500-2,000 for color cover; $800-1,200 for color inside; $100 for spots.

Tips ''Show a wide variety of work in different media and with different subject matter. Good renditions of people are extremely important.''

TRAINS

P.O. Box 1612, 21027 Crossroads Circle, Waukesha WI 53187. (262)796-8776. Fax (262)796-1778. E-mail: tdanneman@kalmbach.com. Website: www.trains.com. **Art Director:** Thomas G. Danneman. Estab. 1940. Monthly magazine about trains, train companies, tourist RR, latest railroad news. Circ. 133,000. Art guidelines available.

- Published by Kalmbach Publishing. Also publishes *Classic Toy Trains*, *Astronomy*, *Finescale Modeler*, *Model Railroader*, *Model Retailer*, *Classic Trains*, *Bead and Button*, *Birder's World*.

Illustration 100% of freelance illustration demands knowledge of Photoshop CS 5.0, Illustrator CS 8.0.

First Contact & Terms Illustrators: Send query letter with printed samples, photocopies and tearsheets. Accepts disk submissions (opticals) or CDs, using programs above. Samples are filed. Art director will contact artist for portfolio review of color tearsheets if interested. Buys one-time rights. Pays on publication.

Tips ''Quick turnaround and accurately built files are a must.''

TRAVEL NATURALLY

P.O. Box 317, Newfoundland NJ 07435. (973)697-3552. Fax (973)697-8313. E-mail: naturally@internaturally.c om. Website: www.internaturally.com. **Publisher/Editor:** Bernard Loibl. Director of Operations Brian J. Ballone. Estab. 1981. Quarterly magazine covering family nudism/naturism and nudist resorts and travel. Circ. 35,000. Sample copies for $7.50 and $4.25 postage; art guidelines for #10 SASE with first-class postage.

Cartoons Approached by 10 cartoonists/year. Buys approximately 3 cartoons/issue. Prefers nudism/naturism.

Illustration Approached by 10 illustrators/year. Buys approximately 3 illustrations/issue. Prefers nudism/naturism. Considers all media.

First Contact & Terms Cartoonists: Send query letter with finished cartoons. Illustrators: Contact directly. Accepts all digital formats or hard copies. Samples are filed. Responds only if interested. Buys one-time rights. Pays on publication. Pays cartoonists $15-70. Pays illustrators $200 for cover; $70/page inside. Fractional pages or fillers are prorated.

ℕ TREASURY & RISK MANAGEMENT MAGAZINE

475 Park Ave . S, Suite 3300, New York NY 10016. (212)557-7480. Fax: (212)557-7653. E-mail: hdevine@treasur yandrisk.com. Website: www.treasuryandrisk.com. **Contact:** Heather Devine, creative director. Monthly trade publication for financial/CFO-treasurers. Circ. 50,000. Sample copies available on request.

Illustration Buys 45-55 illustrations/year. Features business computer illustration, humorous illustration and spot illustrations. Prefers electronic media. Assigns 25% of illustrations to new and emerging illustrators. Freelance artists should be familiar with Illustrator and Photoshop.

First Contact & Terms Illustrators: Send postcard sample. After introductory mailing, send follow-up postcard sample every 3 months. Accepts e-mail submissions with link to website and image file. Prefers Mac-compatible, JPEG files for samples. Responds only if interested. Company will contact artist for portfolio review if interested. Portfolio should include color and tearsheets. Pays illustrators $1,000-1,200 for color cover; $400 for spot; $500 for ½ page color inside; $650 for full page; $800 for spread. Buys first rights, one-time rights, reprint rights and all rights. Finds freelancers through agents, artists' submissions, magazines and word of mouth.

ℕ TRIQUARTERLY

629 Noyes St., Evanston IL 60208-4302. (847)491-7614. Fax: (847)467-2096. Website: www.triquarterly.org. **Editor:** Susan Firestone Hahn. Estab. 1964. *TriQuarterly* literary magazine is ''dedicated to publishing writing and graphics which are fresh, adventurous, artistically challenging and never predictable.'' Circ. 5,000. Originals returned at job's completion.

Illustration Approached by 10-20 illustrators/year. Considers only work that can be reproduced in b&w as line art or screen for pages; all media; 4-color for cover.

First Contact & Terms Illustrators: Send query letter with SASE, tearsheets, photographs or photocopies. Samples are filed or are returned in 3 months (if SASE is supplied). Publication will contact artist if interested. Buys first rights. Pays on publication; $300 for b&w/color cover; $20 for b&w inside.

TRUE WEST MAGAZINE

P.O. Box 8008, Cave Creek AZ 85327. (480)575-1881. Fax (480)575-1903. E-mail: editor@truewestmagazine.com. Website: www.truewestmagazine.com. **Executive Editor:** Bob Boze Bell. Monthly color magazine emphasizing American Western history from 1800 to 1920. For a primarily rural and suburban audience, middle-age and older, interested in Old West history, horses, cowboys, art, clothing and all things Western. Circ. 90,000. Original artwork returned after publication. Sample copy for $5 plus $2.50 postage; art guidelines on website.
 • Cartoons must have a Western theme.

Cartoons Approached by 10-20 cartoonists/year. Buys 2-3 cartoon/issue. Prefers western history theme. Prefers humorous cartoons, single or multiple panel.

Illustration Occasionally buys illustrations. Has featured illustrations by Gary Zaboly, Bob Bose Bell, Sparky Moore and Jack Jackson. Assigns 80% of illustrations to well-known or ''name'' illustrators; 10% to experienced, but not well-known illustrators; 10% to new and emerging illustrators. ''Inside illustrations are usually, but not always, pen & ink line drawings; covers are Western paintings.'' 10% of freelance illustration demands knowledge of Photoshop, Illustrator and QuarkXPress.

First Contact & Terms Cartoonists/Illustrators: Send query letter with photocopies to be kept on file; ''We return anything on request. For inside illustrations, we want samples of artist's line drawings. For covers, we need to see full-color transparencies.'' Responds in 2 weeks if interested. Publication will contact artist for portfolio review if interested. Buys first rights, one-time rights. Pays cartoonists $25-75 for b&w cartoons. Pays illustrators $500-1,000 for color cover; $50-150 for b&w inside; $50-250 for spots.

TURTLE MAGAZINE, For Preschool Kids

Children's Better Health Institute, 1100 Waterway Blvd., Indianapolis IN 46202-0567. (317)636-8881. Fax: (317)684-8094. Website: www.turtlemag.org. **Art Director:** Bart Rivers. Estab. 1979. Emphasizes health, nutrition, exercise and safety for children 2-5 years. Published 6 times/year; 4-color. Circ. 300,000. Original artwork not returned after publication. Sample copy for $1.75; art guidelines for SASE with first-class postage. Needs computer-literate freelancers familiar with Macromedia FreeHand and Photoshop for illustrations.

Illustration Approached by 100 illustrators/year. Works with 20 illustrators/year. Buys 15-30 illustrations/ issue. Interested in ''stylized, humorous, realistic and cartooned themes; also nature and health.'' Works on assignment only.

First Contact & Terms Illustrators: Send query letter with good photocopies and tearsheets. Accepts disk submissions. Samples are filed or are returned by SASE. Responds only if interested. Portfolio review not required. Buys all rights. Pays on publication: $275 for color cover, $35-90 for b&w inside, $70-155 for color inside, $35-70 for spots. Finds most artists through samples received in mail.

Tips ''Familiarize yourself with our magazine and other children's publications before you submit any samples. The samples you send should demonstrate your ability to support a story with illustration.''

TV GUIDE

1211 Sixth Ave., New York NY 10036. (212)852-7500. Fax: (212)852-7470. Website: www.tvguide.com. **Art Director:** Theresa Griggs. Associate Art Director Catherine Suhocki. Estab. 1953. Weekly consumer magazine for television viewers. Circ. 11,000,000. Has featured illustrations by Mike Tofanelli and Toni Persiani.

Illustration Approached by 200 illustrators/year. Buys 50 illustrations/year. Considers all media.

First Contact & Terms Illustrators: Send postcard sample. Samples are filed. Art director will contact artist for portfolio review of color tearsheets if interested. Negotiates rights purchased. **Pays on acceptance**; $1,500-4,000 for color cover; $1,000-2,000 for full page color inside; $200-500 for spots. Finds artists through sourcebooks, magazines, word of mouth, submissions.

U. THE NATIONAL COLLEGE MAGAZINE

12707 High Bluff Dr., Suite 2000, San Diego CA 92130-2035. (858)847-3350. Fax: (858)847-3340. E-mail: tony@colleges.com. Website: www.colleges.com/umagazine.com. **Creative Art Director:** Tony Carrieri. Estab. 1986. Quarterly consumer magazine of news, lifestyle and entertainment geared to college students. Magazine is for college students by college students. Circ. 1 million. Sample copies and art guidelines available for SASE with first-class postage or on website. Do not submit unless you are a college student.

Cartoons Approached by 25 cartoonists/year. Buys 2 cartoons/issue. Prefers college-related themes. Prefers humorous color washes, single or multiple panel with gagline.

Illustration Approached by 100 illustrators/year. Buys 10-20 illustrations/issue. Features caricatures of celebrities; humorous illustration; informational graphics; computer and spot illustration. Assigns 100% of illustrations to new and emerging illustrators. Prefers bright, light, college-related, humorous, color only, no b&w. Considers collage, color washed, colored pencil, marker, mixed media, pastel, pen & ink or watercolor. 20% of freelance illustration demands knowledge of Photoshop, Illustrator and QuarkXPress.

First Contact & Terms Cartoonists: Send query letter with photocopies and tearsheets. Samples are filed and are not returned. Responds only if interested. Pays on publication. Pays cartoonists $25 for color. Pays illustrators $100 for color cover; $25 for color inside; $25 for spots. Finds illustrators through college campus newspapers and magazines.

Tips "We need light, bright, colorful art. We accept art from college students only."

N U.S. LACROSSE MAGAZINE

113 W. University Pkwy., Baltimore MD 21210-3300. (410)235-6882. Fax: (410)366-6735. E-mail: cmenanteau@ uslacrosse.org. Website: www.lacrosse.org. **Art Director:** Claudia Menanteau. Estab. 1978. *"Lacrosse Magazine* includes opinions, news, features, student pages, 'how-to's' for fans, players, coaches, etc. of all ages." Published 8 times/year. Circ. 80,000. Accepts previously published work. Sample copies available.

Cartoons Prefers ideas and issues related to lacrosse. Prefers single panel, b&w washes or b&w line drawings.

Illustration Approached by 12 freelance illustrators/year. Buys 3-4 illustrations/year. Works on assignment only. Prefers ideas and issues related to lacrosse. Considers pen & ink, collage, marker and charcoal. Freelancers should be familiar with Illustrator, FreeHand or QuarkXPress.

First Contact & Terms Cartoonists: Send query letter with finished cartoon samples. Illustrators: Send postcard sample or query letter with tearsheets or photocopies. Accepts disk submissions compatible with Mac. Samples are filed. Call for appointment to show portfolio of final art, b&w and color photocopies. Rights purchased vary according to project. Pays on publication. Pays cartoonists $40 for b&w. Pays illustrators $100 for b&w cover, $150 for color cover; $75 for b&w inside, $100 for color inside.

Tips "Learn/know as much as possible about the sport."

UNIQUE OPPORTUNITIES, The Physician's Resource

214 South 8th Street., Suite 502, Louisville KY 40202-2738. (502)589-8250. Fax: (502)587-0848. E-mail: barb@uo works.com. Website: www.uoworks.com. **Publisher and Design Director:** Barbara Barry. Estab. 1991. Bimonthly trade journal. "Our audience is physicians who are looking for jobs. Editorial focus is on practice-related issues." Circ. 80,000. Originals returned at job's completion. Freelancers should be familiar with Illustrator, Photoshop and FreeHand.

Illustration Approached by 10 illustrators/year. Buys 1-2 illustrations/issue. Works on assignment only. Considers pen & ink, mixed media, collage, pastel and computer illustration. Prefers computer illustration.

First Contact & Terms Illustrators: Publication will contact artist for portfolio of final art, tearsheets, EPS files on a floppy disk if interested. Buys first or one-time rights. Pays 30 days after acceptance; $700 for color cover; $250 for spots. Finds artists through Internet only. Do not send samples in the mail.

N UROLOGY TIMES

7500 Old Oak Blvd., Cleveland OH 44130. (440)891-3108. Fax: (440)891-2735. E-mail: pseltzer@advanstar.com. Website: www.urologytimes.com. **Art Director:** Peter Seltzer. Estab. 1972. Monthly trade publication. The leading news source for urgologists. Circ. 10,000. Art guidelines available.

Illustration Buys 6 illustrations/year. Has featured illustrations by DNA Illustrations, Inc. Assigns 25% of illustrations to new and emerging illustrators. 90% of freelance work demands computer skills. Freelancers should be familiar with Illustrator, Photoshop. E-mail submissions accepted with link to website. Prefers TIFF, JPEG, GIF, EPS. Samples are filed. Art director will contact artist for portfolio review if interested. Portfolio should include finished art and tearsheets. Pays on publication. Buys one-time rights. Finds freelancers through artists' submissions.

First Contact & Terms Illustrators: Send postcard sample with photocopies.

UTNE

1624 Harmon Place, Suite 330, Minneapolis MN 55403. (612)338-5040. Fax: (612)338-6043. Website: www.utne .com. **Contact:** Art Director. Estab. 1984. Bimonthly digest featuring articles and reviews from the best of alternative media; independently published magazines, newsletters, books, journals and websites. Topics covered include national and international news, history, art, music, literature, science, education, economics and psychology. Circ. 250,000.

- *Utne* seeks to present a lively diversity of illustration and photography "voices." We welcome artistic samples which exhibit a talent for interpreting editorial content.

Illustration Buys 10-15 illustrations per issue. Buys 60-day North American rights. Finds artists through submissions, annuals and sourcebooks.

First Contact & Terms Illustrators: Send single-sided postcards, color or b&w photocopies, printed agency/rep samples or small posters. We are unlikely to give an assignment based on only one sample, and we strongly prefer that you send several samples in one package rather than single pieces in separate mailings. Clearly mark your full name, address, phone number, fax number, and e-mail address on everything you send. Do not send electronic disks, e-mails with attachments or references to websites. Do not send original artwork of any kind. Samples cannot be returned.

N ⯑ VALLUM

P.O. Box 48003, Montreal QB H2V 4S8 Canada. E-mail: vallummag@sympatico.ca. Website: www.vallummag.com. **Contact:** Joshua Auerbach or Eleni Auerbach, editors. Estab. 2001. Literary/fine arts magazine published twice yearly. Publishes exciting interplay of poets and artists. Circ. 3,200. Sample copies available for CDN$8.25/US$7. Art guidelines free with SASE or on website.

Illustration Buys 5 illustrations/year. Has featured illustrations by Danielle Borisoff, Allen Martian-Vandever, Barbara Legowski, Charles Weiss. Prefers art that is interesting visually, contemporary and fresh. Uses color for cover, inside of magazine uses b&w or color.

First Contact & Terms Illustrators: Send postcard sample or query letter with brochure, photographs, résumé, samples. After introductory mailing, send follow-up postcard every 6 months. Samples are not filed but are returned by SASE. Responds in 9-12 months. Payment varies. Pays on publication. Buys first North American rights.

VANITY FAIR

4 Times Square, 22nd Floor, New York NY 10036. (212)286-8180. Fax: (212)286-6707. E-mail: vfmail@vf.com. Website: www.vanityfair.com. **Deputy Art Director:** Julie Weiss. Design Director David Harris. Estab. 1983. Monthly consumer magazine. Circ. 1.1 million. Does not use previously published artwork. Original artwork returned at job's completion. 100% of freelance design work demands knowledge of QuarkXPress and Photoshop.

Illustration Approached by "hundreds" of illustrators/year. Buys 3-4 illustrations/issue. Works on assignment only. "Mostly uses artists under contract."

N VARBUSINESS

600 Community Dr., Manhasset NY 11030. (516)562-5000. E-mail: varbizart@cmp.com. Website: www.varbusiness.com. **Senior Art Director:** Scott Gormely. Estab. 1985. Emphasizes computer business, for and about value added resellers. Biweekly 4-color magazine with an "innovative, contemporary, progressive, very creative" design. Circ. 107,000. Original artwork is returned to the artist after publication. Art guidelines not available.

Illustration Approached by more than 100 illustrators/year. Works with 30-50 illustrators/year. Buys 150 illustrations/year. Needs editorial illustrations. Open to all styles. Uses artists mainly for covers, full and single page spreads and spots. Works on assignment only. Prefers "digitally compiled, technically conceptual oriented art (all sorts of media)."

Design Also needs freelancers for design. 100% of design demands knowledge of Photoshop 4.0 and QuarkXPress 3.31.

First Contact & Terms Illustrators: Send postcard sample or query letter with tearsheets. Accepts e-mail submissions. Samples are filed. Responds only if interested. Call or write for appointment to show portfolio, which should include tearsheets, final reproduction/product and slides. Buys one-time rights. Pays on publication. Pays $1,000-1,500 for b&w cover; $1,500-2,500 for color cover; $500-850 for b&w inside; $750-1,000 for color inside; pays $300-600 for spots.

Tips "Show printed pieces or suitable color reproductions. Concepts should be imaginative, not literal. Sense of humor sometimes important."

VEGETARIAN JOURNAL

P.O. Box 1463, Baltimore MD 21203-1463. (410)366-8343. E-mail: vrg@vrg.org. Website: www.vrg.org. **Editor:** Debra Wasserman. Estab. 1982. Quarterly nonprofit vegetarian magazine that examines the health, ecological and ethical aspects of vegetarianism. "Highly educated audience including health professionals." Circ. 27,000. Accepts previously published artwork. Originals returned at job's completion upon request. Sample copies available for $3.

Cartoons Approached by 4 cartoonists/year. Buys 1 cartoon/issue. Prefers humorous cartoons with an obvious vegetarian theme; single panel b&w line drawings.

Illustration Approached by 20 illustrators/year. Buys 6 illustrations/issue. Works on assignment only. Prefers strict vegetarian food scenes (no animal products). Considers pen & ink, watercolor, collage, charcoal and mixed media.

First Contact & Terms Cartoonists: Send query letter with roughs. Illustrators: Send query letter with photostats. Samples are not filed and are returned by SASE if requested by artist. Responds in 2 weeks. Portfolio review not required. Rights purchased vary according to project. **Pays on acceptance.** Pays cartoonists $25 for b&w. Pays illustrators $25-50 for b&w/color inside. Finds artists through word of mouth and job listings in art schools.
Tips Areas most open to freelancers are recipe section and feature articles. "Review magazine first to learn our style. Send query letter with photocopy sample of line drawings of food."

VERMONT MAGAZINE
P.O. Box 800, Middlebury VT 05753-0800. (802)388-8480. Fax (802)388-8485. E-mail: vtmag@sover.net. Website: www.vermontmagazine.com. **Publisher:** Kate Fox. Estab. 1989. Bimonthly regional publication "aiming to explore what life in Vermont is like its politics, social issues and scenic beauty." Circ. 50,000. Accepts previously published artwork. Original artwork returned at job's completion. Sample copies and art guidelines for SASE with first-class postage.
Illustration Approached by 100-150 illustrators/year. Buys 2-3 illustrations/issue. Works on assignment only. Has featured illustrations by Chris Murphy. Features humorous, realistic, computer and spot illustration. Assigns 50% of illustrations to experienced but not well-known illustrators; 50% to new and emerging illustrators. "Particularly interested in creativity and uniqueness of approach." Considers pen & ink, watercolor, colored pencil, oil, charcoal, mixed media and pastel.
First Contact & Terms Illustrators: Send query letter with tearsheets, "something I can keep." Materials of interest are filed. Publication will contact artist for portfolio review if interested. Portfolio should include final art and tearsheets. Buys one-time rights. Considers buying second rights (reprint rights) to previously published work. Pays $400 maximum for color cover; $75-150 for b&w inside; $75-350 for color inside; $300-500 for 2-page spreads; $50-75 for spots. Finds artists mostly through submissions/self-promos and from other art directors.

VIBE
215 Lexington Ave., 6th Floor, New York NY 10016. (212)448-7300. Fax: (212)448-7377. E-mail: fbachleda@vibe.com. Website: www.vibe.com. **Design Director:** Florian Bachleda. Estab. 1993. Monthly consumer magazine focused on music, urban culture. Circ. 800,000. Accepts previously published artwork. Originals returned at job's completion. Sample copies available.
Illustration Works on assignment only.
First Contact & Terms Cartoonists: Send postcard-size sample or query letter with brochure and finished cartoons. Responds to the artist only if interested. Illustrators: Send postcard-size sample or query letter with photocopies. Samples are filed. Publication will contact artist for portfolio review of roughs, final art and photocopies if interested. Buys one-time or all rights.

N VIDEOMAKER MAGAZINE
Box 4591, Chico CA 95927. (530)891-8410. Fax: (530)891-8443. E-mail: bholland@videomaker.com. Website: www.videomaker.com. **Art Director:** Brent Holland. Monthly 4-color magazine for camcorder users with "contemporary, stylish yet technical design." Circ. 90,000. Accepts previously published artwork. 75% of freelance work demands knowledge of QuarkXPress, Illustrator, FreeHand and Photoshop.
Cartoons Prefers technical illustrations.
Illustration Approached by 30 illustrators/year. Buys 3 illustrations/issue. Assigns 80% of illustrations to experienced, but not well-known illustrators; 20% to new and emerging illustrators. Works on assignment only. Considers pen & ink, airbrush, colored pencil, mixed media, watercolor, acrylic, oil, pastel, collage, marker and charcoal. Needs editorial and technical illustration.
First Contact & Terms Illustrators: Send postcard sample and/or query letter with photocopies, brochure, SASE and tearsheets. Designers: Send query letter with brochure, photocopies, SASE, tearsheets. Samples are filed. Publication will contact artist for portfolio review. Portfolio should include thumbnails, tearsheets and photographs. Negotiates rights purchased. Sometimes requests work on spec before assigning job. Pays on publication. Pays cartoonists $30-200 for b&w, $200-800 for color. Pays illustrators $30-800 for b&w inside; $50-1,000 for color inside; $30-50 for spots. Pays designers by the project, $30-1,000. Finds artists through submissions/self-promotions.
Design Needs freelancers for design. Freelance work demands knowledge of QuarkXPress, Photoshop and FreeHand.
Tips "Read a previous article from the magazine and show how it could have been illustrated. The idea is to take highly technical and esoteric material and translate that into something the layman can understand. Since our magazine is mostly designed on desktop, we are increasingly more inclined to use computer illustrations along with conventional art. We constantly need people who can interpret our information accurately for the

satisfaction of our readership. Want artists with quick turnaround (21 days maximum). Magazine was redesigned in October 2000 with a digital emphasis.''

Ⓝ VIM & VIGOR

1010 E. Missouri Ave., Phoenix AZ 85014. (602)395-5850. Fax: (602)395-5853. **Senior Art Director:** Susan Knight. Creative Director Randi Karabin. Estab. 1985. Quarterly consumer magazine focusing on health. Circ. 1.2 million Originals returned at job's completion. Sample copies available. Art guidelines available.
 • The company publishes many other titles as well.

Illustration Approached by 100 illustrators/year. Buys 10 illustrations/issue. Works on assignment only. Considers mixed media, collage, charcoal, acrylic, oil, pastel and computer.

First Contact & Terms Illustrators: Send postcard sample with tearsheets and online portfolio/website information. Accepts disk submissions. Samples are filed. Rights purchased vary according to project. **Pays on acceptance.** Finds artists through agents, Web sourcebooks, word of mouth and submissions.

VOGUE PATTERNS

11 Penn Plaza, New York NY 10001. (212)465-6800. Fax: (212)465-6814. E-mail: mailbox@voguepatterns.com. Website: www.voguepatterns.com. **Associate Art Director:** Christine Lipert. Manufacturer of clothing patterns with the Vogue label. Circ. 99,162. Uses freelance artists mainly for fashion illustration for the *Vogue Patterns* catalog and editorial illustration for *Vogue Patterns* magazine. ''The nature of catalog illustration is specialized; every button, every piece of top-stitching has to be accurately represented. Editorial illustration assigned for our magazine should have a looser-editorial style. We are open to all media.''

Illustration Approached by 50 freelancers. Works with 10-20 illustrators and 1-5 graphic designers/year. Assigns 18 editorial illustration jobs and 100-150 fashion illustration jobs/year. Looking for ''sophisticated modern fashion and intelligent creative and fresh editorial.''

First Contact & Terms Illustrators: Send query letter with résumé, tearsheets, slides or photographs. Samples not filed are returned by SASE. Call or write for appointment to drop-off portfolio. Pays for design by the hour, $15-25; for illustration by the project, $150-300.

Tips ''Drop off comprehensive portfolio with a current business card and sample. Make sure name is on outside of portfolio. When a job becomes available, we will call illustrator to view portfolio again.''

Ⓝ WASHINGTON CITY PAPER

2390 Champlain St. N.W., Washington DC 20009. (202)332-2100. Fax: (202)332-8500. E-mail: mail@washcp.com. Website: www.washingtoncitypaper.com. **Art Director:** Pete Morelewicz. Estab. 1980. Weekly tabloid ''distributed free in DC and vicinity. We focus on investigative reportage, arts, and general interest stories with a local slant.'' Circ. 95,000. Art guidelines not available.

Cartoons Only accepts weekly features, no spots or op-ed style work.

Illustration Approached by 100-200 illustrators/year. Buys 2-8 illustrations/issue. Has featured illustrations by Michael Kupperman, Peter Hoey, Greg Houston, Joe Rocco, Susie Ghahremani, and Robert Meganck. Features caricatures of politicians; humorous illustration; informational graphics; computer and spot illustration. Considers all media, if the results do well in b&w.

First Contact & Terms Illustrators: Send query letter with printed or e-mailed samples, photocopies or tearsheets. Art director will contact artist for more if interested. Buys first-rights. Pays on publication which is usually pretty quick. Pays cartoonists $25 minimum for b&w. Pays illustrators $110 minimum for b&w cover; $220 minimum for color cover; $85 minimum for inside. Finds illustrators mostly through submissions.

Tips '' We are a good place for freelance illustrators, we use a wide variety of styles, and we're willing to work with beginning illustrators. We like illustrators who are good on concept and can work fast if needed. We avoid cliché DC imagery such as the capitol and monuments.''

Ⓝ WASHINGTON FAMILIES MAGAZINE

485 Spring Park Pl., Suite 550, Herndon VA 20170. (703)318-1385. Fax: (703)318-5509. E-mail: production@familiesmagazines.com. Website: www.familiesmagazines.com. **Contact:** Kirsten Schneider. Estab. 1991. Monthly. Consumer magazine. Parenting magazine.Circ. 100,000. Art guidelines available by e-mail.

Illustration Approached by 100 illustrators/year. Features computer illustration. Preferred subjects: children, families, women. Prefers bright colors with process colors of no more than 2 color mixes. Freelancers should be familiar with PageMaker, Illustrator, Photoshop. E-mail submissions not accepted. Prefers JPEG, hi-res. Samples are filed. Portfolio not required. Pays illustrators 100 for color cover. Pays on publication. Buys one-time rights. Finds freelancers through artists' submissions.

First Contact & Terms Illustrators: Send postcard sample, brochure, samples.

WASHINGTONIAN MAGAZINE

1828 L St., NW, Suite 200, Washington DC 20036. (202)296-3600. E-mail: ecrowson@washingtonian.com. Website: www.washingtonian.com. **Contact:** Eileen Crowson, associate design director. Estab. 1965. Monthly 4-color consumer lifestyle and service magazine. Circ. 185,000. Sample copies free for #10 SASE with first-class postage.

Illustration Approached by 200 illustrators/year. Buys 7-10 illustrations/issue. Has featured illustrations by Pat Oliphant, Chris Tayne and Richard Thompson. Features caricatures of celebrities, caricatures of politicians, humorous illustration, realistic illustrations, spot illustrations, computer illustrations and photo collage. Preferred subjects men, women and creative humorous illustration. Assigns 20% of illustrations to new and emerging illustrators. 20% of freelance illustration demands knowledge of Photoshop.

First Contact & Terms Illustrators: Send postcard sample and follow-up postcard every 6 months. Send nonreturnable samples. Send query letter with tearsheets. Accepts Mac-compatible submissions. Send EPS or TIFF files. Responds only if interested. Will contact artist for portfolio review if interested. Buys first rights. **Pays on acceptance**; $900-1,200 for color cover; $200-800 for b&w, $400-900 for color inside; $900-1,200 for 2-page spreads; $400 for spots. Finds illustrators through magazines, word of mouth, promotional samples, sourcebooks.

Tips "We like caricatures that are fun, not mean and ugly. Want a well-developed sense of color, not just primaries."

WATERCOLOR MAGIC

4700 E. Galbraith Rd., Cincinnati OH 45236. (513)531-2690. Fax: (513)531-2902. E-mail: wcmedit@aol.com. **Art Director:** Cindy Rider. Editor: Kelly Kane. Estab. 1995. Bi-monthly 4-color consumer magazine to "help artists explore and master watermedia." Circ. 92,000. Art guidelines free for #10 SASE with first-class postage.

First Contact & Terms Illustration: Pays on publication. Finds illustrators through word of mouth, visiting art exhibitions, unsolicited queries, reading books.

Tips "We are looking for watermedia artists who are willing to teach special aspects of their work and their techniques to our readers."

WEEKLY ALIBI

2118 Central Ave. SE, PMB 151, Albuquerque NM 87106-4004. (505)346-0660. Fax: (505)256-9651. E-mail: ads@alibi.com. Website: www.Alibi.com. **Art Director:** Tom Nayder. Estab. 1992. Small, 4-color, alternative weekly newspaper/tabloid focusing on local news, music and the arts. Circ. 50,000. Sample copies free for 10×13 SAE and 4 first-class stamps. Art guidelines for #10 SAE with first-class postage.

Cartoons Approached by 30 cartoonists/year. Buys 10 cartoons/issue. Prefers strange, humorous and clean styles. Prefers single panel, double panel, multiple panel, political, humorous, b&w line drawings.

Illustration Approached by 50 illustrators/year. Buys 3-7 illustrations/issue. Has featured illustrations by Lloyd Dangle, Tony Millionair, Brian Biggs and Sean Tejaratchi. Features caricatures of politicians; humorous, realistic, spot illustration; charts & graphs; and informational graphics. Prefers "anything that looks good on newsprint." Assigns 20% of work to new and emerging illustrators.

First Contact & Terms Cartoonists: Send query letter with b&w photocopies. Illustrators: Accepts Mac-compatible disk submissions. Send TIFF files. Samples are filed. Responds only if interested. Will contact artist for portfolio review if interested. Rights purchased vary according to project. Pays on publication. Pays cartoonists $5-20 for b&w; $10-20 for comic strips. Pays illustrators $150-200 for b&w cover; $150-200 for color cover; $10-20 for b&w inside; $15-25 for color inside; $25 for spots. Finds illustrators through artists' submissions/artists' websites.

Tips "Send finished art. We get a ton of unfinished pencil drawings that usually get thrown out!"

WEEKLY READER

Weekly Reader Corp., 200 First Stamford Place, Stamford CT 06912. (203)705-3500. Website: www.weeklyreader.com. **Contact:** Amy Gery. Estab. 1928. Educational periodicals, posters and books. *Weekly Reader* teaches the news to kids pre-K through high school. The philosophy is to connect students to the world. Publications are 4-color. Accepts previously published artwork. Original artwork is returned at job's completion. Sample copies are available.

Illustration Needs editorial and technical illustration. Style should be "contemporary and age-level appropriate for the juvenile audience." Buys more than 50/week. Works on assignment only. Uses computer and reflective art.

First Contact & Terms Illustrators: Send brochure, tearsheets, SASE and photocopies. Samples are filed or are returned by SASE if requested by artist. Payment is usually made within 3 weeks of receiving the invoice. Finds artists through artists' submissions/self-promotions, sourcebooks, agents and reps. Some periodicals need quick turnarounds.

Tips "Our primary focus is the children's and young adult marketplace. Art should reflect creativity and knowledge of audience's needs. Our budgets are tight, and we have very little flexibility in our rates. We need artists who can work with our budgets. Avoid using fluorescent dyes. Use clear, bright colors. Work on flexible board."

[N] WESTERN DAIRY BUSINESS

(formerly The Dairyman), 6437 Collamer Rd., ESyracuse NY 13057. (315)703-7979. Fax: (315)703-7988. E-mail: mdbise@aol.com. Website: www.dairybusiness.com. **Art Director:** Maria Bise. Estab. 1922. Monthly trade journal with audience comprised of "Western-based milk producers, herd size 100 and larger, all breeds of cows, covering the 13 Western states." Circ. 23,000. Accepts previously published artwork. Samples copies and art guidelines available.

Illustration Approached by 5 illustrators/year. Buys 1-4 illustrations/issue. Works on assignment only. Preferred themes "depend on editorial need." Considers 3-D and computer illustration.

First Contact & Terms Send query letter with brochure, tearsheets and résumé. Samples are filed or are returned by SASE if requested by artist. Responds in 2 weeks. Write for appointment to show portfolio of thumbnails, tearsheets and photographs. Buys all rights. Pays on publication; $100 for b&w, $200 for color cover; $50 for b&w, $100 for color inside.

Tips "We have a small staff. Be patient if we don't get back immediately. A follow-up letter helps. Being familiar with dairies doesn't hurt. Quick turnaround will put you on the 'A' list."

[✓] WESTWAYS

3333 Fairview Rd., A327, Costa Mesa CA 92808. (714)885-2396. Fax: (714)885-2335. E-mail: vaneyke.eric@aaa-calif.com. **Art Director:** Eric Van Eyke. Estab. 1918. A bimonthly lifestyle and travel magazine. Circ. 3,000,000. Original artwork returned at job's completion. Sample copies and art guidelines available for SASE.

Illustration Approached by 20 illustrators/year. Buys 2-6 illustrations/issue. Works on assignment only. Preferred style is arty-tasteful, colorful. Considers pen & ink, watercolor, collage, airbrush, acrylic, colored pencil, oil, mixed media and pastel.

First Contact & Terms Illustrators: Send query letter with brochure, tearsheets and samples. Samples are filed. Responds in 2 weeks only if interested. To show a portfolio, mail appropriate materials. Portfolio should include thumbnails, final art, b&w and color tearsheets. Buys first rights. Pays on publication; $250 minimum for color inside.

[N] WISCONSIN REVIEW

800 Algoma Blvd., Oshkosh WI 54901. (920)424-2267. E-mail: wireview@yahoo.com. **Contact:** Art Editor. Triquarterly review emphasizing literature (poetry, short fiction, reviews). Black & white with 4-color cover. Circ. 2,000. Accepts previously published artwork. Original artwork returned after publication "if requested." Sample copy for $4; art guidelines available; for SASE with first-class postage.

Illustration Uses 5-10 illustrations/issue. Has featured illustrations by Kurt Zivlonghi and Simone Bonde. Assigns 75% of illustrations to new and emerging illustrators. "Cover submissions can be color, size $5^{1/2} \times 8^{1/2}$ or smaller or slides. Submissions for inside must be b&w, size $5^{1/2} \times 8^{1/2}$ or smaller unless artist allows reduction of a larger size submission.

First Contact & Terms Illustrators: Send postcard sample, SASE and slides with updated address and phone number to be kept on file for possible future assignments. Send query letter with roughs, finished art or samples of style. Samples returned by SASE. Responds in 5 months. Pays in 2 contributor's copies.

[N] WOODENBOAT MAGAZINE

Box 78, Brooklin ME 04616-0078. (207)359-4651. Fax: (207)359-8920. E-mail: olga@woodenboat.com. Website: www.woodenboat.com. **Art Director:** Olga Lange. Estab. 1974. Bimonthly magazine for wooden boat owners, builders and designers. Circ. 106,000. Previously published work OK. Sample copy for $4. Art guidelines free for SASE with first-class postage.

Illustration Approached by 10-20 illustrators/year. Buys 2-10 illustrations/issue on wooden boats or related items. Has featured illustrations by Sam Manning and Kathy Bray. Assigns 10% of illustrations to well-known or "name" illustrators; 80% to experienced but not well-known illustrators; 10% to new and emerging illustrators.

Design Not currently using freelancers.

First Contact & Terms Illustrators: Send postcard sample or query letter with printed samples and tearsheets. Designers: Send query letter with tearsheets, résumé and slides. Samples are filed. Does not report back. Artist should follow up with call. Pays on publication. Pays illustrators $50-400 for spots. Pays designers by project.

Tips "We work with several professionals on an assignment basis, but most of the illustrative material that we use in the magazine is submitted with a feature article. When we need additional material, however, we will try to contact a good freelancer in the appropriate geographic area."

WORKFORCE MANAGEMENT

4 Executive Circle, Suite 185, Irvine CA 92614. (949)255-5345. Fax: (949)221-8964. E-mail: ddeay@workforce.com. Website: www.workforce.com. **Art Director:** Douglas R. Deay. Estab. 1922. Monthly trade journal for human resource business executives. Circ. 36,000. Sample copies available in libraries.

Illustration Approached by 100 illustrators/year. Buys 3-4 illustrations/issue. Prefers business themes. Considers all media. 40% of freelance illustration demands knowledge of Photoshop, QuarkXPress and Illustrator. Send postcard sample. Send follow-up postcard sample every 3 months. Samples are filed and are not returned. Does not reply, artist should call. Art director will contact for portfolio review if interested. Rights purchased vary according to project. **Pays on acceptance**; $350-500 for color cover; $100-400 for b&w and/or color inside; $75-150 for spots. Finds artists through agents, sourcebooks such as *LA Workbook*, magazines, word of mouth and submissions.

Tips "Read our magazine."

☑ WORKING MOTHER MAGAZINE

60 E. 42nd St., 27th Floor, New York NY 10165. (212)351-6400. Fax: (212)351-6487. E-mail: editors@workingmother.com. Website: www.workingmother.com. **Art Director:** Ebby Antigua. Estab. 1979. "A monthly service magazine for working mothers focusing on work, money, children, food and fashion." Circ. 930,000. Original artwork is returned at job's completion. Sample copies and art guidelines available.

Illustration Approached by 100 illustrators/year. Buys 3-5 illustrations/issue. Works on assignment only. Prefers light humor and child/parent, work themes. Considers watercolor, collage, airbrush, acrylic, colored pencil, oil, mixed media and pastel.

First Contact & Terms Illustrators: Send query letter with postcard or printed samples of tearsheets. Samples are filed and are not returned. Does not report back, in which case the artist should call or drop off portfolio. Portfolio should include tearsheets, slides and photographs. Buys first rights. **Pays on acceptance.** $150-2,000 for color inside.

WORKSPAN

14040 N. Northsight Blvd., Scottsdale AZ 85260. (480)922-2063. Fax: (480)483-8352. E-mail: mmunoz@worldatwork.org. Website: www.worldatwork.org. **Contact:** Mark Anthony Munoz, Art Director. Estab. 2000. Monthly publication with a circulation of 26,000, targeting an audience which includes human resources, benefits, and compensation professionals. It serves as an informative resource with respect to practices, trends, knowledge and contemporary issues in the field. Sample copies available on request. Art guidelines are available by contacting the art director.

Illustration Approached by 500+ illustrators/year. Buys 20-25 illustrations/year. Has featured illustrations by Bill Mayer, Gerard DuBois, Curtis Parker, Charlie Hill, Adam Nikewicz, Doug Frasier, Tim Grasser. Features computer illustrations, realistic illustrations, spot illustrations or traditional illustrations of business. Prefers vibrant, rich, modern. Assigns 10% to new and emerging illustrators. 20% of freelance illustration demands knowledge of FreeHand, Illustrator, QuarkXPress and Photoshop.

First Contact & Terms Cartoonists/Illustrators: Send postcard samples with photocopies, samples, tearsheets, transparencies and URL. After introductory mailing, send follow-up postcard every 6 months. All samples are kept on file. Accepts e-mail submissions with link to website and e-mail submissions with image file. Prefers Mac-compatible TIFF and JPEG files. Samples are filed and returned by SASE. Responds only if interested. Portfolios may be dropped off every Monday. Company will contact artist for portfolio review if interested. Portfolio should include color photographs, tearsheets, thumbnails and film usage samples. Pays illustrators $1,500-3,000 for color cover, $900-2,000 for color inside; $1,000-2,000 for 2-page spreads. **Pays on acceptance.** Buys one-time rights, reprint rights (negotiated upon reprinting). Rights purchased vary according to project. Finds freelancers through agents, magazines, word of mouth, artists' submissions, sourcebooks, *Workbook*, GAD Directory, American Showcase and samples.

Tips "Research types of magazines that are appropriate before sending samples; although artwork may be exceptional, it may not fit our image guidelines. Also, any Web URLs should be tested before sending."

WRITER'S DIGEST

4700 E. Galbraith Rd., Cincinnati OH 45236. E-mail: writersdig@fwpubs.com. Website: www.writersdigest.com. **Art Director:** Tari Clidence. Editor: Kristin Godsey. Monthly magazine emphasizing freelance writing for freelance writers. Circ. 175,000. Art guidelines free for SASE with first-class postage.

• Submissions are also considered for inclusion in annual *Writer's Yearbook* and other one-shot publications.

Illustration Buys 2-4 feature illustrations per month. Theme the writing life. Works on assignment only. Send postcard or any printed/copied samples to be kept on file (limit size to 8½×11).

First Contact & Terms Prefer snail-mail submissions to keep on file. Buys one-time rights **Pays on acceptance**;

$500-1,000 for color cover; $100-800 for inside b&w. Can send final via e-mail. Prefer EPS, TIFF or JPEG, 300 dpi.

Tips "We're also looking for black & white spots of writing-related subjects. We buy all rights; $15-25/spot. I like having several samples to look at. Online portfolios are great."

WRITER'S DIGEST GUIDES & YEARBOOKS

4700 E. Galbraith Rd., Cincinnati OH 45236. **Art Director:** Tari Clidence. Publications featuring "the best writing on writing." Topics include writing and marketing techniques, business issues for writers and writing opportunities for freelance writers and people getting started in writing. Affiliated with *Writer's Digest*. Illustrations and photos submitted to either publication are considered for both.

Illustration Uses 4-5 illustrations/issue. Theme the writing life. Works on assignment only.

First Contact & Terms Send postcard or any printed/copied samples to be kept on file (limit size to 8½×11). Can send final, purchased art via e-mail, JPEG, TIFF or EPS, 300 dpi. Buys first North American serial rights for one-time use. **Pays on acceptance.** $100-500 inside b&w, up to $700 for cover.

N YM

Dept. AM, 15 E. 26th St., New York NY 10010. (646)758-0555. Fax: (646)758-0808. **Art Director:** Amy Demas. Deputy Art Director Karmen Lizzul. A fashion magazine for teen girls between the ages of 14-21. Twelve issues. Circ. 2,276,939. Original artwork returned at job's completion. Sample copies available.

Illustration Buys 1-2 illustrations/issue. Buys 12-36 illustrations/year. Prefers funny, whimsical illustrations related to girl/guy problems, horoscopes and dreams. Considers watercolor, collage, acrylic, colored pencil, oil, charcoal, mixed media, pastel.

First Contact & Terms Samples are filed or not filed (depending on quality). Samples are not returned. Responds to the artist only if interested. Buys one-time rights. **Pays on acceptance** or publication. Offers one half of original fee as kill fee.

Posters & Prints

Have you ever noticed, perhaps at the opening of an exhibition or at an art fair, that though you have many paintings on display, everybody wants to buy the same one? Do friends, relatives and co-workers ask you to paint duplicates of work you already sold? Many artists turn to the print market because they find certain images have a wide appeal and will sell again and again. This section lists publishers and distributors who can publish and market your work as prints or posters. It is important to understand the difference between the terms "publisher" and "distributor" before you begin your research. Art *publishers* work with you to publish a piece of your work in print form. Art *distributors* assist you in marketing a pre-existing poster or print. Some companies function as both publisher and distributor. Look in the first paragraph of each listing to determine if the company is a publisher, distributor or both.

RESEARCH THE MARKET

Some listings in this section are fine art presses, others are more commercial. Read the listings carefully to determine if they create editions for the fine art market or for the decorative market. Visit galleries, frame shops, furniture stores and other retail outlets that carry prints to see where your art fits in. You may also want to visit designer showrooms and interior decoration outlets.

To further research this market, check each publisher's Web site or send for each publisher's catalog. Some publishers will not send their catalogs because they are too expensive, but you can often ask to see one at a local poster shop, print gallery, upscale furniture store or frame shop. Examine the colors in the catalogs to make sure the quality is high.

What to send

To approach a publisher, send a brief query letter, a short bio, a list of galleries that represent your work and five to ten slides or whatever samples they specify in their listing. It helps to send printed pieces or tearsheets as samples, as these show publishers that your work reproduces well and that you have some understanding of the publication process. Most publishers will accept digital submissions via e-mail or CD.

Signing and numbering your editions

Before you enter the print arena, follow the standard method of signing and numbering your editions. You can observe how this is done by visiting galleries and museums and talking to fellow artists.

If you are creating a limited edition, with a specific set number of prints, all prints are

numbered, such as 35/100. The largest number is the total number of prints in the edition; the smaller number is the number of the print. Some artists hold out 10% as artist's proofs and number them separately with AP after the number (such as 5/100 AP). Many artists sign and number their prints in pencil.

Types of prints

Original prints. Original prints may be woodcuts, engravings, linocuts, mezzotints, etchings, lithographs or serigraphs. What distinguishes them is that they are produced by hand

Your Publishing Options

Important

1 **Working with a commercial poster manufacturer or art publisher.** If you don't mind creating commercial images and following current trends, the decorative market can be quite lucrative. On the other hand, if you work with a fine art publisher, you will have more control over the final image.

2 **Working with a fine art press.** Fine art presses differ from commercial presses in that press operators work side by side with you every step of the way, sharing their experience and knowledge of the printing process. You may be charged a fee for the time your work is on the press and for the expert advice of the printer.

3 **Working at a co-op press.** Instead of approaching an art publisher, you can learn to make your own hand-pulled original prints—such as lithographs, monoprints, etchings or silk-screens. If there is a co-op press in your city, you can rent time on a press and create your own editions. It is rewarding to learn printing skills and have the hands-on experience. You also gain total control of your work. The drawback is you have to market your images yourself by approaching galleries, distributors and other clients.

4 **Self-publishing with a printing company.** Several national printing concerns advertise heavily in artists' magazines, encouraging artists to publish their own work. If you are a savvy marketer who understands the ins and outs of trade shows and direct marketing, this is a viable option. However it takes a large investment up front. You could end up with a thousand prints taking up space in your basement, or if you are a good marketer, you could end up selling them all and making a much larger profit than if you had gone through an art publisher or poster company.

5 **Marketing through distributors.** If you choose the self-publishing route but don't have the resources to market your prints, distributors will market your work in exchange for a percentage of sales. Distributors have connections with all kinds of outlets like retail stores, print galleries, framers, college bookstores and museum shops.

by the artist (and consequently often referred to as hand-pulled prints). In a true original print the work is created specifically to be a print. Each print is considered an original because the artist creates the artwork directly on the plate, woodblock, etching stone or screen. Original prints are sold through specialized print galleries, frame shops and high-end decorating outlets, as well as fine art galleries.

Offset reproductions and posters. Offset reproductions, also known as posters and image prints, are reproduced by photochemical means. Since plates used in offset reproductions do not wear out, there are no physical limits on the number of prints made. Quantities, however, may still be limited by the publisher in order to add value to the edition.

Giclée prints. As color-copier technology matures, inkjet fine art prints, also called giclée prints, are gaining popularity. Iris prints, images that are scanned into a computer and output on oversized printers, are even showing up in museum collections.

Canvas transfers. Canvas transfers are becoming increasingly popular. Instead of, and often in addition to, printing an image on paper, the publisher transfers your image onto canvas so the work has the look and feel of a painting. Some publishers market limited editions of 750 prints on paper, along with a smaller edition of 100 of the same work on canvas. The edition on paper might sell for $150 per print, while the canvas transfer would be priced higher, perhaps selling for $395.

Pricing criteria for limited editions and posters

Because original prints are always sold in limited editions, they command higher prices than posters, which are not numbered. Since plates for original prints are made by hand, and as a result can only withstand a certain amount of use, the number of prints pulled is limited by the number of impressions that can be made before the plate wears out. Some publishers impose their own limits on the number of impressions to increase a print's value. These limits may be set as high as 700 to 1,000 impressions, but some prints are limited to just 250 to 500, making them highly prized by collectors.

A few publishers buy work outright for a flat fee, but most pay on a royalty basis. Royalties for handpulled prints are usually based on retail price and range from 5 to 20 percent, while percentages for posters and offset reproductions are lower (from $2\frac{1}{2}$ to 5 percent) and are based on the wholesale price. Be aware that some publishers may hold back royalties to cover promotion and production costs. This is not uncommon.

Prices for prints vary widely depending on the quantity available; the artist's reputation; the popularity of the image; the quality of the paper, ink and printing process. Since prices for posters are lower than for original prints, publishers tend to select images with high-volume sales potential.

Negotiating your contract

As in other business transactions, ask for a contract and make sure you understand and agree to all the terms before you sign. Make sure you approve the size, printing method, paper, number of images to be produced and royalties. Other things to watch for include insurance terms, marketing plans and a guarantee of a credit line or copyright notice.

Always retain ownership of your original work. Work out an arrangement in which you're selling publication rights only. You'll also want to sell rights only for a limited period of time. That way you can sell the image later as a reprint or license it for other use (for example as a calendar or note card). If you are a perfectionist about color, make sure your contract gives you final approval of your print. Stipulate that you'd like to inspect a press proof prior to the print run.

MORE INDUSTRY TIPS

Find a niche. Consider working within a specialized subject matter. Prints with Civil War themes, for example, are avidly collected by Civil War enthusiasts. But to appeal to Civil War buffs, every detail, from weapons and foliage in battlefields to uniform buttons, must be historically accurate. Signed limited editions are usually created in a print run of 950 or so and can average about $175-200; artist's proofs sell from between $195-250, with canvas transfers selling for $400-500. The original paintings from which images are taken often sell for thousands of dollars to avid collectors.

Sport art is another lucrative niche. There's a growing trend toward portraying sports figures from football, basketball and racing (both sports car and horse racing) in prints that include both the artist's and the athlete's signatures. Movie stars and musicians from the 1950s (such as James Dean, Marilyn Monroe and Elvis) are also cult favorites.

Work in a series. It is easier to market a series of small prints exploring a single theme than to market single images. A series of similar prints works well in long hospital corridors, office meeting rooms or restaurants. Also marketable are "paired" images. Hotels often purchase two similar prints for each of their rooms.

Study trends. If you hope to get published by a commercial art publisher or poster company, your work will have a greater chance of acceptance if you use popular colors and themes.

Attend trade shows. Many artists say it's the best way to research the market and make contacts. Increasingly it has become an important venue for self-published artists to market their work. Decor Expo is held each year in four cities: Atlanta, New York, Orlando and Los Angeles. For more information call (888)608-5300 or visit www.decormagazine.com/expo/home.htm.

Insider Tips

Tips

- Read industry publications, such as *Decor* magazine and *Art Business News*, to get a sense of what sells.

- To find out what trade shows are coming up in your area, check the event calendars in industry trade publications. Many shows, such as the Decor Expo, coincide with annual stationery or gift shows, so if you work in both the print and greeting card markets, be sure to take that into consideration. Remember, traveling to trade shows is a deductible business expense, so don't forget to save your receipts!

- Consult *Business and Legal Forms for Fine Artists* by Tad Crawford (Allworth Press) for sample contracts.

ACTION IMAGES INC.

7148 N. Ridgeway, Lincolnwood IL 60712. (847)763-9700. Fax: (847)763-9701. E-mail: actionim@aol.com. Website: www.actionimagesinc.com. **President:** Tom Green. Estab. 1989. Art publisher of sport art. Publishes limited edition prints, open edition posters as well as direct printing on canvas. Specializes in sport art prints for events such as the Super Bowl, Final Four, Stanley Cup, etc. Clients include retailers, distributors, sales promotion agencies.

Needs Ideally seeking sport artists/illustrators who are accomplished in both traditional and computer generated artwork as our needs often include tight deadlines, exacting attention to detail and excellent quality. Primary work relates to posters & T-shirt artwork for retail and promotional material for sporting events. Considers all media. Artists represented include Cheri Wenner, Andy Wenner, Ken Call, Konrad Hack and Alan Studt. Approached by approximately 25 artists/year. Publishes the work of 1 emerging artist 2-3 years.

First Contact & Terms Send submissions on e-mail, JPEG, or PDF files or via mailed disk, compatible with Mac, + color printout. Samples are filed. Responds only if interested. If interested in samples, will ask to see more of artist's work. Pays flat fee $1,000-2,000. Buys exclusive reproduction rights. Rarely acquires original painting. Provides insurance while work is at firm and outbound in-transit insurance. Promotional services vary depending on project. Finds artists through recommendations from other artists, word of mouth and submissions.

Tips "If you're a talented artist/illustrator and know your PhotoShop/Illustrator software, you have great prospects."

N AEROPRINT AND SPOFFORD HOUSE

South Shore Rd., Box 154, Spofford NH 03462. (603)363-4713. **Owner:** H. Westervelt. Estab. 1972. Art publisher/distributor handling limited editions and open editions of offset reproductions for galleries and collectors. Clients: aviation art collectors and history buffs.

Needs Artists represented include Merv Corning, Jo Kotula, Terry Ryan, Gil Cohen, James Deitz, Nixon Galloway, John Willis, Harley Copic, Robert Taylor, Nicholas Trudgian, Keith Ferris, William Phillips, John Shaw and Robert Bailey. Publishes the work of 8 established artists. Distributes the work of 32 established artists.

ALEXANDRE ENTERPRISES

P.O. Box 34, Upper Marlboro MD 20773. (301)627-5170. Fax: (301)627-5106. **Artistic Director:** Walter Mussienko. Estab. 1972. Art publisher and distributor. Publishes and distributes handpulled originals, limited editions and originals. Clients: retail art galleries, collectors and corporate accounts.

Needs Seeking creative and decorative art for the serious collector and designer market. Considers oil, watercolor, acrylic, pastel, ink, mixed media, original etchings and colored pencil. Prefers landscapes, wildlife, abstraction, realism and impressionism. Artists represented include Cantin and Gantner. Editions created by collaborating with the artist. Approached by 30 artists/year. Publishes the work of 2 emerging artists/year. Distributes the work of 2-4 emerging artists/year.

First Contact & Terms Send query letter with résumé, tearsheets and photographs. Samples are filed. Responds in 6 weeks only if interested. Call to schedule an appointment to show a portfolio or mail photographs and original pencil sketches. Payment method is negotiated consignment and/or direct purchase. Offers an advance when appropriate. Negotiates rights purchased. Provides promotion, a written contract and shipping from firm.

Tips "Artist must be properly trained in the basic and fundamental principles of art and have knowledge of art history. Have work examined by art instructors before attempting to market your work."

☑ APPLEJACK ART PARTNERS

(formerly Applejack Limited Editions), P.O. Box 1527, Historic Rt. 7A, Manchester Center VT 05255. (802)362-3662. E-mail: tino@applejackart.co. Website: www.applejackart.com.
 ● See listing in Greeting Cards, Gifts & Products.

Artist Liason Tino Barbarossa. Major publisher of limited edition prints.

Needs Seeking fine art for the serious collector and the commercial market. Artists represented include Mort Kunstler.

First Contact & Terms Send query letter with slides and SASE to Submissions. Publisher will contact artist for portfolio review if interested.

ARNOLD ART STORE & GALLERY

210 Thames St., Newport RI 02840. (401)847-2273 (800)352-2234. Fax: (401)848-0156. E-mail: info@arnoldart.com. Website: www.arnoldart.com. **Owner:** Bill Rommel. Estab. 1870. Poster company, art publisher, distributor, gallery specializing in marine art. Publishes/distributes limited and unlimited edition, fine art prints, offset reproduction and posters.

Needs Seeking creative, fashionable, decorative art for the serious collector, commercial and designer markets. Considers oil, acrylic, watercolor, mixed media, pastel, pen & ink, sculpture. Prefers sailing images—Americas Cup or other racing images. Artists represented include Kathy Bray, Thomas Buechner and James DeWitt. Editions created by working from an existing painting. Approached by 100 artists/year. Publishes/distributes the work of 10-15 established artists/year.

First Contact & Terms Send query letter with 4-5 photographs. Samples are filed or returned by SASE. Call to arrange portfolio review. Pays flat fee, royalties or consignment. Negotiates rights purchased; rights purchased vary according to project. Provides advertising and promotion. Finds artists through word of mouth.

HERBERT ARNOT, INC.

250 W. 57th St., New York NY 10107. (212)245-8287. Website: www.arnotart.com. **President:** Peter Arnot. Vice President: Vicki Arnot. Art dealer of original oil paintings. Clients: galleries, design firms.

Needs Seeking creative and decorative art for the serious collector and designer market. Considers oil and acrylic paintings. Has wide range of themes and styles "mostly traditional/impressionistic, not abstract." Artists represented include Raymond Campbell, Christian Nesvadba, Gerhard Nesvadba and Lucien Delarue. Distributes the work of 250 artists/year.

First Contact & Terms Send query letter with brochure, résumé, business card, slides or photographs to be kept on file. Samples are filed or are returned by SASE. Responds in 1 month. Portfolios may be dropped off every Monday-Friday or mailed. Provides promotion.

Tips "Artist should be professional."

N ART BROKERS OF COLORADO

2419 W. Colorado Ave., Colorado Springs CO 80904. (719)520-9177. Fax: (719)633-5747. Website: www.artbrokers.com. **Contact:** Nancy Stovall. Estab. 1991. Art publisher. Publishes limited and unlimited editions, posters and offset reproductions. Clients: galleries, decorators, frame shops.

Needs Seeking decorative art by established artists for the serious collector. Prefers oil, watercolor and acrylic. Prefers western theme. Editions created by collaborating with the artist. Approached by 20-40 artists/year. Publishes the work of 1-2 established artists/year.

First Contact & Terms Send query letter with photographs. Samples are not filed and are returned by SASE. Responds in 4-6 weeks. Company will contact artist for portfolio review of final art if interested. Pays royalties. Rights purchased vary according to project. Provides insurance while work is at firm.

Tips Advises artists to attend all the trade shows and to participate as often as possible.

ART DALLAS INC.

2325 Valdina St., Dallas TX 75207. (214)688-0244. Fax: (214)688-7758. E-mail: info@artdallas.com. Website: www.artdallas.com. **President:** Judy Martin. Estab. 1988. Art distributor, gallery, framing and display company. Distributes handpulled originals, offset reproductions. Clients: designers, architects.

Needs Seeking creative art for the commercial and designer markets. Considers mixed media. Prefers abstract, landscapes. Artists represented include Tarran Caldwell, Jim Colley, Tony Bass and Mick Sharp. Editions created by working from an existing painting. Approached by 10 artists/year. Publishes the work of 2 and distributes the work of 4 established artists/year.

First Contact & Terms Send query letter with résumé, photocopies, slides, photographs and transparencies. Samples are filed or are returned. Responds in 2 weeks. Call for appointment to show portfolio of slides and photographs. Pays flat fee $50-5,000. Offers advance when appropriate. Negotiates rights purchased.

ART EMOTION CORP.

1758 S. Edgar, Palatine IL 60067. (847)397-9300. E-mail: gperez@artcom.com. **President:** Gerard V. Perez. Estab. 1977. Art publisher and distributor. Publishes and distributes limited editions. Clients: corporate/residential designers, consultants and retail galleries.

Needs Seeking decorative art. Considers oil, watercolor, acrylic, pastel and mixed media. Prefers representational, traditional and impressionistic styles. Artists represented include Garcia, Johnson and Sullivan. Editions created by working from an existing painting. Approached by 50-75 artists/year. Publishes and distributes the work of 2-5 artists/year.

First Contact & Terms Send query letter with slides or photographs. "Supply a SASE if you want materials returned to you." Samples are filed. Does not necessarily reply. Pays royalties of 10%.

Tips "Send visuals first."

N ART IMPRESSIONS, INC.

23586 Calabasas Rd., Suite 210, Calabasas CA 91302. (818)591-0105. Fax: (818)591-0106. E-mail: info@artimpressionsinc.com. Website: www.artimpressionsinc.com. **Contact:** Jennifer Ward. Estab. 1990. Licensing agent.

Clients: major manufacturers worldwide. Current clients include Hasbro, Spring Industries, Lexington Furniture, American Greetings, Portal Publications and Mead.

Needs Seeking art for the commercial market. Considers oil, acrylic, mixed media, pastel and photography. Prefers proven themes like children, domestic animals, fantasy/fairies, nostalgia. No abstract, nudes or "dark" themes. Artists represented include Schim Schimmel, Valerie Tabor-Smith, Susan Branch, Josephine Wall and Dana Simson. Approached by over 70 artists/year.

First Contact & Terms Send query letter with photocopies, photographs, slides, transparencies or tearsheets and SASE. Accepts disk submissions. Samples are not filed and are returned by SASE. Responds in 2 months. Company will contact artist for portfolio review if interested. Artists are paid percentage of licensing revenues generated by their work. No advance. Requires exclusive representation of artist. Provides advertising, promotion, written contract and legal services. Finds artists through attending art exhibitions, word of mouth, publications and artists' submissions.

Tips "Artists should have at least 25 images available and be able to reproduce an equal number annually. Artwork must be available on disc or transparency, and be of reproduction quality."

ART IN MOTION

2000 Brigatine Dr., Coquitlam BC V3K 7B5 Canada. (800)663-1308 or (604)525-3900. Fax: (877)525-6166. E-mail: artistrelations@artinmotion.com. Website: www.artinmotion.com. **CEO:** Garry Peters. Artist Relations: Department. Fine art publisher, distributor and framer. Publishes, licenses and distributes open edition reproductions. Licenses all types of artwork for all industries including wallpaper, fabric, stationery and calendars. Clients: galleries, high-end retailers, designers, distributors worldwide and picture frame manufacturers.

Needs "Our collection of imagery reflects today's interior decorating tastes; we publish a wide variety of techniques. View our collection online before submitting. However, we are always interested in new looks, directions and design concepts." Considers oil and mixed media.

First Contact & Terms Please send slides, photographs and transparencies or e-mail digital files. Samples are filed or are returned. "Artists that are selected for publication can look forward to regular income from royalties (paid on a monthly basis); an arrangement that does not affect sales or originals in any way, allowing you to carry on business as you have always done with galleries and other outlets; additional royalty opportunities from licensing your images; worldwide exposure through advertising, publicity and marketing support; representation at over 60 North American and international trade shows each year; commitment to protecting your intellectual property rights (artist maintains copyright at all times); coverage of all costs, including reproduction, insurance and courier charges."

Tips "We are a world leader in fine art publishing with distribution in over 72 countries. The publishing process utilizes the latest technology and state-of-the-art printing equipment and uses the finest inks and papers available. Artist input and participation are highly valued and encouraged at all times. We warmly welcome artist inquiries."

ART LICENSING INTERNATIONAL INC.

7350 S. Tamiami Trail, #227, Sarasota FL 34231. (941)966-8912. Fax: (941)966-8914. E-mail: artlicensing@comc ast.net. Website: www.artlicensinginc.com. **Creative Director:** Michael Woodward. Estab. 1986. Licensing agency, which "represents artists who wish to establish a licensing program for their work."

- See listings in Greeting Cards, Gifts & Products and Artists' Rep sections of this book. This company licenses images internationally for a range of products including posters and prints, greeting cards, calendars, toys, etc.

First Contact & Terms Send a CD and photocopies or e-mail JPEGs or a link to your website. Send SASE for return of material. Commission rate is 50%.

Tips "Prints and posters should be in pairs or sets of 4 or more with regard for trends and color palettes related to the home decor market."

ARTBEATS, INC.

129 Glover Ave., Norwalk CT 06850-1311. (800)677-6947. Fax: (203)846-2105. Website: www.nygs.com. Estab. 2002. Art publisher. Publishes and distributes open edition posters and matted prints. Clients: retailers of fine wall decor. Current clients include Prints Plus, Hobby Lobby, and others. Member of New York Graphic Society Publishing Group.

Needs Seeking creative, fashionable and decorative art for the home design market. Art guidelines free for SASE with first-class postage. Artwork should be current, appropriate for home decor, professional and polished. Publishes approx. 400 new works each year.

First Contact & Terms Send query letter with résumé, color-correct photographs, transparencies or lasers. Samples are not filed and are returned by SASE if requested by artist. Responds in 3 months. Publisher will contact artist for portfolio review if interested. DO NOT SEND ORIGINALS, AND DO NOT CALL. Terms negoti-

ated at time of contact. Provides written contract. Finds artists through art shows, licensing agents, exhibits, word of mouth and submissions.

ARTEFFECT DESIGNS & LICENSING

P.O. Box 1090, Dewey AZ 86327. (928)632-0530. Fax: (928)632-9052. E-mail: moniqueart@earthlink.net. **Manager:** William F. Cupp. Product development, art licensing and representation of European publishers.

Needs Seeking creative, decorative art for the commercial and designer markets. Considers oil, acrylic, mixed media. Interested in all types of design. Artists represented include Debbie Meyers, Judy Kaufman, Wendy Stevenson, Timothy Easton, Joelle Katan and Nadia Clark. Editions created by working from an existing painting.

First Contact & Terms Send brochure, photographs, SASE, slides. "Must have SASE or will not return." Responds only if interested. Company will contact artist for portfolio review of transparencies if interested. Pays flat fee or royalties. No advance. Rights purchased vary according to project. Provides advertising and representation at international trade shows.

ARTFINDERS.COM

2508 E. Marcia St., Inverness FL 34453. (352)344-2711. Fax: (352)344-8711. E-mail: art@artfinders.net. Website: www.artfinders.com. **Contact:** Tammy and Jim Skodinski. Publisher/distributor of wildlife art.

• This publisher also owns www.artprintbargains.com.

Needs Seeking paintings, graphics, posters for the fine art and commercial markets. Specializes in all forms of art.

First Contact & Terms Send e-mail to art@artfinders.com. Publisher will contact for portfolio review if interested.

ARTS UNIQ' INC.

1710 S. Jefferson Ave., P.O. Box 2085, Cookeville TN 38502. (800)833-0317. Fax: (615)528-8904. E-mail: Carrie W@artsuniq.com. Website: www.artsuniq.com. **Contact:** Carrie Wallen. Licensing: Carol White. Estab. 1985. Art publisher. Publishes limited and open editions. Licenses a variety of artwork for cards, throws, figurines, etc. Clients: art galleries, gift shops, furniture stores and department stores.

Needs Seeking creative and decorative art for the designer market. Considers all media. Artists represented include D. Morgan, Jack Terry, Judy Gibson and Carolyn Wright. Editions created by collaborating with the artist or by working from an existing painting.

First Contact & Terms Send query letter with slides or photographs. Samples are filed or are returned by request. Responds in 2 months. Pays royalties monthly. Requires exclusive representation rights. Provides promotion, framing and shipping from firm.

N ARTSOURCE INTERNATIONAL INC.

1081 E. Santa Anita Ave., Burbank CA 91501. (818)558-5200. Fax: (818)657-1414. E-mail: artsourceintl@aol.com. Website: www.artsource-online.com. **Contact:** Ripsime Marashian, managing editor. Estab. 1997. Art publisher of fine art and business management consultations. Handles fine art prints, unlimited edition, limited edition and posters. Clients: decorators, frame shops, distributors and galleries. Current clients include: art galleries, dealers, distributors, furniture stores and interior designers.

Needs Seeking decorative art for the commercial market and any art of exceptional quality. Considers acrylic, pastel and mixed media. "We prefer artwork with creative expression—figurative, landscapes, still lifes." Artists represented include Ruben Abovian, Carols and Alexander Sadoyan. Editions created by working from an existing painting. Approached by 20 artists/year. Works with 1-2 emerging artists/year.

First Contact & Terms Send query letter, brochure, SASE, photographs, tearsheets and résumé. Accepts e-mail submissions. Prefers JPEG. Samples are not filed. Samples returned by SASE. Responds only if interested. Company will contact artist for portfolio review if interested. Pays artists royalties of 10-15%. Negotiates payment. Our standard commission is 50% less 50% off retail. Offers advance when appropriate. Negotiates rights purchased according to project. Requires exclusive representation of artist. Provides advertising, written contract, promotion and exhibitions. Finds artists through submissions, art exhibits/fairs.

Tips "Provide a body of work along a certain theme to show a fully developed style that can be built upon. We offer services to artists who are serious about their career, individuals who want to become professional artist representatives, galleries and dealers who want to target new artists. For guidelines, go to website."

ARTVISIONS

12117 SE 26th St., Bellevue WA 98005-4118. (425)746-2201. Website: www.artvisions.com. **Owner:** Neil Miller. Estab. 1993. Markets include publishers of limited edition prints, calendars, home decor, stationery, note cards and greeting cards, posters, and manufacturers of giftware, home furnishings, textiles, puzzles and games.

Artists must have 4×5 transparencies or high resolution scans of artwork. Handles fine art licensing for listed markets. See complete listing in Artists' Reps section.

ⓝ ASHLAND ART
1005 Highland Ave., Ashland KY 41102. Phone/fax: (606)325-1816. **Contact:** Bob Coffey, owner. Estab. 1974. Art publisher, distributor. Publishes/distributes hand-pulled originals, monoprints, monotypes, original art. Clients: art consultants, corporate curators, decorators, distributors, frame shops, galleries.
Needs Seeking decorative art for the commercial and designer markets. Considers acrylic, mixed media, oil, watercolor, serography, etchings. Editions created by collaborating with the artist and working with the needs of the customer. Approached by over 25 artists/year. Publishes work of 6-8 emerging artists/year. Distributes the work of over 60 emerging artists/year.
First Contact & Terms Send photographs, slides and transparencies. Samples are not filed but are returned. Responds in 2 weeks. Portfolios not required. Request portfolio review in original query. Company will contact artist for portfolio review if interested. Portfolio should include color art, in whatever presentation is easiest for artist. Pays on consignment basis. Firm receives variable commission. No advance. Rights purchased vary according to project. Requires regional exclusive representation of artist. Provides insurance while work is at firm, shipping from our firm, all sales expenses. Finds artists through artist's submissions, referrals.

ⓝ AURA EDITIONS
4943 McConnell Ave., Suite J, Los Angeles CA 90066. (310)305-3900. Fax: (310)305-3960. **Art Director:** Allen Cathey. Estab. 1996. Art publisher, poster company and distributor. Publishes/distributes limited edition, unlimited edition and posters. Clients: frame shops, distributors, galleries, retail chain stores, O.E.M. framers.
Needs Seeking creative, fashionable and decorative art for the commercial and designer markets. Considers acrylic, pastel, watercolor, mixed media, photography and oil. Artists represented include Allayn Stevens, Inka Zlin and Peter Colvin. Editions created by collaborating with the artist or by working from an existing painting. Approached by 100 artists/year. Publishes work of 30 emerging, 15 mid-career and 10 established artists/year. Distributes the work of 5 emerging, 3 mid-career and 2 established artists/year.
First Contact & Terms Send query letter with brochure, photocopies, photographs and tearsheets. Samples are filed and are not returned. Responds in 6 months only if interested. Company will contact artist for portfolio review if interested. Portfolio should include photographs, slides and tearsheets. Pays flat fee: $300-700; royalties of 10%. Offers advance when appropriate. Negotiates rights purchased. Requires exclusive representation of artist. Finds artists through sourcebooks, art fairs and word of mouth.
Tips "Follow catalog companies—colors/motifs."

BANKS FINE ART
1231 Dragon St., Dallas TX 75207. (214)352-1811. Fax: (214)352-6360. E-mail: mb@banksfineart.com. Website: www.banksfineart.com. **Owner:** Bob Banks. Estab. 1980. Distributor, gallery of original oil paintings. Clients: galleries, decorators.
Needs Seeking decorative, traditional and impressionistic art for the serious collector and the commercial market. Considers oil, acrylic. Prefers traditional and impressionistic styles. Artists represented include Joe Sambataro, Jan Bain and Marcia Banks. Approached by 100 artists/year. Publishes/distributes the work of 2 emerging artists/year.
First Contact & Terms Send photographs. Samples are returned by SASE. Responds in 1 week. Offers advance. Rights purchased vary according to project. Provides advertising, in-transit insurance, insurance while work is at firm, promotion, shipping from firm, written contract.
Tips Needs Paris and Italy street scenes. Advises artists entering the poster and print fields to attend Art Expo, the industry's largest trade event, held in New York City every spring. Also recommends reading *Art Business News*.

BENJAMANS ART GALLERY
419 Elmwood Ave., Buffalo NY 14222. (716)886-0898. Fax: (716)886-0546. E-mail: eileen2134@aol.com. Website: www.benart.com. Licensing: Barry Johnson. Estab. 1970. Art publisher, distributor, gallery, frame shop and appraiser. Publishes and distributes handpulled originals, limited and unlimited editions, posters, offset reproductions and sculpture. Clients include P&B International.
Needs Seeking decorative art for the serious collector. Considers oil, watercolor, acrylic and sculpture. Prefers art deco and florals. Artists represented include J.C. Litz, Jason Barr and Eric Dates. Editions created by collaborating with the artist. Approached by 20-30 artists/year. Publishes and distributes the work of 4 emerging, 2 mid-career and 1 established artists/year.
First Contact & Terms Send query letter with SASE, slides, photocopies, résumé, transparencies, tearsheets and/or photographs. Samples are filed or returned. Responds in 2 weeks. Company will contact artist for

portfolio review if interested. Pays on consignment basis. Firm receives 30-50% commission. Offers advance when appropriate. Rights purchased vary according to project. Does not require exclusive representation of artist. Provides advertising, promotion, shipping to and from firm, written contract and insurance while work is at firm.

Tips "Keep trying to join a group of artists and try to develop a unique style."

BENTLEY PUBLISHING GROUP

1410 Lesnick Lane, Suite J, Walnut Creek CA 94597. (925)935-3186. Fax: (925)935-0213. E-mail: alp@bentleypu blishinggroup.com. Website: www.bentleypublishinggroup.com. **Product Development Coordinator:** Jan Weiss. Estab. 1986. Art publisher of open and limited editions of offset reproductions and canvas replicas; also agency for licensing of artists' images worldwide. Licenses florals, teddy bear, landscapes, wildlife and Christmas images to appear on puzzles, tapestry products, doormats, stitchery kits, giftbags, greeting cards, mugs, tiles, wall coverings, resin and porcelain figurines, waterglobes and various other gift items. Clients: framers, galleries, distributors and framed picture manufacturers.

Needs Seeking decorative fine art for the designer, residential and commercial markets. Considers oil, watercolor, acrylic, pastel, mixed media and photography. Artists represented include Sherry Strickland, Lisa Chesaux and Andre Renoux. Editions created by collaborating with the artist or by working from an existing painting. Approached by 1,000 artists/year.

First Contact & Terms Submit JPEG images via e-mail or send query letter with brochure showing art style or résumé, advertisements, slides and photographs. Samples are filed or are returned by SASE if requested by artist. Responds in 6 weeks. Pays royalties of 10% net sales for prints monthly plus 50 artist proofs of each edition. Pays 50% monies received from licensing. Obtains all reproduction rights. Usually requires exclusive representation of artist. Provides national trade magazine promotion, a written contract, worldwide agent representation, 5 annual trade show presentations, insurance while work is at firm and shipping from firm.

Tips "Feel free to call and request guidelines. Bentley House is looking for experienced artists with images of universal appeal."

BERGQUIST IMPORTS INC.

1412 Hwy. 33 S., Cloquet MN 55720. (218)879-3343. Fax: (218)879-0010. E-mail: bbergqu106@aol.com. **President:** Barry Bergquist. Estab. 1948. Distributor. Distributes unlimited editions. Clients: gift shops.

Needs Seeking creative and decorative art for the commercial market. Considers oil, watercolor, mixed media and acrylic. Prefers Scandinavian or European styles. Artists represented include Jacky Briggs, Dona Douma and Suzanne Tostey. Editions created by collaborating with the artist or by working from an existing painting. Approached by 20 artists/year. Publishes the work of 2-3 emerging, 2-3 mid-career and 2 established artists/year. Distributes the work of 2-3 emerging, 2-3 mid-career and 2 established artists/year.

First Contact & Terms Send brochure, résumé and tearsheets. Samples are not filed and are returned. Responds in 2 months. Artist should follow up. Portfolio should include color thumbnails, final art, photostats, tearsheets and photographs. Pays flat fee $50-300, royalties of 5%. Offers advance when appropriate. Negotiates rights purchased. Provides advertising, promotion, shipping from firm and written contract. Finds artists through art fairs. Do not send art attached to e-mail. Will not download from unknown sources.

Tips Suggests artists read *Giftware News Magazine*.

BERNARD FINE ART

P.O. Box 1528, Manchester Center VT 05255. (802)362-0373. Fax: (802)362-1082. E-mail: Michael@applejackart .com. Website: www.applejackart.com. **Managing Director:** Michael Katz. Art publisher. Publishes open edition prints and posters. Clients: picture frame manufacturers, distributors, manufacturers, galleries and frame shops. This company is a division of Applejack Art Partners, along with the high-end poster lines Hope Street Editions and Rose Selavy of Vermont. Applejack Licensing International, another division of Applejack Art Partners is an internationally known art licensing company.

Needs Seeking creative, fashionable, and decorative art and photography (b&w as well as color) for commercial and designer markets. Considers all media, including oil, watercolor, acrylic, pastel, mixed media and printmaking (all forms). Art guidelines free for SASE with first-class postage. Editions created by collaborating with the artist or by working from an existing painting. Some of the artists and photographers represented include Lisa Audit, Erin Dertner, Kevin Daniel, Valerie Wenk, Bill Bell, Harold Silverman, John Zaccheo, and Michael Harrison. Approached by hundreds of artists/year. Publishes the work of 8-10 emerging, 10-15 mid-career and 100-200 established artists.

First Contact and Terms Send query letter with brochure showing art style and/or résumé, tearsheets, photostats, photocopies, slides, photographs or transparencies, or e-mail with JPEGs. Samples are returned by SASE. Responds only if interested. Call or write for appointment to show portfolio of thumbnails, roughs, original/ final art, b&w and color photostats, tearsheets, photographs, slides and transparencies. Pays royalty. Offers an

advance when appropriate. Buys all rights. Usually requires exclusive representation of artist. Provides in-transit insurance, insurance while work is at firm, promotion, shipping from firm and a written contract. Finds artists through submissions, sourcebooks, agents, art shows, galleries and word of mouth.

Tips "We look for subjects with a universal appeal. Some subjects that would be appropriate are florals, still lifes, wildlife, religious themes and landscapes and contemporary images/abstracts. Please send enough examples of your work so we can see a true representation of style and technique."

THE BILLIARD LIBRARY CO.

1570 Seabright Ave., Long Beach CA 90813. (562)437-5413. Fax: (562)436-8817. E-mail: info@billiardlibrary.com. **Creative Director:** Darian Baskin. Estab. 1973. Art publisher. Publishes unlimited and limited editions and offset reproductions. Clients: galleries, frame shops, decorators. Current clients include Deck the Walls, Prints Plus, Adventure Shops.

Needs Seeking creative, fashionable and decorative art for the commercial and designer markets. Considers oil, watercolor, mixed media, pastel, sculpture and acrylic. Artists represented include George Bloomfield, Dave Harrington and Lance Slaton. Approached by 100 artists/year. Publishes and distributes the work of 1-3 emerging, 1-3 mid-career and 1-2 established artists/year. Also uses freelancers for design. Prefers local designers only.

First Contact & Terms Send query letter with slides, photocopies, résumé, photostats, transparencies, tearsheets and photographs. Samples are filed and not returned. Responds only if interested. Publisher/Distributor will contact artists for portfolio review if interested. Pays royalties of 10%. Negotiates rights purchased. Provides promotion, advertising and a written contract. Finds artists through submissions, word of mouth and sourcebooks.

Tips "The Billiard Library Co. publishes and distributes artwork of all media relating to the sport of pool and billiards. Themes and styles of any type are reviewed with an eye towards how the image will appeal to a general audience of enthusiasts. We are experiencing an increasing interest in nostalgic pieces, especially oils. Will also review any image relating to bowling or darts."

TOM BINDER FINE ARTS

825 Wilshire Blvd., #708, Santa Monica CA 90401. (800)332-4278. Fax: (800)870-3770. E-mail: info@artman.net. Website: www.artman.net and www.alexanderchen.com. **Owner:** Tom Binder. Wholesaler of handpulled originals, limited editions and fine art prints. Clients: galleries and collectors.

Needs Seeking art for the commercial market. Considers acrylic, mixed media, giclee and pop art. Artists represented include Alexander Chen, Ken Shotwell and Elaine Binder. Editions created by working from an existing painting.

First Contact & Terms Send brochure, photographs, photostats, slides, transparencies and tearsheets. Accepts disk submissions if compatible with Illustrator 5.0. Samples are not filed and are returned by SASE. Does not reply; artist should contact. Offers advance when appropriate. Rights purchased vary according to project. Provides shipping. Finds artists through New York Art Expo and World Wide Web.

THE BLACKMAR COLLECTION

P.O. Box 537, Chester CT 06412. Phone/fax: (860)526-9303. E-mail: carser@mindspring.com. Estab. 1992. Art publisher. Publishes offset reproduction and giclee prints. Clients: individual buyers.

Needs Seeking creative art. "We are not actively recruiting at this time." Artists represented include DeLos Blackmar, Blair Hammond, Gladys Bates and Keith Murphey. Editions created by working from an existing painting. Approached by 24 artists/year. Publishes the work of 3 established artists/year. Provides advertising, in-transit insurance, insurance while work is at firm. Finds artists through personal contact. All sales have a buy back guarantee.

BON ART & ARTIQUE

Divisions of Art Resources International Ltd., 281 Fields Lane, Brewster NY 10509. (845)277-8888 or (800)228-2989. Fax: (845)277-8602. E-mail: randy@fineartpublishers.com. Website: www.artiq.com. **Vice President:** Robin E. Bonnist. Estab. 1980. Art publisher. Publishes unlimited edition offset lithographs and posters. Does not distribute previously published work. Clients: galleries, department stores, distributors, framers worldwide.

Needs Seeking creative and decorative art for the commercial market. Considers oil, acrylic, giclee, watercolor and mixed media. Art guidelines free for SASE with first-class postage. Artists represented include Martin Wiscombe, Mid Gordon, Tina Chaden, Nicky Boehme, Jennifer Wiley, Claudine Hellmuth, Diane Knott, Joseph Kiley, Brenda Walton, Gretchen Shannon, Craig Biggs. Editions created by collaborating with the artist. Approached by hundreds of artists/year. Publishes the work of 15 emerging, 10 mid-career and 10 established artists/year.

First Contact & Terms E-mail or send query letter with photocopies, photographs, tearsheets, slides and photo-

graphs to be kept on file. Samples returned by SASE only if requested. Portfolio review not required. Prefers to see slides or transparencies initially as samples, then reviews originals. Responds in 2 months. Appointments arranged only after work has been sent with SASE. Negotiates payment. Offers advance in some cases. Requires exclusive representation for prints/posters during period of contract. Provides advertising, in-transit insurance, insurance while work is at publisher, shipping from firm, promotion and a written contract. Artist owns original work. Finds artists through art and trade shows, magazines and submissions.

Tips "Please submit decorative, fine quality artwork. We prefer to work with artists who are creative, professional and open to art direction."

BRINTON LAKE EDITIONS

Box 888, Brinton Lake Rd., Concordville PA 19331-0888. (610)459-5252. Fax: (610)459-2180. E-mail: galleryone @mindspring.com. **President:** Lannette Badel. Estab. 1991. Art publisher, distributor, gallery. Publishes/distributes limited editions and canvas transfers. Clients: independent galleries and frame shops. Current clients include over 100 galleries, mostly East Coast.

Needs Seeking fashionable art. Considers oil, acrylic, watercolor, mixed media and pastel. Prefers realistic landscape and florals. Artists represented include Gary Armstrong and Lani Badel. Editions created by collaborating with the artist. Approached by 20 artists/year. Publishes/distributes the work of 1 emerging and 1 established artist/year.

First Contact & Terms Send query letter with samples. Samples are not filed and are returned. Responds in 2 months. Company will contact artist for portfolio review of final art, photographs, slides, tearsheets and transparencies if interested. Negotiates payment. Rights purchased vary according to project. Requires exclusive representation of artist.

Tips "Artists submitting must have good drawing skills no matter what medium used."

JOE BUCKALEW

1825 Annwicks Dr., Marietta GA 30062. (800)971-9530. Fax: (770)971-6582. E-mail: joesart@bellsouth.com. Website: www.joebuckalew.com. **Contact:** Joe Buckalew. Estab. 1990. Distributor and publisher. Distributes limited editions, canvas transfers, fine art prints and posters. Clients: 600-800 frame shops and galleries.

Needs Seeking creative, fashionable, decorative art for the serious collector. Considers oil, acrylic and watercolor. Prefers florals, landscapes, Civil War and sports. Artists represented include B. Sumrall, R.C. Davis, F. Buckley, M. Ganeck, D. Finley, Dana Coleman, Jim Booth, Sandra Roper, Jill Strickland, Cherrie Nute and Steven Gunter. Approached by 25-30 artists/year. Distributes work of 10 emerging, 10 mid-career and 50 established artists/year. Art guidelines free for SASE with first-class postage.

First Contact & Terms Send sample prints. Accepts disk submissions. "Please call. Currently using a 460 commercial computer." Samples are filed or are returned. Does not reply. Artist should call. To show portfolio, artist should follow up with call after initial query. Portfolio should include sample prints. Pays on consignment basis. Firm receives 50% commission paid net 30 days. Provides advertising on website, shipping from firm and company catalog. Finds artists through ABC shows, regional art & craft shows, frame shops, other artists.

Tips "Paint your own style."

🍁 CANADIAN ART PRINTS INC.

110-6311 Westminster Hwy., Richmond BC V7C 4V4 Canada. (800)663-1166 or (604)276-4551. Fax: (604)276-4552. E-mail: sales@canadianartprints.com. Website: www.canadianartprints.com. **Creative Director:** Niki Krieger. Estab. 1965. Art publisher/distributor. Publishes or distributes unlimited edition, fine art prints, posters and art cards. Clients: galleries, decorators, frame shops, distributors, corporate curators, museum shops, giftshops and manufacturing framers. Licenses all subjects of open editions for wallpaper, writing paper, placemats, books, etc.

Needs Seeking fashionable and decorative art for the commercial and designer markets. Considers oil, acrylic, watercolor, mixed media, pastel. Prefers representational florals, landscapes, marine, decorative and street scenes. Artists represented include Linda Thompson, Jae Dougall, Philip Craig, Joyce Kamikura, Kiff Holland, Victor Santos, Dubravko Raos, Don Li-Leger, Michael O'Toole and Will Rafuse. Editions created by collaborating with the artist and working from an existing painting. Approached by 300-400 artists/year. Publishes/distributes the work of more than 150 artists/year.

First Contact & Terms Send query letter with photographs, SASE, slides, tearsheets, transparencies. Samples are not filed and are returned by SASE. Responds in 1 month. Will contact artist for portfolio review of photographs, slides or transparencies if interested. Pays range of royalties. Buys reprint rights or negotiates rights purchased. Provides advertising, in-transit insurance, insurance while work is at firm, promotion, shipping and contract. Finds artists through art exhibitions, art fairs, word of mouth, art reps, submissions.

Tips "Keep up with trends by following decorating magazines."

CARMEL FINE ART PRODUCTIONS, LTD.

3489 N. Shepard Ave., Milwaukee WI 53211. (414)967-4994. Fax (414)967-4995. E-mail: carmelfineart@sbcglob al.net. Website: www.carmelprod.com. **Vice President Sales:** Louise Perrin. Estab. 1995. Art publisher/distributor. Publishes/distributes originals, limited and open edition fine art prints. Clients: galleries, corporate curators, distributors, frame shops, decorators.

Needs Seeking creative art for the serious collector, commercial and designer markets. Considers oil, acrylic, pastel. Prefers family-friendly abstract and figurative images. Artists represented include William Calhoun, Jon Jones, Okay Babs, G.L. Smothers, Anthony Armstrong, Woodrow Nash, Ted Ellis and Hector Anchundia. Editions created by collaborating with the artist and working from an existing painting. Approached by 10-20 artists/year. Publishes the work of 2-3 emerging, 1 mid-career and 2-3 established artists/year.

First Contact & Terms Send query letter with brochure, photographs. Samples are filed. Responds in 1 month. Will contact artist for portfolio review of final art, roughs if interested. Rights purchased vary according to project. Provides advertising, promotion, shipping from firm and contract. Finds artists through established networks.

Tips ''Be true to your creative callings and keep the faith.''

◼N◼ CARPENTREE, INC.

2724 N. Sheridan, Tulsa OK 74115. (918)582-3600. Fax: (918)587-4329. Website: www.carpentree.com. **Contact:** Marj Miller, product development. Estab. 1976. Wholesale framed art manufacturer. Distributes posters and unlimited edition. Clients: decorators, frame shops, galleries, gift shops and museum shops.

Needs Seeking decorative art for the commercial market. Considers acrylic, mixed media, oil, pastel, pen & ink, sculpture, watercolor and photography. Prefers traditional, family-oriented, Biblical themes, landscapes. Editions created by collaborating with the artist and by working from an existing painting. Approached by 50 artists/year.

First Contact & Terms Send photographs, SASE and tearsheets. Accepts e-mail submissions with link to website and image file. Prefers Windows-compatible, JPEG files. Samples are not filed, returned by SASE. Responds in 2 months. Portfolio not required. Negotiates payment. No advance. Negotiates rights purchased. Requires exclusive regional representation of artist. Provides advertising, promotion and written contract. Finds artists through art exhibits/fairs and artist's submissions.

CHALK & VERMILION FINE ARTS

55 Old Post Rd., #2, Greenwich CT 06830. (203)869-9500. Fax: (203)869-9520. E-mail: mail@chalk-vermilion.c om. Website: www.chalk-vermilion.com. **Contact:** Artist Submission Department. Estab. 1976. Art publisher. Publishes original paintings, handpulled serigraphs and lithographs, posters, limited editions and offset reproductions. Clients: 4,000 galleries worldwide.

Needs Publishes decorative art for the serious collector and the commercial market. Considers oil, mixed media, acrylic and sculpture. Artists represented include Thomas McKnight, Bruce Ricker and Fanny Brennan. Editions created by collaboration. Approached by 350 artists/year.

First Contact & Terms Send query letter with résumé and/or biography, contact information and slides or photographs. Samples are filed or are returned by SASE if requested by artist. Responds in 3 months. Publisher will contact artist for portfolio review if interested. Payment ''varies with artist, generally fees and royalties.'' Offers advance. Negotiates rights purchased. Prefers exclusive representation of artist. Provides advertising, intransit insurance, promotion, shipping to and from firm, insurance while work is at firm and written contract. Finds artists through exhibitions, trade publications, catalogs, submissions.

CIRRUS EDITIONS

542 S. Alameda St., Los Angeles CA 90013. (213)680-3473. Fax: (213)680-0930. E-mail: cirrus@cirrusgallery.c om. Website: www.cirrusgallery.com. **Owner:** Jean R. Milant. Produces limited edition handpulled originals. Clients: museums, galleries and private collectors.

Needs Seeking contemporary paintings and sculpture. Prefers abstract, conceptual work. Artists represented include Lari Pittman, Joan Nelson, John Millei, Charles C. Hill and Bruce Nauman. Publishes and distributes the work of 6 emerging, 2 mid-career and 1 established artists/year.

First Contact & Terms Prefers slides as samples. Samples are returned by SASE.

CLASSIC COLLECTIONS FINE ART

1 Bridge St., Irvington NY 10533. (914)591-4500. Fax: (914)591-4828. **Acquisition Manager:** Larry Tolchin. Estab. 1990. Art publisher. Publishes unlimited editions and offset reproductions. Clients: galleries, interior designers, hotels. Licenses florals, landscapes, animals for kitchen/bathroom.

Needs Seeking decorative art for the commercial and designer markets. Considers oil, acrylic, watercolor, mixed media and pastel. Prefers landscapes, still lifes, florals. Artists represented include Harrison Rucker, Henrietta

Milan, Sid Willis, Charles Zhan and Henry Peeters. Editions created by collaborating with the artist and by working with existing painting. Approached by 100 artists/year. Publishes the work of 6 emerging, 6 mid-career and 6 established artists/year.

First Contact & Terms Send slides and transparencies. Samples are filed. Responds in 3 months. Company will contact artist for portfolio review if interested. Offers advance when appropriate. Buys first and reprint rights. Provides advertising; insurance while work is at firm; and written contract. Finds artists through art exhibitions, fairs and competitions.

CLAY STREET PRESS, INC.

1312 Clay St., Cincinnati OH 45202. (513)241-3232. E-mail: mpginc@iac.net. Website: www.patsfallgraphics.com. **Contact:** Mark Patsfall, owner. Estab. 1981. Art publisher and contract printer. Publishes fine art prints, hand-pulled originals, limited edition. Clients: architects, corporate curators, decorators, galleries and museum print curators.

Needs Seeking serious collectors. Prefers conceptual/contemporary. Artists represented include Nam June Paik, Kay Rosen, Bill Allen, Bern Porter, Mark Fox. Editions created by collaborating with the artist. Publishes the work of 2-3 emerging artists/year.

First Contact & Terms Contact only through artist rep. Accepts e-mail submissions with image file. Prefers Mac-compatible JPEG files. Responds in 1 week. Negotiates payment. Negotiates rights purchased. Services provided depend on contract. Finds artists through art reps, galleries and word of mouth.

CLEARWATER PUBLISHING

161 MacEwan Ridge Circle NW, Calgary AB T3K 3W3 Canada. (403)295-8885. Fax: (403)295-8981. E-mail: clearwaterpublishing@shaw.ca. Website: www.clearwater-publishing.com. **Contact:** Laura Skorodenski. Estab. 1989. Art publisher. Handles canvas transfers, fine art prints and offset reproduction. Clients: decorators, frame shops, gift shops, galleries and museum shops.

Needs Seeking artwork for the serious collector and commercial market. Considers acrylic, watercolor, mixed media and oil. Prefers largely high realism or impressionistic works. Artists represented can be seen on website.

First Contact & Terms Accepts e-mail submissions with link to website and image file. Windows-compatible. Prefers JPEG. Samples are not filed. Samples not returned. Responds only if interested. Company will contact artist for portfolio review if interested. Portfolios should include slides. No advance. Requires exclusive representation of artist.

© Glenn Olson, courtesy of Clearwater Publishing

Clearwater Publishing produces limited-edition reproductions of Glenn Olson's work in prints, canvas transfers and giclee. Olson is not only a prolific and skilled painter, he has a great insight into what captures the imagination of art collectors. "Most people who choose art do so because of a certain feeling the art evokes. In each painting, I strive to create that magical element." This image of three lion cubs with an Agama Lizard, which Olson titled *African Explorer's Club*, certainly achieves those goals. Visit the publisher's website at www.clearwater-publishing. com for more of Olson's work.

THE COLONIAL ART CO.

1336 NW First St., Oklahoma City OK 73106. (405)232-5233. Fax: (405)232-6607. E-mail: info@colonialart.com. **Owner:** Willard Johnson. Estab. 1919. Publisher and distributor of offset reproductions for galleries. Clients: retail and wholesale. Current clients include Osburns, Grayhorse and Burlington.

Needs Artists represented include Felix Cole, Dennis Martin, John Walch and Leonard McMurry. Publishes the work of 2-3 emerging, 2-3 mid-career and 3-4 established artists/year. Distributes the work of 10-20 emerging, 30-40 mid-career and hundreds of established artists/year. Prefers realism and expressionism—emotional work.

First Contact & Terms Send sample prints. Samples not filed are returned only if requested by artist. Publisher/ distributor will contact artist for portfolio review if interested. Pays negotiated flat fee or royalties or on a consignment basis (firm receives 33% commission). Offers an advance when appropriate. Does not require exclusive representation of the artist. Considers buying second rights (reprint rights) to previously published work.

Tips "The current trend in art publishing is an emphasis on quality."

COLOR CIRCLE ART PUBLISHING, INC.

P.O. Box 190763, Boston MA 02119. (617)437-1260. Fax (617)437-9217. E-mail: t123@msn.com. Website: www.colorcircle.com. **Contact:** Bernice Robinson. Estab. 1991. Art publisher. Publishes limited editions, unlimited editions, fine art prints, offset reproductions, posters. Clients: galleries, art dealers, distributors, museum shops. Current clients include Deck the Walls, Things Graphics, Essence Art.

Needs Seeking creative, decorative art for the serious collector and the commercial market. Considers oil, acrylic, watercolor, mixed media, pastel, pen & ink. Prefers ethnic themes. Artists represented include Paul Goodnight, Essud Fungcap, Charly and Dorothea Palmer. Editions created by collaborating with the artist or by working from an existing painting. Approached by 12-15 artists/year. Publishes the work of 2 emerging, 1 mid-career artists/year. Distributes the work of 4 emerging, 1 mid-career artists/year.

First Contact & Terms Send query letter with slides. Samples are filed or returned by SASE. Responds in 2 months. Negotiates payment. Rights purchased vary according to project. Provides advertising, insurance while work is at firm, promotion, shipping from our firm and written contract. Finds artists through submissions, trade shows and word of mouth.

Tips "We like to present at least two pieces by a new artist that are similar in theme, treatment or colors."

CRAZY HORSE PRINTS

23026 N. Main St., Prairie View IL 60069. (847)634-0963. **Owner:** Margaret Becker. Estab. 1976. Art publisher and gallery. Publishes limited editions, offset reproductions and greeting cards. Clients: Native American art collectors.

Needs "We publish only Indian-authored subjects." Considers oil, pen & ink and acrylic. Prefers nature themes. Editions created by working from an existing painting. Approached by 10 artists/year. Publishes the work of 2 and distributes the work of 20 established artists/year.

First Contact & Terms Send résumé and photographs. Samples are filed. Responds only if interested. Publisher will contact artist for portfolio review if interested. Portfolio should include photographs and bio. Pays flat fee $250-1,500 or royalties of 5%. Offers advance when appropriate. Buys all rights. Provides promotion and written contract. Finds artists through art shows and submissions.

CREATIF LICENSING CORP.

31 Old Town Crossing, Mt. Kisco NY 10549-4030. (914)241-6211. E-mail: info@creatifusa.com. Website: www.c reatifusa.com. **Contact:** Marcie Silverman. Estab. 1975. Art licensing agency. Clients: manufacturers of gifts, stationery, toys and home furnishings.

- Creatif posts submission guidelines on its Web page www.creatifusa.com/about_creatif/Creatif_Submissio n_Guide1.html.

CUPPS OF CHICAGO, INC.

225 Stanley St., Elk Grove IL 60007. (847)593-5655. Fax: (847)593-5550. E-mail: cuppsofchicago@aol.com. **President:** Gregory Cupp. Estab. 1967. Art publisher and distributor of limited and open editions, offset reproductions and posters and original paintings. Clients: galleries, frame shops, designers and home shows.

- Pay attention to contemporary/popular colors when creating work for this design-oriented market.

Needs Seeking creative and decorative art for the commercial and designer markets. Also needs freelance designers. Artists represented include Gloria Rose and Rob Woodrum. Editions created by collaborating with the artist or by working from an existing painting. Considers oil and acrylic paintings in "almost any style— only criterion is that it must be well done." Prefers individual works of art. Approached by 150-200 artists/ year. Publishes and distributes the work of 25-50 emerging artists/year.

First Contact & Terms Send query letter with résumé, photographs, photocopies and tearsheets. Samples are

filed or are returned by SASE if requested. Responds only if interested. Company will contact artist for portfolio review of color photographs if interested. Negotiates payment. Rights purchased vary according to project. Provides advertising, promotion, shipping from firm, insurance while work is at firm.

Tips This distributor sees a trend toward traditional and the other end of the spectrum—contemporary. ''Please send in photos, original work, prints and photocopies in CD form.''

DARE TO MOVE

1117 Broadway, Suite 301, Tacoma WA 98402. (253)284-0975. Fax: (253)284-0977. E-mail: daretomove@aol.com. Website: www.daretomove.com. **President:** Steve W. Sherman. Estab. 1987. Art publisher, distributor. Publishes/distributes limited editions, unlimited editions, canvas transfers, fine art prints, offset reproductions. Licenses aviation and marine art for puzzles, note cards, book marks, coasters etc. Clients: art galleries, aviation museums, frame shops and interior decorators.

- This company has expanded from aviation-related artwork to work encompassing most civil service areas. Steve Sherman likes to work with artists who have been painting for 10-20 years. He usually starts off distributing self-published prints. If prints sell well, he will work with artist to publish new editions.

Needs Seeking naval, marine, firefighter, civil service and aviation-related art for the serious collector and commercial market. Considers oil and acrylic. Artists represented include John Young, Ross Buckland, Mike Machat, James Dietz, Jack Fellows, William Ryan, Patrick Haskett. Editions created by collaborating with the artist or working from an existing painting. Approached by 15-20 artists/year. Publishes the work of 1 emerging, 2-3 mid-career and established artists/year. Distributes the work of 9 emerging and 2-3 established artists/year.

First Contact & Terms Send query letter with photographs, slides, tearsheets and transparencies. Samples are filed or sometimes returned by SASE. Artist should follow up with call. Portfolio should include color photographs, transparencies and final art. Pays royalties of 10% commission of wholesale price on limited editions and 5% commission of wholesale price on unlimited editions. Buys one-time or reprint rights. Provides advertising, in-transit insurance, insurance while work is at firm, promotion, shipping from firm and written contract.

Tips ''Present your best work—professionally.''

DECORATIVE EXPRESSIONS, INC.

3595 Clearview Place, Atlanta GA 30340. (770)457-8008. Fax: (770)457-8018. **President:** Robert Harris. Estab. 1984. Distributor. Distributes original oils. Clients: galleries, designers, antique dealers.

Needs Seeking creative and decorative art for the designer market. Styles range from traditional to contemporary to impressionistic. Artists represented include Javier Mulio and Giner Bueno. Approached by 6 artists/year. Distributes the work of 1-4 emerging, 2-4 mid-career and 10-20 established artists/year.

First Contact & Terms Send photographs. Samples are returned by SASE if requested by artist. Responds back only if interested. Portfolios may be dropped off every Monday. Portfolio should include final art and photographs. Negotiates payment. Offers advance when appropriate. Negotiates rights purchased. Requires exclusive representation of artist. Provides advertising, in-transit insurance, promotion and distribution through sale force and trade shows. Finds artists through word of mouth, exhibitions, travel.

Tips ''The design market is a major source for placing art. We seek art that appeals to designers.''

DELJOU ART GROUP, INC.

1630 Huber St., Atlanta GA 30318. (404)350-7190. Fax: (404)350-7195. E-mail: submit@deljouartgroup.com. **Contact:** Art Director. Estab. 1980. Art publisher, distributor and gallery of limited editions (maximum 250 prints), handpulled originals, monoprints/monotypes, sculpture, fine art photography, fine art prints and paintings on paper and canvas. Clients: galleries, designers, corporate buyers and architects. Current clients include Coca Cola, Xerox, Exxon, Marriott Hotels, General Electric, Charter Hospitals, AT&T and more than 3,000 galleries worldwide, ''forming a strong network throughout the world.''

Needs Seeking creative, fine and decorative art for the designer market and serious collectors. Considers oil, acrylic, pastel, sculpture and mixed media. Artists represented include Yunessi, T.L. Lange, Michael Emani, Vincent George, Nela Soloman, Alterra, Ivan Reyes, Mindeli, Sanford Wakeman, Niri Vessali, Lee White, Alexa Kelemen, Bika, Kamy, Craig Alan, Roya Azim, Jian Chang, Elya DeChino, Antonio Dojer and Mia Stone. Editions created by collaborating with the artist. Approached by 300 artists/year. Publishes the work of 10 emerging, 20 mid-career artists/year and 20 established artists/year.

First Contact & Terms Send query letter with photographs, slides, brochure, photocopies, tearsheets, SASE and transparencies. Prefers contact and samples via e-mail submit@deljouartgroup.com. Samples not filed are returned only by SASE. Responds in 6 months. Will contact artist for portfolio review if interested. Payment method is negotiated. Offers an advance when appropriate. Negotiates rights purchased. Requires exclusive representation. Provides promotion, a written contract and advertising. Finds artists through visiting galleries, art fairs, word of mouth, World Wide Web, art reps, submissions, art competitions and sourcebooks. Pays highest royalties in the industry.

Tips "We need landscape artists, monoprint artists, strong figurative artists, sophisticated abstracts and soft-edge abstracts. We are also beginning to publish sculptures and are interested in seeing slides of such. We have had a record year in sales and have recently relocated again into a brand new gallery, framing and studio complex. We also have the largest gallery in the country. We have added a poster division and need images in different categories for our poster catalogue as well."

DIRECTIONAL PUBLISHING, INC.

2812 Commerce Square E., Birmingham AL 35210. (205)951-1965. Fax: (205)951-3250. E-mail: customerservice @dp1.com. Website: www.directionalart.com. **President:** David Nichols. Art Director: Tony Murray. Estab. 1986. Art publisher. Publishes limited and unlimited editions, offset reproductions, contemporary and coastal. Clients: galleries, frame shops and picture manufacturers. Licenses decorative stationery, rugs, home products.
Needs Seeking decorative art for the designer market. Considers oil, watercolor, acrylic and pastel. Prefers casual designs in keeping with today's interiors. Artists represented include A. Kamelhair, H. Brown, R. Lewis, L. Brewer, S. Cairns, N. Strailey, D. Swartzendruber, D. Nichols, M.B. Zeitz and N. Raborn. Editions created by working from an existing painting. Approached by 50 artists/year. Publishes and distributes the work of 5-10 emerging, 5-10 mid-career and 3-5 established artists/year.
First Contact & Terms Send query letter with slides and photographs or digital disc. Samples are not filed and are returned by SASE. Responds in 3 months. Pays royalties. Buys all rights. Provides in-transit insurance, insurance while work is at firm, promotion, shipping from firm and written contract.
Tips "Always include SASE. Do not follow up with phone calls. All work published is first of all *decorative.* The application of artist-designed borders to artwork can sometimes greatly improve the decorative presentation. We follow trends in the furniture/accessories market. Aged and antiqued looks are currently popular—be creative! Check out what's being sold in home stores for trends and colors."

DODO GRAPHICS, INC.

145 Cornelia St., P.O. Box 585, Plattsburgh NY 12901. (518)561-7294. Fax: (518)561-6720. **Manager:** Frank How. Art publisher of offset reproductions, posters and etchings for galleries and frame shops.
Needs Considers pastel, watercolor, tempera, mixed media, airbrush and photographs. Prefers contemporary themes and styles. Prefers individual works of art, 16×20 maximum. Publishes the work of 5 artists/year.
First Contact & Terms Send query letter with brochure showing art style or photographs, slides or CD ROM. Samples are filed or are returned by SASE. Responds in 3 months. Write for appointment to show portfolio of original/final art and slides. Payment method is negotiated. Offers an advance when appropriate. Buys all rights. Requires exclusive representation of the artist. Provides written contract.
Tips "Do not send any originals unless agreed upon by publisher."

DOLICE GRAPHICS

649 East 9th St., Suite C2, New York NY 10009. (212)529-2025. Fax: (212)260-9217. E-mail: joe@dolice.com. Website: www.dolice.com. **Contact:** Joe Dolice, publisher. Estab. 1968. Art publisher. Publishes fine art prints, limited edition, offset reproduction, unlimited edition. Clients: architects, corporate curators, decorators, distributors, frame shops, galleries, gift shops and museum shops. Current clients include Bloomingdale's (Federated Dept. Stores).
Needs Seeking decorative, representational, antiquarian "type" art for the commercial and designer markets. Considers acrylic, mixed media, pastel, pen & ink, prints (intaglio, etc.) and watercolor. Prefers traditional, decorative, antiquarian type. Editions created by collaborating with the artist and working from an existing painting. Approached by 12-20 artists/year.
First Contact & Terms Send query letter with color photocopies, photographs, résumé, SASE, slides and transparencies. Samples are returned by SASE or not returned. Responds only if interested. Company will contact artist for portfolio review if interested. Negotiates payment. Buys all rights on contract work. Rights purchased vary according to project. Provides free website space and promotion and written contract. Finds artists through art reps and artist's submissions.
Tips "We publish replicas of antiquarian-type art prints for decorative arts markets and will commission artists to create "works for hire" in the style of pre-century artists and occasionally to color black & white engravings, etchings, etc. Artists interested should be well schooled and accomplished in traditional painting and printmaking techniques and should be able to show samples of this type of work if we contact them."

EDELMAN FINE ARTS, LTD.

141 W. 20th St., Third Floor, New York NY 10011-3601. (646)336-1104. E-mail: artprices@aol.com. Website: www.hheatheredelmangallery.com. **Vice President:** H. Heather Edelman. Art distributor of original acrylic and oil paintings. "Additional company distributes works of art on paper, sculptures, blown glass, tapestry and unique objects d' Art." Clients: galleries, dealers, consultants, interior designers and furniture stores worldwide.

● The mainstream art market is demanding traditional work with great attention to detail. Impressionism is still in vogue but with a cutting edge to it, with strong colors; Madonna & Child old world, high quality landscapes; woman and woman-and-children in all techniques needed. Abstracts with an image.

Needs Seeking creative and decorative art for the serious collector and designer markets. Considers oil and acrylic paintings, watercolor, sculpture and mixed media. Artists represented include Marc Chagall, Joan Miro and Pablo Picasso. Distributes the work of 150 emerging, 70 mid-career and 150 established artists.

First Contact & Terms Send six 3×5 photos of your best work (no slides), résumé, tearsheets. Slides are not returned. Samples are filed. Call before dropping off portfolios. You can also e-mail a link to your website. Portfolio should include bio, exhibition history, price of work, photographs and/or original/final art. Responds as soon as possible. Pays royalties of 40% on works on consignment basis, 20% commission for trade sales; 50/50 retail. Buys all rights. Provides in-transit insurance, insurance while work is at firm, promotion and shipping from firm.

Tips "Know what's salable and available in the marketplace."

EDITIONS LIMITED GALLERIES, INC.

4090 Halleck St., Emeryville CA 94608. (510)923-9770. Fax: (510)923-9777. e-mail submissions@editionslimited.com. Website: www.editionslimited.com. **Director:** Todd Haile. Art publisher and distributor of limited edition graphics and fine art posters. Clients: contract framers, galleries, framing stores, art consultants and interior designers.

Needs Seeking art for the original and designer markets. Considers oil, acrylic and watercolor painting, monoprint, monotype, photography and mixed media. Prefers landscape, floral and abstract imagery. Editions created by collaborating with the artist or by working from existing works.

First Contact & Terms Send query letter with résumé, slides and photographs or JPEG files (8" maximum at 72 dpi) via e-mail at website. Samples are filed or are returned by SASE. Responds in 2 months. Publisher/distributor will contact artist for portfolio review if interested. Payment method is negotiated. Negotiates rights purchased.

Tips "We deal both nationally and internationally, so we need art with wide appeal. When sending slides or photos, send at least six so we can get an overview of your work. We publish artists, not just images."

ENCORE GRAPHICS & FINE ART

P.O. Box 18846, Huntsville AL 35804. (800)248-9240. E-mail: encore@randenterprises.com. Website: www.egart.com. **President:** J. Rand, Jr. Estab. 1995. Poster company, art publisher, distributor. Publishes/distributes limited edition, unlimited edition, fine art prints, offset reproduction, posters. Clients: galleries, frame shops, distributors.

Needs Creative art for the serious collector. Considers all media. Prefers African-American and abstract. Art guidelines available on company's website. Artists represented include Greg Gamble, Tim Hinton, Mario Robinson, Lori Goodwin, Wyndall Coleman, T.H. Waldman, John Will Davis, Burl Washington, Henry Battle, Cisco Davis, Delbert Iron-Cloud, Gary Thomas and John Moore. Also Buffalo Soldier Prints and historical military themes. Editions created by working from an existing painting. Approached by 15 artists/year. Publishes the work of 3 emerging artists, 1 mid-career artist/year. Distributes the work of 3 emerging, 2 mid-career and 3 established artists/year.

First Contact & Terms Send photocopies, photographs, résumé, tearsheets. Samples are filed. Responds only if interested. Company will contact artist for portfolio review of color, photographs, tearsheets if interested. Negotiates payment. Offers advance when appropriate. Requires exclusive representation of artist. Provides advertising, in-transit insurance, insurance while work is at firm, promotion, shipping from firm, written contract. Finds artists through the World Wide Web and art exhibits.

Tips "Prints of African-Americans with religious themes or children are popular now. Paint from the heart."

FAIRFIELD ART PUBLISHING

87 35th Street, 3rd Floor, Brooklyn NY 11232. (800)835-3539. **Vice President:** Peter Lowenkron. Estab. 1996. Art publisher. Publishes posters, unlimited editions and offset reproductions. Clients: galleries, frame shops, museum shops, decorators, corporate curators, giftshops, manufacturers and contract framers.

Needs Decorative art for the designer and commercial markets. Considers collage, oil, watercolor, pastel, pen & ink, acrylic. Artists represented include Daniel Pollera, Roger Vilarchao, Yves Poinsot.

First Contact & Terms Send query letter with slides and brochure. Samples are returned by SASE if requested by artist. Responds only if interested. Pays flat fee, $400-2,500 maximum, or royalties of 7-15%. Offers advance when appropriate. Rights purchased vary according to project. Interested in buying second rights (reprint rights) to previously published artwork.

Tips "If you don't think you're excellent, wait until you have something excellent. Posters are a utility, they go somewhere specific, so images I use fit somewhere—over the couch, kitchen, etc."

FLYING COLORS, INC.

3434 Overland Ave., Los Angeles CA 90034. (800)937-3436 or (310)204-4182. Fax: (310)204-5318. E-mail: joe@flying-colors.net. Website: www.flying-colors.net. **Contact:** Joe McCormick, president. Estab. 1993. Poster company and art publisher. Publishes unlimited edition, fine art prints, posters. Clients: galleries, frame shops, distributors, museum shops, giftshops, mail order, end-users, retailers, chains, direct mail.

Needs Seeking decorative art for the commercial market. Considers oil, acrylic, watercolor, mixed media, pastel. Prefers multicultural, religious, inspirational wildlife, Amish, country, scenics, still life, American culture. Also needs freelancers for design. Prefers designers who own Mac computers. Artists represented include Greg Gorman, Deidre Madsen. Editions created by collaborating with the artist or by working from an existing painting. Approached by 200 artists/year. Publishes the work of 20 emerging, 5-10 mid-career, 1-2 established artists/year.

First Contact & Terms May contact via e-mail or send photocopies, photographs, SASE, slides, transparencies. Accepts disk submissions if compatible with SyQuest, Dat, Jazzy, ZIP, QuarkXPress, Illustrator, Photoshop or FreeHand. Samples are filed or returned by SASE. Responds only if interested. Artist should follow-up with call to show portfolio. Portfolio should include color, photographs, roughs, slides, transparencies. Negotiates payment. Offers advance when appropriate. Negotiates rights purchased, all rights preferred. Provides advertising, promotion, written contract. Finds artists through attending art exhibitions, art fairs, word of mouth, artists' submissions, clients, local advertisements.

Tips ''Ethnic and inspirational/religious art is very strong. Watch the furniture industry. Come up with themes, sketches and series of at least two pieces. Art has to work on 8×10, 16×20, 22×28, 24×36, greeting cards and other possible mediums.''

FORTUNE FINE ART

2908 Oregon Ct., #G3, Torrance CA 90503. (310)618-1231. Fax: (310)618-1232. E-mail: carolv@fortunefa.com. Website: www.fortunefa.com. **Contact:** Carol J. Vidic, President. Licensing: Peter Iwasaki. Publishes fine art prints, hand-pulled serigraphs, originals, limited edition, offset reproduction, posters and unlimited edition. Clients: art galleries, dealers and designers.

Needs Seeking creative art for the serious collector. Considers oil on canvas, acrylic on canvas, mixed media on canvas and paper. Artists represented include John Powell, Daniel Gerhartz, Marilyn Simandle and Don Hatfield. Publishes and distributes the work of a varying number of emerging artists/year.

First Contact & Terms Send query letter with résumé, slides, photographs, transparencies, biography and SASE. Samples are not filed. Responds in 1 month. To show a portfolio, mail appropriate materials. Payment method and advances are negotiated. Prefers exclusive representation of artist. Provides in-transit insurance, insurance while work is at firm, promotion and written contract.

Tips ''Establish a unique style, look or concept before looking to be published.''

N FRONT LINE ART PUBLISHING

165 Chub Ave., Lyndhurst NJ 07071. (201)842-8500. Fax: (201)842-8546. Website: www.theartpublishinggroup .com. **Creative Director:** Rachael Cronin. Estab. 1981. Publisher of posters, prints, offset reproductions and limited editions. Clients: galleries, frame shops, gift shops and corporate curators.

Needs Seeking creative and decorative art reflecting popular trends for the commercial and designer markets. Also needs freelancers for design. Considers oil, acrylic, pastel, pen & ink, watercolor and mixed media. Prefers contemporary interpretations of landscapes, seascapes, florals, abstracts and African-American subjects. Artists represented include Hannum, Graves, Van Dyke and Cacalono. Editions created by working from an existing painting or by collaborating with the artist. Approached by 300 artists/year. Publishes the work of 40 artists/ year.

First Contact & Terms Send query letter with brochure, photocopies, photographs, tearsheets and slides. Samples not filed are returned by SASE. Responds in 1 month if interested. Company will contact artist for portfolio review of photographs and slides if interested. Payment method is negotiated; royalty based contracts. Requires exclusive representation of the artist. Provides advertising, promotion, written contract and insurance while work is at firm.

Tips ''Front Line Art Publishing is looking for artists who are flexible and willing to work to develop art that meets the specific needs of the print and poster marketplace. We actively seek out new art and artists on an ongoing basis.''

FUNDORA ART STUDIO

205 Camelot Drive, Tavernier FL 33070. (305)852-1516. Fax: (305)853-0345. E-mail: thomasfund@aol.com. **Director:** Manny Fundora. President: Thomas Fundora. Estab. 1987. Art publisher/distributor/gallery. Publishes limited edition fine art prints. Clients: galleries, decorators, frameshops. Current clients include Ocean Reef Club, Paul S. Ellison.

Needs Seeking creative and decorative art for the serious collector. Considers oil, watercolor, mixed media. Prefers nautical, maritime, tropical. Artists represented include Tomas Fundora, Gaspel, Juan A. Carballo, Carlos Sierra. Editions created by collaborating with the artist and working from an existing painting. Approached by 15 artists/year. Publishes/distributes the work of 2 emerging, 1 mid-career and 3 established artists/year.

First Contact & Terms Send query letter with brochure, photographs, slides or printed samples. Samples are filed. Will contact artist for portfolio review if interested. Pays royalties. Buys first rights. Requires exclusive representation of artist in US. Provides advertising and promotion. Also works with freelance designers.

Tips "Trends to watch: tropical sea and landscapes."

N. G.C.W.A.P. INC.

12075 Marina Loop, West Yellowstone MT 59758. (406)646-9551. Fax: (406)646-9552. E-mail: GCWAP@wyello wstone.com. **Executive Vice President:** Cindy Carter. Estab. 1980. Publishes limited edition art. Clients: galleries and individuals.

Needs Seeking art for the serious collector and commercial market. Considers oil and pastel. Prefers western, wildlife and train themes. Artists represented include Gary Carter, Arlene Hooker Fay, Jim Norton. Editions created by collaborating with the artist. Approached by 10-20 artists/year. Publishes/distributes the work of 3 established artists/year.

First Contact & Terms Send query letter with photographs, résumé and transparencies. Samples are returned. Responds in 1 month. Company will contact artists for portfolio review if interested. Negotiates payment. Buys reprint rights. Requires exclusive representation of artist. Provides advertising.

GALAXY OF GRAPHICS, LTD.

20 Murray Hill Pkwy., Suite 160, East Rutherford NJ 07073-2180. (201)806-2100. Fax: (201)806-2050. E-mail: christine.gaccione@kapgog.com. Website: www.galaxyofgraphics.com. **Art Director:** Christine Gaccione. Estab. 1983. Art publisher and distributor of unlimited editions. Licensing handled by Colleen Buchweitz. Clients: galleries, distributors and picture frame manufacturers.

Needs Seeking creative, fashionable and decorative art for the commerical market. Artists represented include Richard Henson, Betsy Brown, John Butler, Charlene Olson, Ros Oesterle, Joyce Combs, Christa Kieffer, Ruane Manning and Carol Robinson. Editions created by collaborating with the artist or by working from an existing painting. Considers any media. "Any currently popular and generally accepted themes." Art guidelines free for SASE with first-class postage. Approached by several hundred artists/year. Publishes and distributes the work of 20 emerging and 20 mid-career and established artists/year.

First Contact & Terms Send query letter with résumé, tearsheets, slides, photographs and transparencies. Samples are not filed and are returned by SASE. Responds in 2 weeks. Call for appointment to show portfolio. Pays royalties of 10%. Offers advance. Buys rights only for prints and posters. Provides insurance while material is in-house and while in transit from publisher to artist/photographer. Provides written contract to each artist.

Tips "There is a trend of strong jewel-tone colors and spice-tone colors. African-American art very needed."

ROBERT GALITZ FINE ART & ACCENT ART

(formerly Robert Galitz Fine Art), 166 Hilltop Lane, Sleepy Hollow IL 60118-1816. (847)426-8842. Fax: (847)426-8846. Website: www.galitzfineart.com. **Owner:** Robert Galitz. Estab. 1986. Distributor of fine art prints, hand-pulled originals, limited editions, monoprints, monotypes and sculpture. Clients: architects and galleries.

 ● See also listing in Galleries.

Needs Seeking creative, decorative art for the commercial and designer markets. Considers acrylic, mixed media, oil, sculpture and watercolor.

First Contact & Terms Send query letter with brochure, SASE, slides and photographs. Samples are not filed and are returned by SASE. Responds in 1 month. Company will contact artist for portfolio review if interested. Pays flat fee. No advance. Rights purchased vary according to project. Finds artists through art fairs and submissions.

GALLERIA FINE ARTS & GRAPHICS

1011 Beecher St., San Leandro CA 94577. (510)639-0388. Fax: (510)639-0688. Website: www.galleriavases.com. **Director:** Thomas Leung. Estab. 1985. Art publisher/distributor. Publishes/distributes limited editions, open editions, canvas transfers, fine art prints, offset reproductions, posters.

Needs Seeking creative, decorative art for the serious collector and the commercial market. Considers oil, acrylic, watercolor. Editions created by collaborating with the artist or by working from an existing painting. Approached by 50 artists/year.

First Contact & Terms Send query letter with photographs. Samples are filed. Responds only if interested. Company will contact artist for portfolio review of color photographs, slides, transparencies if interested. Negotiates payment. Buy all rights. Requires exclusive representation of artist. Provides advertising, in-transit insur-

ance, insurance while work is at firm, promotion, shipping to and from our firm, written contract.
Tips ''Color/composition/subject are important.''

GALLERY GRAPHICS
20136 St. Highway 59, Noel MO 64854. (417)475-6191. Fax: (417)475-3542. E-mail: info@gallerygraphics.com. Website: www.gallerygraphics.com. Estab. 1980. Wholesale producer and distributor of prints, cards, sachets, stationery, calendars, framed art, stickers. Clients: frame shops, craft shops, florists, pharmacies and gift shops.
Needs Seeking art with nostalgic look, country, Victorian, children, angels, florals, landscapes, animals—nothing abstract or non-representational. Considers oil, watercolor, mixed media, pastel and pen & ink. 10% of editions created by collaborating with artist. 90% created by working from an existing painting. Artists include Barbara Mock, Glynda Turley, Sandra Kuck and Laurie Korsaden.
First Contact & Terms Send query letter with brochure showing art style and tearsheets. Designers send photographs, photocopies and tearsheets. Accepts disk submissions compatible with IBM or Mac. Samples are filed or are returned by SASE. Responds in 2 months. To show portfolio, mail finished art samples, color tearsheets. Can buy all rights or pay royalties. Provides a written contract.
Tips '' Please submit artwork on different subjects and styles. Some artists do certain subjects particularly well, but you don't know if they can do other subjects. Don't concentrate on just one area. Don't limit yourself, or you could be missing out on some great opportunities.''

GANGO EDITIONS, INC.
351 NW 12th Ave., Portland OR 97209. (503)223-9694. Fax: (503)223-0925. E-mail: info@gangoeditions.com. Website: www.gangoeditions.com. **Contact:** Debi Gango, art director. Estab. 1977. Art publisher/distributor. Publishes/distributes offset reproduction and posters. Clients: contract framers, architects, decorators, distributors, frame and gift shops, and galleries.
Needs Seeking decorative art for the commercial and designer markets. Considers oil, watercolor, acrylic, pastel, mixed media. Prefers art that follows current trends and colors. Artists represented include Amy Melious and Pamela Gladding. Editions created by working from an existing painting or other artwork and by collaborating with the artist. Publishes and distributes the work of 70 emerging artists/year.
First Contact & Terms Send query letter with slides, SASE, tearsheets, transparencies and/or photographs. e-mail submissions accepted with link to website or image file. Prefers Windows-compatible JPEG files. Samples returned by SASE. Artist is contacted by mail. Responds in 6 weeks. Company will contact artist for portfolio review if interested. Portfolio should include b&w and color finished, original art, photographs, slides or transparencies. Pays royalties of 10%. Requires exclusive representation of artist. Buys first rights and reprint rights. Provides advertising, in-transit insurance, insurance while work is at firm, promotion, shipping from our firm and written contract. Finds artists through art exhibits/fairs, art reps, artist's submissions, Internet and word of mouth.
Tips ''We require work that can be done in pairs. Artist may submit a single but must have a mate available if piece is selected. To be a pair, the works must both be horizontal or vertical. Palette must be the same. Perspective the same. Content must coordinate.''

GEME ART INC.
209 W. Sixth St., Vancouver WA 98660. (360)693-7772. Fax: (360)695-9795. E-mail: help@gemeart.com. **Art Director:** Merilee Will. Estab. 1966. Art publisher. Publishes fine art prints and reproductions in unlimited and limited editions. Clients: galleries, frame shops, art museums. Licenses designs.
Needs Considers oil, acrylic, watercolor and mixed media. ''We use a variety of styles from realistic to whimsical, catering to ''Mid-America art market.'' Artists represented include Lois Thayer, Crystal Skelley, Steve Nelson.
First Contact & Terms Send color slides, photos or brochure. Include SASE. Publisher will contact artist for portfolio review if interested. Simultaneous submissions OK. Payment on a royalty basis. Purchases all rights. Provides promotion, shipping from publisher and contract.
Tips ''We have added new sizes and more artists to our lines since last year.''

GLEEDSVILLE ART PUBLISHERS
5 W. Loudoun St., Leesburg VA 20175. (703)771-8055. Fax: (703)771-0225. E-mail: buyart@gleedsvilleart.com. Website: www.gleedsvilleart.com. **Contact:** Lawrence J. Thomas, president. Estab. 1999. Art publisher and gallery. Publishes and/or distributes fine art prints and limited edition. Clients: decorators, distributors, frame shops and galleries.
Needs Seeking decorative art for the serious collector, commercial and designer markets. Considers acrylic, mixed media, oil, pastel, pen & ink and watercolor. Prefers impressionist, landscapes, figuratives, city scenes,

realistic and whimsical. Artists represented include Antony Andrews, Lillian D. August, Grant Hacking, and Bill Schmidt. Editions created by collaborating with the artist.

First Contact & Terms Send photographs, slides, tearsheets, transparencies and URL. Accepts e-mail submissions with link to website. Prefers Windows-compatible, JPEG files. Samples are filed or returned. Responds in 3 months. Company will contact artist for portfolio review if interested. Portfolio should include original art, slides, tearsheets, thumbnails and transparencies. Pays royalties. Negotiates rights purchased. Requires exclusive representation of artist. Provides advertising, promotion, shipping from our firm and written contract. Finds artists through art competitions, art exhibits/fairs, artist's submissions and word of mouth.

GRAPHIQUE DE FRANCE

9 State St., Woburn MA 01801. (781)935-3405. Fax: (781)935-5145. E-mail: artworksubmissions@graphiquedefr ance.com. Website: www.graphiquedefrance.com. **Contact:** Licensing Department. Estab. 1979. Manufacturer of fine art, photographic and illustrative greeting cards, notecard gift boxes, posters and calendars. Clients: galleries, foreign distributors, museum shops, high-end retailers, book trade, museum shops.

First Contact & Terms Artwork may be submitted in the form of slides, transparencies or high-quality photocopies. Please do not send original artwork. Please allow 2 months for response. SASE is required for any submitted material to be returned.

Tips "It's best not to insist on speaking with someone at a targeted company prior to submitting work. Let the art speak for itself and follow up a few weeks after submitting."

☑ RAYMOND L. GREENBERG ART PUBLISHING

116 Costa Rd. Highlands NY 12528. (845)883-4220. Fax: (845)883-4122. E-mail: info@raymondlgreenberg.com. Website: www.raymondlgreenberg.com. **Owner:** Ray Greenberg. Licensing: Ray Greenberg. Estab. 1995. Art publisher. Publishes unlimited edition fine art prints for major framers and plaque manufacturers. Licenses inspirational, ethnic, Victorian, kitchen and bath artwork for prints for wall decor. Clients include Crystal Art Galleries, North American Art.

Needs Seeking decorative artwork in popular styles for the commercial and mass markets. Considers oil, acrylic, watercolor, mixed media, pastel and pen & ink. Prefers inspirational, ethnic, Victorian, nostalgic, country, floral and religious themes. Art guidelines free for SASE with first-class postage. Artists represented include Barbara Lanza, David Tobey, Diane Viera, Robert Daley and Marilyn Rea. Editions created by collaborating with the artist and/or working from an existing painting. Approached by 35 artists/year. Publishes 7 emerging, 13 mid-career and 5 established artists/year.

First Contact & Terms Send query letter with photographs, slides, SASE; "any good, accurate representation of your work." Samples are filed or returned by SASE. Responds in 6 weeks. Company will contact artist for portfolio review if interested. Pays flat fee $50-200 or royalties of 5-7%. Offers advance against royalties when appropriate. Buys all rights. Prefers exclusive representation. Provides insurance, promotion, shipping from firm and contract. Finds artists through word of mouth.

Tips "Versatile artists who are willing to paint for the market can do very well with us. Be flexible and patient."

THE GREENWICH WORKSHOP, INC.

151 Main St., P.O. Box 231, Seymour CT 06483. Website: www.greenwichworkshop.com. **Contact:** Artist Selection Committee. Art publisher and gallery. Publishes limited and open editions, offset reproductions, fine art lithographs, serigraphs, canvas reproductions and fine art porcelains and books. Clients: independent galleries in US, Canada and United Kingdom.

Needs Seeking creative, fashionable and decorative art for the serious collector, commercial and designer markets. Considers oil, watercolor, mixed media, pastel and acrylic. Considers all but abstract. Artists represented include James C. Christensen, Howard Terpning, James Reynolds, James Bama, Bev Doolittle, Scott Gustafson, Braldt Bralds. Editions created by collaborating with the artist or by working from an existing painting. Approached by 100 artists/year. Publishes the work of 4-5 emerging, 15 mid-career and 25 established artists. Distributes the work of 4-5 emerging, 15 mid-career and 25 established artists/year.

First Contact & Terms Send query letter with brochure, slides, photographs, SASE and transparencies. Samples are not filed and are returned by SASE. Responds in 3 months. Publisher will contact artist for portfolio review if interested. Portfolio should include final art, tearsheets, photographs, slides and transparencies. Pays royalties. No advance. Rights purchased vary according to project. Requires exclusive representation of artist. Provides advertising, insurance while work is at firm, promotion, shipping to and from firm, and written contract. Finds artists through art exhibits, submissions and word of mouth.

GREGORY EDITIONS

13003 Southwest Freeway, Suite 180, Stafford TX 77477. (800)288-2724. Fax: (281)494-4755. E-mail: mleace@a ol.com. **President:** Mark Eaker. Estab. 1988. Art publisher and distributor of originals, limited editions, seri-

graphs and bronze sculptures. Licenses variety art for Texture Touch™ canvas reproduction. Clients: Retail art galleries.

Needs Seeking contemporary, creative artwork. Considers oil and acrylic. Open to all subjects and styles. Artists represented include G. Harvey, JD Challenger, Stan Solomon, James Talmadge, Denis Paul Noyer, Liliana Frasca, Michael Young, James Christensen, Gary Ernest Smith, Douglas Hofmann, Alan Hunt, Joy Kirton-Smith, BH Brody, Nel Whatmore, Larry Dyke, Tom DuBois, Michael Jackson, Robert Heindel and sculptures by Ting Shao Kuang and JD Challenger. Editions created by working from an existing painting. Publishes and distributes the work of 50 emerging, 20 mid-career and 25 established artists/year.

First Contact & Terms Send query letter with brochure or slides showing art style. Call for appointment to show portfolio of photographs and transparencies. Purchases paintings outright; pays percentage of sales. Negotiates payment on artist-by-artist basis based on flat negotiated fee per visit. Requires exclusive representation of artist.

GUILDHALL, INC.

P.O. Box 136550, Fort Worth TX 76136. (800)356-6733. Fax (817)236-0015. E-mail: westart@guildhall.com. Website: www.guildhall.com. **President:** John M. Thompson III. Art publisher/distributor of limited and unlimited editions, offset reproductions and handpulled originals for galleries, decorators, offices and department stores. Current clients include over 500 galleries and collectors nationwide.

Needs Seeking creative art for the serious and commercial collector and designer market. Considers pen & ink, oil, acrylic, watercolor, and bronze and stone sculptures. Prefers historical Native American, Western, equine, wildlife, landscapes and religious themes. Prefers original works of art. Over past 25 years have represented over 50 artists in printing and licensing work. Editions created by collaborating with the artist and by working from existing art. Approached by 150 artists/year.

First Contact & Terms Send query letter with résumé, tearsheets, photographs, slides and 4×5 transparencies or electronic file, preferably cowboy art in photos or printouts. Samples are not filed and are returned only if requested. Responds in 1 month. Payment options include paying a flat fee for a single use; paying 10-20% royalties for multiple images; paying 35% commission on consignment. Negotiates rights purchased. Requires exclusive representation for contract artists. Provides insurance while work is at firm.

Tips "The new technologies in printing are changing the nature of publishing. Self-publishing artists have flooded the print market. Printing is the easy part. Selling it is another problem. Many artists, in order to sell their work, have to price it very low. In many markets this has caused a glut. Some art would be best served if it was only one of a kind. There is no substitute for scarcity and quality."

HADDAD'S FINE ARTS INC.

3855 E. Miraloma Ave., Anaheim CA 92806. (714)996-2100. Website: www.haddadsfinearts.com. **President:** Paula Haddad. Art Director: Beth Hedstrom. Estab. 1953. Art publisher and distributor. Produces unlimited edition offset reproductions and posters. Clients: galleries, art stores, museum stores and manufacturers. Sells to the trade only—no retail.

Needs Seeking creative and decorative art for the commercial and designer markets. Prefers traditional, realism with contemporary flair; unframed individual works and pairs; all media including photography. Editions created by collaborating with the artist or by working from an existing painting. Approached by 200-300 artists/year. Publishes the work of 10-15 emerging artists/year. Also uses freelancers for design. 20% of projects require freelance design. Design demands knowledge of QuarkXPress and Illustrator.

First Contact & Terms Illustrators: Send query letter with brochure, transparencies, slides, photos representative of work for publication consideration. Include SASE. Designers: Send query letter explaining skills. Responds in 3 months. Publisher/distributor will contact artist for portfolio review if interested. Portfolio should include slides, roughs, final art, transparencies. Pays royalties quarterly, 10% of base net price. Rights purchased vary according to project. Provides advertising and written contract.

Ⓝ HADLEY HOUSE PUBLISHING

1157 Valley Park Dr., Suite 130, Shakopee MN 55379. (952)943-8474. Fax: (952)943-8098. Website: www.hadley licensing.com.or www.hadleyhouse.com. **Director of Art Publishing:** Lisa Laliberte Belak. Licensing: Gary Schmidt. Estab. 1974. Art publisher, distributor and 30 retail galleries. Publishes and distributes canvas transfers, fine art prints, giclées, limited and unlimited editions, offset reproductions and posters. Licenses all types of flat art. Clients: wholesale and retail.

Needs Seeking artwork with creative artistic expression and decorative appeal. Considers oil, watercolor, acrylic, pastel and mixed media. Prefers wildlife, florals, landscapes, figurative and nostalgic Americana themes and styles. Art guidelines free for SASE with first-class postage. Artists represented include Nancy Howe, Steve Hamrick, Cha Ilyong, Sueellen Ross, Larry Chandler, Collin Bogle, Lee Bogle, Adele Earnshaw and Bruce Miller. Editions created by collaborating with artist and by working from an existing painting. Approached by 200-300

artists/year. Publishes the work of 3-4 emerging, 15 mid-career and 8 established artists/year. Distributes the work of 1 emerging and 4 mid-career artists/year.

First Contact & Terms Send query letter with brochure showing art style or résumé and tearsheets, slides, photographs and transparencies. Samples are filed or are returned. Responds in 2 months. Call for appointment to show portfolio of slides, original final art and transparencies. Pays royalties. Requires exclusive representation of artist and/or art. Provides insurance while work is at firm, promotion, shipping from firm, a written contract and advertising through dealer showcase.

Tips "Build a market for your originals by affiliating with an art gallery or two. Never give away your copyrights! When you can no longer satisfy the overwhelming demand for your originals . . . *that* is when you can hope for success in the reproduction market."

HOOF PRINTS

13849 N. 200E, Alexandria IN 46001. (765)724-7004. Fax: (765)724-4632. E-mail: gina@hoofprints.com. Website: www.hoofprints.com. Estab. 1991. Mail order art retailer and wholesaler. Handles handpulled originals, limited and unlimited editions, offset reproductions, posters and engravings. Clients: farriers, veterinarians, individuals, galleries, tack shops.

Needs Considers only existing horse and dog prints. Especially welcome submission of unpublished farrier and veterinarian art.

First Contact & Terms Send brochure, tearsheets, photographs and samples. Samples are filed. Will contact artist for portfolio review if interested. Pays per print. No advance. Provides advertising and shipping from firm. Finds artists through sourcebooks, magazine ads, word of mouth.

IMAGE CONNECTION

456 Penn St., Yeadon PA 19050. (610)626-7770. Fax: (610)626-2778. E-mail: imageco@earthlink.net. Website: www.imageconnection.biz. **Art Coordinator:** Helen Casale. Estab. 1988. Publishes and distributes limited editions and posters. Represents several European publishers.

Needs Seeking fashionable and decorative art for the commercial market. Considers oil, pen & ink, watercolor, acrylic, pastel and mixed media. Prefers contemporary and popular themes, realistic and abstract art. Editions created by collaborating with the artist and by working from an existing painting. Approached by 200 artists/year.

First Contact & Terms Send query letter with brochure showing art style or résumé, slides, photocopies, photographs, tearsheets and transparencies. Accepts e-mail submissions with link to website or Mac-compatible image file. Samples are not filed and are returned by SASE. Responds in 2 months. Company will contact artist for portfolio review if interested. Portfolio should include b&w and color finished, original art, photographs, slides, tearsheets and transparencies. Payment method is negotiated. Offers advance when appropriate. Negotiates rights purchased. Requires exclusive representation of artist for product. Finds artists through art competitions, exhibits/fairs, reps, submissions, Internet, sourcebooks and word of mouth.

IMAGE CONSCIOUS

1261 Howard St., San Francisco CA 94103. (415)626-1555. Fax: (415)626-2481. E-mail: cbardy@imageconscious .com. Website: www.imageconscious.com. **Creative Director:** Cindy Bardy. Estab. 1980. Art publisher and domestic and international distributor of offset and poster reproductions. Clients: poster galleries, frame shops, department stores, design consultants, interior designers and gift stores. Current clients include Z Gallerie, Deck the Walls and Bed Bath & Beyond.

Needs Seeking creative and decorative art for the designer market. Considers oil, acrylic, pastel, watercolor, tempera, mixed media and photography. Prefers individual works of art, pairs or unframed series. Artists represented include Bill Brauer, Alan Blaustein, Monica Stewart, S.G. Rose, Eva Carter, Cynthia Markert and Haibin. Editions created by collaborating with the artist and by working from an existing painting or photograph. Approached by hundreds of artists/year. Publishes the work of 4-6 emerging, 4-6 mid-career and 8-10 established artists/year. Distributes the work of 50 emerging, 200 mid-career and 700 established artists/year.

First Contact & Terms Send query letter with brochure, résumé, tearsheets, photographs, slides and/or transparencies. Samples are filed or are returned by SASE. Responds in 1 month. Publisher/distributor will contact artist for portfolio review if interested. No original art. Payment method is negotiated. Negotiates rights purchased. Provides promotion, shipping from firm and a written contract.

Tips "Research the type of product currently in poster shops. Note colors, sizes and subject matter trends."

⬛ IMAGE SOURCE INTERNATIONAL

630 Belleville Ave., New Bedford MA 02745. (508)999-0090. Fax: (508)999-9499. E-mail: pdownes@isiposters.c om. Website: www.isiposters.com. **Contact:** Patrick Downes. **Art Editor:** Kevin Miller. **Licensing:** Patrick Downes. Estab. 1992. Poster company, art publisher, distributor, foreign distributor. Publishes/distributes un-

limited editions, fine art prints, offset reproductions, posters. Clients: galleries, decorators, frame shops, distributors, architects, corporate curators, museum shops, gift shops, foreign distributors (Germany, Holland, Asia, South America).

 • Image Source International is one of America's fastest-growing publishers.

Needs Seeking fashionable, decorative art for the designer market. Considers oil, acrylic, pastel. Artists represented include Micarelli, Kim Anderson, Bertram Bahner, Juarez Machado, Anthony Watkins, Rob Brooks and Karyn Frances Gray. Editions created by collaborating with the artist or by working from an existing painting. Approached by hundreds of artists/year. Publishes the work of 6 emerging, 2 mid-career and 2 established artists/year. Distributes the work of 50 emerging, 25 mid-career, 50 established artists/year.

First Contact & Terms Send query letter with brochure, photocopies, photographs, résumé, slides, tearsheets, transparencies, postcards. Samples are filed and are not returned. Responds only if interested. Company will contact artist for portfolio review if interested. Pays flat fee "that depends on artist and work and risk." Buys all rights. Requires exclusive representation of artist.

Tips Notes trends as sports art, neo-classical, nostalgic, oversize editions. "Think marketability. Watch the furniture market."

IMAGES OF AMERICA PUBLISHING COMPANY

P.O. Box 608, Jackson WY 83001. (800)451-2211. Fax: (307)739-1199. E-mail: info@artsfortheparks.com. Website: www.artsfortheparks.com. **Executive Director:** Joseph D. Vermilyea. Estab. 1990. Art publisher. Publishes limited editions, posters. Clients: galleries, frame shops, distributors, gift shops, national parks, natural history associations.

 • This company publishes the winning images in the Arts for the Parks competition which was created in 1986 by the National Park Academy of the Arts in cooperation with the National Park Foundation. The program's purpose is to celebrate representative artists and to enhance public awareness of the park system. The top 100 paintings tour the country and receive cash awards. Over $100,000 in prizes in all.

Needs Seeking national park images. Considers oil, acrylic, watercolor, mixed media, pastel, pen & ink. Prefers nature and wildlife images from one of the sites administered by the National Park Service. Art guidelines available on company's website. Artists represented include Jim Wilcox, Linda Tippetts, Howard Hanson, Dean Mitchell, Steve Hanks. Editions created by collaborating with the artist. Approached by over 2,000 artists/year.

First Contact & Terms Submit by entering the Arts for the Parks contest for a $40 entry fee. Entry form and slides must be postmarked by June 1 each year. Send for prospectus before April 1st. Samples are filed. Portfolio review not required. Pays flat fee of $50-50,000. Buys one-time rights. Provides advertising.

Tips "All artwork selected must be representational of a National Park site."

IMCON

68 Greene St., Oxford NY 13830. (607)843-5130. E-mail: imcon@mkl.com. **President:** Fred Dankert. Estab. 1986. Fine art printer of handpulled originals. "We invented the waterless litho plate, and we make our own inks." Clients: galleries, distributors.

Needs Seeking creative art for the serious collector. Editions created by collaborating with the artist "who must produce image on my plate. Artist given proper instruction."

First Contact & Terms Call or send query letter with résumé, photographs and transparencies.

Tips "Artists should be willing to work with me to produce original prints. We do *not* reproduce; we create new images. Artists should have market experience."

IMPACT IMAGES

4949 Windplay Dr., El Dorado Hills CA 95762. (916)933-4700. Fax: (916)933-4717. Website: www.impactimages direct.com. **Owner:** Benny Wilkins. Estab. 1975. Publishes unlimited edition prints and posters. Clients: frame shops, museum and gift shops, wholesalers, retailers, overseas importers, clock and plaque manufacturers. Current line includes 1,500 subjects of art and photography.

Needs Seeking traditional and contemporary artwork. Considers oils, acrylics, pastels, watercolors, mixed media. Accepts contemporary and traditional themes, including landscapes, domestic and wild animals, western, southwestern, country, children, floral, aviation, fantasy and humor. Also considers ethnic subjects, including Native American, Hispanic, African American and Oriental.

First Contact & Terms Send query letter with brochure, tearsheets, photographs, slides or transparencies. Samples are not filed and are returned if requested by SASE. Responds in 4-5 weeks. Offers royalty or flat-fee payment. Does not require exclusive rights to the artist or image. Provides written contract.

Tips "Published sizes are 16×20 and 8×10 therefore we need artwork that can be cropped to a 4 to 5 ratio."

INSPIRATIONART & SCRIPTURE, INC.

P.O. Box 5550, Cedar Rapids IA 52406. (319)365-4350. Fax: (319)861-2103. E-mail: charles@inspirationart.com. Website: www.inspirationart.com. **Creative Director:** Charles R. Edwards. Estab. 1993 (incorporated 1996).

Produces Christian poster prints. "We create and produce jumbo-sized (24×36) posters targeted at pre-teens (10-14), teens (15-18) and young adults (18-30). A Christian message is contained in every poster. Some are fine art and some are very commercial. We prefer very contemporary images."

Needs Approached by 150-200 freelance artists/year. Works with 10-15 freelancers/year. Buys 10-15 designs, photos, illustrations/year. Christian art only. Uses freelance artists for posters. Considers all media. Looking for "something contemporary or unusual that appeals to teens or young adults and communicates a Christian message." Art guidelines available via website or for SASE with first-class postage. Catalog available for $3.

First Contact & Terms Send query letter with photographs, slides, SASE or transparencies. Accepts submissions on disk (call first). Samples are filed or are returned by SASE. Responds in 6 months. Company will contact artist for portfolio review if interested. Portfolio should include color roughs, final art, photographs and transparencies. "We need to see the artist's range. It is acceptable to submit 'secular' work, but we also need to see work that is Christian-inspired." Originals are returned at job's completion. Pays by the project, $50-250. Pays royalties of 5% "only if the artist has a body of work that we are interested in purchasing in the future." Rights purchased vary according to project.

Tips "The better the quality of the submission, the better we are able to determine if the work is suitable for our use (slides are best). The more complete the submission (i.e., design, art layout, scripture, copy), the more likely we are to see how it may fit into our poster line. We do accept traditional work but are looking for work that is more commercial and hip (think MTV with values). A poster needs to contain a Christian message that is relevant to teen and young adult issues and beliefs. Understand what we publish before submitting work. Artists can either purchase a catalog for $3 or visit our website to see what it is that we do. We are not simply looking for beautiful art, but rather we are looking for art that communicates a specific scriptural passage."

INTERCONTINENTAL GREETINGS LTD.

176 Madison Ave., New York NY 10016. (212)683-5830. Fax: (212)779-8564. E-mail: interny@intercontinental-ltd.com. Website: www.intercontinental-ltd.com. **Art Director:** Haeran Park. Estab. 1967. Sells reproduction rights of designs to publisher/manufacturers in 50 countries around the world. Specializing in greeting cards, gift bags, stationery and novelty products, ceramics, textile, bed and bath accessories, and kitchenware.

Needs Seeking creative, commercial and decorative art in traditional and computer media and photography. Accepts seasonal and holiday material any time. Animals, children, babies, fruits/wine, sports, scenics and Americana themes are specially requested.

First Contact & Terms Send query letter with brochure, tearsheets, slides, photographs, photocopies or CDs. Samples are filed or returned by SASE if requested by artist. Pays the artist a percentage once used for publication. No credit line given. Sells one-time rights and exclusive product rights. Simultaneous submissions and previously published work okay. Please state reserved rights if any.

Tips Recommends New York Surtex Show held annually. "In addition to having good painting/designing skills, artists should be aware of market needs. We're looking for artists who possess a large collection of designs, and we are interested in series of interrelated images."

⊕ INTERNATIONAL GRAPHICS GMBH.

Junkersring 11, 76344, Eggenstein 011 Germany. (49)721-978-0620. Fax: (49)721-978-0651. E-mail: LW@ig-team.de. Website: www.international-graphics.com. **President:** Lawrence Walmsley. Publishing Assistant: Anita Cieslar. Estab. 1981. Poster company/art publisher/distributor. Publishes/distributes limited edition monoprints, monotypes, offset reproduction, posters, original paintings and silkscreens. Clients: galleries, framers, department stores, gift shops, card shops and distributors. Current clients include Windsor Art, Intercontinental Art and Balangier.

Needs Seeking creative, fashionable and decorative art for the commercial and designer markets. Also seeking Americana art for our gallery clients. Considers oil, acrylic, watercolor, mixed media, pastel. Prefers landscapes, florals, still lifes. Art guidelines free for SASE with first-class postage. Artists represented include Christian Choisy, Benevolenza and Mansart. Editions created by working from an existing painting. Approached by 100-150 artists/year. Publishes the work of 4-5 emerging artists/year. Distributes the work of 40-50 emerging artists/year.

First Contact & Terms Send query letter with brochure, photocopies, photographs, photostats, résumé, slides, tearsheets. Accepts disk submissions in Mac or Windows. Samples are filed and returned. Responds in 2 months. Will contact artist for portfolio review if interested. Negotiates payment on basis of per-piece-sold arrangement. Offers advance when appropriate. Buys first rights. Provides advertising, promotion, shipping from our firm and contract. Also work with freelance designers. Prefers local designers only. Finds artists through exhibitions, word of mouth, submissions.

Tips "Pastel landscapes and still life pictures are good at the moment. Earthtones are popular—especially lighter shades."

ISLAND ART PUBLISHERS

6687 Mirah Rd., Saanichton BC V8M 1Z4 Canada. (250)652-5181. Fax: (250)652-2711. E-mail islandart@island-art.com. Website: www.islandart.com. **President:** Myron D. Arndt. Estab. 1985. Art publisher and distributor. Publishes and distributes art cards, posters, open-edition prints, giclees and custom products. Clients: galleries, department stores, distributors, gift shops. Current clients include Public Galleries and Museums, Host-Marriott, HDS, etc.

Needs See website for current needs and requirements. Considers oil, watercolor and acrylic. Prefers lifestyle themes/Pacific Northwest. Art guidelines available on company's website. Over 50 artists represented. Editions created by working from an existing painting. Approached by 100 artists/year. Publishes the work of 2-8 emerging artists/year. Distributes the work of 4 emerging artists/year.

First Contact & Terms Send résumé, tearsheets, slides and photographs. Designers send photographs, slides or transparencies (do not send originals). Accepts submissions on disk compatible with Photoshop. Send EPS of TIFF files. Samples are not filed and are returned by SASE if requested by artist. Responds in 3 months. Publisher/distributor will contact artist for portfolio review if interested. Portfolio should include color roughs, final art, slides and 4×5 transparencies. Pays royalties of 5-10%. Licenses reproduction rights. Requires exclusive representation of artist for selected products only. Provides insurance while work is at firm, promotion, shipping from firm, written contract, trade fair representation and Internet service. Finds artists through art fairs, referrals and submissions.

Tips ''Provide a body of work along a certain theme to show a fully developed style that can be built upon. We are influenced by our market demands. Please ask for our submission guidelines before sending work on spec.''

JADEI GRAPHICS INC.

4943 McConnell Ave., Suite ''W,'' Los Angeles CA 90066. (310)578-0082. Fax: (310)823-4399. Website: www.jadeigraphics.com. **Contact:** Judy Smith, office manager. Licensing: Dennis Gaskin. Poster company. Publishes limited edition, unlimited edition and posters. Clients: galleries, framers. Licenses calendars, puzzles, etc.

Needs Seeking creative, decorative art for the commercial market. Considers oil, acrylic, watercolor and photographs. Editions created by collaborating with the artist or by working from an existing painting. Approached by 100 artists/year. Publishes work of 3-5 emerging artists each year. Also needs freelancers for design. Prefers local designers only.

First Contact & Terms Send query letter with brochure, photocopies, photographs and slides. Accepts disk submissions. Samples are returned by SASE. Responds only if interested. Company will contact artist for portfolio review of color, photographs, slides and transparencies. Negotiates payment. Offers advance. Rights purchased vary according to project. Provides advertising.

LESLI ART, INC.

Box 6693, Woodland Hills CA 91365. (818)999-9228. E-mail: lesliart@adelthia.net. Website: www.lesliart.com. **President:** Stan Shevrin. Estab. 1965. Artist agent handling paintings for art galleries and the trade.

Needs Considers oil paintings and acrylic paintings. Prefers realism and impressionism—figures costumed with narrative content, landscapes, still lifes and florals. Works with 20 artists/year.

First Contact & Terms To show portfolio, mail slides or color photographs. Samples not filed are returned by SASE. Responds in 1 month. Payment method is negotiated. Offers an advance. Provides national distribution, promotion and written contract.

Tips ''Considers only those artists who are serious about having their work exhibited in important galleries throughout the United States and Europe.''

LESLIE LEVY FINE ART PUBLISHING, INC.

7137 Main St., Scottsdale AZ 85251. (480)947-2925. Fax: (480)945-1518. E-mail: art@leslielevy.com. Website: www.leslielevy.com. **President:** Leslie Levy. Estab. 1976. Art publisher of posters. ''Our publishing customers are mainly frame shops, galleries, designers, framed art manufacturers, distributors and department stores. Currently works with over 10,000 clients.''

Needs Seeking creative and decorative art for the residential, hospitality, health care, commercial and designer markets. Artists represented include Steve Hanks, Terry Isaac, Stephen Morath, Kent Wallis, Cyrus Afsary, Raymond Knaub, June Carey and many others. Considers oil, acrylic, pastel, watercolor, tempera and mixed media. Prefers art depicting florals, landscapes, wildlife, semiabstract, nautical, figurative works and b&w photography. Approached by hundreds of artists/year.

First Contact & Terms Send query letter with résumé, slides or photos and SASE. Samples are returned by SASE. ''Portfolio will not be seen unless interest is generated by the materials sent in advance.'' Please do not send limited editions, transparencies or original works. Pays royalties quarterly based on wholesale price. Insists on acquiring reprint rights for posters. Requires exclusive representation of the artist. Provides advertising,

promotion and written contract. "Please, don't call us. After we review your materials, we will contact you or return materials within 1 month.

Tips "Please, if you are a beginner, do not go through the time and expense of sending materials."

LOLA LTD./LT'EE

1817 Egret St. SW, Shallotte NC 28470-5433. (910)754-8002. E-mail: lolaltd@yahoo.com. **Owner:** Lola Jackson. Distributor of limited editions, offset reproductions, unlimited editions, handpulled originals, antique prints and etchings. Clients: art galleries, architects, picture frame shops, interior designers, major furniture and department stores, industry and antique gallery dealers.

- • This distributor also carries antique prints, etchings and original art on paper and is interested in buying/selling to trade.

Needs Seeking creative and decorative art for the commercial and designer markets. "Handpulled graphics are our main area." Also considers oil, acrylic, pastel, watercolor, tempera or mixed media. Prefers unframed series, up to 30×40 maximum. Artists represented include Buffet, White, Brent, Jackson, Mohn, Baily, Carlson, Coleman. Approached by 100 artists/year. Publishes the work of 5 emerging, 5 mid-career and 5 established artists/year. Distributes the work of 40 emerging, 40 mid-career and 5 established artists/year.

First Contact & Terms Send query letter with sample. Samples are filed or are returned only if requested. Responds in 2 weeks. Payment method is negotiated. "Our standard commission is 50% less 50% off retail." Offers an advance when appropriate. Provides insurance while work is at firm, shipping from firm and written contract.

Tips "We find we cannot sell b&w only. Best colors emerald, mauve, blues and gem tones. Leave wide margins on prints. Send all samples before end of May each year as our main sales are targeted for summer. We do a lot of business with birds, botanicals, boats and shells—anything nautical."

Ⓝ LYNESE OCTOBRE, INC.

P.O. Box 5002, Clearwater FL 33758. (727)789-2800. Fax: (727)724-8352. E-mail: jerry@lyneseoctobre.com. Website: www.lyneseoctobre.com. **President:** Jerry Emmons. Estab. 1982. Distributor. Distributes unlimited editions, offset reproductions and posters. Clients: picture framers and gift shops.

Needs Seeking fashionable and decorative art for the commercial and designer markets. Considers oil, watercolor, mixed media, pastel, pen & ink and acrylic. Artists represented include Neil Adamson, AWS, NWS, FWS; Roger Isphording, Betsy Monroe, Paul Brendt, Sherry Vintson, Jean Grastorf. Approached by 50 artists/year.

First Contact & Terms Send brochure, tearsheets, photographs and photocopies. Samples are sometimes filed or are returned. Responds in 1 month. Distributor will contact artist for portfolio review if interested. Portfolio should include final art, photographs and transparencies. Negotiates payment. No advance. Rights purchased vary according to project. Provides written contract.

Tips Recommends artists attend decor expo shows. "The trend is toward quality, color-oriented regional works."

Ⓝ MACH 1, LLC

2415 Sagamore Pkwy. S., Lafayette IN 47905. (800)955-6224. Fax: (765)446-2144. E-mail: sales@mach1.com. Website: www.mach1.com. **Vice President Marketing:** James Gordon. Estab. 1987. Art publisher. Publishes unlimited and limited editions and posters. Clients: museums, galleries, frame shops and mail order customers. Current clients include the Smithsonian Museum, the Intrepid Museum, Deck the Walls franchisers and Sky's The Limit.

Needs Seeking creative and decorative art for the commercial and designer markets. Considers mixed media. Prefers aviation related themes. Artists represented include Jarrett Holderby and Jay Haiden. Editions created by collaborating with the artist or by working from an existing painting. Publishes the work of 2-3 emerging, 2-3 mid-career and 2-3 established artists/year.

First Contact & Terms Send query letter with résumé, slides and photographs. Samples are not filed and are returned. Responds in 1 month. To show a portfolio, mail slides and photographs. Pays royalties. Offers an advance when appropriate. Requires exclusive representation of the artist. Provides promotion, shipping to and from firm and a written contract.

Tips "Find a good publisher."

Ⓝ MAIN FLOOR EDITIONS

4943 McConnell Ave., Suite Y, Los Angeles CA 90066. (310)823-5686. Fax: (310)823-4399. **Art Director:** Jim Ketterl. Estab. 1996. Poster company, art publisher and distributor. Publishes/distributes limited edition, unlimited edition and posters. Clients: distributors, retail chain stores, galleries, frame shops, O.E.M. framers.

Needs Seeking creative, fashionable and decorative art for the commercial and designer markets. Considers oil, acrylic, watercolor, mixed media, pastel and photography. Artists represented include Allayn Stevens, Inka

Zlin and Peter Colvin. Editions created by collaborating with the artist or by working from an existing painting. Approached by 100 artists/year. Publishes work of 30 emerging, 15 mid-career and 10 established artists/year. Distributes the work of 5 emerging, 3 mid-career and 2 established artists/year.

First Contact & Terms Send query letter with brochure, photocopies, photographs and tearsheets. Samples are filed and are not returned. Responds in 6 months only if interested. Company will contact artist for portfolio review if interested. Portfolio should include photographs, slides and tearsheets. Pays flat fee $300-700; royalties of 10%. Offers advance when appropriate. Negotiates rights purchased. Requires exclusive representation of artist. Finds artists through art fairs, sourcebooks and word of mouth.

Tips "Follow catalog companies—colors/motifs."

SEYMOUR MANN, INC.

230 Fifth Ave., Suite 910, New York NY 10001. (212)683-7262. Fax: (212)213-4920. E-mail: smanninc@aol.com. Website: www.seymourmann.com. Manufacturer.

Needs Seeking fashionable and decorative art for the serious collector and the commercial and designer markets. Also needs freelancers for design. 15% of products require freelance design. Considers watercolor, mixed media, pastel, pen & ink and 3-D forms. Editions created by collaborating with the artist. Approached by "many" artists/year. Publishes the work of 2-3 emerging, 2-3 mid-career and 4-5 established artists/year.

Tips "Focus on commercial end purpose of art."

MARCO FINE ARTS

201 Nevada St., El Segundo CA 90245. (310)615-1818. Fax: (310)615-1850. E-mail: info@marcofinearts.com. Website: www.marcofinearts.com. Publishes/distributes limited edition, fine art prints and posters. Clients: galleries, decorators and frame shops.

Needs Seeking creative and decorative art for the serious collector and design market. Considers oil, acrylic and mixed media. Prefers landscapes, florals, figurative, Southwest, contemporary, impressionist, antique posters. Accepts outside serigraph and digital printing (giclée) production work. Artists represented include John Nieto, Aldo Luongo, John Axton, Guy Buffet, Linda Kyser Smith and Nobu Haihara. Editions created by collaborating with the artist or working from an existing painting. Approached by 80-100 artists/year. Publishes the work of 3 emerging, 3 mid-career and 3-5 established artists/year.

First Contact & Terms Send query letter with brochure, photocopies, photographs, photostats, résumé, SASE, slides, tearsheets and transparencies. Accepts disk submissions. Samples are filed and are returned by SASE. Responds only if interested. Company will contact artist for portfolio review or original artwork (show range of ability) if interested. Payment to be discussed. Requires exclusive representation of artist.

BRUCE MCGAW GRAPHICS, INC.

389 W. Nyack Rd., West Nyack NY 10994. (845)353-8600. Fax: (845)353-8907. E-mail: acquisitions@bmcgaw.c om. Website: www.bmcgaw.com. **Acquisitions:** Martin Lawlor. Clients: poster shops, galleries, I.D., frame shops.

● Bruce McGaw publishes nearly 300 images per year.

Needs Artists represented include Diane Romanello, Romero Britto, David Doss, Ray Hendershot, Jacques Lamy, Bob Timberlake, Robert Bateman, Michael Kahn, Albert Swayhoover, William Mangum and P.G. Gravele. Other important fine art poster licenses include Disney, Andy Warhol, MOMA, New York and others. Publishes the work of 30 emerging and 30 established artists/year.

First Contact & Terms Send slides, transparencies or any other visual material that shows the work in the best light. "We review all types of 2-dimensional art with no limitation on media or subject. Review period is 1 month, after which time we will contact you with our decision. If you wish the material to be returned, enclose a SASE. If forwarding material electronically, send easily opened JPEG files for initial review consideration only. 10-15 JPEGs are preferred. Referrals to artists' websites will not be addressed." Contractual terms are discussed if work is accepted for publication." Forward 20-60 examples. We look for a body of work from which to publish.

Tips "Simplicity is very important in today's market (yet there still needs to be 'a story' to the image). Form and palette are critical to our decision process. We have a tremendous need for decorative pieces, especially new abstracts, landscapes and florals. Decorative still life images are very popular, whether painted or photographed, and much needed as well. There are a lot of prints and posters being published into the marketplace these days. Market your best material! There are a number of important shows—the largest American shows being Art Expo, New York (March); Galeria, New York (March); and the Atlanta A.B.C. Show (September). Review our catalog at your neighborhood gallery or poster shop or visit our website before submitting. Send your best."

⃞Ⓝ METALART STUDIOS, INC.

202 Roosevelt Rd., Valparaiso IN 46383. (219)465-5188. Fax: (219)548-0145. E-mail: metalartstudios@worldnet. att.net. **Contact:** Heather McGill, managing partner. Estab. 1979. Photoengraver of metal etchings. Publishes metal etchings/reproductions. Clients: architects, decorators, frame shops, gift shops, museum shops. Current clients include Accent Chicago, City of Chicago Store, Chicago Architecture Foundation.

Needs Seeking decorative art for the commercial market. Considers pen & ink, line art illustrations. Prefers cityscapes, architectural renderings (cities, university); line art illustrations of automobiles, motorcycles, railroad, still life, animal etc. Artists represented include William Carr Olendorf. Editions created by collaborating with the artist, by working from an existing painting.

First Contact & Terms Send brochure, photocopies, photographs, slides, tearsheets, transparencies, URL. Accepts e-mail submissions with image file. Prefers Windows-compatible, JPEG files. Samples are filed. Responds in 1 week. Company will contact artist for portfolio review if interested. Negotiates payment. Offers advance when appropriate. Buys reprint rights in metal only, rights purchased vary according to project. Requires exclusive representation of artist in metal only. Provides promotion and written contract. Finds artists through artist's submissions.

Tips "Line art illustrations are reproduced in zinc or copper; shading and color wash cannot be reproduced."

⃞☑ MILL POND PRESS COMPANIES

310 Center Court, Venice FL 34285. (800)535-0331. Fax: (941)497-6026. E-mail: ellen@millpond.com. Website: www.millpond.com. **Public Relations Director:** Ellen Collard. Licensing: Angela Sauro. Estab. 1973. Publishes limited editions, unlimited edition, offset reproduction and giclees. Divisions include Mill Pond Press, Visions of Faith, Mill Pond Art Licensing and NextMonet. Clients: galleries, frameshops and specialty shops, Christian book stores, licensees. Licenses various genres on a range of products.

Needs Seeking creative, decorative art. Open to all styles. Considers oil, acrylic, watercolor and mixed media. Prefers wildlife, spiritual, figurative, landscapes and nostalgic. Artists represented include Greg Olsen, Paul Calle, Terry Isaac, Jane Jones, John Seerey-Lester, Robert Bateman, Carl Brenders, Nita Engle, Luke Buck and Maynard Reece. Editions created by collaborating with the artist or by working from an existing painting. Approached by 400-500 artists/year. Publishes the work of 2-3 emerging, 2-3 mid-career and 8-10 established artists/year.

First Contact & Terms Send query letter with photographs, résumé, SASE, slides, transparencies and description of artwork. Samples are not filed and are returned by SASE. Responds in 1 year. Company will contact artist for portfolio review if interested. Pays royalties. Rights purchased vary according to project. Requires exclusive representation of artist. Provides advertising, in-transit insurance, insurance while work is at firm, promotion, shipping to and from firm and written contract. Finds artists through art exhibitions, submissions and word of mouth.

Tips "We continue to expand the genre published. Inspirational art has been part of expansion. Realism is our base but we are open to looking at all art."

⃞Ⓝ MODARES ART PUBLISHING

2305 Louisiana Ave. N, Golden Valley MN 55427. (800)896-0965. Fax: (763)513-1357. Website: gallery394.com. **President:** Mike Modares. Estab. 1993. Art publisher, distributor. Publishes/distributes limited edition, unlimited edition, canvas transfers, monoprints, monotypes, offset reproduction and posters. Clients: galleries, decorators, frame shops, distributors, architects, corporate curators, museum shops and giftshops.

Needs Seeking creative and decorative art for the commercial and designer market. Considers oil, acrylic, watercolor mixed media and pastel. Prefers realism and impressionism. Artists represented include Jim Hansel, Derk Hansen and Michael Schofield. Editions created by collaborating with the artist or working from an existing painting. Approached by 10-50 artists/year. Distributes the work of 10-30 emerging artists/year. Also needs freelancers for design.

First Contact & Terms Send query letter with brochure, photographs, photostats, slides and transparencies. Samples are not filed and are returned. Responds in 5 days. Portfolio may be dropped off every Monday, Tuesday and Wednesday. Artist should follow up with a call. Portfolio should include color, final art, photographs, photostats, thumbnails. Payment negotiated. Offers advance when appropriate. Buys one-time rights and all rights. Sometimes requires exclusive representation of artist. Provide advertising, in-transit insurance, insurance while work is at firm, promotion, shipping from our firm and written contract. Finds artists through attending art exhibitions, art fairs and word of mouth.

MODERNART EDITIONS

165 Chubb Ave., Lyndhurst NJ 07071. (201)842-8500. Fax: (201)842-8546. E-mail: submitart@theartpublishingg roup.com. Website: www.moderneditions.com. **Contact:** Artists Submissions. Estab. 1973. Art publisher and

distributor of "top of the line" open edition posters and offset reproductions. Clients: galleries and custom frame shops worldwide.

Needs Seeking decorative art for the commercial and designer markets. Considers oil, watercolor, mixed media, pastel and acrylic. Prefers fine art landscapes, floral, abstracts, representational, still life, decorative, collage, mixed media. Size 16×20. Artists represented include Carol Ann Curran, Diane Romanello, Pat Woodworth, Patrick Adam, Penny Feder and Neil Faulkner. Editions created by collaboration with the artist or by working from an existing painting. Approached by 200 artists/year. Publishes the work of 10-15 emerging artists/year. Distributes the work of 100 emerging artists/year.

First Contact & Terms Send postcard size sample of work, contact through artist rep, or send query letter with slides, photographs, brochure, photocopies, résumé, photostats, transparencies. Submissions via e-mail are preferred. Responds in 6 weeks. Request portfolio review in original query. Publisher/distributor will contact artist for portfolio review if interested. Portfolio should include color photostats, photographs, slides and trasparencies. Pays flat fee of $200-300 or royalties of 10%. Offers advance against royalties. Provides insurance while work is at firm, shipping to firm and written contract. "Art submitted digitally should be in JPEG format. Limit 4 files; no more than 300 KB each."

Tips Advises artists to attend Art Expo New York City and Atlanta ABC.

MUNSON GRAPHICS

1209 Parkway Dr., Suite A, Santa Fe NM 87507. (505)424-4112. Fax: (505)424-6338. E-mail: michael@munsongr aphics.com. Website: www.munsongraphics.com. **President:** Michael Munson. Estab. 1997. Poster company, art publisher and distributor. Publishes/distributes limited edition, fine art prints and posters. Clients: galleries, museum shops, gift shops and frame shops.

Needs Seeking creative art for the serious collector and commercial market. Considers oil, acrylic, watercolor and pastel. Artists represented include O'Keeffe, Baumann, Nieto, Abeyta. Editions created by working from an existing painting. Approached by 75 artists/year. Publishes work of 3-5 emerging, 3-5 mid-career and 3-5 established artists/year. Distributes the work of 5-10 emerging, 5-10 mid-career and 5-10 established artists/year.

First Contact & Terms Send query letter with slides, SASE and transparencies. Samples are not filed and are returned by SASE. Responds in 1 month. Company will contact artist for portfolio review if interested. Negotiates payment. Offers advance. Rights purchased vary according to project. Provides written contract. Finds artists through art exhibitions, art fairs, word of mouth and artists' submissions.

Ⓝ MUSEUM EDITIONS WEST

4130 Del Rey Ave., Marina Del Rey CA 90292. (310)822-2558. Fax: (310)822-3508. E-mail: sales@museumeditio nswest.com. Website: www.museumeditionswest.com. **Director:** Grace Yu. Poster company, distributor, gallery. Distributes unlimited editions, canvas transfers, posters. Clients: galleries, decorators, frame shops, distributors, architects, corporate curators, museum shops, giftshops. Current clients include San Francisco Modern Art Museum and The National Gallery, etc.

Needs Seeking creative, fashionable art for the commercial and designer markets. Considers oil, acrylic, watercolor, pastel. Prefers landscape, floral, abstract. Artists represented include John Botzy and Carson Gladson. Editions created by working from an existing painting. Approached by 150 artists/year. Publishes/distributes the work of 5 mid-career and 20 established artists/year. Also needs freelancers for design.

First Contact & Terms Send query letter with brochure, photocopies, photographs, résumé, SASE, slides, tearsheets, transparencies. May submit via e-mail with a link to artists' website. Samples are not filed and are returned by SASE. Responds in 3 months. Company will contact artist for portfolio review of photographs, slides, tearsheets and transparencies if interested. Pays royalties of 8-10%. Offers advance when appropriate. Rights purchased vary according to project. Provides advertising, insurance while work is at firm, promotion, shipping from firm, written contract. Finds artists through art exhibitions, art fairs, word of mouth, submissions.

Tips "Look at our existing catalog or website for samples."

NEW YORK GRAPHIC SOCIETY

129 Glover Ave., Norwalk CT 06850. (203)661-2400. Website: www.nygs.com. **Publisher:** Richard Fleischmann. President: Owen Hickey. Estab. 1925. Publisher of offset reproductions, posters, unlimited edition. Clients: galleries, frame shops and museums shops. Current clients include Deck The Walls, Artistry, Prints Plus.

Needs Considers oil, acrylic, pastel, watercolor, mixed media and colored pencil drawings. Publishes reproductions, posters. Artists represented include Dan Campanelli, Doug Rega. Publishes and distributes the work of numerous emerging artists/year. Art guidelines free with SASE. Response to submissions in 90 days.

First Contact & Terms Send query letter with transparencies or photographs. All submissions returned to artists by SASE after review. Pays royalties of 10%. Offers advance. Buys all print reproduction rights. Provides in-

transit insurance from firm to artist, insurance while work is at firm, promotion, shipping from firm and a written contract; provides insurance for art if requested. Finds artists through submissions/self promotions, magazines, visiting art galleries, art fairs and shows.

Tips "We publish a broad variety of styles and themes. We actively seek all sorts of fine decorative art."

☑ NEXTMONET

310 Center Ct., Venice FL 34285. (941)497-6020. Fax: (941)497-6026. E-mail: jobs@nextmonet.com. Website: www.nextmonet.com. **Contact:** Artwork Submissions. Estab. 1998. Art publisher, distributor. Publishes/distributes limited edition and fine art prints as well as originals. Clients: decorators, corporate curators and private consumers.

Needs Seeking creative, decorative art for the serious collector, commercial and designer markets. Considers oil, acrylic, watercolor, mixed media, pastel, pen & ink and photography. Prefers all styles. Artists represented include James Stagg, Susan Friedman and Eric Zener. Editions created by collaborating with the artist and working from an existing painting. Approached by 1,000 artists/year.

First Contact & Terms Send query letter with résumé, SASE, slides and documentation for each work: title, date, media, dimension and edition number, if applicable. Include artist's statement. Do not send digital submissions in any format. Samples are filed, kept on disk or returned by SASE. Portfolio review not required. Finds artists through World Wide Web, sourcebooks, art exhibitions, art fairs, artists' submissions, publications and word of mouth.

NORTHLAND POSTER COLLECTIVE

1613 E. Lake St., Minneapolis MN 55407. (612)721-2273. E-mail: art@northlandposter.com. Website: www.northlandposter.com. **Manager:** Ricardo Levins Morales. Estab. 1979. Art publisher and distributor of handpulled originals, unlimited editions, posters and offset reproductions. Clients: mail order customers, teachers, bookstores, galleries, unions.

Needs "Our posters reflect themes of social justice and cultural affirmation, history, peace." Artists represented include Ralph Fasanella, Frank Escalet, Christine Wong, Beatriz Aurora, Betty La Duke, Ricardo Levins Morales and Janna Schneider. Editions created by collaborating with the artist or by working from an existing painting.

First Contact & Terms Send query letter with tearsheets, slides and photographs. Accepts digital files. Samples are filed or are returned by SASE. Responds in months; if does not report back, the artist should write or call to inquire. Write for appointment to show portfolio. Payment method is negotiated. Offers an advance when appropriate. Negotiates rights purchased. Contracts vary, but artist always retains ownership of artwork. Provides promotion and a written contract.

Tips "We distribute work that we publish as well as pieces already printed. We screenprint as well as produce digital prints."

NOVA MEDIA INC.

1724 N. State, Big Rapids MI 49307. (231)796-4637. E-mail: trund@netone.com. Website: www.novamediainc.com. **Editor:** Tom Rundquist. Licensing: Arne Flores. Estab. 1981. Poster company, art publisher, distributor. Publishes/distributes limited editions, unlimited editions, fine art prints, posters, e-prints. Current clients: various galleries. Licenses e-prints.

Needs Seeking creative art for the serious collector. Considers oil, acrylic. Prefers expressionism, impressionism, abstract. Editions created by collaborating with the artist or by working from an existing painting. Approached by 14 artists/year. Publishes/distributes the work of 2 emerging, 2 mid-career and 1 established artists/year. Artists represented include Jill Everest Fonner and Tom Rundquist. Also needs freelancers for design. Prefers local designers.

First Contact & Terms Send query letter with photographs, résumé, SASE, slides, tearsheets. Samples are returned by SASE. Responds in 2 weeks. Request portfolio review in original query. Company will contact artist for portfolio review of color photographs, slides, tearsheets if interested. Pays royalties of 10% or negotiates payment. No advance. Rights purchased vary according to project. Provides promotion.

Tips Predicts colors will be brighter in the industry. "Focus on companies that sell your style."

OLD GRANGE GRAPHICS

40 Scitico Rd., Somersville CT 06072. (800)282-7776. Fax: (800)437-3329. E-mail: ogg@denunzio.com. Website: www.oldgrangegraphics.com. **CEO/President:** Gregory Panjian. Estab. 1976. Distributor/canvas transfer studio. Publishes/distributes canvas transfers, posters. Clients: galleries, frame shops, museum shops, publishers, artists.

Needs Seeking decorative art for the commercial and designer markets. Considers lithographs. Prefers prints of artworks that were originally oil paintings. Editions created by working from an existing painting. Approached by 100 artists/year.

First Contact & Terms Send query letter with brochure. Samples are not filed and are returned. Responds in 1 month. Will contact artist for portfolio review of tearsheets if interested. Negotiates payment. Rights purchased vary according to project. Provides promotion and shipping from firm. Finds artists through art publications.
Tips Recommends Galeria, Artorama and ArtExpo shows in New York and *Decor*, *Art Trends*, *Art Business News* and *Picture Framing* as tools for learning the current market.

OLD WORLD PRINTS, LTD.

2601 Floyd Ave., Richmond VA 23220-4305. (804)213-0600. Fax: (804)213-0700. E-mail: LLemco@oldworldprin tsltd.com. Website: www.oldworldprintsltd.com. **President:** Scott Ellis. Licensing: Lonnie Lemco. Estab. 1973. Art publisher and distributor of open-edition, hand-printed reproductions of antique engravings as well as all subject matter of color printed art. Clients: retail galleries, frame shops and manufacturers, hotels and fund raisers.

• Old World Prints reports the top-selling art in their 10,000-piece collection includes botanical and decorative prints.

Needs Seeking traditional and decorative art for the commercial and designer markets. Specializes in handpainted prints. Considers "b&w (pen & ink or engraved) art which can stand by itself or be hand painted by our artists or originating artist." Prefers traditional, representational, decorative work. Editions created by collaborating with the artist. Distributes the work of more than 1,000 artists. "Also seeking golf, coffee, tea, and exotic floral images."
First Contact & Terms Send query letter with brochure showing art style or résumé and tearsheets and slides. Samples are filed. Responds in 6 weeks. Write for appointment to show portfolio of photographs, slides and transparencies. Pays flat fee of $100/piece and royalties of 10% of profit. Offers an advance when appropriate. Negotiates rights purchased. Provides in-transit insurance, insurance while work is at firm, promotion, shipping from firm and a written contract. Finds artists through word of mouth.
Tips "We are a specialty art publisher, the largest of our kind in the world. We are actively seeking artists to publish and will consider all forms of art."

OPUS ONE PUBLISHING

129 Glover Ave., Norwach CT 06850. (203)847-2000. Fax: (203)846-2105. **Contact:** Owen F. Hickey. Estab. 1970. Art Publisher. Publishes fine art prints.
Needs Seeking creative, fashionable and decorative art for the commercial and designer markets. Considers all media. Art guidelines free for SASE with first-class postage. Artists represented include Kate Frieman, Jack Roberts, Jean Richardson, Richard Franklin, Lee White. Approached by 100 artists/year. Publishes the work of 20% emerging, 20% mid-career and 60% established artists.
First Contact & Terms Send brochure, tearsheets, slides, photographs, photocopies, transparencies. Samples are not filed and are returned. Responds in 1 month. Artist should follow up with call after initial query. Portfolio should include final art, slides, transparencies. Pays royalties of 10%. Rights purchased vary according to project.
Tips "Please attend the Art Expo New York City trade show."

N PALATINO EDITIONS

341 Sutter St., San Francisco CA 94108. (415)392-7237. Fax: (415)392-4609. Website: www.palatino.com. **Contact:** Acquisitions Director. Estab. 1983. Art publisher of handpulled originals, limited editions, fine art prints, monoprints, monotypes, posters and originals. Clients: galleries, decorators, frame shops and corporate curators.
Needs Seeking decorative art for serious collectors and the commercial market; original, interesting art for art galleries. Considers oil, acrylic, watercolor and mixed media. Prefers landscapes, figuratives, some abstract and realism. Artists represented include Thomas Pradzynski, Manel Anoro and Regina Saura. Editions created by collaborating with the artist and by working from an existing painting. Approached by 500-2,500 artists/year. Publishes/distributes the work of 1 emerging artist and 2 mid-career artists/year.
First Contact & Terms Send query letter with brochure, photographs, résumé, slides, transparencies, tearsheets and SASE; send only visual material including exhibition catalog. Samples are not filed and are returned by SASE. Responds in 3-4 weeks. Company will contact artist for portfolio review of final art if interested. Payment to be determined. Rights purchased vary according to project. Requires exclusive representation of artist. Provides advertising, in-transit insurance/return, insurance while work is at firm, promotion, shipping from our firm, written contract and marketing and public relations efforts, established gallery network for distribution. Finds artists through art exhibitions, art fairs, word of mouth, art reps, sourcebooks, artists' submissions and watching art competitions.
Tips "We prefer to set trends. We are looking for innovation and original thought and aesthetic. Know your market and be familiar with printing techniques and what works best for your work."

PALOMA EDITIONS

2906 Morton Way, San Diego CA 92139. (619)434-8056. Fax: (619)434-8057. E-mail: customerservice@palomaeditions.com. Website: www.palomaeditions.com. **Publisher:** Kim A. Butler. Art publisher/distributor of limited and unlimited editions, fine art prints, offset reproductions and posters. Specializes in African-American art. Clients include galleries, specialty shops, retail chains, framers, distributors, museum shops.

Needs Seeking creative and decorative art for the commercial and designer market. Considers all media. Prefers African-American art. Artists represented include Albert Fennell, Raven Williamson, Tod Haskin Fredericks. Editions created by working from existing painting. Approached by hundreds of artists/year. Publishes the work of 4 emerging artists/year. Distributes the work of 10 emerging artists/year.

First Contact & Terms Send query letter with brochure, photocopies, photographs, tearsheets and/or transparencies or JPEGs. Samples are returned by SASE, only if requested. Responds in 2 months, only if interested. Publisher will contact for portfolio review of color final art, photographs, tearsheets and transparencies if interested. Payment negotiable, royalties vary. Offers advance when appropriate. Negotiates rights purchased. Requires exclusive representation of artist. Provides advertising, promotion, shipping and written contract. Also needs designers. Prefers designers who own IBM PCs. Freelance designers should be experienced in QuarkXPress, Photoshop and FreeHand. Finds artists through art shows, magazines and referrals.

Tips "African-American art is hot! Read the trade magazines and watch the furniture and fashion industry. Keep in mind that your work must appeal to a wide audience. It is helpful if fine artists also have basic design skills so they can present their artwork complete with border treatments. We advertise in *Decor*, *Art Business News*, *Art Trends*. See ads for examples of what we choose to publish."

PANACHE EDITIONS LTD

234 Dennis Lane, Glencoe IL 60022. (847)835-1574. Fax: (847)835-2662. E-mail: info@artofrunning.com. **President:** Donna MacLeod. Estab. 1981. Art publisher and distributor of offset reproductions and posters focusing on marathon running. Clients: galleries, frame shops, domestic and international distributors. Current clients are mostly individual collectors.

Needs Considers acrylic, pastel, watercolor and mixed media. "Looking for contemporary compositions in soft pastel color palettes; also renderings of children on beach, in park, etc." Artists represented include Andrew Yelenak, Bart Forbes, Peter Eastwood and Carolyn Anderson. Prefers individual works of art and unframed series. Publishes and distributes work of 1-2 emerging, 2-3 mid-career and 1-2 established artists/year.

First Contact & Terms Send query letter with brochure showing art style or photographs, photocopies and transparencies. Samples are filed. Responds only if interested. To show portfolio, mail roughs and final reproduction/product. Pays royalties of 10%. Negotiates rights purchased. Requires exclusive representation of artist. Provides in-transit insurance, insurance while work is at firm, promotion, shipping to and from firm and written contract.

Tips "We are looking for artists who have not previously been published [in the poster market] with a strong sense of current color palettes. We want to see a range of style and coloration. Looking for a unique and fine art approach to collegiate type events, i.e., Saturday afternoon football games, Founders Day celebrations, homecomings, etc. We do not want illustrative work but rather an impressionistic style that captures the tradition and heritage of one's university. We are very interested in artists who can render figures."

PENNY LANE PUBLISHING INC.

1791 Dalton Dr., New Carlisle OH 45344. (937)849-1101. Fax: (937)849-9666. E-mail: info@PennyLanePublishing.com. Website: www.PennyLanePublishing.com. **Art Coordinators:** Kathy Benton. Licensing: Renee Franck and Beth Schenck. Estab. 1993. Art publisher. Publishes limited editions, unlimited editions, offset reproductions. Clients: galleries, frame shops, distributors, decorators.

Needs Seeking creative, decorative art for the commercial market. Considers oil, acrylic, watercolor, mixed media, pastel. Artists represented include Linda Spivey, Becca Barton, Pat Fischer, Annie LaPoint, Fiddlestix, Mary Ann June. Editions created by collaborating with the artist or working from an existing painting. Approached by 40 artists/year. Publishes the work of 3-4 emerging, 15 mid-career and 6 established artists/year.

First Contact & Terms Send query letter with brochure, résumé, photographs, slides, tearsheets. Samples are filed or returned by SASE. Responds in 2 months. Company will contact artist for portfolio review of color, final art, photographs, slides, tearsheets if interested. Pays royalties. Buys first rights. Requires exclusive representation of artist. Provides advertising, shipping from firm, promotion, written contract. Finds artists through art exhibitions, art fairs, submissions, decorating magazines.

Tips Advises artists to be aware of current color trends and work in a series. "Please review our website to see the style of artwork we publish."

[N] [⊕] PGM ART WORLD

Carl-von-Linde-Str. 33, Garching 85738 Germany. (01149)89-320-02-170. Fax: (01149)89-320-02-270. E-mail: info@pgm-art-world.com. Website: www.pgm-art-world.de. **General Manager:** Andrea Kuborn. Estab. 1995.

(German office established 1969.) International fine art publisher, distributor, gallery. Publishes/distributes limited and unlimited edition, offset reproductions, posters. Clients: world-wide supplier of galleries, framers, distributors, decorators.

 • This publisher's main office is in Germany. PGM publishes more than 300 images and distributes more than 6,000 images in Europe and Asia. The company also operates three galleries in Munich.

Needs Seeking creative, fashionable and decorative art for the commercial and designer markets. Considers oil, acrylic, watercolor, mixed media, pastel, pen & ink. Considers any well accomplished work of any theme or style. Artists represented include Renato Casaro, Diane French-Gaugush, Leslie Hunt, Patricia Nix, Nina Nolte. Editions created by working from an existing painting. Approached by 100 artists/year. Publishes the work of 25 artists/year.

First Contact & Terms Send query letter with photographs, résumé, SASE, slides, transparencies. Samples are not filed and are returned by SASE. Responds in 3 months. Will contact artist for portfolio review if interested. Pays royalties; negotiable. Does not require exclusive representation of artist. Provides advertising, promotion, written contract.

Tips "Get as much exposure as possible! Advises artists to attend ABC shows, Art Expo and Galeria for exposure. Advises artists to read *Art World News* and *Art Trends.* The world wide web is very important (like a gallery online)."

PORTAL PUBLICATIONS, LTD.
201 Alameda del Prado, Suite 200, Novato CA 94949. (415)884-6200. **Vice President, Publishing:** Pamela Prince. Estab. 1954. Poster company and art publisher. Publishes art prints, posters, blank and greeted cards, stationery and calendars.

 • See listing in Greeting Cards, Gifts & Products section.

PORTER DESIGN—EDITIONS PORTER
The Old Estate Yard, Newton St. Loe, Bath BA2 9BR United Kingdom. (866)293-2079. Fax: (01144)1225-874251. E-mail: Mary@porter-design.com. Website: www.porter-design.com. **Partners:** Henry Porter, Mary Porter. Estab. 1985. Publishes limited and unlimited editions and offset productions and hand-colored reproductions. Clients: international distributors, interior designers and hotel contract art suppliers. Current clients include Devon Editions, Top Art, Harrods and Bruce McGaw.

Needs Seeking fashionable and decorative art for the designer market. Considers watercolor. Prefers 16th-19th century traditional styles. Artists represented include Victor Postolle, Joseph Hooker and Adrien Chancel. Editions created by working from an existing painting. Approached by 10 artists/year. Publishes and distributes the work of 10-20 established artists/year.

First Contact & Terms Send query letter with brochure showing art style or résumé and photographs. Accepts disk submissions compatible with QuarkXPress on Mac. Samples are filed or are returned. Responds only if interested. To show portfolio, mail photographs. Pays flat fee or royalties. Offers an advance when appropriate. Negotiates rights purchased.

PORTERFIELD'S FINE ART LICENSING
5 Mountain Rd., Concord NH 03301-5479. (800)660-8345 or (603)228-1864. Fax: (603)228-1888. E-mail: information@porterfieldsfineart.com. Website: www.portersfieldfineart.com. **President:** Lance J. Klass. Full-service licensing representative.

 • See listing in Greeting Cards, Gifts and Products section.

PORTFOLIO GRAPHICS, INC.
P.O. Box 17437, Salt Lake City UT 84117. (801)424-2574. E-mail: info@portfoliographics.com. Website: www.nygs.com. **Creative Director:** Kent Barton. Estab. 1986. Publishes and distributes unlimited editions and posters. Clients: galleries, designers, poster distributors (worldwide) and framers. Licensing: All artwork is available for license for large variety of products. Portfolio Graphics works with a large licensing firm who represents all of their imagery.

Needs Seeking creative, fashionable and decorative art for commercial and designer markets. Considers oil, watercolor, acrylic, pastel, mixed media and photography. Publishes 100+ new works/year. Editions created by working from an existing painting, transparency or high-resolution digital file.

First Contact & Terms Send query letter with résumé, bio and the images you are submitting via photos, transparencies, tearsheets or gallery booklets. Please be sure to label each item. Please do no send original artwork. Make sure to include a SASE for any materials you would like returned. Samples are not filed. Responds in 3 months. Pays royalties of 10%. Provides promotion and a written contract.

Tips "We find artists through galleries, magazines, art exhibits, submissions. We're looking for a variety of artists and styles/subjects."

POSTER PORTERS

P.O. Box 9241, Seattle WA 98109-9241. (800)531-0818. Fax: (206)286-0820. E-mail: markwithposterporters@msn.com. Website: www.posterporters.com. **Marketing Director:** Mark Simard. Art rep/publisher/distributor/gift wholesaler. Publishes/distributes limited and unlimited edition, posters and art T-shirts. Clients: galleries, decorators, frame shops, distributors, corporate curators, museum shops, giftshops. Current clients include Prints Plus, W.H. Smith, Smithsonian, Nordstrom.

Needs Publishes/distributes creative art for regional commercial and designer markets. Considers oil, watercolor, pastel. Prefers regional art. Artists represented include Beth Logan, Carolin Oltman, Jean Casterline, M.J. Johnson. Art guidelines free for SASE with first-class postage. Editions created by collaborating with the artist or working from an existing painting. Approached by 144 artists/year. Publishes the work of 2 emerging, 2 mid-career and 1 established artist/year. Distributes the work of 50 emerging, 25 mid-career, 20 established artists/year.

First Contact & Terms Send photocopies, SASE, tearsheets. Accepts disk submissions. Samples are filed or returned by SASE. Will contact artist for Friday portfolio drop off. Pays flat fee $225-500; royalties of 5%. Offers advance when appropriate. Buys all rights. Provides advertising, promotion, contract. Also works with freelance designers. Prefers local designers only. Finds artists through exhibition, art fairs, art reps, submissions.

Tips "Be aware of what is going on in the interior design sector. Be able to take criticism. Be more flexible."

POSTERS INTERNATIONAL

1200 Castlefield Ave., Toronto ON M6B 1G2 Canada. (416)789-7156. Fax: (416)789-7159. E-mail: artist@postersinternational.net. Website: www.postersinternational.net. **President:** Esther Cohen-Bartfield. Creative Director Lyn Kungel. Licensing Richie Cohen. Estab. 1976. Poster company, art publisher. Publishes fine art posters. Licenses for gift and stationery markets. Clients: galleries, decorators, distributors, hotels, restaurants etc., in U.S., Canada and international. Current clients include Holiday Inn and Bank of Nova Scotia.

Needs Seeking creative, fashionable art for the commercial market. Considers oil, acrylic, watercolor, mixed media, b&w and color photography. Prefers landscapes, florals, abstracts, photography, vintage, collage and tropical imagery. Artists represented include Patricia George, Scott Steele and Shojaei. Editions created by collaborating with the artist or by working from an existing painting. Approached by 100 artists/year. Art guidelines free for SASE with first-class postage or IRC.

First Contact & Terms Send query letter with brochure, photographs, slides, transparencies to Lyn Kungel. "No originals please!" Samples are filed or returned by SASE. Responds in 2 months. Company will contact artist for portfolio review of photographs, photostats, slides, tearsheets, thumbnails, transparencies if interested. Pays flat fee or royalties of 10%. Offers advance when appropriate. Rights purchased vary according to project. Provides advertising, promotion, shipping from firm, written contract. Finds artists through art fairs, art reps, submissions.

Tips "Be aware of current color trends and always work in a series of two or more. Visit poster shops to see what's popular before submitting artwork."

PRESTIGE ART INC.

3909 W. Howard St., Skokie IL 60076. (847)679-2555. E-mail: prestige@prestigeart.com. Website: www.prestigeart.com. **President:** Louis Schutz. Estab. 1960. Publisher/distributor/art gallery. Represents a combination of 18th and 19th century work and contemporary material. Publishes and distributes handpulled originals, limited and unlimited editions, canvas transfers, fine art prints, offset reproductions, posters, sculpture. Licenses artwork for note cards, puzzles, album covers and posters. Clients: galleries, decorators, architects, corporate curators.

• Company president Louis Shutz does consultation for new artists on publishing and licensing their art in various media.

Needs Seeking creative and decorative art. Considers oil, acrylic, mixed media, sculpture, glass. Prefers figurative art, impressionism, surrealism/fantasy, photo realism. Artists represented include Jean-Paul Avisse. Editions created by collaborating with the artist or by working from an existing painting. Approached by 15 artists/year. Publishes the work of 2 emerging artists/year. Distributes the work of 5 emerging artists/year.

First Contact & Terms Send query letter with résumé and tearsheets, photostats, slides, photographs and transparencies. Accepts IBM compatible disk submissions. Samples are not filed and are returned by SASE. Responds only if interested. Company will contact artist for portfolio review of tearsheets if interested. Pays flat fee. Offers an advance when appropriate. Rights purchased vary according to project. Provides insurance in-transit and while work is at firm, advertising, promotion, shipping from firm and written contract.

Tips "Be professional. People are seeking better quality, lower-sized editions, fewer numbers per edition—1/100 instead of 1/750."

PRIME ART PRODUCTS

2800 S. Nova Rd., Bldg. A, South Daytona FL 32119. (800)749-7393. E-mail: tropicalframe@aol.com. Website: www.primeartproducts.com. **Owner:** Ken Kozimor. Estab. 1990. Art publisher, distributor. Publishes/distributes limited editions, unlimited editions, fine art prints, offset reproductions. Clients include galleries, specialty giftshops, interior design and home accessory stores.

Needs Seeking art for the commercial and designer markets. Considers oil, acrylic, watercolor. Prefers realistic shore birds and beach scenes. Artists represented include Robert Binks, Keith Martin Johns, Christi Mathews, Art LaMay and Barbara Klein Craig. Editions created by collaborating with the artist or by working from an existing painting. Approached by 30 artists/year. Publishes the work of 1-2 emerging artists/year. Distributes the work of many emerging and 4 established artists/year.

First Contact & Terms Send photographs, SASE and tearsheets. Samples are filed or returned by SASE. Responds in 5 days. Company will contact artist for portfolio review if interested. Negotiates payment per signature. Offers advance when appropriate. Rights purchased vary according to project. Finds artists through submissions and small art shows.

THE PRINTS AND THE PAPER

106 Walnut St., Montclair NJ 07042. (973)746-6800. Fax: (973)746-6801. Estab. 1996. Distributor of handpulled originals, limited and unlimited edition antiques and reproduced illustration, prints, hand colored etchings and offset reproduction. Clients: galleries, decorators, frame shops, giftshops.

Needs Seeking reproductions of decorative art. Considers watercolor, pen & ink. Prefers illustration geared toward children; also florals. Artists represented include Helga Hislop, Raymond Hughes, Dorothy Wheeler, Arthur Rackham, Richard Doyle.

First Contact & Terms Send query letter with SASE, slides. Samples are filed or returned by SASE. Will contact artist for portfolio review of slides if interested. Negotiates payment. Rights purchased vary according to project. Finds artists through art exhibitions, word of mouth.

Tips "We are a young company (9 years). We have not established all guidelines. We are attempting to establish a reputation for having quality illustration which covers a broad range."

RIGHTS INTERNATIONAL GROUP, LLC

453 First St., Hoboken NJ 07030. (201)239-8118. Fax: (201)222-0694. E-mail: info@rightsinternational.com. Website: www.rightsinternational.com. **Contact:** Robert Hazaga. Estab. 1996. Agency for cross licensing. Represents artists for licensing into publishing, stationery, posters, prints, calendars, giftware, home furnishing. Clients: giftware, stationery, posters, prints, calendars, wallcoverings and home decor publishers.

- This company is also listed in the Greeting Card, Gifts & Products section.

Needs Seeking creative, decorative art for the commercial and designer markets. Also looking for country/Americana with a new fresh interpretation of country with more of a cottage influence. Think Martha Stewart, *Country Living* magazine; globally inspired artwork. Considers all media. Prefers commercial style. Artists represented include Forest Michaels, Susan Hayes and Susan Osborne. Approached by 50 artists/year.

First Contact & Terms Send brochure, photocopies, photographs, SASE, slides, tearsheets, transparencies, JPEGs, CD-ROM. Accepts disk submissions compatible with PC platform. Samples are not filed and are returned by SASE. Responds in 2 weeks. Company will contact artist for portfolio review if interested. Negotiates payment.

Tips "Check our website for trend, color and style forecasts!"

RINEHART FINE ARTS

A division of Bentley Publishing Group, 250 W. 57th St., Suite 2202A, New York NY 10107. (212)399-8958. Fax: (212)399-8964. E-mail: hwrinehart@aol.com. Website: www.bentleypublishinggroup.com. Poster/open edition print publisher and product licensing agent. **President:** Harriet Rinehart. Licenses 2D artwork for posters. Clients include large change stores and wholesale framers, furniture stores, decorators, frame shops, museum shops, gift shops and substantial overseas distribution.

- Harriet Rinehart does product development for all five divisions of Bentley Publishing Group. See also listing for Bentley Publishing Group for more information on this publisher.

Needs Seeking creative, fashionable and decorative art. Considers oil, acrylic, watercolor, mixed media, pastel. Images created by collaborating with the artist or working from an existing painting. Approached by 200-300 artists/year. Publishes the work of 50 new artists/year.

First Contact & Terms Send query letter with photographs, SASE, slides, tearsheets, transparencies or "whatever the artist has that represents artwork best." Samples are not filed. Responds in 3 months. Portfolio review not required. Pays royalties of 8-10%. Rights purchased vary according to project. Provides advertising, promotion, written contract and substantial overseas exposure.

Tips "Submit work in pairs or groups of four. Work in standard sizes. Visit high-end furniture store chains for color trends."

⊕ FELIX ROSENSTIEL'S WIDOW & SON LTD.

33-35 Markham St., London SW3 3NR United Kingdom. (44)207-352-3551. Fax: (44)207-351-5300. E-mail: sales@felixr.com. Website: www.felixr.com. **Contact:** Mrs. Lucy McDowell. Licensing Miss Caroline Dyas. Estab. 1880. Publishes handpulled originals, limited edition, canvas transfers, fine art prints and offset reproductions. Licenses all subjects on any quality product. Art guidelines on website.

Needs Seeking decorative art for the serious collector and the commercial market. Considers oil, acrylic, watercolor, mixed media and pastel. Prefers art suitable for homes or offices. Artists represented include Spencer Hodge, Barbara Olsen, Ray Campbell and Richard Akerman. Editions created by collaborating with the artist or by working from an existing painting. Approached by 200-500 artists/year.

First Contact & Terms Send query letter with photographs. Samples are not filed and are returned by SAE. Responds in 2 weeks. Company will contact artist for portfolio review of final art and transparencies if interested. Negotiates payment. Offers advance when appropriate. Rights purchased vary according to project.

Tips "We don't view artwork sent digitally via e-mail or CD-Rom."

RUSHMORE HOUSE PUBLISHING

P.O. Box 1591, Sioux Falls SD 57107-1591. (800)456-1895. E-mail: info@rushmorehouse.com. Website: www.rushmorehouse.com. **Publisher:** Stan Cadwell. Estab. 1989. Art publisher and distributor of limited editions. Clients: art galleries and picture framers.

Needs Seeking artwork for the serious collector and commercial market. Considers oil, watercolor, acrylic, pastel and mixed media. Prefers realism, all genres. Artists represented include W.M. Dillard and Tom Phillips. Editions created by collaborating with the artist.

First Contact & Terms Send query letter with résumé, tearsheets, photographs and transparencies. Samples are filed or are returned by SASE if requested by artist. Responds in 1 month. Write for appointment to show portfolio of original/final art, tearsheets, photographs and transparencies. Payment method is negotiated. Offers an advance when appropriate. Negotiates rights purchased. Exclusive representation of artist is negotiable. Provides in-transit insurance, insurance while work is at firm, promotion, shipping and written contract. "We market the artist and their work."

Tips "Current interests include wildlife, Native American, Western."

SAGEBRUSH FINE ART

3065 South West Temple, Salt Lake City UT 84115. (801)466-5136. Fax: (801)466-5048. E-mail: chris@sagebrushfineart.com. **Art Review Coordinator:** Stephanie Merrit. Licensing Director: Dena Peat. Co-Owner: Mike Singleton. Estab. 1991. Art publisher. Publishes fine art prints and offset reproductions. Clients: frame shops, distributors, corporate curators and chain stores.

Needs Seeking decorative art for the commercial and designer markets. Considers oil, acrylic, watercolor and photography. Prefers traditional themes and styles. Current clients include Mark Arian, Michael Humphries and Jo Moulton. Editions created by collaborating with the artist or by working from an existing painting. Approached by 200 artists/year. Publishes the work of 20 emerging artists/year.

First Contact & Terms Send SASE, slides and transparencies. Samples are not filed and are returned by SASE. Responds in 3 weeks. Company will contact artist for portfolio review if interested. Pays royalties of 10% or negotiates payment. Offers advance when appropriate. Rights purchased vary according to project. Provides advertising, promotion, shipping from firm and written contract.

SALEM GRAPHICS, INC.

P.O. Box 15134, Winston-Salem NC 27113. (336)727-0659. Fax: (336)761-8439. Website: www.salemgraphics.com. **Contact:** Betty Andrews, office manager. Estab. 1981. Art publisher/distributor. Publishes/distributes canvas transfers, fine art prints, hand-pulled originals, limited edition, offset reproduction, unlimited edition.

Needs Seeking decorative art for the serious collector, commercial and designer markets. Prefers landscapes, seascapes, coastal scenes and florals. Artists represented include Phillip Philbeck, Amy Youngblood, Larry Burge.

First Contact & Terms Send query letter with slides or photographs and SASE. Publisher will contact for portfolio review if interested. Buys reprint rights. Requires exclusive representation of artist. Provides advertising, in-transit insurance and insurance while work is at firm, promotion and written contract.

ℕ SCAFA ART, ART PUBLISHING GROUP

165 Chubb Ave., Lyndhurst NJ 07071 Sweden. (201)842-8500. Fax: (201)842-8546. E-mail: submitart@theartpublishggroup.com. Website: www.scafa.com. **Art Coordinator and Licensing:** Elaine Citron. Produces open

edition offset reproductions. Clients: framers, commercial art trade and manufacturers worldwide. Licenses florals, still lifes, landscapes, animals, religious, etc. for placemats, puzzles, textiles, furniture, cassette/CD covers.

Needs Seeking decorative art for the wall decor market. Considers unframed decorative paintings, posters, photos and drawings. Prefers pairs and series. Artists represented include T.C. Chiu, Jack Sorenson, Kay Lamb Shannon and Marianne Caroselli. Editions created by collaborating with the artist and by working from a pre-determined subject. Approached by 100 artists/year. Publishes and distributes the work of dozens of artists/year. ''We work constantly with our established artists, but are always on the lookout for something new.''

First Contact & Terms Send query letter first with slides, transparencies, color copies, photographs and SASE. Please do not send original art. Also accepts digital images. Supply in JPEG format, limit of 4 files of no more than 300KB each. Responds in about 1 month. Pays $200-350 flat fee for some accepted pieces. Royalty arrangements with advance against 5-10% royalty is standard. Buys only reproduction rights. Provides written contract. Artist maintains ownership of original art. Requires exclusive publication rights to all accepted work.

Tips ''Do not limit your submission. We are interested in seeing your full potential. Please be patient. All inquiries will be answered.''

N ⊕ SCANDECOR MARKETING AB
Box 656, 751 27 Uppsala Sweden. E-mail: mariekadestam@scandecor-marketing.se. Website: www.scandecor-marketing.se. **Contact:** Marie Kadestam. Poster company, art publisher/distributor. Publishes/distributes fine art prints and posters. Clients include gift and stationery stores, craft stores and frame shops.

Needs Seeking fashionable, decorative art. Considers acrylic, watercolor and pastel. Themes and styles vary according to current trends. Editions created by working from existing painting. Approached by 150 artists/year. Publishes the work of 5 emerging, 10 mid-career and 10 established artists/year. Also uses freelance designers. 25% of products require freelance design.

First Contact & Terms Send query letter with brochure, photocopies, photographs, slides, tearsheets, CDs, transparencies and SASE. Samples not filed are returned by SASE in 2 months. Company will contact artist for portfolio review if interested. Portfolio should include color photographs, slides, tearsheets and/or transparencies. Pays flat fee, $250-1,000. Rights vary according to project. Provides written contract. Finds artists through art exhibitions, art and craft fairs, art reps, submissions and looking at art already in the marketplace in other forms (e.g., collectibles, greeting cards, puzzles).

SCHIFTAN INC.
1300 Steel Rd. W, Suite 4, Morrisville PA 19067. (215)428-2900 or (800)255-5004. Fax: (215)295-2345. E-mail: schiftan@erols.com. Website: www.schiftan.com. **President:** Harvey S. Cohen. Estab. 1903. Art publisher, distributor. Publishes/distributes unlimited editions, fine art prints, offset reproductions, posters and hand-colored prints. Clients: galleries, decorators, frame shops, architects, wholesale framers to the furniture industry.

Needs Seeking fashionable, decorative art for the commercial market. Considers watercolor, mixed media. Editions created by collaborating with the artist. Approached by 15-20 artists/year. Also needs freelancers for design.

First Contact & Terms Send query letter with transparencies. Samples are not filed and are returned. Responds in 1 week. Company will contact artist for portfolio review of final art, roughs, transparencies if interested. Pays flat fee or royalties. Offers advance when appropriate. Negotiates rights purchased. Provides advertising, written contract. Finds artists through art exhibitions, art fairs, submissions.

SCHLUMBERGER GALLERY
P.O. Box 2864, Santa Rosa CA 95405. (707)544-8356. Fax: (707)538-1953. E-mail: sande@schlumberger.org. **Owner:** Sande Schlumberger. Estab. 1986. Art publisher, distributor and gallery. Publishes and distributes limited editions, posters, original paintings and sculpture. Specializes in decorative and museum-quality art and photographs. Clients: collectors, designers, distributors, museums, galleries, film and television set designers. Current clients include: Bank of America Collection, Fairmont Hotel, Editions Ltd., Sonoma Cutter Vineyards, Dr. Robert Jarvis Collection and Tom Sparks Collection.

Needs Seeking decorative art for the serious collector and the designer market. Prefers trompe l'oeil, realist, architectural, figure, portrait. Artists represented include Charles Giulioli, Deborah Deichler, Susan Van Camden, Aurore Carnero, Borislav Satijnac, Robert Hughes, Fletcher Smith, Jacques Henri Lartigue, Ruth Thorn Thompson, Ansel Adams and Tom Palmore. Editions created by collaborating with the artist or by working from an existing painting. Approached by 50 artists/year.

First Contact & Terms Send query letter with tearsheets and photographs. Samples are not filed and are returned by SASE if requested by artist. Publisher/distributor will contact artist for portfolio review if interested. Portfolio should include color photographs and transparencies. Negotiates payment. Offers advance when appropriate. Rights purchased vary according to project. Provides advertising, in-transit insurance, insurance while work is

at firm, promotion, shipping to and from firm, written contract and shows. Finds artists through exhibits, referrals, submissions and "pure blind luck."

Tips "Strive for quality, clarity, clean lines and light, even if the style is impressionistic. Bring spirit into your images. It translates!"

ROSE SELAVY OF VERMONT

P.O. Box 1528, Manchester Center VT 05255. (802)362-0373. Fax (802)362-1082. E-mail: michael@applejackart.com. Website: www.applejackart.com. Publishes/distributes unlimited edition fine art prints. Clients: galleries, decorators, frame shops, distributors, architects, corporate curators, museum shops and giftshops.

Needs Seeking decorative art for the serious collector, commercial and designer markets. Considers oil, acrylic, watercolor, mixed media, pastel and pen & ink. Prefers folk art, antique, traditional and botanical. Artists represented include Lisa Audit, Susan Clickner and Valorie Evers Wenk. Editions created by collaborating with the artist or by working from an existing painting.

First Contact & Terms Send query letter (or e-mail) with brochure (or JPEGs), photocopies, photographs, slides and tearsheets. Samples are not filed and are returned by SASE. Responds only if interested. Company will contact artist for portfolio review if interested. Negotiates payment. Offers advance when appropriate. Rights purchased vary according to project. Usually requires exclusive representation of artist. Provides promotion and written contract. Also needs freelancers for design. Finds artists through art exhibitions and art fairs.

SIDE ROADS PUBLICATIONS

177 NE 39th St., Miami FL 33137. (305)576-1355. Fax: (305)576-0551. E-mail: sideropub@aol.com. Website: www.sideroadspub.com. **Contact:** Tamar Erdberg. Estab. 1998. Art publisher and distributor of originals and handpulled limited edition serigraphs. Clients: galleries, decorators and frame shops.

Needs Seeking creative art for the commercial market. Considers oil, acrylic, mixed media and sculpture. Open to all themes and styles. Artists represented include Clemens Briels. Editions created by working from an existing painting.

First Contact & Terms Send query letter with brochure, photographs, résumé, slides and SASE. Samples are filed or returned by SASE. Company will contact artist for portfolio review if interested. Payment on consignment basis. Rights purchased vary according to project. Requires exclusive representation of artist. Provides advertising and promotion. Finds artists through art exhibitions and artists' submissions.

SIPAN LLC

300 Glenwood Ave., Raleigh NC 27603. Phone/fax: (919)833-2535. **Member:** Owen Walker III. Estab. 1994. Art publisher. Publishes handpulled originals. Clients: galleries and frame shops.

Needs Seeking art for the serious collector and the commercial market. Considers oil, acrylic, watercolor. Prefers traditional themes. Artists represented include Altino Villasante. Editions created by collaborating with the artist. Approached by 5 artists/year. Publishes/distributes the work of 1 emerging artist/year.

First Contact & Terms Send photographs, SASE and transparencies. Samples are not filed and are returned by SASE. Responds in 2 weeks. Company will contact artist for portfolio review of color final art if interested. Negotiates payment. Offers advance when appropriate. Buys all rights. Requires exclusive representation of artist. Provides advertising, in-transit insurance, insurance while work is at firm, promotion, written contract.

N ⊕ SJATIN PUBLISHING & LICENSING B.V.

(formerly Sjatin BV), P.O. Box 4028, Belfeld 5951CC The Netherlands. 31 77 475 1965. Fax 31774 475 1965. E-mail: art@sjatin.nl. Website: www.sjatin.nl. **President:** Inge Colbers. Estab. 1977. Art publisher. Publishes handpulled originals, limited editions, fine art prints. Licenses romantic art to appear on placemats, notecards, stationery, photo albums, posters, puzzles and gifts. Clients: furniture stores, department stores. Current clients include Karstadt (Germany), Prints Plus (USA).

• Sjatin actively promotes worldwide distribution for artists they sign.

Needs Seeking decorative art for the commercial market. Considers oil, acrylic, watercolor, mixed media, pastel. Prefers romantic themes, florals, landscapes/garden scenes, women. Artists represented include Willem Haenraets, Peter Motz, Reint Withaar. Editions created by collaborating with the artist or by working from an existing painting. Approached by 50 artists/year. "We work with 20 artists only, but publish a very wide range from cards to oversized prints and we sell copyrights."

First Contact & Terms Send brochure and photographs. Responds only if interested. Company will contact artist for portfolio review of color photographs (slides) if interested. Negotiates payment. Offers advance when appropriate. Buys all rights. Provides advertising, promotion, shipping from firm and written contract (if requested).

Tips "Follow the trends in interior decoration; look at the furniture and colors. I receive so many artworks that are beautiful and very artistic, but are not commercial enough for reproduction. I need designs which appeal

to many many people, worldwide such as flowers, gardens, interiors and kitchen scenes. I do not wish to receive graphic art. Artists entering the poster/print field should attend the I.S.F. Show in Birmingham, Great Britain, or the ABC show in Atlanta.''

SOHO GRAPHIC ARTS WORKSHOP

433 W. Broadway, Suite 5, New York NY 10012. (212)966-7292. **Director:** Xavier H. Rivera. Estab. 1977. Art publisher, distributor and gallery. Publishes and distributes limited editions.

Needs Seeking art for the serious collector. Considers prints. Editions created by collaborating with the artist or working from an existing painting. Approached by 10-15 artists/year.

First Contact & Terms Send résumé. Responds in 2 weeks. Artist should follow up with letter after initial query. Portfolio should include slides and 35mm transparencies and SASE. Negotiates payment. No advance. Buys first rights. Provides written contract.

SOMERSET HOUSE PUBLISHING

10688 Haddington Dr., Houston TX 77043. (800)444-2540. Fax: (713)465-6062. E-mail: sallen@somersethouse.com. Website: www.somersethouse.com. **Executive Vice President:** Stephanie Allen. Licensing: Daniel Klepper. Estab. 1972. Art publisher of fine art limited and open editions, handpulled original graphics, offset reproductions, giclees and canvas transfers. Clients include independent galleries in U.S., Canada, Australia.

Needs Seeking fine art for the serious collector and decorative art for the designer market. Considers oil, acrylic, watercolor, mixed media, pastel. Also prefer religious art. Artists represented include G. Harvey, Larry Dyke, Nancy Glazier, Martin Grelle, Tom du Bois, Christa Kieffer and J.D. Challenger. Editions created by collaborating with the artist or by working from an existing painting. Approached by 1,500 artists/year. Publishes the work of 7 emerging, 4 mid-career and 7 established artists/year.

First Contact & Terms Send query letter accompanied by 10-12 slides or photos representative of work with SASE. Samples are filed for future projects unless return is requested. Samples are not filed and are returned. Responds in 2 months. Publisher will contact artist for portfolio review if interested. Pays royalties. Rights purchased vary according to project. Provides advertising, insurance in-transit and while work is at firm, promotion, shipping from firm, written contract.

Tips ''Considers mature, full-time artists. Special consideration given to artists with originals selling above $5,000. Be open to direction.''

N SPORT'EN ART

R.R. #3, Box 17, Sullivan IL 61951-1058. (217)797-6770. Fax: (217)797-6482. E-mail: sportart@moultrie.com. **Contact:** Dan Harshman.

First Contact & Terms Send query letter with slides and SASE. Publisher will contact for portfolio review if interested.

SPORTS ART INC

1675 Powers Lake Rd., Powers Lake WI 53159. (800)552-4430. Fax: (262)279-9830. E-mail: angela@golfgiftsgallery.com. **President:** Dean Chudy. Estab. 1989. Art publisher and distributor of limited and unlimited editions, offset reproductions and posters. Clients: over 2,000 active art galleries, frame shops and specialty markets.

Needs Seeking artwork with creative artistic expression for the serious collector and the designer market. Considers oil, watercolor, acrylic, pastel, pen & ink and mixed media. Prefers sports themes. Artists represented include Ken Call and Brent Hayes. Editions created by collaborating with the artist or working from an existing painting. Approached by 150 artists/year. Distributes the work of 30 emerging, 60 mid-career and 30 established artists/year.

First Contact & Terms Send query letter with brochure showing art style or résumé, tearsheets, SASE, slides and photographs. Accepts submissions on disk. Samples are filed or returned by SASE if requested by artist. To show a portfolio, mail thumbnails, slides and photographs. Pays royalties of 10%. Offers an advance when appropriate. Negotiates rights purchased. Sometimes requires exclusive representation of the artist. Provides promotion and shipping from firm.

Tips ''We are interested in generic sports art that captures the essence of the sport as opposed to specific personalities.''

N SULIER ART PUBLISHING

111 Conn Terrace, Lexington KY 40508-3205. (859)223-3272. Fax: (859)296-0650. E-mail: info@NeilSulier.com. **Art Director:** Neil Sulier. Art publisher and distributor. Publishes and distributes handpulled originals, limited and unlimited editions, posters, offset reproductions and originals. Clients: designers.

Needs Seeking creative, fashionable and decorative art for the serious collector and the commercial and designer markets. Considers oil, watercolor, mixed media, pastel and acrylic. Prefers impressionist. Artists represented

include Judith Webb, Neil Sulier, Eva Macie, Neil Davidson, William Zappone, Zoltan Szabo, Henry Faulconer, Mariana McDonald. Editions created by collaborating with the artist or by working from an existing painting. Approached by 20 artists/year. Publishes the work of 5 emerging, 30 mid-career and 6 established artists/year. Distributes the work of 5 emerging artists/year.

First Contact & Terms Send query letter with brochure, slides, photocopies, résumé, photostats, transparencies, tearsheets and photographs. Samples are filed or are returned. Responds only if interested. Request portfolio review in original query. Artist should follow up with call. Publisher will contact artist for portfolio review if interested. Portfolio should include slides, tearsheets, final art and photographs. Pays royalties of 10%, on consignment basis or negotiates payment. Offers advance when appropriate. Negotiates rights purchased (usually one-time or all rights). Provides in-transit insurance, promotion, shipping to and from firm, insurance while work is at firm and written contract.

SUMMIT PUBLISHING

746 Higuera, Suite 4, San Luis Obispo CA 93401. (805)549-9700. Fax: (805)549-9710. E-mail: summit@summitart.com. Website: www.summitart.com. **Owner:** Ralph Gorton. Estab. 1987. Art publisher, distributor and gallery. Publishes and distributes handpulled originals and limited editions.

Needs Seeking creative, fashionable and decorative art for the serious collector. Considers oil, watercolor, mixed media and acrylic. Prefers fashion, contemporary work. Artists represented include Manuel Nunez, Catherine Abel and Tim Huhn. Editions created by collaborating with the artist or by working from an existing painting. Approached by 20 artists/year. Publishes and distributes the work of emerging, mid-career and established artists.

First Contact & Terms Send postcard-size sample of work or send query letter with brochure, résumé, tearsheets, slides, photographs and transparencies. Samples are filed. Responds in 5 days. Artist should follow up with call. Publisher/distributor will contact artist for portfolio review if interested. Portfolio should include color thumbnails, roughs, final art, tearsheets and transparencies. Pays royalties of 10-15%, 60% commission or negotiates payment. Offers advance when appropriate. Buys first rights or all rights. Requires exclusive representation of artist. Provides advertising, in-transit insurance, insurance while work is at firm, promotion, shipping to and from firm and written contract. Finds artists through attending art exhibitions, art fairs, word of mouth and submissions. Looks for artists at Los Angeles Expo and New York Expo.

Tips Recommends artists attend New York Art Expo, ABC Shows.

☑ SUN DANCE GRAPHICS & NORTHWEST PUBLISHING

9580 Delegates Dr., Orlando FL 32837. (407)240-1091. Fax: (407)240-1951. E-mail: sales@sundancegraphics.com or sales@northwestpublishing.com. Website: www.sundancegraphics.com. **Art Director:** Pat Lien. Estab. 1996. Publishers and printers of giclée prints, fine art prints, and posters. **Sun Dance Graphics** provides trend forward images to customers that manufacture for upscale Hospitality, Retail, and Home Furnishings markets. Primarily looking for images in sets/pairs with compelling color palette, subject, and style. **Northwest Publishing** provides fine art prints and posters in the following categories: Classics, Traditional, Inspirational, Contemporary, Home and Hearth, Photography, Motivationals, Wildlife, Landscapes and Ethnic Art.

Needs Approached by 300 freelancers/year. Works with 50 freelancers/year. Buys 200 freelance designs and illustrations/year. Art guidelines free for SASE with first-class postage. Works on assignment only. Looking for high-end art. 20% of freelance design work demands knowledge of Photoshop, Illustrator and QuarkXPress.

First Contact & Terms Art submissions may be electronic (e-mail low res image or website link) or via mail. Please do not send original art unless specifically requested. Artists will be contacted if there is interest in further review. All submissions are reviewed for potential inclusion in either line as well as for licensing potential, and are kept on file for up to six months. Art may be purchased or signed under royalty agreement. Royalty/licensing contracts will be signed before any images can be considered for inclusion in either line.

Tips "Focus on style. We tend to carve our own path with unique, compelling and high quality art, and as a result are not interested in 'me too' images."

☑ SUNSET MARKETING

14301 Panama City Beach Pkwy., Panama City Beach FL 32408. (850)233-6261. Fax: (850)233-9169. E-mail: info@sunsetartprints.com. Website: www.sunsetartprints.com. **Product Development:** Leah Moseley. Estab. 1986. Art publisher and distributor of unlimited editions, canvas transfers and fine art prints. Clients: galleries, decorators, frame shops, distributors and corporate curators. Current clients include Paragon, Propac, Uttermost, Lieberman's and Bruce McGaw.

Needs Seeking fashionable and decorative art for the commercial and designer market. Considers oil, acrylic and watercolor art and home decor furnishings. Artists represented include Steve Butler, Merri Paltinian, Van Martin, Kimberly Hudson, Carol Flallock and Barbara Shipman. Editions created by collaborating with the artist.

First Contact & Terms Send query letter with brochure, photocopies and photographs. Samples are filed.

Company will contact artist for portfolio review of color final art, roughs and photographs if interested. Requires exclusive representation of artist.

SYRACUSE CULTURAL WORKERS

P.O. Box 6367, Syracuse NY 13217. (315)474-1132. Fax: (877)265-5399. E-mail: scw@syrculturalworkers.com. Website: www.syrculturalworkers.com. **Art Director:** Karen Kerney. Produces posters, notecards, postcards, greeting cards, T-shirts and calendars that are feminist, multicultural, lesbian/gay allied, racially inclusive and honor elders and children (environmental and social justice).

Needs Art guidelines free for SASE with first-class postage and also available on company's website. View our website to get an idea of appropriate artwork for our company.

First Contact & Terms Pays flat fee, $85-400; royalties of 6% of gross sales.

JOHN SZOKE EDITIONS

591 Broadway, 3rd Floor, New York NY 10012-3232. (212)219-8300. Fax: (212)966-3064. E-mail: info@johnszok eeditions.com. Website: www.johnszokeeditions.com. **Director:** John Szoke. Retail gallery and art publisher. Estab. 1974. Represents 30 mid-career artists including Louise Bourgeois, Jean Cocteau, Ellsworth Kelly, Larry Rivers, Pablo Picasso, Donald Sultan. Publishes the work of Richard Haas, James Rizzi, Jeannette Pasin Sloan. Located downtown in Soho. Open all year. Clients include other dealers and collectors. 20% of sales are to private collectors.

● Not considering new artists at the present time.

Media Exhibits works on paper, multiples in relief, and intaglio and sculpture.

TAKU GRAPHICS

5763 Glacier Hwy., Juneau AK 99801. (907)780-6310. Fax: (907)780-6314. E-mail: info@takugraphics.com. Website: www.takugraphics.com. **Owner:** Adele Hamey. Estab. 1991. Distributor. Distributes handpulled originals, limited edition, unlimited edition, fine art prints, offset reproduction, posters, paper cast, bead jewelry and note cards. Clients: galleries and gift shops.

Needs Seeking art from Alaska and the Pacific Northwest exclusively. Considers oil, acrylic, watercolor, mixed media, pastel and pen & ink. Prefers regional styles and themes. Artists represented include JoAnn George, Barbara Lavalle, Byron Birdsall, Brenda Schwartz and Barry Herem. Editions created by working from an existing painting. Approached by 30-50 artists/year. Distributes the work of 20 emerging, 6 mid-career and 6 established artists/year.

First Contact & Terms Send query letter with brochure, photographs and tearsheets. Samples are not filed and are returned. Responds in 1 month. Company will contact artist for portfolio review if interested. Pays on consignment basis. Firm receives 35% commission. No advance. Requires exclusive representation of artist. Provides advertising, insurance while work is at firm, promotion, sales reps, trade shows and mailings. Finds artists through word of mouth.

TELE GRAPHICS

153 E. Lake Brantley Dr., Longwood FL 32779. E-mail: RonRybak@TelegraphicsOnline.com. **President:** Ron Rybak. Art publisher/distributor handling original mixed media and handpulled originals. Clients: galleries, picture framers, interior designers and regional distributors.

Needs Seeking decorative art for the serious collector. Artists represented include Beverly Crawford, Diane Lacom, Joy Broe and W.E. Coombs. Editions created by collaborating with the artist or by working from an existing painting. Approached by 30-40 artists/year. Publishes the work of 1-4 emerging artists/year.

First Contact & Terms Send query letter with résumé and samples. Samples are not filed and are returned only if requested. Responds in 1 month. Call or write for appointment to show portfolio of original/final art. Pays by the project. Considers skill and experience of artist and rights purchased when establishing payment. Offers advance. Negotiates rights purchased. Requires exclusive representation. Provide promotions, shipping from firm and written contract.

Tips "Be prepared to show as many varied examples of work as possible. Show transparencies or slides plus photographs in a consistent style. We are not interested in seeing only one or two pieces."

N: BRUCE TELEKY INC.

87 35th St., 3rd Floor, Brooklyn, NY 11232. (718)965-9690. Fax: (718)832-8432. Website: www.teleky.com. **President:** Bruce Teleky. Estab. 1975. Clients include galleries, manufacturers and other distributors.

Needs Works from existing art to create open edition posters or works with artist to create limited editions. Visit our website to view represented artists. Also likes coastal images, music themes and Latino images. Uses photographs. Likes to see artists who can draw. Prefers depictions of African-American, Carribean scenes or African themes.

First Contact & Terms Send query letter with slides, transparencies, postcard or other appropriate samples and SASE. Publisher will contact artist for portfolio review if interested. Payment negotiable. Samples returned by SASE only.

Ⓝ THINGS GRAPHICS & FINE ART

8791 D'Arcy Rd., Forestville MD 20747. (301)333-1632. Fax: (301)333-1824. Website: www.thingsgraphics.com. **Special Assistant New Acquisitions:** Edward Robertson. Estab. 1984. Art publisher and distributor. Publishes/distributes limited and unlimited editions, offset reproductions and posters. Clients: gallery owners. Current clients include Savacou Gallery and Deck the Walls.

Needs Seeking artwork with creative expression for the commercial market. Considers oil, watercolor, acrylic, pen & ink, mixed media and serigraphs. Prefers Afro-American, Caribbean and "positive themes." Artists represented include Charles Bibbs, John Holyfield, James Denmark and Leroy Campbell. Editions created by working from an existing painting. Approached by 60-100 artists/year. Publishes the work of 1-5 emerging, 1-5 mid-career and 1-5 established artists/year. Distributes the work of 10-20 emerging, 10-20 mid-career and 60-100 established artists/year.

First Contact & Terms Send query letter with résumé, tearsheets, photostats, photocopies, slides, photographs, transparencies and full-size print samples. Samples are filed. Responds in 3-4 weeks. To show a portfolio, mail thumbnails, tearsheets, photographs, slides and transparencies. Payment method is negotiated. Does not offer an advance. Negotiates rights purchased. Provides promotion and a written contract.

Tips "Continue to create new works; if we don't use the art the first time, keep trying us."

Ⓝ VARGAS FINE ART PUBLISHING, INC.

Southgate at Washington Business Park., 9700 Martin Luther King, Jr. Hwy., Suite D, Lanham MD 20706. (301)731-5175. Fax: (301)731-5712. E-mail: vargasfineart@aol.com. Website: www.vargasfineart.com. **President:** Elba Vargas-Colbert. Estab. 1987. Art publisher and worldwide distributor of serigraphs, limited and open edition offset reproductions, etchings, sculpture, music boxes, keepsake boxes, ceramic art tiles, art magnets, art mugs, collector plates, calendars, canvas transfers and figurines. Clients: galleries, frame shops, museums, decorators, movie sets and TV.

Needs Seeking creative art for the serious collector and commercial market. Considers oil, watercolor, acrylic, pastel pen & ink and mixed media. Prefers ethnic themes. Artists represented include Joseph Holston, Kenneth Gatewood, Tod Haskin Fredericks, Betty Biggs, Charles Bibbs, Sylvia Walker, Ted Ellis, Leroy Campbell, William Tolliver, Sylvia Walker, Paul Goodnight, Wayne Still and Paul Awuzie. Approached by 100 artists/year. Publishes/distributes the work of about 80 artists.

First Contact & Terms Send query letter with résumé, slides and/or photographs. Samples are filed. Responds only if interested. To show portfolio, mail photographs. Payment method is negotiated. Requires exclusive representation of the artist.

Tips "Continue to hone your craft with an eye towards being professional in your industry dealings."

Ⓝ VIBRANT FINE ART

3941 W. Jefferson Blvd., Los Angeles CA 90016. (323)766-0818. Fax: (323)737-4025. E-mail: vibrant2@earthlink.net. **Art Director:** Phyliss Stevens. Licensing: Tom Nolen. Design Coordinator: Jackie Stevens. Estab. 1990. Art publisher and distributor. Publishes and distributes fine art prints, limited and unlimited editions and offset reproductions. Licenses ethnic art to appear on ceramics, gifts, textiles, miniature art, stationery and note cards. Clients: galleries, designers, giftshops, furniture stores and film production companies.

Needs Seeking decorative and ethnic art for the commercial and designer markets. Considers oil, watercolor, mixed media and acrylic. Prefers African-American, Native-American, Latino themes. Artists represented include Sonya A. Spears, Van Johnson, Momodou Ceesay, William Crite and Darryl Daniels. Editions created by collaborating with the artist or by working from an existing painting. Approached by 40 artists/year. Publishes the work of 5 emerging, 5 mid-career and 2 established artists/year. Distributes the work of 5 emerging, 5 mid-career and 2 established artists/year. Also needs freelancers for design. 20% of products require design work. Designers should be familiar with Illustrator and Mac applications. Prefers local designers only.

First Contact & Terms Send query letter with brochure, tearsheets and slides. Samples are filed or are returned by SASE. Publisher/distributor will contact artist for portfolio review if interested. Portfolio should include color tearsheets, photographs, slides and biographical sketch. Pays royalties of 10%. Rights purchased vary according to project. Provides advertising, insurance while work is at firm, promotion, written contract and shipping from firm. Finds artists through art exhibitions, referrals, sourcebooks, art reps, submissions.

Tips "Ethnic art is hot. The African-American art market is expanding. I would like to see more submissions from artists that include slides of ethnic imagery, particularly African-American, Latino and Native American. We desire contemporary cutting edge, fresh and innovative art. Artists should familiarize themselves with the

technology involved in the printing process. They should possess a commitment to excellence and understand how the business side of the art industry operates.''

SHAWN VINSON FINE ART

119 E. Court St., Suite 100, Decatur GA 30030. (404)370-1720. E-mail: shawn@shawnvinsongallery.com. Website: www.shawnvinsongallery.com. **Owner:** Shawn Vinson. Fine arts gallery, dealer and consultant, specializing in contemporary paintings and works on paper. Clients: galleries, designers and collectors. Current clients include Gallery 71, New York City, Universal Studios Florida, Naomi Judd.

Needs Seeking fine art originals for the serious collector. Considers oil, acrylic, mixed media and pastel. Prefers contemporary and painterly styles. Represents American, English and Dutch artists. Approached by 6-12 artists/year. Publishes the work of 1-2 emerging, 1-2 mid-career and 1-2 established artists/year. Distributes the work of 8-10 emerging, 8-10 mid-career and 8-10 established artists/year.

First Contact & Terms Send query letter with photographs, résumé, SASE, slides and tearsheets. Accepts disk submissions compatible with Microsoft applications. Samples are filed. Responds only if interested. Company will contact artist for portfolio review if interested. Pays on consignment basis or negotiates payment. Rights purchased vary according to project. Provides advertising, in-transit insurance, insurance while work is at firm and promotion.

Tips ''Maintain integrity in your work. Limit number of dealers.''

VLADIMIR ARTS USA INC.

2504 Sprinkle Rd., Kalamazoo MI 49001. (269)383-0032. Fax: (269)383-1840. E-mail: vladimir@vladimirarts.com. Website: www.vladimirarts.com. **Contact:** Lew Iwlew. Art publisher, distributor and gallery. Publishes/distributes handpulled originals, limited edition, unlimited edition, canvas transfers, fine art prints, monoprints, monotypes, offset reproduction, posters and giclee. Clients: galleries, decorators, frame shops, distributors, architects, corporate curators, museum shops, giftshops and West Point military market.

Needs Seeking creative, fashionable and decorative art for the serious collector, commercial market and designer market. Considers oil, acrylic, watercolor, mixed media, pastel, pen & ink and sculpture. Artists represented include Hongmin Zou, Ben Maile, Bev Doolittle and Charles Wysocki. Editions created by collaborating with the artist. Approached by 30 artists/year. Publishes work of 10 emerging, 10 mid-career and 10 established artists/year. Distributes work of 1-2 emerging, 1 mid-career and 1-2 established artists/year.

First Contact & Terms Send query letter with brochure, photocopies, photographs and tearsheets. Accepts disk submissions compatible with Illustrator 5.0 for Windows 95 and later. Samples are filed or returned with SASE. Responds only if interested. Company will contact artist for portfolio review if interested. Portfolio should include b&w, color, fine art, photographs and roughs. Negotiates payment. No advance. Provides advertising, promotion and shipping from our firm. Finds artists through attending art exhibitions, art fairs, word of mouth, World Wide Web, art reps, sourcebooks, artists' submissions and watching art competitions.

Tips ''The industry is growing in diversity of color. There are no limits.''

WANDA WALLACE ASSOCIATES

323 E. Plymouth, Suite #2, Inglewood CA 90306-0436. (310)419-0376. Fax: (310)419-0382. **President:** Wanda Wallace. Estab. 1980. Art publisher, distributor, gallery and consultant for corporations, businesses and residential. Publishes handpulled originals, limited and unlimited editions, canvas transfers, fine art prints, monotypes, posters and sculpture. Clients: decorators, galleries, distributors.

● This company operates a nonprofit organization called Wanda Wallace Foundation that educates children through utilizing art and creative focus.

Needs Seeking art by and depicting African-Americans. Considers oil, acrylic, watercolor, mixed media, pastel, pen & ink and sculpture. Prefers traditional, modern and abstract styles. Artists represented include Alex Beaujour, Dexter, Aziz, Momogu Ceesay, Charles Bibbs, Betty Biggs, Tina Allen, Adrian Won Shue. Editions created by collaborating with the artist or by working from an existing painting. Approached by 100 artists/year. Publishes/distributes the work of 10 emerging, 7 mid-career and 3 established artists/year.

First Contact & Terms Send query letter with brochure, photocopies, photographs, tearsheets and transparencies. Samples are filed and are not returned. Responds only if interested. Company will contact artist for portfolio review of color, final art, photographs and transparencies. Pays on consignment basis. Firm receives 50% commission or negotiates payment. Offers advance when appropriate. Buys all rights. Requires exclusive representation of artist. Provides advertising, promotion, shipping from firm and written contract.

Tips ''African-American art is very well received. Depictions that sell best are art by black artists. Be creative, it shows in your art. Have no restraints. Educational instruction available.''

WEBSTER FINE ART LTD.

1003 High House Road, Suite 101, Cary NC 27513. (919)388-9370. Fax: (919)388-9377. E-mail: info@websterfineart.com. Website: www.websterfineart.com. **Contact:** Brandon O'Neill. Art publisher/distributor. Estab. 1987.

Publishes open editions and fine art prints. Clients: galleries, frame shops, distributors, giftshops.

Needs Considers oil, acrylic, watercolor, pastel, pen & ink, mixed media. "Seeking creative artists that can take directions; decorative, classic, traditional, fashionable, realistic, impressionistic, landscape, artists who know the latest trends." Artists represented include Janice Brooks, Lorraine Rossi, Fiona Butler. Editions created by collaborating with the artist.

First Contact & Terms Send query letter with brochure, photocopies, photographs, slides, tearsheets, transparencies and SASE. Samples are filed or returned by SASE. Responds in 1 month. Company will contact artist for portfolio review if interested. Negotiates payment. Offers advance when appropriate. Buys all or reprint rights. Finds artists by word of mouth, attending art exhibitions and fairs, submissions and watching art competitions.

Tips "Check decorative home magazines *Southern Accents*, *Architectural Digest*, *House Beautiful*, etc. for trends. Understand the decorative art market."

ℕ THE WHITE DOOR PUBLISHING COMPANY

P.O. Box 427, New London MN 56273. (320)796-2209. Fax (320)796-2968. **President:** Mark Quale. Estab. 1988. Art publisher. Publishes limited editions, offset reproductions. Clients: 1,000 galleries (authorized dealer network).

Needs Seeking creative art for the commercial market. Considers oil, acrylic, watercolor, mixed media, pastel. Prefers "traditional" subject matter. Artists represented include Charles L. Peterson, Morten Solberg, Jan Martin McGuire, Greg Alexander, Dan Mieduch and D. Edward Kucera. Editions created by collaborating with the artist or by working from an existing painting. Approached by 250 artists/year. Publishes the work of 2-3 emerging, 2-3 mid-career and 4-6 established artists/year.

First Contact & Terms Send photographs, SASE, slides, tearsheets, transparencies. Samples are not filed and are returned by SASE. Responds in 4 weeks. Company will contact artist for portfolio review of color photographs, slides, transparencies. Pays royalties. Buys one-time and reprint rights. Requires exclusive representation of artist. Provides advertising, in-transit insurance, insurance while work is at firm, shipping to and from firm, written contract. Finds artists through attending art exhibitions, word of mouth, submissions and art publications.

Tips "Nostalgia and images reflecting traditional values are good subjects. Versatility not important. Submit only the subjects and style you love to paint."

WHITEGATE FEATURES SYNDICATE

71 Faunce Dr., Providence RI 02906. (401)274-2149. Website: www.whitegatefeatures.com. **Talent Manager:** Eve Green.

- This syndicate is looking for fine artists and illustrators. See listing in Syndicates section for information on their needs.

First Contact & Terms "Please send (nonreturnable) slides or photostats of fine arts works. We will call if a project suits your work." Pays royalties of 50% if used to illustrate for newspaper or books.

Tips "We also work with collectors of fine art and we are starting a division that will represent artists to galleries."

WILD APPLE GRAPHICS, LTD.

526 Woodstock Rd., Woodstock VT 05091. (802)457-3003. Fax: (802)457-5891. E-mail: deanne.carvalho@wildapple.com. Website: www.wildapple.com. **Art Development Coordinator:** Deanne Carvalho. Estab. 1990. Wild Apple publishes, distributes and represents a diverse group of contemporary artists. Clients: manufacturers, galleries, designers, poster distributors (worldwide) and framers. Licensing: Acting as an artist's agent, we present your artwork to manufacturers for consideration.

Needs We are always looking for fresh talent and varied images to show. Considers oil, watercolor, acrylic, pastel, mixed media and photography. Publishes 400+ new works each year.

First Contact & Terms Send query letter with résumé, biography, slides and photographs. Samples are not filed. Responds in 2 months. To show portfolio, e-mail JPGs or mail slides, transparencies, tearsheets and photographs with SASE. (Material will not be returned without an enclosed SASE.)

Tips "We would love to hear from you. Use the telephone, fax machine, e-mail, post office or carrier pigeon (you must supply your own) to contact us."

WILD ART GROUP

31630 Sierra Verde Rd., Homeland CA 92548. (800)669-1368. Fax: (888)219-2710. E-mail: sales@WildArtGroup.com. Website: www.WildArtGroup.com. Art Publisher/Distributor/Framer. Publishes lithographs, canvas transfers, serigraphs, giclee printing, digital photography and offset/digital printing.

Needs Seeking fine art for serious collectors and decorative art for the commercial market. Considers all media.

Artists represented include GAMBOA, JD Wild, Annie Lee, Terry Wilson, Merryl Jaye, Bernice Kendrick, Marty Tobias and Teddie Oatey.

First Contact & Terms Send query letter with slides, transparencies or other appropriate samples and SASE. Will accept submissions on disk or CD-ROM. Publisher will contact artist for portfolio review if interested.

WILD WINGS LLC

2101 S. Highway 61, Lake City MN 55041. (651)345-5355. Fax: (651)345-2981. E-mail: info@wildwings.com. Website: www.wildwings.com. **Vice President:** Sara Koller. Estab. 1968. Art publisher, distributor and gallery. Publishes and distributes limited editions and offset reproductions. Clients: retail and wholesale.

Needs Seeking artwork for the commercial market. Considers oil, watercolor, mixed media, pastel and acrylic. Prefers wildlife. Artists represented include David Maass, Lee Kromschroeder, Ron Van Gilder, Robert Abbett, Michael Sieve and Persis Clayton Weirs. Editions created by working from an existing painting. Approached by 300 artists/year. Publishes the work of 36 artists/year. Distributes the work of numerous emerging artists/ year.

First Contact & Terms Send query letter with slides and résumé. Samples are filed and held for 6 months then returned. Responds in 3 weeks if uninterested or 6 months if interested. Publisher will contact artist for portfolio review if interested. Pays royalties for prints. Accepts original art on consignment and takes 40% commission. No advance. Buys first rights or reprint rights. Requires exclusive representation of artist. Provides in-transit insurance, promotion, shipping to and from firm, insurance while work is at firm and a written contract.

WINN DEVON ART GROUP

6015 Sixth Ave. S., Seattle WA 98108. (206)763-9544. Fax: (206)762-1389. Website: www.winndevon.com. **Contact:** Aimee Clarke, vice president of product and marketing. Estab. 1976. Art publisher. Publishes open and limited editions, offset reproductions, giclees and serigraphs. Clients: mostly trade, designer, decorators, galleries, retail frame shops. Current clients include Pier 1, Z Gallerie, Intercontinental Art, Chamton International, Bombay Co.

Needs Seeking decorative art for the designer market. Considers oil, watercolor, mixed media, pastel, pen & ink and acrylic. Artists represented include Buffet, Lourenco, Jardine, Hall, Goerschner, Lovelace, Bohne, Romeu and Tomao. Editions created by working from an existing painting. Approached by 300-400 artists/year. Publishes and distributes the work of 0-3 emerging, 3-8 mid-career and 8-10 established artists/year.

First Contact & Terms Send query letter with brochure, slides, photocopies, résumé, photostats, transparencies, tearsheets or photographs. Samples are returned by SASE if requested by artist. Responds in 4-6 weeks. Publisher will contact artist for portfolio review if interested. Portfolio should include "whatever is appropriate to communicate the artist's talents." Payment varies. Rights purchased vary according to project. Provides written contract. Finds artists through attending art exhibitions, agents, sourcebooks, publications, submissions.

Tips Advises artists to attend Art Expo New York City, Decor Expo Atlanta. "I would advise artists to attend just to see what is selling and being shown, but keep in mind that this is not a good time to approach publishers/ exhibitors with your artwork."

Book Publishers

Walk into any bookstore and start counting the number of images you see on books and calendars. Publishers don't have enough artists on staff to generate such a vast array of styles. The illustrations you see on covers and within the pages of books are, for the most part, created by freelance artists. If you like to read and work creatively to solve problems, the world of book publishing could be a great market for you.

While not as easy to break into as the magazine market, book publishing is an excellent market to specialize in. The artwork you create for book covers must grab readers' attention and make them want to pick up the book. Secondly, it must show at a glance what type of book it is and who it is meant to appeal to. In addition, the cover has to include basic information such as title, the author's name, the publisher's name, blurbs and price.

Most assignments for freelance work are for jackets/covers. The illustration on the cover, combined with typography and the layout choices of the designer, announce to the prospective readers at a glance the style and content of a book. If it is a romance novel, it will show a windswept couple and the title is usually done in calligraphy. Suspenseful spy novels tend to feature stark, dramatic lettering and symbolic covers. Covers for fantasy and science fiction novels, as well as murder mysteries and historical fiction, tend to show a scene from the story. Visit a bookstore and then decide which kind of book you'd like to work on.

Book interiors are also important. The page layouts and illustrations direct readers through the text and complement the story. This is particularly important in children's books and textbooks. Many publishing companies hire freelance designers with computer skills to design interiors on a contract basis. Look within each listing for the subheading Book Design to find the number of jobs assigned each year and how much is paid per project.

Finding your best markets

The first paragraph of each listing describes the types of books each publisher specializes in. This may seem obvious, but submit only to publishers who specialize in the type of book you want to illustrate or design. There's no use submitting to a publisher of literary fiction if you want to illustrate for children's picture books.

The publishers in this section are just the tip of the iceberg. You can find additional publishers by visiting bookstores and libraries and looking at covers and interior art. When you find covers you admire, write down the name of the books' publishers in a notebook. If the publisher is not listed in *Artist's & Graphic Designer's Market*, go to your public library and ask to look at a copy of *Literary Market Place*, also called *LMP*, published annually by Information Today, Inc. The cost of this large directory is prohibitive to most freelancers, but you should become familiar with it if you plan to work in the industry. Though it won't tell you how to submit to each publisher, it does give art directors' names.

Publishing Terms to Know

Important

- **Mass market** paperbacks are sold in supermarkets, newsstands, drugstores, etc. They include romance novels, diet books, mysteries and paperbacks by popular authors like Stephen King.

- **Trade books** are the hardcovers and paperbacks found only in bookstores and libraries. The paperbacks are larger than those on the mass market racks. They are printed on higher quality paper and often feature matte-paper jackets.

- **Textbooks** feature plenty of illustrations, photographs and charts to explain their subjects.

- **Small press** books are produced by small, independent publishers. Many are literary or scholarly in theme and often feature fine art on the cover.

- **Backlist titles** or **reprints** refer to publishers' titles from past seasons that continue to sell year after year. These books are often updated and republished with freshly designed covers to keep them up to date and attractive to readers.

Book Publishers

How to submit

Send one to five nonreturnable samples along with a brief letter. Never send originals. Most art directors prefer samples $8^{1}/_{2} \times 11$ or smaller that can fit in file drawers. Bulky submissions are considered a nuisance. After sending your initial introductory mailing, you should follow up with postcard samples every few months to keep your name in front of art directors. If you have an e-mail account and can send TIFF or JPEG files, check the publishers' preferences and see if they will accept submissions via e-mail.

Getting paid

Payment for design and illustration varies depending on the size of the publisher, the type of project and the rights bought. Most publishers pay on a per-project basis, although some publishers of highly illustrated books (such as children's books) pay an advance plus royalties. A few very small presses may only pay in copies.

Children's book illustration

Working in children's books requires a specific set of skills. You must be able to draw the same characters in a variety of action poses and situations. Like other publishers, many children's publishers are expanding their product lines to include multimedia projects. While a number of children's publishers are listed in this book, *Children's Writer's & Illustrator's Market*, also published by Writer's Digest Books, is an invaluable resource if you enter this field. You can order this essential book on www.writersdigest.com/store/books.asp or by calling (800)448-0915.

Helpful Resources

For More Info

If you decide to focus on book publishing, become familiar with *Publishers Weekly*, the trade magazine of the industry. Its Web site, www.publishers weekly.com, will keep you abreast of new imprints, publishers that plan to increase their title selection and the names of new art directors. You should also look for articles on book illustration and design in *HOW*, *Print* and other graphic design magazines. *Jackets Required: An Illustrated History of American Book Jacket Design, 1920-1950*, by Steven Heller and Seymour Chwast (Chronicle Books), offers nearly 300 examples of book jackets.

☑ A&B PUBLISHERS GROUP

223 Duffield St., Brooklyn NY 11201. (718)783-7808. Fax: (718)783-7267. Website: www.anbdonline.com. **Production Manager:** Eric Gift. Estab. 1992. Publishes trade paperback originals, calendars and reprints. Types of books include comic books, cookbooks, history, juvenile, preschool, reference, self-help and young adult. Specializes in history. Publishes 12 titles/year. Recent titles include: *Nutrition Made Simple*; *What They Never Told You in History Class, Vol. I and II.* 70% require freelance illustration; 25% require freelance design. Catalog available.

Needs Approached by 60 illustrators and 32 designers/year. Works with 12 illustrators and 6 designers/year. Prefers local illustrators experienced in airbrush and computer graphics. Uses freelancers mainly for "book covers and insides." 85% of freelance design demands knowledge of Photoshop, Illustrator and QuarkXPress. 60% of freelance design demands knowledge of Photoshop, Illustrator, QuarkXPress and Painter. 20% of titles require freelance art direction.

First Contact & Terms Designers: Send query letter with photocopies. Illustrators: Send postcard sample, photocopies, printed samples or tearsheets. Send follow-up postcard sample every 4 months. Accepts disk submissions from designers compatible with QuarkXPress, Photoshop and Illustrator. Send EPS and TIFF files. Samples are filed. Portfolio review required. Portfolio should include artwork portraying children, animals, perspective, anatomy and transparencies. Rights purchased vary according to project.

Book Design Assigns 14 freelance design jobs/year. Pays by the hour, $15-65 and also a flat fee.

Jackets/Covers Assigns 14 freelance design jobs and 20 illustration jobs/year. Pays by the project, $250-1,200. Prefers "computer generated titles, pen & ink and watercolor or airbrush for finish."

Text Illustration Assigns 11 freelance illustration jobs/year. Pays by the hour, $8-25 or by the project, $800-2,400 maximum. Prefers "airbrush or watercolor that is realistic or childlike, appealing to young school-age children." Finds freelancers through word of mouth, submissions, NYC school of design.

Tips "I look for artists who are knowledgeable about press and printing systems—from how color reproduces to how best to utilize color for different presses."

HARRY N. ABRAMS, INC.

100 Fifth Ave., New York NY 10011. (212)206-7715. Fax: (212) 645-8437. Website: www.abramsbooks.com. **Contact:** Mark LaRiviere, creative director. Estab. 1951. Company publishes hardcover originals, trade paperback originals and reprints. Types of books include fine art and illustrated books. Publishes 240 titles/year. 60% require freelance design. Visit website for art submission guidelines.

Needs Uses freelance designers to design complete books including jackets and sales materials. Uses illustrators mainly for maps and occasional text illustration. 100% of freelance design and 50% of illustration demands knowledge of Illustrator, InDesign or QuarkXPress and Photoshop. Works on assignment only.

First Contact & Terms Send query letter with résumé, tearsheets, photocopies. Accepts disk submissions or supply web address. Samples are filed "if work is appropriate." Samples are returned by SASE if requested by artist. Portfolio should include printed samples, tearsheets and/or photocopies. Originals are returned at job's completion, with published product. Finds artists through word of mouth, submissions, attending art exhibitions and seeing published work.

Book Design Assigns several freelance design jobs/year. Pays by the project.

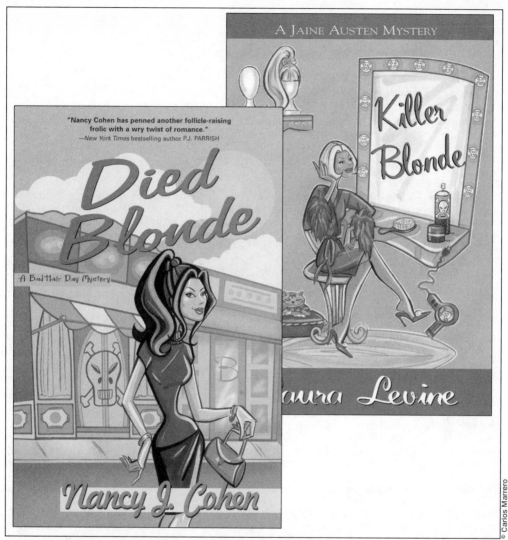

© Carlos Marrero

Although Carlos Marrero began his illustration career in fashion design, his work—easily identifiable for its expressive, sophisticated, stylish characters; bold lines; and bright colors—has since appeared in many high-profile magazines (*Mademoiselle, Glamour, Cosmo Girl, Modern Bride*), newspapers (*The Wall Street Journal, The New York Times*), corporate and retail brochures (Bloomingdale's, Abercrombie & Fitch), and on book covers, such as these examples from mysteries by Nancy J. Cohen and Laura Levine (Kensington Publishing).

ACROPOLIS BOOKS, INC.

8601 Dunwoody Pl., Suite 303, Atlantic GA 30350. (770)643-1118. Fax: (770)643-1170. E-mail: acropolisbooks@ mindspring.com. Website: www.acropolisbooks.com. **Vice President Operations:** Christine Lindsay. Imprints include Awakening. Publishes hardcover originals and reprints, trade paperback originals and reprints. Types of books include mysticism and spiritual. Specializes in books of higher consciousness. Publishes 4 titles/year. Recent titles include: *The Journey Back to the Fathers Home*, by Joel S. Goldsmith; *Showing Forth the Presence of God*, by Joel S. Goldsmith. 30% require freelance design. Catalog available.

Needs Approached by 7 illustrators and 5 designers/year. Works with 2-3 illustrators and 2-3 designers/year. Knowledge of Photoshop and QuarkXPress useful in freelance illustration and design.

First Contact & Terms Designers: Send brochure and résumé. Illustrators: Send query letter with photocopies

and résumé. Samples are filed. Responds in 2 months. Will contact artist for portfolio review if interested. Buys all rights.

Book Design Assigns 3-4 freelance design jobs/year. Pays by the project.

Jackets/Covers Assigns 3-4 freelance design jobs/year. Pays by the project.

Tips "We are looking for people who are familiar with our company and understand our focus."

ADAMS MEDIA CORPORATION

Imprint of F+W Publications, 57 Littlefield St., Avon MA 02322. (508)427-7100. Fax: (508)427-6790. E-mail: pbeatrice@adamsmedia.com. Website: www.adamsmedia.com. **Art Director:** Paul Beatrice. Estab. 1980. Company publishes hardcover originals, trade paperback originals and reprints. Types of books include biography, business, gardening, pet care, cookbooks, history, humor, instructional, New Age, nonfiction, reference, self-help and travel. Specializes in business and careers. Publishes 100 titles/year. 15% require freelance illustration. Recent titles include: *101 Things You Didn't Know About Da Vinci*; *Tales from the Scales*; *The 10 Women You'll Be Before You're 35*. Book catalog free by request.

Needs Works with 8 freelance illustrators and 7-10 designers/year. Uses freelancers mainly for jacket/cover illustration, text illustration and jacket/cover design. 100% of freelance work demands computer skills. Freelancers should be familiar with QuarkXPress 4.1 and Photoshop.

First Contact & Terms Send postcard sample of work. Samples are filed. Art director will contact artist for portfolio review if interested. Portfolio should include tearsheets. Rights purchased vary according to project, but usually buys all rights.

Jackets/Covers Assigns 50 freelance design jobs/year. Pays by the project, $700-1,500.

Text Illustration Assigns 30 freelance illustration jobs/year.

Ⓝ AFRICA WORLD PRESS, INC.

541 W. Ingham Ave., Suite B, Trenton NJ 08638. (609)695-3200. Fax: (609)695-6466. E-mail: africawpress@nyo.com. Website: www.africanworld.com. **Art Director:** Linda Nickens. Estab. 1984. Publishes hardcover and trade paperback originals. Types of books include biography, preschool, juvenile, young adult and history. Specializes in any and all subjects that appeal to an Afrocentric market. Publishes 124 titles/year. Titles include: *Blacks Before America*, by Mark Hyman; and *Too Much Schooling Too Little Education*, by Mwalimu J. Shujaa. 60% require freelance illustration; 10% require freelance design. Book catalog available by request. Approached by 50-100 freelancers/year. Works with 5-10 illustrators and 4 designers/year. Buys 50-75 illustrations/year. Prefers artists with experience in 4-color separation and IBM-compatible PageMaker. Uses freelancers mainly for book illustration. Also for jacket/cover design and illustration. Uses designers for typesetting and formatting.

Needs "We look for freelancers who have access to or own their own computer for design and illustration purposes but are still familiar and proficient in creating mechanicals, mock-ups and new ideas by hand." 50% of freelance work demands knowledge of PageMaker 5.0, CorelDraw 4.0 and Word Perfect 6.0. Works on assignment only.

First Contact & Terms Send query letter with brochure, tearsheets, photostats, bio, résumé, SASE, photocopies and transparencies. Samples are filed or are returned by SASE if requested by artist. Responds in 6 weeks. Write for appointment to show portfolio, or mail b&w and color photostats, tearsheets and 8½×11 transparencies. Rights purchased vary according to project. Originals are returned at job's completion if artist provides SASE and instructions.

Book Design Assigns 100 freelance design jobs/year. Pays by the project.

Jackets/Covers Assigns 100 freelance design and 50-75 illustration jobs/year. Prefers 2- or 4-color process covers. Pays by the project.

Text Illustration Assigns 25 illustration jobs/year. Prefers "boards and film with proper registration and color specification." Pays by the project.

Tips "Artists should have a working knowledge of the Windows 3.1 platform of the IBM computer; be familiar with the four-color process (CMYK) mixtures and changes (5-100%) and how to manipulate them mechanically as well as on the computer; have a working knowledge of typefaces and styles, the ability to design them in an appealing manner; swift turn around time on projects from preliminary through the manipulation of changes and a clear understanding of African-centered thinking, using it to promote and professionally market books and other cultural items creatively. Work should be colorful, eyecatching and controversial."

ALLYN AND BACON, INC.

75 Arlington St., Suite 300, Boston MA 02116. (617)848-6000. Fax: (617)848-6016. E-mail: AandBpub@aol.com. Website: www.ablongman.com. **Art Director:** Linda Knowles. Publishes more than 300 hardcover and paperback college textbooks/year. 60% require freelance cover designs. Subject areas include education, psychology and sociology, political science, theater, music and public speaking. Recent titles include: *Electronic Media*; *Psychology*; *Foundations of Education*.

Needs Designers must be strong in book cover design and contemporary type treatment. 50% of freelance work demands knowledge of Illustrator, Photoshop and FreeHand.

Jackets/Covers Assigns 100 design jobs and 2-3 illustration jobs/year. Pays for design by the project, $500-1,000. Pays for illustration by the project, $500-1,000. Prefers sophisticated, abstract style in pen & ink, airbrush, charcoal/pencil, watercolor, acrylic, oil, collage and calligraphy.

Tips "Keep stylistically and technically up to date. Learn *not* to over-design; read instructions and ask questions. Introductory letter must state experience and include at least photocopies of your work. If I like what I see, and you can stay on budget, you'll probably get an assignment. Being pushy closes the door. We primarily use designers based in the Boston area."

THE AMERICAN BIBLE SOCIETY

1865 Broadway, New York NY 10023-7505. (212)408-1200. Fax: (212)408-1259. E-mail: info@americanbible.org. Website: www.americanbible.org. **Associate Director, Product Development:** Christina Murphy. Estab. 1816. Company publishes religious products including Bibles/New Testaments, portions, leaflets, calendars and bookmarks. Additional products include religious children's books, posters, seasonal items, teaching aids, audio casettes, videos and CD-ROMs. Specializes in contemporary applications to the Bible. Publishes 15 titles/year. Recent titles include: *Contemporary English Children's Illustrated Bible.* 25% requires freelance illustration; 90% requires freelance design. Book catalog on website.

Needs Approached by 50-100 freelancers/month. Works with 10 freelance illustrators and 20 designers/year. Uses freelancers for jacket/cover illustration and design, text illustration, book design and children's activity books. 90% of freelance work demands knowledge of Illustrator, QuarkXPress, Photoshop. Works on assignment only. 5% of titles require freelance art direction.

First Contact & Terms Send postcard samples of work or send query letter with brochure and tearsheets. Samples are filed and/or returned. **Please do not call.** Responds in 2 months. Product design department will contact artist for portfolio review if additional samples are needed. Portfolio should include final art and tearsheets. Buys all rights. Finds artists through artists' submissions, *The Workbook* (by Scott & Daughters Publishing) and *RSVP Illustrator.*

Book Design Assigns 3-5 freelance interior book design jobs/year. Pays by the project, $350-1,000 depending on work involved.

Jackets/Covers Assigns 60-80 freelance design and 20 freelance illustration jobs/year. Pays by the project, $350-2,000.

Text Illustration Assigns several freelance illustration jobs/year. Pays by the project.

Tips "Looking for contemporary, multicultural artwork/designs and good graphic designers familiar with commercial publishing standards and procedures. Have a polished and professional-looking portfolio or be prepared to show polished and professional-looking samples."

☑ AMERICAN EAGLE PUBLICATIONS, INC.

P.O. Box 1507, Show Low AZ 85902-1507. (623)556-2925. Fax: (623)556-2926. E-mail: ameagle@ameaglepubs.com. Website: www.ameaglepubs.com. **President:** Mark Ludwig. Estab. 1988. Publishes hardcover originals and reprints and trade paperback originals and reprints. Types of books include historical fiction, history and computer books. Publishes 10 titles/year. Titles include: *The Little Black Book of E-mail Viruses*; *The Quest for Water Planets.* 100% require freelance illustration and design. Book catalog free for large SAE with 2 first-class stamps.

Needs Approached by 10 freelance artists/year. Works with 4 illustrators and 4 designers/year. Buys 20 illustrations/year. Uses freelancers mainly for covers. Also for text illustration. 100% of design and 25% of illustration demand knowledge of Ventura Publisher and CorelDraw. Works on assignment only.

First Contact & Terms Send query letter with résumé, SASE and photocopies. Accepts disk submissions compatible with CorelDraw or Ventura Publisher on PC. Send TIFF files. Samples are filed. Responds only if interested. Call for appointment to show portfolio, which should include final art, b&w and color photostats, slides, tearsheets, transparencies and dummies. Buys all rights. Originals are returned at job's completion.

Jackets/Covers Assigns 10 design and 10 illustration jobs/year. Payment negotiable (roughly $20/hr minimum). "We generally do 2-color or 4-color covers composed on a computer."

Text Illustration Assigns 7 illustration jobs/year. Pays roughly $20/hr minumum. Prefers pen & ink.

Tips "Show us good work that demonstrates you're in touch with the kind of subject matter in our books. Show us you can do good, exciting work in two colors."

AMERICAN JUDICATURE SOCIETY

2700 University Ave., Des Moines IA 50311. (515)271-2281. Fax: (515)279-3090. E-mail: drichert@ajs.org. Website: www.ajs.org. **Editor:** David Richert. Estab. 1913. Publishes journals and books. Specializes in courts,

judges and administration of justice. Publishes 5 titles/year. 75% requires freelance illustration. Catalog available free for SASE.

Needs Approached by 20 illustrators and 6 designers/year. Works with 3-4 illustrators and 1 designer/year. Prefers local designers. Uses freelancers mainly for illustration. 100% of freelance design demands knowledge of PageMaker, FreeHand, Photoshop and Illustrator. 10% of freelance illustration demands knowledge of QuarkXPress, FreeHand, Photoshop and Illustrator.

First Contact & Terms Designers: Send query letter with photocopies. Illustrators: Send query letter with photocopies and tearsheets. Send follow-up postcard every 3 months. Samples are not filed and are returned by SASE. Responds in 1 month. Will contact artist for portfolio review of photocopies, roughs and tearsheets if interested. Buys one-time rights.

Book Design Assigns 1-2 freelance design jobs/year. Pays by the project, $500-1,000.

Text Illustration Assigns 10 freelance illustration jobs/year. Pays by the project, $75-375.

☑ AMERICAN PSYCHIATRIC PRESS, INC.

1000 Wilson Blvd., Suite 1825, Arlington VA 22209-3901. (703)907-7322. Website: www.appi.org. **Contact:** Production Manager. Estab. 1981. Imprint of American Psychiatric Association. Company publishes hardcover originals and textbooks. Specializes in psychiatry and its subspecialties. Publishes 60 titles/year. Recent titles include: *Coping With Trauma*; and *Fatal Flaws*. 10% require freelance illustration; 10% require freelance design. Book catalog free by request.

Needs Uses freelancers for jacket/cover design and illustration. Needs computer-literate freelancers for design. 100% of freelance work demands knowledge of QuarkXPress, Illustrator 3.0, PageMaker 5.0. Works on assignment only.

First Contact & Terms Designers: Send query letter with brochure, photocopies, photographs and/or tearsheets. Illustrators: Send postcard sample. Samples are filed. Promotions Coordinator will contact artist for portfolio review if interested. Portfolio should include final art, slides and tearsheets. Rights purchased vary according to project.

Book Design Pays by the project.

Jackets/Covers Assigns 10 freelance design and 10 illustation jobs/year. Pays by the project.

Tips Finds artists through sourcebooks. ''Book covers are now being done in Corel Draw 5.0 but will work with Mac happily. Book covers are for professional books with clean designs. Type treatment design are done in-house.''

AMHERST MEDIA, INC.

175 Rano St., Suite 200, Buffalo NY 14207. (716)874-4450. Fax: (716)874-4508. Website: www.AmherstMedia.com. **Publisher:** Craig Alesse. Estab. 1974. Company publishes trade paperback originals. Types of books include instructional and reference. Specializes in photography, how-to. Publishes 30 titles/year. Recent titles include: *Portrait Photographer's Handbook*; *Creating World Class Photography*. 20% require freelance illustration; 80% require freelance design. Book catalog free for 9×12 SAE with 3 first-class stamps.

Needs Approached by 12 freelancers/year. Works with 3 freelance illustrators and 3 designers/year. Uses freelance artists mainly for illustration and cover design. Also for jacket/cover illustration and design and book design. 80% of freelance work demands knowledge of QuarkXPress or Photoshop. Works on assignment only.

First Contact & Terms Send brochure, résumé and photographs. Samples are filed. Responds only if interested. Art director will contact artist for portfolio review if interested. Portfolio should include slides. Rights purchased vary according to project. Originals are returned at job's completion. Finds artists through word of mouth.

Book Design Assigns 12 freelance design jobs/year. Pays for design by the hour $25 minimum; by the project $2,000.

Jackets/Covers Assigns 12 freelance design and 4 illustration jobs/year. Pays $200-1200. Prefers computer illustration (QuarkXPress/Photoshop).

Text Illustration Assigns 12 freelance illustration jobs/year. Pays by the project. Prefers computer illustration (QuarkXPress).

ANDREWS MCMEEL PUBLISHING

4520 Main, Kansas City MO 64111-7701. (816)932-6700. Fax: (816)932-6781. E-mail: tlynch@amuniversal.com. Website: www.andrewsmcmeel.com. **Art Director:** Tim Lynch. Estab. 1972. Publishes hardcover originals and reprints; trade paperback originals and reprints. Types of books include humor, instructional, nonfiction, reference, self help. Specializes in calendars and cartoon/humor books. Publishes 200 titles/year. Recent titles include: *Hard Sell*; *Made You Laugh*; *The Blue Day Book*; *Complete Calvin and Hobbes*. 10% requires freelance illustration; 80% requires freelance design.

Needs Approached by 100 illustrators and 50 designers/year. Works with 15 illustrators and 25 designers/year.

Prefers freelancers experienced in book jacket design. Freelance designers must have knowledge of Illustrator, Photoshop, QuarkXPress or InDesign.

First Contact & Terms Send sample sheets and web address or contact through artists' rep. Samples are filed and not returned. Responds only if interested. Portfolio review not required. Rights purchased vary according to project.

Book Design Assigns 60 freelance design jobs and 20 illustration jobs/year. Pays for design $600-3,000.

Tips "We want designers who can read a manuscript and design a concept for the best possible cover. Communicate well and be flexible with design." Designer portfolio review once a year in New York City.

ANTARCTIC PRESS

7272 Wurzbach, Suite 204, San Antonio TX 78240. (210)614-0396. Fax: (210)614-5029. E-mail: rod_espinosa@antarctic-press.com or apcog@hotmail.com. Website: www.antarctic-press.com. **Contact:** Rod Espinosa, submissions editor. Estab. 1985. Publishes CD ROMs, mass market paperback originals and reprints, trade paperback originals and reprints. Types of books include adventure, comic books, fantasy, humor, juvenile fiction. Specializes in comic books. Publishes 18 titles/year. Recent titles include: *Ninja High School*; *Gold Digger*; *Twilight X*. 50% requires freelance illustration. Book catalog free with 9×12 SASE ($3 postage). Submission guidelines on website.

Needs Approached by 60-80 illustrators/year. Works with 12 illustrators/year. Prefers local illustrators. 100% of freelance illustration demands knowledge of Photoshop.

First Contact & Terms Send query letter or postcard sample with brochure and photocopies. Do not send originals. Send copies only. Accepts e-mail submissions from illustrators. Prefers Mac-compatible, Windows-compatible, TIFF, JPEG files. Samples are filed or returned by SASE. Portfolios may be dropped off every Monday-Friday. Portfolio should include b&w, color finished art. Buys first rights. Rights purchased vary according to project. Finds freelancers through anthologies published, artist's submissions, Internet, word of mouth. Payment is made on royalty basis after publication.

Text Illustration Negotiated.

Tips "You must love comics and be proficient in doing sequential art."

APPALACHIAN MOUNTAIN CLUB BOOKS

5 Joy St., Boston MA 02108. (617)523-0655. Fax: (617)523-0722. E-mail: amcbooks@amcinfo.org. Website: www.outdoors.org. **Production:** Belinda Thresher. Estab. 1876. Publishes trade paperback originals and reprints. Types of books include adventure, instructional, nonfiction, travel and children's nature books. Specializes in hiking guidebooks. Publishes 7-10 titles/year. Recent titles include: *Northeastern Wilds*; *Women on High*. 5% requires freelance illustration; 100% requires freelance design. Book catalog free for #10 SAE with 1 first-class stamp.

Needs Approached by 5 illustrators and 2 designers/year. Works with 1 illustrator and 2 designers/year. Prefers local freelancers experienced in book design. 100% of freelance design demands knowledge of FreeHand, Photoshop, QuarkXPress. 100% of freelance illustration demands knowledge of FreeHand, Illustrator.

First Contact & Terms Designers: Send postcard sample or query letter with photocopies. Illustrators: Send postcard sample. Accepts Mac-compatible disk submissions. Samples are not filed and are not returned. Will contact artist for portfolio review of book dummy, photocopies, photographs, tearsheets, thumbnails if interested. Negotiates rights purchased. Finds freelancers through professional recommendation (word of mouth).

Book Design Assigns 10-12 freelance design jobs/year. Pays for design by the project, $1,200-1,500.

Jackets/Covers Assigns 10-12 freelance design jobs and 1 illustration job/year. Pays for design by the project.

ART DIRECTION BOOK CO. INC.

456 Glenbrook Rd., Glenbrook CT 06906. (203)353-1441. Fax: (203)353-1371. **Contact:** Karyn Mugmon, production manager. Publishes hardcover and paperback originals on advertising design and photography. Publishes 10-12 titles/year. Titles include disks of *Scan This Book* and *Most Happy Clip Art*; book and disk of *101 Absolutely Superb Icons* and *American Corporate Identity #11*. Book catalog free on request.

Needs Works with 2-4 freelance designers/year. Uses freelancers mainly for graphic design.

First Contact & Terms Send query letter to be filed and arrange to show portfolio of 4-10 tearsheets. Portfolios may be dropped off Monday-Friday. Samples returned by SASE. Buys first rights. Originals are returned to artist at job's completion. Advertising design must be contemporary. Finds artists through word of mouth.

Book Design Assigns 8 freelance design jobs/year. Pays $350 maximum.

Jackets/Covers Assigns 8 freelance design jobs/year. Pays $350 maximum.

ARTIST'S & GRAPHIC DESIGNER'S MARKET

Writer's Digest Books, Cincinnati OH 45236. E-mail: artdesign@fwpubs.com. **Editor:** Mary Cox. Annual directory of markets for designers, illustrators and fine artists. Buys one-time rights.

Needs Buys 35-45 illustrations/year. "I need examples of art that have been sold to the listings in *Artist's & Graphic Designer's Market*. Look through this book for examples. The art must have been freelanced; it cannot have been done as staff work. Include the name of the listing that purchased or exhibited the work, what the art was used for and, if possible, the payment you received. Bear in mind that interior art is reproduced in black and white, so the higher the contrast, the better. I also need to see promo cards, business cards and tearsheets."

First Contact & Terms Send printed piece, photographs or tearsheets. "Since *Artist's & Graphic Designer's Market* is published only once a year, submissions are kept on file for the upcoming edition until selections are made. Material is then returned by SASE if requested." Pays $75 to holder of reproduction rights and free copy of *Artist's & Graphic Designer's Market* when published.

☑ AUGSBURG FORTRESS PUBLISHERS

100 S. Fifth St., Suite 700, Minneapolis MN 55402-1222. (612)330-3300. Fax: (612)330-3455. Website: www.augs burgfortress.org. **Contact:** Director of Design, Marketing Services. Publishes hard cover and paperback Protestant/Lutheran books (90 titles/year), religious education materials, audiovisual resources, periodicals. Recent titles include: *Ecotheraphy*, by Howard Clinebell; *Thistle*, by Walter Wangerin.

Needs Uses freelancers for advertising layout, design, illustration and circulars and catalog cover design. Freelancers should be familiar with QuarkXPress 4.1, Photoshop 5.5 and Illustrator 8.01.

First Contact & Terms "Majority, but not all, of our freelancers are local." Works on assignment only. Responds on future assignment possibilities in 2 months. Call, write or send brochure, disk, flier, tearsheet, good photocopies and 35mm transparencies; if artist is not willing to have samples filed, they are returned by SASE. Buys all rights on a work-for-hire basis. May require designers to supply overlays on color work.

Jackets/Covers Uses designers primarily for cover design. Pays by the project, $600-900. Prefers covers on disk using QuarkXPress.

Text Illustration Negotiates pay for 1-, 2- and 4-color. Generally pays by the project, $25-500.

Tips Be knowledgeable "of company product and the somewhat conservative contemporary Christian market."

Ⓝ AVATAR PRESS

9 Triumph Dr., Urbana IL 61802. (217)384-2216. Fax: (217)384-2216. E-mail: submissions@avatarpress.net. Website: www.avatarpress.com. **Contact:** William A. Christensen, editor-in-chief. Publishes trade paperback originals. Types of books include comic book fiction. Publishes 50 titles/year. Recent titles include: *A Nightmare on Elm Street* and *Lady Death*; *Scars*, by Warren Ellis and Jason Burrows; *Shi Pandora's Box #1*, by Robert Lugibihl and Juan Jose Ryp. Book catalog available on website.

• See this company's website before submitting.

First Contact & Terms Illustrators: Send query letter with tearsheets, samples "showcasing all your abilities and panel to panel continuity." Accepts Zip disk or CD submissions from colorists. Prefers Windows-compatible, CMYK mode at size 6.875×10.5 at 600 dpi. Responds only if interested. Company will contact artist for portfolio review if interested.

Tips "Avatar Press is always looking for quality creator-owned projects. The ideal submission will include an overview of the story, a detailed plot synopsis, sample script pages, and sample art pages (panel to panel continuity)."

BAEN BOOKS

P.O. Box 1403, Riverdale NY 10471. (919)570-1640. Fax: (919)570-1644. E-mail: jim@baen.com. Website: www.baen.com. **Publisher:** Jim Baen. Editor Toni Weisskopf. Estab. 1983. Publishes science fiction and fantasy. Publishes 60-70 titles/year. Titles include: *Music to My Sorrow* and *At All Costs*. 90% requires freelance illustration; 90% requires freelance design. Book catalog free on request.

First Contact & Terms Approached by 500 freelancers/year. Works with 10 freelance illustrators and 3 designers/year. 50% of work demands computer skills. Designers: Send query letter with résumé, color photocopies, tearsheets (color only) and SASE. Illustrators: Send query letter with color photocopies, SASE, slides and tearsheets. Samples are filed. Originals are returned to artist at job's completion. Buys exclusive North American book rights.

Jackets/Covers Assigns 64 freelance design and 64 illustration jobs/year. Pays by the project. $200 minimum, design; $1,000 minimum, illustration.

Tips Wants to see samples within science fiction, fantasy genre only. "Do not send black & white illustrations or surreal art. Please do not waste our time and your postage with postcards. Serious submissions only."

Ⓝ BARBOUR PUBLISHING

1810 Barbour Dr., P.O. Box 719, Uhrichsville OH 44683. (740)922-6045. Fax: (740)922-5948. E-mail: info@barbo urbooks.com. Website: www.barbourbooks.com. **Creative Director:** Robyn Martins. Estab. 1981. Publishes

hardcover, trade paperback and mass market paperback originals and reprints. Types of books include general Christian contemporary and Christian romance, self-help, young adult, reference and Christian children's books. Specializes in short, easy-to-read Christian bargain books. Publishes 150 titles/year. 60% require freelance illustration.

Needs Prefers freelancers with experience in people illustration and photorealistic styles. Uses freelancers mainly for fiction romance jacket/cover illustration. Works on assignment only.

First Contact & Terms Send query letter with photocopies or tearsheets and SASE. Accepts Mac disk submissions compatible with Illustrator 6.0 and Photoshop. Buys all rights. Originals are returned. Finds artists through word of mouth, recommendations, sample submissions and placing ads.

Jackets/Covers Assigns 10 freelance design and 90 illustration jobs/year. Pays by the project, $450-750.

Tips "Submit a great illustration of people suitable for a romance cover or youth cover in a photorealistic style. I am also looking for great background illustrations, such as florals and textures. As a publisher of bargain books, I am looking for top-quality art on a tight budget."

BECKER&MAYER! LTD

11010 Northup Way, Bellevue WA 98004. (425)827-7120. Fax: (425)828-9659. Website: www.beckermayer.com. **Contact:** Adult or juvenile design department. Estab. 1973. Publishes nonfiction biography, humor, history and coffee table books. Publishes 100+ titles a year. Recent titles include: *10-Minute University*; *77 Habits of Highly Ineffective People*; *Be Elvis*; *Best Friends Kit*; *Disney Treasures*; *Uncover the Human Body.* 10% of titles require freelance design; 75% require freelance illustration. Book catalog available on website.

- becker&mayer! is spelled all lower case with an exclamation mark. Publisher requests that illustration for children's books should be sent to Juvenile Submissions. All other illustration should be sent to Adult Submission.

Needs Works with 6 designers and 20-30 illustrators/year. Freelance design work demands skills in FreeHand, InDesign, Illustrator, Photoshop, QuarkXPress. Freelance illustration demands skills in FreeHand, Illustrator, Photoshop.

First Contact & Terms Designers: Send query letter with résumé and tearsheets. Illustrators: Send query letter, nonreturnable postcard sample, résumé and tearsheets. After introductory mailing, send follow-up postcard every 6 months. Does not accept e-mail submissions. Samples are filed. Responds only if interested. Company will request portfolio review of color finished art, roughs, thumbnails and tearsheets, only if interested. Rights purchased vary according to project.

Text illustration Assigns 30 freelance illustration jobs a year. Pays by the project.

Tips "Our company is divided into adult and juvenile divisions; please send samples to the appropriate division. No phone calls!"

BEDFORD/ST. MARTIN'S

75 Arlington St., Boston MA 02116. (617)399-4000. Fax: (617)350-7544. Website: www.bedfordstmartins.com. **Advertising Assistant Manager:** Jill Chmelko. Promotions Manager: Thomas Macy. Creative Supervisors: Hope Tompkins and Pelle Cass. Estab. 1981. Publishes college textbooks in English, history and communications. Publishes 40 titles/year. Recent titles include: *Rules for Writers*, Fifth Edition; *Media & Culture*, Fifth Edition; *American's History*, Fifth Edition. Books have "contemporary, classic design." 5% require freelance illustration; 90% require freelance design.

Needs Approached by 25 freelance artists/year. Works with 2-4 illustrators and 6-8 designers/year. Buys 2-4 illustrations/year. Prefers artists with experience in book publishing. Uses freelancers mainly for cover and brochure design. Also for jacket/cover and text illustration and book and catalog design. 75% of design work demands knowledge of Adobe Illustrator, QuarkXPress and Adobe Photoshop.

First Contact & Terms Send query letter with brochure, tearsheets and SASE. Samples are filed or are returned by SASE if requested by artist. Responds only if interested. Request portfolio review in original query. Art director or promotions manager will contact artists for portfolio review if interested. Portfolio should include roughs, original/final art, color photostats and tearsheets. Interested in buying second rights (reprint rights) to previously published work. Originals are returned at job's completion.

Jackets/Covers Assigns 40 design jobs and 2-4 illustration jobs/year. Pays by the project. Finds artists through magazines, self-promotion and sourcebooks. Contact Donna Dennison.

Tips "Regarding book cover illustrations, we're usually interested in buying reprint rights for artistic abstracts or contemporary, multicultural scenes and images of writers and writing-related scenes (i.e. desks with typewriters, paper, open books, people reading, etc.)."

BEHRMAN HOUSE, INC.

11 Edison Place, Springfield NJ 07081. (973)379-7200. Fax: (973)379-7280. Website: www.behrmanhouse.com. **Executive Editor:** Gila Gevirtz. Vice President: Terry Kaye. Estab. 1921. Book and software publisher. Publishes

textbooks. Types of books include preschool, juvenile, young adult, history (all of Jewish subject matter) and Jewish texts. Specializes in Jewish books for children and adults. Publishes 12 titles/year. Recent titles include: *Jewish History Observer.* ''Books are contemporary with lots of photographs and artwork; colorful and lively. Design of textbooks is very complicated.'' 50% require freelance illustration; 100% require freelance design. Book catalog free by request.

Needs Approached by 50 freelancers/year. Works with 6 freelance illustrators and 6 designers/year. Prefers freelancers with experience in illustrating for children; ''Jewish background helpful.'' Uses freelancers for textbook illustration and book design. Works on assignment only.

First Contact & Terms Send postcard samples or query letter with résumé and tearsheets. Samples are filed. Responds only if interested. Buys reprint rights. Sometimes requests work on spec before assigning a job.

Book Design Assigns 8 freelance design and 3 illustration jobs/year. Pays by project, $4,000-20,000.

Jackets/Covers Assigns 8 freelance design and 4 illustration jobs/year. Pays by the project, $500-1,000.

Text Illustration Assigns 6 freelance design and 4 illustration jobs/year. Pays by the project.

THE BENEFACTORY, INC.

P.O. Box 128, Cohasset MA 02025. (781)383-8027. Fax: (781)383-8026. E-mail: thebenefactory@aol.com. Website: www.readplay.com. **Creative Director:** Cynthia A. Germain. Estab. 1990. Publishes audio tapes, hardcover and trade paperback originals. Types of books include children's picture books. Specializes in true stories about real animals. Publishes 13 titles/year. Recent titles include: *Chocolate, A Glazier Grizzly; Condor Magic.* 100% requires freelance illustration. Book catalog free for $8^{1}/_{2} \times 11$ SAE with 3 first-class stamps.

Needs Approached by 5 illustrators/year. Works with 9 illustrators/year.

First Contact & Terms Send nonreturnable postcard samples. Samples are filed. Will contact artist for portfolio review of artwork portraying animals, children, nature if interested. Rights purchased vary according to project.

Tips ''We look for realistic portrayal of children and animals with great expression. We bring our characters and stories to life for children.''

BLOOMSBURY CHILDREN'S BOOKS

175 Fifth Ave., Suite 315, New York NY 10010. (212)674-5151, ext. 515. Fax: (212)982-2837. E-mail: bloomsbury.kids@bloomsburyusa.com. Website: www.bloomsburyusa.com. **Contact:** Lizzy Bromley, senior designer. Estab. 2001. Publishes children's hardcover originals and reprints, trade paperback and reprints. Types of books include children's picture books, fantasy, humor, juvenile and young adult fiction. Publishes 50 titles/year. Recent titles include: *Ruby Sings the Blues; The Last Burp of Mac McGerp.* 50% requires freelance design; 100% requires freelance illustration. Book catalog not available.

Needs Works with 5 designers and 20 illustrators/year. Prefers local designers. 100% of freelance design work demands knowledge of Illustrator, QuarkXPress and Photoshop.

First Contact & Terms Designers: Send postcard sample or query letter with brochure, résumé, tearsheets. Illustrators: Send postcard sample or query letter with brochure, photocopies and SASE. After introductory mailing, send follow-up postcard sample every 6 months. Samples are filed or returned by SASE. Responds only if interested. Company will contact artist for potfolio review if interested. Portfolio should include color finished art and tearsheets. Buys all rights. Finds freelancers through word of mouth.

Jackets/Covers Assigns 5 freelance cover illustration jobs/year.

Ⓝ BLUEWOOD BOOKS

38 South B St., Suite 202, San Mateo CA 94401. (650)548-0754. Fax: (650)548-0654. E-mail: bluewoodb@aol.com. **Director:** Richard Michaels. Estab. 1990. Publishes trade paperback originals. Types of books include biography, history, nonfiction and young adult. Publishes 4-10 titles/year. Titles include: *True Stories of Baseball's Hall of Famers; 100 Scientists Who Shaped World History;* and *American Politics in the 20th Century.* 100% require freelance illustration; 75% require freelance design. Catalog not available.

Needs Works with 5 illustrators and 3 designers/year. Prefers local freelancers experienced in realistic, b&w line illustration and book design. Uses freelancers mainly for illustration and design. 80-100% of freelance design demands knowledge of Photoshop, Illustrator and QuarkXPress. 80-100% of freelance illustration demands knowledge of FreeHand, Photoshop, Illustrator and QuarkXPress.

First Contact & Terms Designers: Send query letter with brochure, photocopies, résumé, SASE and tearsheets. Illustrators: Send query letter with photocopies, résumé, SASE and tearsheets. Samples are filed. Responds only if interested. Will contact artist for portfolio review of photocopies, photographs, roughs, slides, tearsheets, thumbnails and transparencies if interested. Buys all rights.

Book Design Assigns 4-10 freelance design jobs/year. Pays by the hour or project.

Jackets/Covers Pays by the project, $150-200 for color.

Text Illustration Assigns 4-10 freelance illustration jobs/year. Pays $15-30 for each b&w illustration. Finds freelancers through submissions.

☑ BONUS BOOKS, INC.

1452 Second St., Santa Monica CA 90403. (310)260-9400. Fax: (310)260-9494. E-mail: submissions@bonusbook s.com. Website: www.bonusbooks.com. **Managing Editor:** Devon Freeny. Imprints include Precept Press, Volt Press. Company publishes textbooks and hardcover and trade paperback originals. Specializes in sports/gambling, broadcasting, biography, medical, fundraising, entertainment/pop culture, current events. Publishes 30 titles/year. Recent titles include: *Funding Evil*; *Casino Gambling*. 1% require freelance illustration; 40% require freelance design.

Needs Approached by 100 freelancers/year. Works with 0-1 freelance illustrator and 5 designers/year. Prefers local freelancers with experience in designing on the computer. Uses freelancers for jacket/cover illustration and design and direct mail design. Also for multimedia projects. 100% of design and 90% of illustration demand knowledge of Photoshop, Illustrator and QuarkXPress. Works on assignment only.

First Contact & Terms Designers: Send brochure, résumé and tearsheets. Illustrators: Send postcard sample or query letter with brochure, résumé. Samples are filed. Responds only if interested. Artist should not follow up with call. Portfolio should include color final art. Rights purchased vary according to project. Finds artists through artists' submissions and authors' contacts.

Book Design Assigns 4 freelance design jobs/year.

Jackets/Covers Assigns 10 freelance design and 0-1 illustration job/year. Pays by the project, $250-1,000.

Tips First-time assignments are usually regional, paperback book covers; book jackets for national books are given to "proven" freelancers.

BOOK DESIGN

Box 193, Moose WY 83012-0193. Phone/fax: (307)733-6248. **Art Director:** Robin Graham. Specializes in high quality hardcover and paperback originals. Publishes more than 12 titles/year. Recent titles include: *Tales of the Wolf*; *Wildflowers of the Rocky Mountains*; *Mattie A Woman's Journey West*; *Cubby in Wonderland*; *Windswept*; *The Iron Shirt*.

Needs Works with 20 freelance illustrators and 10 designers/year. Works on assignment only. "We are looking for top-notch quality only." 90% of freelance work demands knowledge of PageMaker and FreeHand for electronic submissions.

First Contact & Terms Send query letter with "examples of past work and one piece of original artwork which can be returned." Samples not filed are returned by SASE if requested. Responds in 20 days. Originals are not returned. Write for appointment to show portfolio. Negotiates rights purchased.

Book Design Assigns 6 freelance design jobs/year. Pays by the project, $50-3,500.

Jackets/Covers Assigns 2 freelance design and 4 illustration jobs/year. Pays by the project, $50-3,500.

Text Illustration Assigns 26 freelance jobs/year. Prefers technical pen illustration, maps (using airbrush, overlays etc.), watercolor illustration for children's books, calligraphy and lettering for titles and headings. Pays by the hour, $5-20, or by the project, $50-3,500.

THOMAS BOUREGY & CO., INC.(AVALON BOOKS)

160 Madison Ave., 5th Floor, New York NY 10016-5412. (212)598-0222. Fax: (212)979-1862. Website: www.ava lonbooks.com. **Contact:** Art Director. Estab. 1950. Book publisher. Publishes hardcover originals. Types of books include romance, mysteries and Westerns. Publishes 60 titles/year. Recent titles include: *Vicksburg*; *The Marrying Kind*. 100% require freelance illustration and design. Prefers local artists and artists with experience in dust jackets. Works on assignment only.

First Contact & Terms Send samples. Samples are filed if appropriate. Responds if interested.

⃞Ñ BOWLING GREEN UNIVERSITY POPULAR PRESS

Bowling Green University, Bowling Green OH 43403. (419)372-7867. Fax: (419)372-8095. **Director:** Pat Browne. Publishes hardcover and paperback originals on popular culture, folklore, women's studies, science fiction criticism, detective fiction criticism, music and drama. Publishes 15-20 titles and 8 journals/year.

First Contact & Terms Send previously published work and SASE. Responds in 2 weeks. Buys all rights. Free catalog.

Jackets/Covers Assigns 20 jobs/year. Pays $250 minimum, color washes, opaque watercolors, gray opaques, b&w line drawings and washes.

⃞Ñ CACTUS GAME DESIGN, INC.

751 Tusquittee St., Hayesville, NC 28904. (828)389-1536. Fax: (828)389-1534. E-mail: rob@cactusgamedesign.c om. Website: www.cactusgamedesign.com. **Art Director:** Doug Gray. Estab. 1995. Publishes comic books, game/trading cards, posters/calendars, CD-ROM/online games and board games. Main style/genre of games science fiction, fantasy and Biblical. Uses freelance artists mainly for illustration. Publishes 2-3 titles or products/

year. *Outburst Bible Edition*, *Redemption 2nd Edition*, *Gil's Bible Jumble*. 100% requires freelance illustration; 25% requires freelance design.

Needs Approached by 50 illustrators and 5 designers/year. Works with 10 illustrators and 1 designer/year. Prefers freelancers experienced in fantasy and Biblical art. 100% of freelance design demands knowledge of Corel Draw, Photoshop, QuarkXPress and Adobe Illustrator.

First Contact & Terms Send query letter with résumé and photocopies. Accepts disk submissions in Windows format. Send via CD, floppy disk, Zip as TIFF, GIF or JPEG files. Samples are filed. Responds only if interested. Portfolio review not required. Rights purchased vary according to project. Finds freelancers through submission packets and word of mouth.

Visual Design Assigns 30-75 freelance design jobs/year. Pays for design by the hour, $20.

Book Covers/Posters/Cards Pays for illustration by the project, $25-250. "Artist must be aware of special art needs associated with Christian retail environment."

Tips "We like colorful action shots."

CANDLEWICK PRESS

2067 Massachusetts Ave., Cambridge MA 02140. (617)661-3330. Fax: (617)661-0565. **Contact:** Anne Moore, art resource coordinator. Estab. 1992. Imprints include Walker Books, London. Publishes hardcover, trade paperback children's books. Publishes 200 titles/year. 100% requires freelance illustration. Book catalog not available.

Needs Works with 170 illustrators and 1-2 designers/year. 100% of freelance design demands knowledge of Photoshop, Illustrator or QuarkXPress.

First Contact & Terms Designers: Send query letter with résumé. Illustrators: Send query letter with photocopies. Accepts nonreturnable disk submissions from illustrators. Samples are filed and are not returned. Will contact artist for portfolio review of artwork and tearsheets if interested. Buys all rights or rights purchased vary according to project.

Text Illustration Finds illustrators through agents, sourcebooks, word of mouth, submissions, art schools.

Tips "We generally use illustrators with prior trade book experience."

CANDY CANE PRESS

Ideals Publications, a division of Guideposts, 535 Metroplex Dr., Suite 250, Nashville TN 37211. (615)333-0478. Fax: (615)781-1447. Website: www.idealspublications.com. **Art Director:** Eve DeGrie. Publisher: Patricia Pingry. Publishes hardcover and trade paperback originals. Types of books include children's picture books, juvenile and preschool. Publishes 10 titles/year.

 • See listing for Ideals Publications.

CARTWHEEL BOOKS

Imprint of Scholastic, Inc., Trade Division, 557 Broadway, New York NY 10012-3999. (212)343-6100. Fax: (212)343-4444. Website: www.scholastic.com. **Art Director:** Richard Deas. Estab. 1990. Publishes mass market and trade paperback originals. Types of books include children's picture books, instructional, juvenile, preschool, novelty books. Specializes in books for very young children. Publishes 100 titles/year. Titles include: *I Spy*, by Jean Marzollo and Walter Wick. 100% requires freelance illustration; 25% requires freelance design; 5% requires freelance art direction. Book catalog available for SASE with first-class stamps.

Needs Approached by 500 illustrators and 50 designers/year. Works with 75 illustrators, 5 designers and 3 art directors/year. Prefers local designers. 100% of freelance design demands knowledge of QuarkXPress.

First Contact & Terms Designers: Send query letter with printed samples, photocopies, SASE. Illustrators: Send postcard sample or query letter with printed samples, photocopies and follow-up postcard every 2 months. Samples are filed. Responds in 1 month. Will contact artist for portfolio review of artwork portraying children and animals, artwork of characters in sequence, tearsheets if interested. Rights purchased vary according to project. Finds freelancers through submissions on file, reps.

Book Design Assigns 10 freelance design and 2 art direction projects/year. Pays for design by the hour, $30-50; art direction by the hour, $35-50.

Text Illustration Assigns 200 freelance illustration jobs/year. Pays by the project, $500-10,000.

Tips "I need to see cute fuzzy animals, young, lively kids, and/or clear depictions of objects, vehicles and machinery."

THE CENTER FOR WESTERN STUDIES

P.O. Box 727, Augustana College, Sioux Falls SD 57197. (605)274-4007. Fax: (605)274-4999. E-mail: hthomps@a ugie.edu. Website: http//augie.edu/CWS/. **Publications Director:** Harry F. Thompson. Estab. 1970. Publishes hardcover originals and trade paperback originals and reprints. Types of books include western history. Specializes in history and cultures of the Northern Plains, especially Plains Indians, such as the Sioux and Cheyenne.

Publishes 1-2 titles/year. Recent titles include: *Soldier, Settler, Sioux Fort Ridgeley and the Minnesota River Valley*; *The Lizard Speaks Essays on the Writings of Frederick Manfred.* 25% require freelance design. Books are conservative, scholarly and documentary. Book catalog free by request.

Needs Approached by 1-2 freelancers/year. Works with 1-2 freelance designers and 1-2 illustrators/year. Uses freelancers mainly for cover design. Also for book design and text illustration. Works on assignment only.

First Contact & Terms Send query letter with résumé, SASE and photocopies. Request portfolio review in original query. Responds only if interested. Portfolio should include roughs and final art. Sometimes requests work on spec before assigning a job. Rights purchased vary according to project. Originals are not returned. Finds illustrators and designers through word of mouth and submissions/self promotion.

Book Design Assigns 1-2 freelance design jobs/year. Pays by the project, $500-750.

Jackets/Covers Assigns 1-2 freelance design jobs/year. Pays by the project, $250-500.

Text Illustration Pays by the project, $100-500.

Tips ''We are a small house, and publishing is only one of our functions, so we usually rely on the work of graphic artists with whom we have contracted previously. Send samples.''

CENTERSTREAM PUBLISHING

P.O. Box 17878, Anaheim Hills CA 92817-7878. (714)779-9390. Fax: (714)779-9390. E-mail: centerstrm@aol.com. Website: www.centerstream-usa.com. **Production:** Ron Middlebrook. Estab. 1978. Publishes DVDs, audio tapes, and hardcover and softcover originals. Types of books include music reference, biography, music history and music instruction. Publishes 10-20 titles/year. Recent titles include: *On Wings of Music Jerry Byrd Bio*; *Melodic Lines for the Intermediate Guitarist*; *Tony Ellis*; *Banjo*; *The Early Minstrel Banjo*; ''More Dobro'' DVD. 100% requires freelance illustration. Book catalog free for 6×9 SAE with 2 first-class stamps.

Needs Approached by 12 illustrators/year. Works with 3 illustrators/year.

First Contact & Terms Illustrators: Send postcard sample or tearsheets. Accepts Mac-compatible disk submissions. Samples are not filed and are returned by SASE. Responds only if interested. Buys all rights, or rights purchased vary according to project.

Tips ''Publishing is a quick way to make a slow buck.''

Ⓝ CHARIOT VICTOR PUBLISHING

Cook Communication Ministries, 4050 Lee Vance View, Colorado Springs CO 80918-7100. (719)536-3271. Fax: (719)536-3269. Website: www.cookministries.com. **Creative Director:** Randy Maid. Estab. late 1800s. Imprints include Chariot Publishing, Victor Publishing, Lion Publishing and Rainfall Educational Toys. Imprint publishes hardcover and trade paperback originals and mass market paperback originals. Also toys. Types of books include contemporary and historical fiction, mystery, self-help, religious, juvenile, some teen and preschool. Publishes 100-150 titles/year. Recent titles include: *Gifts from God*; *Kids Hope.* 100% require freelance illustration; 60% require freelance design.

Needs Approached by dozens of freelance artists/year. Works with 150 freelance illustrators and 30 freelance designers/year. Buys 1,050-1,200 freelance illustrations/year. Prefers artists with experience in children's publishing and/or packaging. Uses freelance artists mainly for covers, educational products and picture books. Also uses freelance artists for text illustration, jacket/cover and book design. 50% of design work demands knowledge of Illustrator, QuarkXPress, Photoshop or FreeHand. Works on assignment only.

First Contact & Terms Send postcard sample or query letter with résumé, tearsheets and photocopies. ''Only send samples you want me to keep.'' Samples are not returned. Responds only if interested. Artist should follow up with call. Rights purchased vary according to project. Originals are ''usually'' returned at the job's completion. Finds artists through submissions and word of mouth.

Book Design Assigns 40 freelance design jobs/year.

Jackets/Covers Assigns 100 freelance design/illustration jobs/year. Pays by the project, $300-2,000. Prefers computer design for comps, realistic illustration for fiction, cartoon or simplified styles for children's.

Text Illustration Assigns 225 freelance illustration jobs/year. Pays by the project, $2,000-5,000 buyout for 32-page picture books. ''Sometimes we offer royalty agreement.'' Prefers from simplistic, children's styles to realistic.

Tips ''First-time assignments are frequently available as we are always looking for a fresh look. However, our larger 'A' projects usually are assigned to those who we've worked with in the past.''

CHARLESBRIDGE PUBLISHING

85 Main St., Watertown MA 02472. E-mail: tradeart@charlesbridge.com. Phone/fax: (617)926-0329. Website: www.charlesbridge.com. **Contact:** Art Director. Estab. 1980. Publishes hardcover and softcover children's trade picture books and transitional ''bridge books,'' books ranging from early readers to middle-grade chapter books. Publishes 35 titles/year, nonfiction and fiction. Recent titles include: *Amelia to Zora* and *Fluffy, Scourge of the*

Sea. Books "off accurate information, promote a positive worldview, and embrace a child's innate sense of wonder and fun."

Needs Works with 15-20 freelance illustrators/year. Looks for illustrators who "demonstrate strong originality, excellent conceptual abilities, and technical accomplishment in their chosen media."

First Contact & Terms Send résumé, tearsheets and photocopies. Samples not filed are returned by SASE. Responds only if interested. Originals are not returned. Considers complexity of project and project's budget when establishing payment. Buys all rights.

Text Illustration Assigns 15-20 jobs/year. Pays royalty with advance.

CHATHAM PRESS, INC.

P.O. Box A, Old Greenwich CT 06870. (203)531-7755. Fax: (203)359-8568. **Art Director:** Arthur G.D. Mark. Estab. 1971. Publishes hardcover originals and reprints, trade paperback originals and reprints. Types of books include coffee table books, cookbooks, history, nonfiction, self-help, travel, western, political, Irish and photographic. Publishes 12 titles/year. Recent titles include: *Exploring Old Cape Cod*; *Photographers of New England*. 5% requires freelance illustration; 5% requires freelance design; 5% requires freelance art direction. Book catalog free for 7×10 SASE with 4 first-class stamps.

Needs Approached by 16 illustrators and 16 designers/year. Works with 2 illustrators, 2 designers and 2 art directors/year. Prefers local illustrators and designers. Seeks b&w photographs of maritime and New England-oriented coastal scenes.

First Contact & Terms Send query letter with photocopies and SASE. Samples are not filed and are returned by SASE. Responds in 2 months. Will contact artist for portfolio review if interested. Negotiates rights purchased. Finds freelancers through word of mouth and individual contacts.

Jackets/Covers Assigns 4 freelance design jobs and 1 illustration job/year. Pays for design by the project. Pays for illustration by the project.

Tips "We accept and look for contrast (black & whites rather than grays), simplicity in execution, and immediate comprehension (i.e., not cerebral, difficult-to-quickly-understand) illustrations and design. We have one-tenth of a second to capture our potential customer's eyes—book jacket art must help us do that."

CHELSEA HOUSE PUBLISHERS

1974 Sproul Rd., Suite 204, Broomall PA 19008-0914. (610)353-5166, ext. 188. Fax: (610)353-5191. **Contact:** Art Director. Estab. 1973. Publishes hardcover originals and reprints. Types of books include biography, history, juvenile, reference, young adult. Specializes in young adult literary books. Publishes 150 titles/year. Recent titles include: *Coretta Scott King*, by Lisa Renee Rhodes. 85% requires freelance illustration; 30% requires freelance design; 10% requires freelance art direction. Book catalog not available.

Needs Approached by 100 illustrators and 50 designers/year. Works with 25 illustrators, 10 designers, 5 art directors/year. Prefers freelancers experienced in Macintosh computer for design. 100% of freelance design demands knowledge of Photoshop, QuarkXPress. 20% of freelance illustration demands knowledge of Illustrator, Photoshop, QuarkXPress.

First Contact & Terms Designers: Send query letter with nonreturnable printed samples, photocopies. Illustrators: Send postcard sample and follow-up postcard every 3 months. Accepts Mac-compatible disk submissions. Samples are filed and are not returned. Will contact artist for portfolio review if interested. Buys first rights. Finds freelancers through networking, submissions, agents and *American Showcase*.

Book Design Assigns 25 freelance design and 5 art direction projects/year. Pays for design by the hour, $15-35; for art direction by the hour, $25-45.

Jackets/Covers Assigns 50 freelance design jobs and 150 illustration jobs/year. Prefers oil, acrylic. Pays for design by the hour, $25-35. Pays for illustration by the project, $650-850. Prefers portraits that capture close likeness of a person.

Tips "Most of the illustrations we purchase involve capturing an exact likeness of a famous or historical person. Full color only, no black & white line art. Please send nonreturnable samples only."

CHINA BOOKS & PERIODICALS

360 Swift Ave. #48, South San Francisco CA 94080. (650)872-7076. Fax: (650)872-7808. Website: www.chinabooks.com. **Art Director:** Linda Revel. Estab. 1960. Publishes hardcover and trade paperback originals. Types of books include contemporary fiction, instrumental, biography, juvenile, reference, history and travel. Specializes in China-related books. Publishes 10 titles/year. Recent titles include: *Chinese Folk Art*; *Be a Cat*, by Tsai Chih Chung. 10% require freelance illustration; 75% require freelance design. Books are "tastefully designed for the general book trade." Free book catalog.

Needs Approached by 50 freelancers/year. Works with 5 freelance illustrators and 3 designers/year. Prefers freelancers with experience in Chinese topics. Uses freelancers mainly for illustration, graphs and maps. 50% of freelance work demands knowledge of QuarkXPress.

First Contact & Terms Send postcard sample or query letter with résumé, samples and SASE. Samples are filed. Responds in 1 month. Write for appointment to show portfolio of thumbnails, b&w slides and photographs. Originals are returned at job's completion.
Book Design Assigns 4 freelance jobs/year. Pays by the project, $500-3,000.
Jackets/Covers Assigns 4 freelance design and 2 illustration jobs/year. Pays by the project, $700-2,000.
Text Illustration Assigns 2 freelance jobs/year. Pays by the hour, $15-30; or by the project, $100-2,000. Prefers line drawings, computer graphics and photos.

CHRONICLE BOOKS

85 Second St., 6th Floor, San Francisco CA 94105. (415)537-4424. Website: www.chroniclebooks.com. **Creative Director:** Michael Carabetta. Estab. 1976. Company publishes high quality, affordably priced hardcover and trade paperback originals and reprints. Types of books include cookbooks, art, design, architecture, contemporary fiction, travel guides, gardening and humor. Publishes approximately 200 titles/year. Recent best-selling titles include: *The Bad Girl's Sticky Notes*; *Mooses Come Walking*; *Worst Case Scenario Survival Handbooks*; *Extreme Dinosaurs* Book catalog free on request (call 1-800-722-6657). Guidelines on website.
• Chronicle has a separate children's book division and a gift division, which produces blank greeting cards, calendars, address books, journals and the like.
Needs Approached by hundreds of freelancers/year. Works with 15-20 illustrators and 30-40 designers/year. Uses artists for cover and interior design and illustration. 99% of design work demands knowledge of Page-Maker, QuarkXPress, FreeHand, Illustrator or Photoshop; "mostly QuarkXPress—software is up to discretion of designer." Works on assignment only.
First Contact & Terms Send query letter with tearsheets, color photocopies or printed samples no larger than 8½×11. Samples are filed or are returned by SASE. Responds only if interested. Art Director will contact artist for portfolio review if interested. Portfolio should include thumbnails, roughs, final art, photostats, tearsheets, slides, tearsheets and transparencies. Buys all rights. Originals are returned at job's completion. Finds artists through submissions, *Communication Arts* and sourcebooks.
Book Design Assigns 30-50 freelance design jobs/year. Pays by the project; $750-1200 for covers; varying rates for book design depending on page count.
Jackets/Covers Assigns 30 freelance design and 30 illustration jobs/year. Pays by the project.
Text Illustration Assigns 25 freelance illustration jobs/year. Pays by the project.
Tips "Please write instead of calling; don't send original material."

CIRCLET PRESS, INC.

1770 Massachusetts Ave., #278, Cambridge MA 02140. (617)864-0492. Fax: (617)864-0663. E-mail: circlet-info@circlet.com. Website: www.circlet.com. **Publisher:** Cecilia Tan. Estab. 1992. Company publishes trade paperback originals. Types of books include erotica, erotic science fiction and fantasy. Publishes 8-10 titles/year. Recent titles include: *Nymph*, by Francesca Lia Block; *Master Han's Daughter*, by Midori; *Sex Noir*, by Jamie Joy Gato. 100% require freelance illustration. Book catalog free for business size SAE with 1 first-class stamp.
Needs Approached by 300-500 freelancers/year. Works with 4-5 freelance illustrators/year. Uses freelancers for cover art. Needs computer-literate freelancers for illustration. 100% of freelance work demands knowledge of QuarkXPress or Photoshop. Works on assignment only. 10% of titles require freelance art direction.
First Contact & Terms Send e-mail with attachments, pitching an idea for specific upcoming books. List of upcoming books available for 37¢ SASE or on website. Ask for "Artists Guidelines." Samples are discarded. Responds only if interested. Portfolio review not required. Buys one-time rights or reprint rights. Originals are returned at job's completion. Finds artists through art shows at science fiction conventions and submission samples. "I need to see human figures well-executed with sensual emotion. No tentacles or gore! Photographs, painting, computer composites all welcomed. We use much more photography these days."
Book Design Assigns 2-4 freelance design jobs/year. Pays by the project, $15-100.
Jackets/Covers Assigns 2-4 freelance illustration jobs/year. Pays by the project, $100-200. Now using 4-color and halftones.
Tips "I have not bought any art from a physical submission in five years. It has all been via e-mail. Follow the instructions in this listing: Don't send me color samples on slides. I have no way to view them. Any jacket and book design experience is also helpful. I prefer to see a pitch idea for a cover aimed at a specific title, a way we can use an image that is already available to fit a theme. The artists I have hired in the past 3 years have come to me through the Internet by e-mailing JPEG or GIF files of samples in response to the guidelines on our website. The style that works best for us is photographic collage and post-modern."

CLARION BOOKS

215 Park Ave. S., 10th Floor, New York NY 10003. (212)420-5800. Website: www.hmco.com. **Art Director:** Joann Hill. Imprint of Houghton Mifflin Company. Imprint publishes hardcover originals and trade paperback

reprints. Specializes in picture books, chapter books, middle grade novels and nonfiction, including historical and animal behavior. Publishes 60 titles/year. 90% requires freelance illustration. Book catalog free for SASE.
- *The Three Pigs*, by David Weisner was awarded the 2002 Caldecott Medal. *A Single Shard*, by Linda Sue Park was awarded the 2002 Newbery Medal.

Needs Approached by "countless" freelancers. Works with 48 freelance illustrators/year. Uses freelancers mainly for picture books and novel jackets. Also for jacket/cover and text illustration.

First Contact & Terms Send query letter with tearsheets and photocopies. Samples are filed "if suitable to our needs." Responds only if interested. Portfolios may be dropped off every Monday. Art Director will contact artist for portfolio review if interested. Rights purchased vary according to project. Originals are returned at job's completion.

Text Illustration Assigns 48 freelance illustration jobs/year. Pays by the project.

Tips "Be familiar with the type of books we publish before submitting. Send a SASE for a catalog or look at our books in the bookstore. Send us children's book-related samples."

THE COUNTRYMAN PRESS

(Division of W.W. Norton & Co., Inc.), Box 748, Woodstock VT 05091. (802)457-4826. Fax: (802)457-1678. E-mail: countrymanpress@wwnorton.com. Website: www.countrymanpress.com. **Asst. Production Manager:** Jennifer Thompson. Estab. 1976. Book publisher. Publishes hardcover originals and reprints, and trade paperback originals and reprints. Types of books include history, travel, nature and recreational guides. Specializes in recreational (biking/hiking) guides. Publishes 60 titles/year. Titles include: *The King Arthur Flour Baker's Companion* and *Maine: An Explorer's Guide.* 10% require freelance illustration; 60% require freelance cover design. Book catalog free by request.

Needs Works with 4 freelance illustrators and 7 designers/year. Uses freelancers for jacket/cover and book design. Works on assignment only. Prefers working with computer-literate artists/designers within New England/New York with knowledge of Photoshop, Illustrator, QuarkXPress.

First Contact & Terms Send query letter with appropriate samples. Samples are filed. Responds to the artist only if interested. To show portfolio, mail best representations of style and subjects. Negotiates rights purchased.

Book Design Assigns 10 freelance design jobs/year. Pays for design by the project, $600-1,000.

Jackets/Covers Assigns 10 freelance design jobs/year. Pays for design $600-1,000.

CRC PRODUCT SERVICES

2850 Kalamazoo Ave. SE, Grand Rapids MI 49560. (616)224-0780. Fax: (616)224-0834. Website: www.crcna.org. **Art Director:** Dean Heetderks. Estab. 1866. Publishes hardcover and trade paperback originals and magazines. Types of books include instructional, religious, young adult, reference, juvenile and preschool. Specializes in religious educational materials. Publishes 8-12 titles/year. 85% requires freelance illustration.

Needs Approached by 30-45 freelancers/year. Works with 12-16 freelance illustrators/year. Prefers freelancers with religious education, cross-cultural sensitivities. Uses freelancers for jacket/cover and text illustration. Works on assignment only. 5% requires freelance art direction.

First Contact & Terms Send query letter with brochure, résumé, tearsheets, photographs, photocopies, slides and transparencies. Submissions will not be returned. Illustration guidelines are available on website. Samples are filed. Portfolio should include thumbnails, roughs, finished samples, color slides, tearsheets, transparencies and photographs. Buys one-time rights. Originals are returned at job's completion.

Jackets/Covers Assigns 2-3 freelance illustration jobs/year. Pays by the project, $200-1,000.

Text Illustration Assigns 50-100 freelance illustration jobs/year. Pays by the project, $75-100. "This is high-volume work. We publish many pieces by the same artist."

Tips "Be absolutely professional. Know how people learn and be able to communicate a concept clearly in your art."

Ⓝ CREATIVE WITH WORDS PUBLICATION

P.O. Box 223226, Carmel CA 93922. E-mail: cwwpub@usa.net. Website: members.tripod.com/CreateWithWords. **Editor-in-Chief:** Brigitta Geltrich. Nature Editor: Bert Hower. Estab. 1975. Publishes mass market paperback originals. Types of anthologies include adventure, children's picture books, history, humor, juvenile, preschool, travel, young adult and folklore. Specializes in anthologies. Publishes 10-12 titles/year. Recent titles include: *Folkhumor; We are Writers, Too!* Books are listed on website.

Needs Approached by 5 illustrators/month. Works with 6-12 illustrators/year. Prefers freelancers experienced in b&w drawings. Does not want computer art.

First Contact & Terms Send postcard sample and follow-up postcard every 3 months, or query letter with printed samples, photocopies, SASE. Samples are filed or returned by SASE. Responds in 2 weeks if SASE was enclosed. Will contact artist for portfolio review if interested. Buys one-time rights and sometimes negotiates rights purchased.

Book Design Assigns 12-14 freelance design jobs/year. Pays for design by the project, $2-20 a sketch.

Jackets/Covers Assigns 10-12 illustration jobs/year. Pays for illustration by the project, $2-20 a sketch. Prefers folkloristic themes, general-public appeal.

Text Illustration Assigns 10-12 freelance illustration jobs/year. Pays by the project, $2-20. Prefers b&w sketches.

Tips ''We aim for a folkloristic slant in all of our publications. Therefore, we always welcome artists who weave this slant into our daily lives for a general (family) public. We also like to have the meanings of a poem or prose expressed in the sketch.''

THE CROSSING PRESS

P.O. Box 7123, Berkeley CA 94707. (510)559-1600. Fax: (510)524-1052. E-mail: crossing@crossingpress.com. Website: www.crossingpress.com. **Art Director:** Nancy Austin. Estab. 1966. Publishes audio tapes, trade paperback originals and reprints. Types of books include nonfiction and self-help. Specializes in natural healing, New Age spirituality, cookbooks. Publishes 40 titles/year. Recent titles include: *A Woman's I Ching*; *Zen Judaism*; *Psycho Kitty*. Art guidelines on website.

- Part of Ten Speed Press.

Needs Freelance illustrators, photographers, artists and designers welcome to submit samples. Prefers designers experienced in Quark, Photoshop and book text design.

First Contact & Terms Send query letter with printed samples, photocopies or 3-5 slides, or color copies, SASE if materials are to be returned. Samples are filed or returned by SASE. Will contact artist for portfolio review if interested. Rights purchased vary according to project. Finds freelancers through submissions, promo mailings, *Directory of Illustration*, *California Image*, *Creative Black Book*.

Tips ''We look for artwork that is expressive, imaginative, colorful, textural—abstract or representational—appropriate as cover art for books on natural healing or New Age spirituality. We also are interested in artists/photographers of prepared food for cookbooks.''

CROWN PUBLISHERS, INC.

1745 Broadway, Mail Drop 13-1, New York NY 10019. (212)572-2600. **Art Director:** Whitney Cookman. Art Director: Mary Sarah Quinn. Specializes in fiction, nonfiction and illustrated nonfiction. Publishes 250 titles/year. Titles include: *The Crazyladies of Pearl Street* and *The Bright Forever*.

- Crown is an imprint of Random House. Within that parent company, several imprints—including Clarkson Potter, Crown Arts & Letters, and Harmony—maintain separate art departments.

Needs Approached by several hundred freelancers/year. Works with 15-20 illustrators and 25 designers/year. Prefers local artists. 100% of design demands knowledge of QuarkXPress and Illustrator. Works on assignment only.

First Contact & Terms Send query letter with samples showing art style. Responds only if interested. Originals are not returned. Rights purchased vary according to project.

Jackets/Covers Assigns 15-20 design and/or illustration jobs/year. Pays by the project.

Tips ''There is no single style. We use different styles depending on nature of the book and its perceived market. Become familiar with the types of books we publish. For example, don't send juvenile, sci-fi or romance. Book design has changed to Mac-generated layout.''

DA CAPO PRESS

11 Cambridge Center, Cambridge MA 02142. (617)252-5241. E-mail: alex.camlin@perseusbooks.com. Website: www.dacapopress.com. **Contact:** Alex Camlin, art director. Estab. 1975. Publishes hardcover originals, trade paperback originals, trade paperback reprints. Types of books include self-help, biography, coffee table books, history, travel, music, and film. Specializes in music and history (trade). Publishes 100 titles/year. 25% requires freelance design; 5% requires freelance illustration.

Needs Approached by 30+ designers and 30+ illustrators/year. Works with 10 designers and 1 illustrator/year.

First Contact & Terms Send query letter with résumé, URL, color prints/copies. Send follow-up postcard sample every 6 months. Prefers Mac-compatible, JPEG, and PDF files. Samples are filed. Responds only if interested. Portfolios may be dropped off every Wednesday, Thursday and Friday and should include color finished art. Rights purchased vary according to project. Finds freelancers through art competitions, artists' submissions, Internet and word of mouth.

Jackets/Covers Assigns 20 freelance cover illustration jobs/year.

Text Illustration Does not assign freelance illustration jobs/year.

Tips ''Visit our website (www.dacapopress.com) to view work produced/assigned by Da Capo.''

DARK HORSE

10956 SE Main, Milwaukie OR 97222. E-mail: dhcomics@darkhorse.com. Website: www.darkhorse.com. **Contact:** Submissions. Estab. 1986. Publishes mass market and trade paperback originals. Types of books include

comic books and graphic novels. Specializes in comic books. Recent titles include: *Star Wars: General Grievous #3*, by Chuck Dixon, Rick Leonardi, Mark Pennington; *Hellboy: The Island #1*, by Mike Mignola; *Concrete: The Human Dilemma #6*, by Paul Chadwick. Book catalog available on website.

First Contact & Terms Send photocopies (clean, sharp, with name, address and phone number written clearly on each page). Samples are not filed and not returned. Responds only if interested. Company will contact artist for portfolio review interested.

Tips "If you're looking for constructive criticism, show your work to industry professionals at conventions."

JONATHAN DAVID PUBLISHERS

68-22 Eliot Ave., Middle Village NY 11379. (718)456-8611. Fax: (718)894-2818. E-mail: info@jdbooks.com. Website: www.jdbooks.com. **Contact:** Editorial Review. Estab. 1948. Company publishes hardcover and paperback originals. Types of books include biography, religious, young adult, reference, juvenile and cookbooks. Specializes in Judaica. Publishes 25 titles/year. Titles include: *Drawing a Crowd* and *The Presidents of the United States & the Jews.* 50% require freelance illustration; 75% require freelance design.

Needs Approached by numerous freelancers/year. Works with 5 freelance illustrators and 5 designers/year. Prefers freelancers with experience in book jacket design and jacket/cover illustration. 100% of design and 5% of illustration demand computer literacy. Works on assignment only.

First Contact & Terms Designers: Send query letter with résumé and photocopies. Illustrators: Send postcard sample and/or query letter with photocopies, résumé. Samples are filed. Production coordinator will contact artist for portfolio review if interested. Portfolio should include color final art and photographs. Buys all rights. Originals are not returned. Finds artists through submissions.

Book Design Assigns 15-20 freelance design jobs/year. Pays by the project.

Jackets/Covers Assigns 15-20 freelance design and 4-5 illustration jobs/year. Pays by the project.

Tips First-time assignments are usually book jackets, mechanicals and artwork.

DAW BOOKS, INC.

375 Hudson St., 3rd Floor, New York NY 10014-3658. (212)366-2096. Fax: (212)366-2090. **Art Directors:** Betsy Wollheim and Sheila Gilbert. Estab. 1971. Publishes hardcover and mass market paperback originals and reprints. Specializes in science fiction and fantasy. Publishes 72 titles/year. Recent titles include: *Sanctuary*, by Mercedes Lackey; *Shadowmarch*, by Tad Williams. All require freelance illustration. Book catalog free by request.

Needs Works with numerous illustrators and 1 designer/year. Buys more than 36 illustrations/year. Works with illustrators for covers. Works on assignment only.

First Contact & Terms Send postcard sample or query letter with brochure, résumé, tearsheets, transparencies, photocopies, photographs and SASE. "Please don't send slides." Samples are filed or are returned by SASE only if requested. Responds in 3 days. Originals returned at job's completion. Call for appointment to show portfolio of original/final art, final reproduction/product and transparencies. Considers complexity of project, skill and experience of artist and project's budget when establishing payment. Buys first rights and reprint rights.

Jacket/Covers Pays by the project, $1,500-8,000. "Our covers illustrate the story."

Tips "We have a drop-off policy for portfolios. We accept them on Tuesdays, Wednesdays and Thursdays and report back within a day or so. Portfolios should contain science fiction and fantasy color illustrations *only*. We do not want to see anything else. Look at several dozen of our covers."

DEVELOPING HEARTS SYSTEMS

2048 Elm St., Stratford CT 06615. (203)378-6725. Fax: (203)380-0456. E-mail: berquist@ntplx.net. **President:** Tom Berquist. Estab. 1985. Publishes children's picture and board books. Recent titles include: *Bonding with Baby Developmental Books.*

Needs Approached by 15-20 freelancers/year. Works with 3-5 freelancers/year on volunteer basis for credit only. Considers photography, art, acrylic and watercolor. Looking especially for developmental books for infants.

First Contact & Terms Designers/Cartoonists: Send query letter with photocopies. Samples are filed and are not returned. Responds only if interested. Rights purchased vary according to project. Pays royalties of under 1% for original art. Finds freelancers through word of mouth.

DIAL BOOKS FOR YOUNG READERS

345 Hudson St., New York NY 10014. (212)414-3412. Fax: (212)414-3398. **Editors:** Nancy Mercado, Rebecca Waugh. Specializes in juvenile and young adult hardcovers. Publishes 50 titles/year. Recent titles include: *Snowmen at Night*, by Caralyn and Mark Buchner; *The Surprise Visitor*, by Juli Kangas. 100% require freelance illustration. Books are "distinguished children's books."

Needs Approached by 400 freelancers/year. Works with 40 freelance illustrators/year. Prefers freelancers with some book experience. Works on assignment only.

First Contact & Terms Send query letter with photocopies, tearsheets and SASE. Samples are filed and returned by SASE. Responds only if interested. Originals returned at job's completion. Send query letter with samples for appointment to show portfolio of original/final art and tearsheets. Considers complexity of project, skill and experience of artist and project's budget when establishing payment. Rights purchased vary.

Jackets/Covers Assigns 8 illustration jobs/year. Pays by the project.

Text Illustration Assigns 40 freelance illustration jobs/year. Pays by the project.

DUTTON CHILDREN'S BOOKS

Penguin Putnam Inc., 345 Hudson St., New York NY 10014. Website: www.penguin.com. **Art Director:** Sara Reynolds. Publishes hardcover originals. Types of books include biography, children's picture books, fantasy, humor, juvenile, preschool, young adult. Publishes 100-120 titles/year. 75% require freelance illustration.

Needs Prefers local designers.

First Contact & Terms Send postcard sample, printed samples, tearsheets. Samples are filed or returned by SASE. Will contact artist for portfolio review if interested. Portfolios may be dropped off every Tuesday and picked up by end of the day. Do not send samples via e-mail.

Jackets/Covers Pays for illustration by the project $1,800-2,500.

ECCO

Imprint of HarperCollins, 10 E. 53rd, New York NY 10022. (212)207-7000. Fax: (212)702-7633. E-mail: eccopress @snip.net. Website: www.harpercollins.com. **Art Director:** Roberto deVicq. Estab. 1972. Publishes hardcover and trade paperback originals and reprints. Types of books include biography, cookbooks, experimental and mainstream fiction, poetry, nonfiction and travel. Specializes in literary fiction, poetry and cookbooks. Publishes 60 titles/year. Recent titles include: *Blonde*, by Joyce Carol Oates; *Dirty Havana Trilogy*, by Pedro Juan Couitterez. 10% requires freelance illustration; 100% requires freelance design.

- Ecco is one of the world's most prestigious literary publishers. The press was acquired by HarperCollins in 1999.

Needs Approached by 40 illustrators and 60 designers/year. Works with 2 illustrators and 20 designers/year. Prefers freelancers experienced in book jacket design and interior book design. 100% of freelance design demands knowledge of QuarkXPress or InDesign. 80% of freelance illustration demands knowledge of Photoshop and Illustrator.

First Contact & Terms Designers/Illustrators: Send postcard sample or query letter with photocopies and tearsheets. Accepts Mac-compatible disk submissions. Some samples filed, most not kept and not returned. Will contact artist for portfolio review if interested. You may also drop off portfolio on Wednesday and pick up Friday afternoon. Rights purchased vary according to project. Finds freelancers through word of mouth, sourcebooks, design magazines and browsing bookstores.

Book Design Pays for design by the project.

Jackets/Covers Assigns 60 freelance design jobs and 1 illustration job/year. Pays by the project, $500-1,000 for design, $200-500 for illustration. "We prefer sophisticated and hip experienced designers."

Tips "The best designers read the manuscript or part of the manuscript. Artwork should reflect the content of the book and be original and eye-catching. Submit design samples. Ask questions. Jacket font should be readable."

EDUCATIONAL IMPRESSIONS, INC.

116 Washington Ave., Hawthorne NJ 07507. (973)423-4666. Fax: (973)423-5569. E-mail: awpeller@optionline.n et. Website: www.awpeller.com. **Art Director:** Karen Birchak. Estab. 1983. Publishes original workbooks with 2-4 color covers and b&w text. Types of books include instructional, juvenile, young adult, reference, history and educational. Specializes in all educational topics. Publishes 4-12 titles/year. Recent titles include: *September, October and November*, by Rebecca Stark; *Tuck Everlasting*; *Walk Two Moons Lit Guides*. Books are bright and bold with eye-catching, juvenile designs/illustrations.

Needs Works with 1-5 freelance illustrators/year. Prefers freelancers who specialize in children's book illustration. Uses freelancers for jacket/cover and text illustration. Also for jacket/cover design. 50% of illustration demands knowledge of QuarkXPress and Photoshop. Works on assignment only.

First Contact & Terms Send query letter with tearsheets, SASE, résumé and photocopies. Samples are filed. Art director will contact artist for portfolio review if interested. Buys all rights. Interested in buying second rights (reprint rights) to previously published work. Originals are not returned. Prefers line art for the juvenile market. Sometimes requests work on spec before assigning a job.

Book Design Pays by the project, $20 minimum.

Jackets/Covers Pays by the project, $20 minimum.

Text Illustration Pays by the project, $20 minimum.

Tips ''Send juvenile-oriented illustrations as samples.''

Ⓝ ELCOMP PUBLISHING, INC.

8780 19th St., #199, Alta Loma CA 91701. Phone/fax: (909)949-0262. E-mail: elcomp@csi.com. Website: www.c lipshop.com. **President:** Winifred Hofacker. Estab. 1979. Publishes mass market paperback originals and CD-ROMs. Types of books include reference, textbooks, travel and computer. Specializes in computer and software titles. Publishes 2-3 titles/year. Recent titles include: *Windows XP Pocket Reference*; *The World's Easiest Database*. 90% require freelance illustration; 90% require freelance design. Catalog free for 2 first-class stamps.

Needs Approached by 2 illustrators and 2 designers/year. Works with 1 illustrator and 1 designer/year. Prefers freelancers experienced in cartoon drawing and clip art drawing. Uses freelancers mainly for clip art drawing. 10% of freelance design demands knowledge of Photoshop. 10% of freelance illustration demands knowledge of Photoshop and Illustrator.

First Contact & Terms Designers: Send photocopies. Illustrators: Send photocopies, printed sample and follow-up postcard samples every 2 months. Accepts disk submissions compatible with EPS or WMF files for Windows. Samples are returned. Responds in 6 weeks. Art director will contact artist for portfolio review if interested.

Book Design Pays for design by the project, $20-50.

Jackets/Covers Pays for design by the project, $10-50. Pays for illustration by the project, $10-20.

Text Illustration Pays by the project, $10-20.

EDWARD ELGAR PUBLISHING INC.

136 West St., Suite 202, Northampton MA 01060. (413)584-5551. Fax: (413)584-9933. E-mail: elgarinfo@e-elgar.com. Website: www.e-elgar.com. **Marketing Manager:** Katy Wight. Estab. 1986. Publishes hardcover originals and textbooks. Types of books include instructional, nonfiction, reference, textbooks, academic monographs, references in economics and business and law. Publishes 200 titles/year. Recent titles include: *Who's Who in Economics, Fourth Edition*; *The IPO Decision*.

● This publisher uses only freelance designers. Its academic books are produced in the United Kingdom. Direct Marketing material is done in U.S. There is no call for illustration.

Needs Approached by 2-4 designers/year. Works with 2 designers/year. Prefers local designers. Prefers freelancers experienced in direct mail and academic publishing. 100% of freelance design demands knowledge of Photoshop, InDesign.

First Contact & Terms Designers: Send query letter with printed samples. Accepts Mac-compatible disk submissions. Samples are filed. Will contact artist for portfolio review if interested. Buys one-time rights or rights purchased vary according to project. Finds freelancers through word of mouth, local sources i.e. phone book, newspaper, etc.

Ⓝ ELTON-WOLF PUBLISHING

1800 Westlake Ave. N #205, Seattle WA 98121. (206)748-0345. Fax: (206)748-0343. E-mail: info@elton-wolf.c om. Website: www.elton-wolf.com. **President:** Beth Farrell. Administrative Assistant: Kylee Krida. Estab. 1972. Book publisher. Publishes 100 titles/year. 30% require freelance illustration. Titles include: *The Blood Remembers*; *Silent Partners*; *Museum of Flight*; and *Contemporary Pedorthics*.

Needs Approached by 70 freelance artists/year. 95% of design demands computer skills.

First Contact & Terms Works on assignment only. Send résumé and samples of art style or tearsheets, photostats and photocopies. Accepts disk submissions. Samples not filed are returned only if requested. Responds only if interested. To show portfolio, mail appropriate materials. Payment negotiable.

Tips ''Books contain pen & ink and 4-color photos. Quality, service, and timeliness are our bywords. Our goal is to exceed our authors' expectations both in our production services and post-production services.''

EXCELSIOR CEE PUBLISHING

P.O. Box 5861, Norman OK 73070. (405)329-3909. Fax: (405)329-6886. E-mail: ecp@oecadvantage.net. Website: excelsiorcee.com. Estab. 1989. Publishes trade paperback originals. Types of books include how-to, instruction, nonfiction and self help. Specializes in how-to and writing. Publishes 6 titles/year. Titles include: *When I Want Your Opinion I'll Tell it to You*.

Needs Uses freelancers mainly for jacket and cover design.

First Contact & Terms Designers: Send query letter with SASE. Illustrators: Send query letter with résumé and SASE. Accepts disk submissions from designers. Samples returned by SASE. Negotiates rights purchased.

Book Design Assigns 2 freelance design jobs/year. Pays by the project.

Jackets/Covers Assigns 6 freelance illustration jobs/year. Pays by the project; negotiable.

Text Illustration Pays by the project. Finds freelancers through word of mouth and submissions.

N FABER & FABER, INC.

Division of Farrar, Straus and Giroux, 19 Union Square W., New York NY 10003-3304. (212)741-6900. Fax: (212)633-9385. Website: www.fsgbooks.com/faberandfaber.htm. **Senior Editor:** Denise Oswald. Estab. 1976. Publishes hardcover originals, trade paperback originals and reprints. Types of books include biography, cookbooks, history, mainstream fiction, nonfiction, self help and travel. Publishes 35 titles/year. 30% require freelance design.

Needs Approached by 60 illustrators and 40 designers/year. Works with 2 illustrators and 5 designers/year. Uses freelancers mainly for book jacket design. 80% of freelance design demands knowledge of Photoshop and QuarkXPress.

First Contact & Terms Designers: Send query letter with photocopies. Illustrators: Send postcard sample or photocopies. Samples are filed or returned by SASE. Will contact artist for portfolio review if interested. Rights purchased vary according to project.

Jackets/Covers Assigns 20 freelance design and 4 illustration jobs/year. Pays by project.

FACTS ON FILE

132 W. 31st St., 17th Floor, New York NY 10001. (212)967-8800. Fax: (212)967-9196. Website: www.factsonfile. com. **Creative Director:** Zina Scarpulla. Estab. 1940. Publisher of school, library and trade books, CD-ROMs and OnFiles. Types of reference and trade books include science, history, biography, language/literature/writing, pop culture, self-help. Specializes in general reference. Publishes 100 print, 14 online titles/year. Recent titles include: *The Encyclopedia of American History.* 10% require freelance illustration. Book catalog free by request.

Needs Approached by 100 freelance artists/year. Works with 2 illustrators and 5 designers/year. Uses freelancers mainly for jacket and direct mail design. Needs computer-literate freelancers for design and illustration. Demands knowledge of Macintosh and IBM programs. Works on assignment only.

First Contact & Terms Send query letter with SASE, tearsheets and photocopies. Samples are filed. Responds only if interested. Call to show a portfolio, which should include thumbnails, roughs, color tearsheets, photographs and comps. Rights purchased vary. Originals returned at job's completion.

Jackets/Covers Assigns 50 freelance design jobs/year. Pays by the project, $500-1,000.

Tips "Our books range from straight black and white to coffee-table type four-color. We're using more freelancers for technical, computer generated line art—charts, graphs, maps. We're beginning to market some of our titles in CD-ROM and online format; making fuller use of desktop publishing technology in our production department."

FALCON PRESS PUBLISHING CO., INC.

Imprint of Globe Pequot Press, 246 Goose Lane, P.O. Box 480, Guilford CT 06437. (203)458-4500. Fax: (203)458-4601. E-mail: artwork@globepequot.com. Website: www.globepequot.com. **Art/Production Director:** Michael Cirone. Estab. 1978. Book publisher. Publishes hardcover originals and reprints, trade paperback originals and reprints, and mass market paperback originals and reprints. Types of books include instruction, juvenile, travel and cookbooks. Specializes in recreational guidebooks and high-quality, four-color coffeetable photo books. Publishes 130 titles/year. Recent titles include: *Allen and Mike's Really Cool Telemark Tips,* by John Pukite; *Birder's Dictionary,* by Randall Cox. Book catalog free by request.

Needs Approached by 250 freelance artists/year. Works with 2-5 freelance illustrators/year. Buys 100 freelance illustrations/year. Uses freelance artists mainly for illustrating children's books, map making and technical drawing.

First Contact & Terms Send postcard sample or query letter with résumé, tearsheets, photographs, photocopies or photostats. Samples are filed if they fit our style. Accepts disk submissions compatible with PageMaker, QuarkXPress or Illustrator. Responds to the artist only if interested. Do not send anything you need returned. Originals are returned at job's completion.

Book Production Assigns 30-40 freelance production jobs and 1-2 design projects/year. Pays by the project.

Jackets/Covers Assigns 1-4 freelance design and 1-4 illustration jobs/year.

Text Illustration Assigns approximately 10 freelance illustration jobs/year. Pays by the project. No preferred media or style.

Tips "If we use freelancers, it's usually to illustrate nature-oriented titles. These can be for various children's titles or adult titles. We tend to look for a more 'realistic' style of rendering but with some interest."

N FANTAGRAPHICS BOOKS, INC.

7563 Lake City Way, Seattle WA 98115. (206)524-1967. Fax: (206)524-2104. E-mail: fbicomix@fantagraphics.c om. Website: www.fantagraphics.com. **Contact:** Submissions Editor. Estab. 1976. Publishes hardcover and trade paperback originals and reprints. Types of books include contemporary, experimental, mainstream, historical, humor and erotic. "All our books are comic books or graphic stories." Publishes 100 titles/year. Recent

titles include: *Love & Rockets*; *Hate*; *Eightball*; *Acme Novelty Library*; *JIM*; *Naughty Bits*. 10% requires freelance illustration. Book catalog free by request.

Needs Approached by 500 freelancers/year. Works with 25 freelance illustrators/year. Must be interested in and willing to do comics. Uses freelancers for comic book interiors and covers.

First Contact & Terms Send query letter addressed to submissions editor with résumé, SASE, photocopies and finished comics work. Samples are not filed and are returned by SASE. Responds to the artist only if interested. Call or write for appointment to show portfolio of original/final art and b&w samples. Buys one-time rights or negotiates rights purchased. Originals are returned at job's completion. Pays royalties.

Tips "We want to see completed comics stories. We don't make assignments, but instead look for interesting material to publish that is pre-existing. We want cartoonists who have an individual style, who create stories that are personal expressions."

Ⓝ FIRST BOOKS

6750 SW Franklin St., Suite A, Portland OR 97223. (503)968-6777. Fax: (503)968-6779. Website: www.firstbooks .com. **President:** Jeremy Solomon. Estab. 1988. Publishes trade paperback originals. Publishes 50 titles/year. Recent titles include: *Newcomer's Handbook For Seattle*; *Notes from the G-Spot*. 100% require freelance illustration.

Needs Works with 5 designers and 5 illustrators/year. Uses freelance designers not illustrators mainly for interiors and covers.

First Contact & Terms Designers: Send "any samples you want to send and SASE but no original art, please!" Illustrators: Send query letter with a few photocopies or slides. Samples are filed or returned by SASE. Responds in 1 month. Rights purchased vary according to project.

Book Design Payment varies per assignment.

Tips "Small samples get looked at more than anything bulky and confusing. Little samples are better than large packets and binders. Postcards are easy. Save a tree!"

FORT ROSS INC.

26 Arthur Place, Yonkers NY 10701. (914)375-6448. Fax: (914)375-6439. E-mail: fort.ross@verizon.net or vkarts ev2000@yahoo.com. Website: www.fortross.net. **Executive Director:** Dr. Vladimir P. Kartsev. Represents leading Russian, Polish, Spanish, etc., publishing companies in the US and Canada. Estab. 1992. Specializes in books in Russian and Russian-related books in English. Hardcover originals, mass market paperback originals and reprints, and trade paperback reprints. Works with adventure, children's picture books, fantasy, horror, romance, science fiction and western. Specializes in romance, science fiction, fantasy, mystery. Publishes 5 titles/year. Represents 500 titles/year. Recent titles include: translations of *Judo*, by Vladamir Putin; *The Redemption*, by Howard Fast. 100% requires freelance illustration. Book catalog not available.

- "Since 1996 we have introduced a new generation of outstanding Russian book illustrators and designers to the American and Canadian publishing world. At the same time, we have drastically changed the exterior of books published in Europe using classical American illustrations and covers."

Needs Approached by 100 illustrators/year. Works with 40 illustrators/year. Prefers freelancers experienced in romance, science fiction, fantasy, mystery cover art.

First Contact & Terms Illustrators: Send query letter with printed samples, photocopies, SASE, tearsheets. Accepts Windows-compatible disk submissions. Send EPS files. Samples are filed. Will contact artist for portfolio review if interested. Buys secondary rights. Finds freelancers through agents, networking events, sourcebooks, *Black Book*; *RSVP*; *Spectrum*.

Jackets/Covers Buys up to 1,000 illustrations/year. Pays for illustration by the project, $50-150 for secondary rights (for each country). Prefers experienced romance, mystery, science fiction, fantasy cover illustrators.

Tips "Fort Ross is the best place for experienced cover artists to sell secondary rights for their images in Russia, Poland, Czech Republic, countries of the former USSR, Western, Central and Eastern Europe. We prefer realistic, thoroughly executed expressive images on our covers."

FORWARD MOVEMENT PUBLICATIONS

412 Sycamore St., Cincinnati OH 45202-2656. (513)721-6659. Fax: (513)721-0729. E-mail: forward.movement@ msn.com. Website: www.forwardmovement.org. **Director/Editor:** Edward S. Gleason. Estab. 1935. Publishes trade paperback originals. Types of books include religious. Publishes 4 titles/year. Recent titles include: *Downsized*, by Leland Davis; *Alcoholism A Family Affair*. 17% require freelance illustration.

Needs Works with 2-4 freelance illustrators and 1-2 designers/year. Uses freelancers mainly for illustrations required by designer. "We also keep original clip-art-type drawings on file to be paid for as used."

First Contact & Terms Send query letter with tearsheets, photocopies or postcard samples. Samples are sometimes filed. Art director will contact artist for portfolio review if interested. Sometimes requests work on spec before assigning a job. Interested in buying second rights (reprint rights) to previously published work. Rights

purchased vary according to project. Originals sometimes returned at job's completion. Finds artists mainly through word of mouth.

Jackets/Covers Assigns 1-4 freelance design and 6 illustration jobs/year. Pays by the project, $25-175.

Text Illustration Assigns 1-4 freelance jobs/year. Pays by the project, $10-200; pays $5-25/picture. Prefers pen & ink.

Tips ''We need clip art. If you send clip art, include fee you charge for use.''

WALTER FOSTER PUBLISHING

23062 La Cadena, Laguna Hills CA 92653. (949)380-7510. Fax: (949)380-7575. E-mail: info@walterfoster.com. Website: www.walterfoster.com. **Art Director:** David Rosemeyer. Estab. 1922. Publishes trade paperback and mass market paperback originals and reprints. Types of books include instructional, juvenile, ''all art related.'' Specializes in art & craft. Publishes 30-50 titles/year. 80% require freelance illustration; 20% require freelance design. Catalog $5 with 8½×11 SASE.

Needs Approached by 500 illustrators and 50-100 designers/year. Works with 25-30 illustrators and 5-10 designers/year. 70% of freelance design demands knowledge of Photoshop, Illustrator and QuarkXPress.

First Contact & Terms Designers: Send query letter with brochure. Illustrators: Send postcard sample or query letter with color photocopies. Accepts disk submissions. ''If samples suit us they are filed.'' Responds only if interested. Art director will contact artist for portfolio review of photocopies, photographs, photostats, slides and transparencies if interested. Buys all rights.

Book Design Assigns 10-25 freelance design jobs/year. Pays by the project.

Jackets/Covers Assigns 10-25 freelance design jobs and 25-30 illustration jobs/year. Pays by the project. Finds freelancers through agents, sourcebooks, magazines, word of mouth and submissions.

☑ FRANKLIN WATTS

90 Old Sherman Turnpike, Danbury CT 06816. (203)797-3500. Fax: (203)797-3657. Website: www.scholasticlibrary.com. **Contact:** Art Director. Estab. 1942. Imprint of Scholastic Library Publishing. Publishes juvenile nonfiction and specialty reference sets.

- See listing for Scholastic Library Publishing. Its imprints include Children's Press and Grolier, in addition to Franklin Watts.

FULCRUM PUBLISHING

16100 Table Mountain Parkway #300, Golden CO 80403. (303)277-1623. Fax: (303)279-7111. Website: www.fulcrum-books.com. **Contact:** Art Director. Estab. 1984. Book publisher. Publishes hardcover originals and trade paperback originals and reprints. Types of books include biography, Native American, reference, history, self-help, children's, teacher resource books, travel, humor, gardening and nature. Specializes in history, nature, teacher resource books, travel, Native American, environmental and gardening. Publishes 50 titles/year. Recent titles include: *Valley of the Dunes: Great Sand Dunes National Park & Preserve*, by Bob Rozinski and Wendy Shattil; *Rembrandt and Titus: Artist and Son*, by Thomas Locker and Medeleine Comora. 15% requires freelance illustration; 15% requires freelance design. Book catalog free by request.

Needs Uses freelancers mainly for cover and interior illustrations for gardening books. Also for other jacket/covers, text illustration and book design. Works on assignment only.

First Contact & Terms Send query letter with tearsheets, photographs, photocopies and photostats. Samples are filed. Responds to artist only if interested. To show portfolio, mail b&w photostats. Buys one-time rights. Originals are returned at job's completion.

Book Design Pays by the project.

Jackets/Covers Pays by the project.

Text Illustration Pays by the project.

Tips Previous book design experience a plus.

GALISON BOOKS/MUDPUPPY PRESS

28 W. 44th St., New York NY 10036. (212)354-8840. Fax: (212)391-4037. E-mail: lorena@galison.com. Website: www.galison.com. **Contact:** Lorena Siminovich. Publishes note cards, journals, stationery, children's products. Publishes 120 titles/year.

- Also has listing in greeting cards, gifts and products section.

Needs Works with 20 illustrators and stock photographers/year. Assigns 30 freelance cover illustrations/year. Some freelance design demands knowledge of Photoshop, Illustrator and QuarkXPress.

First Contact & Terms Illustrators: Send photocopies, printed samples, tearsheets or e-mail to direct to website. Samples are filed or returned SASE. Will contact artist for portfolio review if interested. Rights purchased vary according to project.

GALLAUDET UNIVERSITY PRESS

800 Florida Ave. NE, Washington DC 20002-3695. (202)651-5488. Fax: (202)651-5489. E-mail: jill.porco@gallau det.edu. Website: gupress.gallaudet.edu. **Contact:** Jill Porco, production coordinator. Estab. 1980. Publishes hardcover and trade paperback originals, hardcover and trade paperback reprints, DVDs, videotapes and textbooks. Types of books include reference, biography, coffee table books, history, instructional and textbook nonfiction. Specializes in books related to deafness. Publishes 12-15 new titles/year. Recent titles include: *Deaf People in Hitler's Europe*; *The Parents' Guide to Cochlear Inplants*. 90% requires freelance design; 2% requires freelance illustration. Book catalog free on request.

Needs Approached by 10-20 designers and 30 illustrators/year. Works with 15 designers/year. 100% of freelance design work demands knowledge of Illustrator, PageMaker, Photoshop and QuarkXPress.

First Contact & Terms Send query letter with postcard sample with résumé, sample of work and URL. After introductory mailing, send follow-up postcard sample every 6 months. Accepts disk submissions. Prefers Windows-compatible, PDF files. Samples are filed. Responds only if interested. Company will contact artist for portfolio review if interested. Portfolio should include color finished art. Rights purchased vary according to project. Finds freelancers through Internet and word of mouth.

Tips "Do not call us."

☑ GAUNTLET PRESS

5307 Arroyo St., Colorado Springs CO 80922. E-mail: info@gauntletpress.com. Website: www.gauntletpress.c om. **Contact:** Barry Hoffman, president. Estab. 1991. Publishes hardcover originals and reprints, trade paperback originals and reprints. Types of books include horror, science fiction and young adult. Specializes in signed limited collectibles. Publishes 4 titles/year. Recent titles include: *It Came From Outerspace*; *Gateways*; *Lost Souls*.

- ● Currently Gauntlet Press is not accepting submissions, as they are solidly booked for the next few years.

GAYOT PUBLICATIONS

4911 Wilshire Blvd., Los Angeles CA 90010. (323)965-3529. Fax: (323)936-2883. E-mail: gayots@aol.com. Website: www.gayot.com. **Publisher:** Alain Gayot. Estab. 1986. Publishes trade paperback originals although most content is now published on the Internet. Types of books include travel and restaurant guides. Publishes 8 titles/year. Recent titles include: *The Best of London*; *The Best of Las Vegas*; *The Best of New York*; *The Best of Hawaii*. 50% requires freelance design. Catalog available.

Needs Approached by 30 illustrators and 2 designers/year. Works with 2 designers/year. Prefers local designers. 50% of freelance design demands knowledge of Dreamweaver, Flash, Photoshop, Illustrator and QuarkXPress.

First Contact & Terms Designers: Send query letter with brochure, photocopies and résumé. Send follow-up postcard every 6 months. Accepts disk submissions compatible with Mac, any program. Samples are filed. Responds only if interested. Will contact artist for portfolio review if interested. Rights purchased vary according to project.

Book Design Pays by the hour or by the project.

Jackets/Covers Assigns 40 freelance design jobs/year. Pays for design by the hour. Pays for illustration by the project, $800-1,200.

Tips "We look for rapidity, flexibility, eclecticism and an understanding of the travel guide business."

GEM GUIDES BOOK CO.

315 Cloverleaf Dr., Suite F, Baldwin Park CA 91706. (626)855-1611. Fax: (626)855-1610. E-mail: gembooks@aol. com. Website: www.gemguidesbooks.com. **Editors:** Kathy Mayerski, Nancy Fox. Estab. 1964. Book publisher and wholesaler of trade paperback originals and reprints. Types of books include earth sciences, western, instructional, travel, history and regional (western US). Specializes in travel and local interest (western Americana). Publishes 7 titles/year. Recent titles include: *Baby's Day Out in Southern California: Fun Places to Go with Babies and Toddlers*, by Jobea Holt; *The Nevada Trivia Book*, by Richard Moreno; *Free Mining and Mineral Adventures in the Eastern U.S.*, by James Martin and Jeannette Hathaway Monaco. 75% requires freelance cover design.

Needs Approached by 24 freelancers/year. Works with one designer/year. Uses freelancers mainly for covers. 100% of freelance work demands knowledge of Quark, Photoshop. Works on assignment only.

First Contact & Terms Send query letter with brochure, résumé and SASE. Samples are filed. Editor will contact artist for portfolio review if interested. Requests work on spec before assigning a job. Buys all rights. Originals are not returned. Finds artists through word of mouth and "our files."

Jackets/Covers Pays by the project.

GLENCOE/MCGRAW-HILL PUBLISHING COMPANY

3008 W. Willow Knolls Rd., Peoria IL 61615. (309)689-3200. Fax: (309)689-3211. **Contact:** Ardis Parker, director of Art/Design & Production. Specializes in secondary educational materials (hardcover, paperback, CDs, soft-

ware), in technology education, including industrial carpentry, computer, family consumer science, child care, family living, foods, nutrition, career education. Publishes more than 50 titles/year.

Needs Works with over 30 freelancers/year. 60% of freelance work demands knowledge of Illustrator, QuarkX-Press or Photoshop. Works on assignment only.

First Contact & Terms Send query letter with brochure, résumé and "any type of samples." Samples not filed are returned if requested. Responds in weeks. Originals are not returned; works on work-for-hire basis with rights to publisher. Considers complexity of the project, skill and experience of the artist, project's budget, turnaround time and rights purchased when establishing payment. Buys all rights.

Book Design Assigns 10 freelance design jobs/year. Pays by the project.

Jackets/Covers Assigns 10 freelance design jobs/year. Pays by the project.

Text Illustration Assigns 20 freelance jobs/year. Pays by the hour or by the project.

Tips "Try not to cold call and never drop in without an appointment."

GLOBE PEQUOT PRESS

246 Goose Lane, Guilford CT 06437. (203)458-4500. Fax: (203)458-4601. E-mail: info@globepequot.com. Website: www.globepequot.com. **Production Director:** Kevin Lynch. Estab. 1947. Publishes hardcover and trade paperback originals and reprints. Types of books include (mostly) travel, kayak, outdoor, cookbooks, instruction, self-help and history. Specializes in regional subjects New England, Northwest, Southeast bed-and-board country inn guides. Publishes 600 titles/year. 20% require freelance illustration; 75% require freelance design. Titles include: *Lost Lighthouses*, by John Grant; *Michael Shapiro's Internet Travel Planner*. Design of books is "classic and traditional, but fun." Book catalog available.

Needs Works with 10-20 freelance illustrators and 15-20 designers/year. Uses freelancers mainly for cover and text design and production. Also for jacket/cover and text illustration and direct mail design. Needs computer-literate freelancers for production. 100% of design and 75% of illustration demand knowledge of QuarkXPress 3.32, Illustrator 7.0 or Photoshop 5. Works on assignment only.

First Contact & Terms Send query letter with résumé, photocopies and photographs. Accepts disk submissions compatible with QuarkXPress 3.32, Illustrator 7.0 or Photoshop 5. Samples are filed and not returned. Request portfolio review in original query. Artist should follow up with call after initial query. Art Director will contact artist for portfolio review if interested. Portfolio should include roughs, original/final art, photostats, tearsheets and dummies. Requests work on spec before assigning a job. Considers complexity of project, project's budget and turnaround time when establishing payment. Buys all rights. Originals are not returned. Finds artists through word of mouth, submissions, self promotion and sourcebooks.

Book Design Pays by the hour, $20-28 for production; or by the project, $400-600 for cover design.

Jackets/Covers Prefers realistic style. Pays by the hour, $20-35; or by the project, $500-1,000.

Text Illustration Pays by the project, $25-150. Mostly b&w illustration, preferably computer-generated.

Cover Illustration Pays by the project, $500-700 for color.

Tips "Our books are being produced on Macintosh computers. We like designers who can use the Mac competently enough that their design looks as if it *hasn't* been done on the Mac."

GOLD RUSH GAMES

P.O. Box 2531, Elk Grove CA 95759-2531. (916)313-3575. E-mail: mark@goldrushgames.com. Website: www.goldrushgames.com. **President:** Mark Arsenault. Vice President: Margaret Arsenault. Estab. 1992. Publishes role-playing game books, newsletter. Main style/genre of games science fiction, fantasy, historical (16th-century Japan) and superheroes. Uses freelance artists mainly for full-color covers and b&w interior book illustrations. Publishes 4-6 titles or products/year. Game/product lines include: *Gunslingers Wild West Action*; *The Dragon's Gate* and miscellaneous role-playing games. 100% requires freelance illustration; 50% requires freelance design; 25% requires freelance art direction. Art guidelines free for SASE with 2 first-class stamps. Art guidelines available on website.

Needs Approached by 100 illustrators and 25 designers/year. Works with 20 illustrators and 2 designers/year. 100% of freelance design demands knowledge of Illustrator, PageMaker, Photoshop. 50% of freelance illustration demands knowledge of Photoshop.

First Contact & Terms Send query letter with printed samples, such as postcards or photocopies. Prefers samples printed on paper or cardstock. "Include a large enough SASE with sufficient postage if you want samples returned." Do not send originals. Accepts digital submissions. Although art director prefers to see hardcopy of art, he will accept e-mail submissions if art is sent as TIFF or JPEG files at 100-200 dpi "may use Zip or Stuff it compression. No LZW compressed Zip files." Samples are filed. Responds in 3 months if interested. Will contact artist for portfolio review if interested. Portfolio should include artwork portraying superheroes and historical Japanese (16th century), b&w, color photocopies. Buys first and reprint rights. Finds freelancers through submissions packets, conventions and referrals.

Visual Design Assigns 2 freelance design and 2 art direction projects/year. Pays for design by the project, $100-500; for art direction by the project, $100-300.

Book Covers/Posters/Cards Assigns 2 freelance design jobs and 6 illustration jobs/year. Pays for illustration by the project, $250-1,000; royalties of 2-3%. Prefers multicultural portrayal of characters, detailed backgrounds.

Text Illustration Assigns 18 freelance illustrations jobs/year. Pays by the full page, $75-150 pro-rated. Pays by the half page, $35-75.

Tips "We need reliable freelance artists and designers who can meet deadlines. We prefer a mix of 'action' and 'mood' illustrations. Historical accuracy for Japanese art a must."

ⓝ GOLDEN BOOKS

1745 Broadway, New York NY 10019. (212)782-9000. Fax: (212)782-9020. Website: www.goldenbooks.com. **Contact:** Roberta Ludlow, Tracy Tyler and Liz Alexander, art directors. Publishing company. Imprint is Golden Books. Publishes preschool and juvenile. Specializes in picture books themed for infant to 8-year-olds. Publishes 250 titles/year. Titles include: *Pat the Bunny*; *Little Golden Books*; *Nickelodeon*; *Mattel*.

Needs Approached by several hundred artists/year. Works with approximately 100 illustrators/year. Very little freelance design work. Most design is done in-house. Buys enough illustration for over 200 new titles, approximately 70% being licensed character books. Artists must have picture book experience; illustrations are generally full color but b&w art is required for coloring and activity books. Uses freelancers for picture books, storybooks. Traditional illustration, as well as digital illustration is accepted, although digital is preferred.

First Contact & Terms Send query letter with SASE and tearsheets. Samples are filed or are returned by SASE if requested by artist. Art director will call for portfolio if interested. Will look at original artwork and/or color representations in portfolios, but please do not send original art through the mail. Royalties or work-for-hire limited according to project.

Jackets/Covers All design done in-house. Makes outright purchase on licensed character properties only.

Text Illustration Assigns approximately 250 freelance illustration jobs/year. Payment varies.

Tips "We are open to a wide variety of styles. Contemporary illustrations that have strong bright colors and mass market appeal featuring appealing multicultural children will get strongest consideration."

⬚ ☑ GOOSE LANE EDITIONS LTD.

469 King St., Fredericton NB E3B 1E5, Canada. (506)450-4251. Fax: (506)450-4251. E-mail: gooselane@gooselane.com. Website: www.gooselane.com. **Art Director:** Julie Scriver. Estab. 1954. Publishes trade paperback originals of poetry, fiction and nonfiction. Types of books include poetry, biography, cookbooks, fiction, reference and history. Publishes 10-20 titles/year. 0-5% requires freelance illustration. Books are "high quality, elegant, generally with full-color fine art reproduction on cover." Book catalog free for SAE with Canadian first-class stamp or IRC.

Needs Approached by 30 freelancers/year. Works with 0-1 illustrators/year. Only works with freelancers in the region. Works on assignment only.

First Contact & Terms Send Web portfolio address. Illustrators may send postcard samples. Samples are filed or are returned by SASE. Responds in 2 months.

Book Design Pays by the project, $400-1,200 CAN.

Jackets/Covers Assigns 0-1 freelance design job and 0-1 illustration jobs/year. Pays by the project, $200-500 CAN.

Text Illustration Assigns 0-1 freelance illustration job/year. Pays by the project, $300-1,500.

ⓝ THE GRADUATE GROUP

P.O. Box 370351, W. Hartford CT 06137-0351. (860)233-2330. E-mail: graduategroup@hotmail.com. Website: www.graduategroup.com. **President:** Mara Whitman. Estab. 1967. Publishes trade paperback originals. Types of books include instructional and reference. Specializes in internships and career planning. Publishes 35 titles/year. Recent titles include: *Create Your Ultimate Résumé, Portfolio and Writing Samples An Employment Guide for the Technical Communicator*, by Mara W. Cohen Ioannides. 10% require freelance illustration and design. Book catalog free by request.

Needs Approached by 20 freelancers/year. Works with 1 freelance illustrator and 1 designer/year. Prefers local freelancers only. Uses freelancers for jacket/cover illustration and design; direct mail, book and catalog design. 5% of freelance work demands computer skills. Works on assignment only.

First Contact & Terms Send query letter with brochure and résumé. Samples are not filed. Responds only if interested. Write for appointment to show portfolio.

GRAYWOLF PRESS

2402 University Ave., #203, St. Paul MN 55114. (651)641-0077. Fax: (651)641-0036. E-mail: czarniec@graywolf press.org. Website: www.graywolfpress.org. **Executive Editor:** Anne Czarniecki. Estab. 1974. Publishes hard-

cover originals, trade paperback originals and reprints. Specializes in novels, nonfiction, memoir, poetry, essays and short stories. Publishes 25 titles/year. Recent titles include: *Wounded*, by Percival Everett; *Record Palace*, by Susan Wheeler; *Dictionary Days*, by Ilan Stavans. 100% require freelance cover design. Books use solid typography, strikingly beautiful and well-integrated artwork. Book catalog free by request.

 • Graywolf is recognized as one of the finest small presses in the nation.

Needs Approached by 100 freelance artists/year. Works with 7 designers/year. Buys 25 illustrations/year (existing art only). Prefers artists with experience in literary titles. Uses freelancers mainly for cover design. Works on assignment only.

First Contact & Terms Send query letter with résumé and photocopies. Samples are returned by SASE if requested by artist. Executive editor will contact artist for portfolio review if interested. Portfolio should include b&w, color photostats and tearsheets. Negotiates rights purchased. Interested in buying second rights (reprint rights) to previously published work. Originals are returned at job's completion. Pays by the project. Finds artists through submissions and word of mouth.

Jackets/Covers Assigns 25 design jobs/year. Pays by the project, $800-1,200. "We use existing artboth contemporary and classicaland emphasize fine typography."

Tips "Have a strong portfolio of literary (fine press) design."

GREAT QUOTATIONS PUBLISHING

8102 Lemont Rd., #300, Woodridge IL 60517. (630)390-3580. Fax: (630)390-3585. **Contact:** Tami Suite. Estab. 1985. Imprint of Greatime Offset Printing. Company publishes hardcover, trade paperback and mass market paperback originals. Types of books include humor, inspiration, motivation and books for children. Specializes in gift books. Publishes 50 titles/year. Recent titles include: *Only a Sister Could Be Such a Good Friend*; *Words From the Coach*. 50% requires freelance illustration and design. Book catalog available for $2 with SASE.

Needs Approached by 100 freelancers/year. Works with 20 designers and 20 illustrators/year. Uses freelancers to illustrate and/or design books and catalogs. 50% of freelance work demands knowledge of QuarkXPress and Photoshop. Works on assignment only.

First Contact & Terms Send letter of introduction and sample pages. Name, address and telephone number should be clearly displayed on the front of the sample. All appropriate samples will be placed in publisher's library. Design Editor will contact artist under consideration, as prospective projects become available. Rights purchased vary according to project.

Jackets/Covers Assigns 20 freelance cover illustration jobs/year. Pays by the project, $300-3,000.

Text Illustration Assigns 30 freelance text illustration jobs/year. Pays by the project, $100-1,000.

Tips "We're looking for bright, colorful cover design on a small size book cover (around 6×6). Outstanding humor or motivational titles will be most in demand."

GREAT SOURCE EDUCATION GROUP

181 Ballardvale St., Wilmington MA 01887. (978)661-1564. Fax: (978)661-1331. E-mail: richard_spencer@hmco .com. Website: www.greatsource.com. **Contact:** Richard Spencer, design director. Specializes in supplemental educational materials. Publishes more than 25 titles/year. 90% requires freelance design; 80% requires freelance illustration. Book catalog free with 9×12 SASE or check website.

Needs Approached by more than 100 illustrators/year. Works with 25 illustrators/year. 50% of freelance illustration demands knowledge of Illustrator and Photoshop.

First Contact & Terms Send nonreturnable samples such as postcards, photocopies and/or tearsheets. After introductory mailing, send follow-up postcard sample every year. Accepts disk submissions from illustrators. Prefers Mac-compatible, JPEG files. Samples are filed or returned by SASE. Responds only if interested. Company will contact artist for portfolio review if interested. Portfolio should include b&w, color tearsheets. Rights purchased vary according to project. Finds freelancers through art reps, artist's submissions, Internet.

Jackets/Covers Assigns 10 freelance cover illustration jobs/year. Pays for illustration by the project, $500-3,000. Prefers kid-friendly styles.

Text Illustration Assigns 25 freelance illustration jobs/year. Pays by the project, $30-1,000. Prefers professional electronic submissions.

GROUP PUBLISHING BOOK PRODUCT

1515 Cascade Ave., Loveland CO 80539. (970)669-3836. Fax: (970)292-4391. Website: www.group.com. **Art Directors (for interiors):** Jean Bruns, Kari Monson and Randy Kady. Company publishes books, Bible curriculum products (including puzzles, posters, etc.), clip art resources and audiovisual materials for use in Christian education for children, youth and adults. Publishes 35-40 titles/year. Recent titles include: *Group's Scripture Scrapbook Series*, *The Dirt on Learning*; *Group's Hands-On Bible Curriculum*; *Group's Treasure Serengeti Trek Vacation Bible School*; *Faith Weaver Bible Curriculum*.

• This company also produces magazines. See listing in Magazines section for more information.
Needs Uses freelancers for cover illustration and design. 100% of design and 50% of illustration demand knowledge of QuarkXPress 4.0, InDesign, Macromedia Freehand 8.0, Photoshop 7.0, Illustrator 9.0. Occasionally uses cartoons in books and teacher's guides. Uses b&w and color illustration on covers and in product interiors.
First Contact & Terms Contact Jeff Storm, Marketing Art Director, if interested in cover design or illustration. Contact if interested in book and curriculum interior illustration and design and curriculum cover design. Send query letter with nonreturnable b&w or color photocopies, slides, tearsheets or other samples. Accepts disk submissions. Samples are filed, additional samples may be requested prior to assignment. Responds only if interested. Rights purchased vary according to project.
Jackets/Covers Assigns minimum 15 freelance design and 10 freelance illustration jobs/year. Pays for design, $250-1,200; pays for illustration, $250-1,200.
Text Illustration Assigns minimum 20 freelance illustration projects/year. **Pays on acceptance.** $40-200 for b&w (from small spot illustrations to full page). Fees for color illustration and design work vary and are negotiable. Prefers b&w line or line and wash illustrations to accompany lesson activities.
Tips ''We prefer contemporary, nontraditional styles appropriate for our innovative and upbeat products and the creative Christian teachers and students who use them. We seek experienced designers and artists who can help us achieve our goal of presenting biblical material in fresh, new and engaging ways. Submit design/illustration on disk. Self promotion pieces help get you noticed. Have book covers/jackets, brochure design, newsletter or catalog design in your portfolio. Include samples of Bible or church-related illustration.''

☑ GRYPHON PUBLICATIONS

P.O. Box 209, Brooklyn NY 11228-0209. Website: www.gryphonbooks.com. Estab. 1983. Book and magazine publisher of hardcover originals, trade paperback originals and reprints, reference and magazines. Types of books include science fiction, mystery and reference. Specializes in crime fiction and bibliography. Publishes 20 titles/year. Titles include: *Difficult Lives*, by James Salli; and *Vampire Junkies*, by Norman Spinrad. 40% require freelance illustration; 10% require freelance design. Book catalog free for #10 SASE.
• Also publishes *Hardboiled*, a quarterly magazine of noir fiction, and *Paperback Parade* on collectable paperbacks.
Needs Approached by 75-200 freelancers/year. Works with 10 freelance illustrators and 1 designer/year. Prefers freelancers with ''professional attitude.'' Uses freelancers mainly for book and magazine cover and interior illustrations. Also for jacket/cover, book and catalog design. Works on assignment only.
First Contact & Terms Send query letter with résumé, SASE, tearsheets or photocopies. Samples are filed. Responds in 2 weeks only if interested. Buys one-time rights. ''I will look at reprints if they are of high quality and cost effective.'' Originals are returned at job's completion if requested. Send b&w samples only.
Jackets/Covers Assigns 2 freelance design and 5-6 illustration jobs/year. Pays by the project, $25-150.
Text Illustration Assigns 2 freelance jobs/year. Pays by the project, $10-100. Prefers b&w line drawings.
Tips ''It is best to send photocopies of your work with an SASE and query letter. Then we will contact on a freelance basis.''

☒ GUERNICA EDITIONS

P.O. Box 117, Station P, Toronto ON M5S 2S6 Canada. (416)658-9888. Fax: (416)657-8885. E-mail: guernicaeditions@cs.com. Website: www.guernicaeditions.com. **Publisher/Editor:** Antonio D'Alfonso. Estab. 1978. Book publisher and literary press specializing in translation. Publishes trade paperback originals and reprints. Types of books include contemporary and experimental fiction, biography and history. Specializes in ethnic/multicultural writing and translation of European and Quebecois writers into English. Publishes 20-25 titles/year. Recent titles include: *Hard Edge*, by F.G. Paci (artist Normand Cousineau); *Unholy Stories*, by Carole David (artist Hono Lulu). 40-50% require freelance illustration. Book catalog available for SAE; nonresidents send IRC.
Needs Approached by 6 freelancers/year. Works with 6 freelance illustrators/year. Uses freelancers mainly for jacket/cover illustration.
First Contact & Terms Send query letter with résumé, SASE (or SAE with IRC), tearsheets, photographs and photocopies. Samples are filed or are returned by SASE if requested by artist. Responds only if interested. To show portfolio, mail photostats, tearsheets and dummies. Buys one-time rights. Originals are not returned at job completion.
Jackets/Covers Assigns 10 freelance illustration jobs/year. Pays by the project, $150-200.
Tips ''We really believe that the author should be aware of the press they work with. Try to see what a press does and offer your own view of that look. We are looking for strong designers. We have three new series of books, so there is a lot of place for art work.''

HARLAN DAVIDSON, INC.

773 Glenn Ave., Wheeling IL 60090-6000. (847)541-9720. Fax: (847)541-9830. E-mail: harlandavidson@harlandavidson.com. Website: www.harlandavidson.com. **Production Manager:** Lucy Herz. Imprints include Forum

Press and Crofts Classics. Publishes textbooks. Types of books include biography, classics in literature, drama, political science and history. Specializes in US and European history. Publishes 6-15 titles/year. Titles include: *The History of Texas*. 20% requires freelance illustration; 20% requires freelance design. Catalog available.

Needs Approached by 2 designers/year. Works with 1-2 designers/year. 100% of freelance design demands knowledge of Photoshop.

First Contact & Terms Designers: Send query letter with brochure and résumé. Samples are filed or are returned by SASE. Responds in 2 weeks. Portfolio review required from designers. Will contact artist for portfolio review of book dummy if interested. Buys all rights.

Book Design Assigns 3 freelance design jobs/year. Pays by the project, $500-1,000.

Jackets/Covers Assigns 3 freelance design jobs/year. Pays by the project, $500-1,000. Finds freelancers through networking.

Tips "Have knowledge of file preparation for electronic prepress."

HARLEQUIN ENTERPRISES LTD.

225 Duncan Mill Rd., Toronto ON M3B 3K9 Canada. (416)445-5860. Fax: (416)445-8736. **Contact:** Vivian Ducas, art director. Publishes mass market paperbacks. Specializes in women's fiction. Publishes more than 100 titles/year. 15% requires freelance design; 100% requires freelance illustration. Book catalog not available.

Needs Approached by 1-3 designers and 20-50 illustrators/year. Works with 3 designers and 25 illustrators/year. 100% of freelance design work demands knowledge of Illustrator, Photoshop and InDesign.

First Contact & Terms Designers: Send postcard sample with brochure, photocopies, résumé, tearsheets and URL. Illustrators: Send postcard sample with brochure, photocopies, tearsheets and URL. After introductory mailing, send follow-up postcard sample every 6 months. Samples are filed and not returned. Does not reply. Company will contact artist for portfolio review if interested. Portfolio should include b&w and color tearsheets and color outputs. Buys all rights. Finds freelancers through art competitions, art exhibits/fairs, art reps, artist's submissions, competition/book credits, Internet, sourcebooks, word of mouth.

Jackets/Covers Assigns more than 50 freelance cover illustration jobs/year. Prefers variety of representational art—not just romance genre.

HARMONY HOUSE PUBLISHERS—LOUISVILLE

P.O. Box 90, Prospect KY 40059. (502)228-4446. Fax: (502)228-2010. **Art Director:** William Strode. Estab. 1980. Publishes hardcover "coffee table" books. Specializes in general books, photographic books and education. Publishes 20 titles/year. Titles include: *Sojourn in the Wilderness* and *Christmas Collections*. 10% require freelance illustration.

Needs Approached by 10 freelancers/year. Works with 2-3 freelance illustrators/year. Prefers freelancers with experience in each specific book's topic. Uses freelancers mainly for text illustration. Also for jacket/cover illustration. Usually works on assignment basis.

First Contact & Terms Send query letter with brochure, résumé, SASE and appropriate samples. Samples are filed or are returned. Responds only if interested. "We don't usually review portfolios, but we will contact the artist if the query interests us." Buys one-time rights. Returns originals at job's completion. Assigns several freelance design and 2 illustration jobs/year. Pays by the project.

[N] HARPERCOLLINS PUBLISHERS, LTD. (CANADA)

55 Avenue Rd., Suite 2900, Hazelton Lanes, Toronto ON M5R 3L2 Canada. (416)975-9334. Fax: (416)975-9884. Website: www.harpercanada.com. **Contact:** Vice President Production. Publishes hardcover, trade paperback and mass market paperback originals and reprints. Types of books include adventure, biography, coffee table books, fantasy, history, humor, juvenile, mainstream fiction, New Age, nonfiction, preschool, reference, religious, self-help, travel, true crime, western and young adult. Publishes 100 titles/year. 50% require freelance illustration; 25% require freelance design.

Needs Prefers freelancers experienced in mixed media. Uses freelancers mainly for illustration, maps, cover design. 100% of freelance design demands knowledge of Photoshop, Illustrator, QuarkXPress. 25% of freelance illustration demands knowledge of Photoshop and Illustrator.

First Contact & Terms Designers: Send query letter with brochure, photocopies, tearsheets. Illustrators: Send postcard sample and/or query letter with photocopies, tearsheets. Accepts disk submissions compatible with QuarkXPress. Send EPS or TIFF files. Samples are filed. Will contact artist for portfolio review "only after review of samples if I have a project they might be right for." Portfolio should include book dummy, photocopies, photographs, slides, tearsheets, transparencies. Rights purchased vary according to project.

Book Design Assigns 5 freelance design jobs/year. Pays by the project.

Jackets/Covers Assigns 20 freelance design and 50 illustration jobs/year. Pays by the project.

Text Illustration Assigns 10 freelance illustration jobs/year. Pays by the project.

Yuyi Morales

Critique groups, culture
& the creative process

When Yuyi Morales stood to accept her Golden Kite award for picture book illustration at the Society of Children's Book Writers and Illustrators award luncheon, she told the room full of writers, illustrators, and editors that had it not been for her critique group, her award-winning book might not have been written.

"The Revisionaries," as her group called themselves, consisted simply of Morales and several friends she met at a class on writing children's books. "After the course was over we stayed together as a critique group and our bond grew very strong," Morales says. "We not only criticized each other's work, but gave each other support and found ways to keep learning together." Because all three writers were also interested in illustrating, they decided to enroll in an evening class taught by illustrator Ashley Wolf.

Here, Morales tells how that class led to a book, *Just a Minute: A Trickster Tale and Counting Book*, the story of a grandmother with twinkling eyes who outsmarts Death. She also discusses cultural differences, her experience with publishers, and her passion for writing and illustrating children's books. To read more about Morales, visit her website, www.yuyimorales.com.

So, the idea for *Just a Minute* came because of an evening class?

Yes. Our first assignment was to come up with either an alphabet or counting book to use as a framework for our illustrations. Our teacher gave us one week to hand in the story and sketches. I decided on a counting book. But what to count? I always loved the folktales from my country—especially those where ordinary folks defeat great enemies. Taking inspiration from the Mexican tradition, I sat down to write.

Sometimes stories seem to come out of nowhere. In reality our stories come from very deep inside us. Grandma Beetle came alive as the embodiment of the women who took care of me when I was a child—hard-working women like my grandma, my mother, my aunts, and my sisters. Always tending their chores, these women love their children more than anything in the world. In my mind Grandma was also the personification of a beetle from my homeland—round and brown, always flaying and moving.

Did everybody tell you not to write about death in such a humorous way?

Many people told me my story would never find a place in the children's book world. Death was a delicate subject, they said, and my story was scary. Growing up in Mexico, I was surrounded by the image of death as an inevitable companion. Our sayings, our traditions— even our candies and toys—have a playful affair with the image of death. I understood the cultural differences and how they affected my chances of having my book published. But I also felt my story was valid, and I pushed it forward.

How did you get your book deal with Chronicle?

I didn't have an agent at that time, so I mailed a cover letter, manuscript, dummy, and two color samples to a handful of houses that accepted multiple submissions. Soon rejection letters started coming in saying things like ''we like your artwork, but your skeleton is scary. We would never be able to sell this book. Do you have any other work?''

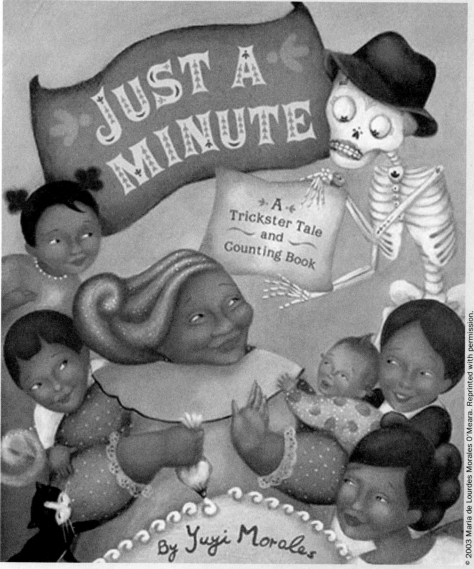

In *Just a Minute*, author Yuyi Morales' Grandma Beetle outsmarts Death—who has come to her door in the form of Senior Calavera (''Mr. Skull'')—and teaches readers to count from one to ten in both English and Spanish. ''Even if children don't grasp the implications of the skeleton's visit, they'll enjoy seeing him join the fun,'' says a starred *Booklist* review. ''And when he extends Grandma's lease on life, the relieved, loving embrace she gives her grandchildren will satisfy young ones at a gut level.''

More than a year passed. I had already gotten a contract to illustrate a school market book, and was accepting an offer to illustrate a book about César Chávez. Then one day I got a call from an editor at Tricycle Press. She found my manuscript, lost in the limbo of their offices for more than a year. She wanted to know if it was still available, for she loved the book! I was still catching my breath from the excitement when, a few days later, I got a call from Chronicle asking me to resubmit that "death story"! I had just started meeting with my agent Charlotte Sheedy, so she took charge of talking with the publishers. Although both houses were excellent matches for my book, in the end we signed with Chronicle.

Once you started getting book deals, what was it like working with editors and art directors?

The process was slightly different with each house. For *Harvesting Hope: The Story of César Chávez* (Harcourt) I worked with editor Jeannette Larson who was my link to the art department. The cover was the most strenuous part. It took me a long time to come up with the right design. I originally took inspiration from my favorite muralist, Jorge Gonzales Camarena, trying to recreate the regal feeling he portrayed in his subjects. But my attempts were very stiff. I sketched many versions, none of them right. But like the great editor she is, Jeannette helped me without interfering in my creative process. She kept me going by sending me images of fruit crate labels for inspiration. She gave suggestions, told me what worked and what needed revision. Throughout the long process, she stirred my imagination, helping me come up with the right piece of artwork all by myself.

With *Just a Minute* for Chronicle, I worked on the text with editor Samantha McFerrin, and illustrations with art director Sarah Gulliham. Both kept me focused and happy while I was hard at work.

Did you do any research for *Harvesting Hope*?

I immediately loved the manuscript by Kathleen Krull, but I had no knowledge of the life and work of César Chávez. So I embarked on a journey of learning about this man of gentle ways but strong resolutions. I read books, old newspapers, searched the Internet and traveled with my brother, my son, and husband to places where Chávez worked and lived.

I am not a realistic-style painter, but my illustrations still have to tell the truth. The landscape, the people, the feelings I experienced found a way into my work that was more in accordance with my feelings and emotions than with what my eyes saw.

Jacket illustration © 2003 Yuyi Morales

Yuyi Morales credits Harcourt editor Jeannette Larson with helping her hone her vision for the illustrations for Kathleen Krull's *Harvesting Hope: The Story of Cesar Chávez* (here shown in the Spanish-language edition). "I sketched many versions, none of them right," says Morales. "She gave suggestions and stirred my imagination, helping me come up with the right piece of artwork all by myself."

How important is it for illustrators and authors to do school visits?

I did school visits before I had a book contract. After the publication of my first two books, I found myself traveling all over the country. It is exhausting, but once I shake the librarian's hand, or walk into a room full with children, every effort is worth it. Writing your book is only the beginning. It isn't until you see your readers face to face that the

real connection begins. It is then that reader and author become linked forever. I usually come back home all hugged and kissed, and with my hands still feeling warm from holding so many tiny beautiful hands.

What motivates you? How do you stay inspired?

Before I start any new project, I clean and reorganize my workspace. It might be just one more way of procrastinating, but it is useful. To prepare to start working, I decided I must one, put on music; and two, be inspired. Being inspired mostly means that I have gone and looked at a bunch of books I like from other authors and illustrators. It means I searched for reference pictures on the Internet, and, most important, that I *believe* I am about to create—even though I probably don't have the slightest idea what I am going to do. The beautiful thing is that we don't need to know what we will create, because inside every one of us there are files and files brimming with the knowledge. These files are full with memories, fears, passion, dreams, and many, many more. It is never-ending. Because of this interior knowledge, all I need to do is sit with a pencil in my hand, and I let my body work. As my hand moves and writes the first word—any word—or draws a line—any line—I have to push myself to do it again and again. And it is chaos at first! Words make no sense; my drawings are horrible and pointless. But exploration is like that. How can I know what I want to write or paint if I don't look for it first?

Tell us about your workspace. Do you have a studio?

When we moved to our new house my husband encouraged me to take the biggest, sunniest room as my studio. It was such a shock! I came from having created my books inside a working space the size of a small closet, with only a drawing table and a chair. In that tiny space my world revolved. Now I have all the space I need. Tim built me a drawing table and a long desk full of shelves and drawers. I painted the walls *Rosa Mexicano*, hot pink. My desk is yellow, my chair is red, and my organizing boxes are orange. It wasn't my intention, but I realized that my new studio is beginning to look like a page for my book *Just a Minute*. What a great place to be.

So, life as an author and illustrator sounds good. What are you working on now?

I am currently working on a book written by Puerto Rican author Marisa Montes. Her story is a very playful interaction of English and Spanish, combined in a Halloween book. And I love it! I am painting all kinds of sketetons, monsters, ghosts, witches, you name it. But the most thrilling part for me is that they are coming out looking like people I know! As for writing, I am currently working on a longer piece, perhaps a novel. I won't know 'til I get it all out of me.

What advice would you give those hoping to write and illustrate children's books?

Create from your inside out—from your dreams, from the things you are passionate about, and from the themes that trigger your wonderment. Writing and illustrating, like all art, is an exploration of oneself. If we keep writing or painting consistently, we begin to recognize ourselves and what makes us powerful. And when one is feeling powerful, everything can happen!

—Mary Cox

[N] HARVEST HOUSE PUBLISHERS

990 Owen Loop N., Eugene OR 97402. (541)343-0123. Fax: (541)242-8819. **Contact:** Cover Coordinator. Specializes in hardcover and paperback editions of Christian evangelical adult fiction and nonfiction, children's books, gift books and youth material. Publishes 100-125 titles/year. Recent titles include: *Why is the Sky Blue?*; *Power of a Praying Teen*; *Discovering Your Divine Assignment*; *My Little Angel.* Books are of contemporary designs which compete with the current book market.

Needs Works with 1-2 freelance illustrators and 4-5 freelance designers/year. Uses freelance artists mainly for cover art. Also uses freelance artists for text illustration. Works on assignment only.

First Contact & Terms Send query letter with brochure, résumé, tearsheets and photographs. Art director will contact artist for portfolio review if interested. Requests work on spec before assigning a job. Originals may be returned at job's completion. Buys all rights. Finds artists through word of mouth and submissions/self-promotions.

Book Design Pays by the project.

Jackets/Covers Assigns 100-125 design and less than 5 illustration jobs/year. Pays by the project.

Text Illustration Assigns less than 5 jobs/year. Pays by the project.

[■] HAY HOUSE, INC.

P.O. Box 5100, Carlsbad CA 92018-5100. (760)431-7695 or (800)431-7695. Fax: (760)431-6948. E-mail: csalinas @hayhouse.com. Website: www.hayhouse.com. **Art Director:** Christy Salinas. Publishes hardcover originals and reprints, trade paperback originals and reprints, audio tapes, CD-ROM. Types of books include New Age, astrology, metaphysics, psychology and gift books. Specializes in self-help. Publishes 100 titles/year. Recent titles include: *The Western Guide to Feng Shui*; *Heal Your Body A-Z*; *New York Times* bestseller *Adventures of a Psychic.* 40% require freelance illustration; 30% require freelance design.

• Hay House is also looking for people who design for the gift market.

Needs Approached by 50 freelance illustrators and 5 freelance designers/year. Works with 20 freelance illustrators and 2-5 freelance designers/year. Uses freelancers mainly for cover design and illustration. 80% of freelance design demands knowledge of Photoshop, Illustrator, QuarkXPress. 20% of titles require freelance art direction.

First Contact & Terms Designers: Send photocopies (color), résumé, SASE "if you want your samples back." Illustrators: Send photocopies. "We accept TIFF and EPS images compatible with the latest versions of QuarkX-Press, Photoshop and Illustrator. Samples are filed or are returned by SASE. Art director will contact artist for portfolio review of printed samples or original artwork if interested. Buys all rights. Finds freelancers through word of mouth, submissions.

Book Design Assigns 20 freelance design jobs/year; 10 freelance art direction projects/year.

Jacket/Covers Assigns 50 freelance design jobs and 25 illustration jobs/year. Pays for design by the project, $800-1,000. Payment for illustration varies for covers.

Text Illustration Assigns 10 freelance illustration jobs/year.

Tips "We look for freelancers with experience in graphic design, desktop publishing, printing processes, production and illustrators with strong ability to conceptualize."

HEAVY METAL

100 N. Village Rd., Suite 12, Rookvill Center NY 11570. Website: www.metaltv.com. **Contact:** Submissions. Estab. 1977. Publishes trade paperback originals. Types of books include comic books, fantasy and erotic fiction. Specializes in fantasy. Recent titles include: *The Universe of Cromwell*; *Serpieri Clone.* Art guidelines on website.

• See also listing in Magazine section.

First Contact & Terms Send contact information (mailing address, phone, fax, e-mail), photocopies, photographs, SASE, slides. Samples are returned only by SASE. Responds in 3 months.

Tips "Please look over the kinds of work we publish carefully so you get a feel for the kinds of work we are looking for."

[N] [●] HEMKUNT PUBLISHERS PVT. LTD.

A-78 Naraina Indl. Area Ph.I, New Delhi 110028. 011-91-11 2579-2083, 2579-0032 or 2579-5079. E-mail: hemkun t@ndf.vsnl.net.in. Website: www.hemkuntpublishers.com. **Chief Executive:** Mr. G.P. Singh. Director Marketing: Arvinder Singh. Director Production: Deepinder Singh. Specializes in educational text books, illustrated general books for children and also books for adults on different subjects. Subjects include religion, history, etc. Publishes 30-50 new titles/year. Recent titles include: *More Tales of Birbal and Akbar*; *Whiz Kid General Knowledge*; *Bedtime Stories from Around the World*; *Benaras—Visions of a Living Ancient Tradition.*

Needs Works with 30-40 freelance illustrators and 3-5 designers/year. Uses freelancers mainly for illustration and cover design. Also for jacket/cover illustration. Works on assignment only.

First Contact & Terms Send query letter with résumé and samples to be kept on file. Prefers photographs and tearsheets as samples. Samples not filed are not returned. Art director will contact artist for portfolio review if

interested. Requests work on spec before assigning a job. Originals are not returned. Considers complexity of project, skill and experience of artist and project's budget when establishing payment. Buys all rights. Interested in buying second rights (reprint rights) to previously published artwork.

Book Design Assigns 40-50 freelance design jobs/year. Payment varies.

Jackets/Covers Assigns 30-40 freelance design jobs/year. Pays $20-50.

Text Illustration Assigns 30-40 freelance jobs/year. Pays by the project.

HERALDIC GAME DESIGN

1013 W. Virginia Ave., Peoria IL 61604. (305)686-0845. E-mail: heraldic@aol.com. Website: www.heraldicgame .com. **Owner:** Keith W. Sears. Estab. 1993. Publishes roleplaying game books. Main style/genre of games science fiction, cyberpunk, fantasy, Victorian, horror. Recent titles include: *Steeltown, The Outsider Chronicles, Volume One; Inside Outsider, The Outsider Chronicles, Volume Two.* Uses freelance artists mainly for b&w interior illustrations. Publishes 2 titles or products/year. 100% requires freelance illustration.

First Contact & Terms Accepts disk submissions in Windows format. Send via CD, floppy disk, Zip or e-mail as TIFF, GIF or JPEG files. Samples are filed. Portfolio review not required. Negotiates rights purchased. Finds freelancers through e-mail and submission packets.

Text Illustration Assigns 2 freelance text illustration jobs/year. Pays 5% royalty.

HILL AND WANG

19 Union Square W., New York NY 10003. (212)741-6900. Fax: (212)633-9385. Website: www.fsgbooks.com. **Art Director:** Susan Mitchell. Imprint of Farrar, Straus & Giroux. Imprint publishes hardcover, trade and mass market paperback originals and hardcover reprints. Types of books include biography, coffee table books, cookbooks, experimental fiction, historical fiction, history, humor, mainstream fiction, New Age, nonfiction and self-help. Specializes in literary fiction and nonfiction. Publishes 120 titles/year. Recent titles include: *The Love-Artist; Grace Paley Collected Stories.* 20% require freelance illustration; 10% require freelance design.

Needs Approached by hundreds of freelancers/year. Works with 10-20 freelance illustrators and 10-20 designers/year. Prefer artist without rep with a strong portfolio. Uses freelancers for jacket/cover illustration and design. Works on assignment only.

First Contact & Terms Send postcard sample of work or query letter with portfolio samples. Samples are filed and are not returned. Responds only if interested. Artist should continue to send new samples. Portfolios may be dropped off every Wednesday and should include printed jackets. Rights purchased vary according to project. Originals are returned at job's completion. Finds artists through word of mouth and submissions.

Book Design Pays by the project.

Jackets/Covers Assign 10-20 freelance design and 10-20 illustration jobs/year. Pays by the project, $500-1,500.

Text Illustration Assigns 10-20 freelance illustration jobs/year. Pays by the project, $500-1,500.

HOLCOMB HATHAWAY, PUBLISHERS

6207 N. Cattle Track Rd., Suite 5, Scottsdale AZ 85250. (480)991-7881. Fax: (480)991-4770. E-mail: ckelly@hh-pub.com. Website: www.hh-pub.com. **Production Director:** Gay Pauley. Managing Editor: Collette Kelly. Estab. 1997. Publishes college textbooks. Specializes in education, communication. Publishes 10 titles/year. Recent titles include: *Applied Exercise and Sport Physiology; Consumer Economics.* 50% requires freelance cover illustration; 10% requires freelance design. Book catalog not available.

Needs Approached by 15 illustrators and 15 designers/year. Works with 3 illustrators and 10 designers/year. Prefers freelancers experienced in cover design, typography, graphics. 100% of freelance design and 50% of freelance illustration demands knowledge of Photoshop, Illustrator, QuarkXPress.

First Contact & Terms Send query letter with brochure. Illustrators: Send postcard sample. Will contact artist for portfolio review of photocopies and tearsheets if interested. Rights purchased vary according to project.

Book Design Assigns 3 freelance design jobs/year. Pays for design by the project, $500-1,500.

Jackets/Covers Assigns 10 design jobs/year. Pays by the project, $750-1,000. Pays for cover illustration by the project.

Text Illustration Assigns 2 freelance illustration jobs/year. Pays by the piece. Prefers computer illustration. Finds freelancers through word of mouth, submissions.

Tips "It is helpful if designer has experience with college textbook design and good typography skills."

HOLIDAY HOUSE

425 Madison Ave., New York NY 10017. (212)688-0085. Fax: (212)421-6134. Website: www.holidayhouse.com. **Editor-in-Chief:** Regina Griffin. Director of Art and Design: Claire Counihan. Specializes in hardcover children's books. Publishes 70 titles/year. 75% require illustration. Recent titles include: *Bare Bear*, by Miriam Moss; *Two by Two*, by John Winch; *Chickerella*, by Mary Jane Auch.

Needs Only accepts art suitable for children and young adults. Works on assignment only.

First Contact & Terms Send cover letter with photocopies and SASE. Samples are filed or are returned by SASE. Request portfolio review in original query. Responds only if interested. Originals are returned at job's completion. Finds artists through submissions and agents.

Jackets/Covers Assigns 5-10 freelance illustration jobs/year. Pays by the project, $900-1,200.

Text Illustrations Assigns 35 freelance jobs/year (picture books). Pays royalty.

HOLLOW EARTH PUBLISHING

P.O. Box 51480, Boston MA 02205. (617)249-0161. Fax: (617)249-0161. E-mail: hep2@aol.com. **Publisher:** Helian Yvette Grimes. Estab. 1983. Company publishes hardcover, trade paperback and mass market paperback originals and reprints, textbooks, electronic books and CD-ROMs. Types of books include contemporary, experimental, mainstream, historical and science fiction, instruction, fantasy, travel and reference. Specializes in mythology, photography, computers (Macintosh). Publishes 5 titles/year. Titles include: *Norse Mythology*; *Legend of the Niebelungenlied.* 50% require freelance illustration; 50% require freelance design. Book catalog free for #10 SAE with 1 first-class stamp.

Needs Approached by 250 freelancers/year. Prefers freelancers with experience in computer graphics. Uses freelancers mainly for graphics. Also for jacket/cover design and illustration, text illustration, book design and multimedia projects. 100% of freelance work demands knowledge of Illustrator, QuarkXPress, Photoshop, FreeHand, Director or rendering programs. Works on assignment only.

First Contact & Terms Send e-mail queries only. Responds in 1 month. Art director will contact artist for portfolio review if interested. Portfolio should include color thumbnails, roughs, tearsheets and photographs. Buys all rights. Originals are returned at job's completion. Finds artists through submissions and word of mouth.

Book Design Assigns 12 book and magazine covers/year. Pays by the project, $100 minimum.

Jackets/Covers Assigns 12 freelance design and 12 illustration jobs/year. Pays by the project, $100 minimum.

Text Illustration Assigns 12 freelance illustration jobs/year. Pays by the project, $100 minimum.

Tips Recommends being able to draw well. First-time assignments are usually article illustrations; covers are given to "proven" freelancers.

HENRY HOLT BOOKS FOR YOUNG READERS

Imprint of Henry Holt and Company, 115 W. 18th St., 6th Floor, New York NY 10011. (212)886-9200. Fax: (212)633-0748. Website: www.henryholt.com. **Creative Director:** Raquel Jaramillo. Estab. 1833. Imprint publishes hardcover originals and reprints. Types of books include children's picture books, juvenile, preschool and young adult. Publishes 250 titles/year. Recent titles include: *Hondo & Fabian*, by Peter McCarty; *The House at Awful End*, by Philip Ardaugh. 100% requires freelance illustration. Book catalog free with 9×12 SASE.

Needs Approached by 2,500 freelancers/year.

First Contact & Terms Send query letter with photocopies and SASE. Samples are returned by SASE if requested by artist. Responds in 3 months if interested. Portfolios may be dropped off every Monday by 9 a.m. for 5 p.m. pickup. Art director will contact artist for portfolio review if interested. Portfolio should include tearsheets. "Anything artist feels represents style, ability and interests." Buys all rights. Finds artists through word of mouth, artists' submissions and attending art exhibitions.

Jackets/Covers Assigns 8-16 freelance illustration jobs/year. Pays by the project.

HOMESTEAD PUBLISHING

P.O. Box 193, Moose WY 83012. Phone/fax: (307)733-6248. Website: www.homesteadpublishing.net. **Contact:** Art Director. Estab. 1980. Publishes hardcover and paperback originals. Types of books include art, biography, history, guides, photography, nonfiction, natural history, and general books of interest. Publishes more than 6 print, 100 online titles/year. Recent titles include: *Cubby in Wonderland*; *Windswept*; *Banff-Jasper Explorer's Guide.* 75% requires freelance illustration. Book catalog free for SAE with 4 first-class stamps.

Needs Works with 20 freelance illustrators and 10 designers/year. Prefers pen & ink, airbrush, pencil and watercolor. 25% of freelance work demands knowledge of PageMaker or FreeHand. Works on assignment only.

First Contact & Terms Send query letter with printed samples to be kept on file or write for appointment to show portfolio. For color work, slides are suitable; for b&w, technical pen, photostats. Samples not filed are returned by SASE only if requested. Responds in 10 days. Rights purchased vary according to project. Originals are not returned.

Book Design Assigns 6 freelance design jobs/year. Pays by the project, $50-3,500.

Jackets/Covers Assigns 2 freelance design and 4 illustration jobs/year. Pays by the project, $50-3,500.

Text Illustration Assigns 50 freelance illustration jobs/year. Prefers technical pen illustration, maps (using airbrush, overlays, etc.), watercolor illustrations for children's books, calligraphy and lettering for titles and headings. Pays by the hour, $5-20 or by the project, $50-3,500.

Tips "We are using more graphic, contemporary designs and looking for exceptional quality."

HONOR BOOKS

Imprint of Cook Communications, 4050 Lee Vance View, Colorado Springs CO 80918. (719)536-0100. Fax: (719)536-3269. E-mail: info@honorbooks.com. Website: www.cookministries.com. **Creative Director:** Randy Maid. Estab. 1991. Publishes hardcover originals, trade paperback originals, mass market paperback originals and gift books. Types of books include biography, coffee table books, humor, juvenile, motivational, religious and self-help. Specializes in inspirational and motivational. Publishes 30 titles/year. Recent titles include: *God's Hands on my Shoulder*; *Breakfast for the Soul.* 40% require freelance illustration; 90% require freelance design.

Needs Works with 4 illustrators and 10 designers/year. Prefers illustrators experienced in line art; designers experienced in book design. Uses freelancers mainly for design and illustration. 100% of freelance design demands knowledge of FreeHand, Photoshop, Illustrator and QuarkXPress. 20% of freelance illustration demands knowledge of FreeHand, Photoshop and Illustrator. 15% of titles require freelance art direction.

First Contact & Terms Designers: Send query with photocopies and tearsheets. Illustrators: Send postcard, printed samples or tearsheets. Send follow-up postcard every 3 months. Accepts disk submissions compatible with QuarkXPress or EPS files. Samples are filed. Responds in 3 weeks. Request portfolio review in original query. Will contact artist for portfolio review of book dummy, photographs, roughs and tearsheets if interested. Rights purchased vary according to project.

Book Design Assigns 60 freelance design jobs/year. Pays by the project, $300-1,800.

Jackets/Covers Assigns 60 freelance design jobs and 30 illustration jobs/year. Pays for design by the project, $700-2,400. Pays for illustration by the project, $400-1,500.

Text Illustration Pays by the project. Finds freelancers through *Creative Black Book*, word of mouth, conventions and submissions.

HOUGHTON MIFFLIN COMPANY

Children's Book Department, 222 Berkeley St., Boston MA 02116. (617)351-3297. Fax: (617)351-1111. Website: www.hmco.com. **Creative Director:** Sheila Smallwood. Estab. 1880. Company publishes hardcover originals. Types of books include juvenile, preschool and young adult. Publishes 60-70 titles/year. 100% requires freelance illustration; 10% requires freelance design. Recent titles include: *What Do You Do with a Tail Like This*, by Steve Jenkins (winner of the Caldecott Medal); *Remember*, by Toni Morrison; *The Red Book*, by Barbara Lehman.

- Houghton Mifflin now has a new imprint, Graphia, a high-end paperback book series for teens.

Needs Approached by 6-10 freelancers/year. Works with 50 freelance illustrators and 10 designers/year. Prefers artists with interest in or experience with children's books. Uses freelance illustrators mainly for jackets, picture books. Uses freelance designers primarily for photo essay books. 100% of freelance design work demands knowledge of QuarkXPress, Photoshop and Illustrator.

First Contact & Terms Please send samples through artist rep only. Finds artists through artists' reps, sourcebooks, word of mouth.

Book Design Assigns 10-20 freelance design jobs/year. Pays by the project.

Jackets/Covers Assigns 5-10 freelance illustration jobs/year. Pays by the project.

Text Illustration Assigns up to 50 freelance illustration jobs/year. Pays by the project.

HUMANICS PUBLISHING GROUP

12 S. Dixie Hwy., Suite 203, Lake Worth FL 33460. (800)874-8844. Fax: (888)874-8844. E-mail: humanics@mind spring.com. Website: www.humanicspub.com or www.humanicslearning.com. **Acquisitions Editor:** W. Arthur Bligh. Art Director: Hart Paul. Estab. 1976. Publishes college textbooks, paperback trade, New Age and educational activity books. Publishes 30 titles/year. Recent titles include: *Learning Before and After School Activities*; *Homespun Curriculum*; *Learning Through Art.* Learning books are workbooks with 4-color covers and line art within; trade paperbacks are 6×9 with 4-color covers. Book catalog for 9×12 SASE. Specify which imprint when requesting catalog Learning or trade paperbacks.

- No longer publishes children's fiction or picture books.

First Contact & Terms Send query letter with résumé, SASE and photocopies. Samples are filed or are returned by SASE if requested by artist. Rights purchased vary according to project. Originals are not returned.

Book Design Pays by the project.

Jackets/Covers Pays by the project.

Text Illustration Pays by the project.

Tips "We use 4-color covers, and our illustrations are line art with no halftones."

Ⓝ HUMANOIDS PUBLISHING

P.O. Box 931658, Hollywood CA 90093. Website: www.humanoids-publishing.com. **Contact:** Submissions. Estab. 1988. Publishes hardcover reprint and trade paperback originals. Types of books include comic books, romance, science fiction and graphic novels. Publishes 20-30 titles/year. Recent titles include: *The Metabarons-Alpha/Omega*; *Metal Hurlant #4*; *Negative Exposure.* Book catalog available on website.

First Contact & Terms Send tearsheets and pencils only, pencils and inks (color optional) or sequential art. **Do not** send originals. Do not send e-mails. Accepts CD submissions for illustrators. Prefers high resolution Photoshop files. Samples are not returned. Responds only if interested.

Tips ''By submitting material to Humanoids, the submitter waives the ability to make a claim against Humanoids or any of its subsidiary companies in the event a work appears that is substantially similar to the work submitted.''

N HUNTINGTON HOUSE PUBLISHERS

P.O. Box 53788, Lafayette LA 70505. (337)237-7049. Fax: (337)237-7060. Website: www.huntinghousebooks.com. **Contact:** Kathy Doyle. Publisher: Mark Anthony. Marketing Director: Theresa Tresclair. Estab. 1979. Book publisher. Publishes hardcover, trade paperback and mass market paperback originals. Types of books include contemporary fiction, juvenile, religious and political issues. Specializes in politics, exposés and religion. Publishes 30 titles/year. Recent titles include: *The Heavenly Odyssey*; *Jericho Syndrome*. 5% require freelance illustration. Book catalog free upon request.

Needs Approached by 15 freelancers/year. Works with 2 freelance illustrators/year. Uses freelancers for jacket/cover illustration and design and text illustration. Works on assignment only.

First Contact & Terms Send query letter with résumé and photocopies. Samples are filed. Responds to artist only if interested. To show a portfolio, mail thumbnails, roughs and dummies. Buys all rights. Originals are returned at job's completion.

Text Illustration Assigns 1 freelance design and 1 illustration job/year. Payment ''is arranged through author.''

Tips ''We do not publish children's fiction or picture books any longer.''

✓ IDEALS PUBLICATIONS INC.

A division of Guideposts, 535 Metroplex Dr., Suite 250, Nashville TN 37211. (615)333-0478. Fax: (615)781-1447. Website: www.idealsbooks.com. Art Director: Eve DeGrie. Publisher: Patricia Pingry. Estab. 1944. Imprints include Candy Cane Press, Williamson Books. Company publishes hardcover originals and *Ideals* magazine. Specializes in nostalgia and holiday themes. Publishes 100 book titles and 6 magazine issues/year. Recent titles include: *Blessings of a Husband's Love, Dear Santa*. 50% require freelance illustration. Guidelines free for #10 SASE with 1 first-class stamp or on website.

Needs Approached by 100 freelancers/year. Works with 10-12 freelance illustrators/year. Prefers freelancers with experience in illustrating people, nostalgia, botanical flowers. Uses freelancers mainly for flower borders (color), people and spot art. Also for text illustration, jacket/cover and book design. Works on assignment only.

First Contact & Terms Send tearsheets which are filed. Responds only if interested. Buys all rights. Finds artists through submissions.

Text Illustration Assigns 75 freelance illustration jobs/year. Pays by the project. Prefers watercolor or gouache.

Tips ''Looking for illustrations with unique perspectives, perhaps some humor, that not only tells the story but draws the reader into the artist's world. We accept all styles.''

IDW PUBLISHING

4411 Morena Blvd., Suite 106, San Diego CA 92117. Website: www.idwpublishing.com. **Contact:** Editorial Offices. Publishes hardcover, mass market and trade paperback originals. Types of books include comic books, illustrated novel and art book nonfiction. Publishes 18 titles/year. Recent titles include: *30 Days of Night Return to Barrow #4*; *24 One Shot*. Submission guidelines available on website.

First Contact & Terms Send proposal with cover letter, photocopies (5 fully inked and lettered 8½×11 pages showing story and art), 1-page synopsis of overall story. Samples are not returned. Responds only if interested.

Tips ''Do not send original art. Make sure photocopies are clean, sharp, and easy to read. Be sure that each page has your name, address, and phone number written clearly on it.'' Do not call.

N IMAGE COMICS

1942 University Ave., Suite 305, Berkeley CA 94704. E-mail: info@imagecomics.com. Website: www.imagecomics.com. **Contact:** Erik Larsen. Estab. 1992. Publishes comic books, graphic novels. Recent titles include: *Athena Inc.*; *Noble Causes Family Secrets #2*; *Powers #25*. See this company's website for detailed guidelines.

Needs ''We are looking for good, well-told stories and exceptional artwork that run the gamut in terms of both style and genre.''

First Contact & Terms Send proposals only. See website for guidelines. No e-mail submissions. All comics are creator-owned. Image only wants proposals for comics, not ''art submissions.'' Proposals/samples not returned. Do not include SASE. Responds as soon as possible.

Tips ''Please do not try to 'impress' us with all the deals you've lined up or testimonials from your Aunt Matilda. We are only interested in the comic.''

IMPACT BOOKS

4700 East Galbraith Rd., Cincinnati OH 45236. (513)531-2690. Fax: (513)531-2686. E-mail: pam.wissman@fwpu bs.com. Website: www.fwpublications.com. **Aquisitions Editor:** Pam Wissman. Publishes trade paperback originals. Specializes in illustrated instructional books. Publishes 8 titles/year. Recent titles include: *Manga Madness* and *Manga Monster Madness*, by David Okum; *Comics Crash Course*, by Vince Giarrano. Book catalog free with 9×12 SASE (6 first-class stamps).

• IMPACT Books publishes titles that emphasize illustrated how-to-draw-comic-books instruction. Currently emphasizing traditional superhero and American comics styles; Japanese-style (Manga and Anime), and fantasy art. This market is for experienced comic-book artists who are willing to work with an IMPACT editor to produce a step-by-step how-to book about the artists' creative process.

Needs Approached by 25 author-artists/year. Works with 8 author-artists/year.

First Contact & Terms Send query letter or e-mail; digital art, tearsheets, photocopies, photographs, transparencies or slides; résumé, SASE and URL. Accepts Mac-compatible e-mail submissions from artists (TIFF or JPEG). Samples may be filed but are usually returned. Responds only if interested. Company will contact artist for portfolio review of color finished art, digital art, roughs, photographs, slides, tearsheets and/or transparencies if interested. Buys all rights. Finds freelancers through artist's submissions, Internet, and word of mouth.

[N] INCENTIVE PUBLICATIONS, INC.

3835 Cleghorn Ave., Nashville TN 37215. (615)385-2934. Fax: (615)385-2967. E-mail: info@incentivepublicatio ns.com. Website: www.incentivepublications.com. **Contact:** Art Director. Specializes in supplemental teacher resource material, workbooks and arts and crafts books for children K-8. Publishes 15-30 titles/year. Recent titles include: *If You Don't Feed the Teachers They Eat the Students*; *Basic Not Boring Book of Tests*; *Can We Eat the Art*. 40% require freelance illustration. Books are "cheerful, warm, colorful, uncomplicated and spontaneous."

Needs Works with 3-6 freelance illustrators/year. Uses freelancers for covers and text illustration. Also for promo items (occasionally). Works on assignment only, primarily with local artists.

First Contact & Terms Illustrators: Send query letter with photocopies, SASE and tearsheets. Samples are filed. Samples not filed are returned by SASE. Art director will contact artist for portfolio review if interested. Portfolio should include original/final art, photostats, tearsheets and final reproduction/product. Sometimes requests work on spec before assigning a job. Considers complexity of project, project's budget and rights purchased when establishing payment. Buys all rights. Originals are not returned.

Jackets/Covers Assigns 4-6 freelance illustration jobs/year. Prefers 4-color covers in any medium. Pays by the project, $350-450.

Text Illustration Assigns 4-6 freelance jobs/year. Black & white line art only. Pays by the project, $175-1,250.

Tips "We look for a warm and whimsical style of art that respects the integrity of the child. We sell to parents and teachers. Art needs to reflect specific age children/topics for immediate association of parents and teachers to appropriate books."

INNER TRADITIONS INTERNATIONAL/BEAR & COMPANY

One Park St., Rochester VT 05767. (802)767-3174. Fax: (802)767-3726. E-mail: peri@InnerTraditions.com. Website: www.InnerTraditions.com. **Art Director:** Peri Champine. Estab. 1975. Publishes hardcover originals and trade paperback originals and reprints. Types of books include self-help, psychology, esoteric philosophy, alternative medicine, Eastern religion, teen self-help and art books. Publishes 60 titles/year. Recent titles include: *The Virgin Mary Conspiracy*; *Strength Training on the Ball*; *The Discovery of the Nag Hammadi*. 25% requires freelance illustration; 25% requires freelance design. Book catalog free by request.

Needs Works with 8-9 freelance illustrators and 3-4 freelance designers/year. 100% of freelance design demands knowledge of QuarkXPress, Illustrator, FreeHand or Photoshop. Buys 25 illustrations/year. Uses freelancers for jacket/cover illustration and design. Works on assignment only.

First Contact & Terms Send query letter with résumé, SASE, tearsheets, photocopies, photographs and slides. Accepts disk submissions. Samples filed if interested or are returned by SASE if requested by artist. Responds to the artist only if interested. To show portfolio, mail tearsheets, photographs, slides and transparencies. Rights purchased vary according to project. Originals returned at job's completion. Pays by the project.

Jackets/Covers Assigns approximately 25 design and illustration jobs/year. Pays by the project.

[N] INTERCULTURAL PRESS, INC.

P.O. Box 700, 374 U.S. Route 1, Yarmouth ME 04096. (207)846-5168. Fax: (207)846-5181. E-mail: books@interc ulturalpress.com. Website: www.interculturalpress.com. **Production Manager:** Patty Topel. Estab. 1982. Company publishes paperback originals. Types of books include text and reference. Specializes in intercultural and multicultural. Publishes 12 titles/year. Recent titles include: *Wimmin, Wimps & Wallflowers*, by Philip Herbst; *Germany Unravelling an Enigma*, by Greg Nees. 10% require freelance illustration. Book catalog free by request.

Needs Approached by 20 freelancers/year. Works with 2-3 freelance illustrators/year. Prefers freelancers with

experience in trade books, multicultural field. Uses freelancers mainly for jacket/cover design and illustration. 80% of freelance work demands knowledge of PageMaker or Illustrator. "If a freelancer is conventional (i.e., not computer driven) they should understand production and pre-press."

First Contact & Terms Send query letter with brochure, tearsheets, résumé and photocopies. Samples are filed or are returned by SASE if requested by artist. Does not report back. Will contact artist for portfolio review if interested. Portfolio should include b&w final art. Buys all rights. Originals are not returned. Finds artists through submissions and word of mouth.

Jackets/Covers Assigns 6 freelance illustration jobs/year. Pays by the project, $300-500.

Text Illustration Assigns 1 freelance illustration job/year. Pays "by the piece depending on complexity." Prefers b&w line art.

Tips First-time assignments are usually book jackets only; book jackets with interiors (complete projects) are given to "proven" freelancers. "We look for artists who have flexibility with schedule and changes to artwork. We appreciate an artist who will provide artwork that doesn't need special attention by pre-press in order for it to print properly. For black & white illustrations keep your lines crisp and bold. For color illustrations keep your colors pure and saturated to keep them from reproducing 'muddy.'"

JALMAR PRESS/INNERCHOICE PUBLISHING

P.O. Box 370, Fawnskin CA 92333. (909)866-2912. Fax: (909)866-2961. E-mail: jalmarpress@att.net. Website: www.jalmarpress.com. **President:** Bradley L. Winch. Operations Manager: Cathy Winch. Estab. 1971. Publishes books emphasizing healthy self-esteem, character building, emotional intelligence, nonviolent communication, peaceful conflict resolution, stress management and whole brain learning. Publishes 12 titles/year. Recent titles include: *How to Handle a Bully*; *The Anger Workout for Teens*; *Positive Attitudes and Peacemaking*. Books are contemporary, yet simple and activity-driven.

- Jalmar has developed a line of books to help counselors, teachers and other caregivers deal with the 'tough stuff' including violence, abuse, divorce, AIDS, low self-esteem, the death of a loved one, etc.

Needs Works with 3-5 freelance illustrators and 3 designers/year. Uses freelancers mainly for cover design and illustration. Also for direct mail and book design. Works on assignment only.

First Contact & Terms Send query letter with brochure showing art style. Samples not filed are returned by SASE. 80% of freelance work demands knowledge of Photoshop, Illustrator, QuarkXPress and PDF. Buys all rights. Considers reprints but prefers original works. Considers complexity of project, budget and turnaround time when establishing payment.

Book Design Pays by the project, $200 minimum.

Jackets/Covers Pay by the project, $200 minimum.

Text Illustration Pays by the project, $15 minimum.

Tips "Portfolio should include samples that show experience. Don't include 27 pages of 'stuff.' Stay away from the 'cartoonish' look. If you don't have any computer design and/or illustration knowledge—get some! If you can't work on computers, at least understand the process of using traditional artwork with computer generated electronic files. For us to economically get more of our product out (with fast turnaround and a minimum of rough drafts), we've gone exclusively to computers for total book design; when working with traditional artists, their artwork will be placed within the computer-generated document."

JEWISH LIGHTS PUBLISHING

Sunset Farm Offices, Rt. 4, P.O. Box 237, Woodstock VT 05091. (802)457-4000. Fax: (802)457-5032. E-mail: production@jewishlights.com. Website: www.jewishlights.com. **Production Manager:** Tim Holtz. Estab. 1990. Publishes hardcover originals, trade paperback originals and reprints. Types of books include children's picture books, history, juvenile, nonfiction, reference, religious, self-help, spirituality, life cycle, theology and philosophy, wellness. Specializes in adult nonfiction and children's picture books. Publishes 50 titles/year. Recent titles include: *I Am Jewish*; *The Quotable Jewish Woman*; *The Jewish Journaling Book*. 10% requires freelance illustration; 50% requires freelance design. Book catalog free on request.

Needs Approached by 75 illustrators and 20 designers/year. Works with 3 illustrators and 10 designers/year. Prefers freelancers experienced in fine arts, children's book illustration, typesetting and design. 100% of freelance design demands knowledge of QuarkXPress. 50% of freelance design demands knowledge of Photoshop.

First Contact & Terms Designers: Send postcard sample, query letter with printed samples, tearsheets. Illustrators send postcard sample or other printed samples. Samples are filed and are not returned. Portfolio review not required. Buys all rights. Finds freelancers through submission packets, websites, searching local galleries and shows, Graphic Artists' Guild's *Directory of Illustrators* and *Picture Book*.

Book Design Assigns 40 freelance design jobs/year. Pays for design by the project.

Jackets/Covers Assigns 30 freelance design jobs and 5 illustration jobs/year. Pays for design by the project.

Tips "We prefer a painterly, fine-art approach to our children's book illustration to achieve a quality that

would intrigue both kids and adults. We do not consider cartoonish, caricature-ish art for our children's book illustration.''

N JIREH PUBLISHING COMPANY

P.O. Box 1911, Suisun City CA 94585-1911. (510)276-3322. E-mail: jaholman@jirehpublishing.com. Website: www.jirehpublishing.com. **Contact:** J. Holman, editor. Publishes CD ROMs, hardcover and trade paperback originals. Types of books include adventure and religious fiction; instructional, religious and e-books nonfiction. Publishes 2 titles/year. Recent titles include: *Accessible Bathroom Design*; *The Art of Seeking God.* 85% requires freelance design; 50% requires freelance illustration. Book catalog not available. (See website for current titles.)
Needs Approached by 15 designers and 12 illustrators/year. Works with 2 designers and 1 illustrator/year. 85% of freelance design work and 75% of freelance illustration work demands knowledge of Corel Draw, Illustrator and Photoshop.
First Contact & Terms Designers/Illustrators: Send postcard samples with résumé, URL. Samples are filed. Responds only if interested. Company will contact artist for portfolio review if interested. Portfolio should include color finished art. Rights purchased vary according to project. Finds freelancers through art reps, artist's submissions and Internet.
Jackets/Covers Assigns 2 freelance cover illustration jobs/year. Pays for illustration by the project, $1,000 minimum. Prefers experienced Christian cover designer.
Text Illustration Assigns 1 freelance illustration job/year. $50 minimum/hour.
Tips ''Be experienced in creating Christian cover designs for fiction and nonfiction titles.''

KAEDEN BOOKS

P.O. Box 16190, Rocky River OH 44116. (440)617-1400. Fax: (440)617-1403. E-mail: curmston@kaeden.com. Website: www.kaeden.com. **Publisher:** Craig Urmston. Estab. 1989. Publishes children's books and picture books. Types of books include picture books and early juvenile. Specializes in educational elementary content. Publishes 8-16 titles/year. 90% require freelance illustration. Book catalog available upon request. Recent new titles include: *Rainy Day for Sammy*; *There's a Bear in My Chair*; and *Grandma's Patchy Pocket*.
 • Kaeden Books is now providing content for Thinkbox.com and the TAE Kindlepark Electronic Book Program.
Needs Approached by 100-200 illustrators/year. Works with 5-10 illustrators/year. Prefers freelancers experienced in juvenile/humorous illustration and children's picture books. Uses freelancers mainly for story illustration.
First Contact & Terms Designers: Send query letter with brochure and résumé. Illustrators: Send postcard sample or query letter with photocopies, photographs, printed samples, tearsheets and résumé. Samples are filed and not returned. Responds only if interested. Art director will contact artist for portfolio review if interested. Buys all rights.
Text Illustration Assigns 10-25 jobs/year. Pays by the project. Looks for a variety of styles.
Tips ''We look for professional-level drawing and rendering skills, plus the ability to interpret a juvenile story. There is a tight correlation between text and visual in our books, plus a need for attention to detail. Drawings of children are especially needed. Please send only samples that pertain to our market.''

KALMBACH PUBLISHING CO.

21027 Crossroads Circle, P.O. Box 1612, Waukesha WI 53187. (262)796-8776. Fax: (262)796-1142. E-mail: tford@kalmbach.com. Website: www.kalmbach.com. **Books Art Director:** Tom Ford. Estab. 1934. Types of books include reference and how-to books for serious hobbyists in the railfan, model railroading, plastic modeling, and toy train collecting/operating hobbies. Also publishes books and booklets on jewelry-making, beading and general crafts. Publishes 50+ new titles/year. Recent titles include: *Legendary Lionel Trains*, by John Grams and Terry Thompson; *The Model Railroader's Guide to Industries Along the Tracks*, by Jeff Wilson; *Tourist Trains 2005—The 40th Annual Guide to Tourist Railroads and Museums*; and *Chic&Easy Beading, 100 Fast and Fun Fashion Jewelry Projects*, edited by Alice Korach.
Needs 10-20% require freelance illustration; 10-20% require freelance design. Book catalog free upon request. Approached by 25 freelancers/year. Works with 2 freelance illustrators and 2 graphic designers/year. Prefers freelancers with experience in the hobby field. Uses freelance artists mainly for book layout/design and line art illustrations. Freelancers should have the most recnet versions of Adobe InDesign, Photoshop and Illustrator. Some projects will require QuarkXPress 4.1 through the end of 2005; all jobs will be moved to InDesign thereafter. Projects by assignment only.
First Contact & Terms Send query letter with résumé, tearsheets and photocopies. No phone calls please. Samples are filed and will not be returned. Art Director will contact artist for portfolio review. Finds artists through word of mouth, submissions. Assigns 10-12 freelance design jobs/year. Pays by the project, $500-3,000. Assigns 3-5 freelance illustration jobs/year. Pays by the project, $250-2,000.

Tips First-time assignments are usually illustrations or book layouts. Complex projects (i.e., track plans, 100+ page books) are given to proven freelancers. Admires freelancers who present an organized and visually strong portfolio that meet deadlines and follow instructions carefully.''

KIRKBRIDE BIBLE CO. INC.

Kirkbride Bible & Technology, 335 W. 9th St., Indianapolis IN 46202-0606. (317)633-1900. Fax: (317)633-1444. E-mail: sales@kirkbride.com. Website: www.kirkbride.com. **Director of Production and Technical Services:** Michael B. Gage. Estab. 1915. Publishes hardcover originals, CD-ROM and many styles and translations of the Bible. Types of books include reference and religious. Specializes in reference and study material. Publishes 6 main titles/year. Recent titles include: *NIV Thompson Student Bible.* 5% require freelance illustration; 20% require freelance design. Catalog available.

Needs Approached by 1-2 designers/year. Works with 1-2 designers/year. Prefers freelancers experienced in layout and cover design. Uses freelancers mainly for artwork and design. 100% of freelance design and most illustration demands knowledge of PageMaker, FreeHand, Photoshop, Illustrator and QuarkXPress. 5-10% of titles require freelance art direction.

First Contact & Terms Designers: Send query letter with photostats, printed samples and résumé. Illustrators: Send query letter with photostats, printed samples and résumé. Accepts disk submissions compatible with QuarkXPress or Photoshop files4.0 or 3.1. Samples are filed. Responds only if interested. Rights purchased vary according to project.

Book Design Assigns 1 freelance design job/year. Pays by the hour $100 minimum.

Jackets/Covers Assigns 1-2 freelance design jobs and 1-2 illustration jobs/year. Pays for design by the project, $100-1,000. Pays for illustration by the project, $100-1,000. Prefers modern with traditional text.

Text Illustration Assigns 1 freelance illustration/year. Pays by the project, $100-1,000. Prefers traditional. Finds freelancers through sourcebooks and references.

Tips "Quality craftsmanship is our top concern, and it should be yours also!"

DENIS KITCHEN PUBLISHING CO., LLC

P.O. Box 2250, Amherst MA 01004-2250. (413)259-1627. Fax: (413)259-1812. E-mail: publishing@deniskitchen. com. Website: www.deniskitchenpublishing.com. **Contact:** Denis Kitchen or Steven Krupp. Estab. 1999. Previously Kitchen Sink Press (1969-1999). Publishes hardcover originals and trade paperback originals. Types of books include art prints, coffee table books, graphic novels, illustrated books, postcard books, and boxed trading cards. Specializes in comix and graphic novels. Publishes 4-6 titles/year. Recent titles include: *Heroes of the Blues,* by R. Crumb; *Grasshopper & Ant,* by Harvey Kurtzman; *Mr. Natural Postcard Book,* by R. Crumb. 50% requires freelance design; 10% requires freelance illustration. Book catalog not available.

Needs Approached by 50 illustrators and 100 designers/year. Works with 6 designers and 2 illustrators/year. Prefers local designers. 90% of freelance design work demands knowledge of QuarkXPress and Photoshop. Freelance illustration demands QuarkXPress, Photoshop and sometimes old-fashioned brush and ink.

First Contact & Terms Send postcard sample with SASE, tearsheets, URL and other appropriate samples. After introductory mailing, send follow-up postcard sample every 6 months. Samples are filed or returned by SASE. Responds in 4-6 weeks. Portfolio not required. Finds freelancers through artist's submissions, art exhibits/fairs and word of mouth.

Jackets/Covers Assigns 2-3 freelance cover illustrations/year. Prefers "comic book" look where appropriate.

ALFRED A. KNOPF, INC.

Subsidiary of Random House Inc., 1745 Broadway, New York NY 10019-4305. (212)751-2600. Fax: (212)572-2593. Website: www.randomhouse.com/knopf. **Art Director:** Carol Carson. Publishes hardcover originals for adult trade. Specializes in history, fiction, art and cookbooks. Publishes 200 titles/year. Recent titles include: *My Life,* by Bill Clinton; *A Good Year,* by Peter Mayle; *The Undressed Art: Why We Draw,* by Peter Steinhart.

- Random House Inc. and its publishing entities are not accepting unsolicited submissions via e-mail at this time.

Needs Works with 3-5 freelance illustrators and 3-5 freelance designers/year. Prefers artists with experience in b&w. Uses freelancers mainly for cookbooks and biographies. Also for text illustration and book design.

First Contact & Terms Send query letter with SASE. Request portfolio review in original query. Artist should follow up. Sometimes requests work on spec before assigning a job. Originals are returned at job's completion.

Book Design Pays by the hour, $15-30; by the project, $450 minimum.

Text Illustration Pays by the project, $100-5,000; $50-150/illustration; $300-800/maps.

Tips Finds artists through submissions, agents and sourcebooks. "Freelancers should be aware that Macintosh/Quark is a must for design and becoming a must for maps and illustration."

HJ KRAMER/STARSEED PRESS

P.O. Box 1082, Tiburon CA 94920. (415)435-5367. Fax: (415)435-5364. E-mail: hjkramer@jps.net. **Contact:** Linda Kramer, vice president. Estab. 1987. Publishes children's hardcover and trade paperback originals. Types of books include children's picture books, personal growth, spiritual (nondenominational) fiction and non-fiction. Publishes 3-7 titles/year. Recent titles include: *Just for Today*; *Sudden Awakening*; *Saying What's Real*; *What All Children Want Their Parents to Know.* 20% requires freelance illustration. Book catalog free on request.
Needs Approached by 100 illustrators/year. Works with 1-2 illustrators/year.
First Contact & Terms Send query letter with brochure, photocopies, résumé, SASE, tearsheets. Samples are filed or returned by SASE. Responds only if interested. Company will contact artist for portfolio review if interested. Buys all rights. Finds freelancers through artist's submissions, Internet and word of mouth.
Text Illustration Assigns 1-2 freelance illustration jobs/year. Pays by the project. Prefers children's illustrators.

PETER LANG PUBLISHING, INC.

275 Seventh Ave., 28th Floor, New York NY 10001-6708. (212)647-7700. Fax: (212)647-7707. Website: www.pet erlangusa.com. **Production & Creative Director:** Lisa Dillon. Publishes humanities textbooks and monographs. Publishes 300 titles/year. Book catalog available on request and on website.
Needs Works with a small pool of designers/year. Prefers local freelance designers experienced in scholarly book covers. Most covers will be CMYK. 100% of freelance design demands knowledge of Illustrator, Photoshop and QuarkXPress.
First Contact & Terms Send query letter with printed samples, photocopies and SASE. Accepts Windows-compatible and Mac-compatible disk submissions. Samples are filed. Responds only if interested. Will contact artist for portfolio review if interested. Finds freelancers through referrals.
Jackets/Covers Assigns 100 freelance design jobs/year. Only accepts Quark electronic files. Pays for design by the project.

LAREDO PUBLISHING CO./RENAISSANCE HOUSE DBA

9400 Lloydcrest Dr., Beverly Hills CA 90210. (310)860-9930. Fax: (310)860-9902. E-mail: laredo@renaissanceho use.net. Website: renaissancehouse.net. **Art Director:** Sam Laredo. Estab. 1991. Publishes juvenile, preschool textbooks. Specializes in Spanish texts, educational/readers. Publishes 16 titles/year. Recent titles include: *Legends of America* (series of 21 titles); *Extraordinary People* (series of 6 titles); *Breast Health with Nutribionics.*
Needs Approached by 10 freelance illustrators and 2 freelance designers/year. Works with 2 freelance designers/year. Uses freelancers mainly for book development. 100% of freelance design demands knowledge of Photoshop, Illustrator, QuarkXPress. 20% of titles require freelance art direction.
First Contact & Terms Designers: Send query letter with brochure, photocopies. Illustrators: Send photocopies, photographs, résumé, slides, tearsheets. Samples are not filed and are returned by SASE. Responds only if interested. Portfolio review required for illustrators. Art director will contact artist for portfolio review if interested. Portfolio should include book dummy, photocopies, photographs, tearsheets and artwork portraying children. Buys all rights or negotiates rights purchased.
Book Design Assigns 5 freelance design jobs/year. Pays for design by the project.
Jacket/Covers Pays for illustration by the project, page.
Text Illustration Pays by the project, page.

LEE & LOW BOOKS

95 Madison Ave., #1205, New York NY 10016-7801. (212)779-4400. Fax: (212)532-6035. E-mail: general@leean dlow.com. Website: www.leeandlow.com. **Editor-in-Chief:** Louise May. Estab. 1991. Book publisher. Publishes hardcover originals and reprints for the juvenile market. Specializes in multicultural children's books. Publishes 12-15 titles/year. First list published in spring 1993. Titles include: *Rent Party Jazz*, by William Miller; *Where On Earth Is My Bagel?*, by Frances Park and Ginger Park; and *Love to Mama*, edited by Pat Mora. 100% requires freelance illustration and design. Book catalog available.
Needs Approached by 100 freelancers/year. Works with 12-15 freelance illustrators and 4-5 designers/year. Uses freelancers mainly for illustration of children's picture books. 100% of design work demands computer skills. Works on assignment only.
First Contact & Terms Contact through artist rep or send query letter with brochure, résumé, SASE, tearsheets or photocopies. Samples of interest are filed. Art director will contact artist for portfolio review if interested. Portfolio should include color tearsheets and dummies. Rights purchased vary according to project. Originals are returned at job's completion.
Book Design Pays by the project.
Text Illustration Pays by the project.
Tips ''We want an artist who can tell a story through pictures and is familiar with the children's book genre. We are now also developing materials for older children, ages 8-12, so we are interested in seeing work for this

age group, too. Lee & Low Books makes a special effort to work with writers and artists of color and encourages new talent. We prefer filing samples that feature children, particularly from diverse backgrounds.''

Ⓝ LIPPINCOTT WILLIAMS & WILKINS

Parent company: Wolters Kluwer., 351 W. Camden St., Baltimore MD 21201-2436. (410)528-4000. Fax: (410)528-4414. E-mail: mfernand@lww.com. Website: www.lww.com. **Senior Design Coordinator:** Mario Fernandez. Estab. 1890. Publishes audio tapes, CD-ROMs, hardcover originals and reprints, textbooks, trade paperbook originals and reprints. Types of books include instructional and textbooks. Specializes in medical publishing. Publishes 400 titles/year. Recent titles include: *Principles of Medical Genetics-2nd Edition*; *Communication Development: Foundations Processes and Clinical Applications*. 100% requires freelance design.

Needs Approached by 20 illustrators and 20 designers/year. Works with 10 illustrators and 30 designers/year. Prefers freelancers experienced in medical publishing. 100% of freelance design demands knowledge of Illustrator, Photoshop, QuarkXPress.

First Contact & Terms Send query letter with printed samples and tearsheets. Accepts Mac-compatible disk submissions. Send EPS or TIFF files. Responds only if interested. Will contact artist for portfolio review if interested. Buys all rights. Finds freelancers through submission packets, word of mouth.

Book Design Assigns 150 freelance design jobs/year. Pays by the project, $350-5,000.

Jackets/Covers Assigns 150 freelance design jobs/year. Pays for design by the project, $350-5,000. Prefers medical publishing experience.

Text Illustration Assigns 150 freelance illustration jobs/year. Pays by the project, $350-500. Prefers freelancers with medical publishing experience.

Tips ''We're looking for freelancers who are flexible and have extensive clinical and textbook medical publishing experience. Designers must be proficient in Quark, Illustrator and Photoshop and completely understand how design affects the printing (CMYK 4-color) process.''

LITURGY TRAINING PUBLICATIONS

An agency of the Roman Catholic Archdiocese of Chicago, 1800 N. Hermitage, Chicago IL 60622. (773)486-8970. Fax: (773)486-7094. **Contact:** Design Manager. Estab. 1964. Publishes hardcover originals and trade paperback originals and reprints. Types of books include religious instructional books for adults and children. Publishes 50 titles/year. 60% require freelance illustration. Book catalog free by request.

Needs Approached by 30-50 illustrators/year. Works with 10-15 illustrators/year. 10% of freelance illustration demands knowledge of Photoshop.

First Contact & Terms Illustrators: Send postcard sample or send introductory letter with printed samples, photocopies and tearsheets. Accepts Mac-compatible disk submissions. Send EPS or TIFF files. Samples are filed and are not returned. Will contact artist for portfolio review if interested. Rights purchased vary according to project.

Text Illustration Assigns 15-20 freelance illustration jobs/year. Pays by the project. ''There is more opportunity for illustrators who are good in b&w or 2-color, but illustrators who work exclusively in 4-color are also utilized.''

Tips ''Two of our books were in the AIGA 50 Best Books of the Year show in recent years and we win numerous awards. Sometimes illustrators who have done religious topics for others have a hard time working with us because we do not use sentimental or traditional religious art. We look for sophisticated, daring, fine art-oriented illustrators and artists. Those who work in a more naturalistic manner need to be able to portray various nationalities well. We never use cartoons.''

LLEWELLYN PUBLICATIONS

P.O. Box 64383, St. Paul MN 55164-0383. (651)291-1970. Fax: (651)291-1908. Website: www.llewellyn.com. **Art Director:** Lynne Menturweck. Estab. 1909. Book publisher. Publishes trade paperback and mass market originals and reprints, tarot kits and calendars. Types of books include reference, self-help, metaphysical, occult, mythology, health, women's spirituality and New Age. Publishes 80 titles/year. Books have photography, realistic painting and computer generated graphics. 60% require freelance illustration. Book catalog available for large SASE and 5 first-class stamps.

Needs Approached by 100 freelancers/year. Buys 30-50 freelance illustrations/year. Prefers freelancers with experience in book covers, New Age material and realism. Uses freelancers mainly for realistic paintings and drawings. Works on assignment only.

 • Art Director asks that you consult their website for submission guidelines.

First Contact & Terms Send e-mail with link to your site or query letter with printed samples, tearsheets, photographs, photocopies or slides (preferred). Samples are filed or are returned by SASE. Art Director will contact artist for portfolio review if interested. Sometimes requests work on spec before assigning a job. Negotiates rights purchased.

Jackets/Covers Assigns 40 freelance illustration jobs/year. Pays by the illustration, $150-700. Media and style

preferred "are usually realistic, well-researched, airbrush, watercolor, acrylic, oil, colored pencil. Artist should know our subjects."

Text Illustration Assigns 25 freelance illustration jobs/year. Pays by the project, or $30-100/illustration. Media and style preferred are pencil and pen & ink, "usually very realistic; there are usually people in the illustrations."

Tips "I need artists who are aware of occult themes, knowledgeable in the areas of metaphysics, divination, alternative religions, women's spirituality, and who are professional and able to present very refined and polished finished pieces. Knowledge of history, mythology and ancient civilization is a big plus."

LOOMPANICS UNLIMITED

P.O. Box 1197, Port Townsend WA 98368. (360)385-2230. Fax: (360)385-7785. E-mail: publicity@loompanics.c om. Website: www.loompanics.com. **Editor:** Gia Cosindas. Estab. 1973. Publishes mass market paperback originals and reprints, trade paperback originals and reprints. Types of books include nonfiction, crime, police science, illegal drug manufacture, self-sufficiency and survival. Specializes in how-to with an edge. Publishes 25 titles/year. Recent titles include: *The New Bullwhip Book*; *Under the Table and Into Your Pocket*; *The Freedom Outlaw's Handbook—179 Things to Do 'Til the Revolution*. 75% requires freelance illustration. Book catalog available for $5.

Needs Prefers freelancers experienced in action drawing, action comic ink drawing, some technical illustrations.

First Contact & Terms Send website link only or send query letter with printed samples, photocopies and SASE. Samples are returned by SASE. Responds only if interested. Will contact artist for portfolio review if interested. Buys one-time rights, with the right to publish on the website. Usually works with freelancers publisher has worked with in the past, but tries a few new artists every year.

Book Design Pays for design by the project.

Jackets/Covers Assigns 10 freelance design jobs and 15 illustration jobs/year. Pays for design and illustration by the project. Prefers creative illustrators willing to work with controversial and unusual material.

Text Illustration Assigns 50 freelance illustration jobs/year.

Tips "Please do not call us. We develop good, long-lasting relationships with our illustrators, who are used to our method of throwing out design ideas and the artist taking off on that and running with it."

LUMEN EDITIONS/BROOKLINE BOOKS

P.O. Box 1209, Newton MA 02445. (617)734-6772. Fax: (617)734-3952. E-mail: milt@brooklinebooks.com. Website: www.brooklinebooks.com. **Editor:** Milt Budoff. Estab. 1970. Publishes hardcover originals, textbooks, trade paperback originals and reprints. Types of books include biography, children's picture books, experimental and mainstream fiction, instructional, nonfiction, reference, self-help, textbooks, travel. Specializes in translations of literary works/education books. Publishes 10 titles/year. Titles include: *Writing*, by Marguerite Duras; *Pursuit of a Woman*, by Hans Koning; *Study Power*; *The Well Adjusted Dog*. 100% requires freelance illustration; 70% requires freelance design. Book catalog free for 6×9 SAE with 2 first-class stamps.

Needs Approached by 20 illustrators and 50 designers/year. Works with 5 illustrators and 20 designers/year. Prefers freelancers experienced in book jacket design. 100% of freelance design demands knowledge of Photoshop, PageMaker, QuarkXPress.

First Contact & Terms Send query letter with printed samples, SASE. Samples are filed. Will contact artist for portfolio review of book dummy, photocopies, tearsheets if interested. Negotiates rights purchased. Finds freelancers through agents, networking, other publishers, Book Builders.

Book Design Assigns 30-40 freelance design/year. Pays for design by the project, varies.

Jackets/Covers Pays for design by the project, varies. Pays for illustration by the project, $200-2,500. Prefers innovative trade cover designs. Classic type focus.

Text Illustration Assigns 5 freelance illustration jobs/year. Pays by the project, $200-2,500.

Tips "We have a house style, and we recommend that designers look at some of our books before approaching us. We like subdued colors—that still pop. Our covers tend to be very provocative, and we want to keep them that way. No 'mass market' looking books or display typefaces. All designers should be knowledgeable about the printing process and be able to see their work through production."

MADISON HOUSE PUBLISHERS

4501 Forbes Blvd., Suite 200, Lanham MD 20706. (301)459-3366. Fax: (301)429-5748. Website: www.rowmanlit tlefield.com. **Contact:** Vice President, Design. Estab. 1984. Publishes hardcover and trade paperback originals. Specializes in biography, history and popular culture. Publishes 10 titles/year. Titles include: *Connected Lives*; *Love and Limerence*; *Three Golden Ages*. 40% require freelance illustration; 100% require freelance jacket design. Book catalog free by request.

● Madison House is just one imprint of Rowman & Littlefield Publishing Group, which has eight imprints.

Needs Approached by 20 freelancers/year. Works with 4 freelance illustrators and 12 designers/year. Prefers freelancers with experience in book jacket design. Uses freelancers mainly for book jackets. Also for catalog

design. 80% of freelance work demands knowledge of Illustrator, QuarkXPress, Photoshop or FreeHand. Works on assignment only.

First Contact & Terms Send query letter with tearsheets, photocopies and photostats. Samples are filed or are returned by SASE if requested by artist. Responds to the artist only if interested. Call for appointment to show portfolio of roughs, original/final art, tearsheets, photographs, slides and dummies. Buys all rights. Interested in buying second rights (reprint rights) to previously published work.

Jackets/Covers Assigns 16 freelance design and 2 illustration jobs/year. Pays by the project, $400-1,000. Prefers typographic design, photography and line art.

Text Illustration Pays by project, $100 minimum.

Tips "We are looking to produce trade-quality designs within a limited budget. Covers have large type, clean lines; they 'breathe.' If you have not designed jackets for a publishing house but want to break into that area, have at least five 'fake' titles designed to show ability. I would like to see more Eastern European style incorporated into American design. It seems that typography on jackets is becoming more assertive, as it competes for attention on bookstore shelf. Also, trends are richer colors, use of metallics."

ᴺ MANDALA PUBLISHING

17 Paul Dr., San Rafael CA 94903. (415)883-4055. Fax: (415)884-0500. E-mail: mandala@mandala.org. Website: www.mandala.org. **Contact:** Lisa Fitzpatrick, acquiring editor. Estab. 1987. Publishes art and photography books, calendars, journals, postcards and greeting card box sets. Types of books include New Age, spiritual, philosophy, art, biography, coffee table books, cookbooks, instructional, religious and travel nonfiction. Specializes in art books, spiritual. Publishes 12 titles/year. Recent titles include: *Ramayana A Tale of Gods & Demons*; *Prince of Dharma The Illustrated Life of the Buddha*. 100% requires freelance design and illustration. Book catalog free on request.

Needs Approached by 50 illustrators/year. Works with 12 designers and 12 illustrators/year. Location of designers/illustrators not a concern.

First Contact & Terms Send photographs and résumé. Accepts disk submissions from designers and illustrators. Prefers Mac-compatible, TIFF and JPEG files. Samples are filed. Responds only if interested. Company will contact artist for portfolio review if interested. Buys first, first North American serial, one-time and reprint rights. Rights purchased vary according to project. Finds freelancers through artist's submissions, word of mouth.

Jackets/Covers Assigns 24 freelance cover illustration jobs/year. Pays for illustration by the project. Prefers original "Indian" edge.

Text Illustration Assigns 24 freelance illustration jobs/year. Pays by the project.

Tips "Look at our published books and understand what we represent and how your work could fit."

MAPEASY, INC.

P.O. Box 80, 54 Industrial Rd., Wainscott NY 11975-0080. (631)537-6213. Fax: (631)537-4541. E-mail: info@mapeasy.com. Website: www.mapeasy.com. **Production:** Chris Harris. Estab. 1990. Publishes maps. 100% requires freelance illustration; 25% requires freelance design. Book catalog not available.

Needs Approached by 15 illustrators and 10 designers/year. Works with 3 illustrators and 1 designer/year. Prefers local freelancers. 100% of freelance design and illustration demands knowledge of Illustrator, Photoshop, QuarkXPress and Painter.

First Contact & Terms Send query letter with photocopies. Accepts Mac-compatible disk submissions. Samples are filed. Responds only if interested. Will contact artist for portfolio review if interested. Portfolio should include photocopies. Finds freelancers through ads and referrals.

Text Illustration Pays by the hour, $45 maximum.

ᴹ MCFARLAND & COMPANY, INC., PUBLISHERS

P.O. Box 611, Jefferson NC 28640-0611. (336)246-4460. Fax: (336)246-5018. E-mail: info@mcfarlandpub.com. Website: www.mcfarlandpub.com. **Sales Manager:** Rhonda Herman. Estab. 1979. Company publishes hardcover and trade paperback originals. Subjects include Civil War history and chess. Specializes in nonfiction reference and scholarly monographs, including film and sports. Publishes 190 titles/year. Recent titles include: *The Women of Afghanistan Under the Taliban*; *James Arness: An Autobiography*. Book catalog free by request.

Needs Approached by 50 freelancers/year. Works with 5-8 freelance illustrators/year. Prefers freelancers with experience in catalog and brochure work in performing arts and school market. Uses freelancers mainly for promotional material. Also for direct mail and catalog design. Works on assignment only. 20% of illustration demands knowledge of QuarkXPress, version 3.3.

First Contact & Terms Send query letter with résumé, SASE, tearsheets and photocopies. "Send relevant samples. We aren't interested in children's book illustrators, for example, so we do not need such samples." Samples are filed. Responds in 2 weeks. Portfolio review not required. Buys all rights. Originals are not returned.

Tips First-time assignments are usually school promotional materials; performing arts promotional materials are given to "proven" freelancers. "Send materials relevant to our subject areas, otherwise we can't fully judge the appropriateness of your work."

N MCGRAW-HILL EDUCATION

148 Princeton-Hightstown Rd., Hightstown NJ 08520-1412. (609)426-5000. **Director of Design and Production:** Barbara Kopel. Estab. 1969. Independent book producer/packager of textbooks and reference books. Specializes in social studies, history, geography, vocational, math, science, etc. Recent titles include: *The American Journey*; *The Middle Ages*. 80% require freelance design.

Needs Approached by 30 freelance artists/year. Works with 4-5 illustrators and 5-15 designers/year. Buys 5-10 illustrations/year. Prefers artists with experience in textbooks, especially health, medical, social studies. Works on assignment only.

First Contact & Terms Send query letter with tearsheets and résumé. Samples are filed. Responds to the artist only if interested. To show portfolio, mail roughs and tearsheets. Rights purchased vary according to project. Originals returned at job's completion.

Book Design Assigns 5-15 jobs/year. Pays by the project.

Jackets/Covers Assigns 1-2 design jobs/year. Pays by the project.

Tips "Designers, if you contact us with samples we will invite you to do a presentation and make assignments as suitable work arises. Graphic artists, when working assignments we review our files. Enclose typical rate structure with your samples."

MCGRAW-HILL HIGHER EDUCATION GROUP

2460 Kerper Blvd., Dubuque IA 52001. (563)588-1451. Fax: (563)589-2955. Website: www.mhhe.com or www.mcgraw-hill.com. **Art Director:** Wayne Harris. Estab. 1944. Publishes hardbound and paperback college textbooks. Specializes in science, engineering and math. Produces more than 200 titles/year. 10% require freelance design; 70% require freelance illustration.

Needs Works with 15-25 freelance designers and 30-50 illustrators/year. Uses freelancers for advertising. 90% of freelance work demands knowledge of PageMaker, Illustrator, QuarkXPress, Photoshop or FreeHand. Works on assignment only.

First Contact & Terms Prefers color 35mm slides and color or b&w photocopies. Send query letter with brochure, résumé, slides and/or tearsheets. "Do not send samples that are not a true representation of your work quality." Responds in 1 month. Accepts disk submissions. Samples returned by SASE if requested. Responds on future assignment possibilities. Buys all rights. Pays $35-350 for b&w and color promotional artwork. Pays half contract for unused assigned work.

Book Design Assigns 100-140 freelance design jobs/year. Uses artists for all phases of process. Pays by the project. Payment varies widely according to complexity.

Jackets/Covers Assigns 100-140 freelance design jobs and 20-30 illustration jobs/year. Pays $1,700 for 4-color cover design and negotiates pay for special projects.

Text Illustration Assigns 75-100 freelance jobs/year. Considers b&w and color work. Prefers computer-generated, continuous tone, some mechanical line drawings; ink preferred for b&w. Pays $30-500.

Tips "In the McGraw-Hill field, there is more use of color. There is need for sophisticated color skills—the artist must be knowlegeable about the way color reproduces in the printing process. Be prepared to contribute to content as well as style. Tighter production schedules demand an awareness of overall schedules. *Must* be dependable."

MEADOWBROOK PRESS

5451 Smetana Dr., Minnetonka MN 55343. (952)930-1100. Fax: (952)930-1940. E-mail: artdirector@meadowbrookpress.com. Website: www.meadowbrookpress.com and www.production.meadowbrookpress.com. **Art Director.** Company publishes hardcover and trade paperback originals. Types of books include: pregnancy, childbirth and parenting instruction; baby names; preschool and children's poetry; party and humor. Publishes 20 titles/year. Titles include: *Pregnancy, Childbirth and the Newborn*; *Very Best Baby Name Book*; *Mary Had A Little Jam*; *Age Happens*; *Themed Baby Showers*. 80% require freelance illustration; 10% require freelance design.

Needs Uses freelancers mainly for humor, activity books, spot art. Also for jacket/cover and text illustration. 100% of design work demands knowledge of QuarkXPress, Photoshop or Illustrator. Works on assignment only.

First Contact & Terms Designers: Send query letter with résumé and photocopies. Illustrators: Send query letter with photocopies. Samples are filed and are not returned. Responds only if interested. Art director will contact artist if interested. Finds artists through agents, sourcebooks and submissions.

Book Design Assigns 2 freelance design jobs/year. "Pay varies with complexity of project."

Jackets/Covers Assigns 6 freelance jobs/year.

Tips "We want hardcopy samples to keep on file for review, not on disk or via e-mail, but do appreciate ability to illustrate digitally."

Ⓝ MENNONITE PUBLISHING HOUSE/HERALD PRESS

616 Walnut Ave., Scottdale PA 15683. (724)887-8500. Fax: (724)887-3111. E-mail: hp@mph.org. Website: www.heraldpress.com. **Art Director:** James M. Butti. Estab. 1918. Publishes hardcover and paperback originals and reprints; textbooks and church curriculum. Specializes in religious, inspirational, historical, juvenile, theological, biographical, fiction and nonfiction books. Publishes 17 titles/year. Recent titles include: *The Amish in Their Own Words*; *Yonie Wondernose*. Books are "fresh and well illustrated." 30% require freelance illustration. Catalog available free by request.

Needs Approached by 150 freelancers each year. Works with 8-10 illustrators/year. Prefers oil, pen & ink, colored pencil, watercolor, and acrylic in realistic style. "Prefer artists with experience in publishing guidelines who are able to draw faces and people well." Uses freelancers mainly for book covers. 10% of freelance work demands knowledge of Illustrator, QuarkXPress or CorelDraw. Works on assignment only.

First Contact & Terms Send query letter with résumé, tearsheets, photostats, slides, photocopies, photographs and SASE. Samples are filed ("if we feel freelancer is qualified") and are returned by SASE if requested by artist. Responds only if interested. Art director will contact artist for portfolio review of final art, photographs, roughs and tearsheets. Buys one-time or reprint rights. Originals are not returned at job's completion "except in special arrangements." To show portfolio, mail photostats, tearsheets, final reproduction/product, photographs and slides and also approximate time required for each project. Considers complexity of project, skill and experience of artist and project's budget when establishing payment. Buys all rights.

Jackets/Covers Assigns 8-10 illustration jobs/year. Pays by the project, $200 minimum. "Any medium except layered paper illustration will be considered."

Text Illustration Assigns 6 jobs/year. Pays by the project. Prefers b&w, pen & ink or pencil.

Tips "Design we use is colorful, realistic and religious. When sending samples, show a wide range of styles and subject matter—otherwise you limit yourself."

Ⓝ MERLYN'S PEN

P.O. Box 2550, Providence RI 02906. (401)751-3766. Fax: (401)274-1541. E-mail: merlyn@merlynspen.org. Website: www.merlynspen.org. **President:** R. James Stahl. Estab. 1985. Imprints include The American Teen Writer Series. Publishes trade paperback originals, textbooks, audio tapes and magazines. Types of books include young adult—most are by teen authors. Publishes 6 titles/year. Titles include: *White Knuckles*; *Merlyn's Pen Annual*; *Eighth Grade* and *Sophomores*. 100% requires freelance illustration and design. Catalog free.

Needs Approached by 5 illustrators and 5 designers/year. Works with 10 illustrators/year. Prefers freelancers experienced in design and typography and illustration. Uses freelancers mainly for book jackets and magazine articles. 100% of freelance design demands knowledge of Photoshop, Illustrator and QuarkXPress.

First Contact & Terms Designers: Send query letter with brochure, photocopies, SASE and tearsheets. Illustrators: Send postcard sample, photocopies and printed samples. Send follow-up postcard every 3 months. Accepts disk submissions compatible with QuarkXPress. Samples are filed and are not returned. Responds only if interested. Will contact artist for portfolio review if interested. Portfolio should include artwork portraying teens, sci-fi, real life and story illustrations. Rights purchased vary according to project.

Book Design Assigns 2 freelance design jobs/year. Pays by the project, $250-1,000.

Jackets/Covers Assigns 10 freelance design and 10 illustration jobs/year. Pays for design by the hour, $20-50 or by the project, $250-1,000. Pays for illustration by the project, $400-600.

Text Illustration Assigns 50 freelance illustration jobs/year. Pays by the project, $100-250. Prefers pen and ink, scratchboard, watercolor, tempera and oil. Finds freelancers through Rhode Island School of Design.

Tips "We look for professionalism and unique points of view."

MITCHELL LANE PUBLISHERS, INC.

P.O. Box 196, Hockessin DE 19707. (302)234-9426. Fax: (302)234-4742. Website: www.mitchelllane.com. **Publisher:** Barbara Mitchell. Estab. 1993. Publishes hardcover and trade paperback originals. Types of books include biography. Specializes in multicultural biography for young adults. Publishes 35-40 titles/year. Recent titles include: *Unlocking the Secrets of Science*. 50% requires freelance illustration; 10% requires freelance design.

Needs Approached by 20 illustrators and 5 designers/year. Works with 2 illustrators/year. Prefers freelancers experienced in illustrations of people.

First Contact & Terms Send query letter with printed samples, photocopies. Interesting samples are filed and are not returned. Will contact artist for portfolio review if interested. Buys all rights.

Jackets/Covers Prefers realistic portrayal of people.

⬛ MODERN PUBLISHING

155 E. 55th St., New York NY 10022. (212)826-0850. Fax: (212)758-4166. E-mail: ntocco@modernpublishing.c om. Website: www.modernpublishing.com. **Senior Project Editor:** Nicole Tocco. Specializes in children's coloring and activity books, novelty books, hardcovers, paperbacks (both generic and based on licensed characters). Publishes approximately 200 titles/year. Recent titles include: Fisher Price books; Care Bears books; The Wiggles books; Bratz and Lil' Bratz books.

Needs Approached by 15-30 freelancers/year. Works with 25-30 freelancers/year. Works on assignment and royalty.

First Contact & Terms Send query letter with résumé and samples. Samples are not filed and are returned by SASE only if requested. Responds only if interested. Originals not returned. Considers turnaround time, complexity of work and rights purchased when establishing payment.

Jackets/Covers Pays by the project, $100-250/cover, usually 2-4 books/series.

Text Illustration Pays by the project, $35-75/page; line art, 24-384 pages per book, usually 2-4 books/series. Pays $50-125/page; full-color art.

Tips "Research our books at bookstores or on our website to get a good feel for our product line; do not submit samples that do not reflect the styles we use."

MONDO PUBLISHING

980 Avenue of the Americas, New York NY 10018. E-mail: mondopub@aol.com. Website: www.mondopub.c om. **Executive Editor:** Susan DerKazarian. Estab. 1992. Publishes hardcover and trade paperback originals and reprints and audio tapes. Types of books include juvenile. Specializes in fiction, nonfiction. Publishes 50 titles/ year. Recent titles include: *Right Outside My Window*, by Mary Ann Hoberman; *Signs of Spring*, by Justine Fontes; *Dreams by Day, Dreams by Night*, by Nikki Grimes. Book catalog for 9×12 SASE with $3.20 postage.

Needs Works with 40 illustrators and 10 designers/year. Prefers freelancers experienced in children's hardcovers and paperbacks, plus import reprints. Uses freelancers mainly for illustration, design. 100% of freelance design demands knowledge of Photoshop, Illustrator, QuarkXPress.

First Contact & Terms Send query letter with photocopies, printed samples and tearsheets. Samples are filed. Will contact for portfolio review if interested. Portfolio should include artist's areas of expertise, photocopies, tearsheets. Rights purchased vary according to project. Finds freelancers through agents, sourcebooks, illustrator shows, submissions, recommendations of designers and authors.

Book Design Assigns 40 jobs/year. Pays by project.

Text Illustration Assigns 45-50 freelance illustration jobs/year. Pays by project.

⬛ ✅ MORGAN KAUFMANN PUBLISHERS, INC.

Academic Press, A Harcourt Science and Technology Company, 500 Sansome, Suite 400, San Francisco CA 94111. (415)392-2665. Fax: (415)982-2665. E-mail: design@mkp.com. Website: www.mkp.com. **Vice President Production and Manufacturing:** Scott Norton. Estab. 1984. Company publishes computer science books for academic and professional audiences in paperback, hardback and book/CD-ROM packages. Publishes 60 titles/year. Recent titles include: *GUI Bloopers*, by Jeff Johnson. 75% require freelance interior illustration; 100% require freelance text and cover design; 15% require freelance design and production of 4-color inserts.

Needs Approached by 150-200 freelancers/year. Works with 10-15 freelance illustrators and 10-15 designers/ year. Uses freelancers for covers, text design and technical and editorial illustration, design and production of 4-color inserts. 100% of freelance work demands knowledge of at least one of the following Illustrator, QuarkXPress, Photoshop, Ventura, Framemaker, or laTEX (multiple software platform). Works on assignment only.

First Contact & Terms Send query letter with samples. Samples must be nonreturnable or with SASE. "No calls, please." Samples are filed. Production editor will contact artist for portfolio review if interested. Portfolio should include final printed pieces. Buys interior illustration on a work-for-hire basis. Buys first printing and reprint rights for text and cover design. Finds artists primarily through word of mouth and submissions.

Book Design Assigns freelance design jobs for 40-50 books/year. Pays by the project. Prefers Illustrator and Photoshop for interior illustration and QuarkXPress for 4-color inserts.

Jackets/Covers Assigns 40-50 freelance design; 3-5 illustration jobs/year. Pays by the project. Uses primarily stock photos. Prefers designers take cover design through production to film and MatchPrint. "We're interested in a look that is different from the typical technical publication." For covers, prefers modern, clean, spare design, with emphasis on typography and high-impact imagery.

Tips "Although experience with book design is an advantage, sometimes artists from another field bring a fresh approach, especially to cover design. Currently the tough find is an affordable Photoshop artist for manipulation of images and collage work for covers."

WILLIAM MORROW & CO. INC.

Harper Collins Publishers, 10 E. 53rd St., New York NY 10022. (212)261-6695. Fax: (212)207-6968. Website: www.harpercollins.com. **Senior Art Director:** Richard Aquan. Specializes in hardcover originals, adult trade,

fiction and nonfiction. Publishes 150 titles/year. Recent titles include: *The Dream Room*; *Acid Tongues and Tranquil Dreams.* 100% require freelance illustration. Book catalog free for 8½×11 SASE with 3 first-class stamps.

First Contact & Terms Works with 30 freelance artists/year. Uses artists mainly for picture books and jackets. Works on assignment only. Send query letter with résumé and samples, "followed by call." Samples are filed. Responds in 1 month. Originals returned to artist at job's completion. Portfolio should include original/final art and dummies. Considers complexity of project and project's budget when establishing payment. Negotiates rights purchased.

Book Design "Most design is done on staff." Assigns 25-45 freelance design jobs/year. Pays by the project.

Jackets/Covers Assigns 1 or 2 freelance design jobs/year. Pays by the project.

Text illustration Assigns 17 freelance jobs/year. Pays by the project.

Tips "Be familiar with our publications."

MOUNTAIN PRESS PUBLISHING CO.

P.O. Box 2399, Missoula MT 59806. (406)728-1900. Fax: (406)728-1635. E-mail: info@mtnpress.com. Website: www.mountain-press.com. **Design and Production:** Kim Ericsson and Jeannie Nuckolls. Estab. 1960s. Company publishes trade paperback originals and reprints; some hardcover originals and reprints. Types of books include western history, geology, natural history/nature. Specializes in geology, natural history, history, horses, western topics. Publishes 20 titles/year. Recent titles include: *From Angels to Hellcats: Legendary Texas Women*; regional photographic field guides. Book catalog free by request.

Needs Approached by 100 freelance artists/year. Works with 2-5 freelance illustrators/year. Buys 5-10 freelance illustrations/year. Prefers artists with experience in book illustration and design, book cover illustration. Uses freelance artists for jacket/cover illustration, text illustration and maps. 100% of design work demands knowledge of InDesign, Photoshop, FreeHand or Illustrator. Works on assignment only.

First Contact & Terms Send query letter with résumé, SASE and any samples. Samples are filed or are returned by SASE. Responds only if interested. Project editor will contact artist for portfolio review if interested. Buys one-time rights or reprint rights depending on project. Originals are returned at job's completion. Finds artists through submissions, word of mouth, sourcebooks and other publications.

Book Design Pays by the project.

Jackets/Covers Assigns 0-1 freelance design and 3-6 freelance illustration jobs/year. Pays by the project.

Text Illustration Assigns 0-1 freelance illustration jobs/year. Pays by the project. Prefers b&w pen & ink, scratchboard, ink wash, pencil.

Tips First-time assignments are usually book cover/jacket illustration or map drafting; text illustration projects are given to "proven" freelancers.

MOYER BELL

549 Old North Road, Kingston RI 02881. (401)783-5480. Fax: (401)284-0959. E-mail: acornalliance@yahoo.com. Website: www.acornalliance.com. **Contact:** Britt Bell. Estab. 1984. Imprints include: Asphodel Press, Olmstead Press, Albion Press, Paper-Maché Press. Publishes hardcover originals, trade paperback originals and reprints. Types of books include biography, coffee table books, history, instructional, mainstream fiction, nonfiction, reference, religious, self-help. Publishes 12 titles/year. 25% require freelance illustration; 25% require freelance design. Book catalog free.

Needs Works with 5 illustrators and 5 designers/year. Prefers electronic media. Uses freelancers mainly for illustrated books and book jackets. 100% of design and illustration demand knowledge of Photoshop, Illustrator, QuarkXPress and Postscript.

First Contact & Terms Designers: Send query letter with photocopies. Illustrators: Send postcard sample and/or photocopies. Accepts disk submissions. Samples are filed or returned by SASE. Rights purchased vary according to project.

Book Design Assigns 5 freelance design jobs/year. Pays by project; rates vary.

Jackets/Covers Assigns 5 design jobs and 5 illustration jobs/year. Pays by project; rates vary. Prefers Postscript.

Text Illustration Assigns 5 freelance illustration jobs/year. Payment varies. Prefers Postscript.

NBM PUBLISHING INC.

555 Eighth Ave., Suite 1202, New York NY 10018. (212)643-5407. Fax: (212)643-1545. Website: www.nbmpub.com. **Publisher:** Terry Nantier. Publishes graphic novels for an audience of 18-34 year olds. Types of books include fiction, fantasy, mystery, science fiction, horror and social parodies. Recent titles include: *A Treasury of Victorian Murder*; *Boneyard.* Circ. 5,000-10,000.

● Not accepting submissions unless for graphic novels. Publisher reports too many inappropriate submissions from artists who "don't pay attention." Check their website for instructions before submitting, so you're sure that your art is appropriate for them.

⬛ NELSON

A Division of Thomson Canada Ltd., 1120 Birchmount Rd., Scarborough ON M1K 5G4 Canada. (416)752-9100, ext. 343. Fax: (416)752-7144. E-mail: acluer@nelson.com. Website: www.nelson.com. **Creative Director:** Angela Cluer. Estab. 1931. Company publishes hardcover originals and reprints and textbooks. Types of books include instructional, juvenile, preschool, reference, high school math and science, primary spelling, textbooks and young adult. Specializes in a wide variety of education publishing. Publishes 150 titles/year. Recent titles include: *Marketing Our Environment: A Canadian Perspective*; *Language Arts K-6*; *The Learning Equation Mathematics 9*. 70% requires freelance illustration; 25% requires freelance design. Book catalog free by request.

Needs Approached by 50 freelancers/year. Works with 30 freelance illustrators and 10-15 designers/year. Prefers Canadian artists, but not a necessity. Uses freelancers for jacket/cover design and illustration, text illustration and book design. Also for multimedia projects. 100% of design and illustration demands knowledge of Illustrator, QuarkXPress and Photoshop. Works on assignment only.

First Contact & Terms Designers: Send query letter with tearsheets and résumé. Illustrators: Send postcard sample, brochure and tearsheets. Accepts disk submissions. Samples are filed. Art Director will contact artist for portfolio review if interested. Portfolio should include book dummy, transparencies, final art, tearsheets and photographs. Rights purchased vary according to project. Originals usually returned at job's completion. Finds artists through *American Showcase*, *Creative Source*, submissions, designers' suggestions (word of mouth).

Book Design Assigns 15 freelance design jobs/year. Pays by the project, $800-1,200 for interior design, $800-1,200 for cover design.

Jackets/Covers Assigns 15 freelance design and 40 illustration jobs/year. Pays by the project, $800-1,300.

Text Illustration Pays by the project, $30-450.

Ⓝ THOMAS NELSON PUBLISHERS

Nelson Publishing Group, 501 Nelson Place, Nashville TN 37214. **Contact:** Art Director. (615)889-9000. Fax: (615)902-1610. Estab. 1798. Book publisher. Publishes hardcover and trade paperback originals and reprints. Types of books include contemporary, experimental and historical fiction; mystery; juvenile; young adult; reference; self-help; humor; and inspirational. Specializes in Christian living, apologetics and fiction. Publishes 515 titles/year. Recent titles include: *Success God's Way*; *Prayer: My Soul's Adventure with God*, by Robert Schuller. 20-30% require freelance illustration; 90% require freelance design. Book catalog available by request.

Needs Approached by 10-30 artists/year. Works with 6-8 freelance illustrators and 4-6 freelance designers/year. Buys 15-20 freelance illustrations/year. Prefers artists with experience in full-color illustration, computer graphics and realism. Uses freelance artists mainly for cover illustration. Also uses freelance artists for jacket/cover design. Works on assignment only. 100% of design and 25% of illustration demand knowledge of QuarkXPress, Illustrator, Photoshop, FreeHand (Mac only).

First Contact & Terms Designers: Send query letter with brochure, SASE, tearsheets, photographs, slides and photocopies. Illustrators: Send postcard sample or query letter with photocopies, photographs, SASE, slides, tearsheets and transparencies. Accepts disk submissions compatible with Mac QuarkXPress or Abobe Photoshop. Samples are filed or are returned by SASE if requested by artist. Responds to the artist only if interested. Call to schedule an appointment to show a portfolio. Portfolio should include roughs, color photostats, tearsheets, photographs and slides. Rights purchased vary according to project. Originals returned to artist at job's completion unless negotiated otherwise.

Jackets/Covers Assigns 25-30 freelance design and 15-20 freelance illustration jobs/year. Prefers various media, including airbrush, acrylic, ink and multimedia. "No pastels or abstract art." Pays for design by the project, $600-1,500; illustration fees vary by project.

Tips "Request a catalog and see if your style fits our materials. I want to see new ideas, but there are some styles of illustration that just don't fit who we are. I don't have a great deal of time to spend looking through art submissions, but those artists who catch my eye are usually hired soon after."

THE NEW ENGLAND PRESS

P.O. Box 575, Shelburne VT 05482. (802)863-2520. Fax: (802)863-1510. E-mail: nep@together.net. Website: www.nepress.com. Specializes in paperback originals on regional New England subjects and nature. Publishes 6-8 titles/year. Recent titles include: *Rum Runners & Revenuers: Prohibition in Vermont*; *Green Mountain Boys of Summer: Vermonters in the Major Leagues 1882-1993*; *Spanning Time: Vermont's Covered Bridges*. 50% require freelance illustration. Books have "traditional, New England flavor."

First Contact & Terms Approached by 50 freelance artists/year. Works with 2-3 illustrators and 1-2 designers/year. Send query letter with photocopies and tearsheets. Samples are filed. Responds only if interested. Considers complexity of project, skill and experience of artist, project's budget and turnaround time when establishing payment. Negotiates rights purchased. Originals not usually returned to artist at job's completion, but negotiable.

Book Design Assigns 1-2 jobs/year. Payment varies.

Jackets/Covers Assigns 2-4 illustration jobs/year. Payment varies.
Text Illustration Assigns 2-4 jobs/year. Payment varies.
Tips Send a query letter with your work, which should be "generally representational, but also folk-style and humorous; nothing cute."

NORTH LIGHT BOOKS

4700 East Galbraith Rd., Cincinnati OH 45236. (513)531-2690. Fax: (513)531-2686. E-mail: jamie.markle@fwpubs.com. Website: www.fwpublications.com. **Executive Editor:** Jamie Markle. Publishes trade paperback originals. Specializes in fine art instruction books. Publishes 75 titles/year. Recent titles include: *Lifelike Drawing with Lee Hammond*; *Creative Watercolor Workshop*; *Color Harmony*. Book catalog free with 9 × 12 SASE (6 first-class stamps).

● North Light Books publishes art, craft and design books, including watercolor, drawing, colored pencil and decorative painting titles that emphasize illustrated how-to art instruction. This market is for experienced fine artists who are willing to work with a North Light editor to produce a step-by-step how-to book about the artists' creative process.

Needs Approached by 100 author-artists/year. Works with 30 artists/year.
First Contact & Terms Send query letter with photographs, slides or transparencies. Accepts e-mail submissions with art. Samples are not filed and are returned. Responds only if interested. Company will contact artist for portfolio review of color slides if interested. Buys all rights. Finds freelancers through art competitions, art exhibits, artist's submissions, Internet and word of mouth.
Tips "Send 30 slides along with a possible book idea and outline and a sample step-by-step demonstration."

NORTHLAND PUBLISHING

2900 Fort Valley Rd., Flagstaff AZ 86001. (928)774-5251. Fax: (928)774-0592. E-mail: info@northlandpub.com. Website: www.northlandpub.com. **Art Director:** David Jenney. Estab. 1958. Company publishes hardcover and trade paperback originals. Types of books include western, travel, Native American art, cookbooks and children's picture books. Publishes 25 titles/year. Recent titles include: *Southwest Slow Cooking*; *Outdoor Style*. 50% requires freelance illustration. Art guidelines on website.

● Rising Moon is Northland's children's imprint.

Needs Approached by 1,000 freelancers/year. Works with 5-12 freelance illustrators/year. Prefers freelancers with experience in illustrating children's titles. Uses freelancers mainly for children's books. 100% of freelance work demands knowledge of Illustrator, QuarkXPress or Photoshop. Works on assignment only.
First Contact & Terms Send query letter with résumé, SASE and tearsheets. Samples are filed or are returned by SASE if requested by artist. Will contact artist for portfolio review if interested. Portfolio should include color tearsheets. Rights purchased vary according to project. Originals are returned at job's completion. Finds artists mostly through submissions.
Jackets/Covers No jacket/cover art needed.
Text Illustration Assigns 5-12 freelance illustration jobs/year. Pays by the project, $1,000-10,000. Royalties are preferred—gives cash advances against royalties.
Tips "Creative presentation and promotional pieces filed."

NORTHWOODS PRESS

P.O. Box 298, Thomaston ME 04861. Website: www.americanletters.org. **Editor:** Robert Olmsted. Estab. 1972. Specializes in hardcover and paperback originals of poetry. Publishes approximately 6 titles/year. Titles include: *Aesop's Eagles*. 10% require freelance illustration. Book catalog for SASE.

● The Conservatory of American Letters now publishes the *Northwoods Journal*, a quarterly literary magazine. They're seeking cartoons and line art and pay cash on acceptance. Get guidelines from website.

Needs Approached by 40-50 freelance artists/year. Works with 1-2 illustrators/year. Uses freelance artists mainly for cover illustration. Rarely uses freelance artists for text illustration.
First Contact & Terms Send query letter to be kept on file. Art Director will contact artist for portfolio review if interested. Sometimes requests work on spec before assigning a job. Considers complexity of project, skill and experience of artist, project's budget, turnaround time and rights purchased when establishing payment. Buys one-time rights and occasionally all rights. Originals are returned at job's completion.
Book Design Pays by the project, $10-100.
Jackets/Covers Assigns 2-3 design jobs and 4-5 illustration jobs/year. Pays by the project, $10-100.
Text Illustration Pays by the project, $5-20.
Tips Portfolio should include "art suitable for book coverscontemporary, usually realistic."

NORTHWORD BOOKS FOR YOUNG READERS

Imprint of Creative Publishing International, 18705 Lake Drive East, Chanhassen MN 55317. (952)936-4700. Fax: (952)933-1456. Website: www.northwordpress.com. **Executive Editor:** Aimee Jackson. Publishes juvenile

fiction and nonfiction, children's picture books; hardcover, mass market and trade paperback originals and reprints. Specializes in nature, animals and natural history. Publishes 20 titles/year. Book catalog available on website.

Needs Approached by 1-2 designers/week and 10-20 illustrators/week. Works with 2 designers and 20 illustrators/year. Freelance design work demands skills in Illustrator, InDesign, QuarkXPress and Photoshop.

First Contact & Terms NorthWord is not looking for designers at this time, but illustrators can send postcard samples with nonreturnable photocopies and tearsheets to be kept on file. Does not accept e-mail submissions. Responds only if interested. Portfolio review not required. Buys all rights. Finds freelancers through art reps, artist's submissions, Internet, sourcebooks and word of mouth.

Text Illustration Assigns 4-8 freelance illustration jobs/year. Pays by the project. Prefers freelancers who can illustrate nature, animals and natural history subjects.

Tips "Review our books to see what styles we use, what types of books we publish, etc."

ⓝ OCTAMERON PRESS

1900 Mount Vernon Ave., Alexandria VA 22301. (703)836-5480. Fax: (703)836-5650. Website: www.octameron. com. **Editorial Director:** Karen Stokstod. Estab. 1976. Specializes in paperbacks—college financial and college admission guides. Publishes 9 titles/year. Titles include: *College Match* and *The Winning Edge*.

Needs Approached by 25 freelancers/year. Works with 1-2 freelancers/year. Works on assignment only.

First Contact & Terms Send query letter with brochure showing art style or résumé and photocopies. Samples not filed are returned if SASE included. Considers complexity of project and project's budget when establishing payment. Rights purchased vary according to project.

Jackets/Covers Works with 1-2 designers and illustators/year on 15 different projects. Pays by the project, $500-1,000.

Text Illustration Works with variable number of artists/year. Pays by the project, $35-75. Prefers line drawings to photographs.

Tips "The look of the books we publish is friendly! We prefer humorous illustrations."

ORCHARD BOOKS

Scholastic, 557 Broadway, New York NY 10012. (212)343-4490. Fax: (212)343-4890. Website: www.scholastic.c om. **Art Director:** David Saylor. Estab. 1987. Publishes hardcover children's books. Specializes in picture books and novels for children and young adults. Publishes 20 titles/year. Recent titles include: *Talkin About Bessi*, by Nikki Grimes, illustrated by E.B. Lewis. 100% require freelance illustration.

Needs Works with 20 illustrators/year. Works on assignment only. 5% of titles require freelance art direction.

First Contact & Terms Designers: Send brochure and/or photocopies. Illustrators: Send samples, photocopies and/or tearsheets. Samples are filed or are returned by SASE only if requested. Responds to queries/submissions only if interested. Portfolios may be dropped off on Mondays and are returned the same day. Originals returned to artist at job's completion. Considers complexity of project, skill and experience of artist and project's budget when establishing payment.

OREGON CATHOLIC PRESS

5536 NE Hassalo, Portland OR 97213-3638. (503)281-1191. Fax: (503)282-3486. E-mail: jeang@ocp.org. Website: www.ocp.org. **Art Director:** Jean Germano. Division estab. 1997. Types of books include religious and liturgical books specifically for, but not exclusively to, the Roman Catholic market. Publishes 2-5 titles/year. 30% requires freelance illustration. Book catalog available for 9×12 SAE with first-class stamps.

• Oregon Catholic Press (OCP Publications) is a nonprofit publishing company, producing music and liturgical publications used in parishes throughout the United States, Canada, England and Australia. This publisher also has listings in the Magazine and Record Labels sections.

Tips "I am always looking for appropriate art for our projects. We tend to use work already created on a one-time-use basis, as opposed to commissioned pieces. I look for tasteful, not overtly religious art."

THE OVERLOOK PRESS

141 Wooster St., New York NY 10012. (212)965-8400. Fax: (212)965-9834. Website: www.overlookpress.com. **Contact:** Art Director. Estab. 1970. Book publisher. Publishes hardcover originals. Types of books include contemporary and experimental fiction, health/fitness, history, fine art and children's books. Publishes 90 titles/year. Recent titles include: *Right Ho, Jeeves*, by P.G. Wodehouse. 60% require freelance illustration; 40% require freelance design. Book catalog for SASE.

Needs Approached by 10 freelance artists/year. Works with 4 freelance illustrators and 4 freelance designers/year. Buys 5 freelance illustrations/year. Prefers local artists only. Uses freelance artists mainly for jackets. Works on assignment only.

First Contact & Terms Send query letter with printed samples or other nonreturnable material. Samples are

filed. To show a portfolio, mail tearsheets and slides. Buys one-time rights. Originals returned to artist at job's completion.

Jackets/Covers Assigns 10 freelance design jobs/year. Pays by the project, $250-350.

THE OVERMOUNTAIN PRESS

Sabre Industries, Inc., P.O. Box 1261, Johnson City TN 37605-1261. (423)926-2691. Fax: (423)929-2464. E-mail: beth@overmtn.com. Website: www.overmountainpress.com. **Senior Editor:** Elizabeth L. Wright. Estab. 1970. Publishes hardcover and trade paperback originals and reprints. Types of books include biography, children's picture books, cookbooks, history and nonfiction. Specializes in regional nonfiction (Appalachian). Publishes 25 titles/year. Recent titles include: *Lost Heritage*; *Our Living Heritage*; *Ten Friends*; *The Book of Kings*; *A History of Bristol*. 20% requires freelance illustration. Book catalog free for 3 first-class stamps.

Needs Approached by 10 illustrators/year. Works with 3 illustrators/year. Prefers local illustrators, designers and art directors. Prefers freelancers experienced in children's picture books. 100% of freelance design and illustration demands knowledge of Photoshop and QuarkXPress.

First Contact & Terms Illustrators: Send query letter with printed samples. Samples are filed. Will contact artist for portfolio review including artwork and photocopies portraying children/kids' subjects if interested. Rights purchased vary according to project.

Jackets/Covers Assigns 5-10 illustration jobs/year. Considers any medium and/or style. Pays by the project, royalty only, no advance. Prefers children's book illustrators.

Text Illustration Assigns 2 freelance illustration jobs/year. Pays by the project, royalty only. Considers any style, medium, color scheme or type of work.

Tips "We are starting a file of children's book illustrators. At this time we are not 'hiring' freelance illustrators. We are collecting names, addresses, numbers and samples of those who would be interested in having an author contact them about illustration."

N RICHARD C. OWEN PUBLICATIONS INC.

P.O. Box 585, Katonah NY 10536. (914)232-3903. Fax: (914)232-3977. Website: www.rcowen.com. **Art Director:** Janice Boland. Estab. 1986. Company publishes children's books. Types of books include juvenile fiction and nonfiction. Specializes in books for 5-, 6- and 7-year-olds. Publishes 15-20 titles/year. Recent titles include: *I Went to the Beach*; *Cool*; *So Sleepy*; *Bedtime*; *Sea Lights*; *Mama Cut My Hair*; *The Author on My Street*; and *My Little Brother Ben*. 100% require freelance illustration.

- "Focusing on adding nonfiction for young children on subjects such as history, biography, social studies, science and technology."

Needs Approached by 200 freelancers/year. Works with 20-40 freelance illustrators/year. Prefers freelancers with focus on children's books who can create consistency of character from page to page in an appealing setting. Needs illustrators who can illustrate human characters, figures and architecture in an appropriate and appealing manner to young children. Uses freelancers for jacket/cover and text illustration. Works on assignment only.

First Contact & Terms Send samples of work (color brochure, tearsheets and photocopies). Samples are filed. Art director will contact artist if interested and has a suitable project available. Buys all rights. Original illustrations are returned at job's completion.

Text Illustration Assigns 20-40 freelance illustration jobs/year. Pays by the project, $1,000 for a full book; $25-100 for spot illustrations.

Tips "Show adequate number and only best samples of work. Send work in full color, but target the needs of the individual publisher. Send color copies of work—no slides. Be willing to work with the art director. All our books have a trade book look. No odd, distorted figures. Our readers are 5-8 years old. Try to create worlds that will captivate them."

OXFORD UNIVERSITY PRESS

English as a Second Language (ESL), New York NY 10016. E-mail: jun@oup-usa.org. Website: www.oup.com/us. **Senior Art Editor:** Jodi Waxman. Chartered by Oxford University. Estab. 1478. Specializes in fully illustrated, not-for-profit, contemporary textbooks emphasizing English as a second language for children and adults. Also produces wall charts, picture cards, CDs and cassettes. Recent titles include: *Grammar Sense* and various Oxford Picture Dictionaries.

Needs Approached by 1,000 freelance artists/year. Works with 100 illustrators and 8 designers/year. Uses freelancers mainly for interior illustrations of exercises. Also uses freelance artists for jacket/cover illustration and design. Some need for computer-literate freelancers for illustration. 20% of freelance work demands knowledge of QuarkXPress or Illustrator. Works on assignment only.

First Contact & Terms Send query letter with brochure, tearsheets, photostats, slides or photographs. Samples are filed. Art Buyer will contact artist for portfolio review if interested. Artists work from detailed specs. Consid-

ers complexity of project, skill and experience of artist and project's budget when establishing payment. Artist retains copyright. Originals are returned at job's completion. Finds artists through submissions, artist catalogs such as *Showcase, Guild Book*, etc. occasionally from work seen in magazines and newspapers, other illustrators.

Jackets/Covers Pays by the project.

Text Illustration Assigns 500 jobs/year. Uses black line, half-tone and 4-color work in styles ranging from cartoon to realistic. Greatest need is for natural, contemporary figures from all ethnic groups, in action and interaction. Pays for text illustration by the project, $45/spot, $2,500 maximum/full page.

Tips ''Please wait for us to call you. You may send new samples to update your file at any time. We would like to see more natural, contemporary, nonwhite people from freelance artists. Art needs to be fairly realistic and cheerful.''

☑ P&R PUBLISHING

P.O. Box 817, Phillipsburg NJ 08865. (908)454-0505. Fax: (908)454-0859. E-mail: dawn@prpbooks.com. Website: www.prpbooks.com. **Contact:** Dawn Premako, art director. Estab. 1930. Publishes trade paperback and hardcover originals and reprints. Types of books include religious nonfiction. Specializes in confessional publications. Publishes 40 titles/year. Recent titles include: *The Reformation Study Bible*; *Amazing Stories From Times Past*; and *Treasures in Darkness: A Grieving Mother Shares Her Heart*. 100% requires freelance design; 15% requires freelance illustration. Book catalog free with 9×12 SASE.

Needs Approached by 3 designers and 3 illustrators/year. Works with 3 designers and 3 illustrators/year. 100% of freelance design work demands knowledge of Illustrator, QuarkXPress, Photoshop and InDesign.

First Contact & Terms Designers/Illustrators: Send query letter with résumé, tearsheets and samples. After introductory mailing, send follow-up postcard sample every 6 months. Responds only if interested. Company will contact artist for portfolio review if interested. Portfolio should include b&w and color finished art, photographs, tearsheets and thumbnails. Negotiates rights purchased. Finds freelancers through artist's submissions and word of mouth.

Jackets/Covers Assigns 2 freelance cover illustration jobs/year. Prefers color, oils/acrylics, pencil and pen & ink. Pays for illustration by the project. Prefers children's literature.

Text Illustration Assigns 2 freelance illustration jobs/year. Pays by the project.

Tips ''Send letters of recommendation.''

PARENTING PRESS, INC.

11065 Fifth Ave. NE, #F, Seattle WA 98125. (206)364-2900. Fax: (206)364-0702. E-mail: office@parentingpress.com. Website: www.parentingpress.com. **Contact:** Carolyn Threadgill, publisher. Estab. 1979. Publishes trade paperback originals and hardcover originals. Types of books include nonfiction; instruction and parenting fiction. Specializes in parenting and social skill building books for children. Recent titles include: *The Way I Feel*; *Is This a Phase?*; *What About Me?* 100% requires freelance design; 100% requires freelance illustration. Book catalog free on request.

Needs Approached by 10 designers/year and 100 illustrators/year. Works with 2 designers/year. Prefers local designers. 100% of freelance design work demands knowledge of PageMaker, Photoshop and QuarkXPress.

First Contact & Terms Send query letter with brochure, SASE, postcard sample with photocopies, photographs and tearsheets. After introductory mailing, send follow-up postcard sample every 6 months. Accepts e-mail submissions. Prefers Windows-compatible, TIFF, JPEG files. Samples returned by SASE if not filed. Responds only if interested. Company will contact artist for portfolio review if interested. Portfolio should include b&w or color tearsheets. Rights purchased vary according to project.

Jackets/Covers Assigns 4 freelance cover illustrations/year. Pays for illustration by the project $300-1,000. Prefers appealing human characters, realistic or moderately stylized.

Text Illustration Assigns 3 freelance illustration jobs/year. Pays by the project or shared royalty with author.

Tips ''Be willing to supply 2-4 roughs before finished art.''

PATHWAY BOOK SERVICE

4 White Brook Rd., Gilsum NH 03448. (800)345-6665. Fax: (603)357-2073. E-mail: pbs@pathwaybook.com. Website: www.stemmer.com. **President/Publisher:** Ernest Peter. Specializes in design resource originals, children's nonfiction and nature/environmental books in series format or as individual titles. Publishes 6-8 titles/year. Recent titles include: *Designs of Tonga*; *Art Deco Designs*; *Arts & Crafts Patters & Designs*; and *I Hear the Wind*. Books are ''well illustrated.'' 10% requires freelance design; 75% requires freelance illustration.

● Pathway Book Service acquired Stemmer House Publishers as of July 1, 2003.

Needs Approached by more than 200 freelancers/year. Works with 4 freelance illustrators and 1 designer/year. Works on assignment only.

First Contact & Terms Designers: Send query letter with brochure, tearsheets, SASE, photocopies. Illustrators: Send postcard sample or query letter with brochure, photocopies, photographs, SASE, slides and tearsheets.

Do not send original work. Material not filed is returned by SASE. Call or write for appointment to show portfolio. Responds in 6 weeks. Works on assignment only. Originals are returned to artist at job's completion on request. Negotiates rights purchased.

Book Design Assigns 1 freelance design and 2 illustration projects/year. Pays by the project.

Jackets/Covers Assigns 4 freelance design jobs/year. Prefers paintings. Pays by the project.

Text Illustration Assigns 3 freelance jobs/year. Prefers full-color artwork for text illustrations. Pays by the project.

Tips Looks for "draftmanship, flexibility, realism, understanding of the printing process." Books are "rich in design quality and color, stylized while retaining realism; not airbrushed. We prefer noncomputer. Review our books. No picture book illustrations considered currently."

PAULINE BOOKS & MEDIA

50 Saint Pauls Ave., Boston MA 02130-3491. (617)522-8911. Fax: (617)541-9805. E-mail: design@pauline.org. Website: www.pauline.org. **Art Director:** Sr. Helen Rita Lane. Estab. 1932. Book publisher. "We also publish a children's magazine and produce music and spoken recordings." Publishes hardcover and trade paperback originals. Types of books include instructional, biography, for children of all ages and adults, reference, history, self-help, prayer and religious. Specializes in religious topics. Publishes 30-40 titles/year. Art guidelines available. Send requests and art samples with SASE using first-class postage.

Needs Approached by 50 freelancers/year. Works with 10-20 freelance illustrators/year. Also needs freelancers for multimedia projects. Knowledge and use of QuarkXPress, InDesign, Illustrator, Photoshop, etc. is valued.

First Contact & Terms Send query letter with résumé, SASE, tearsheets and photocopies. Accepts disk submissions compatible with PC or Mac. Send JPEG, EPS, TIFF or GIF files. Samples are filed or are returned by SASE. Responds in 3 months only if interested. Rights purchased vary according to project. Originals are returned at job's completion.

Jackets/Covers Assigns 3-4 freelance illustration jobs/year. Pays by the project.

Text Illustration Assigns 6-10 freelance illustration jobs/year. Pays by the project.

PAULIST PRESS

997 Macarthur Blvd., Mahwah NJ 07430. (201)825-7300. Fax: (201)825-8345. E-mail: pmcmahon@paulistpress.com. Website: www.paulistpress.com. **Managing Editor:** Paul McMahon. Estab. 1869. Company publishes hardcover and trade paperback originals and textbooks. Types of books include biography, juvenile and religious. Specializes in academic and pastoral theology. Publishes 90 titles/year. Recent titles include: *Sustaining Heart in the Heartland*; *Father Mychal Judge*; *How to Read A Church*; *Traveling with the Saints in Italy*. 5% requires freelance illustration; 5% requires freelance design.

● Paulist Press recently began to distribute a general trade imprint HiddenSpring.

Needs Works with 10 freelance illustrators and 10 designers/year. Prefers local freelancers. Uses freelancers for juvenile titles, jacket/cover and text illustration. Prefers knowledge of QuarkXPress. Works on assignment only.

First Contact & Terms Send query letter with brochure, résumé and tearsheets. Samples are filed. Responds only if interested. Portfolio review not required. Negotiates rights purchased. Originals are returned at job's completion if requested.

Book Design Assigns 10-12 freelance design jobs/year.

Jackets/Covers Assigns 50 freelance design jobs/year. Pays by the project, $400-800.

Text Illustration Assigns 3-4 freelance illustration jobs/year. Pays by the project.

Ⓝ PEACHPIT PRESS, INC.

Division of Addison Wesley, 1249 Eighth St., Berkeley CA 94710. (510)524-2178. Fax: (510)524-2221. Website: www.peachpit.com. Estab. 1986. Book publisher. Types of books include instruction and computer. Specializes in graphics and design. Publishes 50-60 titles/year. Recent titles include: *HTML 4 Visual Quickstart Guide*; *Flash 4 Creative Web Animation*; *The Little iMac Book*. 20% requires freelance design. Book catalog free by request.

Needs Approached by 50-75 artists/year. Works with 4 freelance designers/year. Prefers artists with experience in computer book cover design. Uses freelance artists mainly for covers, fliers and brochures. Also uses freelance artists for direct mail and catalog design. Works on assignment only.

First Contact & Terms Send query letter with résumé, photographs and photostats. Samples are filed. Responds to the artist only if interested. Call for appointment to show a portfolio of original/final art and color samples. Buys all rights. Originals are not returned at job's completion.

Book Design Pays by the project, $500-2,000.

Jackets/Covers Assigns 40-50 freelance design jobs/year. Pays by the project, $1,000-5,000.

PEACHTREE PUBLISHERS

1700 Chattahoochee Ave., Atlanta GA 30318. (404)876-8761. Fax: (404)875-2578. E-mail: hello@peachtree-online.com. Website: www.peachtree-online.com. **Art Director:** Loraine Joyner. Production Manager: Melanie McMahon Ives. Estab. 1977. Publishes hardcover and trade paperback originals. Types of books include children's picture books, young adult fiction, early reader fiction, juvenile fiction, parenting, regional. Specializes in children's and young adult titles. Publishes 24-30 titles/year. 100% requires freelance illustration. Call for catalog.

Needs Approached by 750 illustrators/year. Works with 15-20 illustrators. "If possible, send samples that show your ability to depict subjects or characters in a consistent manner. See our website to view styles of artwork we utilize."

First Contact & Terms Illustrators: Send query letter with photocopies, SASE, tearsheets. "Prefer not to receive samples from designers." Accepts Mac-compatible disk submissions but not preferred. Samples are returned by SASE. Responds only if interested. Will contact artist for portfolio review if interested. Rights purchased vary according to project. Finds freelancers through submission packets, agents and sourcebooks, including *Directory of Illustration* and *Picturebook*.

Jackets/Covers Assigns 18-20 illustration jobs/year. Prefers acrylic, watercolor or a mixed media on flexible material. Pays for design by the project.

Text Illustration Assigns 4-6 freelance illustration jobs/year. Pays by the project.

Tips "We are an independent, high-quality house with a limited number of new titles per season, therefore each book must be a jewel. We expect the illustrator to bring creative insights which expand the readers' understanding of the storyline through visual clues not necessarily expressed within the text itself."

[N] PEARSON EDUCATION

One Lake St., Upper Saddle River NJ 07458. (201)236-7000. Fax: (201)236-3400. Website: www.pearsoned.com. **Art Director:** Maureen Eide. Specializes in college textbooks in biology, chemistry, anatomy and physiology, computer science, computer information systems, engineering, nursing and allied health. Publishes 40 titles/year. 90% require freelance design and illustration. Recent titles include: *Human Anatomy and Physiology*, by Marieb; *Microbiology*, by Tortora; *Biology*, by Neil Campbell; *Computer Currents*, by George Beekman.

Needs Approached by 100 freelance artists/year. Works with 30-40 illustrators and 10-20 designers/year. Specializes in 1-, 2- and 4-color illustrations—technical, biological and medical. "Heavily illustrated books tying art and text together in market-appropriate and innovative approaches. Our biologic texts require trained bio/med illustrators. Proximity to Bay Area is a plus, but not essential." Needs computer-literate freelancers for design, illustration, and production. 80% of illustration and 90% of design demands knowledge of QuarkXPress, Photoshop, FreeHand or Illustrator. Works on assignment only.

First Contact & Terms Send query letter with résumé and samples. Samples returned only if requested. Originals not returned.

Book Design Assigns 40 jobs/year. "From manuscript, designer prepares specs and layouts for review. After approval, final specs and layouts are required." Pays by the project, $1,000-3,500.

Jackets/Covers Assigns 60 jobs/year. Pays by the project, $800-5,000.

Text Illustration Pays by the project, $25-1,500.

Tips "We are moving into digital pre-press for our technical illustrations, for page design and covers. We are producing our first multimedia. We need *good* text designers and illustrators who are computer literate."

☑ PELICAN PUBLISHING CO.

1000 Burmaster, Gretna LA 70053. (504)368-1175. Fax: (504)368-1195. E-mail: tcallaway@pelicanpub.com. Website: www.pelicanpub.com. **Contact:** Production Manager. Publishes hardcover and paperback originals and reprints. Publishes 70 titles/year. Types of books include travel guides, cookbooks, business/motivational, architecture, golfing, history and children's books. Books have a "high-quality, conservative and detail-oriented" look. Recent titles include: *The Jamlady Cookbook*; *CIA Spymaster*; *The Principal's Night Before Christmas*.

Needs Approached by 2000 freelancers/year. Works with 20 freelance illustrators/year. Uses freelancers for illustration and photo projects. Works on assignment only. 100% of design and 50% of illustration demand knowledge of QuarkXPress, Photoshop 4.0, Illustrator 4.0.

First Contact & Terms Designers: Send photocopies, photographs, SASE, slides and tearsheets. Illustrators: Send postcard sample or query letter with photocopies, SASE, slides and tearsheets. Samples are not returned. Responds on future assignment possibilities. Buys all rights. Originals are not returned.

Book Design Pays by the project, $500 minimum.

Jackets/Covers Pays by the project, $150-500.

Text Illustration Pays by the project, $50-250.

Tips "Show your versatility. We want to see realistic detail and color samples."

Jarrett J. Krosoczka

Showcasing work on the Web

When I was 19 and a junior at the Rhode Island School of Design, I created a project called *'Hello,' said this Slug*. As I wanted to get all of my rejection letters out of the way while still a student, I sent the project to a number of publishers," says children's author and illustrator Jarrett J. Krosoczka. "Everyone who saw it rejected it, but I received a lot of positive feedback."

Positive feedback has graduated into a successful career for Krosoczka, the author and illustrator of picture books: *Good Night, Monkey Boy*; *Bubble Bath Pirates*; *Annie Was Warned*; *Baghead*; and *Max for President*. The books create whimsical, somewhat ridiculous and yet relatable characters and situations, beautifully illustrated in acrylic paint. They are a lovely balance of punk rock rebelliousness, old-fashioned adventure, and a slight dash of the ancient morality tale that slides in a lesson without the notice of the young reader.

Children's books seemed a natural fit for Krosoczka. "I drew a lot when I was a kid. I mean, all the time—after school, on weekends, on road trips . . . even if my grandparents took me out to eat I would bring along a sketchbook and draw," he says. "My drawings were always character-based and I was constantly creating story lines for them. When I wasn't drawing, they lived in my head."

What wasn't so pre-ordained for Krosoczka's career is his intricate, elaborate, and amusing website, studiojjk.com. Far from the typical illustrator's website, functioning merely as a private art gallery, studiojjk.com is an interactive site where the viewer can not only read excerpts, purchase books, and evaluate his illustrations, but also play video games based on his books, view works-in-progress in his sketchbook, and download buddy icons for instant messaging or computer wallpaper.

"The first incarnation of what eventually became studiojjk.com was created when I was a junior at the Rhode Island School of Design. It started off as a simple vehicle to showcase my illustration work, and was just crude intro and portfolio pages. As my work has progressed, the site has progressed," he explains.

"I do all the design and programming for my site. I knew nothing about computers when I entered college and I've never taken a class on the subject. I'm completely self-taught, mostly by trial and error, but I've also read books and taken tutorials on various programs," he says. "The more unusual sections were created to help my site (and my work) stand above the crowd. The video games were created to draw people back to the site again and again. They were incredibly difficult to program—they're designed in Flash (as is the site) and involved a lot of math."

As more and more people have begun purchasing books from online vendors, as well as

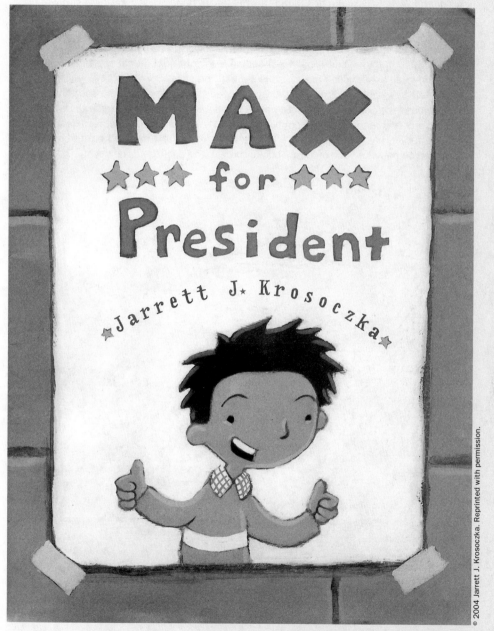

Released during a presidential election year, Jarrett J. Krosoczka's *Max for President* teaches kids a little about the election process, the ups and downs of winning and losing, and that every president needs help to do the job. Visit www.studiojjk.com to see more examples of Krosoczka's work.

learning about different artists and authors and deciding what they're interested in from the Internet, it's become increasingly important for authors and illustrators to have a presence on the Web. Krosoczka has faced this challenge head-on by creating a site where his fans (or soon-to-be fans) can explore his work in unique and interesting ways, such as the games and sketchbook, learn about him from his "serious," "fake," or "short" bio, and ultimately purchase his work—online or from a bookstore. "I wouldn't say I'm selling a lot of books through my website, but I am selling a lot of books *because* of my website. It builds up my fan base, which in turn sells books," he says.

Another sales opportunity facilitated by the website are the visits Krosoczka makes to schools around the country, giving interactive presentations on how he came to be an author and illustrator and reading aloud from his books. "My site provides a detailed description of my presentation, has a Flash video, lets schools know what I expect from them, and has information on how they can order my books through the publisher," he says.

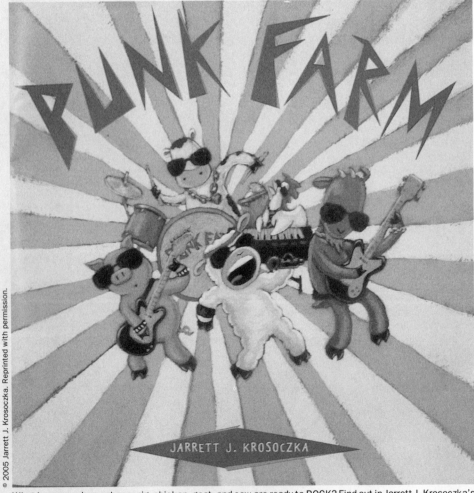

What happens when a sheep, pig, chicken, goat, and cow are ready to ROCK? Find out in Jarrett J. Krosoczka's latest picture book *Punk Farm*—and be sure to visit the totally rockin' www.punkfarm.com, where you can get stickers and posters, download wallpaper and buddy icons, buy Punk Farm merchandize, load the band's "barn blazing" cover of "Old McDonald Had a Farm" into your MP3 player, and join the Punk Farm revolution e-mail list.

Throughout its incarnations from a mere gallery to an interactive, multi-functional marketing tool, studiojjk.com has remained true to its original intent: to showcase the work. ''My main goal has always been for the reader to look at my site and recognize the personality and attitude that is present in the books,'' Krosoczka says. ''I've also wanted to stay true to the look of my books, so everything on the site is painted.'' By sticking to his original purpose for the site and adding interesting, playful features, Krosoczka has created a site that is both a fitting and exemplary display of his work and a virtual playground that children and adults alike can enjoy.

So how did Krosoczka go from positive feedback to writing and illustrating success? Drive, hard work, and a little bit of good advice. ''[Children's author and illustrator] Grace Lin helped me kick the door into publishing wide open,'' he explains. ''It was November 1999 and she had just seen the release of her first book, *The Ugly Vegetables*. She suggested sending my postcards to the editors—I had been sending them to the art directors—because of their pull in the acquisitions process.'' Within four days, Krosoczka got the phone call that eventually led to the publication of his first book, *Good Night, Monkey Boy*, by Knopf in 2001.

Advice alone, however, will not that elusive book contract make. Krosoczka recommends a mixture of enthusiasm, individuality, and old-fashioned pride and enjoyment in your work. ''Be insatiable,'' he says. ''Constantly submit your work and then resubmit it. Work on your craft, improve on improvements, and continually set goals for yourself. Put yourself into your work as much as you can—the more you enjoy the process of creating, the better your story and illustrations will be.'' And always remember what makes a good book. ''Publishers have their eyes on the immediate dollar with this whole celebrities-writing-children's books thing, but honestly, only well-crafted picture books will stand the test of time.''

Next up for Krosoczka is *Punk Farm*, due for release in May 2005 from Knopf (check out the website at www.punkfarm.com). Following in spring 2006 is *Giddy Up, Cowgirl!* from Viking, about a well meaning girl who tries to help her mom run errands. And the pièce de résistance? ''*Slug*, which is derived from that story I started back when I was a student at the Rhode Island School of Design, is due from Knopf in fall 2006! The publication of that book will truly be a dream come true,'' says Krosoczka.

—*Erin Nevius*

⚠ PEN NOTES, INC.

2385 7th St., East Meadow NY 11554-3106. (516)796-3939. Fax: (516)796-3773. E-mail: pennotes@worldnet.att. net. Website: www.PenNotes.com. **President:** Lorette Konezny. Produces learning books for children ages 3 and up. Clients Bookstores, toy stores and parents.

Needs Prefers artists with book or advertising experience. Works on assignment only. Each year assigns 1-2 books (with 24 pages of art) to freelancers. Uses freelancers for children's illustration, P-O-P display and design and mechanicals for catalog sheets for children's books. 100% of freelance design and up to 50% of illustration demands computer skills. Prefers knowledge of press proofs on first printing. Prefers imaginative, realistic style with true perspective and color. 100% of titles require freelance art direction.

First Contact & Terms Designers: Send brochure, résumé, SASE, tearsheets and photocopies. No e-mails. Illustrators: Send sample with tearsheets. Samples are filed. Call or write for appointment to show portfolio or mail final reproduction/product, color and b&w tearsheets and photostats. Pays for design by the hour, $15-36; by the project, $60-125. Pays for illustration by the project, $60-500/page. Buys all rights.

Tips ''Everything should be provided digitally. The style must be geared for children's toys. Looking for realistic/ cartoon outline with flat color. You must work on deadline schedule set by printing needs. Must have full range of professional and technical experience for press proof. All work is property of Pen Notes, copyright property of Pen Notes.''

⚠ ⚠ PEREGRINE

40 Seymour Ave., Toronto ON M4J 3T4 Canada. (416)461-9884. Fax: (416)461-4031. E-mail: peregrine@peregr ine-net.com. Website: www.peregrine-net.com. **Creative Director:** Kevin Davies. Estab. 1993. Publishes role-playing game books, audio music, and produces miniatures supplements. Main style/genre of games science

fiction, cyberpunk, mythology, fantasy, military, horror and humor. Uses freelance artists mainly for interior art (b&w, greyscale) and covers (color). Publishes 1-2 titles or products/year. Game/product lines include: *Murphy's World* (role-playing game); *Bob, Lord of Evil* (role-playing game); *Adventure Areas* (miniatures supplements); *Adventure Audio.* 90% requires freelance illustration; 10% requires freelance design. Art guidelines available on website.

Needs Approached by 20 illustrators and 2 designers/year. Works with 2-5 illustrators/year. Prefers freelancers experienced in anatomy, structure, realism, cartoon and greyscale. 100% of freelance design demands knowledge of Illustrator, Photoshop and QuarkXPress.

First Contact & Terms Send self-promotion photocopy and follow-up postcard every 9-12 months. Send query letter with résumé, business card. Illustrators: Send photocopies and/or tearsheets. Send 5-10 samples. Accepts digital submissions in Mac format via CD or e-mail attachment as EPS, TIFF or JPEG files at 72-150 ppi (for samples) and 300 ppi (for finished work). Paper and digital samples are filed and are not returned. Responds only if interested. Portfolio review not required. Rights purchased vary according to project. Finds freelancers through conventions, internet and word of mouth.

Book Covers/Posters/Cards Assigns 1-2 illustration jobs/year. Pays for illustration by the project.

Text Illustration Assigns 1-5 illustration jobs/year (greyscale/b&w). Pays by the full page, $50-100. Pays by the half page $10-25. "Price varies with detail of image required and artist's experience."

Tips "Check out our existing products at www.peregrine-net.com. Make sure at least half of the samples submitted reflect the art styles we're currently publishing. Other images can be provided to demonstrate your range of capability."

PERFECTION LEARNING CORPORATION

10520 New York Ave., Des Moines IA 50322-3775. (515)278-0133, ext. 209. Fax: (515)278-2980. E-mail: rmesser @plconline.com. Website: www.perfectionlearning.com. **Art Director:** Randy Messer. Senior Designer: Deb Bell. Estab. 1927. Publishes hardcover originals and reprints, mass market paperback originals and reprints, educational resources, trade paperback originals and reprints, high general interest/low reading level, multicultural, nature, science, social issues, sports. Specializes in high general interest/low reading level and Lit-based teacher resources. Publishes 30 titles/year. Recent titles include: *American Justice II*; *The Secret Room*; *The Message, the Promise, and How Pigs Figure In*; *River of Ice*; *Orcas: High Seas Supermen.* All 5 titles have been nominated for ALA Quick Picks. 50% requires freelance illustration.

• Perfection Learning Corporation has had several books nominated for awards including *Iditarod*, nominated for a Golden Kite award and *Don't Bug Me*, nominated for an ALA-YALSA award.

Needs Approached by 70 illustrators and 10-20 designers/year. Works with 30-40 illustrators/year. Prefers local designers and art directors. Prefers freelancers experienced in cover illustration and interior spot—4-color and b&w. 100% of freelance design demands knowledge of QuarkXPress.

First Contact & Terms Illustrators: Send postcard or query letter with printed samples, photocopies, SASE, tearsheets. Accepts Mac-compatible disk submissions. Send EPS. Samples are filed or returned by SASE. Responds only if interested. Portfolio review not required. Rights purchased vary according to project. Finds freelancers through tearsheet submissions, illustration annuals, phone calls, artists' reps.

Jackets/Covers Assigns 40-50 freelance illustration jobs/year. Pays for illustration by the project, $750-1,750, depending on project. Prefers illustrators with conceptual ability.

Text Illustration Assigns 40-50 freelance illustration jobs/year. Pays by the project. Prefers freelancers who are able to draw multicultural children and good human anatomy.

Tips "We look for good conceptual skills, good anatomy, good use of color. Our materials are sold through schools for classroom use—they need to meet educational standards."

THE PILGRIM PRESS/UNITED CHURCH PRESS

700 Prospect Ave. E., Cleveland OH 44115-1100. (216)736-3761. Fax: (216)736-2207. Website: www.pilgrimpress.com. **Art Director:** Martha Clark. Production: Janice Brown. Estab. 1957. Company publishes hardcover originals and trade paperback originals and reprints. Types of books include environmental ethics, human sexuality, devotion, women's studies, justice, African-American studies, world religions, Christian education, curriculum, reference and social and ethical philosophical issues. Specializes in religion. Publishes 60 titles/ year. Recent titles include: *In Good Company: A Woman's Journal for Spiritual Reflection*; *Still Groovin'.* 75% require freelance illustration; 50% require freelance design. Books are progressive, classic, exciting, sophisticated—conceptually looking for "high design." Book catalog free by request.

Needs Approached by 50 freelancers/year. Works with 20 freelance illustrators and 10 designers/year. Buys 50 illustrations/year. Prefers freelancers with experience in book publishing. Uses freelancers mainly for covers, catalogs and illustration. Also for book design. Works on assignment only.

First Contact & Terms Send query letter with résumé, tearsheets and photocopies. Samples are filed and are not returned. Art Director will contact artist for portfolio review if interested. Negotiates rights purchased.

Interested in buying second rights (reprint rights) to previously published work based on need, style and concept/subject of art and cost. "I like to see samples." Originals are returned at job's completion. Finds artists through agents and stock houses.
Book Design Assigns 50 freelance design jobs/year. Pays by the project, $500.
Jackets/Covers Assigns 125 freelance design jobs/year. Prefers contemporary styles. Pays by the project, $500-700.
Text Illustration Assigns 15-20 design and 15-20 illustration jobs/year. Pays by the project, $200-500; negotiable, based on artist estimate of job, number of pieces and style.
Tips "I also network with other art directors/designers for their qualified suppliers/freelancers. If interested in curriculum illustration, show familiarity with illustrating biblical art and diverse races and ages."

PLAYERS PRESS

P.O. Box 1132, Studio City CA 91614. (818)789-4980. E-mail: playerspress@att.net. **Associate Editor:** Jean Sommers. Specializes in plays and performing arts books. Recent titles include: *Principles of Stage Combat*; *Theater Management*; *Scenery, Design and Fabrication*.
Needs Works with 3-15 freelance illustrators and 1-3 designers/year. Uses freelancers mainly for play covers. Also for text illustration. Works on assignment only.
First Contact & Terms Send query letter with brochure showing art style or résumé and samples. Samples are filed or are returned by SASE. Request portfolio review in original query. Art director will contact artist for portfolio review if interested. Portfolio should include thumbnails, final reproduction/product, tearsheets, photographs and "as much information as possible." Sometimes requests work on spec before assigning a job. Buys all rights. Considers buying second rights (reprint rights) to previously published work, depending on usage. "For costume books this is possible."
Book Design Pays by the project, rate varies.
Jackets/Covers Pays by the project, rate varies.
Text Illustration Pays by the project, rate varies.
Tips "Supply what is asked for in the listing and don't waste our time with calls and unnecessary cards. We usually select from those who submit samples of their work which we keep on file. Keep a permanent address so you can be reached."

CLARKSON N. POTTER, INC.

Imprint of Crown Publishers. Parent company: Crown Publishing Group, 1745 Broadway, New York NY 10019. (212)782-9000. Fax: (212)572-6181. Website: www.clarksonpotter.com. **Art Director:** Marysarah Quinn. Publishes hardcover originals and reprints. Types of books include coffee table books, cookbooks, gardening, crafts, gift, style, decorating. Specializes in lifestyle (cookbooks, gardening, decorating). Publishes 50-60 titles/year. Recent titles include: *Barefoot in Paris*; *Moosewood Restaurant's Simple Suppers*. 20% requires freelance illustration; 25% requires freelance design.
Needs Works with 10-15 illustrators and 15 designers/year. Prefers freelancers experienced in illustrating food in traditional styles and mediums and designers with previous book design experience. 100% of freelance design demands knowledge of Illustrator, Photoshop, QuarkXPress, InDesign.
First Contact & Terms Send postcard sample or query letter with printed samples, photocopies, tearsheets. Samples are filed and are not returned. Will contact artist for portfolio review if interested or portfolios may be dropped off any day. Leave for 2-3 days. Negotiates rights purchased. Finds freelancers through submission packets, promotional postcards, Web sourcebooks and illustration annuals, previous books.
Book Design Assigns 20 freelance design jobs/year.
Jackets/Covers Assigns 20 freelance design and 15 illustration jobs/year. Pays for design by the project. Jackets are designed by book designer, i.e. the whole book and jacket are viewed as a package.
Text Illustration Assigns 15 freelance illustration jobs/year.
Tips "We no longer have a juvenile books department. We do not publish books of cartoons or humor. We look at a wide variety of design styles. We look at mainly traditional illustration styles and mediums and are always looking for unique food and garden illustrations."

PRAKKEN PUBLICATIONS, INC.

832 Phoenix Dr., Box 8623, Ann Arbor MI 48107. (734)975-2800. Fax: (734)975-2787. Website: www.techdirecti ons.com or www.eddigest.com. **Production and Design Manager:** Sharon Miller. Estab. 1934. Imprints include The Education Digest, Tech Directions. Company publishes educator magazines, reference books and posters. Specializes in vocational, technical, technology and general education. Publishes 2 magazines. Titles include: *Technology's Past* and *More Technology Projects for the Classroom*. Book catalog free by request.
Needs Rarely uses freelancers. 50% of freelance work demands knowledge of PageMaker. Works on assignment only.

First Contact & Terms Send samples. Samples are filed or are returned by SASE if requested by artist. Responds only if interested. Art director will contact artist for portfolio review if interested. Portfolio should include b&w and color final art and tearsheets.

ⓝ PRENTICE HALL

Pearson Publishing, School Division Art Dept., Upper Saddle River NJ 07458. (201)236-7000. Fax: (201)236-7755. Website: www.phschool.com. Imprint publishes textbooks. ''Will be getting into consumer market.'' Specializes in history, science, language arts, multimedia. 50% require freelance illustration; 75% require design.

Needs Buys 15 covers and hundreds of interior illustrations/year. Uses freelancers for jacket/cover design and illustration, text illustration and book design. Needs computer-literate freelancers for design, illustration, production and presentation. Freelancers should be familiar with Illustrator, QuarkXPress and Photoshop. Works on assignment only.

First Contact & Terms Send postcard sample of work or send query letter with samples. Samples are filed. Art Director will contact artist for portfolio review if interested. Portfolio should include book dummy, final art, photographs and tearsheets. Buys all rights. Originals are not returned.

Tips Finds artists through agents, sourcebooks, word of mouth, artist's submissions, attending art exhibitions.

ⓝ PROLINGUA ASSOCIATES

P.O. Box 1348, Brattleboro VT 05302-1348. (802)257-7779. Fax: (802)257-5117. E-mail: prolingu@sover.net. Website: www.prolinguaAssociates.com. **President:** Arthur A. Burrows. Estab. 1980. Company publishes textbooks. Specializes in language textbooks. Publishes 3-8 titles/year. Recent titles include: *Writing Strategies*; *Dictations and Discussions*. Most require freelance illustration. Book catalog free by request.

Needs Approached by 10 freelance artists/year. Works with 2-3 freelance illustrators/year. Uses freelance artists mainly for pedagogical illustrations of various kinds. Also uses freelance artists for jacket/cover and text illustration. Works on assignment only.

First Contact & Terms Send postcard sample and/or query letter with brochure, photocopies and photographs. Samples are filed. Responds in 1 month. Portfolio review not required. Buys all rights. Originals are returned at job's completion if requested. Finds artists through word of mouth and submissions.

Text Illustration Assigns 5 freelance illustration jobs/year. Pays by the project, $200-1,200.

PUSSYWILLOW

1212 Punta Gorda St., #13, Santa Barbara CA 93103. (805)899-2145. E-mail: bandanna@cox.net. **Contact:** Briar Newborn, publisher. Estab. 2002. Publishes fiction and poetry trade paperback originals and reprints. Types of books include erotic classics mainly in translation for the connoisseur or collector. Recent titles include: *Wife of Bath*; *Aretino's Sonnetti Lussuriosi*. Target audience is mature adults of both sexes. No porn, yes erotica.

Needs Sensual suggestive art pieces in any genre.

First Contact & Terms Send samples for our files, not originals. Responds in 2 months only if interested.

Jackets/Covers Pays at least $200.

Text Illustration Pays by the project.

Tips ''We're more likely to commission pieces than to buy originals. Show us what you can do. Send samples we can keep on file.''

G.P. PUTNAM'S SONS, PHILOMEL BOOKS

345 Hudson St., 14th Floor, New York NY 10014-3657. (212)366-2000. Website: www.penguin.com. **Art Director, Children's Books :** Cecilia Yung. Publishes hardcover juvenile books. Publishes 84 titles/year. Free catalog available.

Needs Illustration on assignment only.

First Contact & Terms Provide flier, tearsheet, brochure and photocopy to be kept on file for possible future assignments. Samples are returned by SASE only. ''We take drop-offs on Tuesday mornings before noon and return them to the front desk after 4 p.m. the same day. Please call Katrina Damkoehler, (212)366-2000, in advance with the date you want to drop of your portfolio. Do not send samples via e-mail or CDs.''

Jackets/Covers ''Uses full-color paintings, realistic painterly style.''

Text Illustration ''Uses a wide cross section of styles for story and picture books.''

QUITE SPECIFIC MEDIA GROUP LTD.

7373 Pyramid Place, Hollywood CA 90046. (323)851-5797. Fax: (323)851-5798. Website: www.quitespecificmedia.com. **Contact:** Ralph Pine. Estab. 1967. Publishes hardcover originals and reprints, trade paperback reprints and textbooks. Specializes in costume, fashion, theater and performing arts books. Publishes 12 titles/year.

Recent titles include: *The Medieval Tailor's Assistant.* 10% requires freelance illustration; 60% requires freelance design.

- Imprints of Quite Specific Media Group Ltd. include Drama Publishers, Costume & Fashion Press, By Design Press, Entertainment Pro and Jade Rabbit.

Needs Works with 2-3 freelance designers/year. Uses freelancers mainly for jackets/covers. Also for book, direct mail and catalog design and text illustration. Works on assignment only.

First Contact & Terms Send query letter with brochure and tearsheets. Samples are filed. Responds to the artist only if interested. Rights purchased vary according to project. Originals not returned. Pays by the project.

RADIO COMIX

PMB 117, 11765 West Ave., San Antonio TX 78216. E-mail: radiocomix@aol.com. Website: www.radiocomix.c om. **Contact:** Will Allison. Types of books include fantasy, science fiction, American manga, animal/anthropomorphic, independent or adults only fiction. Recent titles include: *Milk! #3* (adults only); *Mangaphile*; *The Collected Skunkworks* (adults only). Book catalog on website.

First Contact & Terms Does not accept any submissons via e-mail. Any e-mail submission will be deleted unread. Send photocopies (6.875×10.5 in size) (no larger than 8½×11). All pages must have your contact info on them. Digital submissions (Zip disk or CD but must be accompanied by photocopies). Prefers TIFF files, 400 dpi minimum. Samples are not filed or returned. Responds as soon as possible. Company will contact artist for portfolio review if interested.

Tips "All published work is creator-owned. Visit website to see what submissions we are currently looking for." No superheroes.

RAINBOW BOOKS, INC.

P.O. Box 430, Highland City FL 33846-0430. (863)648-4420. Fax: (863)647-5951. E-mail: RBIbooks@aol.com. **Media Buyer:** Betsy A. Lampe. Estab. 1979. Company publishes hardcover and trade paperback originals. Types of books include instruction, adventure, biography, travel, self-help, religious, mystery, reference, history and cookbooks. Specializes in nonfiction, self-help, mystery fiction, and how-to. Publishes 20 titles/year. Recent titles include: *How to Handle Bullies and Teasers and Other Meanies*; *Medical School Is Murder*.

Needs Approached by hundreds of freelance artists/year. Works with 2 illustrators/year. Prefers freelancers with experience in book-cover design and line illustration. Uses freelancers for jacket/cover illustration and design and text illustration. Needs computer-literate freelancers for design, illustration and production. 90% of freelance work demands knowledge of draw or design programs. Works on assignment only.

First Contact & Terms Send brief query, tearsheets, photographs and book covers or jackets. Samples are not returned. Responds in 2 weeks. Art director will contact artist for portfolio review if interested. Portfolio should include b&w and color tearsheets, photographs and book covers or jackets. Rights purchased vary according to project. Originals are returned at job's completion.

Jackets/Covers Assigns 10 freelance illustration jobs/year. Pays by the project, $250-1,000.

Text Illustration Pays by the project. Prefers pen & ink or electronic illustration.

Tips "Nothing Betsy Lampe receives goes to waste. After consideration for Rainbow Books, Inc., artists/designers are listed free in her newsletter (Publisher's Report), which goes out to over 500 independent presses (weekly). Then, samples are taken to the art department of a local school to show students how professional artists/designers market their work. Send samples (never originals), be truthful about the amount of time needed to complete a project, learn to use the computer. Study the competition (when doing book covers), don't try to write cover copy, learn the publishing business (attend small press seminars, read books, go online, make friends with the local sales reps of major book manufacturers). Pass along what you learn. Do not query via e-mail attachment."

▣ RAINBOW PUBLISHERS

P.O. Box 261129, San Diego CA 92196. (858)668-3260. Fax: (858)668-3328. E-mail: rbpub@earthlink.net. **Creative Director:** Sue Miley. Estab. 1979. Publishes trade paperback originals. Types of books include religious books, reproducible Sunday School books for children ages 2-12 and Bible teaching books for children and adults. Publishes 20 titles/year. Titles include: *Favorite Bible Children*; *Make It Take It Crafts*; *Worship Bulletins for Kids*; *Cut, Color & Paste*; *God's Girls*; *Gotta Have God*; and *God and Me.* Book catalog for SASE with 2 first-class stamps.

Needs Approached by hundreds of illustrators and 50 designers/year. Works with 5-10 illustrators and 5-10 designers/year. 100% of freelance design and illustration demands knowledge of Illustrator, Photoshop and QuarkXPress.

First Contact & Terms Send query letter with printed samples, SASE and tearsheets. Samples are filed or returned by SASE. Responds only if interested. Will contact artist for portfolio review if interested. Finds freelancers through samples sent and personal referrals.

Book Design Assigns 25 freelance design jobs/year. Pays for design by the project, $350 minimum. Pays for art direction by the project, $350 minimum.

Jackets/Covers Assigns 25 freelance design jobs and 25 illustration jobs/year. "Prefers computer generated-high energy style with bright colors appealing to kids." Pays for design and illustration by the project, $350 minimum. "Prefers designers/illustrators with some Biblical knowledge."

Text Illustration Assigns 20 freelance illustration jobs/year. Pays by the project, $500 minimum. "Prefers black & white line art, preferably computer generated with limited detail yet fun."

Tips "We look for illustrators and designers who have some Biblical knowledge and excel in working with a fun, colorful, high-energy style that will appeal to kids and parents alike. Designers must be well versed in Quark, Illustrator and Photoshop, know how to visually market to kids and have wonderful conceptual ideas!"

RANDOM HOUSE VALUE PUBLISHING

1745 Broadway, New York NY 10019. (212)782-9000. Fax: (212)572-2114. **Contact:** Art Director. Imprint of Random House, Inc. Other imprints include Wings, Testament, Gramercy and Crescent. Imprint publishes hardcover, trade paperback and reprints, and trade paperback originals. Types of books include adventure, coffee table books, cookbooks, children's books, fantasy, historical fiction, history, horror, humor, instructional, mainstream fiction, New Age, nonfiction, reference, religious, romance, science fiction, self-help, travel and western. Specializes in contemporary authors' work. Recent titles include: work by John Saul, Mary Higgins Clark, Tom Wolfe, Dave Barry, Stephen King, Rita Mae Brown and Michael Crichton (all omnibuses). 80% requires freelance illustration; 50% requires freelance design.

Needs Approached by 50 freelancers/year. Works with 20 freelance illustrators and 20 designers/year. Uses freelancers mainly for jacket/cover illustration and design for fiction and romance titles. 100% of design and 50% of illustration demands knowledge of Illustrator, QuarkXPress, Photoshop and FreeHand. Works on assignment only.

First Contact & Terms Designers: Send résumé and tearsheets. Illustrators: Send postcard sample, brochure, résumé and tearsheets. Samples are filed. Request portfolio review in original query. Art Director will contact artist for portfolio review if interested. Portfolio should include tearsheets. Buys first rights. Originals are returned at job's completion. Finds artists through *American Showcase*, *Workbook*, *The Creative Illustration Book*, artist's reps.

Book Design Pays by the project.

Jackets/Covers Assigns 50 freelance design and 20 illustration jobs/year. Pays by the project, $500-1,500.

Tips "Study the product to make sure styles are similar to what we have done new, fresh, etc."

N READ'N RUN BOOKS

imprint of Crumb Elbow, Box 294, Rhododendron OR 97049. (503)622-4798. **Publisher:** Michael P. Jones. Estab. 1985. Specializes in fiction, history, environment and wildlife books for children through adults. "Books for people who do not have time to read lengthy books." Publishes 60 titles/year. Recent titles include: *Sir Dominick's Bargain*, by J. Sheridan LeFanu. "Our books, printed in b&w or sepia, are both hardbound and softbound, and are not slick looking. They are home-grown-looking books that people love." Accepts previously published material. Art guidelines for #10 SASE.

● Read'N Run is an imprint of Crumb Elbow publishing. See listing for other imprints.

Needs Works with 55 freelance illustrators and 10 designers/year. Prefers pen & ink, airbrush, charcoal/pencil, markers, calligraphy and computer illustration. Uses freelancers mainly for illustrating books. Also for jacket/cover, direct mail, book and catalog design. 50% of freelance work demands computer skills.

First Contact & Terms Send query letter with brochure, tearsheets, photocopies and SASE. Samples not filed are returned by SASE. Request portfolio review in original query. Art Director will contact artist for portfolio review if interested. Artist should follow up after initial query. Portfolio should include thumbnails, roughs, final reproduction/product, color and b&w tearsheets, photostats and photographs. Will not respond to postcards. Buys one-time rights. Interested in buying second rights (reprint rights) to previously published work. Originals are returned at job's completion. Pays in copies, on publication.

Book Design Assigns 20 freelance design jobs/year.

Jackets/Covers Assigns 20 freelance design and 30 illustration jobs/year. Pays $75-250 or in published copies.

Text Illustration Assigns 70 freelance illustration jobs/year. Pays by the project, $75-250.

Tips "Generally, the artists find us by submitting sampleslots of them, I hope. We will not return phone calls. We will be publishing short-length cookbooks. I want to see a lot of illustrations showing a variety of styles. There is little that I don't want to see. We have a tremendous need for illustrations on the Oregon Trail (i.e., oxen-drawn covered wagons, pioneers, mountain men, fur trappers, etc.) and illustrations depicting the traditional way of life of Plains Indians and those of the North Pacific Coast and Columbia River with emphasis on mythology and legends. Pen & ink is coming back stronger than ever! Be versatile with your work. We will

also evaluate your style and may utilize your work through another imprint that is under us, or even through our *Wy-East Historical Journal.*''

◨ RED DEER PRESS

Trailer C, 2500 University Dr. NW, Calgary T2N 1N4 Canada. (403)220-4334. Fax: (403)210-8191. E-mail: rdp@ucalgary.ca. **Managing Editor:** Dennis Johnson. Estab. 1975. Book publisher. Publishes hardcover and trade paperback originals. Types of books include contemporary and mainstream fiction, fantasy, biography, preschool, juvenile, young adult, humor and cookbooks. Specializes in contemporary adult and juvenile fiction, picture books and natural history for children. Recent titles include: *Hidden Buffalo*; *In Abby's Hands.* 100% require freelance illustration; 30% require freelance design. Book catalog available for SASE with Canadian postage.

Needs Approached by 50-75 freelance artists/year. Works with 10-12 freelance illustrators and 2-3 freelance designers/year. Buys 50 freelance illustrations/year. Prefers artists with experience in book and cover illustration. Also uses freelance artists for jacket/cover and book design and text illustration. Works on assignment only.

First Contact & Terms Send query letter with résumé to Erin Woodward, tearsheets, photographs and slides. Samples are filed. To show a portfolio, mail b&w slides and dummies. Rights purchased vary according to project. Originals returned at job's completion.

Book Design Assigns 3-4 design and 6-8 illustration jobs/year. Pays by the project.

Jackets/Covers Assigns 6-8 design and 10-12 illustration jobs/year. Pays by the project, $300-1,000 CDN.

Text Illustration Assigns 3-4 design and 4-6 illustration jobs/year. Pays by the project. May pay advance on royalties.

Tips Looks for freelancers with a proven track record and knowledge of Red Deer Press. ''Send a quality portfolio, preferably with samples of book projects completed.''

RED WHEEL/WEISER

368 Congress St., 4th Floor, Boston MA 02210. (617)542-1324. Fax: (617)482-9676. E-mail: kfivel@redwheelwei ser.com. Website: www.redwheelweiser.com. **Contact:** Kathleen Wilson Fivel, art director. Specializes in hardcover and paperback originals, reprints and trade publications: Red Wheel: spunky self-help; Weiser Books metaphysics/oriental mind-body-spirit/esoterica; Conari Press: self-help/inspirational. Publishes 70 titles/year.

Needs Freelancers for jacket/cover design and illustration.

First Contact & Terms Designers: Send résumé, photocopies and tearsheets. Illustrators: Send photocopies, photographs, SASE and tearsheets. ''We can use art or photos. I want to see samples I can keep.'' Samples are filed or are returned by SASE only if requested by artist. Responds only if interested. Originals are returned to artist at job's completion. To show portfolio, mail tearsheets, color photocopies or slides. Considers complexity of project, skill and experience of artist, project's budget, turnaround time and rights purchased when establishing payment. Buys one-time nonexclusive rights. Finds most artists through references/word of mouth, portfolio reviews and samples received through the mail.

Jackets/Covers Assigns 40 design jobs/year. Prefers a variety of media—depends entirely on project. Pays by the project, $100-500.

Tips ''Send samples by mail, preferably in color. We work electronically and prefer digital artwork or scans. Do not send drawings of witches, goblins, and demons for Weiser Books; we don't put those kinds of images on our covers. Please take a moment to look at our books before submitting anything; we have characteristic looks for all three imprints.''

REGNERY PUBLISHING INC.

One Massachusetts Ave. NW, Washington DC 20001. (202)216-0601. Fax: (202)216-0612. E-mail: editorial@reg nery.com. Website: www.regnery.com. **Contact:** Art Director. Estab. 1947. Publishes hardcover originals and reprints, trade paperback originals and reprints. Types of books include biography, history, nonfiction. Specializes in nonfiction. Publishes 30 titles/year. Recent titles include: *God, Guns and Rock & Roll*, by Ted Nugent. 20-50% requires freelance design. Book catalog available for SASE.

Needs Approached by 20 illustrators and 20 designers/year. Works with 6 designers/year. Prefers local illustrators and designers. Prefers freelancers experienced in Mac, QuarkXPress and Photoshop. 100% of freelance design demands knowledge of QuarkXPress. 50% of freelance illustration demands knowledge of Photoshop, QuarkXPress.

First Contact & Terms Send postcard sample and follow-up postcard every 6 months. Accepts Mac-compatible disk submissions. Send TIFF files. Samples are filed. Will contact artist for portfolio review if interested. Finds freelancers through *Workbook*, networking and submissions.

Book Design Assigns 5-10 freelance design jobs/year. Pays for design by the project; negotiable.

Jackets/Covers Assigns 5-10 freelance design and 1-5 illustration jobs/year. Pays by the project; negotiable.

Tips ''We welcome designers with knowledge of Mac platforms . . . and the ability to design 'bestsellers' under extremely tight guidelines and deadlines!''

RIVER CITY PUBLISHING

1719 Mulberry St., Montgomery AL 36106. (334)265-6753. Fax: (334)265-8880. E-mail: web@rivercitypublishing.com. Website: www.rivercitypublishing.com. **Design and Production:** Lissa Monroe. Estab. 1991. Small press. Publishes hardcover and trade paperback originals. Types of books include biography, history, coffee table books, illustrated histories, novels and travel. Specializes in Americana, history, natural history. Publishes 15 titles/year. Recent titles include: *Speaks the Nightbird*, by Robert McCammon; *Course of the Waterman*, by Nancy Robson; *Love to the Spirits*, by Stephen March.

⌜N⌝ ROWMAN & LITTLEFIELD PUBLISHERS, INC.

Parent company: University Press of America, 4501 Forbes Blvd., Suite 200, Lanham MD 20706. (301)459-3366. Fax: (301)429-5748. E-mail: ghenry@univpress.com. Website: www.rowmanlittlefield.com. **Art Director:** Gisele Byrd Henry. Estab. 1975. Publishes hardcover originals and reprints, textbooks, trade paperback originals and reprints. Types of books include biography, history, nonfiction, reference, self help, textbooks. Specializes in nonfiction trade. Publishes 250 titles/year. Recent titles include: *Orphans of Islam.* 100% of titles require freelance design. Does not use freelance illustrations. Book catalog not available.

Needs Approached by 10 designers/year. Works with 20 designers/year. Prefers freelancers experienced in typographic design, Photoshop special effects. 100% of freelance design demands knowledge of Photoshop and QuarkXPress.

First Contact & Terms Designers: Send query letter with printed samples, photocopies, tearsheets, SASE. Accepts Mac-compatible disk submissions. Send TIFF files. Samples are filed or returned by SASE. Responds only if interested. Portfolio review not required. Buys all rights. Finds freelancers through submission packets and word of mouth.

Jackets/Covers Assigns 150 freelance design jobs/year. Prefers postmodern, cutting-edge design and layering, filters and special Photoshop effects. Pays for design by the project $500-1,100. Prefers interesting ''on the edge'' typography. Must be experienced book jacket designer.

Tips ''All our designers must work on a Mac platform, and all files imported into Quark. Proper file set up is essential. Looking for cutting edge trade nonfiction designers who are creative and fluent in all special effect software.''

⌜I⌝ SCHOLASTIC INC.

557 Broadway, New York NY 10012. Website: www.scholastic.com. **Creative Director:** David Saylor. Specializes in hardcover and paperback originals of childen's picture books, young adult, biography, classics, historical and contemporary teen. Publishes 750 titles/year. Recent titles include: *The Three Questions*; *When Marian Sang.* 80% require freelance illustration.

 • David Saylor is in charge of all imprints, from mass market to high end. Publisher uses digital work only for mass market titles. All other imprints usually prefer traditional media such as watercolors and pastels.

Needs Approached by thousands of freelancers/year. Works with 75 freelance illustrators and 2 designers/year. Prefers local freelancers with experience. Also for jacket/cover illustration and design and book design. 40% of illustration demands knowledge of QuarkXPress, Illustrator, Photoshop.

First Contact & Terms Illustrators: Send postcard sample or tearsheets. Samples are filed or are returned only if requested, with SASE. Art Director will contact artist for portfolio review if interested. Considers complexity of project and skill and experience of artist when establishing payment. Originals are returned at job's completion. Finds artists through word of mouth, *American Showcase*, *RSVP* and Society of Illustrators.

Book Design Pays by the project, $2,000 and up.

Jackets/Covers Assigns 200 freelance illustration jobs/year. Pays by the project, $2,000-5,000.

Text Illustration Pays by the project, $1,500 minimum.

Tips ''Illustrators should research the publisher. Go into a bookstore and look at the books. Gear what you send according to what you see is being used. It is particularly helpful when illustrators include on their postcard a checklist of phrases, such as 'Please keep mailing samples' or 'No, your work is not for us.' That way, we can prevent the artists who we don't want from wasting postage and we can encourage those we'd like to work with.''

SCHOLASTIC LIBRARY PUBLISHING

90 Old Sherman Turnpike, Danbury CT 06816. (203)797-3500 Fax: (203) 797-3657. Website: www.scholasticlibrary.com. Parent company of imprints Children's Press, Franklin Watts, Grolier and Grolier Online. Types of books include biography, young adult, reference, history and juvenile. Specializes in history, science and biography. Publishes 500 titles/year. 5% require freelance illustration; 10% require freelance design.

● Scholastic Library Publishing specializes in children's nonfiction, reference and online reference.
Needs Approached by over 500 freelance artists/year. Works with 10 freelance illustrators and 20 freelance designers/year. Buys 30 freelance illustrations/year. Uses freelance artists mainly for jacket/cover design and technical illustrations. Needs computer-literate freelancers for design. 100% of freelance work demands knowledge of Illustrator, QuarkXPress, Photoshop.
First Contact & Terms Send query letter with brochure, résumé, SASE and photocopies. Samples are not filed and are returned by SASE if requested by artist. Art Director will contact artist for portfolio review if interested. Portfolio should include website URL, b&w and color thumbnails, roughs, final art, tearsheets. Rights purchased vary according to project. Originals are returned at job's completion. Finds artists through artists' submissions.
Book Design Assigns 30 freelance design jobs/year. Pays by the project.
Jackets/Covers Assigns 75 freelance design and 10 freelance illustration jobs/year. Pays by the project.
Text Illustration Assigns 20-30 freelance illustration jobs/year. Pays by the project.

17TH STREET PRODUCTIONS

Division of Alloy, 151 W. 26th St., 11th Floor, New York NY 10001. (212)244-4307. **Contact:** Sandy Demarco, art director. Independent book producer/packager. Publishes mass market paperback originals. Publishes mainstream fiction, juvenile, young adult, self-help and humor. Publishes 125 titles/year. Recent titles include: *Roswell High*; *Sweet Valley High*; *Sweet Valley Twins* series; *Summer* series; *Bonechillers* series. 80% require freelance illustration; 25% require freelance design. Book catalog not available.
Needs Approached by 50 freelance artists/year. Works with 20 freelance illustrators and 5 freelance designers/year. Only uses artists with experience in mass market illustration or design. Uses freelance artists mainly for jacket/cover illustration and design. Also uses freelance artists for book design. Works on assignment only.
First Contact & Terms Send query letter with résumé, SASE, tearsheets, photographs and photocopies. Samples are filed or returned by SASE if requested by artist. Responds to the artist only if interested. To show portfolio, mail original/final art, slides dummies, tearsheets and transparencies. Sometimes requests work on spec before assigning a job. Rights purchased vary according to project. Originals are returned at job's completion.
Jackets/Covers Assigns 10 freelance design and 50-75 freelance illustration jobs/year. Only criteria for media and style is that they reproduce well.
Tips "Know the market and have the professional skills to deliver what is requested on time. Book publishing is becoming very competitive. Everyone seems to place a great deal of importance on the cover design as that affects a book's sell through in the book stores."

SMITH AND KRAUS, INC.

177 Lyme Rd., Hanover NH 03755. (603)643-6431. Fax: (603)643-1831. E-mail: sandk@sover.net. Website: www.smithandkraus.com. **Production Manager:** Julia Hill. Company publishes hardcover and trade paperback originals. Types of books include young adult, drama and acting. Specializes in books for actors. Publishes 35 titles/year. Recent titles include: *The Best Men's/Women's Monologues of 1995*; *The Sanford Meisner Approach*; *Auditioning for Musical Theatre*. 20% require freelance illustration. Book catalog free for SASE with 3 first-class stamps.
Needs Approached by 2 freelancers/year. Works with 2-3 freelance illustrators/year. Uses freelancers mainly for cover art, inside illustration. Also for text illustration. 10% of freelance work demands knowledge of Illustrator, QuarkXPress and Photoshop. Works on assignment only.
First Contact & Terms Send postcard sample of work or send query letter with brochure, résumé. Samples are filed. Art Director will contact artist for portfolio review if interested. Portfolio should include book dummy and roughs. Buys one-time and reprint rights. Originals are returned at job's completion. Finds artists through word of mouth.
Text Illustration Assigns 1-3 freelance illustration jobs/year. Pays by the project. Prefers pen & ink, oil, pastel.

SOUNDPRINTS

353 Main Ave., Norwalk CT 06851-1552. (203)846-2274. Fax: (203)846-1776. E-mail: soundprints@soundprints.com. Website: www.soundprints.com. **Art Director:** Marcin Pilchowski. Estab. 1989. Company publishes hardcover originals. Types of books include juvenile. Specializes in wildlife, worldwide habitats, social studies and history. Publishes 30 titles/year. Recent titles include: *Screech Owl at Midnight Hollow*, by Drew Lamm; *Koala Country*, by Deborah Dennand; *Box Turtle at Silver Pond Lane*, by Susan Korman. 100% require freelance illustration. Book catalog free for 9×12 SAE with $1.21 postage.
Needs Works with 8-10 freelance illustrators/year. Prefers freelancers with experience in realistic wildlife illustration and children's books. Heavy visual research required of artists. Uses freelancers for illustrating children's books (cover and interior).
First Contact & Terms Send query letter with samples, tearsheets, ré sumé and SASE. Samples are filed or returned by SASE if requested by artist. Responds in 1 month. Art director will contact artist for portfolio review

if interested. Portfolio should include color final art and tearsheets. Rights purchased vary according to project. Originals are returned at job's completion. Finds artists through agents, sourcebooks, reference, unsolicited submissions.

Text Illustration Assigns 12-14 freelance illustration jobs/year.

Tips "Wants realism, not cartoons. Animals illustrated are not anthropomorphic. Artists who love to produce realistic, well-researched wildlife and habitat illustrations, and who care deeply about the environment, are most welcome."

SOURCEBOOKS, INC.

1935 Brookdale Rd., Suite 139, Naperville IL 60563. (630)961-3900. Fax: (630)961-2168. Website: www.sourceb ooks.com. Estab. 1987. Company publishes hardcover and trade paperback originals and ancillary items. Types of books include humor, New Age, nonfiction, fiction, preschool, reference, self-help and gift books. Specializes in business books and gift books. Publishes 250 titles/year. Recent titles include: *Poetry Speaks to Children*; *How to Kill a Rock Star*; *Fiske Guide to Colleges 2006*. Book catalog free for SAE with $3.15 postage.

Needs Uses freelancers mainly for ancillary items, journals, jacket/cover design and illustration, text illustration, direct mail, book and catalog design. 100% of design and 25% of illustration demand knowledge of QuarkXPress 6.0, Photoshop 8.0 and Illustrator 11.0. Works on assignment only.

First Contact & Terms Designers: Send query letter with photocopies. Illustrators: Send postcard sample. Accepts disk submissions compatible with Illustrator 11.0, Photoshop 8.0. Send EPS files. Responds only if interested. Request portfolio review in original query. Negotiates rights purchased.

Book Design Pays by the project.

Jackets/Covers Pays by the project.

Text Illustration Pays by the project.

Tips "We have expanded our list tremendously and are, thus, looking for a lot more artwork. We have terrific distribution in retail outlets and are looking to provide more great-looking material."

N SPARTACUS PUBLISHING, LLC

3906 Grace Ellen Dr., Columbia MO 65202-1739. E-mail: cclark@spartacuspublishing.com. **Art Director:** Thomas Thurman. Senior Editor: Casey Clark. Estab. 2001. Publishes role-playing game books and comedy books. Main style/genre of games mythology and fantasy. Uses freelance artists mainly for interior art. Publishes 2-3 titles or products/year. Game/product lines include: *Inferno*; *Out of the Abyss*; *Gods of Hell*; *Battle Dragons*; *Arcanum*; *Bestiary*; and *Lexicon*. 50% requires freelance illustration.

Needs Approached by 6-10 illustrators and 0-1 designer/year. Works with 1-2 illustrators/year. Prefers freelancers experienced in b&w line art with good comic book background.

First Contact & Terms Send query letter with résumé and photocopies. Send 1 sample. Samples are filed. Responds in weeks. Will contact artist for portfolio review if interested. Rights purchased vary according to project. Finds freelancers through conventions and word of mouth.

Visual Design Assigns 1-2 freelance design jobs/year. Pays for design by the project, $20-600.

THE SPEECH BIN, INC.

1965 25th Ave., Vero Beach FL 32960. (772)770-0007. Fax: (772)770-0006. E-mail: info@speechbin.com. Website: www.speechbin.com. **Senior Editor:** Jan J. Binney. Estab. 1984. Publishes textbooks and educational games and workbooks for children and adults. Specializes in tests and materials for treatment of individuals with all communication disorders. Publishes 20-25 titles/year. Recent titles include: *I Can Say R*; *I Can Say S*; *R & L Stories Galore*. 50% require freelance illustration; 50% require freelance design. Book catalog available for 8½×11 SAE with $1.42 postage.

Needs Works with 8-10 freelance illustrators and 2-4 designers/year. Buys 1,000 illustrations/year. Work must be suitable for handicapped children and adults. Uses freelancers mainly for instructional materials, cover designs, gameboards, stickers. Also for jacket/cover and text illustration. Occasionally uses freelancers for catalog design projects. Works on assignment only.

First Contact & Terms Send query letter with SASE, tearsheets and photocopies. Samples are filed or are returned by SASE if requested by artist. Responds to the artist only if interested. Do not send portfolio; query only. Usually buys all rights. Considers buying second rights (reprint rights) to previously published work. Finds artists through "word of mouth, our authors and submissions by artists."

Book Design Pays by the project.

Jackets/Covers Assigns 10-12 freelance design jobs and 10-12 illustration jobs/year. Pays by the project.

Text Illustration Assigns 6-10 freelance illustration jobs/year. Prefers b&w line drawings. Pays by the project.

STAR PUBLISHING

Box 68, Belmont CA 94002. (650)591-3505. Fax: (650)591-3898. E-mail: mail@starpublishing.com. Website: www.starpublishing.com. **Publisher:** Stuart Hoffman. Estab. 1978. Specializes in original paperbacks and text-

books on science, art, business. Publishes 12 titles/year. 33% require freelance illustration. Titles include: *Microbiology Techniques*; *Interpersonal Communication*; *Geology*.

STOREY PUBLISHING

210 Mass MoCA Way, North Adams MA 01247. (413)346-2100. Fax: (413)346-2252. Website: www.storey.com. **Creative Director:** Kent Lew. Illustration Coordinator: Ilona Sherratt. Estab. 1982. Publishes hardcover and trade paperback originals. Publishes gardening, crafts, knitting & crochet, horses, animals, cookbooks, building, instructional. Publishes 40 titles/year. Recent titles include: *The Perennial Gardener's Design Primer*; *Hooked on Crochet*; and *The Fence Bible*. 80% requires freelance illustration; 20% requires freelance design; 20% require freelance cover/jacket design. Catalog available by request.

Needs Approached by 100 illustrators and 30 designers/year. Works with 20 illustrators and 8 designers/year. Prefers local freelancers (but not necessary). Freelance designers must be experienced in book design and building. 100% of freelance design demands knowledge of QuarkXPress. Knowledge of Photoshop, InDesign or Illustrator a plus. Uses illustration mainly for interior text, mostly how-to. Uses mostly illustration based in traditional media, scanning from originals, but will also work with digital workflows, depending upon illustrator's expertise and equipment.

First Contact & Terms "Please be familiar with our books before contacting." Prefers printed examples. Send query letter with printed samples, tearsheets, photocopies. Samples are filed or returned by SASE (if provided). Will contact artist for portfolio review if interested. Buys all rights or one-time rights.

Book Design Assigns 8-10 freelance design projects/year. Pays by the project.

Jackets/Covers Assigns 8-10 freelance designs/year. Pays by the project.

Text Illustration Assigns 30 freelance illustration projects/year. Pays by the project.

Tips "Storey books are mostly illustrated how-to books and have multiple elements and levels of information. I value book designers who can think—who understand how to organize content and can problem-solve with good visual hierarchy, clarity, and style. Designers should have good typographic skills. Our authors are experts in their fields, and we prefer illustrators who also have a strong personal understanding of their subjects. Good drawing skills are a must. I'm always looking for how-to illustrators who can present information clearly and accurately with a fresh style."

Ⓝ SWAMP PRESS

15 Warwick Ave., Northfield MA 01360. Phone/fax: (413)498-4343. **Owner:** Ed Rayher. Estab. 1977. Publishes trade paperback originals. Types of books include poetry. Specializes in limited letterpress editions. Publishes 2 titles/year. Recent titles include: *Scripture of Venus*; *Tightrope*. 75% requires freelance illustration. Book catalog not available.

Needs Approached by 10 illustrators/year. Works with 2 illustrators/year. Prefers freelancers experienced in single and 2-color woodblock/linocut illustration.

First Contact & Terms Illustrators: Send query letter with photocopies and SASE. Accepts Mac-compatible disk submissions. Samples are filed or returned by SASE. Responds in 2 months. Rights purchased vary according to project.

Jackets/Covers Pays for illustration by the project, $20-50.

Text Illustration Assigns 2 freelance illustration jobs/year. Pays by the project, $20-50 plus copies. Prefers knowledge of letterpress.

Tips "We are a small publisher of limited edition letterpress printed and hand-bound poetry books. We use fine papers, archival materials and original art."

JEREMY P. TARCHER, INC.

375 Hudson St., New York NY 10014. (212)366-2000. **Art Director:** David Walker. Estab. 1970s. Imprint of Penguin. Imprint publishes hardcover and trade paperback originals and trade paperback reprints. Types of books include instructional, New Age, adult contemporary and self-help. Publishes 45-50 titles/year. Recent titles include: *The End of Work*, by Jeremy Riskin; *The Artist's Way*, by Julia Cameron; *The New Drawing on the Right Side of the Brain*, by Betty Edwards. 30% require freelance illustration; 30% require freelance design.

Needs Approached by 10 freelancers/year. Works with 10-12 freelance illustrators and 4-5 designers/year. Works only with artist reps. Uses jacket/cover illustration. 50% of freelance work demands knowledge of QuarkXPress. Works on assignment only.

First Contact & Terms Send postcard sample of work or send query letter with brochure, tearsheets and photocopies. Samples are filed. Art Director will contact artist for portfolio review if interested. Portfolio should include book dummy, final art, photographs, roughs, tearsheets and transparencies. Buys first rights or one-time rights. Originals are returned at job's completion. Finds artists through sourcebooks, *Communication Arts*, word of mouth, submissions.

Book Design Assigns 4-5 freelance design jobs/year. Pays by the project, $800-1,000.

Jackets/Covers Assigns 4-5 freelance design and 10-12 freelance illustration jobs/year. Pays by the project, $950-1,100.
Text Illustration Assigns 1 freelance illustration job/year. Pays by the project, $100-500.

⃞N⃞ TECHNICAL ANALYSIS, INC.

4757 California Ave. SW, Seattle WA 98116-4499. (206)938-0570. Fax: (206)938-1307. Website: www.traders.com. **Art Director:** Christine Morrison. Estab. 1982. Magazine, books and software producer. Publishes trade paperback reprints and magazines. Types of books include instruction, reference, self-help and financial. Specializes in stocks, options, futures and mutual funds. Publishes 3 titles/year. Recent titles include: *Charting the Stock Market.* Books look "technical, but creative; original graphics are used to illustrate the main ideas." 100% requires freelance illustration; 10% requires freelance design.

Needs Approached by 100 freelance artists/year. Works with 20 freelance illustrators/year. Buys 100 freelance illustrations/year. Uses freelance artists for magazine illustration. Also uses freelance artists for text illustration and direct mail design. Works on assignment only.

First Contact & Terms Send query letter with nonreturnable tearsheets, photographs or photocopies. Samples are filed. Will contact for possible assignment if interested. Buys first rights or reprint rights. Most originals are returned to artist at job's completion.

Book Design Assigns 5 freelance design, 100 freelance illustration jobs/year. Pays by project, $30-230.
Jackets/Covers Assigns 1 freelance design, 15 freelance illustration jobs/year. Pays by project $30-230.
Text Illustration Assigns 5 freelance design and 100 freelance illustration jobs/year. Pays by the hour, $50-90; by the project, $100-140.

⃞⃞ ⃞i⃞ ⃞✓⃞ THISTLEDOWN PRESS LTD.

633 Main St., Saskatoon SK S7H 0J8 Canada. (306)244-1722. Fax: (306)244-1762. E-mail: tdpress@shaw.ca. Website: www.thistledown.sk.ca. **Director, Production:** Allan Forrie. Estab. 1975. Publishes trade and mass market paperback originals. Types of books include contemporary and experimental fiction, juvenile, young adult and poetry. Specializes in poetry and young adult fiction. Publishes 10-12 titles/year. Titles include: *Filling the Belly,* by Tara Manuel; *Four Wheel Drift,* by Mel Dagg.

Needs Approached by 25 freelancers/year. Works with 8-10 freelance illustrators/year. Prefers local, Canadian freelancers. Uses freelancers for jacket/cover illustration. Uses only Canadian artists and illustrators for its title covers. Works on assignment only.

First Contact & Terms Designers: Send query letter with résumé and photocopies. Illustrators: Send postcard samples. Samples are filed or are returned by SASE. Responds to the artist only if interested. Call for appointment to show portfolio of original/final art, tearsheets, photographs, slides and transparencies. Buys one-time rights.

Jackets/Covers Assigns 10-12 illustration jobs/year. Prefers painting or drawing, "but we have used tapestry—abstract or expressionist to representational." Also uses 10% computer illustration. Pays by the project, $250-600.

Tips "Look at our books and send appropriate material. More young adult and adolescent titles are being published, requiring original cover illustration and cover design. New technology (Illustrator, Photoshop) has slightly altered our cover design concepts."

THOMSON DELMAR LEARNING

5 Maxwell Dr., Clifton Park NY 12065. (518)464-3500. Fax: (518)464-0393. Website: www.delmarlearning.com or www.thomson.com. **Contact:** Larry Main, auto cad, electronics, architecture, drafting; Mary Ellen Black, automotive, electrical, welding, construction; Linda Helfrich, allied health, travel, fashion; Wendy Troeger, agriculture, paralegal; Karen Leet, nursing and education; Andrew Crouth, Auto Desk. Estab. 1946. Specializes in original hardcovers and paperback textbooks—science, health, cosmetology, Auto Cad, education, automotive, electricity and electronics, graphic arts, fashion, paralegal, etc. Publishes 250+ titles/year. Titles include: *License to Drive* and *Standard Textbook of Cosmetology.*

Needs Approached by 200 artists/year. Works with 40 artists/year. Prefers text illustrators and designers, paste-up artists, technical/medical illustrators and computer graphic/AUTOCAD artists. Works on assignment only.

First Contact & Terms Send query letter with brochure, résumé, tearsheets, photostats, photocopies, slides or photographs. Samples not requested to be returned will be filed for one year. Any material needed back must return via certified mail. Not responsible for loss of unsolicited material. Responds only if interested. Considers complexity of project, budget and turnaround time when establishing payment. Buys all rights.

Book Design Assigns 50 design jobs/year. Pays by the project.
Covers Assigns 150 design jobs/year. Pays by the project.
Text Illustration Assigns up to 125 jobs/year. Prefers electronic art. Two-color application is most common form. Four-color art is needed less frequently but still a requirement. Charts, graphs, technical illustration and general pictorials are common. Pays by the project/piece.

Tips ''Quote prices for samples shown. Quality and meeting deadlines most important. Experience with textbook publishing a benefit.'' Look of design and illustration used is ''basic, clean, conservative, straightforward technical art. Lots of elements in design, knowledge of web printing limitations a plus. Know style sheets and master pages.''

☑ TOP COW

Imprint of Image Comics, 10350 Santa Monica Blvd., #110, Los Angeles CA 90025. E-mail: submissions@topcow .com. Website: www.topcow.com. **Contact:** Submissions Editor. Types of books include comic books. Recent titles include: *Darkness #1*; *Witchblade #60*; *Battle of the Planets #4*. Book catalog and submissions guidelines available on website.

First Contact & Terms Submission guidelines on website. Send photocopies, résumé. It's best to include Top Cow characters. Show ''3-4 pages of good storytelling using sequential panels.'' Samples not filed and not returned. Responds only if interested.

Tips ''Include only your best work. Show your grasp of dynamic anatomy, ability to draw all types of people, faces and expressions. Show your grasp of perspective. Show us detailed background.''

ℕ TORAH AURA PRODUCTIONS/ALEF DESIGN GROUP

4423 Fruitland Ave., Los Angeles CA 90058. (323)585-7312. Fax: (323)585-0327. E-mail: misrad@torahaura.c om. Website: www.torahaura.com. **Art Director:** Jane Golub. Estab. 1981. Publishes hardcover and trade paperback originals, textbooks. Types of books include children's picture books, cookbooks, juvenile, nonfiction and young adult. Specializes in Judaica titles. Publishes 15 titles/year. Recent titles include: *S'fatai Tiftan (Open My Lips)*; *I Have Some Questions About God*. 85% requires freelance illustration. Book catalog free for 9×12 SAE with 10 first-class stamps.

Needs Approached by 50 illustrators and 20 designers/year. Works with 5 illustrators/year.

First Contact & Terms Illustrators: Send postcard sample and follow-up postcard every 6 months, printed samples, photocopies. Accepts Windows-compatible disk submissions. Samples are filed. Will contact artist for portfolio review if interested. Rights purchased vary according to project. Finds freelancers through submission packets.

Jackets/Covers Assigns 6-24 illustration jobs/year. Pays by the project.

TREEHAUS COMMUNICATIONS, INC.

906 W. Loveland Ave., P.O. Box 249, Loveland OH 45140. (513)683-5716. Fax: (513)683-2882. E-mail: treehaus1 @earthlink.net. Website: www.treehaus1.com. **President:** Gerard Pottebaum. Estab. 1973. Publisher. Specializes in books, periodicals, texts, TV productions. Product specialties are social studies and religious education. Recent titles include: *The Stray*; *ROSANNA The Rainbow Angel* for children ages 4-8.

Needs Approached by 12-24 freelancers/year. Works with 2 or 3 freelance illustrators/year. Prefers freelancers with experience in illustrations for children. Works on assignment only. Uses freelancers for all work. Also for illustrations and designs for books and periodicals. 5% of work is with print ads. Needs computer-literate freelancers for illustration.

First Contact & Terms Send query letter with résumé, transparencies, photocopies and SASE. Samples sometimes filed or are returned by SASE if requested by artist. Responds in 1 month. Art director will contact artist for portfolio review if interested. Portfolio should include final art, tearsheets, slides, photostats and transparencies. Pays for design and illustration by the project. Rights purchased vary according to project. Finds artists through word of mouth, submissions and other publisher's materials.

Tips ''We are looking for original style that is developed and refined. Whimsy helps.''

ℕ TSR, INC.

A subsidiary of Wizards of the Coast, P.O. Box 707, Renton WA 98057-0707. (425)204-7289. Fax: (425)204-5816. Website: www.wizards.com. **Contact:** Art Submissions. Estab. 1975. Produces games, books and calendars. ''We produce the *Dungeons & Dragons*® roleplaying game and the game worlds and fiction books that support it.''

Needs Art guidelines free with SASE or on website. Works on assignment only. Uses freelancers for book and game covers and interiors and trading card game art. Considers any media. ''Artists interested in cover work should show us tight, action-oriented 'realistic' renderings of fantasy or science fiction subjects in oils or acrylics.''

First Contact & Terms Send cover letter with contact information and 6-10 pieces, color copies or copies of black & white work. Do not send originals—they will be returned without review. If you wish to have your portfolio returned, send a SASE.

Tips Finds artists through submissions, reference from other artists and by viewing art on display at the annual Gencon® Game Fair in Milwaukee, Wisconsin. ''Be familiar with the adventure game industry in general and

our products in particular. Make sure pieces in portfolio are tight, have good color and technique.''

TYNDALE HOUSE PUBLISHERS, INC.
351 Executive Dr., Carol Stream IL 60188. (630)668-8300. E-mail: talindaiverson@tyndale.com. Website: www.t yndale.com. **Art Buyer:** Talinda M. Iverson. Vice President, Production: Joan Major. Specializes in hardcover and paperback originals as well as children's books on ''Christian beliefs and their effect on everyday life.'' Publishes 150 titles/year. 20% require freelance illustration. Books have ''high quality innovative design and illustration.'' Recent titles include: *The Warrior—Sons of Encouragement*; and *Zion Covenant Series*.
Needs Approached by 75-125 freelance artists/year. Works with 5-10 illustrators and cartoonists/year.
First Contact & Terms Send query letter and tearsheets. Samples are filed or are returned by SASE. Responds only if interested. Considers complexity of project, skill and experience of artist, project's budget and rights purchased when establishing payment. Negotiates rights purchased. Originals are returned at job's completion except for series logos.
Jackets/Covers Assigns 5-10 illustration jobs/year. Prefers progressive but friendly style. Pays by the project.
Text Illustration Assigns 1-5 jobs/year. Prefers progressive but friendly style. Pays by the project.
Tips ''Only show your best work. We are looking for illustrators who can tell a story with their work and who can draw the human figure in action when appropriate.'' A common mistake is ''neglecting to make follow-up calls. Be able to leave sample(s). Be available by friendly phone reminders, sending occasional samples. Schedule yourself wisely, rather than missing a deadline.''

THE UNIVERSITY OF ALABAMA PRESS
P.O. Box 870380, Tuscaloosa AL 35487-0380. (205)348-5180 or (205)348-1571. Fax: (205)348-9201. E-mail: rcook@uapress.ua.edu. Website: www.uapress.ua.edu. **Production Manager:** Rick Cook. Designer: Michele Myatt Quinn. Specializes in hardcover and paperback originals and reprints of academic titles. Publishes 60-70 titles/year. Recent titles include: *Satchel Paige's America*, by William Price Fox; *When Good Men Do Nothing*, by Alan Grady; *The Battle for Alabama's Wilderness*, by John N. Randolph; and *Split-Gut Song*, by Karen Jackson Ford. 35% requires freelance design.
Needs Works with 5-6 freelancers/year. Requires book design experience, preferably with university press work. Works on assignment only. 100% of freelance design demands knowledge of PageMaker 6.5, Photoshop 7.0, QuarkXPress, InDesign and Illustrator.
First Contact & Terms Send query letter with résumé, tearsheets and slides. Accepts disk submissions if compatible with Macintosh versions of above programs, provided that a hard copy that is color accurate is also included. Samples not filed are returned only if requested. Responds in a few days. To show portfolio, mail tearsheets, final reproduction/product and slides. Considers project's budget when establishing payment. Buys all rights. Originals are not returned.
Book Design Assigns 1-2 freelance jobs/year. Pays by the project, $600 minimum.
Jackets/Covers Assigns about 30 freelance design jobs/year. Pays by the project, $600 minimum.
Tips Has a limited freelance budget. ''We often need artwork that is abstract or vague rather than very pointed or focused on an obvious idea. For book design, our requirements are that they be classy.''

Ⓝ THE UNIVERSITY OF NEBRASKA PRESS
1111 Lincoln Mall, Lincoln NE 68588-0630. (402)472-3581. Fax: (402)472-0308. Website: www.unp.unl.edu. **Production Manager:** Alison Rold. Estab. 1941. Publishes hardcover originals and trade paperback originals and reprints. Types of books include history, translations. Specializes in Western history, American Indian ethnohistory, Judaica, nature, Civil War, sports history, women's studies. Publishes 180 titles/year. Recent titles include: *A World of Light*, by Floyd Skloot; *Algonquian Spirit*, by Bryan Swann. 5-10% require freelance illustration; 10% require freelance design. Book catalog free by request and available online.
Needs Approached by 10 freelancers/year. Works with 2-3 freelance illustrators/year. Prefers freelancers experienced in 4-color, action in Civil War, basketball or Western topics. ''We must use Native American artists for books on that subject.'' Uses freelancers for jacket/cover illustration. Works on assignment only.
First Contact & Terms Send query letter with photocopies. Samples are filed. Responds to the artist only if interested. Buys one-time rights. Originals are returned at job's completion.
Jackets/Covers Assigns 2-3 illustration jobs/year. Usually prefers realistic, western, action styles. Pays by the project, $200-500.

Ⓝ UNIVERSITY OF OKLAHOMA PRESS
1005 Asp Ave., Norman OK 73019. (405)325-2000. Fax: (405)325-4000. E-mail: gcarter@ou.edu. Website: www. oupress.com. **Design Manager:** Tony Roberts. Estab. 1927. Company publishes hardcover and trade paperback originals, reprints and textbooks. Types of books include biography, coffee table books, history, nonfiction,

reference, textbooks, western. Specializes in western/Indian nonfiction. Publishes 100 titles/year. 5% requires freelance design. Book catalog free by request.

Needs Approached by 50-100 freelancers/year. Works with 40-50 freelance illustrators and 10-15 designers/year. "We cannot commission work, must find existing art." Uses freelancers mainly for jacket/cover illustrations. Also for book design. 25% of freelance work demands knowledge of Illustrator, QuarkXPress, Photoshop, FreeHand, and InDesign.

First Contact & Terms Send query letter with brochure, résumé and photocopies. Samples are filed. Does not reply. Design Manager will contact artist for portfolio review if interested. Portfolio should include book dummy and photostats. Buys reprint rights. Originals are returned at job's completion. Finds artists through submissions, attending exhibits, art shows and word of mouth.

Book Design Assigns 5-10 freelance design jobs/year. Pays by the project.

UNIVERSITY OF PENNSYLVANIA PRESS

3905 Spruce St., Philadelphia PA 19104-4112. (215)898-6261. Fax: (215)898-0404. E-mail: wmj@pobox.upenn.edu. Website: www.upenn.edu/pennpress/. **Design Director:** John Hubbard. Estab. 1920. Publishes hardcover originals. Types of books include biography, history, nonfiction, landscape architecture, art history, anthropology, literature and regional history. Publishes 80 titles/year. Recent titles include: *The Man Who Had Been King*. 10% requires freelance design.

Needs Works with 4 designers/year. 100% of freelance work demands knowledge of Illustrator, Photoshop and QuarkXPress.

First Contact & Terms Designers: Send query letter with photocopies. Illustrators: Send postcard sample. Accepts Mac-compatible disk submissions. Samples are not filed or returned. Will contact artist for portfolio review if interested. Portfolio should include book dummy and photocopies. Rights purchased vary according to project. Finds freelancers through submission packets and word of mouth.

Book Design Assigns 2 freelance design jobs/year. Pays by the project, $600-1,000.

Jackets/Covers Assigns 6 freelance design jobs/year. Pays by the project, $600-1,000.

W PUBLISHING GROUP

A Division of Thomas Nelson Inc., P.O. Box 14100, Nashville TN 37214-1000. (615)889-9000. Fax: (615)902-2112. E-mail: twilliams@wpublishinggroup.com. Website: www.wpublishing.com. **Executive Art Director:** Tom Williams. Estab. 1951. Imprints include Word Bibles. Company publishes hardcover, trade paperback and mass market paperback originals and reprints; audio and video. Types of books include biography, fiction, nonfiction, religious, self-help and sports biography. "All books have a strong Christian content—including fiction." Publishes 50 titles/year. Recent titles include: *Stories of the Heart and Home*, by James Dobson; *He Chose the Nails*, by Max Lucado; *The Wounded Spirit*, by Frank Peretti. 30-35% require freelance illustration; 100% require freelance design.

Needs Approached by 700 freelancers/year. Works with 20 freelance illustrators and 30 designers/year. Buys 20-30 freelance illustrations/year. Uses freelancers mainly for book cover and packaging design. Also for jacket/cover illustration and design and text illustration. 100% of design and 10% of illustration demand knowledge of Illustrator, QuarkXPress and Photoshop. Works on assignment only.

First Contact & Terms Prefer e-mail with link to website. Send query letter with SASE, tearsheets, photographs, photocopies, photostats, "whatever shows artist's work best." Accepts disk submissions, but not preferred. Samples are returned by SASE. Art director will contact artist for portfolio review if interested. Portfolio should include tearsheets and transparencies. Purchases all rights. Originals are returned at job's completion. Finds artists through agents, *Creative Illustration Book, American Showcase, Workbook, Directory of Illustration.*

Jacket/Covers Assigns 65 freelance design and 20-30 freelance illustration jobs/year. Pays by the project $2,000-5,000. Considers all media oil, acrylic, pastel, watercolor, mixed.

Text Illustration Assigns 10 freelance illustration jobs/year. Pays by the project $75-250. Prefers line art.

Tips "Please do not phone. I'll choose artists who work with me easily and accept direction and changes gracefully. Meeting deadlines is also extremely important. I regret to say that we are not a good place for newcomers to start. Experience and success in jacket design is a must for our needs and expectations. I hate that. How does a newcomer start? Probably with smaller companies. Beauty is still a factor with us. Our books must not only have shelf-appeal in bookstores, but coffee-table appeal in homes."

WARNER BOOKS INC.

Imprint of AOL Time Warner Book Group, 1271 Avenue of the Americas, 9th Floor, New York NY 10020. (212)522-7200. Website: www.twbookmark.com. **Vice President and Creative Director:** Anne Twomey. Publishes mass market paperbacks and adult trade hardcovers and paperbacks. Publishes 300 titles/year. Recent titles include: *Find Me*, by Rosie O'Donnell; *The Millionaires*, by Brad Meltzer; *Cancer Schmancer*, by Fran Drescher. 20% requires freelance design; 80% requires freelance illustration.

• Others in the department are Diane Luger and Flamur Tonuzi. Send them mailers for their files as well.
Needs Approached by 500 freelancers/year. Works with 75 freelance illustrators and photographers/year. Uses freelancers mainly for illustration and handlettering. Works on assignment only.

First Contact & Terms Do not call for appointment or portfolio review. Mail samples only. Send nonreturnable brochure or tearsheets and photocopies. Samples are filed. Art Director will contact artist for portfolio review if interested. Negotiates rights purchased. Considers buying second rights (reprint rights) to previously published work. Originals are returned at job's completion (artist must pick up). ''Check for most recent titles in bookstores.'' Finds artists through books, mailers, parties, lectures, judging and colleagues.

Jackets/Covers Pays for design and illustration by the project. Uses all styles of jacket illustrations.

Tips Industry trends include ''graphic photography and stylized art.'' Looks for ''photorealistic style with imaginative and original design and use of eye-catching color variations. Artists shouldn't talk too much. Good design and art should speak for themselves.''

N WEBB RESEARCH GROUP PUBLISHERS

P.O. Box 314, Medford OR 97501. (541)664-5205. Fax: (541)664-9131. Website: www.pnorthwestbooks.com. **Owner:** Bert Webber. Estab. 1979. Publishes hardcover and trade paperback originals. Types of books include biography, reference, history and travel. Specializes in the history and development of the Pacific Northwest and the Oregon Trail and selected areas of WWII in the Pacific. Recent titles include: *Dredging for Gold*, by Bert Webber; *Top Secret*, by James Martin Davis and Bert Webber. 5% require freelance illustration. Book catalog for SAE with 2 first-class stamps.

Needs Approached by more than 30 freelancers/year, ''most artists waste their and our time.'' Uses freelancers for localizing travel maps and doing sketches of Oregon Trail scenes. Also for jacket/cover and text illustration. Works on assignment only.

First Contact & Terms Send query letter with SASE and photocopied samples of the artists' Oregon Trail subjects. ''We will look only at subjects in which we are interested—Oregon history, development and Oregon Trail. No wildlife or scenics.'' Samples are not filed and are only returned by SASE if requested by artist. Responds to the artist only if interested and SASE is received. Portfolios are not reviewed. Rights purchased vary according to project. Originals often returned at job's completion.

Jackets/Covers Assigns about 10 freelance design jobs/year. Payment negotiated.

Text Illustration Assigns 6 freelance illustration jobs/year. Payment negotiated.

Tips ''Freelancers negatively impress us because they do not review our specifications and send samples unrelated to what we do. We do not want to see 'concept' examples of what some freelancer thinks is 'great stuff.' If the subject is not in our required subject areas, do not waste samples or postage or our time with unwanted heavy mailings. We, by policy do not, will not, will never, respond to postal card inquiries. Most fail to send SASE thus submissions go into the trashcan, never looked at, for the first thing we consider with unsolicited material is if there is a SASE. Time is valuable for artists and for us. Let's not waste it.''

N WEIGL EDUCATIONAL PUBLISHERS LIMITED.

6325 Tenth St. SE, Calgary AB T2H 2Z9 Canada. (403)233-7747. Fax: (403)233-7769. E-mail: info@weigl.com. Website: www.weigl.com. **Contact:** Managing Editor. Estab. 1979. Textbook and library series publisher catering to juvenile and young adult audience. Specializes in social studies, science-environmental, life skills, multicultural American and Canadian focus. Publishes over 100 titles/year. Titles include: *The Love of Sports*; *A Guide to American States*; *20th Century USA*. Book catalog free by request.

Needs Approached by 300 freelancers/year. Uses freelancers only during peak periods. Prefers freelancers with experience in children's text illustration in line art/watercolor. Uses freelancers mainly for text illustration or design. Also for direct mail design. Freelancers should be familiar with QuarkXPress 5.0, Illustrator 10.0 and Photoshop 7.0.

First Contact & Terms Send résumé for initial review prior to selection for interview. Limited freelance opportunities. Graphic designers required on site. Extremely limited need for illustrators. Samples are returned by SASE if requested by artist. Responds to the artist only if interested. Write for appointment to show portfolio of original/final art (small), b&w photostats, tearsheets and photographs. Rights purchased vary according to project.

Text Illustration Pays on project basis, depending on job. Prefers line art and watercolor appropriate for elementary and secondary school students.

N WHALESBACK BOOKS

P.O. Box 9546, Washington DC 20016. (202)333-2182. Fax: (202)333-2184. E-mail: hhi@ix.netcom.com. **Publisher:** W. D. Howells. Estab. 1988. Imprint of Howells House. Company publishes hardcover and trade paperback originals and reprints. Types of books include biography, history, art, architecture, social and human sciences. Publishes 4 print, 2 online titles/year. 80% require freelance illustration; 80% require freelance design.

Needs Approached by 6-8 freelance artists/year. Works with 1-2 freelance illustrators and 1-3 freelance designers/year. Buys 10-20 freelance illustrations/job. Prefers local artists with experience in color and desktop. Uses freelance artists mainly for illustration and book/jacket designs. Also uses freelance artists for jacket/cover illustration and design; text, direct mail, book and catalog design. 20-40% of freelance work demands knowledge of PageMaker, Illustrator or QuarkXPress. Works on assignment only.

First Contact & Terms Send query letter with brochure, SASE and photocopies. Samples are not filed and are returned by SASE if requested by artist. Responds only if interested. Art Director will contact artist for portfolio review if interested. Portfolio should include b&w roughs and photostats. Rights purchased vary according to project.

Book Design Assigns 2-4 freelance design jobs/year. Pays by the project.

Jackets/Covers Assigns 2-4 freelance design jobs/year. Pays by the project.

Text Illustration Assigns 6-8 freelance illustration jobs/year. Pays by the project.

[N] WHITE MANE PUBLISHING COMPANY, INC.

73 W. Burd St., P.O. Box 708, Shippensburg PA 17257. (717)532-2237. Fax: (717)532-6110. Website: www.white mane.com. **Vice President:** Harold Collier. Estab. 1987. Publishes hardcover originals and reprints, trade paperback originals and reprints. Types of books include biography, history, juvenile, nonfiction, religious, self-help and young adult. Publishes 70 titles/year. 10% requires freelance illustration. Book catalog free with SASE.

Needs Works with 2-8 illustrators and 2 designers/year.

First Contact & Terms Illustrators/Designers: Send query letter with printed samples. Samples are filed. Responds only if interested. Will contact artist for portfolio review if interested. Rights purchased vary according to project. Finds freelancers through submission packets and postcards.

Jackets/Covers Assigns 10 freelance design jobs and 2 illustration jobs/year. Pays for design by the project.

Tips Uses art for covers only—primarily historical scenes.

[N] WHITE WOLF PUBLISHING

1554 Litton Dr., Stone Mountain GA 30083. Website: www.white-wolf.com. **Art Director:** Aileen Miles. Estab. 1986. Imprints include Borealis, World of Darkness. Publishes hardcover originals, trade and mass market paperback originals and reprints. Types of books include experimental fiction, fantasy, horror, science fiction. Specializes in alternative horror and dark fantasy. Publishes 24 titles/year. Recent titles include: *Lankhmar Series*, by Fritz Leiber; *The Eternal Champion Series*, by Michael Moorcock. 65% require freelance illustration. Book catalog free.

Needs Approached by 50 illustrators/year. Works with 20 illustrators/year. Prefers freelancers experienced in 4-color, b&w, and photo collage. Uses freelancers mainly for book covers and some interior illustration.

First Contact & Terms Send photocopies, photographs, photostats and/or printed samples. Send follow-up postcard every year. Accepts disk submissions from illustrators. Samples are filed or returned by SASE. Responds only if interested. Buys all rights.

Jackets/Covers Assigns 20 freelance illustration jobs/year. Pays for illustration by project, $500-2,000. Prefers collage, figurative, painterly, and/or experimental work.

Text Illustration Assigns 2 freelance illustration jobs/year. Pays by project, $50-100. Prefers line art and figurative work. Finds freelancers through submissions, conventions and word of mouth.

Tips "We are looking for work that is experimental and unusual."

ALBERT WHITMAN & COMPANY

6340 Oakton, Morton Grove IL 60053-2723. (847)581-0033. Fax: (847)581-0039. E-mail: mail@awhitmanco.com. Website: www.albertwhitman.com. **Art Director:** Carol Gildar. Specializes in hardcover original juvenile fiction and nonfiction—many picture books for young children. Publishes 35 titles/year. Recent titles include: *Mabella the Clever*, by Margaret Read MacDonald; *Bravery Soup*, by Maryann Cocca-Leffle. 100% requires freelance illustration. Books need "a young look—we market to preschoolers and children in grades 1-3."

Needs Prefers working with artists who have experience illustrating juvenile trade books. Works on assignment only.

First Contact & Terms Illustrators: Send postcard sample and tearsheets. "One sample is not enough. We need at least three. Do *not* send original art through the mail." Accepts disk submissions. Samples are not returned. Responds "if we have a project that seems right for the artist. We like to see evidence that an artist can show the same children and adults in a variety of moods, poses and environments." Rights purchased vary. Original work returned at job's completion.

Cover/Text Illustration Cover assignment is usually part of text illustration assignment. Assigns 2-3 covers per year. Prefers realistic and semi-realistic art. Pays by flat fee for covers; royalties for picture books.

Tips Especially looks for "an artist's ability to draw people, especially children and the ability to set an appropriate mood for the story."

WILLIAMSON BOOKS

P.O. Box 185, Charlotte VT 05445. E-mail: susan@kidsbks.net. Website: www.idealspublications.com/williams onbooks.htm. **Editorial Director:** Susan Williamson. Estab. 1983. Publishes trade paperback originals/casebound. Types of books include children's nonfiction (science, history, the arts), creative play, early learning, preschool and educational. Specializes in children's active hands-on learning. Publishes 9 titles/year. Recent titles include: *WordPlay Cafe*, by Michael Kline; *Using Color in Your Art*, by Sandy Henry; and *Animal Habitats*, by Judy Press. Book catalog free for 8½×11 SASE with 6 first-class stamps.

• This publisher is an imprint of Ideals Publications, a division of Guideposts.

Needs Approached by 100 illustrators and 10 designers/year. Works with 10 illustrators and 10 designers/year. 100% of freelance design demands Quark computer skills. "We especially need illustrators whose art communicates with kids and has a vibrant style, as well as a sense of humor evident in illustrations. We are not looking for traditional or picture book styles." All illustrations must be provided in scanned, electronic form.

First Contact & Terms "Please do not e-mail large files to us. We prefer receiving postcards with references to your websites. We really will look if we are interested." Designers: Send query letter with brochure, photocopies, résumé, SASE. Illustrators: Send postcard sample and/or query letter with photocopies, résumé and SASE. Samples are filed. Responds only if interested.

Book Design Pays for design by the project.

Tips "We are actively seeking freelance illustrators and book designers to support our growing team. We are looking for full color distinctive illustration, along with an "energized" view of how-to-do-it illustrations (always drawn with personality as opposed to technical drawings). Go to the library and look up several of our books in our four series. You'll immediately see what we're all about. Then do a few samples for us. If we're excited about your work, you'll definitely hear from us. We always need designers who are interested in a non-traditional approach to kids' book design. Our books are award-winners, and design and illustration are key elements to our books' phenomenal success."

WILSHIRE BOOK CO.

12015 Sherman Rd., North Hollywood CA 91605. (818)765-8579. E-mail: mpowers@mpowers.com. Website: www.mpowers.com. **President:** Melvin Powers. Company publishes trade paperback originals and reprints. Types of books include internet marketing, humor, instructional, New Age, psychology, self-help, inspirational and other types of nonfiction. Publishes 25 titles/year. Titles include: *Think Like a Winner!*; *The Dragon Slayer with a Heavy Heart*; *The Knight in Rusty Armor*. 100% require freelance design. Catalog for SASE with first-class stamps.

Needs Uses freelancers mainly for book covers, to design cover plus type. Also for direct mail design. "We need graphic design ready to give to printer. Computer cover designs are fine."

First Contact & Terms Send query letter with fee schedule, tearsheets, photostats, photocopies (copies of previous book covers). Portfolio may be dropped off every Monday-Friday. Portfolio should include book dummy, slides, tearsheets, transparencies. Buys first, reprint or one-time rights. Interested in buying second rights (reprint rights) to previously published work. Negotiates payment.

Book Design Assigns 25 freelance design jobs/year.

Jackets/Covers Assigns 25 cover jobs/year.

WINDSTORM CREATIVE

P.O. Box 28, Port Orchard WA 98366. (360)769-7174. e-mail queries@windstormcreative.com. Website: www.windstormcreative.com. **Senior Editor:** Cris DiMarco. Publishes books, CD-ROMs, e-books, Internet guides. Trade paperback. Children's books as well as illustrated novels for adults. Genre work as well as general fiction and nonfiction. Publishes 80 titles/year. Recent titles: *Miss Panda in Japan*; *The New Star Tarot*; *Tonight I Heard the Ghost Cat*; *Roses & Thorns: Beauty & the Beast Retold*.

Needs Anime and Manga artists, versatile artists with an ability to work both with computer graphics as well as in nonelectronic media, b&w photorealism.

First Contact & Terms See Web page for guidelines. Portfolios submitted without SASE are not reviewed. Prefer a preprinted postcard for response. Portfolios kept on file. Must be able to take direction from art director and utilize author input on projects. Must be able to meet strict deadlines. Artists paid either a flat fee or on a royalty (up to 15%) for cover and/or interior work. Artist retains copyright and originals.

WRIGHT GROUP/MCGRAW-HILL

Parent company: McGraw-Hill Companies. 1 Prudential Plaza, Chicago IL 60601. (312)233-6600. Fax: (312)233-6605. Website: www.wrightgroup.com. **Contact:** Amy Krupp, design manager. Publishes educational children's books. Types of books include children's picture books, history, nonfiction, preschool, educational reading

materials. Specializes in education pre K-8. Publishes 200 titles/year. 100% requires freelance illustration; 5% requires freelance design.

Needs Approached by 100 illustrators and 10 designers/year. Works with 50 illustrators and 2 designers/year. Prefers local designers and art directors. Prefers freelancers experienced in children's book production. 100% of freelance design demands knowledge of Photoshop, FreeHand, QuarkXPress or InDesign.

First Contact & Terms Send query letter with printed samples, color photocopies and follow-up postcard every 6 months. Samples are filed or returned. Will contact artist for portfolio review if interested. Buys all rights. Finds freelancers through submission packets, agents, sourcebooks, word of mouth.

Book Design Assigns 2 freelance design and 2 freelance art direction projects/year. Pays for design by the hour, $30-35.

Text Illustration Assigns 150 freelance illustration jobs/year. Pays by the project, $3,000-3,800.

Tips "Illustrators will have fun and enjoy working on our books, knowing the end result will help children learn to love to read."

☑ YE GALLEON PRESS

107 E. Main St., Fairfield WA 99012. (509)283-2422. Fax: (509)283-2422. Estab. 1937. Publishes hardcover and paperback originals and reprints. Types of books include rare Western history, Indian material, antiquarian shipwreck and old whaling accounts, and town and area histories. Publishes 20 titles/year. 10% requires freelance illustration. Book catalog on request.

First Contact & Terms Works with 2 freelance illustrators/year. Query with samples and SASE. No advance. Pays promised fee for unused assigned work. Buys book rights.

Galleries

Most artists dream of seeing their work in a gallery. It's the equivalent of "making it" in the art world. That dream can be closer than you realize. The majority of galleries are actually quite approachable and open to new artists. Though there will always be a few austere establishments manned by snooty clerks, most are friendly places where people come to browse and chat with the gallery staff.

So don't let galleries intimidate you. The majority of galleries will be happy to take a look at your slides if you make an appointment or mail your slides to them. If they feel your artwork doesn't fit their gallery, most will steer you toward a more appropriate one.

A few guidelines

- **Never walk into a gallery without an appointment,** expecting to show your work to the gallery director. When we ask gallery directors for pet peeves they always discuss the talented newcomer walking into the gallery with paintings in hand. Send a polished package of about 8 to 12 neatly labeled, mounted duplicate slides of your work submitted in plastic slide sheet format. (Refer to the listings for more specific information on each gallery's preferred submission method.) Do not send original slides, as you will need them to reproduce later. Send a SASE, but realize you may not get your packet returned.
- **Seek out galleries that show the type of work you create.** Each gallery has a specific "slant" or mission.
- **Visit as many galleries as you can.** Browse for a while and see what type of work they sell. Do you like the work? Is it similar to yours in quality and style? What about the staff? Are they friendly and professional? Do they seem to know about the artists the gallery handles? Do they have convenient hours? If you are interested in galleries outside your city and you can't manage a personal visit before you submit, read the listing carefully to make sure you understand what type of work is shown in that gallery and get a feel for what the space is like. Ask a friend or relative who lives in that city to check out the gallery for you.
- **Attend openings.** You'll have a chance to network and observe how the best galleries promote their artists. Sign each gallery's guest book or ask to be placed on galleries' mailing lists. That's also one good way to make sure the gallery sends out professional mailings to prospective collectors.

Showing in multiple galleries

Most successful artists show in several galleries. Once you have achieved representation on a local level, you are ready to broaden your scope by querying galleries in other cities. You

Types of Galleries

As you search for the perfect gallery, it's important to understand the different types of spaces and how they operate. The route you choose depends on your needs, the type of work you do, your long term goals and the audience you're trying to reach.

Retail or commercial galleries. The goal of the retail gallery is to sell and promote artists while turning a profit. Retail galleries take a commission of 40 to 50 percent of all sales.

Co-op galleries. Co-ops exist to sell and promote artists' work, but they are run by artists. Members exhibit their own work in exchange for a fee, which covers the gallery's overhead. Some co-ops also take a small commission of 20 to 30 percent to cover expenses. Members share the responsibilities of gallery-sitting, sales, housekeeping and maintenance.

Rental galleries. The gallery makes its profit primarily through renting space to artists and consequently may not take a commission on sales (or will take only a very small commission). Some rental spaces provide publicity for artists, while others do not. Showing in this type of gallery is risky. Rental galleries are sometimes thought of as "vanity galleries" and, consequently, they do not have the credibility other galleries enjoy.

Nonprofit galleries. Nonprofit spaces will provide you with an opportunity to sell work and gain publicity but will not market your work aggressively, because their goals are not necessarily sales-oriented. Nonprofits normally take a small commission of 20 to 30 percent.

Museums. Though major museums generally show work by established artists, many small museums are open to emerging artists.

Art consultancies. Generally, art consultants act as liasions between fine artists and buyers. Most take a commission on sales (as would a gallery). Some maintain small gallery spaces and show work to clients by appointment.

Galleries

may decide to concentrate on galleries in surrounding states, becoming a "regional" artist. Some artists like to have an East Coast and a West Coast gallery.

If you plan to sell work from your studio, or from a Web site or other galleries, be up front with your gallery. Work out a commission arrangement you can all live with, and everybody wins.

Pricing your fine art

A common question of beginning artists is "What do I charge for my paintings?" There are no hard and fast rules. The better known you become, the more collectors will pay for your work. Though you should never underprice your work, you must take into consideration what people are willing to pay. Also keep in mind that you must charge the same amount for a painting sold in a gallery as you would for work sold from your studio.

Juried shows, competitions and other outlets

It may take months, maybe years, before you find a gallery to represent you. But don't worry; there are plenty of other venues to show in until you are accepted in a commercial gallery.

If you get involved with your local art community, attend openings and read the arts section of your local paper, you'll see there are hundreds of opportunities.

Enter group shows and competitions every chance you get. Go to the art department of your local library and check out the bulletin board, then ask the librarian to steer you to magazines like *Art Calendar* (www.artcalendar.com) that list ''calls to artists'' and other opportunities to exhibit your work. Subscribe to the *Art Deadlines List*, available in hard copy or online versions (www.artdeadlineslist.com). Join a co-op gallery and show your work in a space run by artists for artists.

Another opportunity to show your work is through local restaurants and retail shops that show the work of local artists. Ask the manager how you can show your work. Become an active member in an arts group. It's important to get to know your fellow artists. And since art groups often mount exhibitions of their members' work, you'll have a way to show your work until you find a gallery to represent you.

Helpful Resources

For More Info

To develop a sense of various galleries and how to approach them, look to the myriad of art publications that contain reviews and articles. A few such publications are *ARTnews*, *Art in America* and regional publications such as *ARTweek* (West Coast), *Southwest Art*, *dialogue* and *Art New England*. Lists of galleries can be found in *Art in America's Guide to Galleries* and *Art Now*. *The Artist's Magazine*, *Art Papers* and *Art Calendar* are invaluable resources for artists and feature dozens of helpful articles about dealing with galleries.

ALABAMA

THE ATCHISON GALLERY

2847 Culver Rd., Birmingham AL 35223. (205)871-6233. **Director:** Larry Atchison. Retail gallery and art consultancy. Estab. 1974. Represents 35 emerging, mid-career and a few established artists/year. Exhibited artists include Bruno Zupan and Cynthia Knapp. Sponsors 12 shows/year. Average display time 1 month. Open all year; Monday-Friday, 9:30-5; Saturday, 10-2. Located in the Mountain Brook Village; 2,000 sq. ft.; open ceiling, large open spaces. 25-30% of space for special exhibitions; 75% of space for gallery artists. Clientele: upscale, residential and corporate. 70-75% private collectors, 25-30% corporate collectors. Overall price range $600-15,000; most work sold at $1,800-3,500 (except for exclusive pieces, Dine's, Warhols, etc.).

Media Considers all media except fiber, paper and pen & ink. Considers engravings, lithographs and etchings. Most frequently exhibits oil-acrylic, mixed media and pastel.

Style Exhibits expressionism, painterly abstraction, minimalism, impressionism, photorealism and realism. Genres include florals, landscapes and figurative work. Prefers painterly abstraction, impressionism and realism/figurative.

Terms Accepts work on consignment (50% commission). Retail price set by both the gallery and artist. Gallery provides insurance, promotion and contract; shipping costs are shared. Prefers artwork unframed.

Submissions Most artists are full-time professionals. Send query letter with résumé, bio and artist's statement with slides, brochure, photographs and/or reviews. Write for appointment to show portfolio of photographs, slides and transparencies. Responds in 1 month. Files résumé, slides, bio, photographs, artist statement and brochure. Finds artists through referrals by other artists, submissions, visiting exhibits, reviewing art journals/magazines.

Ⓝ CORPORATE ART SOURCE

2960-F Zelda Rd., Montgomery AL 36106. (334)271-3772. E-mail: casjb@mindspring.com. Website: casgallery.com. **Owner:** Jean Belt. Consultant: Keven Belt. Retail gallery and art consultancy. Estab. 1985. Interested in mid-career and established artists. ''I don't represent artists, but keep a slide bank to draw from as resources.'' Exhibited artists include Beau Redmond and Dale Kenington. Open Monday-Friday, 10-5. Located in exclusive shopping center; 1,000 sq. ft. Clientele: corporate upscale, local. 25% private collectors, 75% corporate collectors. Overall price range $100-50,000. Most work sold at $1,500.

Media Considers all media and all types of prints. Most frequently exhibits oil/acrylic paintings on canvas, glass, prints, pastel and watercolor. Also interested in sculpture.

Style Exhibits expressionism, neo-expressionism, pattern painting, color field, geometric, abstraction, postmodernism, painterly abstraction, impressionism and realism. Genres include landscapes, abstract and architectural work.

Terms Artwork is accepted on consignment (50% commission). Retail price set by artist. Gallery provides insurance. Prefers artwork unframed.

Submissions Send query letter with résumé, slides or photographs and SASE. Call for appointment to show portfolio of slides and photographs. Responds in 6 weeks.

Tips ''Always send several photos (or slides) of your work. An artist who sends a letter and one photo and says 'write for more info' gets trashed. We don't have time to respond unless we feel strongly about the work—and that takes more than one sample.''

GALLERY 54, INC.

54 Upham, Mobile AL 36607. (251)473-7995. E-mail: gallery54art1@aol.com. **Owner:** Leila Hollowell. Retail gallery. Estab. 1992. Represents 35 established artists/year. May be interested in seeing the work of emerging artists in the future. Exhibited artists inlcude Charles Smith and Lee Hoffman. Sponsors 5 shows/year. Average display time 1 month. Open all year; Tuesday-Saturday, 11-4:30. Located in midtown, about 560 sq. ft. Clientele local. 70% private collectors, 30% corporate collectors. Overall price range $20-6,000; most work sold at $200-1,500.

Media Considers oil, acrylic, watercolor, pastel, pen & ink, drawing, mixed media, collage, sculpture, ceramics, glass, photography, woodcuts, serigraphs and etchings. Most frequently exhibits acrylic/abstracts, watercolor and pottery.

Style Exhibits expressionism, painterly abstraction, impressionism and realism. Prefers realism, abstract and Impressionism.

Terms Accepts work on consignment (40% commission) or buys outright for 50% of retail price (net 30 days). Retail price set by the artist. Gallery provides contract. Artist pays shipping costs. Prefers artwork framed.

Submissions Southern artists preferred (mostly Mobile area). It's easier to work with artist's work on consignment. Send query letter with slides and photographs. Write for appointment to show portfolio of photographs

and slides. Responds in 2 weeks. Files information on artist. Finds artists through art fairs, referrals by other artists and information in mail.

Tips "Don't show up with work without calling and making an appointment."

N: LEON LOARD GALLERY OF FINE ARTS

2781 Zelda Rd., Montgomery AL 36106. (334)272-0077. Fax: (334)270-0150. E-mail: info@leonloard.com. Website: www.leonloard.com. **Gallery Director:** Betty Richardson. Retail gallery. Estab. 1989. Represents about 70 emerging, mid-career and established artists/year. Exhibited artists include Paige Harvey, Barbara Reed, Cheryl McClure, McCreery Jordan and Pete Beckman. Sponsors 4 shows/year. Average display time 3 months. Open all year; Monday-Friday, 10-4; weekends by appointment. Located in upscale suburb; cloth walls. 45% of space for special exhibitions; 45% of space for gallery artists. Clientele: local community—many return clients. 80% private collectors, 20% corporate collectors. Overall price range $100-75,000; most work sold at $500-5,000.

Media Considers oil, acrylic, watercolor, pastel, pen & ink, drawing, mixed media, collage, paper, sculpture, ceramics, fiber and glass. Most frequently exhibits oil on canvas, acrylic on canvas and watercolor on paper.

Style Exhibits all styles and all genres. Prefers impressionism, realism and abstract.

Terms Accepts work on consignment. Retail price set by the gallery and the artist. Gallery provides insurance, promotion and contract. Shipping costs are shared. Prefers artwork unframed.

Submissions Send query letter with résumé, slides, bio and photographs. Portfolio should include photographs and slides. Responds in 2 weeks. Files bios and slides.

MARCIA WEBER/ART OBJECTS, INC.

1050 Woodley Rd., Montgomery AL 36106. (334)262-5349. Fax: (334)567-0060. E-mail: weberart@mindspring.com. Website: www.marciaweberartobjects.com. **Owner:** Marcia Weber. Retail, wholesale gallery. Estab. 1991. Represents 21 emerging, mid-career and established artists/year. Exhibited artists include Woodie Long, Jimmie Lee Sudduth. Sponsors 6 shows/year. Open all year except July by appointment only. Located in Old Cloverdale near downtown in older building with hardwood floors in section of town with big trees and gardens. 100% of space for gallery artists. Clientele tourists, upscale. 90% private collectors, 10% corporate collectors. Overall price range $300-20,000; most work sold at $300-4,000.

- This gallery owner specializes in the work of self-taught, folk, or outsider artists. Many artists shown generally "live down dirt roads without phones," so a support person first contacts the gallery for them. Marcia Weber moves the gallery to New York's Soho district 3 weeks each winter and routinely shows in the Atlanta area.

Media Considers all media except prints. Must be original one-of-a-kind works of art. Most frequently exhibits acrylic, oil, found metals, found objects and enamel paint.

Style Exhibits genuine contemporary folk/outsider art, self-taught art and some Southern antique original works.

Terms Accepts work on consignment (variable commission) or buys outright. Gallery provides insurance, promotion and contract if consignment is involved. Prefers artwork unframed so the gallery can frame it.

Submissions Folk/outsider artists usually do not contact dealers. They have a support person or helper, who might write or call, send query letter with photographs, artist's statement. Call or write for appointment to show portfolio of photographs, original material. Finds artists through word of mouth, other artists and "serious collectors of folk art who want to help an artist get in touch with me." Gallery also accepts consignments from collectors.

Tips "An artist is not a folk artist or an outsider artist just because their work resembles folk art. They have to *be* folks who began creating art without exposure to fine art. Outsider artists live in their own world outside the mainstream and create art. Academic training in art excludes artists from this genre." Prefers artists committed to full-time creating.

ARIZONA

ARIZONA STATE UNIVERSITY ART MUSEUM

Nelson Fine Arts Center and Ceramics Research Center, Tempe AZ 85287-2911. (480)965-2787. Fax: (480)965-5254. Website: asuartmuseum.asu.edu. **Director:** Marilyn Zeitlin. Estab. 1950. Presents mid-career, established and emerging artists. Sponsors 12 shows/year. Average display time 2 months. Open all year; Tuesday, 10-9 (school year); Tuesday, 10-5 (summer); Wednesday-Saturday, 10-5; Closed Sunday, Monday and Holidays. Located downtown Tempe ASU campus. Nelson Fine Arts Center features award-winning architecture, designed by Antoine Predock. "The Ceramics Research Center, located just next to the main museum, features open storage of our 3,000 works plus collection and rotating exhibitions. The museum also presents an annual short film and video festival."

Media Considers all media. Greatest interests are contemporary art, crafts, video, and work by Latin American and Latin artists.

Submissions "Interested artists should submit slides to the director or curators."

Tips "With the University cutbacks, the museum has scaled back the number of exhibitions and extended the average show's length. We are always looking for exciting exhibitions that are also inexpensive to mount."

ELEVEN EAST ASHLAND INDEPENDENT ART SPACE

11 E. Ashland, Phoenix AZ 85004. (602)257-8543. Fax: (602)257-8543. **Contact:** David Cook. Estab. 1986. Represents emerging, mid-career and established artists. Exhibited artists include David Cook, Frank Mell, Ron Crawford and Mark Dolce. Sponsors 2 invitationals: Fall—Best of the West—non-Cowboy Art Show; Spring—Adults Only—Open Invitational; 2 months each; group/solo shows. Located in "two-story old farm house in central Phoenix, off Central Ave." Overall price range $100-5,000; most artwork sold at $100-800.

- An anniversary exhibition is held every year in April and is open to national artists. Work must be submitted by the end of February. Work will be for sale and considered for permanent collection and traveling exhibition.

Media Considers all media and all types of prints. Most frequently exhibits photography, painting, mixed media and sculpture.

Style Exhibits all styles, preferably conceptualism, minimalism and neo-expressionism.

Terms Accepts work on consignment (25% commission); rental fee for space covers 2 months. Retail price set by artist. Artist pays for shipping.

Submissions Accepts proposal in person or by mail to schedule shows 6 months in advance. Send query letter with résumé, brochure, business card, 3-5 slides, photographs, bio and SASE. Call or write for appointment to show portfolio of slides and photographs. Be sure to follow through with proposal format. Responds only if interested within 1 month. Samples are filed or returned if not accepted or under consideration.

Tips "Be active and enthusiastic."

ETHERTON GALLERY

135 S. Sixth Ave., Tucson AZ 85701. (520)624-7370. Fax: (520)792-4569. E-mail: ethertongallery@mindspring.com. Website: www.ethertongallery.com. **Contact:** Terry Etherton. Retail gallery and art consultancy. Specializes in vintage and contemporary photography. Estab. 1981. Represents 50+ emerging, mid-career and established artists. Exhibited artists include Holly Roberts, Rocky Schenck, Kate Breakey, James G. Davis and Mark Klett. Sponsors 4 shows/year. Average display time 8 weeks. Open year round. Located "downtown; 3,000 sq. ft.; in historic building—wood floors, 16 ft. ceilings." 75% of space for special exhibitions; 10% of space for gallery artists. Clientele: 50% private collectors, 25% corporate collectors, 25% museums. Overall price range $500-50,000; most work sold at $1,000-4,000.

Media Considers all types of photography, oil, acrylic, drawing, mixed media, collage, sculpture, ceramic, original handpulled prints, woodcuts, wood engravings, linocuts, engravings, mezzotints, etchings and lithographs. Most frequently exhibits photography and painting.

Style Exhibits expressionism, neo-expressionism, primitivism, postmodern works. Genres include landscapes, portraits and figurative work. Prefers expressionism, primitive/folk and post-modern. Interested in seeing work that is "cutting-edge, contemporary, issue-oriented, political."

Terms Accepts work on consignment (50% commission). Buys outright for 50% of retail price (net 30 days). Retail price set by gallery and artist. Gallery provides insurance and promotion; shipping costs are shared. Prefers framed artwork.

Submissions Only "cutting-edge contemporary—no decorator art." No "unprepared, incomplete works or too wide a range—not specific enough." Send résumé, brochure, disk, slides, photographs, reviews, bio and SASE. Call or write to schedule an appointment to show a portfolio, which should include disk. Responds in 6 weeks only if interested.

Tips "Become familiar with the style of our gallery and with contemporary art scene in general."

THE GALLOPING GOOSE

162 S. Montezuma, Prescott AZ 86303. (928)778-7600. Fax: (928)776-1806. E-mail: gallopgoose@aol.com. Website: www.gallopinggoosegallery.com. **Owner:** Zack Batikh. Retail gallery. Estab. 1987. Represents 200 emerging, mid-career and established artists. Exhibited artists include Bev Doolittle and Maija. Average display time 2 weeks. Open all year. Located in the "SW corner of historic Whiskey Row across from the courthouse in downtown Prescott; newly remodeled with an additional 2,000 sq. ft. of gallery space." 10% of space for special exhibitions. Clients: established art collectors and tourists. 95% private collectors, 5% corporate collectors. Overall price range $20-5,000; most work sold at $150-1,000.

Media Considers oil, pen & ink, fiber, acrylic, drawing, sculpture, watercolor, mixed media, ceramic, pastel,

original handpulled prints, reliefs, lithographs, offset reproductions and posters. Most frequently exhibits pastel, oil, tempera and watercolor.

Style Exhibits surrealism, imagism and realism. Genres accepted include landscapes, Americana, Southwestern, Western, wildlife and Indian themes only. Prefers wildlife, Southwestern cowboy art and landscapes.

Terms Buys outright for 50% of the retail price; net 30 days. Customer discounts and payment by installment are available. Retail price set by the gallery and the artist. Gallery pays for shipping costs to gallery. Prefers artwork unframed.

Submissions Send query letter with bio, brochure, photographs and business card. To show a portfolio, call for appointment. Gallery prefers written correspondence. Files photographs, brochures and biographies. Finds artists through visiting exhibitions, word of mouth and various art publications.

Tips "Stop by to see our gallery, determine if artwork would be appropriate for our clientele and meet the owner to see if an arrangement is possible."

ⓝ THE LARSEN GALLERY

(formerly The Cultural Exchange Gallery), 3705 N. Bishop Lane, Scottsdale AZ 85251. (480)941-0900. Fax: (480)941-0814. Website: www.larsengallery.com or www.culturalexchange.com. **Art Gallery Director**: Polly Larsen (plarsen@larsengallery.com). Retail gallery and art consultancy. Exhibits the work of 100s of mid-career and established artists/year. Exhibited artists include Christopher Pelley and Sandy Skoglund. Average display time 1 month. Open all year; Monday-Friday, 9-5; Thursday evenings, 7-9; Saturday, 10-5; Sunday, 12-4. Located downtown; 7,500 sq. ft. "Have vast array of artwork from the 1900s to contemporary." Clientele: upscale, local and tourists. 75% private collectors, 25% corporate collectors. Overall price range: $100-150,000; most work sold at $3,000-7,000.

Media Considers all media except weavings and tapestry. Considers all types of prints except posters. Most frequently exhibits oils/acrylics, bronze and pastels/lithos and photography.

Style Exhibits expressionism, neo-expressionism, painterly abstraction, conceptualism, minimalism, color field, postmodern works, photorealism, hard-edge geometric abstraction, realism and imagism. Exhibits all genres.

Terms Artwork is accepted on consignment and there is a 40% commission (from clients not artists). Retail price set by the gallery. Gallery provides insurance, promotion and contract; shipping costs are shared.

Submissions Accepts consignments from private and corporate clients. Represent contemporary artists.

ⓝ MESA CONTEMPORARY ARTS

155 N. Center, Box 1466, Mesa AZ 85211-1466. (480)644-2056. Fax: (480)644-2901. E-mail: patty_haberman@ci .mesa.az.us. Website: www.mesaarts.com. Owned and operated by the City of Mesa. Estab. 1981. Exhibits the work of emerging, mid-career and established artists. "We only do national juried shows and curated invitationals. We are an exhibition gallery, NOT a commercial sales gallery." Sponsors 6 shows/year. Average display time 4-6 weeks. Located downtown; 1,300 sq. ft., "wood floors, 14 ft. ceilings and monitored security." 100% of space for special exhibitions. Clientele "cross section of Phoenix metropolitan area." 95% private collectors, 5% gallery owners. "Artists selected only through national juried exhibitions." Overall price range $100-10,000; most artwork sold at $200-400.

Media Considers all media including sculpture, painting, printmaking, photography, fibers, glass, wood, metal, video, ceramics, installation and mixed.

Style Exhibits all styles and genres. Interested in seeing contemporary work.

Terms Charges 25% commission. Retail price set by artist. Gallery provides insurance, promotion and contract; pays for shipping costs from gallery. Requires framed artwork.

Submissions Send a query letter or postcard with a request for a prospectus. After you have reviewed prospectus, send slides of up to 4 works (may include details if appropriate.) "We do not offer portfolio review. Artwork is selected through national juried exhibitions." Files slides and résumés. Finds artists through gallery's placement of classified ads in various art publications, mailing news releases and word of mouth.

Tips "Scout galleries to determine their preferences before you approach them. Have professional quality slides. Present only your very best work in a professional manner."

ⓝ SCOTTSDALE MUSEUM OF CONTEMPORARY ART

7380 E. Second St., Scottsdale AZ 85251. (480)874-4630. Fax: (480)874-4655. Website: www.smoca.org. **Contact:** Susan Krane, director. Museum. Approached by 30-50 artists/year. "Arizona's only museum devoted to the art, architecture and design of our time." Sponsors 12 exhibits/year. Average display time 10 weeks. Open Tuesday, Wednesday, Friday, Saturday, 10-5; Thursday, 10-8; Sunday, 12-5. Closed Monday. Located in downtown Scottsdale; more than 20,000 sq. ft. of exhibition space. Clients include local community, students and tourists.

Media Considers all media.

Style Considers works of contemporary art, architecture and design.

Submissions Send query letter with artist's statement, bio, photocopies, résumé, reviews and SASE. Returns material with SASE. Responds in 3 weeks.

Tips Make your submission clear and concise. Fully identify all slides. All submission material, such as artist's statement and slide labels should be typed, not handwritten.

Ⓝ RIVA YARES GALLERY

3625 Bishop Lane, Scottsdale AZ 85251. (480)947-3251. Fax: (480)947-4251. E-mail: art@rivayaresgallery.com. Website: www.rivayaresgallery.com. Second gallery at 123 Grant Ave., Santa Fe NM 87501. (505)984-0330. Retail gallery. Estab. 1963. Represents 30-40 emerging, mid-career and established artists/year. Exhibited artists include Rodolfo Morales and Esteban Vicente. Sponsors 12-16 shows/year. Average display time 3-6 weeks. Open all year; Tuesday-Saturday, 10-5; Sunday by appointment. Located in downtown area; 8,000 sq. ft.; national design award architecture; international artists. 50% of space for special exhibitions; 50% of space for gallery artists. Clientele: collectors. 90% private collectors; 10% corporate collectors. Overall price range $1,000-1,000,000; most work sold at $20,000-50,000.

Media Considers all media except craft and fiber and all types of prints. Most frequently exhibits paintings (all media), sculpture and drawings.

Style Exhibits expressionism, photorealism, neo-expressionism, minimalism, pattern painting, color field, hard-edge geometric abstraction, painterly abstraction, realism, surrealism and imagism. Prefers abstract expressionistic painting and sculpture, surrealistic sculpture and modern schools' painting and sculpture.

Terms Accepts work on consignment (50% commission). Retail price set by the artist. Gallery provides insurance, promotion and contract; gallery pays for shipping from gallery; artist pays for shipping to gallery. Prefers artwork framed.

Submissions Not accepting new artists at this time.

Tips "Few artists take the time to understand the nature of a gallery and if their work even applies."

ARKANSAS

ARKANSAS STATE UNIVERSITY FINE ARTS CENTER GALLERY

P.O. Drawer 1920, State University AR 72467. (870)972-3050. E-mail: csteele@astate.edu. Website: www.clt.ast ate.edu/art/. **Chair, Department of Art:** Curtis Steele. University—Art Department Gallery. Estab. 1968. Represents/exhibits 3-4 emerging, mid-career and established artists/year. Sponsors 3-4 shows/year. Average display time 1 month. Open fall, winter and spring; Monday-Friday, 10-4. Located on university campus; 1,600 sq. ft.; 60% of time devoted to special exhibitions; 40% to faculty and student work. Clientele: students/community.

Media Considers all media. Considers all types of prints. Most frequently exhibits painting, sculpture and photography.

Style Exhibits conceptualism, photorealism, neo-expressionism, minimalism, hard-edge geometric abstraction, painterly abstraction, postmodern works, realism, impressionism and pop. "No preference except quality and creativity."

Terms Exhibition space only; artist responsible for sales. Retail price set by the artist. Gallery provides insurance, promotion and contract; shipping costs are shared. Prefers artwork framed.

Submissions Send query letter with résumé, slides and SASE. Portfolio should include photographs, transparencies and slides. Responds only if interested within 2 months. Files résumé. Finds artists through call for artists published in regional and national art journals.

Tips "Show us 20 slides of your best work. Don't overload us with lots of collateral materials (reprints of reviews, articles, etc.). Make your vita as clear as possible."

ARTISTS WORKSHOP

810 Central Ave., Hot Springs AR 71901. (501)623-6401. Website: www.artistsworkshopgallery.com. **Chairman:** Millie Steveken. Cooperative gallery. Estab. 1990. Represents 35 emerging, mid-career and established artists/year. Sponsors 12 shows/year. Average display time 2 months. Open all year; Monday-Saturday, 10-4. Gallery Walk Night—1st Friday of each month 10a.m.-9p.m. Summer hours: from Memorial Day to Labor Day, 11a.m.-5p.m. Located in historic district; approximately 920 sq. ft.; in historic building. 10% of space for special exhibitions; 90% of space for gallery artists. Clientele: primarily tourist, some local. 100% private collectors. Overall price range $12-4,500; most work sold at $100-500.

Media Considers all media and all types of prints.

Style Exhibits painterly abstraction, impressionism, photorealism and realism. Exhibits all genres.

Terms Co-op membership fee plus donation of time (15% commission). Retail price set by the artist. Gallery provides promotion; gallery pays shipping to client. Prefers framed artwork.

Submissions Accepts only artists from Arkansas. Send query letter with bio and SASE. Call or write for appoint-

ment to show examples of work brought to co-op membership meeting (held once/month). Does not reply. Artist should attend monthly meetings. Finds artists through word of mouth, referrals by other artists, visiting art fairs and exhibitions and submissions.

▣ HERR-CHAMBLISS FINE ARTS

P.O. Box 2840, Hot Springs AR 71914. (501)624-7188. Fax: (501)624-7188. **Director:** Malinda Herr-Chambliss. Corporate art consultant. Estab. 1988. Represents emerging, mid-career and established artists. Overall price range $50-24,000.

- This art consultant formerly ran a retail gallery for 12 years. She now works exclusively with corporate and private clients as an art consultant.

Media Considers oil, acrylic, watercolor, pastel, pen & ink, drawings, mixed media, sculpture, fiber, glass, etchings, charcoal and large scale work.

Style Exhibits all styles, specializing in Italian contemporary art.

Terms "Negotiation is part of acceptance of work; generally commission is 40%." Gallery provides insurance, promotion and contract (depends on negotiations); artist pays for shipping to and from gallery. Prefers artwork framed.

Submissions Prefers painting and sculpture of regional, national and international artists. Send query letter with résumé, slides, bio, brochure, photographs, SASE, business card and reviews. Do not send any materials that are irreplaceable. Write for appointment to show portfolio of originals, slides, photographs and transparencies. Responds in 6 weeks.

Tips "When mailing your submission to galleries, make your presentation succinct, neat and limited. Consider how you would review the information if you received it. Respect the art gallery owner's position—realizing the burdens that face them each day—help the gallery help you and your career by providing support in their requests to you. Slides should include the date, title, medium, size, and directional information. Also, résumé should show the number of one-person shows, educational background, group shows, list of articles (as well as enclosure of articles). The neater the presentation, the greater chance the dealer can glean important information quickly. Put yourself behind the dealer's desk, and include what you would like to have for review."

WALTON ARTS CENTER

P.O. Box 3547, 495 N. Dickson St., Fayetteville AR 72702. (479)443-9216. Fax: (479)443-9784. Website: www.waltonartscenter.org. **Contact:** Michele McGuire, curator of visual arts. Nonprofit gallery. Estab. 1990. Approached by 50 artists/year. Represents 10 emerging, mid-career and established artists. Exhibited artists include E. Fay Jones, Judith Leiber (handbags). Average display time 2 months. Open all year; Monday-Friday, 10-6; weekends 12-4. Closed Thanksgiving, Christmas, July 4. Joy Pratt Markham Gallery is 2,500 sq. ft. with approximately 200 running wall feet. McCoy Gallery also has 200 running wall feet in the Education Building. Clients include local community and upscale. Overall price range $100-10,000. "Walton Arts Center serves as a resource to showcase a variety of thought-provoking visual media that will challenge new and traditional insights and encourage new dialogue in a museum level environment."

Media Considers all media and all types of prints. Most frequently exhibits oil, installation, paper.

Style Considers all styles and genres.

Terms Artwork is accepted on consignment and there is a 30% commission. Retail price set by the artist. Gallery provides insurance and contract. Accepted work should be framed. Requires exclusive representation locally.

Submissions Mail portfolio for review. Send query letter with artist's statement, bio, business card, résumé, reviews, SASE and slides. Returns material with SASE. Responds in 3 months. Finds artists through submissions, art exhibits, referrals by other artists and travelling exhibition companies.

CALIFORNIA

▣ ALEF JUDAICA, INC.

8440 Warner Dr., Culver City CA 90232. (310)202-0024. Fax: (310)202-0940. E-mail: alon@alefjudaica.com. **President:** Alon Rozov. Estab. 1979. Manufacturer and distributor of a full line of Judaica, including menorahs, Kiddush cups, greeting cards, giftwrap, tableware, etc.

Needs Approached by 15 freelancers/year. Works with 10 freelancers/year. Buys 75-100 freelance designs and illustrations/year. Prefers local freelancers with experience. Works on assignment only. Uses freelancers for new designs in Judaica gifts (menorahs, etc.) and ceramic Judaica. Also for calligraphy, pasteup and mechanicals. All designs should be upper scale Judaica.

First Contact & Terms Mail brochure, photographs of final art samples. Art director will contact artist for portfolio review if interested, or portfolios may be dropped off every Friday. Sometimes requests work on spec

before assigning a job. Pays $300 for illustration/design; pays royalties of 10%. Considers buying second rights (reprint rights) to previously published work.

N. THE ART COLLECTOR

4151 Taylor St., San Diego CA 92110. (800)987-4151. Fax: (619)299-8709. **Contact:** Janet Disraeli. Retail gallery and art consultancy. Estab. 1972. Represents emerging, mid-career and established artists. Exhibited artists include Susan Singleton and Reed Cardwell. Average display time 1 month. Open all year; Monday-Friday. 1,000 sq. ft.; 100% of space for gallery artists. Clientele: upscale, business, decorators, health facilities, hotels, resorts, liturgical and residential artwork with interior designers, architects, landscape architects, developers and space planners. 50% private collectors, 50% corporate collectors. Overall price range $175-10,000; most work sold at $450-1,000. Other services include giclée printing, online artist resource (slide collection), custom commission work available and beginning to do governmental work.
Media Considers all media and all types of prints. Most frequently exhibits paintings, sculpture, monoprints.
Style Exhibits all styles. Genres include all genres, especially florals, landscapes and figurative work. Prefers abstract, semi-realistic and realistic.
Terms Artwork is accepted on consignment and there is a 50% commission. Retail price set by the artist. Gallery provides insurance. Gallery pays for shipping from gallery. Artist pays for shipping to gallery. Prefers artwork unframed.
Submissions Accepts artists from United States only. Send query letter with résumé and slides. Call for appointment to show portfolio of slides. Responds in 2 weeks. Files slides, biographies, information about artist's work.
Tips Finds artists through artist's submissions and referrals.

N. ART SOURCE LA INC.

Southern California Corporate Office, 2801 Ocean Park Blvd., # 7, Santa Monica CA 90405. (310)452-4411. Fax: (310)452-0300. E-mail: info@artsourcela.com. Website: www.artsourcela.com. **Contact:** Francine Ellman, president Southern California Corporate Office. Estab. 1980.
Media Considers fine art in all media, including works on canvas, paper, sculpture, giclée and a broad array of accessories handmade by American artists. Also sells photography, works on paper and sculpture. Considers all types of prints.
Terms Artwork is accepted on consignment, and there is a 50% commission. No geographic restrictions.
Submissions "Submit a minimum of 20 slides, photographs or inkjet prints (laser copies not acceptable), clearly labeled with name, date, title of work; plus résumé, catalogs, brochures, pricelist and SASE. E-mail submissions accepted; but not as good as slides, etc." Responds in 2 months.
Tips "Be professional when submitting visuals. Remember, first impressions can be critical! Submit a body of work that is consistent and of the highest quality. Work should be in excellent condition and already photographed for your records. Framing does not enhance presentation to the client."

N. ATHENAEUM MUSIC AND ARTS LIBRARY

1008 Wall St., La Jolla CA 92037-4418. (858)454-5872. Fax: (858)454-5835. **Director:** Erika Torri. Nonprofit gallery. Estab. 1899. Represents/exhibits emerging, mid-career and established artists. Exhibited artists include Ming Mur-Ray, Italo Scanga and Mauro Staccioli. Sponsors 8 exhibitions/year. Average display time 2 months. Open all year; Tuesday-Saturday, 10-5:30; Wednesday 10-8:30. Located downtown La Jolla. An original 1921 building designed by architect William Templeton Johnson 12-foot high wood beam ceilings, casement windows, Spanish-Italianate architecture. 100% of space for special exhibitions. Clientele tourists, upscale, local community, students and Athenaeum members. 100% private collectors. Overall price range $100-1,000; most work sold at $100-500.
Media Considers all media. Considers all types of prints. Most frequently exhibits painting, multi-media and book art.
Style Exhibits all styles. Genres include florals, portraits, landscapes and figurative work.
Terms Artwork is accepted on consignment, and there is a 25% commission. Retail price set by the artist. Gallery provides insurance and promotion; shipping costs are shared. Prefers artwork framed.
Submissions Artists must be considered and accepted by the art committee. Send query letter with slides, bio, SASE and reviews. Write for appointment to show portfolio of photographs, slides and transparencies. Responds in 2 months. Files slide and bio only if there is initial interest in artist's work.
Tips Finds artists through word of mouth and referrals.

N. TOM BINDER FINE ARTS

825 Wilshire Blvd., #708, Santa Monica CA 90401. (310)822-1080. Fax: (310)822-1580. E-mail: info@artman.n et. Website: www.artman.net. For profit gallery. Exhibits established artists. Also has location in Marina Del Rey. Clients include local community, tourists and upscale. Overall price range $200-2,000.

• Tom Binder Fine Arts also has a listing in the Poster & Prints section of this book.

Media Considers all media; types of prints include etchings, lithographs, posters and serigraphs.

Style Considers all styles and genres.

Making Contact & Terms Artwork accepted on consignment or bought outright. Retail price set by the gallery. Gallery provides insurance. Accepted work should be mounted.

Submissions Write to arrange a personal interview to show portfolio. Returns material with SASE. Responds in 2 weeks.

CENTRAL CALIFORNIA ART ASSOCIATION/MISTLIN GALLERY

1015 J St., Modesto CA 95354. (209)529-3369. Fax: (209)529-9002. E-mail: artcenter@ccartassn.org. Website: www.ccartassn.org. **Gallery Director:** Nancy Hawn. Cooperative, nonprofit sales, rental and exhibition gallery. Estab. 1951. Represents emerging, mid-career and established artists. Average display time 3 months. Open all year. Located downtown. Overall price range $50-3,000; most artwork sold at $300-800.

Media Considers oil, pen & ink, works on paper, fiber, acrylic, drawing, sculpture, watercolor, mixed media, ceramic, pastel, collage, photography and original handpulled prints. Most frequently exhibits watercolor, oil and acrylic.

Style Exhibits mostly impressionism, realism and abstract. Will consider all styles and genres.

Terms Artwork is accepted on consignment (40% commission). Price set by artist. Installment payment available. Prefers framed artwork.

Submissions Call for information. All works subject to jury process. Portfolio review not accepted. Finds artists primarily through referrals from other artists.

N CONTEMPORARY CENTER

2630 W. Sepulveda Blvd., Torrance CA 90505. (310)539-1933. Fax: (310)539-0724. **Director:** Sharon Fowler. Retail gallery. Estab. 1953. Represents 150 emerging, mid-career and established artists. Exhibited artists include Steve Main, Cheryl Williams. Open all year; Tuesday-Saturday, 10-6; Sunday 12-5; closed Monday. Space is 5,000 sq. ft. "We sell contemporary American crafts along with contemporary production and handmade furniture." Clientele: private collectors, gift seekers, many repeat customers. Overall price range $20-800; most work sold at $20-200.

Media Considers paper, sculpture, ceramics, fiber and glass.

Terms Retail price set by the gallery and the artist.

Submissions Send query letter with brochure, slides and photographs. Call for appointment to show portfolio of photographs and slides. Responds in 2 weeks. Finds artists through word of mouth and attending craft shows.

Tips "Be organized with price, product and realistic ship dates."

N PATRICIA OORREIA GALLERY

2525 Michigan Ave., Bergamot Station #E2, Santa Monica CA 90404. (310)264-1760. Fax: (310)264-1762. E-mail: correia@earthlink.net. Website: www.correiagallery.com. **Director:** Patricia Correia. Associate Director: Rae Anne Robinett. Retail gallery. Estab. 1991. Represents 8 established artists only (at museum level). Exhibited artists include Patssi Valdez and Frank Romero. Sponsors 8 shows/year. Average display time 6 weeks. Open all year. 80% of space for special exhibitions; 20% of space for gallery artists. Clientele: upper middle class. 70% private collectors, 10% corporate collectors, 20% museum collection. Overall price range $500-100,000; most work sold at $10,000-20,000.

• Located in fashionable Bergamot Station, arts district surrounded by other interesting galleries.

Media Considers all media.

Style Exhibits contemporary art.

Terms Accepts work on consignment (50% commission). Retail price set by gallery and artist. Gallery provides insurance, promotion, contract and shipping costs from gallery.

Submissions Must be collected by museums.

Tips "The role as a dealer is different in contemporary time. It is as helpful for the artist to learn how to network with museums, press and the art world, as well as the gallery doing the same. It takes creative marketing on both parts. Please include your résumé, cover letter and slides with dimensions, median and retail price. Visit the gallery first and know their policies."

CUESTA COLLEGE ART GALLERY

P.O. Box 8106, San Luis Obispo CA 93403-8106. (805)546-3202. Fax: (805)546-3904. E-mail: pmckenna@cuesta. edu. Website: academic.cuesta.cc.ca.us/finearts/gallery.htm. **Contact:** Pamela McKenna, gallery assistant. Nonprofit gallery. Estab. 1965. Exhibits the work of emerging, mid-career and established artists. Exhibited artists include Italo Scanga and JoAnn Callis. Sponsors 5 shows/year. Average display time 4½ weeks. Open

all year. Space is 1,300 sq. ft.; 100% of space for special exhibitions. Overall price range $250-5,000; most work sold at $400-1,200.

Media Considers all media and all types of prints. Most frequently exhibits painting, sculpture and photography.

Style Exhibits all styles, mostly contemporary.

Terms Accepts work on consignment (20% commission). Retail price set by artist. Customer payment by installment available. Gallery provides insurance, promotion and contract; shipping costs are shared. Prefers artwork framed.

Submissions Send query letter with résumé, slides, bio, brochure, SASE and reviews. Call for appointment to show portfolio. Responds in 6 months. Finds artists mostly by reputation and referrals, sometimes through slides.

Tips ''We have a medium budget, thus cannot pay for extensive installations or shipping. Present your work legibly and simply. Include reviews and/or a coherent statement about the work. Don't be too slick or too sloppy.''

⋈ DELPHINE GALLERY

1324 State St., Suite J, Santa Barbara CA 93101. **Director:** Michael Lepere. Retail gallery and custom frame shop. Estab. 1979. Represents/exhibits 10 mid-career artists/year. Exhibited artists include Jim Leonard, Katie Uptown and Steve Vessels. Sponsors 8 shows/year. Average display time 4-6 weeks. Open all year; Tuesday-Friday, 10-5; Saturday, 10-3. Located downtown Santa Barbara; 1,300 sq. ft.; natural light (4th wall is glass). 33% of space for special exhibitions. Clientele: upscale, local community. 40% private collectors, 20% corporate collectors. Overall price range $1,000-4,500; most work sold at $1,000-3,000.

Media Considers all media except photography, installation and craft. Considers serigraphs. Most frequently exhibits oil on canvas, acrylic on paper and pastel.

Style Exhibits conceptualism and painterly abstraction. Includes all genres and landscapes.

Submissions No longer accepting submissions.

⋈ DEVORZON GALLERY

2720 Ellison Dr., Beverly Hills CA 90210-1208. (310)888-0111. Website: www.devorzongallerycom. **Owner:** Barbara DeVorzon. Private gallery. ''We also work in the design trade.'' Represents emerging and mid-career artists. Exhibited artists include Vasa, John Kennedy, Zdenek Sorf, Fulvia Levi-Bianchi, Enrique Senis Oliver. Average display time varies. Open all year. Located in Beverly Hills; 6,000 sq. ft. 100% of space for special exhibitions. 25% private collectors; 25% corporate collectors; 50% designers. Overall price range $500-10,000.

Media Considers oil, acrylic, watercolor, pastel, mixed media and sculpture. Most frequently exhibits oil or acrylic canvases, mixed media or three dimensional sculpture.

Style Exhibits neo-expressionism, painterly abstraction, conceptualism, color field, realism, photorealism and neo-renaissance. ''Original work only!''

Terms Accepts work on consignment. Retail price set by the gallery. Gallery provides insurance. Artist pays for shipping. Prefers artwork unframed.

Submissions Call for appointment to show portfolio.

FALKIRK CULTURAL CENTER

1408 Mission Ave., P.O. Box 151560, San Rafael CA 94915-1560. (415)485-3328. Fax: (415)485-3404. Website: www.falkirkculturalcenter.org. Nonprofit gallery. Estab. 1974. Approached by 500 artists/year. Exhibits 350 emerging, mid-career and established artists. Sponsors 8 exhibits/year. Average display time 2 months. Open Tuesday, Wednesday, Thursday, 1-5; Saturday, 10-1. Closed Sundays. Three galleries located on second floor with lots of natural light (UV filtered). National historic place (1888 Victorian) converted to multi-use cultural center. Clients include local community, students, tourists and upscale.

Media Considers all media and all types of prints. Most frequently exhibits painting, sculpture and works on paper.

Making Contact & Terms Artwork is accepted on consignment, and there is a 30% commission. Retail price set by the artist. Gallery provides insurance. Prefers only Marin County artists.

Submissions Marin County and San Francisco Bay Area artists only. Send artist's statement, bio, résumé and slides. Returns material with SASE. Responds within 3 months.

GALLERY BERGELLI

483 Magnolia Ave., Larkspur CA 94939. (415)945-9454. Fax: (415)945-0311. E-mail: rcritelli@bergelli.com. Website: www.gallerybergelli.com. **Contact:** Robin Critelli, owner. For-profit gallery. Estab. 2000. Approached by 200 artists/year; exhibits 15 emerging artists/year. Exhibited artists include Jeff Faust and James Leonard (acrylic painting). Sponsors 8-9 exhibits/year. Average display time 6 weeks. Open all year; Tuesday-Saturday, 10-5; Sunday, 12-5. ''We're located in affluent Marin County, just across the Golden Gate Bridge from San

Francisco. The Gallery is in the center of town, on the main street of Larkspur, a charming village known for its many fine restaurants. It is spacious and open with 2,500 square feet of exhibition space with large window across the front of the building. Moveable hanging walls (see the home page of our website) give us great flexibility to customize the space to best show the current exhibition.'' Clients include local community, upscale in the Marin County & Bay Area. Overall price range is $2,000-26,000; most work sold at $4,000-10,000.

Media Considers acrylic, collage, mixed media, oil, pastel, sculpture. Most frequently exhibits acrylic, oil and sculpture.

Style Exhibits geometric abstraction, imagism, new-expressionism, painterly abstraction, postmodernism, surrealism. Most frequently exhibits painterly abstraction, imagism and neo-expressionism.

Terms Artwork is accepted on consignment and there is a 50% commission. Retail price set by the artist with gallery input. Gallery provides insurance and promotion. Accepted work should be matted, stretched, unframed and ready to hang. Requires exclusive representation locally. Artwork evidencing geographic and cultural differences is viewed favorably.

Submissions Mail portfolio for review or send query letter with artist's statement, bio, brochure, business card, photographs, résumé, reviews, SASE and slides. Returns material with SASE. Responds to queries in 1 month. Files material not valuable to the artist (returns slides) that displays artist's work. Finds artists through art exhibits, portfolio reviews, referrals by other artists, submissions and word of mouth.

Tips ''Your submission should be about the artwork, the technique, the artist's accomplishments, and perhaps the artist's source of creativity. Many artist's statements are about the emotions of the artist, which is irrelevant when selling paintings.''

GALLERY EIGHT

7464 Girard Ave., La Jolla CA 92037. (858)454-9781. **Director:** Ruth Newmark. Retail gallery with focus on contemporary crafts. Estab. 1978. Represents 100 emerging and mid-career artists. Interested in seeing the work of emerging artists. Exhibited artists include Philip Moulthrop, Patrick Crab and Karen Massaro. Sponsors 6 shows/year. Average display time 6-8 weeks. Open all year; Monday-Saturday, 10-5. Located downtown; 1,200 sq. ft. 25% of space for special exhibitions; 75% of space for gallery artists. Clientele upper middle class, mostly 35-60 in age. Overall price range $5-5,000; most work sold at $25-150.

Media Considers ceramics, mixed media, sculpture, craft, fiber, glass. Most frequently exhibits ceramics, jewelry, mixed media.

Terms Accepts work on consignment (50% commission) or buys outright for 50% of retail price (net 30 days). Retail price set by the gallery and the artist. Gallery provides insurance, promotion and shipping costs from gallery; artist pays shipping costs to gallery.

Submissions Send query letter with résumé, slides, photographs, reviews and SASE. Call or write for appointment to show portfolio of photographs and slides. Responds in 3 weeks. Files ''generally only material relating to work by artists shown at gallery.'' Finds artists by visiting exhibitions, word of mouth, various art publications and sourcebooks, submissions, through agents, and juried fairs.

Tips ''Enclose résumé, cost of item (indicate if retail or wholesale), make appointment.''

Ⓝ GREENLEAF GALLERY

20315 Orchard Rd., Saratoga CA 95070. (408)867-3277. **Owner:** Janet Greenleaf. Director Chris Douglas. Collection and art consultancy and advisory. Estab. 1979. Represents 45 to 60 emerging, mid-career and established artists. By appointment only. ''Features a great variety of work in diverse styles and media. We have become a resource center for designers and architects, as we will search to find specific work for all clients.'' Clientele professionals, collectors and new collectors. 50% private collectors, 50% corporate clients. Prefers ''very talented emerging or professional full-time artistsalready established.'' Overall price range $400-15,000; most artwork sold at $500-8,000.

Media Considers oil, acrylic, watercolor, pastel, mixed media, collage, works on paper, sculpture, glass, original handpulled prints, lithographs, serigraphs, etchings and monoprints.

Style Deals in expressionism, neo-expressionism, minimalism, impressionism, realism, abstract work or ''whatever I think my clients want—it keeps changing.'' Traditional, landscapes, florals, wildlife, figurative and still lifes.

Terms Artwork is accepted on consignment. ''The commission varies.'' Artist pays for shipping or shipping costs are shared.

Submissions Send query letter, résumé, 6-12 photographs (but slides OK), bio, SASE, reviews and ''any other information you wish.'' Call or write to schedule an appointment for a portfolio review, which should include originals. If does not reply, the artist should call. Files ''everything that is not returned. Usually throw out anything over two years old.'' Finds artists through visiting exhibits, referrals from clients, or artists, submissions and self promotions.

Tips ''Send good photographs with résumé and ask for an appointment. Send to many galleries in different

areas. It's not that important to have a large volume of work. I would prefer to know if you are full time working artist and have representation in other galleries.''

JUDITH HALE GALLERY

2890 Grand Ave., P.O. Box 884, Los Olivos CA 93441-0884. (805)688-1222. Fax: (805)688-2342. E-mail: info@judithhalegallery.com. Website: www.judithhalegallery.com. **Owner:** Judy Hale. Retail gallery. Estab. 1987. Represents 70 mid-career and established artists. Exhibited artists include Dirk Foslien, Howard Carr, Kelly Donovan and Mehl Lawson. Sponsors 4 shows/year. Average display time 6 months. Open all year. Located downtown; 2,100 sq. ft.; "the gallery is eclectic and inviting, an old building with six rooms." 20% of space for special exhibitions which are regularly rotated and rehung. Clientele: homeowners, tourists, decorators, collectors. Overall price range $500-15,000; most work sold at $500-5,000.

- This gallery opened a second location and connecting sculpture garden next door at 2884 Grand Ave. Representing nationally recognized artists, including Ted Goerschner, Marilyn Simandle, Dave DeMatteo, Dick Heichberger, this old building once housed the blacksmith's shop.

Media Considers oil, acrylic, watercolor, pastel, sculpture, engravings and etchings. Most frequently exhibits watercolor, oil, acrylic and sculpture.

Style Exhibits impressionism and realism. Genres include landscapes, florals, western and figurative work. Prefers figurative work, western, florals, landscapes, structure. No abstract or expressionistic.

Terms Accepts work on consignment (40% commission). Retail price set by artist. Offers payment by installments. Gallery arranges reception and promotion; artist pays for shipping. Prefers artwork framed.

Submissions Call ahead, or e-mail a link to your website, or a couple of representative images. This saves the mailing of slides, etc., and I don't have to return them. Send query letter with 10-12 slides, bio, brochure, photographs, business card and reviews. Call for appointment to show portfolio of photographs. Responds in 2 weeks. Files bio, brochure and business card.

Tips "Create a nice portfolio. See if your work is comparable to what the gallery exhibits. Do not plan your visit when a show is on; make an appointment for future time. I like 'genuine' people who present quality with fair pricing. Rotate artwork in a reasonable time, if unsold. Bring in your best work, not the 'seconds' after the show circuit.''

N LA ARTISTS GALLERY

3222 La Cienega Ave., #301, Culver City CA 90232. (310)841-2738. E-mail: susan100art@yahoo.com. Website: www.laartists.com. **Contact:** Susan Anderson, director. Alternative space. Estab. 2000. Approached by 25 artists/year. Represents 25 mid-career artists. Exhibited artists include Dan Shupe, Esau Andrade. Gallery not open to walk-ins. Open by appointment. Clients include upscale dealers, designers, private clients. 10% of sales are to corporate collectors. Overall price range $1,500-5,000.

Media Considers collage, oil, sculpture, watercolor. Most frequently exhibits oil on canvas. Considers all types of prints.

Style Exhibits neo-expressionism, postmodernism, figurative, contemporary, folk. Most frequently exhibits figurative/contemporary.

Terms Artwork is accepted on consignment and there is a 10-50% commission. Retail price set by the artist.

Submissions Write to arrange personal interview to show portfolio of photographs. Mail portfolio for review. Returns material with SASE. Does not reply to queries. File work I can sell.

Tips "Keep submissions really short and enclose photographs, not slides."

LEUCADIA GALLERY

1038 N. Coast Highway 101, Leucadia CA 92024. (760)753-8829.

- This gallery was opened by the owners of Grove St. Gallery in Illinois. Leucadia Gallery specializes in original and limited edition ocean/surf artwork and custom framing. See Grove St. listing for information on needs and submissions policies.

LIZARDI/HARP GALLERY

P.O. Box 91895, Pasadena CA 91109. (626)791-8123. Fax: (626)791-8887. E-mail: lizardiharp@earthlink.net. **Director:** Grady Harp. Retail gallery and art consultancy. Estab. 1981. Represents 15 emerging, mid-career and established artists/year. Exhibited artists include Wes Hempel, Gerard Huber, Wade Reynolds, Robert Peterson and William Fogg. Sponsors 4 shows/year. Average display time 2 months. Open all year; Tuesday-Saturday by appointment only. 80% private collectors, 20% corporate collectors. Overall price range $900-80,000; most work sold at $2,000-15,000.

Media Considers oil, acrylic, watercolor, pastel, pen & ink, drawing, mixed media, sculpture, installation, photography, lithographs, and etchings. Most frequently exhibits works on paper and canvas, sculpture, photography.

Style Exhibits representational art. Genres include landscapes, figurative work—both portraiture and narrative and still life. Prefers figurative, landscapes and experimental.

Terms Accepts work on consignment (50% commission). Retail price set by the gallery and the artist. Gallery provides insurance, promotion, contract; artist pays shipping costs.

Submissions Send query letter with artist's statement, résumé, 20 slides, bio, photographs, SASE and reviews. Write for appointment to show portfolio of photographs, slides and transparencies. Responds in 1 month. Files "all interesting applications." Finds artists through studio visits, group shows, submissions.

Tips "Timelessness of message is a plus (rather than trendy). Our emphasis is on quality or craftsmanship, evidence of originality . . . and maturity of business relationship concept." Artists are encouraged to send an "artist's statement with application and at least one 4×5 or print along with 20 slides. Whenever possible, send images over the Internet via e-mail."

JESSEL MILLER GALLERY

1019 Atlas Peak Rd., Napa CA 94558. (707)257-2350. E-mail: jessel@napanet.net. Website: www.jesselgallery.com. **Owner:** Jessel Miller. Retail gallery. Represents 50 emerging, mid-career and established artists. Exhibited artists include Clark Mitchell, Timothy Dixon and Jessel Miller. Sponsors 2-6 shows/year. Average display time 1 month. Open all year; 7 days/week 10:00-5:00. Located 1 mile out of town; 9,000 sq. ft. 20% of space for special exhibitions; 50% of space for gallery artists. Clientele upper income collectors. 95% private collectors, 5% corporate collectors. Overall price range $25-10,000; most work sold at $2,000-3,500.

Media Oil, acrylic, watercolor, pastel, collage, sculpture, ceramic and craft. Most frequently exhibits acrylic, watercolor and pastel.

Style Exhibits painterly abstraction, photorealism, realism and traditional. Genres include landscapes, florals and figurative work. Prefers figurative, landscape and abstract.

Terms Accepts work on consignment (50% commission). Retail price set by gallery. Gallery provides promotion; artist pays for shipping costs. Prefers artwork framed.

Submissions Send query letter with résumé, slides, bio, SASE and reviews. Call (after sending slides and background info) for appointment to show portfolio of photographs or slides. Responds in 1 month.

☒ MOCTEZUMA BOOKS & GALLERY

289 Third Ave., Chula Vista CA 91910-2721. (619)426-1283. Fax: (619)426-0212. E-mail: lisamoctezuma@hotmail.com. Website: www.latambooks.com. **Contact:** Lisa Moctezuma, owner. For-profit gallery. Estab. 1999. Approached by 40 artists/year. Represents 12 emerging, mid-career and established artists. Exhibited artists include: Alberto Blanco (painting, Chinese ink drawings, collage, mixed media) and Norma Michel (painting, mixed media and boxes). Sponsors 8 exhibits/year. Average display time 6 weeks. Open all year; Monday-Saturday, 10-5. Located just south of San Diego, in downtown Chula Vista. The gallery space is approximately 1,000 sq. ft. and is coupled with a bookstore. Clients include local community and upscale. 10% of sales are to corporate collectors. Overall price range: $200-2,000; most work sold at $800.

Media Considers all media and all types of prints. Most frequently exhibits paper, canvas, watercolor and acrylic.

Style Considers all styles and genres. Most frequently exhibits painterly abstraction, primitivism realism and conceptualism.

Terms Artwork is accepted on consignment and there is a 40% commission. Retail price set by the gallery. Gallery provides promotion and contract. Accepted work should be framed. Does not require exclusive representation locally. We focus on established and emerging artists from the San Diego/Tijuana border area, Mexico and the Californias.

Submissions Mail portfolio for review. Send query letter with artist's statement, bio, photocopies, photographs, résumé, reviews, SASE and slides. Responds in 2 months. Finds artists through word of mouth and referrals by other artists.

MUSEUM WEST FINE ART

332 Commercial St., San Jose CA 95112. (408)275-0303. E-mail: info@museumwest.com. Website: www.museumwest.com. **Director:** Anne Larsen. Retail gallery. Estab. 1995. Of artists represented 35% are emerging, 35% are mid-career and 30% are established. Exhibited artists include Robert Motherwell, Bill Barrett, Franco Prayer, Ricardo Mazal, Janette Urso, Shawn Dulaney, Pat Sherwood, Richard Diebenkorn, John Kapel, Donna McGinnis and Joan Miro. Sponsors 4-5 shows/year. Average display time 40 days in rotation. Open all year; Monday-Friday, 10-9; Saturday, 10-7; Sunday, 11-6. Located in the heart of the Silicon Valley; 2,000 sq. ft.; 40% of space for special exhibitions. Clientele: international collectors and private art consultants. 70% private collectors, 20% corporate collectors, 10% private art consultants. Overall price range $500-40,000; most work sold at $2,000-8,000. Works with architects and designers for site-specific commissions—often in the $8,000-60,000 range.

Media Considers oil, acrylic, sculpture, watercolor, mixed media, pastel, collage, photography, original hand-pulled prints, woodcuts, wood engravings, linocuts, engravings, mezzotints, etchings, lithographs and serigraphs. Most frequently exhibits high-quality paintings, prints, sculpture and photography.

Style Exhibits primarily abstract work. Genres include landscapes, florals, figurative work and city scapes.

Terms Retail price set by gallery and artist. Gallery provides insurance, promotion, contract and shipping costs from gallery; artist pays for shipping costs to gallery.

Submissions Prefers mature artists who know quality and who are professional in their creative and business dealings. "Know how to put together a submittal properly. Artists can no longer be temperamental." Send query letter with résumé, minimum of 20 current slides, bio, brochure, photographs, SASE, business card and reviews. Responds if interested within 3 weeks; if not interested, replies in a few days.

Tips "First, determine just how unique or well crafted or conceived your work really is. Secondly, determine your market—who would want this type of art and especially your type of art; then decide what is the fair price for this work and how does this price fit with the price for similar work by artists of similar stature. Lastly, have a well-thought-out presentation that shows consistent work and/or consistent development over a period of time. We work best with full-time artists."

ⓝ ORLANDO GALLERY

18376 Ventura Blvd., Tarzana CA 91356. (818)705-5368. E-mail: orlando2@earthlink.com. Website: www.emp ken.com/orlando.html. **Co-Directors:** Robert Gino and Don Grant. Retail gallery. Estab. 1958. Represents 30 emerging, mid-career and established artists. Sponsors 22 solo shows/year. Average display time is 1 month. Accepts only California artists. Overall price range up to $50,000; most artwork sold at $800. Open Tuesday-Saturday, 9:30-3:30.

Media Considers oil, acrylic, watercolor, pastel, pen & ink, drawings, mixed media, collage, works on paper, sculpture, ceramic and photography. Most frequently exhibits oil, watercolor and acrylic.

Style Exhibits painterly abstraction, conceptualism, primitivism, impressionism, photorealism, expressionism, neo-expressionism, realism and surrealism. Genres include landscapes, florals, Americana and figurative work. Prefers impressionism, surrealism and realism. Interested in seeing work that is contemporary. Does not want to see decorative art. Also on exhibit is tribal African art.

Terms Accepts work on consignment. Retail price set by artist. Offers customer discounts and payment by installments. Exclusive area representation required. Gallery provides insurance and promotion; artist pays for shipping.

Submissions Send query letter, résumé and 12 or more slides. Portfolio should include slides and transparencies. Finds artists through submissions. Portfolio may be sent by e-mail.

Tips "Be inventive, creative and be yourself."

ⓝ THE MARY PORTER SESNON GALLERY

Porter College, UCSC, Santa Cruz CA 95064. (831)459-3606. Fax: (831)459-3535. E-mail: lfellows@cats.ucsc.e du. Website: www.arts.ucsc.edu/sesnon. **Director:** Shelby Graham. University gallery, nonprofit. Estab. 1971. Features new and established artists. Sponsors 4-6 shows/year. Average display time 4-6 weeks. Open September-June; Tuesday-Saturday, noon-5. Located on campus; 1,000 sq. ft. 100% of space for changing exhibitions. Clientele: academic and community-based. "We are not a commercial gallery. Visitors interested in purchasing work are put in direct contact with artists."

Media Considers all media.

Style Exhibits experimental, conceptually-based work.

Terms Gallery provides insurance, promotion, shipping costs to and from gallery and occasional publications.

Submissions Send query letter with résumé, slides, statement, SASE and reviews. Responds only if interested within 6 months. "Material is retained for committee review and returned in SASE."

ⓝ POSNER FINE ART

13234 Fuji Way #G, Marina del Rey CA 90292. (310)822-2600. Fax: (310)578-8501. E-mail: posartl@aol.com. Website: www.posnergallery.com. **Director:** Judith Posner. Retail gallery and art publisher. Estab. 1994. Represents 200 emerging, mid-career and established artists. Sponsors 5 shows/year. Average display time 6 weeks. Open all year, Tuesday-Saturday, 10-6; Sunday, 12-5 or by appointment. Clientele: upscale and collectors. 50% private collectors, 50% corporate collectors. Overall price range $25-50,000; most work sold at $500-10,000.

Media Considers oil, acrylic, watercolor, pastel, mixed media, collage, works on paper, sculpture, ceramics, original handpulled prints, engravings, etchings, lithographs, posters and serigraphs. Most frequently exhibits paintings, sculpture and original prints.

Style Exhibits painterly abstraction, minimalism, impressionism, realism, photorealism, pattern painting and hard-edge geometric abstraction. Genres include florals and landscapes. Prefers abstract, trompe l'oeil, realistic.

Terms Accepts work on consignment (50% commission). Retail price set by the gallery. Customer discount

and payment by installments. Gallery provides insurance and promotion; shipping costs are shared. Prefers artwork unframed.

Submissions Send query letter with résumé, slides and SASE. Portfolio should include slides. Responds only if interested in 2 weeks. Finds artists through submissions and art collectors' referrals.

Tips "We are looking for artists for corporate collections."

SAN DIEGO ART INSTITUTE (SDAI: Museum of the Living Artist)

House of Charm, Balboa Park, San Diego CA 92101-1617. (619)236-0011. Fax: (619)236-1974. E-mail: director@ sandiego-art.org. Website: www.sandiego-art.org. **Executive Director:** Timothy J. Field. Membership Associate: Kerstin Robers. Art Director: K.D. Benton. Nonprofit gallery. Estab. 1941. Represents 600 emerging and mid-career member/artists. 2,400 artworks juried into shows each year. Sponsors 11 all-media exhibits/year. Average display time 4-6 weeks. Open Tuesday-Saturday, 10-4; Sunday 12-4. Closed major holidays—all Mondays. 10,000 sq. ft. located in the heart of Balboa Park. Clients include local community, students and tourists. 10% of sales are to corporate collectors. Overall price range $100-4,000. Most work sold at $800.

Media Considers all media and all types of prints. Most frequently exhibits oil, mixed media and pastel.

Style Considers all styles and genres. No craft or installations.

Making Contact & Terms Artwork is accepted on consignment, and there is a 40% commission. Membership fee $125. Retail price set by the artist. Accepted work should be framed. Work must be hand carried in for each monthly show except for annual international show juried by slides.

Submissions Request membership packet and information about juried shows. Membership not required for submittal in monthly juried shows, but fee required. Returns material with SASE. Finds artists through word of mouth and referrals by other artists.

Tips "All work submitted must go through jury process for each monthly exhibition. Work required to be framed in professional manner."

N SMITH ANDERSEN EDITIONS

440 Pepper St., Palo Alto CA 94306. **Contact:** Paula Kirkeby, owner. For-profit gallery; publish monotypes and exhibit artists who print with us. Estab. 1969. Exhibits emerging, mid-career, established artists. Approached by 50 artists/year. Exhibited artists include Sam Francis, prints and works on paper; Steven Sorman, unique prints. Sponsors 5 exhibits/year. Average display time 6 weeks. Open Wednesday-Saturday, 10-3. Open all year. 2,500 sq. ft.; exhibition 800 sq. ft.Clients include museums, private and corporate collectors. Overall price range: $300-50,000; most work sold at $3,000.

Media Considers acrylic, ceramics, collage, drawing, paper, pastel, pen & ink, watercolor. Most frequently exhibits monotypes and monoprints. Considers engravings, etchings, linocuts, lithographs, mezzotints, woodcuts.

Style Exhibits minimalism, painterly abstraction. Most frequently exhibits abstract and minimalist.

Making Contact & Terms Artwork is accepted on consignment and there is a 50% commission. Retail price set by the artist. Gallery provides insurance and promotion. Does not require exclusive representation locally.

Submissions Mail portfolio for review including SASE and slides. Returns material with SASE. Responds to queries only if interested within 3 weeks.

JILL THAYER GALLERIES AT THE FOX

1700 20th St., Bakersfield CA 93301-4329. (661)328-9880. Fax: (661)631-9711. E-mail: jill@jillthayer.com. Website: www.jillthayer.com. **Director:** Jill Thayer. For profit gallery. Estab. 1994. Represents 20 emerging, mid-career and established artists. Features 6-8 exhibits/year. Average display time 6 weeks. Open Thursday-Friday, 10-4; Saturday 1-4 or by appointment. Closed holidays. Located at the historic Fox Theater, built in 1930. Thayer renovated the 400 sq. ft. space in 1994. The space features large windows, high ceilings, wood floor and bare wire, SoLux halogen lighting system. Clients include regional southern California upscale. 50% of sales are to corporate collectors. Overall price range $250-10,000; most work sold at $1,500.

Media Considers all media and all types of prints. Exhibits painting, drawing, photography, montage, assemblage, glass.

Style Color field, conceptualism, expressionism, impressionism, neo-expressionism and painterly abstraction. Most frequently exhibits contemporary, abstract, impressionistic and expressionistic.

Terms Artwork is accepted on consignment and there is a 50% commission. Artist pays all shipping. Retail price set by the gallery and the artist. Gallery provides promotion and contract. Artist shares cost of mailings and receptions.

Submissions Send query letter with artist's statement bio, résumé, reviews, SASE and slides. Responds in 1 month if interested. Finds artists through submissions and portfolio reviews.

Tips "When submitting to galleries, be concise, professional, send up-to-date vitae (listing of exhibitions and education/bio) and a slide sheet."

NATALIE AND JAMES THOMPSON ART GALLERY

School of Art Design, San Jose CA 95192-0089. (408)924-4723. Fax: (408)924-4326. E-mail: jfh@cruzio.com. Website: www.sjsu.edu. **Contact:** Jo Farb Hernandez, director. Nonprofit gallery. Approached by 100 artists/year. Sponsors 6 exhibits/year of emerging, mid-career and established artists. Average display time 1 month. Open during academic year; Tuesday, 11-4, 6-7:30; Wednesday-Friday, 11-4. Closed semester breaks, summer and weekends. Clients include local community, students and upscale.

Media Considers all media and all types of prints.

Style Considers all styles and genres.

Terms Retail price set by the artist. Gallery provides insurance, transportation and promotion. Accepted work should be framed and/or ready to display. Does not require exclusive representation locally.

Submissions Send query letter with artist's statement, bio, résumé, reviews, SASE and slides. Returns material with SASE.

N EDWARD WESTON FINE ART

10511 Andora Ave., P.O. Box 3098, Chatsworth CA 91313. (818)885-1044. Fax: (818)885-1021. Art consultancy, for profit gallery, rental and wholesale gallery. Estab. 1960. Approached by 50 artists/year. Represents 100 emerging, mid-career and established artists. Exhibited artists include George Barris, George Hurrell, C.S. Bull, Milton Greene and Laszlo Willinger. Sponsors 16 exhibits/year. Average display time 4-6 weeks. Open 7 days a week by appointment. Located in a 2-story 30×60 showroom gallery, office and storage facility. Clients include local community, tourists, upscale and dealers. 5% of sales are to corporate collectors. Overall price range $50-75,000; most work sold at $1,000.

Media Considers all media and all types of prints. Most frequently exhibits photography, paintings, sculpture and Picasso ceramics.

Style Considers all styles. Most frequently exhibits figurative work, landscapes. Considers all genres.

Making Contact & Terms Artwork is accepted on consignment, and there is a 50% commission. Artwork is bought outright for 10-20% of the retail price; net 30 days. Retail price set by the gallery. Gallery provides contract. Accepted work should be framed and matted. Requires exclusive representation locally.

Submissions Write to arrange a personal interview to show portfolio of photographs and transparencies. Mail portfolio for review. Send query letter with bio, brochure, business card, photocopies, photographs and reviews. Cannot return material. Responds in 1 month. Files materials if interesting. Finds artists through word of mouth, art exhibits and art fairs.

Tips "Be thorough and complete."

SYLVIA WHITE GALLERY CONTEMPORARY ARTISTS' SERVICES

1013 Pico Blvd, Santa Monica CA 90405. (310)452-4000. E-mail: info@artadvice.com. Website: www.artadvice.com. **Owner:** Sylvia White. Retail gallery, advisor and artist's career development services. Estab. 1979. Represents 25 emerging, mid-career and established artists. Interested in seeing work of emerging artists. Sponsors 12 shows/year. Average display time 1 month. Open all year; Tuesday-Friday, 10-5; Saturday by appointment. Located in downtown Santa Monica; 2,000 sq. ft.; 100% of space for special exhibitions. Clientele upscale. 50% private collectors, 50% corporate collectors. Overall price range $1,000-10,000; most work sold at $3,000.

• Sylvia White also has representatives in Chicago and San Francisco.

Media Considers all media, including photography. Most frequently exhibits painting and sculpture.

Style Exhibits all styles, including painterly abstraction and conceptualism.

Terms Retail price set by gallery and artist. Gallery provides insurance, promotion and contract. Artist pays for shipping costs.

Submissions Send query letter with résumé, slides, bio and SASE. Portfolio should include slides.

N WINFIELD GALLERY

P.O. Box 7393, Carmel CA 93921-7393. (831)624-3369. Fax: (831)624-5618. E-mail: chris@winfieldgallery.com. Website: www.winfieldgallery.com. **Contact:** Chris Winfield, director. For-profit gallery. Estab. 1993. Approached by 75 artists/year; exhibits 75 emerging, mid-career and established artists/year. Sponsors 4 exhibits/year. Average display time is 6 weeks. Open all year; Monday-Saturday, 11-5; Sunday, 12-5. Located "in the heart of Carmel on Dolores between Ocean and 7th. The 2,400 square foot gallery with open-beamed ceilings and skylights leads up to a 400 square foot stage of designated exhibition space." Clients include local community, students, tourists, upscale. Overall price range $300-100,000; most work sold at $2,500.

Media Considers acrylic, ceramics, drawing, mixed media, oil, sculpture, watercolor. Most frequently exhibits oil painting, sculpture and ceramics.

Style Considers all styles. Genres include figurative work, florals and landscapes.

Terms Artwork is accepted on consignment and there is a 50% commission. Retail price set by the artist and the gallery. Gallery provides insurance and contract. Requires exclusive representation locally.

Galleries

Submissions Write to arrange personal interview to show portfolio of prints. Send query letter with artist's statement, bio or résumé, and SASE. Returns material with SASE. Responds to queries only if interested in 2 months. Finds artist's through portfolio reviews, referrals by other artists, submissions and word of mouth.
Tips "Always include a SASE."

LEE YOUNGMAN GALLERIES

1316 Lincoln Ave., Calistoga CA 94515. (707)942-0585. Fax: (707)942-6657. E-mail: leeyg@sbcglobal.net. Website: www.leeyoungmangalleries.com. **Owner:** Ms. Lee Love Youngman. Retail gallery. Estab. 1985. Represents 40 established artists. Exhibited artists include Ralph Love and Paul Youngman. Sponsors 3 shows/year. Average display time 1 month. Open all year. Located downtown; 3,000 sq. ft.; "contemporary decor." Clientele 100% private collectors. Overall price range $500-24,000; most artwork sold at $1,000-3,500.
Media Considers oil, acrylic, watercolor and sculpture. Most frequently exhibits oils, bronzes and alabaster.
Style Exhibits impressionism and realism. Genres include landscapes, Southwestern, Western and wildlife. Interested in seeing American realism. No abstract art.
Terms Accepts work on consignment (50% commission). Retail price set by gallery. Customer discounts and payment by installment are available. Gallery provides insurance and promotion. Artist pays for shipping to and from gallery. Prefers framed artwork.
Submissions Accepts only artists from Western states. "No unsolicited portfolios." Portfolio review requested if interested in artist's work. "The most common mistake artists make is coming on weekends, the busiest time, and expecting full attention." Finds artists through publication, submissions and owner's knowledge.
Tips "Don't just drop in—make an appointment. No agents."

LOS ANGELES

ⓝ CRAFT & FOLK ART MUSEUM (CAFAM)

5814 Wilshire Blvd., Los Angeles CA 90036. (323)937-4230. Fax: (323)937-5576. **Director:** Maryna Hrushetska. E-mail: info@cafam.org. Museum. Estab. 1973. Sponsors 3-4 shows/year. Average display time 2-3 months. Open all year; Tuesday-Sunday 11-5; closed Monday. Located on Miracle Mile; features design, contemporary crafts, international folk art.
Media Considers all media, woodcut and wood engraving. Most frequently exhibits ceramics, found objects, wood, fiber, glass, textiles.
Style Exhibits all styles, all genres. Prefers culturally specific, craft and folk art.
Submissions Send query letter with résumé, slides and bio. Write for information. Portfolio should include slides. Finds artists through written submissions, word of mouth and visiting exhibits.

ⓘ GALLERY 825, LA Art Association

825 N. La Cienega Blvd., Los Angeles CA 90069. (310)652-8272. Fax: (310)652-9251. **Executive Director:** Peter Mays. Artistic Director: Sinead Finnerty. Nonprofit gallery. Estab. 1925. Exhibits emerging and established artists. "Artists must be Southern California-based." Interested in seeing the work of emerging artists. Approximately 200 members. Sponsors 11 juried shows/year. Average display time 3-4 weeks. Open all year; Tuesday-Saturday, 12-5. Located in Beverly Hills/West Hollywood. 25% of space for special exhibitions (2 rooms); 75% for gallery artists (2 large main galleries). Clientele set decorators, interior decorators, general public. 90% private collectors.
Media Considers all media and original handpulled prints. "Fine art only. No crafts." Most frequently exhibits mixed media, oil/acrylic and watercolor.
Style All styles.
Terms Requires $ 225 annual membership fee plus entry fees or 6 hours volunteer time for artists. Retail price set by artist (33% commission). Gallery provides promotion. "No shipping allowed." "Artists must apply via jury process held at the gallery 2 times per year in February and August." Phone for information.
Tips "No commercial work (i.e. portraits/advertisements)."

LA LUZ DE JESUS GALLERY

4633 Hollywood Blvd., Los Angeles CA 90027. (323)666-7667. Fax: (323)663-0243. E-mail: sales@laluzdejesus.com. Website: www.laluzdejesus.com. **Gallery Manager:** Rhoda Lopez. Retail gallery, retail store attached with ethnic/religious and pop culture merchandise. "We provide a space for low-brow/cutting edge and alternative artists to show their work." Estab. 1986. Represents emerging, mid-career and established artists. Exhibited artists include Shag, the Clayton brothers, Owen Smith, and Michael Hussar. Sponsors 12 shows/year; "each show ranges from 1 person to large group (as many as 100)." Average display time 4 weeks. Open all year; Sunday, 12-6; Monday-Wednesday, 11-7; Thursday-Saturday, 11-9. Clientele: "mostly young entertainment biz

types, celebrities, studio and record company types, other artists, business people, tourists.'' 95% private collectors, 5% corporate collectors. Overall price range $500-10,000; most work sold at $500-2,500.

Media Considers all media except digitally produced work. Considers all types of prints, which are usually shown with paintings and drawings by the same artist. Most frequently exhibits acrylic or oil, pen & ink.

Style Prefers alternative/underground/cutting-edge, comix-inspired.

Terms Accepts work on consignment (50% commission). Retail price set by the gallery and the artist.''We ask for an idea of what artist thinks and discuss it.'' Gallery provides insurance, promotion, contract. Gallery pays shipping costs from gallery, artist pays shipping costs to gallery, buyer pays for shipping if piece goes out of town. Prefers artwork framed.

Submissions Send query letter with résumé, slides, bio, photographs, SASE, reviews and an idea price range for artist's work. Responds on a quarterly basis. Finds artists through word of mouth (particularly from other artists), artists' submissions, visiting exhibitions.

Tips ''Visit the space before contacting us. If you are out of town, ask a friend to visit and give you an idea. We are a very different gallery.''

N LOS ANGELES MUNICIPAL ART GALLERY

Barnsdall Art Park, Los Angeles CA 90027. **Curators:** Noel Korten. and Scott Canty. Nonprofit gallery. Estab. 1971. Interested in emerging, mid-career and established artists. Sponsors 5 solo and group shows/year. Average display time 2 months. 10,000 sq. ft. Accepts primarily Southern California artists.

Media Considers oil, acrylic, watercolor, pastel, pen & ink, drawings, contemporary sculpture, ceramic, fiber, photography, craft, mixed media, performance art, video, collage, glass, installation and original handpulled prints.

Style Exhibits contemporary works only. ''We organize and present exhibitions which primarily illustrate the significant developments and achievements of living Southern California artists. The gallery strives to present works of the highest quality in a broad range of media and styles. Programs reflect the diversity of cultural activities in the visual arts in Los Angeles.''

Terms Gallery provides insurance, promotion and contract. This is a curated exhibition space, not a sales gallery.

Submissions Send query letter, résumé, brochure, slides and photographs. Slides and résumés are filed. Submit slides to Noel Korten.

Tips ''No limits, contemporary only.''

N BEN MALTZ GALLERY AT OTIS COLLEGE OF ART & DESIGN

9045 Lincoln Blvd., Los Angeles CA 90045. (310)665-6905. Fax: (310)665-6908. E-mail: galleryinfo@otis.edu. Website: www.otis.edu. **Gallery Director:** Meg Linton. Nonprofit gallery. Estab. 1957. Represents emerging and mid-career artists. Sponsors 4-6 exhibits/year. Average display time 1-2 months. Open Tuesday-Saturday, 10-5; Thursday, 10-7; closed major holidays. Located near Los Angeles International Airport (LAX). Approximately 3,520 sq. ft., wall height 14 ft. Clients include local community, students, tourists, upscale and artists.

Media Considers all media and all types of prints. Most frequently exhibits painting, mixed media. Finds artists through word of mouth, art exhibits, referrals by other artists.

Submissions Submit reproductions (slides, CD, DVD, video, photographs) with complete information, artist statement, and curriculum vitae, résumé or bio.

Tips Submit good quality 35mm slides of artwork—with information (name, title, date, media, dimensions) on slide—be patient. Submit reproductions (slides, CD, DVD, video, photographs) with complete information, artist statement, and curriculum vitae, résumé or bio.

SAN FRANCISCO

INTERSECTION FOR THE ARTS

446 Valencia, San Francisco CA 94103. (415)626-2787. Fax: (415)626-1636. E-mail: info@theintersection.org. Website: www.theintersection.org. **Program Director:** Kevin B. Chen. Alternative space and nonprofit gallery. Estab. 1965. Exhibits the work of 10 emerging and mid-career artists/year. Sponsors 8 shows/year. Average display time 6 weeks. Open all year. Located in the Mission District of San Francisco; 1,000 sq. ft.; gallery has windows at one end and cement pillars betwen exhibition panels. 100% of space for special exhibitions. Clientele: 100% private collectors.

• This gallery supports emerging and mid-career artists who explore experimental ideas and processes. Interdisciplinary, new genre, video performance and installation are encouraged.

Media Considers oil, pen & ink, acrylic, drawings, watercolor, mixed media, installation, collage, photography,

site-specific installation, video installation, original handpulled prints, woodcuts, lithographs, posters, wood engravings, mezzotints, linocuts and etchings.

Style Exhibits all styles and genres.

Terms Retail price set by artist. Customer discounts and payment by installment are available. Gallery provides promotion; shipping costs are shared.

Submissions Send query letter with résumé, 20 slides, reviews, bio, clippings and SASE. Portfolio review not required. Responds within 6 months only if interested and SASE has been included. Files slides.

Tips ''Create proposals which consider the unique circumstances of this location, utilizing the availability of the theater and literary program/resources/audience.''

THE LAB

2948 16th St., San Francisco CA 94103. (415)864-8855. Fax: (415)864-8860. Website: www.thelab.org. **Co-directors:** Kristen Chappa and Sherry Koyama. Nonprofit gallery and alternative space. Estab. 1983. Exhibits numerous emerging, mid-career artists/year. Interested in seeing the work of emerging artists. Sponsors 5-7 shows/year. Average display time 1 month. Open all year; Wednesday-Saturday, 1-6. 40×55 ft.; 17 ft. height; 2,200 sq. ft.; white walls. Doubles as a performance and gallery space. Clientele: artists and Bay Area communities.

 • The LAB often curates panel discussions, performances or other special events in conjunction with exhibitions. They also sponsor an annual conference and exhibition on feminist activism and art.

Media Considers all media with emphasis on interdisciplinary and experimental art. Most frequently exhibits installation art, interdisciplinary art, media art and group exhibitions.

Terms Artists receive honorarium from the art space. Work can be sold, but that is not the emphasis.

Submissions Submission guidelines online. Finds artists through word of mouth, submissions, calls for proposals.

Tips Ask to be put on their mailing list to get a sense of the LAB's curatorial approach and interests.

MUSEO ITALOAMERICANO

Fort Mason Center Bldg. C, San Francisco CA 94123. (415)673-2200. Fax: (415)673-2292. E-mail: sfmuseo@sbcglobal.net. Website: www.museoitaloamericano.org. Museum. Estab. 1978. Approached by 80 artists/year. Exhibits 15 emerging, mid-career and established artists/year. Exhibited artists include Sam Provenzano. Sponsors 7 exhibits/year. Average display time 3-4 months. Open all year; Wednesday-Sunday, 12-4. Closed major holidays. Located in the San Francisco Marina District with beautiful view of the Golden Gate Bridge. 3,500 sq. ft. of exhibition space. Clients include local community, students, tourists, upscale and members.

Media Considers all media and all types of prints. Most frequently exhibits mixed media, paper, photography, oil, sculpture and glass.

Style Considers all styles and genres. Most frequently exhibits primitivism realism, geometric abstraction, figurative and conceptualism; 20th century and contemporary art.

Terms The museum sells pieces in agreement with the artist, and if it does, it takes 25% of the sale. Gallery provides insurance and promotion. Accepted work should be framed, mounted and matted. Accepts only Italian or Italian-American artists.

Submissions Submissions accepted with artist's statement, bio, brochure, photography, résumé, reviews, SASE and slides or CDs. Returns material with SASE. Responds in 2 months. Files 2 slides and biography and artist's statement for each artist. Finds artists through word of mouth and submissions.

Tips Looks for good quality slides and clarity in writing statements and résumés. ''Be concise.''

▣ A NEW LEAF GALLERY/SCULPTURESITE.COM

SCULPTURESITE Gallery: 201 Third St., Suite 103, San Francisco CA 94103. (415)495-6400. E-mail: info@sculpturesite.com. Hours: Tuesday-Saturday, 10-6; Thursday 10-8. A NEW LEAF Gallery: Cornerstone Gardens, 23570 Arnold Drive (Hwy. 121), Sonoma CA 95476. (707)933-1300. E-mail: info@sculpturesite.com. Hours: Thursday-Monday, 10-6; closed Tuesday and Wednesday. **Contact:** Brigitte Micmacker, curator. Retail gallery. Estab. 1990. Represents 100 emerging, mid-career and established artists. Sponsors 10 sculpture shows/year. Average display time 3-4 months. Clients include local community, USA and upscale. Overall price range $1,000-1,000,000; most work sold at $5,000-20,000.

Media Considers sculpture, mixed media, ceramic and glass. Most frequently exhibits sculpture. No crafts. ''No paintings or works on paper, please.''

Style Exhibits only contemporary abstract and abstract figurative.

Terms Accepts artwork on consignment (40-50% commission). Exclusive area representation required. Retail price set by artist in cooperation with gallery. Gallery provides insurance.

Submissions Check website for submission requirements; digital images best or send e-mail link to your site for review. Responds 2-3 times per year.

Tips "We suggest artists visit us if possible: these two galleries have unique settings. Sculpturesite is much more upscale. Sculpturesite.com, our extensive website, shows difference in the artwork shown at both galleries."

OCTAVIA'S HAZE GALLERY

498 Hayes St., San Francisco CA 94102. (415)255-6818. Fax: (415)255-6827. E-mail: octaviashaze@mindspring. com. Website: www.octaviashaze.com. **Director:** Kelly Yount. For profit gallery. Estab. 1999. Approached by 60 artists/year. Represents 30 emerging and mid-career artists. Exhibited artists include Tsuchida Yasuhiko and James Michalopoulos. Sponsors 6 exhibits/year. Average display time 60 days. Open all year; Wednesday-Saturday, 12-6; Sunday, 12-5. Closed Christmas through New Years. Clients include local community, tourists and upscale. 13% of sales are to corporate collectors. Overall price range $200-6,000; most work sold at $600.
Media Most frequently exhibits glass, paintings (all media) and photography. Considers all types of prints.
Style Considers all styles. Most frequently exhibits abstract, surrealism and expressionism. Genres include figurative work and landscapes.
Terms Artwork is accepted on consignment and there is a 50% commission. Retail price set by the gallery. Gallery provides promotion and contract. Accepted work should be framed and matted.
Submissions Send query letter with artist's statement, résumé, SASE and slides. Returns material with SASE. Responds in 4 months. Finds artists through word of mouth, submissions and art exhibits.

COLORADO

Ⓝ 🏛 BUSINESS OF ART CENTER

513 Manitou Ave., Manitou Springs CO 80829. (719)685-1861. Website: www.thebac.org. Nonprofit gallery. Estab. 1988. Approached by 200 emerging, mid-career and established artists/year. Sponsors 40 exhibits/year. Average display time 1 month. Open all year; Tuesday-Saturday, 10-5. Shorter winter hours, please call. Clients include local community, students and upscale. 10% of sales are to corporate collectors.
Media Considers all media and all types of prints. Most frequently exhibits painting, photography and ceramic.
Style Considers all styles and genres.
Terms Artwork is accepted on consignment and there is a 40% commission. Retail price set by the artist. Gallery provides insurance, promotion and contract. Accepted work should be framed. Requires exclusive representation locally. Primary focus on Colorado artists.
Submissions Write to arrange a personal interview to show portfolio. Send query letter with artist's statement, bio and slides. Returns material with SASE. Finds artists through word of mouth, submissions, portfolio reviews, art exhibits and referrals by other artists.
Tips Archival quality materials are mandatory to the extent possible in the medium.

Ⓝ COGSWELL GALLERY

223 Gore Creek Dr., Vail CO 81657. (970)476-1769 or (866)476-1769. Fax: (970)479-1141. E-mail: cogswellgaller y@qwest.net. Website: www.cogswellgallery.com. **Contact:** Steven C. DeWitt, Jr., director. Owner: John Cogswell. Retail gallery. Estab. 1980. Represents over 40 emerging, mid-career and established artists. Exhibited artists include Don Brackett, Edward S. Curtis and Sherry Sander. Sponsors 8-10 shows/year. Average display time 3 weeks. Open all year. Located in Creekside Building in Vail Village; 3,000 sq. ft. 50% of space used for special exhibitions. Clientele is both American and International with 80% private collectors and 20% corporate collectors. Overall price range $100-50,000; most work sold at $1,000-5,000. Works closely with design firms to provide art solutions for both commercial and private parties.
Media Considers sculpture, oil, watercolor, pastels, engravings, lithographs, giclées, serigraphs and jewelry. Most frequently exhibits bronze sculpture, paintings, jewelry and antique photography.
Style Exhibits color field and impressionism. Genres include Southwestern, Western, landscape, figurative work, wildlife, bronze.
Terms Accepts work on consignment (commission to be discussed). Retail price set by the artist. Offers payment by installments. Gallery provides insurance and promotion; shipping costs from gallery. Prefers artwork framed.
Submissions Send query letter or e-mail with résumé, images and bio. Call for appointment to show portfolio. Responds only if interested within 1 month.

Ⓝ FIRST PEOPLES GALLERY

P.O. Box 2090, 111 E. Main St., Frisco CO 80443. (970)513-8038 or (888)663-3900. Fax: (970)513-8053. E-mail: indianart@direcway.com. Website: www.FIRSTPeoples.net. **Director:** Victoria Torrez Kneemeyer. Retail gallery. Estab. 1992. Represents 30 mid-career and established artists/year. Interested in seeing the work of emerging North American Native and Southwestern artists. Exhibited artists include Bill Mittag, Lisa Fi Field, Pablo Luzardo and Raymond Nordwall. Sponsors 2 shows/year. Average display time 6 weeks. Open all year;

Tuesday-Sunday, 11-6. Located in Summit City—Colorado's playground. Space is 2,000 sq. ft. (new construction) in ski resort location. 60% of space for special exhibitions; 40% of space for gallery artists. Clientele collectors, walk-in traffic, tourists. 30% private collectors, 10% corporate collectors. Overall price range $100-1,000 (40%), $1,000-15,000 (10%); most work sold at $7,000 (50%).

Media Considers oil, acrylic, watercolor, pastel, pen & ink, mixed media, sculpture, pottery (coiled, traditional style only) and Cape Dorset Soapstone sculpture. Most frequently exhibits oil and acrylic, watercolors.

Style Only North American Native fine art paintings. Exhibits expressionism, landscapes, traditional, wildlife and (figurative) realism by several artists, Southwest artists (Art Deco, Kiowa), who work in Santa Fe school, Jalisco and other local styles. Genres includes Southwestern, portraits and figurative work. Prefers expressionism, landscapes, wildlife, traditional styles.

Terms Accepts work on consignment (40-50% commission) or buys outright for 50% of retail price (net 30 days). Retail price set by the gallery and the artist. Gallery provides insurance, promotion and contract; artist pays shipping costs to gallery. Prefers artwork framed in wood.

Submissions Accepts only artists native to North America. Send query letter with résumé, slides, bio, brochure, price list, list of exhibitions, business card and reviews. Call for appointment to show portfolio. Responds in 3-4 weeks. Responds if interested within 1 week. Files entire portfolio. Finds artists through exhibits, submissions, publications and Indian markets.

Tips "Send artist statement, bio and profile describing work and photos/slides. First Peoples Gallery accepts only North American Native art and a minimum of ten pieces."

FORT COLLINS MUSEUM OF CONTEMPORARY ART

201 S. College Ave., Ft. Collins CO 80524. (970)482-2787. Website: www.fcmoca.org. **Executive Director:** Jeanne Shoaff. Private nonprofit noncollecting museum. Estab. 1983. Presents 10 rotating exhibitions/year in two galleries, 1,800 sq. ft. each. Showing the work of emerging and mid-career regional, national and international artists. Open all year; Tuesday-Saturday, 10-6. Located downtown; in 1911 renovated Italian renaissance post office building.

Media Considers all media.

Style Exhibits work by living artists with emphasis on new media, form or techniques and work that gives visual expression to contemporary issues.

Submissions Send 15-20 slides of latest work with résumé and artist's statement with SASE. Slides may be kept for 4 months before responding; if works accepted for exhibition, slides will be kept for promotional and educational purposes. Works may be made available for sale, MOCA keeps 30% commission.

WILLIAM HAVU GALLERY

1040 Cherokee St., Denver CO 80204 (303)893-2360. Fax: (303)893-2813. E-mail: bhavu@mho.net. Website: www.williamhavugallery.com. **Owner:** Bill Havu. Gallery Administrator: Nick Ryan. For-profit gallery. Estab. 1998. Approached by emerging, mid-career and established artists. Exhibits 50 artists. Exhibited artists include Emilio Lobato, painter and printmaker; Amy Metier, painter. Sponsors 7-8 exhibits/year. Average display time 6-8 weeks. Open all year; Tuesday-Friday, 10-6; Saturday, 11-5. Closed Sundays, Christmas and New Year's Day. Located in the Golden Triangle Arts District of downtown Denver. The only gallery in Denver designed as a gallery; 3,000 square feet, 18 foot high ceilings, 2 floors of exhibition space; sculpture garden. Clients include local community, students, tourists, upscale, interior designers and art consultants. Overall price range $250-18,000; most work sold at $1,000-4,000.

Media Considers acrylic, ceramics, collage, drawing, mixed media, oil, paper, pastel, pen & ink, sculpture and watercolor. Most frequently exhibits painting, prints. Considers etchings, linocuts, lithographs, mezzotints, woodcuts, monotypes, monoprints and silkscreens.

Style Exhibits expressionism, geometric abstraction, impressionism, minimalism, postmodernism, surrealism and painterly abstraction. Most frequently exhibits painterly abstraction and expressionism.

Terms Artwork is accepted on consignment and there is a 50% commission. Retail price set by the gallery and the artist. Gallery provides insurance, promotion and contract. Accepted work should be framed. Primarily accepts only artists from Rocky Mountain, Southwestern region.

Submissions Mail portfolio for review. Send query letter with artist's statement, bio, brochure, résumé, SASE and slides. Returns material with SASE. Responds only if interested within 1 month. Files slides and résumé, if we are interested in the artist. Finds artists through word of mouth, submissions and referrals by other artists.

Tips Always mail a portfolio packet. We do not accept walk-ins or phone calls to review work. Explore website or visit gallery to make sure work would fit with the gallery's objective. Archival-quality materials play a major role in selling fine art to collectors. We only frame work with archival-quality materials and feel its inclusion in work can "make" the sale.

SANGRE DE CRISTO ARTS CENTER AND BUELL CHILDREN'S MUSEUM

210 N. Santa Fe Ave., Pueblo CO 81003. (719)295-7200. Fax: (719)295-7230. E-mail: mail@sdc-arts.org. **Curator of Visual Arts:** Jina Pierce. Nonprofit gallery and museum. Estab. 1972. Exhibits emerging, mid-career and established artists. Sponsors 20 shows/year. Average display time 10 weeks. Open all year. Admission $4 adults; $3 children. Located "downtown, right off Interstate I-25"; 16,000 sq. ft.; six galleries, one showing a permanent collection of western art; changing exhibits in the other five. Also a new 12,000 sq. ft. children's museum with changing, interactive exhibits. Clientele: "We serve a 19-county region and attract 200,000 visitors yearly." Overall price range for artwork $50-100,000; most work sold at $50-2,500.

Media Considers all media.

Style Exhibits all styles. Genres include southwestern, regional and contemporary.

Terms Accepts work on consignment (40% commission). Retail price set by artist. Gallery provides insurance, promotion, contract and shipping costs. Prefers artwork framed.

Submissions "There are no restrictions, but our exhibits are booked into 2007 right now." Send query letter with portfolio of slides. Responds in 2 months.

PHILIP J. STEELE GALLERY AT ROCKY MOUNTAIN COLLEGE OF ART + DESIGN

1600 Pierce St., Lakewood CO 80214. (303)753-6046. Fax: (303)225-8610. E-mail: lspivak@rmcad.edu. Website: www.rmcad.edu. **Gallery Director:** Lisa Spivak. For-profit college gallery. Estab. 1962. Represents emerging, mid-career and established artists. Sponsors 10-12 shows/year. Exhibited artists include Christo, Jenny Holzer. Average display time 1 month. Open all year; Monday-Friday, 12-5; Saturday, 12-5. Located between downtown Denver and the mountains; 1,700 sq. ft.; in very prominent location (art college with 450 students enrolled). 100% of space for gallery artists. Clientele: local community, students, faculty.

Media Considers all media and all types of prints.

Style Exhibits all styles.

Terms Artists sell directly to buyer; gallery takes no commission. Retail price set by the artist. Gallery provides insurance and promotion; artist pays shipping costs to and from gallery.

Submissions Send query letter with résumé, slides, bio, SASE and reviews by April 15 for review for exhibit the following year.

Tips Impressed by "professional presentation of materials, good-quality slides or catalog."

CONNECTICUT

FARMINGTON VALLEY ARTS CENTER'S FISHER GALLERY

25 Arts Center Lane, Avon CT 06001. (860)678-1867. Fax: (860)674-1877. E-mail: info@fvac.net. Website: www.fvac.net. **Executive Director:** Marie Dalton-Meyer. Nonprofit gallery. Estab. 1972. Exhibits the work of 100 emerging, mid-career and established artists. Open all year; Wednesday-Saturday, 11-5; Sunday, 12-5; extended hours November-December. Located in Avon Park North just off Route 44; 600 sq. ft.; "in a beautiful 19th-century brownstone factory building once used for manufacturing." Clientele: upscale contemporary craft buyers. Overall price range $35-500; most work sold at $50-100.

Media Considers "primarily crafts," also considers some mixed media, works on paper, ceramic, fiber, glass and small size prints. Most frequently exhibits jewelry, ceramics and fiber.

Style Exhibits contemporary, handmade craft.

Terms Accepts artwork on consignment (50% commission). Retail price set by the artist. Gallery provides promotion and contract; shipping costs are shared. Requires artwork framed where applicable.

Submissions Send query letter with résumé, bio, slides, photographs, SASE. Responds only if interested. Files a slide or photo, résumé and brochure.

⃞N⃞ SILVERMINE GUILD GALLERY

1037 Silvermine Rd., New Canaan CT 06840. (203)966-5617. Fax: (203)972-7236. E-mail: gallery@silvermineart. org. Website: www.silvermineart.org. **Director:** Helen Klisser During. Nonprofit gallery. Estab. 1922. Represents 300 emerging, mid-career and established artists/year. Sponsors 24 shows/year. Average display time 1 month. Open all year; Tuesday-Saturday, 11-5; Sunday, 1-5. 5,000 sq. ft. 95% of space for gallery artists. Clientele: private collectors, corporate collectors. Overall price range $250-10,000; most work sold at $1,000-2,000.

Media Considers all media and all types of prints. Most frequently exhibits paintings, sculpture and ceramics.

Style Exhibits all styles.

Terms Accepts guild member work on consignment (50% commission). Co-op membership fee plus donation of time (50% commission.) Retail price set by the gallery and the artist. Gallery provides insurance, promotion and contract. Prefers artwork framed.

Submissions Send query letter.

DELAWARE

BEYOND DIMENSIONS

59 S. Governors Ave., Dover DE 19904. (302)674-9070. Website: www.beyonddimensionstoo.com. **Owner:** Jean Francis. Retail gallery. Estab. 1990. Represents 15-20 emerging and mid-career artists; 25-30 emerging and mid-career craftspersons. Average display time 4-6 weeks. Open all year; Monday-Friday, 10-6; Saturday, 10-4. Located downtown; Victorian house with contemporary interior. Clientele: tourists, upscale. Overall price range $10-1,000; most work sold at $30-95.

Media Considers all media; types of prints include limited artist pulled.

Style Exhibits expressionism, painterly abstraction, conceptualism, photorealism and realism.

Terms Accepts work on consignment (35% commission) or buys outright for 50% of retail price (net 30 days) fine craft only. Retail price set by the artist. Gallery provides insurance and promotion. Shipping costs are shared. Prefers artwork framed (acid free, clean, well presented).

Submissions Send query letter with résumé or brochure, photographs, artist's statement and telephone number. Call or write for appointment to show portfolio of photographs. Responds only if interested within 3 weeks. Files all relative to specific works and of artist/craftsperson. Finds artists through referrals, juried art fairs and exhibitions, artist submissions.

DELAWARE CENTER FOR THE CONTEMPORARY ARTS

200 S. Madison St., Wilmington DE 19801. (302)656-6466. Fax: (302)656-6944. E-mail: hbennett@thedcca.org. Website: www.thedca.org. **Director:** Belena Chapp. Nonprofit gallery. Estab. 1979. Exhibits the work of emerging, mid-career and established artists. Sponsors 30 solo/group shows/year of both national and regional artists. Average display time is 1 month. 3,000 sq. ft. Overall price range $50-10,000; most artwork sold at $500-1,000.

Media Considers all media, including contemporary crafts.

Style Exhibits contemporary, abstract, figurative, conceptual, representational and nonrepresentational, painting, sculpture, installation and contemporary crafts.

Terms Accepts work on consignment (35% commission). Retail price is set by the gallery and the artist. Exclusive area representation not required. Gallery provides insurance and promotion; shipping costs are shared.

Submissions Send query letter, résumé, slides and/or photographs and SASE. Write for appointment to show portfolio. Seeking consistency within work as well as in presentation. Slides are filed. Submit up to 20 slides with a corresponding slide sheet describing the work (i.e. media, height by width by depth), artist's name and address on top of sheet and title of each piece in the order in which you would like them reviewed.

Tips "Before submitting slides, call and inquire about an organization's review schedule so your slides won't be tied up for an extended period. Submit at least ten slides that represent a cohesive body of work."

Ⓝ MICHELLE'S OF DELAWARE

831 North Market St., Wilmington DE 19801. (302)655-3650. Fax: (302)661-ARTS. **Art Director:** Raymond Bullock. Retail gallery. Estab. 1991. Represents 18 mid-career and established artists/year. May be interested in seeing the work of emerging artists in the future. Exhibited artists include Ernie Barnes (acrylic) and Verna Hart (oil). Sponsors 8 shows/year. Average display time 1-2 weeks. Open all year; Saturday-Sunday, 11-5 and 1-5 respectively. Located in Market Street Mall (downtown); 2,500 sq. ft. 50% of space for special exhibitions. Clientele local community. 97% private collectors; 3% corporate collectors. Overall price range $300-20,000; most work sold at $1,300-1,500.

Media Considers all media except craft and fiber; considers all types of prints. Most frequently exhibits acrylic, pastel and oil.

Style Exhibits geometric abstraction and impressionism. Prefers jazz, landscapes and portraits.

Terms Retail price set by the artist. Gallery provides insurance and contract; shipping costs are shared. Prefers artwork framed.

Submissions Send slides. Write for appointment to show portfolio of artwork samples. Responds only if interested within 1 month. Files bio. Finds artists through art trade shows and exhibitions.

Tips "Use conservation materials to frame work."

DISTRICT OF COLUMBIA

Ⓝ BIRD-IN-HAND BOOKSTORE & GALLERY

323 7th St. SE, Box 15258, Washington DC 20003. (202)543-0744. Fax: (202)547-6424. E-mail: chrisbih@aol.com. **Directors:** Christopher and Ester Ackerman. Retail gallery. Estab. 1987. Represents 20 emerging artists. Exhibited artists include Dario Scholis, Kristin Lingle, Janet Dowling and Evan Parker. Sponsors 6 shows/year. Average display time 6-8 weeks. Located on Capitol Hill at Eastern Market Metro; 300 sq. ft.; space includes

small bookstore, art and architecture. ''Most of our customers live in the neighborhood.'' Clientele: 100% private collectors. Overall price range $40-900; most work sold at $50-400.

Media Considers original handpulled prints, woodcuts, wood engravings, artists' books, linocuts, engravings, etchings. Also considers small paintings. Prefers small prints, works on paper and fabric.

Terms Accepts work on consignment (40% commission). Retail price set by gallery. Gallery provides insurance, promotion and contract; shipping costs are shared.

Submissions Send query letter with résumé, 10-12 slides and SASE. Write for appointment to show portfolio of originals and slides. Interested in seeing tasteful work. Responds in 1 month. Files résumé; slides of accepted artists.

Tips ''The most common mistake artists make in presenting their work is dropping off slides/samples without SASE and without querying first. We suggest a visit to the gallery before submitting slides. We show framed and unframed work of our artists throughout the year as well as at time of individual exhibition. Also, portfolio/slides of work should have a professional presentation, including media, size, mounting, suggested price, and copyright date.''

ROBERT BROWN GALLERY

2030 R St., NW, Washington DC 20009. (202)483-4383. Fax: (202)483-4288. E-mail: rbgal@wizard.net. Website: www.robertbrowngallery.com. **Director:** Robert Brown. Retail gallery. Estab. 1978. Represents emerging, mid-career and established artists specializing in international artists. The gallery also specializes in Chinese antiques and advertising posters from 1912-1937. Exhibited artists include Joseph Solman, Oleg Kudryashov, Andy Goldsworthy, Dan Flayin, David Nash, Donald Sultan and William Kentridge plus Rimma Gerlovina and Valeriy Gerlovin. Sponsors 6 shows/year. Average display time 6 weeks. Open all year; Tuesday-Saturday, 12-6; and 12-8 the 1st Friday of each month. Located in Dupont Circle area; 600 sq. ft.; English basement level on street of townhouse galleries. 100% of space for gallery artists. Clientele: local, national and international. Overall price range $500-20,000.

● Robert Brown also has a gallery in New York: 1930 Broadway at 65th St., #12H, New York NY 10023.

Media Considers oil, acrylic, watercolor, pen & ink, drawing, mixed media, collage, paper, photography, woodcut, engraving, lithograph, wood engraving, mezzotint, serigraphs, linocut and etching. Most frequently exhibits works on paper, prints, paintings.

Style Exhibits all styles.

Terms Accepts work on consignment (50% commission). Retail price set by the gallery and the artist by agreement. Gallery provides insurance and promotion. Prefers artwork framed.

Submissions Send query letter with slides, bio, brochure, SASE and any relevant information. No originals. Write for appointment to show portfolio of originals. ''Will return information/slides without delay if SASE provided.'' Files ''only information on artists we decide to show.'' Finds artists through exhibitions, word of mouth, artist submissions.

DADIAN GALLERY

4500 Massachusetts Ave. NW, Washington DC 20016. (202)885-8674. Fax: (202)885-8605. E-mail: dsokolove@wesleysem.edu. Website: www.luceartsandreligion.org/dadian.htm. **Curator:** Deborah Sokolove. Nonprofit gallery. Estab. 1989. Approached by 50 artists a year. Exhibits 7-10 emerging, mid-career and established artists. Sponsors 7 exhibits/year. Average display time 2 months. Open Monday-Friday, 11-5. Closed August, December 24-January 1. Gallery is within classroom building of Methodist seminary; 550 sq. ft.; glass front open to foyer, moveable walls for exhibition and design flexibility.

Media Considers all media and all types of prints. Most frequently exhibits painting, drawing and sculpture.

Style Considers all styles and genres.

Terms Artists are requested to make a donation to the Henry Luce III Center for the Arts and Religion at Wesley Theological Seminary from any sales. Gallery provides insurance. Accepted work should be framed. ''We look for strong work with a spiritual or religious intention.''

Submissions Send query letter with artist's statement, SASE and slides. Returns material with SASE. Responds only if interested within 1 year. Finds artists through word of mouth, submissions, art exhibits and referrals by other artists.

[N] DISTRICT OF COLUMBIA ARTS CENTER (DCAC)

2438 18th St. NW, Washington DC 20009. (202)462-7833. Fax: (202)328-7099. E-mail: info@dcartscenter.org. Website: dcartscenter.org. **Executive Director:** B. Stanley. Nonprofit gallery and performance space. Estab. 1989. Exhibits emerging and mid-career artists. Sponsors 7-8 shows/year. Average display time 1-2 months. Open Wednesday-Sunday, 2-7; Friday-Saturday, 2-10; and by appointment. Located ''in Adams Morgan, a downtown neighborhood; 132 running exhibition feet in exhibition space and a 52-seat theater.'' Clientele: all types. Overall price range $200-10,000; most work sold at $600-1,400.

Media Considers all media including fine and plastic art. ''No crafts.'' Most frequently exhibits painting, sculpture and photography.

Style Exhibits all styles. Prefers ''innovative, mature and challenging styles.''

Terms Accepts artwork on consignment (30% commission). Artwork only represented while on exhibit. Retail price set by the gallery and artist. Offers payment by installments. Gallery provides promotion and contract; artist pays for shipping. Prefers artwork framed.

Submissions Send query letter with résumé, slides, bio and SASE. Portfolio review not required. Responds in 4 months. More details are available on website.

Tips ''We strongly suggest the artist be familiar with the gallery's exhibitions and the kind of work we show strong, challenging pieces that demonstrate technical expertise and exceptional vision. Include SASE if requesting reply and return of slides!''

Ⓝ FOUNDRY GALLERY

1314 18th St. NW, 1st Floor, Washington DC 20036. (202)463-0203. E-mail: president@foundrygallery.org. Website: www.foundry_gallery.org. **Director:** Julianne Fuchs-Musgrave. Cooperative gallery and alternative space. Estab. 1971. Sponsors 10-20 solo and 2-3 group shows/year. Average display time 1 month. Open Wednesday-Sunday, 12-6. Interested in emerging artists. Clientele: 80% private collectors; 20% corporate clients. Overall price range $100-5,000; most work sold at $100-1,000.

Media Considers oil, acrylic, watercolor, pastel, pen & ink, drawings, mixed media, collage, paper, sculpture, ceramic, fiber, glass, installation, photography, woodcuts, engravings, mezzotints, etchings, pochoir and serigraphs. Most frequently exhibits painting, sculpture, paper and photography.

Style Exhibits ''serious artists in all mediums and styles.'' Prefers nonobjective, expressionism and neo-geometric. ''Founded to encourage and promote Washington area artists and to foster friendship with artists and arts groups outside the Washington area. The Foundry Gallery is known in the Washington area for its promotion of contemporary works of art.''

Terms Co-op membership fee plus donation of time required; 30% commission. Retail price set by artist. Offers customer discounts and payment by installments. Exclusive area representation not required. Gallery provides insurance and a promotion contract. Prefers framed artwork.

Submissions Send query letter with résumé, 20 slides, and SASE. ''Local artists drop off actual work.'' Call or write for appointment to drop off portfolio. Finds artists through submissions.

Tips ''Build up résumé by entering/showing at juried shows. Visit gallery to ascertain where work fits in. Have coherent body of work. Show your very best, strongest work. Present yourself well—clearly label slides. Before approaching us, you should have a minimum of 10 actual, finished works. See website for membership application.''

Ⓝ FOXHALL GALLERY

3301 New Mexico Ave. NW, Washington DC 20016. (202)966-7144. Fax: (202)363-2345. E-mail: foxhallgallery@ foxhallgallery.com. Website: www.foxhallgallery.com. **Director:** Jerry Eisley. Retail gallery. Represents emerging and established artists. Sponsors 6 solo and 6 group shows/year. Average display time 3 months. Overall price range $500-20,000; most artwork sold at $1,500-6,000.

Media Considers oil, acrylic, watercolor, pastel, sculpture, mixed media, collage and original handpulled prints (small editions).

Style Exhibits contemporary, abstract, impressionistic, figurative, photorealistic and realistic works and landscapes.

Terms Accepts work on consignment (50% commission). Retail price set by gallery and artist. Customer discounts and payment by installment are available. Exclusive area representation required. Gallery provides insurance.

Submissions Send résumé, brochure, slides, photographs and SASE. Call or write for appointment to show portfolio. Finds artists through agents, by visiting exhibitions, word of mouth, various art publications and sourcebooks, artists' submissions, self promotions and art collectors' referrals.

Tips To show in a gallery artists must have ''a complete body of work—at least 30 pieces, participation in a juried show and commitment to their art as a profession.''

THE FRASER GALLERY

1054 31st St., NW, Washington DC 20007. (202)298-6450. Fax: (202)298-6450. E-mail: info@frasergallery.com. Website: www.thefrasergallery.com. **Director:** Catriona Fraser. For profit gallery. Estab. 1996. Approached by 400 artists/year. Represents 40 emerging, mid-career and established artists and sells the work of another 100 artists. Exhibited artists include David FeBland (oil painting) and Joyce Tenneson (photography). Sponsors 12 exhibits/year. Average display time 1 month. Open all year; Tuesday-Friday, 12-3; weekends, 12-6. 400 sq. ft. Located in the center of Georgetown, Ind.—inside courtyard with 3 other galleries. Clients include local commu-

nity, tourists, Internet browsers and upscale. Overall price range $200-15,000; most work sold under $5,000. The Fraser Gallery is charter associate dealer for Southebys.com and member of Art Dealers Association of Greater Washington.

Media Considers acrylic, drawing, mixed media, oil, paper, pastel, pen & ink, sculpture and watercolor. Most frequently exhibits oil, photography and drawing. Considers engravings, etchings, linocuts, mezzotints and woodcuts.

Style Most frequently exhibits contemporary realism. Genres include figurative work and surrealism.

Terms Artwork is accepted on consignment and there is a 50% commission. Retail price set by the artist. Gallery provides insurance, promotion and contract. Accepted work should be framed. Requires exclusive representation locally.

Submissions Write to arrange a personal interview to show portfolio of photographs and slides. Send query letter with bio, photographs, résumé, reviews, SASE and slides or CD-ROM with images and résumé. Returns material with SASE. Responds in 3 weeks. Finds artists through submissions, portfolio reviews, art exhibits and art fairs.

Tips "Research the background of the gallery and apply to galleries that show your style of work. All work should be framed or matted to full museum standards."

N STUDIO GALLERY

2108 R Street NW, Washington DC 20008. (202)232-8734. E-mail: info@studiogallerydc.com. Website: www.studiogallerydc.com. **Contact:** Lana Lyons. Cooperative and nonprofit gallery. Estab. 1964. Exhibits the work of 30 emerging, mid-career and established local artists. Sponsors 11 shows/year. Average display time 1 month. Gallery for rent the last of August. Located downtown in the Dupont Circle area; 700 sq. ft.; "gallery backs onto a courtyard, which is a good display space for exterior sculpture and gives the gallery an open feeling." Clientele: private collectors, art consultants and corporations. 85% private collectors; 8% corporate collectors. Overall price range $300-10,000; most work sold at $500-3,000.

Media Considers glass, oil, acrylic, watercolor, pastel, pen & ink, drawings, mixed media, collage, works on paper, sculpture, ceramic, fiber, original handpulled prints, woodcuts, lithographs, monotypes, linocuts and etchings. Most frequently exhibits oil, acrylic and paper.

Style Considers all styles. Most frequently exhibits expressionism, conceptualism, geometric abstraction.

Terms Co-op membership fee plus a donation of time (70% commission).

Submissions Send query letter with SASE. Artists must be local or willing to drive to Washington for monthly meetings and receptions. Artist is informed as to when there is a membership opening and a selection review. Files artist's name, address, telephone.

Tips "This is a cooperative gallery. Membership is decided by the gallery membership. Ask when the next review for membership is scheduled. An appointment for a portfolio review with the director is required before the jurying process, however. Dupont Circle is an exciting gallery scene with a variety of galleries. First Fridays from 6-8 for all galleries of DuPont Circle."

TOUCHSTONE GALLERY

406 Seventh St. NW, Washington DC 20004-2217. (202)347-2787. E-mail: info@touchstonegallery.com. Website: www.touchstonegallery.com. Cooperative gallery, rental gallery. Estab. 1976. Interested in emerging, mid-career and established artists. Approached by 240 artists a year; represents over 35 artists. Sponsors 12 total exhibits/year; 3 photography exhibits/year. Average display time 1 month. Open Wednesday-Saturday from 11-5; Sundays from 12-5. Closed Christmas through New Years. Located downtown Washington, DC on Gallery Row. Large main gallery with several additional exhibition areas. High ceilings. Clients include local community, students, tourists, upscale. Overall price range $100-3,200. Most artwork sold at $600.

Media/Style Considers all media. Most frequently exhibits photography, paintings, sculpture, prints, with painterly abstraction and conceptualism. Considers all genres.

Terms There is a co-op membership fee plus a donation of time. There is a 40% commission. There is a rental fee for space. The rental fee covers 1 month. Retail price set by artist. Gallery provides contract. Accepted work should be framed and matted. Exclusive area representation not required.

Submissions Call. Returns material with SASE. Responds to queries in 1 month. Finds artists through referrals by other artists and word of mouth.

Tips "Visit website first. Read new members prospectus on the front page. Call with additional questions. Do not 'drop in' with slides or art. Do not show everything you do. Show 10-25 images that are cohesive in subject, style and presentation."

WASHINGTON PRINTMAKERS GALLERY

1732 Connecticut Ave. NW, Washington DC 20009. (202)332-7757. E-mail: wpg@visi.net. Website: www.washingtonprintmakers.com. **Director:** Gail Vollrath. Cooperative gallery. Estab. 1985. Exhibits 40 emerging and

mid-career artists/year. Exhibited artists include Lee Newman, Max-Karl Winkler, Trudi Y. Ludwig and Margaret Adams Parker. Sponsors 12 exhibitions/year. Average display time 1 month. Open all year; Tuesday-Thursday, 12-6; Friday, 12-9; Saturday-Sunday, 12-5. Located downtown in Dupont Circle area. 100% of space for gallery artists. Clientele varied. 90% private collectors, 10% corporate collectors. Overall price range $65-1,500; most work sold at $200-400.

Media Considers all types of original prints, hand pulled by artist. No posters. Most frequently exhibits etchings, lithographs, serigraphs, relief prints.

Style Considers all styles and genres.

Terms Co-op membership fee plus donation of time (35% commission). Retail price set by artist. Gallery provides promotion, pays shipping costs to and from gallery. Purchaser pays shipping costs of work sold.

Submissions Send query letter. Call for appointment to show portfolio of original prints. Responds in 1 month.

Tips "There is a monthly jury for prospective members. Call to find out how to present work. We are especially interested in artists who exhibit a strong propensity for not only the traditional conservative approaches to printmaking, but also the looser, more daring and innovative experimentation in technique."

FLORIDA

☑ ALBERTSON-PETERSON GALLERY

329 Park Ave. S., Winter Park FL 32789. (407)628-1258. Fax: (407)647-6928. **Owner:** Judy Albertson. Retail gallery. Estab. 1984. Represents 10-25 emerging, mid-career and established artists/year. "We no longer have a retail space—open by appointment only."

Media Considers oil, acrylic, watercolor, pastel, mixed media, collage, paper, sculpture, ceramics, craft, fiber, glass, installation, photography, woodcut, engraving, lithograph, wood engraving, mezzotint, serigraphs, linocut and etching. Most frequently exhibits paintings, ceramic, sculpture.

Style Exhibits all styles. Prefers abstract, contemporary landscape and nonfunctional ceramics.

Terms Accepts work on consignment (varying commission). Retail price set by the gallery and the artist. Gallery provides insurance, promotion, contract and shipping costs from gallery; artist pays shipping costs to gallery. Prefers artwork unframed.

Submissions Accepts only artists "exclusive to our area." Send query letter with résumé, slides, bio, photographs, SASE and reviews. Call or write for appointment to show portfolio of photographs, slides and transparencies. Responds within a month. Finds artists through exhibitions, art publications and artists' submissions.

ALLIANCE FOR THE ARTS GALLERY

(formerly Frizzell Cultural Centre Gallery), 10091 McGregor Blvd., Ft. Myers FL 33919. (239)939-2787. Fax: (239)939-0794. E-mail: arts@artinlee.org. Website: www.artinlee.org. **Contact:** Exhibition committee. Nonprofit gallery. Estab. 1979. Represents emerging, mid-career and established artists. 800 members. Sponsors 12 shows/year. Average display time 1 month. Open all year; Monday-Friday, 9-5; Saturday, 10-3. Located in Central Lee County—near downtown; 1,400 sq. ft.; high ceiling, open ductwork—ultra modern and airy. Clientele local to national. 90% private collectors, 10% corporate collectors. Overall price range $200-100,000; most work sold at $500-5,000.

Media Considers all media and all types of print. Most frequently exhibits oil, sculpture, watercolor, print, drawing and photography.

Style Exhibits all styles, all genres.

Terms Retail price set by the artist. Prefers artwork framed. Only 30% commission.

Submissions Send query letter with slides, bio and SASE. Write for appointment to show portfolio of photographs and slides. Responds in 3 months. Files "all material unless artist requests slides returned." Finds artists through visiting exhibitions, word of mouth and artists' submissions.

ARTS ON DOUGLAS

123 Douglas, New Smyrna Beach FL 32168. (386)428-1133. Fax: (386)428-5008. E-mail: aod@ucnsb.net. Website: www.artsondouglas.com. **Gallery Manager:** Meghan F. Martin. For profit gallery. Estab. 1996. Approached by many artists/year. We represent 56 professional Florida artists and exhibit 12 established artists/year. Average display time 1 month. Open all year; Tuesday-Friday, 11-6; Saturday, 10-2. 5,000 sq. ft. of exhibition space. Clients include local community, tourists and upscale. Overall price range varies.

Media Considers all media except installation.

Style Considers all styles and genres. Exhibits vary.

Terms Artwork is accepted on consignment and there is a 50% commission. Retail price set by the artist. Gallery provides insurance and promotion. Accepted work should be framed. Requires exclusive representation locally. Accepts only professional artists from Florida.

Submissions Returns material with SASE. Files slides, bio and résumé. Artists may want to call gallery prior to sending submission package—not always accepting new artists.
Tips "We want current bodies of work—please send slides of what you're presently working on."

N ATLANTIC CENTER FOR THE ARTS, INC.

1414 Arts Center Ave., New Smyrna Beach FL 32168. (386)427-6975. Fax: (386)427-5669. Website: www.atlanti ccenterforthearts.org. Nonprofit interdisciplinary, international artists-in-residence program. Estab. 1977. Sponsors 5-6 residencies/year. Located on secluded bayfront3½ miles from downtown.
 ● This location accepts applications for residencies only, but they also run Harris House of Atlantic Center for the Arts, which accepts Florida artists only for exhibition opportunities. Harris House is located at 214 S. Riverside Dr., New Smyrna Beach FL 32168. (386)423-1753.
Media Most frequently exhibits paintings/drawings/prints, video installations, sculpture, photographs.
Style Contemporary.
Terms Call Harris House for more information.
Submissions Call Harris House for more information.

N BAKEHOUSE ART COMPLEX

561 N.W. 32 St., Miami FL 33127. (305)576-2828. E-mail: bakehouse@belsouth.net. Website: www.bakehousea rtcomplex.org. Alternative artist working space and exhibition galleries in not-for-profit complex. Estab. 1986. Represents moer than 100 emerging and mid-career artists. 65 tenants, more than 50 associate artists. Sponsors numerous shows and cultural events annually. Average display time 3-5 weeks. Open to public all year; daily, Noon-5. Office hours Monday-Friday, 9-5. Located in Wynwood Art District; 3,200 sq. ft. gallery; 33,000 sq. ft. retro fitted commercial bakery, 17 ft. ceilings. Clientele: 80% private collectors, 20% corporate collectors. Overall price range $500-10,000.
Media Considers all media.
Style Exhibits all styles, all genres.
Terms Co-op membership fee plus donation of time. Rental fee for studio space. Retail price of art set by the artist.
Submissions Accepts artists to juried membership. Send query letter for application.
Tips "Don't stop painting, sculpting, etc. while you are seeking representation. Daily work (works-in-progress, studies) evidences a commitment to the profession. Speaking to someone about your work while you are working brings an energy and an urgency that moves the art and the gallery representation relationship forward."

N BETTCHER GALLERY—MIAMI

Soyka's 55th Street Station, 5582 NE Fourth Court, Miami FL 33137. (305)758-7556. Fax: (305)758-8297. E-mail: bettcher@aol.com. Website: www.bettchergallery.com. **Contact:** Cora Bettcher, president/director. Art consultancy; for-profit gallery. Estab. 1995. Exhibits emerging, mid-career, established artists. Approached by 400-500 artists/year; represents 40-50 artists/year. In our cycle from 10/2004-6/2005, Bettcher Gallery exhibited (solo or curated small group) the following artists, more than two of whom are "bestselling:" Marc Dennis, Luis Sanchez, Ray Beldner, Jean Blackburn, Scott Cawood, Caui Lofgren, Lisa Bertnick, Jeff Schaller, Robin Koenig, R E Sanchez, Sinisa Kukec, Jon Peters. Sponsors 8 total exhibits/year. Average display time 6 weeks. Open Tuesday-Wednesday, 11-6; Thursday-Saturday, 1-11pm. Open all year. Clients include local community, students, tourists, upscale. 5-10% sales are to corporate collectors. Overall price range: $500-50,000; most work sold at $5,000-15,000.
Media Considers all media except giclées, similar mechanical prints. Original fine art or limited edition (i.e, photography/sculpture) only. Most frequently exhibits sculpture/multi-media installation (various), paintings (o/c, a/c, encaustic), works on paper (photography, drawings). Considers all types of prints except posters.
Style Exhibits realism/slight surreal (two dimensional). Most frequently exhibits some abstract/minimal. "Our curriculum is fairly content based, medium/process based, new use of medium, and use of new medium. In essence, we strive the unique, and that which is defines both 'exquisite' AND 'provocative.' "
Making Contact & Terms Retail price of the art set by the existing market (current, most recent exhibit or auction). Gallery provides contract.
Submissions Artist should contact by e-mail. Responds to queries only if interested within 6 months.
Tips "Keep it clean and simple, and INCLUDE retail prices."

BOCA RATON MUSEUM OF ART

501 Plaza Real, Mizner Park, Boca Raton FL 33432. (561)392-2500. Fax: (561)391-6410. E-mail: info@bocamuse um.org. Website: www.BocaMuseum.org. **Executive Director:** George S. Bolge. Museum. Estab. 1950. Represents established artists. 5,500 members. Exhibits change every 2 months. Open all year; Tuesday, Thursday

and Friday, 10-5; Wednesday, 10-9; Saturday and Sunday, 12-5. Located one mile east of I-95 in Mizner Park in Boca Raton; 44,000 sq. ft.; national and international temporary exhibitions and impressive second-floor permanent collection galleries. Three galleries—one shows permanent collection, two are for changing exhibitions. 66% of space for special exhibitions.

Media Considers all media. Exhibits modern masters including Braque, Degas, Demuth, Glackens, Klee, Matisse, Picasso and Seurat; 19th and 20th century photographers; Pre-Columbian and African art, contemporary sculpture.

Submissions "Contact executive director, in writing."

Tips "Photographs of work of art should be professionally done if possible. Before approaching museums, an artist should be well-represented in solo exhibitions and museum collections. Their acceptance into a particular museum collection, however, still depends on how well their work fits into that collection's narrative and how well it fits with the goals and collecting policies of that museum."

ALEXANDER BREST MUSEUM/GALLERY

2800 University Blvd., Jacksonville University, Jacksonville FL 32211. (904)745-7371. Fax: (904)745-7375. E-mail: dlauder@ju.edu. Website: www.dept.ju.edu/art/. **Director:** David Lauderdale. Museum. Estab. 1970. Sponsors group shows of various number of artists. Average display time 6 weeks. Open all year; Monday-Friday, 9-4:30; Saturday, 12-5. "We close 2 weeks at Christmas and University holidays." Located in Jacksonville University, near downtown; 1,600 sq. ft.; 11½ foot ceilings. 50% of space for special exhibitions. "As an educational museum we have few if any sales. We do not purchase work—our collection is through donations."

Media "We rotate style and media to reflect the curriculum offered at the institution. We only exhibit media that reflect and enhance our teaching curriculum. (As an example we do not teach bronze casting, so we do not seek such artists.)."

Style Exhibits expressionism, neo-expressionism, primitivism, painterly abstraction, surrealism, all styles, primarily contemporary.

Terms Retail price set by the artist. Gallery provides insurance and promotion; artist pays shipping costs to and from gallery. "The art work needs to be ready for exhibition in a professional manner."

Submissions Send query letter with résumé, slides, brochure, business card and reviews. Write for appointment to show portfolio of slides. "Responds fast when not interested. Yes takes longer." Finds artists through visiting exhibitions and submissions.

Tips "Being professional impresses us. But circumstances also prevent us from exhibiting all artists we are impressed with."

☑ BUTTERFIELD GARAGE ART GALLERY

137 King St., St. Augustine FL 32084. (904)825-4577. E-mail: gallery@butterfieldgarage.com. Website: www.butterfieldgarage.com. **Coordinator:** Jan Miller. Cooperative gallery. Estab. 1999. Represents 22 established artists. Exhibited artists include Jan Miller (acrylic painting) and Beau Redmond (oil painting). Sponsors 12 exhibits/year. Average display time 28 days. Open all year; Wednesday-Monday, 11 to 5; closed Tuesday. Located downtown St. Augustine—3200 sq. ft. exhibition space. Garage renovated into art space. Built in 1929 originally. Clients include local community, tourists, and upscale. 5% of sales are to corporate collectors. Overall price range $50-5,000; most work sold at $500.

Media Considers all media. Most frequently exhibits acrylic, watercolor and mixed media. Considers prints including engravings, etchings, linocuts, lithographs, mezzotints, serigraphs, woodcuts and monoprint.

Style Considers all styles. Most frequently exhibits painterly abstration, impressionsm and postmodernism. Genres include figurative work, florals, wildlife and landscapes.

Terms Artwork is accepted on consignment and there is a 40% commission for nonmembers. There is a co-op membership fee plus a donation of time. There is a 10% commission for members. There is a rental fee for space. The rental covers 1 month for invited guest artist. Retail price set by the artist. Gallery provides contract. Accepted work should be framed. Does not require exclusive representation locally. Accepts only artists from 50 mile radius of St. Augustine.

Submissions Write to arrange personal interview to show portfolio of slides or mail portfolio for review. Send query letter with artist's statement, bio, résumé, SASE and slides. Returns material with SASE. Responds to queries in 1 month. Finds artists through referrals by other artists and word of mouth.

Ⓝ CHURCH STREET GALLERY OF CONTEMPORARY ART

418 Church St., Orlando FL 32801. (407)835-8822. E-mail: rvbadjet@earthlink.net. Website: www.rvbadjet.com. **Contact:** Robin Van Arsdol, owner. Wholesale gallery. Estab. 1983. Approached by 100 artists/year; exhibits 10 emerging, mid-career and established artists/year. Exhibited artists include Ekathreina Savtchenko (paintings) and Robin VanArsdol (sculpture). Sponsors 25 exhibits/year. Average display time 3 weeks. Closed May

15-September 15. Located 1 block west of Church Street Exchange; 3,000 square foot studio. Clients include local community. Overall price range $300-15,000; most work sold at $500-1,000.

Media Considers acrylic, drawing, oil, sculpture. Most frequently exhibits paintings, sculpture and performance/installation.

Style Exhibits conceptualism, expressionism, minimalism, painterly abstraction, primitivism realism.

Terms Artwork is accepted on consignment and there is a 50% commission. Retail price of the art set by the gallery and the artist. Gallery provides insurance and promotion. Does not require exclusive representation locally. Owner must "like you and your work" to be represented.

Submissions Artists should call for first contact, gallery does not reply to queries. Gallery cannot return material.

N CLAYTON GALLERIES, INC.

4105 S. MacDill Ave., Tampa FL 33611. (813)831-3753. Fax: (813)837-8750. E-mail: claytongalry@earthlink.net. Website: www.claytongalleries.net. **Director:** Cathleen Clayton. Retail gallery. Estab. 1986. Represent 28 emerging and mid-career artists. Exhibited artists include Bruce Marsh and Craig Rubadoux. Sponsors 7 shows/year. Average display time 5-6 weeks. Open all year. Located in the southside of Tampa 1 block from the Bay; 1,400 sq. ft.; "post-modern interior with glass bricked windows, movable walls, center tiled platform." 30% of space for special exhibitions. Clientele 40% private collectors, 60% corporate collectors. Overall price range $100-15,000; most artwork sold at $500-2,000.

Media Considers oil, pen & ink, works on paper, fiber, acrylic, sculpture, glass, watercolor, mixed media, ceramic, pastel, craft, photography, original handpulled prints, woodcuts, wood engravings, engravings, mezzotints, etchings, lithographs, collagraphs and serigraphs. Prefers oil, metal sculpture and mixed media.

Style Considers neo-expressionism, painterly abstraction, post-modern works, realism and hard-edge geometric abstraction. Genres include landscapes and figurative work. Prefers figurative, abstraction and realism "realistic, dealing with Florida, in some way figurative."

Terms Accepts work on consignment (50% commission). Retail price set by gallery and the artist. Gallery provides insurance, promotion and contract; artist pays for shipping. Prefers unframed artwork.

Submissions Prefers Florida or Southeast artists with M.F.A.s. Send résumé, slides, bio, SASE and reviews. Write to schedule an appointment to show a portfolio, which should include photographs and slides. Responds in 6 months. Files slides and bio, if interested.

Tips Looking for artist with "professional background i.e., B.A. or M.F.A. in art, awards, media coverage, reviews, collections, etc." A mistake artists make in presenting their work is being "not professional, i.e., no letter of introduction; poor or unlabeled slides; missing or incomplete résumé."

N THE DELAND MUSEUM OF ART, INC.

600 N. Woodland Blvd., De Land FL 32720-3447. (386)734-4371. Fax: (386)734-7697. E-mail: info@delandmuseum.com. Website: www.delandmuseum.com. **Contact:** Executive Director. Museum. Exhibits the work of established artists. Sponsors 8-10 shows/year. Open all year. Located near downtown; 5,300 sq. ft.; in The Cultural Arts Center; 18 ft. carpeted walls, two gallery areas, including a modern space. Clientele 85% private collectors, 15% corporate collectors. Overall price range $100-30,000; most work sold at $300-5,000.

Media Considers oil, acrylic, watercolor, pastel, works on paper, sculpture, ceramic, woodcuts, wood engravings, engravings and lithographs. Most frequently exhibits painting, sculpture, photographs and prints.

Style Exhibits contemporary art, the work of Florida artists, expressionism, surrealism, impressionism, realism and photorealism; all genres. Interested in seeing work that is finely crafted and expertly composed, with innovative concepts and professional execution and presentation. Looks for "quality, content, concept at the foundation—any style or content meeting these requirements considered."

Terms Accepts work on consignment for exhibition period only. Retail price set by artist. Gallery provides insurance, promotion and contract; shipping costs may be shared.

Submissions Send résumé, slides, bio, brochure, SASE and reviews. Files slides and résumé. Reviews slides twice a year.

Tips "Artists should have a developed body of artwork and an exhibition history that reflects the artist's commitment to the fine arts. Museum contracts 2-3 years in advance. Label each slide with name, medium, size and date of execution."

FLORIDA ART CENTER & GALLERY

208 First St. NW, Havana FL 32333. (850)539-1770. E-mail: drdox@juno.com. **Executive Director:** Dr. Kim Doxey. Retail gallery, studio and art school. Estab. 1993. Represents 30 emerging, mid-career and established artists. Interested in seeing the work of emerging artists. Open all year. Located in a small but growing town in north Florida; 2,100 st. ft.; housed in a large renovated 50-year-old building with exposed rafters and beams. Clientele: private collectors. 100% private collectors.

Media Considers all media and original handpulled prints (a few).

Style Exhibits all styles, tend toward traditional styles. Genres include landscapes and portraits.

Terms Accepts work on consignment (45% commission). Retail price set by gallery and artist. Gallery provides insurance, promotion and contract.

Submissions Send query letter with slides. Call or write for appointment.

Tips "Prepare a professional presentation for review, (i.e. quality work, good slides, clear, concise and informative backup materials). Include size, medium, price and framed condition of painting. In order to effectively express your creativity and talent, you must be a master of your craft, including finishing and presentation."

FLORIDA STATE UNIVERSITY MUSEUM OF FINE ARTS

250 Fab, corner of Copeland & W. Tennessee St., Tallahassee FL 32306-1140. (850)644-6836. Fax: (850)644-7229. E-mail: apcraig@mailer.fsu.edu. Website: www.mofa.fsu.edu. **Director:** Allys Palladino-Craig. Estab. 1970. Shows work by over 100 artists/year; emerging, mid-career and established. Sponsors 12-22 shows/year. Average display time 3-4 weeks. Located on the university campus; 16,000 sq. ft. 50% of space for special exhibitions.

Media Considers all media, including electronic imaging and performance art. Most frequently exhibits painting, sculpture and photography.

Style Exhibits all styles. Prefers contemporary figurative and nonobjective painting, sculpture, printmaking, photography.

Terms "Sales are almost unheard of; the museum takes no commission." Retail price set by the artist. Museum provides insurance, promotion and shipping costs to and from the museum for invited artists.

Submissions Send query letter or call for Artist's Proposal Form.

Tips "The museum offers a yearly competition with an accompanying exhibit and catalog. Artists' slides are kept on file from this competition as a resource for possible inclusion in other shows. Write for prospectus, available late December through January."

LOCUST PROJECTS

105 NW 23rd St., Miami FL 33127. (305)576-8570. E-mail: locustprojects@yahoo.com. Website: www.locustprojects.org. Alternative space and nonprofit gallery. 1,271 sq. ft. Estab. 1998. Exhibited artists include Randy Moore (video/drawing), David Rohn (installation) and Elizabeth Wild (installation). Sponsors 6 exhibits/year. Average display time 4-6 weeks. Open by appointment; weekends, 12-4. Closed summer.

Media Most frequently exhibits installation.

Style Exhibits postmodernism and contemporary.

Terms Retail price set by the artist. Gallery provides promotion. Does not require exclusive representation locally.

Submissions Send query letter with artist's statement, bio, résumé, reviews, slides and SASE. Returns material with SASE. Responds in 6 months. Finds artists through curated shows.

N MIAMI ART MUSEUM

101 W. Flagler St., Miami FL 33130. (305)375-3000. Fax: (305)375-1725. Website: www.miamiartmuseum.org. **Director:** Suzanne Delehanty. Museum. Estab. 1996. Represents emerging, mid-career and established artists. Average display time 3 months. Open all year; Tuesday-Friday, 10-5; Saturday and Sunday, noon-5 pm. Located downtown; cultural complex designed by Philip Johnson. 16,000 sq. ft. for exhibitions.

Media Considers all media.

Style Exhibits international of the 20th and 21st centuries; large scale traveling exhibitions, retrospective of internationally known artists.

Submissions Accepts only artists nationally and internationally recognized. Send query letter with résumé, slides, bio, brochure, photographs, SASE and reviews. Responds in 3 months. Finds artists through visiting exhibitions, word of mouth, art publications and artists' submissions.

N MICHAEL MURPHY GALLERY INC.

2722 S. MacDill Ave., Tampa FL 33629. (813)902-1414. Fax: (813)835-5526. E-mail: mmurphy@michaelmurphygallery.com. Website: www.michaelmurphygallery.com. **Contact:** Michael Murphy, owner. For-profit gallery. Estab. 1988. Approached by 100 artists/year; exhibits 35 emerging and mid-career artists/year. Exhibited artists include Marsha Hammel and Peter Pettegrew. Sponsors 6 exhibits/year. Average display time 1 month. Open all year; Monday-Saturday, 10-6. Clients include local community and upscale. 20% of sales are to corporate collectors. Overall price range is $500-15,000; most work sold at less than $1,000.

Media Considers all media. Most frequently exhibits acrylic, oil and watercolor. Considers all types of prints.

Style Considers all styles. Most frequently exhibits color field, impressionism and painterly abstraction. Considers all genres.

Terms Artwork is accepted on consignment and there is a 50% commission. Retail price set by the gallery. Accepted work should be framed. Requires exclusive representation locally.

Submissions Send query with artist's statement, bio, brochure, business card, photocopies, photographs, résumé, reviews, SASE and slides. Cannot return material. Responds to queries only if interested in 1 month. Files all materials. Finds artist's through art fairs and exhibits, portfolio reviews, referrals by other artists, submissions and word of mouth.

NUANCE GALLERIES

804 S. Dale Mabry, Tampa FL 33609. (813)875-0511. Fax: (813)849-1261. E-mail: art@nuancegalleries.com. Website: www.nuancegalleries.com. **Owner:** Robert A. Rowen. Retail gallery. Estab. 1981. Represents 70 emerging, mid-career and established artists. Sponsors 3 shows/year. Open all year. 3,000 sq. ft. "We've reduced the size of our gallery to give the client a more personal touch. We have a large extensive front window area."

Media Specializing in watercolor, original mediums and oils.

Style "Majority of the work we like to see are realistic landscapes, escapism pieces, bold images, bright colors and semitropical subject matter. Our gallery handles quite a selection, and it's hard to put us into any one class."

Terms Accepts work on consignment (50% commission). Retail price set by gallery and artist. Offers customer discounts and payment by installments. Gallery provides insurance and contract; shipping costs are shared.

Submissions Send query letter with slides and bio, SASE if want slides/photos returned. Portfolio review requested if interested in artist's work.

Tips "Be professional; set prices (retail) and stick with them. There are still some artists out there that are not using conservation methods of framing. As far as submissions we would like local artists to come by to see our gallery and get the idea what we represent. Tampa has a healthy growing art scene, and the work has been getting better and better. But as this town gets more educated, it is going to be much harder for up-and-coming artists to emerge."

☑ OPUS 71 FINE ARTS, HEADQUARTERS

(formerly Opus 71 Galleries, Headquarters), 4115 Carriage Dr., Villa P-2, Misty Oaks, Pompano Beach FL 33069. (954)974-4739. E-mail: lionxsx@aol.com. **Co-Directors:** Charles Z. Candler III. and Gary R. Johnson. Retail and wholesale private gallery, alternative space, art consultancy and salon style organization. Estab. 1969. Represents 40 (15-20 on regular basis) emerging, mid-career and established artists/year. By appointment only. Clientele: upscale, local, international and regional. 75% private collectors; 25% corporate collectors. Overall price range $200-85,000; most work sold at $500-7,500.

- This gallery is a division of The Leandros Corporation. Other divisions include The Alexander Project and Opus 71 Art Bank.

Media Considers oil, acrylic, pastel, pen & ink, drawing, mixed media, collage, sculpture and ceramics; types of prints include woodcuts and wood engravings. Most frequently exhibits oils or acrylic, bronze and marble sculpture and pen & ink or pastel drawings.

Style Exhibits expressionism, neo-expressionism, primitivism, painterly abstraction, surrealism, conceptualism, minimalism, color field, postmodern works, impressionism, photorealism, hard-edge geometric abstraction (paintings), realism and imagism. Exhibits all genres. Prefers figural, objective and nonobjective abstraction and realistic bronzes (sculpture).

Terms Accepts work on consignment or buys outright. Retail price set by "consulting with the artist initially." Gallery provides insurance (with limitations), promotion and contract; artist pays for shipping to gallery and for any return of work. Prefers artwork framed, unless frame is not appropriate.

Submissions Telephone call is important. Call for appointment to show portfolio of photographs and actual samples. "We will not look at slides." Responds in 2 weeks. Files résumés, press clippings and some photographs. "Artists approach us from a far flung area. We currently have artists from about 12 states and 4 foreign countries. Most come to us. We approach only a handful of artists annually."

Tips "Know yourself . . . be yourself . . . ditch the jargon. Quantity of work available not as important as quality and the fact that the presenter is a working artist. We don't want hobbyists."

P.A.S.T.A. FINE ART (PROFESSIONAL ARTISTS OF ST. AUGUSTINE) GALLERY INC.

214 Charlotte St., St. Augustine FL 32084. (904)824-0251. E-mail: jwtart479@aol.com. Website: www.staugustinegalleries.com. **President and Director:** Jean W. Treimel. Cooperative nonprofit gallery. Estab. 1984. Represents 18 emerging, mid-career and established artists/year; all artist members. Exhibited artists include Jean W. Treimel and Linda Brandt. Continuous exhibition of members' work plus a featured artist each month. Average display time 2 months. Open all year; Monday-Friday, 12-4; Saturday and Sunday, 12-5. Located downtown "South of The Plaza"; 1,250 sq. ft.; a 100-year-old building adjoining a picturesque antique shop and located on a 400-year-old street in our nation's oldest city." 100% of space for gallery artists. Clientele:

tourists and visitors. 100% private collectors. "We invite two guest artists for two month exhibitions. Same conditions as full membership." Overall price range $10-3,000; most work sold at $10-800.

Media Considers oil, acrylic, watercolor, pastel, pen & ink, drawing, mixed media, collage, sculpture, ceramics, photography, alkyd, serigraphs and mono prints. Most frequently exhibits watercolor, oil and alkyd.

Style Exhibits expressionism, primitivism, painterly abstraction, impressionism and realism. Genres include landscapes, florals, portraits and figurative work. Prefers impressionism and realism.

Terms Co-op membership fee (30% commission). Retail price set by the artist. Gallery provides insurance, promotion and contract; artist pays shipping costs to and from gallery.

Submissions Accepts only artists from Northeast Florida. Work must be no larger than 60 inches. Send query letter with résumé, 5 slides or photographs, bio, brochure, and SASE. Call or write for appointment to show portfolio of originals, photographs and brochures. "New members must meet approval of a committee and sign a 4-month contract with the 1st and 4th month paid in advance." Responds only if interested within 2 weeks. Finds artists through visiting exhibitions, word of mouth, artists' submissions.

Tips "We can tell when artists are ready for gallery representation by their determination to keep producing and improving regardless of negative sales plus individual expression and consistent good workmanship. They should have up to ten workslarge pieces, medium sizes and small pieces—in whatever medium they choose. Every exhibited artwork should have a bio of the artist on the books. A résumé on the backside of each art work is good publicity for the artist and gallery."

PALM AVENUE GALLERY

45 S. Palm Ave., Sarasota FL 34236. (941)953-5757. E-mail: info@palmavenuegallery.com. Website: www.palmavenuegallery.com. **Owner/Director:** Mary Bates. Retail gallery. Represents 20 emerging and mid-career artists. Featuring one artist each month. Open all year; Tuesday-Saturday, 10-5. Located in arts and theater district downtown; 1,700 sq. ft.; "high tech, 10 ft. ceilings with street exposure in restored hotel." Clientele 75% private collectors, 25% corporate collectors. Overall price range $500-5,000; most artwork sold at $500-2,000.

Media Considers oil, acrylic, watercolor, mixed media, collage, works on paper, sculpture, glass and pottery. Most frequently exhibits painting, graphics and sculpture.

Style Exhibits expressionism, painterly abstraction, surrealism, impressionism, realism and hard-edge geometric abstraction. All genres. Prefers impressionism, surrealism.

Terms Accepts artwork on consignment (50% commission). Retail price set by artist. Sometimes offers customer discounts. Gallery provides insurance, promotion and contract. Prefers framed work. Exhibition costs shared 50/50.

Submissions Send résumé, brochure, slides, bio and SASE. Write for appointment to show portfolio of originals and photographs. "Be organized and professional. Come in with more than slides; bring P.R. materials, too!" Responds in 1 week.

☑ PARADISE ART GALLERY

1359 Main St., Sarasota FL 34236. (941)366-7155. Fax: (941)366-8729. Website: www.paradisegallery.com. **President:** Gudrun Newman. Retail gallery, art consultancy. Represents hundreds of emerging, mid-career and established artists/year. May be interested in seeing the work of emerging artists in the future. Exhibited artists include John Lennon, Sheri, Pradzynski, G. Newman. Open all year; Monday-Saturday, 10-5; Sunday by appointment. Located in downtown Sarasota; 3,500 sq. ft. 50% of space for special exhibitions. Clientele: tourists, upscale. 90% private collectors, 10% corporate collectors. Overall price range $500-30,000; most work sold at $2,000.

Media Considers all media. Most frequently exhibits original artwork, acrylics, 3-D art.

Style Exhibits all styles. Prefers contemporary, pop.

Terms Accepts work on consignment (50% commission). Buys outright for 50-70% of retail price (net 30-60 days). Retail price set by the gallery. Gallery provides promotion and contract; shipping costs are shared. Prefers artwork framed.

Submissions Send query letter with résumé, brochure, photographs, artist's statement and bio. Call for appointment to show portfolio of photographs. Responds in 3 weeks.

POLK MUSEUM OF ART

800 E. Palmetto St., Lakeland FL 33801-5529. (863)688-7743. Fax: (863)688-2611. E-mail: info@PolkMuseum of Art.org. Website: www.PolkMuseumofArt.org. **Contact:** Todd Behrens, curator of art. Estab. 1966. Approached by 75 artists/year. Sponsors 19 exhibits/year. Open all year; Tuesday through Saturday, 10-5. Closed Mondays and major holidays. Four different galleries of various sizes and configurations. Visitors include local community, students and tourists.

Media Considers all media. Most frequently exhibits prints, photos and paintings. Considers all types of prints except posters.

Style Considers all styles. Considers all genres, provided the artistic quality is very high.

Terms Gallery provides insurance, promotion and contract. Accepted work should be framed.

Submissions Mail portfolio for review. Send query letter with artist's statement, bio, résumé and SASE. Returns material with SASE. Reviews 2-3 times/year and responds shortly after each review. Files slides and résumé.

STETSON UNIVERSITY DUNCAN GALLERY OF ART

421 N. Woodland Blvd., Unit 8252, Deland FL 32723-3756. (386)822-7266. Fax: (386)822-7268. E-mail: cnelson @stetson.edu. Website: stetson.edu/departments/art. **Gallery Director:** Dan Gunderson. Nonprofit university gallery. Approached by 20 artists/year. Represents 8-12 emerging and established artists. Exhibited artists include Jack Earl (ceramics). Sponsors 4-6 exhibits/year. Average display time 4-5 weeks. Open Sept.-April; Monday-Friday, 10-4; weekends 1-4. Approximately 2,400 sq. ft. gallery space at Stetson University. Clients include local community, students, tourists, school groups and elder hostelers.

Media Considers acrylic, ceramics, drawing, installation, mixed media, oil, pen & ink, sculpture. Most frequently exhibits oil/acrylic, sculpture and ceramics.

Style Most frequently exhibits contemporary.

Terms 30% of price is returned to gallery. Retail price set by the artist. Gallery provides insurance. Accepted work should be framed, mounted and matted. Does not require exclusive representation locally.

Submissions Send query letter with artist's statement, bio, letter of proposal, résumé, reviews, SASE and 20 slides. Returns material with SASE. May respond, but artist should contact by phone. Files "whatever is found worthy of an exhibition—even if for future year." Finds artists through word of mouth, submissions, art exhibits, and referrals by other artists.

Tips Looks for "professional-quality slides. Good letter of proposal."

TERRACE GALLERY

400 S. Orange Ave., Orlando FL 32801. (407)246-4279. E-mail: public.art@cityoforlando.net. **Contact:** Paul Wenzel, director. Estab. 1996. Approached by 50 artists/year. Represents 4 emerging, mid-career and established artists. Average display time 3 months. Open all year; Monday-Friday, 8-9; weekends, 12-5. Closed major holidays. Terrace Gallery does not sell art; they showcase various exhibits to the community.

Submissions Mail portfolio for review. Send query letter with artist's statement, bio, brochure, business card, photocopies, photographs, résumé, reviews, slides, and images that don't have to be sent back. Responds in 1 month. Finds artists through word of mouth, submissions, portfolio reviews, art exhibits, art fairs and referrals by other artists.

THE VON LIEBIG ART CENTER

585 Park St., Naples FL 34102. (239)262-6517. Fax: (239)262-5404. E-mail: info@naplesartcenter.org. Website: naplesartcenter.org. Full nonprofit contemporary visual arts center with galleries, professional studios, photography lab, resource library and outdoor festivals. Estab. 1954—new facility 1998. Represents 200 emerging, mid-career and established artists with membership of nearly 1,500. Exhibited artists include Clyde Butcher, Jim Rosenquist and Jonathan Green. Sponsors 14 exhibits/year. Average display time 6 weeks. Open all year; Monday-Saturday, 10-4. Closed holidays. Located in downtown Naples; 16,000 sq. ft. visual arts facility. Audience includes local community, students, upscale.

Media Considers original works in all media.

Style Considers all styles. Most frequently exhibits contemporary American art in all media from 1950 forward.

Terms Artwork is accepted on consignment and there is a 30% commission. All members' exhibitions are juried. Must be a member to participate. Director selects artists for curated exhibitions. Retail price set by the artist. Gallery provides insurance. Accepted work should be framed. Requires exclusive representation locally. Prefers only Florida artists.

Submissions Finds artists through word of mouth, juried exhibits, and referrals by other artists and curators.

Tips "Must have had work exhibited in number of accredited fine art museums included in private, public and corporate collections. Must have received grant awards or fellowships."

GEORGIA

AMERICAN PRINT ALLIANCE

Office only: 302 Larkspur Turn, Peachtree City GA 30269-2210. E-mail: director@printalliance.org. Website: www.printalliance.org. **Contact:** Carol Pulin, director. Nonprofit arts organization with on-line gallery and exhibitions, actual travelling exhibitions, and journal publication. Estab. 1992, first publications and exhibitions 1993. Gallery and some exhibitions are on-line, other exhibitions travel. Exhibits emerging, mid-career, established artists. Approached by hundreds of artists/year; represents dozens of artists/year. "We only exhibit

original prints, artists' books and paperworks. We don't know who sells the most (we don't take a percentage of sales), but largest number of "hits" in Gallery include Ann Chernow, Kenneth Kerlake, Dorothy Krause and Stephanie Smith; even larger numbers visit the Print Bin, but I can't tell which artists they are viewing." Sponsors usually 2 travelling exhibits/year—all prints, paperworks and artists' books; photography within printmaking processes but not as a separate medium. Most exhibits travel for 2 years. Hours depend on the host gallery/museum/arts center. "We travel exhibits coast to coast and occasionally to Hawaii." Overall price range for Print Bin: $150-3,200; most work sold at $300-500.

Media Considers and exhibits original prints, paperworks, artists' books. Also all original prints including any combination of printmaking techniques, no reproductions/posters.

Style Considers all styles. Most frequently exhibits postmodern, but we accept all styles, genres and subjects; the decisions are made on quality of work.

Making Contact & Terms On-line gallery cost is $30-35/subscription plus $15 for the first image, $10 each additional image up to five; Print Bin is free with subscription; subscribers have free entry to jurying of travelling exhibitions but must pay for framing, shipping to and from our office. Gallery provides promotion. Accepted work should be slides for internet; specific instructions are given for frames for travelling exhibitions. Does not require exclusive representation locally. Most artists are in the U.S. and Canada, but there is no restriction.

Submissions Subscribe to our journal (see www.printalliance.org, direct page is http://www.printalliance.org/alliance/al_subform.html), send one slide and signed permission form (see http://www.printalliance.org/gallery/printbin_info.html). Returns slide if requested with SASE. Usually does not respond to queries from non-subscribers. Files slides and permission forms. Submissions to the gallery or print bin, and especially portfolio reviews at printmakers conferences (unfortunately, we don't have the staff for individual portfolio reviews though we may—and often do—request additional images after seeing one work, often for journal articles; generally about 100 images are reproduced per year in the journal).

Tips "See the Standard Forms area of our website (http://www.printalliance.org/library/li_forms.html) for correct labels on slides and much, much more about professional presentation."

THE CITY GALLERY AT CHASTAIN

135 W. Wieuca Rd. NW, Atlanta GA 30342. (404)252-2927. Fax: (404)851-1270. E-mail: cac135@mindspring.com. **Contact:** Erin Bailey. Nonprofit gallery. Estab. 1979. Average display time 6-8 weeks. Open all year; hours vary. Located in Northwest Atlanta; 2,000 sq. ft.; historical building; old architecture with much character. Clientele: local community, students. Overall price range $50-10,000.

 • For submissions, call or write Erin Bailey, art center supervisor, at address above. You can also reach her by e-mail cac135@mindspring.com. She reports that "all policies regarding media, style, genre, etc. are currently being reviewed." So we advise you to call or write for updated information before submitting.

Media Considers all media. Most frequently exhibits sculpture, painting, mixed media.

Terms Retail price set by the artist. Gallery provides insurance.

Submissions Send query letter with résumé, brochure, slides, photographs, reviews, artist's statement, bio. Call or write for appointment to show portfolio of photographs, slides. Finds artists through word of mouth, referrals by other artists, visiting art fairs and exhibitions, submissions.

SKOT FOREMAN FINE ART

315 Peters St. SW, Atlanta GA 30313. (404)222-0440. E-mail: info@skotforeman.com. Website: www.skotforeman.com. **Contact:** Erica Stevens, assistant. For-profit gallery. Estab. 1994. Approached by 1,500-2,000 artists/year; exhibits 30 mid-career and established artists/year. In-house exhibited artists include Purvis Young (house paint on wood), Chris Dolan (oil/acrylic on canvas). Also brokering works by Warhol, Haring, Finster, Escher, Dali, Wesselman and Matta. Sponsors 6-8 exhibits/year. Average display time 30-45 days. Open Wednesday-Saturday, 12-5:30 and by appointment. Located "in a downtown metropolitan loft district of Atlanta. The 100-year-old historical building features 2,000 sq. ft. of hardwood floors and 18 ft. ceilings." Clients include local community, tourists, upscale and art consultants. 25% of sales are to corporate collectors. Overall price range is $500-50,000; most work sold at $3,000-5,000.

Media Considers acrylic, collage, drawing, glass, installation, mixed media, oil, paper, pastel, pen & ink, sculpture, watercolor. Most frequently exhibits acrylic, oil and mixed media. Considers engravings, etchings, linocuts, lithographs, mezzotints, posters, serigraphs, woodcuts.

Style Exhibits expressionism, realism, neo-expressionism, painterly abstraction, postmodernism, surrealism. Most frequently exhibits painterly abstraction, neo-expressionism and realism. Genres include figurative work, landscapes, portraits and perspective.

Terms Artwork is accepted on consignment and there is a variable commission. Retail price set by the gallery. Gallery provides insurance, promotion and contract. Requires exclusive representation locally. No outdoor Fair self-representation.

Submissions Send e-mail with bio and digital photos. Returns material with SASE. Responds to queries only if

interested in 3 weeks. Finds artist's through art fairs and exhibits, portfolio reviews, referrals by other artists, submissions and word of mouth.

Tips ''Be concise. Not too much verbage—let the art speak on your behalf.''

Ⓝ ANN JACOB GALLERY

3261 Roswell Rd. NE, Atlanta GA 30305. (404)262-3399. E-mail: gallery@annjacob.com. **Director:** Yvonne J. Spiotta. Co-Director Ellen Bauman. Retail gallery. Estab. 1968. Represents 35 emerging, mid-career and established artists/year. Sponsors 4 shows/year. Open all year; Tuesday-Saturday 10-5. Located in Buckhead; 1,600 sq. ft. 100% of space for special exhibitions; 100% of space for gallery artists. Clientele private and corporate. 80% private collectors, 20% corporate collectors.

Media Considers oil, acrylic, watercolor, sculpture, ceramics, craft and glass. Most frequently exhibits paintings, sculpture and glass.

Style Exhibits all styles, all genres.

Terms Accepts work on consignment (50% commission). Retail price set by the gallery and the artist. Gallery provides promotion; artist pays shipping costs.

Submissions Send query letter with résumé, slides, bio, brochure, photographs and SASE. Write for appointment. Responds in 2 weeks.

Ⓝ NOVUS, INC.

439 Hampton Green, Peachtree City GA 30269. (770)487-0706. Fax: (770)487-2112. E-mail: novusus@bellsouth. net. **Vice President:** Pamela Marshall. Art dealer. Estab. 1987. Represents 200 emerging, mid-career and established artists. Clientele corporate, hospitality, healthcare. 5% private collectors, 95% corporate collectors. Overall price range $500-20,000; most work sold at $800-5,000.

Media Considers oil, acrylic, watercolor, pastel, mixed media, collage, paper, sculpture, ceramics, craft, fiber, glass, photography, and all types of prints.

Style Exhibits all styles. Genres include landscapes, abstracts, florals and figurative work. Prefers landscapes, abstract and figurative.

Terms Accepts work on consignment (50% commission). Retail price set by the artist. Gallery provides promotion and contract; shipping costs are shared. Prefers artwork unframed.

Submissions Send query letter with résumé, slides, brochure and reviews. Write for appointment to show portfolio of originals, photographs and slides. Responds only if interested within 1 month. Files slides and bio. Finds artists through agents, visiting exhibitions, word of mouth, art publications and sourcebooks, submissions.

Tips ''Send complete information and pricing. Do not expect slides and information back. Keep the dealer updated with current work and materials.''

RAIFORD GALLERY

1169 Canton St., Roswell GA 30075. (770)645-2050. Fax: (770)992-6197. E-mail: raifordgallery@mindspring.c om. Website: www.raifordgallery.com. For profit gallery. Estab. 1996. Approached by many artists/year. Represents 400 mid-career and established artists. Exhibited artists include Cathryn Hayden (collage, painting and photography), Richard Jacobus (metal). Sponsors 8 exhibits/year. Average display time 6 weeks. Open all year; Tuesday-Saturday, 10-6. Located in historic Roswell GA; 4,500 sq. ft. in an open 2-story timber frame space. Clients include local community, tourists and upscale. Overall price range $10-2,000; most work sold at $200-300.

Media Considers all media except installation. Most frequently exhibits painting, sculpture and glass.

Style Exhibits contemporary American art & craft.

Terms Artwork is accepted on consignment and there is a 50% commission. Retail price set by the artist. Gallery provides insurance, promotion and contract. Accepted work should be framed. Requires exclusive representation locally.

Submissions Call or write to arrange to show portfolio of photographs, slides and originals. Send query letter with artist's statement, bio, brochure, photocopies, photographs, résumé, reviews, SASE and slides. Returns material with SASE. Finds artists through submissions, portfolio reviews, art exhibits and art fairs.

TRINITY GALLERY

315 E. Paces Ferry Rd., Atlanta GA 30305. (404)237-0370. Fax: (404)240-0092. E-mail: info@trinitygallery.com. Website: www.trinitygallery.com. **President:** Alan Avery. Retail gallery and corporate sales consultants. Estab. 1983. Represents/exhibits 67 mid-career and established artists and old masters/year. Exhibited artists include Roy Lichtenstein, Jim Dine, Robert Raushenberg, Cindy Warhol, Larry Gray, Ray Donley, Robert Marx, Lynn Davison and Russell Whiting. Sponsors 6-8 shows/year. Average display time 6 weeks. Open all year; Tuesday-Friday, 10-6; Saturday, 11-5 and by appointment. Located mid-city; 6,700 sq. ft.; 25-year-old converted restau-

rant. 50-60% of space for special exhibitions; 40-50% of space for gallery artists. Clientele: upscale, local, regional, national and international. 70% private collectors, 30% corporate collectors. Overall price range $2,500-100,000; most work sold at $2,500-5,000.

Media Considers all media and all types of prints. Most frequently exhibits painting, sculpture and work on paper.

Style Exhibits expressionism, conceptualism, color field, painterly abstraction, postmodern works, realism, impressionism and imagism. Genres include landscapes, Americana and figurative work. Prefers realism, abstract and figurative.

Terms Artwork is accepted on consignment (negotiable commission). Retail price set by gallery. Gallery pays promotion and contract. Shipping costs are shared. Prefers artwork framed.

Submissions Send query letter with résumé, at least 20 slides, bio, prices, medium, sizes and SASE. Reviews every 6 weeks. Finds artists through word of mouth, referrals by other artists and artists' submissions.

Tips ''Be as complete and professional as possible in presentation. We provide submittal process sheets listing all items needed for review. Following this sheet is important.''

Ⓝ VESPERMANN GLASS GALLERY

309 E. Paces Ferry Rd., Atlanta GA 30305. (404)266-0102. Fax: (404)266-0190. Website: www.vespermann.com. **Owner:** Seranda Vespermann. Manager: Tracey Lofton. Retail gallery. Estab. 1984. Represents 200 emerging, mid-career and established artists/year. Sponsors 4-5 shows/year. Average display time 1 month. Open all year; Tuesday-Friday, 11-5 and Saturday 12-5. 2,500 sq. ft.; features contemporary art glass. Overall price range $100-10,000; most work sold at $200-2,000.

Media Art glass.

Style Exhibits contemporary.

Terms Accepts work on consignment (50% commission). Buys outright for 50% of retail price (net 30 days). Retail price set by the gallery and the artist. Gallery provides insurance, promotion and contract; shipping costs are shared.

Submissions Send query letter with résumé, slides, bio. Write for appointment to show portfolio of photographs, transparencies and slides. Responds only if interested within 2 weeks. Files slides, résumé, bio.

HAWAII

DOLPHIN GALLERIES

230 Hana Highway, Suite 12, Kahalui HI 96732. (800)669-5051, ext. 207. Fax: (808)873-0820. E-mail: ChristianAdams@DolphinGalleries.com. **Contact:** Christian Adams, director of sales. For-profit gallery. Estab. 1976. Exhibits emerging, mid-career and established artists. Exhibited artists include Alexandra Nechita, Pino and Thomas Pradzynski. Sponsors numerous exhibitions/year; running at all times through 9 separate Fine Art or Fine Jewelry Gallery. Average display time varies from one-night events to a 30-day run. Open 7 days a week, 9 a.m. to 10 p.m. Located in upscale, high traffic tourist locations throughout Hawaii. On Oahu, Dolphin has galleries at the Hilton Hawaiian Village. On Big Island they have galleries located at the Kings Shops at Waikoloa. Clients include local community and upscale tourists. Overall price range $100-100,000; most work sold at $1,000-5,000.

- The above address is for Dolphin Galleries' corporate offices. Dolphin Galleries has 9 locations throughout the Hawaiian islands.

Media Considers all media. Most frequently exhibits oil and acrylic paintings and limited edition works of art. Considers all types of prints.

Style Most frequently exhibits impressionism, figurative and abstract art. Considers American landscapes, portraits and florals.

Terms Artwork is accepted on consignment with negotiated commission, promotion and contract. Retail price set by the gallery. Gallery provides insurance, promotion and contract. Accepted work should be framed, mounted and matted. Requires exclusive representation locally.

Submissions E-mail submissions to ChristianAdams@DolphinGalleries.com. Finds artists mainly through referrals by other artists, art exhibits, submissions, portfolio reviews and word of mouth.

Ⓝ HANA COAST GALLERY

Hotel Hana-Maui, P.O. Box 565, Hana Maui HI 96713. (808)248-8636. Fax: (808)248-7332. E-mail: info@hanacoast.com. Website: www.hanacoast.com. **Managing Director:** Patrick Robinson. Retail gallery and art consultancy. Estab. 1990. Represents 78 established artists. Sponsors 12 group shows/year. Average display time 1 month. Open all year. Located in the Hotel Hana-Maui at Hana Ranch; 3,000 sq. ft.; ''an elegant ocean-view setting in one of the top small luxury resorts in the world.'' 20% of space for special exhibitions. Clientele

ranges from very upscale to highway traffic walk-ins. 85% private collectors, 15% corporate collectors. Overall price range $150-50,000; most work sold at $1,000-6,500.

Media Considers oil, acrylic, watercolor, pastel, mixed media, collage, works on paper, sculpture, ceramic, craft, fiber, glass, photography, original handpulled prints, engravings, lithographs, pochoir, wood engravings, mezzotints, serigraphs and etchings. Most frequently exhibits oil, watercolor and original prints.

Style Exhibits expressionism, primitivism, impressionism and realism. Genres include landscapes, florals, portraits, figurative work and Hawaiiana. Prefers landscapes, florals and figurative work. ''We also display decorative art and master-level craftwork, particularly turned-wood bowls, blown glass, fiber, bronze sculpture and studio furniture.

Terms Accepts artwork on consignment (60% commission). Retail price set by gallery and artist. Gallery provides insurance, promotion and shipping costs from gallery. Framed artwork only.

Submissions Accepts only full-time Hawaii resident artists. Send query letter with résumé, slides, bio, brochure, photographs, SASE and reviews. Write for appointment to show portfolio after query and samples submitted. Portfolio should include originals, photographs, slides and reviews. Responds only if interested within 1 week. If not accepted at time of submission, all materials returned.

Tips ''Know the quality and price level of artwork in our gallery and know that your own art would be companionable with what's being currently shown. Be able to substantiate the prices you ask for your work. We do not offer discounts, so the mutually agreed upon price/value must stand the test of the market.''

Ⓝ HONOLULU ACADEMY OF ARTS

900 S. Beretania St., Honolulu HI 96814. (808)532-8700. Fax: (808)532-8787. E-mail: academypr@honoluluacademy.org. Website: www.honoluluacademy.org. **Director:** Stephen Little, Ph.D. Nonprofit museum. Estab. 1927. Exhibits emerging, mid-career and established Hawaiian artists. Interested in seeing the work of emerging artists. Sponsors 40-50 shows/year. Average display time 6-8 weeks. Open all year; Tuesday-Saturday 10-4:30, Sunday 1-5. Located just outside of downtown area; 40,489 sq. ft. 30% of space for special exhibition. Clientele general public and art community.

Media Considers all media. Most frequently exhibits painting, works on paper, sculpture.

Style Exhibits all styles and genres. Prefers traditional, contemporary and ethnic.

Terms ''On occasion, artwork is for sale.'' Retail price set by artist. Museum provides insurance and promotion; museum pays for shipping costs. Prefers artwork framed.

Submissions Exhibits artists of Hawaii. Send query letter with résumé, slides and bio directly to curator(s) of Western and/or Asian art. Curators are Jennifer Saville, Western art; Julia White, Asian art. Write for appointment to show portfolio of slides, photographs and transparencies. Responds in 3-4 weeks. Files résumés, bio.

Tips ''Be persistent but not obnoxious.'' Artists should have completed a body of work of 50-100 works before approaching galleries.

RAMSAY MUSEUM

1128 Smith St., Honolulu HI 96817. (808)537-ARTS. Fax: (808)531-MUSE. E-mail: ramsay@lava.net. Website: www.ramsaymuseum.org. **CEO:** Ramsay. Gallery, museum shop, permanent exhibits and artists' archive documenting over 200 exhibitions including 500 artists of Hawaii. Estab. 1981. Open all year; Monday-Friday, 10-5; Saturday, 10-4. Located in downtown historic district; 5,000 sq. ft.; historic building with courtyard. Displaying permanent collection of Ramsay Quill and Ink originals spanning 50 years. Clientele 50% tourist, 50% local. 25% private collectors, 75% corporate collectors.

Media Especially interested in ink.

Style Currently focusing on the art of tattoo.

Terms Accepts work on consignment. Retail price set by the artist.

Submissions Send query letter with résumé, 20 slides, bio, SASE. Write for appointment to show portfolio of original art. Responds only if interested within 1 month. Files all material that may be of future interest.

Tips ''Keep a record of all artistic endeavors for future use, and to show your range to prospective commissioners and galleries. Prepare your gallery presentation packet with the same care that you give to your art creations. Quality counts more than quantity. Show samples of current work with an exhibit concept in writing.''

Ⓝ VOLCANO ART CENTER GALLERY

P.O. Box 129, Volcano HI 96785. (808)967-7565. Fax: (808)967-8512. E-mail: gallery@volcanoartcenter.org. Website: www.volcanoartcenter.org. **Gallery Manager:** Fia Mattice. Nonprofit gallery to benefit arts education; nonprofit organization. Estab. 1974. Represents 300 emerging, mid-career and established artists/year. 1,400 member organization. Exhibited artists include Dietrich Varez and Brad Lewis. Sponsors 8 shows/year. Average display time 6 weeks. Open all year; daily 9-5 except Christmas. Located Hawaii Volcanoes National Park; 3,000 sq. ft.; in the historic 1877 Volcano House Hotel. 15% of space for special exhibitions; 85% of space for gallery

artists. Clientele affluent travelers from all over the world. 95% private collectors, 5% corporate collectors. Overall price range $20-12,000; most work sold at $50-400.

Media Considers all media, all types of prints. Most frequently exhibits wood, ceramics, glass and 2 dimensional.

Style Prefers traditional Hawaiian, contemporary Hawaiian and contemporary fine crafts.

Terms "Artists must become Volcano Art Center members." Accepts work on consignment (50% commission). Retail price set by the gallery. Gallery provides promotion and contract; artist pays shipping costs to gallery.

Submissions Prefers work relating to the area and by Hawaii resident artists. Call for appointment to show portfolio. Responds only if interested within 1 month. Files "information on artists we represent."

WAILOA CENTER

Division of State Parks, Department of Land & Natural Resources State of Hawaii, DLNR P.O. Box 936, Hilo HI 96721. (808)933-0416. Fax: (808)933-0417. E-mail: wailoa@yahoo.com. **Contact:** Codie M. King, director. Nonprofit gallery and museum. Focus is on propagation of the culture and arts of the Hawaiian Islands and their many ethnic backgrounds. Estab. 1968. Represents/exhibits 300 emerging, mid-career and established artists. Interested in seeing work of emerging artists. Sponsors 60 shows/year. Average display time 1 month. Open all year; Monday, Tuesday, Thursday, and Friday, 8:30-4:30; Wednesday, noon-4:30; closed weekends and state holidays. Located downtown; 10,000 sq. ft.; 4 exhibition areas main gallery, mini fountain gallery, rotunda gallery, and one local airport. Clientele: tourists, upscale, local community and students. Overall price range $25-25,000; most work sold at $1,500.

Media Considers all media and all types of prints. No giclée prints; original artwork only. Most frequently exhibits mixed media.

Style Exhibits all styles. "We cannot sell, but will refer buyer to seller." Gallery provides promotion. Artist pays for shipping costs. Artwork must be framed.

Submissions Send query letter with résumé, slides, photographs and reviews. Call for appointment to show portfolio of photographs and slides. Responds in 3 weeks. Finds artists through word of mouth, referrals by other artists, visiting art fairs and exhibitions, submissions.

Tips "We welcome all artists, and try to place them in the best location for the type of art they have. Drop in and let us review what you have."

IDAHO

N GALLERY DENOVO

P.O. Box 7214, Ketchum ID 83340-7214. (208)726-8180. Fax: (208)726-1007. E-mail: info@gallerydenovo.com. Website: www.gallerydenovo.com. **Contact:** Robin Reiners, gallery director. For-profit gallery. Estab. 2002. Exhibits internationally exhibited mid-career and established artists. Represents approximately 25 artists/year. Exhibited artists include Andrew Lui, Ink and Acrylic on Rice Paper; Marta Moreu, Bronze. Sponsors 9 exhibits/year. Average display time 1 month. Open Monday-Saturday, 10-6; Sunday, 12-5 (during winter and summer season); closed a week or two in late April, early May. Located Downtown Ketchum, ID (in Sun Valley Area) right along "gallery row." 1,000 sq. ft. of clean contemporary gallery with crisp white walls and stained concrete floor. Three galleries are housed in this same building. Clients include local community, tourists, upscale. Overall price range: $500-15,000; most work sold at $2,000-5,000.

Media Considers all media except craft. Most frequently exhibits oil, acrylic, mixed media. Considers all types of prints.

Style Contemporary. Considers all styles. Most frequently exhibits painterly abstraction, expressionism, conceptualism. Genres include figurative work, florals, landscapes, portraits.

Making Contact & Terms Artwork is accepted on consignment and there is a 50% commission. Artwork is bought outright for varying% of retail price. Retail price set by the artist. Requires exclusive representation locally. Accepts only artists from Internationally shown artists—many living outside the US.

Submissions E-mail with exhibition history, artist statement and 3-5 images attached. Send query letter with artist's statement, bio, slides or CD of works including SASE. Return of material not guaranteed without SASE. Responds to queries only if interested within 1 months. Try to respond to others, but receive so may that it is not guaranteed. Files interesting work that may fit in gallery at some other time. Finds artists mostly via art exhibits, but also by referrals by other artists and art fairs.

Tips "Spell check! Be concise and organized with information, and look at the type of gallery and type of work that is shown to see if new work would fit into that gallery and what they tend to represent."

N ANNE REED GALLERY

P.O. Box 597, Ketchum ID 83340. (208)726-3036. Fax: (208)726-9630. E-mail: gallery@annereedgallery.com. Website: www.annereedgallery.com. **Director:** L'Anne Gilman. Retail Gallery. Estab. 1980. Represents mid-

career and established artists. Exhibited artists include Robert Kelly, Deborah Butterfield, Sean Scully, Timothy McDowell, Peter Woytuk and Inez Storer. Sponsors 10 exhibitions/year. Average display time 1 month. Open all year. Located at 391 First Avenue North. 10% of space for special exhibitions; 90% of space for gallery artists. Clientele: 80% private collectors, 20% corporate collectors.

Media Most frequently exhibits sculpture, wall art and photography.

Style Exhibits expressionism, abstraction, conceptualism, impressionism, photorealism, realism. Prefers contemporary.

Terms Accepts work on consignment (50% commission). Retail price set by gallery and artist. Sometimes offers customer discounts and payment by installment. Gallery provides insurance, promotion, contract and shipping costs from gallery. Prefers artwork framed.

Submissions Contact the gallery before sending any work. Anne Reed Gallery is not responsible for unsolicited materials.

Tips "Please send only slides or other visuals of current work accompanied by updated résumé. Check gallery representation prior to sending visuals. Always include SASE."

ILLINOIS

CEDARHURST CENTER FOR THE ARTS

Richview Road, Mt. Vernon IL 62864. (618)242-1236. Fax: (618)242-9530. E-mail: mitchellmuseum@cedarhurst .org. Website: www.cedarhurst.org. **Director of Visual Arts:** Kevin Sharp. Museum. Estab. 1973. Exhibits emerging, mid-career and established artists. Average display time six weeks. Open all year; Tuesday through Saturday, 10-5; Sunday 1-5; closed Mondays and federal holidays.

Submissions Call or send query letter with artist's statement, bio, résumé, SASE and slides.

FREEPORT ARTS CENTER

121 N. Harlem Ave., Freeport IL 61032. (815)235-9755. Fax: (815)235-6015. E-mail: artscenter@aeroinc.net. **Director:** Mary Fay Schoonover. Estab. 1975. Interested in emerging, mid-career and established artists. Sponsors 21 solo and group shows/year. Open all year; Tuesdays, 10-6; Wednesday-Friday, 10-5, Saturday and Sunday noon to 5 p.m. Clientele 30% tourists; 60% local; 10% students. Average display time 7 weeks.

Media Considers all media and prints.

Style Exhibits all styles and genres. "FAC is a regional museum serving Northwest Illinois, Southern Wisconsin and Eastern Iowa. There are extensive permanent collections and 8-9 special exhibits per year representing the broadest possible range of regional and national artistic trends. Some past exhibitions include 'Regional Juried Exhibition III,' 'Pattterns of Life New Indonesian Textiles from the Collection,' and 'Through the Camera's Eye Lost Freeport Photographs and Works by David Anderson.'"

Terms Gallery provides insurance and promotion; artist pays shipping costs. Prefers artwork framed.

Submissions Send query letter with résumé, slides, SASE, brochure, photographs and bio. Responds in 4 months. Files résumés.

Tips "The Exhibition Committee meets quarterly each year to review the slides submitted."

N ROBERT GALITZ FINE ART

166 Hilltop Court, Sleepy Hollow IL 60118. (847)426-8842. Fax: (847)426-8846. Website: www.galitzfineart.c om. **Owner:** Robert Galitz. Wholesale representation to the trade. Makes portfolio presentations to corporations. Estab. 1986. Represents 40 emerging, mid-career and established artists. Exhibited artists include Marko Spalatin and Jack Willis. Open by appointment. Located in far west suburban Chicago.

Media Considers oil, acrylic, watercolor, mixed media, collage, ceramic, fiber, original handpulled prints, engravings, lithographs, pochoir, wood engravings, mezzotints, serigraphs and etchings. "Interested in original works on paper."

Style Exhibits expressionism, painterly abstraction, surrealism, minimalism, impressionism and hard-edge geometric abstraction. Interested in all genres. Prefers landscapes and abstracts.

Terms Accepts artwork on consignment (variable commission) or artwork is bought outright (25% of retail price; net 30 days). Retail price set by artist. Customer discounts and payment by installment are available. Gallery provides promotion and shipping costs from gallery. Prefers artwork unframed only.

Submissions Send query letter with SASE and submission of art. Portfolio review requested if interested in artist's work. Files bio, address and phone.

Tips "Do your thing and seek representation—don't drop the ball! Keep going—don't give up!"

HEUSER ART CENTER GALLERY & HARTMANN CENTER ART GALLERY

Bradley University 1501 West Bradley Ave., Peoria IL 61625. (309)677-2989. Fax: (309)677-3642. E-mail: payres mc@bradley.edu. Website: gcc.bradley.edu/art/. **Director of galleries, exhibition and collections:** Pamela

Ayres. Alternative space, nonprofit gallery, educational. Estab. 1984. Approached by 260 artists/year. Represents 50 emerging, mid-career and established artists. Sponsors 10 exhibits/year; 1 photography exhibit/year. Average display time 4-6 weeks. Open Tuesday- Friday, 9-4; Thursday, 9-7; closed weekends and during Christmas break. Clients include local community and upscale. 10% of sales are to corporate collectors. Overall price range $100-5,000; most work sold at $500.

Media Considers all media. Most frequently exhibits printmaking, photo and group theme exhibitions. Considers all types of prints except posters.

Style Considers all styles and genres. Most frequently exhibits conceptualism, painter abstraction and neo-expressionism.

Terms Artwork is accepted on consignment and there is a 35% commission. Retail price set by the artist. Gallery provides promotion and contract. Accepted work should be framed. Does not require exclusive representation locally. ''We consider all professional artists.''

Submissions Mail portfolio of 20 slides for review. Send query letter with artist's statement, bio, brochure, business card, photocopies, photographs, résumé, reviews, SASE, slides and CD. Returns material with SASE. Does not reply to queries. Queries are reviewed in January and artists are notified in June. Files résumé, artist statments and bios. Finds artists through art exhibits, portfolio reviews, referrals by other artists, submissions and national calls.

Tips ''Please, no hand-written letters. Print or type slide lables. Only send 20 slides total.''

NAF GALLERY

4448 Oakton, Skokie IL 60076. (847)674-7990. Fax: (847)675-8116. E-mail: naf@aol.com. Website: www.nafgallery.com. **Contact:** Harry Hagen. Retail/wholesale gallery and art consultancy. Estab. 1987. Represents/exhibits 60-80 emerging, mid-career and established artists/year. Interested in seeing the work of emerging artists. Exhibited artists include Christana-Sahagian. Sponsors 3-4 shows/year. Average display time 4-6 weeks. Open all year; Monday-Sunday, 10-4. Located on main street of Skokie; 2,000 sq. ft. 80-100% of space for gallery artists. 5-10% private collectors, 5-10% corporate collectors. Overall price range $50-3,000; most work sold at $200-2,000.

Media Considers acrylic, ceramics, mixed media, oil, pastel, sculpture and watercolor. Most frequently exhibits oil, watercolor.

Style Exhibits expressionism, imagism, impressionism, painterly abstraction, postmodernism, surrealism. Genres include Americana, figurative work, florals, landscapes, portraits, Southwestern and wildlife. Prefers impressionism, abstraction and realism.

Terms Artwork is accepted on consignment (30% commission). Retail price set by the gallery and the artist. Gallery provides insurance and promotion. Artist pays for shipping costs. Prefers artwork framed.

Submissions Send query letter with résumé, slides and SASE. Include price and size of artwork. Call or write for appointment to show portfolio of photographs, slides and transparencies. Responds in 2 weeks. Finds artists through word of mouth, referrals by other artists, visiting art fairs and exhibitions, submissions.

Tips ''Be persistent.''

CHICAGO

A.R.C. GALLERY/EDUCATIONAL FOUNDATION

734 N. Milwaukee Ave., Chicago, IL 60622. (312)733-2787. E-mail: ARCgallery@yahoo.com. Website: www.ARCgallery.org. **President:** Carolyn King. Nonprofit gallery. Estab. 1973. Exhibits emerging, mid-career and established artists. Review work for solo and group shows on an ongoing basis. 21 members. (Visit website for prospectus.) Exhibited artists include Miriam Schapiro. Average display time 1 month. Closed August. Located in the River West area; 3,500 sq. ft. Clientele: 80% private collectors, 20% corporate collectors. Overall price range $50-40,000; most work sold at $200-4,000.

Media Considers oil, acrylic, drawings, mixed media, paper, sculpture, ceramics, installation, photography and original handpulled prints. Most frequently exhibits painting, sculpture (installation) and photography.

Style Exhibits all styles and genres. Prefers postmodern and contemporary work.

Terms Rental fee for space. Rental fee covers 1 month. Gallery provides promotion; artist pays shipping costs. Prefers work framed.

Submissions Send query letter with résumé, slides, bio and SASE. Call for deadlines for review. Portfolio should include slides.

N JEAN ALBANO GALLERY

215 W. Superior St., Chicago IL 60610. (312)440-0770. E-mail: jeanalbano@aol.com. Website: jeanalbanoartgallery.com. **Director:** Jean Albano Broday. Retail gallery. Estab. 1985. Represents 24 mid-career artists.

Somewhat interested in seeing the work of emerging artists. Exhibited artists include Martin Facey and Jim Waid. Average display time 5 weeks. Open all year. Located downtown in River North gallery district; 1,600 sq. ft. 60% of space for special exhibitions; 40% of space for gallery artists. Clientele 80% private collectors, 20% corporate collectors. Overall price range $1,000-20,000; most work sold at $2,500-6,000.
Media Considers oil, acrylic, sculpture and mixed media. Most frequently exhibits mixed media, oil and acrylic. Prefers nonrepresentational, nonfigurative and abstract styles.
Terms Accepts artwork on consignment (50% commission). Retail price set by gallery and artist; shipping costs are shared.
Submissions Send query letter with résumé, bio, SASE and well-labeled slides "size, name, title, medium, top, etc." Write for appointment to show portfolio. Responds in 6 weeks. "If interested, gallery will file bio/résumé and selected slides."
Tips "We look for artists whose work has a special dimension in whatever medium. We are interested in unusual materials and unique techniques."

BALZEKAS MUSEUM OF LITHUANIAN CULTURE ART GALLERY

6500 S. Pulaski Rd., Chicago IL 60629. (773)582-6500. Fax: (773)582-5133. Museum, museum retail shop, nonprofit gallery and rental gallery. Estab. 1966. Approached by 20 mid-career and established artists/year. Sponsors 8 exhibits/year. Average display time 6 weeks. Open 7 days a week. Closed holidays. Clients include local community, tourists and upscale. 74% of sales are to corporate collectors. Overall price range $150-6,000; most work sold at $545.
Media Considers all media and all types of prints.
Style Considers all styles and genres.
Terms Artwork is accepted on consignment and there is a 33% commission. Retail price set by the gallery. Gallery provides promotion. Accepted work should be framed.
Submissions Write to arrange a personal interview to show portfolio. Cannot return material. Responds in 2 months. Finds artists through word of mouth, art exhibits, and referrals by other artists.

[N] PETER BARTLOW GALLERY

9 E. Huron St., 2nd Floor, Chicago IL 60611. (312)337-1782. Fax: (312)337-2516. E-mail: pbartlow@bartlowgallery.com. Website: www.bartlowgallery.com. **Contact:** Peter Bartlow, president. For-profit gallery. Estab. 1991. Exhibits emerging, mid-career and established artists. Approached by many artists/year; represents 0-2 new artists/year. Exhibited artists include Jean Gaudaire-Thor, painting, etching/aquatint; Doug Hatch, painting, etching/aquatint. Sponsors 3-4 exhibits/year. Average display time 3-4 weeks solo/ongoing group. Open Tuesday-Friday, 10-5:30; Saturday, 11-5; closed Thanksgiving, Christmas and New Years. Exhibition space approximately 700 sq. ft., located in 2nd floor space/3 large windows in Chicago's Near North Neighborhood off the Magnificent Mile. Clients include local community, tourists, upscale. 10-15% sales are to corporate collectors. Overall price range: $500-85,000; most work sold at $2,000-12,000.
Media Considers acrylic, ceramics, collage, drawing, mixed media, oil, paper, pastel, pen & ink, sculpture, watercolor. Most frequently exhibits prints, acrylic and oil. Considers all types of prints.
Style Considers all styles. Most frequently exhibits modern/contemporary abstraction, master graphics, sculpture. Genres include figurative work, florals, landscapes, portraits, abstracts.
Making Contact & Terms Artwork is accepted on consignment and there is a 50% commission. Retail price set by the gallery, based on the artist's wholesale. Requires exclusive representation locally.
Submissions E-mail preferred. Portfolio should contain ditigal photographs. Send query letter with artist's statement, bio, photographs, résumé, reviews, SASE. Returns material with SASE. Responds to queries only if interested within 2 weeks. Don't file unless accepted. Finds artists through referrals by other artists, submissions, word of mouth.

MARY BELL GALLERIES

740 N. Franklin, Chicago IL 60610. (312)642-0202. Fax: (312)642-6672. Website: www.marybell.com. **President:** Mary Bell. Retail gallery. Estab. 1975. Represents mid-career artists. Interested in seeing the work of emerging artists. Exhibited artists include Mark Dickson. Sponsors 4 shows/year. Average display time 6 weeks. Open all year. Located downtown in gallery district; 5,000 sq. ft. 25% of space for special exhibitions. Clientele corporations, designers and individuals. 50% private collectors, 50% corporate collectors. Overall price range: $500-15,000.
Media Considers oil, acrylic, pastel, mixed media, collage, paper, sculpture, ceramic, fiber, glass, original handpulled prints, offset reproductions, woodcuts, engravings, lithographs, pochoir, posters, wood engravings, mezzotints, serigraphs, linocuts and etchings. Most frequently exhibits canvas, unique paper and sculpture.
Style Exhibits expressionism, painterly abstraction, impressionism, realism and photorealism. Genres include

landscapes and florals. Prefers abstract, realistic and impressionistic styles. Does not want "figurative or bizarre work."

Terms Accepts artwork on consignment (50% commission). Retail price set by gallery and artist. Offers customer discounts and payment by installments. Gallery provides insurance and contract; shipping costs are shared. Prefers artwork unframed.

Submissions Send query letter with slides and SASE. Portfolio review requested if interested in artist's work. Portfolio should include slides or photos.

BELL STUDIO

3428 N. Southport Ave., Chicago IL 60657. (773)281-2172. Fax: (773)281-2415. E-mail: paul@bellstudio.net. Website: www.bellstudio.net. **Director:** Paul Therieau. For-profit gallery. Estab. 2001. Approached by 60 artists/year. Represents 10 emerging artists. Sponsors 10 exhibits/year; 3 photography exhibits/year. Average display time 6 weeks. Open all year; Monday-Friday, 12-7; Saturday, 11-7; Sunday, 12-5. Located in brick storefront, 750 sq. ft. exhibition space. Clients include local community, tourists, upscale. 1% of sales are to corporate collectors. Overall price range $150-3,500; most work sold at $600.

Media Considers acrylic, collage, drawing, mixed media, oil, paper, pastel, pen & ink and watercolor. Considers all types of prints except posters. Most frequently exhibits watercolor, oils and photography.

Style Exhibits minimalism, postermodernism and painterly abstraction. Genres include figurative work and landscapes.

Terms Artwork is accepted on consignment and there is a 50% commission. Retail price set by the gallery. Gallery provides insurance, promotion and contract. Accepted work should be framed. Requires exclusive representation locally.

Submissions Write to arrange personal interview to show portfolio and include a bio and résumé. Returns material with SASE. Responds to queries only if interested with 3 months. Finds artists through referrals by other artists, submissions and word of mouth.

Tips "Type submission letter and include your show history, résumé and a SASE."

CHIAROSCURO

700 N. Michigan Ave., Chicago IL 60611. (312)988-9253. **Contact:** Peggy Wolf. Contemporary retail gallery. Estab. 1987. Represents over 200 emerging artists. Located on Chicago's "Magnificent Mile"; 2,500 sq. ft. on Chicago's main shopping boulevard, Michigan Ave. "Space was designed by award winning architects Himmel & Bonner to show art and contemporary crafts in an innovative way." Overall price range $5-2,000; most work sold at $50-200.

Media All 2-dimensional workmixed media, oil, acrylic; ceramics (both functional and decorative works); sculpture, art furniture, jewelry. "We moved out of Chicago's gallery district to a more 'retail' environment 12 years ago because many galleries were closing. Paintings seemed to stop selling, even at the $500-1,000 range, where functional pieces (i.e. furniture) would sell at that price."

Style "Generally we exhibit bright contemporary works representative of those being done by today's leading contemporary craft artists. We specialize in affordable art for the beginning collector, and are focusing on 'functional works' and gifts for the home.

Terms Accepts work on consignment (50% commission).

Submissions Send query letter (Attn: Peggy Wolf) with résumé, slides, photographs, price list, bio and SASE. Portfolio review requested if interested in artist's work. All material is returned if not accepted or under consideration. Finds artists through agents, by visiting exhibitions and national craft and gift shows, word of mouth, various art publications and sourcebooks, submissions/self-promotions and art collectors' referrals.

Tips "Don't be afraid to send photos of anything you're working on. I'm happy to work with the artist, suggest what's selling (at what prices). If it's not right for this gallery, I'll let them know why."

FINE ARTS BUILDING GALLERY

410 S. Michigan Ave., #433, Chicago IL 60605-1300. (312)913-0537. Fax: (312)913-1148. E-mail: fabgallery@aol.com. Website: www.fabgallery.com. Cooperative for profit gallery. Estab. 1995. Represents 24 mid-career and established artists. Average display time 1 month. Open all year; Wednesday-Saturday, 12-6. Closed Sundays and holidays. Located on 4th floor of historic landmark building; Venetian court (open courtyard in addition to gallery). Clients include local community, tourists and upscale. 15% of sales are to corporate collectors. Overall price range $100-15,000; most work sold at $1,500.

Media Considers acrylic, ceramics, collage, drawing, mixed media, oil, paper, pastel, pen & ink, sculpture and watercolor. Most frequently exhibits paintings on canvas, works on paper, mixed media sculpture. Considers etchings, linocuts, lithographs and monotypes.

Style Exhibits color field, geometric abstraction, imagism, pattern painting, surrealism, painterly abstraction and realism. Most frequently exhibits realism, surrealism and painterly abstraction. Considers all genres.

Artist Charles Gniech painted "The Teacher Learns" as one piece in a series of seven, which as a whole were meant to illustrate "the moment between sleeping and waking, life and death." The painting was first exhibited at the Chicago Fine Arts Building in 2004. Gniech asserts that press is very important in determining the success of an exhibition. He suggests giving publishers a minimum of six weeks advance notice of the event and sending press releases with promotional cards featuring the work to local newspapers, art critics, and art publications. His advice to young artists: "Only show quality work. You are always creating your reputation."

Terms Artwork is accepted on consignment and there is a 35% commission. There is a co-op membership fee plus a donation of time. There is a 25% commission. There is a rental fee for space. The rental fee covers 1 month. Retail price set by the artist. Gallery provides insurance and promotion. Accepted work should be framed and matted. Does not require exclusive representation locally. Member artists must be from the Chicago area. Guest artists may come from anywhere.

Submissions Send query letter with artist's statement, bio, brochure, business card, photocopies, photographs, résumé, reviews, SASE and slides. Returns material with SASE. Files résumés and artist's statements. Finds artists through word of mouth, submissions, portfolio reviews, art exhibits, and referrals by other artists.

Tips "Quality of slides and or transparencies or photocopies must be of high quality and correctly represent the artwork! Archival-quality materials play a very important role. Hopefully even if the artist uses 'new materials,' he/she tries to learn about the archival quality of the materials that are used. Materials do not have to be expensive or official art materials."

N OSKAR FRIEDL GALLERY

1029 W 35th St., Chicago IL 606 09. (312)493-4330. E-mail: o@friedlgallery.com. Website: www.friedlgallery.com. Retail gallery. Estab. 1988. Represents 10 emerging, mid-career and established artists. Exhibited artists include (Art)Laboratory, Miroslaw Rogala and Zhou Brothers. Sponsors 6 shows/year. Average display time 7 weeks. Open all year; Thursday, Friday, Saturday, 12-7. Located downtown in River North gallery district; 800 sq. ft. Clientele emerging private collectors. 80% private collectors, 20% corporate collectors. Overall price range $500-30,000; most work sold at $3,000-8,000.

• This gallery has an emphasis on interactive material and CD-ROM.

Media Considers oil, acrylic, pastel, pen & ink, drawings, mixed media, collage, sculpture, interactive multimedia, CD-ROM and installation. Most frequently exhibits oil, acrylic and sculpture.

Style Exhibits expressionism, neo-expressionism, conceptualism and painterly abstraction. Prefers contemporary, abstract expressionist and conceptualist styles.

Terms Accepts artwork on consignment (50% commission). Retail price set by gallery and artist. Gallery provides insurance, promotion, contract and some shipping costs from gallery.

Submissions Send query letter with résumé, sheet of slides, bio, brochure, photographs, SASE and reviews. Portfolio review requested if interested in artist's work. Portfolio should include photographs, slides and transparencies. Responds in 6 weeks.

Tips "Apply only to galleries that you know are right for you. Have a body of work of 100 pieces before approaching galleries."

GALLERY 400, UNIVERSITY OF ILLINOIS AT CHICAGO

1240 W. Harrison (MC034), Chicago IL 60607. (312)996-6114. Fax: (312)355-3444. Website: gallery400.aa.uic.edu. **Director:** Lorelei Stewart. Nonprofit gallery. Estab. 1983. Approached by 500 artists/year. Exhibits 80 emerging and mid-career artists. Exhibited artists include Ruben Ortiz Torres, Jenny Perlin and Scott Reeder. Sponsors 6 exhibits/year. Average display time 4-6 weeks. Open Tuesday-Friday, 10-6; Saturday, 12-6. Closed holiday season. Located in 2,400 sq. ft. former supermarket. Clients include local community, students, tourists and upscale.

Media Considers drawing, installation, mixed media and sculpture. Most frequently exhibits sculpture, drawing and installation.

Style Exhibits conceptualism, minimalism and postmodernism. Most frequently exhibits contemporary conceptually based artwork.

Terms Gallery provides insurance and promotion.

Submissions Send query letter with SASE. Returns material with SASE. Responds in 5 months. Files résumé only. Finds artists through word of mouth, art exhibits and referrals by other artists.

Tips Please check our website for guidelines for proposing an exhibition.

GALLERY 1633

1633 N. Damen Ave., Chicago IL 60647. (773)384-4441. E-mail: montanaart@att.net. Website: home.att.net/~montanaart. **Director:** Montana Morrison. Consortium of contributing artists. Estab. 1986. Represents/exhibits a number of emerging, mid-career and established artists. Interested in seeing the work of emerging artists. Exhibited artists include painters, printmakers, sculptors, photographers. Sponsors 11 shows/year. Average display time 1 month. Open all year; Friday, 12-930; Saturday and Sunday, 12-5. Located in Bucktown; 900 sq. ft.; original tin ceiling, storefront charm. 35% of space for special exhibitions; 65% of space for gallery artists. Clientele tourists, local community, local artists, "suburban visitors to popular neighborhood." Sells to both private collectors and commercial businesses. Overall price range $50-5,000; most work sold at $250-500.

Media Considers all media and types of prints. Most frequently exhibits painting and drawing; ceramics, sculpture and photography.

Style Exhibits all styles including usable crafts (i.e. tableware). All genres. Montana Morrison shows neo-expressionism, activated minimalism and post modern works.

Terms Artwork is accepted on consignment, and there is a 25% commission. There is a rental fee for space. Available memberships include "gallery artists" who may show work every month for 1 year; associate gallery artists who show work for 6 months; and guest artists, who show for one month. Retail price set by the artist. Gallery provides promotion and contract. Artist pays for shipping costs. Call for appointment to show portfolio. Artist should call and visit gallery.

Tips "If you want to be somewhat independent and handle your own work under an 'umbrella' system where artists work together, in whatever way fits each individual join us."

HYDE PARK ART CENTER

5307 S. Hyde Park Blvd., Chicago IL 60615. (773)324-5520. Fax: (773)324-6641. E-mail: info@hydeparkart.org. Website: hydeparkart.org. **Executive Director:** Chuck Thurow. Nonprofit gallery. Estab. 1939. Exhibits emerging artists. Sponsors 8 group shows/year. Average display time is 4-6 weeks. Office-Gallery open Monday-Friday, 9-5; Saturday, 12-5. Located in the historic Del Prado building, in a former ballroom. "Primary focus on Chicago area artists not currently affiliated with a retail gallery." Clientele: general public. Overall price range $100-10,000.

Media Considers all media. Interested in seeing "innovative work by new artists; also interested in proposals from curators, groups of artists."

Terms Accepts work "for exhibition only." Retail price set by artist. Sometimes offers payment by installment. Exclusive area representation not required. Gallery provides insurance and contract.

Submissions Send query letter with résumé, no more than 10 slides and SASE. Will not consider poor slides. "A coherent artist's statement is helpful." Portfolio review not required. Send: Attn. Allison Peters, Exhibition Coordinator. Finds artists through open calls for slides, curators, visiting exhibitions (especially MFA programs) and artists' submissions. Prefers not to receive phone calls.

Tips "Do not bring work in person."

N ILLINOIS ARTISANS PROGRAM

James R. Thompson Center, Chicago IL 60601. (312)814-5321. Fax: (312)814-3891. E-mail: cpatterson@museum.state.il.us. **Director:** Carolyn Patterson. Four retail shops operated by the nonprofit Illinois State Museum Society. Estab. 1985. Represents over 1,500 artists; emerging, mid-career and established. Average display time 6 months. "Accepts only juried artists living in Illinois." Clientele tourists, conventioneers, business people, Chicagoans. Overall price range $10-5,000; most artwork sold at $25-100.

Media Considers all media. "The finest examples in all media by Illinois artists."

Style Exhibits all styles. "Seeks contemporary, traditional, folk and ethnic arts from all regions of Illinois."

Terms Accepts work on consignment (50% commission). Retail price set by gallery and artist. Sometimes offers customer discounts. Exclusive area representation not required. Gallery provides promotion and contract.

Submissions Send résumé and slides. Accepted work is selected by a jury. Resume and slides are filed. "The finest work can be rejected if slides are not good enough to assess." Portfolio review not required. Finds artists through word of mouth, requests by artists to be represented and by twice-yearly mailings to network of Illinois crafters announcing upcoming jury dates.

N ILLINOIS STATE MUSEUM CHICAGO GALLERY

(formerly Illinois Art Gallery), Suite 2-100, 100 W. Randolph, Chicago IL 60601. (312)814-5322. Fax: (312)814-3471. E-mail: jstevens@museum.state.il.us. Website: www.museum.state.il.us. **Assistant Administrator:** Jane Stevens. Museum. Estab. 1985. Exhibits emerging, mid-career and established artists. Sponsors 6-7 shows/year. Average display time 7-8 weeks. Open all year. Located "in the Chicago loop, in the James R. Thompson Center designed by Helmut Jahn." 100% of space for special exhibitions.

Media All media considered, including installations.

Style Exhibits all styles and genres, including contemporary and historical work.

Terms "We exhibit work, do not handle sales." Gallery provides insurance and promotion; artist pays for shipping. Prefers artwork framed.

Submissions Accepts only artists from Illinois. Send résumé, 10 high quality slides, bio and SASE.

DAVID LEONARDIS GALLERY

1346 N. Paulina St., Chicago IL 60622. (773)278-3058. Fax: (773)278-3068. E-mail: david@dlg-gallery.com. Website: www.DLG-GALLERY.COM. **Owner:** David Leonardis. For-profit gallery. Estab. 1992. Approached by 100 artists/year. Represents 12 emerging, mid-career and established artists. Exhibited artists include Kristen Thiele and Christopher Makos. Average display time 30 days. Open all year; Tuesday-Saturday, 12-7; weekends from 12-6. Located in downtown Chicago. Clients include local community, tourists, upscale. 10% of sales are to corporate collectors. Overall price range $50-5,000; most work sold at $500.

Media Most frequently exhibits painting, photography and lithography. Considers lithographs and serigraphs.

Style Exhibits pop. Most frequently exhibits contemporary, pop, folk, photo. Genres include figurative work and portraits.

Terms Artwork is accepted on consignment and there is a 50% commission. Retail price set by the gallery and the artist. Gallery provides promotion. Accepted work should be framed. Does not require local representation. Prefers artists who are professional and easy to deal with.

Submissions E-mail. Responds only if interested. Files e-mail and JPEGs. Finds artists through word of mouth, art exhibits, and referrals by other artists.

PETER MILLER GALLERY

118 N. Peoria St., Chicago IL 60607. (312)226-5291. Fax: (312)226-5441. E-mail: info@petermillergallery.com. Website: petermillergallery.com. **Director:** Natalie R. Domchenko. Retail gallery. Estab. 1979. Represents 15 emerging, mid-career and established artists. Sponsors 9 solo and 3 group shows/year. Average display time is 1 month. Clientele: 80% private collectors, 20% corporate clients. Overall price range $500-30,000; most artwork sold at $5,000 and up.

Media Considers oil, acrylic, mixed media, collage, sculpture, installations and photography. Most frequently exhibits oil and acrylic on canvas and mixed media.

Style Exhibits abstraction, conceptual and realism.

Terms Accepts work on consignment (50% commission). Retail price set by gallery and artist. Exclusive area representation required. Insurance, promotion and contract negotiable.

Submissions Send a sheet of 20 slides of work done in the past 18 months with a SASE. Slides, show card are filed.

VALE CRAFT GALLERY

230 W. Superior St., Chicago IL 60610. (312)337-3525. Fax: (312)337-3530. E-mail: peter@valecraftgallery.com. Website: www.valecraftgallery.com. **Owner:** Peter Vale. Retail gallery. Estab. 1992. Represents 100 emerging,

mid-career artists/year. Exhibited artists include Tana Acton, Mark Brown, Tina Fung Holder, John Neering and Kathyanne White. Sponsors 4 shows/year. Average display time 3 months. Open all year; Tuesday-Friday, 1030-530; Saturday, 11-5. Located in River North gallery district near downtown; 2,100 sq. ft.; lower level of prominent gallery building; corner location with street-level windows provides great visibility. Clientele: private collectors, tourists, people looking for gifts, interior designers and art consultants. Overall price range; $50-2,000; most work sold at $100-500.

Media Considers paper, sculpture, ceramics, craft, fiber, glass, metal, wood and jewelry. Most frequently exhibits fiber wall pieces, jewelry, glass, ceramic sculpture and mixed media.

Style Exhibits contemporary craft. Prefers decorative, sculptural, colorful, whimsical, figurative, and natural or organic.

Terms Accepts work on consignment (50% commission). Retail price set by the artist. Gallery provides insurance, promotion, contract and shipping costs from gallery; artist pays shipping costs to gallery.

Submissions Accepts only craft media. No paintings, prints, or photographs, please. By mail: Send query letter with résumé, bio or artist's statement, reviews if available, 10-20 slides, CD of images (in JPEG format) or photographs (including detail shots if possible), price list, record of previous sales, and SASE if you would like materials returned to you. By e-mail, please include a link to your website or send JPEG images, as well as any additional information listed above. Call for appointment to show portfolio of originals and photographs. Responds in 2 months. Files résumé (if interested). Finds artists through submissions, art and craft fairs, publishing a call for entries, artists' slide registry and word of mouth.

Tips "Call ahead to find out if the gallery is interested in showing the particular type of work that you make. Try to visit the gallery ahead of time or check out the gallery's website to find out if your work fits into the gallery's focus. I would suggest you have completed at least 20 pieces in a body of work before approaching galleries."

INDIANA

ⓝ ARTLINK

437 E. Berry St., Suite 202, Fort Wayne IN 46802-2801. (219)424-7195. Fax: (219)424-8453. E-mail: artlinkfw@juno.com. Website: www.artlinkfw.com. **Executive Director:** Betty Fishman. Nonprofit gallery. Estab. 1979. Exhibits emerging and mid-career artists. 620 members. Sponsors 18 shows/year, 2 galleries. Average display time 5-6 weeks. Open all year. Located 4 blocks from central downtown, 2 blocks from art museum and theater for performing arts; in same building as a cinema theater, dance group and historical preservation group; 1,600 sq. ft. 100% of space for special exhibitions. Overall price range $100-500; most artwork sold at $200.

- Publishes a quarterly newsletter, *Genre*, which is distributed to members. Includes features about upcoming shows, profiles of members and other news. Some artwork shown at gallery is reproduced in b&w in newsletter. Send SASE for sample and membership information.

Media Considers all media, including prints. Prefers work for annual print show and annual photo show, sculpture and painting.

Style Exhibits expressionism, neo-expressionism, painterly abstraction, conceptualism, color field, postmodern works, photorealism, hard-edge geometric abstraction; all styles and genres. Prefers imagism, abstraction and realism. "Interested in a merging of craft/fine arts resulting in art as fantasy in the form of bas relief, photo/books, all experimental media in nontraditional form."

Terms Accepts work on consignment only for exhibitions (35% commission). Retail price set by artist. Gallery provides insurance. Shipping costs are shared. Prefers framed artwork.

Submissions Send query letter with résumé, no more than 6 slides and SASE. Reviewed by 14-member panel. Responds in 1 month. "Jurying takes place three times per year unless it is for a specific call for entry. A telephone call will give the artist the next jurying date."

Tips "Call ahead to ask for possibilities for the future and an exhibition schedule for the next two years will be forwarded." Common mistakes artists make in presenting work are "bad slides and sending more than requested—large packages of printed material. Printed catalogues of artist's work without slides are useless." Sees trend of community-wide cooperation by organizations to present art to the community.

EDITIONS LIMITED GALLERY OF FINE ART

838 E. 65th St., Indianapolis IN 46220. (317)466-9940 or (888)622-4927. **Owner:** John Mallon. Retail gallery. Estab. 1969. Represents emerging, mid-career and established artists. Sponsors 4 shows/year. Average display time 1 month. Open all year. Located "north side of Indianapolis; track lighting, exposed ceiling, white walls." Clientele: 60% private collectors, 40% corporate collectors. Overall price range $100-8,500; most artwork sold at $200-1,200.

Media Considers oil, acrylic, watercolor, pastel, pen & ink, drawings, mixed media, collage, works on paper,

sculpture, ceramics, craft, fiber, glass, photography, original handpulled prints, woodcuts, engravings, mezzo-tints, etchings, lithographs, pochoir and serigraphs. Most frequently exhibits mixed media, acrylic and pastel. **Style** Exhibits all styles and genres. Prefers abstract, landscapes and still lifes.

Terms Accepts work on consignment (50% commission). Retail price set by artist. "I do discuss the prices with artist before I set a retail price." Sometimes offers customer discounts and payment by installment. Gallery provides insurance; shipping costs are shared. Prefers artwork unframed.

Submissions Send query letter with slides, SASE and bio. Portfolio review requested if interested in artist's work. Portfolio should include photos, CD disk or slides, résumé and bio. Files bios, reviews, slides and photos.

Tips Does not want to see "hobby art."

GREATER LAFAYETTE MUSEUM OF ART

102 S. Tenth St., Lafayette IN 47901. (765)742-1128. E-mail: glma@glmart.org. Website: glma.org. **Executive Director:** Les Reker. Museum. Estab. 1909. Temporary exhibits of American and Indiana art as well as work by emerging, mid-career and established artists from Indiana and the midwest. 1,340 members. Sponsors 5-7 shows/year. Average display time 10 weeks. Located 6 blocks from city center; 3,318 sq. ft.; 4 galleries. Clientele includes Purdue University faculty, students and residents of Lafayette/West Lafayette and 14 county area.

Style Exhibits all styles. Genres include landscapes, still life, portraits, abstracts, non-objective and figurative work.

Terms Accepts some crafts for consignment in gift shop (35% mark-up).

Submissions Send query letter with résumé, slides, artist's statement and letter of intent.

Tips "Indiana artists specifically encouraged to apply."

ⓝ HOOSIER SALON PATRONS ASSOCIATION & GALLERY

714 E. 65th St., Indianapolis IN 46220-1610. (317)253-5340. Fax: (317)259-1817. E-mail: hoosiersalon@iquest.net. Website: www.hoosiersalon.org. Nonprofit gallery. Estab. 1925. Membership of 500 emerging, mid-career and established artists. Sponsors 7 exhibits/year (6 in gallery, 1 juried show each year at the Indiana State Museum). Average display time 1 month. Open Tuesday-Friday, 11-5; Saturday, 11-3. Closed over Christmas week. Gallery is in the Village of Broad Ripple, Indianapolis as part of a business building. Gallery occupies about 1,800 sq. ft. Clients include local community and tourists. 20% of sales are to corporate collectors. Overall price range $50-5,000; most work sold at $1,000.

• This gallery opened a new location in 2001 at 507 Church St., New Harmony IN 47631; (812)682-3970.

Media Considers acrylic, ceramics, collage, drawing, fiber, mixed media, oil, paper, pastel, pen & ink, sculpture, watercolor and hand-pulled prints. Most frequently exhibits oil, watercolor and pastel.

Style Exhibits traditional impressionism to abstract. Considers all genres.

Terms Artwork is accepted on consignment and there is a 33% commission. Retail price set by the artist. Gallery provides insurance and contract. Accepted work must be exhibit ready. Requires membership. Criteria for membership is 1 year's residence in Indiana. Accepts only artists from Indiana (1 year residency). Gallery only shows artists who have been in one Annual Exhibit (show of approx. 200 artists each year).

Submissions Call or e-mail for membership and Annual Exhibition information. Responds ASAP. We do not keep artists' materials unless they are members. Finds artists through word of mouth, art exhibits and art fairs.

Tips While not required, all mats, glass etc. need to be archival-quality. Because the Association is widely regarded as exhibiting quality art, artists are generally careful to present their work in the most professional way possible.

INDIANAPOLIS ART CENTER

820 E. 67th St., Indianapolis IN 46220. (317)255-2464. Fax: (317)254-0486. E-mail: exhibs@indplsartcenter.org. Website: www.indplsartcenter.org. Director of Exhibitions and Artist Services: David Kwasigroh. Exhibitions Associate: Susan Grade. Nonprofit art center. Estab. 1934. Prefers emerging artists. Exhibits approximately 100 artists/year. 2,600 members. Sponsors 15-20 shows/year. Average display time 5 weeks. Open Monday-Friday, 9-10; Saturday, 9-3; Sunday, 12-3. Located in urban residential area; 2,560 sq. ft. in 3 galleries; "Progressive and challenging work is the norm!" 100% of space for special exhibitions. Clientele mostly private. 90% private collectors, 10% corporate collectors. Overall price range $50-15,000; most work sold at $100-5,000. Also sponsors annual Broad Ripple Art Fair in May.

Media Considers all media and all types of original prints. Most frequently exhibits painting, sculpture installations and fine crafts.

Style All styles. "In general, we do not exhibit genre works. We do maintain a referral list, though." Prefers postmodern works, installation works, conceptualism, large-scale outdoor projects.

Terms Accepts work on consignment (35% commission). Commission is in effect for 3 months after close of exhibition. Retail price set by artist. Gallery provides insurance, promotion, contract; artist pays for shipping. Prefers artwork framed.

Submissions "Special consideration for IN, OH, MI, IL, KY artists." Send query letter with résumé, minimum of 20 slides, SASE, reviews and artist's statement. Accepted July 1-December 31 each year. Season assembled in February.

Tips "Research galleries thoroughly; get on their mailing lists, and visit them in person at least twice before sending materials. Find out the 'power structure' of the targeted galleries and use it to your advantage. Most artists need to gain experience exhibiting in smaller or nonprofit spaces before approaching a gallery. Work needs to be of consistent, dependable quality. Have slides done by a professional if possible. Stick with one style—no scattershot approaches. Have a concrete proposal with installation sketches (if it's never been built). We book two years in advance—plan accordingly. Do not call. Put me on your mailing list one year before sending application so I can be familiar with your work and record. Ask to be put on my mailing list so you know the gallery's general approach. It works!"

NEW HARMONY GALLERY OF CONTEMPORARY ART

506 Main St., New Harmony IN 47631. (812)682-3156. Fax: (812)682-3870. E-mail: harmony@usi.edu. Website: www.nhgallery.com. **Director:** April Vasher-Dean. Nonprofit gallery. Approached by 25 artists/year. Represents 8 emerging and mid-career artists. Exhibited artists include Patrick Dougherty, sculpture/installation. Sponsors 8 exhibits/year. Average display time 6 weeks. Open all year; Tuesday-Saturday, 10-5; Sundays, 12-4; closed Sundays, January-April. Clients include local community, students, tourists and upscale.

Media Considers all media and all types of prints. Most frequently exhibits sculpture and installation.

Style Exhibits Considers all styles including contemporary. No genre specified.

Terms Artwork is accepted on consignment and there is a 35% commission. Gallery provides insurance, promotion and contract. Accepted work should be framed, mounted and matted. Does not require exclusive representation locally. Prefers midwestern artists.

Submissions Send query letter with artist's statement, bio, résumé, SASE and slides. Returns material with SASE. Finds artists through art fairs, art exhibits, portfolio reviews and submissions.

IOWA

ARTS IOWA CITY

129 E. Washington St., Suite 1, Iowa City IA 52245-3925. (319)337-7447. E-mail: members@artsiowacity.com. Website: www.artsiowacity.com. **Gallery director:** Elise Kendrot. Nonprofit gallery. Estab. 1975. Approached by 65± artists/year. Represents 30± emerging, mid-career and established artists. Sponsors 11 exhibits/year. Average display time 1 month. Open all year; Monday-Friday, 11 to 6; weekends, 12-4. Several locations include: AIC Center & Gallery—129 E. Washington St.; Starbucks Downtown Iowa City; Melrose Meadows Retirement Community in Iowa City; Englert Civic Theatre Gallery, Iowa City. Satellite Galleries: local storefronts, locations vary. Clients include local community, students and tourists. 10% of sales are to corporate collectors. Overall price range $200-6,000; most work sold at $500.

Media Considers all media, types of prints, and all genres. Most frequently exhibits painting, drawing and mixed media.

Terms Artwork is accepted on consignment and there is a 50% commission. Retail price set by the artist. Gallery provides insurance (in gallery, not during transit to/from gallery), promotion and contract. Accepted work should be framed, mounted and matted. Does not require exclusive representation locally.

Submissions "We represent artists who are members of Arts Iowa City; to be a member one must pay a membership fee. Most people are from Iowa and surrounding states." Call or write to arrange personal interview to show portfolio of photographs, slides and transparencies. Send query letter with artist's statement, bio, brochure, business card, photographs, résumé, reviews, SASE and slides. Returns material with SASE. Responds to queries in 1 month. Files printed material and CDs. Slides sent back to artist after review. Finds artists through referrals by other artists, submissions and word of mouth.

Tips "We are a nonprofit gallery with limited staff. Most work is done by volunteers. Artists interested in submitting work should visit our website at www.artsiowacity.com to gain a better understanding of the services we provide and to obtain membership and show proposal information. Please submit applications according to the guidelines on the website."

⃞ THE CHAIT GALLERIES DOWNTOWN

218 E. Washington Street, Iowa City IA 52240. (319)338-4442. Fax: (319)338-3380. E-mail: info@thegalleriesdowntown.com. Website: www.thegalleriesdowntown.com. **Director:** Benjamin Chait. For-profit gallery. Estab. 2003. Approached by 300 artists/year. Represents 30 emerging, mid-career and established artists. Exhibited artists include Jerry Eskin (clay sculpture); Gene Anderson (multi-media sculpture); Doug Russell (mixed media); Corrine Smith (painting); Mary Merkel Hess (fiber art). Sponsors 12 exhibits/year. Average display time

90 days. Open all year; Monday-Friday, 11-6; weekends, 12-5. Located in a downtown building restored to its original look (circa 1882), with 14 ft. molded ceiling and original 9 ft. front door. Professional museum lighting and scamozzi-capped columns complete the elegant gallery. Clients include local community, students, tourists, upscale. Overall price range $50-4,000; most work sold at $500.

Media/Style Considers all media, all types of prints, all styles and all genres. Most frequently exhibits sculpture, ceramic and acrylic.

Terms Artwork is accepted on consignment and there is a 50% commission. Retail price set by the gallery and the artist. Gallery provides insurance, promotion and contract. Accepted work should be framed. Requires exclusive representation locally.

Submissions Call, mail portfolio for review. Returns material with SASE. Responds to queries in 2 weeks. Finds artists through art fairs, art exhibits, portfolio reviews and referrals by other artists.

GUTHART GALLERY & FRAMING

506 Clark St., Suite A, Charles City IA 50616. (641)228-5004. **Owner:** John R. Guthart. Retail gallery and art consultancy. Estab. 1992. Represents 12 emerging, mid-career and established artists. Exhibited artists include John Guthart. Average display time is 2 months. Open all year; Monday-Saturday, 10-5, and by appointment. Located downtown—close to art center and central park. 700 sq. ft. 50% of space for special exhibitions; 50% of space for gallery artists. Clientele tourists, upscale, local community and students. 80% private collectors, 20% corporate collectors. Overall price range $25-10,000; most work sold at $200-800.

Media Considers all media. Considers all types of prints. Most frequently exhibits watercolors, oils and prints.

Style Exhibits expressionism, primitivism, painterly abstraction, surrealism, postmodernism, impressionism and realism. Exhibits all genres. Prefers florals, wildlife and architectural art.

Terms Accepts artwork on consignment (30% commission) or buys outright for 50% of retail price (net 30 days). Retail price set by gallery. Gallery provides insurance and promotion. Shipping costs are shared. Prefers artwork framed.

Submissions Send query letter with résumé, slides and brochure. Write for appointment to show portfolio of photographs and slides. Responds only if interested in 2 weeks. Files résumé, letter and slides. Finds artists through word of mouth, referrals, submissions and visiting art fairs and exhibitions.

KAVANAUGH ART GALLERY

131 Fifth St., W. Des Moines IA 50265. (515)279-8682. Fax: (515)279-7609. E-mail: kagallery@aol.com. Website: www.kavanaughgallery.com. **Director:** Carole Kavanaugh. Retail gallery. Estab. 1990. Represents 25 mid-career and established artists/year. May be interested in seeing the work of emerging artists in the future. Exhibited artists include Kati Roberts, Don Hatfield, Dana Brown, Gregory Steele, August Holland, Ming Feng and Larry Guterson. Sponsors 3-4 shows/year. Averge display time 3 months. Open all year; Monday-Saturday, 10-5. Located in Old Town shopping area; 6,000 sq. ft. 70% private collectors, 30% corporate collectors. Overall price range $300-20,000; most work sold at $800-3,000.

Media Considers all media and all types of prints. Most frequently exhibits oil, acrylic and pastel.

Style Exhibits color field, impressionism, realism, florals, portraits, western, wildlife, southwestern, landscapes, Americana and figurative work. Prefers landscapes, florals and western.

Terms Accepts work on consignment (50% commission). Retail price set by the artist. Gallery provides insurance, promotion and contract. Shipping costs are shared. Prefers artwork unframed.

Submissions Send query letter with résumé, bio and photographs. Portfolio should include photographs. Responds in 3 weeks. Files bio and photos. Finds artists through word of mouth, referrals by other artists, visiting art fairs and exhibitions, artist's submissions.

Tips ''Get a realistic understanding of the gallery/artist relationship by visiting with directors. Be professional and persistent.''

N LUTHER COLLEGE GALLERIES

700 College Dr., Decorah IA 52101. (563)387-1665. Fax: (563)387-1132. E-mail: kammdavi@luther.edu. Website: galleries.luther.edu. **Gallery Coordinator:** David Kamm. Nonprofit college gallery. Estab. 1989. Approached by 20 artists/year. Sponsors 14-16 exhibits/year by emerging, mid-career and established artists. Average display time 4-8 weeks. Monday-Friday, 8-5; weekend hours vary. Closed college holidays and summer. Gallery has 3 exhibition spaces and 2 outdoor sculpture pads; 90-150' wall space; low security, good visibility. Clients include local community, students, tourists and upscale.

Media Considers all media.

Style Considers all styles and genres.

Terms Retail price set by the artist. Gallery provides insurance, promotion and contract. Accepted work should be framed or ready to exhibit.

Submissions Send query letter with artist's statement, résumé, SASE and slides. Responds only if interested

within 6 months. Files résumé and artist's statement. Finds artists through word of mouth, submissions, art exhibits, art fairs, and referrals by other artists.

Tips "Communicate clearly, and have quality slides and professional résumé (form and content)."

MACNIDER ART MUSEUM
303 Second St. SE, Mason City IA 50401. (641)421-3666. E-mail: macnider@macniderart.org. Website: www.macniderart.org. **Director:** Shelia Perry. Nonprofit gallery. Estab. 1966. Exhibits 1-10 emerging, mid-career and established artists. Sponsors 12-20 exhibits/year. Average display time 3 months. Open all year; Tuesday and Thursday, 9-9; Wednesday, Friday and Saturday, 9-5; Sunday, 1-5. Closed Mondays. Large gallery space with track system which we hang works on monofilament line. Smaller gallery items are hung or mounted. Clients include local community, students, tourists and upscale. Overall price range $50-2,500; most work sold at $200-$500.

Media Considers all media and all types of prints.

Style Considers all styles and genres.

Terms Artwork is accepted on consignment and there is a 40% commission. Retail price set by the artist. Gallery provides insurance, promotion and contract. Accepted work should be framed. Does not require exclusive representation locally.

Submissions Mail portfolio for review. Returns material with SASE. Responds only if interested within 3 months. Finds artists through word of mouth, submissions, portfolio reviews, art exhibits, art fairs and referrals by other artists.

Tips "Exhibition opportunities include exhibition in 2 different gallery spaces, entry into competitive exhibits (1 fine craft exhibit open to Iowa artists and 1 all media open to artists within 100 miles of Mason City Iowa), features in museum shop on consignment, booth space in Festival Art Market in August."

WALNUT STREET GALLERY
301 SW Walnut St., Ankeny IA 50021. (515)964-9434. Fax: (515)964-9438. E-mail: wsg@dwx.com. Website: www.walnutstreetgallery.com. **Owner:** Drue Wolfe. Retail gallery. Estab. 1982. Represents 50 emerging, mid-career and established artists/year. Exhibited artists include Steve Hanks, Stew Buck, Larry Zach and Terry Redlin. Sponsors 1 show/year. Average display time 6 months. Open all year; Monday-Thursday, 9-7; Friday, 9-5; Saturday, 9-3. Located downtown; 1,500 sq. ft.; renovated building. 25% of space for special exhibitions. Clientele: local community and suburbs. Overall price range $100-1,000; most work sold at $250-600.

Media Considers all media and all types of prints. Most frequently exhibits watercolor, acrylic and oil.

Style Exhibits expressionism, impressionism and realism. Genres include florals, wildlife, landscapes and Americana. Prefers impressionism, realism and expressionism.

Terms Buys outright for 50% of retail price (net 30 days). Retail price set by the artist. Gallery provides promotion; gallery pays shipping. Prefers artwork unframed.

Submissions Send query letter with brochure and photographs. Write for appointment to show portfolio of photographs. Responds only if interested within 3 weeks. Files all material. Finds artists through visiting art fairs and recommendations from customers.

KANSAS

GALLERY XII
412 E. Douglas, Suite A, Wichita KS 67202. (316)267-5915. E-mail: galleryxii@aol.com. **President:** Rosemary Dugan. Consignment Committee Judy Dove. Cooperative nonprofit gallery. Estab. 1977. Represents 50 mid-career and established artists/year and 20 members. Average display time 1 month. Open all year; Monday-Saturday, 10-5. Usually open with other galleries for "Final Fridays" gallery tour 7-10 p.m., final Friday of month. Located in historic Old Town which is in the downtown area; 1,300 sq. ft.; historic building. 20% of space for special exhibitions; 80% of space for gallery artists. Clientele private collectors, corporate collectors, people looking for gifts, tourists. Overall price range $10-2,000.

Terms Only accepts 3-D work on consignment (35% commission). Co-op membership screened and limited. Annual exhibition fee, 15% commission and time involved. Artist pays shipping costs to and from gallery.

Submissions Limited to local artists or those with ties to area. Work juried from slides. "We are a co-op gallery whose members rigorously screen prospective new members."

Ⓝ PHOENIX GALLERY TOPEKA
2900-F Oakley Dr., Topeka KS 66614. (785)272-3999. E-mail: Phnx@aol.com. Website: www.phnxgallery.com. **Contact:** Kyle Garcia. Retail gallery. Estab. 1990. Represents 60 emerging, mid-career and established artists/year. Exhibited artists include Dave Archer, Louis Copt, Nagel, Phil Starke, Robert Berkeley Green and Raymond

Eastwood. Sponsors 6 shows/year. Average display time 6 weeks-3 months. Open Monday-Saturday, 10-6; closed most Sundays. Located downtown; 2,000 sq. ft. 100% of space for special exhibitions; 100% of space for gallery artists. Clientele: upscale. 75% private collectors, 25% corporate collectors. Overall price range $500-20,000.

Media Considers all media and engravings, lithographs, woodcuts, mezzotints, serigraphs, linocuts, etchings and collage. Most frequently exhibits oil, watercolor, ceramic and artglass.

Style Exhibits expressionism and impressionism, all genres. Prefers regional, abstract and 3-D type ceramic; national glass artists. "We find there is increased interest in original work and regional themes."

Terms Terms negotiable. Retail price set by the gallery and the artist. Prefers artwork framed.

Submissions Call for appointment to show portfolio of originals, photographs and slides.

Tips "We are scouting [for artists] constantly."

ALICE C. SABATINI GALLERY

1515 SW Tenth, Topeka KS 66604-1374. (785)580-4516. Fax: (785)580-4496. E-mail: sbest@mail.tscpl.org. Website: www.tscpl.org. **Gallery Director:** Sherry Best. Nonprofit gallery. Estab. 1976. Exhibits emerging, mid-career and established artists. Sponsors 8-9 shows/year. Average display time 1 month. Open all year; Monday-Friday, 9-9; Saturday, 9-6; Sunday, 12-9. Located 1 mile west of downtown; 2,500 sq. ft.; security, track lighting, plex top cases; recently added five moveable walls. 100% of space for special exhibitions and permanent collections. Overall price range $150-$5,000.

Media Considers oil, fiber, acrylic, sculpture, glass, watercolor, mixed media, ceramic, pastel, collage, metal work, woodcuts, wood engravings, linocuts, engravings, mezzotints, etchings, lithographs and photography. Most frequently exhibits ceramic, oil and watercolor.

Style Exhibits neo-expressionism, painterly abstraction, postmodern works and realism. Prefers painterly abstraction, realism and neo-expressionism.

Terms Artwork accepted or not accepted after presentation of portfolio/résumé. Retail price set by artist. Gallery provides insurance; artist pays for shipping costs. Prefers artwork framed.

Submissions Usually accepts only artists from KS, MO, NE, IA, CO, OK. Send query letter with résumé and 12-24 slides. Call or write for appointment to show portfolio of slides. Responds in 2 months. Files résumé. Finds artists through visiting exhibitions, word of mouth and submissions.

Tips "Find out what each gallery requires from you and what their schedule for reviewing artists' work is. Do not go in unannounced. Have good quality slides. If slides are bad they probably will not be looked at. Have a dozen or more to show continuity within a body of work. Your entire body of work should be at least 50-100 pieces. Competition gets heavier each year. Looks for originality."

N EDWIN A. ULRICH MUSEUM OF ART

Wichita State University, Wichita KS 67260-0046. (316)978-3664. Fax: (316)978-3898. E-mail: ulrich@wichita.edu. Website: www.ulrich.wichita.edu. **Director:** Dr. David Butler. Museum. Estab. 1974. Wichita's premier venue for modern and contemporary art. Sponsors 7 shows/year. Average display time 6-8 weeks. Open Tuesday-Friday, 11-5; Saturday and Sunday, 1-5; closed Mondays and major holidays. Free admission. Located on campus; 6,732 sq. ft.; high ceilings, neutral space. 75% of space for special exhibitions.

Media Considers sculpture, installation, new media.

Style Exhibits conceptualism and new media.

Submissions Currently not accepting submissions.

KENTUCKY

CENTRAL BANK GALLERY

300 W. Vine St., Lexington KY 40507. (859)253-6161. Fax: (859)253-6432. **Director:** John Irvin. Nonprofit gallery. Estab. 1985. Interested in seeing the work of emerging artists. Represented more than 1,400 artists in the past 17 years. Exhibited artists include Helen Price Stacy and Catherine Wells. Sponsors 12 shows/year. Average display time 3 weeks. Open all year; Monday-Friday, 9-4. Located downtown. 100% of space for special exhibitions. Clientele: local community. 100% private collectors. Overall price range $100-5,000; most work sold at $350-500.

● Central Bank Gallery considers Kentucky artists only.

Media Considers all media. Most frequently exhibits oils, watercolor, sculpture.

Style Exhibits all styles. "Please, no nudes."

Terms Retail price set by the artist "100% of proceeds go to artist." Gallery provides insurance and promotion; artist pays for shipping.

Submissions Call or write for appointment.

Tips "Don't be shy, call me. We pay 100% of the costs involved once the art is delivered."

KENTUCKY MUSEUM OF ART AND CRAFT

715 West Main, Louisville KY 40202. (502)589-0102. Fax: (502)589-0154. Website: www.kentuckyarts.org. **Contact:** Brion Clinkingbeard, deputy director of programming/curator. Nonprofit gallery, museum. Estab. 1981. Approached by 300 artists/year. Represents 100 emerging, mid-career and established artists. Sponsors 20 exhibits/year. Average display time 4-6 weeks. Open all year; Monday-Friday, 10-5; Saturday, 11-5. Located in downtown Louisville, one block from the river; 3 galleries, one on each floor. Clients include local community, students, tourists, upscale. 10% of sales are to corporate collectors. Overall price range $50-40,000; most work sold at $200.

Media Considers all media and all types of prints. Most frequently exhibits ceramics, glass, craft.

Style Exhibits primitivism realism.

Terms Artwork is accepted on consignment and there is a 50% commission. Retail price set by the artist. Gallery provides insurance, promotion and contract. Accepted work should be framed and matted. Does not require exclusive representation locally.

Submissions Send query letter with artist's statement, bio, photocopies, photographs, SASE and slides. Returns material with SASE. Responds to queries in 1 month. Files bio, artist's statement and copy of images. Finds artists through art fairs, art exhibits, portfolio reviews, referrals by other artists and submissions.

Tips "Clearly identify reason for wanting to work with KMAC. Show a level of professionalism and a proven track record of exhibitions."

MAIN AND THIRD FLOOR GALLERIES

Northern Kentucky University, Highland Heights KY 41099. (859)572-5148. Fax: (859)572-6501. E-mail: knight @nku.edu. Website: www.nku.edu/~art/galleries.html. Gallery Director of Exhibitions and Collections: David Knight. University galleries. Program established 1975. Main gallery and third floor gallery. Represents emerging, mid-career and established artists. Sponsors 10 shows/year. Average display time 1 month. Open Monday-Friday, 9-9 or by appointment; closed major holidays and between Christmas and New Year's. Located in Highland Heights, KY, 8 miles from downtown Cincinnati; 3,000 sq. ft.; two galleries—one small and one large space with movable walls. 100% of space for special exhibitions. 90% private collectors, 10% corporate collectors. Overall price range; $25-50,000; most work sold at $25-2,000.

Media Considers all media and all types of prints. Most frequently exhibits painting, printmaking and photography.

Style Exhibits all styles, all genres.

Terms Proposals are accepted for exhibition. Retail price set by the artist. Gallery provides insurance, promotion and contract; shipping costs are shared. Prefers artwork framed "but we are flexible." Commission rate is 20%.

Submissions Send query letter with résumé, slides, bio, photographs, SASE and reviews. Write for appointment to show portfolio of originals, photographs and slides. Submissions are accepted in December for following academic school year. Files résumés and bios. Finds artists through agents, visiting exhibitions, word of mouth, art publications, sourcebooks and submissions.

LOUISIANA

⚄ BATON ROUGE GALLERY, INC.

1442 City Park Ave., Baton Rouge LA 70808-1037. (225)383-1470. Fax: (225)336-0943. E-mail: brgallery@brec.o rg. **Director:** Amelia Cox. Cooperative gallery. Estab. 1966. Exhibits the work of 50 professional artists. 300 members. Sponsors 12 shows/year. Average display time 1 month. Open all year. Located in the City Park Pavilion. Overall price range $100-10,000; most work sold at $200-600.

- The gallery hosts a spoken word series featuring literary readings of all genres. We also present special performances including dance, theater and music, including movies and music on the lawn and Flatscape Video Series.

Media Considers all media. Most frequently exhibits painting, sculpture and glass.

Style Exhibits all styles and genres.

Terms Co-op membership fee plus donation of time. Gallery takes 40% commission. Retail price set by artist. Artist pays for shipping. Artwork must be framed.

Submissions Membership and guest exhibitions are selected by screening committee. Send query letter for application.

Tips "The screening committee screens applicants in October each year. Call for application to be submitted with portfolio and résumé."

CASELL GALLERY

818 Royal St., New Orleans LA 70116. (800)548-5473. Fax: (504)524-0671. Website: www.casellartgallery.com. **Title/Owner-Directors:** Joachim Casell. Retail gallery. Estab. 1970. Represents 20 mid-career artists/year. Exhibited artists include J. Casell and Don Picou. Sponsors 2 shows/year. Average display time 10 weeks. Open all year; 10-6. Located in French Quarter; 800 sq. ft. 25% of space for special exhibitions. Clientele tourists and local community. 20-40% private collectors, 10% corporate collectors. Overall price range $100-1,200; most work sold at $300-600.

Media Considers all media, wood engravings, etchings, lithographs, serigraphs and posters. Most frequently exhibits pastel and pen & ink drawings.

Style Exhibits impressionism. All genres including landscapes. Prefers pastels.

Terms Artwork is accepted on consignment (50% commission). Retail price set by the artist. Gallery provides promotion and pays for shipping costs. Prefers artwork unframed.

Submissions Accepts only local area and southern artists. Responds only if interested within 1 week.

CONTEMPORARY ARTS CENTER

900 Camp St., New Orleans LA 70130. (504)528-3805. Fax: (504)528-3828. E-mail: info@cacno.org. Website: cacno.org. **Curator of Visual Arts:** David S. Rubin. Alternative space, nonprofit gallery. Estab. 1976. Exhibits emerging, mid-career and established artists. Open all year; Tuesday-Sunday, 11-5; weekends 11-5. Closed Mardi Gras, Christmas and New Year's Day. Located in Central Business District of New Orleans; renovated/converted warehouse. Clients include local community, students, tourists and upscale.

Media Considers all media and all types of prints. Most frequently exhibits painting, sculpture, installation and photography.

Style Considers all styles. Exhibits anything contemporary.

Terms Artwork is accepted on loan for curated exhibitions. Retail price set by the artist. CAC provides insurance and promotion. Accepted work should be framed. Does not require exclusive representation locally. The CAC is not a sales venue, but will refer inquiries. CAC receives 20% on items sold as a result of an exhibition.

Submissions Send query letter with bio, SASE and slides or CDs. Responds in 4 months. Files letter and bio—slides when appropriate. Finds artists through word of mouth, submissions, art exhibits, art fairs, referrals by other artists, professional contacts and periodicals.

Tips "Use only one slide sheet with proper labels (title, date, medium and dimensions)."

Ⓝ INSLEY ART GALLERY

427 Esplanade Ave., New Orleans LA 70116. (504)949-3512. Fax: (504)949-1909. E-mail: insleyartgallery@aol.com. Website: www.insleyart.com. **Contact:** Charlene Insley, Director/Artist. For-profit gallery. Estab. 2004. Exhibits mid-career, established artists. Approached by 40 artists/year; represents 7 artists/year. Exhibited artists include Dr. Gerald Domingue, abstract naturalism, oil on canvas; Charles Foster, surrealist, oil on canvas. Sponsors 5-7 exhibits/year. Average display time 1 month. Open Tuesday-Saturday, 12-5; weekends, 10-3; closed most holidays. Located on the edge of the French Quarter, Insley Art Gallery is an eclectic gallery with a low key, welcoming attitude. A new participant in the rich and bountiful art tradition of New Orleans—a rustic yet contemporary space of approximately 6,000 sq. ft. in a convenient, historic, part of the city. Clients include local community, tourists, upscale. Overall price range: $350-6,000; most work sold at $3,000.

Media Considers acrylic, ceramics, collage, drawing, glass, mixed media, oil, sculpture. Considers giclées.

Style Exhibits conceptualism, surrealism, painterly abstraction.

Making Contact & Terms Artwork is accepted on consignment and there is a 30-50% commission. Retail price set by the artist. Gallery provides insurance, promotion, contract. Accepted work should be framed. Requires exclusive representation locally.

Submissions Call. Write to arrange personal interview to show portfolio. Send query letter with bio, photocopies, SASE. Returns material with SASE. Responds to queries in 3 months. Finds artists through art exhibits, portfolio reviews, referrals by other artists.

STELLA JONES GALLERY

201 St. Charles Ave., New Orleans LA 70170. (504)568-9050. Fax: (504)568-0840. E-mail: jones6941@aol.com. Website: www.stellajones.com. **Contact:** Stella Jones. For-profit gallery. Estab. 1996. Approached by 40 artists/year. Represents 121 emerging, mid-career and established artists. Exhibited artists include Elizabeth Catlett (prints and sculpture), Richard Mayhew (paintings). Sponsors 7 exhibits/year. Average display time 6-8 weeks. Open all year; Monday-Friday, 11-6; Saturday, 12-5. Located in downtown New Orleans, one block from French Quarter. Clients include local community, tourists and upscale. 10% of sales are to corporate collectors. Overall price range $500-150,000; most work sold at $1,000-5,000.

Media Considers all media. Most frequently exhibits oil and acrylic. Considers all types of prints except posters.

Style Considers all styles. Most frequently exhibits postmodernism and geometric abstraction. Exhibits all genres.

Terms Artwork is accepted on consignment and there is a 50% commission. Retail price set by the artist. Gallery provides insurance, promotion and contract. Accepted work should be framed. Requires exclusive representation locally.

Submissions To show portfolio of photographs, slides and transparencies, mail for review. Send query letter with artist's statement, bio, brochure, business card, photocopies, photographs, résumé, reviews, SASE and slides. Returns material with SASE. Responds in 1 month. Files all. Finds artists through word of mouth, submissions, portfolio reviews, art exhibits, and referrals by other artists.

Tips ''Send organized, good visuals.''

N LE MIEUX GALLERIES

332 Julia St., New Orleans LA 70130. (504)522-5988. Fax: (504)522-5682. E-mail: mail@lemieuxgalleries.com. Website: www.lemieuxgalleries.com. **Contact:** Christy Wood, Denise Berthiaume. Retail gallery and art consultancy. Estab. 1983. Represents 30 mid-career artists. Exhibited artists include Shirley Rabe Masinter and Alan Gerson. Sponsors 10 shows/year. Average display time 6 months. Open all year. Located in the warehouse district/downtown; 1,400 sq. ft. 20-75% of space for special exhibitions. Clientele 75% private collectors; 25% corporate clients.

Media Considers all media; engravings, etchings, linocuts, lithographs, mezzotints, serigraphs, woodcuts. Most frequently exhibits oil, watercolor and drawing.

Style Exhibits impressionism, neo-expressionism, realism and hard-edge geometric abstraction. Genres include landscapes, florals, wildlife and figurative work. Prefers landscapes, florals and figural/narrative.

Terms Accepts work on consignment (50% commission). Retail price set by artist. Exclusive area representation required. Gallery provides promotion and contract; artist pays for shipping.

Submissions Accepts only artists from the Southeast. Send query letter with SASE, bio, brochure, résumé, slides and photographs. Write for appointment to show portfolio of originals. Responds in 3 weeks. All material is returned if not accepted or under consideration.

Tips ''Send information before calling. Give me the time and space I need to view your work and make a decision; you cannot sell me on liking or accepting it; that I decide on my own.''

STONE AND PRESS GALLERIES

238 Chartres St., New Orleans LA 70130. (504)561-8555. Fax: (504)561-5814. E-mail: info@stoneandpress.com. Website: www.stoneandpress.com. **Owner:** Earl Retif. Retail gallery. Estab. 1988. Represents/exhibits 20 mid-career and established artists/year. Interested in seeing the work of emerging artists. Exhibited artists include Carol Wax and Benton Spruance. Average display time 1 month. Open all year; Monday-Saturday, 10:30-5:30. Located in historic French Quarter; 1,200 sq. ft.; in historic buildings. 50% of space for special exhibitions; 50% of space for gallery artists. Clientele: collectors nationwide also tourists. 90% private collectors, 10% corporate collectors. Overall price range $50-10,000; most work sold at $400-900.

Media Considers all and all types of prints. Most frequently exhibits mezzotint, etchings and lithograph.

Style Exhibits realism. Genres include Americana, portraits and figurative work. Prefers American scene of '30s and '40s and contemporary mezzotint.

Terms Artwork is accepted on consignment (50% commission). Retail price set by the gallery and the artist. Gallery provides insurance, promotion and contract; shipping costs are shared. Prefers artwork unframed.

Submissions Send e-mail only.

Tips Finds artists through word of mouth and referrals of other artists.

MAINE

N DUCKTRAP BAY TRADING COMPANY

37 Bayview St., Camden ME 04843. (207)236-9568. Fax: (207)236-6203. E-mail: info@ducktrapbay.com. Website: www.ducktrapbay.com. **Owners:** Tim and Joyce Lawrence. Retail gallery. Estab. 1983. Represents 200 emerging, mid-career and established artists/year. Exhibited artists include Sandy Scott, Doug Hunt, Yvonne Davis, Beki Killorin, Jim O'Reilly and Gary Eigenberger. Open all year; Monday-Saturday, 9-5, Sunday, 11-4. Located downtown waterfront; 2 floors 3,000 sq. ft. 100% of space for gallery artists. Clientele: tourists, upscale. 70% private collectors, 30% corporate collectors. Overall price range $250-18,000; most work sold at $250-2,500.

Media Considers watercolors, oil, acrylic, pastel, pen & ink, drawing, paper, sculpture, bronze and carvings. Types of prints include lithographs. Most frequently exhibits woodcarvings, watercolor, acrylic and bronze.

Style Exhibits realism. Genres include nautical, wildlife and landscapes. Prefers marine and wildlife.

Terms Accepts work on consignment (40% commission) or buys outright for 50% of the retail price (net 30 days). Retail price set by the artist. Gallery provides insurance and minimal promotion; artist pays for shipping. Prefers artwork framed.

Submissions Send query letter with 10-20 slides or photographs. Call or write for appointment to show portfolio of photographs. Files all material. Finds artists through word of mouth, referrals by other artists and submissions.

Tips "Find the right gallery and location for your subject matter. Have at least eight to ten pieces or carvings or three to four bronzes."

GOLD/SMITH GALLERY

41 Commercial St., BoothBay Harbor ME 04538. (207)633-6252. Fax: (207)633-6252. **Contact:** Karen Swartsberg. Retail gallery. Estab. 1974. Represents 30 emerging, mid-career and established artists. Exhibited artists include John Vander and John Wissemann. Sponsors 6 shows/year. Average display time 6 weeks. Open May-October; Monday-Saturday, 10-6. Located downtown across from the harbor. 1,500 sq. ft.; traditional 19th century house converted to contemporary gallery. 75% of space for special exhibitions; 25% of space for gallery artists. Clientele residents and visitors. 90% private collectors, 10% corporate collectors. Overall price range $350-5,000; most work sold at $1,000-2,500.

- One of 2 Gold/Smith Galleries. The other is in Sugar Loaf; the 2 are not affiliated with each other. Artists creating traditional and representational work should try another gallery. The work shown here is strong, self-assured and abstract.

Media Considers oil, acrylic, watercolor, pastel, pen & ink, drawing, mixed media, collage, paper, sculpture, photography, woodcuts, engravings, wood engravings and etchings. Most frequently exhibits acrylic and watercolor.

Style Exhibits expressionism, painterly abstraction "emphasis on nontraditional work." Prefers expressionist and abstract landscape.

Terms Commission 50%. Retail price set by the artist. Gallery provides insurance and promotion; artist pays shipping costs to and from gallery. Prefers artwork framed.

Submissions No restrictions—emphasis on artists from Maine. Send query letter with slides, bio, photographs, SASE, reviews and retail price. Write for appointment to show portfolio of originals. Responds in 2 weeks. Artist should write the gallery.

Tips "Present a consistent body of mature work. We need 12 to 20 works of moderate size. The sureness of the hand and the maturity interest of the vision are most important."

GREENHUT GALLERIES

146 Middle St., Portland ME 04101. (207)772-2693. E-mail: greenhut@maine.com. Website: www.greenhutgalleries.com. **Contact:** Peggy Greenhut Golden. Retail gallery. Estab. 1990. Represents/exhibits 20 emerging and mid-career artists/year. Sponsors 12 shows/year. Exhibited artists include Connie Hayes (oil/canvas), Sarah Knock (oil/canvas). Average display time 3 weeks. Open all year; Monday-Friday, 10-530; Saturday, 10-5. Located in downtown-Old Port; 3,000 sq. ft. with neon accents in interior space. 60% of space for special exhibitions. Clientele tourists and upscale. 55% private collectors, 10% corporate collectors. Overall price range $500-12,000; most work sold at $600-3,000.

Media Considers acrylic, paper, pastel, sculpture, drawing, oil, watercolor. Most frequently exhibits oil, watercolor, pastel.

Style Considers all styles; etchings, lithographs, mezzotints. Genres include figurative work, landscapes, still life, seascape. Prefers landscape, seascape and abstract.

Terms Artwork is accepted on consignment (50% commission). Retail price set by the gallery and artist. Gallery provides insurance and promotion. Artists pays for shipping costs. Prefers artwork framed (museum quality framing).

Submissions Accepts only artists from Maine or New England area with Maine connection. Send query letter with slides, reviews, bio and SASE. Call for appointment to show portfolio of slides. Responds in 1 month. Finds artists through word of mouth, referrals by other artists, visiting art shows and exhibitions, and submissions.

Tips "Visit the gallery and see if you feel your work fits in."

JAMESON GALLERY & FRAME AND THE JAMESON ESTATE COLLECTION

305 Commercial St., Portland ME 04101. (207)772-5522. Fax: (207)774-7648. E-mail: art@jamesongallery.com. **Gallery Director:** Martha Gilmartin. Retail gallery, custom framing, restoration, appraisals, consultation. Estab. 1992. Represents 20+ emerging, mid-career and established artists/year. Exhibited artists include Ronald Frontin, Jon A. Marshall, Nathaniel Larrabee and Thomas Paquette. Mounts 6 shows/year. Average display time 3-4 weeks. Open all year; Monday-Saturday, 10-6. Located on the waterfront in the heart of the shopping district; 4,000 sq. ft. 50% of space for contemporary artists; 25% for frame shop; 25% of space for The Jameson

Estate Collection dealing later 19th and early 20th century paintings, drawings and photographs. Clientele local community, tourists, upscale. 80% private collectors, 20% corporate collectors. Overall price range most work sold at $1,500-30,000.

Media Most frequently exhibited: oil, watercolor, photographs, sculpture.

Style Exhibits strong focus on American realism and b&w photography, but all media are considered. Genres include: landscapes, figures and still life.

Terms TBD. Retail price set by the gallery. Gallery provides insurance, promotion and contract; artist pays shipping costs. Prefers artwork unframed, but will judge on a case by case basis. Artist may buy framing contract with gallery.

Submissions Send CV and artist's statement, a sampling of images on a PC-compatible CD, zip of floppy disc and SASE if you would like the materials returned.

THE LIBRARY ART STUDIO

1467 State Rt. 32 at Munro Brook, Round Pond ME 04564. (207)529-4210. **Contact:** Sally DeLorme Pedrick, owner/director. Art consultancy and gallery. Estab. 1989. Exhibits established artists. Number of exhibits varies each year. Average display time 6 weeks. Open year round by appointment or chance. Located in a small coastal village (Round Pond) on the Pemaquid Peninsula, midcoast Maine. Clients include local community, tourists and upscale. Overall price range $50-7,500; most work sold at $350.

Media Considers all media. Most frequently exhibits oil, woodcuts, and mixed media with glass.

Style Considers all styles. Most frequently exhibits painterly abstraction, expressionism, conceptualism. "Most art is associated with literature, thus *The Library Art Studio*."

Terms Artwork is accepted on consignment and there is a 30% commission. Retail price set by the artist. Gallery provides promotion. Accepted work should be framed. Does not require exclusive representation locally.

Submissions Send query letter with SASE and slides. Returns material with SASE. Responds in 1 month.

MARYLAND

ℕ CREATIVE PARTNERS GALLERY

4600 E. West Hwy., Suite 120, Bethesda MD 20814. (301)951-9441. Fax: (301)951-9441. Website: www.creative partnersart.com. **Contact:** Dick Lasner. Cooperative gallery. Estab. 1994. Approached by 8 artists/year. Represents 25 mid-career artists. Exhibited artists include Ella Tulin and Ann Leonard. Average display time 1 month. Open Tuesday-Saturday, 12-6. Closed Sundays and Mondays. Located downtown Bethesda MD; suburban center 20 minutes from downtown Washington DC; beautiful open space with large windows 2,000 sq. ft. Clients include local community and tourists. Overall price range $5-20,000; most work sold at $200.

Media Considers all media. Most frequently exhibits painting, sculpture and photography. Considers all types of prints.

Style Considers all styles.

Terms There is a co-op membership fee plus a donation of time. Retail price set by artist. Gallery provides promotion and contract. Accepted work should be framed and matted. Does not require exclusive representation locally. Accepts only artists from 50 miles of Washington DC.

Submissions Call or write to arrange a personal interview to show portfolio of photographs, slides and original work. Returns material with SASE. Reviews portfolios January, April and September. Finds artists through word of mouth, submissions, portfolio reviews, and referrals by other artists.

THE FRASER GALLERY

7700 Wisconsin Ave., Suite E, Bethesda MD 20814. (301)718-9651. Fax: (301)718-9652. E-mail: info@frasergalle ry.com. Website: www.thefrasergallery.com. **Contact:** Catriona Fraser, director. For-profit gallery. Estab. 1996. Approached by 400 artists/year; represents 25 emerging, mid-career and established artists/year and sells the work of another 100 artists. Exhibited artists include Joyce Tenneson (figurative photography) and David Febland (oil painting). Average display time 1 month. Open all year; Tuesday-Saturday, 11:30-6. Located in the center of Bethesda in courtyard next to Discovery Channel HQ. 1,680 square feet. Clients include local community, internet browsers, tourists and upscale. Overall price range $200-25,000; most work sold at under $5,000.

- The Fraser Gallery is charter associate dealer for Southebys.com and member of Art Dealers Association of Greater Washington and Bethesda Chamber of Commerce. See their listing in the Washington DC section for their submission requirements.

THE GLASS GALLERY

Ongoing display at 4720 Hampden Lane, Bethesda MD 20814. (301)657-3478. **Owner:** Sally Hansen. Retail gallery. Estab. 1981. Sponsors 5 shows/year. Open all year; Monday-Saturday 11-5. Clientele collectors.

Media Considers sculpture in glass and monoprints (only if they are by glass sculptors who are represented by The Glass Gallery). Also interested in sculpture in glass incorporated with additional materials (bronze, steel etc.). "Focus is on creativity as well as on ability to handle the material well. The individuality of the artist must be evident."

Terms Accepts work on consignment. Retail price set by artist. Sometimes offers customer discounts and payment by installment. Gallery provides insurance (while work is in gallery), promotion, contract and shipping costs from gallery.

Submissions Send query letter with résumé, slides, photographs, reviews, bio and SASE. Portfolio review requested if interested in artist's work.

Tips Finds artists through visits to exhibitions and professional glass conferences, plus artists' submissions and keeping up-to-date with promotion of other galleries (show announcements and advertising). "Send good slides with SASE and clear, concise cover letter and/or description of process. Familiarize yourself with the work of gallery displays to evaluate whether the quality of your work meets the standard."

⧉ GOMEZ GALLERY

3600 Clipper Mill Rd., Suite 100, Baltimore MD 21211. (410)662-9510. Fax: (410)662-9496. E-mail: walter@gomez.com. Website: www.gomezgallery.com. **Director:** Walter Gomez. Contemporary art and photography gallery. Estab. 1988. Sponsors 8 shows/year. Average display time 4-5 weeks. Open all year. Located in Baltimore City; 7,000 sq. ft. 80% private collectors, 20% corporate collectors. Overall price range $500-50,000.

Media Considers painting, sculpture and photography in all media.

Style Interested in all genres. Prefers figurative, abstract and landscapes with an experimental edge.

Terms Accepts artwork on consignment. Retail price set by the gallery and the artist. Gallery provides insurance and promotion. Artist pays for shipping.

Submissions Send query letter with résumé, slides, bio, brochure, SASE and reviews.

Tips "Find out a little bit about this gallery first; if work seems comparable, send a slide package."

MARIN-PRICE GALLERIES

7022 Wisconsin Ave., Chevy Chase MD 20815. (301)718-0622. E-mail: fmp@marin-price.com. Website: www.marin-pricegalleries.com. **President:** F. Marin-Price. Retail/wholesale gallery. Estab. 1992. Represents/exhibits 25 established painters and 4 sculptors/year. Exhibited artists include Joseph Sheppard. Sponsors 24 shows/year. Average display time 3 weeks. Open Monday-Saturday, 10:30-7; Sunday, 12-5. 1,500 sq. ft. 50% of space for special exhibitions. Clientele: upscale. 90% private collectors, 10% corporate collectors. Overall price range $3,000-25,000; most work sold at 6,000-12,000.

Media Considers oil, drawing, watercolor and pastel. Most frequently exhibits oil, watercolor and pastels.

Style Exhibits expressionism, photorealism, neo-expressionism, primitivism, realism and impressionism. Genres include landscapes, florals, Americana and figurative work.

Terms Retail price set by the gallery and the artist. Gallery provides insurance, promotion and contract. Artist pays for shipping costs. Prefers artwork framed.

Submissions Prefers only oils. Send query letter with résumé, slides, bio and SASE. Responds in 6 weeks.

⧉ MARLBORO GALLERY

Prince George's Community College, Largo MD 20774-2199. (301)322-0965. Fax: (301)808-0418. E-mail: tberault@pgcc.edu. Website: academic.pg.cc.md.us/. **Contact:** Thomas A. Berault, curator-director. Nonprofit gallery. Estab. 1976. Interested in emerging, mid-career and established artists. Sponsors 4 solo and 4 group shows/year. Average display time 1 month. Seasons for exhibition September-May. 2,100 sq. ft. with 10 ft. ceilings and 25 ft. clear story over 50% of spacetrack lighting (incandescent) and daylight. Clientele: 100% private collectors. Overall price range $200-10,000; most work sold at $500-700.

Media Considers all media. Most frequently exhibits acrylics, oils, photographs, watercolors and sculpture.

Style Exhibits expressionism, neo-expressionism, realism, photorealism, minimalism, primitivism, painterly abstraction, conceptualism and imagism. Exhibits all genres. "We are open to all serious artists and all media. We will consider all proposals without prejudice."

Terms Accepts artwork on consignment. Retail price set by artist. Exclusive area representation not required. Gallery provides insurance. Artist pays for shipping. Prefers artwork ready for display.

Submissions Send query letter with résumé, slides, SASE, photographs, artist's statement and bio. Portfolio review requested if interested in artist's work. Portfolio should include slides and photographs. Responds every 6 months. Files résumé, bio and slides. Finds artists through word of mouth, visiting exhibitions and submissions.

Tips Impressed by originality. "Indicate if you prefer solo shows or will accept inclusion in group show chosen by gallery."

PYRAMID ATLANTIC

8230 Georgia Ave., Silver Spring MD 20910. (301)608-9101 or (301)608-9102. E-mail: info@pyramid-atlantic.o rg. Website: www.pyramidatlanticartcenter.org. **Artistic Director:** Helen Frederick. Nonprofit gallery/library. Estab. 1981. Represents emerging, mid-career and established artists. Sponsors 6 shows/year. Average display time 2 months. Open all year; 10-6. 15% of space for special exhibitions; 10% of space for gallery artists. Also features research library. Clientele: print and book collectors, general audiences. Overall price range $1,000-10,000; most work sold at $800-2,500.

Media Considers watercolor, pastel, pen & ink, drawing, mixed media, collage, paper, sculpture, craft, installation, photography, artists' books and all types of prints. Most frequently exhibits works in and on paper, prints and artists' books and mixed media by faculty who teach at the facility and members of related programs.

Style Exhibits all styles and genres.

Terms Accepts work on consignment (50-60% commission). Print subscription series produced by Pyramid; offers 50% to artists. Retail prices set by gallery and artist. Gallery provides insurance, promotion and contract; shipping costs are shared.

Submissions Send query letter with résumé, slides, bio, brochure, SASE and reviews. Call or write for an appointment to show portfolio, which should include originals and slides. Responds in 1 month. Files résumés.

STEVEN SCOTT GALLERY

9169 Reisterstown Rd., Owings Mill MD 21117. (410)752-6218. Website: www.stevenscottgallery.com. **Director:** Steven Scott. Retail gallery. Estab. 1988. Represents 20 mid-career and established artists/year. May be interested in seeing the work of emerging artists in the future. Exhibited artists include Hollis Sigler, Gary Bukovnik. Sponsors 6 shows/year. Average display time 2 months. Open all year; Tuesday-Saturday, 12-6. Located in the suburbs of NW Baltimore; 1,000 sq. ft.; white walls, grey carpet—minimal decor. 80% of space for special exhibitions; 20% of space for gallery artists. 80% private collectors, 20% corporate collectors. Overall price range $300-15,000; most work sold at $1,000-7,500.

Media Considers oil, acrylic, watercolor, pastel, pen & ink, drawing, mixed media, collage, paper and photography. Considers all types of prints. Most frequently exhibits oil, prints and drawings.

Style Exhibits expressionism, neo-expressionism, surrealism, postmodern works, photorealism, realism and imagism. Genres include florals, landscapes and figurative work. Prefers florals, landscapes and figurative.

Terms Retail price set by the gallery and the artist. Gallery provides insurance, promotion and contract; shipping costs are shared. Prefers artwork unframed.

Submissions Accepts only artists from US. Send query letter with résumé, brochure, slides, photographs, reviews, bio and SASE. Call for appointment to show portfolio of photographs and slides. Responds in 2 weeks.

Tips "Don't send slides which are unlike the work we show in the gallery, i.e. abstract or minimal."

MASSACHUSETTS

[N] ART@NET INTERNATIONAL GALLERY

(617)495-7451 (++359)98448132. Fax: (617)495-7049 (++359)251-2838. E-mail: Artnetg@Yahoo.com. Website: www.designbg.com. **Director:** Yavor Shopov-Bulgari. For profit gallery, Internet gallery. Estab. 1998. Approached by 150 artists/year. Represents 20 emerging, mid-career and established artists. Exhibited artists include Nicolas Roerich (paintings) and Yavor Shopov-Bulgari (photography). Sponsors 15 exhibits/year. Average display time permanent. Open all year; Monday-Sunday, 24 hours. "Internet galleries like ours have a number of unbelievable advantages over physical galleries and work far more efficiently, so they are expanding extremely rapidly and taking over many markets held by conventional galleries for many years. Our gallery exists only in Internet giving us a number of advantages both for our clients and artists. Our expenses are reduced to the absolute minimum, so we charge our artists lowest commission in the branch (only 10%) and offer to our clients lowest prices for the same quality of work. Unlike physical galleries we have over 100 million potential internet clients world-wide and are able to sell in over 150 countries without need to support offices or representatives everywhere. We mount cohesive shows of our artists, which are unlimited in size and may be permanent. Each artist has individual 'exhibition space' divided to separate thematic exhibitions along with bio and statement. We are just hosted in the Internet space, otherwise our organization is the same as of a traditional gallery." Clients include collectors and business offices spread world-wide. 30% corporate collectors. Overall price range $150-50,000.

Media Considers ceramics, craft, drawing, oil, pastel, pen & ink, sculpture and watercolor. Most frequently exhibits photos, oil and drawing. Considers all types of prints.

Style Considers expressionism, geometric abstraction, impressionism and surrealism. Most frequently exhibits impressionism, expressionism and surrealism. Considers Americana, figurative work, florals, landscapes and wildlife.

Terms Artwork is accepted on consignment and there is a 10% commission and a rental fee for space of $1/image per month or $5/images per year (first 6 images are displayed free of rental fee). Retail price set by the gallery or the artist. Gallery provides promotion. Accepted work should be matted. Does not require exclusive representation locally. Every exhibited image will contain your name and copyright as watermark and cannot be printed or illegally used, sold or distributed anywhere.

Submissions E-mail portfolio for review. E-mail attached scans 900×1200 px (300dpi for prints or 900 dpi for 36mm slides) as JPEG files for IBM computers. "We accept only computer scans, no slides please." E-mail artist's statement, bio, résumé, and scans of the work. Cannot return material. Responds in 6 weeks. Finds artists through submissions, portfolio reviews, art exhibits, art fairs, and referrals by other artists.

Tips "E-mail us or send a disk or CD with a tightly edited selection of less than 20 scans of your best work. All work must be very appealing and interesting, and must force any person to look over it again and again. Main usage of all works exhibited in our gallery is for limited edition (photos) or original (paintings) wall decoration of offices and homes. Photos must have the quality of paintings. We like to see strong artistic sense of mood, composition, light and color and strong graphic impact or expression of emotions. We exhibit only artistically perfect work in which value will last for decades. We would like to see any quality work facing these requirements on any media, subject or style. No distractive subjects. For us only quality of work is important, so new artists are welcome. Before you send us your work, ask yourself, 'who and why will someone buy this work? Is it appropriate and good enough for this purpose?' During the exhibition all photos must be available in signed limited edition museum quality 8×10 or larger matted prints."

CHASE GALLERY

129 Newbury St., Boston MA 02116-0292. (617)859-7222. Fax: (617)266-8645. Website: www.chasegallery.com. **Director:** Stephanie L. Walker. Retail gallery. Estab. 1990. Represents 20 mid-career and established artists/year. Exhibited artists include Enrique Santana, Cynthia Packard. Sponsors 11 shows/year. Average display time 1 month. Open all year; Monday-Saturday, 10-6. 1,400 sq. ft. 80% of space for special exhibitions; 20% of space for gallery artists. 95% private collectors, 5% corporate collectors. Overall price range: $500-25,000; most work sold at $2,000-10,000.

Media Considers oil, acrylic and sculpture. Most frequently exhibits oil paintings, alkyd, acrylic.

Style Exhibits narrative/representational. Genres include landscapes and figurative work.

Terms Accepts work on consignment (50% commission). Retail price set by the artist. Gallery provides insurance and promotion; artist pays shipping costs. Prefers artwork framed.

Submissions Prefers only oil, acrylic, alkyd. Send query letter with résumé, brochure, slides, reviews and SASE. Responds in 1 month. Files cards; "SASE should be provided for return of materials." Finds artists through referrals, submissions.

Tips "Don't send one or two images—20 slides of recent work should be submitted."

GALLERY NAGA

67 Newbury St., Boston MA 02116. (617)267-9060. Fax: (617)267-9040. E-mail: mail@gallerynaga.com. Website: www.gallerynaga.com. **Director:** Arthur Dion. Retail gallery. Estab. 1977. Represents 30 emerging, mid-career and established artists. Exhibited artists include Robert Ferrandini and George Nick. Sponsors 9 shows/year. Average display time 1 month. Open Tuesday-Saturday 10-530. Closed August. Located on "the primary street for Boston galleries; 1,500 sq. ft.; housed in an historic neo-gothic church." Clientele 90% private collectors, 10% corporate collectors. Overall price range $850-35,000; most work sold at $2,000-3,000.

Media Considers oil, acrylic, mixed media, sculpture, photography, studio furniture and monotypes. Most frequently exhibits painting and furniture.

Style Exhibits expressionism, painterly abstraction, postmodern works and realism. Genres include landscapes, portraits and figurative work. Prefers expressionism, painterly abstraction and realism.

Terms Accepts work on consignment (50% commission). Retail price set by gallery and artist. Gallery provides insurance and promotion; artist pays for shipping. Prefers artwork framed.

Submissions "Not seeking submissions of new work at this time."

Tips "We focus on Boston and New England artists. We exhibit the most significant studio furnituremakers in the country. Become familiar with any gallery to see if your work is appropriate before you make contact."

ⓝ KINGSTON GALLERY

450 Harrison Ave. #43, Boston MA 02118. (617)423-4113. E-mail: director@hingstongallery.com. Website: www.kingstongallery.com. **Director:** Janet Hansen Kawada. Cooperative gallery. Estab. 1982. Exhibits the work of 19 emerging, mid-career and established artists. Sponsors 11 shows/year. Average display time 1 month. Open Tuesday-Saturday, 12-5. Closed August. Located "in downtown Boston (South End); 1,300 sq. ft.; large, open room with 12 ft. ceiling and smaller center gallery—can accomodate large installation." Overall price range $100-7,000; most work sold at $600-1,000.

Media Considers all media. 20% of space for special exhibitions.

Style Exhibits all styles.

Terms Co-op membership requires dues plus donation of time. 25% commission charged on sales by members. Retail price set by the artist. Sometimes offers payment by installments. Gallery provides insurance, some promotion and contract. Rental of center gallery by arrangement.

Submissions Accepts only artists from New England for membership. Artist must fulfill monthly co-op responsibilities. Send query letter with résumé, slides, SASE and "any pertinent information. Slides are reviewed every other month. Gallery will contact artist within 1 month." Does not file material but may ask artist to re-apply in future.

Tips "Please include thorough, specific information on slides size, price, etc."

N: NIELSEN GALLERY

179 Newbury St., Boston MA 02116. (617)266-4835. Fax: (617)266-0480. E-mail: contact@nielsengallery.com. Website: www.nielsengallery.com. **Owner/Director:** Nina Nielsen. Retail gallery. Estab. 1963. Represents 25 emerging, mid-career and established artists/year. Exhibited artists include Joan Snyder and John Walker. Sponsors 8 shows/year. Average display time 3-5 weeks. Closed in August. Located downtown; 2,500 sq. ft.; brownstone with 2 floors. 100% of space for gallery artists. 80% private collectors, 20% corporate collectors. Overall price range $1,000-100,000; most work sold at $5,000-20,000.

Media Considers contemporary painting, sculptures, prints, drawings and mixed media.

Style Exhibits all styles.

Terms Retail price set by the gallery and the artist. Gallery provides insurance and promotion.

Submissions Send query letter with slides and SASE. Responds in 2 months. Finds artists through word of mouth, referrals by other artists, visiting art fairs and exhibitions, submissions.

N: THE NORMAN ROCKWELL MUSEUM

P.O. Box 308, Stockbridge MA 01262. (413)298-4100. Fax: (413)298-4145. E-mail: spunkett@NRM.org. Website: www.nrm.org. **Associate Director:** Stephanie Plunkett. Museum. Estab. 1969. Exhibits 2-10 emerging, mid-career and established artists. Exhibited artists include Maxfield Parrish, Fred Marcellino, and many contemporary illustrators. Sponsors 4 exhibits/year. Average display time 3 months. Open all year; Monday-Sunday, 10-5. Closed Thanksgiving, Christmas and New Years. Located in Stockbridge on 36-acre site bordering the Housatonic River. 11,000 sq. ft. of exhibition and classroom space. Clients include local community, students, tourists, upscale and international.

Media Considers all media. Most frequently exhibits oil, drawing media and acrylic.

Style Considers illustration art in all styles and genres.

Terms Gallery provides insurance, promotion and contract. Requires exclusive representation locally.

Submissions Send query letter with artist's statement, proposal and visuals. Responds in 3 months. Files proposals, bios and visuals. Finds artists through word of mouth, portfolio reviews, referrals by other artists, publications and research.

N: SPAIGHTWOOD GALLERIES, INC.

P.O. Box 1193, Upton MA 01568-6193. (508)529-2511. E-mail: sptwd@verizon.net. Website: www.spaightwood galleries.com. **Contact:** Sonja Hansard-Weiner, President. Vice President: Andy Weiner. For-profit gallery. Estab. 1980. Exhibits mostly established artists. See artists page on our website: http://spaightwoodgalleries.com/Pages/Artists.html (9000 works from late 15th century to present in inventory). Exhibited artists include Marc Chagal, original lithographs and etchings; Claude Garache, original aquatints and lithographs. Sponsors 6 exhibits/year. Average display time 2 months. Open by appointment. "We are located in a renovated ex-Unitarian Church; basic space is 90×46 ft; ceilings 25 ft. high at center, 13 ft. at walls. See http://spaightwoodgalleries. com/Pages/Upton.html for views of the gallery."Clients include mostly internet and visitors drawn by internet; we are currently trying to attract visitors from Boston and vicinity via advertising and press releases. 2% sales are to corporate collectors. Overall price range: $175-125,000; most work sold at $1,000-4,000.

Media Considers all media except installations, photography, glass, craft, fiber. Most frequently exhibits oil, drawing and ceramic sculpture. Considers all types of prints.

Style Exhibits old master to contemporary; most frequently impressionist and post-impressionist (Cassatt, Renoir, Cezanne, Signac, Gauguin, Bonnard), Fauve (Matisse, Rouault, Vlaminck, Derain) modern (Picasso, Matisse, Chagall, Miró, Giacometti), German Expressionist (Heckel, Kollwitz, Kandinsky, Schmidt-Rottluff), Surrealist (Miró, Fini, Tanning, Ernst, Lam, Matta); COBRA (Alechinsky, Appel, Jorn), Abstract Expressionist (Tàpies, Tal-Coat, Saura, Llèdos, Bird, Mitchell, Frankenthaler, Olitski), Contemporary (Claude Garache, Titus-Carmel, Joan Snyder, John Himmelfarb, Manel Llèdos, Jonna Rae Brinkman). Most frequently exhibits modern, contemporary, impressionist and post-impressionist. Most work shown is part of our inventory; we buy mostly at

auction. In the case of some artists, we buy directly from the artist or the publisher; in others we have works on consignment.

Making Contact & Terms Retail price set by both artist and gallery. Accepted work should be unmatted and unframed. Requires exclusive representation locally.

Submissions Prefers link to website with bio, exhibition history and images. Returns material with SASE. Responds to queries only if interested. Finds artists through art exhibits (particularly museum shows), referrals by other artists, books.

Tips "Make high quality art."

Ⓝ ST. GEORGE GALLERY

245 Newbury St., Boston MA 02116. E-mail: arts@stgeorgegallery.com. Website: www.stgeorgegallery.com. **Contact:** William St. George. For-profit gallery. Estab. 1999. Approached by 100 artists/year; exhibits 2-4 emerging and established artists/year. Sponsors 8 exhibits/year. Average display time 45 days. Open all year; Tuesday-Saturday, 10-5:30; Sunday, 12-5; Monday by appointment. Located on Newbury St.; 1,800-2,000 square feet. Clients include local community, tourists and upscale. 10% of sales are to corporate collectors. Overall price range $1,000-20,000; most work sold at $3,500-6,500.

Media Considers acrylic, collage, drawing, mixed media, oil, pastel, encaustic and watercolor. Most frequently exhibits oil, acrylics and pastel. Considers giclée prints.

Style Exhibits expressionism, impressionism and painterly abstraction. Most frequently exhibits expressionism, fauvism and impressionism. Genres include figurative work, florals, horses, landscapes, cityscapes, portraits and swimmers.

Terms Artwork is accepted on consignment and there is a 50% commission. Retail price of the art set by the artists. Gallery provides general gallery promotion and contract. Accepted work should be framed. Does not require exclusive representation locally.

Submissions Send query letter with artist's statement, bio, brochure, business card, photographs, résumé, reviews and SASE. Returns material only with SASE. Responds to queries in 3 weeks. Selected artist will be called for review of work. Files bio and 2-3 photographs. Finds artist's through referrals by other artists and submissions.

Tips No phone calls or unscheduled visits please. To make your submissions professional use a covering letter, folder containing your business card in flap slot. Keep your bio, résumé and photos with sizes medium and price on one side. Have a separate price list or indicate in letter specs on back of photos. Place publicity stuff on the right (possibly, it's up to you). Use a white or black glossy folder (Staples stores have them.)

Ⓝ WORCESTER CENTER FOR CRAFTS GALLERIES

25 Sagamore Rd., Worcester MA 01605. (508)753-8183. Fax: (508)797-5626. E-mail: wcc@worcestercraftcenter. org. Website: www.worcestercraftcenter.org. **Executive Director:** David Leach. Nonprofit rental gallery. Dedicated to promoting artisans and American crafts. Estab. 1856. Has several exhibits throughout the year, including 1 juried, catalogue show and 2 juried craft fairs in May and November. Exhibits student, faculty, visiting artists, regional, national and international artists. Open all year; Monday-Saturday, 10-5. Located at edge of downtown; 2,205 sq. ft. (main gallery); track lighting, security. Overall price range $20-400; most work sold at $65-100.

Media Considers all media except paintings and drawings. Most frequently exhibits wood, metal, fiber, ceramics, glass and photography.

Style Exhibits all styles.

Terms Artwork is accepted on consignment (40% commission). Retail price set by the artist. Gallery provides insurance, promotion and contract. Shipping costs are shared.

Submissions Call for appointment to show portfolio of photographs and slides. Responds in 1 month.

MICHIGAN

THE ANN ARBOR CENTER/GALLERY SHOP

117 W. Liberty, Ann Arbor MI 48104. (734)994-8004. Fax: (734)994-3610. E-mail: info@annarborartcenter.org. Website: www.annarborartcenter.org. **Gallery Shop Director:** Millie Rae Webster. Gallery Shop Assistant Director: Cindy Marr. Estab. 1978. Represents over 350 artists, primarily Michigan and regional. Gallery Shop purchases support the Art Center's community outreach programs.

- The Ann Arbor Art Center also has exhibition opportunities for Michigan artists in its Exhibition Gallery and Art Consulting Program.

Media Considers original work in virtually all 2- and 3-dimensional media, including jewelry, prints and etchings, ceramics, glass, fiber, wood, photography and painting.

Style The gallery specializes in well-crafted and accessible artwork. Many different styles are represented, including innovative contemporary.

Terms Accepts work on consignment. Retail price set by artist. Offers member discounts and payment by installments. Exclusive area representation not required. Gallery provides contract; artist pays for shipping.

Submissions "The Art Center seeks out artists through the exhibition visitation, wholesale and retail craft shows, networking with graduate and undergraduate schools, word of mouth, in addition to artist referral and submissions."

N ☑ ART CENTER OF BATTLE CREEK

265 E. Emmett St., Battle Creek MI 49017. (269)962-9511. Fax: (269)969-3838. **Acting Director:** Linda Holberbaum. Estab. 1948. Represents 150 emerging, mid-career and established artists. 90% private collectors, 10% corporate clients. Exhibition program offered in galleries, usually 3-4 solo shows each year, two artists' competitions, and a number of theme shows. Also offers Michigan Artworks Shop featuring work for sale or rent. Average display time 1-2 months. "Three galleries, converted from church—handsome high-vaulted ceiling, arches lead into galleries on either side. Welcoming, open atmosphere." Overall price range $20-1,000; most work sold at $20-300. Hours: Tuesday-Friday 10-5 p.m. Saturdays: 11-3 p.m. Closed Sundays, Mondays and major holidays.

Media Considers oil, acrylic, watercolor, pastel, pen & ink, drawings, mixed media, collage, works on paper, sculpture, ceramic, craft, fiber, glass, photography and original handpulled prints.

Style Exhibits painterly abstraction, minimalism, impressionism, photorealism, expressionism, neo-expressionism and realism. Genres include landscapes, florals, Americana, portraits and figurative work. Prefers Michigan artists.

Terms Accepts work on consignment (40% commission). Retail price set by artist. Exclusive area representation not required. Gallery provides insurance, promotion and contract; artist pays for shipping.

Submissions Michigan artists receive preference. Send query letter, résumé, brochure, slides and SASE. Slides returned; all other material is filed.

Tips "Contact Art Center before mailing materials. We are working on several theme shows with groupings of artists."

N THE ART CENTER

125 Macomb Place, Mount Clemens MI 48043. (586)469-8666. Fax: (586)469-4529. **Executive Director:** Jo-Anne Wilkie. Nonprofit gallery. Estab. 1969. Represents emerging, mid-career and established artists. 500 members. Sponsors 10 shows/year. Average display time 1 month. Open all year except July and August; Tuesday-Friday, 11-5; Saturday, 9-2. Located in downtown Mount Clemens; 1,300 sq. ft. The Art Center is housed in the historic Carnegie Library Building, listed in the State of Michigan Historical Register. 100% of space for special exhibitions. Clients include private and corporate collectors. Overall price range: $5-1,000; most work sold at $50-500.

Media Considers oil, acrylic, watercolor, pastel, pen & ink, drawing, mixed media, collage, paper, sculpture, ceramics, photography, jewelry, metals, craft, fiber, glass, all types of printmaking. Most frequently exhibits oils/acrylics, watercolor, ceramics and mixed media.

Style Exhibits all styles, all genres.

Terms The Art Center receives a 30% commission on sales of original works; 50% commission on prints.

Submissions Send query letter with good reviews, 12 or more professional slides and a professional artist biography. Send photographs or slides and résumé with SASE for return. Finds artists through submissions, queries, exhibit announcements, word of mouth and membership.

Tips "Join The Art Center as a member, call for placement on our mailing list, enter the Michigan Annual Exhibition."

ARTS EXTENDED GALLERY, INC.

2966 Woodward Ave., The Art Bldg., Detroit MI 48201. (313)831-0321. Fax: (313)831-0415. E-mail: cctart@comcast.net. **Director:** Dr. C.C. Taylor. Retail, nonprofit gallery, educational 501C3 space art consultancy and appraisals. Estab. 1959. Represents/exhibits many emerging, mid-career and established artists. Exhibited artists include Michael Kelly Williams, Samuel Hodge, Marie-Helene Cauvin and Charles McGee. Sponsors 6 shows/year. Average display time 8-10 weeks. Open all year; Wednesday-Saturday, 11-5. Located near Wayne State University; 1,000 sq. ft. Clients include tourists, upscale, local community. 80% of sales are to private collectors, 20% corporate collectors. Overall price range $150-4,000 up; most work sold at $200-500 (craft items are considerably less).

● Gallery also sponsors art classes and exhibits outstanding work produced there.

Media Considers all media, woodcuts, engravings, linocuts, etchings and monoprints. Most frequently exhibits painting, fibers, photographs and antique African art.

Style "The work which comes out of the community we serve is varied but rooted in realism, ethnic symbols and traditional designs/patterns with some exceptions."

Terms Artwork is accepted on consignment, and there is a 45% commission, or artwork is bought outright for 55% of the retail price. Retail price set by the gallery and the artist. Gallery provides insurance, promotion and contract; shipping costs are shared. Prefers artwork framed or ready to install.

Submissions Send query letter with résumé, slides, photographs and reviews. Call for appointment to show a portfolio of photographs, slides and bio. Responds in 3 weeks. Files biographical materials sent with announcements, catalogs, résumés, visual materials to add to knowledge of local artists, letters, etc.

Tips "Our work of recruiting local artists is known, and consequently artists beginning to exhibit or seeking to expand are sent to us. Many are sent by relatives and friends who believe that ours would be a logical place to inquire. Study sound technique—there is no easy way or scheme to be successful. Work up to a standard of good craftsmanship and honest vision. Come prepared to show a group of artifacts. Have clearly in mind a willingness to part with work and understand that market moves fairly slowly."

CAIN GALLERY

322 Butler St., Saugatuck MI 49453. (269)857-4353. **Owners:** Priscilla and John Cain. Retail gallery. Estab. 1973. Represents 75 emerging, mid-career and established artists. "Although we occasionally introduce unknown artists, because of high overhead and space limitations, we usually accept only artists who are somewhat established, professional and consistently productive." Sponsors 6 solo shows/year. Average display time 6 months. Clientele: 80% private collectors, 20% corporate clients. Overall price range $100-6,000; most artwork sold at $500-1,000.

Media Considers oil, acrylic, watercolor, mixed media, collage, sculpture, crafts, ceramic, woodcuts, engravings, mezzotints, etchings, lithographs and serigraphs. Most frequently exhibits acrylic, watercolor and serigraphs.

Style Exhibits impressionism, realism, surrealism, painterly abstraction, imagism. Genres include landscapes, florals, figurative work. Prefers impressionism, abstraction and realism. "Our gallery is a showcase for living American artists—mostly from the Midwest, but we do not rule out artists from other parts of the country who attract our interest. The gallery attracts buyers from all over the country."

Terms Accepts artwork on consignment. Retail price set by artist. Sometimes offers customer payment by installment. Exclusive area representation required. Gallery provides insurance, promotion, contract and shipping costs from gallery. Prefers artwork framed.

Submissions Send query letter with résumé and slides. Portfolio review requested if interested in artist's work. Portfolio should include originals and slides. Finds artists through visiting exhibitions, word of mouth, submissions/self-promotions and art collectors' referrals.

Tips "We are now showing more fine crafts, especially art glass and sculptural ceramics. The most common mistake artists make is amateurish matting and framing."

DE GRAAF FORSYTHE GALLERIES, INC.

Park Place No. 4, 403 Water St. on Main, Saugatuck MI 49453. (616)857-1882. Fax: (616)857-3514. E-mail: director@degraaffineart.com. Website: www.degraaffineart.com. **Director:** Tad De Graaf. Retail gallery and art consultancy. Estab. 1950. Represents/exhibits 18 established artists/year. May be interested in seeing emerging artists in the future. Exhibited artists include Stefan Davidek and C. Jagdish. Average display time 3-4 weeks. Open May-December; Monday-Saturday, 11-5; Sunday, 1-5. Located in center of town, 1,171 sq. ft.; adjacent to two city parks. 60% of space for gallery artists. Clients include upscale. 50% of sales are to private collectors; 10% corporate collectors. Overall price range $500-50,000; most work sold at $2,000-5,000.

Media Considers all media except photography and crafts. Most frequently exhibits sculpture, paintings and tapestry.

Style Exhibits all styles.

Terms Artwork is accepted on consignment and there is a 50% commission. Retail price set by the gallery and the artist. Gallery provides promotion. Shipping costs are shared.

Submissions Accepts only artists with endorsements from another gallery or museum. Send query letter with résumé, brochure, slides, photographs, reviews, bio and SASE. Write for appointment to show portfolio. Responds in 2 months, or if interested 3 weeks. Files résumé if possible future interest.

N Y DETROIT REPERTORY THEATRE LOBBY GALLERY

13103 Woodrow Wilson, Detroit MI 48238. (313)868-1347. Fax: (313)868-1705. E-mail: detrepth@aol.com. Website: www.detroitreptheatre.com/gallery.htm. **Gallery Director:** Gilda Snowden. Alternative space, non-profit gallery, theater gallery. Estab. 1965. Represents emerging, mid-career and established artists. Exhibited artists include Curt Winnega, Marcy Parzych and Jocelyn Rainey. Sponsors 4 shows/year. Average display time 6-10 weeks. Exhibits November through June; Thursday-Friday, 8:30-11:30 pm; Saturday-Sunday, 7:30-10:30. Located in midtown Detroit; 750 sq. ft.; features lobby with a wet bar and kitchen; theatre. 100% of space for

special exhibitions. Clientele: theatre patrons. 100% private collectors. Overall price range $50-500; most work sold at $125-300.

Media Considers oil, acrylic, watercolor, pastel, pen & ink, drawing, mixed media, collage and paper. "Must be two-dimensional; no facilities for sculpture." Most frequently exhibits painting, photography and drawing.

Style Exhibits all styles, all genres. Prefers figurative painting, figurative photography and collage.

Terms "No commission taken by gallery; artist keeps all revenues from sales." Retail price set by the artist. Gallery provides insurance and promotion (catalog, champagne reception); artist pays shipping costs to and from gallery. Prefers artwork framed.

Submissions Accepts only artists from Metropolitan Detroit area. Prefers only two-dimensional wall work. Artists install their own works. Send query letter with résumé, slides, bio and SASE. Write for appointment to show portfolio of slides, résumé and bio. Responds in 3 months.

Tips Finds artists through word of mouth and visiting exhibitions.

N ALDEN B. DOW MUSEUM OF SCIENCE & ART

Of the Midland Center for the Arts, 1801 W. St. Andrews, Midland MI 48640. (989)631-5930. Fax: (989)631-7890. Website: www.mcfta.org. **Director:** Bruce Winslow. Nonprofit visual art gallery and school. Estab. 1956. Exhibits emerging, mid-career and established artists. Sponsors 20 shows/year. Average display time 2 months. Open all year, 7 days a week, 10-6. Located in a cultural center; "an Alden B. Dow design." 100% of space for special exhibitions.

Media Considers all media and all types of prints.

Style Exhibits all styles and genres.

Terms "Exhibited art may be for sale" (30% commission). Retail price set by the artist. Gallery provides insurance, promotion and contract; shipping costs are shared. Artwork must be exhibition ready.

Submissions Send query letter with résumé, slides, bio, SASE and proposal. Write to schedule an appointment to show a portfolio, which should include slides, photographs and transparencies. Responds only if interested as appropriate. Files résumé, bio and proposal.

N FIELD ART STUDIO

24242 Woodward Ave., Pleasant Ridge MI 48069. (248)399-1320. Fax: (248)399-7018. E-mail: fieldartstudio@8b cglobal.net. **Director:** Jerome Feig. Retail gallery and art consultancy. Estab. 1950. Represents 6 mid-career and established artists. Hours are Monday to Friday from 10:00 to 6:00 p.m. and Saturday from 10:00 to 5:00 p.m. Average display time 1 month. Overall price range $25-3,000; most work sold at $100-800.

Media Considers watercolor, pastel, pen & ink, mixed media, collage, paper, fiber and original handpulled prints. Specializes in etchings and lithographs.

Style Exhibits landscapes, florals and figurative work. Genres include aquatints, watercolor and acrylic paintings.

Terms Accepts work on consignment (40% commission). Retail price set by gallery and artist. Exclusive area representation not required. Gallery provides insurance, promotion and contract; shipping costs are shared.

Submissions Send query letter, résumé, slides or photographs. Write for appointment to show portfolio of originals and slides. Bio and résumé are filed.

Tips "We are looking for creativeness in the artists we consider. Do not want to see commercial art. Approach gallery in a businesslike manner."

GRAND RAPIDS ART MUSEUM

155 Division N, Grand Rapids MI 49503-3154. (616)831-1000. Fax: (616)559-0422. E-mail: pr@gr-artmuseum.o rg. Website: www.gramonline.org. Museum. Estab. 1910. Exhibits established artists. Sponsors 3 exhibits/year. Average display time 4 months. Open all year; Tuesday-Thursday, 10-5; Friday, 10-830; Sunday, 12-5. Closed Mondays and major holidays. Located in the heart of downtown Grand Rapids, the Grand Rapids Art Museum presents exhibitions of national caliber and regional distinction. The museum collection spans Renaissance to modern art, with particular strength in 19th and 20th century paintings, prints and drawings. Clients include local community, students, tourists, upscale.

Media Considers all media and all types of prints. Most frequently exhibits paintings, prints and drawings.

Style Considers all styles and genres. Most frequently exhibits impressionist, modern and Renaissance.

ELAINE L. JACOB GALLERY

Wayne State University, Detroit MI 48202. (313)993-7813. Fax: (313)577-8935. E-mail: ac1370@wayne.edu. Website: www.art.wayne.edu. **Curator of Exhibition:** Sandra Dupret. Nonprofit university gallery. Estab. 1997. Exhibits national and international artists. Approached by 40 artists/year. Sponsors 5 exhibits/year. Average display time 6 weeks. Open Tuesday-Friday, 10-6. Closed week between Christmas and the New Year. Call for

summer hours. Located in the annex of the Old Main building on campus. The gallery space is roughly 3,000 sq. ft. and is divided between 2 floors. Clients include local community, students, tourists.

Media Considers all types of media.

Style Mainly contemporary art exhibited.

Terms Exhibition only, with occasional sales. Retail price set by the artist. Gallery provides insurance, promotion and contract. Accepted work should be framed, mounted and matted. Does not require exclusive representation locally.

Submissions Send query letter with artist's statement, bio, brochure, business card, photocopies, photographs, résumé, reviews, SASE and slides to attn. Sandra Dupret, 150 Community Arts Bldg., Detroit MI 48202. Responds in 2 months. Files slides, curriculum vitae and artist statements.

Tips "Include organized and pertinent information, professional slides, and a clear and concise artist statement."

N RUSSELL KLATT GALLERY

33644 Woodward, Birmingham MI 48009. (248)647-1120. Fax: (248)644-5541. **Director:** Sharon Crane. Retail gallery. Estab. 1987. Represents 100 established artists/year. Interested in seeing the work of emerging artists. Exhibited artists include Henri Plisson, Roy Fairchild, Don Hatfield, Mary Mark, Eng Tay. Open all year; Monday-Friday, 10-6; Saturday, 10-5. Located on Woodward, 4 blocks north of 14 mile on the east side; 800 sq. ft. 100% private collectors. Overall price range $800-1,500; most work sold at $1,000.

Media Considers oil, acrylic, watercolor, pastel, ceramics, lithograph, mezzotint, serigraphs, etching and posters. Most frequently exhibits serigraphs, acrylics and oil pastels.

Style Exhibits painterly abstraction, impressionism and realism. Genres include landscapes, florals and figurative work. Prefers traditional European style oil paintings on canvas.

Terms Accepts work on consignment (60% commission) or buys outright for 50% of retail price (net 30-60 days). Retail price set by the gallery and the artist. Gallery provides insurance and shipping to gallery; artist pays shipping costs from gallery. Prefers artwork unframed.

Submissions Send query letter with brochure and photographs. Write for appointment to show portfolio of photographs. Finds artists through visiting exhibitions.

KRASL ART CENTER

707 Lake Blvd., St. Joseph MI 49085. (269)983-0271. Fax: (269)983-0275. E-mail: info@krasl.org. Website: www.krasl.org. **Director:** Dar Davis. Retail gallery of a nonprofit arts center. Estab. 1980. Clients include community residents and summer tourists. Sponsors 30 solo and group shows/year. Average display time is 1 month. Interested in emerging and established artists.

Media Considers oils, acrylics, watercolor, pastels, pen & ink, drawings, mixed media, collage, paper, sculpture, ceramics, crafts, fibers, glass, installations, photography and performance.

Style Exhibits all styles. "The works we select for exhibitions reflect what's happening in the art world. We display works of local artists as well as major traveling shows from SITES. We sponsor sculpture invitationals and offer holiday shows each December."

Terms Accepts work on consignment (35% commission). Retail price is set by artist. Sometimes offers customer discounts. Exclusive area representation not required. Gallery provides insurance, promotion, shipping and contract.

Submissions Send query letter, résumé, slides, and SASE. Call for appointment to show portfolio of originals.

N MEADOW BROOK ART GALLERY

208 Wilson Hall, Oakland University, Rochester MI 48309-4401. (248)370-3005. Fax: (248)370-3005. E-mail: jaleow@oakland.edu. Website: www.oakland.edu/mbag. **Contact:** Dick Goody, Director. Nonprofit gallery. Estab. 1962. Exhibits emerging, mid-career, established artists. Approached by 10 artists/year; represents 10-25 artists/year. Exhibited artists include Ed Fraga, painting; Jane Lackey, mixed media. Sponsors 3 exhibits/year. Average display time 4-5 weeks. Open Tuesday-Sunday, 12-5: evenings during theatre performances, 7-9; weekends 12-5: evenings during theatre performances, 5:00-1st intermission; closed June-August. Located on the campus of Oakland University and hosts 6-7 exhibitions annually, with associated programming: artists' lectures, panel discussions, symposia, and opening receptions all free and open to the public. We are supported in part by the Michigan Council for Arts and Cultural Affairs. Exhibition space is approximately 2,350 sq. ft. of floor space; 301 linear feet wall space, with 10 ft. 7 in. ceiling. The Gallery is situated across the hall from the Meadow Brook Theatre. Clients include local community, students, upscale, also tri-county community and art community. Due to nonprofit, we do not "sell" work but do make available price lists for visitors with contact information noted for inquiries.

Media Considers all media and types of prints. Most frequently exhibits photography, drawing, oil.

Style Exhibits conceptualism, expressionism, geometric abstraction, imagism, minimalism, postmodernism, painterly abstraction. Considers all styles.

Making Contact & Terms Price list at attendant's desk with contact info for purchase inquiries—no commission. Retail price set by the artist. Gallery provides insurance, promotion and contract. Accepted work should be framed, mounted, matted. Does not require exclusive representation locally. No restrictions on representation, however, prefer emerging Detroit artists.

Submissions E-mail bio, education, artist's statement and JPEG images to director: goody@oakland.edu. Mail portfolio for review. Send query letter with artist's statement, bio, photocopies, résumé, slides. Returns material with SASE. Responds to queries in 1-2 months. Files bio, images, artist's statement. Finds artists through referrals by other artists, word of mouth, art community, advisory board and other arts organizations.

N JOYCE PETTER GALLERY

161 Blue Star, Saugatuck MI 49406. (269)857-7861 or (888)808-7920. Fax: (269)857-1586. E-mail: sales@joycepetterygallery.com. Website: www.joycepettergallery.com. **Owner:** Joyce Petter. Retail gallery. Estab. 1973. Represents 50 artists; emerging, mid-career and established. Exhibited artists include Harold Larsen and Fran Larsen. Sponsors group or individual shows each year. Average display time 2 weeks. Open all year; Monday-Saturday, 10-5:30; Sunday, 12-5:30. Located on the main corridor connecting the art mecca of Saugatuck and Douglas, Michigan. It is housed in a spacious 1930s building designed by Carl Hoerman, artist and architect. It offers 12,500 sq. ft. of exhibition space. It includes the main display area, print gallery, sculpture barn and garden. Overall price range $150-8,000.

Media Considers oil, acrylic, watercolor, pastel, drawings, mixed media, sculpture, ceramic, glass, original handpulled prints, woodcuts, etchings, lithographs, serigraphs ("anything not mechanically reproduced").

Style Exhibits painterly abstraction, surrealism, impressionism, realism, hard-edge geometric abstraction and all styles and genres. Prefers landscapes, abstracts, figurative and "art of timeless quality."

Terms Accepts work on consignment (50% commission). Retail price set by the artist. Gallery provides insurance, promotion, contract and cost for return shipping of work. The artwork should be framed with the exception of prints.

Submissions Send query letter with résumé and photographs or slides, including dimensions and prices. "It's a mistake not to have visited the gallery to see if the artist's work fits the feeling or culture of the establishment."

Tips "Art is judged on its timeless quality. We are not interested in the 'cutting edge.' After 30 seasons we continue to maintain relationships with artists who joined at the onset and to take on new artists who exhibit those same traits of career longevity and solid commitment to their art."

SAPER GALLERIES

433 Albert Ave., East Lansing MI 48823. (517)351-0815. E-mail: roy@sapergalleries.com. Website: www.sapergalleries.com. **Director:** Roy C. Saper. Retail gallery. Estab. in 1978; in 1986 designed and built new location. Displays the work of 150 artists; mostly mid-career, and artists of significant national prominence. Exhibited artists include Picasso, Peter Max, Rembrandt. Sponsors 2 shows/year. Average display time 2 months. Open all year. Located downtown; 5,700 sq. ft.; "We were awarded *Decor* magazine's Award of Excellence for gallery design." 50% of space for special exhibitions. Clients include students, professionals, experienced and new collectors. 80% of sales are to private collectors, 20% corporate collectors. Overall price range $100-100,000; most work sold at $1,000.

Media Considers oil, acrylic, watercolor, pastel, drawings, mixed media, collage, paper, sculpture, ceramic, craft, glass and original handpulled prints. Considers all types of prints except offset reproductions. Most frequently exhibits intaglio, serigraphy and sculpture. "Must be of highest professional quality."

Style Exhibits expressionism, painterly abstraction, surrealism, postmodern works, impressionism, realism, photorealism and hard-edge geometric abstraction. Genres include landscapes, florals, southwestern and figurative work. Prefers abstract, landscapes and figurative. Seeking extraordinarily talented, outstanding artists who will continue to produce exceptional work.

Terms Accepts work on consignment (negotiable commission); or buys outright for negotiated percentage of retail price. Retail price set by the artist. Offers payment by installments. Gallery provides insurance, promotion and contract; shipping costs are shared. Prefers artwork unframed (gallery frames).

Submissions Prefers digital pictures e-mailed to roy@sapergalleries.com. Call for appointment to show portfolio of originals or photos of any type. Responds in 1 week. Files any material the artist does not need returned. Finds artists mostly through NY Art Expo.

Tips "Present your very best work to galleries which display works of similar style, quality and media. Must be outstanding, professional quality. Student quality doesn't cut it. Must be great. Be sure to include prices and SASE."

URBAN INSTITUTE FOR CONTEMPORARY ARTS

41 Sheldon Blvd. Grand Rapids MI 49503. (616)459-5994. Fax: (616)459-9395. E-mail: jteunis@uica.org. Website: www.uica.org. **Visual and Performing Arts Program Manager:** Janet Teunis. Alternative space, nonprofit

gallery. Estab. 1977. Approached by 250 artists/year. Exhibits 50 emerging, mid-career and established artists. ''We have four galleries and places for site-specific work.'' Exhibited artists include Sally Mann, photography. Sponsors 20 exhibits/year. Average display time 6 weeks. Open Tuesday-Saturday, 12-10; Sunday, 12-7.

Media Considers all media and all types of prints. Most frequently exhibits mixed media, avant-garde and nontraditional.

Style Exhibits conceptualism and postmodernism.

Terms Gallery provides insurance, promotion and contract.

Submissions Check website for gallery descriptions and how to apply. Send query letter with artist's statement, bio, résumé, reviews, SASE, application fee, and slides. Returns material with SASE. Does not reply. Artist should see website, inquire about specific calls for submissions. Finds artists through submissions.

Tips ''Get submission requirements before sending materials.''

MINNESOTA

ART DOCK INC.

394 Lake Ave. S., Duluth MN 55802. (218)722-1451 or (218)722-6410. E-mail: artdock@qwest.net. **Contact:** Bev L. Johnson. Retail consignment gallery. Estab. 1985. Represents 170 emerging and mid-career artists/year. Exhibited artists include Cheng Khee Chee and Jay Steinke. Sponsors 2 exhibitions/year. Average display time 6 months. Open all year; Monday-Friday, 10-9; Saturday, 10-8; Sunday, 11-5. Located in Canal Park, 1,200 sq. ft. historical building. #1 tourist attraction in the state on the shores of Lake Superior. We feature local artists within a 100-mile radius of Duluth. Clientele: 50% local, 50% tourists. 95% private collectors, 5% corporate collectors. Over all price range $1-5,000; most work sold at $30-75.

Media Considers acrylic, ceramics, collage, craft, drawing, fiber, glass, mixed media, oil, paper, pastel, pen & ink, sculpture, watercolor, jewelry, wood all types of prints. Most frequently exhibits watercolor, pottery and photographs.

Style Exhibits painterly abstraction, photorealism and realism. Genres include regional images.

Terms Accepts work on consignment (40% commission). Retail price set by the artist. Gallery provides insurance, promotion and contract; artists pays for shipping.

Submissions Accepts only artists from 100-mile radius of Duluth. Send query letter with photographs, or call for appointment to show portfolio of photographs and slides. Responds in 2 months. Files current artist information. Finds artists through submissions.

Tips ''They should present as if they are selling the work. No portfolio.''

Ⓝ CALLAWAY GALLERIES, INC.

101 SW First Ave., Rochester MN 55902. (507)287-6525. Fax: (507)292-8892. E-mail: artgal101@aol.com. Website: www.callawaygalleries.com. **Owner:** Barbara Callaway. Retail gallery. Estab. 1971. Represents 50+ emerging, mid-career and established artists/year. Average display time 1 month. Open all year; Monday-Friday, 930-530; Saturday, 10-4. Located downtown; 700 sq. ft. Clientele tourists and upscale corporate. 30% corporate collectors. Overall price range $100-4,000; most work sold at $200-1,000.

Media Considers acrylic, craft, fiber, glass, mixed media, oil, paper, pastel, sculpture and watercolor. Considers all types of prints except numbered photo repros. Most frequently exhibits pastel, mixed media and glass.

Style Considers all styles. Genres include florals, southwestern, landscapes and figurative work.

Terms Accepts work on consignment (50% commission) or buys outright for 50% of retail price (net 30 days). Retail price set by the artist. Shipping costs are shared. Prefers artwork unframed.

Submissions Send query letter with bio, photographs, SASE, reviews and artist's statement. Write for appointment to show portfolio of photographs or slides. Responds in 1 month (if SASE provided). Finds artists through word of mouth, referrals by other artists, visiting art fairs and exhibitions and submissions.

Tips Send ''slides or photos and biographical with SASE.''

Ⓝ EAGLE CREEK GALLERY

12358 Boone Ave S., Savage, MN 55378. (952)445-3035. Fax: (952)445-0292. E-mail: mark@eaglecreekgallery.com. Website: www.eaglecreekgallery.com. **Gallery Director:** Mark Roberts. Estab. 1975. Represents 75-100 emerging, mid-career and established artists. Interested in seeing the work of emerging artists. Open all year; Monday-Wednesday, 10-5:30; Thursday, 10-8; Friday and Saturday, 10-5; closed Sunday. 2,000 sq. ft. 10% of space for special exhibitions; 50% of space for gallery artists. Clientele: private homeowners and corporate. 80% private collectors, 20% corporate collectors. Overall price range $10-1,000; most work sold at $100-500.

Media Considers oil, acrylic, watercolor, pastel, mixed media, paper, woodcuts, wood engravings, engravings, mezzotints, etching, lithographs, serigraphs and posters. Most frequently exhibits watercolor, serigraphs/lithographs and offset reproductions.

Style Exhibits painterly abstraction, impressionism and realism. Genres include landscapes and florals.
Terms Accepts work on consignment (50% commission). Retail price set by artist. Payment by installment. Gallery provides promotion; artist pays for shipping.
Submissions Send query letter with résumé, slides, bio, photographs, business card, reviews and SASE. Portfolio review requested if interested in artist's work. Files résumé and card. Finds artists through visiting exhibitions, word of mouth and artists' submissions.
Tips ''The mood of our clients has leaned towards quality, colorful artwork that has an uplifting appeal.''

FARIBAULT ART CENTER, INC.

212 Central Ave., Suite A, Faribault MN 55021. (507)332-7372. E-mail: fac@deskmedia.com. Website: www.faribaultart.org. **Contact:** Executive Director. Nonprofit gallery. Represents 10-12 emerging and mid-career artists/year. 200 members. Sponsors 8 shows/year. Average display time 1 month. Open all year; Monday-Saturday, 930-5. Located downtown; 1,600 sq. ft. 50% of space for special exhibitions; 50% of space for gallery artists. Clientele local and tourists. 90% private collectors.
Media Considers all media and all types of prints.
Style Open.
Terms Accepts work on consignment (30% commission for nonmembers). Retail price set by the artist. Artist pays for shipping. Prefers artwork framed.
Submissions Accepts local and regional artists. Send query letter with slides, bio, photographs, SASE and artist's statement. Call or write for appointment to show portfolio of photographs or slides. Responds only if interested within 2 weeks. Artist should call. Finds artists through word of mouth, referrals by other artists, visiting art fairs and exhibitions and submissions.
Tips ''Artists should respond quickly upon receiving reply.''

☑ ICEBOX QUALITY FRAMING & GALLERY

1500 Jackson St. NE, Suite 443, Minneapolis MN 55413. (612)788-1790. Fax: (612)788-6947. E-mail: icebox@bitstream.net. Website: www.iceboxminnesota.com. **Fine Art Representative:** Howard Christopherson. Retail gallery and alternative space. Estab. 1988. Represents emerging and mid-career artists. Sponsors 4-7 shows/year. Average display time 1-2 months. Open all year. Historic Northrup King Building.
Media Considers photography and all fine art with some size limitations.
Style Exhibits any thought-provoking artwork.
Terms ''Exhibit expenses and promotional material paid by the artist along with a sliding scale commission.'' Gallery provides great exposure, mailing list of 2,000 and good promotion.
Submissions Accepts predominantly Minnesota artists but not exclusively. Send 20 slides, materials for review, letter of interest.
Tips ''Be more interested in the quality and meaning in your artwork than in a way of making money.''

MIKOLS RIVER STUDIO INC.

717 Main St. NW, Elk River MN 55330. (763)441-6385. **President:** Anthony Mikols. Retail gallery. Estab. 1985. Represents 12 established artists/year. Exhibited artists include Steve Hanks. Sponsors 2 shows/year. Open all year; Mon.-Fri., 9:00-6:00 and Sat. from 9:00-12:00. Located in downtown; 2,200 sq. ft. 10% of space for special exhibitions; 50% of space for gallery artists. Overall price range $150-500.
Media Considers watercolor, sculpture, acrylic, paper and oil; types of prints include lithographs, posters and seriographs.
Style Genres include florals, portraits, wildlife, landscapes and western. Prefers wildlife, florals and portraits.
Terms Buys outright for 50% of retail price (net on receipt). Retail price set by the gallery. Gallery provides insurance; gallery pays for shipping.
Submissions Send photographs. Artist's portfolio should include photographs. Responds only if interested within 2 weeks. Files artist's material. Finds artists through word of mouth.

THE CATHERINE G. MURPHY GALLERY

The College of St. Catherine, 2004 Randolph Ave. St. Paul MN 55105. (612)690-6637. Fax: (612)690-6024. E-mail: kmdaniels@stkate.edu. Website: www.stkate.edu. **Director:** Kathleen M. Daniels. Nonprofit gallery. Estab. 1973. Represents emerging, mid-career and nationally and regionally established artists. ''We have a mailing list of 1,000.'' Sponsors 5 shows/year. Average display time 4-5 weeks. Open September-June; Monday-Friday, 8-8; Saturday, 12-6; Sunday, 12-6. Located in the Visual Arts Building on the college campus of the College of St. Catherines; 1,480 sq. ft.
• This gallery also exhibits historical art and didactic shows of visual significance. Gallery shows 75% women's art since it is an all-women's undergraduate program.
Media Considers a wide range of media for exhibition.

Style Exhibits Considers a wide range of styles.

Terms Artwork is loaned for the period of the exhibition. Gallery provides insurance. Shipping costs are shared. Prefers artwork framed.

Submissions Send query letter with artist statement and checklist of slides (title, size, medium, etc.), résumé, slides, bio and SASE. Responds in 6 weeks. Files résumé and cover letters. Serious consideration is given to artists who do group proposals under one inclusive theme.

NORTH COUNTRY MUSEUM OF ARTS

301 Court St., Park Rapids MN 56470. (218)237-5900. E-mail: ncma@unitelc.com. **Curator/Administrator:** Dawn M. Cast. Museum. Estab. 1977. Collection consists of the 17th to 21st Century European and American paintings and prints, as well as a collection of Nigerian artifacts. Interested in seeing the work of emerging and established artists. 100 members. Sponsors 8 shows/year. Average display time 3 weeks. Open all year; May-October; Tuesday-Sunday, 11-5. Located next to courthouse; 5 rooms in a Victorian building built in 1900 (on Register of Historic Monuments). 50% of space for special exhibitions; 50% of space for gallery artists.

Media Considers all media and all types of prints. Most frequently exhibits acrylic, watercolor and sculpture.

Style Exhibits all genres; prefers realism.

Terms Accepts work on consignment (20% commission). Retail price set by the artist. Artist pays shipping costs to and from gallery. Prefers artwork framed.

Submissions "Work should be of interest to general public." Send query letter with résumé and 4-6 slides. Portfolio should include photographs or slides. Responds only if interested within 2 months. Finds artists through word of mouth.

ℕ: OPENING NIGHT FRAMING SERVICES & GALLERY

(formerly Opening Night Gallery), 2836 Lyndale Ave. S., Minneapolis MN 55408-2108. (612)872-2325. Fax: (612)872-2385. E-mail: deen@onframe-art.com. Website: www.onframe-art.com. Rental gallery. Estab. 1974. Approached by 40 artists/year. Exhibits 15 emerging and mid-career artists. Sponsors 4 exhibits/year. Average display time 6-10 weeks. Open all year; Monday-Friday, 8:30-5; Saturday, 10:30-4. Located on a main street the space is approximately 2,500 sq. ft. Clients include local community, tourists and upscale. 50% of sales are to corporate collectors. Overall price range $300-15,000; most work sold at $2,500.

Media Considers acrylic, ceramics, collage, drawing, fiber, glass, oil, paper, sculpture and watercolor. Most frequently exhibits paintings, drawings and pastels. Considers engravings, etchings, linocuts, lithographs, mezzotints, posters and serigraphs.

Style Exhibits impressionism and painterly abstraction. Genres include Americana, florals and landscapes.

Terms Artwork is accepted on consignment and there is a 50% commission. Retail price set by the gallery. Gallery provides insurance, promotion and contract. Accepted work should be framed. Requires exclusive representation locally.

Submissions Write to arrange a personal interview to show portfolio of photographs or slides. Mail portfolio for review. Send query letter with artist's statement, bio, résumé, SASE and slides. Responds in 2 months. Files slides and bio. Finds artists through word of mouth, submissions and portfolio reviews.

Tips "Please include a cover letter, along with your most appealing creations. Archival-quality materials are everything—we are also a framing service whom museums use for framing."

SIVERTSON GALLERY

14 W. Wisconsin St., Grand Marais MN 55604. (218)387-2491. Fax: (218)387-1350. E-mail: info@sivertson.com. Website: www.sivertson.com. **Proprietor:** Jan Sivertson. Retail gallery. Estab. 1980. Represents 20 established artists/year. Exhibited artists include Howard Sivertson and Betsy Bowen. Sponsors 3-4 shows/year. Average display time 6 months. Open all year; daily with evening hours additional in summer. Located in downtown Grand Marais (1,700 sq. ft.) and downtown Duluth (800 sq. ft.). 25% of space for special exhibitions; 75% of space for gallery artists. Clientele: tourists and local community. 100% private collectors. Overall price range $25-10,000; most work sold at $100-1,000.

Media Considers oil, acrylic, watercolor, pastel, mixed media, collage, paper, sculpture, ceramics, craft and fiber; all types of prints. Most frequently exhibits oil/acrylics, watercolors and original prints, preferably woodcuts.

Style Exhibits regional representational, not abstract. Genres include wildlife and landscapes. Prefers area landscape-regional, wildlife and variety of work from Alaska and Inuit natives.

Terms Accepts work on consignment (50% commission) or buys outright for 50% of retail price (net 30 days). Retail price set by the gallery and artist. Gallery provides promotion; artist pays for shipping. Prefers artwork framed.

Submissions Accepts only artists from northeast Minnesota or Canadian/Alaskan. The artwork must fit the gallery theme-art of the north. Send query letter with résumé, slides, bio and artist's statement. Call for appoint-

ment to show portfolio of photographs or slides. Responds in 1 month. Finds artists through word of mouth, referrals by other artists, visiting art fairs and exhibitions and submissions. "We review portfolios, 1-2 a year."
Tips "Don't come in with artwork in hand during busy season."

JEAN STEPHEN GALLERIES

917 Nicollet Mall, Minneapolis MN 55402. (612)338-4333. Fax: (612)337-8435. E-mail: jsg@jeanstephengalleries .com. Website: jeanstephengalleries.com. **Directors:** Steve or Jean Danko. Retail gallery. Estab. 1987. Represents 12 established artists. Interested in seeing the work of emerging artists. Exhibited artists include Jiang, Hart, Yuroz and Dr. Seuss. Sponsors 2 shows/year. Average display time 4 months. Open all year; Monday-Saturday, 10-6. Located downtown; 2,300 sq. ft. 15% of space for special exhibitions; 85% of space for gallery artists. Clients include upper income. 90% of sales are to private collectors, 10% corporate collectors. Overall price range $600-12,000; most work sold at $1,200-2,000.
Media Considers oil, acrylic, pastel, pen & ink, drawing, mixed media, collage, paper, sculpture, ceramics, woodcuts, engravings, lithographs, wood engravings, mezzotints, serigraphs, linocuts and etchings. Most frequently exhibits serigraphs, stone lithographs and sculpture.
Style Exhibits expressionism, neo-expressionism, surrealism, minimalism, color field, postmodern works and impressionism. Genres include landscapes, southwestern, portraits and figurative work.
Terms Accepts work on consignment (50% commission). Retail price set by the gallery. Gallery provides insurance and contract; artist pays shipping costs to and from gallery.
Submissions Send query letter with résumé, slides and bio. Call for appointment to show portfolio of originals, photographs and slides. Responds in 2 months. Finds artists through art shows and visits.

ⓃＦREDERICK R. WEISMAN ART MUSEUM

333 East River Rd., Minneapolis MN 55455. (612)625-9494. Fax: (612)625-9630. E-mail: benruool@umn.edu. Website: www.weisman.umn.edu. **Contact:** Lyndel King, director. Frederick R. Weisman Art Museum opened in November 1993; University of Minnesota Art Museum established in 1934. Represents 20,000 works in permanent collection. Represents established artists. 1,000 members. Sponsors 6-7 shows/year. Average display time 10 weeks. Open all year; Tuesday, Wednesday, Friday, 10-5; Thursday, 10-8; Saturday-Sunday, 11-5. Located at the University of Minnesota, Minneapolis; 10,000 sq. ft.; designed by Frank O. Gehry. 40% of space for special exhibitions.
Media Considers all media and all types of prints.
Style Exhibits all styles, all genres.
Terms Gallery provides insurance. Prefers artwork framed.
Submissions "Generally we do not exhibit one-person shows. We prefer thematic exhibitions with a variety of artists. However, we welcome exhibition proposals. Exhibitions which are multi-disciplinary are preferred."

MISSISSIPPI

CHIMNEYVILLE CRAFTS GALLERY

Agricultural & Forestry Museum, Jackson MS 39216. (601)981-2499. Fax: (601)981-0488. **Director:** Kit Barksdale. Retail and nonprofit gallery. Estab. 1985. Represents all 400 members of Craftsmen Guild Mission. Exhibited artists include George Berry and Ann Baker. Open all year; Monday-Saturday, 9-5; closed some holidays. Located on the grounds of the State Agricultural & Forestry Museum; 2,000 sq. ft.; in a traditional log cabin. Clientele travelers and local patrons. 99% private collectors. Overall price range $250-900; most work sold at $10-60. Also sponsors Chimneyville Crafts Festival first weekend of December.
Media Considers paper, sculpture, ceramic, craft, fiber and glass. Most frequently exhibits clay, basketry and metals.
Style Exhibits all styles. Crafts media only. Interested in seeing a "full range of craftworkNative American, folk art, production crafts, crafts as art, traditional and contemporary. Work must be small enough to fit our limited space."
Terms Accepts work on consignment (40% commission), and purchases 50% of based on retail price (net 30 days), subsequent orders. Retail price set by the gallery and the artist. Gallery provides promotion and shipping costs to gallery.
Submissions Out of state submissions accepted. Out of state members have all privileges of members, but cannot vote. Artists must be juried members of the Craftsmen's Guild of Mississippi. Ask for standards review application form. Standards Review 1st Saturday in March and September.
Tips "All emerging craftsmen should read *Crafts Report* regularly and know basic business procedures. Read books on the business of art like *Crafting as a Business* by Wendy Rosen, distributed by Chilton—available by

mail order through our crafts center or the *Crafts Report*. An artist should have mastered the full range of his medium.

MERIDIAN MUSEUM OF ART

628 25th Ave., Meridian MS 39302. (601)693-1501. E-mail: MeridianMuseum@aol.com. **Director:** Terence Heder. Museum. Estab. 1970. Represents emerging, mid-career and established artists. Interested in seeing the work of emerging artists. Exhibited artists include Terry Cherry, Alex Loeb, Jere Allen, Patt Odom, James Conner, Joseph Gluhman, Bonnie Busbee and Hugh Williams. Sponsors 15 shows/year. Average display time 5 weeks. Open all year; Tuesday-Sunday, 1-5. Located downtown; 1,750 sq. ft.; housed in renovated Carnegie Library building, originally constructed 1912-13. 50% of space for special exhibitions. Clientele general public. Overall price range $150-2,500; most work sold at $300-1,000.

- Sponsors annual Bi-State Art Competition for Mississippi and Alabama artists.

Media Considers all media. Most frequently exhibits oils, watercolors and sculpture.

Style Exhibits all styles, all genres.

Terms Work available for sale during exhibitions (25% commission). Retail price set by the artist. Gallery provides insurance and promotion; shipping costs are shared. Prefers artwork framed.

Submissions Prefers artists from Mississippi, Alabama and the Southeast. Send query letter with résumé, slides, bio and SASE. Responds in 3 months. Finds artists through submissions, referrals, work included in competitions and visiting exhibitions.

MISSOURI

BARUCCI'S ORIGINAL GALLERIES

8101 Maryland Ave., St. Louis MO 63105. (314)727-2020. E-mail: baruccigallery@dellmail.com. Website: baruccigallery.com. **President:** Shirley Taxman Schwartz. Retail gallery and art consultancy specializing in hand-blown glass by national juried artists. Estab. 1977. Represents 40 artists. Interested in emerging and established artists. Sponsors 3-4 solo and 4 group shows/year. Average display time is 6 weeks. Located in "affluent county, a charming area." Clientele: affluent young area. 70% private collectors, 30% corporate clients. Overall price range $100-10,000; most work sold at $1,000.

- This gallery has moved into a corner location featuring three large display windows. They specialize in hand blown glass by national juried artists.

Media Considers oil, acrylic, watercolor, pastel, collage and works on paper. Most frequently exhibits watercolor, oil, acrylic and hand blown glass.

Style Exhibits painterly abstraction and impressionism. Currently seeking contemporary works abstracts in acrylic and fiber and some limited edition serigraphs.

Terms Accepts work on consignment (50% commission). Retail price set by gallery or artist. Sometimes offers payment by installment. Gallery provides contract.

Submissions Send query letter with résumé, slides and SASE. Portfolio review requested if interested in artist's work. Slides, bios and brochures are filed.

Tips "More clients are requesting discounts or longer pay periods."

BOODY FINE ARTS, INC.

10706 Trenton Ave., St. Louis MO 63132. (314)423-2255. E-mail: bfa@boodyfinearts.com. Website: www.boodyfinearts.com. Retail gallery and art consultancy. "Gallery territory is nationwide. Staff travels on a continual basis to develop collections within the region." Estab. 1978. Represents 200 mid-career and established artists. Clientele: 20% private collectors, 30% public and 50% corporate clients. Overall price range $500-1,000,000.

Media Considers oil, acrylic, watercolor, pastel, drawings, mixed media, collage, sculpture, ceramic, fiber, metalworking, glass, works on handmade paper, neon and original handpulled prints.

Style Exhibits color field, painterly abstraction, minimalism, impressionism and photorealism. Prefers non-objective, figurative work and landscapes.

Terms Accepts work on consignment. Retail price is set by gallery and artist. Customer discounts and payment by installments available. Gallery provides insurance, promotion and contract; shipping costs are shared.

Submissions Send query letter, résumé and slides. "Accepts e-mail introductions with referrals or invitations to websites; no attachments. Write to schedule an appointment to show a portfolio, which should include originals, slides and transparencies. All material is filed. Finds artists by visiting exhibitions, word of mouth, artists' submissions, Internet and art collectors' referrals.

Tips "I very seldom work with an artist until they have been out of college about ten years."

CENTRAL MISSOURI STATE UNIVERSITY ART CENTER GALLERY

217 Clark St., Warrensburg MO 64093. (660)543-4498. Fax: (660)543-8006. **Gallery Director:** Morgan Gallatin. University Gallery. Estab. 1984. Exhibits emerging, mid-career and established artists. Sponsors 11 exhibitions/year. Average display time 1 month. Open Monday through Friday, 8-5; Saturday, 10-2. Open during academic year. Located on the University campus. 3,778 sq. ft. 100% of space is devoted to special exhibitions. Clientele: local community, students.

Media Considers all media and all styles.

Terms No commission: "We are primarily an education gallery, not a sales gallery." Gallery provides insurance. Shipping costs are shared. Prefers artwork framed.

Submissions Send query letter with résumé, slides, bio, photographs, SASE. Write for appointment to show portfolio of photographs and slides. Responds in 6 months. Finds artists through The Greater Midwest International Art Competition sponsored by the Gallery.

MILDRED COX GALLERY AT WILLIAM WOODS UNIVERSITY

One University Dr., Fulton MO 65251. (573)642-2251. Website: www.williamwoods.edu. **Contact:** Julie Gaddy, gallery coordinator. Nonprofit gallery. Estab. 1970. Approached by 20 artist/year; exhibits 8 emerging, mid-career and established artists/year. Exhibited artists include Elizabeth Ginsberg and Terry Martin. Average display time 2 months. Open Monday-Friday, 8-430; Saturday-Sunday, 1-4. Closed Christmas-January 20. Located within large moveable walls; 300 running feet. Clients include local community, students, upscale and foreign visitors. Overall price range $1,000-10,000; most work sold at $800-1,000. Gallery takes no commission. "Our mission is education."

Media Considers all media except installation. Most frequently exhibits drawing, painting and sculpture. Considers all prints except commercial off-set.

Style Exhibits expressionism, geometric abstraction, impressionism, surrealism, painterly abstraction and realism. Most frequently exhibits figurative and academic. Genres include Americana, figurative work, florals, landscapes and portraits.

Terms Artists work directly with person interested in purchase. Retail price of the art set by the artist. Gallery provides insurance and contract. Accepted work should be framed and matted. Does not require exclusive representation locally. Artists are selected by a committee from slides or original presentation to faculty committee.

Submissions Write to arrange a personal interview to show portfolio of slides or send query letter with artist's statement, résumé and slides. Returns material with SASE. Does not reply to queries. Artist should call. Files slides, statement and résumé until exhibit concludes. Finds artists through word of mouth.

Tips To make your gallery submissions professional you should send "good quality slides! Masked with sliver opaque tapeno distracting backgrounds."

Ⓝ HAL DAVID FINE ART

P.O. Box 411213, St. Louis MO 63141. (314)533-2887. E-mail: mscharf@swbell.net. Website: www.maxrscharf.net or www.maxrscharf.com. **Contact:** Max Scharf, Director. For-profit gallery. Estab. 1991. Exhibits established artists. Approached by 30 artists/year; represents 3 artists/year. Exhibited artists include Max R. Scharf (acrylic on canvas) and Sandy Kaplan (terra cotta sculpture). Sponsors 3 exhibits/year. Average display time 2 months. Open Monday through Friday from 10-4; weekends by appointment. Open all year. Located in historical central west end of St. Louis, MO. Clients include upscale. 30% sales are to corporate collectors. Overall price range: $2,000-30,000; most work sold at $10,000.

Style Exhibits expressionism, impressionism, painterly abstraction. Most frequently exhibits impressionism and expressionism.

Making Contact & Terms Artwork is accepted on consignment and there is a 50% commission. Retail price set by the artist. Accepted work should be framed. Does not require exclusive representation locally.

Submissions Returns material with SASE. Responds to queries in 3 weeks. Finds artists through referrals by other artists.

Tips "Have a good website to look at."

GALERIE BONHEUR

10046 Conway Rd., St. Louis MO 63124. (314)993-9851. Fax: (314)993-9260. E-mail: gbonheur@aol.com. Website: www.galeriebonheur.com. **Owner:** Laurie Griesedieck Carmody. Gallery Assistant: Sharon Ross. Private retail and wholesale gallery. Focus is on international folk art. Estab. 1980. Represents 60 emerging, mid-career and established artists/year. Exhibited artists include Milton Bond and Justin McCarthy. Sponsors 6 shows/year. Average display time 1 year. Open all year; by appointment. Located in Ladue (a suburb of St. Louis); 3,000 sq. ft.; art is displayed all over very large private home. 75% of sales to private collectors. Overall price range $25-25,000; most work sold at $50-1,000.

• Galerie Bonheur also has a location at 9243 Clayton Rd., Ladue MO.

Media Considers oil, acrylic, watercolor, pastel, pen & ink, drawing, mixed media, collage, paper, sculpture, ceramics and craft. Most frequently exhibits oil, acrylic and metal sculpture.

Style Exhibits expressionism, primitivism, impressionism, folk art, self-taught, outsider art. Genres include landscapes, florals, Americana and figurative work. Prefers genre scenes and figurative.

Terms Accepts work on consignment (50% commission) or buys outright for 50% of retail price. Retail price set by the gallery and the artist. Gallery provides promotion; artist pays shipping costs to and from gallery. Prefers artwork framed.

Submissions Prefers only self-taught artists. Send query letter with bio, photographs and business card. Write for appointment to show portfolio of photographs. Responds only if interested within 6 weeks. Finds artists through agents, visiting exhibitions, word of mouth, art publications and sourcebooks and submissions.

Tips "Be true to your inspirations. Create from the heart and soul. Don't be influenced by what others are doing; do art that you believe in and love and are proud to say is an expression of yourself. Don't copy; don't get too sophisticated or you will lose your individuality!"

N DANA GRAY & ASSOCIATES

P.O. Box 9244, StLouis MO 63117. (314)589-4541. E-mail: info@danagray.com. Website: www.danagray.com. **Contact:** Dana Gray, president. Art consultancy. Estab. 2000. Represents over 12 mid-career and established artists/year. Exhibited artists include Miquel Berrocal (sculpture) and Salvador Dali (prints). Sponsors 1 exhibit/year. Average display time 3-6 weeks. Open by appointment only. Consultant works from home office and travels to client's location or does negotiations by phone, e-mail and mail. Clients include local community and upscale. 5% of sales are to corporate collectors. Overall price range $1,000-10,000; most work sold at $2,500.

Media Considers collage, drawing, glass, mixed media, oil, paper, pastel, pen & ink, sculpture, watercolor. Most frequently exhibits paintings, prints and sculpture. Considers all types of prints except giclée.

Style Exhibits impressionism, realism and surrealism. Considers all genres.

Terms "Generally, I broker artworks and the percentage is agreed in advance between the artist/owner and the broker." Retail price of the art set by the artist/owner. Does not require exclusive representation locally.

Submissions; Responds to queries only if interested. Finds artists through art fairs and exhibits, referrals by other artists, word of mouth and periodicals.

SHERRY LEEDY CONTEMPORARY ART

2004 Baltimore Ave., Kansas City MO 64108. (816)474-1919. Fax: (816)221-8689. E-mail: sherryleedy@sherryleedy.com. **Director:** Sherry Leedy. Retail gallery. Estab. 1985. Represents 50 mid-career and established artists. Exhibited artists include Jun Kancke, Michael Eastman. Sponsors 6 shows/year. Average display time 6 weeks. 5,000 sq. ft. of exhibit area in 3 galleries. Clients include established and beginning collectors. 80% of sales are to private collectors, 20% corporate clients. Price range $50-100,000; most work sold at $3,500-35,000.

Media Considers all media and one-of-a-kind or limited-edition prints; no posters. Most frequently exhibits painting, photography, ceramic sculpture and glass.

Style Exhibits all styles.

Terms Accepts work on consignment (50% commission). Retail price set by gallery. Sometimes offers customer discounts and payment by installment. Exclusive area representation required. Gallery provides insurance, promotion; shipping costs are shared. Prefers artwork framed.

Submissions Send query letter, résumé, good slides, prices and SASE. Write for appointment to show portfolio of originals, slides and transparencies. Bio, vita, slides, articles, etc. are filed if they are of potential interest.

Tips "Please allow three months for gallery to review slides."

N MORTON J. MAY FOUNDATION GALLERY

Maryville University, St. Louis MO 63141. (314)576-9300. **Director:** Steve Teczar. Nonprofit gallery. Exhibits the work of 6 emerging, mid-career and established artists/year. Sponsors 10 shows/year. Average display time 1 month. Open all year. Located on college campus. 10% of space for special exhibitions. Clients include college and greater St. Louis community. Overall price range $100-4,000.

• The gallery is long and somewhat narrow, therefore it is inappropriate for very large 2-D work. There is space in the lobby for large 2-D work but it is not as secure.

Media Considers oil, acrylic, watercolor, pastel, pen & ink, drawings, mixed media, collage, works on paper, sculpture, ceramic, fiber, installation, photography, original handpulled prints, woodcuts, engravings, lithographs, wood engravings, mezzotints, linocuts and etchings. Exhibits all genres.

Terms Artist receives all proceeds from sales. Retail price set by artist. Gallery provides insurance and promotion; artist pays for shipping. Prefers framed artwork.

Submissions Prefers regional artists. Send query letter with résumé, slides, bio, brochure and SASE. Portfolio review requested if interested in artist's work. Portfolio should include slides, photographs or CD. Responds

only if interested within 3 months. Finds artists through referrals by colleagues, dealers, collectors, etc. "I also visit group exhibits especially if the juror is someone I know and/or respect."

Tips Does not want "hobbyists/crafts fair art." Looks for "a body of work with thematic/aesthetic consistency."

MORGAN GALLERY

2011 Tracy Ave., Kansas City MO 64108. (816)842-8755. E-mail: dmorgangallery@sbcglobal.net. Website: www.morgangallery.com. **Director:** Dennis Morgan. Associate Director: Adelia Ganson. For-profit gallery. Estab. 1969. Exhibits emerging, mid-career and established artists. Sponsors 6 exhibits/year. Average display time 6-8 weeks. Open all year; Tuesday-Friday, 10-5:30; Saturday 10-4. Closed Sundays. Clients include local community, students, tourists and upscale.

Media Considers all media and all types of prints.

Style Considers all styles.

Terms Artwork is accepted on consignment and there is a 50% commission. Retail price set by the gallery and the artist. Gallery provides insurance, promotion and contract. Requires exclusive representation locally.

Submissions Call or write to arrange a personal interview to show portfolio. Send query letter with artist's statement, bio, résumé, reviews, SASE and 20 slides. Returns material with SASE. Responds in 6 months. Files contact information. Finds artists through word of mouth, submissions, portfolio reviews, art exhibits, art fairs, and referrals by other artists.

THE SOURCE FINE ARTS, INC.

1505 Westport Rd. #102, Kansas City MO 64111. (816)931-8282. Cell Phone: (816)217-7871. Fax: (816)931-8283. E-mail: sourcefinearts@earthlink.net. **President:** Denyse Ryan Johnson. Art Consultant. Estab. 1985. Represents/exhibits 50 mid-career artists/year. Exhibited artists include Jack Roberts and John Gary Brown. Open all year; Monday-Friday, 9-5; Saturday, by appointment only. Located in midtown Westport Shopping District; 1,500 sq. ft. Clients include designers, architects and residential clients. 60% of sales are to corporate collections or residential clients, 40% to interior design firms. Overall price range $200-6,500; most work sold at $1,000-4,500.

Media Considers all media except photography. Most frequently exhibits oil, acrylic, mixed media, fiber ceramics and glass.

Style Exhibits expressionism, minimalism, color field, hard-edge geometric abstraction, painterly abstraction and impressionism. Genres include landscapes. Prefers nonobjective, abstraction and impressionism. Specializes in commissions for special corporate, residential projects.

Terms Artwork is accepted on consignment (50% commission). Retail price set by the gallery. Gallery provides insurance, promotion and contract; show and shipping costs are shared.

Submissions Prefers artists with professional exhibit, sales, gallery record. Send query letter with résumé, brochure, business card, 8-12 slides, photographs, reviews and SASE. Call for appointment to show portfolio of photographs, slides and transparencies. Responds in 1 month. Files slides and résumé. Finds artists through word of mouth, referrals by other artists, visiting art fairs and exhibitions and artists' submissions. Reviews submissions regularly.

Tips Advises artists who hope to gain gallery representation to "visit the gallery to see what media and level of expertise is represented. If unable to travel to a gallery outside your region, review gallery guides for area to find out what styles the gallery shows. Prior to approaching galleries, artists need to establish an exhibition record through group shows. When you are ready to approach galleries, present professional materials and make follow-up calls."

MONTANA

ARTISTS' GALLERY

111 S. Grand, #106, Bozeman MT 59715. (406)587-2127. **Chairperson:** Justine Heisel. Retail and cooperative gallery. Estab. 1992. Represents the work of 20 local emerging and mid-career artists, 20 members. Sponsors 12 shows/year. Average display time 3 months. Open all year; Monday-Saturday, 10-5. Located near downtown; 900 sq. ft.; located in Emerson Cultural Center with other galleries, studios, etc. Clients include tourists, upscale and local community. 100% of sales are to private collectors. Overall price range $55-700.

Media Considers oil, acrylic, watercolor, pastel, pen & ink, drawing, mixed media, collage, paper, sculpture, ceramics and glass, woodcuts, engravings, linocuts and etchings. Most frequently exhibits oil, watercolor and ceramics.

Style Exhibits painterly abstraction, impressionism, photorealism and realism. Exhibits all genres. Prefers realism, impressionism and western.

Terms Co-op membership fee plus donation of time (20% commission). Rental fee for space; covers 1 month.

Retail price set by the artist. Gallery provides promotion; artist pays for shipping costs to gallery. Prefers artwork framed.

Submissions Artists must be able to fulfill "sitting" time or pay someone to sit. Send query letter with résumé, slides, photographs, artist's statement or actual work. Write for appointment to show portfolio of photographs and slides. Responds in 2 weeks.

THE BET ART & ANTIQUES

416 Central Ave., Great Falls MT 59401. (406)453-1151. **Partners:** D. Carter and E. Bowden. Retail gallery-antiques, old prints and art. Estab. 1955. Represents 12 mid-career and established artists/year. Interested in seeing the work of emerging artists. Exhibited artists include Lisa Lorimer and King Kuka. Open all year; Monday-Saturday, 10-530. Located downtown; 140 sq. ft. 50% of space for gallery artists. Clientele: tourists and locals. 50% private collectors. Overall price range $150-5,000; most work sold at $150-500.

Media Considers oil, acrylic, watercolor, pastel, pen & ink, drawing, sculpture and photography; all types of prints. Most frequently exhibits oil paintings, watercolors and woodblock prints.

Style Exhibits expressionism and neo-expressionism. Exhibits all genres. Prefers western, expressionism and landscapes.

Terms Accepts work on consignment (30% commission) or buys outright for 50% of retail price. Retail price set by the gallery and artist. Gallery provides promotion; shipping costs are shared. Prefers artwork framed.

Submissions Call or write for appointment to show portfolio of photographs. Responds in 1 month. Finds artists through word of mouth, local art shows and ads in phone book.

Tips "Don't bring in work in bad condition or unframed. Don't set exaggerated and unrealistic prices."

N CUSTER COUNTY ART & HERITAGE CENTER

P.O. Box 1284, Miles City MT 59301. (406)234-0635. Fax: (406)234-0637. E-mail: ccartc@midrivers.com. Website: www.ccac.milescity.org. **Executive Director:** Mark Browning. Nonprofit gallery. Estab. 1977. Interested in emerging and established artists. 90% of sales are to private collectors, 10% corporate clients. Sponsors 8 group shows/year. Average display time is 6 weeks. Overall price range $200-10,000; most artwork sold at $300-500. Open Tuesday-Sunday, 1-5 p.m.; May-September 9-5; Closed Mondays.

- The galleries are located in the former water-holding tanks of the Miles City WaterWorks. The underground, poured concrete structure is listed on the National Register of Historic Places. It was constructed in 1910 and 1924 and converted to its current use in 1976-77. 2003 recipient of Governor's Award for the Arts.

Media Considers all media and original handpulled prints. Most frequently exhibits painting, sculpture and photography.

Style Exhibits painterly abstraction, conceptualism, primitivism, impressionism, expressionism, neo-expressionism and realism. Genres include landscapes, western, portraits and figurative work. "Our gallery is seeking artists working with traditional and nontraditional Western subjects in new, contemporary ways." Specializes in western, contemporary and traditional painting and sculpture.

Terms Accepts work on consignment (30% commission). Retail price is set by gallery and artist. Exclusive area representation not required. Gallery provides insurance, promotion and contract; shipping expenses are shared.

Submissions Send query letter, résumé, brochure, slides, photographs and SASE. Write for appointment to show portfolio of originals, "a statement of why the artist does what he/she does" and slides. Slides and résumé are filed.

N HARRIETTE'S GALLERY OF ART

510 First Ave. N., Great Falls MT 59405. (406)761-0881. E-mail: harriette@msn.net. **Owner:** Harriette Stewart. Retail gallery. Estab. 1970. Represents 20 artists. Exhibited artists include Larry Zabel, Frank Miller, Arthur Kober, Richard Luce and Susan Guy. Sponsors 1 show/year. Average display time 6 months. Open all year. Located downtown; 1,000 sq. ft. 100% of space for special exhibitions. 90% of sales are to private collectors, 10% corporate collectors. Overall price range $100-10,000; most artwork sold at $200-750.

Media Considers oil, acrylic, watercolor, pastel, pencils, pen & ink, mixed media, sculpture, original handpulled prints, lithographs and etchings. Most frequently exhibits watercolor, oil and pastel.

Style Exhibits expressionism. Genres include wildlife, landscape, floral and western.

Terms Accepts work on consignment (33 1/3% commission); or outright for 50% of retail price. Retail price set by gallery and artist. Sometimes offers customer discounts and payment by installment. Gallery provides promotion; "buyer pays for shipping costs." Prefers artwork framed.

Submissions Send query letter with résumé, slides, brochure and photographs. Portfolio review requested if interested in artist's work. "Have Montana Room in the largest Western Auction in U.S.The Charles Russell Auction, in March every year—looking for new artists to display."

Tips "Proper framing is important."

JAILHOUSE GALLERY

218 Center Ave., Hardin MT 59034. (406)665-3239. Fax: (406)665-3220. Website: www.forevermontana.com. **Director:** Terry Jeffers. Nonprofit gallery. Estab. 1978. Represents 25 emerging, mid-career and established artists/year. Exhibited artists include Gale Running Wolf, Sr. and Mary Blain. Sponsors 9 shows/year. Average display time 6 weeks. Open all year; January-April; Tuesday-Friday, 10-5 (winter); May-December; Monday-Saturday, 9:30-5:30. Located downtown; 1,440 sq. ft. 75% space for special exhibitions; 25% of space for gallery artists. Clientele: all types. 95% private collectors, 5% corporate collectors. Overall price range $20-2,000; most work sold at $20-500.

Media Considers all media and all types of prints. Most frequently exhibits mixed media, watercolor and pen & ink.

Style Exhibits all styles and all genres. Prefers western, Native American and landscapes.

Terms Accepts work on consignment (30% commission). Retail price set by the gallery. Gallery provides insurance, promotion and contract. Artist pays shipping costs.

Submissions Send query letter with résumé, business card, artist's statement and bio. Call for appointment to show portfolio of photographs. Responds in 3 weeks. Finds artists through word of mouth, referrals by other artists, visiting art fairs and exhibitions and artists' submissions.

LIBERTY VILLAGE ARTS CENTER

400 S. Main, Chester MT 59522. (406)759-5652. **Contact:** Director. Nonprofit gallery. Estab. 1976. Represents 12-20 emerging, mid-career and established artists/year. Sponsors 6-12 shows/year. Average display time 6-8 weeks. Open all year; Tuesday-Friday, 1230-430. Located near a school; 1,000 sq. ft.; former Catholic Church. Clients include tourists and local community. 100% of sales are to private collectors. Overall price range $100-2,500; most work sold at $250-500

Media Considers all media; types of prints include woodcuts, lithographs, mezzotints, serigraphs, linocuts and pottery. Most frequently exhibits paintings in oil, water, acrylic, b&w photos and sculpture assemblages.

Style Exhibits all styles. Prefers contemporary and historic

Terms Accepts work on consignment (30% commission) or buys outright for 40% of retail price. Retail price set by the gallery. Gallery provides insurance and promotion; shipping costs are shared. Prefers artwork framed or unframed.

Submissions Send query letter with slides, bio and brochure. Portfolio should include slides. Responds only if interested within 1 year. Artists should cross us off their list. Files everything. Finds artists through word of mouth and seeing work at shows.

Tips "Artists make the mistake of not giving us enough information and permission to pass information on to other galleries."

NEBRASKA

ARTISTS' COOPERATIVE GALLERY

405 S. 11th St., Omaha NE 68102. (402)342-9617. Website: www.artistsco-opgallery.com. **President:** Susan Barnes. Cooperative and nonprofit gallery. Estab. 1974. Exhibits the work of 30-35 emerging, mid-career and established artists. 35 members. Exhibited artists include Mary Kolar and Jerry Jacoby. Sponsors 14 shows/year. Average display time 1 month. Open all year; Wednesday and Thursday, 11-5; Friday and Saturday, 11-10; Sunday, 12-5; closed Monday and Tuesday. Located in historic Old Market area; 5,000 sq. ft.; "large open area for display with 25 ft. high ceiling." 20% of space for special exhibitions. Clientele: 85% private collectors, 15% corporate collectors. Overall price range $20-2,000; most work sold at $20-1,000.

Media Considers oil, acrylic, watercolor, pastel, drawings, mixed media, collage, paper, sculpture, ceramic, fiber, glass, photography, woodcuts, serigraphs. Most frequently exhibits sculpture, acrylic, oil and ceramic.

Style Exhibits all styles and genres.

Terms Co-op membership fee plus donation of time. Retail price set by artist. Sometimes offers payment by installment. Artist provides insurance; artist pays for shipping. Prefers artwork framed. No commission charged by gallery.

Submissions Accepts only artists from the immediate area. "We each work one day a month." Send query letter with résumé, slides and bio. Write for appointment to show portfolio of originals and slides. "Applications are reviewed and new members accepted and notified in August if any openings are available." Files applications.

Tips "Fill out application and touch base with gallery in July."

CARNEGIE ARTS CENTER

P.O. Box 375, 204 W. Fourth St., Alliance NE 69301. (308)762-4571. Fax: (308)762-4571. E-mail: carnegieartscenter@bbc.net. Website: www.carnegieartscenter.com. **Contact:** Gretchen Garwood, director or Peggy Weber,

assistant gallery director. Nonprofit gallery. Estab. 1993. Represents 300 emerging, mid-career and established artists/year. 350 members. Exhibited artists include Liz Enyeart (functional pottery), Silas Kern (handblown glass). Sponsors 12 shows/year. Average display time 6 weeks. Open all year; Tuesday-Saturday, 10-4; Sunday, 1-4. Located downtown; 2,346 sq. ft.; renovated Carnegie library built in 1911. Clients include tourists, upscale, local community and students. 90% of sales are to private collectors, 10% corporate collectors. Overall price range $10-2,000; most work sold at $10-300.

Media Considers all media and all types of prints. Most frequently exhibits pottery, blown glass, 2-dimensional, acrylics, bronze sculpture, watercolor, oil and silver jewelry.

Style Exhibits all styles and genres. Most frequently exhibits realism, modern realism, geometric, abstraction.

Terms Accepts work on consignment (35% commission). Retail price set by the artist. Gallery provides promotion. Shipping costs negotiated. Prefers artwork framed.

Submissions Accepts only quality work. Send query. Write for appointment to show portfolio review of photographs, slides or transparencies. Responds only if interested within 1 month. Files résumé and contracts. Finds artists through word of mouth, referrals by other artists, visiting art fairs and exhibitions and artist's submissions.

Tips ''Presentations must be clean, 'new' quality, that is, ready to meet the public. Two-dimensional artwork must be nicely framed with wire attached for hanging. Unframed prints need protective wrapping in place.''

Ⓝ GALLERY 72

2709 Leavenworth, Omaha NE 68105-2399. (402)345-3347. Fax: (402)348-1203. Website: gallery72@novia.net. **Director:** Robert D. Rogers. Retail gallery and art consultancy. Estab. 1972. Interested in emerging, mid-career and established artists. Represents 10 artists. Sponsors 4 solo and 4 group shows/year. Average display time is 3 weeks. Clients include individuals, museums and corporations. 75% of sales are to private collectors, 25% corporate clients. Overall price range $750 and up.

Media Considers oil, acrylic, digital, watercolor, pastel, pen & ink, drawings, mixed media, collage, sculpture, ceramic, installation, photography, original handpulled prints and posters. Most frequently exhibits paintings, prints and sculpture.

Style Exhibits hard-edge geometric abstraction, color field, minimalism, impressionism and realism. Genres include landscapes and figurative work. Most frequently exhibits color field/geometric, impressionism and realism.

Terms Accepts work on consignment (commission varies), or buys outright. Retail price is set by gallery or artist. Gallery provides insurance; shipping costs and promotion are shared.

Submissions Send query letter with résumé, slides and photographs. Call to schedule an appointment to show a portfolio, which should include originals, slides and transparencies. Vitae and slides are filed.

Tips ''It is best to call ahead and discuss whether there is any point in sending your material.''

NOYES ART GALLERY

119 S. 9th St., Lincoln NE 68508. (402)475-1061. E-mail: julianoyes@aol.com. Website: www.noyesartgallery.com. **Director:** Julia Noyes. For profit gallery. Estab. 1992. Exhibits 150 emerging artists. 25 members. Average display time 1 month minimum. (If mutually agreeable this may be extended or work exchanged.) Open all year. Located downtown, ''near historic Haymarket District; 3093 sq. ft.; renovated 128-year-old building.'' 25% of space for special exhibitions. Clientele private collectors, interior designers and decorators. 90% private collectors, 10% corporate collectors. Overall price range $100-5,000; most work sold at $200-750.

Media Considers oil, acrylic, watercolor, pastel, pen & ink, drawings, mixed media, collage, paper, sculpture, ceramic, fiber, glass and photography; original handpulled prints, woodcuts, wood engravings, linocuts, engravings, mezzotints, etchings, lithographs and serigraphs. Most frequently exhibits oil, watercolor and mixed media.

Style Exhibits expressionism, neo-expressionism, impressionism, realism, photorealism. Genres include landscapes, florals, Americana, wildlife, figurative work. Prefers realism, expressionism, photorealism.

Terms Accepts work on consignment (10-35% commission). Retail price set by artist (sometimes in conference with director). Gallery provides promotion and contract; artist pays for shipping. Prefers artwork framed.

Submissions Send query letter with résumé, slides, bio, SASE; label slides concerning size, medium, price, top, etc. Submit at least 6-8 slides. Reviews submissions monthly. Responds in 1 month. Files résumé, bio and slides of work by accepted artists (unless artist requests return of slides). All materials are returned to artists whose work is declined.

Ⓝ ADAM WHITNEY GALLERY

8725 Shamrock Rd., Omaha NE 68114. (402)393-1051. Fax: (402)390-8643. E-mail: adamwhitney@uswest.net. **Director:** Carol Copple. Retail gallery. Estab. 1986. Represents 350 emerging, mid-career and established artists. Exhibited artists include Richard Murray, Debra May, Dan Boylan, Ken and Kate Andersen, Scott Potter, Phil

Hershberger and Brian Hirst. Average display time 3 months. Open all year; Monday-Saturday, 10-5. Located in countryside village; 5,500 sq. ft. 40% of space for special exhibitions. Overall price range $150-10,000.

Media Considers oil, paper, fiber, acrylic, sculpture, glass, watercolor, mixed media, ceramic, installation, pastel, collage, craft, jewelry. Most frequently exhibits glass, jewelry, two-dimensional works.

Style Exhibits all styles and genres.

Terms Accepts work on consignment (50% commission). Retail price set by gallery and artist. Gallery provides insurance, promotion and contract; shipping costs are shared. Prefers artwork framed.

Submissions Send query letter with résumé, slides, photographs and reviews. Call or write for appointment to show portfolio of originals, photographs and slides. Files résumé, slides, reviews.

NEVADA

ARTIST'S CO-OP OF RENO

627 Mill St., Reno NV 89502. (775)322-8896. Website: www.eldoradoreno.com. **President:** Mahree Roberts. Cooperative nonprofit gallery. Estab. 1966. Exhibits 12 feature shows/year and quarterly all-gallery change of show. Open all year; Monday-Sunday, 11-4. Located downtown; 1,000 sq. ft. in historic, turn of century "French laundry" building. Clients include tourists, upscale and local community.

Media Considers all media. Most frequently exhibits watercolor, oil, mixed media, pottery and photography.

Style Genres include western, landscapes, florals, wildlife, Americana, portraits, southwestern and figurative work. Prefers Nevada landscapes.

Terms There is co-op membership fee plus a donation of time. Retail price set by the artist. Gallery provides promotion. Artist pays for shipping costs from gallery. Prefers art framed.

Submissions Accepts only artists from northern Nevada. Send query letter with résumé, slides, photographs, reviews and bio. Call for appointment to show portfolio. Finds artists through word of mouth and artists' visits.

Tips "We limit our membership to 20 local artists so that each artist has ample display space."

CONTEMPORARY ARTS COLLECTIVE

101 E. Charlesten Blvd., Suite 101, Las Vegas NV 89104. (702)382-3886. Website: www.cac-lasvegas.org. **Acting President:** Jacie Maynard. Alternative space, nonprofit gallery. Estab. 1989. Represents emerging and mid-career artists, 250 members. Exhibited artists include Mary Warner, Eric Murphy, Wendy Kveck and Daryl DePry. Sponsors 9 shows/year. Average display time 5 weeks. Open all year; Tuesday-Saturday, 12-4; 1st Friday of each month 6-10p.m.; 1st Sunday following 1st Friday, 12-2p.m. Located downtown; 800 sq. ft. Clients include tourists, local community and students. 75% of sales are to private collectors, 25% corporate collectors. Overall price range $250-2,000; most work sold at $400.

Media Considers all media and all types of prints. Most frequently exhibits painting, photography and mixed media.

Style Exhibits conceptualism, group shows of contemporary fine art. Genres include all contemporary art/all media. Artist pays shipping costs. Prefers artwork ready for display. Finds artists through entries.

Tips "We prioritize group shows that are self-curated, or curated by outside curators. Groups need to be three to four artists or more. Annual guidelines are sent out in January for next coming year. We are looking for experimental and innovative work."

NEW HAMPSHIRE

MILL BROOK GALLERY & SCULPTURE GARDEN

236 Hopkinton Rd., Concord NH 03301. (603)226-2046. E-mail: artsculpt@mindspring.com. Website: www.the millbrookgallery.com. For-profit gallery. Estab. 1996. Exhibits over 70 emerging, mid-career and established artists. Exhibited artists include John Bott (painter), Laurence Young (painter), John Lee (sculptor) and Wendy Klemperer (sculptor). Sponsors 7 exhibits/year. Average display time 6 weeks. Open Tuesday-Saturday, 11-5; April 1-December 24th. Otherwise, by appointment. Located 3 miles west of The Concord NH Center; surrounding gardens, field and pond; outdoor juried sculpture exhibit. Three rooms inside for exhibitions, 1,800 sq. ft. Clients include local community, tourists and upscale, 10% of sales are to corporate collectors. Overall price range $80-30,000; most work sold at $500-1,000.

Media Considers acrylic, ceramics, collage, drawing, glass, mixed media, oil, pastel, sculpture, watercolor, etchings, mezzotints, serigraphs and woodcuts. Most frequently exhibits oil, acrylic and pastel.

Style Considers all styles. Most frequently exhibits color field/conceptualism, expressionism. Genres include landscapes. Prefers more contemporary art.

Terms Artwork is accepted on consignment and there is a 50% commission. Retail price set by the artist. Gallery provides insurance, promotion and contract. Accepted work should be framed and matted.

Submissions Call or write to show portfolio of photographs and slides. Send query letter with artist's statement, bio, photocopies, photographs, résumé, SASE and slides. Returns material with SASE. Responds in 1 month. Finds artists through word of mouth, submissions, art exhibits and referrals by other artists.

THE OLD PRINT BARN—ART GALLERY

P.O. Box 978, Winona Rd., Meredith NH 03253-0978. (603)279-6479. Fax: (603)279-1337. **Director:** Sophia Lane. Retail gallery. Estab. 1976. Represents 100-200 mid-career and established artists/year. May be interested in seeing the work of emerging artists in the future. Exhibited artists include Michael McCurdy, Ryland Loos and Joop Vegter. Sponsors 3-4 shows/year. Average display time 3-4 months. Open daily 10-5 (except Thanksgiving and Christmas Day). Located in the country; over 4,000 sq. ft.; remodeled antique 18th-century barn. 30% of space for special exhibitions; 70% of space for gallery artists. Clients include tourists and local. 99% of sales are to private collectors. Overall price range $10-30,000; most work sold at $200-900.

Media Considers watercolor, pastel and drawing; types of prints include woodcuts, engravings, lithographs, mezzotints, serigraphs, linocuts and etchings. Most frequently exhibits etchings, engravings (antique), watercolors.

Style Exhibits color field, expressionism, postmodernism, realism. Most frequently exhibits color field, realism, postmodernism. Genres include florals, wildlife, landscapes and Americana.

Terms Accepts work on consignment. Retail price set by the gallery and artist. Gallery provides promotion; shipping costs are shared.

• Artist is responsible for insurance. Prefers artwork unframed but shrink-wrapped with 1 inch on top for clips so work can hang without damage to image or mat.

Submissions Prefers only works of art on paper. No abstract art. Send query letter with résumé, brochure, 10-12 slides and artist's statement. Title, medium and size of artwork must be indicated clearly on slide label. Call or write for appointment to show portfolio or photographs. Responds in a few weeks. Files query letter, statements, etc. Finds artists through word of mouth, referrals of other artists, visiting art fairs and exhibitions and submissions.

Tips "Show your work to gallery owners in as many different regions as possible. Most gallery owners have a feeling of what will sell in their area. I certainly let artists know if I feel their images are not what will move in this area."

Ⓝ SHARON ARTS CENTER

30 Grove Street, Peterborough, NH 03458. (603)924-7676. Fax: (603)924-6795. E-mail: sharonarts@sharonarts.org. Website: www.sharonarts.org. Nonprofit. Estab. 1947. Represents 7-9 invitationals, 140 juried, 210 members emerging, mid-career and established artists/year. 1,100 members. Sponsors 10 shows/year. Average display time 6 weeks. Open all year; Monday-Saturday, 10-5; Sunday, 12-5. School of Art and Crafts located in a woodland setting; 2,500 sq. ft. 80% of space for special exhibitions; 20% of space for member artists. Clients include tourist, local and regional. 85% of sales are to private collectors, 15% corporate collectors. Overall price range $200-10,000; most work sold at $500-1,000.

Media Considers all media and all types of prints including computer generated. Most frequently exhibits fine arts, crafts and historical.

Style Exhibits expressionism, primitivism, realism, impressionism, abstract, still life, portraiture, painting, sculpture, glass, wood, tapestry, textiles, photography, collage, monoprint, jewelry, book arts. Exhibits all genres. Prefers representation, impressionism and abstractions.

Terms Accepts work on consignment (40% commission). Retail price set by the artist. Gallery provides insurance, promotion and contract; artist pays for shipping. Prefers artwork framed.

Submissions Send query letter with résumé, slides, bio, photographs and reviews. Call for appointment to show portfolio of photographs or slides. Responds in 2 months. Files résumé, sample slides or photos. Send copies. Finds artists through visiting exhibitions, submissions and word of mouth.

Tips "Artists shouldn't expect to exhibit right away. We plan exhibits 18 months in advance."

NEW JERSEY

BARRON ARTS CENTER

582 Rahway Ave., Woodbridge NJ 07095. (732)634-0413. Fax: (732)634-8633. E-mail: barronarts@twp.woodbridge.nj.us. Website: www.twp.woodbridge.nj.us. **Director:** Cynthia Knight. Nonprofit gallery. Estab. 1977. Interested in emerging, mid-career and established artists. Sponsors several solo and group shows/year. Average display time is 1 month. Clients include culturally minded individuals mainly from the central New Jersey

region. 80% of sales are to private collectors, 20% corporate clients. Overall price range $200-5,000. Gallery hours during exhibits: Monday-Friday 11-4; Sunday 2-4; Closed holidays.

Media Considers oil, acrylic, watercolor, pastel, pen & ink, drawings, mixed media, collage, works on paper, sculpture, ceramic, craft, fiber, glass, installation, photography, performance and original handpulled prints. Most frequently exhibits water color, oils, photography and mixed media.

Style Exhibits painterly abstraction, impressionism, photorealism, realism and surrealism. Genres include landscapes and figurative work. Prefers painterly abstraction, photorealism and realism.

Terms Accepts work on consignment. Retail price set by artist. Exclusive area representation not required. Gallery provides insurance, promotion and contract; artist pays for shipping.

Submissions Send query letter, résumé and slides. Call for appointment to show portfolio. Résumés and slides are filed.

Tips Most common mistakes artists make in presenting their work are "improper matting and framing and poor quality slides. There's a trend toward exhibition of more affordable pieces—pieces in the lower end of price range."

N CENTER GALLERY AT OLD CHURCH

561 Piermont Rd., Demarest NJ 07627. (201)767-7160. Fax: (201)767-0497. E-mail: gallery@occcartschool.org. Website: www.occcartschool.org. **Contact:** Paula Madawick, gallery director. Nonprofit gallery. Estab. 1974. Exhibits emerging, mid-career, established artists. Approached by 20-30 artists/year; 5 time slots available/year for individual, dual or group exhibits. Exhibited artists include: Permanent annual exhibits are faculty, student, NJ Small Works Show, Select Faculty Exhibit, Voices of the World Exhibit, Pottery Show and Sale and Photography Invitational every other year. Exhibited artists include Karen Karnes (pottery) and Matthew Metz (pottery). Sponsors 12 total exhibits/year with 1 photography exhibit/year. Average display time 1 month. Open Monday-Friday, 9-5; call for weekend and evening hours; closed National and some religious holidays. Center Gallery is prominently situated in the front of the Art School at Old Church building, light and with an open feel, configured in an L-shape. Approximately 800 sq. ft. Clients include local community, students, tourists, upscale. Overall price range: $50-4,000; most work sold at $500.

Media Considers all media except no reproductions. All work needs to be original. Most frequently exhibits ceramics, mixed media, painting—oil, watercolor and acrylic. Considers all types of prints.

Style Considers all styles. Most frequently exhibits realism, expressionism, imagism. Considers all genres.

Making Contact & Terms Gallery 33 1/3% of gross sale. Retail price set by the artist. Gallery provides promotion and contract. Accepted work should be framed, mounted. Does not require exclusive representation locally.

Submissions Call for information or visit website for submission details; slides and digital images on CD. Send query letter with artist's statement, bio, photographs, résumé, reviews, SASE, slides, CDs. Returns material with SASE. Responds to queries in 2 weeks. No permanent files. Finds artists through referrals by other artists, submissions, word of mouth, solicitations through professional periodicals.

Tips "Follow gallery guidelines available online or through phone contact."

N GALMAN LEPOW ASSOCIATES, INC.

1879 Old Cuthbert Rd., #12, Cherry Hill NJ 08034. (856)354-0771. Fax: (856) 428-7559. **Contact:** Judith Lepow. Art consultancy. Estab. 1979. Represents emerging, mid-career and established artists. Open all year. 1% of sales are to private collectors, 99% corporate collectors. Overall price range $300-20,000; most work sold at $500-5,000.

Media Considers oil, acrylic, watercolor, pastel, mixed media, collage, paper, sculpture, ceramic, craft, fiber, glass, photography, original handpulled prints, woodcuts, engravings, lithographs, pochoir, wood engravings, mezzotints, linocuts, etchings, and serigraphs.

Style Exhibits painterly abstraction, impressionism, realism, photorealism, pattern painting and hard-edge geometric abstraction. Genres include landscapes, florals and figurative work.

Terms Accepts artwork on consignment (40-50% commission). Retail price set by artist. Gallery provides insurance; shipping costs are shared. Prefers artwork unframed.

Submissions Send query letter with résumé, slides and SASE. Call for appointment to show portfolio of originals, slides and transparencies. Responds in 3 weeks. Files "anything we feel we might ultimately show to a client."

DAVID GARY LTD. FINE ART

158 Spring St., Millburn NJ 07041. (973)467-9240. Fax: (973)467-2435. **Director:** Steve Suskauer. Retail and wholesale gallery. Estab. 1971. Represents 17-20 mid-career and established artists. Exhibited artists include John Talbot and Theo Raucher. Sponsors 3 shows/year. Average display time 3 weeks. Open all year. Located in the suburbs; 2,000 sq. ft.; high ceilings with sky lights. Clients include "upper income." 70% of sales are to private collectors, 30% corporate collectors. Overall price range $250-25,000; most work sold at $1,000-15,000.

Media Considers oil, acrylic, watercolor, drawings, sculpture, pastel, woodcuts, engravings, lithographs, wood

engravings, mezzotints, linocuts, etchings and serigraphs. Most frequently exhibits oil, original graphics and sculpture.

Style Exhibits primitivism, painterly abstraction, surrealism, impressionism, realism and collage. All genres. Prefers impressionism, painterly abstraction and realism.

Terms Accepts artwork on consignment (50% commission). Retail price set by gallery and artist. Gallery services vary; artist pays for shipping. Prefers artwork unframed.

Submissions Send query letter with résumé, photographs and reviews. Call for appointment to show portfolio of originals, photographs and transparencies. Responds in 2 weeks. Files "what is interesting to gallery."

Tips "Have a basic knowledge of how a gallery works, and understand that the gallery is a business."

GROUNDS FOR SCULPTURE

18 Fairgrounds Rd., Hamilton NJ 08619. (609)586-0616. E-mail: info@groundsforsculpture.org. Website: www.groundsforsculpture.com. **Contact:** Brooke Barrie, director/curator. Museum. Estab. 1992. Exhibits emerging, mid-career and established artists. Exhibited artists in the museum include Dale Chihuly (glass) and Beverly Pepper (cast iron, stone). Exhibited artists in the sculpture park include George Segal and Isaac Witkin (bronze). Sponsors 5-8 exhibits/year. Average display time 2-7 months. Open all year; Tuesday-Sunday, 10-9. Located in an industrial area in Hamilton, New Jersey—centrally located between New York City and Philadelphia. Two-10,000 square feet museum buildings and 35 acre sculpture park.

Media Considers sculpture. Most frequently exhibits stone, bronze, metals and mixed media.

Style Most frequently exhibits all styles of contemporary sculpture.

Submissions Only sculpture is considered/reviewed. Send query letter with artist's statement, bio, reviews, slides and exhibition catalogues. Does not return material. Keeps materials in artist registry. Responds to queries in 2 months. Files all materials in artist registry unless artist requests their return. Finds artists through art exhibits, portfolio reviews and referrals by other artists and art reps.

KEARON-HEMPENSTALL GALLERY

536 Bergen Ave., Jersey City NJ 07304. (201)333-8855. Fax: (201)333-8488. E-mail: suzann@khgallery.com. Website: www.khgallery.com. **Director:** Suzann Anderson. Retail gallery. Estab. 1981. Represents emerging, mid-career and established artists. Exhibited artists include Dong Sik-Lee, Mary Buondies, Jesus Rivera, Stan Mullins, Linda Marchand, Stephen McKenzie, Elizabeth Bisbing and Kamil Kubik. Sponsors 3 shows/year. Average display time 2 months. Open Monday-Friday, 10-3; closed July and August. Located on a major commercial street; 150 sq. ft.; brownstone main floor, ribbon parquet floors, 14 ft. ceilings, ornate moldings, traditional. 100% of space for special exhibitions. Clients include local community and corporate. 60% of sales are to private collectors, 40% corporate collectors. Overall price range $200-8,000; most work sold at $1,500-2,500.

Media Considers oil, acrylic, watercolor, pastel, drawing, mixed media, collage, paper, sculpture, fiber, glass, installation, photography, engravings, lithographs, serigraphs, etchings and posters. Most frequently exhibits mixed media painting, photography and sculpture.

Style Prefers figurative expressionism and realism.

Terms Accepts work on consignment (50% commission). Retail price set by the gallery. Gallery provides promotion; artist pays for shipping. Prefers artwork framed.

Submissions Send query letter with résumé, slides, bio, brochure, SASE, reviews, artist's statement, price list of sold work. Write for appointment to show portfolio of photographs and slides. Responds in 6 weeks. Files slides and résumés. Finds artists through art exhibitions, magazines (trade), submissions.

Tips "View gallery website for artist requirements."

KERYGMA GALLERY

38 Oak St., Ridgewood NJ 07450. (201)444-5510. E-mail: vihuse@aol.com. Website: www.kerygmagallery.com. **Contact:** Vi Huse. Retail gallery. Estab. 1988. Represents 30 mid-career artists. Sponsors 9 shows/year. Average display time 4-6 weeks. Open all year. Located in downtown business district; 2,000 sq. ft.; "professionally designed contemporary interior with classical Greek motif accents." Clientele: primarily residential, some corporate. 80-85% private collectors, 15-20% corporate collectors. Most work sold at $2,000-5,000.

Media Considers oil, acrylic, watercolor, pastel, mixed media, sculpture. Prefers oil or acrylic on canvas.

Style Exhibits painterly abstraction, impressionism and realism. Genres include landscapes, florals, still life and figurative work. Prefers impressionism and realism.

Terms Accepts artwork on consignment (50% commission). Retail price set by gallery and artist. Gallery provides insurance, promotion and in some cases, a contract; shipping costs are shared.

Submissions Send query letter with résumé, slides, bio, photographs, reviews and SASE. Call for appointment to show portfolio originals, photographs and slides "only after interest is expressed by slide/photo review." Responds in 1 month. Files all written information, returns slides/photos.

Tips "An appointment is essential—as is a slide register."

N LANDSMAN'S GALLERY & PICTURE FRAMING

401 S. Rt. 30, Magnolia NJ 08049. Fax: (856)784-0334. E-mail: landsman401@aol.com. **Owner:** Howard Landsman. Retail gallery and art consultancy. Estab. 1965. Represents/exhibits 25 emerging, mid-career and established artists/year. Interested in seeing the work of emerging artists. Open all year; Tuesday-Saturday, 9-5. Located in suburban service-oriented area; 2,000 sq. ft. "A refuge in an urban suburban maze." Clients include upscale, local and established. 50% of sales are to private collectors, 50% corporate collectors. Overall price range $100-10,000; most work sold at $300-1,000.

Media Considers all media and all types of prints. Most frequently exhibits serigraphs, oils and sculpture.

Style Exhibits all styles and genres. Gallery provides insurance, promotion and contract. Artist pays for shipping costs. Prefers artwork framed.

Terms Artwork is accepted on consignment (50% commission). Retail price set by artist. Gallery provides insurance, promotion, contract. Artist pays shipping costs. Prefers artwork framed.

Submissions Send query letter with slides, photographs and reviews. Write for appointment to show portfolio of photographs and slides. Files slides, bios and résumé. Finds artists through word of mouth, referrals by other artists, visiting art fairs and exhibitions and submissions.

LIMITED EDITIONS & COLLECTIBLES

697 Haddon, Collingswood NJ 08108. (856)869-5228. Fax: (856)869-5228. E-mail: JDL697ltd@juno.com. Website: www.LTDeditions.net. **Owner:** John Daniel Lynch, Sr. For profit gallery. Estab. 1997. Approached by 24 artists/year. Exhibited artists include Richard Montmurro, James Allen Flood and Gino Hollander. Open all year. Located in downtown Collingswood; 700 sq. ft. Overall price range $190-20,000; most work sold at $450.

Media Considers all media and all types of prints. Most frequently exhibits acrylic, watercolors and oil.

Style Considers all styles and genres.

Terms Artwork is accepted on consignment and there is a 30% commission. Retail price set by the artist. Gallery provides insurance, promotion and contract. Accepted work should be framed, mounted and matted. Does not require exclusive representation locally.

Submissions Call or write to arrange a personal interview to show portfolio. Send query letter with bio, business card and résumé. Responds in 1 month. Finds artists through word of mouth, portfolio reviews, art exhibits, and referrals by other artists.

MARKEIM ART CENTER

Lincoln Ave. and Walnut St., Haddonfield NJ 08033. (856)429-8585. E-mail: LPUCHALSKI@aol.com. Website: www.markeimartcetner.com. **Center Manager:** Lisa Hamill. Nonprofit gallery. Estab. 1956. Represents emerging, mid-career and established artists. 465 members. Exhibited artists include Ben Cohen and Steve Kuzma. Sponsors 8-10 shows/year, both on and off site. Average display time 1 month. Open all year; Monday-Thursday, 10-4; Friday, 11-1; Saturday and Sunday, by appointment. Located downtown; 600 sq. ft. 75% of space for special exhibitions; 20% of space for gallery artists. Overall price range $100-2,000.

Media Considers all media. Must be original. Most frequently exhibits paintings, photography and sculpture.

Style Exhibits all styles and genres.

Terms Work not required to be for sale (20% commission taken if sold). Retail price set by the artist. Gallery provides promotion and contract. Artwork must be ready to hang.

Submissions Send query letter with résumé, slides, bio/brochure, photographs, SASE, business card, reviews and artist's statement. Write for appointment to show portfolio of photographs and slides. Files slide registry.

THE NOYES MUSEUM OF ART

Lily Lake Rd., Oceanville NJ 08231. (609)652-8848. Fax: (609)652-6166. E-mail: info@noyesmuseum.org. Website: www.noyesmuseum.org. **Curator of Collections and Exhibitions:** A. Weaver. Museum. Estab. 1983. Exhibits emerging, mid-career and established artists. Sponsors 9-12 shows/year. Average display time 6 weeks to 3 months. Open all year; Tuesday-Saturday, 10-430; Sunday, 12-5. 9,000 sq. ft.; "modern, window-filled building successfully integrating art and nature; terraced interior central space with glass wall at bottom overlooking Lily Lake." 75% of space for special exhibitions. Clients include rural, suburban, urban mix; high percentage of out-of-state vacationers during summer months.

Media All types of American fine art, craft and folk art.

Style Exhibits all styles and genres.

Submissions Send query letter with résumé, slides, photographs and SASE. "Letter of inquiry must be sent; then museum will set up portfolio review if interested." Portfolio should include slides. "Materials only kept on premises if artist is from New Jersey and wishes to be included in New Jersey Artists Resource File or if artist is being considered for inclusion in future exhibitions."

N PETERS VALLEY CRAFT EDUCATION CENTER

19 Kuhn Rd., Layton NJ 07851. (973)948-5200. Fax: (973)948-0011. E-mail: pv@warwick.net. Website: www.pv crafts.org. **Gallery Manager:** Jim Sittig. Nonprofit gallery. Estab. 1970. Approached by about 50 artists/year. Represents about 250 emerging, mid-career and established artists. Exhibited artists include William Abranowitz and Ann Baver. Average display time 2 months. Open year round, call for hours. Located in northwestern New Jersey in Delaware Water Gap National Recreation Area; 2 floors; approximately 3,000 sq. ft. Clients include local community, students, tourists and upscale. 5% of sales are to corporate collectors. Overall price range $5-3,000; most work sold at $100-300.

Media Considers all media and all types of prints. Also exhibits nonreferential, mixed media, collage and sculpture.

Style Considers all styles. Most frequently exhibits contemporary fine art and craft.

Terms Artwork is accepted on consignment and there is a 50% commission. There is a rental fee for space. The rental fee covers 1-2 months. Retail price set by the gallery. Gallery provides insurance and promotion. Accepted work should be framed, mounted and matted. Does not require exclusive representation locally. Accepts only artists from North America.

Submissions Call or write to arrange a personal interview to show portfolio. Send query letter with artist's statement, bio, résumé and slides. Returns material with SASE. Responds in 2 months. Files résumé and bio. Finds artists through submissions, art exhibits, art fairs, and referrals by other artists.

Tips ''Be neat and well organized. This gives it the 'edge' toward a sale.''

N PIERRO GALLERY OF SOUTH ORANGE

(formerly The Gallery of South Orange), Baird Center, 5 Mead St., S. Orange NJ 07079. (973)378-7755, ext. 3. Fax: (973)378-7833. E-mail: pierrogallery@southorange.org. Website: www.pierrogallery.org. **Director:** Judy Wukitsch. Nonprofit gallery. Estab. 1994. Approached by 75-185 artists/year. Exhibits 75-100 emerging, mid-career and established artists. Sponsors 5 openings, number of exhibits within each time slot varies. Average display time 7 weeks. Open all year; Wednesday-Thursday, 10-2 and 4-6; weekends, 1-4. Closed Mid-December through mid-January; August. Located in park setting, 100 year old building; 3 rooms from intimate to large on second floor with wrap-around porch for receptions. Artists enjoy the quality of exhibition space and professionalism of staff. Visitors include students, upscale and artists. ''As nonprofit we are not sales driven.''

Media Considers all media and prints, except posters—must be original works. Most frequently exhibits painting, mixed media/collage/sculpture.

Style Considers all styles and genres.

Terms Artwork is accepted on consignment and there is a 15% commission. Retail price set by the artist. Gallery provides insurance, promotion and contract. Accepted work should be framed. Does not require exclusive representation locally.

Submissions Mail portfolio for review. GOSO has 3 portfolio reviews per year January, June and October. Send query letter with artist's statement, résumé, slides and any other items they choose. Returns material with SASE. Responds in 2 months from review date. Accepted portfolios go in active file from which all exhibitions are curated. Finds artists through word of mouth, submissions, portfolio reviews and referrals by other artists.

Tips Send legible, clearly defined, properly identified slides.

NEW MEXICO

THE ALBUQUERQUE MUSEUM OF ART & HISTORY

2000 Mountain Rd. NW, Albuquerque NM 87104. (505)243-7255. Fax: (505)764-6546. Website: www.cabq.gov/museum. **Curator of Art:** Douglas A. Fairfield. Curator of History: Deb Slaney. Nonprofit museum. Estab. 1967. Located in Old Town, west of downtown.

Style Mission is to collect, promote, and showcase art and artifacts from Albuquerque, the state of New Mexico, and the Southwest. Sponsors mainly group shows and work from the permanent collection. Exhibits run 3-4 months.

Submissions Artists may send portfolio for exhibition consideration: slides, photos, disk, artist statement, résumé, SASE.

N ART CENTER AT FULLER LODGE

2132 Central Ave., Los Alamos NM 87544. (505)662-9331. Fax: (505)662-9334. E-mail: artful@losalamos.com. Website: www.artfulnm.org. **Executive Director:** John Werenko. Nonprofit gallery, education facility and retail shop for members. Estab. 1977. 388 members. Sponsors 9 shows/year. Average display time 5 weeks. Sponsors 2 fairs/year. One one-day fair in August, and one two-day fair during early November. Open all year; Monday-Saturday, 10-4. Located downtown; 3,400 sq. ft. 90% of space for special exhibitions. Clients include local,

regional and international visitors. 99% of sales are to private collectors, 1% corporate collectors. Overall price range $50-1,200; most artwork sold at $30-300.

Media Considers all media.

Style Exhibits all styles and genres.

Terms Accepts work by member artists on consignment (30% commission). Retail price set by the artist. Gallery provides insurance and promotion; artist pays for shipping. "Work should be in exhibition form (ready to hang)."

Submissions "Prefer the unique." Send query letter with résumé, slides, bio, brochure, photographs, SASE and reviews. Files "résumés, etc.; slides returned only by SASE." Applications for fairs, shows, teaching, and membership are on the website.

Tips "We put on juried competitions, guild exhibitions and special shows throughout the year. Send SASE for prospectus and entry forms."

BENT GALLERY AND MUSEUM

117 Bent St., Box 153, Taos NM 87571. (505)758-2376. Website: www.laplaza.org/art/museums_bent.php3. **Owner:** Tom Noeding. Retail gallery and museum. Estab. 1961. Represents 15 emerging, mid-career and established artists. Exhibited artists include E. Martin Hennings, Charles Berninghaus, C.J. Chadwell and Leal Mack. Open all year; 9-5 (summer); 10-4 (winter). Located 1 block off of the Plaza; "in the home of Charles Bent, the first territorial governor of New Mexico." 95% of sales are to private collectors, 5% corporate collectors. Overall price range $100-10,000; most work sold at $500-1,000.

Media Considers oil, acrylic, watercolor, pastel, pen & ink, drawings, sculpture, original handpulled prints, woodcuts, engravings and lithographs.

Style Exhibits impressionism and realism. Genres include traditional, landscapes, florals, southwestern and western. Prefers impressionism, landscapes and western works. "We continue to be interested in collectors' art deceased Taos artists and founders' works."

Terms Accepts work on consignment (33⅓-50% commission). Retail price set by gallery and artist. Artist pays for shipping. Prefers artwork framed.

Submissions Send query letter with brochure and photographs. Write for appointment to show portfolio of originals and photographs. Responds if applicable.

Tips "It is best if the artist comes in person with examples of his or her work."

Ⓝ FENIX GALLERY

228-B N. Pueblo Rd., Taos NM 87571. (505)758-9120. E-mail: jkendall@fenixgallery.com. Website: www.fenixgallery.com. **Director/Owner:** Judith B. Kendall. Retail gallery. Estab. 1989. Represents 18 emerging, mid-career and established artists. Exhibited artists include Alyce Frank and Earl Stroh. Sponsors 4 shows/year. Average display time 4-6 weeks. Open all year; daily, 10-5; Sunday, 12-5; closed Wednesday; by appointment only during winter months. Located on the main road through Taos; 2,000 sq. ft.; minimal hangings; clean, open space. 100% of space for special exhibitions during one-person shows; 50% of space for gallery artists during group exhibitions. Clientele experienced and new collectors. 90% private collectors, 10% corporate collectors. Overall price range $100-25,000; most work sold at $1,000-2,500.

Media Considers all media; primarily nonrepresentational, all types of prints except posters. Most frequently exhibits oil, sculpture and paper work/ceramics.

Style Exhibits expressionism, painterly abstraction, conceptualism, minimalism and postmodern works. Prefers conceptualism, expressionism and abstraction.

Terms Accepts work on consignment (50% commission). Retail price set by the artist or a collaboration. Gallery provides insurance, promotion and contract; artist pays shipping costs to and from gallery. Prefers artwork framed.

Submissions Prefers artists from area; "we do very little shipping of artist works." Send query letter with résumé, slides, bio, brochure, photographs, SASE, business card and reviews. Call for appointment to show portfolio of photographs. Responds in 3 weeks. Files "material I may wish to consider later—otherwise it is returned." Finds artists through personal contacts, exhibitions, studio visits, reputation regionally or nationally.

Tips "I rely on my experience and whether I feel conviction for the art and whether sincerity is present."

Ⓝ GALLERY A

105-107 Kit Carson, Taos NM 87571. (505)758-2343. E-mail: gallery@gallerya.com. Website: www.gallerya.com. **Owners/Directors:** Gene and Jules Sanchez. Director: Jules Sanchez. Retail gallery. Estab. 1960. Represents 40 emerging, mid-career and established artists. Exhibited artists include Gene Kloss and Fran Larsen. Sponsors 3-6 shows/year. Average display time 2 weeks. Open all year. Located one block from the plaza; 4,000 sq. ft. Clientele: "from all walks of life." 98% private collectors. Overall price range $400-25,000; most artwork sold at $1,500-5,000.

Media Considers oil, acrylic, watercolor, pastel, sculpture—bronze, stone or wood. Most frequently exhibits oil, pastels, watercolor and acrylic.

Style Exhibits traditional and contemporary.

Terms Accepts work on consignment (50% commission). Retail price set by artist. Sometimes offers customer discount and payment by installment. Gallery and artist provide promotion; artist pays for shipping. Expects artwork framed.

Submissions Send query letter with bio and photographs. Responds only if interested. Portfolio review not required. Files bios. Finds artists through artists' submissions. Artist must include SASE for return of submitted material.

N̲ IAC CONTEMPORARY ART

P.O. Box 21426, Albuquerque NM 87154-1426. (505)292-3675. E-mail: rs1@swcp.com. Website: www.iac1.free servers.com. **Art Consultant/Broker:** Michael F. Herrmann. Estab. 1992. Represents emerging, mid-career and established local artists from website. Coordinates studio visits for small groups and individuals. Represented artists include Michelle Cook and Vincent Distasio. Overall price range $250-40,000; most work sold at $800-7,000.

Media Considers all media.

Style Represents painterly abstraction, postmodern works and surrealism. Genres include figurative work.

Terms Retail price set by collaborative agreement with artist.

Submissions Send query letter with résumé, brochure, business card, slides, photographs, reviews, bio and SASE. Call or write for appointment to show portfolio. Responds in 1 month.

Tips ''I characterize the work we represent as Fine Art for the *Non*-McMainstream. We are always interested in seeing new work. We look for a strong body of work and when considering emerging artists we inquire about the artist's willingness to financially commit to their promotion. We prefer a website rather than slides. When sending slides, always include a SASE.''

CHARLOTTE JACKSON FINE ART

200 W. Marcy St., #101, Santa Fe NM 87501. (505)989-8688. Fax: (505)989-9898. E-mail: cgjart@aol.com. Website: www.charlottejackson.com. **Contact:** Charlotte Jackson, director. For-profit gallery. Estab. 1989. Approached by 50 artists/year; exhibits 25 emerging, mid-career and established artists/year. Exhibited artists include Joseph Marioni and Florence Pierce. Sponsors 12 exhibits/year. Average display time 3-4 weeks. Open all year; Tuesday-Friday, 10-5:30, Saturday, 11-4. Located in 2 exhibition spaces and offices. Clients include local community and upscale.

Media Considers acrylic, drawing, oil and watercolor. Reductive work only. Emphasis on monochrome painting.

Style Exhibits reductive style.

Terms Retail price of the art set by the artist. Gallery provides promotion. Requires exclusive representation locally. Prefers only reductive and monochrome.

Submissions Mail portfolio for review or send query letter with bio, SASE and visuals. Returns material with SASE. Responds to queries in 6 months.

N̲ JONSON GALLERY, UNIVERSITY OF NEW MEXICO

1909 Las Lomas NE, Albuquerque NM 87131-1416. (505)277-4967. Fax: (505)277-3188. E-mail: jonsong@unm.e du. Website: www.unm.edu/~jonsong/. **Contact:** Robert Ware, curator. Alternative space, museum and non-profit gallery. Estab. 1950. Approached by 20-30 artists/year. Represents emerging and mid-career artists. Exhibited artists include Raymond Jonson (oil/acrylic on canvas/masonite). Sponsors 6-8 exhibits/year. Average display time 6 weeks. Open Tuesday-Friday, 9-4. Closed Christmas through New Years. Clients include local community, students and tourists. Overall price range $150-15,000; most work sold at $3,000-4,000.

Media Considers all media.

Style Exhibits conceptualism, geometric abstraction, minimalism and postmodernism. Most frequently exhibits conceptual, postmodernism and geometric abstraction.

Terms Artwork is accepted on consignment and there is a 25% commission. Retail price set by dealer. Gallery provides insurance and promotion. Accepted work should be ready for display. Does not require exclusive representation locally.

Submissions Write to arrange a personal interview to show portfolio of photographs, slides, transparencies and originals. Send query letter with artist's statement, bio, brochure, business card, photocopies, photographs, résumé, reviews, SASE and slides. Responds in 1 week. Files slides, bios, CVs, reviews of artists' works in exhibitions. Finds artists through word of mouth, submissions, art exhibits and referrals by other artists.

Tips Submit a viable exhibition proposal.

☑ MARGEAUX KURTIE MODERN ART

39 Yerba Buena, P.O. Box 39, Cerrillos NM 87010. (505)473-2250. E-mail: mkma@att.net. Website: www.mkma madrid.com. **Contact:** Jill Alikas St. Thomas, director. Art consultancy. Estab. 1996. Approached by 200 artists/year. Represents 13 emerging, mid-career and established artists. Exhibited artists include Thomas St. Thomas, mixed media painting and sculpture; Gary Groves, color infrared film photography. Sponsors 8 exhibits/year. Average display time 5 weeks. Open January-April; Friday-Sunday, 11-5 or by appointment; April-December, 11-5, except Tuesday and Wednesday or by appointment. Located within an historic adobe home, 18 miles S.E. of Santa Fe; 5,000 sq. ft. Clients include local community, students and tourists. 5% of sales are to corporate collectors. Overall price range $500-15,000; most work sold at $2,800.

Media Considers acrylic, glass, mixed media, paper, sculpture. Most frequently exhibits acrylic on canvas, oil on canvas, photography.

Style Exhibits conceptualism, pattern painting. Most frequently exhibits narrative/whimsical, pattern painting, illussionistic. Genres include figurative work, florals.

Terms Artwork is accepted on consignment and there is a 50% commission. Retail price set by the gallery. Gallery provides insurance. Accepted work should be framed, mounted or matted. Requires exclusive representation locally.

Submissions Website: lists criteria for review process. Send query letter with artist's statement, bio, résumé, reviews, SASE, slides, $25 review fee, check payable to gallery. Returns material with SASE. Responds to queries in 1 month. Finds artists through art fairs, art exhibits, portfolio reviews, referrals by other artists, submissions, word of mouth.

Tips "Label all slides, medium, size, title and retail price, send only works that are available."

☒ RICHARD LEVY GALLERY

514 Central Ave. SW, Albuquerque NM 87102. (505)766-9888. E-mail: info@levygallery.com. Website: www.le vygallery.com. **Contact:** Richard Levy or Viviette Hunt. Estab. 1992. Approached by 100 artists/year; exhibits 25 emerging and mid-career artists/year. Exhibited artists include Frederick Hammersley (oil on canvas) and Stuart Arends (mixed media). Sponsors 10 exhibits/year. Average display time 4-6 weeks. Open Tuesday-Saturday, 11-4. Closed during art fairs (always noted on voice message). Located on Central Ave. between 5th and 6th. Clients include upscale. 60% of sales are to corporate collectors. Overall price range $2,000-5,000; most work sold at $5,000.

Media Considers all media. Most frequently exhibits paintings, prints and photography. Considers engravings, etchings, linocuts, lithographs and mezzotints.

Style Exhibits conceptualim, geometric abstraction, minimalism and painterly abstraction. Most frequently exhibits contemporary, minimalism and geometric abstraction. Considers all genres.

Terms Artwork is accepted on consignment and there is a 50% commission or artwork is bought outright for 50% of retail price. Retail price of the art set by the gallery and the artist. Gallery provides insurance and some promotion. Artwork should either be framed, mounted AND matted or presented without the same. Prefers exclusive representation locally.

Submissions Write to arrange a personal interview to show portfolio or send query letter with artist's statement, bio, brochure, business card, photocopies, photographs, résumé, reviews, SASE and/or slides. Responds to queries only if interested within 6 months. Files artists that "we intend to watch or contact." Finds artists through art fairs and exhibits, portfolio reviews, referrals by other artists and word of mouth.

Tips "Do not just show up with a portfolio. We are in the business of selling art and this is very disruptive."

NEDRA MATTEUCCI GALLERIES

1075 Paseo De Peralta, Santa Fe NM 87501. (505)982-4631. Fax: (505)984-0199. E-mail: inquiry@matteucci.com. Website: www.matteucci.com. **Director of Advertising/Public Relations:** Alex Hanna. For-profit gallery. Estab. 1972. Main focus of gallery is on deceased artists of Taos, Sante Fe and the West. Approached by 20 artists/year. Represents 100 established artists. Exhibited artists include Dan Ostermiller and Glenna Goodacre. Sponsors 3-5 exhibits/year. Average display time 1 month. Open all year; Monday-Saturday, 830-5. Clients include upscale.

Media Considers ceramics, drawing, oil, pen & ink, sculpture and watercolor. Most frequently exhibits oil, watercolor and bronze sculpture.

Style Exhibits impressionism. Most frequently exhibits impressionism, modernism and realism. Genres include Americana, figurative work, landscapes, portraits, Southwestern, Western and wildlife.

Terms Artwork is accepted on consignment. Retail price set by the gallery and the artist. Requires exclusive representation within New Mexico.

Submissions Write to arrange a personal interview to show portfolio of transparencies. Send query letter with bio, photographs, résumé and SASE.

ⓃMICHAEL MCCORMICK GALLERIES

106-C Paseo del Pueblo Norte, Taos NM 87571. (505)758-1372 or (800)279-6879. Fax: (505)751-0090. E-mail: mail@mccormickgallery.com. Website: McCormickgallery.com. Retail gallery. Estab. 1983. Represents 10 emerging and established artists. Provides 3 solo and 1 group show/year. Average display time 6 weeks. 90% of sales are to private collectors, 10% corporate clients. Overall price range $1,500-85,000; most work sold at $3,500-10,000.

Media Considers oil, acrylic, watercolor, pastel, pen & ink, drawings, mixed media, collage, works on paper, sculpture, ceramic, photography, wood engravings, linocuts, engravings, mezzotints, etchings, lithographs, pochoir, serigraphs and posters. Most frequently exhibits oil, pottery and sculpture/stone.

Style Exhibits impressionism, neo-expressionism, surrealism, primitivism, painterly abstraction, conceptualism and postmodern works. Genres include landscapes and figurative work. Interested in work that is "classically, romantically, poetically, musically modern." Prefers figurative work, lyrical impressionism and abstraction.

Terms Accepts work on adjusted consignment (approximately 50% commission). Retail price set by gallery and artist. Customer discounts and payment by installment are available. Exclusive area representation required. Gallery provides promotion and contract; artist pays for shipping. Prefers artwork framed.

Submissions Send query letter with résumé, brochure, slides, photographs, bio and SASE. Portfolio review requested if interested in artist's work. Responds in 7 weeks. Finds artists usually through word of mouth and artists traveling through town.

Tips "Send a brief, concise introduction with several color photos. During this last year there seem to be more art and more artists but fewer sales. The quality is declining based on a mad, frantic scramble to find something that will sell. Take some business courses. Try to be objective within your goals. If you want something you've never had, you have to do something you've never done."

ⓃNEW MILLENNIUM ART/THE FOX GALLERY

217 W. Water, Santa Fe NM 87501. (505)983-2002. **Owner:** Stephen Fox. Retail gallery. Estab. 1980. Represents 12 mid-career artists. Exhibited artists include R.C. Gorman and T.C. Cannon. Sponsors 4 shows/year. Average display time 1 month. Open all year. Located 3 blocks from plaza; 3,000 sq. ft.; "one large room with 19 ft. ceilings." 20% of space for special exhibitions. Clientele "urban collectors interested in Indian art and contemporary Southwest landscapes." 90% private collectors; 10% corporate collectors.

Media Considers oil, acrylic, watercolor, pastel, mixed media, sculpture, original handpulled prints, offset reproductions, woodcuts, lithographs, serigraphs and posters. Most frequently exhibits acrylic, woodblock prints and posters.

Style Exhibits expressionism and impressionism. Genres include Southwestern.

Terms Accepts artwork on consignment (40% commission). Retail price set by the gallery. Gallery provides insurance and promotion. Shipping costs are shared. Prefers artwork framed.

Submissions Accepts only Native American artists from the Southwest. Send query letter with résumé, brochure, photographs and reviews. Write for appointment to show a portfolio of photographs. Responds in 2 weeks.

Tips "We are primarily interested in art by American Indians; occasionally we take on a new landscapist."

UNIVERSITY ART GALLERY, NEW MEXICO STATE UNIVERSITY

Williams Hall, Box 30001, MSC 3572, Las Cruces NM 88003-8001. (505)646-2545. E-mail: artglry@nmsu.edu. Website: www.nmsu.edu/~artgal. **Director:** Mary Anne Redding. Estab. 1972. Represents emerging, mid-career and established artists. Exhibited artists include Judy Chicago, Joyce & Max Kozloff and Luis Jimenez. Sponsors 5-6 shows/year. Average display time 6-8 weeks. Closed on university holidays. Located at university; 4,600 sq. ft. 100% of space for special exhibitions. Overall price range $200-10,000; most artwork sold at $1,000.

Media Considers all media and all types of prints.

Style Exhibits all styles and genres.

Terms Accepts work on consignment (33% commission). Retail price set by the artist. Shipping costs are paid by the gallery. Prefers artwork framed, or ready to hang.

Submissions Send query letter with résumé, 20 slides, bio, SASE, brochure, photographs, business card and reviews. Write for appointment to show portfolio of originals, photographs, transparencies and slides. Responds in 4 months. Files résumés.

Tips "Tenacity is a must."

NEW YORK

ⓃADIRONDACK LAKES CENTER FOR THE ARTS

Route 28, Blue Mountain Lake NY 12812. (518)352-7715. E-mail: alca@telenet.net. **Director:** Ellen C. Butz. Nonprofit galleries in multi-arts center. Estab. 1967. Represents 107 emerging, mid-career and established

artists/year. Sponsors 6-8 shows/year. Average display time 1 month. Open Monday-Friday, 10-4; July and August daily. Located on Main Street next to post office; 176 sq. ft.; "pedestals and walls are white, some wood and very versatile." Clients include tourists, summer owners and year-round residents. 90% of sales are to private collectors, 10% corporate collectors. Overall price range $100-10,000; most work sold at $100-1,000.

Media Considers all media and all types of prints. Most frequently exhibits paintings, sculpture, wood and fiber arts.

Style Exhibits all styles. Genres include landscapes, Americana, wildlife and portraits.

Terms Accepts work on consignment (30% commission). Retail price set by the artist. Gallery provides insurance, contract; shares promotion. Prefers artwork framed.

Submissions Send query letter with slides or photos and bio. Annual submission deadline early November; selections complete by February 1. Files "slides, photos and bios on artists we're interested in." Reviews submissions once/year. Finds artists through word of mouth, art publications and artists' submissions.

Tips "We love to feature artists who can also teach a class in their media for us. It increases interest in both the exhibit and the class."

Ⓝ ART WITHOUT WALLS, INC.

P.O. Box 341, Sayville NY 11782. (631)567-9418. Fax: (63)567-9418. E-mail: artwithoutwalls@webtv.net. **Contact:** Sharon Lippman, executive director. Nonprofit gallery. Estab. 1985. Approached by 300 artists/year. Represents 100 emerging, mid-career and established artists. Exhibited artists include Tone Aanderaa (painting), Yanka Cantor (sculpture) and Stephanie Isles (photography). Sponsors 10 exhibits/year. Average display time 1 month. Open all year; Sunday-Monday, 9-5. Closed December 22-January 5 and Easter week. Clients include students, upscale and emerging artists. Overall price range $1,000-25,000; most work sold at $3,000-5,000.

Media Considers all media and all types of prints. Most frequently exhibits painting, sculpture and drawing.

Style Considers all styles and genres. Most frequently exhibits impressionism, expressionism, postmodernism.

Terms Artwork is accepted on consignment and there is 20% commission. Retail price set by the artist. Gallery provides promotion and contract. Accepted work should be framed, mounted and matted.

Submissions Mail portfolio for review. Send query letter with artist's statement, brochure, photographs, résumé, reviews, SASE and slides. Returns material with SASE. Responds in 1 month. Files artist résumé, slides, photos and artist's statement. Finds artists through submissions, portfolio reviews and art exhibits.

Tips Work should be properly framed with name, year, medium, title and size.

COURTHOUSE GALLERY, LAKE GEORGE ARTS PROJECT

1 Amherst St., Lake George NY 12845. (518)668-2616. Fax: (518)668-3050. E-mail: mail@lakegeorgearts.org. **Gallery Director:** Laura Von Rosk. Nonprofit gallery. Estab. 1986. Approached by 200 artists/year. Exhibits 10-15 emerging, mid-career and established artists. Sponsors 5-8 exhibits/year. Average display time 5-6 weeks. Open all year; Tuesday-Friday, 12-5; Saturday, 12-4. Closed mid-December to mid-January. Clients include local community, tourists and upscale. Overall price range $100-5,000; most work sold at $500.

Media Considers all media and all types of prints. Most frequently exhibits painting, mixed media and sculpture.

Style Considers all styles and genres.

Terms Artwork is accepted on consignment and there is a 25% commission. Retail price set by the artist. Gallery provides insurance, promotion and contract. Accepted work should be framed, mounted and matted.

Submissions Mail portfolio for review. Deadline always January 31st. Send query letter with artist's statement, bio, résumé, SASE and slides. Returns material with SASE. Responds in 2 months. Finds artists through word of mouth, submissions, portfolio reviews, art exhibits, art fairs and referrals by other artists.

FOCAL POINT GALLERY

321 City Island Ave., City Island NY 10464. (718)885-1403. Fax: (718)885-1451. E-mail: RonTerner@aol.com. Website: www.FocalPointGallery.com. **Contact:** Ron Terner. Retail gallery and alternative space. Estab. 1974. Interested in emerging and mid-career artists. Exhibited artists include Marguerite Chadwick-Juner (watercolor). Sponsors 2 solo and 6 group shows/year. Average display time 3-4 weeks. Open Tuesday-Sunday, 12-7 with additional evening hours; Friday and Saturday, 7:30-9. Clients include locals and tourists. Overall price range $175-750; most work sold at $300-500.

Media Considers all media. Most frequently exhibits photography, watercolor, oil. Also considers etchings, giclée, color prints, silver prints.

Style Exhibits all styles. Most frequently exhibits painterly abstraction, conceptualism, expressionism. Genres include figurative work, florals, landscapes, portraits. Open to any use of photography.

Terms Accepts work on consignment (40% commission). Exclusive area representation required. Customer discounts and payment by installment are available. Gallery provides promotion. Prefers artwork framed.

Submissions "Please call for submission information. Do not include résumés. The work should stand by itself. Slides should be of high quality."

Tips "Care about your work."

▒ THE GRAPHIC EYE GALLERY OF LONG ISLAND

402 Main St., Port Washington NY 11050. (516)883-9668. Cooperative gallery. Estab. 1974. Represents 25 artists. Sponsors solo, 2-3 person and 4 group shows/year. Average display time 1 month. Interested in emerging and established artists. Overall price range $35-7,500; most artwork sold at $500-800.

Media Considers mixed media, collage, works on paper, pastels, photography, paint on paper, woodcuts, wood engravings, linocuts, engravings, mezzotints, etchings, lithographs, serigraphs, and monoprints.

Style Exhibits impressionism, expressionism, realism, primitivism and painterly abstraction. Considers all genres.

Terms Co-op membership fee plus donation of time. Retail price set by artist. Offers payment by installments. Exclusive area representation not required. Prefers framed artwork.

Submissions Send query letter with résumé, SASE, slides and bio. Portfolio should include originals and slides. "When submitting a portfolio, the artist should have a body of work, not a 'little of this, little of that.'" Files historical material. Finds artists through visiting exhibitions, word of mouth, artist's submissions and self-promotions.

Tips "Artists must produce their *own* work and be actively involved. We have a competitive juried art exhibit annually. Open to all artists who work on paper."

EDWARD HOPPER HOUSE ART CENTER

82 North Broadway, Nyack NY 10960. (845)358-0774. E-mail: edwardhopper.house@verizon.net. Website: www.edwardhopperhouseartcenter.org. **Director:** Cathy Shiga-Gattullo. Nonprofit gallery, historic house. Estab. 1971. Approached by 200 artists/year. Exhibits 100 emerging, mid-career and established artists. Sponsors 11 exhibits/year. Average display time 1 month. Open all year; Thursday-Sunday from 1-5. The house was built in 1858. There are four gallery rooms on the first floor. Clients include local community, students, tourists, upscale. Overall price range $100-12,000; most work sold at $750.

Media Considers all media and all types of prints except posters. Most frequently exhibits watercolor, photography, oil.

Style Considers all styles and genres. Most frequently exhibits realism, abstraction, expressionism.

Terms Artwork is accepted on consignment and there is a 30% commission. Retail price set by the artist. Gallery provides insurance, promotion and contract. Accepted work should be framed, mounted and matted. Does not require exclusive representation locally.

Submissions Call. Mail portfolio for review. Send query letter with artist's statement, bio, brochure, business card, photocopies, photographs, résumé, reviews, SASE and slides. Returns material with SASE. Responds to queries in 3 weeks. Files all materials unless return specified and paid. Finds artists through art fairs, art exhibits, portfolio reviews, referrals by other artists, submissions and word of mouth.

Tips "When shooting slides, don't have your artwork at an angle and don't have a chair or hands in the frame. Make sure the slides look professional and are an accurate representation of your work."

▒ IMPACT ARTIST GALLERY, INC.

2495 Main St., Suite 545, Buffalo NY 14214. (716)835-6817. E-mail: impact@buffalo.com. Website: www.buffalo.com/impact. Cooperative gallery, nonprofit gallery and rental gallery. Estab. 1993. Approached by 500 artists/year. Represents 310 emerging, mid-career and established artists. Sponsors 12 exhibits/year. Open all year; Tuesday-Friday, 11-4. Clients include local community, tourists and upscale.

Media Considers all media except glass, installation and craft. Considers engravings, etchings, lithographs, serigraphs and woodcuts.

Style Considers all styles. Most frequently exhibits expressionism, painterly abstraction, surrealism. Considers all genres.

Terms Artwork is accepted on consignment and there is a 25% commission. Retail price set by the artist. Gallery provides promotion. Accepted work should be framed, matted and ready for hanging. Does not require exclusive representation locally. Women's art except for Fall National Show and Summer Statewide Show.

Submissions Write to arrange a personal interview to show portfolio of slides. Mail portfolio for review. Send query letter with SASE and slides. Responds in 2 months. Files artist statement and résumé.

ISLIP ART MUSEUM

50 Irish Lane, East Islip NY 11730. (631)224-5402. Fax: (631)224-5417. E-mail: info@islipartmuseum.org. Website: www.islipartmuseum.org. **Director:** M. Cohalan. Nonprofit museum gallery. Estab. 1973. Interested in emerging and mid-career artists. Sponsors 14 group shows/year. Average display time is 6 weeks. Open Wednesday-Saturday, 10-4; Sunday, 12-4. Clients include contemporary artists from Long Island, New York City and abroad.

Media Considers oil, acrylic, watercolor, pastel, pen & ink, drawings, mixed media, collage, works on paper, sculpture, ceramic, craft, fiber, glass, installation, photography, performance and original handpulled prints. Most frequently exhibits installation, oil and sculpture.

Style Exhibits all styles, emphasis on experimental. Genres include landscapes, Americana, portraits, figurative work and fantasy illustration. "We consider many forms of modern work by artists from Long Island, New York City and abroad when organizing exhibitions. Our shows are based on themes, and we only present group exhibits. Museum expansion within the next two years will allow for one and two person exhibits to occur simultaneously with the ongoing group shows."

Terms Gallery provides insurance, promotion, contract and shipping.

Submissions Send résumé, brochure, slides and SASE. Slides, résumé, photos and press information are filed. The most common mistake artists make in presenting their work is that "they provide little or no information on the slides they have sent to the museum for consideration."

N MADELYN JORDON FINE ART

40 Cushman Rd., Scarsdale NY 10583. (914)472-4748. E-mail: mrjart@aol.com. Website: www.madelynjordanfi neart.com. **Contact:** Madelyn Jordon. Art consultancy, for-profit gallery. Estab. 1991. Approached by 50 artists/year. Exhibits 40 mid-career and established artists. Exhibited artists include Ted Larsen and Derek Buckner. Clients include local community and upscale. 10% of sales are to corporate collectors. Overall price range $500-20,000; most work sold at $3,000-5,000.

Media Considers all media and all types of prints. Most frequently exhibits paintings, works on paper and sculpture.

Style Considers all styles and genres.

Terms Gallery provides insurance and promotion. Requires exclusive representation locally.

Submissions Send artist's statement, bio, photographs, SASE or slides. Returns material with SASE.

N KIRKLAND ART CENTER

9½ E. Park Row, P.O. Box 213, Clinton NY 13323-0213. (315)853-8871. Fax: (315)853-2076. E-mail: kacinc@dre amscape.com. **Contact:** Director. Nonprofit gallery. Estab. 1960. Interested in emerging, mid-career and established artists. Sponsors about 8 shows/year. Average display time is 7 weeks. Clients include general public and art lovers. 99% of sales are to private collectors, 1% corporate clients. Overall price range $60-4,000; most artwork sold at $200-1,200.

Media Considers oil, acrylic, watercolor, pastel, pen & ink, drawings, mixed media, collage, works on paper, sculpture, ceramic, craft, fiber, glass, installation, photography, performance art and original handpulled prints. Most frequently exhibits watercolor, oil/acrylic, prints, sculpture, drawings, photography and fine crafts.

Style Exhibits painterly abstraction, conceptualism, impressionism, photorealism, expressionism, realism and surrealism. Genres include landscapes, florals and figurative work.

Terms Accepts work on consignment (25% commission). Retail price set by artist. Exclusive area representation not required. Gallery provides insurance, promotion and contract; artist pays for one-way shipping.

Submissions Send query letter, résumé, slides, slide list and SASE.

Tips "Shows are getting very competitive—artists should send us slides of their most challenging work, not just what is most saleable. We are looking for artists who take risks in their work and display a high degree of both skill and imagination. It is best to call or write for instructions and more information."

N LANDING GALLERY

7956 Jericho Turnpike, Woodbury NY 11797. (516)364-2787. Fax: (516)364-2786. E-mail: landinggallery@aol.c om. **President:** Bruce Busko. For-profit gallery. Estab. 1985. Approached by 40 artists/year. Exhibits 50 emerging, mid-career and established artists. Exhibited artists include Bruce Busko, mixed media; Edythe Kane, watercolor. Sponsors 2 exhibits/year. Average display time 2-3 months. Open all year; Monday-Saturday, 10-6; Sunday, 11-4. Closed Tuesdays all year. Sundays closed in Summer. Located in the middle of Long Island's affluent North Shore communities, 30 miles east of New York City. 3,000 sq. ft. on 2 floors with 19 ft. ceilings. The brick building is on the corner of a major intersection. Clients include local community, tourists and upscale. 5% of sales are to corporate collectors. Overall price range $100-12,000; most work sold at $1,500-2,000.

Media Considers all media. Most frequently exhibits paintings, prints and sculpture. Considers engravings, etchings, lithographs, mezzotints and serigraphs.

Style Considers all styles. Most frequently exhibits realism, abstract and impressionism. Considers figurative work, florals and landscapes.

Terms Artwork is accepted on consignment and there is a 50% commission. Retail price set by the gallery. Gallery provides insurance, promotion and contract. Accepted work should be framed. Requires exclusive representation locally.

Submissions Call to arrange a personal interview to show portfolio of photographs, slides and transparencies. Mail portfolio for review. Send query letter with artist's statement, bio, brochure, business card, photocopies, photographs, résumé, reviews, SASE and slides. Returns material with SASE. Responds in 2 weeks. Files photos, slides, photocopies and information. Finds artists through word of mouth, submissions, portfolio reviews, art exhibits, art fairs and referrals by other artists.

Tips Permanence denotes quality and professionalism.

LIMNER GALLERY

59 Main St., Phoenicia NY 12464. (845)688-7129. E-mail: slowart@aol.com. Website: www.slowart.com. **Director:** Tim Slowinski. Limner Gallery is an artist-owned alternative retail (consignment) gallery. Estab. 1987. Represents emerging and mid-career artists. Hosts periodic thematic exhibitions of emerging artists selected by competition, cash awards up to $1,000. Entry available for SASE or from website. Sponsors 6-8 shows/year. Average display time one month. Open Thursday-Sunday, 12-6; year-round, by appointment. Located in storefront 400 sq. ft. 60-80% of space for special exhibitions; 20-40% of space for gallery artists. Clients include lawyers, real estate developers, doctors, architects. 95% of sales are to private collectors, 5% corporate collectors. Overall price range $300-10,000.

Media Considers all media, all types of prints except posters. Most frequently exhibits painting, sculpture and works on paper.

Style Exhibits primitivism, surrealism, political commentary, satire, all styles, postmodern works, all genres. "Gallery exhibits all styles but emphasis is on nontraditional figurative work."

Terms Accepts work on consignment (50% commission). Retail price set by the gallery and the artist. Gallery provides promotion and contract; artist pays shipping costs to and from gallery. Prefers artwork framed.

Submissions Send query letter with résumé, slides, bio and SASE. Call for appointment to show portfolio of originals, photographs, slides and transparencies. Responds in 3 weeks. Files slides, résumé. Finds artists through word of mouth, art publications and sourcebooks, submissions.

MAIN STREET GALLERY

105 Main Street, P.O. Box 161, Groton NY 13073. (607)898-9010. E-mail: maingal@localnet.com. Website: www.mainstreetgal.com. **Director:** Adrienne Smith. For-profit gallery, art consultancy. Estab. 2003. Exhibits 15 emerging, mid-career and established artists. Sponsors 8 exhibits/year. Average display time 5-6 weeks. Open all year; Thursday-Friday 12-7 p.m.; Saturday from 11 a.m. to 7 p.m.; Sunday 1-5 p.m; closed January and February. Located in the village of Groton in the Finger Lakes Region of New York, 20 minutes to Ithaca; 900 sq. ft. space. Clients include local community, tourists, upscale. Overall price range $120-5,000.

Media Considers all media. Considers prints, including engravings, etchings, linocuts, lithographs, mezzotints and woodcuts. Most frequently exhibits painting, sculpture, ceramics, prints.

Style Considers all styles and genres.

Terms Artwork is accepted on consignment and there is a 40% commission. Retail price set by the artist. Gallery provides insurance, promotion and contract. Accepted work should be framed, mounted and matted. Requires exclusive representation locally.

Submissions Write to arrange personal interview to show portfolio of photographs and slides. Send query letter with artist's statement, bio, brochure, photographs, résumé, reviews, SASE and slides. Returns material with SASE. Responds to queries only if interested in 4 weeks. Finds artists through art exhibits, portfolio reviews, referrals by other artists, submissions and word of mouth.

Tips 1. After initial submitting of materials, the artist will be set an appointment to talk over work. 2. Slides should be subject matter without background. 3. Artists should send up-to-date résumé and artist's statement.

⚄ OXFORD GALLERY

267 Oxford St., Rochester NY 14607. (585)271-5885. Fax: (585)271-2570. E-mail: info@oxfordgallery.com. Website: www.oxfordgallery.com. **Director:** Erin Tobin. Retail gallery. Estab. 1961. Represents 70 emerging, mid-career and established artists. Sponsors 10 shows/year. Average display time 1 month. Open all year; Tuesday-Friday, 12-5; Saturday, 10-5; and by appointment. Located "on the edge of downtown; 1,000 sq. ft.; large gallery in a beautiful 1910 building." Overall price range $100-30,000; most work sold at $1,000-2,000.

Media Considers oil, acrylic, watercolor, pastel, pen & ink, drawings, mixed media, collage, paper, sculpture, ceramic, fiber, original handpulled prints, woodcuts, engravings, lithographs, wood engravings, mezzotints, serigraphs, linocuts and etchings.

Styles All styles.

Terms Accepts artwork on consignment (50% commission). Retail price set by gallery and artist. Gallery provides promotion and contract.

Submissions Send query letter with résumé, slides, bio and SASE. Responds in 3 months. Files résumés, bios and brochures.

Tips ''Have professional slides done of your artwork. Have a professional résumé and portfolio. Do not show up unannounced and expect to show your slides. Either send in your information or call to make an appointment. An artist should have enough work to have a one-person show (20-30 pieces). This allows an artist to be able to supply more than one gallery at a time, if necessary. It is important to maintain a strong body of available work.''

Ⓝ SCULPTURECENTER

44-19 Purves St., Long Island City NY 11101. (718)361-1750. Fax: (718)786-9336. E-mail: info@sculpture-center.org. Website: www.sculpture-center.org. **Executive Director:** Mary Ceruti. Alternative space, nonprofit gallery. Estab. 1928. Exhibits emerging and mid-career artists. Sponsors 8-10 shows/year. Average display time 2-4 months. Open all year; Thursday-Monday, 11-6. Does not actively sell work.

Media Considers drawing, mixed media, sculpture and installation. Most frequently exhibits sculpture, installations and video installations.

Terms Accepts work on consignment (25% commission). Retail price set by the gallery and the artist. Gallery provides promotion; artist pays shipping costs.

Submissions Send query letter with résumé, 10-20 slides, bio and SASE. See website.

NEW YORK CITY

ADC GALLERY

106 W. 29th St., New York NY 10001. (212)643-1440. Fax: (212)643-4266. E-mail: info@adcglobal.org. Website: www.adcglobal.org. **Executive Director:** Myrna Davis. Nonprofit gallery. Exhibits groups in the field of visual communications (advertising, graphic design, publications, art schools). Estab. 1920. Exhibits emerging and professional work; 6-8 shows/year. Average display time 1 month. Closed August; Monday-Friday, 10-6. Located in Chelsea district; 4,500 sq. ft.; 1 gallery street level. 100% of space for special exhibitions. Clients include professionals, students.

Media Considers all media and all types of prints. Most frequently exhibits posters, printed matter, photos, digital media and 3-D objects.

Style Genres include advertising, graphic design, publications, packaging, photography, illustration and interactive media.

Terms The space is available by invitation and/or approved rental.

Submissions Submissions are through professional groups. Group rep should send reviews and printed work. Responds within a few months.

Ⓝ ALASKA MOMMA, INC.

303 Fifth Ave., New York NY 10016. (212)679-4404. Fax: (212)696-1340. E-mail: licensing@alaskamomma.com. **President, licensing:** Shirley Henschel. ''We are a licensing company representing artists, illustrators, designers and established characters. We ourselves do not buy artwork. We act as a licensing agent for the artist. We license artwork and design concepts such as wildlife, florals, art deco and tropical to toy, clothing, giftware, textiles, stationery and housewares manufacturers and publishers.''

Needs ''We are looking for people whose work can be developed into dimensional products. An artist must have a distinctive and unique style that a manufacturer can't get from his own art department. We need art that can be applied to products such as posters, cards, puzzles, albums, bath accessories, figurines, calendars, etc. No cartoon art, no abstract art, no b&w art.''

First Contact & Terms ''Artists may submit work in any form as long as it is a fair representation of their style.'' Prefers to see several multiple color samples in a mailable size. No originals. ''We are interested in artists whose work is suitable for a licensing program. We do not want to see b&w art drawings. What we need to see are transparencies or color photographs or color photocopies of finished art. We need to see a consistent style in a fairly extensive package of art. Otherwise, we don't really have a feeling for what the artist can do. The artist should think about products and determine if the submitted material is suitable for licensed products. Please send SASE so the samples can be returned. We work on royalties that run from 5-10% from our licensees. We require an advance against royalties from all customers. Earned royalties depend on whether the products sell.''

Tips ''Publishers of greeting cards and paper products have become interested in more traditional and conservative styles. There is less of a market for novelty and cartoon art. We need artists more than ever as we especially need fresh talent in a difficult market. Look at product! Know what companies are willing to license.''

Ⓝ ATLANTIC GALLERY

40 Wooster St., 4th Floor, New York NY 10013. (212)219-3183. Website: www.atlanticgallery.org. Cooperative gallery. **President:** Pamela Talese. Estab. 1974. Approached by 50 artists/year. Represents 40 emerging, mid-

career and established artists. Exhibited artists include Carol Hamann (watercolor); Sally Brody (oil, acrylic); Richard Lincoln (oil). Average display time 3 weeks. Open Tuesday-Saturday, 12-6. Closed August. Located in Soho. Has kitchenette. Clients include local community, tourists and upscale. 2% of sales are to corporate collectors. Overall price range $100-13,000; most work sold at $1,500-5,000.

Media Considers all media. Considers all types of prints. Most frequently exhibits watercolor, acrylic and oil.

Style Considers all styles and genres. Most frequently exhibits impressionism, realism, imagism.

Terms Artwork is accepted on consignment and there is a 20% commission. There is a co-op membership fee plus a donation of time. There is a 10% commission. Rental fee for space covers 3 weeks. Retail price set by the artist. Gallery provides promotion and contract. Accepted work should be framed. Does not require exclusive representation locally. Prefers only East Coast artists.

Submissions Call or write to arrange a personal interview to show portfolio of slides. Send query letter with artist's statement, bio, brochure, SASE and slides. Returns material with SASE. Responds in 2 weeks. Files only accepted work. Finds artists through word of mouth, submissions, art exhibits and referrals by other artists.

Tips Submit an organized folder with slides, bio, and 3 pieces of actual work; if we respond with interest, we then review again.

⁅N⁆ BLUE MOUNTAIN GALLERY

530 W. 25th St., New York NY 10001. (646)486-4730. Fax: (646)486-4345. Website: www.artincontext.org/new_york/blue_mountain_gallery/. **Contact:** Marcia Clark. Artist-run cooperative gallery. Estab. 1980. Exhibits 32 mid-career artists. Sponsors 13 solo and 1 group shows/year. Display time is 3 weeks. "We are located on the 4th floor of a building in Chelsea. We share our floor with two other well-established cooperative galleries. Each space has white partitioning walls and an individual floor-plan." Clients include art lovers, collectors and artists. 90% of sales are to private collectors, 10% corporate clients. Overall price range: $100-8,000; most work sold at $100-4,000.

Media Considers painting, drawing and sculpture.

Style "The base of the gallery is figurative but we show work that shows individuality, commitment and involvement with the medium."

Terms Co-op membership fee plus donation of time. Retail price set by artist. Exclusive area representation not required. Gallery provides insurance, some promotion and contract; artist pays for shipping.

Submissions Send name and address with intent of interest and sheet of 20 good slides. "We cannot be responsible for material return without SASE." Finds artists through artists' submissions and referrals.

Tips "This is a cooperative gallery it is important to represent artists who can contribute actively to the gallery. We look at artists who can be termed local or in-town more than out-of-town artists and would choose the former over the latter. The work should present a consistent point of view that shows individuality. Expressive use of the medium used is important also."

CORPORATE ART PLANNING INC.

27 Union Square W., Suite 407, New York NY 10003. (212)242-8995. Fax: (212)242-9198. **Principal:** Maureen McGovern. Fine art exhibitors, virtual entities. Estab. 1986. Represents 2 illustrators, 2 photographers, 5 fine artists (includes 1 sculptor). Guidelines available for #10 SASE. Markets include corporate collections; design firms; editorial/magazines; publishing/books; art publishers; private collections. Represents Richard Rockwell, Suzanne Brookers, Michael Freidman and Barry Michlin.

Handles Fine art only.

Terms Consultant receives 50%. For promotional purposes, prefers all artists have museum connections and auction profiles. Advertises in *The Workbook*, *Art in America*, Americans for the Arts, in NYC, Art Now Gallery Guide, and five targeted industry guides.

How to Contact Will contact artist if artwork is requested by the corporate board. Portfolio should include color photocopies only (nonreturnable).

⁅N⁆ GALLERY 10

7 Greenwich Ave., New York NY 10014. (212)206-1058. E-mail: marcia@gallery10.com. Website: www.gallery10.com. **Director:** Marcia Lee Smith. Retail gallery. Estab. 1972. Open all year. Represents approximately 150 emerging and established artists. 100% of sales are to private collectors. Overall price range $24-1,000; most work sold at $50-300.

Media Considers ceramic, craft, glass, wood, metal and jewelry.

Style "The gallery specializes in contemporary American crafts."

Terms Accepts work on consignment (50% commission); or buys outright for 50% of retail price (net 30 days). Retail price set by gallery and artist.

Submissions Call or write for appointment to show portfolio of originals, slides, transparencies or photographs.

ⓃSANDRA GERING GALLERY

534 W. 22nd St., New York NY 10011. (646)336-7183. Fax: (646)336-7185. E-mail: sandra@geringgallery.com. Website: www.geringgallery.com. **Director:** Marianna Baer. For-profit gallery. Estab. 1991. Approached by 240 artists/year. Exhibits 12 emerging, mid-career and established artists. Exhibited artists include John F. Simon, Jr., computer software panels; Xavier Veilhan, electronic sculpture and digital photography. Sponsors 9 exhibits/year. Average display time 5 weeks. Open all year; Tuesday-Saturday, 10-6; weekends, 10-6. Located on ground floor; 600 sq. ft. of storefront space.

Media Considers mixed media, oil, sculpture and hightech/digital. Most frequently exhibits computer-based work, electric (light) sculpture and video/DVD.

Style Exhibits geometric abstraction. Most frequently exhibits cutting edge.

Terms Artwork is accepted on consignment.

Submissions Send e-mail query with link to website and JPEGs. Cannot return material. Responds only if interested within 6 months. Finds artists through word of mouth, art exhibits, art fairs and referrals by other artists.

Tips Most important is to research the galleries and only submit to those that are appropriate. Visit websites if you don't have access to galleries. "We don't exhibit traditional, figurative painting or sculpture."

ⓃO.K. HARRIS WORKS OF ART

383 W. Broadway, New York NY 10012. (212)431-3600. Fax: (212)925-4797. E-mail: okharris@okharris.com. Website: www.okharris.com. **Director:** Ivan C. Karp. Commercial exhibition gallery. Estab. 1969. Represents 55 emerging, mid-career and established artists. Sponsors 50 solo shows/year. Average display time 1 month. Open Tuesday-Saturday, 10-6; in June, Tuesday-Friday 10-6; Saturday by appointment; in July, Tuesday-Friday, 12-5; closed all of August and December 24th-January 3rd. "Four separate galleries for four separate one-person exhibitions. The back room features selected gallery artists which also change each month." 90% of sales are to private collectors, 10% corporate clients. Overall price range $50-250,000; most work sold at $12,500-100,000.

Media Considers all media. Most frequently exhibits painting, sculpture and photography.

Style Exhibits realism, photorealism, minimalism, abstraction, conceptualism, photography and collectibles. Genres include landscapes, Americana but little figurative work. "The gallery's main concern is to show the most significant artwork of our time. In its choice of works to exhibit, it demonstrates no prejudice as to style or materials employed. Its criteria demands originality of concept and maturity of technique. It believes that its exhibitions have proven the soundness of its judgment in identifying important artists and its pertinent contribution to the visual arts culture."

Terms Accepts work on consignment (50% commission). Retail price set by gallery. Customer discounts and payment by installment are available. Exclusive area representation required. Gallery provides insurance and limited promotion. Prefers artwork ready to exhibit.

Submissions Send query letter with 1 sheet of slides (20 slides) "labeled with size, medium, etc." and SASE. Responds in 1 week.

Tips "We suggest the artist be familiar with the gallery's exhibitions and the kind of work we prefer to show. Visit us either in person or online at www.okharris.com. Always include SASE." Common mistakes artists make in presenting their work are "poor, unmarked photos (size, material, etc.), submissions without return envelope, inappropriate work. We affiliate about one out of 10,000 applicants."

ⓃHELLER GALLERY

420 W. 14th St., New York NY 10014. (212)414-4014. Fax: (212)414-2636. E-mail: info@hellergallery.com. Website: www.hellergallery.com. **Director:** Douglas Heller. Retail gallery. Estab. 1973. Represents/exhibits emerging, mid-career and established artists. Exhibited artists include Bertil Vallien and Robin Grebe. Sponsors 11 shows/year. Average display time 3 weeks. Open all year; Tuesday-Saturday, 11-6; Sunday, 12-5. "For the past 6 years Heller Gallery has been located in Manhattan's Meat Packing District. The gallery is a bi-level 7,200 sq. ft. space." 60% of space for special exhibitions. Clients include serious private collectors and museums. 80% of sales are to private collectors, 10% corporate collectors and 10% museum collectors. Overall price range $1,000-45,000; most work sold at $3,000-10,000.

Media Glass and wood sculpture. Most frequently exhibits glass, glass and mixed media and wood.

Style Geometric abstraction and figurative.

Terms Artwork is accepted on consignment (50% commission). Retail price set by the artist. Gallery provides insurance and limited promotion; shipping costs are shared.

Submission Send query letter with résumé, slides, photographs, reviews, bio and SASE. Call or write for appointment to show portfolio of photographs, slides and résumé. Responds in 1 month. Files information on artists represented by the gallery. Finds artists through word of mouth, referrals by other artists, visiting art fairs and exhibitions and submissions.

Ⓝ 🏆 MARTHA HENRY FINE ART

400 E. 57th St., Suite 7L, New York NY 10022. (212)308-2759. Fax: (212)754-4419. E-mail: info@marthahenry.c om. Website: www.artnet.com/marthahenry.html. **Contact:** Martha Henry, president. Estab. 1987. Art consultancy. Exhibits emerging, mid-career and established African-American artists. Approached by over 200 artists/ year; exhibits over 12 artists/year. Exhibited artists include Jay Milder (oil paintings) and Bob Thompson (oil paintings). Sponsors 2 exhibits/year. Average display time 4 days to 6 weeks. Open all year; Monday-Friday, 12-6; weekends by appointment only. Located in a private gallery in an apartment building. 5% of sales are to corporate collectors. Overall price range $5,000-200,000; most work sold under $50,000.
Terms Accepts only African-American artists.
Submissions Mail portfolio for review or send query letter with artist's statement, bio, photocopies, photographs, SASE and slides. Returns material with SASE. Responds in 3 months. Files slides, bio or postcard. Finds artists through art fairs and exhibits, portfolio reviews, referrals by other artists, submissions, word of mouth and press.

MICHAEL INGBAR GALLERY OF ARCHITECTURAL ART

568 Broadway, New York NY 10012. (212)334-1102. Fax: (212)334-1100. Website: www.artnet.com. **Curator:** Millicent Hathaway. Retail gallery. Estab. 1977. Represents 145 emerging, mid-career and established artists. Exhibited artists include Richard Haas and Judith Turner. Sponsors 6 shows/year. Average display time 6 weeks. Open all year; Tuesday-Saturday, 12-6. Located in Soho; 1,000 sq. ft. 60% of sales are to private collectors, 40% corporate clients. Overall price range $500-10,000; most work sold at $5,000.
Media Considers all media and all types of prints. Most frequently exhibits paintings, works on paper and b&w photography.
Style Exhibits photorealism, realism and impressionism. Specializes in New York City architecture. Prefers New York City buildings, New York City structures (bridges, etc.) and New York City cityscapes.
Terms Artwork accepted on consignment (50% commission). Artists pays shipping costs.
Submissions Accepts artists only from New York City metro area. Send query letter with SASE to receive "how to submit" information sheet. Responds in 1 week.
Tips "Study what the gallery sells before you go through lots of trouble and waste their time. Be professional in your presentation." The most common mistakes artists make in presenting their work are "coming in person, constantly calling, poor slide quality (or unmarked slides) and not understanding how to price their work."

JADITE GALLERIES

413 W. 50th St., New York NY 10019. (212)315-2740. Fax: (212)315-2793. E-mail: jaditeart@aol.com. Website: www.jadite.com. **Director:** Roland Sainz. Retail gallery. Estab. 1985. Represents 25 emerging and established, national and international artists. Sponsors 10 solo and 2 group shows/year. Average display time 3 weeks. Clientele: 80% private collectors, 20% corporate clients. Overall price range $500-9,000; most artwork sold at $1,000-3,000.
Media Considers oil, acrylic, watercolor, pastel, pen & ink, drawings, mixed media, collage, sculpture and original handpulled prints. Most frequently exhibits oils, acrylics, pastels and sculpture.
Style Exhibits minimalism, postmodern works, impressionism, neo-expressionism, realism and surrealism. Genres include landscapes, florals, portraits, western collages and figurative work. Features mid-career and emerging international artists dealing with contemporary works.
Terms Accepts work on consignment (40% commission). Retail price set by gallery and artist. Exclusive area representation not required. Gallery provides insurance, promotion and contract; exhibition costs are shared.
Submissions Send query letter, résumé, brochure, slides, photographs and SASE. Call or write for appointment to show portfolio of originals, slides or photos. Résumé, photographs or slides are filed.

HAL KATZEN GALLERY

459 Washington Street, New York NY 10013. (212)925-9777. E-mail: hkatzen916@aol.com. For-profit gallery. Estab. 1984. Exhibits established artists. Open Monday-Friday from 10 to 6, closed August. Clients include local community, tourists and upscale. 10-20% of sales are to corporate collectors. Overall price range $2,000-20,000; most work sold at $5,000.
Media Considers acrylic, collage, drawing, oil, paper, pen & ink, sculpture and watercolor. Most frequently exhibits paintings, works on paper and sculpture. Considers all types of prints.
Style Considers all styles and genres.
Terms Artwork is accepted on consignment or is bought outright. Accepts only established artists.

LA MAMA LA GALLERIA

6 E. First St., New York NY 10003. (212)505-2476. **Curator:** Gretchen Green. Nonprofit gallery. Estab. 1981. Exhibits the work of emerging, mid-career and established artists. Sponsors 14 shows/year. Average display

time 3 weeks. Open September-June; Thursday-Sunday 1-6. Located in East Village; 2,500 sq. ft. "Large and versatile space." 20% of sales are to private collectors, 20% corporate clients. Overall price range $500-1,000; most work sold at $500 or less.

Media Considers oil, acrylic, watercolor, pastel, pen & ink, mixed media, collage, fiber, paper, craft. "No performance art." Prefer flat 2-D work. Most frequently exhibits acrylic, watercolor, installation.

Style Considers all types of prints. Considers all styles. Most frequently exhibits postmodernism, expressionism, primitive realism. Genres include pop-culture art, landscapes, cityscapes.

Terms Accepts work on consignment (20% commission). Retail price set by artist, approved by gallery. Artist is responsible for delivery of sales. Artwork must be framed and ready to hang.

Submissions "Call first to see if we are accepting slides at the time. Must include return mailer including postage."

Tips "Most important is to call first to see if I'm currently looking at work. I sometimes make special acceptances. Try to have a clean and neat portfolio or book."

N THE JOE & EMILY LOWE ART GALLERY AT HUDSON GUILD

441 W. 26th St., New York NY 10001. (212)760-9837. E-mail: jfurlong@hudsonguild.org. **Director:** Jim Furlong. Nonprofit gallery. Estab. 1948. Represents emerging, mid-career, community-based and established artists. Sponsors 8 shows/year. Average display time 6 weeks. Open all year. Located in West Chelsea; 1,200 sq. ft.; a community center gallery in a New York City neighborhood. 100% of space for special exhibitions. 100% of sales are to private collectors.

Media Considers oil, acrylic, watercolor, pastel, pen & ink, drawings, mixed media, collage, paper, sculpture, original handpulled prints, woodcuts, wood engravings, linocuts, engravings, mezzotints, etchings, lithographs, pochoir and serigraphs. Most frequently exhibits paintings, sculpture and graphics. Looking for artist to do an environmental "installation."

Style Exhibits all styles and genres.

Terms Accepts work on consignment (20% commission). Retail price set by artist. Gallery provides insurance; artist pays for shipping. Prefers artwork framed.

Submissions Send query letter, résumé, slides, bio and SASE. Portfolio should include photographs and slides. Responds in 1 month. Finds artists through visiting exhibitions, word of mouth, various art publications and sourcebooks, artists' submissions/self-promotions, art collectors' referrals.

Tips "Medium or small works by emerging artists are more likely to be shown in group shows than large work."

THE MARBELLA GALLERY, INC.

28 E. 72nd St., New York NY 10021. (212)288-7809. Fax: (212)288-7810. **President:** Mildred Thaler Cohen. Retail gallery. Estab. 1971. Represents/exhibits established artists of the nineteenth century. Exhibited artists include The Ten and The Eight. Sponsors 1 show/year. Average display time 6 weeks. Open all year; Tuesday-Saturday, 11-5:30. Located uptown; 750 sq. ft. 100% of space for special exhibitions. Clients include tourists and upscale. 50% of sales are to private collectors, 10% corporate collectors, 40% dealers. Overall price range $1,000-60,000; most work sold at $2,000-4,000.

Style Exhibits expressionism, realism and impressionism. Genres include landscapes, florals, Americana and figurative work. Prefers Hudson River, "The Eight" and genre.

Terms Artwork is bought outright. Retail price set by the gallery. Gallery provides insurance.

MULTIPLE IMPRESSIONS, LTD.

128 Spring Street, New York NY 10012. (212)925-1313. Fax: (212)431-7146. E-mail: info@multipleimpressions.com. Website: www.multipleimpressions.com. **Contact:** Director. Estab. 1972. For-profit gallery. Approached by 100 artists/year. Represents 50 emerging, mid-career and established artists. Sponsors 5 exhibits/year. Average display time is 2 weeks. Open Tuesday-Saturday from 11 to 6:30; Sundays from 12 to 6:30; Monday 11-5:30; closed December 29-January 5. Located in the center of Soho, street level, 1,400 sq. ft. mezzanine and full basement. Clients: local community, tourists and upscale. 10% of sales are to corporate collectors. Overall price range $500-40,000; most work sold at $1,500.

Media Considers oil and pastel and prints of engravings, etchings, lithographs and mezzotints. Most frequently exhibits etchings, oils and pastels.

Styles Exhibits imagism and painterly abstraction. Genres include figurative work, landscapes and abstract.

Terms Artwork is accepted on consignment and there is a 40% commission. Retail price set by the gallery and the artist. Requires exclusive representation locally.

Submissions Send query letter with artist's statement, bio, photocopies, photographs, résumé, SASE, slide and price list. Returns material with SASE. Responds to queries in 1 week. Finds artists through art fairs, portfolio reviews, referrals by other artists, submissions, word of mouth and travel.

N ANNINA NOSEI GALLERY

530 W. 22nd St., 2nd Floor, New York NY 10011. (212)741-8695. Fax: (212)741-2379. Estab. 1980. Exhibits emerging artists. Exhibited artists include Federico Uribe, sculptor; and Heidi McFall, works on paper. Open all year; Tuesday-Saturday, 11-6. Closed Christmas week and August. Located in Chelsea; includes 2 exhibition spaces. Clients include local community and upscale. Overall price range $5,000-15,000; most work sold at $10,000.

Media Considers all media. Most frequently exhibits paintings.

Style Considers all styles and genres.

Submissions Mail portfolio for review. Send query letter with artist's statement, reviews, SASE and images.

N NURTUREART NON-PROFIT, INC.

160 Cabrini Blvd., Suite 134, New York NY 10033-1145. (212)795-5566. E-mail: nurtureart@nurtureart.org. Website: www.nurtureart.org. **Executive Director:** George J. Robinson. All volunteer, tax-exempt charitable art services organization. Estab. 1997. Approached by and exhibits 400 emerging and mid-career artists/year. Exhibited artists include Patrick Meagher, painting and works on paper. Sponsors 6 exhibits/year. Average display time 1 month. Open Monday-Friday, 10-6; Saturday, 11-5. Closed December 23-January 2; and July 1-August 31. Clients include local community, students, tourists and upscale. 25% of sales are to corporate collectors. Overall price range $500-10,000; most work sold at $1,000-3,000.

Media Considers all media except craft. Most frequently exhibits painting, work on paper and photography. Considers engravings, etchings, linocuts, lithographs, mezzotints and woodcuts.

Style Considers all styles.

Terms "Collector and artist are brought together for sale; if in commercial host venue, host acts as agent of sale for a commission. Retail price set by the artist. Gallery provides promotion and contract. Accepted work should be exhibition-ready per prior discussion, agreement. Does not require exclusive representation locally. Accepts only artists over 21 years of age, who do not have ongoing gallery representation.

Submissions Send artist's statement, bio, color photocopies, résumé, reviews, SASE and slides (required). Artist should inquire first via website; also by phone if in New York City ("we cannot return long-distance phone calls.") Finds artists through word of mouth, website, portfolio submissions, jurors, curators, portfolio reviews, art exhibits, referrals by other artists.

Tips "Solicit experience of professionals (for instance, peers and artist reps)."

N SCOTT PFAFFMAN GALLERY

35 E. First St., New York NY 10003. **Contact:** Scott Pfaffman, director. Estab. 1996. Exhibits emerging, mid-career and established artists. Approached by 20 artists/year. Very small exhibition space. Clients include local community, collectors and artists. Overall price range $100-5,000; most work sold at $300-500.

Media Considers installation art, film, video, photography.

Style Considers all styles.

Terms Artwork is accepted on consignment and there is a 40% commission. Retail price of the art set by the the artist. Gallery provides promotion and contract. Does not require exclusive representation locally.

Submissions Write to arrange a personal interview to show portfolio of photographs, slides and transparencies or send query letter with photographs, reviews and SASE. Returns material with SASE. Responds to queries only if interested within 2 months. Finds artists through referrals by other artists.

N THE PHOENIX GALLERY

210 11th Ave. at 25th St., Suite 902, New York NY 10001. (212)226-8711. E-mail: info@phoenix-gallery.com. Website: www.phoenix-gallery.com. **Director:** Linda Handler. Nonprofit gallery. Estab. 1958. Exhibits the work of emerging, mid-career and established artists. 32 members. Exhibited artists include Robert Blank and Steven Dono. Sponsors 10-12 shows/year. Average display time 1 month. Open fall, winter and spring. Located in Soho; 180 linear ft. "We are in a landmark building in Soho, the oldest co-op in New York. We have a movable wall which can divide the gallery into two large spaces." 100% of space for special exhibitions. 75% of sales are to private collectors, 25% corporate clients, also art consultants. Overall price range $50-20,000; most work sold at $300-10,000.

- The Phoenix Gallery actively reaches out to the members of the local community, scheduling juried competitions, dance programs, poetry readings, book signings, plays, artists speaking on art panels and lectures. A special exhibition space, The Project Room, has been established for guest-artist exhibits.

Media Considers oil, acrylic, watercolor, pastel, pen & ink, drawings, mixed media, collage, works on paper, sculpture, ceramic, photography, original handpulled prints, woodcuts, engravings, wood engravings, linocuts, etchings and photographs. Most frequently exhibits oil, acrylic and watercolor.

Style Exhibits painterly abstraction, minimalism, realism, photorealism, hard-edge geometric abstraction and all styles.

Terms Co-op membership fee plus donation of time for active members, not for in-active or associate members, (25% commission). Retail price set by gallery. Offers customer discounts and payment by installment. Gallery provides promotion and contract; artist pays for shipping. Prefers artwork framed.

Submissions Send query letter with résumé, slides and SASE. Call for appointment to show portfolio of slides. Responds in 1 month. Only files material of accepted artists. The most common mistakes artists make in presenting their work are ''incomplete résumés, unlabeled slides and an application that is not filled out properly. We find new artists by advertising in art magazines and art newspapers, word of mouth, and inviting artists from our juried competition to be reviewed for membership.'' All information about the gallery can be dowloaded from the gallery's website: www.phoenix-gallery.com.

Tips ''Come and see the gallery—meet the director.''

[N] ANITA SHAPOLSKY GALLERY

152 E. 65th St., (patio entrance), New York NY 10021. (212)452-1094. Fax: (212)452-1096. E-mail: ashapolsky@ nyc.rr.com. Website: www.anitashapolskygallery.com. For-profit gallery. Estab. 1982. Exhibits established artists. Exhibited artists include Ernest Briggs, painting; Michael Loew, painting; Buffie Johnson, painting; William Manning, painting; Clement Meadmore, sculpture; Betty Parsons, painting and sculpture and others. Open all year; Wednesday-Saturday, 11-6. Call for summer hours. Clients include local community and upscale.

Media Considers acrylic, collage, drawing, mosaic, mixed media, oil, paper, sculpture, etchings, lithographs, serigraphs. Most frequently exhibits oil, acrylic and sculpture.

Style Exhibits expressionism and geometric abstraction and painterly abstraction.

Terms Prefers only 1950s and 1960s abstract expressionism.

Submissions Mail portfolio for review in May and October only. Send query letter with artist's statement, bio, SASE and slides. Returns material with SASE.

[N] PAUL SHARPE CONTEMPORARY ART

86 Walker Street, Floor Six, New York NY 10013. Phone/fax: (646)613-1252. E-mail: paulsharpe1@msn.com. Website: www.paulsharpegallery.com. **Contact:** Paul Sharpe, director. art gallery and consulting. Exhibits emerging, established artists. Exhibited artists include Gloria Garfinkel, painting, prints, sculpture; Lenore RS Lim, prints. Sponsors 8-10 exhibits/year lasting one month each (photography is included in various shows throughout the year). Open Wednesday-Saturday, 12-6; closed the last two weeks of July and the month of August. 2,000 sq. ft. gallery in a loft building in TriBeCa. Overall price range for photography: $1,000-50,000.

Media Considersall media, mostly paintings and conceptual art.

Style Most frequently exhibits abstract and abstract landscape.

Terms There is a co-op membership fee plus a donation of time. Artwork is accepted on consignment and commission.

Submissions Interested artists should submit color Xeroxes of their work with a bio and statement along with a SASE. Finds artists through referrals by other artists, word of mouth.

JOHN SZOKE EDITIONS

591 Broadway, 3rd Floor, New York NY 10012. (212)219-8300. Fax: (212)219-0864. E-mail: info@johnszokeediti ons.com. Website: www.johnszokeeditions.com. **President:** John Szoke. Retail gallery and art dealer/publisher. Estab. 1974. Contemporary artists include: Christo, Jim Dine, Janet Fish, Helen Frankenthaler, Richard Haas, Jasper Johns, Alex Katz, Ellsworth Kelly, Jeff Koons, Peter Milton Robert Rauschenberg, Larry Rivers, Frank Stella and Donald Sultan. Modern Masters include: Picasso, Jean Cocteau and Matisse. Catalogues Raisonne Published: Janet Fish, Richard Haas and Jeannette Pasin Sloan. Open all year. Located downtown in Soho. Clients include other dealers and collectors. 20% of sales are to private collectors.

Media Exhibits works on paper, multiples in relief and intaglio and sculpture.

[N] TIBOR DE NAGY GALLERY

724 Fifth Ave., New York NY 10019. (212)262-5050. Fax: (212)262-1841. **Owners:** Andrew H. Arnot and Eric Brown. Retail gallery. Estab. 1950. Represents emerging and mid-career artists. Exhibited artists include Jane Freilicher, Estate of Nell Blaine, Robert Berlind, George Nick, David Kapp and Estate of Rudy Burckhardt. Sponsors 12 shows/year. Average display time 1 month. Closed August. Located midtown; 3,500 sq. ft. 100% of space for work of gallery artists. 60% private collectors, 40% corporate collectors. Overall price range $1,000-100,000; most work sold at $5,000-20,000.

● The gallery focus is on painting within the New York school traditions and photography.

Media Considers oil, pen & ink, paper, acrylic, drawings, sculpture, watercolor, mixed media, pastel, collage, etchings, and lithographs. Most frequently exhibits oil/acrylic, watercolor and sculpture.

Style Exhibits representational work as well as abstract painting and sculpture. Genres include landscapes and figurative work. Prefers abstract, painterly realism and realism.

Submissions Gallery is not looking for submissions at this time.

"U" GALLERY

221 E. Second St., New York NY 10009. (212)995-0395. E-mail: ugallery@ugallery.org. Website: www.ugallery.c jb.net. **Contact:** Darius. Alternative space, for-profit gallery, art consultancy and rental gallery. Estab. 1989. Approached by 100 artists/year. Represents 3 emerging, and established artists. Sponsors 2 exhibits/year. Open all year. Located in Manhattan; 800 sq. ft.

Media Considers acrylic, drawing, oil, paper, pastel, sculpture and watercolor. Considers all types of prints.

Style Exhibits conceptualism, geometric abstraction, impressionism, minimalism and surrealism. Genres include figurative work, landscapes, portraits and wildlife.

Submissions Write to arrange a personal interview to show portfolio of photographs and slides. Send query letter with artist's statement, photocopies, photographs and slides. Cannot return material. Finds artists through word of mouth and portfolio reviews.

N VIRIDIAN ARTISTS INC.

530 W. 25th St., Suite 407, New York NY 10001-5546. (212)245-2882. E-mail: info@viridianartists.com. Website: www.viridianartists.com. **Director:** Vernita Nemec. Cooperative gallery. Estab. 1970. Exhibits the work of 35 emerging, mid-career and established artists. Sponsors 13 solo and 2 group shows/year. Average display time 3 weeks. Clients include consultants, corporations, private collectors. 50% of sales are to private collectors, 50% corporate clients. Overall price range $500-20,000; most work sold at $1,000-8,000.

Media Considers oil, acrylic, watercolor, pastel, pen & ink, drawings, mixed media, collage, works on paper, sculpture, installation, photography and limited edition prints. Most frequently exhibits works on canvas, sculpture, mixed media, works on paper and photography.

Style Exhibits hard-edge geometric abstraction, color field, painterly abstraction, conceptualism, postmodern works, primitivism, photorealism, abstract, expressionism, and realism. "Eclecticism is Viridian's policy. The only unifying factor is quality. Work must be of the highest technical and aesthetic standards."

Terms Accepts work on consignment (30% commission). Retail price set by gallery and artist. Sometimes offers customer discounts and payment by installment. Exclusive area representation not required. Gallery provides promotion, contract and representation.

Submissions Send query letter, slides or call ahead for information on procedure. Portfolio review requested if interested in artist's work.

Tips "Artists often don't realize that they are presenting their work to an artist-owned gallery where they must pay each month to maintain their representation. We feel a need to demand more of artists who submit work. Because of the number of artists who submit work, our criteria for approval has increased as we receive stronger work than in past years, due to commercial gallery closings."

WALTER WICKISER GALLERY

568 Broadway, Suite #104B, New York NY 10012. (212)941-1817. Fax: (212)625-0601. E-mail: wwickiserg@aol. com. Website: www.walterwickisergallery.com. For-profit gallery. Shows only established artists.

N WOODWARD GALLERY

476 Broome Street, 5th Floor, New York NY 10013-2281. (212)966-3411. Fax: (212)966-3491. E-mail: woodward gallery@aol.com. Website: www.artnet.com/woodward.html. **Contact:** Tom Hall, gallery manager. For-profit gallery. Estab. 1994. Exhibits emerging, mid-career and established artists. Approached by 2000+ artists/year; represents 10 artists/year in stable plus group shows. Exhibited artists include Cristina Vergano (oil on canvas/wood panel) and Charles Yoder (oil on canvas; works on paper). Sponsors 6 exhibits/year. Average display time 2 months. Open Tuesday-Saturday, 11-6; weekends 11-6. August by private appointment only. Clients include local community, tourists, upscale, and other art dealers. 20% sales are to corporate collectors. Overall price range: $3,000-5 million US dollars; most work sold at $10-100,000.

Media Considers acrylic, collage, drawing, mixed media, oil, paper, pastel, pen & ink, sculpture, watercolor. Most frequently exhibits canvas, paper and sculpture. Considers all types of prints.

Style Most frequently exhibits realism/surrealism, P-O-P, abstract and landscapes. Genres include figurative work, florals, landscapes and portraits.

Making Contact & Terms Artwork is bought outright; net 30 days. Retail price set by the gallery. Does not require exclusive representation locally.

Submissions Call. Send query letter with artist's statement, bio, brochure, photocopies, photographs, reviews and SASE. Returns material with SASE. Finds artists through referrals or submissions.

Tips "An artist must follow our artist review criteria, which is available every new year around 1st-2nd week with updated policy from director."

NORTH CAROLINA

N ARTS UNITED FOR DAVIDSON COUNTY

220 S. Main St., Lexington NC 27292. (336)249-7862. Website: www.co.davidson.nc.us/arts. **Executive Director:** Erik Salzwedel. Nonprofit gallery. Estab. 1968. Exhibits 30 emerging, mid-career and established artists. Interested in seeing the work of emerging artists. 400 members. Exhibited artists include Bob Timberlake and Zoltan Szabo. Disney Animation Archives (1993), Ansel Adams (1994), P. Buckley Moss (1996). Sponsors 11 shows/year. Average display time 1 month. Open all year. 6,000 sq. ft; historic building, good location, marble foyer. 80% of space for special exhibitions; 10% of space for gallery artists. Clientele: 98% private collectors, 2% corporate collectors. Overall price range $50-20,000; most work sold at $50-4,000.

Media Considers all media and all types of prints. "Originals only for exhibition. Most frequently exhibits painting, photography and mixed media. "We try to provide diversity."

Style Exhibits expressionism, painterly abstraction, postmodern works, expressionism, photorealism and realism. Genres include landscapes and Southern artists.

Terms Accepts work on consignment (30% commission). Members can exhibit art for 2 months maximum per piece in our members gallery. 30% commission goes to Guild. Retail price set by gallery and artist. Gallery provides insurance, promotion and contract; artist pays for shipping. Prefers artwork framed for exhibition and unframed for sales of reproductions.

Submissions Send query letter with résumé, slides, bio, brochure, photographs, business card, reviews and SASE. Write for appointment to show portfolio of originals, photographs and slides. Entries reviewed every May for following exhibition year.

DURHAM ART GUILD, INC.

120 Morris St., Durham NC 27701. (919)560-2713. E-mail: artguild1@yahoo.com. Website: www.durhamartguild.org. **Gallery Director:** Lisa Morton. Gallery Assistant: Diane Amato. Nonprofit gallery. Estab. 1948. Represents/exhibits 500 emerging, mid-career and established artists/year. Sponsors more than 20 shows/year including an annual juried art exhibit. Average display time 5 weeks. Open all year; Monday-Saturday, 9-9; Sunday, 1-6. Free and open to the public. Located in center of downtown Durham in the Arts Council Building; 3,600 sq. ft.; large, open, movable walls. 100% of space for special exhibitions. Clientele: general public. 80% private collectors, 20% corporate collectors. Overall price range $100-14,000; most work sold at $200-1,200.

Media Considers all media. Most frequently exhibits painting, sculpture and photography.

Style Exhibits all styles, all genres.

Terms Artwork is accepted on consignment (30-40% commission). Retail price set by the artist. Gallery provides insurance and promotion. Artist installs show. Prefers artwork framed.

Submissions Artists 18 years or older. Send query letter with résumé, slides and SASE. We accept slides for review by February 1 for consideration of a solo exhibit or special projects group show. Artist should include SASE. Finds artists through word of mouth, referral by other artists, call for slides.

Tips "Before submitting slides for consideration, be familiar with the exhibition space to make sure it can accommodate any special needs your work may require."

N LEE HANSLEY GALLERY

225 Glenwood Ave., Raleigh NC 27603. (919)828-7557. **Proprietor:** Lee Hansley. Retail gallery, art consultancy. Estab. 1993. Represents 40 mid-career and established artists/year. Exhibited artists include Paul Hartley. Sponsors 10 shows/year. Average display time 5-7 weeks. Open all year; Monday-Thursday, 11-6; Friday, 11-9; Saturday, 11-5. Located in Glenwood South; 2,800 sq. ft.; 5 small, intimate exhibition galleries, one small hallway interior. 75% of space for special exhibitions; 25% of space for gallery artists. Clientele local, state collectors. Overall price range $250-18,000; most work sold at $500-2,500.

Media Considers all media except large-scale sculpture. Considers all types of prints except poster. Most frequently exhibits painting/canvas, mixed media on paper.

Style Exhibits expressionism, neo-expressionism, painterly abstraction, minimalism, color field, photorealism, pattern painting, hard-edge geometric abstraction. Genres include landscapes, figurative work. Prefers geometric abstraction, expressionism, minimalism.

Terms Accepts work on consignment (50% commission). Retail price set by the gallery and the artist. Gallery provides insurance, promotion and verbal contract; shipping costs are shared. Prefers artwork framed.

Submissions "Work must be strong, not political please." Send query letter with slides, bio and artist's statement. Write for appointment to show portfolio of photographs or slides. Responds in 2 months. Files slides, résumés.

JERALD MELBERG GALLERY INC.

625 S. Sharon Amity Rd., Charlotte NC 28211. (704)365-3000. Fax: (704)365-3016. E-mail: gallery@jeraldmelberg.com. Website: jeraldmelberg.com. **President:** Jerald Melberg. Retail gallery. Estab. 1983. Represents 35 emerg-

ing, mid-career and established artists/year. Exhibited artists include Robert Motherwell and Wolf Kahn. Sponsors 15-16 shows/year. Average display time 6 weeks. Open all year; Monday-Saturday, 10-6. 4,000 sq. ft. 100% of space for gallery artists. Clientele national. 70-75% private collectors, 25-30% corporate collectors. Overall price range $1,000-80,000; most work sold at $2,000-15,000.

Media Considers all media except photography. Considers all types of prints. Most frequently exhibits pastel, oil/acrylic and monotypes.

Style Genres include painterly abstraction, color field, impressionism and realism. Genres include florals and landscapes. Prefers landscapes, abstraction and still life.

Terms Artwork is accepted on consignment (50% commission). Retail price set by the gallery and the artist. Gallery provides insurance, promotion. Gallery pays for shipping costs from gallery. Artists pays for shipping costs to gallery. Prefers artwork unframed.

Submissions Send query letter with résumé, slides, reviews, bio, SASE and price structure. Responds in 2-3 weeks. Finds artists through art fairs, other artists, travel.

Tips "The common mistake artists make is not finding out what I handle and not sending professional quality materials."

SOMERHILL GALLERY

3 Eastgate E. Franklin St., Chapel Hill NC 27514. (919)968-8868. Fax: (919)967-1879. **Director:** Joseph Rowand. Retail gallery. Estab. 1972. Represents emerging, mid-career and established artists. Sponsors 10 major shows/year, plus a varied number of smaller shows. Open all year. 10,000 sq. ft.; gallery features "architecturally significant spaces, pine floor, 18 ft. ceiling, 6 separate gallery areas, stable, photo, glass." 50% of space for special exhibitions.

Media Considers all media, woodcuts, wood engravings, linocuts, engravings, mezzotints, etchings, lithographs and serigraphs. Does not consider installation. Most frequently exhibits painting, sculpture and glass.

Style Exhibits all styles and genres.

Submissions Focus is on contemporary art of the United States; however artists from all over the world are exhibited. Send query letter with résumé, slides, bio, SASE and any relevant materials. Responds in 2 months. Files slides and biographical information of artists.

TYLER-WHITE ART GALLERY

307 State St. Station, Greensboro NC 27408. (336)279-1124. Fax: (336)279-1102. **Owners:** Marti Tyler and Judy White. Retail gallery. Estab. 1985. Represents 60 emerging, mid-career and established artists. Exhibited artists include Marcos Blahove, Connie Winters and Susie Pryor. Sponsors 8 shows/year. Open all year. Located in State Street Station, a unique shopping district 1 mile from downtown. Overall price range $100-4,000; most work sold at $1,500.

Media Considers oil, acrylic, watercolor and pastel.

Style Considers contemporary expressionism, impressionism and realism. Genres include landscapes, florals and figurative work.

Terms Accepts artwork on consignment. Retail price set by the artist. Gallery provides some insurance, promotion and contract; artist pays for shipping. Prefers artwork framed if oil, or a finished canvas. Prefers matted watercolors.

Submissions Send query letter with slides, résumé, brochure, photographs and SASE. Write to schedule an appointment to show a portfolio, which should include originals, slides and transparencies. Responds in 1 month. Files brochures, résumé and some slides.

Tips "We only handle original work."

NORTH DAKOTA

THE ARTS CENTER

115 Second St. SW, Box 363, Jamestown ND 58402. (701)251-2496. Fax: (701)251-1749. E-mail: artscenter@csicable.net. Website: www.jamestownartscenter.org. **Director:** Taylor Barnes. Nonprofit gallery. Estab. 1981. Sponsors 8 solo and 4 group shows/year. Average display time 6 weeks. Interested in emerging artists. Overall price range $50-600; most work sold at $50-350.

Style Exhibits contemporary, abstraction, impressionism, primitivism, photorealism and realism. Genres include Americana, figurative and 3-dimensional work.

Terms 20% commission on sales from regularly scheduled exhibitions. Retail price set by artist. Gallery provides insurance, promotion and contract; shipping costs are shared.

Submissions Send query letter, résumé, brochure, slides, photograph and SASE. Write for appointment to show portfolio. Invitation to have an exhibition is extended by Arts Center gallery manager.

Tips "We are interested in work of at least 20-30 pieces, depending on the size."

⦃Ñ⦄ HUGHES FINE ART CENTER ART GALLERY

Department of Visual Arts, University of North Dakota, Grand Forks ND 58202-7099. (701)777-2257. E-mail: mcelroye@badland.nodak.edu. Website: www.nodak.edu/dept/fac/visualhome.html. **Director:** Brian Paulsen. Nonprofit gallery. Estab. 1979. Exhibits emerging, mid-career and established artists. Sponsors 5 shows/year. Average display time 3 weeks. Open all year. Located on campus; 96 running ft. 100% of space for special exhibitions.

- • Director states gallery is interested in "well-crafted, clever, sincere, fresh, inventive, meaningful, unique, well-designed compositionssurprising, a bit shocking, etc."

Media Considers all media. Most frequently exhibits painting, photographs and jewelry/metal work.

Style Exhibits all styles and genres.

Terms Retail price set by artist. Gallery provides "space to exhibit work and some limited contact with the public and the local newspaper." Gallery pays for shipping costs. Prefers artwork framed.

Submissions Send query letter with 10-20 slides and résumé. Portfolio review not required. Responds in 1 week. Files "duplicate slides, résumés." Finds artists from submissions through *Artist's & Graphic Designer's Market* listing, *Art in America* listing in their yearly museum compilation; as an art department listed in various sources as a school to inquire about; the gallery's own poster/ads.

Tips "We are not a sales gallery. Send slides and approximate shipping costs."

NORTHWEST ART CENTER

Minot State University, 500 University Ave. W., Minot ND 58707. (701)858-3264. Fax: (701)858-3894. E-mail: nac@minotstateu.edu. Website: www.minotstateu.edu/nac. **Director:** Catherine Walker. Nonprofit gallery. Estab. 1970. Represents emerging, mid-career and established artists. Sponsors 18-20 shows/year. Average display time 4-6 weeks. Open all year. Two galleries—Hartnett Hall Gallery: Monday-Friday, 8-4:30; The Library Gallery: Sunday-Thursday, 8-9. Located on university campus; 1,000 sq. ft. 100% of space for special exhibitions. 100% private collectors. Overall price range $100-40,000; most work sold at $100-4,000.

Media Considers all media and all types of prints except posters.

Style Exhibits all styles, all genres.

Terms Retail price set by the artist. 30% commission. Gallery provides insurance, promotion and contract; shipping costs are shared. Prefers artwork framed.

Submissions Send query letter with résumé, slides, bio, SASE and artist's statement. Call for appointment to show portfolio of originals, photographs, slides and transparencies. Responds in 4 months. Files all material. Finds artists through submissions, visiting exhibitions, word of mouth.

OHIO

⦃Ñ⦄ ACME ART COMPANY

At The Continent, Huntington Building, 6172 Busch Boulevard, Columbus OH 43229. (614)430-9450. **Contact:** Melesa A.C. Klosek, CEO/Artistic Director. Volunteer and artist run nonprofit gallery. Estab. 1987. Gives exhibiting opportunities to thousands of emerging and mid-career artists/year. 400 members. Sponsors 12 shows/year. Average display time 1 month. Open all year; Tuesday-Saturday, 11 am-7 pm; Evening hours, Tuesdays until 9 pm, Fridays and Saturdays until 1:30 am. Located in Worthington area; 13,000 sq. ft.; 4 gallery areas. 90% of space for special exhibitions; 50% of space for gallery artists. Clientele avant-garde collectors, private and professional. 85% private collectors, 15% corporate collectors. Overall price range $30-5,000; most work sold at $50-1,000.

Media All media is accepted; including performance, film, dance, music and installation.

Style Exhibits all styles. Most frequently exhibits contemporary art. Considers all genres.

Terms Accepts work on consignment (30% commission to Acme Art). Retail price set by the gallery and the artist. Gallery provides promotion and contract; shipping costs are shared. Prefers artwork framed or ready to hang.

Submissions Prefers "artists who push the envelope, who explore new vision and materials of presentation." Send query letter with SASE for a call for entries prospectus. Call for following fiscal year line-up ("we work one year in advance"). Members exhibit in the months of August and December. Files bio, slides, résumé and other support materials sent by artists. The Artistic Director selects the work to be exhibited with an Advisory Panel.

⦃Ñ⦄ ALAN GALLERY

101 Front St., Berea OH 44017. (440)243-7794. Fax: (440)243-7772. Website: www.alangalleryberea.com. **President:** Linda Roberts. Retail gallery and arts consultancy. Estab. 1983. Represents 25-30 emerging, mid-career

and established artists. Sponsors 4 solo shows/year. Average display time 6-8 weeks. Clientele: 40% private collectors, 60% corporate clients. Overall price range $700-6,000; most work sold at $1,500-2,000.

Media Considers all media and limited edition prints. Most frequently exhibits watercolor, works on paper and mixed media.

Style Exhibits color field, painterly abstraction and surrealism. Genres include landscapes, florals, western and figurative work.

Terms Accepts work on consignment (40% commission). Retail price set by gallery and artist. Gallery provides insurance, promotion and contract; shipping costs are shared.

Submissions Send résumé, slides and SASE. Call or write for appointment to show portfolio of originals and slides. All material is filed.

THE ART EXCHANGE

539 E. Town St., Columbus OH 43215. (614)464-4611. Fax: (614)464-4619. E-mail: artexg@ix.netcom.com. Art consultancy. Estab. 1978. Represents 40 emerging, mid-career and established artists/year. Exhibited artists include Mary Beam, Carl Krabill. Open all year; Monday-Friday, 9-5. Located near downtown; historic neighborhood; 2,000 sq. ft.; showroom located in Victorian home. 100% of space for gallery artists. Clientele corporate leaders. 20% private collectors; 80% corporate collectors. Overall price range $150-6,000; most work sold at $1,000-1,500.

Media Considers oil, acrylic, watercolor, pastel, mixed media, collage, sculpture, ceramics, fiber, glass, photography and all types of prints. Most frequently exhibits oil, acrylic, watercolor.

Style Exhibits painterly abstraction, impressionism, realism, folk art. Genres include florals and landscapes. Prefers impressionism, painterly abstraction, realism.

Terms Accepts work on consignment. Retail price set by the gallery and the artist.

Submissions Send query letter with résumé and slides or photographs. Write for appointment to show portfolio. Responds in 2 weeks. Files slides or photos and artist information. Finds artists through word of mouth, referrals by other artists, visiting art fairs and exhibitions, submissions.

Tips "Our focus is to provide high-quality artwork and consulting services to the corporate, design and architectural communities. Our works are represented in corporate offices, health care facilities, hotels, restaurants and private collections throughout the country."

N: THE CANTON MUSEUM OF ART

1001 Market Ave. N., Canton OH 44702. (330)453-7666. Fax: (330)453-1034. E-mail: al@cantonart.org. Website: www.cantonart.org. **Executive Director:** M. Joseph Albacete. Nonprofit gallery. Estab. 1935. Represents emerging, mid-career and established artists. "Although primarily dedicated to large format touring and original exhibitions, the CMA occasionally sponsors solo shows by local and original artists, and one group show every 2 years featuring its own 'Artists League.'" Average display time is 6 weeks. Overall price range $50-3,000; few sales above $300-500.

Media Considers all media. Most frequently exhibits oil, watercolor and photography.

Style Considers all styles. Most frequently exhibits painterly abstraction, post-modernism and realism.

Terms "While every effort is made to publicize and promote works, we cannot guarantee sales, although from time to time sales are made, at which time a 25% charge is applied." One of the most common mistakes in presenting portfolios is "sending too many materials. Send only a few slides or photos, a brief bio and a SASE."

Tips There seems to be "a move back to realism, conservatism and support of regional artists."

N: KUSSMAUL GALLERY

140 E. Broadway, Granville OH 43023. (740)587-4640 or (740)321-1400. E-mail: young@kussmaulgallery.com. Website: www.kussmaulgallery.com. **Owners:** James and Jennifer Young. Retail gallery, custom framing. Estab. 1989. Represents 4-6 emerging and mid-career artists/year. Sponsors 1-2 shows/year. Average display time 30-100 days. Open all year; Tuesday-Saturday, 10-5; Sunday, 12-4. Located downtown; 3,200 sq. ft.; restored building erected 1830—emphasis on interior brick walls and restored tin ceilings. Gallery space upstairs has cathedral ceilings, exposed brick walls, skylights, approximately 1,600 sq. ft. devoted only to framed art and sculpture. 50% of space for art displays. Clients include upper-middle class. 75% of sales are to private collectors, 25% corporate collectors. Overall price range $75-4,000; most work sold at $200-750.

Media Considers oil, acrylic, watercolor, mixed media, sculpture, glass. "We are looking for hand-blown glass priced within reason! Also ceramics, wood carving, and any hand-crafted unique works. Our gallery has changed its focus to mostly 'contemporary American crafts.' We do still exhibit 2-D framed art." Also in need of primitive and outsider art.

Style Exhibits primitivism, impressionism, realism.

Terms Accepts work on consignment (40% commission) or buys outright. Retail price set by the gallery. Gallery

provides insurance on work purchased outright and promotion; artist pays shipping costs to and from gallery. Prefers artwork unframed.

Submissions Send query letter with résumé, slides, bio and SASE. Responds only if interested within 1 month. Files slides, bio or returns them. Finds artists through networking, talking to emerging artists. E-mail with attached photos accepted.

Tips "Don't overprice your work, be original. Have large body of work representing your overall talent and style."

Ⓝ LICKING COUNTY ART GALLERY

P.O. Box 4277, Newark OH 43058-4277. (740)349-8031. Nonprofit gallery. Estab. 1959. Represents 30 artists; emerging, mid-career and established. Sponsors 12 shows/year. Average display time 3 months. Located 6 blocks north of downtown; 784 sq. ft.; in a Victorian brick building. 70% of space for special exhibitions. Clientele 90% private collectors, 10% corporate clients. Overall price range $30-6,000; most work sold at $50-200.

Media Considers oil, acrylic, watercolor, pastel, pen & ink, drawings, mixed media, collage, works on paper, sculpture, ceramic, fiber, glass, installation, photography, original handpulled prints, woodcuts, engravings, lithographs, wood engravings, serigraphs and etchings. Most frequently exhibits watercolor, oil/acrylic and photography.

Style Exhibits conceptualism, color field, impressionism, realism, photorealism and pattern painting. Genres include landscapes, florals, wildlife, portraits and all genres.

Terms Artwork is accepted on consignment (30% commission.) Retail price set by artist. Gallery provides insurance, promotion and contract; artist pays for shipping. Prefers framed artwork.

Submissions Send query letter with résumé, brochure and photographs. Write to schedule an appointment to show a portfolio, which should include originals and/or slides. Artists who submit must be members of the Licking County Art Association.

MALTON GALLERY

2643 Erie Ave., Cincinnati OH 45208. (513)321-8614. Fax: (513)321-8716. E-mail: info@maltonartgallery.com. Website: www.maltonartgallery.com. **Director:** Sylvia Rombis. Retail gallery. Estab. 1974. Represents about 100 emerging, mid-career and established artists. Exhibits 20 artists/year. Exhibited artists include Carol Henry, Mark Chatterley, Terri Hallman and Esther Levy. Sponsors 7 shows/year. Average display time 1 month. Open all year; Tuesday-Friday, 11-5; Saturday, 12-5. Located in high-income neighborhood shopping district. 2,500 sq. ft. "Friendly, nonintimidating environment." 2-person shows alternate with display of gallery artists. Clientele: private and corporate. Overall price range $250-10,000; most work sold at $400-2,500.

Media Considers oil, acrylic, drawing, sculpture, watercolor, mixed media, pastel, collage and original handpulled prints.

Style Exhibits all styles. Genres include contemporary landscapes, figurative and narrative and abstractions work.

Terms Accepts work on consignment (50% commission). Retail price set by artist (sometimes in consultation with gallery). Gallery provides insurance, promotion, contract and shipping costs from gallery; artist pays shipping costs to gallery. Prefers framed works for canvas; unframed works for paper.

Submissions Send query letter with résumé, slides or photographs, reviews, bio and SASE. Responds in 4 months. Files résumé, review or any printed material. Slides and photographs are returned.

Tips "Never drop in without an appointment. Be prepared and professional in presentation. This is a business. Artists themselves should be aware of what is going on, not just in the 'art world,' but with everything."

Ⓝ MCDONOUGH MUSEUM OF ART

Youngstown State University, 525 Wick Ave., Youngstown OH 44555. (330)941-1400. Fax: (330)941-1492. E-mail: labrothe@ysu.edu. Website: www.fpa.ysu.edu. **Director:** Leslie A. Brothers. Alternative space, museum and nonprofit gallery. Estab. 1991. Located in the center of campus; has 3 traditional galleries, a raw-space gallery and a 2-story, sky-lit large installation gallery. Open Tuesday, Thursday, Friday and Saturday, 11-4; Wednesday, 11-8.

Media Considers all media and all types of prints. Most frequently exhibits installation, painting, sculpture and photography.

Style Considers all styles and genres.

Terms Artwork is accepted on consignment and there is a 20% commission. Retail price set by the artist. Gallery provides insurance, promotion and contract. Accepts only artists from 400-500 mile radius.

SPACES

2220 Superior Viaduct, Cleveland OH 44113. (216)621-2314. E-mail: info@spacesgallery.org. Website: www.spacesgallery.org. Alternative space. Estab. 1978. Represents emerging artists. Has 400+ members. Sponsors 5-

THE BEST IN...

PRODUCT DESIGN: from cars to kitchen sinks, tires to televisions, we cover the new and notable

GRAPHIC DESIGN: breakout design in books, periodicals, brochures, annual reports, packaging, signage, and more

INTERACTIVE DESIGN: the latest games, websites, CD-ROMs, and software

ENVIRONMENTAL DESIGN: from restaurants and museums to schools, offices, and boutiques, you'll take a tour of the world's best environmental design

I.D.® THE BEST IN DESIGN

6 shows/year. Average display time 6 weeks. Open all year; Tuesday-Sunday. Located downtown Cleveland; 6,000 sq. ft.; "loft space with row of columns." 100% private collectors.

Media Considers all media. Most frequently exhibits installation, painting, video and sculpture.

Style Exhibits all styles. Prefers challenging new ideas.

Terms Accepts work on consignment. 20% commission. Retail price set by the artist. Sometimes offers payment by installment. Gallery provides insurance, promotion and contract.

Submissions Contact for an application. Annual deadline in spring for submissions.

Tips "Present yourself professionally and don't give up."

OKLAHOMA

N I COLOR CONNECTION GALLERY

2050 Utica Square, Tulsa OK 74114. (918)742-0515. E-mail: info@colorconnectiongallery.com. Website: www.colorconnectiongallery.com. Retail and cooperative gallery. Estab. 1991. Represents 9 established artists. Sponsors 12 shows/year. Average display time 1 month. Open all year; Tuesday-Saturday, 10-5:30. Located in midtown. Clientele: upscale, local community. 85% private collectors, 15% corporate collectors. Overall price range $100-3,000; most work sold at $250-1,500.

Media Considers oil, acrylic, watercolor, pastel, pen & ink, drawing, mixed media, collage, paper, sculpture, ceramics, glass, linocuts and etchings. Most frequently exhibits watercolor, oil, pastel and etchings.

Style Exhibits expressionism, neo-expressionism, painterly abstraction, impressionism and realism. Genres include florals, portraits, southwestern, landscapes and Americana. Prefers impressionism, painterly abstraction and realism.

Terms Co-op membership fee plus donation of time. Retail price set by the artist. Gallery provides promotion and contract.

Submissions Accepts only artists from Oklahoma. Send query letter with résumé, slides and bio. Call for appointment to show portfolio of photographs, slides and sample of 3-D work. Does not reply. Artist should contact in person. Finds artists through word of mouth, referrals by other artists, visiting art fairs and exhibitions and artist's submissions.

LACHENMEYER ARTS CENTER

700 S. Little, Cushing OK 74023. (918)225-7525. Fax: (918)223-2919. E-mail: roblarts@brightok.net. **Director:** Rob Smith. Nonprofit. Estab. 1984. Exhibited artists include Darrell Maynard, Steve Childers and Dale Martin. Sponsors 3 shows/year. Average display time 2 weeks. Open in August, September, December; Monday, Wednesday, Friday, 9-5; Tuesday, Thursday, 6-9. Located inside the Cushing Youth and Community Center; 550 sq. ft. 80% of space for special exhibitions; 80% of space for gallery artists. 100% private collectors.

Media Considers oil, acrylic, watercolor, pastel, pen & ink, drawing, mixed media, collage, paper, sculpture, ceramics, fiber, photography, woodcuts, engravings, lithographs, wood engravings, mezzotints, serigraphs, linocuts and etchings. Most frequently exhibits oil, acrylic and works on paper.

Style Exhibits all styles. Prefers landscapes, portraits and Americana.

Terms Retail price set by the artist. Gallery provides promotion; shipping costs are shared. Prefers artwork framed.

Submissions Send query letter with résumé, professional quality slides, SASE and reviews. Call or write for appointment to show portfolio of originals. Responds in 1 month. Files résumés. Finds artists through visiting exhibits, word of mouth, other art organizations.

Tips "We prefer local and regional artists."

PERSIMMON HILL

Published by the National Cowboy & Western Heritage Museum, 1700 NE 63rd St., Oklahoma City OK 73111. (405)478-6404. Fax: (405)478-4714. E-mail: editor@nationalmuseum.org. Website: www.nationalcowboymuseum.org. **Director of Publications:** M.J. Van Deventer. Estab. 1970. Quarterly 4-color journal of western heritage "focusing on both historical and contemporary themes. It features nonfiction articles on notable persons connected with pioneering the American West; art, rodeo, cowboys, floral and animal life; or other phenomena of the West of today or yesterday. Lively articles, well written, for a popular audience. Contemporary design follows style of *Architectural Digest* and *European Travel and Life*." Circ. 15,000. Original artwork returned after publication. Sample copy for $10.50.

Illustration Fine art only.

First Contact & Terms Send query letter with tearsheets, SASE, slides and transparencies or digital files. Samples are filed or returned by SASE if requested. Publication will contact artist for portfolio review if interested. Portfolio should include original/final art, photographs or slides. Buys first rights. Requests work on spec before

assigning job. Payment varies. Finds artists through word of mouth, submissions and professional writers groups.

Tips "We are a museum publication. Most illustrations are used to accompany articles. Work with our writers, or suggest illustrations to the editor that can be the basis for a freelance article or a companion story. More interest in the West means we have to provide more contemporary photographs and articles about what people in the West are doing today. Study the magazine first—at least four issues."

OREGON

N ☆ BLACKFISH GALLERY

420 NW Ninth Ave., Portland OR 97209. (503)224-2634. E-mail: bfish@teleport.com. Website: www.blackfish.c om. **Director:** Gina Carrington. Retail cooperative gallery. Estab. 1979. Represents 26 emerging and mid-career artists. Exhibited artists include Michael Knutson (oil paintings). Sponsors 12 shows/year. Open all year; Tuesday-Saturday, 11-5 and by appointment. Located downtown, in the "Northwest Pearl District; 2,500 sq. ft.; street-level, 'garage-type' overhead wide door, long, open space (100' deep)." 70% of space for feature exhibits, 15-20% for gallery artists. 80% of sales are to private collectors, 20% corporate clients. Overall price range $250-12,000; most artwork sold at $500-2,000.

Media Considers oil, acrylic, watercolor, pastel, pen & ink, drawings, mixed media, collage, sculpture, ceramic, photography, woodcuts, wood engravings, linocuts, engravings, mezzotints, etchings, lithographs, pochoir and serigraphs. Most frequently exhibits paintings, sculpture and prints.

Style Exhibits expressionism, neo-expressionism, painterly abstraction, surrealism, conceptualism, minimalism, color field, postmodern works, impressionism and realism. Prefers neo-expressionism, conceptualism and painterly abstraction.

Terms Accepts work on consignment from invited artists (50% commission); co-op membership includes monthly dues plus donation of time (40% commission on sales). Retail price set by artist with assistance from gallery on request. Customer discounts and payment by installment are available. Gallery provides insurance, promotion and contract, and shipping costs from gallery. Prefers artwork framed.

Submissions Accepts only artists from northwest Oregon and southwest Washington ("unique exceptions possible"); "must be willing to be an active cooperative memberwrite for details." Send query letter with résumé, slides, SASE, reviews and statement of intent. Write for appointment to show portfolio of photographs and slides. "We review throughout the year." Responds in 1 month. Files material only if exhibit invitation extended. Finds artists through agents, visiting exhibitions, word of mouth, various art publications and sourcebooks, submissions/self-promotions and art collectors' referrals.

Tips "Understand—via research—what a cooperative gallery is. Call or write for information packet. Do not bring work or slides to us without first having contacted us by phone, mail, or e-mail."

N BUSH BARN ART CENTER

600 Mission St. SE, Salem OR 97302. (503)581-2228. Website: www.salemart.org/about/bushbarn.htm. **Gallery Director:** Saralyn Hilde. Nonprofit gallery. Represents 125 emerging, mid-career and established artists/year. Sponsors 18 shows/year. Average display time 5 weeks. Open all year; Tuesday-Friday, 10-5; Saturday-Sunday, 12-5. Located near downtown in an historic park near Mission and High Streets in a renovated historic barn—the interior is very modern. 50% of space for special exhibitions; 50% of space for gallery artists. Overall price range $10-2,500.

Media Considers oil, acrylic, watercolor, pastel, pen & ink, drawing, mixed media, collage, paper, sculpture, ceramics, fiber, glass, installation, photography, all types of prints.

Style Exhibits all styles.

Terms Accepts work on consignment (40% commission). Gallery provides contract. Prefers artwork framed.

Submissions Send query letter with résumé, 1 sheet of slides and bio. Write for appointment.

Tips "Visit prospective galleries to insure your work would be compatible and appropriate to the space."

COOS ART MUSEUM

235 Anderson Avenue, Coos Bay OR 97420. (541)267-3901. E-mail: info@coosart.org. Website: www.coosart.o rg. **Executive Director:** M. Koreiva. Nonprofit art museum. Estab. 1950. Approached by 30 artists/year. Exhibits group shows of 140+ artists and single/solo shows of established artists. Sponsors 12 exhibits/year. Average display time 4-6 weeks. Open Tuesday-Friday, 10-4; Saturday only, 1-4; closed 3rd Tuesday in December until the 1st Tuesday in January. Located downtown Coos Bay. One large main gallery and 3 smaller gallery areas. Clients include local community, students, tourists and upscale.

Media Considers all media except computer generated and craft and all types of prints except posters. Most frequently exhibits paintings (oil, acrylic, watercolor), sculpture (glass, metal), drawings, etchings and prints.

Style Considers all styles and genres. Most frequently exhibits primitivism, realism, postmodernism and expressionism.

Terms No gallery floor sales. All inquiries are referred directly to the artist. Artist handles the sale. Retail price set by the artist. Museum provides insurance, promotion and contract. Accepted work should be framed, mounted and matted. Does not require exclusive representation locally. Accepts only artists from Oregon or Western USA.

Submissions Send query letter with artist's statement, bio, résumé, SASE, JPEGs and web address. Responds to queries in 6 months. Never send only copies of slides, résumés or portfolios. Files proposals. Finds artists through portfolio reviews and submissions.

Tips ''Have complete files electronically on a website or CD. Have a completely written positioning statement and proposal of their show. Do no expect the museum to produce or create their exhibition. They should have all costs figured ahead of time and submit only when they have their work completed and ready. We do not develop artists. They must be professional.''

N THE MAUDE KERNS ART CENTER

1910 E. 15th Ave., Eugene OR 97403. (541)345-1571. Fax: (541)345-6248. E-mail: staff@mkartcenter.org. Website: www.mkartcenter.org. **Contact:** Tina Schrager. Nonprofit gallery and educational facility. Estab. 1963. Exhibits hundreds of emerging, mid-career and established artists. Exhibited artists include Mark Clarke (acrylic). Interested in seeing the work of emerging artists. 600 members. Sponsors 10 shows/year. Average display time 6 weeks. Open all year. Located in church building on Historic Register. 4 renovated galleries with over 2,500 sq. ft. of modern exhibit space. 100% of space for special exhibitions. Overall price range $200-20,000; most work sold at $200-500.

Media Considers all media. Most frequently exhibits oil/acrylic, mixed media, sculpture and photography.

Style Contemporary artwork.

Terms Accepts work on consignment (30% commission). Retail price set by artist. Gallery provides insurance and contract; artist pays for shipping. Artwork must be framed or ready to hang.

Submissions Send query letter with résumé, slides, bio and SASE. Finds artists through calls to artists, word of mouth, and local arts council publications.

Tips ''Come visit to see exhibits and think about whether the gallery suits you. Include application form from call to artist/prospectus. Do not send more slides than requested. Send appropriate size SASE.''

N LITTMAN GALLERY

P.O. Box 751, Portland OR 97207-0751. (503)725-5656. **Contact:** Cris Estribou, art exhibition committee co-coordinator. Nonprofit gallery. Estab. 1968. Represents emerging, mid-career and established artists. Sponsors 11 shows/year. Average display time 1 month. Closed December. Located downtown at Portland State University; 1,500 sq. ft.; wood floors, 18 ft. 11 in. running window space. 100% of space for special exhibitions.

Media Considers acrylic, collage, drawing, installation, mixed media, oil, paper, pen & ink, sculpture; all types of prints. Most frequently exhibits mixed media, oil and installation.

Style Exhibits all styles. Genres include fine art only.

Terms Retail price set by the artist, gallery keeps 30%. Gallery provides insurance and promotion. Does not pay for shipping. Prefers artwork framed.

Submissions Send query letter, résumé, slides and bio. ''A common mistake of artists is not sending enough slides.'' Responds in 2 months. Files all information.

Tips ''We are a nonprofit university gallery which looks specifically for educational and innovative work.''

MINDPOWER GALLERY

417 Fir Ave., Reedsport OR 97467. (800)644-2485 or (541)271-2485. E-mail: gallery@mindpowergallery.com. Website: www.mindpowergallery.com. **Manager:** Tamara Szalewski. Retail gallery. Estab. 1989. Currently exhibiting over 100 artists. Exhibited artists include John Stewart. Sponsors 6 shows/year. Average display time 2 months to continuous. Open all year; Tuesday-Saturday, 10-5. Located in ''Oldtown'' areafront street is Hwy. 38; 5,000 sq. ft.; 8 rooms with 500 ft. of wall space. 20% of space for ''Infinity'' gift store (hand-crafted items up to $100 retail, New Age music, books); 10% for special exhibitions; 70% of space for gallery artists. Clients include ⅔ from state, ⅓ travelers. 90% of sales are to private collectors, 10% small business collectors. Overall price range $100-20,000; most work sold at $500.

Media Considers oil, acrylic, watercolor, pastel, mixed media, paper, batik, computer, sculpture wood, metal, clay, glass; all types of prints. Most frequently exhibits sculpture, acrylic/oil, watercolor, pastel.

Style Exhibits all styles and genres. ''We have a visual computer catalog accessible to customers, showing work not currently at gallery.''

Terms Accepts work on consignment (40% commission). Retail price set by the artist. Gallery provides promotion, contract and insurance; artist pays shipping costs to and from gallery. Prefers artwork framed.

Submissions Send query letter with typewritten résumé, slides, photographs and SASE. Responds within 1 month. Files résumés. Finds artists through artists' submissions, visiting exhibitions, word of mouth.

Tips Please call between 9-9:30 and 5-5:30 to verify your submission was received.

ROGUE GALLERY & ART CENTER

40 S. Bartlett, Medford OR 97501. (541)772-8118. Fax: (541)772-0294. E-mail: judy@roguegallery.org. Website: www.roguegallery.org. **Executive Director:** Judy Barnes. Nonprofit sales rental gallery. Estab. 1961. Represents emerging, mid-career and established artists. Sponsors 8 shows/year. Average display time 6 weeks. Open all year; Tuesday-Friday, 10-5; Saturday, 11-3. Located downtown; main gallery 240 running ft. (2,000 sq. ft.); rental/sales and gallery shop, 1,800 sq. ft.; classroom facility, 1,700 sq. ft. "This is the only gallery/art center/exhibit space of its kind in the region, excellent facility, good lighting." 33% of space for special exhibitions; 33% of space for gallery artists. 95% of sales are to private collectors. Overall price range $100-5,000; most work sold at $400-1,000.

Media Considers all media and all types of prints. Most frequently exhibits mixed media, drawing, installation, painting, sculpture, watercolor.

Style Exhibits all styles and genres. Prefers figurative work, collage, landscape, florals, handpulled prints.

Terms Accepts work on consignment (35% commission to members; 40% nonmembers). Retail price set by the artist. Gallery provides insurance, promotion and contract; in the case of main gallery exhibit.

Submissions Send query letter with résumé, 10 slides, bio and SASE. Call or write for appointment. Responds in 1 month.

Tips "The most important thing an artist needs to demonstrate to a prospective gallery is a cohesive, concise view of himself as a visual artist and as a person working with direction and passion."

PENNSYLVANIA

FLEISHER/OLLMAN GALLERY

1616 Walnut St., Suite 100, Philadelphia PA 19103. (215)545-7562. Fax: (215)545-6140. E-mail: info@fleisher-ollmangallery.com. Website: www.fleisher-ollmangallery.com. **Director:** John Ollman. Retail gallery. Estab. 1952. Represents 12 emerging and established artists. Exhibited artists include James Castle and Bill Traylor. Sponsors 10 shows/year. Average display time 5 weeks. Closed August. Located downtown; 4,500 sq. ft. 75% of space for special exhibitions. Clientele primarily art collectors. 90% private collectors, 10% corporate collectors. Overall price range $2,500-100,000; most work sold at $2,500-30,000.

Media Considers oil, acrylic, watercolor, pastel, pen & ink, drawing, mixed media and collage. Most frequently exhibits drawing, painting and sculpture.

Style Exhibits self-taught and contemporary works.

Terms Accepts artwork on consignment (commission) or buys outright. Retail price set by the gallery. Gallery provides insurance and promotion; shipping costs are shared. Prefers artwork framed.

Submissions Send query letter with résumé, slides, bio and SASE; gallery will call if interested within 1 month.

Tips "Be familiar with our exhibitions and the artists we exhibit."

LANCASTER MUSEUM OF ART

135 N. Lime St., Lancaster PA 17602. (717)394-3497. Fax: (717)394-0101. E-mail: info@lmapa.org. Website: www.lmapa.org. **Executive Director:** Cindi Morrison. Nonprofit organization. Estab. 1965. Represents over 100 emerging, mid-career and established artists/year. 900+ members. Sponsors 12 shows/year. Average display time 6 weeks. Open all year; Monday-Saturday, 10-4; Sunday, 12-4. Located downtown Lancaster; 4,000 sq. ft.; neoclassical architecture. 100% of space for special exhibitions. 100% of space for gallery artists. Overall price range $100-25,000; most work sold at $100-10,000.

Media Considers all media.

Terms Accepts work on consignment (30% commission). Retail price set by the artist. Gallery provides insurance; shipping costs are shared. Artwork must be ready for presentation.

Submissions Send query letter with résumé, slides, photographs or CDs, SASE, and artist's statement for review by exhibitions committee. Annual deadline February 1st.

Tips Advises artists to submit quality slides and well-presented proposal. "No phone calls."

🅽 MCS GALLERY

1110 Northampton St., Easton PA 18102. (610)253-2332, ext. 236. Fax: (610)253-6722. E-mail: mcsgallery@aol.com. Website: www.mcsgallery.com. **Director:** Thomas Burke. For-profit gallery. Estab. 1999. Approached by 20 artists/year. Exhibits 8 emerging, mid-career and established artists. Sponsors 6 exhibits/year. Average display time 6 weeks. Open all year; Tuesday-Saturday, 11-5; weekends, 12-5. Located in downtown Easton

PA; approximately 4,000 sq. ft. that is divided in 3 gallery spaces. Clients include local community and upscale. 5% of sales are to corporate collectors. Overall price range $500-5,000; most work sold at $1,500.

Media Considers acrylic, collage, drawing, fiber, installation, mixed media, oil, paper, pen & ink, sculpture, watercolor, engravings, etchings, linocuts, lithographs, mezzotints, serigraphs and woodcuts. Most frequently exhibits paintings, sculpture and mixed media.

Style Exhibits expressionism, impressionism, postmodernism, surrealism and painterly abstraction. Most frequently exhibits painterly abstraction, impressionism and surrealism. Genres include figurative and landscapes.

Terms Artwork is accepted on consignment and there is a 40% commission. Retail price set by the gallery and the artist. Gallery provides insurance, promotion and contract. Accepted work should be framed. Does not require exclusive representation locally.

Submissions Write to arrange a personal interview to show portfolio of slides and transparencies. Mail portfolio for review. Send artist's statement, bio, résumé, SASE and slides. Returns material with SASE. Responds in 1 month. Files slides, résumé and statements. Finds artists through word of mouth, submissions, art exhibits and referrals by other artists.

NEWMAN GALLERIES

1625 Walnut St., Philadelphia PA 19103. (215)563-1779. Fax: (215)563-1614. E-mail: info@newmangalleries186 5.com. Website: www.newmangalleries1865.com. **Owners:** Walter A. Newman, Jr., Walter A. Newman III, Terrence C. Newman. Retail gallery. Estab. 1865. Represents 10-20 emerging, mid-career and established artists/year. Exhibited artists include Elise Phillips, David Coolidge, James Mcginley, Anthony J. Rudisill, Leonard Mizerek, Mary Anna Goetz, John Murray, George Gallo and John English. Sponsors 2-4 shows/year. Average display time 1 month. Open September through June, Monday-Friday, 9-5:30; Saturday, 10-4:30; July through August, Monday-Friday, 9-5. Located in Center City Philadelphia. 4,000 sq. ft. "We are the largest and oldest gallery in Philadelphia." 50% of space for special exhibitions; 100% of space for gallery artists. Clientele: traditional. 70% private collectors, 30% corporate collectors. Overall price range $1,000-100,000; most work sold at $2,000-20,000.

Media Considers oil, acrylic, watercolor, pastel, sculpture and etching. Most frequently exhibits watercolor, oil/acrylic, and pastel.

Style Exhibits expressionism, impressionism and realism. Genres include landscapes, florals, Americana and figurative work. Prefers landscapes, Americana, marines and still life.

Terms Accepts work on consignment (45% commission). Retail price set by gallery and artist. Gallery provides insurance. Promotion and shipping costs are shared. Prefers oils framed; prints, pastels and watercolors unframed but matted.

Submissions Send query letter with résumé, 12-24 slides, bio and SASE. Call for appointment to show portfolio of originals, photographs and transparencies. Responds in 1 month." Finds artists through agents, visiting exhibitions, word of mouth, art publications, sourcebooks and artists' submissions.

NEXUS/FOUNDATION FOR TODAYS ART

137 North Second Street, Philadelphia PA 19106. (215)629-1103. E-mail: info@nexusphiladelphia.org. Website: www.nexusphiladelphia.org. **Executive Director:** Nick Cassway. Alternative space, cooperative gallery, non-profit gallery. Estab. 1975. Approached by 40 artists/year. Represents 20 emerging and mid-career artists. Exhibited artists include Matt Pruden (illegal art extravaganza). Sponsors 10 exhibits/year. Average display time 1 month. Open Wednesday-Sunday from 12 to 6 p.m.; closed July and August. Located Old City, Philadelphia; 2 gallery spaces approx. 750 sq. ft. each. Clients include local community, students, tourists and upscale. Overall price range $75-1,200; most work sold at $200-400.

Media Considers acrylic, ceramics, collage, craft, drawing, fiber, glass, installation, mixed media, oil, paper, pen & ink and sculpture. Prints include etchings, linocuts, lithographs, posters, serigraphs and woodcuts. Most frequently exhibits installation, collage and mixed media.

Style Exhibits conceptualism, expressionism, neo-expressionism, postmodernism and surrealism. Most frequently exhibits conceptualism, expressionism and postmodernism.

Terms Artwork is accepted on consignment and there is a 50% commission. Retail price set by the artist. Gallery provides promotion. Accepted work should be framed. Does not require exclusive representation locally. Accepts only artists from Philadelphia for membership in organization.

Submissions Send query letter with artist's statement, bio, photocopies, photographs, SASE and slides. Returns material with SASE. Finds artists through portfolio reviews, referrals by other artists, submissions. Nexus juries artists 3 times a year. Please visit our website for submission dates.

Tips "Get great slides made by someone who knows how to take professional slides. Learn how to write a cohesive and understandable artist statement."

PENTIMENTI GALLERY

145 North Second St., Philadelphia PA 19106. (215)625-9990. Fax: (215)625-8488. E-mail: mail@pentimenti.c om. Website: www.pentimenti.com. **Contact:** Christine Pfister, director. Retail and commercial gallery. Estab. 1992. Represents 20-30 emerging, mid-career and established artists. Sponsors 7-9 exhibits/year. Average display time 4-6 weeks. Open all year; Wednesday-Friday, 12-5:30; weekends 12-5. Closed Sundays, August, Christmas and New Year. Located in the heart of Old City Cultural district in Philadelphia. Overall price range $250-12,000; most work sold at $1,500-7,000.

Media Considers all media. Most frequently exhibits paintingsall media except pastel/watercolor.

Style Exhibits conceptualism, minimalism, postmodernism and painterly abstraction. Most frequently exhibits postmodernism, minimalism and conceptualism.

Terms Artwork is accepted on consignment and there is a 50% commission. Retail price set by the gallery and the artist. Gallery provides insurance and promotion. Requires exclusive representation locally.

Submissions Call to arrange a personal interview to show portfolio of photographs, slides and transparencies. Send query letter with artist's statement, bio, brochure, photographs, résumé, SASE and slides. Returns material with SASE. Responds in 3 months. Finds artists through word of mouth, submissions, portfolio reviews, art exhibits, art fairs and referrals by other artists.

THE PRINT CENTER

1614 Latimer St., Philadelphia PA 19103. (215)735-6090. Fax: (215)735-5511. E-mail: info@printcenter.org. Website: www.printcenter.org. Nonprofit gallery. Estab. 1915. Exhibits emerging, mid-career and established artists. Approached by 500 artists/year. Sponsors 11 exhibits/year. Average display time 2 months. Open all year; Tuesday-Saturday, 11-5:30. Closed December 21-January 3. Gallery houses 3 exhibit spaces as well as a separate Gallery Store. We are located in historic Rittenhouse area of Philadelphia. Clients include local community, students, tourists and high end collectors. 30% of sales are to corporate collectors. Overall price range $15-15,000; most work sold at $200.

Media Considers all forms of printmaking, photography and digital printing. Send original artwork—no reproductions.

Style Considers all styles and genres.

Terms Artwork is accepted on consignment and there is a 50% commission. Retail price set by the artist. Gallery provides insurance, promotion and contract. Accepted work should be framed and matted for exhibitions; unframed for Gallery Store. Does not require exclusive representation locally. Only accepts prints and photos.

Submissions Membership based—slides of members reviewed by Curator and Gallery Store Manager. Send membership. Finds artists through submissions, art exhibits and membership.

Tips Be sure to send proper labeling and display of slides with attached slide sheet.

SAMEK ART GALLERY OF BUCKNELL UNIVERSITY

Elaine Langone Center, Lewisburg PA 17837. (570)577-3792. Fax: (570)577-3215. E-mail: peltier@bucknell.edu. Website: www.departments.bucknell.edu/samek-artgallery/. **Director:** Dan Mills. Gallery Manager: Cynthia Peltier. Assistant Registrar: Jeffery Brunner. Nonprofit gallery. Estab. 1983. Exhibits emerging, mid-career and established international and national artists. Sponsors 6 shows/year. Average display time 6 weeks. Open all year; Monday-Friday, 11-5; Saturday-Sunday, 1-4. Located on campus; 3,500 sq. ft. including main gallery, project room and Kress Study Collection Gallery.

Media Considers all media, traditional and emerging media. Most frequently exhibits painting, sculpture, works on paper and video.

Style Exhibits all styles, genres and periods.

Terms Retail price set by the artist. Gallery provides insurance, promotion (local) and contract; artist pays shipping costs to and from gallery. Prefers artwork framed or prepared for exhibition.

Submissions Send query letter with résumé, slides and bio. Write for appointment to show portfolio of originals. Responds in 12 months. Files bio, résumé, slides. Finds artists through museum and gallery exhibits, and through studio visits.

Tips "Most exhibitions are curated by the director or by a guest curator."

RHODE ISLAND

ARTIST'S COOPERATIVE GALLERY OF WESTERLY

12 High St., Westerly RI 02891. (401)596-2020. E-mail: info@westerlyarts.com. Website: www.westerlyarts.c om. Cooperative gallery and nonprofit corporation. Estab. 1992. Represents 45-50 emerging, mid-career and established artists/year. Sponsors 12 shows/year. Average display time 1 month. Offers spring and fall open juried shows. Open all year; Tuesday-Saturday, 10-5. Located downtown on a main street; 30 ft. × 80 ft.; ground

level, store front, arcade entrance, easy parking. 80% of sales are to private collectors, 20% corporate collectors. Overall price range $20-3,000; most work sold at $20-300.

Media Considers all media and all types of prints. Most frequently exhibits oils, watercolors, ceramics, sculpture and jewelry.

Style Exhibits expressionism, primitivism, painterly abstraction, postmodern works, impressionism and realism.

Terms Co-op membership fee of $120/year, plus donation of time and hanging/jurying fee of $10. Gallery takes no percentage. Regional juried shows each year. Retail price set by the artist. Gallery provides promotion; artist pays for shipping. Prefers artwork framed.

Submissions Send query letter with 3-6 slides or photos and artist's statement. Call or write for appointment. Responds in 3 weeks. Membership flyer and application available on request.

Tips "Take some good quality pictures of your work in person, if possible, to galleries showing the kind of work you want to be associated with. If rejected, reassess your work, presentation and the galleries you have selected. Adjust what you are doing appropriately. Try again. Be upbeat and positive."

HERA EDUCATIONAL FOUNDATION, HERA GALLERY

327 Main St., Wakefield RI 02880-0336. (401)789-1488. E-mail: info@heragallery.org. Website: www.heragallery.org. **Director:** Katherine Veneman. Nonprofit professional artist cooperative gallery. Estab. 1974. Located in downtown Wakefield, a Northeast area resort community (near beaches, Newport and Providence). Exhibits the work of emerging and established artists who live in New England, Rhode Island and throughout the US. 30 members. Sponsors 9-10 shows/year. Average display time 4-5 weeks. Hours Wednesday, Thursday and Friday, 1-5; Saturday, 10-4. Closed January. Located downtown; 1,200 sq. ft. 40% of space for special exhibitions.

Media Considers all media and original handpulled prints.

Style Exhibits installations, conceptual art, expressionism, neo-expressionism, painterly abstraction, surrealism, conceptualism, postmodern works, realism and photorealism, basically all styles. "We are interested in innovative, conceptually strong, contemporary works that employ a wide range of styles, materials and techniques." Prefers "a culturally diverse range of subject matter which explores contemporary social and artistic issues important to us all."

Terms Co-op membership. Retail price set by artist. Sometimes offers customer discount and payment by installments. Gallery provides promotion; artist pays for shipping and shares expenses like printing and postage for announcements. Commission is 25%. No insurance.

Submissions Send query letter with SASE. "After sending query letter and SASE, artists interested in membership receive membership guidelines with an application. Twenty slides or a CD-Rom are required for application review along with résumé, artist statement and slide list." Portfolio required for membership; slides for invitational/juried exhibits. Finds artists through word of mouth, advertising in art publications, and referrals from members.

Tips "Please write for membership guidelines. We have two categories of membership, one of which is ideal for out of state artists."

SOUTH CAROLINA

CHARLESTON CRAFTS

87 Hasell St., Charleston SC 29401. (843)723-2938. E-mail: info@charlestoncrafts.org. Website: www.charlestoncrafts.org. **Chairperson:** June Sullivan (will change in September 2005). Cooperative gallery. Estab. 1989. Represents 50 emerging, mid-career and established artists/year. 50-70 members. Open all year; Monday-Saturday 10-5. Located downtown. 5% of space for special exhibitions; 95% of space for gallery artists. Clientele: tourists and local community. 98% private collectors, 2% corporate collectors. Overall price range $5-800; most work sold at $30-125.

Media Considers basketry, wood, paper, fiber, sculpture, glass, fine craft, fine photography, graphics, handpulled prints. Most frequently exhibits clay, glass, fiber and jewelry.

Terms Co-op membership fee plus donation of time (35% commissions). Retail price set by the artist. Gallery provides promotion; shipping costs are shared. Prefers artwork either framed or unframed.

Submissions Accepts only artists residing in South Carolina. Send query letter with SASE. Responds in 2 weeks. Files only applications to jury as member. Finds artists through word of mouth; jury twice a year, referrals and craft shows call for new member-press releases. Produces a two-weekend fine craft show for Piccolo Spoleto. E-mail for craft show information is piccolo@charlestoncrafts.org.

Tips "Artists must realize we are a cooperative of juried members—all local South Carolina artists. We look at expertise in technique, finishing and how work is presented—professional display, packaging or tagging."

⬛ HAMPTON III GALLERY LTD.

3110 Wade Hampton Blvd., Taylors (Greenville) SC 29687. E-mail: hampton3gallery@mindspring.com. **Contact:** Sandra Rupp, director. Rental gallery. Estab. 1970. Approached by 20 artists/year; exhibits 25 mid-career and established artists/year. Exhibited artists include Carl Blair (oil paintings) and Darell Koons (acrylic paintings). Sponsors 8 exhibits/year. Average display time 4-6 weeks. Open all year; Tuesday-Friday, 1-5; Saturday and Sunday, 10-5. Located 3 miles outside of downtown Greenville, SC; one large exhibition room in center with 7 exhibition rooms around center gallery. Clients include local community and upscale. 5% of sales are to corporate collectors. Overall price range $200-15,000; most work sold at $2,500.

Media Considers acrylic, ceramics, collage, drawing, mixed media, oil, paper, pastel, pen & ink, sculpture and watercolor. Most frequently exhibits oil and watercolor. Also considers engravings, etchings, linocuts, lithographs, mezzotints, serigraphs and woodcuts.

Style Exhibits color field, expressionism, geometric abstraction, imagism, impressionism and painterly abstraction. Most frequently exhibits painterly abstration and realism. Considers all genres.

Terms Artwork is accepted on consignment and there is a 40% commission. Retail price of the art set by the artist. Gallery provides insurance, promotion and contract. Accepted work should be framed. Requires exclusive representation locally.

Submissions Send query letter with artist's statement, bio, reviews, SASE and slides. Returns material with SASE. Responds to queries in 3 months. Finds artists through art exhibits, referrals by other artists and word of mouth.

⬛ STEVEN JORDAN GALLERY

24 Broadway, Mt. Pleasant SC 29464. (843)881-1644. Website: www.stevenjordan.com. **Owner:** Steven Jordan. Retail gallery. Estab. 1987. Represents various three-dimensional artists and two-dimensional work by Steven Jordan A.W.S. Open all year; Monday-Saturday, 11-6. Located 5 miles from downtown; 1,600 sq. ft. Clientele tourists, upscale, local community, students. 80% private collectors, 20% corporate collectors.

Media Considers only sculpture and ceramics.

Style Prefers coastal realism, humor and abstracts.

Terms Accepts work on consignment (40% commission) to gallery. Retail price set by the artist. Gallery provides promotion. Shipping costs are shared.

Submissions Accepts only artists from America. Prefers three-dimensional work. Send query letter with slides, bio, brochure and photographs. Call for appointment to show portfolio of photographs or slides. Responds in 2 weeks. Finds artists through word of mouth, referrals by other artists, visiting art fairs and exhibitions and artist's submissions.

Tips "Be optimistic! Don't be discouraged by failures. Perseverance is more important than talent."

MCCALLS

111 W. Main, Union SC 29379. (864)427-8781. **Contact:** Bill McCall. Retail gallery. Estab. 1972. Represents 5-7 established artists/year. Open all year; Tuesday-Friday, 10-5 (10 months); Monday-Saturday, 10-6 (2 months). Located downtown; 900 sq. ft. 10% of space for special exhibitions; 90% of space for gallery artists. Clientele: upscale. 60% private collectors, 40% corporate collectors. Overall price range $150-2,500; most work sold at $150-850.

Media Considers oil, pen & ink, acrylic, glass, craft (jewelry), watercolor, mixed media, pastel, collage; considers all types of prints. Most frequently exhibits jewelry, collage and watercolor.

Style Exhibits painterly abstraction, primitivism, realism, geometric abstraction and impressionism. Genres include florals, western, southwestern, landscapes, wildlife and Americana. Prefers southwestern, florals and landscapes.

Terms Accepts work on consignment (negotiable commission). Retail price set by the gallery and the artist. Gallery provides insurance, promotion and contract.

Submissions "I prefer to see actual work by appointment only."

Tips "Present only professional quality slides and/or photographs."

⬛ PORTFOLIO ART GALLERY

2007 Devine St., Columbia SC 29205. (803)256-2434. E-mail: artgal@portfolioartgal.com. Website: www.portfolioartgal.com. **Owner:** Judith Roberts. Retail gallery and art consultancy. Estab. 1980. Represents 40-50 emerging, mid-career and established artists. Exhibited artists include Donald Holden, Sigmund Abeles and Joan Ward Elliott. Sponsors 4-6 shows/year. Average display time 3 months. Open all year. Located in a 1930s shopping village, 1 mile from downtown; 2,000 sq. ft.; features 12 foot ceilings. 100% of space for work of gallery artists. "A unique feature is glass shelves where matted and medium to small pieces can be displayed without hanging on the wall." Clientele: professionals, corporations and collectors. 40% private collectors, 40% corporate collectors. Overall price range $150-12,500; most work sold at $300-3,000.

• Portfolio Art Gallery was selected by readers of the local entertainment weekly paper and by *Columbia Metropolitan* magazine as the best gallery in the area.

Media Considers oil, acrylic, watercolor, pastel, mixed media, collage, works on paper, sculpture, ceramic, glass, original handpulled prints, woodcuts, wood engravings, linocuts, engravings, mezzotints, etchings, lithographs and serigraphs. Most frequently exhibits watercolor, oil and original prints.

Style Exhibits neo-expressionism, painterly abstraction, imagism, minimalism, color field, impressionism, realism, photorealism and pattern painting. Genres include landscapes and figurative work. Prefers landscapes/seascapes, painterly abstraction and figurative work. "I especially like mixed media pieces, original prints and oil paintings. Pastel medium and watercolors are also favorites. Kinetic sculpture and whimsical clay pieces."

Terms Accepts work on consignment (40% commission). Retail price set by gallery and artist. Offers payment by installments. Gallery provides insurance, promotion and contract; artist pays for shipping. Artwork may be framed or unframed.

Submissions Send query letter with slides, bio, brochure, photographs, SASE and reviews. Write for appointment to show portfolio of originals, slides, photographs and transparencies. Responds only if interested within 1 month. Files tearsheets, brochures and slides. Finds artists through visiting exhibitions and referrals.

Tips "The most common mistake beginning artists make is showing all the work they have ever done. I want to see only examples of recent best work—unframed, originals (no copies)—at portfolio reviews."

SOUTH DAKOTA

☒ DAKOTA ART GALLERY

902 Mt. Rushmore Rd., Rapid City SD 57701. (605)394-4108. **Director:** Marie Bachmeier. Retail gallery. Estab. 1971. Represents approximately 200 emerging, mid-career and established artists, approximately 180 members. Exhibited artists include James Van Nuys and Russell Norberg. Sponsors 8 shows/year. Average display time 6 weeks. Also sponsors 6-week-long spotlight exhibits 8 times a year. Average display time 6 weeks. Open all year; Monday-Saturday, 10-5. Located in downtown Rapid City; 1,800 sq. ft. 40% of space for special exhibitions; 60% of space for gallery artists. 80% private collectors, 20% corporate collectors. Overall price range $25-7,500; most work sold at $25-400.

Media Considers all media and all types of prints. Most frequently exhibits oil, acrylics, watercolors, pastels, jewelry, stained glass and ceramics.

Style Exhibits expressionism, painterly abstraction and impressionism and all genres. Prefers landscapes, western, regional, still lifes and traditional.

Terms Accepts work on assignment (40% commission). Retail price set by the artist. Gallery provides insurance, promotion and contract. Artist pays shipping costs.

Submissions "Our main focus is on artists from SD, ND, MN, WY, CO, MT and IA. We also show artwork from any state that has been juried in." Must be juried in by committee. Send query letter with résumé, 15-20 slides, bio and photographs. Call for appointment to show portfolio of photographs, slides, bio and résumé. Responds in 1 month. Files résumés and photographs. Finds artists through word of mouth, referrals by other artists, visiting art fairs and exhibitions, artist's submissions.

Tips "Make a good presentation with professional résumé, biographical material, slides, etc. Know the gallery quality and direction in sales, including prices."

TENNESSEE

BENNETT GALLERIES

5308 Kingston Pike, Knoxville TN 37919. (865)584-6791. Fax: (865)588-6130. Website: www.bennettgalleries.com. **Director:** Marga Hayes. Owner: Rick Bennett. Retail gallery. Represents emerging and established artists. Exhibited artists include Richard Jolley, Carl Sublett, Scott Duce, Andrew Saftel and Tommie Rush, Akira Blount, Scott Hill, Marga Hayes Ingram, John Boatright, Grace Ann Warn, Timothy Berry, Cheryl Warrick, Dion Zwirne. Sponsors 10 shows/year. Average display time 1 month. Open all year; Monday-Thursday, 10-6; Friday-Saturday, 10-530. Located in West Knoxville. Clientele 80% private collectors, 20% corporate collectors. Overall price range $200-20,000; most work sold at $2,000-8,000.

Media Considers oil, acrylic, watercolor, pastel, drawing, mixed media, works on paper, sculpture, ceramic, craft, photography, glass, original handpulled prints. Most frequently exhibits painting, ceramic/clay, wood, glass and sculpture.

Style Exhibits contemporary works in abstraction, figurative, narrative, realism, contemporary landscape and still life.

Terms Accepts artwork on consignment (50% commission). Retail price set by the gallery and the artist.

Sometimes offers customer discounts and payment by installments. Gallery provides insurance on works at the gallery, promotion and contract. Prefers artwork framed. Shipping to gallery to be paid by the artist.

Submissions Send query letter with résumé, no more than 10 slides, bio, photographs, SASE and reviews. Finds artists through agents, visiting exhibitions, word of mouth, various art publications, sourcebooks, submissions/self-promotions and referrals.

N EATON GALLERY

1401 Heistan Place, Memphis TN 38104. (901)274-0000. Fax: (901)274-4147. **Owner/Director:** Sandra Saunders. Retail gallery. Estab. 1984. Represents 25 emerging, mid-career and established artists. Exhibited artists include Marjorie Liebman, Jiaxian Hao, Taylor Lin, Weimin. 30% of space for special exhibitions. Clientele 60% private collectors, 40% corporate clients. Overall price range $350-10,000; most work sold at $700-4,500.

Media Considers oil, acrylic, watercolor, pastel, drawings, mixed media, works on paper, sculpture, original handpulled prints, woodcuts, engravings, lithographs, mezzotints, serigraphs and etchings. Most frequently exhibits oil, acrylic and watercolor.

Style Exhibits expressionism, painterly abstraction, color field, impressionism and realism. Genres include landscapes, florals, Americana, Southwestern, portraits and figurative work. Prefers impressionism, expressionism and realism.

Terms Accepts work on consignment (50% commission). Retail price set by artist or both gallery and artist. Gallery provides insurance, promotion and contract; artist pays for shipping. Prefers artwork framed.

Submissions Send query letter with résumé, bio, slides, photographs and reviews. Write for appointment to show portfolio of originals "so that we may see how the real work looks" and photographs. Responds in 1 week. Files photos and "anything else the artists will give us."

Tips "Just contact us—we are here for you."

JAY ETKIN GALLERY

409 S. Main St., Memphis TN 38103. (901)543-0035. E-mail: etkinart@hotmail.com. Website: www.jayetkingallery.com. **Owner:** Jay S. Etkin. Retail gallery. Estab. 1989. Represents/exhibits 20 emerging, mid-career and established artists/year. Exhibited artists include Annabelle Meacham, Jeff Scott and Pamela Cobb. Sponsors 10 shows/year. Average display time 1 month. Open all year; Tuesday-Saturday, 10-5. Located in downtown Memphis; 10,000 sq. ft.; gallery features public viewing of works in progress. 30% of space for special exhibitions; 5% of space for gallery artists. Clientele: young upscale, corporate. 80% private collectors, 20% corporate collectors. Overall price range $200-12,000; most work sold at $1,000-3,000.

Media Considers all media except craft, papermaking. Also considers kinetic sculpture and conceptual work. "We do very little with print work." Most frequently exhibits oil on paper canvas, mixed media and sculpture.

Style Exhibits expressionism, conceptualism, neo-expressionism, painterly abstraction, postmodern works, realism, surrealism. Genres include landscapes and figurative work. Prefers figurative expressionism, abstraction, landscape.

Terms Artwork is accepted on consignment (60% commission). Retail price set by the gallery and the artist. Gallery provides promotion. Artist pays for shipping or costs are shared at times.

Submissions Accepts artists generally from mid-south. Prefers only original works. Looking for long-term committed artists. Send query letter with 6-10 sildes or photographs, bio and SASE. Write for appointment to show portfolio of photographs, slides and cibachromes. Responds only if interested within 1 month. Files bio/slides if interesting work. Finds artists through referrals, visiting area art schools and studios, occasional drop-ins.

Tips "Be patient. The market in Memphis for quality contemporary art is only starting to develop. We choose artists whose work shows technical know-how and who have ideas about future development in their work. Make sure work shows good craftsmanship and good ideas before approaching gallery. Learn how to talk about your work."

LISA KURTS GALLERY

766 S. White Station Rd., Memphis TN 38117. (901)683-6200. Fax: (901)683-6265. E-mail: art@lisakurts.com. Website: www.lisakurts.com. **Contact:** Stephen Barker, communications. For-profit gallery. Estab. 1979. Approached by 500 artists/year; exhibits 20 mid-career and established nationnally and internationally known aritsts. Exhibited artists include Marcia Myers and Anita Huffington. Sponsors 9 total exhibitions/year. Average display time 4-6 weeks. Open all year; Tuesday-Friday, 10-5; Saturday, 11-4. "Lisa Kurts Gallery is Memphis' oldest gallery and is known to be one of the leading galleries in the USA. Exhibits nationally in International Art Fairs and is regularly reviewed in the national press. Publishes catalogues and works closely with serious collectors and museums. This gallery's sister company, Lisa Kurts Ltd. specializes in blue chip Impressionist and Early Modern paintings and sculpture." Clients include national and international. Overall price range $5,000-100,000; most work sold at $7,500-15,000.

Media Exhibits "80% oil painting, 18% sculpture, 2% photography."

Style Most frequently exhibits "artists with individual vision and who create works of art that are well crafted or painted." Considers all genres.

Terms Artwork is accepted on consignment and there is a 50% commission. Retail price of the art set by the artist and the market if the artist's career is mature; set by the gallery if the artist's career is young. Gallery provides insurance, promotion and contract. Accepted work should be "professionally framed or archively mounted as approved by gallery's standards." Requires exclusive representation in the South.

Submissions Send query letter with artist's statement, résumé, reviews and slides. Returns materials with SASE. Responds to queries in 3 months. Files slides and complete information. Finds artists through art fairs and exhibits, portfolio reviews, referrals by other artists, submissions and word of mouth.

Tips To make their gallery submissions professional artists must send "clearly labeled slides and a minimum of 1 sheet, with the total résumé, artist's statement, letter why they contacted our gallery reviews, etc. Do not call. E-mail if you've not heard from us in 3 months."

RIVER GALLERY

400 E. Second St., Chattanooga TN 37403. (423)265-5033, ext. 5. Fax: (423)265-5944. E-mail: details@river-gallery.com. **Owner Director:** Mary R. Portera. Retail gallery. Estab. 1992. Represents 150 emerging, mid-career and established artists/year. Exhibited artists include Leonard Baskin and Scott E. Hill. Sponsors 12 shows/year. Display time 1 month. Open all year; Monday-Saturday, 10-5; Sunday, 1-5. Located in Bluff View Art District in downtown area; 2,500 sq. ft.; restored early New Orleans-style 1900s home; arched openings into rooms. 20% of space for special exhibitions; 80% of space for gallery artists. Clients include upscale tourists, local community. 95% of sales are to private collectors, 5% corporate collectors. Overall price range $5-5,000; most work sold at $200-1,000.

Media Considers all media. Most frequently exhibits oil, original prints, photography, watercolor, mixed media, clay, jewelry, wood, glass and sculpture.

Style Exhibits all styles and genres. Prefers painterly abstraction, impressionism, photorealism.

Terms Accepts work on consignment (50% commission). Retail price set by the gallery. Gallery provides insurance, promotion and contract; shipping costs are shared. Prefers artwork framed.

Submissions Send query letter with résumé, slides, bio, photographs, SASE, reviews and artist's statement. Call or e-mail for appointment to show portfolio of photographs and slides. Files all material "unless we are not interested then we return all information to artist." Finds artists through word of mouth, referrals by other artists, visiting art fairs and exhibitions, submissions, ads in art publications.

TEXAS

N ART LEAGUE OF HOUSTON

1953 Montrose Blvd., Houston TX 77006. (713)523-9530. E-mail: artleagh@neosoft.com. **Interim Executive Director:** Diana Griffin Gregory. Nonprofit gallery. Estab. 1948. Represents emerging and mid-career artists. Sponsors 12 individual and group shows/year. Average display time 3-4 weeks. Located in a contemporary metal building; 1,300 sq. ft., specially lighted; smaller inner gallery/video room. Clientele general, artists and collectors. Overall price range $100-5,000; most artwork sold at $100-2,500.

Media Considers all media.

Style Exhibits contemporary avant-garde, socially aware work. Features "high-quality artwork reflecting serious aesthetic investigation and innovation. Additionally the work should have a sense of personal vision."

Terms 30% commission. Retail price set by artist. Exclusive area representation not required. Gallery provides insurance, promotion and contract; artist pays for shipping.

Submissions Must be a Houston-area resident. Send query letter, résumé and slides that accurately portray the work. Portfolio review not required. Submissions reviewed once a year in mid-June, and exhibition agenda determined for upcoming year.

N AUSTIN MUSEUM OF ART

823 Congress Ave., Austin TX 78701 Fax: (512)495-9024. E-mail: krobertson@amoa.org. Website: www.amoa.org. **Director:** Elizabeth Ferrer. Museum. Estab. 1961. Downtown and Laguna Gloria locations. Interested in emerging, mid-career and established artists. Sponsors 2-3 solo and 6 group shows/year. Average display time 1½ months. Clientele tourists and Austin and central Texas citizens.

Media Currently exhibits 20th-21st Century art of the Americas and the Caribbean with an emphasis on two-dimensional and three-dimensional contemporary artwork to include experimental video, mixed media and outdoor site-specific installations.

Style Exhibits all styles and genres. No commercial clichéd art.

Terms Retail price set by artist. Gallery provides insurance and contract; shipping costs to be determined. Exhibitions booked 2 years in advance. "We are not a commercial gallery."

Submissions Send query letter with résumé, slides and SASE. Responds only if interested within 3 months. Files slides, résumé and bio. Material returned only when accompanied by SASE. Common mistakes artists make are "not enough informationpoor slide quality, too much work covering too many changes in their development."

BARNARD'S MILL ART MUSEUM

307 SW. Barnard St., Glen Rose TX 76043. (254)897-2611. **Contact:** Richard H. Moore, president. Museum. Estab. 1989. Represents 30 mid-career and established artists/year. Interested in seeing the work of emerging artists. Sponsors 2 shows/year. Open all year; Saturday, 10-5; Sunday, 1-5. Located 2 blocks from the square. "Barnards Mill is the oldest structure (rock exterior) in Glen Rose." 20% of space for special exhibitions; 80% of space for gallery artists.

Media Considers oil, acrylic, watercolor, pastel, pen & ink, drawing, mixed media, collage, paper, sculpture, ceramics, fiber, glass, installation, photography, woodcuts, engravings, lithographs, wood engravings, mezzotints, serigraphs, linocuts and etchings. Most frequently exhibits oil, pastel and watercolor.

Style Exhibits expressionism, postmodern works, impressionism and realism, all genres. Prefers realism, impressionism and Western.

Terms Gallery provides promotion. Prefers artwork framed.

Submissions Send query letter with résumé, slides or photographs, bio and SASE. Write for appointment to show portfolio of photographs or slides. Responds only if interested within 3 months. Files résumés, photos, slides.

Ⓝ CONTEMPORARY GALLERY

4152 Shady Bend Dr., Dallas TX 75244. (214)247-5246. **Director:** Patsy C. Kahn. Private dealer. Estab. 1964. Interested in established artists. Clients include collectors and retail.

Media Considers original handpulled prints.

Style Contemporary, 20th-century artgraphics.

Terms Accepts work on consignment or buys outright. Retail price set by gallery and artist; shipping costs are shared.

Submissions Send query letter, résumé, slides and photographs. Write for appointment to show portfolio.

Ⓝ DALLAS MUSEUM OF ART

1717 Harwood St., Dallas TX 75201. (214)922-1200. Fax: (214)922-1350. Website: www.DallasMuseumofArt.org. Museum. Estab. 1903. Exhibits emerging, mid-career and established Exhibited artists include Thomas Struth. Average display time 3 months. Open all year; Tuesday-Sunday, 11-5; open until 9 on Thursday. Closed New Year's Day, Thanksgiving and Christmas. Clients include local community, students, tourists and upscale.

● Museum does not accept unsolicited submissions.

Media Exhibits all media and all types of prints.

Style Exhibits all styles and genres.

EL TALLER GALLERY

2438 W. Anderson Lane, #C-3, Austin TX 78757. (800)234-7362 or (512)302-0100. Fax: (512)302-4895. E-mail: olga@eltallergallery.com. Website: www.eltallergallery.com. **Owner:** Olga O. Pina. Retail gallery, art consultant. Representing 50 artists and established artists/year. Exhibiting artists include R.C. Gorman and Amado Pena. Contemporary artists: Truman Marquez; Naoko. Sponsors 5 shows/year. Average display time 2 weeks to a month. Open all year; Tuesday-Saturday, 10-6. 1,850 sq. ft. 100% of space for gallery artists. Fine art framing available. Clientele: tourists, upscale. 90% private collectors, 10% corporate collectors. Overall price range $500-15,000; most work sold at $2,500-4,000.

Media Considers all media and all types of prints. Most frequently exhibits mixed media, pastels, watercolors, giclées (very limited) and sculpture.

Style Exhibits expressionism, primitivism, conceptualism, impressionism. Genres include modern, western, southwestern, landscapes.

Terms Accepts work on consignment (50% commission). Retail price set by the artist. Gallery provides promotion and contract; artist pays shipping costs. Archival framing by artists preferred.

Submissions Send query letter with bio, photographs and reviews. Write for appointments to show portfolio of photographs and actual artwork. Responds only if interested within 2 months.

Ⓝ GREMILLION & CO. FINE ART, INC.

2501 Sunset Blvd., Houston TX 77005. (713)522-2701. E-mail: fineart@gremillion.com. Website: www.gremillion.com. **Director:** Christopher Skidmore. Sales/Marketing Bob Russell. Retail gallery. Estab. 1980. Represents

more than 80 mid-career and established artists. May be interested in seeing the work of emerging artists in the future. Exhibited artists include John Pavlicek and Robert Rector. Sponsors 12 shows/year. Average display time 4-6 weeks. Open all year. Located "West University" area; 12,000 sq. ft. 50% of space for special exhibitions. 60% private collectors; 40% corporate collectors. Overall price range $500-300,000; most work sold at $3,000-10,000.

Media Considers oil, acrylic, watercolor, pastel, pen & ink, drawing, mixed media, collage, works on paper, sculpture, original handpulled prints, woodcuts, engravings, lithographs, wood engravings, mezzotints, linocuts, etchings and serigraphs.

Style Exhibits painterly abstraction, minimalism, color field and realism. Genres include landscapes and figurative work. Prefers abstraction, realism and color field.

Terms Accepts artwork on consignment (varying commission). Retail price set by the gallery and artist. Gallery provides insurance and promotion; shipping costs are shared. Prefers artwork unframed.

Submissions Call for appointment to show portfolio of slides, photographs and transparencies. Responds only if interested within 3 weeks. Files slides and bios. Finds artists through submissions and word of mouth.

⃞ IVANFFY & UHLER GALLERY

4623 W. Lovers Lane, Dallas TX 75209. (214)350-3500. E-mail: info@ivanffyuhler.com. Website: www.ivanffyu hler.com. **Director:** Paul Uhler. Retail/wholesale gallery. Estab. 1990. Represents 20 mid-career and established artists/year. May be interested in seeing the work of emerging artists in the future. Sponsors 1-2 shows/year. Average display time 1 month. Open from October-June; Tuesday-Saturday, 10-6. Located near Love Field Airport. 4,000 sq. ft. 100% of space for gallery artists. Clientele: upscale, local community. 85% private collectors, 15% corporate collectors. Overall price range $1,000-20,000; most work sold at $1,500-4,000.

Media Considers oil, acrylic, watercolor, pastel, pen & ink, drawing, mixed media, collage, paper, sculpture, woodcuts, engravings, lithographs, wood engravings, mezzotints, serigraphs, linocuts and etchings. Most frequently exhibits oils, mixed media, sculpture.

Style Exhibits neo-expressionism, painterly abstraction, surrealism, postmodern works, impressionism, hard-edge geometric abstraction, postmodern European school. Genres include florals, landscapes, figurative work.

Terms Shipping costs are shared.

Submissions Send query letter with résumé, photographs, bio and SASE. Write for appointment to show portfolio of photographs. Responds only if interested within 1 month.

⃞ LONGVIEW MUSEUM OF FINE ARTS

215 E. Tyler St, P.O. Box 3484, Longview TX 75606. (903)753-8103. E-mail: foxhearne@kilgore.net. **Director:** Renee Hawkins. Museum. Estab. 1967. Represents 80 emerging, mid-career and established artists/year. 600 members. Sponsors 6-9 shows/year. Average display time 6 weeks. Open all year; Tuesday-Friday, 10-4; Saturday, 12-4. Located downtown. 75% of space for special exhibitions. Clientele members, visitors (local and out-of-town) and private collectors. Overall price range $200-2,000; most work sold at $200-800.

Media Considers all media, all types of prints. Most frequently exhibits oil, acrylic and photography.

Style Exhibits all styles and genres. Prefers contemporary American art and photography.

Terms Accepts work on consignment (30% commission). Retail price set by the artist. Offers customer discounts to museum members. Gallery provides insurance and promotion. Prefers artwork framed.

Submissions Send query letter with résumé and slides. Portfolio review not required. Responds in 1 month. Files slides and résumés. Finds artists through art publications and shows in other areas.

MCMURTREY GALLERY

3508 Lake St., Houston TX 77098. (713)523-8238. Fax: (713)523-0932. E-mail: info@mcmurtreygallery.com. **Owner:** Eleanor McMurtrey. Retail gallery. Estab. 1981. Represents 20 emerging and mid-career artists. Exhibited artists include Robert Jessup and Jenn Wetta. Sponsors 10 shows/year. Average display time 1 month. Open all year. Located near downtown; 2,600 sq. ft. Clients include corporations. 75% of sales are to private collectors, 25% corporate collectors. Overall price range $400-17,000; most work sold at $1,800-6,000.

Media Considers oil, acrylic, pastel, drawings, mixed media, collage, works on paper, photography and sculpture. Most frequently exhibits mixed media, acrylic and oil.

Style Exhibits figurative, narrative, painterly abstraction and realism.

Terms Accepts work on consignment (50% commission). Retail price set by gallery and artist. Prefers artwork framed.

Submissions Send query letter with résumé, slides and SASE. Call for appointment to show portfolio of originals and slides.

Tips "Be aware of the work the gallery exhibits and act accordingly. Please make an appointment."

MONTICELLO FINE ARTS GALLERY

3700 W. Seventh, Fort Worth TX 76107. (817)731-6412. Fax: (817)731-6413 or (888)374-3435. E-mail: glenna@ monticellogallery.com. Website: www.monticellofineartsgallery.com. **Owner:** Glenna Crocker. Retail gallery and art consultancy. Estab. 1983. Represents about 50 artists; emerging, mid-career and established. Interested in seeing the work of emerging artists. Exhibited artists include Carol Anthony, Patricia Nix and Alexandra Nechita. Sponsors 9 shows/year. Average display time 3 weeks. Open all year; Monday-Friday, 10-6; Saturday, 10-5. Located in museum area; 2500 sq. ft.; diversity of the material and artist mix. ''The gallery is warm and inviting.'' 66% of space for special exhibitions. Clientele upscale, community, tourists. 90% private collectors. Overall price range $30-10,000.

Media Considers oil, acrylic, watercolor, pastel, mixed media, collage, sculpture, ceramic; original handpulled prints; woodcuts, wood engravings, linocuts, engravings, mezzotints, etchings, lithographs and serigraphs. Most frequently exhibits painting and sculpture.

Style Exhibits expressionism, neo-expressionism, painterly abstraction, color field, impressionism, realism and Western. Genres include landscapes, florals and figurative work. Prefers landscape, florals, interiors and still life.

Terms Accepts work on consignment (50% commission). Retail price set by gallery and artist. Gallery provides insurance, promotion and contract. Artist pays for shipping. Prefers artwork framed.

Submissions Send query letter with résumé, slides and bio. Call or write for appointment to show portfolio of two of the following originals, photographs, slides and transparencies, or e-mail digital images and bio.

Tips Artists must have an appointment.

SELECT ART

3530 Travis St. #226, Dallas TX 75204. (214)521-6833. Fax: (214)521-6344. E-mail: selart@swbell.net. **Owner:** Paul Adelson. Private art gallery. Estab. 1986. Represents 25 emerging, mid-career and established artists. Exhibited artists include Barbara Elam and Larry Oliverson. Open all year; Monday-Saturday, 9-5 by appointment only. Located in North Dallas; 2,500 sq. ft. ''Mostly I do corporate art placement.'' Clientele 15% private collectors, 85% corporate collectors. Overall price range $200-7,500; most work sold at $500-1,500.

Media Considers oil, fiber, acrylic, sculpture, glass, watercolor, mixed media, ceramic, pastel, collage, photography, woodcuts, linocuts, engravings, etchings and lithographs. Prefers monoprints, paintings on paper and photography.

Style Exhibits photorealism, minimalism, painterly abstraction, realism and impressionism. Genres include landscapes. Prefers abstraction, minimalism and impressionism.

Terms Accepts work on consignment (50% commission). Retail price set by consultant and artist. Sometimes offers customer discounts. Provides contract (if the artist requests one). Consultant pays shipping costs from gallery; artist pays shipping to gallery. Prefers artwork unframed.

Submissions ''No florals or wildlife.'' Send query letter with résumé, slides, bio and SASE. Call for appointment to show portfolio of slides. Responds only if interested within 1 month. Files slides, bio, price list. Finds artists through word of mouth and referrals from other artists.

Tips ''Be timely when you say you are going to send slides, artwork, etc., and neatly label slides.''

⚏ SICARDI GALLERY

2246 Richmond Ave., Houston TX 77098. (713)529-1313. Fax: (713)529-0443. E-mail: sicardi@sicardi.com. Website: www.sicardi.com. For-profit gallery. Estab. 1994. Approached by 100s of artists/year. Represents 50 emerging, mid-career and established artists. Sponsors 10 exhibits/year. Average display time 1 month. Open all year; Tuesday-Friday, 10-6; Saturday, 11-5. Clients include local community, upscale, and international. Overall price range $400-20,000; most work sold at $5,000.

Media Considers acrylic, collage, drawing, installation, mixed media, oil, paper and sculpture. Most frequently exhibits acrylic, oil and photography. Considers engravings, etchings, linocuts, lithographs, serigraphs and woodcuts.

Style Considers all styles. Most frequently exhibits painterly abstraction. Genres include contemporary.

Terms Artwork is accepted on consignment and there is a 50% commission. Retail price set by the gallery. Gallery provides insurance and promotion. Accepted work should be framed. Requires exclusive representation locally. Accepts only artists from Latin America.

Submissions Mail portfolio for review. Returns material with SASE. Responds only if interested within 2 months. Files artist statement, bio and slides/images. Finds artists through portfolio reviews and art exhibits.

Tips ''Include an organized portfolio with images of a body of work. Archival-quality materials must be used to sell fine art to collectors.''

⚏ ⚑ WEST END GALLERY

5425 Blossom, Houston TX 77007. (713)861-9544. E-mail: kpackl1346@aol.com. **Owner:** Kathleen Packlick. Retail gallery. Estab. 1991. Exhibits emerging and mid-career artists. Exhibited artists include Kathleen Packlick

and Maria Merrill. Open all year; Saturday, 12-4. Located 5 mintues from downtown Houston; 800 sq. ft.; ''The gallery shares the building (but not the space) with West End Bicycles.'' 75% of space for special exhibitions; 25% of space for gallery artists. Clientele: 100% private collectors. Overall price range $30-2,200; most work sold at $300-600.

Media Considers oil, pen & ink, acrylic, drawings, watercolor, mixed media, pastel, collage, woodcuts, wood engravings, linocuts, engravings, mezzotints, etchings, lithographs and serigraphs. Prefers collage, oil and mixed media.

Style Exhibits conceptualism, minimalism, primitivism, postmodern works, realism and imagism. Genres include landscapes, florals, wildlife, Americana, portraits and figurative work.

Terms Accepts work on consignment (40% commission). Retail price set by artist. Payment by installment is available. Gallery provides promotion; artist pays shipping costs. Prefers artwork framed.

Submissions Accepts only artists from Houston area. Send query letter with slides and SASE. Portfolio review requested if interested in artist's work.

WOMEN & THEIR WORK GALLERY

1710 Lavaca St., Austin TX 78701. (512)477-1064. Fax: (512)477-1090. E-mail: wtw@texas.net. Website: www. womenandtheirwork.org. **Associate Director:** Kathryn Davidson. Alternative space and nonprofit gallery. Estab. 1978. Approached by more than 200 artists/year. Represents 8-10 one person and seasonal juried shows of emerging and mid-career Texas women. Exhibited artists include Margarita Cabrera, Misty Keasler, Karyn Olivier. Sponsors 12 exhibits/year. Average display time 5 weeks. Open Monday-Friday, 9-5; Saturday, 12-4. Closed Christmas holidays, December 24 through January 2. Located downtown; 2,000 sq. ft. Clients include local community, students, tourists and upscale. 10% of sales are to corporate collectors. Overall price range $500-5,000; most work sold at $800-1,000.

Media Considers all media and all types of prints. Most frequently exhibits photography, sculpture, installation and painting.

Style Exhibits contemporary. Most frequently exhibits minimalism, conceptualism and imagism.

Terms Selects artists through a juried process and pays artists to exhibit. Takes 25% commission if something is sold. Retail price set by the gallery and the artist. Gallery provides insurance, promotion and contract. Accepted work should be framed, mounted and matted. Does not require exclusive representation locally. Accepts Texas women—all media—in one person shows only. All other artists, male or female in juried show— once a year. Check www.womenandtheirwork.org for more information.

Submissions Call or e-mail to arrange a personal interview to show portfolio. Returns materials with SASE. Responds in 1 month. Filing of material depends on artist and if they are members. We have a slide registry for all our artists if they are members. We have an artists slide registry available online. Finds artists through submissions and annual juried process.

Tips ''Send quality slides, typed résumé, and clear statement with artistic intent. 100% archival material required for framed works. It's important for collectors to understand care of artwork.''

UTAH

BINGHAM GALLERY

136 S. Main St., #210, Salt Lake City UT 84101. (801)832-9220 or (800)992-1066. Website: www.binggallery.c om. **Owners:** Susan and Paul Bingham. Retail and wholesale gallery. Also provides art by important living and deceased artists for collectors. Estab. 1970. Represents 8 established artists. Exhibited artists include Carolyn Ward, Patricia Smith, Kraig Kiedrowski and many others. ''Nationally known for works by Maynard Dixon. Represents the Estate of John Stenvall and have exclusive representation of G. Russel Case. Gallery owns the Maynard Dixon home and studio in Mount Carmel, Utah and Founders of the Thunderbird Foundation for the Arts.'' Sponsors 4 shows/year. Average display time 5 weeks. Open all year. Located downtown; 2,500 sq. ft.; high ceiling/great lighting, open space. 60% of space for special exhibitions; 40% for gallery artists. Clientele: serious collectors. 100% private collectors. Overall price range $1,000-300,000; most work sold at $1,800-5,000.

Media Considers oil, acrylic, watercolor, pastel, pen & ink, drawing and sculpture; original handpulled prints and woodcut. Most frequently exhibits oil, acrylic and pencil.

Style Exhibits painterly abstraction, impressionism and realism. Genres include landscapes, florals, southwestern, western, figurative work and all genres. Prefers California landscapes, Southwestern and impressionism.

Terms Accepts work on consignment (50% commission), or buys outright for 30% of retail price (net 30 days). Retail price set by gallery and artist. Gallery provides insurance, promotion, contract and shipping costs from gallery. Prefers artwork unframed.

Submissions Prefers artists be referred or present work in person. Call for appointment to show portfolio of originals. Responds in 1 week or gives an immediate yes or no on sight of work.

Tips "Gallery has moved to downtown Salt Lake City." The most common mistake artists make in presenting their work is "failing to understand the market we are seeking."

⚜ SERENIDAD GALLERY

360 W. Main, P.O. Box 326, Escalante UT 84726. (435)826-4720 and (888)826-4577. E-mail: hpriska@escalanteretreat.com. Website: www.escalante-cc.com/serenidad/html and www.escalanteretreat.com/gallery/html. **Co-owners:** Philip and Harriet Priska. Retail gallery. Estab. 1993. Represents 8 mid-career and established artists and two deceased artists. Exhibited artists include Lynn Griffin, Clay Wagstaff, Rachel Bentley, Kipp Greene, Harriet Priska, Howard Hutchinson, Laurent Martres, Valerie Orelmann and Mary Kellog. All work is on continuous display. Open all year; Monday-Saturday, 8-8. Located on Highway 12 in Escalante; 1,700 sq. ft.; "rustic western decor with log walls." 50% of space for gallery artists. Clientele tourists. 100% private collectors. Overall price range $100-4,000; most work sold at $300-3,000.

Media Considers oil, acrylic, watercolor, sculpture, fiber (Zapotec rugs), photography and china painting. Most frequently exhibits acrylics, watercolors, photography, pen & ink and oils.

Style Exhibits realism. Genres include western, southwestern and landscapes. Prefers Utah landscapes—prefer local area here, northern Arizona-Navajo reservation and California-Nevada landscapes.

Terms Accepts work on consignment (commission set by artist) or buys outright (prices set by artist). Retail price set by the gallery. Gallery provides promotion.

Submissions Finds artists "generally by artists coming into the gallery."

Tips "Work must show professionalism and have quality. This is difficult to explain; you know it when you see it."

VERMONT

PARADE GALLERY

P.O. Box 245, Warren VT 05674. (802)496-5445. Fax: (802)496-4994. E-mail: jeff@paradegallery.com. Website: www.paradegallery.com. **Owner:** Jeffrey S. Burnett. Retail gallery. Estab. 1982. Represents 15-20 emerging, mid-career and established artists. Clients include tourist and upper middle class second-home owners. 98% of sales are to private collectors. Overall price range $20-5,000; most work sold at $100-500.

Media Considers oil, acrylic, watercolor, pastel, mixed media, collage, limited edition prints, fine arts posters, works on paper, sculpture and original handpulled prints. Most frequently exhibits etchings, silkscreen and watercolor. Currently looking for oil/acrylic and watercolor.

Style Exhibits primitivism, impressionistic and realism. "Parade Gallery deals primarily with representational works with country subject matter. The gallery is interested in unique contemporary pieces to a limited degree." Does not want to see "cutesy or very abstract art."

Terms Accepts work on consignment (40% commission) or occasionally buys outright (net 30 days). Retail price set by gallery or artist. Sometimes offers customer discounts and payment by installment. Exclusive area representation required. Gallery provides insurance and promotion.

Submissions Send query letter with résumé, slides and photographs. Portfolio review requested if interested in artist's work. A common mistake artists make in presenting their work is having "unprofessional presentation or poor framing." Biographies and background are filed. Finds artists through customer recommendations, shows, magazines or newspaper stories and photos.

Tips "We need to broaden offerings in price ranges which seem to offer a good deal for the money."

VIRGINIA

ARTSPACE

Zero East Fourth Street, Richmond VA 23224. (804)232-6464. Fax: (804)232-6465. E-mail: artspacegallery@att.net. Website: www.artspacegallery.org. **Exhibition Committee:** Judy Anderson. Nonprofit gallery. Estab. 1988. Approached by 100 artists/year. Represents approx. 50 emerging, mid-career artists. Sponsors approx. 2 exhibits/year. Average display time 1 month. Open all year; Wednesday-Sunday from 12-4. Located in the newly designated Arts District in Manchester, in Richmond, VA. Brand new gallery facilities; 4 exhibition spaces; approx. 3,000 sq. ft. Clients include local community, students, tourists and upscale. 2% of sales are to corporate collectors. Overall price range $100-800; most work sold at $450.

Media Considers all media and all types of prints. Most frequently exhibits photography, painting and graphic design.

Style Considers all styles and genres.

Terms There are exhibition fees; work sold = 33% commission. Retail price set by the artist. Gallery provides

insurance and contract. Accepted work should be framed, mounted and matted. Does not require exclusive representation locally.

Submissions Send query letter with artist's statement, bio, résumé, SASE, slides and proposal form. Returns material with SASE. Responds to queries in 3 weeks. If accepted, all materials submitted are filed. Finds artists through referrals by other artists, submissions and word of mouth.

N GALLERY WEST

205 S. Union St., Alexandria VA 22314. (703)549-7359. Fax: (703)549-8355. E-mail: gallerywest@starpower.net. Website: www.gallery-west.com. **President:** Mary Allen. Cooperative gallery and alternative space. Estab. 1979. Exhibits the work of 24 emerging, mid-career and established artists. Sponsors 12 shows/year. Average display time 1 month. Open all year. Located in Old Town; 1,000 sq. ft. 60% of space for special exhibitions. Clients include individual, corporate and decorators. 90% of sales are to private collectors, 10% corporate collectors. Overall price range $100-3,500; most work sold at $500-700.

Media Considers all media except video and film.

Style All styles and genres.

Terms Co-op membership fee plus a donation of time. (30% commission.) Retail price set by artist. Sometimes offers customer discounts and payment by installments. Gallery assists promotion; artist pays for shipping. Prefers artwork framed.

Submissions Send query letter with résumé, slides, bio and SASE. Call for appointment to show portfolio of slides. Responds in 1 month. Files résumés. Holds jury shows once/year open to all artists.

Tips "High-quality slides are imperative."

N HAMPTON UNIVERSITY MUSEUM

Huntington Building on Ogden Circle, Hampton VA 23668. (757)727-5308. Fax: (757)727-5170. Website: www.hamptonu.edu. **Director:** Mary Lou Hultgren. Museum. Estab. 1868. Represents/exhibits established artists. Exhibited artists include Elizabeth Catlett and Jacob Lawrence. Sponsors 3-4 shows/year. Average display time 12-18 weeks. Open all year; Monday-Friday, 8-5; Saturday, 12-4; closed on Sunday, major and campus holidays. Located on the campus of Hampton University.

Media Considers all media and all types of prints. Most frequently exhibits oil or acrylic paintings, ceramics and mixed media.

Style Exhibits African American, African and/or Native American art.

Submissions Send query letter with résumé and a dozen or more slides. Portfolio should include photographs and slides.

Tips "Familiarize yourself with the type of exhibitions the Hampton University Museum typically mounts. Do not submit an exhibition request unless you have at least 35-45 pieces available for exhibition. Call and request to be placed on the Museum's mailing list so you will know what kind of exhibitions and special events we're planning for the upcoming year(s)."

N HARNETT MUSEUM OF ART

University of Richmond Museums, Richmond VA 23173. (804)289-8276. Fax: (804)287-1894. E-mail: museums @richmond.edu. Website: oncampus.richmond.edu/museums. **Executive Director:** Richard Waller. Museum. Estab. 1968. Represents emerging, mid-career and established artists. Sponsors 10 shows/year. Average display time 6 weeks. Open all year; with limited summer hours May-August. Located on University campus; 5,000 sq. ft. 100% of space for special exhibitions.

Media Considers all media and all types of prints. Most frequently exhibits painting, sculpture, photography and drawing.

Style Exhibits all styles and genres.

Terms Work accepted on loan for duration of special exhibition. Retail price set by the artist. Gallery provides insurance, promotion, contract and shipping costs. Prefers artwork framed.

Submissions Send query letter with résumé, 8-12 slides, brochure, SASE, reviews and printed material if available. Write for appointment to show portfolio of photographs, slides, transparencies or "whatever is appropriate to understanding the artist's work." Responds in 1 month. Files résumé and other materials the artist does not want returned (printed material, slides, reviews, etc.).

THE PRINCE ROYAL GALLERY

204 S. Royal St., Alexandria VA 22314. (703)548-5151. Fax: (703)548-5627. E-mail: princeroyal@earthlink.net. Website: www.princeroyalgallery.com. **Director:** John Byers. Retail gallery. Estab. 1977. Interested in emerging, mid-career and established artists. Sponsors 6 shows/year. Average display time 3-4 weeks. Located in middle of Old Town Alexandria. "Gallery is the ballroom and adjacent rooms of historic hotel." Clientele: primarily

Virginia, Maryland and Washington DC residents. 95% private collectors, 5% corporate clients. Overall price range $75-8,000; most artwork sold at $700-1,200.

Media Considers oil, acrylic, watercolor, mixed media, sculpture, egg tempera, engravings, etchings and lithographs. Most frequently exhibits oil, watercolor and sculptures in wood, stone, and bronze.

Style Exhibits impressionism, expressionism, realism, primitivism and painterly abstraction. Genres include landscapes, florals, portraits, still lifes, and figurative work. "The gallery deals primarily in original, representational art. Abstracts are occasionally accepted but are hard to sell in northern Virginia. Limited edition prints are accepted only if the gallery carries the artist's original work."

Terms Accepts work on consignment (40% commission). Retail price set by artist. Customer discounts and payment by installment are available, but only after checking with the artist involved and getting permission. Exclusive area representation required. Gallery provides insurance, promotion and contract. Requires framed artwork.

Submissions Send query letter with résumé, brochure, slides and SASE. Call or write to schedule an appointment to show a portfolio, which should include originals, slides and transparencies. Responds in 1 week. Files résumés and brochures. All other material is returned.

Tips "Write or call for an appointment before coming. Have at least six pieces framed and ready to consign if accepted. Can't speak for the world, but in northern Virginia collectors are slowing down. Lower-priced items continue okay, but sales over $3,000 are becoming rare. More people are buying representational rather than abstract art. Impressionist art is increasing. Get familiar with the type of art carried by the gallery and select a gallery that sells your style work. Study and practice until your work is as good as that in the gallery. Then call or write the gallery director to show photos or slides."

WASHINGTON

N ART SHOWS

P.O. Box 245, Spokane WA 99210-0245. (509)922-4545. E-mail: info@artshows.net. Website: www.artshows.net. **President:** Don Walsdorf. Major art show producer. Estab. 1988. Sponsors large group shows. Clientele: collectors, hotel guests and tourists. 70% private collectors, 30% corporate collectors. Overall price range $200-250,000; most work sold at $500-3,000.

Media Considers all media except craft.

Style Interested in all genres.

Submissions Send query letter with bio, brochure and photographs. Portfolio review requested if interested in artist's work. This information is retained in our permanent files.

Tips Selecting quality art shows is important. Read all the prospectus materials. Then re-read the information to make certain you completely understand the requirements, costs and the importance of early responses. Respond well in advance of any suggested deadline dates. Producers cannot wait until 60 days in advance of a show, due to contractual requirements for space, advertising, programming etc. If you intend to participate in a quality event, seek applications a year in advance for existing events. Professional show producers are always seeking to upgrade the quality of their shows. Seek new marketing venues to expand your horizons and garner new collectors. List your fine art show events with info@artshow.net by providing name, date, physical location, full contact information of sponsor or producer. This is a free database at www.artshows.net. Any time you update a brochure, biography or other related materials, be certain to date the material. Outdated material in the hands of collectors works to the detriment of the artist.

FOSTER/WHITE GALLERY

123 S. Jackson St., Seattle WA 98104. (206)622-2833. Fax: (206)622-7606. E-mail: seattle@fosterwhite.com. Website: www.fosterwhite.com. **Owner/Director:** Phen Huang. Retail gallery. Estab. 1973. Represents 60 emerging, mid-career and established artists. Interested in seeing the work of local emerging artists. Exhibited artists include Dale Chihuly, Mark Tobey, George Tsutakawa, Morris Graves, and William Morris. Average display time 1 month. Open all year; Monday-Saturday, 10-5:30; Sunday, 12-5. Located historic Pioneer Square; 5,800 sq. ft. Clientele private, corporate and public collectors. Overall price range $300-35,000; most work sold at $2,000-8,000.

- Gallery has additional spaces at 107 Park Lane, Kirkland WA 98033 (425)822-2305. Fax: (425)828-2270, and Ranier Square, 1331 Fifth Ave., Seattle WA 98101, (206)583-0100. Fax: (206)583-7188.

Media Considers oil, acrylic, watercolor, pastel, pen & ink, drawing, mixed media, collage, paper, sculpture, ceramics, craft, fiber, glass and installation. Most frequently exhibits glass sculpture, works on paper and canvas and ceramic and metal sculptures.

Style Contemporary Northwest art. Prefers contemporary Northwest abstract, contemporary glass sculpture.

Terms Gallery provides insurance, promotion and contract.

Submissions Send query letter with résumé, slides, bio and reviews. Write for appointment to show portfolio of slides. Responds in 3 weeks.

⦿ THE HENRY ART GALLERY

15th Ave. NE and NE 41st St., Seattle WA 98195-1410. (206)543-2280. Fax: (206)685-3123. E-mail: hartg@u.was hington.edu. Website: www.henryart.org. **Contact:** Karen Bangsund, curatorial assistant. Museum. Estab. 1927. Exhibits emerging, mid-career and established artists. Sponsors 18 exhibits/year. Open Tuesday-Sunday, 11-5; Thursday, 11-8. Located "on the western edge of the University of Washington campus. Parking is often available in the underground Central Parking garage at NE 41st St. On Sundays, free parking is usually available. The Henry Art Gallery can be reached by over twenty bus routes. Call Metro at (206)553-3000 (http://transit.met roke.gov) or Community Transit at (425)778-2785 for additional information." Clients include local community, students, tourists and upscale.

Media Considers all media. Most frequently exhibits painting, photography and video. Exhibits all types of prints.

Style Exhibits all styles and genres.

Terms Does not require exclusive representation locally.

Submissions Send query letter with artist's statement, résumé, reviews, SASE, slides and transparencies. Returns material with SASE. Responds to queries quarterly. "If we are interested in an artist we will send them an informational letter and ask to keep their materials on file. The materials could include résumé, bio, reviews, slides, photographs, or transparencies." Finds artist's through art exhibits, exhibition announcements, individualized research, periodicals, portfolio reviews, referrals by other artists, submissions and word of mouth.

KIRSTEN GALLERY, INC.

5320 Roosevelt Way NE, Seattle WA 98105. (206)522-2011. E-mail: r2thetop@hotmail.com. Website: www.kirst engallery.com. **President:** R. Kirsten. Retail gallery. Estab. 1974. Represents 60 emerging, mid-career and established artists. Exhibited artists include Birdsall and Daiensai. Sponsors 4 shows/year. Average display time 1 month. Open all year. Open Monday-Sunday, 11-6. 3,500 sq. ft.; outdoor sculpture garden. 40% of space for special exhibitions; 60% of space for gallery artists. 90% private collectors, 10% corporate collectors. Overall price range $75-15,000; most work sold at $75-2,000.

Media Considers oil, acrylic, watercolor, mixed media, sculpture, glass and offset reproductions. Most frequently exhibits oil, watercolor and glass.

Style Exhibits surrealism, photorealism and realism. Genres include landscapes, florals, Americana. Prefers realism.

Terms Accepts work on consignment (50% commission). Retail price set by artist. Offers payment by installments. Gallery provides promotion; artist pays shipping costs. "No insurance; artist responsible for own work."

Submissions Send query letter with résumé, slides and bio. Write for appointment to show portfolio of photographs and/or slides. Responds in 2 weeks. Files bio and résumé. Finds artists through visiting exhibitions and word of mouth.

Tips "Keep prices down. Be prepared to pay shipping costs both ways. Work is not insured (send at your own risk). Send the best work—not just what you did not sell in your hometown. Do not show up without an appointment."

⦿ PHINNEY CENTER GALLERY

6532 Phinney Ave. N., Seattle WA 98103. (206)783-2244. Fax: (206)783-2246. E-mail: Mylinda@phinneycenter. org. Website: www.phinneycenter.org. **Arts Coordinator:** Mylinda Sneed. Nonprofit gallery. Estab. 1982. Represents 10-12 emerging artists/year. Sponsors 10-12 shows/year. Average display time 1 month. Open all year; Monday-Friday, 9-9; Saturday, 9-2. Located in a residential area; 92 sq. ft.; in 1904 building—hardwood floors, high ceilings. 20% of space for special exhibitions; 80% of space for gallery artists. Overall price range $50-4,000; most work sold at $300-1,000.

• Phinney Center Gallery is open to Puget Sound artists only.

Media Considers oil, acrylic, watercolor, pastel, pen & ink, drawing, mixed media, collage, paper, sculpture, ceramics, installation, photography, all types of prints. Most frequently exhibits painting, sculpture and photography.

Style Exhibits painterly abstraction, all genres. Holds theme (fiber, sculpture, etc.) calls twice a year (March and October). Juried show in September.

Terms Accepts work on consignment (30% commission). Retail price set by the artist. Gallery provides promotion and contract; artist pays shipping costs to and from gallery. Prefers artwork framed. Artist pays for invitations and mailings.

Submissions Send query letter with résumé, bio, 10 slides and SASE. Finds artists through calls for work in local publications.

Tips "Do not send slides that show many styles of your work. Send a collection of slides that have a uniform feel—a theme—or a complete body of work."

WEST VIRGINIA

THE ART STORE

1013 Bridge Rd., Charleston WV 25314. (304)345-1038. Fax: (304)345-1858. E-mail: theartstore@aol.com. **Director:** E. Schaul. Retail gallery. Estab. 1974. Represents 16 mid-career and established artists. Sponsors 6 shows/year. Average display time 3 weeks. Open all year. Located in a suburban shopping center; 2,000 sq. ft. 50% of space for special exhibitions. Clientele: professionals, executives, decorators. 80% private collectors, 20% corporate collectors. Overall price range $200-8,000; most work sold at $2,000.

Media Considers oil, acrylic, watercolor, pastel, mixed media, works on paper, ceramics, wood and metal.

Style Exhibits expressionism, painterly abstraction, color field and impressionism.

Terms Accepts artwork on consignment (50% commission). Retail price set by gallery and artist. Gallery provides insurance, promotion and shipping costs from gallery. Prefers artwork unframed.

Submissions Send query letter with résumé, slides, SASE, announcements from other gallery shows and press coverage. Gallery makes the contact after review of these items; responds in 6 weeks.

Tips "Do not send slides of old work."

WISCONSIN

⒩ DAVID BARNETT GALLERY

1024 E. State St., Milwaukee WI 53202. (414)271-5058. Fax: (414)271-9132. Retail and rental gallery and art consultancy. Estab. 1966. Represents 300-400 emerging, mid-career and established artists. Exhibited artists include Claude Weisbuch and Carol Summers. Sponsors 12 shows/year. Average display time 1 month. Open all year. Located downtown at the corner of State and Prospect; 6,500 sq. ft.; "Victorian-Italianate mansion built in 1875, three floors of artwork displayed." 25% of space for special exhibitions. Clientele: retail, corporations, interior decorators, private collectors, consultants, museums and architects. 20% private collectors, 10% corporate collectors. Overall price range $50-375,000; most work sold at $1,000-50,000.

Media Considers oil, acrylic, watercolor, pastel, pen & ink, drawings, mixed media, collage, sculpture, ceramic, fiber, glass, photography, bronzes, marble, woodcuts, engravings, lithographs, wood engravings, serigraphs, linocuts, etchings and posters. Most frequently exhibits prints, drawings and oils.

Style Exhibits expressionism, neo-expressionism, primitivism, painterly abstraction, surrealism, imagism, conceptualism, minimalism, postmodern works, impressionism, realism and photorealism. Genres include landscapes, florals, Southwestern, Western, wildlife, portraits and figurative work. Prefers old master graphics, contemporary and impressionistic.

Terms Accepts artwork on consignment (50% commission). Retail price set by gallery and artist. Sometimes offers customer discounts and payment by installment. Gallery provides insurance and promotion; artist pays for shipping. Prefers artwork framed.

Submissions Send query letter with slides, bio, brochure and SASE. "We return everything if we decide not to carry the artwork." Finds artists through agents, word of mouth, various art publications, sourcebooks, submissions and self-promotions.

GRACE CHOSY GALLERY

1825 Monroe St., Madison WI 53711. (608)255-1211. Fax: (608)663-2032. E-mail: gchosy@chorus.net. **Director:** Karin Ketarkus. Retail gallery. Estab. 1979. Represents/exhibits 80 emerging, mid-career and established artists/year. Exhibited artists include Wendell Arneson, John Mominee, and William Weege. Sponsors 11 shows/year. Average display time 3 weeks. Open all year; Tuesday-Saturday, 10-5. Located downtown; 2,000 sq. ft.; "open uncluttered look." 45% of space for special exhibitions; 55% of space for gallery artists. Clientele: primarily local community. 60% private collectors, 40% corporate collectors. Overall price range $200-7,000; most work sold at $500-2,000.

Media Considers all media except photography and fiber; all types of original prints except giclées, reproductions, and posters. Most frequently exhibits paintings, drawings and sculpture.

Style Exhibits all styles. Genres include landscapes, florals and figurative work. Prefers landscapes, still life and abstract.

Terms Artwork is accepted on consignment. Retail price set by the gallery and the artist. Gallery provides insurance, promotion and contract. Artist pays for shipping costs.

Submissions Send query letter with résumé, bio and SASE. Call or write for appointment to show portfolio. Responds in 3 months.

Ⓝ THE FLYING PIG LLC

N6975 State Hwy. 42, Algoma WI 54201. (920)487-9902. Fax: (920)487-9904. E-mail: theflyingpig@charterinter net.com. Website: www.theflyingpig.biz. **Contact:** Susan Connor, owner/member. For-profit gallery. Estab. 2002. Exhibits 30 emerging artists. Exhibited artists include Kim Clayton and Eric Legge (acrylic on mixed media). Open Thursday-Tuesday, 10-5 (winter); May 1st-October 31st daily, 9-6. Clients include local community, tourists and upscale. Overall price range $5-3,000; most work sold at $300.

Media Considers all media. Most frequently exhibits acrylic, mixed media and ceramics.

Style Exhibits impressionism, minimalism, painterly abstraction and primitivism realism. Most frequently exhibits primitivism realism, impressionism and minimalism. Genres include outsider.

Terms Artwork is accepted on consignment and there is a 40% commission or artwork is bought outright for 50% of retail price; net 15 days. Retail price set by the artist. Gallery provides insurance, promotion and contract. Accepted work should be framed. Does not require exclusive representation locally. Prefers only self-taught or outsider.

Submissions Send query letter with artist's statement, bio and photographs. Returns material with SASE. Responds to queries in 3 weeks. Files artist's statement, bio and photographs if interested. Finds artist's through art fairs and exhibitions, referrals by other artsts, submissions, word of mouth and online.

TORY FOLLIARD GALLERY

233 N. Milwaukee St., Milwaukee WI 53202. (414)273-7311. Fax: (414)273-7313. E-mail: info@toryfolliard.com. Website: www.toryfolliard.com. **Contact:** Richard Knight. Retail gallery. Estab. 1988. Represents emerging and established artists. Exhibited artists include Tom Uttech and John Wilde. Sponsors 8-9 shows/year. Average display time 4-5 weeks. Open all year; Tuesday-Friday, 11-5; Saturday, 11-4. Located downtown in historic Third Ward; 3,000 sq. ft. 60% of space for special exhibitions; 40% of space for gallery artists. Clientele: tourists, upscale, local community and artists. 90% private collectors, 10% corporate collectors. Overall price range $500-25,000; most work sold at $1,500-8,000.

Media Considers all media except installation and craft. Most frequently exhibits painting, sculpture.

Style Exhibits expressionism, abstraction, realism, surrealism and imagism. Prefers realism.

Terms Accepts work on consignment. Retail price set by the gallery and the artist. Gallery provides insurance and promotion; artist pays shipping costs. Prefers artwork framed.

Submissions Prefers artists working in midwest regional art. Send query letter with résumé, slides, photographs, reviews, artist's statement and SASE. Portfolio should include photographs or slides. Responds in 2 weeks. Finds artists through referrals by other artists.

THE FANNY GARVER GALLERY

230 State St., Madison WI 53703. (608)256-6755. E-mail: art@fannygarvergallery.com. Website: www.fannygar vergallery.com. **President:** Jack Garver. Retail Gallery. Estab. 1972. Represents 100 emerging, mid-career and established artists/year. Exhibited artists include Lee Weiss, Harold Altman and Josh Simpson. Sponsors 11 shows/year. Average display time 1 month. Open all year; Monday-Wednesday, 10-6; Thursday-Saturday, 10-8, Sunday, 12-4. Located downtown; 3,000 sq. ft.; older refurbished building in unique downtown setting. 33% of space for special exhibitions; 95% of space for gallery artists. Clientele private collectors, gift-givers, tourists. 40% private collectors, 10% corporate collectors. Overall price range $10-10,000; most work sold at $100-1,000.

Media Considers oil, pen & ink, paper, fiber, acrylic, drawing, sculpture, glass, watercolor, mixed media, ceramics, pastel, collage, craft, woodcuts, wood engravings, linocuts, engravings, mezzotints, etchings, lithographs and serigraphs. Most frequently exhibits watercolor, oil and glass.

Style Exhibits all styles. Prefers landscapes, still lifes and abstraction.

Terms Accepts work on consignment (50% commission) or buys outright for 50% of retail price (net 30 days). Retail price set by gallery. Gallery provides promotion and contract, artist pays shipping costs both ways. Prefers artwork framed.

Submissions Send query letter with résumé, 8 slides, bio, brochure, photographs and SASE. Write for appointment to show portfolio, which should include originals, photographs and slides. Responds only if interested within 1 month. Files announcements and brochures.

Tips "Don't take it personally if your work is not accepted in a gallery. Not all work is suitable for all venues."

LATINO ARTS, INC.

1028 S. Ninth, Milwaukee WI 53204. (414)384-3100 ext. 61. Fax: (414)649-4411. E-mail: info@latinoartsinc.org. Website: www.latinoartsinc.org. **Visual Artist Specialist:** Zulay Oszkay. Nonprofit gallery. Represents emerging, mid-career and established artists. Sponsors up to 5 individual and group exhibitions/year. Average display

time 2 months. Open all year; Monday-Friday, 9-4. Located in the near southeast side of Milwaukee; 1,200 sq. ft.; one-time church. Clientele: the general Hispanic community. Overall price range $100-2,000.

Media Considers all media, all types of prints. Most frequently exhibits original two- and three-dimensional works and photo exhibitions.

Style Exhibits all styles, all genres. Prefers artifacts of Hispanic cultural and educational interests.

Terms "Our function is to promote cultural awareness (not to be a sales gallery)." Retail price set by the artist. Artist is encouraged to donate 15% of sales to help with operating costs. Gallery provides insurance, promotion, contract, shipping costs to gallery; artist pays shipping costs from gallery. Prefers artwork framed.

Submissions Send query letter with résumé, slides, bio, business card and reviews. Call or write for appointment to show portfolio of photographs and slides. Responds in 2 weeks. Finds artists through recruiting, networking, advertising and word of mouth.

NEW VISIONS GALLERY, INC.

At Marshfield Clinic, 1000 N. Oak Ave., Marshfield WI 54449. (715)387-5562. E-mail: newvisions.gallery@verizon.net. Website: www.newvisionsgallery.org. **Executive Director:** Ann Waisbrot. Nonprofit educational gallery. Runs museum and art center program for community. Represents emerging, mid-career and established artists. Organizes a variety of group and thematic shows (10 per year), very few one-person shows, sponsors Marshfield Art Fair and "Mighty Midwest Biennial" every two years (send SASE for prospectus). "Culture and Agriculture" annual springtime invitational exhibit of art with agricultural themes. Does not represent artists on a continuing basis but does accept exhibition proposals. Average display time 6 weeks. Open all year; Monday-Friday, 9-5:30; Saturday 11-3. 1,500 sq. ft. Price range varies with exhibit. Small gift shop with original jewelry, notecards and crafts at $10-50. "We do not show 'country crafts.' "

Media Considers all media.

Style Exhibits all styles and genres.

Terms Accepts work on consignment (35% commission). Retail price set by artist. Gallery provides insurance and promotion. Prefers artwork framed.

Submissions Send query letter with résumé, high-quality slides and SASE. Label slides with size, title, media. Responds in 1 month. Files résumé. Will retain some slides if interested, otherwise they are returned.

Tips "Meet deadlines, read directions, make appointments—in other words respect yourself and your work by behaving as a professional."

WYOMING

⚓ WYOMING ARTS COUNCIL GALLERY

2320 Capitol Ave., Cheyenne WY 82002. (307)777-7742. Fax: (307)777-5499. E-mail: lfranc@state.wy.us. Website: wyoarts.state.wy.us. **Visual Arts Specialist:** Liliane Francuz. Nonprofit gallery. Estab. 1990. Sponsors up to 5 exhibitions/year. Average display time 6½ weeks. Open 11 months out of the year, Monday-Friday 8-5. Located downtown in capitol complex; 660 sq. ft.; in historical carriage house. 100% of space devoted to special exhibitions. Clientele: tourists, upscale, local community. 98% private collectors. Overall price range $50-$1,500; most work sold at $100-250.

Media Considers all media. Most frequently exhibits photography, paintings/drawings, mixed media and fine crafts.

Style Exhibits all styles and all genres. Most frequently exhibits contemporary styles and craft.

Terms Retail price set by the artist. Gallery provides insurance, promotion and contract. Shipping costs are shared. Prefers artwork framed.

Submissions Accepts only artists from Wyoming. Send query letter with résumé, slides and bio. Call for portfolio review of photographs and slides. Responds in 2 weeks. Files résumé and slides. Finds artists through artist registry slide bank, word of mouth and studio visits.

Tips "I appreciate artists letting me know what they are doing. Send me updated slides, show announcements, or e-mail to keep me current on your activities."

CANADA

✂ DALES GALLERY

537 Fisgard St., Victoria BC V8W 1R3 Canada. Fax: (250)383-1552. E-mail: dalesgallery@shaw.ca. Website: www.dalesgallery.ca. **Contact:** Sheila Watson. Museum retail shop. Estab. 1976. Approached by 6 artists/year; represents 40 emerging, mid-career and established artists/year. Exhibited artists include Grant Fuller and Graham Clarke. Sponsors 2-3 exhibits/year. Average display time 2 weeks. Open all year; Monday-Saturday,

10-5:30; Sunday, 12-4. Gallery situated in Chinatown (Old Town); approximately 650 sq. ft. of space—one side brick wall. Clients include local community, students, tourists and upscale. Overall price range $100-4,600; most work sold at $350.

Media Considers most media except photography. Most frequently exhibits oils, etching and watercolor. Considers all types of prints.

Style Exhibits expressionism, impressionism, postmodernism, primitivism, realism and surrealism. Most frequently exhibits impressionism, realism and expressionism. Genres include figurative, florals, landscapes, humorous whimsical.

Terms Accepts work on consignment (40% commission) or buys outright for 50% of retail price (net 30 days). Retail price set by both gallery and artist. Gallery provides promotion. Accepted work should be framed by professional picture framers. Does not require exclusive representation locally.

Submissions Call to arrange a personal interview to show portfolio of photographs or slides or send query letter with photographs. Portfolio should include résumé, reviews, contact number and prices. Responds only if interested within 2 months. Finds artists through word of mouth, art exhibits, submissions, art fairs, portfolio reviews and referral by other artists.

◼ OPEN SPACE

510 Fort St., Victoria BC V8W 1E6 Canada. (250)383-8833. E-mail: openspace@openspace.ca. Website: www.op enspace.ca. **Director:** Todd Davis. Gallery Administrator: Andrea Harty. Prep. Tech.: Aston Coles. Alternative space and nonprofit gallery. Estab. 1971. Represents emerging, mid-career and established artists. 150 members. Sponsors 10-12 shows/year. Average display time 3½ weeks. Open January 15-August 1, September 1-December 15. Located downtown; 2,700 sq. ft.; "multi-disciplinary exhibition venue." 100% of space for gallery artists. Overall price range $300-10,000.

Media Considers oil, acrylic, watercolor, pastel, pen & ink, drawing, mixed media, collage, works on paper, sculpture, ceramic, installation, photography, video, performance art, original handpulled prints, woodcuts, wood engravings, linocuts, engravings, mezzotints, etchings.

Style Exhibits conceptualism, postmodernism.

Terms "No acquisition. Artists selected are paid exhibition fees for the right to exhibit their work." Retail price set by artist. Gallery provides insurance, promotion, contract and fees; shipping costs shared. Only artwork "ready for exhibition." Artists should be aware of the trend of "de-funding by governments at all levels."

Submissions "Non-Canadian artists must submit by September 30 in order to be considered for visiting foreign artists' fees." Send query letter with recent curriculm vitae, 10-20 slides, bio, a list of any special equipment required, SASE (with IRC, if not Canadian), reviews and proposal outline. "No original work in submission." Responds in 3 months.

INTERNATIONAL

Ⓝ ◉ GALERIAS PRINARDI

Condominio El Centro I 14-A Ave. Munoz Rivera #500, Hato Rey 00198 Mexico. (787)763-5727. Fax: (787)763-0643. E-mail: prinardi@prinardi.com. Website: www.prinardi.com. **Contact:** Andres Marrero, director. Administrator: Judith Nieves. Art consultancy and for-profit gallery. Approached by many artists/year; represents with exclusivity 10 artists and exhibits many emerging, mid-career and established artists' works. Exhibited artists include Rafael Tufiño, Domingo Izquierdo and Carlos Santiago (oil painting). Sponsors 12 exhibits/year. Average display time 2-3 weeks. Open all year; Monday-Friday, 10-6; Saturday, 11-4. Or by appointment. Closed Sunday. Clients include upscale. 50% of sales are to corporate collectors. Overall price range $3,000-25,000; most work sold at $8,000. "We also have serigraphs from $500-$3,500 and other works of art at different prices."

Media Considers oil, acrylic, ceramics, drawing, glass, installation, mixed media, paper, pastel, pen & ink, sculpture and watercolor. Considers most media. Most frequently exhibits oil, sculpture and works of art on paper. Considers all types of prints, especially limited editions.

Style Exhibits color field, expressionism, imagism, minimalism, neo-expressionism, postmodernism, painterly abstraction and some traditional works of art.

Terms Artwork is accepted on consignment and there is a 40% or 50% commission, or artwork is bought outright for 100% of retail price; net 30 days. Retail price set by the gallery and the artist. Gallery provides promotion and contract. Sometimes requires exclusive representation locally. Accepts only fine artists.

Submissions Mail portfolio for review or send query letter with artist's statement, bio, brochure, business card, photocopies, photographs, résumé, reviews and e-mail letter with digital photos. Cannot return material. Responds to queries in 1 month. If interested, files artist's statement, bio, brochure, photographs, résumé and reviews. Finds artist's through portfolio reviews, referrals by other artists and submissions.

Tips "Present an artist's portfolio which should include biography, artist's statement, curriculum and photos or slides of his/her work of art."

⊕ PRAXIS MEXICO

Arquimedes 175, Colonia Polanco C.P. 11570. (5255)5254-8813. Fax: (5255)5255-5690. E-mail: info@praxismex ico.com. Website: www.praxismexico.com. For-profit gallery. Estab. 1998. Exhibits emerging, mid-career and established artists. Approached by 8 artists/year. Sponsors 4 exhibitions/year. Average display time 30 days. Open all year; Monday-Friday, 10-7:30, Saturday and Sunday, 10-3. Located in a basement with two separate rooms, a temporary room and the collective space. Clients include local community and tourists. 70% of sales are to corporate collectors. Overall price range $5,000-100,000.

Media Considers acrylic, craft, drawing, oil and sculpture. Also considers etchings, lithographs and serigraphs.

Style Exhibits postmodernism. Genres include figurative work.

Terms Artwork is accepted on consignment and there is a 50% commission or artwork is bought outright; net 30 days. There is a co-op membership fee plus a donation of time. There is a 10% commission. Retail price set by the gallery. Gallery provides promotion. Accepted work should be framed. Requires exclusive representation locally.

Submissions Send e-mail. Returns material with SASE. Responds to queries in 1 month. Finds artists through art fairs and exhibits, portfolio reviews and referrals by other artists.

Syndicates & Cartoon Features

Syndicates are agents who sell comic strips, panels and editorial cartoons to newspapers and magazines. If you want to see your comic strip in the funny papers, you must first get the attention of a syndicate. They promote and distribute comic strips and other features in exchange for a cut of the profits.

The syndicate business is one of the hardest markets to break into. Newspapers are reluctant to drop long-established strips for new ones. Consequently, spaces for new strips do not open up often. When they do, syndicates look for a "sure thing," a feature they'll feel comfortable investing more than $25,000 in for promotion and marketing. Even after syndication, much of your promotion will be up to you.

To crack this market, you have to be more than a fabulous cartoonist. The art won't sell if the idea isn't there in the first place. Work worthy of syndication must be original, salable and timely, and characters must have universal appeal to attract a diverse audience. And you'll need lots of fortitude in the face of rejection along the way.

Although newspaper syndication is still the most popular and profitable method of getting your comic strip to a wide audience, the Web has become an exciting new venue for comic strips. There are hundreds of strips available on the Web. With the click of your mouse, you can be introduced to *Adam@Home*, by Brian Basset; *The 5th Wave*, by Rich Tennant; and *The Elderberries*, by Phil Frank and Joe Troise. (UComics.com provides a great list of online comics.)

Such sites may not make much money for cartoonists, but it's clear they are a great promotional tool. It is rumored that scouts for the major syndicates have been known to surf the more popular comic strip sites in search of fresh voices.

HOW TO SUBMIT TO SYNDICATES

Each syndicate has a preferred method for submissions, and most have guidelines you can send for or access on the syndicate's Web site. Availability is indicated in the listings.

To submit a strip idea, send a brief cover letter (50 words or less is ideal) summarizing your idea, along with a character sheet (the names and descriptions of your major characters) and photocopies of 24 of your best strip samples on $8^1/_2 \times 11$ paper, six daily strips per page. Sending at least one month of samples shows that you're capable of producing high-quality humor, consistent artwork and a long lasting idea. Never submit originals; always send photocopies of your work. Simultaneous submissions are acceptable. It is often possible to query syndicates online, attaching art files or links to your Web site. Response time can take several months. Syndicates understand it would be impractical for you to wait for replies before submitting your ideas to other syndicates.

Editorial cartoons

If you're an editorial cartoonist, you'll need to start out selling your cartoons to a base newspaper (probably in your hometown) and build up some clips before approaching a syndicate. Submitting published clips proves to the syndicate that you have a following and are able to produce cartoons on a regular basis. Once you've built up a good collection of clips, submit at least 12 photocopied samples of your published work along with a brief cover letter.

Payment and contracts

If you're one of the lucky few to be picked up by a syndicate, your earnings will depend on the number of publications in which your work appears. It takes a minimum of about 60 interested newspapers to make it profitable for a syndicate to distribute a strip. A top strip such as *Garfield* may be in as many as 2,000 papers worldwide.

Newspapers pay in the area of $10-15 a week for a daily feature. If that doesn't sound like much, multiply that figure by 100 or even 1,000 newspapers. Your payment will be a percentage of gross or net receipts. Contracts usually involve a 50/50 split between the syndicate and cartoonist. Check the listings for more specific payment information.

Before signing a contract, be sure you understand the terms and are comfortable with them.

Self-syndication

Self-syndicated cartoonists retain all rights to their work and keep all profits, but they also have to act as their own salespeople, sending packets to newspapers and other likely outlets. This requires developing a mailing list, promoting the strip (or panel) periodically, and developing a pricing, billing and collections structure. If you have a knack for business and the required time and energy, this might be the route for you. Weekly suburban or alternative newspapers are the best bet here. (Daily newspapers rarely buy from self-syndicated cartoonists.)

Helpful Resources

For More Info You'll get an excellent overview of the field by reading *Your Career in Comics*, by Lee Nordling (Andrews McMeel), a comprehensive review of syndication from the viewpoints of the cartoonist, the newspaper editor and the syndicate. *Successful Syndication: A Guide for Writers and Cartoonists*, by Michael H. Sedge (Allworth Press), also offers concrete advice to aspiring cartoonists.

If you have access to a computer, another great source of information is Stu's Comic Strip Connection at www.stus.com. Here you'll find links to most syndicates and other essential sources, including helpful books, courtesy of Stu Rees.

ⓝ ASHLEIGH BRILLIANT ENTERPRISES

117 W. Valerio St., Santa Barbara CA 93101. (805)682-0531. **Art Director:** Ashleigh Brilliant. Estab. 1967. Syndicate and publisher. Outlets vary. "We supply a catalog and samples for $2 plus SASE."

Needs Considers illustrations and complete word and picture designs. Prefers single panel. Maximum size of artwork $5\frac{1}{2} \times 3\frac{1}{2}$, horizontal only.

First Contact & Terms Samples are returned by SASE if requested by artist. Responds in 2 weeks. **Pays on acceptance**; minimum flat fee of $60. Buys all rights. Syndicate owns original art.

Tips "Our product is so unusual that freelancers will be wasting their time and ours unless they first carefully study our catalog."

CELEBRATION: AN ECUMENICAL WORSHIP RESOURCE

P.O. Box 419281, Kansas City MO 64141-6493. (800)444-8910. Fax: (816)968-2268. E-mail: patmarrin @aol.com. Website: www.celebrationpubs.org. **Editor:** Patrick Marrin. Syndicate serving churches, clergy and worship committees.

Needs Buys 50 religious theme cartoons/year. Does not run an ongoing strip. Buys cartoons on church themes (worship, clergy, scripture, etc.) with a bit of the off-beat.

First Contact & Terms Originals returned to artist at job's completion. Payment upon use, others returned. Send copies. Simultaneous submissions OK. Pays $30/ cartoon. "We grant reprint permission to subscribers to use cartoons in parish bulletins, but we request they send the artist an additional $5. Celebration is published both in print and online in pdf format.

Tips "We only use religious themes (black & white). The best cartoons tell the 'truth'—about human nature, organizations—by using humor."

CITY NEWS SERVICE, L.L.C.

P.O. Box 39, Willow Springs MO 65793. (417)469-2423. E-mail: cns@townsqr.com. **President:** Richard Weatherington. Estab. 1969. Editorial service providing editorial and graphic packages for magazines.

Needs Buys from 12 or more freelance artists/year. Considers caricature, editorial cartoons and tax and business subjects as themes; considers b&w line drawings and shading film.

First Contact & Terms Send query letter with résumé, tearsheets or photocopies. Samples should contain business subjects. "Send 5 or more b&w line drawings, color drawings, shading film or good line drawing editorial cartoons." Does not want to see comic strips. Samples not filed are returned by SASE. Responds in 4-6 weeks. To show a portfolio, mail tearsheets or photostats. Pays 50% of net proceeds; pays flat fee of $25 minimum. "We may buy art outright or split percentage of sales."

Tips "We have the markets for multiple sales of editorial support art. We need talented artists to supply specific projects. We will work with beginning artists. Be honest about talent and artistic ability. If it isn't there then don't beat your head against the wall."

"...Oh that? I was a music teacher...."

This is an example of the type of cartoon published by the syndicate, Celebration. James F. Woodard, who signs his cartoons "Woody" has been using *Artist's & Graphic Designer's Market* to sell his cartoons for more than 10 years. In addition to working with syndicates, Woodard has had cartoons published in *The Star*, *Saturday Evening Post* and many other magazines and books. "Never give up," advises Woodard. "Just because a cartoon editor doesn't like a cartoon today, doesn't mean they won't buy the same one submitted a few months later."

ⓝ CONTINENTAL FEATURES/CONTINENTAL NEWS SERVICE

501 W. Broadway, Plaza A, P.O. PMB 265, San Diego CA 92101. (858)492-8696. E-mail: continentalnewsservice @yahoo.com. Website: www.continentalnewsservice.com. **Editor-in-Chief:** Gary P. Salamone. Parent firm established August, 1981. Syndicate serving 3 outlets house publication, publishing business and the general public through the *Continental Newstime* general interest news magazine. Features include *Portfolio*, a collection of cartoon and caricature art.

Needs Approached by 200 cartoonists/year. Number of new strips introduced each year varies. Considers comic strips and gag cartoons. Does not consider highly abstract, computer-produced or stick-figure art. Prefers single panel with gagline. Recent features include "Alice and Alanna" by Sophia Chen, "Half Baked" by Rick Ellis, and "Wally's Pond" by Shaun Kettunen. Guidelines available for #10 SASE with first-class postage. Maximum size of artwork 8×10, must be reducible to 65% of original size.

First Contact & Terms Sample package should include cover letter, photocopies (10-15 samples). Samples are filed or are returned by SASE if requested by artist. Responds in 1 month only if interested or if SASE is received. To show portfolio, mail photocopies and cover letter. Pays 70% of gross income on publication. Rights purchased vary according to project. Minimum length of contract is 1 year. The artist owns the original art and the characters.

Tips "We need single-panel cartoons and comic strips appropriate for English-speaking, international audience including cartoons that communicate feelings or predicaments, without words. Do not send samples reflecting the highs and lows and different stages of your artistic development. CF/CNS wants to see consistency and quality, so you'll need to send your best samples."

CREATORS SYNDICATE, INC.

5777 W. Century Blvd., Suite 700, Los Angeles CA 90045. (310)337-7003. Fax: (310)337-7625. E-mail: info@creators. Website: www.creators.com. **President:** Richard S. Newcombe. Director of Operations Christina Lee. Estab. 1987. Serves 2,400 daily newspapers, weekly and monthly magazines worldwide. Guidelines on website.

Needs Syndicates 100 writers and artists/year. Considers comic strips, caricatures, editorial or political cartoons and "all types of newspaper columns." Recent introductions *Speedbump*, by Dave Coverly; *Strange Brew*, by John Deering.

First Contact & Terms Send query letter with brochure showing art style or résumé and "anything but originals." Samples are not filed and are returned by SASE. Responds in a minimum of 10 weeks. Considers salability of artwork and client's preferences when establishing payment. Negotiates rights purchased.

Tips "If you have a cartoon or comic strip you would like us to consider, we will need to see at least four weeks of samples, but not more than six weeks of dailies and two Sundays. If you are submitting a comic strip, you should include a note about the characters in it and how they relate to each other. As a general rule, drawings are most easily reproduced if clearly drawn in black ink on white paper, with shading executed in ink wash or Benday® or other dot-transfer. However, we welcome any creative approach to a new comic strip or cartoon idea. Your name(s) and the title of the comic or cartoon should appear on every piece of artwork. If you are already syndicated elsewhere, or if someone else owns the copyright to the work, please indicate this."

⊕ DRAWN & QUARTERED LTD.

4 Godmersham Park, Canterbury, Kent CT4 7DT. (44) 1227-730-565. E-mail: red@drawnandquartered.com. Website: www.drawnandquartered.com. **Contact:** Robert Edwards, chief executive. Estab. 2000. Syndicate serving over 100 weekly and monthly Internet sites, magazines, newsletters, newspapers and tabloids. Guidelines available.

• This company operates similarly to a stock agency. See their website for details.

Needs Considers caricatures, cartoons, single panel, line, pen & ink, spot drawings, editorial/political cartoons, illustrations, portrait art of politicians and celebrities. Prefers topical, timely, as-the-news-happens images; newspaper emphasis (i.e. political, sports, entertainment figures). Maximum size of artwork 7″ in height; artwork must be reducible to 20% of original size. Prefers to receive CDs or Zips of work, JPEGs or PNGs; b&w or RGB color, resolution 250-350dpi.

First Contact & Terms Sample package should include cover letter, brochure, photocopies, résumé, contact information, tearsheets and self-caricature/portrait if possible. 5-10 samples should be included. Samples are filed. Samples are returned by SASE if requested by artist. Portfolio not required. Pays 50% of net proceeds or gross income. Established average amount of payment US $20 per download. Pays on publication or downloads by client. Responds to submissions in 1 week. Minimum length of contract is 1 year. Offers automatic renewal. Artist owns copyright, original art and original characters.

Tips "Identify and date" samples.

HISPANIC LINK NEWS SERVICE

1420 N St. NW, Washington DC 20005. (202)234-0280. Fax: (202)234-4090. E-mail: charlie@hispaniclink.org. Website: www.hispaniclink.org. **Editor:** Charles Ericksen. Syndicated column service to 250 newspapers and a newsletter serving 2,000 subscribers "movers and shakers in the Hispanic community in U.S., plus others interested in Hispanics." Guidelines available.

Needs Buys from a few freelancers/year. Considers single panel cartoons; b&w, pen & ink line drawings. Work should have a Hispanic angle; "most are editorial cartoons, some straight humor."

First Contact & Terms Send query letter with résumé and photocopies to be kept on file. Samples not filed are

returned by SASE. Responds in 3 weeks. Portfolio review not required. **Pays on acceptance**; $25 flat fee (average). Considers clients' preferences when establishing payment. Buys reprint rights and negotiates rights purchased. "While we ask for reprint rights, we also allow the artist to sell later."

Tips Interested in seeing more cultural humor. "While we accept work from all artists, we are particularly interested in helping Hispanic artists showcase their work. Cartoons should offer a Hispanic perspective on current events or a Hispanic view of life."

INTERPRESS OF LONDON AND NEW YORK

90 Riverside Dr., New York NY 10024. (212)873-0772. **Editor/Publisher:** Jeffrey Blyth. Syndicates to several dozen European magazines and newspapers.

Needs Buys from 4-5 freelancers and writers/year. Prefers material universal in appeal; no "American only."

First Contact & Terms Send query letter and photographs; write for artists' guidelines. Samples not kept on file are returned by SASE. Responds in 3 weeks. Purchases European rights. Pays 60% of net proceeds on publication.

KING FEATURES SYNDICATE

888 Seventh Ave., 2nd Floor, New York NY 10019. (212)455-4000. Website: www.Kingfeatures.com. **Editor-in-Chief:** Jay Kennedy. Estab. 1915. Syndicate servicing over 3,000 newspapers worldwide. Guidelines available for #10 SASE.

- This is one of the oldest, most established syndicates in the business. It runs such classics as *Blondie*, *Hagar*, *Dennis the Menace* and *Beetle Bailey* and such contemporary strips as *Zippy the Pinhead*, *Zits* and *Mutts*.

Needs Approached by 6,000 freelancers/year. Introduces 3 new strips/year. Considers comic strips and single panel cartoons. Prefers humorous single or multiple panel, b&w line drawings. Maximum size of artwork $8\frac{1}{2} \times 11$. Comic strips must be reducible to $6\frac{1}{2}''$ wide; single panel cartoons must be reducible to $3\frac{1}{2}''$ wide.

First Contact & Terms Sample package should include cover letter, character sheet that names and describes major characters, and photocopies of finished cartoons. "Résumé optional but appreciated." 24 samples should be included. Returned by SASE. Full submission guidelines available on website. Responds in 2 months. Pays 50% of net proceeds. Rights purchased vary according to project. Artist owns original art and characters. Length of contract and other terms negotiated.

Tips "We look for a uniqueness that reflects the cartoonist's own individual slant on the world and humor. If we see that slant, we look to see if the cartoonist is turning his attention to events other people can relate to. We also study a cartoonist's writing ability. Good writing helps weak art, better than good art helps weak writing."

PLAIN LABEL PRESS

P.O. Box 240331, Ballwin MO 63024. E-mail: mail@plainlabelpress.com. Website: www.plainlabelpress.com. **Contact:** Laura Meyer, submissions editor. Estab. 1989. Syndicate serving over 100 weekly magazines, newspapers and Internet sites. Guidelines available on website.

Needs Approached by 500 cartoonists and 100 illustrators/year. Buys from 2-3 cartoonists/illustrators/year. Introduces 1-2 new strips/year. Strips introduced include *Barcley & Co.*, by Todd Schowalter and *The InterPETS!* Considers cartoons (single, double and multiple panel), comic strips, editorial/political cartoons and gag cartoons. Prefers comics with cutting edge humor, NOT mainstream. Maximum size of artwork $8\frac{1}{2} \times 11$; artwork must be reducible to 25% of original size.

First Contact & Terms Sample package should include an intro letter, character descriptions, 3-4 weeks of material, photocopies or disk, no original art, SASE if you would like your materials returned. 18-24 samples should be included. Samples are not filed. If samples are not filed, samples are returned by SASE if requested by artist. Portfolio not required. Pays 60% of net proceeds, upon publication. Pays on publication. Responds to submissions in 2 months. Contract is open and may be cancelled at any time by the creator and/or by Plain Label Press. Artist owns original art and original characters.

Tips "Be FUNNY! Remember readers read the comics as well as look at them. Don't be afraid to take risks. Plain Label Press does not wish to be the biggest syndicate, just the funniest. A large portion of our material is purchased for use online so a good knowledge of digital color and imaging puts a cartoonist at an advantage. Good luck!"

TRIBUNE MEDIA SERVICES, INC.

435 N. Michigan Ave., Suite 1400, Chicago IL 60611. (312)222-4444. e-mail submissions@tribune.com. Website: www.comicspage.com. **Submissions Editor:** Tracy Clark. Managing Editor Eve Becker. Syndicate serving daily domestic and international and Sunday newspapers as well as weeklies and new media services. Strips syndicated include *Broom-Hilda*, *Dick Tracy*, *Brenda Starr* and *Helen, Sweetheart of the Internet* "All are original

comic strips, visually appealing with excellent gags.'' Art guidelines available on website or for SASE with first-class postage or on website.

- Tribune Media Services is a leading provider of Internet and electronic publishing content, including the WebPoint Internet Service.

Needs Seeks comic strips and newspaper panels, puzzles and word games. Recent introductions include *Cats With Hands*, by Joe Martin; *Dunagin's People*, by Ralph Dunagin. Prefers original comic ideas, with excellent art and timely, funny gags; original art styles; inventive concepts; crisp, funny humor and dialogue.

First Contact & Terms Send query letter with résumé and photocopies. Sample package should include 4-6 weeks of daily strips or panels. Send 8½×11 copies of your material, not the original. ''Interactive submissions invited.'' Samples not filed are returned only if SASE is enclosed. Responds in 2 months. Pays 50% of net proceeds.

Tips ''Comics with recurring characters should include a character sheet and descriptions. If there are similar comics in the marketplace, acknowledge them and describe why yours is different.''

UNITED FEATURE SYNDICATE/NEWSPAPER ENTERPRISE ASSOCIATION

200 Madison Ave., New York NY 10016. (212)293-8500. Website: www.unitedfeatures.com. **Contact:** Comics Editor. Syndicate serving 2,500 daily/weekly newspapers. Guidelines available for #10 SASE and on website.

- This syndicate told *AGDM* they receive more than 4,000 submissions each year and only accept two or three new artists. Nevertheless, they are always interested in new ideas.

Needs Approached by 5,000 cartoonists/year. Buys 2-3 cartoons/year. Introduces 2-3 new strips/year. Strips introduced include *Dilbert*, *Luann*, *Over the Hedge*. Considers comic strips, editorial political cartoons and panel cartoons.

First Contact & Terms Sample package should include cover letter and nonreturnable photocopies of finished cartoons. 18-36 dailies. Color Sundays are not necessary with first submissions. Responds in 4 months. Does not purchase one shots. Does not accept submissions via fax or e-mail.

Tips ''No oversize packages, please.''

Ⓝ UNITED MEDIA

200 Madison Ave., New York NY 10016. (212)293-8500. Website: www.unitedfeatures.com. **Contact:** Editorial Submissions Editor or Comic Art Submissions Editor. Estab. 1978. Syndicate servicing US and international newspapers. Guidelines for SASE. ''United Media consists of United Feature Syndicate and Newspaper Enterprise Association. Submissions are considered for both syndicates. Duplicate submissions are not needed.'' Guidelines available on website.

Needs Introduces 2-4 new strips/year. Considers comic strips and single, double and multiple panels. Recent introductions include *Frazz*, by Jef Mallett. Prefers pen & ink.

First Contact & Terms Send cover letter, résumé, finished cartoons and photocopies. Include 36 dailies; ''Sundays not needed in first submissions.'' Do not send ''oversize submissions or concepts without strips.'' Samples are not filed and are returned by SASE. Responds in 3 months. ''Does not view portfolios.'' Payment varies by contract. Buys all rights.

Tips ''Send copies, but not originals. Do not send mocked-up licensing concepts.'' Looks for ''originality, art and humor writing. Be aware of long odds; don't quit your day job. Work on developing your own style and humor writing. Worry less about 'marketability' that's our job.''

UNIVERSAL PRESS SYNDICATE

4520 Main St., Suite 700, Kansas City MO 64111. (816)932-6600. Website: www.ucomics.com. **Editorial Director:** Lee Salem. Syndicate serving 2,750 daily and weekly newspapers.

Needs Considers single, double or multiple panel cartoons and strips; b&w and color. Requests photocopies of b&w, pen & ink, line drawings.

First Contact & Terms Responds in 6 weeks. To show a portfolio, mail photocopies. Send query letter with photocopies.

Tips ''Be original. Don't be afraid to try some new idea or technique. Don't be discouraged by rejection letters. Universal Press receives 100-150 comic submissions a week and only takes on two or three a year, so keep plugging away. Talent has a way of rising to the top.''

WHITEGATE FEATURES SYNDICATE

71 Faunce Dr., Providence RI 02906. (401)274-2149. Website: www.whitegatefeatures.com. **Talent Manager:** Eve Green. Estab. 1988. Syndicate serving daily newspapers internationally, book publishers and magazines. Guidelines available on website.

- Send nonreturnable samples. This syndicate says they are not able to return samples ''even with SASE'' because of the large number of submissions they receive.

Needs Introduced Dave Berg's *Roger Kaputnik*. Considers comic strips, gag cartoons, editorial/political cartoons,

illustrations and spot drawings; single, double and multiple panel. Work must be reducible to strip size. Also needs artists for advertising and publicity. Looking for fine artists and illustrators for book publishing projects.

First Contact & Terms Send cover letter, résumé, tearsheets, photostats and photocopies. Include about 12 strips. Does not return materials. To show portfolio, mail tearsheets, photostats, photographs and slides; include b&w. Pays 50% of net proceeds upon syndication. Negotiates rights purchased. Minimum length of contract 5 years (flexible). Artists owns original art; syndicate owns characters (negotiable).

Tips Include in a sample package "info about yourself, tearsheets, notes about the strip and enough samples to tell what it is. Don't write asking if we want to see; just send samples." Looks for "good writing, strong characters, good taste in humor. No hostile comics. We like people who have cartooned for a while and are printed. Get published in local papers first."

Stock Illustration & Clip Art Firms

Stock illustration firms market images to book publishers, advertising agencies, magazines, corporations and other businesses through catalogs and Web sites. Art directors flip through stock illustration catalogs or browse the Web for artwork at reduced prices, while firms split fees with illustrators.

There are those who maintain stock illustration hurts freelancers. They say it encourages art directors to choose ready-made artwork at reduced rates instead of assigning illustrators for standard industry rates. Others maintain the practice gives freelancers a vehicle to resell their work. Marketing your work as stock allows you to sell an illustration again and again instead of filing it away in a drawer. That illustration can mean extra income every time someone chooses it from a stock catalog.

Stock vs. clip art

When most people think of clip art, they think of booklets of copyright-free graphics and cartoons, the kind used in church bulletins, high school newspapers, club newsletters and advertisments for small businesses. But these days, especially with some of the digital images available online, perceptions are changing. With the popularity of desktop publishing, newsletters that formerly looked homemade look more professional.

Copyright and payment

There is another crucial distinction between stock illustration and clip art. That distinction is copyright. Stock illustration firms do not sell illustrations. They license the right to reprint illustrations, working out a "pay-per-use" agreement. Fees charged depend on how many times and for what length of time their clients want to reproduce the artwork. Stock illustration firms generally split their fees 50-50 with artists and pay the artist every time his image is used. You should be aware that some agencies offer better terms than others. So weigh your options before signing any contracts.

Clip art, on the other hand, generally implies buyers are granted a license to use the image as many times as they want, and furthermore, they can alter it, crop it or retouch it to fit their purposes. Some clip art firms repackage artwork created many years ago because it is in the public domain, and therefore, they don't have to pay an artist for the use of the work. But in the case of clip art created by living artists, firms either pay the artists an agreed-upon fee for all rights to the work or negotiate a royalty agreement. Keep in mind that if you sell all rights to your work, you will not be compensated each time it is used unless you also negotiate a royalty agreement. Once your work is sold as clip art, the buyer of that clip art can alter your work and resell it without giving you credit or compensation.

Subscribe to *The Artist's Magazine* Today and Save!
PLUS...GET A FREE GIFT WITH YOUR PAID SUBSCRIPTION!

Packed with innovative ideas, creative inspiration, and detailed demonstrations from the best artists in the world, *The Artist's Magazine* provides everything you need to be the best artist you can be. Here's just a sample of what you'll find inside...

- easy ways to paint dazzling light in watercolor
- simple tips for building alluring depth into your landscapes
- techniques for copying the masters with your own stylistic flair
- sure-fire solutions for still life painting success
- up-to-date information on materials and tools
- expert advice on the business side of being an artist
- and so much more!

YOUR FREE GIFT: You'll also receive the exclusive full-color booklet, *Guide to Being More Creative,* filled with easy and inspiring tips for recharging your imagination and energizing your art. It's our gift to you—and it's yours FREE with your paid subscription!

SUBSCRIBE TODAY!

How to submit artwork

Companies are identified as either stock illustration or clip art firms in the first paragraph of each listing. Some firms, such as Metro Creative Graphics and Dynamic Graphics, seem to be hybrids of clip art firms and stock illustration agencies. Read the information under ''Needs'' to find out what type of artwork each firm needs. Then check ''First Contact & Terms'' to find out what type of samples you should send. Most firms accept samples in the form of slides, photocopies and tearsheets. Increasingly, disk and e-mail submissions are encouraged in this market.

⊕ ARTBANK ILLUSTRATION LIBRARY

114 Clerkenwell Rd., London EC1M 5SA. (+44)020 7608 2288. Fax: (+44)020 8906 2289. E-mail: info@artbank. com. Website: www.artbank.com. Estab. 1989. Picture library. Artists include Rafal Olbinski, Jane Spencer. Clients include advertising agencies, design groups, book publishers, calendar companies, greeting card companies and postcard publishers.
Needs Prefers 4×5 transparencies.

⊕ DRAWN & QUARTERED LTD.

4 Godmersham Park, Canterbury Kent CT4-7DT. (44)1227-730-565. E-mail: red@drawnandquartered.com. Website: www.drawnandquartered.com. **Contact:** Robert Edwards, chief executive.
- See listing in Syndicates & Cartoon Features section.

DYNAMIC GRAPHICS INC.

6000 N. Forest Park Dr., Peoria IL 61614-3592. (800)255-8800 or (309)688-8800. Fax: (309)688-8515. Website: www.dgusa.com. **Art Director:** Mike Ulrich. Distributes clip art, stock images and animation to thousands of magazines, newspapers, agencies, industries and educational institutions.
- Dynamic Graphics is a stock image firm and publisher of *Step into Design*, *Digital Design* newsletter and *Dynamic Graphics* magazine. Uses illustrators from all over the world; 99% of all artwork sold as clip art is done by freelancers.

Needs Works with more than 50 freelancers/year. Prefers illustration, symbols and elements; buying color and b&w, traditional or electronic images. ''We are currently seeking to contact established illustrators capable of handling b&w or color stylized and representational illustrations of contemporary subjects and situations.''
First Contact & Terms Submit portfolio of at least 15 current samples with SASE. Responds in 2 weeks. **Pays on acceptance** Negotiates payment. Buys all rights.
Tips ''We are interested in quality, variety and consistency. Illustrators contacting us should have top-notch samples that show consistency of style (repeatability) over a range of subject matter. We often work with artists who are getting started if their portfolios look promising. Because we publish a large volume of artwork monthly, deadlines are extremely important, but we do provide long lead time. (4-6 weeks is typical.) We are also interested in working with illustrators who would like an ongoing relationship. Not necessarily a guaranteed volume of work, but the potential exists for a considerable number of pieces each year for marketable styles.''

GETTY IMAGES

601 N. 34th St., Seattle WA 98103. (800)462-4379 or (206)925-5000. Fax: (206)925-5001. Website: www.gettyim ages. Leading imagery company, creating and distributing the largest collection of images to communication professionals around the world. Getty Images products are found in newspapers, magazines, advertising, films, television, books and websites.Offering royalty-free and rights-managed images.
Needs Approached by 1,500 artists/year. Buys from 100 freelancers/year. Considers illustrations, photos, typefaces and spot drawings.
First Contact & Terms Visit **www.gettyimages.com/contributors** and select the link ''interested in marketing your imagery through Getty Images?''

Ⓝ INDEX STOCKWORKS

23 W. 18th St., 3rd Floor, New York NY 10011. (800)690-6979. Fax: (212)633-1914. E-mail: portfolio@indexstoc k.com. Website: www.indexstock.com. **Contact:** Desmond Powell. Estab. 1992. Stock illustration firm. Specializes in stock illustration for corporations, advertising agencies and design firms. Guidelines available on website.
Needs Approached by 300 new artists/year. Themes include animals, business, education, healthcare, holidays, lifestyles, technology and computers, travel locations.
First Contact & Terms Visit website. Click on link *For Artists Only* Under **Submitting a Portfolio for review** click on link submitting a portfolio. Download and print the following documents Appropriate guidelines based

on the type of media you wish to submit, Pre-Portfolio Questionnaire Form and 2002 or current year PORTFOLIO SUBMISSION FORM. As instructed in guidelines sign and return forms with your images for review. Samples are filed or are returned through pre-paid return shipping via Federal Express, UPS or US Postal Services at artist's expense, depending on the outcome of the portfolio review. Responds only if interested. E-mail for portfolio review of available stock images and leave behinds. Pays royalties of 40%. Negotiates rights purchased. Finds artists through *Workbook, Showcase, Creative Illustration*, magazines, submissions.

Tips "Index Stock Imagery likes to work with artists to create images specifically for stock. We provide 'Want' lists and concepts to aid in the process. We like to work with illustrators who are motivated to explore an avenue other than just assignment to sell their work."

METRO CREATIVE GRAPHICS, INC.

519 Eighth Ave., New York NY 10018. (212)947-5100. Fax: (212)714-9139. Website: www.metrocreativegraphic s.com. **Senior Art Director:** Darrell Davis. Estab. 1910. Creative graphics/art firm. Distributes to 7,000 daily and weekly paid and free circulation newspapers, schools, graphics and ad agencies and retail chains. Guidelines available. (Send letter with SASE or e-mail art director on website.)

Needs Buys from 100 freelancers/year. Considers all styles of illustrations and spot drawings; b&w and color. Editorial style art, cartoons for syndication not considered. Special emphasis on computer-generated art for Macintosh. Send floppy disk samples using Illustrator 5.0. or Photoshop. Prefers all categories of themes associated with newspaper advertising (retail promotional and classified). Also needs covers for special-interest newspaper, tabloid sections.

First Contact & Terms Send query letter with nonreturnable samples, such as photostats, photocopies, slides, photographs or tearsheets to be kept on file. Accepts submissions on disk compatible with Illustrator 5.0 and Photoshop. Send EPS or TIFF files. Samples returned by SASE if requested. Responds only if interested. Works on assignment only. **Pays on acceptance**; flat fee of $25-1,500 (buy out). Considers skill and experience of artist, saleability of artwork and clients' preferences when establishing payment.

Tips This company is "very impressed with illustrators who can show a variety of styles." When creating electronic art, make sure all parts of the illustration are drawn completely, and then put together. "It makes the art more versatile to our customers."

ONE MILE UP, INC.

7011 Evergreen Court, Annandale VA 22003. (703)642-1177. Fax: (703)642-9088. E-mail: gene@onemileup.c om. Website: www.onemileup.com. **President:** Gene Velazquez. Estab. 1988.

• Gene Velazquez told *AGDM* he is looking for aviation graphics. He does not use cartoons.

Needs Approached by 10 illustrators and animators/year. Buys from 5 illustrators/year. Prefers illustration.

First Contact & Terms Send 3-5 samples via e-mail with résumé and/or link to your website. Pays flat fee; $30-120. **Pays on acceptance.** Negotiates rights purchased.

THE SPIRIT SOURCE.COM

1310 Pendleton St., Cincinnati OH 45202. (513)241-7473. Fax: (513)241-7505. E-mail: mpwiggins@thespiritsour ce.com. Website: www.thespiritsource.com. **Owner:** Paula Wiggins. Estab. 2003. Stock illustration firm. Specializes in religious, spiritual and inspirational images for the print market. Distributes to book publishers, greeting card companies, magazine publishers, newspapers. Clients include *Sojourners* magazine, St. Anthony Messenger Press, Gainey Conference Center. Guidelines available on website.

Needs Approached by 25 illustrators/year. Works with 11 illustrators/year. Prefers digital art, b&w and color drawings with line, pen & ink, spot and any high-quality artwork in any medium that is inspirational in nature. Themes include education, families, fine art, holidays, landscapes/scenics, multicultural and religious. 100% of illusration demands skills in Photoshop.

First Contact & Terms Send brochure, photocopies, URL, images on a CD or e-mail low-res files. Samples are filed or returned by SASE. Accepts e-mail submissions with link to website and with image file. Prefers low-res JPEGs or images on a CD. Responds in 1 week. Portfolio should include at least 10 images, preferably in a digital format or b&w and color finished art. No originals. Pays for illustration 50% of negotiated fee. Buys one-time rights. Finds artists through artists' submissions and word of mouth.

Tips "Although we are a website that specializes in religious/spiritual/inspirational work, that can be interpreted broadly. Our categories include family life, human relationships, nature, virtues/vices and holidays. No overdone or clichéd images. Artist should be prepared to submit digital images for the site according to our specifications."

STOCK ILLUSTRATION SOURCE

16 W. 19th St., 9th Floor, New York NY 10011. (212)849-2900, (800)4-IMAGES. Fax: (212)691-6609. E-mail: submissions@images.com. Website: www.images.com. **Acquisitions Manager:** Margaret Zacharon. Estab.

1992. Stock illustration agency. Specializes in illustration for corporate, advertising, editorial, publishing industries. Guidelines available.

Needs ''We deal with 500 illustrators.'' Prefers painterly, conceptual images, including collage and digital works. Themes include corporate, business, education, family life, healthcare, law and environment, lifestyle.

First Contact & Terms Illustrators should scan sample work onto CD or disk and send that rather than e-mailing links to their sites. Will do portfolio review. Pays royalties of 50% for illustration sales. Negotiates rights purchased.

STOCKART.COM

155 N. College Ave., Suite 225, Ft. Collins CO 80524. (970)493-0087 or (800)297-7658. Fax: (970)493-6997. E-mail: art@stockart.com. Website: www.stockart.com. **Art Manager:** Maile Fink. Estab. 1995. Stock illustration and representative. Specializes in b&w and color illustration for ad agencies, design firms and publishers. Clients include BBDO, Bozell, Pepsi, Chase, Saatchi & Saatchi.

Needs Approached by 250 illustrators/year. Works with 150 illustrators/year. Themes include business, family life, financial, healthcare, holidays, religion and many more.

First Contact & Terms Illustrators send at least 10 samples of work. Accepts hard copies, e-mail or disk submissions compatible with TIFF or EPS files less than 600K/image. Pays 50% stock royalty, 70% commission royalty (commissioned work—artist retains rights) for illustration. Rights purchased vary according to project. Finds artists through sourcebooks, online, word of mouth. ''Offers unprecedented easy-out policy. Not 100% satisfied, will return artwork within 60 days.''

Tips ''Stockart.com has many artists earning a substantial passive income from work that was otherwise in their file drawers collecting dust.''

Advertising, Design & Related Markets

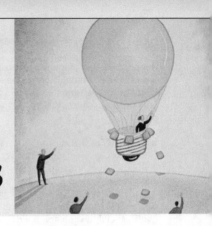

If you are an illustrator who can work in a consistent style or a designer with excellent skills, and you can take direction, this section offers a glimpse at one of the most lucrative markets for artists. Because of space constraints, the markets listed are just the tip of the proverbial iceberg. There are thousands of advertising agencies and public relations, design and marketing firms across the country and around the world. All rely on freelancers. Look for additional firms in industry directories, such as *Workbook* (Scott & Daughters Publishing), *Standard Directory of Advertisers* (National Register Publishing) and *The Adweek Directory*, available in the business section of most large public libraries. Find local firms in the yellow pages and your city's business-to-business directory. You can also pick up leads by reading *Adweek*, *HOW*, *Print*, *STEP inside design*, *Communication Arts* and other design and marketing publications.

Find your best clients

Read listings to identify firms whose clients and specialties are in line with the type of work you create. (You'll find clients and specialties in the first paragraph of each listing.) For example, if you create charts and graphs, contact firms whose clients include financial institutions. Fashion illustrators should approach firms whose clients include department stores and catalog publishers. Sculptors and modelmakers might find opportunities with firms specializing in exhibition design.

Payment and copyright

You will most likely be paid by the hour for work done on the firm's premises (in-house) and by the project if you take the assignment back to your studio. Most checks are issued 40-60 days after completion of assignments. Fees depend on the client's budget, but most companies are willing to negotiate, taking into consideration the experience of the freelancer, the lead time given and the complexity of the project. Be prepared to offer an estimate for your services and ask for a purchase order (P.O.) before you begin an assignment.

Some art directors will ask you to provide a preliminary sketch on speculation or "on spec," which, if approved by the client, can land you a plum assignment. If you are asked to create something "on spec," be aware that you may not receive payment beyond an hourly fee for your time if the project falls through. So be sure to ask upfront about payment policy before you start an assignment.

If you're hoping to retain usage rights to your work, you'll want to discuss this upfront, too. You can generally charge more if the client is requesting a buyout. If research and travel are required, make sure you find out ahead of time who will cover these expenses.

ALABAMA

COMPASS MARKETING, INC.

175 Northshore Place, Gulf Shores AL 36542. (251)968-4600. Fax: (251)968-5938. E-mail: awboone@compassbi z.com. Website: www.compassbiz.com. **Editor:** Chad Kirtland. Estab. 1988. Number of employees 20-25. Approximate annual billing $4 million. Integrated marketing communications agency and publisher. Specializes in tourism products and programs. Product specialties are business and consumer tourism. Current clients include Alabama Bureau of Tourism and Alabama Gulf Coast CVB. Client list available upon request.

Needs Approached by 5-20 designers/year. Works with 4-6 designers/year. Prefers freelancers with experience in magazine work. Uses freelancers mainly for sales collateral, advertising collateral and illustration. 5% of work is with print ads. 100% of design demands skills in Photoshop 5.0 and QuarkXPress.

First Contact & Terms Designers: Send query letter with photocopies, résumé and tearsheets. Samples are filed and are not returned. Responds in 1 month. Art director will contact artist for portfolio review of slides and tearsheets if interested. Pays by the project, $100 minimum. Rights purchased vary according to project. Finds artists through sourcebooks, networking and print.

Tips "Be fast and flexible. Have magazine experience."

A. TOMLINSON/SIMS ADVERTISING, INC.

250 S. Poplar St., Florence AL 35630. (256)766-4222. Fax: (256)766-4106. E-mail: atsadv@hiwaay.net. Website: ATSA-USA.com. **President:** Allen Tomlinson. Estab. 1990. Number of employees 9. Approximate annual billing $5.0 million. Ad agency. Specializes in magazine, collateral, catalog and business-to-business. Product specialties are home building products. Client list available upon request.

Needs Approached by 20 illustrators and 20 designers/year. Works with 5 illustrators and 5 designers/year. Also for airbrushing, billboards, brochure and catalog design and illustration, logos and retouching. 35% of work is with print ads. 85% of design demands skills in PageMaker 6.5, Photoshop, Illustrator and QuarkXPress 4.1. 85% of illustration demands skills in PageMaker 6.5, Photoshop, Illustrator and QuarkXPress 4.1.

First Contact & Terms Designers send query letter with brochure and photocopies. Illustrators send query letter with brochure, photocopies and résumé. Samples are filed and are not returned. Does not reply; artist should call. Artist should also call to arrange for portfolio review of color photographs, thumbnails and transparencies. Pays by the project. Rights purchased vary according to project.

ARIZONA

ARIZONA CINE EQUIPMENT, INC.

2125 E. 20th St., Tucson AZ 85719. (520)623-8268. Fax: (520)623-1092. Website: www.arizonacine.com. **Vice President:** Linda A. Bierk. Estab. 1967. Number of employees 11. Approximate annual billing $850,000. AV firm. Full-service, multimedia firm. Specializes in video. Product specialty is industrial.

Needs Approached by 5 freelancers/year. Works with 5 illustrators and 5 freelance designers/year. Prefers local artists. Uses freelancers mainly for graphic design. Also for brochure and slide illustration, catalog design and illustration, print ad design, storyboards, animation and retouching. 20% of work is with print ads. Also for multimedia projects. 70% of design and 80% of illustration demand knowledge of PageMaker, QuarkXPress, FreeHand, Illustrator or Photoshop.

First Contact & Terms Send query letter with brochure, résumé, photocopies, tearsheets, transparencies, photographs, slides and SASE. Samples are filed. Responds only if interested. Will contact artist for portfolio review if interested. Portfolio should include color thumbnails, final art, tearsheets, slides, photostats, photographs and transparencies. Pays for design by the project, $100-5,000. Pays for illustration by the project, $25-5,000. Buys first rights or negotiates rights purchased.

BOELTS-STRATFORD ASSOCIATES

345 E. University Blvd., Tucson AZ 85705-7848. (520)792-1026. Fax: (520)792-9720. E-mail: bsa@boelts-stratfor d.com. Website: www.boelts-stratford.com. **Principal:** Jackson Boelts. Estab. 1986. Specializes in annual reports, brand identity, corporate identity, display design, direct mail design, environmental graphics, package design, publication design and signage. Client list available upon request.

• This firm has won over 400 international, national and local awards.

Needs Approached by 100 freelance artists/year. Works with 10 freelance illustrators and 5-10 freelance designers/year. Works on assignment only. Uses designers and illustrators for brochure, poster, catalog, P-O-P and ad illustration, mechanicals, retouching, airbrushing, charts/graphs and audiovisual materials.

First Contact & Terms Send query letter with brochure, tearsheets and résumé. Samples are filed. Responds only if interested. Call to schedule an appointment to show portfolio. Portfolio should include roughs, original/

final art, slides and transparencies. Pays for design by the hour and by the project. Pays for illustration by the project. Negotiates rights purchased.

Tips When presenting samples or portfolios, artists "sometimes mistake quantity for quality. Keep it short and show your best work."

CRICKET CONTRAST GRAPHIC DESIGN

6232 N. 7th St., Suite 208, Phoenix AZ 85014. (602)258-6149. Fax: (602)258-0113. E-mail: cricket@thecricketcontrast.com. **Owner:** Kristie Bo. Estab. 1982. Number of employees 5. Specializes in providing solutions for branding, corporate identity, web page design, advertising, package and publication design. Clients: corporations. Professional affiliations: AIGA, Phoenix Society of Communicating Arts, Phoenix Art Museum, Phoenix Zoo.

Needs Approached by 25-50 freelancers/year. Works with 5 freelance illustrators and 5 designers/year. Also uses freelancers for ad illustration, brochure design and illustration, lettering and logos. Needs computer-literate freelancers for design and production. 100% of freelance work demands knowledge of Illustrator, Photoshop and QuarkXPress.

First Contact & Terms Send photocopies, photographs and résumé. Will contact artist for portfolio review if interested. Portfolio should include b&w photocopies. Pays for design and illustration by the project. Negotiates rights purchased. Finds artists through self-promotions and sourcebooks.

Tips "Beginning freelancers should call and set up an appointment or meeting and show their portfolio and then make a follow-up call or calls."

N. GODAT DESIGN INC.

101 W. Simpson St., Tucson AZ 85701-2268. (520)620-6337. E-mail: ken@godatdesign.com. Website: www.godatdesign.com. **Principal:** Ken Godat. Estab. 1983. Number of employees 9. Specializes in corporate identity, marketing communications, website and interactive design. Clients: corporate, retail, institutional, public service. Current clients include Longitude, Covington & Burling, Tucson Airport Authority and University of Arizona. Professional affiliations AIGA, American Ad Federation.

Needs Works with 0-3 freelance illustrators and 0-3 designers/year. Freelancers should be familiar with InDesign, Photoshop and Illustrator.

First Contact & Terms Send query letter with samples or website address. Request portfolio review in original query. Will contact artist for portfolio review if interested. Pays for design by the hour. Pays for illustration by the project. Finds artists online and through sourcebooks.

PAUL S. KARR PRODUCTIONS

2925 W. Indian School Rd., Phoenix AZ 85017. (602)266-4198. **Contact:** Kelly Karr. Utah Division: 1024 N. 300, E. Orem UT 84057. (801)226-3001. Website: www.phoenixvideofilms.com. **Contact:** Michael Karr. Film and video producer. Clients industry, business, education, TV, cable and feature films.

Needs Occasionally works with freelance filmmakers in motion picture and video projects. Works on assignment only.

First Contact & Terms Advise of experience, abilities and funding for project.

Tips "If you know about motion pictures and video or are serious about breaking into the field, there are three avenues 1) have relatives in the business; 2) be at the right place at the right time; or 3) take upon yourself the marketing of your idea, or develop a film or video idea for a sponsor who will finance the project. Go to a film or video production company, such as ours, and tell them you have a client and the money. They will be delighted to work with you on making the production work and approve the various phases as it is being made. Have your name listed as the producer on the credits. With the knowledge and track record you have gained, you will be able to present yourself and your abilities to others in the film and video business and to sponsors."

THE M. GROUP GRAPHIC DESIGN

8722 E. Via De Commercio, Scottsdale AZ 85258. (480)998-0600. Fax: (480)998-9833. E-mail: mail@themgroupinc.com. Website: www.themgroupinc.com. **Head Designer:** Michael Carmagiano. Estab. 1987. Number of employees 7. Approximate annual billing 2.75 million. Specializes in annual reports, corporate identity, direct mail and package design, and advertising. Clients corporations and small business. Current clients include BankOne, Dole Foods, Giant Industries, Intel, Coleman Spas, Subway and Teksoft.

Needs Approached by 50 freelancers/year. Works with 5-10 freelance illustrators/year. Uses freelancers for ad, brochure, poster and P-O-P illustration. 95% of freelance work demands skills in Illustrator, Photoshop and QuarkXPress.

First Contact & Terms Send postcard sample or query letter with samples. Samples are filed or returned by SASE if requested by artist. Responds only if interested. Request portfolio review in original query. Artist should

follow-up. Portfolio should include b&w and color final art, photographs and transparencies. Rights purchased vary according to project. Finds artists through publications (trade) and reps.

Tips Impressed by "good work, persistence, professionalism."

PAPAGALOS STRATEGIC COMMUNICATIONS

7330 N. 16th St., Suite B102, Phoenix AZ 85020. (602)906-3210. Fax: (602)277-7448. E-mail: hrdept@papagalos. com. Website: www.papagalos.com. **Creative Director:** Nicholas Papagalos. Specializes in advertising, brochures, annual corporate identity, displays, packaging, publications and signage. Clients major regional, consumer and business-to-business. Clients include Perini, Goettl Air Conditioning, American Hospice Foundation, Collins College, McMillan Fiberglass Stocks.

Needs Works with 6-20 freelance artists/year. Works on assignment only. Uses artists for illustration, retouching, design and production. Needs computer-literate freelancers, HTML programmers and web designers for design, illustration and production. 100% of freelance work demands skills in Illustrator, QuarkXPress or Photoshop.

First Contact & Terms E-mail résumé and samples. Pays for design by the hour or by the project. Pays for illustration by the project. Considers complexity of project, client's budget, skill and experience of artist, how work will be used, turnaround time and rights purchased when establishing payment. Rights purchased vary according to project.

Tips In presenting samples or portfolios, "two samples of the same type/style are enough."

ℕ RIPE CREATIVE

1543 W. Apollo Road, Phoenix AZ 85041. (602)304-0703. Fax: (480)247-5339. E-mail: info@ripecreative.com. Website: www.ripecreative.com. **Contact:** Mark Anthony Munoz, principal. Estab. 2005. Number of employees: 5. Approximate annual billing: $500,000. Design Firm. Specializes in branding, advertising, strategic marketing, publication, design, trade-show environments. Current clients include: Swing Development, Express Messenger, Invision Photography. Client list available on request. Professional affiliations: AIGA (Phoenix), NAPP.

Needs Approached by 100 illustrators and 10 designers/year. Works with 10 illustrators and 3 designers/year. Works on assignment only. Prefers designers, illustrators and web designers with experience in tearsheets, computer graphics and Macintosh. Uses freelancers mainly for illustration, graphic design, website design. Also for brochure animation, brochure design, brochure illustration, direct mail, industrial/structural design, logos, posters, print ads, storyboards, brochure illustration, catalog design and technical illustration. 15% of work is assigned with print ads. 100% of design work demands skills in InDesign, Illustrator, QuarkXPress and Photoshop. 100% of illustration work demands skills in Illustrator, Photoshop and traditional illustration media.

First Contact & Terms Designers: Send query letter with brochure, résumé, tearsheets, URL. Illustrators: Send tearsheets, URL. Samples are returned if requested and SASE is provided. Designers and illustrators should attach pdf files and/or URL. Samples are filed or returned by SASE. Responds in 2 weeks. Company will contact artist for portfolio review if interested. Portfolio should include color finished art, photographs and tearsheets. Pays for illustration. Set rate negotiated and agreed to between RIPE and talent. Pays for design by the hour $25-100. Rights purchased vary according to project. Finds artists through artists' submissions, word of mouth, *Workbook, Blackbook.*

Tips "Cold calls are discouraged. When making first contact attempt, the preferred method is via mail or electronically. If interested, RIPE will follow up witih talent electronically or by telephone. When providing samples, please ensure talent/rep contact is listed on all samples."

ARKANSAS

MANGAN/HOLCOMB RAINWATER/CULPEPPER & PARTNERS

2300 Cottondale Lane, Suite 300, Little Rock AR 72202. (501)376-0321. E-mail: chip@people-energy-ideas.com. Website: www.people-energy-ideas.com. **Vice President Creative Director:** Chip Culpepper. Number of employees 12. Marketing, advertising and public relations firm. Approximate annual billing $3 million. Ad agency. Clients recreation, financial, tourism, retail, agriculture.

Needs Approached by 50 freelancers/year. Works with 8 freelance illustrators and 20 designers/year. Uses freelancers for consumer magazines, stationery design, direct mail, brochures/flyers, trade magazines and newspapers. Also needs illustrations for print materials. Needs computer-literate freelancers for production and presentation. 30% of freelance work demands skills in Macintosh page layout and illustration software.

First Contact & Terms Query with samples, flier and business card to be kept on file. Include SASE. Responds in 2 weeks. Call or write for appointment to show portfolio of final reproduction/product. Pays by the project, $250 minimum.

Advertising & Design

CALIFORNIA

THE ADVERTISING CONSORTIUM

10536 Culver Blvd., Suite D, Culver City CA 90232. (310)287-2222. Fax: (310)287-2227. E-mail: theadco@pacbel l.net. **Contact:** Kim Miyade. Estab. 1985. Ad agency. Full-service, multimedia firm. Specializes in print, collateral, direct mail, outdoor, broadcast. Current clients include Bernini, Davante, Westime, Modular Communication Systems.

Needs Works with 1 illustrator and 2 art directors/month. Prefers local artists only. Works on assignment only. Uses freelance artists and art directors for everything (none on staff), including brochure, catalog and print ad design and illustration and mechanicals and logos. 80% of work is with print ads. Also for multimedia projects. 100% of freelance work demands knowledge of PageMaker, QuarkXPress, FreeHand, Illustrator and Photoshop.

First Contact & Terms Send postcard sample or query letter with brochure, tearsheets, photocopies, photographs and anything that does not have to be returned. Samples are filed. Write for appointment to show portfolio. ''No phone calls, please.'' Portfolio should include original/final art, b&w and color photostats, tearsheets, photographs, slides and transparencies. Pays for design by the hour, $60-75. Pays for illustration by the project, based on budget and scope.

Tips Looks for ''exceptional style.''

ADVERTISING DESIGNERS, INC.

7087 Snyder Ridge Rd., Mariposa CA 95338-9029. (209)742-6704. E-mail: ad@yosemite.net. **President:** Tom Ohmer. Estab. 1947. Number of employees 2. Specializes in annual reports, corporate identity, ad campaigns, package and publication design and signage. Clients: corporations.

First Contact & Terms Send query letter with postcard sample. Samples are filed. Does not reply. Artist should call. Write for appointment to show portfolio.

BASIC/BEDELL ADVERTISING & PUBLISHING

P. O. Box 6068, Ventura CA 93006. (805)650-1565. E-mail: barriebedell@earthlink.net. **President:** Barrie Bedell. Specializes in advertisements, direct mail, how-to books, direct response websites and manuals. Clients publishers, direct response marketers, retail stores, software developers, web entrepreneurs, plus extensive self-promotion of proprietary advertising how-to manuals.

- This company's president is seeing ''a glut of 'graphic designers,' and an acute shortage of 'direct response' designers.''

Needs Uses artists for publication and direct mail design, book covers and dust jackets, and camera-ready computer desktop production. Especially interested in hearing from professionals experienced in e-commerce and in converting printed training materials to electronic media, as well as designers of direct response websites.

First Contact & Terms Portfolio review not required. Pays for design by the project, $100-2,500 and up and/or royalties based on sales.

Tips ''There has been a substantial increase in use of freelance talent and increasing need for true professionals with exceptional skills and responsible performance (delivery as promised and 'on target'). It is very difficult to locate freelance talent with expertise in design of advertising and direct mail with heavy use of type. Contact with personal letter and photocopy of one or more samples of work that needn't be returned.''

⊠ BERSON, DEAN, STEVENS

P.O. Box 3997, Thousand Oaks CA 91359. (818)713-0134. Fax: (818)713-0417. E-mail: info@bersondeanstevens .com. Website: www.bersondeanstevens.com. **Owner:** Lori Berson. Estab. 1981. Specializes in annual reports, brand and corporate identity, collateral, direct mail, trade show booths, promotions, websites, packaging, and publication design. Clients: manufacturers, professional and financial service firms, ad agencies, corporations and movie studios. Professional affiliation L.A. Ad Club.

Needs Approached by 50 freelancers/year. Works with 10-20 illustrators and 10 designers/year. Works on assignment only. Uses illustrators mainly for brochures, packaging, and comps. Also for catalog, P-O-P, ad and poster illustration, mechanicals retouching, airbrushing, lettering, logos and model-making. 90% of freelance work demands skills in Illustrator, QuarkXPress, Photoshop, as well as web authoring Dreamweaver, Flash/HTML, CGI, Java, etc.

First Contact & Terms Send query letter with tearsheets and photocopies. Samples are filed. Will contact artist for portfolio review if interested. Pays for design and illustration by the project. Rights purchased vary according to project. Considers buying second rights (reprint rights) to previously published work. Finds artists through word of mouth, submissions/self-promotions, sourcebooks and agents.

BRAINWORKS DESIGN GROUP, INC.

5 Harris Court, Building T, Monterey CA 93940. (831)657-0650. Fax: (831)657-0750. E-mail: mail@brainwks.c om. Website: www.brainwks.com. **Contact:** Alfred Kahn, president. Marketing Director: Stephanie Hickey.

Estab. 1970. Number of employees 8. Specializes in ERC (Emotional Response Communications), graphic design, corporate identity, direct mail and publication. Clients colleges, universities, nonprofit organizations; majority are colleges and universities. Current clients include City College of New York, Manhattanville, University of South Carolina-Spartanburg, Queens College, Manhattan College, Nova University, American International College, Teachers College Columbia, University of Rochester.

Needs Approached by 100 freelancers/year. Works with 4 freelance illustrators and 10 designers/year. Prefers freelancers with experience in type, layout, grids, mechanicals, comps and creative visual thinking. Works on assignment only. Uses freelancers mainly for mechanicals and calligraphy. Also for brochure, direct mail and poster design; mechanicals; lettering; and logos. 100% of design work demands knowledge of QuarkXPress, Illustrator, Photoshop and InDesign.

First Contact & Terms Send brochure or résumé, photocopies, photographs, tearsheets and transparencies. Samples are filed. Artist should follow up with call and/or letter after initial query. Will contact artist for portfolio review if interested. Portfolio should include thumbnails, roughs, final reproduction/product and b&w and color tearsheets, photostats, photographs and transparencies. Pays for design by the project, $200-2,000. Considers complexity of project and client's budget when establishing payment. Rights purchased vary according to project. Finds artists through sourcebooks and self-promotions.

Tips "Creative thinking and a positive attitude are a plus." The most common mistake freelancers make in presenting samples or portfolios is that the "work does not match up to the samples they show." Would like to see more roughs and thumbnails.

�🅽 JANN CHURCH PARTNERS, INC./PHILANTHROPY CONSULTANTS GROUP, INC.

PO Box 9527, Newport Beach CA 92660. (949)640-6224. Fax: (949)640-1706. **President:** Jann Church. Estab. 1970. Specializes in annual reports, brand and corporate identity, display, interior, direct mail, package and publication design, and signage. Clients real estate developers, medical/high technology corporations, private and public companies. Current clients include The Nichols Institute, The Anden Group, Institute for Biological Research & Development. Client list available upon request.

Needs Approached by 100 freelance artists/year. Works with 3 illustrators and 5 designers/year. Works on assignment only. Needs technical illustration. 10% of freelance work demands computer literacy.

First Contact & Terms Send query letter with résumé, photographs and photocopies. Samples are filed. Responds only if interested. To show a portfolio, mail appropriate materials. Portfolio should be "as complete as possible." Pays for design and illustration by the project. Rights purchased vary according to project.

CLIFF & ASSOCIATES

10061 Riverside Dr. #808, Toluca Lake CA 91602. (626)799-5906. Fax: (626)799-9809. E-mail: design@cliffassoc.com. **Owner:** Greg Cliff. Estab. 1984. Number of employees 10. Approximate annual billing $1 million. Specializes in annual reports, corporate identity, direct mail and publication design and signage. Clients: Fortune 500 corporations and performing arts companies. Current clients include BP, IXIA, WSPA, IABC, Capital Research and ING.

Needs Approached by 50 freelancers/year. Works with 30 freelance illustrators and 10 designers/year. Prefers local freelancers and Art Center graduates. Uses freelancers mainly for brochures. Also for technical, "fresh" editorial and medical illustration; mechanicals; lettering; logos; catalog, book and magazine design; P-O-P and poster design and illustration; and model making. Needs computer-literate freelancers for design and production. 90% of freelance work demands knowledge of QuarkXPress, FreeHand, Illustrator, Photoshop, etc.

First Contact & Terms Send query letter with résumé and a nonreturnable sample of work. Samples are filed. Art director will contact artist for portfolio review if interested. Portfolio should include thumbnails, b&w photostats and printed samples. Pays for design by the hour, $25-35. Pays for illustration by the project, $50-3,000. Buys one-time rights. Finds artists through sourcebooks.

COAKLEY HEAGERTY ADVERTISING & PUBLIC RELATIONS

1155 N. First St., Suite 201, San Jose CA 95112-4925. (408)275-9400. Fax: (408)995-0600. E-mail: info@coakley-heagerty.com. Website: www.coakley-heagerty.com. **Creative Director:** Bob Meyerson. Estab. 1961. Number of employees 25. Full-service ad agency and PR firm. Clients real estate, consumer, senior care, banking/financial, insurance, automotive, tel com, public service. Client list available upon request. Professional affiliation MAGNET (Marketing and Advertising Global Network).

Needs Approached by 50 freelancers/year. Works with 50 freelance illustrators and 3 designers/year. Works on assignment only. Uses freelancers for illustration, retouching, animation, lettering, logos and charts/graphs. Freelance work demands skills in InDesign, Illustrator, Photoshop or QuarkXPress.

First Contact & Terms E-mail PDF files showing art stylye, or e-mail link to website. Does not report back. Call for an appointment to show portfolio. Pays for design and illustration by the project, $600-5,000.

▓ DENTON DESIGN ASSOCIATES

491 Arbor St., Pasadena CA 91105. (626)792-7141. **President:** Margi Denton. Estab. 1975. Specializes in annual reports, corporate identity and publication design. Clients nonprofit organizations and corporations. Recent clients include California Institute of Technology, University of Southern California, Yellowjackets and SETI Institute.

Needs Approached by 12 freelance graphic artists/year. Works with roughly 5 freelance illustrators and 2 freelance designers/year. Prefers local designers only. "We work with illustrators from anywhere." Works with designers and illustrators for brochure design and illustration, lettering, logos and charts/graphs. Demands knowledge of QuarkXPress, Photoshop and Illustrator.

First Contact & Terms Send résumé, tearsheets and samples (illustrators just send samples). Samples are filed and are not returned. Responds only if interested. Art director will contact artist for portfolio review if interested. Portfolio should include color samples "doesn't matter what form." Pays for design by the hour. Pays for illustration by the project. Rights purchased vary according to project. Finds artists through sourcebooks, AIGA, *Print,CA, Folio Planet* and other Internet sources.

DESIGN 2 MARKET

(formerly Yamaguma & Associates), 909 Weddell Ct., Sunnyvale CA 94089. (408)744-6671. Fax: (408)744-6686. E-mail: info@design2marketinc.com. Website: www.design2marketinc.com. **Production Manager:** Jean Philavong. Estab. 1980. Specializes in corporate identity, displays, direct mail, publication design, signage and marketing. Clients high technology, government and business-to-business. Clients include Sun Microsystems, OKI Semiconductor, IDEC, and City College of San Francisco. Client list available upon request.

Needs Approached by 6 freelancers/year. Works with 3 freelance illustrators and 2 designers/year. Works on assignment only. Uses illustrators mainly for 4-color, airbrush and technical work. Uses designers mainly for logos, layout and production. Also uses freelancers for brochure, catalog, ad, P-O-P and poster design and illustration; mechanicals; retouching; lettering; book, magazine, model-making; direct mail design; charts/graphs; and AV materials. Also for multimedia projects (Director SuperCard). Needs editorial and technical illustration. 100% of design and 75% of illustration demand knowledge of PageMaker, QuarkXPress, FreeHand, Illustrator, Model Shop, Strata, MMDir. or Photoshop.

First Contact & Terms Send postcard sample or query letter with brochure and tearsheets. Accepts disk submissions compatible with Illustrator, QuarkXPress, Photoshop and Strata. Samples are filed. Will contact artist for portfolio review if interested. Portfolio should include thumbnails, roughs, b&w and color photostats, tearsheets, photographs, slides and transparencies. Sometimes requests work on spec before assigning a job. Pays for design by the hour, $25-50. Pays for illustration by the project, $300-3,000. Rights purchased vary according to project. Finds artists through self-promotions.

Tips Would like to see more Macintosh-created illustrations.

▓ DESIGN AXIOM

50 B Peninsula Center Dr., Suite 156, Rolling Hills Estates CA 90274. (310)377-0207. E-mail: tschorer@aol.com. **President:** Thomas Schorer. Estab. 1973. Specializes in graphic, environmental and architectural design, product development and signage.

Needs Approached by 100 freelancers/year. Works with 3 freelance illustrators and 5 designers/year. Works on assignment only. Uses designers for all types of design. Uses illustrators for editorial and technical illustration. 50% of freelance work demands knowledge of PageMaker or QuarkXPress.

First Contact & Terms Send query letter with appropriate samples. Will contact artist for portfolio review if interested. Portfolio should include appropriate samples. Pays for design and illustration by the project. Finds artists through word of mouth, self-promotions, sourcebooks and colleges.

◩ ERVIN/BELL ADVERTISING

2134 Michelson Dr., Irvine CA 92612. (949)251-1166. Fax: (949)417-2239. E-mail: mervin@ervinbell.com. Website: www.ervinbell.com. Estab. 1981. Specializes in annual reports, branding and brand management, corporate identity, retail, direct mail, package and publication design. Clients corporations, malls, financial firms, industrial firms and software publishers. Current clients include First American Financial, Nutro Products, Toyota Certified, Ropak Corporation. Client list available upon request.

Needs Approached by 100 freelancers/year. Works with 10 freelance illustrators and 6 designers/year. Works on assignment only. Uses illustrators mainly for package designs, annual reports. Uses designers mainly for annual reports, special projects. Also uses freelancers for brochure design and illustration, P-O-P and ad illustration, mechanicals, audiovisual materials, lettering and charts/graphs. Needs computer-literate freelancers for production. 100% of freelance work demands knowledge of QuarkXPress or Photoshop.

First Contact & Terms Send résumé and photocopies. Samples are filed and are not returned. Responds only if interested. Request portfolio review in original query. Portfolio should include color roughs, tearsheets and

transparencies. Pays for design by the hour, $15-30; by the project (rate varies); by the day, $120-240. Pays for illustration by the project (rate varies). Buys all rights.

Tips Finds artists through sourcebooks, submitted résumés, mailings.

ⓝ ESSANEE UNLIMITED, INC.

P.O. Box 5168, Santa Monica CA 90409-5168. (310)396-0192. E-mail: essanee@earthlink.net. **Art Director:** Sharon Rubin. Estab. 1982. Integrated marketing communications agency/design firm. Specializes in packaging and promotion. Product specialties are travel and entertainment marketing.

Needs Works with 3-5 freelance illustrators and 3-5 designers/year. Prefers local freelancers with experience in graphic design. Also for web design and multimedia projects.

First Contact & Terms Send nonreturnable samples. Accepts disk submissions. Samples are reviewed, filed or returned by SASE. Portfolio review required only if interested in artist's work. Artist should follow-up with call. Finds artists through word of mouth, submissions.

EVENSON DESIGN GROUP

4445 Overland Ave., Culver City CA 90230. (310)204-1995. Fax: (310)204-4879. E-mail: edgmail@evensondesign.com. Website: evensondesign.com. **Principal:** Stan Evenson. Estab. 1976. Specializes in annual reports, brand and corporate identity, display design, direct mail, package design and signage. Clients ad agencies, hospitals, corporations, law firms, entertainment companies, record companies, publications, PR firms. Current clients include MGM, Pepsi Cola Company, Columbia Tri-Star, Sony Pictures Entertainment.

Needs Approached by 75-100 freelance artists/year. Works with 10 illustrators and 15 designers/year. Prefers artists with production experience as well as strong design capabilities. Works on assignment only. Uses illustrators mainly for covers for corporate brochures. Uses designers mainly for logo design, page layouts, all overflow work. Also for brochure, catalog, direct mail, ad, P-O-P and poster design and illustration, mechanicals, lettering, logos and charts/graphs. 100% of design work demands skills in QuarkXPress, FreeHand, Photoshop or Illustrator.

First Contact & Terms Send query letter with résumé and samples or send samples via e-mail. Responds only if interested. Portfolio should include b&w and color photostats and tearsheets and 4×5 or larger transparencies.

Tips "Be efficient in the execution of design work, producing quality designs over the quantity of designs. Professionalism, as well as a good sense of humor, will prove you to be a favorable addition to any design team."

ⓝ FOOTE, CONE & BELDING

17600 Gillette Ave., Irvine CA 92614. (949)851-3050. Fax: (949)567-9465. Website: www.fcb.com. **Art Buyer:** Connie Mangam. Estab. 1950. Ad agency. Full-service, multimedia firm. Product specialties are package goods, toys, entertainment and retail.

- This is the Southern California office of FCB, a global agency with offices all over the world. FCB is one of the top 3 agencies in the United States, with 188 offices in 102 countries. Main offices are in New York. Other offices are located in Chicago and San Francisco.

Needs Approached by 15-20 freelance artists/month. Works with 3-4 freelance illustrators and 2-3 freelance designers/month. Prefers local artists only with experience in design and sales promotion. Designers must be able to work in-house and have Mac experience. Uses freelance artists for brochure, catalog and print ad design and illustration, storyboards, mechanicals, retouching, lettering, logos and computer (Mac). 30% of work is with print ads.

First Contact & Terms Designers send query letter with résumé, photocopies and tearsheets. Illustrators send postcard, color photocopies, tearsheets or other nonreturnable samples. Samples are filed. Responds only if interested. Write to schedule an appointment to show a portfolio. Portfolio should include roughs and color. Pays for design based on estimate on project from concept to mechanical supervision. Pays for illustration per project. Rights purchased vary according to project.

▣ THE HITCHINS COMPANY

22756 Hartland St., Canoga Park CA 91307. (818)715-0150. Fax: (775)806-2687. E-mail: whitchins@socal.rr.com. **President:** W. Hitchins. Estab. 1985. Advertising agency. Full-service, multimedia firm.

Needs Works with 1-2 illustrators and 3-4 designers/year. Works on assignment only. Uses freelance artists for brochure and print ad design and illustration, storyboards, mechanicals, retouching, TV/film graphics, lettering and logo. Needs editorial and technical illustration and animation. 60% of work is with print ads. 90% of design and 50% of illustration demand knowledge of PageMaker, Illustrator, QuarkXPress or FreeHand.

First Contact & Terms Send postcard sample. Samples are filed if interested and are not returned. Responds only if interested. Call for appointment to show portfolio. Portfolio should include tearsheets. Pays for design and illustration by the project, according to project and client. Rights purchased vary according to project.

N LEKASMILLER

1460 Maria Lane, Suite 260, Walnut Creek CA 94596. (925)934-3971. Fax: (925)934-3978. E-mail: lekasmiller@lekasmiller.com. **Production Manager:** Mike Grey. Estab. 1979. Specializes in annual reports, corporate identity, advertising, direct mail and brochure design. Clients corporate and retail. Current clients include Cost Plus World Market and Interhealth.

Needs Approached by 80 freelance artists/year. Works with 1-3 illustrators and 5-7 designers/year. Prefers local artists only with experience in design and production. Works on assignment only. Uses artists for brochure design and illustration, mechanicals, direct mail design, logos, ad design and illustration. 100% of freelance work demands knowledge of QuarkXPress, Photoshop and Illustrator.

First Contact & Terms Designers and illustrators should e-mail PDF or résumé and portfolio. Responds only if interested. Considers skill and experience of artist when establishing payment. Negotiates rights purchased.

LINEAR CYCLE PRODUCTIONS

P.O. Box 2608, North Hills CA 91393-0608. Phone/fax: (818)347-9880. E-mail: lcp@wgn.net. Website: www.wgn.net. **Producer:** Rich Brown. Production Manager: R. Borowy. Estab. 1980. Number of employees 30. Approximate annual billing $200,000. AV firm. Specializes in audiovisual sales and marketing programs and also in teleproduction for CATV. Current clients include Katz, Inc. and McDave and Associates.

Needs Works with 7-10 freelance illustrators and 7-10 designers/year. Prefers freelancers with experience in teleproductions (broadcast/CATV/non-broadcast). Works on assignment only. Uses freelancers for storyboards, animation, TV/film graphics, editorial illustration, lettering and logos. 10% of work is with print ads. 25% of freelance work demands knowledge of FreeHand, Photoshop or Tobis IV.

First Contact & Terms Send query letter with résumé, photocopies, photographs, slides, transparencies, video demo reel and SASE. Samples are filed or are returned by SASE if requested by artist. Responds only if interested. To show portfolio, mail audio/videotapes, photographs and slides; include color and b&w samples. Pays for design and illustration by the project, $100 minimum. Considers skill and experience of artist, how work will be used and rights purchased when establishing payment. Negotiates rights purchased. Finds artists through reviewing portfolios and published material.

Tips ''We see a lot of sloppy work and samples, portfolios in fields not requested or wanted, poor photos, photocopies, graphics, etc. Make sure your materials are presentable.''

JACK LUCEY/ART & DESIGN

84 Crestwood Dr., San Rafael CA 94901. (415)453-3172. **Contact:** Jack Lucey. Estab. 1960. Art agency. Specializes in annual reports, brand and corporate identity, publications, signage, technical illustration and illustrations/cover designs, courtroom art (trial drawing). Clients businesses, ad agencies and book publishers. Current clients include U.S. Air Force, California Museum of Art & Industry, ABC-TV, CBS-TV, NBC-TV, CNN, Associated Press. Client list available upon request. Professional affiliations Art Directors Club; College of Marin Alumni, Academy of Art Alumni, San Francisco, CA.

Needs Approached by 20 freelancers/year. Works with 1-2 freelance illustrators/year. Uses mostly local freelancers. Uses freelancers mainly for type and airbrush. Also for lettering for newspaper work.

First Contact & Terms Query. Prefers photostats and published work as samples. Provide brochures, business card and résumé to be kept on file. Portfolio review not required. Originals are not returned to artist at job's completion. Requests work on spec before assigning a job. Pays for design by the project.

Tips ''Show variety in your work. Many samples I see are too specialized in one subject, one technique, one style (such as air brush only, pen & ink only, etc.). Subjects are often all similar too.''

MARKETING BY DESIGN

2012 19th St., Suite 200, Sacramento CA 95818. (916)441-3050. **Creative Director:** Joel Stinghen. Estab. 1977. Specializes in corporate identity and brochure design, publications, direct mail, trade show, signage, display and packaging. Client associations and corporations. Client list not available.

Needs Approached by 50 freelance artists/year. Works with 6-7 freelance illustrators and 1-3 freelance designers/year. Works on assignment only. Uses illustrators mainly for editorial. Also uses freelance artists for brochure and catalog design and illustration, mechanicals, retouching, lettering, ad design and charts/graphs.

First Contact & Terms Send query letter with brochure, résumé, tearsheets. Samples are filed or are not returned. Does not report back. Artist should follow up with call. Call for appointment to show portfolio of roughs, b&w photostats, color tearsheets, transparencies and photographs. Pays for design by the hour, $10-30; by the project, $50-5,000. Pays for illustration by the project, $50-4,500. Rights purchased vary according to project. Finds designers through word of mouth; illustrators through sourcebooks.

SUDI MCCOLLUM DESIGN

3244 Cornwall Dr., Glendale CA 91206. (818)243-1345. Fax: (818)243-1345. E-mail: sudimccollum@earthlink.net. **Contact:** Sudi McCollum. Specializes in product design and illustration. Majority of clients are medium- to

large-size businesses. "Specialty in home fashion accents." Clients home furnishing and giftware manufacturers, advertising agencies and graphic design studios.

Needs Use freelance production people either on computer or with painting and product design skills. Potential to develop into full-time job.

First Contact & Terms Send query letter "with whatever you have that's convenient." Samples are filed. Responds only if interested.

Ⓝ MEDIA ENTERPRISES

1644 S. Clementine St., Anaheim CA 92802. (714)778-5336. Fax: (714)778-6367. Website: www.media-enterpris es.com. **Creative Director:** John Lemieux Rose. Estab. 1982. Number of employees 8. Approximate annual billing $2 million. Integrated marketing communications agency. Specializes in interactive multimedia, CD-ROMs, Internet, magazine publishing. Product specialty high tech. Client list available upon request. Professional affiliations Orange County Multimedia Association, Software Council of Southern California, Association of Internet Professionals.

Needs Approached by 30 freelance illustrators and 10 designers/year. Works with 8-10 freelance illustrators and 3 designers/year. Also for animation, humorous illustration, lettering, logos, mechanicals, multimedia projects. 30% of work is with print ads. 100% of freelance work demands skills in PageMaker, Photoshop, Adobe InDesign, Illustrator, Director.

First Contact & Terms Send postcard sample and/or query letter with photocopies, photographs or URL. Accepts disk submissions compatible with Mac or PC. Samples are filed. Will contact for portfolio review of color photographs, slides, tearsheets, transparencies and/or disk. Pays by project; negotiated. Buys all rights.

NEALE-MAY & PARTNERS

409 Sherman Ave., Palo Alto CA 94306. (650)328-5555. Fax: (650)328-5016. E-mail: info@nealemay.com. Website: www.nealemay.com. **Senior Vice President:** Derek L. Kober. Estab. 1986. Number of employees 50. Approximate annual billing $8.5 million. PR firm. Specializes in promotions, packaging, corporate identity, collateral design, annuals, graphic and ad design. Product specialties are Internet, hi-tech, computer systems and peripherals, medical and consumer packaged goods. Clients include eDiets.com, Postini, Hyperion.

● This agency also has an office in New York at 144 E. 30th St., New York NY 10016.

Needs Approached by 20 freelance artists/month. Works with 2-3 freelance illustrators and 2-3 freelance designers/month. Prefers local artists only with experience in all areas of manual and electronic art capabilities. Works on assignment only. Uses freelance artists mainly for brochure design and illustration, print ad illustration, mechanicals, posters, lettering, logos and cartoons. Needs editorial and technical illustration for cartoons and caricatures. Needs freelancers for design, illustration, production and presentation.

First Contact & Terms Send query letter with "best work samples in area you're best in." Samples are filed. Responds in 2 weeks. To show a portfolio, mail thumbnails, roughs and color slides. Pays for design by the hour. Negotiates rights purchased.

Ⓝ ROY RITOLA, INC.

100 Ebbtide, Suite 325, Sausalito CA 94965. (415)332-8611. Fax: (415)332-8607. E-mail: info@royritolainc.com. Website: www.royritolainc.com. **President:** Roy Ritola. Specializes in brand and corporate identity, displays, direct mail, packaging, signage. Clients manufacturers.

Needs Works with 6-10 freelancers/year. Uses freelancers for design, illustration, airbrushing, model-making, lettering and logos.

First Contact & Terms Send query letter with brochure showing art style or résumé, tearsheets, slides and photographs. Samples not filed are returned only if requested. Responds only if interested. To show portfolio, mail final reproduction/product. Pays for design by the hour, $25-100. Considers complexity of project, client's budget, skill and experience of artist, turnaround time and rights purchased when establishing payment.

▣ SOFTMIRAGE

2900 Bristol St., Suite J103, Costa Mesa CA 92626. E-mail: steve@softmirage.com. Website: www.softmirage.c om. **Design Director:** Steve Pollack. Estab. 1995. Number of employees 12. Approximate annual billing $2 million. Visual communications agency. Specializes in architecture, real estate and entertainment. Needs people with strong spatial design skills, modeling and ability to work with computer graphics. Current clients include Four Seasons Hotels, Ford, Richard Meier & Partners and various real estate companies.

Needs Approached by 15 computer freelance illustrators and 5 designers/year. Works with 6 freelance 3D modelers, and 10 graphic designers/year. Prefers West coast designers with experience in architecture, engineering, technology. Uses freelancers mainly for concept, work in process computer modeling. Also for animation, brochure design, mechanicals, multimedia projects, retouching, technical illustration, TV/film graphics. 50%

of work is renderings. 100% of design and 30% of illustration demand skills in Photoshop, 3-D Studio Max, Flash and Director. Need Macromedia Flash developers.

First Contact & Terms Designers: Send e-mail query letter with samples. 3-D modelers: Send e-mail query letter with photocopies or link to website. Accepts disk and video submissions. Samples are filed or returned by SASE. Will contact for portfolio review if interested. Pays for design by the hour, $15-85. Pays for modeling by the project, $100-2,500. Rights purchased vary according to project. Finds artists through Internet, AIGA and referrals.

Tips ''Be innovative, push the creativity, understand the business rationale and accept technology. Check our website, as we do not use traditional illustrators, all our work is now digital. Send information electronically, making sure work is progressive and emphasizing types of projects you can assist with.''

SPLANE DESIGN ASSOCIATES

30634 Persimmon Lane, Valley Center CA 90282. (760)749-6018. E-mail: splane@pacificnet.net. Website: www. splanedesign.com. **President:** Robson Splane. Specializes in product design. Clients small, medium and large companies. Current clients include Hanson Research, Accuride Corp., Hewlett Packard, Sunrise Corp. Client list available upon request.

Needs Approached by 25-30 freelancers/year. Works with 1-2 freelance illustrators and 6-12 designers/year. Works on assignment only. Uses illustrators mainly for logos, mailings to clients, renderings. Uses designers mainly for sourcing, drawings, prototyping, modeling. Also uses freelancers for brochure design and illustration, ad design, mechanicals, retouching, airbrushing, model making, lettering and logos. 75% of freelance work demands skills in FreeHand, Ashlar Vellum, Solidworks and Excel.

First Contact & Terms Send query letter with résumé and photocopies. Samples are filed or are returned. Responds only if interested. Will contact artist for portfolio review if interested. Portfolio should include color roughs, final art, photostats, slides and photographs. Pays for design and illustration by the hour, $7-25. Rights purchased vary according to project. Finds artists through submissions and contacts.

JULIA TAM DESIGN

2216 Via La Brea, Palos Verdes CA 90274. (310)378-7583. Fax: (310)378-4589. E-mail: julia.tam@verizon.net. **Contact:** Julia Tam. Estab. 1986. Specializes in annual reports, corporate identity, brochures, promotional material, packaging and design. Clients: corporations. Current clients include Southern California Gas Co., *Los Angeles Times*, UCLA. Client list available upon request. Professional affiliations: AIGA.

- Julia Tam Design won numerous awards including American Graphic Design Award, Premier Print Award, *Creativity*, *American Corporate Identity* and work showcased in Rockport Madison Square Press and Northlight graphic books.

Needs Approached by 10 freelancers/year. Works with 6-12 freelance illustrators and 2 designers/year. ''We look for special styles.'' Works on assignment only. Uses illustrators mainly for brochures. Also uses freelancers for catalog and ad illustration; retouching; and lettering. 50-100% of freelance work demands knowledge of QuarkXPress, Illustrator or Photoshop.

First Contact & Terms Designers: Send query letter with brochure and résumé. Illustrators: Send query letter with résumé and tearsheets. Samples are filed. Responds only if interested. Artist should follow up. Portfolio should include b&w and color final art, tearsheets and transparencies. Pays for design by the hour, $10-20. Pays for illustration by the project. Negotiates rights purchased. Finds artists through *LA Workbook*.

THARP DID IT

50 University Ave., Loft 21, Los Gatos CA 95030. Fax: (408)354-1450. Website: www.TharpDidIt.com. **Contact:** Art Director/Designer. Estab. 1975. Specializes in brand identity; corporate, non-corporate, and retail visual identity; packaging; and environmental graphic design. Clients direct and through agencies. Current clients include Buckhorn Grill, First 5/California, Cinequest Film Festival, Steven Kent Winery. Professional affiliations American Institute of Graphic Arts (AIGA), Society for Environmental Graphic Design (SEGD), Western Art Directors Club (WADC), TDCTJHTBIPC (The Design Conference That Just Happens To Be In Park City).

- Tharp Did It won a gold medal in the International Packaging Competition at the 30th Vinitaly in Verona, Italy, for wine label design. Their posters for BRIO Toys are in the Smithsonian Institution's National Design Museum archives. The firm's founder, Rick Tharp, was a much-admired member of the design community and frequent contributor to *How Magazine*. He will be missed.

Needs Works with 2-4 freelance illustrators each year.

First Contact & Terms Send query letter with printed promotional material. Samples are filed or are returned by SASE. Will contact artist if interested. ''No phone calls please. We'll call you.'' Pays for illustration by the project, $100-10,000. Considers client's budget and how work will be used when establishing payment. Rights purchased vary according to project. Finds artists through awards annuals, sourcebooks, and submissions/self-promotions.

THE VAN NOY GROUP

3315 Westside Rd., Healdsburg CA 95448-9453. (707)433-3944. Fax: (707)433-0375. E-mail: jim@vannoygroup. com. Website: www.vannoygroup.com. **Vice President:** Ann Van Noy. Estab. 1972. Specializes in brand and corporate identity, displays and package design. Clients corporations. Current clients include Waterford, Wedgewood USA, Leiner Health Products, Pentel of America. Client list available upon request.

Needs Approached by 1-10 freelance artists/year. Works with 2 illustrators and 3 designers/year. Prefers artists with experience in Macintosh design. Works on assignment only. Uses freelancers for packaging design and illustration, Quark and Photoshop production and lettering.

First Contact & Terms Send query letter with résumé and photographs. Samples are filed. Will contact artist for portfolio review if interested. If no reply, artist should follow up. Pays for design by the hour, $35-100. Pays for illustration by the hour or by the project at a TBD fee. Finds artists through sourcebooks, self-promotions and primarily agents. Also have permanent positions available.

Tips "I think more and more clients will be setting up internal art departments and relying less and less on outside designers and talent. The computer has made design accessible to the user who is not design-trained."

VIDEO RESOURCES

1809 E. Dyer Road, #307, Santa Ana CA 92705. (949)261-7266. Fax: (949)261-5908. E-mail: brad@videoresouces .com. **Producer:** Brad Hagen. Number of employees 10. Video and multimedia firm. Specializes in automotive, banks, restaurants, computer, health care, transportation and energy.

Needs Approached by 10-20 freelancers/year. Works with 5-10 freelance illustrators and 5-10 designers/year. Works on assignment only. Uses freelancers for graphics, multimedia, animation, etc.

First Contact & Terms Send query letter with brochure showing art style or résumé, business card, photostats and tearsheets to be kept on file. Samples not filed are returned by SASE. Considers complexity of the project and client's budget when establishing payment. Buys all rights.

■ VISUAL AID/VISAID MARKETING

Box 4502, Inglewood CA 90309. (310)399-0696. **Manager:** Lee Clapp. Estab. 1961. Number of employees 3. Distributor of promotion aids, marketing consultant service, "involved in all phases." Specializes in manufacturers, distributors, publishers and graphics firms (printing and promotion) in 23 SIC code areas.

Needs Approached by 25-50 freelancers/year. Works with 1-2 freelance illustrators and 6-12 designers/year. Prefers freelancers with experience in animation, film/video production, multimedia. Uses freelancers for animation, billboards, brochure illustration, catalog design and illustration, direct mail, logos, posters, signage.

First Contact & Terms Works on assignment only. Send postcard sample or query letter with brochure, photostats, duplicate photographs, photocopies and tearsheets to be kept on file. Responds if interested and has assignment. Write for appointment to show portfolio. Negotiates payment. $100-500. Considers skill and experience of artist and turnaround time when establishing payment.

Tips "Do not say 'I can do anything.' We want to know the best media you work in (pen & ink, line drawing, illustration, layout, etc.)."

ℕ DANA WHITE PRODUCTIONS, INC.

2623 29th St., Santa Monica CA 90405. (310)450-9101. E-mail: dwprods@aol.com. **Owner/Producer:** Dana C. White. AV firm. "We are a full-service audiovisual design and production company, providing video and audio presentations for training, marketing, awards, historical and public relations uses. We have complete inhouse production resources, including computer multimedia, photo digitizing, image manipulation, program assembly, slidemaking, soundtrack production, photography and AV multi-image programming. We serve major industries such as US Forest Services, medical, such as Whittier Hospital, Florida Hospital; schools, such as University of Southern California, Pepperdine University; publishers, such as McGraw-Hill, West Publishing; and public service efforts, including fundraising."

Needs Works with 8-10 freelancers/year. Prefers freelancers local to greater Los Angeles, "with timely turnaround, ability to keep elements in accurate registration, neatness, design quality, imagination and price." Uses freelancers for design, illustration, retouching, characterization/animation, lettering and charts. 50% of freelance work demands knowledge of Illustrator, FreeHand, Photoshop, Quark and Premier.

First Contact & Terms Send query letter with brochure or tearsheets, photostats, photocopies, slides and photographs. Samples are filed or are returned only if requested. Responds in 2 weeks only if interested. Call or write for appointment to show portfolio. Pays by the project. Payment negotiable by job.

Tips "These are tough times. Be flexible. Negotiate. Your work should show that you have spirit, enjoy what you do and that you can deliver high quality work on time."

LOS ANGELES

BRAMSON + ASSOCIATES

7400 Beverly Blvd., Los Angeles CA 90036. (323)938-3595. Fax: (323)938-0852. E-mail: gbramson@aol.com. **Principal/Senior Creative Director:** Gene Bramson. Estab. 1970. Number of employees 15. Approximate annual billing more than $2 million. Advertising agency. Specializes in magazine ads, collateral, ID, signage, graphic design, imaging, campaigns. Product specialties are healthcare, consumer, business to business. Current clients include Johnson & Johnson, Chiron Vision, Lawry's and Isuzu Motors of America.

Needs Approached by 150 freelancers/year. Works with 10 freelance illustrators, 2 animators and 5 designers/year. Prefers local freelancers. Works on assignment only. Uses freelancers for brochure and print ad design; brochure, technical, medical and print ad illustration, storyboards, mechanicals, retouching, lettering, logos. 30% of work is with print ads. 50% of freelance work "prefers" knowledge of Pagemaker, Illustrator, QuarkX-Press, Photoshop, Freehand or 3-D Studio.

First Contact & Terms Send query letter with brochure, photocopies, résumé, photographs, tearsheets, SASE. Samples are filed. Will contact artist for portfolio review if interested. Portfolio should include roughs, color tearsheets. Sometimes requests work on spec before assigning job. Pays for design by the hour, $15-25. Pays for illustration by the project, $250-2,000. Buys all rights or negotiates rights purchased. Finds artists through sourcebooks.

Tips Looks for "very unique talent only." Price and availability are also important.

N FREEASSOCIATES

2300 Westwood Blvd., Suite 105, Los Angeles CA 90064. (310)441-9950. Fax: (310)441-9949. E-mail: jfreeman@ freeassoc.com. Website: www.freeassoc.com. **President:** Josh Freeman. Estab. 1974. Number of employees 4. Design firm. Specializes in marketing materials for corporate clients. Client list available upon request. Professional affiliations AIGA.

Needs Approached by 60 illustrators and 30 designers/year. Works with 3 illustrators and 3 designers/year. Prefers freelancers with experience in top level design and advertising. Uses freelancers mainly for design, production, illustration. Also for airbrushing, brochure design and illustration, catalog design and illustration, lettering, logos, mechanicals, multimedia projects, posters, retouching, signage, storyboards, technical illustration and web page design. 30% of work is with print ads. 90% of design and 50% of illustration demand skills in Photoshop, InDesign CS, Illustrator.

First Contact & Terms Designers send query letter with photocopies, photographs, résumé, tearsheets and transparencies. Illustrators send postcard sample of work and/or photographs and tearsheets. Accepts Mac-compatible disk submissions to view in current version of major software or self-running presentations. CD-ROM OK. Samples are filed or returned by SASE. Will contact for portfolio review if interested. Pays for design and illustration by the project; negotiable. Rights purchased vary according to project. Finds artists through iSpot and other online resources, *LA Workbook*, *CA*, *Print*, *Graphis*, submissions and samples.

Tips "Designers should have their own computer and high speed Internet connection. Must have sensitivity to marketing requirements of projects they work on. Deadline commitments are critical."

RHYTHMS PRODUCTIONS

P.O. Box 34485, Los Angeles CA 90034. (310)836-4678. **President:** Ruth White. Estab. 1955. AV firm. Specializes in music production/publication. Product specialty is educational materials for children.

Needs Works with 2 freelance illustrators and 2 designers/year. Prefers artists with experience in cartoon animation and graphic design. Works on assignment only. Uses freelancers mainly for cassette covers, books, character design. Also for catalog design, multimedia, animation and album covers. 2% of work is with print ads. 75% of design and 50% of illustration demands graphic design computer skills.

First Contact & Terms Send query letter with photocopies and SASE (if you want material returned). Samples are returned by SASE if requested. Responds in 2 months only if interested. Will contact artist for portfolio review if interested. Pays for design and illustration by the project. Buys all rights. Finds artists through word of mouth and submissions.

N STUDIO WILKS

2148-A Federal Ave., Los Angeles CA 90025. (310)478-4442. Fax: (310)478-0013. Website: www.studiowilks.com. Estab. 1990. Specializes in print, collateral, packaging, editorial and environmental work. Clients ad agencies, architects, corporations and small business owners. Current clients include Walt Disney Co., Major League Soccer and Yoga Works.

Needs Works with 6-10 freelance illustrators and 10-20 designers/year. Uses illustrators mainly for packaging illustration. Also for brochures, print ads, collateral, direct mail and promotions.

First Contact & Terms Designers send query letter with brochure, résumé, photocopies and tearsheets. Illustra-

tors send postcard sample or query letter with tearsheets. Samples are returned by SASE if requested by artist. Will contact artist for portfolio review if interested. Pays for design by the project. Buys all rights. Considers buying second rights (reprint rights) to previously published work. Finds artists through *The Workbook* and word of mouth.

SAN FRANCISCO

HOWRY DESIGN ASSOCIATES

354 Pine St., Suite 600, San Francisco CA 94104. (415)433-2035. Fax: (415)433-0816. E-mail: info@howry.com. Website: www.howry.com. **Principal/Creative Director:** Jill Howry. Estab. 1988. Full service design studio. Number of employees 12. Specializes in annual reports, corporate identity, print, advertising and multimedia. Clients startups to Fortune 100 companies. Current clients include Del Monte, Affymetrix, Geron Corporation, McKesson Corp., First Republic Bank, View our website for current information and portfolio viewing. Professional affiliations AIGA.

Needs Works with 30 freelance illustrators, photographers and web and print designers/year. Works on assignment only. Uses illustrators for "anything that applies." Uses designers mainly for newsletters, brochures, corporate identity. Also uses freelancers for production, programming, retouching, photography/illustration, logos and charts/graphs. 100% of design work, 10% of illustration work demands knowledge of QuarkXPress, Illustrator or Photoshop.

First Contact & Terms Samples are filed. Responds only if interested. Portfolios may be dropped off every Thursday. Pays for design/production by the hour, or by the job, $25-60. Pays for photography and illustration on a per-job basis. Rights purchased vary according to project.

Tips Finds artists through sourcebooks, samples, representatives.

N BRENT A. JONES DESIGN

328 Hayes St., San Francisco CA 94102. (415)626-8337. E-mail: jonesdes@pacbell.net. **Principal:** Brent Jones. Estab. 1983. Specializes in corporate identity and advertising design. Clients corporations, museums, book publishers, retail establishments. Client list available upon request.

Needs Approached by 1-3 freelancers/year. Works with 2 freelance illustrators and 1 designer/year. Prefers local freelancers only. Works on assignment only. Uses illustrators mainly for renderings. Uses designers mainly for production. Also uses freelancers for brochure and ad design and illustration, mechanicals, catalog illustration and charts/graphs. "Computer literacy a must." Needs computer-literate freelancers for production. 95% of freelance work demands knowledge of QuarkXPress, Illustrator and Photoshop.

First Contact & Terms Send query letter with brochure and tearsheets. Samples are filed and are not returned. Responds in 2 weeks only if interested. Write for appointment to show portfolio of slides, tearsheets and transparencies. Payment for design is negotiable; or by the project. Pays for illustration by the project. Rights purchased vary according to project.

🖪 PACE DESIGN GROUP

379 Day St., San Francisco CA 94131. (415)931-3400. Fax: (415)931-3484. E-mail: info@pacedesign.com. Website: www.pacedesign.com. **Creative Director:** Joel Blum. Estab. 1988. Number of employees 6. Approximate annual billing $1.2 million. Specializes in branding, advertising and collateral. Product specialties are financial services, high tech, Internet and computer industries. Current clients include E*Trade Securities, Providian Financial Corp., Charles Schwab & Co., Inc., Montgomery Asset Management, LoanCity.com, 401k Forum, Van Wagoner Capital Management, Bank of America, Aldon Computer Group, Informix, Bio-Rad Laboratories, Interex and Sybex. Client list available upon request. Professional affiliations AIP (Artists in Print).

Needs Approached by 100 illustrators and 75 designers/year. Works with 3-5 illustrators and 3-5 designers/year. Prefers local designers with experience in QuarkXPress, InDesign, Illustrator and Photoshop. Uses freelancers mainly for illustration and graphics. Also for brochure design and illustration, logos, technical illustration and Web page design. 2% of work is with print ads. 100% of design and 85% of illustration demand skills in the latest versions of Photoshop, Illustrator, QuarkXPress and InDesign.

First Contact & Terms Designers send query letter with photocopies and résumé. Illustrators send query letter with photocopies, tearsheets, follow-up postcard samples every 6 months. Accepts disk submissions. Submit latest version software, System OS X, EPS files. Samples are filed and are not returned. Will contact for portfolio review of color final art and printed pieces if interested. Pays for design by the hour, $35-65. Pays for illustration by the project. All artists and photographers must sign Unconditional Assignment of Copyright contract (no exceptions), rights purchased vary according to project. Finds artists through sourcebooks, word of mouth, submissions.

TOKYO DESIGN CENTER

703 Market St., Suite 252, San Francisco CA 94103. (415)543-4886. **Creative Director:** Kaoru Matsuda. Specializes in annual reports, brand identity, corporate identity, packaging and publications. Clients consumer products, travel agencies and retailers.

Needs Uses artists for design and editorial illustration.

First Contact & Terms Send business card, slides, tearsheets and printed material to be kept on file. Samples not kept on file are returned by SASE only if requested. Will contact artist for portfolio review if interested. Pays for design and illustration by the project, $100-1,500 average. Sometimes requests work on spec before assigning job. Considers client's budget, skill and experience of artist, turnaround time and rights purchased when establishing payment. Interested in buying second rights (reprint rights) to previously published work. Finds artists through self-promotions and sourcebooks.

COLORADO

JO CULBERTSON DESIGN, INC.

939 Pearl St., Denver CO 80203. (303)861-9046. E-mail: joculdes@aol.com. **President:** Jo Culbertson. Estab. 1976. Number of employees 1. Approximate annual billing $100,000. Specializes in direct mail, packaging, publication and marketing design, annual reports, corporate identity, and signage. Clients: corporations, not-for-profit organizations. Current clients include Love Publishing Company, E-Smart Services Inc., Jaces Management Services, Vitamin Cottage, Sun Gard Insurance Systems. Client list available upon request.

Needs Approached by 15 freelancers/year. Works with 2 freelance illustrators/year. Prefers local freelancers only. Works on assignment only. Uses illustrators mainly for corporate collateral pieces, illustration and ad illustration. 50% of freelance work demands knowledge of QuarkXPress, Photoshop, CorelDraw.

First Contact & Terms Send query letter with résumé, tearsheets and photocopies. Samples are filed. Reports back to the artist only if interested. Artist should follow up with call. Portfolio should include b&w and color thumbnails, roughs and final art. Pays for design by the project, $250 minimum. Pays for illustration by the project, $100 minimum. Finds artists through file of résumés, samples, interviews.

PAGEWORKS COMMUNICATION DESIGN, INC.

Two Tamarac Plaza, 7535 E. Hampden Ave., Suite 350, Denver CO 80231. (303)337-7770. Fax: (303)337-7780. E-mail: info@pageworksthebigidea.com. Website: www.pageworksthebigidea.com. **CEO/Creative Director:** Michael Guzofsky. Art Director: Marcie Fischer. Estab. 1981. Specializes in annual reports, corporate identity, direct mail, product development and packaging and publication design. Clients corporations, associations. Clients include Pradera, Cherry Creek Country Club, Concert American Homes, Esprit Homes, Miller Global Properties, Loup Development Company.

Needs Approached by 50 freelance artists/year. Works with 5 illustrators and 5 designers/year. Prefers local artists with computer experience. Works on assignment only. Uses freelance designers and illustrators for brochure, catalog, magazine, direct mail and ad design; brochure, catalog and ad illustration; logos; and charts/graphs. Needs computer-literate freelancers for design, illustration and production. 90% of freelance work demands knowledge of QuarkXPress, Illustrator or Photoshop.

First Contact & Terms Send query letter with brochure, résumé, tearsheets and photocopies. Samples are filed and are not returned. Responds only if interested. Write for appointment to show portfolio or mail appropriate materials. Portfolio should include thumbnails, roughs, b&w and color tearsheets, printed samples. Pays for design and illustration by the hour, $20-50 or by the project. Negotiates rights purchased.

CONNECTICUT

FREELANCE EXCHANGE, INC.

P.O. Box 271, North Stonington, CT 06359. (860)535-3384. Fax: (860)535-3386. E-mail: stella@freelance-exchange.com. Website: www.freelance-exchange.com. **President:** Stella Neves. Estab. 1983. Number of employees 3. Approximate annual billing $850,000. Specializes in annual reports, brand and corporate identity, direct mail, package and publication design, web page design, illustration (cartoon, realistic, technical, editorial, product and computer). Clients corporations, nonprofit organizations, state and federal government agencies and ad agencies. Current clients include Lego Systems, Mass Mutual, Otis Elevator, Hartford Courant. Client list available upon request. Professional affiliations GAIG, Connecticut Art Directors Club, Chamber of Commerce of Eastern CT.

Needs Approached by 350 freelancers/year. Works with 25-40 freelance illustrators and 30-50 designers/year. Prefers freelancers with experience in publications, website design, consumer products and desktop publishing.

"Home page and website design are becoming more important and requested by clients." Works on assignment only. Uses illustrators mainly for editorial and computer illustration. Design projects vary. 100% of design and 50% of illustration demand knowledge of PageMaker, QuarkXPress, FreeHand, Illustrator, Photoshop, InDesign, Powerpoint, Macromind Director, Page Mill or Hot Metal.

First Contact & Terms Designers send postcard sample or query letter with résumé, SASE, brochure, tearsheets and photocopies. Illustrators send postcard sample or query letter with résumé, printed samples & SASE. Samples are filed and are returned by SASE. Visit website for contact information. Pays for design by the project, $500 minimum. Pays for illustration by the project, $300 minimum. Rights purchased vary according to project.

Tips "Send us one sample of your best work that is unique and special. All styles and media are OK, but we're really interested in computer-generated illustration and websites. If you want to make money, learn to use the new technology. The 'New Media' is where our clients want to be, so adjust your portfolio accordingly. Your portfolio must be spectacular (I don't want to see student work). Having lots of variety and being well-organized will encourage us to take a chance on an unknown artist."

FREEMAN DESIGN GROUP

3 Stoneleigh Knls, Old Lyme CT 06371-1432. (860)434-2474. **President:** Bill Freeman. Estab. 1972. Specializes in annual reports, corporate identity, package and publication design and signage. Clients corporations. Current projects include company magazines. Current clients include Pitney Bowes, Continental Grain Co., IBM Credit, CB Commercial Real Estate. Client list available upon request.

Needs Approached by 35 artists/year. Works with 5 illustrators and 5 designers/year. Prefers artists with experience in production. Works on assignment only. Uses illustrators for mechanicals, retouching and charts/graphs. Looking for technical illustration and editorial illustration with "montage, minimal statement."

First Contact & Terms Send query letter with promotional piece showing art style, résumé and tearsheets. Samples are filed or are returned if accompanied by SASE. Does not report back. Call for appointment to show portfolio or mail appropriate materials and tearsheets. Pays for design by the hour, $30 minimum; by the project, $150-3,000.

◼ MCKENZIE HUBBELL CREATIVE SERVICES

5 Iris Lane, Westport CT 06880. (203)454-2443. Fax: (203)222-8462. E-mail: dmckenzie@mckenziehubbell.com or nhubbell@mckenziehubbell.com. Website: www.mckenziehubbell.com. **Principal:** Dona McKenzie. Specializes in business to business communications, annual reports, corporate identity, direct mail and publication design. Expanded services include copywriting and editing, advertising and direct mail, marketing and public relations, website design and development, and multimedia and CD-ROM.

Needs Approached by 100 freelance artists/year. Works with 5 freelance designers/year. Uses freelance designers mainly for computer design. Also uses freelance artists for brochure and catalog design. 100% of design and 50% of illustration demand knowledge of QuarkXPress, Illustrator and Photoshop.

First Contact & Terms Send query letter with brochure, résumé, photographs and photocopies. Samples are filed or are returned by SASE if requested by artist. Write to schedule an appointment to show a portfolio. Pays for design by the hour, $25-75. Pays for illustration by the project, $150-3,000. Rights purchased vary according to project.

⬚ ◼ REALLY GOOD COPY CO.

92 Moseley Terrace, Glastonbury CT 06033. (860)659-9487. Fax: (860)633-3238. E-mail: copyqueen@aol.com. **President:** Donna Donovan. Estab. 1982. Number of employees 2. Ad agency. Full-service, multimedia firm. Specializes in direct mail and catalogs. Product specialties are medical/health care, consumer products and services. Current clients include The Globe-Pequot Press, Motherwear, Health Management Resources, Plow & Hearth, 1-800-FLOWERS, Mag Systems and CIGNA. Professional affiliations Connecticut Art Directors Association, New England Mail Order Association.

Needs Approached by 40-50 freelancers/year. Works with 1-2 freelance illustrators and 6-8 designers/year. Prefers local freelancers whenever possible. Works on assignment only. Uses freelancers for all projects. "There are no on-staff artists." 50% print, 50% web. 100% of design and 50% of illustration demand knowledge of QuarkXPress, Illustrator or Photoshop and HTML.

First Contact & Terms Designers send query letter with résumé. Illustrators send postcard samples. Accepts disk and CD submissions. Send EPS files only. Samples are filed or are returned by SASE only if requested. Responds only if interested. Portfolio review not required, but portfolio should include roughs and original/final art. Pays for design by the hour, $50-125. Pays by the project or by the hour.

Tips "I continue to depend upon word of mouth from other satisfied agencies and local talent. I'm fortunate to be in an area that's overflowing with good people. Send two or three good samples—not a bundle."

⬛ ULTITECH, INC.

Foot of Broad St., Stratford CT 06615. (203)375-7300. Fax: (203)375-6699. E-mail: comcowic@meds.com. Website: www.meds.com. **President:** W. J. Comcowich. Estab. 1993. Number of employees 3. Approximate annual billing $1 million. Integrated marketing communications agency. Specializes in interactive multimedia, software, online services. Product specialties are medicine, science, technology. Current clients include large pharma companies.

Needs Approached by 10-20 freelance illustrators and 10-20 designers/year. Works with 2-3 freelance illustrators and 6-10 designers/year. Prefers freelancers with experience in interactive media design and online design. Uses freelancers mainly for design of Websites and interactive CD-ROMS/DVDs. Also for animation, brochure design, medical illustration, multimedia projects, TV/film graphics. 10% of work is with print ads. 100% of freelance design demands skills in Photoshop, QuarkXPress, Illustrator, 3D packages.

First Contact & Terms E-mail submission is best. Include links to online "book". Responds only if interested. Pays for design by the project or by the day. Pays for illustration by the project. Buys all rights. Finds artists through sourcebooks, word of mouth, "cold" submissions.

Tips "Learn design principles for interactive media."

DELAWARE

ALOYSIUS BUTLER & CLARK (AB&C)

819 Washington St., Wilmington DE 19801. (302)655-1552. Fax: (302)655-3105. Website: www.a-b-c.com. **Contact:** Tom Desanto. Ad agency. Clients healthcare, banks, industry, restaurants, hotels, businesses, government offices.

Needs Works with 12 or more illustrators and 3-4 designers/year. Uses artists for trade magazines, billboards, direct mail packages, brochures, newspapers, stationery, signage and posters. 95% of design and 15% of illustration demand skills in QuarkXPress, Illustrator or Photoshop.

First Contact & Terms Designers send query letter with résumé and photocopies. Illustrators send postcard samples. Samples are filed; except work that is returned only if requested. Responds only if interested. Works on assignment only. Pays for design by the hour, $20-50. Pays for illustration by the hour; or by the project, $250-1,000.

CUSTOM CRAFT STUDIO

310 Edgewood St., Bridgeville DE 19933. (302)337-3347. Fax: (302)337-3444. **Vice President:** Eleanor H. Bennett. AV producer.

Needs Works with 12 freelance illustrators and 12 designers/year. Works on assignment only. Uses freelancers mainly for work on filmstrips, slide sets, trade magazines and newspapers. Also for print finishing, color negative retouching and airbrush work. Prefers pen & ink, airbrush, watercolor and calligraphy. 10% of freelance work demands knowledge of Illustrator. Needs editorial and technical illustration.

First Contact & Terms Send query letter with résumé, slides or photographs, brochure/flyer and tearsheets to be kept on file. Samples returned by SASE. Responds in 2 weeks. Originals not returned. Pays by the project, $25 minimum.

⬛ GLYPHIX ADVERTISING

105 Second St., Lewes DE 19958. (302)645-0706. Fax: (302)645-2726. E-mail: rjundt@intercom.net. Website: www.glyphixadv.com. **Creative Director:** Richard Jundt. Estab. 1981. Number of employees 2. Approximate annual billing $200,000. Ad agency. Specializes in collateral and advertising. Current clients include local colleges, ATR Galleries locally and New York City and Cytec Industries. Client list available upon request.

Needs Approached by 10-20 freelancers/year. Works with 2-3 freelance illustrators and 2-3 designers/year. Prefers local artists only. Uses freelancers mainly for "work I can't do." Also for brochure and catalog design and illustration and logos. 20% of work is with print ads. 100% of freelance work demands knowledge of Photoshop, QuarkXPress, Illustrator and Delta Graph.

First Contact & Terms Send query letter with samples. Responds in 10 days if interested. Artist should follow-up with call. Portfolio should include b&w and color final art, photographs and roughs. Buys all rights. Finds artists through word of mouth and submissions.

WASHINGTON DC

⬛ LOMANGINO STUDIO INC.

1042 Wisconsin Ave., Washington DC 20007. (202)338-4110. E-mail: info@lomangino.com. Website: www.lomangino.com. **President:** Donna Lomangino. Estab. 1987. Number of employees 6. Specializes in annual reports,

corporate identity, website and publication design. Clients corporations, nonprofit organizations. Client list available upon request. Professional affiliations AIGA Washington DC.

Needs Approached by 25-50 freelancers/year. Works with 1 freelance illustrator/year. Uses illustrators and production designers occasionally for publication. Also for multimedia projects. Accepts disk submissions, but not preferable. 99% of design work demands skills in Illustrator, Photoshop and QuarkXPress.

First Contact & Terms Send postcard sample of work or URL. Samples are filed. Will contact artist for portfolio review if interested. Pays for design and illustration by the project. Finds artists through sourcebooks, word of mouth and studio files.

Tips ''Please don't call. Send samples or URL for consideration.''

DON SCHAAF & FRIENDS, INC.

1640 Wisconsin Ave., NW, Washington DC 20007. (202)965-2600. Fax: (202)965-2669. E-mail: donschaaf@aol. com. **Senior Designer:** Heide Paddock. Estab. 1990. Number of employees 10. Approximate annual billing $4.2 million. Design firm. Specializes in ads, brochures and print campaigns. Product specialty is high tech communication. Current clients include AOL; MCI; Polycom; Legi-Slate. Client list available upon request. Professional affiliations AIGA; Art Directors Club of Metropolitan Washington DC. Listed #265 on Inc. 500 list of fastest growing private companies.

Needs Approached by 50 illustrators and 25 designers/year. Works with 20 illustrators/year. Also for brochure illustration, multimedia projects, TV/film graphics and web page design. 37% of work is with print ads. 90% of illustration demands skills in Photoshop, Illustrator and QuarkXPress.

First Contact & Terms Send postcard sample or query letter with follow-up postcard every 3 months. Samples are filed. Responds only if interested. Portfolios of photographs may be dropped every Thursday and Friday. Pays for illustration by the project, $250-5,000. Rights purchased vary according to project. Finds artists through sourcebooks and word of mouth.

FLORIDA

AURELIO & FRIENDS, INC.

14971 SW 43 Terrace, Miami FL 33185. (305)225-2434. Fax: (305)225-2121. E-mail: aurelio97@aol.com. **President:** Aurelio Sica. Vice President: Nancy Sica. Estab. 1973. Number of employees 3. Specializes in corporate advertising and graphic design. Clients: corporations, retailers, large companies, hotels and resorts.

Needs Approached by 4-5 freelancers/year. Works with 1-2 freelance illustrators and 3-5 designers/year. Also uses freelancers for ad design and illustration, brochure, catalog and direct mail design, and mechanicals. 50% of freelance work demands knowledge of Adobe Ilustrator, Photoshop and QuarkXPress.

First Contact & Terms Send brochure and tearsheets. Samples are filed. Will contact artist for portfolio review if interested. Portfolio should include b&w and color final art, photographs, roughs and transparencies. Pays for design and illustration by the project. Buys all rights.

Ⓝ EXHIBIT BUILDERS INC.

150 Wildwood Rd., Deland FL 32720. (386)734-3196. Fax: (386)734-9391. E-mail: art@exhibitbuilders.com. Website: exhibitbuilders.com. **President:** Penny D. Morford. Produces themed custom trade show exhibits and distributes modular and portable displays, and sales centers. Clients museums, primarily manufacturers, government agencies, ad agencies, tourist attractions and trade show participants.

● Looking for freelance trade show designers.

Needs Works on assignment only. Uses artists for exhibit/display design murals.

First Contact & Terms Provide résumé, business card and brochure to be kept on file. Samples returned by SASE. Reports back for portfolio review. Considers complexity of project, skill and experience of artist, how work will be used, turnaround time and rights purchased when establishing payment.

Tips ''Wants to see examples of previous design work for other clients; not interested in seeing school-developed portfolios.''

Ⓝ ☑ GOLD & ASSOCIATES INC.

6000-C Sawgrass Village Circle, Ponte Vedra Beach FL 32082. (904)285-5669. Fax: (904)285-1579. E-mail: gold@ strikegold.com. Website: www.strikegold.com. **Creative Director/President:** Keith Gold. Incorporated in 1988. Full-service multimedia, marketing and communications firm. Specializes in graphic design and advertising. Product specialties are entertainment, medical, publishing, tourism and sports.

Needs Approached by over 100 freelancers/year. Works with approximately 25 freelance illustrators/year. Works primarily with artist reps. Uses illustrators for annual reports, books, brochures, editorial, technical,

print ad illustration; storyboards, animatics, animation, music videos. 65% of work is in print. 50% of freelance work demands knowledge of Illustrator, QuarkXPress, Photoshop or InDesign.

First Contact & Terms Contact through artist rep or send query letter with photocopies or tearsheets. Samples are filed. Responds *only* if interested. Will contact artists for portfolio review if interested. Follow up with letter after initial query. Portfolio should include tearsheets. Pays for illustration by the project, $200-7,500. Buys all rights. Finds artists primarily through sourcebooks and reps. Does not use freelance designers.

TOM GRABOSKI ASSOCIATES, INC.

4649 Ponce de Leon Blvd., #401, Coral Gables FL 33146. (305)669-2550. Fax: (305)669-2539. E-mail: mail@tgade sign.com. **President:** Tom Graboski. Estab. 1980. Specializes in exterior/interior signage, environmental graphics, corporate identity, urban design and print graphics. Clients corporations, cities, museums, a few ad agencies. Current clients include Universal Studios, Florida; Royal Caribbean Cruise Line; The Equity Group; Disney Development; Celebrity Cruises; Baptist Health So. Florida; City of Miami; City of Coral Gables.

Needs Approached by 20-30 freelance artists/year. Works with approximately 4-8 designers/draftspersons/year. Prefers artists with a background in signage and knowledge of architecture and industrial design. Freelance artists used in conjunction with signage projects, occasionally miscellaneous print graphics. 100% of design and 10% of illustration demand knowledge of Illustrator, Photoshop and QuarkXPress.

First Contact & Terms Send query letter with brochure and résumé. ''We will contact designer/artist to arrange appointment for portfolio review. Portfolio should be representative of artist's work and skills; presentation should be in a standard portfolio format.'' Pays by the project. Payment varies by experience and project. Rights purchased vary by project.

Tips ''Look at what type of work the firm does. Tailor presentation to that type of work.'' For this firm ''knowledge of environmental graphics, detailing, a plus.''

▣ MYERS, MYERS & ADAMS ADVERTISING, INC.

938 N. Victoria Park Rd., Fort Lauderdale FL 33304. (954)523-6262. Fax: (954)523-3517. E-mail: peter@mmanda .com. Website: www.mmanda.com. **Creative Director:** Virginia Myers. Estab. 1986. Number of employees 6. Approximate annual billing $2 million. Ad agency. Full-service, multimedia firm. Specializes in magazines and newspaper ads; radio and TV; brochures; and various collateral. Product specialties are consumer and business-to-business. Current clients include Harley-Davidson, Wendy's and Embassy Suites. Professional affiliation Advertising Federation.

Needs Approached by 10-15 freelancers/year. Works with 3-5 freelance illustrators and 3-5 designers/year. Uses freelancers mainly for overflow. Also for animation, brochure and catalog illustration, model-making, posters, retouching and TV/film graphics. 55% of work is with print ads. Needs computer-literate freelancers for illustration and production. 20% of freelance work demands knowledge of PageMaker, Photoshop, QuarkXPress and Illustrator.

First Contact & Terms Send postcard-size sample of work or send query letter with tearsheets. Samples are filed and are returned by SASE if requested by artist. Will contact artist for portfolio review if interested. Portfolio should include b&w and color final art, roughs, tearsheets and thumbnails. Pays for design and illustration by the project, $50-1,500. Buys all rights. Finds artists through *Creative Black Book*, *Workbook* and artists' submissions.

PRO INK

2826 NE 19th Dr., Gainesville FL 32609-3391. (352)377-8973. Fax: (352)373-1175. E-mail: terry@proink.com. Website: www.proink.com. **President:** Terry Van Nortwick. Estab. 1979. Number of employees 5. Specializes in publications, marketing, healthcare, engineering, development and ads. Professional affiliations Public Relations Society of America, Society of Professional Journalists, International Association of Business Communicators, Gainesville Advertising Federation, Florida Public Relations Association.

Needs Works with 6-10 freelancers/year. Works on assignment only. Uses freelancers for brochure illustration, airbrushing and lettering. 80% of freelance work demands knowledge of PageMaker, Illustrator, QuarkXPress, Photoshop or FreeHand. Needs editorial, medical and technical illustration.

First Contact & Terms Send résumé, samples, tearsheets, photostats, photocopies, slides and photography. Samples are filed or are returned if accompanied by SASE. Responds only if interested. Call or write for appointment to show portfolio of original/final art. Pays for design and illustration by the project, $50-500. Rights purchased vary according to project.

▣ ROBERTS COMMUNICATIONS & MARKETING, INC.

5405 Cypress Center Dr., Suite 250, Tampa FL 33609-1025. (813)281-0088. Fax: (813)281-0271. Website: www.r obertscommunications.com. **Creative Director:** Amy Phillips. Art Director Eugene Newcomb. Production Artist Joel Barbosa. Estab. 1986. Number of employees 15. Ad agency, PR firm. Full-service multimedia firm. Special-

izes in integrated communications campaigns using multiple media and promotion. Professional affiliations AIGA, PRSA, AAF, TBAF and AAAAS.

Needs Approached by 50 freelancers/year. Works with 15 freelance illustrators and designers/year. Prefers local artists with experience in conceptualization and production knowledge. Uses freelancers for billboards, brochure design and illustration, lettering, logos, mechanicals, posters, retouching and website production. 60% of work is with print ads. 80% of freelance work demands knowledge of Photoshop 6.5, QuarkXPress 6.0 and Illustrator 8.5.

First Contact & Terms Send postcard sample or query letter with photocopies, résumé and SASE. Samples are filed or are returned by SASE if requested by artist. Portfolios may be dropped off every Monday. Will contact artist for portfolio review if interested. Portfolio should include b&w and color final art, roughs and thumbnails. Pays for design by the hour, $40-80; by the project, $200 minimum; by the day, $200-600. Pays for illustration by the project, negotiable. Refers to Graphic Arts Guild Handbook for fee structure. Rights purchased vary according to project. Finds artists through agents, sourcebooks, seeing actual work done for others, annuals (*Communication Arts*, *Print*, *One Show*, etc.).

Tips Impressed by "work that demonstrates knowledge of product, willingness to work within budget, contributing to creative process, delivering on-time."

☒ VAN VECHTEN & COMPANY PUBLIC RELATIONS

P.O. Box 99, Boca Raton FL 33429. (561)243-2900. E-mail: vanveco@aol.com. **President:** Lowell Van Vechten. Number of employees 8. Approximate annual billing $1.5 million. PR firm. Clients medical, consumer products, industry. Client list available for SASE.

Needs Approached by 20 freelancers/year. Works with 4 freelance illustrators and 4 designers/year. Works on assignment only. Uses artists for editorial and medical illustration, consumer and trade magazines, brochures, newspapers, stationery, signage, AV presentations and press releases. 100% of freelance work demands computer skills.

First Contact & Terms Send query letter with brochure, résumé, business card, photographs or photostats. Samples not returned. Responds only if interested. Pays for design and illustration by the project. Considers client's budget when establishing payment. Buys all rights.

Tips Advises freelancers starting out in the field to research agencies. "Find out what clients the agency has. Create a thumbnail sketch or original idea to get yourself in the door."

☑ ☒ ☒ MICHAEL WOLK DESIGN ASSOCIATES

31 NE 28th St., Miami FL 33137. (305)576-2898. Fax: (305)576-2899. E-mail: mwolk@wolkdesign.com. Website: www.wolkdesign.com. **Creative Director:** Michael Wolk. Estab. 1985. Specializes in corporate identity, displays, interior design and signage. Clients corporate and private. Client list available on website.

Needs Approached by 10 freelancers/year. Works with 5 illustrators and 5 freelance designers/year. Prefers local artists only. Works on assignment only. Needs editorial and technical illustration mainly for brochures. Uses designers mainly for interiors and graphics. Also for brochure design, mechanicals, logos and catalog illustration. Needs "progressive" illustration. Needs computer-literate freelancers for design, production and presentation. 75% of freelance work demands knowledge of PageMaker, QuarkXPress, FreeHand, Illustrator or other software.

First Contact & Terms Send query letter with slides. Samples are not filed and are returned by SASE. Responds only if interested. To show a portfolio, mail slides. Pays for design by the hour, $10-20. Rights purchased vary according to project.

GEORGIA

☒ DAUER ASSOCIATES

1134 Warren Hall Lane, Atlanta GA 30319. (404)252-0248. Fax: (404)252-1018. **President/CEO:** Jacqueline M. Dauer. Estab. 1978. Number of employees 2. Specialist in researching, concept designing, producing custom, world-class museum quality, digital, full-color, back-lit indoor medal of honor displays. Specializes in annual reports, brand and corporate identity; display, direct mail, fashion, package and publication design; technical illustration and signage.

● Has 50 years experience in the business. Only wants seasoned professionals.

Needs Approached by hundreds of freelancers/year. Uses freelancers for ad, brochure, catalog, poster and P-O-P design and illustration; airbrushing; audiovisual materials; charts/graphs; direct mail and magazine design; lettering; logos; mechanicals; and model making. Freelancers should be familiar with Illustrator, Photoshop, FreeHand, PageMaker and QuarkXPress.

First Contact & Terms Send postcard sample of work or send brochure, photocopies, résumé, slides, tearsheets

and transparencies. Samples are filed and are not returned. Request portfolio review in original query. Artist should follow up with call. Will contact artist for portfolio review if interested. Portfolio should include "work produced on a professional basis." Pays for design and illustration by the project. Rights purchased vary according to project, most of the time buys all rights.

Tips "Computer training isn't enough. The idea is the most important thing. Also, you must understand the basics of design. Be professional; be dedicated; be flexible. Learn how to make every art buyer who uses you once want to work with you again and again. Your reputation is at stake. Every job counts."

☷ EJW ASSOCIATES, INC.

Crabapple Village Office Park, Alpharetta GA 30004. (770)664-9322. Fax: (770)664-9324. E-mail: advertise@ejw assoc.com. Website: www.ejwassoc.com. **President:** Emil Walcek. Estab. 1982. Ad agency. Specializes in space ads, corporate ID, brochures, show graphics. Product specialty is business-to-business.

Needs Works with 2-4 freelance illustrators and designers/year. Prefers local freelancers with experience in Mac computer design and illustration and Photoshop expertise. Works on assignment only. Uses freelancers for brochure, website development, catalog and print ad design and illustration, editorial, technical illustration and logos. 50% of work is with print ads. 75% of freelance work demands skills in FreeHand, Photoshop, web coding, FLASH.

First Contact & Terms Send query letter with résumé, photostats, slides and website. Samples are filed or are returned by SASE if requested by artist. Responds only if interested. Pays for design by the hour, $40-80; by the day, $300-600; or by the project. Buys all rights.

Tips Looks for "experience in non-consumer, industrial or technology account work. Visit our website first, then e-mail or call. Do not send e-mail attachments."

LORENC & YOO DESIGN, INC.

109 Vickery St., Roswell GA 30075. (770)645-2828. Fax: (770)998-2452. E-mail: jan@lorencyoodesign.com. Website: www.lorencyoodesign.com. **President:** Mr. Jan Lorenc. Specializes in architectural signage design; environmental, exhibit, furniture and industrial design. Clients: corporate, developers, product manufacturers, architects, real estate and institutions. Current clients include Gerald D. Hines Interests, MCI, Georgia-Pacific, IBM, Simon Property Company, Mayo Clinic. Client list available upon request.

Needs Approached by 25 freelancers/year. Works with 5 illustrators and 10 designers/year. Local senior designers only. Uses freelancers for design, illustration, brochures, catalogs, books, P-O-P displays, mechanicals, retouching, airbrushing, posters, direct mail packages, model-making, charts/graphs, AV materials, lettering and logos. Needs editorial and technical illustration. Especially needs architectural signage and exhibit designers. 95% of freelance work demands knowledge of QuarkXPress, Illustrator or FreeHand.

First Contact & Terms Send brochure, weblink, or CD, résumé and samples to be kept on file. Prefers digital files as samples. Samples are filed or are returned. Call or write for appointment to show portfolio of thumbnails, roughs, original/final art, final reproduction/product and color photostats and photographs. Pays for design by the hour, $40-100; by the project, $250-20,000; by the day, $80-400. Pays for illustration by the hour, $40-100; by the project, $100-2,000; by the day, $80-400. Considers complexity of project, client's budget, and skill and experience of artist when establishing payment.

Tips "Sometimes it's more cost-effective to use freelancers in this economy, so we have scaled down permanent staff."

☷ T-P DESIGN INC.

7007 Eagle Watch Court, Stone Mountain GA 30087. (770)413-8276. Fax: (770)413-9856. E-mail: tpdesign@min dspring.com. **Creative Director:** Charlie Palmer. Estab. 1991. Number of employees 3. Approximate annual billing $500,000. Specializes in brand identity, display, package and publication design. Clients corporations. Current clients include Georgia Pacific, Cartoon Network, General Mills, KFC.

Needs Approached by 4 freelancers/year. Works with 2 freelance illustrators and 2 designers/year. Prefers local artists with Mac systems, traditional background. Uses illustrators and designers mainly for comps and illustration on Mac. Also uses freelancers for ad, brochure, poster and P-O-P design and illustration; book design, charts/graphs, lettering, logos, mechanicals (important) and page layout. Also for multimedia projects. 75% of freelance work demands skills in Illustrator, Photoshop, FreeHand and QuarkXPress. "Knowledge of multimedia programs such as Director and Premier would also be desirable."

First Contact & Terms Send query letter or photocopies, résumé and tearsheets. Accepts e-mail submissions to tpdesign@mindspring.com. Samples are filed. Will contact artist for portfolio review if interested. Portfolio should include b&w and color final art, roughs (important) and thumbnails (important). Pays for design and illustration by the project. Rights purchased vary according to project. Finds artists through submissions and word of mouth.

Tips "Be original, be creative and have a positive attitude. Need to show strength in illustration with a good design sense. A flair for typography would be desirable."

HAWAII

▣ MILICI VALENTI NG PACK

999 Bishop St., 24th Floor, Honolulu HI 96813. (808)536-0881. Fax: (808)529-6208. Website: www.milici.com. **Creative Director:** George Chalekian. Ad agency. Number of employees 74. Approximate annual billing $40,000,000. Serves clients in travel and tourism, food, finance, utilities, entertainment and public service. Clients include First Hawaiian Bank, Aloha Airlines, Sheraton Hotels.

Needs Works with 2-3 freelance illustrators/month. Artists must be familiar with advertising demands; used to working long distance through the mail and over the Internet; and be familiar with Hawaii. Uses freelance artists mainly for illustration, retouching and lettering for newspapers, multimedia kits, magazines, radio, TV and direct mail.

First Contact & Terms Send brochure, flier and tearsheets or PDFs to be kept on file for future assignments. Pays $200-2,000.

▣ ERIC WOO DESIGN, INC.

733 Bishop St., Suite 1280, Honolulu HI 96813. (808)545-7442. Fax: (808)545-7445. E-mail: ericwoodesign@haw aii.rr.com. Website: www.ericwoodesign.com. **Principal:** Eric Woo. Estab. 1985. Number of employees 3.5. Approximate annual billing 500,000. Design firm. Specializes in identities and visual branding, product packaging, print & web design, and environmental graphics & signage. Majority of clients are government, corporate and non-profits. Current clients include State of Hawaii, Alexander & Baldwin Inc., Western Pacific Regional Fishery Management Council.

Needs Approached by 5-10 illustrators and 10 designers/year. Works with 1-2 illustrators/year. Prefers freelancers with experience in multimedia. Uses freelancers mainly for multimedia projects and lettering. 5% of work is with print ads. 90% of design demands skills in Photoshop, Illustrator, Quark, Flash, Go Live, Dreamweaver and Metropolis.

First Contact & Terms Designers: Send query letter with brochure, photocopies, photographs, résumé and tearsheets. Illustrators: Send postcard sample of work or query letter with brochure, photocopies, photographs, résumé, tearsheets. Send follow-up postcard samples every 1-2 months. Accepts submissions on disk in above software. Samples are filed. Will call if interested. Will contact for portfolio review of final art, photographs, photostats, roughs, slides, tearsheets, thumbnails and transparencies. Pays for design by the hour, $15-50. Pays for illustration by the project. Rights purchased vary according to project.

Tips "Design and draw constantly. Have a good sense of humor and enjoy life."

IDAHO

⬚ HNA IMPRESSION MANAGEMENT

1524 W. Hays St., Boise ID 83702. (208)344-4631. Fax: (208)344-2458. E-mail: tony@hedden-nicely.com. Website: www.hedden-nicely.com. **Production Coordinator:** Tony Uria. Estab. 1986. Number of employees 7. Approximate annual billing $600,000. Ad agency. Specializes in print materialscollateral, display, direct mail. Product specialties are industrial, manufacturing.

Needs Approached by 5 illustrators and 10 designers/year. Works with 1 illustrator and 6 designers/year. Prefers local freelancers. Prefers that designers work electronically with own equipment. Uses freelancers mainly for logos, brochures. Also for airbrushing, animation, billboards, brochure, brochure illustration, lettering, model-making, posters, retouching, storyboards. 10% of work is with print ads. 90% of design demands knowledge of PageMaker, Photoshop, Illustrator 8.0. 40% of illustration demands knowledge of Photoshop, Illustrator, Quark.

First Contact & Terms Designers send query letter with brochure and résumé. Illustrators send postcard sample of work. Accepts any Mac-compatible Photoshop or Adobe file on CD or e-mail. Samples are filed. Responds only if interested when an appropriate project arises. Art director will contact artists for portfolio review of color, final art, tearsheets if interested. Pays by the project. Rights purchased vary according to project, all rights preferred. "All of our freelancers have approached us through query letters or cold calls."

ILLINOIS

⬚ BEDA DESIGN

38663 Thorndale Place, Lake Villa IL 60046. Phone/fax (847)245-8939. **President:** Lynn Beda. Estab. 1971. Number of employees 2-3. Approximate annual billing $250,000. Design firm. Specializes in packaging, publish-

ing, film and video documentaries. Current clients include business-to-business accounts, producers to writers, directors and artists.

Needs Approached by 6-12 illustrators and 6-12 designers/year. Works with 6 illustrators and 6 designers/year. Prefers local freelancers. Also for retouching, technical illustration and production. 50% of work is with print ads. 75% of design demands skills in Photoshop, QuarkXPress, Illustrator, Premiere, Go Live.

First Contact & Terms Designers send query letter with brochure, photocopies and résumé. Illustrators send postcard samples and/or photocopies. Samples are filed and are not returned. Will contact for portfolio review if interested. Payments are negotiable. Buys all rights. Finds artists through word of mouth.

▣ BENTKOVER'S DESIGN & MORE

1222 Cavell, Suite 3C, Highland Park IL 60035. (847)831-4437. Fax: (847)831-4462. **Creative Director:** Burt Bentkover. Estab. 1989. Number of employees 2. Approximate annual billing $200,000. Specializes in annual reports, ads, package and brochure design. Clients business-to-business, foodservice.

Needs Works with 3 freelance illustrators/year. Works with artist reps. Prefers freelancers with experience in computer graphics, multimedia, Macintosh. Uses freelancers for direct mail and brochure illustration. 80% of freelance work demands computer skills.

First Contact & Terms Send brochure, photocopies and tearsheets. No original artonly disposable copies. Samples are filed. Responds in 1 week if interested. Request portfolio review in original query. Will contact artist for portfolio review if interested. Portfolio should include b&w and color photocopies. "No final art or photographs." Pays for design and illustration by the project. Rights purchased vary according to project. Finds artists through sourcebooks and agents.

▣ ⃞ BRAGAW PUBLIC RELATIONS SERVICES

800 E. Northwest Hwy., Palatine IL 60074. (847)934-5580. Fax: (847)934-5596. Website: www.bragawpr.com. **President:** Richard S. Bragaw. Number of employees 3. PR firm. Specializes in newsletters and brochures. Clients professional service firms, associations and industry. Current clients include Kaiser Precision Tooling, Inc. and Nykiel-Carlin and Co., Ltd.

Needs Approached by 12 freelancers/year. Works with 2 freelance illustrators and 2 designers/year. Prefers local freelancers only. Works on assignment only. Uses freelancers for direct mail packages, brochures, signage, AV presentations and press releases. 90% of freelance work demands knowledge of PageMaker. Needs editorial and medical illustration.

First Contact & Terms Send query letter with brochure to be kept on file. Responds only if interested. Pays by the hour, $25-75 average. Considers complexity of project, skill and experience of artist and turnaround time when establishing payment. Buys all rights.

Tips "We do not spend much time with portfolios."

THE CHESTNUT HOUSE GROUP INC.

2121 St. Johns Ave., Highland Park IL 60035. (847)432-3273. Fax: (847)432-3229. E-mail: chestnut@comcast.net. Website: www.chestnuthousegroup.com. **Contact:** Miles Zimmerman. Clients major educational publishers, small publishers, and selected self-publishers.

Needs Illustration, layout and electronic page production. Needs computer-literate freelancers with educational publishing experience. Uses experienced freelancers only. Freelancers should be familiar with QuarkXPress and various drawing and painting programs for illustrators. Pays for production by the hour. Pays for illustration by the project.

First Contact & Terms Illustrators, submit samples.

▣ DESIGN ASSOCIATES

1828 Asbury Ave., Evanston IL 60201-3504. (847)425-4800. E-mail: info@designassociatesinc.com. Website: www.designassociatesinc.com. **Contact:** Paul Uhl. Estab. 1986. Number of employees 5. Specializes in text and trade book design, annual reports, corporate identity, website development. Clients corporations, publishers and museums. Client list available upon request.

Needs Approached by 10-20 freelancers/year. Works with 100 freelance illustrators and 2 designers/year. Uses freelancers for design and production. 100% of freelance work demands knowledge of Illustrator, Photoshop and InDesign.

First Contact & Terms Send query letter with samples that best represent work. Accepts disk submissions. Samples are filed. Will contact artist for portfolio review if interested. Portfolio should include b&w and color samples.

DESIGN RESOURCE CENTER

1548 Bond St., Suite 114, Naperville IL 60563. (630)357-6008. Fax: (630)357-6040. E-mail: info@drcchicago.com. Website: www.drcchicago.com. **President:** John Norman. Estab. 1990. Number of employees 12. Approxi-

mate annual billing $850,000. Specializes in package design and display, brand and corporate identity. Clients corporations, manufacturers, private label.

Needs Approached by 5-10 freelancers/year. Works with 3-5 freelance designers and production artists and 3-5 designers/year. Uses designers mainly for Macintosh or concepts. Also uses freelancers for brochure, poster and P-O-P design and illustration, lettering, logos and package design. Needs computer-literate freelancers for design, illustration and production. 100% of freelance work demands knowledge of Illustrator 10, QuarkXPress and Photoshop.

First Contact & Terms Send query letter with brochure, photocopies, photographs and résumé. Samples are filed. Does not reply. Artist should follow up. Portfolio review sometimes required. Portfolio should include b&w and color final art, photocopies, photographs, photostats, roughs and thumbnails. Pays for design by the hour, $15-40. Pays for illustration by the project. Buys all rights. Finds artists through word of mouth, referrals.

ⓃGUERTIN ASSOCIATES

3703 W. Lake Ave., Glenview IL 60026. (847)729-2674. Fax: (847)729-5190. **Vice President Creative:** Fred Nelson. Estab. 1987. Number of employees 8. Approximate annual billing $3 million. Marketing service agency. Specializes in P.O.S. materials, magazine ads, direct mail and business-to-business communications. Product specialties are boating, gasolines, financial and pharmaceuticals. Current clients include Heinz Pet Foods, Firstar Bank, Unocal, Outboard Marine Corp. Effidac. Client list available upon request.

Needs Approached by 50 freelancers/year. Works with 10 freelance illustrators/year. Prefers freelancers with experience in Mac Quark, Illustrator, Freehand, Photoshop who can work off-site. Uses freelancers mainly for keyline and layout. Also for billboards, brochure design, catalog design and illustration, logos, mechanicals, posters and signage. 10% of work is with print ads. Needs computer-literate freelancers for illustration and production. 90% of freelance work demands skills in FreeHand, Photoshop, QuarkXPress and Illustrator.

First Contact & Terms Send query letter with photocopies and résumé. Samples are not returned. Will contact artist for portfolio review if interested. Pays for design by the project, $100-1,000. Pays for illustration by the project. Buys all rights.

ⓃINNOVATIVE DESIGN & GRAPHICS

1327 Greenleaf St., Evanston IL 60202-1375. (847)475-7772. Fax: (847)475-7784 E-mail: idgemail@sprintmail.com. **Contact:** Tim Sonder. Clients corporate communication and marketing departments.

Needs Works with 1-5 freelance artists/year. Prefers local artists only. Uses artists for editorial and technical illustration and desktop (CorelDraw, FreeHand, Illustrator).

First Contact & Terms Send query letter with résumé or brochure showing art style, tearsheets, photostats, slides and photographs. Will contact artist for portfolio review if interested. Pays for design by the hour, $20-45. Pays for illustration by the project, $200-1,000 average. Considers complexity of project, client's budget and turnaround time when establishing payment. Interested in buying second rights (reprint rights) to previously published work.

Tips "Interested in meeting new illustrators, but have a tight schedule. Looking for people who can grasp complex ideas and turn them into high-quality illustrations. Ability to draw people well is a must. Do not call for an appointment to show your portfolio. Send nonreturnable tearsheets or self-promos, and we will call you when we have an appropriate project for you."

ⓃTEMKIN & TEMKIN, INC.

1954 1st St., Suite 187, Highland Park IL 60035. (847)831-0237. E-mail: steve@temkin.com. **President:** Steve Temkin. Estab. 1945. Number of employees 10. Ad agency. Specializes in business-to-business collateral, consumer direct mail. Product specialties are food, gifts, electronics and professional services. Current clients include Verilux, Office Max, Chase Bank cards.

Needs Approached by 100 freelancers/year. Works with 5-10 freelance illustrators and 10 designers/year. Prefers local artists only. Uses freelancers mainly for design, concept and comps. Also for brochure and catalog design, mechanicals and retouching. 95% of work is with print ads. Needs computer-literate freelancers for design and production. 75% of freelance work demands knowledge of Photoshop, QuarkXPress, InDesign, Draw and Illustrator.

First Contact & Terms Send query letter with photocopies and résumé. To arrange portfolio review artist should follow up with call or letter after initial query. Portfolio should include roughs, tearsheets and thumbnails. Pays for design by the project, $250-5,000. Rights purchased vary according to project.

Tips "Present evidence of hands-on involvement with concept and project development."

WATERS & WOLFE

1603 Orrington, Suite 990, Evanston IL 60201. (847)475-4500. Fax: (847)475-3947. E-mail: jbeuving@wnwolfe.com. Website: www.wnwolfe.com. **Senior Art Director:** Jeff Beuving. President: Paul Frankel. Estab. 1984.

Number of employees 15. Approximate annual billing $2 million. Ad agency, AV firm, PR firm. Full-service, multimedia firm. Specializes in collateral, annual reports, magazine ads, trade show booth design, videos, PR. "We are full service from logo design to implementation of design." Product specialty is business-to-business. Client list not available.

Needs Approached by 50 freelancers/year. Works with 5 freelance illustrators and 5 designers/year. Uses freelancers mainly for layout and illustrations. Also for animation, lettering, logos, mechanicals, retouching, signage and TV/film graphics. 25% of work is with print ads. Needs computer-literate freelancers for design, web programming, illustration, production and presentation. 90% of freelance work demands knowledge of Photoshop 5.0, QuarkXPress 4.0, Illustrator 8.0.

First Contact & Terms Send query letter with brochure, photocopies, photographs, résumé and tearsheets. Will also accept printouts of artist's samples. Samples are filed. Will contact artist for portfolio review if interested. Portfolio should include color final art, roughs, tearsheets and thumbnails. Pays for design by the hour or by the project. Pays for illustration by the project. Rights purchased vary according to project. Finds artists through sourcebooks, word of mouth, artists' submissions and agents.

Tips "I am impressed by professionalism. Complete projects on timely basis, have thorough knowledge of task at hand."

CHICAGO

HUTCHINSON ASSOCIATES, INC.

1147 W. Ohio, Suite 305, Chicago IL 60622. (312)455-9191. Fax: (312)455-9190. E-mail: hutch@hutchinson.com. Website: www.hutchinson.com. **Contact:** Jerry Hutchinson. Estab. 1988. Number of employees 3. Specializes in annual reports, corporate identity, capability brochures, direct mail, publication design and website design and development. Clients corporations, associations and PR firms. Professional affiliations AIGA, ACD.

- Work from Hutchinson Associates has been published in the design books *Work With Computer Type*, Vols. 1-3 by Rob Carter (Rotovision) and *Graphic Design 97*.

Needs Approached by 5-10 freelancers/year. Works with 3-4 freelance illustrators and 5-15 designers/year. Uses freelancers mainly for brochure design, annual reports, multimedia and web designs. Also uses freelancers for ad and direct mail design, catalog illustration, charts/graphs, logos, multimedia projects and mechanicals.

First Contact & Terms Send postcard sample of work or send query letter with résumé, brochure, photocopies and photographs. Accepts disk submissions. Samples are filed. Request portfolio review in original query. Artist should follow up with call. Will contact artist for portfolio review if interested. Portfolio should include transparencies and printed pieces. Pays by the project, $100-10,000. Rights purchased vary according to project. Finds artists through sourcebooks, Illinois reps, submissions.

Tips "Persistence pays off."

KAUFMAN RYAN STRAL INC.

650 N. Dearborn St., Suite 700, Chicago IL 60610. (312)649-9408. Fax: (312)649-9418. E-mail: lkaufman@bworld.com. Website: www.bworld.com. **President/Creative Director:** Laurence Kaufman. Production Manager: Marc Turner. Estab. 1993. Number of employees 7. Ad agency. Specializes in all materials in print and website development. Product specialty is business-to-business. Client list available upon request. Professional affiliations: American Israel Chamber of Commerce.

Needs Approached by 30 freelancers/year. Works with 3 designers/year. Prefers local freelancers. Uses freelancers for design, production, illustration and computer work. Also for brochure, catalog and print ad design and illustration, animation, mechanicals, retouching, model-making, posters, lettering and logos. 5% of work is with print ads. 50% of freelance work demands knowledge of QuarkXPress, html programs FrontPage or Page Mill, Photoshop or Illustrator.

First Contact & Terms Send e-mail with with résumé and JPEGs. Responds only if interested. Will contact artist for portfolio review if interested. Portfolio should include b&w and color roughs and final art. Pays for design by the hour, $40-120; or by the project. Pays for illustration by the project, $75-8,000. Buys all rights. Finds artists through sourcebooks, word of mouth, submissions.

LUCY LESIAK DESIGN

575 W. Madison St., Suite 2809, Chicago IL 60661. (312)902-4533. Fax: (312)775-7224. Current clients include Scott Foresman, McGraw-Hill, World Book. Client list available upon request.

Needs Approached by 20 freelance artists/year. Works with 3-5 illustrators and 1-2 designers/year. Works on assignment only. Uses illustrators mainly for story or cover illustration, also editorial, technical and medical illustration. Uses designers mainly for text design. Also for book design, mechanicals and logos. 100% of design work demands knowledge of QuarkXPress, Illustrator or Photoshop.

Advertising, Design & Related Markets **503**

First Contact & Terms Send postcard sample or query letter with photocopies, brochure and résumé. Accepts disk submissions compatible with Mac Illustrator 7.0 and QuarkXPress 4.1. Samples are filed. Will contact artist for portfolio review if interested. Portfolio should include final art, color tearsheets and transparencies. Pays for design by the hour, $30-50. Pays for illustration by the project, $30-3,000. Rights purchased vary according to project. Finds artists through agents, sourcebooks and self-promotions.

N̄ MEYER/FREDERICKS & ASSOCIATES

333 N. Michigan Ave., #1300, Chicago IL 60601. (312)782-9722. Fax: (312)782-1802. E-mail: sdurning@meyerfr edericks.com. Estab. 1972. Number of employees 15. Ad agency, PR firm. Full-service, multimedia firm.
Needs Prefers local freelancers only. Freelancers should be familiar with Photoshop 7.0, QuarkXPress 4.1 and Illustrator 8.
First Contact & Terms Send query letter with samples. Will contact artist for portfolio review if interested.

THE QUARASAN GROUP, INC.

405 W. Superior St., Chicago IL 60610-3613. (312)981-2500. Fax: (312)981-2507. E-mail: info@quarasan.com. Website: www.quarasan.com. **President:** Randi S. Brill. Specializes in educational products. Clients: educational publishers. Client list not available. Submission guidelines on website.
Needs Approached by 400 freelancers/year. Works with 700-900 illustrators/year. Freelancers with publishing experience preferred. Uses freelancers for illustration, books, mechanicals, charts/graphs, lettering and production. Needs computer-literate freelancers for illustration. 50% of freelance illustration work demands skills in Illustrator, QuarkXPress, Photoshop or FreeHand. Needs editorial, technical, medical and scientific illustration.
First Contact & Terms Send query letter with brochure or résumé and samples to be circulated and kept on file. Prefers ''anything that we can retain for our files photocopies, color tearsheets, e-mail submissions, disks or dupe slides that do not have to be returned'' as samples. Responds only if interested. Pays for illustration by the piece/project, $40-750 average. Considers complexity of project, client's budget, how work will be used and turnaround time when establishing payment. ''For illustration, size and complexity are the key factors.''
Tips ''Our publishers continue to require us to use only those artists willing to work on a work-for-hire basis. This is slowly changing, but at present, this is still often a requirement. Our other markets are more receptive to alternate arrangements. Let us know your requirements early in the game!''

N̄ TESSING DESIGN, INC.

3822 N. Seeley Ave., Chicago IL 60618-3912. (773)525-7704. Fax: (773)525-7756. E-mail: tess46@aol.com. **Principals:** Arvid V. Tessing. and Louise S. Tessing. Estab. 1975. Number of employees 2. Specializes in corporate identity, marketing promotions and publications. Clients publishers, educational institutions and nonprofit groups. Majority of clients are publishers. Professional affiliation Women in Design, Chicago Book Clinic, and the Society of Typographic Arts.
Needs Approached by 30-80 freelancers/year. Works with 3 freelance illustrators and 2 designers/year. Works on assignment only. Uses freelancers mainly for publications. Also for book and magazine design and illustration, charts/graphs and lettering. 90% of design and 75% of illustration demand knowledge of QuarkXPress, Photoshop or Illustrator. Needs textbook, editorial and technical illustration.
First Contact & Terms Designers send query letter with photocopies. Illustrators send postcard samples. Samples are filed and are not returned. Request portfolio review in original query. Artist should follow up with letter after initial query. Will contact artist for portfolio review if interested. Portfolio should include original/final art, final reproduction/product and photographs. Pays for design by the hour, $40-60. Pays for illustration by the project, $100 minimum. Rights purchased vary according to project. Finds artists through word of mouth, submissions/self-promotions and sourcebooks.
Tips ''We prefer to see original work or slides as samples. Work sent should always relate to the need expressed. Our advice for artists to break into the field is as always call prospective clients, show work and follow up.''

N̄ ZUNPARTNERS INCORPORATED

326 W. Chicago Ave., Chicago IL 60610. (312)951-5533. Fax: (312)951-5522. E-mail: request@zunpartners.com. Website: www.zunpartners.com. **Partners:** William Ferdinand. and David Philmlee. Estab. 1991. Number of employees 9. Specializes in annual reports, brand and corporate identity, capability brochures, package and publication design, electronic and interactive. Clients from Fortune 500 to Internet startup companies. Current clients include Arthur Andersen, Unicom, B.P. and Sears. Client list available upon request. Professional affiliations AIGA, ACD.
Needs Approached by 30 freelancers/year. Works with 10-15 freelance illustrators and 15-20 designers/year. Looks for strong personal style (local and national). Uses illustrators mainly for editorial. Uses designers mainly for design and layout. Also uses freelancers for collateral and identity design, illustration; web, video, audiovisual materials; direct mail, magazine design and lettering; logos; and retouching. Needs computer-literate free-

lancers for design, illustration, production and presentation. 90% of freelance work demands knowledge of Illustrator, Photoshop, QuarkXPress, Flash, Dreamweaver and Go Live.

First Contact & Terms Send postcard sample of work or send query letter with brochure or résumé. Samples are filed. Responds only if interested. Portfolios may be dropped off every Friday. Artist should follow up. Portfolio should include b&w and color samples. Pays for design by the hour and by the project. Pays for illustration by the project. Rights purchased vary according to project. Finds artists through reference books and submissions.

Tips Impressed by "to the point portfolios. Show me what you like to do and what you brought to the projects you worked on. Don't fill a book with extra items (samples) for sake of showing quantity."

INDIANA

ASHER AGENCY

535 W. Wayne, Fort Wayne IN 46802. (260)424-3373. Fax: (260)424-0848. E-mail: asherideas@centralnet.net.com. Web site: www.asheragency.com. **Contact:**Ringo Santiato, Senior Art Director. Estab. 1974. Number of employees 21. Approximate annual billing $12 million. Full service ad agency and PR firm. Clients automotive firms, financial/investment firms, area economic development agencies, health care providers, fast food companies, gaming companies and industrial.

Needs Works with 5-10 freelance artists/year. Assigns 25-50 freelance jobs/year. Prefers local artists. Works on assignment only. Uses freelance artists mainly for illustration. Also uses freelance artists for design, brochures, catalogs, consumer and trade magazines, retouching, billboards, posters, direct mail packages, logos and advertisements.

First Contact & Terms Send query letter with brochure showing art style or tearsheets and photocopies. Samples are filed or are returned by SASE. Responds only if interested. Will contact artist for portfolio review if interested. Portfolio should include roughs, original/final art, tearsheets and final reproduction/product. Pays for design by the hour, $40 minimum. Pays for illustration by the project, $40 minimum. Finds artists usually through word of mouth.

BOYDEN & YOUNGBLUTT ADVERTISING & MARKETING.

120 W. Superior St., Fort Wayne IN 46802. (260)422-4499. Fax: (260)422-4044. E-mail: info@b-y.net. Website: www.b-y.net. **Vice President:** Jerry Youngblutt. Estab. 1990. Number of employees 20. Ad agency. Full-service, multimedia firm. Specializes in magazine ads, collateral, web, media, television.

Needs Approached by 10 freelancers/year. Works with 3-4 freelance illustrators and 5-6 designers/year. Uses freelancers mainly for collateral layout and web. Also for annual reports, billboards, brochure design and illustration, logos and model-making. 40% of work is with print ads, 20% web, 20% media, and 10% TV. Needs computer-literate freelancers for design. 100% of freelance work demands knowledge of FreeHand, Photoshop, Adobe Ilustrator, Web Weaver and InDesign.

First Contact & Terms Send query letter with photostats and résumé. Samples are filed. Will contact artist for portfolio review if interested. Portfolio should include b&w and color final art. Pays for design and illustration by the project. Buys all rights.

Tips Finds artists through sourcebooks, word of mouth and artists' submissions. "Send a precise résumé with what you feel are your 'best' samples—less is more."

⃞ GRIFFIN MARKETING SERVICES, INC.

802 Wabash Ave., Chesterton IN 46304-2250. (219)929-1616. Fax: (219)921-0388. E-mail: rob@griffinmarketing services.com. Website: www.griffinmarketingservices.com. **President:** Michael J. Griffin. Estab. 1974. Number of employees 20. Approximate annual billing $4 million. Integrated marketing firm. Specializes in collateral, direct mail, multimedia. Product specialty is industrial. Current clients include Hyatt, USX, McDonalds.

Needs Works with 20-30 freelance illustrators and 2-30 designers/year. Prefers artists with experience in computer graphics. Uses freelancers mainly for design and illustration. Also uses freelancers for animation, model making and TV/film graphics. 75% of work is with print ads. Needs computer-literate freelancers for design, illustration, production and presentation. 95% of freelance work demands knowledge of PageMaker, FreeHand, Photoshop, QuarkXPress and Illustrator.

First Contact & Terms Send query letter with SASE or e-mail. Samples are not filed and are returned by SASE if requested by artist. Responds in 1 month. Will contact artist for portfolio review if interested. Pays for design and illustration by the hour, $20-150; or by the project.

Tips Finds artists through *Creative Black Book*.

■ JMH CORPORATION

157 E. 71st St., Indianapolis IN 46220. (317)255-3400. E-mail: jmh@jmhdesign.com. Website: jmhdesign.com. **President:** J. Michael Hayes. Number of employees 3. Specializes in annual reports, corporate identity, collateral, packaging, publications and website development. Clients publishers, consumer product manufacturers, corporations and institutions. Professional affiliations AIGA.

Needs Approached by 30-40 freelancers/year. Works with 5 freelance illustrators and 2 designers/year. Prefers experienced, talented and responsible freelancers only. Works on assignment only. Uses freelancers for advertising, brochure and catalog design and illustration, P-O-P displays, retouching, charts/graphs and lettering. Needs editorial and medical illustration. 100% of design and 30% of illustration demand skills in QuarkXPress, Illustrator or Photoshop (latest versions).

First Contact & Terms Send query letter with brochure/flyer, résumé, photocopies, photographs, tearsheets and slides. Accepts disk submissions compatible with QuarkXPress 4.0 and Illustrator 8.0. Send EPS files. Samples returned by SASE, "but we prefer to keep them." Response time "depends entirely on our needs." Write for appointment to show portfolio. Pays for design by the hour, $20-50, or by the project, $100-1,000. Pays for illustration by the project, $300-5,000.

Tips "Prepare an outstanding mailing piece and 'leave-behind' that allows work to remain on file. Keep doing great work and stay in touch." Advises freelancers entering the field to "send samples regularly. Call to set a portfolio presentation. Do great work. Be persistent. Love what you do. Have a balanced life."

■ OMNI PRODUCTIONS

P.O. Box 302, Carmel IN 46082-0302. (317)84 6- 2345. E-mail: winston@omniproductions.com. Website: omnip roductions.com. **President:** Winston Long. Estab. 1984. AV firm. Full-service, multimedia firm. Specializes in video, Intranet, CD-ROM and Internet. Current clients include "a variety of industrial clients, government and international agencies."

Needs Works on assignment only. Uses freelancers for brochure design and illustration, storyboards, slide illustration, animation, and TV/film graphics. Needs computer-literate freelancers for design, illustration and production. Most of freelance work demands computer skills.

First Contact & Terms Send résumé. Samples are filed and are not returned. Artist should followup with call and/or letter after initial query. Pays by the project. Finds artists through agents, word of mouth and submissions.

IOWA

■ F.A.C. MARKETING

PO Box 782, Burlington IA 52601. (319)752-9422. Fax: (319)752-7091. Website: www.facmarketing.com. **President:** Roger Sheagren. Estab. 1952. Number of employees 8. Approximate annual billing $500,000. Ad agency. Full-service, multimedia firm. Specializes in newspaper, television, direct mail. Product specialty is funeral home to consumer.

Needs Approached by 30 freelancers/year. Works with 1-2 freelance illustrators and 4-6 designers/year. Prefers freelancers with experience in newspaper and direct mail. Uses freelancers mainly for newspaper design. Also for brochure design and illustration, logos, signage and TV/film graphics. Freelance work demands knowledge of PageMaker, Photoshop, CorelDraw and QuarkXPress.

First Contact & Terms Send query letter with brochure, SASE, tearsheets and photocopies. Samples are filed or returned by SASE if requested by artist. Request portfolio review in original query. Portfolio should include b&w photostats, tearsheets and thumbnails. Pays by the project, $100-500. Rights purchased vary according to project.

KANSAS

■ GRETEMAN GROUP

1425 E. Douglas Ave., Wichita KS 67211. (316)263-1004. Fax: (316)263-1060. E-mail: info@gretemangroup.c om. Website: www.gretemangroup.com. **Owner:** Sonia Greteman. Estab. 1989. Number of employees 19. Capitalized billing $20 million. Creative agency. Specializes in corporate identity, advertising, annual reports, signage, website design, interactive media, brochures, collateral. Professional affiliations AIGA.

Needs Approached by 2 illustrators and 10-20 designers/year. Works with 2 illustrators and 2 designers/year. Also for brochure illustration. 10% of work is with print ads. 100% of design demands skills in PageMaker, FreeHand, Photoshop, QuarkXPress, Illustrator. 30% of illustration demands computer skills.

First Contact & Terms Send query letter with brochure and résumé. Accepts disk submissions. Send EPS files.

Samples are filed. Will contact for portfolio review of b&w and color final art and photostats if interested. Pays for design by the hour. Pays for illustration by the project. Rights purchased vary according to project.

▣ MARKETAIDE SERVICES, INC.

P.O. Box 500, Salina KS 67402-0500. (785)825-7161. Fax: (785)825-4697. Website: www.marketaide.com. **Production Manager:** Dee Warren. Graphic Designer: Marla Kuiper Full-service ad/marketing/direct mail firm. Clients financial, industrial and educational.

Needs Prefers artists within one-state distance who possess professional expertise. Works on assignment only. Needs computer-literate freelancers for design, illustration and web design. 90% of freelance work demands knowledge of QuarkXPress, Illustrator and Photoshop.

First Contact & Terms Send query letter with résumé, business card and samples to be kept on file. Samples not filed are returned by SASE only if requested. Responds only if interested. Write for appointment to show portfolio. Pays for design by the hour, $15-75 average; "since projects vary in size, we are forced to estimate according to each job's parameters." Pays for illustration by the project.

Tips "Artists interested in working here should be highly polished in technical ability, have a good eye for design and be able to meet all deadline commitments."

RHYCOM STRATEGIC ADVERTISING

84 Corporate Woods, 10801 Mastin Blvd., Suite 950, Overland Park KS 66210. (913)451-9102. Fax: (913)451-9106. E-mail: rrhyner@rhycom.com. Website: www.rhycom.com. **President:** Rick Rhyner. Multimedia, full-service integrated marketing communications agency. Clients: food, pharmaceutical, insurance, franchises.

Needs Works on assignment only. Uses freelancers for design, illustration, brochures, catalogs, books, newspapers, consumer and trade magazines, P-O-P display, mechanicals, retouching, animation, billboards, posters, direct mail packages, lettering, logos, charts/graphs and ads.

First Contact & Terms Send samples showing your style. Samples are not filed and are not returned. Responds only if interested. Call for appointment to show portfolio. Considers complexity of project and skill and experience of artist when establishing payment. Buys all rights.

▣ TASTEFUL IDEAS, INC.

5822 Nall Ave., Mission KS 66205. (913)722-3769. Fax: (913)722-3967. E-mail: john@tastefulideas.com. Website: www.tastefulideas.com. **President:** John Thomsen. Estab. 1986. Number of employees 4. Approximate annual billing $500,000. Design firm. Specializes in consumer packaging. Product specialties are largely, but not limited to, food and foodservice.

Needs Approached by 15 illustrators and 15 designers/year. Works with 3 illustrators and 3 designers/year. Prefers local freelancers. Uses freelancers mainly for specialized graphics. Also for airbrushing, animation, humorous and technical illustration. 10% of work is with print ads. 75% of design and illustration demand skills in Photoshop and Illustrator.

First Conact & Terms Designers send query letter with photocopies. Illustrators send query letter with photostats. Accepts disk submissions from designers and illustrators compatible with Illustrator, PhotoshopMac based. Samples are filed. Responds only if interested. Art director will contact artist for portfolio review of final art of photostats if interested. Pays by the project. Finds artists through submissions.

▣ WEST CREATIVE, INC.

9552 W. 116th Terrace, Overland Park KS 66210. (913)661-0561. Fax: (816)561-2688. E-mail: stan@westcreative .com. Website: www.westcreative.com. **Creative Director:** Stan Chrzanowski. Estab. 1974. Number of employees 8. Approximate annual billing $600,000. Design firm and agency. Full-service, multimedia firm. Client list available upon request. Professional affiliation AIGA.

Needs Approached by 50 freelancers/year. Works with 4-6 freelance illustrators and 1-2 designers/year. Uses freelancers mainly for illustration. Also for animation, lettering, mechanicals, model-making, retouching and TV/film graphics. 20% of work is with print ads. Needs computer-literate freelancers for design, illustration and production. 95% of freelance work demands knowledge of FreeHand, Photoshop, QuarkXPress and Illustrator. Full service web design capabilities.

First Contact & Terms Send postcard-size sample of work or send query letter with brochure, photocopies, résumé, SASE, slides, tearsheets and transparencies. Samples are filed or returned by SASE if requested by artist. Responds only if interested. Portfolios may be dropped off every Monday-Thursday. Portfolios should include color photographs, roughs, slides and tearsheets. Pays for illustration by the project; pays for design by the hour, $25-60. "Each project is bid." Rights purchased vary according to project. Finds artists through *Creative Black Book* and *Workbook*.

GET A FREE ISSUE OF HOW

From creativity crises to everyday technology, HOW covers every aspect of graphic design — so you have all the tools, techniques and resources you need for design success.

CREATIVITY idea-boosting tips from the experts and the inspiration behind some innovative new designs

BUSINESS how to promote your work, get paid what you're worth, find new clients and thrive in any economy

DESIGN an inside look at the hottest design workspaces, what's new in production and tips on designing for different disciplines

TECHNOLOGY what's happening with digital design, hardware and software reviews, plus how to upgrade on a budget

With this special introductory offer, you'll get a FREE issue of HOW. If you like what you see, you'll get a full year of HOW at our lowest available rate — a savings of 61% off the newsstand price.

I WANT TO TRY HOW.

Yes! Send my FREE issue and start my trial subscription. If I like what I see, I'll pay just $29.96 for 5 more issues (6 in all). If not, I'll write "cancel" on the invoice, return it and owe nothing. The FREE issue is mine to keep.

Name _____

Company _____

Address _____

City _____

State _____ZIP_____

Email _____

SEND NO MONEY NOW.

In Canada: you'll be invoiced an additional $15 (includes GST/HST). Outside the U.S. and Canada: add $22 ($65 airmail) and remit payment in U.S. funds with order. Please allow 4-6 weeks for first-issue delivery. Annual newsstand rate $77.70.

❑ You may contact me about my subscription, via email. My email address won't be used for any other purpose.

My business is best described as: (choose one)
- ○ Advertising Agency
- ○ Design Studio
- ○ Graphic Arts Vendor
- ○ Company (In-House Design Dept.)
- ○ Educational Institution
- ○ Other (specify)_____

My job title/occupation is: (choose one)
- ○ Owner/Management
- ○ Creative Director
- ○ Art Director/Designer
- ○ Advertising/Marketing Staff
- ○ Instructor
- ○ Student
- ○ Other (specify)_____

J5FAM1

You get three huge annuals:

SELF-PROMOTION — discover the keys to promoting your work and see the winners of our exclusive Self-Promotion Competition

INTERNATIONAL DESIGN — explore the latest design trends from around the world, plus the winning entries from the HOW International Design Competition

BUSINESS — get the scoop on protecting your work, building your business and your portfolio, and growing your career

Plus, get three acclaimed special issues — each focused on one aspect of design, so you'll get everything you need to know about Digital Design, Creativity and Trends & Type.

ested. Pays for design by the hour, $50-65. Pays for illustration by the project. Rights purchased vary according to project. Finds artists through submissions, word of mouth, Internet, *Creative Black Book*, *Workbook* and *American Showcase*, artist's representatives.

Tips "Keep our company on your mailing list; remind us that you are out there."

LOUISIANA

☒ ANTHONY DI MARCO

301 Aris Ave., Metairie LA 70005. (504)833-3122. Fax: (504)833-3122. **Creative Director:** Anthony Di Marco. Estab. 1972. Number of employees 1. Specializes in illustration, sculpture, costume design, and art and photo restoration and retouching. Current clients include Audubon Institute, Louisiana Nature and Science Center, Fair Grounds Race Course. Client list available upon request. Professional affiliations Art Directors Designers Association, Entergy Arts Council, Louisiana Crafts Council, Louisiana Alliance for Conservation of Arts.

● Anthony DiMarco recently completed the re-creation of a 19th-century painting, *Life on the Metairie*, for the Fair Grounds racetrack. The original painting was destroyed by fire in 1993.

Needs Approached by 50 or more freelancers/year. Works with 5-10 freelance illustrators and 5-10 designers/year. Seeks "local freelancers with ambition. Freelancers should have substantial portfolios and an understanding of business requirements." Uses freelancers mainly for fill-in and finish design, illustration, mechanicals, retouching, airbrushing, posters, model-making, charts/graphs. Prefers highly polished, finished art in pen & ink, airbrush, charcoal/pencil, colored pencil, watercolor, acrylic, oil, pastel, collage and marker. 25% of freelance work demands computer skills.

First Contact & Terms Send query letter with résumé, business card, slides, brochure, photocopies, photographs, transparencies and tearsheets to be kept on file. Samples not filed are returned by SASE. Responds in 1 week if interested. Call or write for appointment to show portfolio. Pays for illustration by the hour or by the project, $100 minimum.

Tips "Keep professionalism in mind at all times. Put forth your best effort. Apologizing for imperfect work is a common mistake freelancers make when presenting a portfolio. Include prices for completed works (avoid overpricing). Three-dimensional works comprise more of our total commissions than before."

FOCUS COMMUNICATIONS, INC.

5739 Lovers Ln., Shreveport LA 71105. (318)219-7688. Fax: (318)219-7689. **President:** Jim Huckabay. Estab. 1976. Number of employees 3. Specializes in corporate identity, direct mail design and full service advertising. Clients medical, financial and retail. Professional affiliations AAF.

Needs Approached by 5 freelancers/year. Works with 2 freelance illustrators and designers/year. Prefers local artists with experience in illustration, computer (Mac) design and composition. Uses illustrators mainly for custom projects; print ads. Uses designers mainly for custom projects; direct mail, logos. Also uses freelancers for ad and brochure design and illustration, audiovisual materials, charts/graphs, logos, mechanicals and retouching. Needs computer-literate freelancers for design, illustration and production. 85% of freelance work demands skills in Photoshop, FreeHand and QuarkXPress.

First Contact & Terms Send postcard sample of work or send query letter with brochure, photocopies, photostats, slides, tearsheets and transparencies. Samples are filed. Will contact artist for portfolio review if interested. Portfolio should include b&w and color final art and slides. Pays for design by the hour, $40-75; by the project. Pays for illustration by the project, $100-1,000. Negotiates rights purchased.

Tips Impressed by "turnkey capabilities in Macintosh design and finished film/proof composition."

MAINE

☑ ▣ DW GROUP

19 Commercial St., Portland ME 04101. (207)775-5100. Fax: (207)775-5147. E-mail: dw@dwgroup.com. Website: www.dwgroup.com. **Creative Director:** Frank Laurino. Production Manager: Dana Williams. Estab. 1985. Number of employees 6. Full-service advertising agency.

Needs Works with freelancers for illustration, occasionally for design. Accepts work via disk in compatible Mac formats only. Samples are filed, responds only if interested.

First Contact & Terms Designers and illustrators send samples for review. Pays for design by the hour or by the project, pays for illustration by the project.

▣ MICHAEL MAHAN GRAPHICS

48 Front, P.O. Box 642, Bath ME 04530-0642. (207)443-6110. Fax: (207)443-6085. E-mail: m2design@ime.net. **Contact:** Linda Delorme. Estab. 1986. Number of employees 5. Approximate annual billing $500,000. Design

🖥 ✠ WP POST & GRAPHICS

228 Pennsylvania, Wichita KS 67214-4149. (316)263-7212. Fax: (316)263-7539. E-mail: wppost@aol.com. Website: www.wponline.com. **Art Director:** Kelly Flack. Estab. 1968. Number of employees 4. Ad agency, design firm, video production/animation. Specializes in TV commercials, print advertising, animation, web design, packaging. Product specialties are automative, broadcast, furniture, restaurants. Current clients include Adventure RV and Truck Center, The Wichita Eagle, Dick Edwards Auto Plaza, Turner Tax Wise. Client list available upon request. Professional affiliations Advertising Federation of Wichita.

• Recognized by the American Advertising Federation of Wichita for excellence in advertising.

Needs Approached by 2 illustrators and 10 designers/year. Works with 1 illustrator and 2 designers/year. Prefers local designers with experience in Macintosh production, video and print. Uses freelancers mainly for overflow work. Also for animation, brochure design and illustration, catalog design and illustration, logos, TV/film graphics, web page design and desktop production. 10% of work is with print ads. 100% of freelance work demands knowledge of Photoshop, FreeHand and QuarkXPress.

First Contact & Terms Designers send query letter with résumé and self-promotional sheet. Illustrators send postcard sample of work or query letter with résumé. Send follow-up postcard samples every 3 months. Accepts disk submissions if compatible with Macintosh-formatted, Photoshop 4.0, FreeHand 7.0, or an EPS file. Samples are filed and are not returned. Responds only if interested. Art director will contact artist for portfolio review of b&w, color, final art, illustration if interested. Pays by the project. Rights purchased vary according to project and are negotiable. Finds artists through local friends and coworkers.

Tips ''Be creative, be original, and be able to work with different kinds of people.''

KENTUCKY

HAMMOND DESIGN ASSOCIATES, INC.

206 W. Main, Lexington KY 40507. (859)259-3639. Fax: (859)259-3697. Website: www.hammonddesign.com. **Vice-President:** Grady Walter. Estab. 1986. Specializes in direct mail, package and publication design and annual reports, brand and corporate identity, display and signage. Clients corporations, universities and medical facilities.

Needs Approached by 35-50 freelance/year. Works with 5-7 illustrators and 5-7 designers/year. Works on assignment only. Uses freelancers mainly for brochures and ads. Also for editorial, technical and medical illustration, airbrushing, lettering, P-O-P and poster illustration; and charts/graphs. 100% of design and 50% of illustration require computer skills.

First Contact & Terms Send postcard sample or query letter with brochure or résumé. ''Sample in query letter a must.'' Samples are filed or returned by SASE if requested by artist. Responds only if interested. Will contact artist for portfolio review if interested. Pays by the project.

MERIDIAN COMMUNICATIONS

325 W. Main St., Suite 300, Lexington KY 40507. (859)252-3350. Fax: (859)281-5729. E-mail: mes@meridiancomm.com. Website: www.meridiancomm.com. **CEO:** Mary Ellen Slone. Estab. 1975. Number of employees 58. Ad agency. Full-service, multimedia firm. Specializes in ads (magazine and newspaper), TV and radio spots, packaging, newsletters, etc. Current clients include Three Chimneys Farm, IncrediPet, Banfield Pet Hospitals, Slone's Signature Markets, Georgetown College, University of KY.

Needs Approached by 6 artists/month. Works with 2 illustrators and 6 designers/month. Prefers regional/national artists. Works on assignment only. Uses freelancers for brochure and catalog design and illustration, print ad illustration, storyboards, animatics, animation, posters, TV/film graphics, logos.

First Contact & Terms Send query letter with résumé, photocopies, photographs and tearsheets. Samples are filed. Pays negotiable rates for design and illustration. Rights purchased vary according to project.

THE WILLIAMS McBRIDE GROUP

344 E. Main St., Lexington KY 40507. (859)253-9319. Fax: (859)233-0180. E-mail: wmgdesigner@williamsmcbride.com. Website: www.williamsmcbride.com. **Partners:** Robin Williams Brohm and Kimberly McBride. Estab. 1988. Number of employees: 7. Design firm specializing in brand management, corporate identity and business-to-business marketing.

Needs Approached by 10-20 freelance artists/year. Works with 4 illustrators and 3 designers/year. Prefers freelancers with experience in corporate design, branding. Works on assignment only. 100% of freelance design work demands knowledge of QuarkXPress, Photoshop and Illustrator. Will review résumés of web designers with knowledge of Flash, HTML and java script.

First Contact & Terms Designers send query letter with résumé. Will review portfolios electronically or hardcopy samples. Illustrators send website or postcard sample of work. Samples are filed. Responds only if inter-

firm. Specializes in publication designcatalogs and direct mail. Product specialties are furniture, fine art and high tech. Current clients include Bowdoin College, Bath Iron Works and Bradco Chair. Client list available upon request. Professional affiliations G.A.G., AIGA and Art Director's Club-Portland, ME.

Needs Approached by 5-10 illustrators and 10-20 designers/year. Works with 2 illustrators and 2 designers/year. Uses freelancers mainly for production. Also for brochure, catalog and humorous illustration and lettering. 5% of work is with print ads. 100% of design demands skills in Photoshop and QuarkXPress.

First Contact & Terms Designers send query letter with photocopies and résumé. Illustrators send query letter with photocopies. Accepts disk submissions. Samples are filed and are not returned. Responds only if interested. Art director will contact artist for portfolio review of final art roughs and thumbnails if interested. Pays for design by the hour, $15-40. Pays for illustration by the hour, $18-60. Rights purchased vary according to project. Finds artists through word of mouth and submissions.

MARYLAND

✦ SAM BLATE ASSOCIATES LLC

10331 Watkins Mill Dr., Montgomery Village MD 20886-3950. (301)840-2248. Fax: (301)990-0707. E-mail: info@ writephotopro.com. Website: www.writephotopro.com. **President:** Sam Blate. Number of employees 2. Approximate annual billing $120,000. AV and editorial services firm. Clients business/professional, US government, private.

Needs Approached by 6-10 freelancers/year. Works with 1-5 freelance illustrators and 1-2 designers/year. Prefers to work with freelancers in the Washington DC metropolitan area. Works on assignment only. Uses freelancers for cartoons (especially for certain types of audiovisual presentations), editorial and technical illustrations (graphs, etc.) for 35mm and digital slides, pamphlet and book design. Especially important are "technical and aesthetic excellence and ability to meet deadlines." 80% of freelance work demands knowledge of PageMaker, Photoshop, and/or Powerpoint for Windows.

First Contact & Terms Send query letter with résumé and website, tearsheets, brochure, photocopies, slides, transparencies or photographs to be kept on file. Accepts disk submissions compatible with Photoshop and PageMaker. IBM format only. "No original art." Samples are returned only by SASE. Responds only if interested. Pays by the hour, $20-50. Rights purchased vary according to project, "but we prefer to purchase first rights only. This is sometimes not possible due to client demand, in which case we attempt to negotiate a financial adjustment for the artist."

Tips "The demand for technically-oriented artwork has increased."

DEVER DESIGNS

1056 West St., Laurel MD 20707. (301)776-2812. Fax: (301)953-1196. E-mail: info@deverdesigns.com. Website: www.deverdesigns.com. **President:** Jeffrey Dever. Marketing Director: Holly Hagen. Estab. 1985. Number of employees 8. Specializes in annual reports, corporate identity and publication design. Clients: corporations, museums, government agencies, associations, nonprofit organizations.

Needs Approached by 100 freelance illustrators/year. Works with 30-50 freelance illustrators/year. Prefers artists with experience in editorial illustration. Uses illustrators mainly for publications.

First Contact & Terms Send postcard, samples or query letter with photocopies, résumé and tearsheets. Accepts PDFs and disk submissions compatible with Photoshop, Illustrator or InDesign, but prefers hard copy samples which are filed. Will contact artist for portfolio review if interested. Portfolio should include b&w and/or color photocopies for files. Pays for illustration by the project. Rights purchased vary according to project. Finds artists through referrals and sourcebooks.

Tips Impressed by "uniqueness and consistent quality."

✦ PICCIRILLI GROUP

502 Rock Spring Rd., Bel Air MD 21014. (410)879-6780. Fax: (410)879-6602. E-mail: info@picgroup.com. Website: www.picgroup.com. **President:** Aaron Piccirilli. Creative Director: Micah Piccirilli. Estab. 1974. Specializes in design and advertising; also annual reports, advertising campaigns, direct mail, brand and corporate identity, displays, packaging, publications and signage. Clients recreational sport industries, fleet leasing companies, technical product manufacturers, commercial packaging corporations, direct mail advertising firms, realty companies, banks, publishers and software companies.

Needs Works with 4 freelance designers/year. Works on assignment only. Mainly uses freelancers for layout or production. Prefers local freelancers. 75% of design demands skills in Illustrator and QuarkXPress.

First Contact & Terms Send query letter with brochure, résumé and tearsheets; prefers originals as samples. Samples returned by SASE. Responds on whether to expect possible future assignments. To show a portfolio, mail roughs and finished art samples or call for an appointment. Pays for design and illustration by the hour,

$20-45. Considers complexity of project, client's budget, and skill and experience of artist when establishing payment. Buys one-time or reprint rights; rights purchased vary according to project.

Tips "Portfolios should include work from previous assignments. The most common mistake freelancers make is not being professional with their presentations. Send a cover letter with photocopies of work."

☰ SPIRIT CREATIVE SERVICES INC.

3157 Rolling Rd., Edgewater MD 21037. (410)956-1117. Fax: (410)956-1118. Website: www.spiritcreativeservices.com. **President:** Alice Yeager. Estab. 1992. Number of employees 2. Approximate annual billing $90,000. Specializes in catalogs, signage, books, annual reports, brand and corporate identity, display, direct mail, package and publication design, web page design, technical and general illustration, copywriting, photography and marketing. Clients associations, corporations, government. Client list available upon request.

Needs Approached by 30 freelancers/year. Works with local designers only. Uses freelancers for ad, brochure, catalog, poster and P-O-P design and illustration, books, direct mail and magazine design, audiovisual materials, crafts/graphs, lettering, logos and mechanicals. Also for multimedia and Internet projects. 100% of design and 10% of illustration demands knowledge of Illustrator, Photoshop and PageMaker, A Type Manager and QuarkXPress. Also knowledge of web design.

First Contact & Terms Send 2-3 samples of work with résumé. Accepts hardcopy submissions. Does not accept e-mail submissions. Samples are filed. Responds in 1-2 weeks if interested. Request portfolio review in original query. Artist should follow up with call and/or letter after initial query. Portfolio should include b&w and color final art, tearsheets, sample of comping ability. Pays for design by the project, $50-6,000.

Tips "Paying attention to due dates, details, creativity, communication and intuition is vital."

MASSACHUSETTS

☒ A.T. ASSOCIATES

63 Old Rutherford Ave., Charlestown MA 02129. (617)242-6004. **Partner:** Annette Tecce. Estab. 1976. Specializes in annual reports, industrial, interior, product and graphic design, model making, corporate identity, signage, display and packaging. Clients nonprofit companies, high tech, medical, corporate clients, small businesses and ad agencies. Client list available upon request.

Needs Approached by 20-25 freelance artists/year. Works with 3-4 freelance illustrators and 2-3 freelance designers/year. Prefers local artists; some experience necessary. Uses artists for posters, model making, mechanicals, logos, brochures, P-O-P display, charts/graphs and design.

First Contact & Terms Send résumé and nonreturnable samples. Samples are filed or are returned by SASE if requested by artist. Responds only if interested. Call to schedule an appointment to show a portfolio, which should include a "cross section of your work." Pays for design and illustration by the hour or by the project. Rights purchased vary according to project.

☰ RICHARD BERTUCCI/GRAPHIC COMMUNICATIONS

3 Juniper Lane, Dover MA 02030-2146. (508)785-1301. Fax: (508)785-2072. E-mail: rich.bert@netzero.net. **Owner:** Richard Bertucci. Estab. 1970. Number of employees 1. Approximate annual billing $500,000. Specializes in annual reports, corporate identity, display, direct mail, package design, print advertising, collateral material. Clients companies and corporations. Professional affiliations AIGA.

Needs Approached by 12-24 freelancers/year. Works with 6 freelance illustrators and 3 designers/year. Prefers local artists with experience in business-to-business advertising. Uses illustrators mainly for feature products. Uses designers mainly for fill-in projects, new promotions. Also uses freelancers for ad, brochure and catalog design and illustration, direct mail, magazine and newspaper design and logos. 50% of design and 25% of illustration demand knowledge of Illustrator, Photoshop and QuarkXPress.

First Contact & Terms Send postcard sample of work or send query letter with brochure and résumé. Samples are filed. Will contact artist for portfolio review if interested. Portfolio should include b&w and color roughs. Pays for design by the project, $500-5,000. Pays for illustration by the project, $250-2,500. Rights purchased vary according to project.

Tips "Send more information, not just a postcard with no written information." Chooses freelancers based on "quality of samples, turn-around time, flexibility, price, location."

FLAGLER ADVERTISING/GRAPHIC DESIGN

Box 280, Brookline MA 02446. (617)566-6971. Fax: (617)566-0073. E-mail: sflag@aol.com. **President/Creative Director:** Sheri Flagler. Specializes in corporate identity, brochure design, ad campaigns and package design. Clients: finance, real estate, high-tech and direct mail agencies, infant/toddler manufacturers.

Needs Works with 10-20 freelancers/year. Works on assignment only. Uses freelancers for illustration, photography, retouching, airbrushing, charts/graphs and lettering.

First Contact & Terms Send résumé, business card, brochures, photocopies or tearsheets to be kept on file. Call or write for appointment to show portfolio. Samples filed and are not returned. Responds only if interested. Pays for design and illustration by the project, $150-2,500. Considers complexity of project, client's budget and turnaround time when establishing payment.

Tips "Send a range and variety of styles showing clean, crisp and professional work."

G2 PARTNERS

209 W. Central St., Natick MA 01760. (508)651-8158. Fax: (508)655-1637. Website: www.g2partners.com. Estab. 1975. Number of employees 2. Ad Agency. Specializes in advertising, direct mail, branding programs, literature, annual reports, corporate identity. Product specialty is business-to-business.

Needs Uses freelancers mainly for advertising, direct mail and literature. Also for brochure and print ad illustration.

First Contact & Terms Samples are filed or are returned by SASE if requested by artist. Does not reply. Portfolio review not required. Pays for illustration by the project, $500-3,500. Finds artists through annuals and sourcebooks.

▣ MCGRATHICS

18 Chestnut St., Marblehead MA 01945. (781)631-7510. E-mail: www.mcgrathics.com. Website: www.mcgrathics.com. **Art Director:** Vaughn McGrath. Estab. 1978. Number of employees 4-6. Specializes in corporate identity, annual reports, package and publication and web design. Clients corporations and universities. Professional affiliations AIGA, VUGB.

Needs Approached by 30 freelancers/year. Works with 8-10 freelance illustrators/year. Uses illustrators mainly for advertising, corporate identity (both conventional and computer). Also for ad, brochure, catalog, poster and P-O-P illustration; charts/graphs. Computer and conventional art purchased.

First Contact & Terms Send postcard sample of work or send brochure, photocopies, photographs, résumé, slides and transparencies. Samples are filed. Responds only if interested. Portfolio review not required. Pays for illustration by the hour or by the project. Rights purchased vary according to project. Finds artists through sourcebooks and mailings.

Tips "Annually mail us updates for our review."

DONYA MELANSON ASSOCIATES

5 Bisson Lane, Merrimac MA 01860. (978)346-9240. Fax: (978)346-8345. E-mail: dmelanson@dmelanson.com. Website: www.dmelanson.com. **Contact:** Donya Melanson. Advertising agency. Number of employees 6. Clients industries, institutions, education, associations, publishers, financial services and government. Current clients include US Geological Survey, Mannesmann, Cambridge College, American Psychological Association, Ladoca Enterprises and US Dept. of Agriculture. Client list available upon request.

Needs Approached by 30 artists/year. Works with 3-4 illustrators/year. Most work is handled by staff, but may occasionally use illustrators and designers. Uses artists for stationery design, direct mail, brochures/flyers, annual reports, charts/graphs and book illustration. Needs editorial and promotional illustration. 50% of freelance work demands skills in Illustrator, QuarkXPress, InDesign or Photoshop.

First Contact & Terms Query with brochure, résumé, photostats and photocopies. Provide materials (no originals) to be kept on file for future assignments. Originals returned to artist after use only when specified in advance. Call or write for appointment to show portfolio or mail thumbnails, roughs, final art, final reproduction/product and color and b&w tearsheets, photostats and photographs. Pays for design and illustration by the project, $100 minimum. Considers complexity of project, client's budget, skill and experience of artist and how work will be used when establishing payment.

Tips "Be sure your work reflects concept development. We would like to see more electronic design and illustration capabilities."

▣ MONDERER DESIGN, INC.

2067 Massachusetts Ave., 3rd Floor, Cambridge MA 02140. (617)661-6125. Fax: (617)661-6126. E-mail: info@monderer.com. Website: www.monderer.com. **Creative Director:** Stewart Monderer. Estab. 1982. Specializes in annual reports, corporate identity, package and publication design, employee benefit programs, corporate capability brochures. Clients corporations (hi-tech, industry, institutions, healthcare, utility, consulting, service) and nonprofit organizations. Current clients include Aspen Technology, Spotfire, eCredit.com, Dynisco, Harvard AIDS Project and Project Hope. League School, Pegasystems and Millipore. Client list on website.

Needs Approached by 40 freelancers/year. Works with 5-10 freelance illustrators and 1-5 designers/year. Works on assignment only. Uses illustrators mainly for corporate communications. Uses designers for design and

production assistance. Also uses freelancers for mechanicals and illustration. Needs computer-literate freelancers for design, illustration and production. 50% of freelance work demands knowledge of Illustrator, QuarkXPress, Photoshop or FreeHand. Needs editorial and corporate illustration.

First Contact & Terms Send query letter with brochure, tearsheets, photographs, photocopies or nonreturnable postcards. Will look at links and PDF files. Samples are filed. Will contact artist for portfolio review if interested. Portfolio should include b&w and color-finished art samples. Sometimes requests work on spec before assigning a job. Pays for design by the hour, $15-25; by the project. Pays for illustration by the project, $250 minimum. Negotiates rights purchased. Finds artists through submissions/self-promotions and sourcebooks.

[N] MRW COMMUNICATIONS

2 Fairfield St., Hingham MA 02043. (617)742-4411. Fax: (617)742-4484. E-mail: jim@mrwinc.com. Website: www.mrwinc.com. **President:** Jim Watts. Estab. 1983. Ad agency. Specializes in ads, collateral, DM. Website: development, online marketing. Product specialties are high tech, healthcare. Client list available upon request.

Needs Approached by 40-50 freelance illustrators and 40-50 designers/year. Works with 5-10 freelance illustrators and 2-5 designers/year. Prefers freelancers with experience in a variety of techniques brochure, medical and technical illustration, multimedia projects, retouching, storyboards, TV/film graphics and web page design. 75% of work is with print ads. 90% of design and 90% of illustration demands skills in FreeHand, Photoshop, QuarkXPress, Illustrator.

First Contact & Terms Designers: Send query letter with photocopies, photographs, résumé. Illustrators: Send postcard sample and résumé, follow-up postcard every 6 months. Accepts disk submissions compatible with QuarkXPress 7.5/version 3.3. Send EPS files. Samples are filed. Will contact for portfolio review of b&w, color final art if interested. Pays by the hour, by the project or by the day depending on experience and ability. Rights purchased vary according to project. Finds artist through sourcebooks and word of mouth.

[◼] [✝] PRECISION ARTS ADVERTISING INC.

57 Fitchburg Rd., Ashburnham MA 01430. (978)827-4927. Fax: (978)827-4928. E-mail: artistmarket@precisionarts.com. Website: www.precisionarts.com. **President:** Terri Adams. Estab. 1985. Number of employees 2. Full-service web/print ad agency. Specializes in internet marketing strategy, website/print design, graphic design. Product specialty is manufacturing, including plastics, surgical and medical instruments, electronic equipment and instrumentation. Client list available upon request. Clients include Northern Products, Safety Source Northeast, Ranor.

Needs Approached by 5 freelance illustrators and 5 designers/year. Works with 1 freelance illustrator and 1 designer/year. Prefers local freelancers. 49% of work is with printing/marketing. 36% of work is web design. Freelance web skills required in Macintosh DreamWeaver and Photoshop; freelance print skills required in QuarkXPress, Photoshop, Illlustrator and Pre-Press.

First Contract & Terms Send résumé with links to artwork and suggested hourly rate.

[◼] SELBERT-PERKINS DESIGN COLLABORATIVE

11 Water St., Arlington MA 02476. (781)574-6605. Fax: (781)574-6606. E-mail: lmurphy@spdeast.com. Website: www.selbertperkins.com. Estab. 1980. Number of employees 25. Specializes in annual reports, brand identity design, displays, landscape architecture and urban design, direct mail, product and package design, exhibits, interactive media and CD-ROM design and print and environmental graphic design. Clients: airports, colleges, theme parks, corporations, hospitals, computer companies, retailers, financial institutions, architects. Professional affiliations: AIGA, SEGD.

- This firm has an office at 200 Culver Blvd., Playa del Rey CA 90293. (310)822-5223. Fax: (310)822-5203. E-mail: nmartinez@spdwest.com.

Needs Approached by "hundreds" of freelancers/year. Works with 10 freelance illustrators and 20 designers/year. Prefers artists with "experience in all types of design and computer experience." Uses freelance artists for brochures, mechanicals, logos, P-O-P, poster and direct mail. Also for multimedia projects. 100% of freelance work demands knowledge of QuarkXPress, FreeHand, Photoshop, PageMaker, Canvas and Persuasion, InDesign, Illustrator.

First Contact & Terms Send query letter with brochure, résumé, tearsheets, photographs, photocopies, slides and transparencies. Samples are filed. Responds only if interested. Portfolios may be dropped off every Monday-Friday. Artist should follow up with call and/or letter after initial query. Will contact artist for portfolio review if interested. Pays for design by the hour, $15-35 or by the project. Pays for illustration by the project. Rights purchased vary according to project. Finds artists through word of mouth, magazines, submissions/self-promotions, sourcebooks and agents.

SPECTRUM BOSTON CONSULTING, INC.

9 Park St., Boston MA 02108. (617)367-1008. Fax: (617)367-5824. E-mail: gboesel@spectrumboston.com. **President:** George Boesel. Estab. 1985. Specializes in brand and corporate identity, display and package design and signage. Clients consumer, durable manufacturers.

Needs Approached by 50 freelance artists/year. Works with 15 illustrators and 3 designers/year. All artists employed on work-for-hire basis. Works on assignment only. Uses illustrators mainly for package and brochure work. Also for brochure design and illustration, mechanicals, logos, P-O-P design and illustration and model-making. 100% of design and 85% of illustration demand knowledge of Illustrator, QuarkXPress, Photoshop or FreeHand. Needs technical and instructional illustration.

First Contact & Terms Designers send query letter with résumé and photocopies. Illustrators send query letter with tearsheets, photographs and photocopies. Accepts any Mac-formatted disk submissions except for Page-Maker. Samples are filed. Responds only if interested. Call or write for appointment to show portfolio of roughs, original/final art and color slides.

◼ 🎬 TR PRODUCTIONS

209 W. Central Street, Suite 108, Natick MA 01760. (508)650-3400. Fax: (508)650-3455. Website: www.trprod.com. **Creative Director:** Cary M. Benjamin. Estab. 1947. Number of employees 12. AV firm. Full-service multimedia firm. Specializes in FLASH, collateral, multimedia, web graphics and video.

Needs Approached by 15 freelancers/year. Works with 5 freelance illustrators and 5 designers/year. Prefers local freelancers with experience in slides, web, multimedia, collateral and video graphics. Works on assignment only. Uses freelancers mainly for slides, web, multimedia, collateral and video graphics. Also for brochure and print ad design and illustration, slide illustration, animation and mechanicals. 25% of work is with print ads. Needs computer-literate freelancers for design, production and presentation. 95% of work demands skills in FreeHand, Photoshop, Premier, After Effects, Powerpoint, QuarkXPress, Illustrator, Flash and Front Page.

First Contact & Terms Send query letter. Samples are filed. Does not reply. Artist should follow up with call. Will contact artist for portfolio review if interested. Rights purchased vary according to project.

◼ WEYMOUTH DESIGN, INC.

332 Congress St., Boston MA 02210-1217. (617)542-2647. Fax: (617)451-6233. E-mail: jlizardo@weymouthdesign.com. **Staff Assistant:** Johana Bodnyk. Estab. 1973. Number of employees 16. Specializes in annual reports, corporate collateral, designing websites and laptop presentations, CD-ROMs and miscellaneous multimedia. Clients corporations and small businesses. Client list not available. Professional affiliation AIGA.

Needs Works with 3-5 freelance illustrators and/or photographers. Needs editorial, medical and technical illustration mainly for annual reports. Also uses freelancers for multimedia projects.

First Contact & Terms Send query letter with résumé or illustration samples and/or tearsheets. Samples are filed or are returned by SASE if requested by artist. Will contact artist for portfolio review if interested.

MICHIGAN

BIGGS GILMORE COMMUNICATIONS

261 E. Kalamazoo Ave., Suite 300, Kalamazoo MI 49007-3990. (269)349-7711. Fax: (269)349-3051. Website: www.biggs-gilmore.com. Estab. 1973. Ad agency. Full-service, multimedia firm. Specializes in traditional advertising (print, collateral, TV, radio, outdoor), branding, strategic planning, e-business development, and media planning and buying. Product specialties are consumer, business-to-business, marine and healthcare.

- This is one of the largest agencies in southwestern Michigan. Clients include DuPont, Kellogg Company, Zimmer Inc., Armstrong Machine Works, American Greetings, Forest Laboratories, Pfizer Animal Health and Wilmington Trust.

Needs Approached by 10 artists/month. Works with 1-3 illustrators and designers/month. Works both with artist reps and directly with artist. Prefers artists with experience with client needs. Works on assignment only. Uses freelancers mainly for completion of projects needing specialties. Also for brochure, catalog and print ad design and illustration, storyboards, mechanicals, retouching, billboards, posters, TV/film graphics, lettering and logos.

First Contact & Terms Send query letter with brochure, photocopies and résumé. Samples are filed. Responds only if interested. Call for appointment to show portfolio. Portfolio should include all samples the artist considers appropriate. Pays for design and illustration by the hour and by the project. Rights purchased vary according to project.

◼ LEO J. BRENNAN, INC.

2359 Livernois, Troy MI 48083-1692. (248)524-3222. Fax: (248)362-2355. E-mail: lbrennan@ljbrennan.com. Website: www.ljbrennan.com. **Vice President:** Virginia Janusis. Estab. 1969. Number of employees 11. Ad

agency, PR and marketing firm. Clients: industrial, electronics, robotics, automotive, banks and CPAs.

Needs Works with 2 illustrators and 2 designers/year. Prefers experienced artists Uses freelancers for design, technical illustration, brochures, catalogs, retouching, lettering, keylining and typesetting. Also for multimedia projects. 50% of work is with print ads. 100% of freelance work demands knowledge of IBM software graphics programs.

First Contact & Terms Send query letter with résumé and samples. Samples not filed are returned only if requested. Responds only if interested. Call for appointment to show portfolio of thumbnails, roughs, original/ final art, final reproduction/product, color and b&w tearsheets, photostats and photographs. Payment for design and illustration varies. Buys all rights.

☒ COMMUNICATIONS ELECTRONICS, INC.

Dept AM, Box 2797, Ann Arbor MI 48106-2797. (734)996-8888. E-mail: cei@usascan.com. **Editor:** Ken Ascher. Estab. 1969. Number of employees 38. Approximate annual billing $5 million. Manufacturer, distributor and ad agency (13 company divisions). Specializes in marketing. Clients electronics, computers.

Needs Approached by 500 freelancers/year. Works with 40 freelance illustrators and 40 designers/year. Uses freelancers for brochure and catalog design, illustration and layout, advertising, product design, illustration on product, P-O-P displays, posters and renderings. Needs editorial and technical illustration. Prefers pen & ink, airbrush, charcoal/pencil, watercolor, acrylic, marker and computer illustration. 30% of freelance work demands skills in PageMaker or QuarkXPress.

First Contact & Terms Send query letter with brochure, résumé, business card, samples and tearsheets to be kept on file. Samples not filed are returned by SASE. Responds in 1 month. Will contact artist for portfolio review if interested. Pays for design and illustration by the hour, $10-120; by the project, $10-15,000; by the day, $40-800.

☒ PHOTO COMMUNICATION SERVICES, INC.

P.O. Box 9,Traverse City MI 49864. (231)943-5050. E-mail: artists@UtopianEmpire.com. Website: www.Utopia nEmpire.com. **Contact:** MsM'Lynn Hartwell. Estab. 1970. Full-service, multimedia firm. Specializes in corporate and industrial products, as well as T.V. and radio spots.

Needs Works on assignment. Uses freelancers mainly for internet web page, brochure, catalog and print ad design and illustration storyboards, animation, logos and more. 70% of work is with print ads.

First Contact & Term Send query with brochure, SASE and tearsheets. Samples are filed or returned by SASE if requested by artist. Responds only if interested. To show portfolio, mail tearsheets and transparencies, CD-ROM. Pays for design and illustration by the project, negotiated rate. Rights purchased vary according to project.

☒ J. WALTER THOMPSON USA

500 Woodward Ave., Detroit MI 48226-3428. (313)964-3800. Website: www.jwtworld.com. **Art Administrator:** Steve Brouwer. Number of employees 450. Approximate annual billing $50 million. Ad agency. Clients automotive, consumer, industry, media and retail-related accounts.

Needs Approached by 50 freelancers/year. Works with 15 freelance illustrators and 5 designers/year. "Prefer using local talent. Will use out-of-town talent based on unique style." 75% of design and 50% of illustration demand knowledge of Photoshop. Deals primarily with established artists' representatives and art/design studios. Uses in-house computer/graphic studio.

First Contact & Terms Send postcard sample. Assignments awarded on lowest bid. Call for appointment to show portfolio of thumbnails, roughs, original/final art, final reproduction/product, color tearsheets, photostats and photographs. Pays for design and illustration by the project.

Tips "Portfolio should be comprehensive but not too large. Organization of the portfolio is as important as the sample. Mainly, consult professional rep."

MINNESOTA

▣ PATRICK REDMOND DESIGN

P.O. Box 75430-AGDM, St. Paul MN 55175-0430. (651)503-4480. E-mail: PatrickRedmond@apexmail.com and redmond@patrickredmonddesign.com. Website: www.PatrickRedmondDesign.com. **Designer/Owner/President:** Patrick M. Redmond, M.A. Estab. 1966. Number of employees 1. Specializes in book cover design, logo and trademark design, brand and corporate identity, package, publication and direct mail design, website design, design consulting and education and posters. Has provided design services for many clients in the following categories publishing, advertising, marketing, retail, financial, food, arts, education, computer, manufacturing, small business, healthcare, government and professions. Recent clients include independent publishers, performing artists, etc.

Needs Clients use freelancers mainly for editorial and technical illustration, publications, books, brochures and newsletters. Also for website and multimedia projects. 80% of freelance work demands knowledge of Macintosh, QuarkXPress, Photoshop, Illustrator, InDesign (latest versions).

First Contact & Terms Send postcard sample and/or photocopies. Samples not filed are thrown away. No samples returned. Responds only if interested. "Artist will be contacted for portfolio review if work seems appropriate for client needs. Patrick Redmond Design will not be responsible for acceptance of delivery or return of portfolios not specifically requested from artist or rep. Samples must be presented in person unless other arrangements are made. Unless specifically agreed to in writing in advance, portfolios should not be sent unsolicited." Client pays for design and illustration by the project. Rights purchased vary according to project. Considers buying second rights (reprint rights) to previously published work. Finds artists through word of mouth, magazines, submissions/self-promotions, exhibitions, competitions, CD-ROM, sourcebooks, agents and WWW.

Tips "Provide website address so samples of your work may be viewed on the WWW. I see trends toward extensive use of the WWW and a broader spectrum of approaches to images, subject matter and techniques. Clients also seem to have increasing interest in digitized, copyright-free stock images of all kinds." Advises freelancers starting out in the field to "create as much positive exposure for your images or design examples as possible. Make certain your name and location appear with image or design credits. Photos, illustrations and design are often noticed with serendipity. For example, your work may be just what a client needsso make sure you have name and UFL in credit. If possible, include your e-mail address and www URL with or on your work. Do not send samples via e-mail unless specifically requested. At times, client and project demands require working in teams online, via internet, sending/receiving digital files to and from a variety of locations. *Do not send digital files/images as attachments to e-mails unless specifically requested.* Provide names of categories you specialize in, website addresses/url's where your work/images may be viewed."

MISSOURI

PHOENIX LEARNING GROUP, INC.

2349 Chaffee Dr., St. Louis MO 63146. (314)569-0211. Fax: (314)569-2834. Website: phoenixlearninggroup.com. **President:** Heinz Gelles. Executive Vice President: Barbara Bryant. Vice President, Market Development: Kathy Longsworth. Number of employees 50. Clients: libraries, museums, religious institutions, US government, schools, universities, film societies and businesses. Produces and distributes educational films.

Needs Works with 1-2 freelance illustrators and 2-3 designers/year. Prefers local freelancers only. Uses artists for motion picture catalog sheets, direct mail brochures, posters and study guides. Also for multimedia projects. 85% of freelance work demands knowledge of PageMaker, QuarkXPress and Illustrator.

First Contact & Terms Send postcard sample and query letter with brochure (if applicable). Send recent samples of artwork and rates to director of promotions. "No telephone calls please." Responds if need arises. Buys all rights. Keeps all original art "but will loan to artist for use as a sample." Pays for design and illustration by the hour or by the project. Rates negotiable. Free catalog upon written request.

MONTANA

WALKER DESIGN GROUP

47 Dune Dr., Great Falls MT 59404. (406)727-8115. Fax: (406)791-9655. **President:** Duane Walker. Number of employees 6. Design firm. Specializes in annual reports and corporate identity. Professional affiliations AIGA and Ad Federation.

Needs Uses freelancers for animation, annual reports, brochure, medical and technical illustration, catalog design, lettering, logos and TV/film graphics. 80% of design and 90% of illustration demand skills in PageMaker, Photoshop and Adobe Illustration.

First Contact & Terms Send query letter with brochure, photocopies, photographs, résumé, slides and/or tearsheets. Accepts disk submissions. Samples are filed and are not returned. Responds only if interested. To arrange portfolio review, artist should follow up with call or letter after initial query. Portfolio should include color photographs, photostats and tearsheets. Pays by the project; negotiable. Finds artists through *Workbook*.

Tips "Stress customer service and be very aware of time lines."

NEBRASKA

Ⓝ J. GREG SMITH

1004 Farnam St., Omaha NE 68102. (402)444-1600. Fax: (402)444-1610. **Senior Art Director:** Greg Smith. Estab. 1974. Number of employees 8. Approximate annual billing $1.5 million. Ad agency. Clients financial, banking, associations, agricultural, travel and tourism, insurance. Professional affiliation AAAA.

Needs Approached by 1-10 freelancers/year. Works with 4-5 freelancers illustrators and 1-2 designers/year. Works on assignment only. Uses freelancers mainly for mailers, brochures and projects. Also for consumer and trade magazines, catalogs and AV presentations. Needs illustrations of farming, nature, travel.

First Contact & Terms Send query letter with samples showing art style and/or photocopies. Responds only if interested. To show portfolio, mail final reproduction/product, color and b&w. Pays for design and illustration by the project, $500-5,000. Buys first, reprint or all rights.

SWANSON RUSSELL ASSOCIATES

14301 SNB Parkway, Suite312, Omaha NE 68115. (402)393-4940. Fax: (402)393-6926. E-mail: paul_b@oma.sra marketing.com. Website: www.sramarketing.com. **Associate Creative Director:** Paul Berger. Estab. 1963. Number of employees 70. Approximate annual billing $40 million. Integrated marketing communications agency. Specializes in collateral, catalogs, magazine and newspaper ads, direct mail. Product specialties are healthcare, pharmaceuticals, agriculture. Current clients include Schering-Plough Animal Health, Alegent Health, AGP Inc. Professional affiliations 4A's, PRSA, AIGA, Ad Club.

Needs Approached by 12 illustrators and 3-4 designers/year. Works with 5 illustrators and 2 designers/year. Prefers freelancers with experience in agriculture, pharmaceuticals, human and animal health. Uses freelancers mainly for collateral, ads, direct mail, storyboards. Also for brochure design and illustration, humorous and technical illustration, lettering, logos, mechanicals, posters, storyboards. 10% of work is with print ads. 90% of design demands knowledge of Photoshop 7.0, FreeHand 5.0, QuarkXPress 3.3. 30% of illustration demands knowledge of Photoshop, Illustrator, FreeHand.

First Contact & Terms Designers: Send query letter with photocopies, photographs, photostats, SASE, slides, tearsheets, transparencies. Illustrators: Send query letter with SASE. Send follow-up postcard samples every 3 months. Accepts Mac compatible disk submissions. Send self-expanding archives and player for multimedia, or JPEG, EPS and TIFFs. Software Quark, FreeHand or Adobe. Samples are filed or returned by SASE. Responds only if interested within 2 weeks. Art director will contact artist for portfolio review of final art, photographs, photostats, transparencies if interested. Pays for design by the hour, $50-65; pays for illustration by the project, $250-3,000. Rights purchased vary according to project. Finds artists through agents, submissions, word of mouth, *Laughing Stock; American Showcase.*

WEBSTER DESIGN ASSOCIATES, INC.

5060 Dodge St., Omaha NE 68132. (402)551-0503. Fax: (402)551-1410. **Contact:** Dave Webster. Estab. 1982. Number of employees 12. Approximate annual billing $16.3 million. Design firm specializing in 3 dimensional direct mail, corporate identity, human resources, print communications, Web-interactive brochure/annual report design. Product specialites are telecommunications, Web design, corporate communications and human resources. Client list available upon request. Member of AIGA, Chamber of Commerce and Metro Advisory Council.

● Webster Design has chalked up a long list of awards for their exciting 3-D direct mail campaigns for clients. Work has been featured in *American Corporate Identity* and *Print's Regional Design Annual 1996.*

Needs Approached by 50 freelance illustrators and 50-75 freelance designers/year. Works with 12 freelance illustrators and 6 freelance designers/year. Prefers national and international artists with experience in QuarkXPress, Illustrator and Photoshop. Uses freelancers mainly for illustration, photography and annual reports. 15% of work is with print ads. 100% of freelance design and 70% of freelance illustration require knowledge of Aldus Freehand, Photoshop, Illustrator and QuarkXPress.

First Contact & Terms Designers: Send brochure, photographs and résumé. Illustrators: Send postcard sample of work or query letter with brochure and photographs. Send follow-up postcard every 3 months. Accepts submissions on disk, Photoshop and Illustrator. EPS preferred in most cases. Sample are filed or returned. Responds only if interested. To show portfolio, artist should follow-up with a call and/or letter after initial query. Portfolio should include b&w and color tearsheets, thumbnails and transparencies. Pays by the project. Rights purchased vary according to project. Finds artists through *Creative Black Book*, magazines and submissions.

NEVADA

VISUAL IDENTITY

6250 Mountain Vista, L-5, Henderson NV 89014. (702)454-7773. Fax: (702)454-6293. Website: www.visualid.net. **Creative Designer:** William Garbacz. Estab. 1987. Number of employees 5. Approximate annual billing $500,000. Specializes in annual reports; brand and corporate identity; display, direct mail, package and publication design; signage and gaming brochures. Clients ad agencies and corporations. Current clients include Sam's Town, Sports Club L.V. and Westward-Ho.

Needs Approached by 50 freelancers/year. Works with 3 freelancers and 3 designers/year. Prefers local artists with experience in gaming. Uses illustrators and designers mainly for brochures and billboards. Also uses freelancers for ad, P-O-P and poster design and illustration; direct mail, magazine and newspaper design; lettering; and logos. Needs computer-literate freelancers for design, illustration, production, presentation and 3D. 99% of freelance work demands knowledge of Illustrator, Photoshop, FreeHand, QuarkXPress, Painter, Ray Dream.

First Contact & Terms Send résumé and tearsheets. Samples are filed. Will contact artist for portfolio review if interested. Portfolio should include photocopies and roughs. Pays for design and illustration by the project, $100-1,000. Rights purchased varied according to project.

Tips Finds artists through ''any and every source available.''

NEW JERSEY

BLOCK ADVERTISING & MARKETING, INC.
3 Clairidge Dr., Verona NJ 07044. (973)857-3900. Fax: (973)857-4041. E-mail: blockmark@aol.com. **Senior VP/Creative Director:** Karen DeLuca. Senior Art Director Jay Baumann. Studio Manager: John Murray. Art Director: Evan Daly. Estab. 1939. Number of employees 25. Approximate annual billing $12 million. Product specialties are food and beverage, education, finance, home fashion, giftware, healthcare and industrial manufacturing. Professional affiliations Ad Club of North Jersey.

Needs Approached by 100 freelancers/year. Works with 25 freelance illustrators and 25 designers/year. Prefers to work with ''freelancers with at least 3-5 years experience as Mac-compatible artists and 'on premises' work as Mac artists.'' Uses freelancers for ''consumer friendly'' technical illustration, layout, lettering, mechanicals and retouching for ads, annual reports, billboards, catalogs, letterhead, brochures and corporate identity. Needs computer-literate freelancers for design and presentation. 90% of freelance work demands knowledge of QuarkXPress, Illustrator, Type-Styler and Photoshop.

First Contact & Terms To show portfolio, mail appropriate samples and follow up with a phone call. E-mail résumé and samples of work or mail the same. Responds in 2 weeks. Pays for design by the hour, $20-60. Pays for illustration by the project, $250-5,000 or more.

Tips ''We are fortunately busy—we use four to six freelancers daily. Be familiar with the latest versions of QuarkXPress, Illustrator and Photoshop. We like to see sketches of the first round of ideas. Make yourself available occasionally to work on premises. Be flexible in usage rights!''

N CUTRO ASSOCIATES, INC.
47 Jewett Ave., Tenafly NJ 07670. (201)569-5548. Fax: (201)569-8987. E-mail: cutroassoc@optonline.net. **Manager:** Ronald Cutro. Estab. 1961. Number of employees 2. Specializes in annual reports, corporate identity, direct mail, fashion, package and publication design, technical illustration and signage. Clients corporations, business-to-business, consumer.

Needs Approached by 5-10 freelancers/year. Works with 2-3 freelance illustrators and 2-3 designers/year. Prefers local artists only. Uses illustrators mainly for wash drawings, fashion, specialty art. Uses designers for comp layout. Also uses freelancers for ad and brochure design and illustration, airbrushing, catalog and P-O-P illustration, direct mail design, lettering, mechanicals, and retouching. Needs computer-literate freelancers for design, illustration and production. 98% of freelance work demands knowledge of Illustrator, QuarkXPress and Photoshop.

First Contact & Terms Send postcard sample of work. Samples are filed. Will contact artist for portfolio review if interested. Portfolio should include final art and photocopies. Pays for design and illustration by the project. Buys all rights.

NORMAN DIEGNAN & ASSOCIATES
3 Martens Rd., Lebanon NJ 08833. (908)832-7951. Fax: (908)832-9650. Website: www.diegnan-associates.com. **President:** N. Diegnan. Estab. 1977. Number of employees 5. Approximate annual billing $1 million. PR firm. Specializes in magazine ads. Product specialty is industrial.

Needs Approached by 10 freelancers/year. Works with 20 freelancers illustrators/year. Works on assignment only. Uses freelancers for brochure, catalog and print ad design and illustration, storyboards, slide illustration, animatics, animation, mechanicals, retouching and posters. 50% of work is with print ads. Needs editorial and technical illustration.

First Contact & Terms Send query letter with brochure and tearsheets. Samples are filed and not returned. Responds in 1 week. To show portfolio, mail roughs. Pays for design and illustration by the project. Rights purchased vary according to project.

KJD TELEPRODUCTIONS

30 Whyte Dr., Voorhees NJ 08043. (856)751-3500. Fax: (856)751-7729. E-mail: nbc1@comcast.net. Website: www.kjdteleproductions.com. **President:** Larry Scott. Estab. 1989. Ad agency/AV firm. Full-service multimedia firm. Specializes in magazine, radio and television. Current clients include Roster Financial and Hartcourt Books.

Needs Works with 20 freelance illustrators and 12 designers/year. Prefers freelancers with experience in TV. Works on assignment only. Uses freelancers for brochure and print ad design and illustration, storyboards, animatics, animation, TV/film graphics. 70% of work is with print ads. Also for multimedia projects. 90% of freelance work demands knowledge of QuarkXPress, Illustrator 6.0, PageMaker and FreeHand.

First Contact & Terms Send query letter with brochure, photographs, slides, tearsheets or transparencies and SASE. Samples are filed or are returned by SASE. Accepts submissions on disk from all applications. Send EPS files. Responds only if interested. To show portfolio, mail roughs, photographs and slides. Pays for design and illustration by the project; rate varies. Buys first rights or all rights.

LARRY KERBS STUDIOS

207 W. Cordova Rd., Santa Fe NM 87505. E-mail: kerbscreative@earthlink.net. **Contact:** Larry Kerbs. Specializes in sales promotion design, ad work and placement, annual reports, corporate identity, publications and technical illustration. Clients: industrial, chemical, medical devices, insurance, travel.

- Eastern contact: Jim Lincoln, art director. 581 Mountain Ave., Gillette NJ 07933 (908)604-6137. Fax: (908)647-0543. E-mail: chlincoln@earthlink.net.

OXFORD COMMUNICATIONS, INC.

11 Music Mountain Blvd., Lambertville NJ 08530. (609)397-4242. Fax: (609)397-8863. Website: www.oxfordco mmunications.com. **Creative Director:** Chuck Whitmore. Estab. 1986. Ad agency. Full-service, multimedia firm. Specializes in print advertising and collateral. Product specialties are retail, real estate and destination marketing.

Needs Approached by 6 freelancers/month. Works with 3 designers every 6 months. Prefers local freelancers with experience in Quark, Illustrator and Photoshop. Uses freelancers mainly for production and design. 75% of work is with print ads.

First Contact & Terms E-mail résumé and PDF samples to solutions@oxfordcommunications.com. Samples are filed. Responds only if interested. Will contact artist for portfolio review if interested. Portfolio should include b&w and/or color photostats, tearsheets, photographs and slides. Pays for design and illustration by the project, negotiable. Rights purchased vary according to project.

PRINCETON MARKETECH

196 Rt. 571, Building 2, Suite 15, Princeton Junction NJ 08550. (609)936-0021. Fax: (609)936-0015. E-mail: renee@princetonmarketech.com. Website: www.princetonmarketech.com. **Creative Director:** Renee Hobbs. Estab. 1987. Number of employees 3. Approximate annual billing $3 million. Ad agency. Specializes in direct mail, multimedia, websites. Product specialties are financial, computer, senior markets. Current clients include J.P. Morgan Chase, Citizen's Bank, Simmons Associates. Client list available upon request.

Needs Approached by 12 freelance illustrators and 25 designers/year. Works with 2 freelance illustrators and 5 designers/year. Prefers local designers with experience in Macintosh. Uses freelancers for airbrushing, animation, brochure design and illustration, multimedia projects, retouching, technical illustration, TV/film graphics. 10% of work is with print ads. 90% of design demands skills in Photoshop, QuarkXPress, Illustrator and Macromedia Director. 50% of illustration demands skills in Photoshop, Illustrator.

First Contact & Terms Send query letter with résumé, tearsheets, video or sample disk. Send follow-up postcard every 6 months. Accepts disk submissions compatible with QuarkXPress, Photoshop. Send EPS, PICT files. Samples are filed. Responds only if interested. Pay negotiable. Rights purchased vary according to project.

MIKE QUON/DESIGNATION INC.

543 River Rd., Fair Haven NJ 07704. (732)212-9200. Fax: (732)212-9217. E-mail: mike@quondesign.com. Website: www.quondesign.com. **President:** Mike Quon. Estab. 1982. Number of employees 3. Specializes in corporate identity, displays, direct mail, packaging, publications and Web design. Clients corporations (financial, healthcare, high technology) and ad agencies. Current clients include Pfizer, Bristol-Myers Squibb, American Express, JP Morgan Chase, Hasbro, Verizon, AT&T. Client list available upon request. Professional affiliations AIGA, Society of Illustrators, Graphic Artists Guild.

Needs Approached by 30 illustrators and 30 designers/year. Works with 10 designers/year. Prefers local freelancers. Works on assignment only. Prefers graphic style. Uses artists for brochures, design and catalog illustration, P-O-P displays, logos, mechanicals, charts/graphs and lettering. Especially needs computer artists with skills in QuarkXPress, Illustrator, Photoshop and InDesign.

First Contact & Terms Send query letter with résumé and photocopies. Samples are filed or are returned if accompanied by SASE. Responds only if interested. No portfolio drop-offs. Mail only. Pays for design by the hour, $35-50. Pays for illustration by the project, $100-500. Buys first rights.
Tips "Do good work and continually update art directors with mailed samples."

SMITH DESIGN ASSSOCIATES

205 Thomas St., Box 8278, Glen Ridge NJ 07028. (973)429-2177. Fax: (973)429-7119. E-mail: laraine@smithdesi gn.com. Website: www.smithdesign.com. **Vice President:** Laraine Blauvelt. Clients: grocery, mass market consumer brands, electronics, construction, automotive, toy manufacturers. Current clients Popsicle, Good Humor, Motts. Client list available upon request.
Needs Approached by more than 100 freelancers/year. Works with 10-20 freelance illustrators and 3-4 designers/year. Requires high level, experienced, talent, quality work and reliability. Uses freelancers for package design, concept boards, brochure design, print ads, newsletters illustration, P-O-P display design, retail environments, web programming. 90% of freelance work demands knowledge of Illustrator, QuarkXPress, 3-D rendering programs. Design style must be current to trends. Our work ranges from "classic brands" to "of the moment/cutting edge." Particularly when designing for KIDS and TEENS.
First Contact & Terms Send query letter with brochure/samples showing work, style and experience. Include contact information. Samples are filed or are returned only if requested by artist. Responds in 1 week. Call for appointment to show portfolio. Pays for design by the hour, $35-100; or by the project, $175-5,000. Pays for illustration by the project, $175-5,000. Considers complexity of project and client's budget when establishing payment. Buys all rights. (For illustration work, rights may be limited to a particular use TBD). Also buys rights for use of existing noncommissioned art. Finds artists through word of mouth, self-promotions/sourcebooks and agents.
Tips "Know who you're presenting to (visit our website to see our needs). Show work which is relevant to our business at the level and quality we require. We use more freelance designers and illustrators for diversity of style and talent."

NEW MEXICO

BOOKMAKERS LTD.

P.O. Box 1086, Taos NM 87571. (505)776-5435. Fax: (505)776-2762. E-mail: bookmakers@newmex.com. Website: www.bookmakersltd.com. **President:** Gayle McNeil. "We are agents for professional, experienced children's book illustrators and provide design and product in services to the publishing industry."
First Contact & Terms Send query letter with samples and SASE if samples need returning. E-mail inquiries accepted.
Tips The most common mistake illustrators make in presenting samples or portfolios is "too much variety, not enough focus."

LARRY KERBS STUDIOS

207 W. Cordova Rd., Santa Fe NM 87505. (505)988-5904. Fax: (505)988-9107. E-mail: kerbscreative@earthlink. net. **Contact:** Larry Kerbs. Specializes in sales promotion design, ad work and placement, annual reports, corporate identity, publications and technical illustration. Clients industrial, chemical, insurance, travel, PR.
 ● Eastern US **Contact:** Jim Lincoln, 581 Mountain Ave., Gillette NJ 07433. (908)604-6137. Fax: (908)647-0543. E-mail: chlincoln@earthlink.net.
Needs Works with computer production people, 1 illustrator and 1 designer/month. Uses artists for direct mail, layout, illustration, technical art, annual reports, trade magazine ads, product brochures and direct mail. Needs computer-literate freelancers, prefers those with strong design training. Needs editorial and technical illustration. Looks for realistic editorial illustration, montages, 2-color and 4-color.
First Contact & Terms Mail samples or call for interview. Prefers b&w or color line drawings, renderings, layout roughs and previously published work as samples. Provide business card and résumé to be kept on file for future assignments. Negotiates payment by the project.
Tips "Strengthen typographic knowledge and application; know computers, production and printing in depth to be of better service to yourself and to your clients."

R H POWER AND ASSOCIATES, INC.

9621 Fourth St. NW, Albuquerque NM 87114-2128. (505)761-3150. Fax: (505)761-3153. E-mail: rhpower@qwes t.net. Website: www.rhpower.com. **Art Director:** Bruce Yager. Creative Director Roger L. Vergara. Estab. 1989. Number of employees 12. Ad agency. Full-service, multimedia firm. Specializes in TV, magazine, billboard, direct mail, newspaper, radio. Product specialties are recreational vehicles and automotive. Current clients

include Kem Lite Corporation, RV Sales & Rentals of Albany, Ultra-Fab Products, Collier RV, Nichols RV, American RV and Marine. Client list available upon request.

Needs Approached by 10-50 freelancers/year. Works with 5-10 freelance illustrators and 5-10 designers/year. Prefers freelancers with experience in retail automotive layout and design. Uses freelancers mainly for work overload, special projects and illustrations. Also for annual reports, billboards, brochure and catalog design and illustration, logos, mechanicals, posters and TV/film graphics. 50% of work is with print ads. 100% of design demands knowledge of Photoshop 6.0, QuarkXPress and Illustrator 8.0.

First Contact & Terms Send query letter with photocopies or photographs and résumé. Accepts disk submissions in PC format compatible with CorelDraw, QuarkXPress or Illustrator 8.0. Send PC EPS files. Samples are filed and are not returned. Will contact artist for portfolio review if interested. Portfolio should include b&w and color final art, roughs and thumbnails. Pays for design and illustration by the hour, $12 minimum; by the project, $100 minimum. Buys all rights.

Tips Impressed by work ethic and quality of finished product. "Deliver on time and within budget. Do it until it's right without charging for your own corrections."

NEW YORK

N BOXER DESIGN

548 State St., Brooklyn NY 11216-1619. (718)802-9212. Fax: (718)802-9213. E-mail: eileen@boxerdesign.com. Website: www.boxerdesign.com. **Contact:** Eileen Boxer. Estab. 1986. Approximate annual billing $250,000. Design firm. Specializes in books and catalogs for art institutions, announcements, conceptual, primarily, but not exclusively for cultural institutions. Current clients include Ubu Gallery, Guggenheim Museum, The American Federation of The Merril Arts, Dallas Museum of Fine Arts. AIGA award of excellence (Graphic Design USA) 1997.

Needs 10% of work is with print ads. Design work demands intelligent and mature approach to design. Knowledge of Photoshop, Illustrator, QuarkXPress, InDesign.

First Contact & Terms Send e-mail with written and visual credentials. Accepts disk submissions compatible with Adobe PDFs, Quark 6, InDesign, Photoshop, Illustrator, all Mac, Zip. Samples are filed or returned on request. Responds in 3 weeks if interested in artist's work. Artist should follow-up with call after initial query. Pays by the project. Rights purchased vary according to project.

CARNASE, INC.

21 Dorset Rd., Scarsdale NY 10583. (212)777-1500. Fax: (914)725-9539. E-mail: carnase@carnase.com. Website: www.carnase.com. **President:** Tom Carnase. Estab. 1978. Specializes in annual reports, brand and corporate identity, display, landscape, interior, direct mail, package and publication design, signage and technical illustration. Clients agencies, corporations, consultants. Current clients include Clairol, Shisheido Cosmetics, Times Mirror, Lintas New York. Client list not available.

● President Tom Carnase predicts "very active" years ahead for the design field.

Needs Approached by 60 freelance artists/year. Works with 2 illustrators and 1 designer/year. Prefers artists with 5 years experience. Works on assignment only. Uses artists for brochure, catalog, book, magazine and direct mail design and brochure and collateral illustration. Needs computer-literate freelancers. 50% of freelance work demands skills in QuarkXPress or Illustrator.

First Contact & Terms Send query letter with brochure, résumé and tearsheets. Samples are filed. Responds in 10 days. Will contact artist for portfolio review if interested. Portfolio should include photostats, slides and color tearsheets. Negotiates payment. Rights purchased vary according to project. Finds artists through word of mouth, magazines, artists' submissions/self-promotions, sourcebooks and agents.

DESIGN CONCEPTS

137 Main St., Unadilla NY 13849. (607)369-4709. **Owner:** Carla Schroeder Burchett. Estab. 1972. Specializes in annual reports, brand identity, design and package design. Clients corporations, individuals. Current clients include American White Cross and Private & Natural.

Needs Approached by 6 freelance graphic artists/year. Works with 2 freelance illustrators and designers/year. Prefers artists with experience in packaging, photography, interiors. Uses freelance artists for mechanicals, poster illustration, P-O-P design, lettering and logos.

First Contact & Terms Send query letter with tearsheets, brochure, photographs, résumé and slides. Samples are filed or are returned by SASE if requested by artist. Responds. Artists should follow up with letter after initial query. Portfolio should include thumbnails and b&w and color slides. Pays for design by the hour, $30 minimum. Negotiates rights purchased.

Tips "Artists and designers are used according to talent; team cooperation is very important. If a person is

interested and has the professional qualification, he or she should never be afraid to approach us—small or large jobs.''

GARRITY COMMUNICATIONS, INC.

217 N. Aurora St., Ithaca NY 14850. (607)272-1323. Website: www.garrity.com. **Art Directors:** Allan Roe. and Debra Martens. Estab. 1978. Ad agency, AV firm. Specializes in trade ads, newspaper ads, annual reports, video, etc. Product specialties are financial services, food, higher ed.

Needs Approached by 8 freelance artists/month. Works with 2 freelance illustrators and 1 freelance designer/month. Works on assignment only. Uses freelance artists mainly for work overflow situations; some logo specialization. Also uses freelance artists for brochure design and illustration, print ad illustration, TV/film graphics and logos. 40% of work is with print ads. 90% of freelance work demands knowledge of Photoshop, Illustrator, InDesign.

First Contact & Terms Send query letter with brochure and photocopies. Samples are filed and are not returned. Responds only if interested. Will contact artist for portfolio review if interested. Pays for design by the hour, $25-75. Pays for illustration by the project, $150-1,500. Rights purchased vary according to project. Finds artists through sourcebooks, submissions.

Ⓝ KERRY GAVIN STUDIOS

30 Brookwood Rd., Waterford NY 12188. (518)235-5630. Web site: www.kerrygavinsstudio.com. Specializes in publication design. Clients corporations, companies. Client list available upon request.

Needs Approached by 6-10 freelancers/year. Works with 6-8 freelance illustrators and 1-2 designers/year. Uses illustrators mainly for magazine covers. Uses designers mainly for production. Also uses freelancers for magazine design. Freelancers should be familiar with InDesign, Illustrator and Photoshop.

First Contact & Terms Send postcard sample of work or photocopies and tearsheets. Samples are filed or returned. Reports back to the artist only if interested. Portfolio review not required. Pays for design by the hour, $20-35. Pays for illustration by the project, $450 minimum. Buys one-time rights. Finds artists through sourcebooks, direct mailing, word of mouth and annuals.

Tips Impressed by ''prompt response to query calls, good selection of samples, timely delivery.''

McANDREW ADVERTISING

210 Shields Rd., Red Hook NY 12571. (845)756-2276. E-mail: robertrmca@aol.com. **Art/Creative Director:** Robert McAndrew. Estab. 1961. Number of employees 3. Approximate annual billing $200,000. Ad agency. Clients industrial and technical firms. Current clients include chemical processing equipment, electrical components.

Needs Approached by 10 freelancers/year. Works with 2 freelance illustrators and 2 designers/year. Uses mostly local freelancers. Uses freelancers mainly for design, direct mail, brochures/flyers and trade magazine ads. Needs technical illustration. Prefers realistic, precise style. Prefers pen & ink, airbrush and occasionally markers. 30% of work is with print ads. Freelance work demands computer skills.

First Contact & Terms Query with business card and brochure/flier to be kept on file. Samples not returned. Responds in 1 month. Originals not returned. Will contact artist for portfolio review if interested. Portfolio should include roughs and final reproduction. Pays for illustration by the project, $35-300. Pays for design by the project. Considers complexity of project, client's budget and skill and experience of artist when establishing payment. Finds artists through sourcebooks, word of mouth and business cards in local commercial art supply stores.

Tips Artist needs ''an understanding of the product and the importance of selling it.''

MEDIA LOGIC, INC.

One Park Place, Albany NY 12205. (518)456-3015. Fax: (518)456-4279. E-mail: postmaster@mlinc.com. Website: www.mlinc.com. **Production Manager:** Jen Hoehn. Recruiter Susan Wolff. Estab. 1984. Number of employees 83. Approximate annual billing $20 million. Integrated marketing communications agency. Specializes in advertising, marketing communications, design. Product specialties are retail, entertainment. Current clients include education, business-to-business, industrial. Professional affiliations American Marketing Associates, Ad Club of Northeast NY.

- For the third consecutive year, Media Logic has been ranked as one of th industry's top 100 integrated marketing agencies by *PROMO* magazine.

Needs Approached by 20-30 freelance illustrators and 20-30 designers/year. Works with 2 freelance illustrators and 2 designers/year. Prefers freelancers with experience in Mac/Photoshop. Also for annual reports, brochure design, mechanicals, multimedia projects, retouching, Web page design. 30% of work is with print ads. 100% of design and 60% of illustration demand skills in Photoshop, QuarkXPress, Illustrator, Director.

First Contact & Terms Designers send query letter with photocopies, résumé. Illustrators send postcard and/

or query letter with résumé to Susan Wolff. Accepts disk submissions compatible with QuarkXPress 7.5/version 3.3. Send EPS files. Samples are not filed and are returned. Responds only if interested. Portfolios may be dropped off Monday-Friday. Pays by the project; negotiable. Buys all rights.

Tips "Be fast, flexible, talented and able to work with demanding creative director."

MITCHELL STUDIOS DESIGN CONSULTANTS

1810-7 Front St., East Meadow NY 11554. (516)832-6230. Fax: (516)832-6232. E-mail: msdcdesign@aol.com. **Principals:** Steven E. Mitchell and E.M. Mitchell. Estab. 1922. Specializes in brand and corporate identity, displays, direct mail and packaging. Clients: major corporations.

Needs Works with 5-10 freelance designers and 20 illustrators/year. "Most work is started in our studio." Uses freelancers for design, illustration, mechanicals, retouching, airbrushing, model-making, lettering and logos. 100% of design and 50% of illustration demands skills in Illustrator 5, Photoshop 5 and QuarkXPress 3.3. Needs technical illustration and illustration of food, people.

First Contact & Terms Send query letter with brochure, résumé, business card, photographs and photocopies to be kept on file. Accepts nonreturnable disk submissions compatible with Illustrator, QuarkXPress, FreeHand and Photoshop. Responds only if interested. Call or write for appointment to show portfolio of roughs, original/final art, final reproduction/product and color photostats and photographs. Pays for design by the hour, $25 minimum; by the project, $250 minimum. Pays for illustration by the project, $250 minimum.

Tips "Call first. Show actual samples, not only printed samples. Don't show student work. Our need has increased—we are very busy."

JACK SCHECTERSON ASSOCIATES

5316 251 Place, Little Neck NY 11362. (718)225-3536. Fax: (718)423-3478. **Principal:** Jack Schecterson. Estab. 1967. Ad agency. Specializes in 2D and 3D visual marketing; new product introduction; product; package; graphic and corporate design.

Needs Works direct and with artist reps. Prefers local freelancers. Works on assignment only. Uses freelancers for package, product, and corporate design; illustration, brochures, catalogs, logos. 100% of design and 90% of graphic illustration demands skills in Illustrator, Photoshop and InDesign.

First Contact & Terms Send query letter with brochure, photocopies, tearsheets, résumé, photographs, slides, transparencies and SASE; "whatever best illustrates work." Samples not filed are returned by SASE only if requested by artist. Request portfolio review in original query. Will contact artist for portfolio review if interested. Portfolio should include roughs, b&w and color—"whatever best illustrates creative abilities/work." Pays for design and illustration by the project; depends on budget. Buys all rights.

Ⓝ SCHROEDER BURCHETT DESIGN CONCEPTS

137 Main St. Route 7, Unadilla NY 13849-3303. (607)369-4709. **Designer & Owner:** Carla Schroeder Burchett. Estab. 1972. Specializes in packaging, marketing and restoration. Clients manufacturers.

Needs Works on assignment only. Uses freelancers for design, mechanicals, lettering and logos. 20% of freelance work demands knowledge of PageMaker or Illustrator. Needs technical and medical illustration.

First Contact & Terms Send résumé. "If interested, we will contact artist or craftsperson and will negotiate." Write for appointment to show portfolio of thumbnails, final reproduction/product and photographs. Pays for design by the hour, $15 minimum. Pays for illustration by the project. "If it is excellent work, the person will receive what he asks for!" Considers skill and experience of artist when establishing payment. Finds artists through submissions and word of mouth.

Tips "Creativity depends on each individual. Artists should have a sense of purpose and dependability and must work for long and short range plans. Have perseverance. Top people still get in any agency. Don't give up."

Ⓝ SMITH & DRESS

432 W. Main St., Huntington NY 11743. (631)427-9333. **Contact:** A. Dress. Specializes in annual reports, corporate identity, display, direct mail, packaging, publications and signage. Clients corporations.

Needs Works with 3-4 freelance artists/year. Prefers local artists only. Works on assignment only. Uses artists for illustration, retouching, airbrushing and lettering.

First Contact & Terms Send query letter with brochure showing art style or tearsheets to be kept on file (except for works larger than 8½×11). Pays for illustration by the project. Considers client's budget and turnaround time when establishing payment.

TOBOL GROUP, INC.

14 Vanderventer Ave., #L-2, Port Washington NY 11080. (516)767-8182. Fax: (516)767-8185. E-mail: mt@tobolgroup.com. Website: www.tobolgroup.com. Estab. 1981. Ad agency. Product specialties are "50/50, business to business and business to consumer."

Needs Approached by 2 freelance artists/month. Works with 1 freelance illustrator and 1 designer/month. Works on assignment only. Uses freelancers for brochure, catalog and print ad design and technical illustration, mechanicals, retouching, billboards, posters, TV/film graphics, lettering and logos. 45% of work is with print ads. 75% of freelance work demands knowledge of QuarkXPress, Illustrator, Photoshop or GoLive.

First Contact & Terms Send query letter with SASE and tearsheets. Samples are filed or are returned by SASE. Responds in 1 month. Call for appointment to show portfolio or mail thumbnails, roughs, b&w and color tearsheets and transparencies. Pays for design by the hour, $25 minimum; by the project, $100-800; by the day, $200 minimum. Pays for illustration by the project, $300-1,500 ($50 for spot illustrations). Negotiates rights purchased.

N VISUAL HORIZONS

180 Metro Park, Rochester NY 14623. (585)424-5300. Fax: (585)424-5313. E-mail: slides1@aol.com or info@vis ualhorizons.com. Website: www.visualhorizons.com. Estab. 1971. AV firm. Full-service multimedia firm. Specializes in presentation products; digital imaging of 35mm slides. Current clients include US government agencies, corporations and universities.

Needs Works on assignment only. Uses freelancers mainly for catalog design. 10% of work is with print ads. 100% of freelance work demands skills in PageMaker and Photoshop.

First Contact & Terms Send query letter with tearsheets. Samples are not filed and are not returned. Responds if interested. Portfolio review not required. Pays for design and illustration by the hour or project, negotiated. Buys all rights.

NEW YORK CITY

BBDO NEW YORK

1285 Avenue of the Americas, New York NY 10019-6028. (212)459-5000. Fax: (212)459-6645. Website: www.bb do.com. **Illustration Manager/Creative Project Coordinator:** Ron Williams. Estab. 1891. Number of employees 850. Annual billing $50,000,000. Specializes in business, consumer advertising, sports marketing and brand development. Clients include Texaco, Frito Lay, Bayer, Campbell Soup, FedEx, Pepsi, Visa and Pizza Hut. Ad agency. Full-service multimedia firm.

- BBDO Art Director told our editors he is always open to new ideas and maintains an open drop-off policy. If you call and arrange to drop off your portfolio, he'll review it, and you can pick it up in a couple days.

COUSINS DESIGN

330 E. 33rd St., New York NY 10016. (212)685-7190. Fax: (212)689-3369. E-mail: info@cousinsdesign.com. Website: www.cousinsdesign.com. **President:** Michael Cousins. Number of employees 4. Specializes in packaging and product design. Clients: marketing and manufacturing companies. Professional affiliation: IDSA.

Needs Occassionally works with freelance designers. Prefers local designers. Works on assignment only.

First Contact & Terms Send nonreturnable postcard sample or e-mail your link. Samples are filed. Responds in 2 weeks only if interested. Write for appointment to show portfolio of roughs, final reproduction/product and photostats. Pays for design by the hour or flat fee. Considers skill and experience of artist when establishing payment. Buys all rights.

Tips "Send great work that fits our direction."

ERICKSEN ADVERTISING & DESIGN, INC.

12 W. 37th St., Ninth Floor, New York NY 10018. (212)239-3313. **Director:** Robert Ericksen. **Art Director:** Jin Lim. Full-service ad agency providing all promotional materials and commercial services for clients. Product specialties are promotional, commercial and advertising material for the entertainment industry. Current clients include BBC, National Geographic, Scripps Network.

Needs Works with several freelancers/year. Assigns several jobs/year. Works on assignment only. Uses freelancers mainly for advertising, packaging, brochures, catalogs, trade, P-O-P displays, posters, lettering and logos. Prefers composited and computer-generated artwork.

First Contact & Terms Contact through artist's agent or send query letter with brochure or tearsheets and slides. Samples are filed and are not returned unless requested with SASE; unsolicited samples are not returned. Responds in 1 week if interested or when artist is needed for a project. Does not respond to all unsolicited samples. "Only on request should a portfolio be sent." Pays for illustration by the project, $500-5,000. Buys all rights, and retains ownership of original in some situations. Finds artists through word of mouth, magazines, submissions and sourcebooks.

Tips "Advertising artwork is becoming increasingly 'commercial' in response to very tightly targeted marketing (i.e., the artist has to respond to increased creative team input versus the fine art approach."

GREY WORLDWIDE INC.

777 Third Ave., New York NY 10017. (212)546-2000. Fax: (212)546-2255. Website: www.grey.com. **Vice President/Art Buying Manager:** Jayne Horowitz. Number of employees 1,800. Specializes in cosmetics, food and toys. Clients include BellSouth, Hasbro, Procter & Gamble, Volkswagen, Merck, Lilly. Professional affiliations 4A's Art Services Committee.

 ● This company has six art buyers, each of whom makes about 50 assignments per year. Freelancers are needed mostly for illustration and photography, but also for model-making, fashion styling and lettering.

Needs Approached by hundreds of freelancers/year. Works with some freelance illustrators and few designers/year.

First Contact & Terms Works on assignment only. Call at beginning of the month for appointment to show portfolio of original/final art. Pays by the project. Considers client's budget and rights purchased when establishing fees.

Tips "Be prepared and very professional when showing a portfolio. Show your work in a neat and organized manner. Have sample leave-behinds and do not expect to leave with a job. It takes time to plant your ideas and have them accepted."

HILL AND KNOWLTON, INC.

466 Lexington Ave., New York NY 10017. (212)885-0300. Fax: (212)885-0570. E-mail: maldinge@hillandknowlton.com. Website: www.hillandknowlton.com. **Corporate Design Group:** Michael Aldinger. Estab. 1927. Number of employees 1,200 (worldwide). PR firm. Full-service multimedia firm. Specializes in annual reports, collateral, corporate identity, advertisements and sports marketing.

Needs Works with 0-10 freelancers/illustrators/month. Works on assignment only. Uses freelancers for editorial, technical and medical illustration. Also for storyboards, slide illustration, animatics, mechanicals, retouching and lettering. 10% of work is with print ads. Needs computer-literate freelancers for illustration. Freelancers should be familiar with QuarkXPress, FreeHand, Illustrator, Photoshop or Delta Graph.

First Contact & Terms Send query letter with promo and samples. Samples are filed. Does not reply, in which case the artist should "keep in touch by mail—do not call." Call and drop-off only for a portfolio review. Portfolio should include dupe photographs. Pays for illustration by the project, $250-5,000. Negotiates rights purchased.

Tips Looks for "variety; unique but marketable styles are always appreciated."

Ⓝ LEO AND YOSSHI ATERIER

276 Fifth Ave., Suite 401, New York NY 10001. (212)685-3174. Fax: (212)685-3170. E-mail: leoart2765@aol.com. **President:** Leopold Schein. Studio Manager and Art Director: Robert Schein. Number of employees 3. Approximate annual billing $500,000. Specializes in textile design for home furnishings. Clients wallpaper manufacturers/stylists, glassware companies, furniture and upholstery manufacturers. Current clients include Eisenhart Wallcoverings, Town and Country, Culp, Inc. and Notra Trading. Client list available upon request.

Needs Approached by 25-30 freelancers/year. Works with 3-4 freelance illustrators and 20-25 textile designers/year. Prefers freelancers trained in textile field, not fine arts. Must have a portfolio of original art designs. Should be able to be in NYC on a fairly regular basis. Works both on assignment and speculation. Prefers realistic and traditional styles. Uses freelancers for design, airbrushing, coloring and repeats. "We will look at any freelance portfolio to add to our variety of hands. Our recent conversion to CAD system may require future freelance assistance. Knowledge of Coreldraw, Photoshop or others is a plus."

First Contact & Terms Send query letter with résumé. Do not send slides. Request portfolio review in original query. "We prefer to see portfolio in person. Contact via phone is OK—we can set up appointments with a day or two's notice." Samples are not filed and are returned. Responds in 5 days. Portfolio should include original/final art. Sometimes requests work on spec before assigning job. Pays for design by the project, $500-1,500. "Payment is generally a 60/40 split of what design sells for—slightly less if reference material, art material, or studio space is requested." Considers complexity of project, skill and experience of artist and how work will be used when establishing payment. Buys all rights.

Tips "Stick to the field we are in (home furnishing textiles, upholstery, fabrics, wallcoverings). Understand manufacture and print methods. Walk the market; show that you are aware of current trends. Go to design shows before showing portfolio. We advise all potential textile designers and students to see the annual design show—Surtex at the Jacob Javitz Center in New York, usually in spring. Also attend High Point Design Show in North Carolina and Heimtex America in Florida."

LIEBER BREWSTER DESIGN, INC.

740 Broadway, Suite 1101, New York NY 10003. (212)614-1221. E-mail: anna@lieberbrewster.com. Website: www.lieberbrewster.com. **Principal:** Anna Lieber. Estab. 1988. Specializes in strategic marketing. Clients pub-

lishing, nonprofits, corporate, financial services, foodservice, retail. Client list available upon request. Professional affiliations NAWBO, AIGA.

Needs Approached by more than 100 freelancers/year. Works with 10 freelance illustrators, photographers and 10 designers/year. Works on assignment only. Uses freelancers for HTML programming, multimedia presentations, Web development, logos, direct mail design, charts/graphs, audiovisual materials. Needs computer-literate freelancers for design, illustration, production and presentation. 90% of freelance work demands skills in Illustrator, QuarkXPress or Photoshop. Needs editorial, technical, medical and creative color illustration, photography, photo montage, icons.

First Contact & Terms Send query letter with résumé, tearsheets and photocopies. Samples are filed. Will contact artist for portfolio review if interested. Portfolio should include b&w and color work. Pays for design by the hour. Pays for illustration and photography by the project. Rights purchased vary according to project. Finds artists through promotional mailings.

⒩ JODI LUBY & COMPANY, INC.

808 Broadway, New York NY 10003. (212)473-1922. E-mail: jluby@nyc.rr.com. **President:** Jodi Luby. Estab. 1983. Specializes in corporate identity, packaging, promotion and direct marketing design. Clients magazines, corporations.

Needs Approached by 10-20 freelance artists/year. Works with 5-10 illustrators/year. Uses freelancers for production and Web production. 100% of freelance work demands computer skills.

First Contact & Terms Send postcard sample or query letter with résumé and photocopies. Samples are not filed and are not returned. Will contact artist for portfolio review if interested. Portfolio should include thumbnails, roughs, b&w and color printed pieces. Pays for production by the hour, $25 minimum; by the project, $100 minimum. Pays for illustration by the project, $100 minimum. Rights purchased vary according to project. Finds artists through word of mouth.

⒩ MARKEFXS

449 W. 44th St., Suite 4-C, New York NY 10036. (212)581-4827. Fax: (212)265-9255. Website: www.mfxs.com. **Creative Director/Owner:** Mark Tekushan. Estab. 1985. Full-service multimedia firm. Specializes in TV, video, advertising, design and production of promos, show openings and graphics. Current clients include ESPN and HBO.

Needs Prefers freelancers with experience in television or advertising production. Works on assignment only. Uses freelancers mainly for design production. Also for animation, TV/film graphics and logos. Needs computer-literate freelancers for design, production and presentation.

First Contact & Terms Send query letter with résumé and demo reels. Samples are filed. Coordinating Producer will contact artist for portfolio review if interested. Portfolio should include ³/₄″ video or VHS. Pays for design by the hour, $25-50. Finds artists through word of mouth.

Tips Considers "attitude (professional, aggressive and enthusiastic, not cocky), recommendations and demo sample."

MCCAFFERY RATNER GOTTLIEB & LANE, LLC.

370 Lexington Ave., New York NY 10017. (212)706-8425. E-mail: hjones@mrgl.net. Website: www.mrgl.net. **VP Senior Art Director:** Howard Jones. Estab. 1983. Ad agency specializing in advertising and collateral material. Current clients include General Cigar (Macanudo, Partagas, Bolivar, Punch, Excalibur).

Needs Works with 6 freelance photographers/illustrators/year. Works on assignment only. Also uses artists for brochure and print ad illustration, mechanicals, retouching, billboards, posters, lettering and logos. 80% of work is with print ads.

First Contact & Terms Send query letter with brochure, tearsheets, photostats, photocopies and photographs. Responds only if interested. To show a portfolio, mail appropriate materials or drop off samples. Portfolio should include original/final art, tearsheets and photographs; include color and b&w samples. Pays for illustration by the project, $75-5,000. Rights purchased vary according to project.

Tips "Send mailers and drop off portfolio."

MIZEREK DESIGN INC.

333 E. 14th St., New York NY 10003. (212)777-3344. Fax: (212)777-8181. E-mail: leonard@mizerek.net. Website: www.mizerek.net. **President:** Leonard Mizerek. Estab. 1975. Specializes in catalogs, direct mail, jewelry, fashion and technical illustration. Clients corporations—various product and service-oriented clientele. Current clients include Rolex, Leslie's Jewelry, World Wildlife, The Baby Catalog, Time Life and Random House.

Needs Approached by 20-30 freelancers/year. Works with 10 freelance designers/year. Works on assignment only. Uses freelancers for design, technical illustration, brochures, retouching and logos. 85% of freelance work demands skills in Illustrator, Photoshop and QuarkXPress.

First Contact & Terms Send postcard sample or query letter with résumé, tearsheets and transparencies. Accepts disk submissions compatible with Illustrator and Photoshop 3.0. Will contact artist for portfolio review if interested. Portfolio should include original/final art and tearsheets. Pays for design by the project, $500-5,000. Pays for illustration by the project, $500-3,500. Considers client's budget and turnaround time when establishing payment. Finds artists through sourcebooks and self-promotions.

Tips "Let the work speak for itself. Be creative. Show commercial product work, not only magazine editorial. Keep me on your mailing list!"

NAPOLEON ART STUDIO

420 Lexington Ave., Suite 3020, New York NY 10170. (212)692-9200. Fax: (212)692-0309. E-mail: scott@napny. com. Website: www.napny.com. **Studio Manager:** Scott Stein. Estab. 1985. Number of employees 40. AV firm. Full-service, multimedia firm. Specializes in storyboards, magazine ads, computer graphic art animatics. Product specialty is consumer. Current clients include "all major New York City ad agencies." Client list not available.

Needs Approached by 20 freelancers/year. Works with 15 freelance illustrators and 5 designers/year. Prefers local freelancers with experience in animation, computer graphics, film/video production, multimedia, Macintosh. Works on assignment only. Uses freelancers for airbrushing, animation, direct mail, logos and retouching. 10% of work is with print ads. Needs computer-literate freelancers for design, illustration, production and presentation. 80% of freelance work demands skills in Illustrator or Photoshop.

First Contact & Terms Send query letter with photocopies, tearsheets and ¾" or VHS tape. Samples are filed. Responds only if interested. Will contact artist for portfolio review if interested. Portfolio should include b&w and color thumbnails. Pays for design and illustration by the project. Rights purchased vary acording to project. Finds artists through word of mouth and submissions.

[N] LOUIS NELSON ASSOCIATES INC.

447 Broadway, second floor, New York NY 10013. (212)620-9191. Fax: (212)620-9194. E-mail: info@louisnelson .com. Website: www.louisnelson.com. **President:** Louis Nelson. Estab. 1980. Number of employees 12. Approximate annual billing $1.2 million. Specializes in environmental, interior and product design and brand and corporate identity, displays, packaging, publications, signage, exhibitions and marketing. Clients nonprofit organizations, corporations, associations and governments. Current clients include Stargazer Group, Rocky Mountain Productions, Wildflower Records, Port Authority of New York & New Jersey, Richter + Ratner Contracting Corporation, MTA and NYC Transit. Professional affiliations IDSA, AIGA, SEGD, APDF.

Needs Approached by 30-40 freelancers/year. Works with 30-40 designers/year. Works on assignment only. Uses freelancers mainly for specialty graphics and 3-dimensional design. Also for design, photo-retouching, model-making and charts/graphs. 100% of design demands knowledge of PageMaker, QuarkXPress, Photoshop, Velum, Autocad, Vectorworks, Alias, Solidworks or Illustrator. Needs editorial illustration.

First Contact & Terms Send postcard sample or query letter with résumé. Accepts disk submissions compatible with Illustrator 8.0 or Photoshop 5.0. Send EPS files. Samples are returned only if requested. Responds in 2 weeks. Write for appointment to show portfolio of roughs, color final reproduction/product and photographs. Pays for design by the hour, $15-25 or by the project, negotiable. Needs design more than illustration or photography.

Tips "I want to see how the artist responded to the specific design problem and to see documentation of the processthe stages of development. The artist must be versatile and able to communicate a wide range of ideas. Mostly, I want to see the artist's integrity reflected in his/her work."

[N] NICHOLSON NY L.L.C.

295 Lafayette St., Suite 805, New York NY 10012. (212)274-0470. Fax: (212)274-0380. Website: www.nny.com. President Tom Nicholson. Manager of Design Department and Senior Art Director Maya Kopytman. Estab. 1987. Specializes in design of interactive computer programs. Clients corporations, museums, government agencies and multimedia publishers. Client list available upon request.

Needs Works with 3 freelance illustrators and 12 designers/year. Prefers local freelancers. Uses illustrators mainly for computer illustration and animation. Uses designers mainly for computer screen design and concept development. Also for mechanicals, charts/graphs and AV materials. Needs editorial and technical illustration. Especially needs designers with interest (not necessarily experience) in computer screen design plus a strong interest in information design. 80% of freelance work demands computer skills.

First Contact & Terms Send query letter with résumé include tearsheets and slides if possible. Samples are filed or are returned if requested. Will contact artist for portfolio review if interested. Portfolio should include thumbnails, original/final art and tearsheets. Considers complexity of project, client's budget and skill and experience of artist when establishing payment. Rights purchased vary according to project. Interested in buying

second rights (reprint rights) to previously published work. Finds artists through submissions/self-promotions and sourcebooks.

Tips "I see tremendous demand for original content in electronic publishing."

NOVUS VISUAL COMMUNICATIONS, INC.

121 E. 24th St., 12th Floor, New York NY 10010-2950. (212)473-1377. Fax: (212)505-3300. E-mail: novus@novus communications.com. Website: www.novuscommunications.com. **President:** Robert Antonik. Vice President/ Creative Director Denis Payne. Estab. 1984. Creative marketing and communications firm. Specializes in advertising, annual reports, brand and corporate identity, display, direct mail, fashion, package and publication design, technical illustration and signage. Clients healthcare, telecommunications, consumer products companies. Client list available upon request.

Needs Approached by 12 freelancers/year. Works with 2-4 freelance illustrators and 2-6 designers/year. Works with artist reps. Prefers local artists only. Uses freelancers for ad, brochure, catalog, poster and P-O-P design and illustration, airbrushing, audiovisual materials, book, direct mail, magazine and newpaper design, charts/ graphs, lettering, logos, mechanicals and retouching. 75% of freelance work demands skills in Illustrator, Photoshop, FreeHand, InDesign and QuarkXPress.

First Contact & Terms Contact only through artist rep. Send postcard sample of work. Samples are filed. Responds ASAP. Follow up with call. Pays for design by the hour, $15-75; by the day, $200-300; by the project, $200-1,500. Pays for illustration by the project, $150-1,750. Rights purchased vary according to project. Finds artists through *Creative Illustration*; *Workbook*; agents and submissions.

Tips "First impressions are important, a portfolio should represent the best, whether it's 4 samples or 12." Advises freelancers entering the field to "always show your best creation. You don't need to overwhelm your interviewer, and it's always a good idea to send a thank you or follow-up phone call."

OUTSIDE THE BOX INTERACTIVE

130 W. 25th St., New York NY 10001. (212)463-7160. Fax: (212)463-9179. E-mail: theoffice@outboxin.com. Website: www.outboxin.com. **Partner and Director of Multimedia:** Lauren Schwartz. Estab. 1995. Number of employees 10. OTBI, a full service firm combining graphics, video, animation, text, music and sounds into effective interactive programs, with other media. Our product mix includes internet/intranet/extranet development and hosting, corporate presentations, disk-based direct mail, customer/product kiosks, games, interactive press kits, advertising, marketing and sales tools. We also offer Web hosting for product launches, questionnaires and polls. Our talented staff consists of writers, designers and programmers.

Needs Approached by 5-10 freelance illustrators and 5-10 designers/year. Works with 8-10 freelance illustrators and 8-10 designers/year. Prefers freelancers with experience in computer arts. Also for airbrushing, animation, brochure and humorous illustration, logos, model-making, multimedia projects, posters, retouching, storyboards, TV/film graphics, Web-page design. 90% of design demands skills in Photoshop, QuarkXPress, Illustrator, Director HTML, Java Script and any 3D program. 60% of illustration demands skills in Photoshop, QuarkXPress, Illustrator, any animation and 3D program.

First Contact & Terms Send query letter with brochure, photocopies, photographs, photostats, résumé, SASE, slides, tearsheets, transparencies. Send follow-up postcard every 3 months. Accepts disk submissions compatible with Power PC. Samples are filed and are returned by SASE. Will contact if interested. Pays by project. Rights purchased vary according to project.

Tips "Be able to think on your feet and to test your limits."

ℕ POSNER ADVERTISING

30 Braod St., Ninth floor, New York NY 10004. (212)867-3900. Fax: (212)480-3440. E-mail: pposner@posneradv .com. Website: www.posneradv.com. **Contact:** VP/Creative Director. Estab. 1959. Number of employees 85. AD agency. Full-service multimedia firm. Specializes in ads, collaterals, packaging, outdoor. Product specialties are healthcare, real estate, consumer business to business, corporate.

Needs Approached by 25 freelance aritsts/month. Works with 1-3 illustrators and 5 designers/month. Prefers local artists only with traditional background with experience in computer design. Uses freelancers mainly for graphic design, production, illustration. 80% of work is with print ads. Needs computer-literate freelancers for design, illustration and production. 90% of freelance work demands knowledge of Illustrator, QuarkXPress, Photoshop or FreeHand.

First Contact & Terms Send query letter with photocopies or disk. Samples are filed. Responds only if interested. Write for appointment to show portfolio. Portfolio should include thumbnails, roughs, b&w and color tearsheets, printed pieces. Pays for design by the hour, $15-35 or by the project, $300-2,000. Pays for illustration by the project, $300-2,000. Negotiates rights purchased.

Tips Advises freelancers starting out in advertising field to offer to intern at agencies for minimum wage.

▣ QUADRANT COMMUNICATIONS CO., INC.

137 Varick St., Third Floor, New York NY 10013. (212)352-1400. Fax: (212)352-1411. E-mail: rn@quadrantny.com. Web site: www.quadrantny.com. **President:** Robert Eichinger. Number of employees 4. Approximate annual billing $850,000. Estab. 1973. Specializes in annual reports, corporate identity, direct mail, publication design and technical illustration. Clients corporations. Current clients include AT&T, Citibank, Dean Witter Reynolds, Chase Manhattan Bank, Federal Reserve Bank and Polo/Ralph Lauren. Client list available upon request.

Needs Approached by 100 freelancers/year. Works with 6 freelance illustrators and 4 designers/year. Prefers freelancers with experience in publication production. Works on assignment only. Uses freelancers mainly for publications, trade show collateral and direct mail design. Also for brochure, magazine Internet and intranet design; and charts/graphs. Needs computer-literate freelancers for design and production. 80% of freelance work demands knowledge of QuarkXPress, FreeHand or Illustrator and Photoshop.

First Contact & Terms Send query letter with résumé. Samples are filed. Responds only if interested. Call for appointment to show portfolio of tearsheets and photographs. Pays for design by the hour, $25-35. Pays for illustration by the project, $400-1,200. Rights purchased vary according to project.

Tips "We need skilled people. There's no time for training."

GERALD & CULLEN RAPP, INC.

420 Lexington Ave., Suite 3100, New York NY 10170. (212)889-3337. Fax: (212)889-3341. E-mail: sam@rappart.com. Website: www.rappart.com. Estab. 1944. Clients ad agencies, corporations and magazines. Client list not available. Professional affiliations GAG, SPAR, S.I.

Needs Approached by 500 freelance artists/year. Works with exclusive freelance illustrators. Works on assignment only. Uses freelance illustrators for editorial advertising and corporate illustration.

First Contact & Terms Send query letter with tearsheets and SASE. Samples are filed or returned by SASE if requested by artist. Responds in 2 weeks. Call or write for appointment to show portfolio or mail appropriate materials. Pays for illustration by the project, $500-40,000. Negotiates rights purchased.

▣ RED ROOSTER GROUP

150 Varick St., 8th Floor, New York NY 10013. (212)929-2657. E-mail: howard@redroostergroup.com. Website: www.redroostergroup.com. **Creative Director:** Howard Levy. Estab. 1991. Number of employees 3. Specializes in corporate marketing and communication design identities, brochures, annual reports, magazines, books, website design and promotion. Professional affiliation AIGA.

Needs Approached by 50 freelancers/year. Works with 5 freelance illustrators and 3 designers/year. Prefers artists with experience in QuarkXPress, Illustrator and Photoshop. Uses designers and illustrators mainly for magazines, annual reports, brochures and illustration, lettering, logos, mechanicals, posters and retouching. 80% of freelance work demands knowledge of Photoshop, QuarkXPress and Illustrator.

First Contact & Terms Send query letter with brochure, photocopies, photographs, résumé, SASE and tearsheets and transparencies. Responds only if interested. Pays for design by the hour, $25-35; or by the project, $500-5,000. Pays for illustration, $100-1,000 for color inside; or by the project, $500-2,000 for 2-page spreads. Finds artists through creative sourcebooks and submissions.

Tips "We are seeking illustrators with strong conceptual skills for environmental and nonprofit socially responsible clients. Also seeking local designers with strong financial and corporate experience."

SAATCHI & SAATCHI ADVERTISING WORLDWIDE

375 Hudson St., New York NY 10014-3620. (212)463-2000. Fax: (212)463-9855. Website: www.saatchi-saatchi.com. **Contact:** Senior Art Buyer. Full-service advertising agency. Clients include Delta Airlines, Eastman Kodak, General Mills and Procter & Gamble.

Needs Approached by 50-100 freelancers/year. Works with 1-5 designers and 15-35 illustrators/year. Uses freelancers mainly for illustration and advertising graphics. Prefers freelancers with knowledge of electronic/digital delivery of images.

First Contact & Terms Send query letter and nonreturnable samples or postcard sample. Prefers illustrators' sample postcards or promotional pieces to show "around a half a dozen illustrations," enough to help art buyer determine illustrator's style and visual vocabulary. Files interesting promo samples for possible future assignments. Pays for design and illustration by the project.

ARNOLD SAKS ASSOCIATES

350 E. 81st St., New York NY 10028. (212)861-4300. Fax: (212)535-2590. E-mail: afiorillo@saksdesign.com. **Vice President:** Anita Fiorillo. Estab. 1967. Specializes in annual reports and corporate communications. Clients Fortune 500 corporations. Current clients include Alcoa, Wyeth, Xerox and Hospital for Special Surgery. Client list available upon request.

Needs Works with 1 or 2 computer technicians and 1 designer/year. ''Computer technicians accuracy and speed are important, as is a willingness to work late nights and some weekends.'' Uses illustrators for technical illustration and occasionally for annual reports. Uses designers mainly for in-season annual reports. Also uses artists for brochure design and illustration, mechanicals and charts/graphics. Needs computer-literate freelancers for production and presentation. All freelance work demands knowledge of QuarkXPress, Illustrator or Photoshop.

First Contact & Terms Send query letter with brochure and résumé. Samples are filed. Responds only if interested. Write for appointment to show portfolio. Portfolio should include finished pieces. Pays for design by the hour, $25-60. Pays for illustration by the project, $200 minimum. Payment depends on experience and terms and varies depending upon scope and complexity of project. Rights purchased vary according to project.

Ⓝ STROMBERG CONSULTING
1285 Avenue of the Americas, 3rd floor, New York NY 10019. (646)935-4300. Fax: (646)935-4370. E-mail: clatz@strombergconsulting.com. Website: www.strombergconsulting.com. **Creative Director:** Chad Latz. Number of employees 60. Product specialties are direct marketing, internal and corporate communication using traditional print base as well as Web and new media. Clients industrial and corporate. Produces multimedia, presentations, videotapes and print materials.

Needs Assigns 25-35 jobs/year. Prefers local designers only (Manhattan and its 5 burroughs) with experience in animation, computer graphics, multimedia and Macintosh. Uses freelancers for animation logos, posters, storyboards, training guides, Web Flash, application development, design catalogs, corporate brochures, presentations, annual reports, slide shows, layouts, mechanicals, illustrations, computer graphics and desk-top publishing Web development, application development.

First Contact & Terms ''Send note on availability and previous work.'' Responds only if interested. Provide materials to be kept on file for future assignments. Originals are not returned. Pays hourly or by the project.

Tips Finds designers through word of mouth and submissions.

NORTH CAROLINA

BOB BOEBERITZ DESIGN
247 Charlotte St., Asheville NC 28801. (828)258-0316. E-mail: bobb@main.nc.us. Website: www.bobboeberitzd esign.com. **Owner:** Bob Boeberitz. Estab. 1984. Number of employees 1. Approximate annual billing $80,000. Specializes in graphic design, corporate identity and package design. Clients: retail outlets, hotels and restaurants, dot com companies, record companies, publishers, professional services. Majority of clients are business-to-business. Current clients include Para Research Software, SalesVantage.com, AvL Technologies, Southern Appalachian Repertory Theatre, Billy Edd Wheeler (Songwriter/Playwright), Shelby Stephenson (poet), and High Windy Audio. Professional affiliations AAF, NARAS, Asheville Freelance Network, Asheville Creative Services Group, Public Relations Association of WNC.

● Owner Bob Boeberitz predicts ''everything in art design will be done on computer; more electronic; more stock images; photo image editing and conversions will be used; there will be less commissioned artwork.''

Needs Approached by 50 freelancers/year. Works with 2 freelance illustrators/year. Works on assignment only. Uses freelancers primarily for technical illustration and comps. Prefers pen & ink, airbrush and acrylic. 50% of freelance work demands knowledge of PageMaker, Illustrator, Photoshop or CorelDraw.

First Contact & Terms Send query letter with résumé, brochure, SASE, photographs, slides and tearsheets. ''Anything too large to fit in file'' is discarded. Accepts disk submissions compatible with IBM PCs. Send AI-EPS, PDF, JPEG, GIF, HTML and TIFF files. Samples are returned by SASE if requested. Responds only if interested. Will contact artist for portfolio review if interested. Portfolio should include thumbnails, roughs, final art, b&w and color slides and photographs. Sometimes requests work on spec before assigning a job. Pays for design and illustration, by the project, $50 minimum. Rights purchased vary according to project. Will consider buying second rights to previously published artwork. Finds artists through word of mouth, submissions/self-promotions, sourcebooks, agents.

Tips ''Show sketches. Sketches help indicate how an artist thinks. The most common mistake freelancers make in presenting samples or portfolios is not showing how the concept was developed, what their role was in it. I always see the final solution, but never what went into it. In illustration, show both the art and how it was used. Portfolios should be neat, clean and flattering to your work. Show only the most memorable work, what you do best. Always have other stuff, but don't show everything. Be brief. Don't just toss a portfolio on my desk; guide me through it. A 'leave-behind' is helpful, along with a distinctive-looking résumé. Be persistent but polite. Call frequently. I don't recommend cold calls (you rarely ever get to see anyone) but it is an opportunity for a 'leave behind.' I recommend using the mail. E-mail is okay, but it isn't saved. Asking people to print out your samples to save in a file is asking too much. I like postcards. They get noticed, maybe even

kept. They're economical. And they show off your work. And you can do them more frequently. Plus you'll have a better chance to get an appointment. After you've had an appointment, send a thank you note. Say you'll keep in touch and do it!''

🅽 HOWARD MERRELL & PARTNERS

8521 Six Forks Rd., Suite 400, Raleigh NC 27615. (919)848-2400. Fax: (919)876-2344. E-mail: scrawford@merrel lgroup.com. **Creative Director:** Scott Crawford. Estab. 1993. Number of employees 80. Approximate annual billing $90 million. Ad agency. Full-service, multimedia firm. Specializes in ads, collateral, full service TV, broadcast. Product specialties are industrial and hi-tech. Clients include Kimberly-Clark and Miravant.
- This agency was acquired by the Bozell Group, a unit of True North, in 2000. The agency will continue to operate autonomously under its current name and management.

Needs Approached by 25-50 freelancers/year. Works with 10-12 freelance illustrators and 20-30 designers/year. Prefers local artists only. Uses freelancers for brochure design and illustration, catalog design, logos, mechanicals, posters, signage and P-O-P. 40% of work is with print ads. Needs computer-literate freelancers for design, illustration, production and presentation. 100% of freelance work demands knowledge of Photoshop, QuarkXPress and Illustrator.

First Contact & Terms Send postcard sample of work or query letter with photocopies. Samples are filed. Request portfolio review in original query. Will contact artist for portfolio review if interested. Portfolio should include b&w and color final art. Pays for design by the hour, $25-65. Payment for illustration varies by project.

SMITH ADVERTISING & ASSOCIATES

321 Arch St., Fayetteville NC 28301. (910)323-0920. Fax: (910)486-8075. E-mail: kduke@smithadv.com. Website: www.smithadv.com. **Production Manager:** Kristy Duke. Estab. 1974. Ad agency. Full-service, multimedia firm. Specializes in newspaper, magazine, broadcast, collateral, PR, custom presentations and Web design. Product specialties are financial, healthcare, manufacturing, business-to-business, real estate, tourism. Current clients include Sarasota CVB, NC Ports, Southeastern Regional Medical Center, Standard Tobacco Corp. Client list available upon request.

Needs Approached by 0-5 freelance artists/month. Works with 5-10 freelance illustrators and designers/month. Prefers artists with experience in Macintosh. Works on assignment only. Uses freelance artists mainly for mechanicals and creative. Also uses freelance artists for brochure, catalog and print ad illustration and animation, mechanicals, retouching, model-making, TV/film graphics and lettering. 50% of work is with print ads. Needs computer-literate freelancers for design, illustration, production and presentation. 95% of freelance work demands knowledge of QuarkXPress, Illustrator or Photoshop.

First Contact & Terms Send query letter with résumé and copies of work. Samples are returned by SASE if requested by artist. Responds in 3 weeks. Artist should call. Will contact artist for portfolio review if interested. Portfolio should include b&w and color thumbnails, final art and tearsheets. Pays for design and illustration by the project, $100. Buys all rights.

NORTH DAKOTA

FLINT COMMUNICATIONS

101 Tenth St. N., Suite 300, Fargo ND 58102. (701)237-4850. Fax: (701)234-9680. Website: www.flintcom.com. **Art Directors:** Gerri Lien, Dawn Koranda and Jeff Reed. Estab. 1947. Number of employees 40. Approximate annual billing $9 million. Ad agency. Full-service, multimedia firm. Product specialties are agriculture, manufacturing, healthcare, insurance and banking. Professional affiliations AIGA.

Needs Approached by 50 freelancers/year. Works with 6-10 freelance illustrators and 3-4 designers/year. Uses freelancers for annual reports, brochure design and illustration, lettering, logos and TV/film graphics. 40% of work is with print ads. 20% of freelance work demands knowledge of InDesign, Photoshop, QuarkXPress and Illustrator.

First Contact & Terms Send postcard-size or larger sample of work and query letter. Samples are filed. Will contact artist for portfolio review if interested. Pays for illustration by the project, $100-2,000. Rights purchased vary according to project.

SIMMONS/FLINT ADVERTISING

P.O.Box 5700, Grand Forks ND 58206-5700. (701)746-4573. Fax: (701)746-8067. E-mail: YvonneRW@simmons adv.com. Website: www.simmonsflint.com. **Contact:** Yvonne Westrum. Estab. 1947. Number of employees 8. Approximate annual billing $5.5 million. Ad agency. Specializes in magazine ads, collateral, documentaries, web design etc. Product specialties are agriculture, gardening, fast food/restaurants, electric utilities. Client list available upon request.

● A division of Flint Communications, Fargo ND. See listing in this section.

Needs Approached by 3-6 freelancers/year. Works with 3 freelance illustrators and 2 designer/year. Works on assignment only. Uses freelancers mainly for illustration. Also for brochure, catalog and print ad design and illustration; storyboards; billboards; and logos. 10% of work is with print ads. 10% of freelance work demands knowledge of QuarkXPress, Photoshop, Illustrator.

First Contact & Terms Send postcard sample or tearsheets. Samples are filed or are returned. Will contact artist for portfolio review if interested. Portfolio should include color thumbnails, roughs, tearsheets, photostats and photographs. Pays for design and illustration by the hour, by the project, or by the day. Rights purchased vary according to project.

OHIO

ⓝ BFL MARKETING COMMUNICATIONS
2000 Sycamore St., 4th Floor, Cleveland OH 44113-2340. (216)875-8860. Fax: (216)875-8870. E-mail: dpavan@b flcom.com. Website: www.bflcom.com. **President:** Dennis Pavan. Estab. 1955. Number of employees 12. Approximate annual billing $6.5 million. Marketing communications firm. Full-service, multimedia firm. Specializes in new product marketing, Internet website design, interactive media. Product specialty is consumer home products. Client list available upon request. Professional affiliations North American Advertising Agency Network, BPAA.

Needs Approached by 20 freelancers/year. Works with 5 freelance illustrators and 5 designers/year. Prefers freelancers with experience in advertising design. Uses freelancers mainly for graphic design, illustration. Also for brochure and catalog design and illustration, lettering, logos, model making, posters, retouching, TV/film graphics. 80% of work is with print ads. Needs computer-literate freelancers for design, illustration, production and presentation. 50% of freelance work demands knowledge of FreeHand, Photoshop, QuarkXPress, Illustrator.

First Contact & Terms Send postcard-size sample of work or send query letter with brochure, photostats, tearsheets, photocopies, résumé, slides and photographs. Samples are filed or returned by SASE. Responds in 2 weeks. Artist should follow-up with call and/or letter after initial query. Will contact artist for portfolio review if interested. Portfolio should include b&w and color final art, photographs, photostats, roughs, slides and thumbnails. Pays by the project, $200 minimum.

Tips Finds artists through *Creative Black Book*; *Illustration Annual*; *Communication Arts*; local interviews. "Seeking specialist in Internet design, CD-ROM computer presentations and interactive media."

BRIGHT LIGHT PRODUCTIONS, INC.
602 Main St., Suite 810, Cincinnati OH 45202. (513)721-2574. Fax: (513)721-3329. **President:** Linda Spalazzi. Estab. 1976. AV firm. "We are a full-service film/video communications firm producing TV commercials and corporate communications."

Needs Works on assignment only. Uses artists for editorial, technical and medical illustration and brochure and print ad design, storyboards, slide illustration, animatics, animation, TV/film graphics and logos. Needs computer-literate freelancers for design and production. 50% of freelance work demands knowledge of Photoshop, Illustrator and After Effects.

First Contact & Terms Send query letter with brochure and résumé. Samples not filed are returned by SASE only if requested by artist. Request portfolio review in original query. Portfolio should include roughs and photographs. Pays for design and illustration by the project. Negotiates rights purchased. Finds artists through recommendations.

Tips "Our need for freelance artists is growing."

ⓝ EVENTIV
10116 Blue Creek North, Whitehouse OH 43571. E-mail: jan@eventiv.com. Website: www.eventiv.com. **President/Creative Director:** Janice Robie. Agency specializing in graphics, promotions and tradeshow marketing. Product specialties are industrial, consumer.

Needs Assigns 30 freelance jobs/year. Works with 5 illustrators/year and 20 designers/year. Works on assignment only. Uses freelancers for consumer and trade magazines, brochures, catalogs, P-O-P displays, AV presentations, posters and illustrations (technical and/or creative). 100% of design and 50% of illustration require computer skills. Also needs freelancers experienced in electronic authoring, animation, Web design, programming and design.

First Contact & Terms Send query letter with résumé and slides, photographs, photostats or printed samples. Accepts disk submissions compatible with Mac or Windows. Samples returned by SASE if not filed. Responds only if interested. Write for appointment to show portfolio, which should include roughs, finished art, final

reproduction/product and tearsheets. Pays by the hour, $25-80 or by the project, $100-2,500. Considers client's budget and skill and experience of artist when establishing payment. Negotiates rights purchased.

Tips ''We are interested in knowing your specialty.''

HOLLAND COMMUNICATIONS

700 Walnut St., Suite 300, Cincinnati OH 45202-2011. (513)721-1310. Fax: (513)721-1269. E-mail: holland@holl androi.com. Website: www.hollandROI.com. **Contact:** David Dreisbach. Estab. 1937. Number of employees 17. Approximate annual billing $12 million. Ad agency. Full-service, multimedia firm. Professional affiliation AAAA.

Needs Approached by 6-12 freelancers/year. Works with 5-10 freelance illustrators and 2-3 designers/year. Prefers artists with experience in Macintosh. Uses freelancers for brochure illustration, logos and TV/film graphics. 100% of freelance work demands knowledge of Photoshop, QuarkXPress and Illustrator.

First Contact & Terms Send query letter with photocopies and résumé. Accepts submissions on disk. Samples are filed and are not returned. Will contact artist for portfolio review if interested. Portfolio should include b&w and color final art, photographs, roughs, tearsheets and thumbnails. Pays for design by the hour, by the project and by the day. Pays for illustration by the project. Rights purchased vary according to project.

LIGGETT-STASHOWER

1228 Euclid Ave., Suite 300, Cleveland OH 44115. (216)348-8500. Fax: (216)736-8118. E-mail: rwilliams@liggett .com. Website: www.liggett.com. **Art Buyer:** Rachel Williams. Estab. 1932. Ad agency. Full-service multimedia firm. Works in all formats. Handles all product categories. Current clients include Sears Optical, Forest City Management, Cedar Point, Crane Performance Siding, Henkel Consumer Adhesives, Ohio Lottery and Timber Tech.

Needs Approached by 120 freelancers/year. Works with freelance illustrators and designers. Prefers local freelancers. Works on assignment only. Uses freelancers mainly for brochure, catalog and print ad design and illustration, storyboards, slide illustration, animatics, animation, retouching, billboards, posters, TV/film graphics, lettering and logos. Needs computer-literate freelancers for illustration and production. 90% of freelance work demands skills in QuarkXPress, InDesign, FreeHand, Photoshop or Illustrator.

First Contact & Terms Send query letter. Samples are filed and are not returned. Responds only if interested. To show portfolio, mail tearsheets and transparencies. Pays for design and illustration by the project. Negotiates rights purchased.

Tips Please consider that art buyers and art directors are very busy and receive at least 25 mailings per day from freelancers looking for work opportunities. We might have loved your promo piece, but chances of us remembering it by your name alone when you call are slim. Give us a hint ''it was red and black'' or whatever. We'd love to discuss your piece, but it's uncomfortable if we don't know what you're talking about.

LOHRE & ASSOCIATES

2330 Victory Parkway, Suite 701, Cincinnati OH 45206. (513)961-1174. E-mail: gen@lohre.com. Website: www. lohre.com. **President:** Chuck Lohre. Number of employees 8. Approximate annual billing $1 million. Ad agency. Specializes in industrial firms. Professional affiliation BMA.

Needs Approached by 24 freelancers/year. Works with 10 freelance illustrators and 10 designers/year. Works on assignment only. Uses freelance artists for trade magazines, direct mail, P-O-P displays, multimedia, brochures and catalogs. 100% of freelance work demands knowledge of PageMaker, FreeHand, Photoshop and Illustrator.

First Contact & Terms Send postcard sample or e-mail. Accepts submissions on disk, any Mac application. Pays for design and illustration by the hour, $10 minimum.

Tips Looks for artists who ''have experience in chemical and mining industry, can read blueprints and have worked with metal fabrication. Also needs Macintosh-literate artists who are willing to work at office, during day or evenings.''

STEVENS BARON COMMUNICATIONS

Hanna Bldg., Suite 645, 1422 Euclid Ave., Cleveland OH 44115-1900. (216)621-6800. Fax: (216)621-6806. E-mail: ebaron@stevensbaron.com. Website: www.stevensbaron.com. **President:** Edward M. Stevens, Sr. Estab. 1956. Ad agency. Specializes in public relations, advertising, corporate communications, magazine ads and collateral. Product specialties are business-to-business, food, building products, technical products, industrial food service, healthcare, safety.

Needs Approached by 30-40 freelance artists/month. Prefers artists with experience in food and technical equipment. Works on assignment only. Uses freelance artists mainly for specialized projects. Also uses freelance artists for brochure, catalog and print ad illustration and retouching. Freelancers should be familiar with PageMaker, QuarkXPress, FreeHand, Illustrator and Photoshop.

First Contact & Terms Send query letter with résumé and photocopies. Samples are filed and are not returned. Does not reply back. "Artist should send only samples or copies that do not need to be returned." Will contact artist for portfolio review if interested. Portfolio should include final art and tearsheets. Pay for design depends on style. Pay for illustration depends on technique. Buys all rights. Finds artists through agents, sourcebooks, word of mouth and submissions.

OKLAHOMA

KIZER INCORPORATED ADVERTISING & COMMUNICATIONS

4513 Classen Blvd., Oklahoma City OK 73118. (405)858-4906. E-mail: bill@kizerincorporated.com. Website: www.kizerincorporated.com. **Principal:** William Kizer. Estab. 1998. Number of employees 3. Ad agency. Specializing in magazine ads, print ads, copywriting, design/layout, collateral material. Professional affiliations OKC Ad Club, AMA, AIGA.

Needs Approached by 20 illustrators/year. Works with 3 illustrators and 3 designers/year. 50% of work is with print ads. 100% of design demands knowledge of InDesign, FreeHand, Photoshop. 50% of illustration demands knowledge of FreeHand, Photoshop.

First Contact & Terms Designers: Send or e-mail query letter with samples. Illustrators: Send or e-mail query letter with samples. Accepts disk submissions compatible with FreeHand or Photoshop file. Samples are filed and are not returned. Responds only if interested. To show portfolio, artist should follow up with call. Portfolio should include "your best work." Pays by the project. Rights purchased vary according to project. Finds artists through agents, sourcebooks, online services, magazines, word of mouth, artist's submissions.

OREGON

CREATIVE COMPANY, INC.

726 NE Fourth St., McMinnville OR 97128. Toll-free (866)363-4433. Fax: (503)883-6817. E-mail: jlmorrow@creativeco.com. Website: www.creativeco.com. **President/Owner:** Jennifer Larsen Morrow. Specializes in branding, marketing-driven corporate identity, collateral, direct mail, packaging and ongoing marketing campaigns. Product specialties are food, financial services, colleges, manufacturing, pharmaceutical, medical, agricultural products.

Needs Works with 6-10 freelance designers and 3-7 illustrators/year. Prefers local artists. Works on assignment only. Uses freelancers for design, illustration, computer production (Mac), retouching and lettering. "Looking for clean, fresh designs!" 100% of design and 60% of illustration demand skills in InDesign, FreeHand, Illustrator and Photoshop.

First Contact & Terms Send query letter with brochure, résumé, business card, photocopies and tearsheets to be kept on file. Samples returned by SASE only if requested. Will contact for portfolio review if interested. "We require a portfolio review. Years of experience not important if portfolio is good. We prefer one-on-one review to discuss individual projects/time/approach." Pays for design by the hour or project, $50-90. Pays for illustration by the project. Considers complexity of project and skill and experience of artist when establishing payment.

Tips Common mistakes freelancers make in presenting samples or portfolios are "1) poor presentation, samples not mounted or organized; 2) not knowing how long it took them to do a job to provide a budget figure; 3) not demonstrating an understanding of the audience, the problem or printing process and how their work will translate into a printed copy; 4) just dropping in without an appointment; 5) not following up periodically to update information or a résumé that might be on file."

Ⓝ OAKLEY DESIGN STUDIOS

519 SW Park Ave., Portland OR 97205. (503)241-3705. E-mail: oakleyds@oakleydesign.com. **Creative Director:** Tim Oakley. Estab. 1992. Number of employees 1. Specializes in brand and corporate identity, display, package and publication design and advertising. Clients ad agencies, record companies, surf apparel manufacturers, mid-size businesses. Current clients include TGF Productions, M3 Productions, Oregon State Treasury, Hui Nalu Brand Surf, Stona Bukes: *italy*, Kink FM 102. Professional affiliations GAG, AIGA and PAF.

Needs Approached by 5-10 freelancers/year. Works with 3 freelance illustrators and 2 designers/year. Prefers local artists with experience in technical illustration, airbrush. Also for multimedia projects. Uses illustrators mainly for advertising. Uses designers mainly for logos. Also uses freelancers for ad and P-O-P illustration, airbrushing, catalog illustration, lettering and retouching. 60% of design and 30% of illustration demands skills in Illustrator, Photoshop and QuarkXPress.

First Contact & Terms Contact through artist rep or send query letter with brochure, photocopies, photographs, résumé and tearsheets. Accepts disk submissions compatible with Illustrator 9.0. Send EPS files. Samples are

filed or returned by SASE if requested by artist. Responds in 6 weeks. Request portfolio review in original query. Will contact artist for portfolio review if interested. Portfolio should include b&w and color final art, photocopies, photostats, roughs and slides. Pays for design by the project, $200 minimum. Pays for illustration by the project. Rights purchased vary according to project. Finds artists through design workbooks.

Tips "Be yourself. No phonies. Be patient and have a good book ready."

WISNER ASSOCIATES, Advertising, Marketing & Design

18200 NW Sauvie Island Rd., Portland OR 97231-1338. (503)282-3929. Fax: (503)282-0325. E-mail: wizbiz@wisnercreative.com. **Creative Director:** Linda Wisner. Estab. 1979. Number of employees 1. Specializes in brand and corporate identity, book design, direct mail, packaging, publications and exhibit design. Clients small businesses, manufacturers, restaurants, service businesses and book publishers.

Needs Works with 3-5 freelance illustrators/year. Prefers experienced freelancers and "fast, accurate work." Works on assignment only. Uses freelancers for technical and fashion illustration and graphic production. Knowledge of QuarkXPress, Photoshop, Illustrator and other software required.

First Contact & Terms Send query letter with résumé and samples. Prefers "examples of completed pieces which show the fullest abilities of the artist." Samples not kept on file are returned by SASE only if requested. Will contact artist for portfolio review if interested. Pays for illustration by the hour, $20-45 average or by the project, by bid. Pays for computer work by the hour, $15-25.

PENNSYLVANIA

ℕ BJORNSON DESIGN ASSOCIATES, INC.

217 Church St., Philadelphia PA 19106. (215)928-9000. Fax: (215)928-9019. E-mail: info@bjornsondesign.com. Website: www.bjornsondesign.com. **Principal:** Jon A. Bjornson. Estab. 1989. Number of employees 5. Specializes in corporate identity, publication and Web site design. Professional Affiliations AIGA.

Needs Prefers local artists only. Needs computer-literate freelancers for design, illustration, production and web design. 100% of freelance work demands skills in Photoshop, FreeHand and QuarkXPress.

First Contact & Terms Send query letter. Will contact artist for portfolio review if interested. Pays for design and illustration by the project. Rights purchased vary according to project.

DLD CREATIVE

620 E. Oregon Rd., Lititz PA 17543. (717)569-6568. Fax: (717)569-7410. E-mail: info@dldcreative.com. Website: www.dldcreative.com. **President/Creative Director:** Dave Loose. Estab. 1986. Number of employees 12. Full-service design firm. Specializes in branding and corporate communications. Client list available upon request.

Needs Approached by 4 illustrators and 12 designers/year. Works with 4 illustrators/year. Uses freelancers mainly for illustration. Also for animation, catalog, humorous and technical illustration and TV/film graphics. 10% of work is with print ads. 50% of design demands skills in Photoshop, QuarkXPress, Illustrator.

First Contact & Terms Designers: Send query letter with photocopies, résumé and tearsheets. Illustrators: Send postcard sample of work. Accepts e-mail submissions. Samples are filed. Responds only if interested. No calls, please. Portfolio should include color final art and concept roughs. Pays for design and illustration by the project. Buys all rights. Finds artists through *American Showcase*, postcard mailings, word of mouth.

Tips "Be conscientious of deadlines, willing to work with hectic schedules. Must be top talent and produce highest quality work."

ℕ FULLMOON CREATIONS INC.

100 Mechanic St., Doylestown PA 18901. (215)345-1233. E-mail: artist@fullmooncreations.com. Website: www.fullmooncreations.com. **Contact:** Art Director. Estab. 1986. Number of employees 5. Specializes in brand and corporate identity; packaging design; corporate and product collateral; new brand and product concept development, and Web site development. Clients Fortune 500 corporations. Current clients include M&M Mars, Educom, Paris Technology and The Atlantic Group.

Needs Approached by 100-120 freelancers/year. Works with 5-15 freelance illustrators and 10-20 designers/year. Uses freelancers for ad, brochure and catalog design and illustration; airbrushing; audiovisual materials; book, direct mail and magazine design; logos; mechanicals; poster and P-O-P illustration. Needs computer-literate freelancers for design, illustration and production. 50% of freelance work demands knowledge of Illustrator, Photoshop, FreeHand and QuarkXPress.

First Contact & Terms Send postcard sample of work, photocopies, résumé and URL. Samples are filed. Responds in 1 month with SASE. Will contact artist for portfolio review if interested. Portfolio should include b&w and color roughs, thumbnails and transparencies.

Tips "Fullmoon Creations, Inc. is a multi-dimensional creative development team, providing design and market-

ing services to a growing and diverse group of product and service organizations and staffed by a team of professionals. Complementing these professionals is a group of talented, motivated (you) copywriters, illustrators, Web designers and programmers who are constantly challenging their creative skills, working together with us as a team. We are above all, a professional service organization with a total dedication to our client's marketing needs.''

N SAI COMMUNICATIONS

P.O. Box 743, Media PA 19063. (215)923-6466. AV firm. Full-service, multimedia firm.

Needs Approached by 5 freelance artists/month. Works with 3 freelance designers/month. Uses freelance artists mainly for computer-generated slides. Also uses freelance artists for brochure and print ad design, storyboards, slide illustration and logos. 1% of work is with print ads.

First Contact & Terms Send query letter with résumé. Samples are filed. Call to schedule an appointment to show a portfolio. Portfolio should include slides. Pays for design by the hour, $15-20. Pays for illustration by the project. Buys first rights.

WILLIAM SKLAROFF DESIGN ASSOCIATES

56 Oak Knoll Dr., Berwyn PA 19392. (610)647-4470. E-mail: wsklaroff@aol.com. **Design Director:** William Sklaroff. Estab. 1956. Specializes in display, interior, package and publication design and corporate identity and signage. Clients contract furniture, manufacturers, healthcare corporations. Current clients include Kaufman, Halcon Corporation, Gun Locke, McDonald Products, Shoup Electronic Voting Solutions, BK/Barrit, Herman Miller, Smith Metal Arts, Baker Furniture, Harden Furniture and Metrologic Instruments. Client list available upon request.

Needs Approached by 2-3 freelancers/year. Works with 2-3 freelance illustrators and 2-3 designers/year. Works on assignment only. Uses freelancers mainly for assistance on graphic projects. Also for brochure design and illustration, catalog and ad design, mechanicals and logos.

First Contact & Terms Send query letter with brochure, résumé and slides to William Sklaroff. Samples are returned. Responds in 3 weeks. Pays for design by the hour. Rights purchased vary according to project. Finds artists through word of mouth and submissions.

WARKULWIZ DESIGN ASSOCIATES INC.

2218 Race St., Philadelphia PA 19103. (215)988-1777. Fax: (215)988-1780. E-mail: wda@warkulwiz.com. Website: www.warkulwiz.com. **President:** Bob Warkulwiz. Estab. 1985. Number of employees 6. Approximate annual billing $1 million. Specializes in annual reports, publication design and corporate communications. Clients corporations and universities. Current clients include Firstrust Bank, Penn Law and Wharton School. Client list available upon request. Professional affiliations AIGA, 1ABC.

Needs Approached by 100 freelancers/year. Works with 10 freelance illustrators and 5-10 photographers/year. Works on assignment only. Uses freelance illustrators mainly for editorial and corporate work. Also uses freelance artists for brochure and poster illustration and mechanicals. Freelancers should be familiar with most recent versions of QuarkXPress, Illustrator, Photoshop, FreeHand and Director.

First Contact & Terms Send query letter with tearsheets and photostats. Samples are filed. Responds only if interested. Call for appointment to show portfolio of ''best edited workpublished or unpublished.'' Pays for illustration by the project, ''depends upon usage and complexity.'' Rights purchased vary according to project.

Tips ''Be creative and professional.''

N SPENCER ZAHN & ASSOCIATES

2015 Sansom St., Philadelphia PA 19103. (215)564-5979. Fax: (215)564-6285. E-mail: szahn@erols.com. **President:** Spencer Zahn. Business Manager Brian Zahn. Estab. 1970. Number of employees 10. Specializes in brand and corporate identity, direct mail design, marketing and retail advertising. Clients: corporations.

Needs Approached by 100 freelancers/year. Works with freelance illustrators and designers. Prefers artists with experience in Macintosh computers. Uses freelancers for ad, brochure and poster design and illustration; direct mail design; lettering; and mechanicals. Needs computer-literate freelancers for design, illustration and production. 80% of freelance work demands knowledge of Illustrator, Photoshop, FreeHand and QuarkXPress.

First Contact & Terms Send query letter with samples. Samples are not filed and are returned by SASE if requested by artist. Responds only if interested. Artist should follow up with call. Portfolio should include final art and printed samples. Buys all rights.

RHODE ISLAND

MARTIN THOMAS, INC.

42 Riverside Dr., Barrington RI 02806-2410. (401)245-8500. Fax: (866)899-2710. E-mail: contact@martinthomas .com. Website: www.martinthomas.com. **Contact:** Martin K. Pottle. Estab. 1987. Number of employees 12.

Approximate annual billing $7 million. Ad agency, PR firm. Specializes in industrial, business-to-business. Product specialties are plastics, medical and automotive. Professional affiliations American Association of Advertising Agencies, Boston Ad Club.

Needs Approached by 10-15 freelancers/year. Works with 6 freelance illustrators and 10-15 designers/year. Prefers freelancers with experience in business-to-business/industrial. Uses freelancers mainly for design of ads, literature and direct mail. Also for brochure and catalog design and illustration. 85% of work is print ads. 70% of design and 40% of illustration demands skills in QuarkXPress.

First Contact & Terms Send query letter with brochure and résumé. Samples are filed and are returned. Responds in 3 weeks. Will contact artist for portfolio review if interested. Portfolio should include b&w and color final art. Pays for design and illustration by the hour and by the project. Buys all rights. Finds artists through *Creative Black Book*.

Tips Impress agency by "knowing industries we serve."

TENNESSEE

ⓃMCCLEAREN DESIGN

3901 Brush Hill Rd., Nashville TN 37216. (615)226-8089. Fax: (615)226-9237. E-mail: mcclearen@comcast.net. **Owner:** Brenda McClearen. Estab. 1987. Number of employees 3. Specializes in display, music, package and publication design, websites, photography.

Needs Approached by 5-10 freelancers/year. Works with 5-7 freelance illustrators and designers/year. Uses freelancers for ad design and illustration, model-making and poster design. Needs computer-literate freelancers for design and illustration. 50% of freelance work demands knowledge of QuarkXPress and Macintosh.

First Contact & Terms Samples are filed. Will contact artist for portfolio review if interested. Pays by the project.

ⓃMEDIA GRAPHICS

717 Spring St., P.O. Box 820525, Memphis TN 38182-0525. (901)324-1658. Fax: (901)323-7214. E-mail: mediagraphics@devkinney.com. Website: www.devkinney.com. **CEO:** JKinney. Estab. 1973. Integrated marketing communications agency. Specializes in all visual communications. Product specialties are financial, fundraising, retail, business-to-business. Client list available upon request. Professional affiliations Memphis Area chamber, B.B.B.

● This firm reports they are looking for top illustrators only. When they find illustrators they like, they generally consider them associates and work with them on a continual basis.

First Contact & Terms Send query letter with résumé and tearsheets. Accepts disk submissions compatible with Mac or PC. E-mail 1 sample JPEG, 265K maximum; prefer HTML reference or small PDF file. Samples are filed and are not returned. Will contact for portfolio review on Web or via e-mail if interested. Rights purchased vary according to project.

Tips Chooses illustrators based on "portfolio, availability, price, terms and compatibility with project."

ⓃODEN MARKETING & DESIGN

22 N. Front St., Suite 300, Memphis TN 38103-2162. (901)578-8055. Fax: (901)578-1911. Website: www.oden.com. **Creative Director:** Jess Blankenship. Estab. 1971. Specializes in annual reports, brand and corporate identity, design and package design. Clients corporations. Current clients include International Paper, Maybelline, Federal Express.

Needs Approached by 15-20 freelance graphic artists/year. Works with 5-8 freelance illustrators, photographers and 4-6 freelance designers/year. Works on assignment only. Uses illustrators, photographers and designers mainly for collateral. Also uses freelance artists for brochure design and illustration, mechanicals and ad illustration. Need computer-literate freelancers for design and production. 50% of freelance work demands knowledge of QuarkXPress or Photoshop.

First Contact & Terms Send query letter with brochure, photographs, slides and transparencies. Samples are filed and are not returned. Responds only if interested. Portfolio review not required. Portfolio review not required. Pays for illustration by the project, $500. Rights purchased vary according to project.

Tips Finds artists through sourcebooks.

TEXAS

DYKEMAN ASSOCIATES INC.

4115 Rawlins, Dallas TX 75219. (214)528-2991. Fax: (214)528-0241. E-mail: adykeman@airmail.net. Website: www.dykemanassoc.com. **Contact:** Alice Dykeman. PR/marketing firm. Specializes in business, industry, hospitality, sports, environmental, energy, health.

Needs Works with 5 illustrators and designers/year. Local freelancers only. Uses freelancers for editorial and technical illustration, brochure design, exhibits, corporate identification, POS, signs, posters, ads and all design and finished artwork for graphics and printed materials. PC or Mac.

First Contact & Terms Request portfolio review in original query. Pays by the project, $250-3,000. "Artist makes an estimate; we approve or negotiate."

Tips "Be enthusiastic. Present an organized portfolio with a variety of work. Portfolio should reflect all that an artist can do. Don't include examples of projects for which you only did a small part of the creative work. Have a price structure but be willing to negotiate per project. We prefer to use artists/designers/illustrators who will work with barter (trade) dollars and join one of our trade exchanges. We see steady growth ahead."

JUDE STUDIOS

(formerly Penn-Jude Partners), 8000 Research Forest, Suite 115-266, The Woodlands TX 77382. (281)364-9366. Fax: (281)364-9529. **Creative Director:** Judith Dollar. Estab. 1994. Number of employees 2. Design firm. Specializes in printed material, brochure, trade show, collateral. Product specialties are industrial, restaurant, homebuilder, financial, high-tech business to business event marketing materials. Professional affiliations: Art Directors of Houston, AAF.

Needs Approached by 20 illustrators and 6 designers/year. Works with 10 illustrators and 2 designers/year. Prefers local designers only. Uses freelancers mainly for newsletter, logo and brochures. Also for airbrushing; brochure design and illustration; humorous, medical, technical illustration; lettering, logos, mechanicals and retouching. 90% of design demands skills in FreeHand, Photoshop, QuarkXPress. 30% of illustration demands skills in FreeHand, Photoshop, QuarkXPress.

First Contact & Terms Designers: Send brochure, photocopies, photographs, photostats, résumé, tearsheets. Illustrators: Send query letter with brochure, photocopies, photographs or tearsheets. Accepts disk submissions. Send TIFF, EPS, PDF or JPEG files. Samples are filed and are not returned. Art director will contact artist for portfolio review if interested. Pays by the project; varies. Negotiates rights purchased. Finds artists through *American Show Case*; *Workbook*; *RSVP* and artist's reps.

Tips Wants freelancers with good type usage who contribute to concept ideas. We are open to designers and illustrators who are just starting out their careers.

[N] POWERS DESIGN INTERNATIONAL

A Division of Creative Powers, Inc., P.O. Box 85, Iredell TX 76649. (949)645-2265. Fax: (254)364-2416. E-mail: joequata@our-town.com. Website: www.powersdesign.com. **President:** Ron Powers. Estab. 1978. Specializes in corporate identity; displays; and landscape, interior, package and transportation design. Clients large corporations. Current clients include Paccar Inc., McDonnell Douglas, Ford Motor Co. and GM. Client list available upon request.

Needs Works with varying number of freelance illustrators and 5-10 freelance designers/year. Prefers local artists only with experience in transportation design (such as those from Art Center College of Design), or with "SYD Mead" type abilities. Works on assignment only. Uses freelance designers and illustrators for brochure, ad and catalog design, lettering, logos, model making and Alias Computer Cad-Cam 16 abilities.

First Contact & Terms Send query letter with résumé and appropriate samples. Samples are returned. Responds only if interested. Call to schedule an appointment to show a portfolio, which should include best work and references. Pays for design and illustration by the project.

STEVEN SESSIONS INC.

5177 Richmond, Suite 500, Houston TX 77056. (713)850-8450. Fax: (713)850-9324. E-mail: Steven@Sessionsgroup.com. Website: www.sessionsgroup.com. **President, Creative Director:** Steven Sessions. Estab. 1981. Number of employees 8. Approximate annual billing $2.5 million. Specializes in annual reports; brand and corporate identity; fashion, package and publication design. Clients corporations and ad agencies. Current clients are listed on website. Professional affiliations AIGA, Art Directors Club, American Ad Federation.

Needs Approached by 50 freelancers/year. Works with 10 illustrators and 2 designers/year. Uses freelancers for brochure, catalog and ad design and illustration; poster illustration; lettering; and logos. 100% of freelance work demands knowledge of Illustrator, QuarkXPress, Photoshop. Needs editorial, technical and medical illustration.

First Contact & Terms Designers: Send query letter with brochure, tearsheets, CD's, PDF files and SASE. Illustrators: Send postcard sample or other nonreturnable samples. Samples are filed. Responds only if interested. To show portfolio, mail slides. Payment depends on project, ranging from $1,000-30,000/illustration. Rights purchased vary according to project.

UTAH

BROWNING ADVERTISING

1 Browning Place, Morgan UT 84050. (801)876-2711. Fax: (801)876-3331. **Contact:** Senior Art Director. Estab. 1878. Distributor and marketer of outdoor sports products, particularly firearms. Inhouse agency for 3 main clients. Inhouse divisions include nongun hunting products, firearms and accessories.

Needs Approached by 50 freelancers/year. Works with 20 freelance illustrators and 20 designers/year. Prefers freelancers with experience in outdoor sportshunting, shooting, fishing. Works on assignment only. Uses freelancers mainly for design, illustration and production. Also for advertising and brochure layout, catalogs, product rendering and design, signage, P-O-P displays, and posters.

First Contact & Terms Send query letter with résumé and tearsheets, slides, photographs and transparencies. Samples are not filed and are not returned. Responds only if interested. To show portfolio, mail photostats, slides, tearsheets, transparencies and photographs. Pays for design by the hour, $50-75. Pays for illustration by the project. Buys all rights or reprint rights.

ⓝ FORDESIGN GROUP

5405 South, 550 East., Ogden, Utah, 84405-4771. (801)479-4002. Fax: (801)479-4099. E-mail: steven@fordesign .net. Website: www.fordesign.net. **Principal:** Steve Ford. Estab. 1990. Specializes in brand and corporate identity, package and Web site design. Clients corporations. Current clients include Sony, IBM, Cadbury Beverage, Carrs, MasterCard. Professional affiliations AIGA, PDC.

Needs Approached by 100 freelancers/year. Works with 6-10 freelance illustrators and 4-6 designers/year. Uses illustrators mainly for brochures, ads. Uses designers mainly for corporate identity, packaging, collateral. Also uses freelancers for ad and brochure design and illustration, logos. Needs bright, conceptual designers and illustrators. 90% of freelance work demands skills in Illustrator, Photoshop, FreeHand and Dreamweaver.

First Contact & Terms Send postcard sample of work or send photostats, slides and transparencies. Samples are filed or returned by SASE if requested by artist. Will contact artist for portfolio review if interested. Portfolio should include b&w and color samples. Pays for design by the hour or by the project. Pays for illustration by the project.

Tips "We are sent all *Showcase*, *Workbook*, etc." Impressed by "great work, simply presented." Advises freelancers entering the field to save money on promotional materials by partnering with printers. Create a joint project or tie-in. "Send out samples—good luck!"

ALAN FRANK & ASSOCIATES INC.

Dept. AM, 1524 South 100 East, Salt Lake City UT 84105. (801)486-7455. Fax: (801)486-7454. **Art Director:** Scott Taylor. Serves clients in travel, fast food chains and retailing. Clients include KFC, A&W, Taco Bell and Tuffy Automotive.

Needs Uses freelancers for illustrations, animation and retouching for annual reports, billboards, ads, letterheads, TV and packaging.

First Contract & Terms Mail art with SASE. Responds in 2 weeks. Minimum payment $500, animation; $100, illustrations; $200, brochure layout.

VIRGINIA

ⓝ EDDINS MADISON CREATIVE

6487 Overlook Dr., Alexandria VA 22312. (703)750-2595. Fax: (703)750-3109. E-mail: steve@em-creative.com. Website: www.em-creative.com. **Creative Director:** Marcia Eddins. Estab. 1983. Number of employees 5. Specializes in brand and corporate identity and publication design. Clients corporations, associations and nonprofit organizations. Current clients include Reuters, ABC, National Fire Protection Assoc., Nextel. Client list available upon request.

Needs Approached by 20-25 freelancers/year. Works with 4-6 freelance illustrators and 2-4 designers/year. Uses only artists with experience in Macintosh. Uses illustrators mainly for publications and brochures. Uses designers mainly for simple design and Mac production. Also uses freelancers for airbrushing, brochure and poster design and illustration, catalog design, charts/graphs. Needs computer-literate freelancers for design, production and presentation. 100% of freelance work demands knowledge of Illustrator, Photoshop, and QuarkXPress.

First Contact & Terms Send postcard sample of work or send query letter with photocopies and résumé. Samples are filed. Will contact artist for portfolio review if interested. Rights purchased vary according to project. Finds artists through sourcebooks, design/illustration annuals and referrals.

Tips Impressed by "great technical skills, nice cover letter, good/clean résumé and good work samples."

Discover The Magic of Watercolor...

ABSOLUTELY FREE!

*I*f you're passionate about watercolor, acrylic, gouache or any other water-based media, you'll love *Watercolor Magic*—the #1 magazine for watermedia artists. Open an issue and you'll discover all the creative inspiration, excitement, and superior instruction of a professional art lesson. Here's just a sampling of what you'll find inside:

- step-by-step painting demonstrations showcased in spectacular full-color images
- fresh ideas and exercises for non-stop creative inspiration
- tips and technical advice from the best watermedia artists and instructors in the world, including Stephen Quiller, Frank Francese, Betsy Dillard Stroud, and Charles Reid
- the most up-to-date info on the best painting tools and materials
- and so much more!

Now's the time to develop your unique personal style to its fullest potential by taking advantage of this special offer in *Artist's & Graphic Designer's Market*.

Send for your free issue...
Return the attached postage-paid card today!

SEND MY RISK-FREE TRIAL ISSUE!

☑ *Yes!* Send my FREE trial issue of *Watercolor Magic* and start my introductory subscription. If I like what I see, I'll get 5 more issues (6 in all) for just $19.96—that's a 44% savings off the newsstand price. If not, I'll write "cancel" on the bill, return it and owe nothing. The FREE ISSUE will be mine to keep!

Send no money now...we'll bill you later.

Name _____

Address_____

City _____

State/Prov._____ ZIP/PC _____

Canadian orders will be billed an additional US$7 (includes GST/HST) and invoiced.
Outside the U.S. and Canada, add US$7 and remit payment in U.S. funds with this order.
Annual newsstand rate: $35.94. Please allow 4-6 weeks for first-issue delivery.

Watercolor Magic www.watercolormagic.com

J5FAM4

Get a *FREE ISSUE* of *Watercolor Magic*

From the Publishers of *The Artist's Magazine* and *Artist's and Graphic Designer's Market*

*P*acked with innovative ideas, creative inspiration, and detailed demonstrations from the best watermedia artists in the world, *Watercolor Magic* will offer you everything you need to take your art to the next level. You'll learn how to:

- Choose a great subject every time

- Capture light and shadows to add depth and drama

- Experiment by combining media

- Master shape, detail, texture and color

- Explore cutting-edge techniques and materials

- Get inspired and create breathtaking art!

See for yourself how *Watercolor Magic* will help you turn ordinary works into extraordinary art.

Mail the postage-paid card below for your FREE TRIAL ISSUE!

![N] BERNARD HODES ADVERTISING

8270 Greensboro Dr., Suite 600, McLean VA 22102. (703)848-0810. Fax: (703)848-0895. **Creative Director:** Gregg Petermann. Estab. 1970. Ad agency. Full-service, multimedia firm. Specializes in recruitment advertising and employment communications.

Needs Prefers artists with experience in graphic design and high-tech corporate identity. Works on assignment only. Uses freelancers for illustration. 90% of work is with print ads. 99% of freelance work demands knowledge of QuarkXPress, Illustrator, Photoshop or InDesign.

First Contact & Terms Send query letter with brochure, photocopies, résumé and tearsheets. Samples are filed. Write for an appointment to show a portfolio.

WORK, INC.

2019 Monument Ave., Richmond VA 23220. (804)358-9372. Fax: (804)355-2784. E-mail: cabel@worklabs.com. Website: www.workadvertising.com. **Contact:** Cabell Harris, president, chief creative director. Estab. 1994. Number of employees 38. Approximate annual billing $44 million. Ad agency. Specializes in strategic council, account management, creative and production services. Current clients include Mercedes-Benz, Burger King, Hardee's, McDonald's, Office Depot, Virginia Tourism Corporation, Super 8. Client list available upon request. Professional affiliations Advertising Club of Richmond, AIGA.

Needs Approached by 25 illustrators and 35-40 designers/year. Works with 2-3 illustrators and 6-7 designers/year. Works on assignment only. Prefers freelancers with experience in animation, computer graphics, Macintosh. Uses freelancers mainly for new business pitches and specialty projects. Also for logos, mechanicals, TV/film graphics, posters, print ads and storyboards. 40% of work is with print ads. 95% of design work demands knowledge of FreeHand, Illustrator, Photoshop and QuarkXPress. 20% of illustration work demands knowledge of FreeHand, Illustrator, Photoshop and QuarkXPress.

First Contact & Terms Send query letter with photocopies, photographs, résumé, tearsheets, URL. Accepts e-mail submissions. Check website for formats. Samples are filed or returned. Responds only if interested. Request portfolio review in original query. Company will contact artist for portfolio review if interested. Portfolio should include b&w and color finished art, photographs, slides, tearsheets and transparencies. Pays freelancers usually a set budget with a buyout. Negotiates rights purchased. Finds freelancers through artists' submissions, sourcebooks and word of mouth.

Tips "Send nonreturnable samples (lasers) of work with résumé. Follow up by e-mail.

WASHINGTON

AUGUSTUS BARNETT ADVERTISING/DESIGN

P.O. Box 197, Fox Island WA 98333. (253)549-2396. Fax: (253)549-4707. E-mail: charlieb@augustusbarnett.com. **President/Creative Director:** Charlie Barnett. Estab. 1981. Approximate annual billing $1.2 million. Specializes in food, beverages, financial, agricultural, retail, corporate identity, package design. Clients: corporations, manufacturers. Current clients include Tree Top, Inc., Gilbert Global, Russell Investment Group, Nunhems USA, Tacoma Art Museum, Olympia Federal Savings, VOLTA, City of Tacoma. Client list available upon request. Professional affiliations.

Needs Approached by more than 50 freelancers/year. Works with 2-4 freelance illustrators and 2-3 designers/year. Prefers freelancers with experience in food/retail and Mac usage. Works on assignment and retainer. Uses illustrators for product, theme and food illustration, some identity and business-to-business. Also uses freelancers for illustration and multimedia projects. Send query letter with samples, résumé and photocopies. Samples are filed. Responds in 1 month. Pays for design by the hour, negotiable. Pays for illustration by project/use and buyouts. Rights purchased vary according to project.

Tips "Freelancers must understand design is a business."

![N] BELYEA

1809 Seventh Ave., Suite 1250, Seattle WA 98101. (206)682-4895. Fax: (206)623-8912. Website: www.belyea.com. Estab. 1988. Design firm. Specializes in brand and corporate identity, marketing collateral, in-store P-O-P, direct mail, packages and publication design. Clients: corporate, manufacturers, retail. Current clients include PEMCO Insurance, Genie Industries, and Weyerhaeuser. Client list available upon request.

Needs Approached by 20-30 freelancers/year. Works with 3 freelance illustrators/photographers and no designers/year. Prefers local design freelancers only. Works on assignment only. Uses illustrators for "any type of project." Also uses freelancers for brochure, catalog, poster and ad illustration; and lettering. 100% of design and 70% of illustration demands skills in Adobe CS.

First Contact & Terms Send postcard sample and résumé. Samples are filed. Responds only if interested. Pays

for illustration by the project. Rights purchased vary according to project. Finds artists through submissions by mail and referral by other professionals.

Tips "Designers must be computer-skilled. Illustrators must develop some styles that make them unique in the marketplace. When pursuing potential clients, send something (one or more) distinctive. Follow up. Be persistent (it can take one or two years to get noticed) but not pesky. Get involved in local AIGA. Always do the best work you can—exceed everyone's expectations."

CREATIVE CONSULTANTS

2608 W. Dell Dr., Spokane WA 99208-4428. (509)326-3604. Fax: (509)327-3974. E-mail: ebruneau@creativecon sultants.com. Website: www.creativeconsultants.com. **President:** Edmond A. Bruneau. Estab. 1980. Approximate annual billing $300,000. Ad agency and design firm. Specializes in collateral, logos, ads, annual reports, radio and TV spots. Product specialties are business and consumer. Client list available upon request.

Needs Approached by 20 illustrators and 25 designers/year. Works with 10 illustrators and 15 designers/year. Uses freelancers mainly for animation, brochure, catalog and technical illustration, model-making and TV/film graphics. 36% of work is with print ads. Designs and illustration demands skills in Photoshop and QuarkXPress.

First Contact & Terms Designers: Send query letter. Illustrators: Send postcard sample of work and e-mail. Accepts disk submissions if compatible with Photoshop, QuarkXPress, PageMaker and FreeHand. Samples are filed. Responds only if interested. Pays by the project. Buys all rights. Finds artists through Internet, word of mouth, reference books and agents.

Ⓝ DAIGLE DESIGN INC.

180 Olympic Dr. SE, Bainbridge Island WA 98110. (206)842-5356. Fax: (206)780-2526. E-mail: candace@daigle. com. Website: www.daigledesign.com. **Creative Director:** Candace Daigle. Estab. 1987. Number of employees 6. Approximate annual billing $450,000. Design firm. Specializes in brochures, catalogs, logos, magazine ads, trade show display and websites. Product specialties are telecommunications, furniture, real estate development, aviation, yachts, restaurant equipment and automotive. Professional affiliations AIGA.

Needs Approached by 10 illustrators and 20 designers/year. Works with 5 illustrators and 5 designers/year. Prefers local designers with experience in Photoshop, Illustrator, DreamWeaver, Flash and FreeHand. Uses freelancers mainly for concept and production. Also for airbrushing, brochure design and illustration, lettering, logos, multimedia projects, signage, technical illustration and Web page design. 15% of work is with print. 90% of design demands skills in Photoshop, Illustrator and FreeHand. 50% of illustration demands skills in Photoshop, Illustrator, FreeHand and DreamWeaver.

First Contact & Terms Designers: Send query letter with résumé. Illustrators: Send query letter with photocopies. Accepts disk submissions compatible with Adobe PDF players. Send JPEG files. Samples are filed and are not returned. Responds only if interested. Will contact for portfolio review of b&w, color, final art, slides and tearsheets if interested. Pays for design by the hour, $15; pays for illustration by the project, $100-3,000. Buys all rights. Finds artists through submissions, reps, temp agencies and word of mouth.

Ⓝ DITTMANN DESIGN

P.O. Box 31387, Seattle WA 98103-1387. (206)523-4778. E-mail: dittdsgn@nwlink.com. **Owner/Designer:** Martha Dittmann. Estab. 1981. Number of employess 2. Specializes in brand and corporate identity, display and package design and signage. Clients corporations. Client list available upon request. Professional affiliations AIGA.

Needs Approached by 50 freelancers/year. Works with 5 freelance illustrators and 2 designers/year. Uses illustrators mainly for corporate collateral and packaging. Uses designers mainly for color brochure layout and production. Also uses freelancers for brochure and P-O-P illustration, charts/graphs and lettering. Needs computer-literate freelancers for design, illustration, production and presentation. 75% of freelance work demands knowledge of Illustrator, Photoshop, PageMaker, Persuasion, FreeHand and Painter.

First Contact & Terms Send postcard sample of work or brochure and photocopies. Samples are filed. Will contact artist for portfolio review if interested. Portfolio should include final art, roughs and thumbnails. Pays for design by the hour, $35-100. Pays for illustration by the project, $250-5,000. Rights purchased vary according to project. Finds artists through sourcebooks, agents and submissions.

Tips Looks for "enthusiasm and talent."

GIRVIN STRATEGIC BRANDING AND DESIGN

1601 Second Ave., 5th Floor, Seattle WA 98101-1575. (206)674-7808. Fax: (206)674-7909. Website: www.girvin. com. Design Firm. Estab. 1977. Number of employees 34. Specializes in corporate identity and brand strategy, naming, Internet strategy, graphic design, signage, and packaging. Current clients include Warner Bros., Procter & Gamble, Paramount, Wells Fargo, Johnson & Johnson, and Kraft/Nabisco.

Needs Works with several freelance illustrators, production artists and designers/year.

First Contact & Terms Designers: Send query letter with appropriate samples. Illustrators: Send postcard sample or other nonreturnable samples. Will contact for portfolio review if interested. Payment negotiable.

HORNALL ANDERSON DESIGN WORKS, INC.

710 Second Avenue, Suite 1300, Seattle WA 98104. (206)467-5800. Fax: (206)467-6411. E-mail: info@hadw.c om. Website: www.hadw.com. Estab. 1982. Number of employees 70. Design firm. Specializes in full range brand and marketing strategy consultation; corporate, integrated brand and product identity systems; new media; interactive media websites; packaging; collateral; signage; trade show exhibits; environmental graphics and annual reports. Product specialties are large corporations to smaller businesses. Current clients include Microsoft, K2 Corporation, Weyerhaeuser, Seattle Sonics, Space Needle, CitationShares, Eos, Holland America, Widmer Brothers Brewery, Red Hook Brewery. Professional affiliations AIGA, Society for Typographic Arts, Seattle Design Association, Art Directors Club.

● This firm has received numerous awards and honors, including the International Mobius Awards, National Calendar Awards, London International Advertising Awards, Northwest and National ADDY Awards, Industrial Designers Society of America IDEA Awards, Communication Arts, Los Angeles Advertising Women LULU Awards, Brand Design Association Gold Awards, AIGA, Clio Awards, Communicator Awards, Web Awards.

Needs "Interested in all levels, from senior design personnel to interns with design experience. Additional illustrators and freelancers are used on an as needed basis in design and online media projects."

First Contact & Terms Designers: Send query letter with photocopies and résumé. Illustrators: Send query letter with brochure and follow-up postcard. Accepts disk submissions compatible with QuarkXPress, FreeHand or Photoshop, "but the best is something that is platform/software independent (i.e., Director)." Samples are filed. Responds only if interested. Portfolios may be dropped off. Rights purchased vary according to project. Finds designers through word of mouth and submissions; illustrators through sourcebooks, reps and submissions.

N HOWARD/FROST ADVERTISING COMMUNICATIONS

3131 Western Ave., #520, Seattle WA 98121. (206)378-1909. Fax: (206)378-1910. E-mail: bruce@hofro.com. Website: www.hofro.com. **Creative Director:** Bruce Howard. Estab. 1994. Number of full-time employees 4. Ad agency. Specializes in media advertising, collateral and direct mail. Client list is available upon request.

Needs Approached by 20-30 illustrators and 10-15 designers/year. Works with 10 illustrators and 2 designers/year. Works only with artist reps. Uses freelancers mainly for illustration, design overload. Also for airbrushing, animation, billboards, brochure, humorous and technical illustration, lettering, logos, multimedia projects, retouching, storyboards, Web page design. 60% of work is with print ads. 60% of freelance design demands knowledge of PageMaker, FreeHand and Photoshop.

First Contact & Terms Designers: Send query letter with photocopies. Illustrators: Send postcard sample. Accepts disk submissions. Send files compatible with Acrobat, FreeHand, PageMaker or Photoshop. Samples are filed and not returned. Responds only if interested. Art director will contact artist for portfolio review if interested. Pays for design and illustration by the project. Negotiates rights purchased.

Tips "Be patient."

WISCONSIN

N IMAGINASIUM, INC.

321 St. George St., Green Bay WI 54302-1310. (920)431-7872. Fax: (920)431-7875. E-mail: joe@imaginasium.c om. Website: www.imaginasium.com. **Creative Director:** Joe Bergner. Estab. 1991. Number of employees 18. Approximate annual billing $2 million. Strategic marketing communications firm. Specializes in brand development, graphic design, advertising. Product specialties are business to business retail. Current clients include Wisconsin Public Service, Manitowoc Crane, Ansul. Client list available upon request. Professional affiliation Green Bay Advertising Federation, Second Wind Network.

Needs Approached by 50 illustrators and 25 designers/year. Works with 5 illustrators and 2 designers/year. Prefers local designers. Uses freelancers mainly for overflow. Also for brochure illustration and lettering. 15-20% of work is with print ads. 100% of design and 88% of illustration demands skills in Photoshop, QuarkXPress and Illustrator.

First Contact & Terms Designers: Send query letter with brochure, photographs and tearsheets. Illustrators: Send sample of work with follow-up every 6 months. Accepts Macintosh disk submissions of above programs. Samples are filed and are not returned. Will contact for portfolio review of color tearsheets, thumbnails and transparencies if interested. Pays for design by the hour, $50-75. Pays for illustration by the project. Rights purchased vary according to project. Finds artists through submissions, word of mouth, Internet.

UNICOM

9470 N. Broadmoor Rd., Bayside WI 53217. (414)352-5070. Fax: (414)352-4755. **Senior Partner:** Ken Eichenbaum. Estab. 1974. Specializes in annual reports, brand and corporate identity, display, direct, package and publication design and signage. Clients corporations, business-to-business communications, and consumer goods. Client list available upon request.

Needs Approached by 5-10 freelancers/year. Works with 1-2 freelance illustrators/year. Works on assignment only. Uses freelancers for brochure, book and poster illustration, pre-press composition.

First Contact & Terms Send query letter with brochure. Samples not filed or returned. Does not reply; send nonreturnable samples. Write for appointment to show portfolio of thumbnails, photostats, slides and tearsheets. Pays by the project, $200-3,000. Rights purchased vary according to project.

CANADA

☑ WARNE MARKETING & COMMUNICATIONS

1300 Yonge St., Suite 502, Toronto ON M4T 1X3 Canada. (416)927-0881. Fax: (416)927-1676. E-mail: scott@warne.com. Website: www.warne.com. **Studio Manager:** John Coljee. Number of employees 10. Approximate annual billing $2.5 million. Specializes in business-to-business marketing and communications. Current clients include ACTRA Fraternal Benefits Society, Butler Buildings, Johnston Equipment, KWH Pipe, The Orthotic Group, Virtek Vision. Professional affiliations CIM, BMA, INBA.

Needs Works with 4-5 freelance illustrators and 1-3 designers/year. Works on assignment only. Uses freelancers for design and technical illustrations, advertisements, brochures, catalogs, P-O-P displays, retouching, posters, direct mail packages, logos and interactive. Artists should have "creative concept thinking."

First Contact & Terms Send query letter with résumé and photocopies. Samples are not returned. Responds only if interested. Pays for design by the hour, or by the project. Considers complexity of project, client's budget and skill and experience of artist when establishing payment. Buys all rights.

Record Labels

Record labels hire freelance artists to create packaging, merchandising material, store displays, posters and even T-shirts. But for the most part, you'll be creating work for CD booklets and covers. Your greatest challenge in this market will be working within the size constraints. The dimensions of a CD cover are $4^3/_4 \times 4^3/_4$ inches, packaged in a 5×5 inch jewel box. Inside each CD package is a 4-5 panel fold-out booklet, inlay card and CD. Photographs of the recording artist, illustrations, liner notes, titles, credit lines and lyrics all must be placed into that relatively small format.

It's not unusual for an art director to work with several freelancers on one project. For example, one freelancer might handle typography, another illustration; a photographer is sometimes used and a designer can be hired for layout. Labels also turn to outside creatives for display design, promotional materials, collateral pieces or video production.

LANDING THE ASSIGNMENT

Check the listings in the following section to see how each label prefers to be approached and what type of samples to send. Disk and e-mail submissions are encouraged by many of these listings. Check also to see what type of music they produce. Assemble a portfolio of your best art and design in case an art director wants to see more of your work.

Be sure your portfolio includes quality samples. It doesn't matter if the work is of a different genre—quality is key. If you don't have any experience in the industry, create your own CD package, featuring one of your favorite recording artists or groups.

Get the name of the art director or creative director from the listings in this section and send a cover letter with samples, asking for a portfolio review. If you are not contacted within a couple of months, send a follow-up postcard or sample to the art director or other contact person.

Once you nail down an assignment, get an advance and a contract. Independent labels usually provide an advance and payment in full when a project is done. When negotiating a contract, ask for a credit line on the finished piece and samples for your portfolio.

You don't have to live in one of the recording capitals to land an assignment, but it does help to familiarize yourself with the business. Visit record stores and study the releases of various labels. For further information about CD design read *Rock Art*, by Spencer Drate (PBC International), and *The Best Music CD Art & Design* (Rockport).

Helpful Resources

For More Info Learn more about major labels and "indies" by reading industry trade magazines like *Spin*, *Rolling Stone*, *Vibe*, *Revolver*, *Hit Parader* and *Billboard*. Each year around March, the Recording Industry Association of America (RIAA) releases sales figures for the industry. The RIAA's report also gives the latest trends on packaging and format as well as music sales by genre. To request the most recent report, call the RIAA at (202)775-0101 or visit www.riaa.com.

ACTIVATE ENTERTAINMENT

11328 Magnolia Blvd., Suite 3, North Hollywood CA 91601. (818)505-6573. Fax: (818)508-1101. E-mail: jay@2activate.com. Website: www.2activate.com. **President:** James Warsinske. Estab. 2000. Produces CDs and tapes rock & roll, R&B, soul, dance, rap and pop by solo artists and groups.

Needs Produces 2-6 soloists and 2-6 groups/year. Uses 4-10 visual artists for CD and album/tape cover design and illustration; brochure design and illustration; catalog design, layout and illustration; direct mail packages; advertising design and illustration. 50% of freelance work demands knowledge of PageMaker, Illustrator, QuarkXPress and Photoshop.

First Contact & Terms Send query letter with SASE, tearsheets, photographs, photocopies, photostats, slides and transparencies. Samples are filed. Responds in 1 month. To show portfolio, mail roughs, printed samples, b&w and color photostats, tearsheets, photographs, slides and transparencies. Pays by the project, $100-1,000. Buys all rights.

Tips "Get your art used commercially, regardless of compensation. It shows what applications your work has."

[N] AFTERSCHOOL PUBLISHING COMPANY

P.O. Box 14157, Detroit MI 48214. (313)894-8855. **President:** Herman Kelly. Estab. 1978. Produces CDs and tapes rock, jazz, rap, R&B, soul, pop, classical, folk, educational, country/western, dance and new wave. Recent releases *Enjoyment*, by H. Kelly on M.C.P.; *Do You Remember What it Felt Like*, by M.C.P.

Needs Produces 1 solo artist/year. Works with 10 freelance designers and 10 illustrators/year. Prefers professional artists with experience in all forms of the arts. Uses artists for CD cover design, tape cover and advertising design and illustration, brochure design, multimedia projects and posters. 10% of freelance work demands computer skills.

First Contact & Terms Send query letter with brochure, résumé, SASE, bio, proposal and appropriate samples. Samples are filed or are returned by SASE. Responds in 1 month. Requests work on spec before assigning a job. To show portfolio, mail roughs, printed samples, b&w/color tearsheets, photographs, slides and transparencies. Pays by the project. Negotiates rights purchased. Interested in buying second rights (reprint rights) to previously published work. Finds artists through Michigan Artist Directory and Detroit Area.

Tips "Be on a local or national artist roster to work outside your hometown."

[N] ALBATROSS RECORDS/R'N'D PRODUCTIONS

P.O. Box 540102, Houston TX 77254-0102. (713)521-2616. Fax: (713)529-4914. E-mail: rpds2405@aol.com. Website: www.rnddistribution.com. **Art Director:** Victor Ivey. National Sales Director Darin Dates. Estab. 1987. Produces CDs, DVDs, country, jazz, R&B, rap, rock and pop by solo artists and groups. Recent releases *Mr. Mike*, by From tha Hood to tha Barrio; *Suave House Greatest Hits Volume 1*, by 8 Ball and MJG.

Needs Produces 22 releases/year. Works with 3 freelancers/year. Prefers freelancers with experience in QuarkXPress, Freelance. Uses freelancers for cassette cover design and illustration; CD booklet design; CD cover design and illustration; poster design; Web page design; advertising design/illustration. 50% of freelance work demands knowledge of QuarkXPress, FreeHand, Photoshop.

First Contact & Terms Send postcard sample of work. Samples are filed and not returned. Will contact for portfolio review of b&w and color final art if interested. Pays for design by the project, $400 maximum. Pays for illustration by the project, $250 maximum. Buys all rights. Finds freelancers through word of mouth.

N ALEAR RECORDS

Rt. 2, Box 2910, Berkeley Springs WV 25411. (304)258-2175. E-mail: mccoytroubadour@aol.com. **Owner:** Jim McCoy. Estab. 1973. Produces tapes and CDs country/western. Releases ''The Taking Kind,'' by J.B. Miller; ''If I Throw away My Pride,'' by R.L. Gray; and ''Portrait of a Fool,'' by Kevin Wray.

Needs Produces 12 solo artists and 6 groups/year. Works with 3 freelancers/year. Works on assignment only. Uses artists for CD cover design and tape cover illustration.

First Contact & Terms Send query letter with résumé and SASE. Samples are filed. Responds in 1 month. To show portfolio, mail roughs and b&w samples. Pays by the project, $50-250.

N AMERICATONE INTERNATIONAL—U.S.A.

1817 Loch Lomond Way, Las Vegas NV 89102-4437. (702)384-0030. Fax: (702)382-1926. E-mail: jjj@americaton e.com. Website: www.americatone.com. **President:** Joe Jan Jaros. Estab. 1983. Produces jazz. Recent releases by Joe Farrell, Bobby Shew, Gabriel Rosati, Carl Saunders, Raoul Romero, Bill Perkins, Dick Shearer, Lee Gibson, Roy Wiegand, Mark Masters and Bobby Morris.

Needs Produces 10 solo artists and 3 groups/year. Uses artists for direct mail packages and posters.

First Contact & Terms Samples are returned by SASE. Responds within 2 months only if interested. To show a portfolio, mail appropriate materials.

N ARIANA RECORDS

1312 S. Avenida Polar, #A-8, Tucson AZ 85710. (520)790-7324. E-mail: jgasper1596@earthlink.net. Website: www.arianarecords.com. **President:** Jim Gasper. Estab. 1980. Produces CDs folk, spacefunk and rock, by solo artists and groups. Recent releases *Porn Music*, by Buddy Love; *Songs of the 7 Seas*, by Baby Fish Mouth.

Needs Produces 5 releases/year. Works with 2 freelancers/year. Prefers freelancers with experience in cover design. Uses freelancers for album cover design and illustration; cassette cover design and illustration; CD cover design and illustration and multimedia projects. 70% of design and 50% of illustration demands computer skills. ''We are looking at CD covers for the next two years.''

First Contact & Terms Send postcard sample of work. Samples are filed or returned by SASE if requested by artist. Responds in 1 month. Portfolio review not required. Pays by the project.

Tips ''We like simple, but we also like wild graphics! Give us your best shot!''

ARK 21

The Copeland Group, 14724 Ventura Blvd., Penthouse Suite, Sherman Oaks CA 91403. (818)461-1700. Fax: (818)461-1745. E-mail: jbevilaqua@ark21.com. Website: www.ark21.com. **Production Manager:** John Bevilacqua. President: Miles Copeland. Estab. 1996. Produces CDs and cassettes for a variety of niche markets swing, hillbilly by solo artists and groups. Recent releases *The Red Planet* soundtrack; *Secrets*, by The Human League.

Needs Produces 20-30 releases/year. Works with 5-10 freelancers/year. Prefers local designers and illustrators who own Macs. Uses freelancers for album and CD cover and CD booklet design and illustration; poster design; point of purchase and production work. 100% of design demands knowledge of Illustrator, QuarkXPress, Photoshop.

First Contact & Terms Send postcard sample of work. Accepts disk submissions compatible with Mac. Samples are filed or returned by SASE if requested. Does not reply. Artist should send a different promo in a few months. Portfolios may be dropped off Monday through Friday. Will contact for portfolio review if interested. Portfolio should include b&w and color final art, photocopies, photographs, photostats, roughs, slides, tearsheets, thumbnails or transparencies. Pays by the project. Buys all rights. Finds artists through interesting promos, *The Alternative Pick*.

N ASTRALWERKS

104 W. 29th St., 4th Floor, New York NY 10001. (212)886-7510. Fax: (212)643-5562. E-mail: lisac@astralwerks.c om. Website: www.astralwerks.com. **Contact:** Lisa Smith-Craig, director of production. Estab. 1993. Produces CDs, DVD and vinyl alternative, progressive, rap, reggae, rock by solo artists and groups. Recent release *Paper Tigers,* by Caesars. Art guidelines available on website.

Needs Produces 60-100 releases/year. Works with 2 freelancers/year. Prefers local freelancers. Uses freelancers for CD booklet illustration, CD cover design and illustration. 90% of design work demands knowledge of Illustrator, CD cover design and illustration. 90% of design work demands knowledge Illustrator, Photoshop, InDesign and QuarkXPress. 10% of illustration work demands knowledge of FreeHand.

First Contact & Terms Send postcard sample or query letter. Samples are filed. Responds only if interested. Request portfolio review in original query. Portfolio should include color finished and original art, photographs and roughs. Pays by the project; $100-500. Rights purchased vary according to project. Finds freelancers through word of mouth.

ATLAN-DEC/GROOVELINE RECORDS

2529 Green Forest Ct., Snellville GA 30078-4183. (770)985-1686. E-mail: atlandec@prodigy.net. Website: www. atlan-dec.com. **Art Director:** Wileta J. Hatcher. Estab. 1994. Produces CDs and cassettes gospel, jazz, pop, R&B, rap artists and groups. Recent releases *Stepping Into the Light*, by Mark Cocker.

Needs Produces 2-4 releases/year. Works with 1-2 freelancers/year. Prefers freelancers with experience in CD and cassette cover design. Uses freelancers for album cover, cassette cover, CD booklet and poster design. 80% of freelance work demands knowledge of Photoshop.

First Contact & Terms Send postcard sample of work or query letter with brochure, photocopies, photographs and tearsheets. Samples are filed. Will contact for portfolio review of b&w, color, final art if interested. Pays for design by the project, negotiable. Negotiates rights purchased. Finds artists through submissions.

N BIG BEAR RECORDS

P.O. Box, Birmingham B16 8UT. (021)454-7020. Fax (21)454-9996. E-mail: agency@bigbearmusic.com. Website: www.bigbearmusic.com. **Managing Director:** Jim Simpson. Produces CDs and tapes jazz, R&B. Recent releases *Let's Face the Music*, by Bruce Adams/Alan Barnes Quintet; *Blues & Rhythm, Volume One* and *Smack Dab in the Middle*, both by King Pleasure and The Biscuit Boys; *The Boss Is Home*, by Kenny Bakers Dozen.

Needs Produces 4-6 records/year. Works with 2-3 illustrators/year. Uses freelancers for album cover design and illustration. Needs computer-literate freelancers for illustration.

First Contact & Terms Works on assignment only. Send query letter with photographs or photocopies to be kept on file. Samples not filed are returned only by SAE (nonresidents include IRC). Negotiates payment. Considers complexity of project and how work will be used when establishing payment. Buys all rights. Interested in buying second rights (reprint rights) to previously published work.

BLACK DIAMOND RECORDS INCORPORATED

P.O. Box 222, Pittsburg CA 94565. (510)980-0893. Fax (925)432-4342 or (510)540-0497. E-mail: blkdiamondrec @aol.co. Website: www.blackdiamondrecord.com or www.blackdiamondrecords.snn.gr. **Contact:** Jerry J. Bobelli, President. Estab. 1988. Produces tapes, CDs and vinyl 12-inch and 7-inch records: jazz, pop, R&B, soul, urban hip hop by solo artists and groups. Recent releases: song, "California Flight" by California Flight Project. Lp release's entitled project 1,2,3,4 and others upcoming releases of California Flight to come "X-Boyfriend," by Heye featuring Dashawn; "Simple and Easy," by Dean Gladney; The Lo Mob Lp entitled: "From the Lo."

Needs Produces 2 solo artists and 3 groups/year. Works with 2 freelancers/year. Prefers freelancers with experience in album cover and insert design. Uses freelancers for CD/tape cover and advertising design and illustration; direct mail packages; and posters. Needs computer-literate freelancers for production. 85% of freelance work demands knowledge of PageMaker and FreeHand.

First Contact & Terms Send query letter with résumé. Samples are filed or returned. Responds in 3 months. Write for appointment to show portfolio of b&w roughs and photographs. Pays for design by the hour, $100; by the project, varies. Rights purchased vary according to project.

Tips "Be unique, simple and patient. Most of the time success comes to those whose artistic design is unique and has endured rejection after rejection."

N BLASTER BOXX HITS

519 N. Halifax Ave., Daytona Beach FL 32118. (386)252-0381. Fax: (386)252-0381. E-mail: blasterboxxhits@aol. com. Website: blasterboxxhits.com. **C.O.:** Bobby Lee Cude. Estab. 1978. Produces CDs, tapes and albums rock, R&B. Releases *Blow Blow Stero*, by Zonky-Honky; and *Hootchie-Cootch Girl*.

Needs Approached by 15 designers and 15 illustrators/year. Works with 3 designers and 3 illustrators/year. Produces 6 CDs and tapes/year. Works on assignment only. Uses freelancers for CD cover design and illustration.

First Contact & Terms Send query letter with appropriate samples. Samples are filed. Responds in 1 week. To show portfolio, mail thumbnails. Sometimes requests work on spec before assigning a job. Pays by the project. Buys all rights.

BLUE NOTE, ANGEL AND MANHATTAN RECORDS

150 5th Aveune, 6th Floor, New York NY 10010. (212)786-8600. Website: www.bluenote.com and www.angelre cords.com. **Creative Director:** Gordon H. Jee. Creative Assistant: Geri Francis. Estab. 1939. Produces albums, CDs, cassettes, advertising and point-of-purchase materials. Produces classical, jazz, pop and world music by solo artists and groups. Recent releases by Earl Klugh, Al Green and Terrance Blanchard.

Needs Produces approximately 200 releases in US/year. Works with about 10 freelancers/year. Prefers designers with experience in QuarkXPress, Illustrator, Photoshop who own Macs. Uses freelancers for album cover design and illustration; cassette cover design and illustration; CD booklet and cover design and illustration; poster

design. Also for advertising. 100% of design demands knowledge of Illustrator, QuarkXPress, Photoshop (most recent versions on all).

First Contact & Terms Send postcard sample of work. Samples are filed. Responds only if interested. Portfolios may be dropped off every Thursday and should include b&w and color final art, photographs and tearsheets. Pays for design by the hour, $12-20; by the project, $1,000-5,000. Pays for illustration by the project, $750-2,500. Rights purchased vary according to project. Finds artists and designers through submissions, portfolio reviews, networking with peers.

N BOUQUET-ORCHID ENTERPRISES

P.O. Box 1335, Norcross GA 30091. (770)814-2420. **President:** Bill Bohannon. Estab. 1972. Produces CDs and tapes rock, country, pop and contemporary Christian by solo artists and groups. Recent releases *First Time Feeling*, by Adam Day; *Just Another Day*, by Bandoleers.

Needs Produces 6 solo artists and 4 groups/year. Works with 5-6 freelancers/year. Works on assignment only. Uses freelancers for CD/tape cover and brochure design; direct mail packages; advertising illustration, logos, brochures. 60% of design work demands knowledge of PageMaker and QuarkXPress. 40% of illustration work demands knowledge of FreeHand.

First Contact & Terms Send query letter with photocopies and sample CD booklet. "I prefer a brief but concise overview of an artist's background and works showing the range of his talents." Include SASE. Samples are not filed and are returned by SASE if requested by artist. Responds in 1 month. Company will contact artist for portfolio review if interested. Portfolio should include b&w and color photographs and tearsheets. Pays by the project, in line with industry standards for pay. Rights purchased vary according to project. Finds freelancers through agents, artists' submissions and word of mouth.

Tips "Freelancers should be willing to work within guideline requested along with deadlines on material. They should be open to suggested changes and understand budgetary considerations. If we are pleased with artists' works, we are happy to give repeat business."

N C.L.R. RECORDS

14900 Croom Airport Rd., Upper Marlborough MD 20772. (301)627-5996. E-mail: clrrecords@aol.com. **President of A&R:** Stephen Janis. Estab. 1992. Produces CDs, cassstettes, albums dance and rap. Recent releases *Lock Down*, by Sam "the Beast"; *Deep Marlin Funk*, by Mr. Muse.

Needs Produces 4-5 groups/year. Approached by 25 designers and 25 illustrators/year. Works with 3 designers and 1 illustrator/year. Uses freelancers for CD cover design and illustration, album/tape cover and advertising design and posters.

First Contact & Terms Send query letter with brochure, tearsheets, photostats, résumé, slides and transparencies. Samples are filed and are not returned. Call for appointment to show portfolio of roughs, original/final art, b&w tearsheets. Pays for design by the project, $500-1,000; pays for illustration by the project, $500-1,000. Buys all rights.

N DM/BELLMARK/CRITIQUE RECORDS

301 Yamato Rd., Suite 1250, Baco Raton FL 33431. (561)988-1820. Fax: (561)988-1821. Website: www.dmrecords.com. **Art Director:** Deryck Ragoonan. Estab. 1983. Produces albums, CDs and cassettes country, gospel, urban, pop, R&B, rap, rock. Recent releases *Beautiful Experience*, by Prince; *The Bluegrass Sessions*, by Len Anderson; *Certified Crunk*, by Lil' John and the Eastside Boys.This label recently bought Ichiban Records.

Needs Approached by 6 designers and 12 illustrators/year. Works with 4 illustrators/year. Uses freelancers for album, cassette and CD booklet and cover illustration. 100% of design and 50% of illustration demand knowledge of PageMaker, Illustrator, QuarkXPress, Photoshop, FreeHand.

First Contact & Terms Send postcard sample of work. Samples are filed. Will contact for portfolio review if interested. Pays for illustration by the project, $250-500. Buys all rights. Finds artists through magazines.

Tips "Style really depends on the performing artist we are pushing. I am more interested in illustration than typography when hiring freelancers."

N HARD HAT RECORDS AND CASSETTE TAPES

519 N. Halifax Ave., Daytona Beach FL 32118-4017. (386)252-0381. Fax: (386)252-0381. E-mail: hardhatrecords@aol.com. Website: www.hardhatrecords.com. **CEO:** Bobby Lee Cude. Produces rock, country/western, folk and educational by group and solo artists. Publishes high school/college marching band arrangements. Recent releases *Broadway USA*. CD series (a 3-volume CD program of new and original music); *Times-Square Fantasy Theatre* (CD release with 46 tracks of new and original Broadway style music).

- Also owns Blaster Boxx Hits.

Needs Produces 6-12 records/year. Works with 2 designers and 1 illustrator/year. Works on assignment only. Uses freelancers for album cover design and illustration; advertising design; and sheet music covers. Prefers

"modern, up-to-date, on the cutting edge" promotional material and cover designs that fit the music style. 60% of freelance work demands knowledge of Photoshop.

First Contact & Terms Send query letter with brochure to be kept on file one year. Samples not filed are returned by SASE. Responds in 2 weeks. Write for appointment to show portfolio. Sometimes requests work on spec before assigning a job. Pays by the project. Buys all rights.

HULA RECORDS

99-139 Waiua Way, Unit #56, Aiea HI 96701. (808)485-2294. Fax: (808)485-2296. E-mail: hularecords@hawaii.rr.com. Website: www.hawaiian-music.com. **President:** Donald P. McDiarmid III. Produces educational and Hawaiian records; group and solo artists.

Needs Produces 1-2 soloists and 3-4 groups/year. Works on assignment only. Uses artists for album cover design and illustration, brochure and catalog design, catalog layout, advertising design and posters.

First Contact & Terms Send query letter with tearsheets and photocopies. Samples are filed or are returned only if requested. Responds in 2 weeks. Write for appointment to show portfolio. Pays by the project, $50-350. Considers available budget and rights purchased when establishing payment. Negotiates rights purchased.

IMAGINARY ENTERTAINMENT CORP.

P.O. Box 66, Whites Creek TN 37189. (615)299-9237. E-mail: jazz@imaginaryrecords.com. Website: www.imaginaryrecords.com. **Proprietor:** Lloyd Townsend. Estab. 1982. Produces CDs, tapes and LP's rock, jazz, classical, folk and spoken word. Releases include *Kaki*, by S.P. Somtow; *Triologue*, by Stevens, Siegel and Ferguson; and *Fifth House*, by the New York Trio Project.

Needs Produces 1-2 solo artists and 1-2 groups/year. Works with 1-2 freelancers/year. Works on assignment only. Uses artists for CD/LP/tape cover design and illustration.

First Contact & Terms Prefers first contact through e-mail with link to online portfolio, otherwise send query letter with brochure, tearsheets, photographs and SASE if sample return desired. Samples are filed or returned by SASE if requested by artist. Responds in 3 months. To show portfolio, mail thumbnails, roughs and photographs. Pays by the project, $25-500. Negotiates rights purchased.

Tips "I always need one or two dependable artists who can deliver appropriate artwork within a reasonable time frame."

N INTERSCOPE GEFFEN A&M RECORDS

2220 Colorado Ave., Santa Monica CA 90404. (310)865-1000. Website: www.interscope.com. **Contact:** Director of Creative Services. Produces CDs, cassettes, vinyl, DVD a variety of music by solo artists and groups. Recent releases *Monkey Business*, by the Black Eyed Peas; *Guero*, by Beck; *The Way It Is*, by Keyshia Cole. Art guidelines available with project.

Needs Prefers local designers/illustrators with experience in music. Uses freelancers for cassette illustrations and design; CD booklet and cover illustration and design. 100% of design work demands knowledge of Illustrator, Photoshop and QuarkXPress. 100% of illustration work demands knowledge of FreeHand and Illustrator.

First Contact & Terms Send postcard sample. Samples are filed. Responds only if interested. Portfolio should include b&w and color finished art, original art and photographs. Pays by the project. Rights purchased vary according to project. Finds freelancers through magazines, sourcebooks and word of mouth.

N IRISH MUSIC CORPORATION

P.O. Box 1515 Green Island NY 12183. (518)266-0765. Fax: (518)833-0277. E-mail: info@irishmusicb2b.com. Website: www.regorecords.com. **Managing Director:** T. Julian McGrath. Estab. 1916. Produces CDs, DVD—Irish, Celtic, folk.

Needs Produces 12 releases/year. Works with 2 freelancers/year. Prefers local designers. Uses freelancers for CD booklet and cover design; poster design. 100% of illustration demands computer skills.

First Contact & Terms Send query letter with brochure, résumé, tearsheets. Samples are filed if genre compatible. Will contact artist if interested. Pays by the project, $400 maximum. Assumes all rights.

JAY JAY RECORD, TAPE & VIDEO CO.

P.O. Box 41-4156, Miami Beach FL 33141. (305)758-0000. **President:** Walter Jagiello. Produces CDs and tapes country/western, jazz and polkas. Recent releases *Super Hits*, by Li'l Wally Jagiello; *A Salute to Li'l Wally*, by Florida's Harmony Band with Joe Oberaitis (super polka man).

Needs Produces 7 CDs, tapes and albums/year. Works with 3 freelance designers and 2 illustrators/year. Works on assignment only. Uses freelancers for album cover design and illustration; brochure design; catalog layout; advertising design, illustration and layout; and posters. Sometimes uses freelancers for newspaper ads. Knowledge of MIDI-music lead sheets helpful for freelancers.

First Contact & Terms Send brochure and tearsheets to be kept on file. Call or write for appointment to show

portfolio. Samples not filed are returned by SASE. Responds in 2 months. Requests work on spec before assigning a job. Pays for design by the project, $20-50. Considers skill and experience of artist when establishing payment. Buys all rights.

N̄ KALIFORNIA KILLER RECORDINGS (KKR)

1815 Garnet Ave., San Diego CA 92109. (858)539-3989. **President:** Mark Whitney Mehran. Produces albums and CDs rock. Recent releases: "Know My Name" by Antie Pete; *HotRod Paradise* by The Green Leaf.

Needs Produces 2-7 releases/year. Works with 3 freelancers/year. Prefers local artists. Uses freelancers for CD booklet design, CD cover illustration, poster design, negative prep and shooting.

First Contact & Terms Send query letter and postcard with sample of work. Samples are not filed and are not returned. Responds only if interested. Art director will contact artist for portfolio review if interested. Pays by the project. Buys one-time rights.

KIMBO EDUCATIONAL

10 N. Third Ave., Long Branch NJ 07740. E-mail: kimboed@aol.com. Website: www.kimboed.com. **Production Manager:** Amy Laufer. Educational CD/cassette company. Produces 8 cassettes and compact discs/year for schools, teacher-supply stores and parents. Primarily early childhood/physical fitness.

Needs Works with 3 freelancers/year. Prefers local artists on assignment only. Uses artists for CD/cassette/covers; catalog and flier design; and ads. Helpful if artist has experience in the preparation of CD cover jackets or cassette inserts.

First Contact & Terms "It is very hard to do this type of material via mail." Send letter with photographs or actual samples of past work. Responds only if interested. Pays for design and illustration by the project, $200-500. Considers complexity of project and budget when establishing payment. Buys all rights.

Tips "The jobs at Kimbo vary tremendously. We produce material for various levels—infant to senior citizen. Sometimes we need cute 'kid-like' illustrations, and sometimes graphic design will suffice. We are an educational firm, so we cannot pay commercial record/cassette/CD art prices."

N̄ ▣ LAMON RECORDS INC.

P.O. Box 25371, Charlotte NC 28229. (704)882-2657. E-mail: dave@lamonrecords.com. Website: www.lamonrecords.com. **Chairman of Board:** Dwight L. Moody Jr. Produces CDs and tapes rock, country/western, folk, R&B and religious music; groups. Releases *Play Fiddle*, by Dwight Moody; *Western Hits*, by Ruth and Ted Reinhart; *Now and Then*, by Cathy and Dwight Moody.

Needs Works on assignment only. Works with 3 designers and 4 illustrators/year. Uses freelancers for album cover design and illustration, brochure and advertising design, and direct mail packages. 50% of freelance work demands knowledge of Photoshop.

First Contact & Terms Send brochure and tearsheets. Samples are filed and are not returned. Responds only if interested. Call for appointment to show portfolio or mail appropriate materials. Considers skill and experience of artist and how work will be used when establishing payment. Buys all rights.

Tips "Include work that has been used on album, CD or cassette covers."

PATTY LEE RECORDS

6034½ Graciosa Dr., Hollywood CA 90068. (323)469-5431. Website: www.PattyLeeRecords.com. **Contact:** Patty Lee. Estab. 1986. Produces CDs and tapes New Orleans rock and roll, jazz and eclectic by solo artists. Recent releases: *Sizzlin'*, by Armand St. Martin; *Magnetic Boots*, by Angelyne; *Return to Be Bop*, by Jim Sharpe; remastered *Alligator Ball*, by Armand St. Martin.

Needs Produces 2 soloists/year. Works with several designers and illustrators/year. Works on assignment only. Uses freelancers for CD/tape cover; sign and brochure design; and posters.

First Contact & Terms Send postcard sample. Samples are filed or are returned by SASE. Responds only if interested. "Please do not send anything other than an introductory letter or card." Pays by the project; $100 minimum. Rights purchased vary according to project. Finds new artists through word of mouth, magazines, submissions/self-promotional material, sourcebooks, agents and reps and design studios.

Tips "The postcard of their style and genre is the best indication to us as to what the artists have and what might fit into our needs. If the artist does not hear from us, it is not due to a negative reflection on their art."

N̄ LMNOP®

P.O. Box 33369, Decatur GA 30033. Website: www.babysue.com and www.LMNOP.com. **President:** Don W. Seven. Estab. 1983. Produces CDs, tapes and albums rock, jazz, classical, country/western, folk and pop. Releases: *Homo Trip*, by The Stereotypes; and *Bad is Good*, by Lisa Shame.

Needs Produces 6 solo artists and 10 groups/year. Uses 5 freelancers/year for CD/album/tape cover design

DL Warfield

Professionalism is key to music industry assignments

When your art is endorsed by superstars like Usher, Toni Braxton and Pink, you may never have to compete for an assignment again. *The calls are automatic.* That's what Goldfinger Creative founder DL Warfield discovered after designing music packages for Arista, Universal, Def Jam, Capitol, Sony, and a dozen others. In the backdrop of Atlanta, billed the entertainment capital of the South, Warfield's company works around the clock to conceptualize *image*. "The music industry breathes images, eats images and sells images," says Warfield. As creative director of the former La Face Records (the label responsible for first successes of TLC and Outkast), his words encapsulate a lot of experience. With this in mind, no promotional design—not even a sample—leaves the Goldfinger studio until it is dubbed "spectacular." He believes that every commercial designer should be so particular.

"The art most be showy and imaginative while providing an all-over feel of the artist being promoted. Sometimes this must be achieved in record time before a video is released or the musician's tour schedule is announced," says Warfield. "The most challenging aspect of the task is that one design has to capture the essence of both the human being you may never come in contact with and their music. If a designer does not achieve this, word gets around quickly."

Since the usual turn-around time for an assignment is two weeks—one for the initial development, another for revisions of the overall look and feel—there's virtually no flexibility around concept changes. If the label's president hates the shade of a color, Warfield says altering the tone is acceptable; switching to another color altogether is not. (He used his own judgment before and found out the hard way.) Oftentimes, the text comes in last from the artist (for example, tour dates) and it has to fit in the final design automatically. The text then gets situated with any illustrations, song lyrics, and credit lines sent by the label.

"The trick is to position everything right the first time. This takes a lot of prior experience with layout. It's not enough to have great computer skills," says Warfield. "Every artist interested in designing material for the record industry should have good skills in painting and drawing, which can then be applied to the technical aspect of design. This way, you won't only see a functional design but something that's sparkles with personality."

To better illustrate his point, Warfield compares corporate design for a company like IBM to the colorful, urbane CD covers usually found in the hip hop section of a record store. "Both designs are catchy, but the taxing part for the designer—especially someone working on their first assignment—is to consider the image or personality that's being suggested and then integrate the right amount of flair in the artwork." To help with the

brainstorming process, Warfield suggests looking through source books like *Symbol Soup* and *Pantone Color Boxes* and researching what designers from other countries are doing. Since the music industry flourishes in places like London and Berlin where some major labels have headquarters, Warfield also surveys designs in the import section of record stores. Warfield says it's important to stay up on the latest trends in pop culture.

Because such a quick turn-around is expected by the client, Warfield points out that all skills—from the technical applications to fine art—are tested in the initial sample designs. That said, there is no way to produce the right design by relying on one area of expertise over another. He emphasizes that the greatest disservice artists can do to their reputation is to embellish their skills in their correspondence to a potential client. Whether they submit a portfolio or brochure (in most cases, both are preferred, says Warfield), artists should only present a sample of what they can deliver professionally and on time. In other words, if you're not completely com-

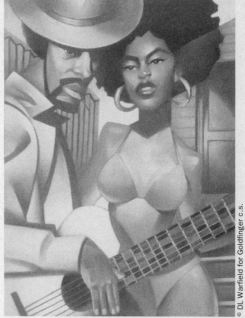

Music industry design and illustration encompasses much more than CD covers. Warfield's firm provides the visuals for all kinds of promotions. This illustration of ex-Fugees Wyclef Jean and Lauryn Hill graced point-of-purchase material for Tanqueray. Catch more images at www.goldfingercreative.com.

© DL Warfield for Goldfinger c.s.

fortable with your drawing or layout skills, do not approach the labels just yet. Every artist is hungry for the work, but patience and confidence are very important, says Warfield.

"The music industry is always expanding. There is plenty of work for the artists who are thoroughly prepared to demonstrate their abilities. But if that artist is not totally prepared before putting his name out there, it will only hinder him from getting future assignments since he honestly couldn't do the work in the first place."

In landing assignments, Warfield suggests contacting the art director by phone within a month of sending a formal portfolio of various samples, a résumé and cover letter. The cover letter should demonstrate familiarity with the label and their artists. On the phone, the artist should introduce himself professionally ("no gushing or small talk") before *asking* for a convenient time to discuss the portfolio. "Art directors are extremely busy people, but they do care that you took the time to approach them. If you are courteous and well-spoken, they will usually make time to discuss your work if they've not already gotten back to you," says Warfield, who has been an art director in the fashion industry as well. Having worked for Edison Brothers Stores and the Tommy Boy label, Warfield oversaw numerous freelance designers.

If the artist scores an assignment, the usual contract from a major label involves a 50% deposit. Warfield says he has required a 75% deposit from smaller, independent labels but only because of the company's tight budget. Nonetheless, if the client is a small, indepen-

dent label, the artist should assume the same loyalty and respect as they would for a major label like Arista, he adds.

In Warfield's eyes, "loyalty" means "giving more value to your work so the client never even thinks about using another artist." Perhaps his best example of loyalty was an emergency assignment for the group Outkast. Warfield was called to execute a photo shoot in a field of sunflowers. He had to find 40 women willing to be photographed in nothing but body paint. Over 300 models responded in one hour because of his company's persistence.

"Our client will never forget how well we pulled that assignment off," says Warfield. "*That* is what I mean by dedication to your work."

—Candi Lace

and illustration, catalog design, advertising design and illustration and posters. 20% of design and 50% of illustration demand computer skills.
First Contact & Terms Send postcard sample or query letter with SASE, photographs, photostats and slides. Samples are not filed and are not returned. Responds only if interested. To show portfolio, mail roughs, b&w and color photostats and photographs. Pays by the day, $250-500. Rights purchased vary according to project.

▣ LUCIFER RECORDS, INC.
P.O. Box 263, Brigantine NJ 08203. (609)266-2623. **President:** Ron Luciano. Produces pop, dance and rock.
Needs Produces 2-12 records/year. Prefers experienced freelancers. Works on assignment only. Uses freelancers for album cover and catalog design; brochure and advertising design, illustration and layout; direct mail packages; and posters.
First Contact & Terms Send query letter with résumé, business card, tearsheets, photostats or photocopies. Responds only if interested. Original art sometimes returned to artist. Write for appointment to show portfolio, or mail tearsheets and photostats. Pays by the project. Negotiates pay and rights purchased.

MAGGIE'S MUSIC, INC.
P.O. Box 490, Shady Side MD 20764. E-mail: mail@maggiesmusic.com. Website: www.maggiesmusic.com. **President:** Maggie Sansone. Estab. 1984. Produces CDs and tapes contemporary acoustic, Christmas and Celtic. Recent releases *Acoustic Journey*, by Al Petteway and Amy White; *Mystic Dance*, by Maggie Sansone; *Early American Roots*, by Hesperus; *Scottish Fire*, by Bonnie Rideout.
Needs Produces 3-4 albums/year. Works with freelance graphic designers. Prefers freelancers with experience in CD covers and Celtic designs. Works on assignment only.
First Contact & Terms Send e-mail query only. Company will contact artist if interested.
Tips This company asks that the artist request a catalog first "to see if their product is appropriate for our company."

ℕ JIM MCCOY MUSIC
Rt. 2 Box 2910, Berkeley Springs WV 25411. (304)258-9381. E-mail: mccoytroubador@aol.com. **Owner:** Bertha McCoy. Estab. 1972. Produces CDs and tapes country/western. Recent releases *Mysteries of Life*, by Carroll County Ramblers.
Needs Produces 12 solo artists and 10 groups/year. Works on assignment only. Uses artists for CD cover design and illustration; tape cover illustration.

ℕ MIA MIND MUSIC
259 W. 30th St., 12th Floor, New York NY 10001. (212)564-4611. Fax: (212)564-4448. E-mail: mimimus@aol.com. Website: www.miamindmusic.com. **Contact:** Stevie B. "Mia Mind Music works with bands at the stage in their careers where they need CD artwork and promotional advertisements. The record label Mia Mind signs about 12 artists per year and accepts artwork through the mail or call for appointment." Recent releases *Museum of Me*, by Chris Butler.
Needs Approached by 40 designers and 50 illustrators/year. Works with 6 designers and 2 illustrators/year.
First Contact & Terms Send query letter with résumé, photocopies, tearsheets. Samples are filed. Responds in 2 weeks. Call for appointment to show portfolio of b&w and color final art and photographs or mail appropriate materials. Pays for design by the project, $200 minimum; pays for illustration by the project, $200 minimum. Rights purchased vary according to project.

Tips ''Be willing to do mock-ups for samples to be added to company portfolio.'' Looks for ''abstract, conceptual art, the weirder, the better. 'Extreme' sells in the music market.''

▣ MIGHTY RECORDS

BMI Music Publishing Co.Corporate Music Publishing Co.ASCAP, Stateside Music Publishing Co.BMI, 150 West End Ave., Suite 6-D, New York NY 10023. (212)873-5968. **Manager:** Danny Darrow. Estab. 1958. Produces CDs and tapes jazz, pop, country/western; by solo artists. Releases New trend jazz release *Impulse*, by Danny Darrow.

Needs Produces 1-2 solo artists/year. Works on assignment only. Uses freelancers for CD/tape cover, brochure and advertising design and illustration; catalog design and layout; and posters.

First Contact & Terms Samples are not filed and are not returned. Rights purchased vary according to project.

NORTH STAR MUSIC INC.

22 London St., East Greenwich RI 02818. (401)886-8888. Fax: (401)886-8880. E-mail: info@northstarmusic.com. Website: www.northstarmusic.com. **President:** Richard Waterman. Estab. 1985. Produces music CDs, jazz, classical, folk, traditional, contemporary, world beat, New Age by solo artists and groups. Recent releases *Wine & Roses*, by The Paul Nagel Trio.

Needs Produces 4 solo artists and 4 groups/year. Works with 2 freelancers/year. Prefers freelancers with experience in CD cover design. Works on assignment only. Uses artists for CD cover and brochure design and illustration; catalog design, illustration and layout; direct mail packages. 80% of design and 20% of illustration demand knowledge of QuarkXPress 4.0.

First Contact & Terms Send postcard sample or query letter with brochure, photocopies and SASE. Accepts disk submissions compatible with QuarkXPress 4.0. Send EPS or TIFF files. Samples are filed. Responds only if interested. To show portfolio, mail color roughs and final art. Pays for design by the project, $500-1,000. Buys first rights, one-time rights or all rights.

Tips ''Learn about our label style of music/art. Send appropriate samples.''

ONE STEP TO HAPPINESS MUSIC

Jacobson & Colfin, P.C., New York NY 10010. (212)691-5630. Fax: (212)645-5038. E-mail: Bruce@thefirm.com. **Attorney:** Bruce E. Colfin. Produces CDs, tapes and albums reggae group and solo artists. Release *Make Place for the Youth*, by Andrew Tosh.

Needs Produces 1-2 soloists and 1-2 groups/year. Works with 1-2 freelancers/year on assignment only. Uses artists for CD/album/tape cover design and illustration.

First Contact & Terms Send query letter with brochure, résumé and SASE. Samples are filed or returned by SASE if requested by artist. Responds in 2 months. Call or write for appointment to show portfolio of tearsheets. Pays by the project. Rights purchased vary according to project.

OPUS ONE

Box 604, Greenville ME 04441. (207)997-3581. **President:** Max Schubel. Estab. 1966. Produces CDs, LPs, 78s, contemporary American concert and electronic music.

Needs Produces 6 releases/year. Works with 1-2 freelancers/year. Prefers freelancers with experience in commercial graphics for compact discs. Uses freelancers for CD cover design.

First Contact & Terms Send postcard sample or query letter with rates and example of previous artwork. Samples are filed. Pays for design by the project. Buys all rights. Finds artists through meeting them in arts colonies, galleries or by chance.

Tips ''Contact record producer directly. Send samples of work that relate in size and subject matter to what Opus One produces. We want witty and dynamic work.''

OREGON CATHOLIC PRESS

5536 NE Hassalo, Portland OR 97213-3638. (503)281-1191. Fax: (503)282-3486. E-mail: jeang@ocp.org. Website: www.ocp.org/. **Art Director:** Jean Germano. Estab. 1934. Produces liturgical music CDs, cassettes, songbooks, missalettes, books.

Needs Produces 10 collections/year. Works with 5 freelancers/year. Uses freelancers for cassette cover design and illustration; CD booklet illustration; CD cover design and illustration. Also for spot illustration.

First Contact & Terms Send query letter with brochure, transparencies, photocopies, photographs, slides, tearsheets and SASE. Samples are filed or returned by SASE. Responds in 2 weeks. Will contact artist if interested. Pays for illustration by the project, $35-500. Finds artists through submissions and the Web.

Tips Looks for attention to detail.

N PANDISC MUSIC/STREET BEAT RECORDS

6157 NW 167th St., Suite F-11, Miami FL 33015. (305)557-1914. Fax: (305)557-9262. E-mail: beth@pandisc.com. Website: www.pandisc.com and www.streetbeatrecords.com. **Director of Production:** Beth Sereni. Estab. 1982. Produces CDs and vinyl dance, underground/club, electronica, bass and rap.

Needs Produces 35-50 releases/year as well as some print ads and miscellaneous jobs. Works with a few freelancers and design firms. Prefers freelancers with experience in record industry. Uses freelancers for CD/records jacket design, posters, direct mail packages as well as print ads, promotional materials, etc. Needs computer-literate freelancers for design and production. 100% of freelance work demands computer knowledge, specifically QuarkXpress and the Adobe suites.

First Contact & Terms Send query letter with samples of work or via e-mail. Samples are filed if found to have potential. Art director will contact artist if interested. "Call for per-job rates." Buys all rights.

Tips "Must be deadline conscious and versatile."

N ▣ PPI ENTERTAINMENT GROUP

103 Eisenhower Pkwy., Roseland NJ 07105. (973)226-1234. **Creative Director:** Eric Lewandoski. Estab. 1923. Produces CDs, DVDs and tapes educational, feature films; aerobics and self-help videos. Specializes in children's health and fitness. Recent releases *The Method*® and *Quick Fix*®, *Peter Pan Records*®.

Needs Produces 200 records and videos/year. Works with 10-15 freelance designers/year and 10-15 freelance illustrators/year. Uses artists for DVD menus and illustration; brochure, catalog and advertising design, illustration and layout; direct mail packages; posters; and packaging.

First Contact & Terms Works on assignment only. Send query letter with samples to be kept on file; call or write for appointment to show portfolio. Prefers photocopies or tearsheets as samples. Samples not filed are returned only if requested. Responds only if interested. Original artwork returned to artist. Pays by the project. Considers complexity of project and turnaround time when establishing payment. Purchases all rights.

N PRAVDA RECORDS

6311 N. Neenah, Chicago IL 60631. (773)763-7509. Fax: (773)763-3252. E-mail: pravdausa@aol.com. Website: www.pravdamusic.com. **Contact:** Kenn Goodman. Estab. 1986. Produces CDs, tapes and posters rock, progressive by solo artists and groups. Recent releases *Vodka and Peroxide*, by Civiltones; *Dumb Ask*, by Cheer Accident.

Needs Produce 1 solo artist and 3-6 groups/year. Works with 1-2 freelancers/year. Works on assignment only. Uses freelancers for CD/tape covers and advertising design and illustration; catalog design and layout; posters. Needs computer-literate freelancers for design and production. 100% of freelance work demands knowledge of Illustrator, QuarkXPress and Photoshop.

First Contact & Terms Send query letter with résumé, photocopes, SASE. Samples are not filed and are returned by SASE if requested by artist. Responds in 2 months. Portfolio should include roughs, tearsheets, slides, photostats, photographs. Pays for design by the project, $250-1,000. Rights purchased vary according to project.

▣ R.E.F. RECORDING COMPANY/FRICK MUSIC PUBLISHING COMPANY

404 Bluegrass Ave., Madison TN 37115. (615)865-6380. E-mail: bob-scott-frick@juno.com. **Contact:** Bob Frick. Produces CDs and tapes southern gospel, country gospel and contemporary Christian. Recent releases *Seasonal Pickin*, by Bob Scott Frick; *Righteous Pair*; *Pray When I Want To*.

Needs Produces 30 records/year. Works with 10 freelancers/year on assignment only.

First Contact & Terms Send résumé and photocopies to be kept on file. Write for appointment to show portfolio. Samples not filed are returned by SASE. Responds in 10 days only if interested.

N ▨ ▣ RAMMIT RECORDS

3282 Ivernia Rd., Mississauga ON L4Y 3E8 Canada. (905)275-8182. **President:** Trevor G. Shelton. Estab. 1988. Produces CDs, tapes and 12-inch vinyl promos for CDs rock, pop, R&B and soul by solo artists and groups. Recent releases: *2 Versatile*, by 2 Versatile, hip hop/R&B, A&M distribution; *Hopping Penguins*, by Trombone Chromosome, ska/reggae, MCA distribution; *Line Up In Paris*, by Line Up in Paris, rock, A&M distribution.

Needs Produces 4 releases/year. Works with 3-5 freelancers/year. Uses freelancers for CD cover design and illustration, tape cover illustration, advertising design and posters. 75% of freelance work demands computer skills.

First Contact & Terms Send query letter with "whatever represents you the best." Responds only if interested. Artist should follow-up with call and/or letter after initial query. Portfolio should include b&w and color photostats. Pays for design by the project, $1,000-3,000. Negotiates rights purchased. Finds artists through word of mouth, referrals and directories.

◼ REDEMPTION RECORDING CO.

P.O. Box 10238, Beverly Hills CA 90213. (323)666-0221. E-mail: info@redemption.net. Website: www.redempti on.net. **Contact:** Ryan Kuper. Estab. 1990. Produces all formats of musical media for indie rock/punk and rock groups. Recent releases: *s/t*, by Race For Titles; *Everyone Here is Wrong*, by The Working Title.

Needs Produces 5-7 releases/year. Works with 5 freelancers/year. Prefers artists with experience in CD design and associated layouts. Uses freelancers for CD covers, posters and web design. 75% of design work demands knowledge of Illustrator and Photoshop.

First Contact & Terms E-mail URL with samples. No calls. Responds only if interested. Portfolio not required. Rights purchased vary according to project. Finds freelancers through websites and examples currently in the market.

◼ RHYTHMS PRODUCTIONS/TOM THUMB MUSIC

P.O. Box 34485, Los Angeles CA 90034-0485. **President:** R. White. Estab. 1955. Produces CDs, cassettes of children's music.

Needs Works on assignment only. Works with 3-4 freelance artists/year. Prefers Los Angeles artists who have experience in advertising, catalog development and cover illustration/design. Uses freelance artists for album, cassette and CD cover design and illustration; animation; CD booklet design and illustration; CD-ROM packaging. Also for catalog development. 95% of design and 50% of illustration demand knowledge of QuarkXPress and Photoshop.

First Contact & Terms Send query letter photocopies and SASE. Samples are filed or are returned by SASE if requested. Responds in 6 weeks. "We do not review portfolios unless we have seen photocopies we like." Pays by the project. Buys all rights. Finds artists through submissions and recommendations.

Tips "We like illustration that is suitable for children. We find that cartoonists have the look we prefer. However, we also like art that is finer and that reflects a 'quality look' for some of our more classical publications. Our albums are for children and are usually educational. We don't use any violent or extreme art which is complex and distorted."

ROCK DOG RECORDS

P.O. Box 3687, Hollywood CA 90078. (800)339-0567. E-mail: gerry.cannizzaro@att.net. Website: www.rockdog records.com. **Vice President of Production:** Gerry North Cannizzaro. CFO: Patt Connolly. Estab. 1987. Produces CDs and tapes rock, R&B, dance, New Age, contemporary instrumental, ambient and music for film, TV and video productions. Recent releases *This Brave New World*, by Brainstorm; *Fallen Angel*, by Iain Hersey; *The Best of Brainstorm*, by Brainstorm.

● This company has a second location at P.O. Box 884, Syosset, NY 11791-0899. (516)544-9596. (516)364-1998

A&R, Promotion and Distribution Maria Cuccia.

Needs Produces 2-3 solo artists and 2-3 groups/year. Approached by 50 designers and 200 illustrators/year. Works with 5-6 designers and 25 illustrators/year. Prefers freelancers with experience in album art. Uses artists for CD album/tape cover design and illustration, direct mail packages, multimedia projects, ad design and posters. 95% of design and 75% of illustration demand knowledge of Print Shop or Photoshop.

First Contact & Terms Send postcard sample or query letter with photographs, SASE and photocopies. Accepts disk submissions compatible with Windows '95. Send Bitmap, TIFF, GIF or JPG files. Samples are filed or are returned by SASE. Responds in 2 weeks. To show portfolio, mail photocopies. Sometimes requests work on spec before assigning a job. Pays for design by the project, $50-500. Pays for illustration by the project, $50-500. Interested in buying second rights (reprint rights) to previously published work. Finds new artists through submissions from artists who use *Artist's & Graphic Designer's Market*.

Tips "Be open to suggestions; follow directions. Don't send us pictures, drawings (etc.) of people playing an instrument. Usually we are looking for something abstract or conceptual. We look for prints that we can license for limited use."

SAHARA RECORDS AND FILMWORKS ENTERTAINMENT

28 E. Jackson Bldg., 10th Floor, #S627, Chicago IL 60604-2263. (773)509-6381. Fax: (312)922-6964. E-mail: info@edmsahara.com. Website: www.edmsahara.com. **Contact:** Dwayne Woolridge, marketing director. Estab. 1981. Produces CDs, cassettes: jazz, pop, R&B, rap, rock, soul, TV-film music by solo artists and groups. Recent releases: *Pay the Price* and *Rice Girl* film soundtracks; *Dance Wit Me*, by Steve Lynn.

Needs Produces 25 releases/year. Works with 2 freelancers/year. Uses freelancers for CD booklet design and illustration; CD cover design and illustration; poster design and animation.

First Contact & Terms Contact only through artist rep. Samples are filed. Responds only if interested. Payment negotiable. Buys all rights. Finds artists through agents, artist's submissions, *The Black Book* and *Directory of Illustration*.

N SHAOLIN COMMUNICATIONS

P.O. Box 900457, San Diego CA 92190. (801)595-1123. E-mail: taichiyouth@worldnet.att.net. **Vice President of A&R:** Don DeLaVega. Estab. 1984. Produces albums, CDs, CD-ROMs, cassettes, books and videos folk, pop, progressive, rock, Chinese meditation music by solo artists and groups. Recent releases: *Levell*, by American Zen; *Tai Chi Magic*, by Master Zhen.

Needs Produces 14 releases/year. Works with 4 freelancers/year. Prefers local freelancers who own Macs. Uses freelancers for album cover design and illustration; animation; cassette cover design and illustration; CD booklet design and illustration; CD cover design and illustration; CD-ROM design and packaging; poster design; Web page design. Also for multimedia, brochures and newsletter *Shaolin Zen*. 80% of design and 20% of illustration demands knowledge of Dreamweaver, Canvas and Photoshop.

First Contact & Terms Send query letter with brochure, résumé, SASE. Samples are filed or returned by SASE if requested by artist. Responds in 6 weeks if interested. Will contact for portfolio review if interested. Pays for design and illustration by the hour, $15-25; by the project, $250-500. Buys all rights. Finds artists through submissions and social contacts.

Tips "Find projects to do for friends, family . . . to build your portfolio and experience. A good designer must have some illustration ability and a good illustrator needs to have design awareness—so usually our designer is creating a lot of artwork short of a photograph or piece of cover art."

SILVER WAVE RECORDS

2475 Broadway, Suite 300, Boulder CO 80304. (303)443-5617. Fax: (303)443-0877. E-mail: valerie@silverwave.com. Website: www.silverwave.com. **Art Director:** Valerie Sanford. Estab. 1986. Produces CDs, cassettes Native American and world music. Recent releases *Feed the Fire*, by Mary Youngblood; *Covenant*, by Joanne Shenandoah; *Indians Indians*, by Robert Mirabal; *Red Moon*, by Peter Kater and R. Carlos Nakai and others.

Needs Produces 4 releases/year. Works with 4-6 illustrators, artists, photographers a year. Uses illustrators for CD cover illustration.

First Contact & Terms Send postcard sample or query letter with 2 or 3 samples. Samples are filed. Will contact for portfolio review if interested. Pays by the project. Rights purchased vary according to project.

Tips "Develop some good samples and experience. I look in galleries, art magazines, *Workbook*, *The Black Book* and other trade publications. I visit artist's booths at Native American 'trade shows.' Word of mouth is effective. We will call if we like work or need someone." When hiring freelance illustrators, looks for a specific style for a particular project. "Currently we are producing contemporary Native American music and will look for art that expresses that."

SOMNIMAGE CORPORATION

P.O. Box 24, Bradley IL 60915. (815)932-8547. E-mail: somnimage@aol.com. Website: www.somnimage.com. **Contact:** Mykel Boyd. Estab. 1998. Produces albums, CDs, CD-ROMs, cassettes and vinyl classical, folk, jazz, pop, progressive, rap, rock, experimental and electronic music by solo artists and groups. Recent releases *Wolf Sheep Cabbage*, by The Hafler Trio; Kafka tribute CD compilation.

Needs Produces 10 releases/year. Works with 10 freelancers/year. Looking for creative art. Uses freelancers for cover design and illustration; cassette cover design and illustration; CD booklet design and illustration; CD cover design and illustration; CD-ROM design and packaging and poster design. Freelancers should be familiar with PageMaker, Illustrator, QuarkXPress, Photoshop, FreeHand.

First Contact & Terms Send query letter with brochure, résumé, photostats, transparencies, photocopies, photographs, slides, SASE, tearsheets. Accepts disk submissions. Samples are filed or returned by SASE if requested by artist. Responds in 3 months. Will contact artist for portfolio review of b&w and color final art, photocopies, photographs, photostats, roughs, slides, tearsheets, thumbnails and transparencies, if interested. Pays by the project. Negotiates rights purchased. Finds artists through word of mouth.

Tips "We are interested in surreal art, dada art, dark themed photography too."

N SONY MUSIC CANADA

1121 Leslie St., Toronto M3C 2J9. (416)391-3311. Fax: (416)447-1823. E-mail: catherine_mcrae@sonymusic.ca. **Art Director:** Catherine McRae. Estab. 1962. Produces albums, CDs, cassettes classical, country, folk, jazz, pop, progressive, R&B, rap, rock, soul. Recent releases LPs by Celine Dion, Chantal Kreviazuk, Our Lady Peace.

Needs Produces 40 domestic releases/year. Works with 10-15 freelancers/year. Prefers local designers who own Mac computers. Uses freelancers for album, cassette and CD cover design and illustration, CD booklet design and illustration, poster design. 80% of design and photography and 20% of illustration demand knowledge of Illustrator, Photoshop, QuarkXPress.

First Contact & Terms E-mail website information. Accepts disk submissions compatible with Mac TIFF or EPS files. Responds only if interested. Will contact for portfolio review of b&w, color, photocopies, photographs,

tearsheets if interested. Pays by the project. Buys all rights. Finds artists through other CD releases, magazines, art galleries, word of mouth.

Tips "Know what is current musically and visually."

N STARDUST RECORDS/WIZARD RECORDS/THUNDERHAWK RECORDS

341 Billy Goat Hill Rd., Winchester TN 37398. (931)649-2577. Fax: (931)649-2732. E-mail: cbd@vallnet.com. Website: http//stardustcountrymusic.com. **Contact:** Col. Buster Doss. Produces CDs, tapes and albums rock, folk, country/western. Recent releases *13 Red Roses Plus One*, by Jerri Arnold; *It's the Heart*, by Brant Miller.

Needs Produces 12-20 CDs and tapes/year. Works with 2-3 freelance designers and 1-2 illustrators/year on assignment only. Uses freelancers for CD/album/tape cover design and illustration; brochure design; and posters.

First Contact & Terms Send query letter with brochure, tearsheets, résumé and SASE. Samples are filed. Responds in 1 week. Call for appointment to show portfolio of thumbnails, b&w photostats. Pays by the project. Finds new artists through *Artist's & Graphic Designer's Market*

TAESUE ENTERTAINMENT LTD.

P.O. Box 803213, Chicago IL 60680. E-mail: Taesue1@aol.com and etaylor950@aol.com. **Contact:** Eric C. Taylor, CEO; Anthony Portee, vice president or Dyrol Washington, vice president. Estab. 1996. Produces CDs, cassettes, video gospel, pop, R&B, rap by solo artists and groups. Recent releases: *In Time*, by Sacred Call; *Mama Say*, by The Fortress; *The Change*, by Rev. Patrick McCall and Praise and Anointed Needs.

Needs Produces 6 releases/year. Works with 5 freelancers/year. Uses freelancers for album cover design and illustration; cassette cover design and illustration; CD booklet design and illustration; CD cover design and illustration; poster design; Web page design. 70% of design and 70% of illustration demands knowledge of Illustrator, Photoshop, FreeHand.

First Contact & Terms Send query letter with brochure, résumé, photocopies, slides. Accepts disk submissions compatible with Mac or PC. Samples are filed or returned by SASE if requested by artist. Responds in 1 month. Art Director will contact artist for portfolio review of b&w, color, final art, photocopies, thumbnails if interested. Pays for design and illustration by the project; negotiable. Rights purchased vary according to project. Finds artists through *Black Book* and magazines.

Tips "Record companies are always looking for a new hook so be creative. Keep your price negotiable. I look for creative and professional-looking portfolio."

N TANGENT® RECORDS

P.O. Box 383, Reynoldsburg OH 43068-0383. (614)751-1962. Fax (614)751-6414. E-mail: info@tangentrecords.c om. **President:** Andrew J. Batchelor. Estab. 1986. Produces CDs, DVDs, CD-ROMs, cassettes, videos contemporary, classical, jazz, progressive, rock, electronic, world beat and New Age fusion. Recent releases "Moments Edge," by Andrew Batchelor.

Needs Produces 20 releases/year. Works with 5 freelancers/year. Prefers local illustrators and designers who own computers. Uses freelancers for CD booklet design and illustration; CD cover design and illustration; CD-ROM design and packaging; poster design; Web page design. Also for advertising and brochure design/illustration and multimedia projects. Most freelance work demands knowledge of Illustrator, QuarkXPress, Photoshop, FreeHand and PageMaker.

First Contact & Terms Send postcard sample or query letter with brochure, one-sheets, photocopies, tearsheets, résumé, photographs. Accepts both Macintosh and IBM-compatible disk submissions. Send JPG file and on 3.5" diskette, CD-ROM or Superdisk 120MB. Samples are filed and not returned. Will contact artist for portfolio review of b&w, color, final art, photocopies, photographs, photostats, slides, tearsheets, thumbnails, transparencies if interested. Pays by the project. "Amount varies by the scope of the project." Negotiates rights purchased. Finds artists through college art programs and referrals.

Tips Looks for "creativity and innovation."

TOM THUMB MUSIC

(Division of Rhythms Productions), Box 34485, Los Angeles CA 90034. **President:** Ruth White. Music and book publisher for children's market.

Needs Works on assignment only. Prefers Los Angeles freelancers with cartooning talents and animation background. Uses freelancers for catalog cover and book illustration, direct mail brochures, layout, magazine ads, multimedia kits, paste-up and album design. Needs computer-literate freelancers for animation. Artists must have a style that appeals to children.

First Contact & Terms Buys 3-4 designs/year. Send query letter with brochure showing art style or résumé, tearsheets and photocopies. Samples are filed or are returned by SASE. Responds in 3 weeks. Pays by the

project. Considers complexity of project, available budget and rights purchased when establishing payment. Buys all rights on a work-for-hire basis.

Tips "You need to be up to date with technology and have a good understanding of how to prepare art projects that are compatible with printers' requirements."

TOPNOTCH® ENTERTAINMENT CORP.

Box 1515, Sanibel Island FL 33957-1515. (239)982-1515. E-mail: topnotch@wolanin.com. Website: www.wolan in.com. **Chairman/CEO:** Vincent M. Wolanin. Estab. 1973. Produces aviation art, advertising layouts, logos, albums, CDs, DVDs, CD-ROMs, tour merchandise, cassettes pop, progressive, R&B, rock, soul by solo artists and groups.

Needs Produces 6-8 unique designs/year. Works with 3-6 freelancers/year on work-for-hire basis. Prefers designers who use PC-based programs. Uses freelancers for design and illustration; animation; creative design and illustration; CD booklet design and illustration; CD cover design and illustration; CD-ROM design and packaging; poster design; Web page design. Also for outside entertainment projects like Superbowl-related events and aviation-related marketing promotions and advertising. 90% of design and illustration demands knowledge of PageMaker, Illustrator, QuarkXPress, Photoshop, FreeHand, Corel, FrontPage, Astound.

First Contact & Terms Send query e-mail or letter with brochure, résumé, photostats, transparencies, photocopies, photographs, slides, SASE, tearsheets. Accepts disk or e-mail submissions compatible with IBM. Samples are filed. Does not report back. Artist should contact again in 1 year. Request portfolio review in original query. Artist should follow up with letter after initial query. Portfolio should include color, final art, photographs, slides, tearsheets. Pays for design and illustration by the project. Buys all rights. Also accepts link submissions to artists' websites.

Tips "We look for new ways, new ideas, eye catchers; let me taste the great wine right away. Create great work and be bold. Don't get discouraged."

TROPIKAL PRODUCTIONS/WORLD BEATNIK RECORDS

20 Amity Lane, Rockwall TX 75087. (972)771-3797. E-mail: tropikal@juno.com. Website: www.tropikalproduct ions.com. **Contact:** Jim Towry. Estab. 1981. Produces albums, CDs, cassettes world beat, soca, jazz, reggae, hip-hop, Latin, Hawaiian, gospel. Recent releases *Cool Runner*; *Alive Montage*; *The Island*, by Watusi; *Inna Dancehall*, by Ragga D.

Needs Produces 5-10 releases/year. Works with 5-10 freelancers/year. Prefers freelancers with experience in CD/album covers, animation and photography. Uses freelancers for CD cover design and illustration; animation; cassette cover design and illustration; CD booklet design and illustration; CD cover design and illustration; poster design. 50% of freelance work demands knowledge of Illustrator, Photoshop.

First Contact & Terms Send brochure, résumé, photostats, photocopies, photographs, tearsheets. Accepts Mac or IBM-compatible disk submissions. Send EPS files. "No X-rated material please." Samples are filed or returned by SASE if requested by artist. Responds in 15 days. Will contact for portfolio review of b&w, color, final art, photocopies, photographs, roughs if interested. Pays by the project; negotiable. Rights purchased vary according to project; negotiable. Finds artists through referrals, submissions.

Tips "Show versatility; create theme connection to music."

◫ TRUE NORTH RECORDS/FINKELSTEIN MANAGEMENT CO. LTD.

260 Richmond St. W., Suite 501, Toronto M5V 1W5. (416)596-8696. Fax: (416)596-6861. E-mail: general_inquiri es@truenorthrecords.com. **Contact:** Dan Broome. Estab. 1969. Produces CDs, tapes and albums rock and roll, folk and pop; solo and group artists. Recent releases *The Charity of Night*, by Bruce Cockburn; *Industrial Lullaby*, by Stephen Fearing; *Bark*, by Blackie and the Rodeo Kings; *Howie Beck*, by Howie Beck.

Needs Produces 2 soloist and 2 groups/year. Works with 4 designers and 1 illustrator/year. Prefers artists with experience in album cover design. Uses artists for CD cover design and illustration, album/tape cover design and illustration, posters and photography. 50% of freelance work demands computer skills.

First Contact & Terms Send postcard sample, brochure, résumé, photocopies, photographs, slides, transparencies with SASE. Samples are filed or are returned by SASE if requested by artist. Responds only if interested. Pays by the project. Buys all rights.

◪ TWILIGHT SOULS MUSIC

264 S. La Cienega Blvd., Beverly Hills CA 90211. E-mail: twilightsoulsmusic@prodigy.net. **Director of Promotions:** Michael Parker. Estab. 1992. Produces CDs and cassettes: pop, adult contemporary, inspirational and metaphysical by solo artists and groups.

Needs Produces 1-2 releases/year. Works with 1-2 freelancers/year. Prefers local freelancers. Uses freelancers for cassette cover design and illustration; CD booklet design and illustration; CD cover design and illustration; poster design. 100% of design and 50% of illustration demands knowledge of Illustrator, Photoshop, FreeHand.

First Contact & Terms Send postcard sample. Samples are filed and not returned. Will contact artist for portfolio review of b&w and color tearsheets and thumbnails. Pays for design by the hour; pays for illustration by the project. Buys all rights. Finds artists through music trade magazines.
Tips ''We are a new company on a shoe-string budget.''

N UNIVERSAL RECORDS/MOTOWN RECORDS

1755 Broadway, 7th Floor, New York NY 10019. (212)373-0600. **Creative Art Director:** Sandy Brummels. Produces CDs, video. Produces all genres of music.
Needs Requires artists with experience in computer graphics (QuarkXPress, Illustrator and Photoshop). Uses artists for CD packaging and advertising design and illustration. 100% of freelance work demands computer skills.
First Contact & Terms Designers: Send query letter with tearsheets, résumé, slides and photocopies. Illustrators: Send postcard sample or other nonreturnable sample. Samples are filed. Responds only if interested. Call for appointment to show portfolio of photographs and slides. Pays by the project. Buys all rights.

N V2 RECORDS

14 E. Fourth, Suite 3, New York NY 10012. (212)320-8588. Fax: (212)320-8600. E-mail: davidcalderley@v2mus ic.com. Website: v2music.com. **Head of Design:** David Calderley. Estab. 1996. Produces 12″ CDs, DVDs pop, alterna-tive and electronica. Recent releases *People, Do You Know House?*, by DFuse; *18*, by Moby; *Music Kills Me*, by Rinocerose.
Needs Produces 15 releases/year. Works with 3 freelancers/year. Prefers local designers with experience in music packaging and typography who own Macs. Uses freelancers for album cover design and illustration; CD booklet design and illustration; CD cover design and illustration and poster design. 100% of freelance design and 50% of illustration demands knowledge of Illustrator, QuarkXPress, Photoshop, Strata, 3D, After Effect.
First Contact & Terms Send postcard sample or query letter with brochure and tearsheets. Samples are returned by SASE if requested by artist. Responds in 4 days if interested. Request portfolio review of photographs, roughs and tearsheets in original query. Pays for design by the project, $75-5,000; pays for illustration by the project, $200-2,000. Buys all rights. Finds artists through submissions, sourcebooks, magazines, Web, artists' reps.
Tips ''Some CD-ROMs are starting to appear as samples. It can be irritating to stop work to load in a portfolio. Show as near to what is final (i.e. real print) as possible—create own briefs if necessary. We look for originality, playfulness, good sense of design and pop culture.''

N VALARIEN PRODUCTIONS

15237 Sunset Blvd., Suite 105, Pacific Palisades CA 90272. (310)445-7737. Fax: (310)455-7737. E-mail: valarien @gte.net. Website: www.valerien.com. **Owner:** Eric Reyes. Estab. 1990. Produces CDs, Ambient, Acoustic Guitar, New Age, DJ/Dance/Electronica, Film Scores, Prog Rock by solo artists. Recent releases ''In Paradise,'' by Valarien.
Needs Produces 1-4 releases/year. Works with 1-2 freelancers/year. Prefers local freelancers who own Macs. Uses freelancers for album cover design and illustration; animation; CD booklet design and illustration; CD cover design and illustration. Also for ads. 100% of freelance work demands knowledge of Illustrator, QuarkXPress.
First Contact & Terms Send postcard sample of work. Samples are filed and not returned. Will contact artist for portfolio review of b&w, color, final art if interested. Pays by the project. Rights purchased vary according to project. Finds artists through word of mouth, submissions, sourcebooks.

VARESE SARABANDE RECORDS

11846 Ventura Blvd., Suite 130, Studio City CA 91604. (818)753-4143. Fax: (818)753-7596. Website: www.vares esarabande.com. **Vice President:** Robert Townson. Estab. 1978. Produces CDs film music soundtracks. Recent releases *Million Dollar Baby*, by Clint Eastwood; *Meet the Fockers*; by Randy Newman; *Stripes*, by Elmer Bern-stein; *Sin City*, by Robert Rodriguez, John Debney and Graeme Revell.
Needs Works on assignment only. Uses artists for CD cover illustration and promotional material.
First Contact & Terms Send query letter with photostats, slides and transparencies. Samples are filed. Responds only if interested. Pays by the project.
Tips ''Be familiar with the label's output before approaching them.''

VERVE MUSIC GROUP

1755 Broadway, 3rd Floor, New York NY 10019. (212)331-2000. Fax: (212)331-2065. Website: www.vervemusic group.com. **Associate Director:** Sherniece Johnson-Smith. Produces albums, CDs jazz, progressive by solo artists and groups. Recent releases *The Girl in the Other Room*, by Diana Krall.
● Verve Music Group houses the Verve, GRP, Impulse! and Verve Forecast record labels.
Needs Produces 120 releases/year. Works with 20 freelancers/year. Prefers designers with experience in CD cover design who own Macs. Uses freelancers for album cover design and illustration; CD booklet design and

illustration; CD cover design and illustration. 100% of freelance design demands computer skills.

First Contact & Terms Send nonreturnable postcard sample of work. Samples are filed. Does not reply. Portfolios may be dropped off Monday through Friday. Will contact artist for portfolio review if interested. Pays for design by the project, $1,500 minimum; pays for illustation by the project, $2,000 minimum.

VIRGIN RECORDS

150 Fifth Ave., New York NY 10011. (212)786-8300. Website: www.virginrecords.com. **Contact:** Creative Dept. Recent releases; *Out of State Plates,* by Fountains of Wayne, *Baptism,* by Lenny Kravitz, *There Will Be A Light,* by Ben Harper and the Blind Boys of Alabama. Uses freelancers for CD and album cover design and illustration. Send query letter with samples. Portfolios may be dropped off on Wednesdays between 10 a.m. and 5 p.m. Samples are filed. Responds only if interested.

Ⓝ WARLOCK RECORDS, INC.

133 W. 25th St., 9th Floor, New York NY 10001. (212)206-0800. Fax: (212)206-1966. E-mail: info@warlockrecords.com. Website: www.warlockrecords.com. **Art Director:** Amy Kwong. Estab. 1986. Produces CDs, tapes and albums rhythm and blues, jazz, rap and dance. Recent releases *No Nagging,* by Froggy Mit; *Lyrical Warfare,* by Chocolate Bandit; *Just Be Free,* by Christina Aguilera.

Needs Produces 5 soloists and 12-15 groups/year. Approached by 30 designers and 75 illustrators/year. Works with 3 designers and 4 illustrators/year. Prefers artists with experience in record industry graphic art and design. Works on assignment only. Uses artists for CD and album/cassette cover design; posters; and advertising design. Seeking artists who both design and produce graphic art, to "take care of everything, including typesetting, stats, etc." 99% of freelance work demands knowledge of Illustrator 6.0, Quark XPress 4.0, Photoshop 4,0, Flight Check 3.2.

First Contact & Terms Send query letter with brochure, résumé, photocopies and photostats. Samples are filed and are not returned. "I keep information on file for months." Responds only if interested; as jobs come up. Call to schedule an appointment to show a portfolio, or drop off for a day or half-day. Portfolio should include photostats, slides and photographs. Pays for design by the project, $50-1,000; pays for illustration by the project, $50-1,000. Rights purchased vary according to project. Finds artists through submissions.

Tips "Create better design than any you've ever seen and never miss a deadline—you'll be noticed. Specialize in excellence."

Ⓝ WARNER BROS. RECORDS

3300 Warner Blvd., Burbank CA 91505. (818)846-9090. Fax: (818)953-3232. Website: www.warnerbrosrecords.com. **Art Dept. Assistant:** Michelle Barish. Produces the artwork for CDs, tapes and sometimes albums rock, jazz, hip-hop, alternative, rap, R&B, soul, pop, folk, country/western by solo and group artists. Releases include *Greatest Hits and Videos,* by the Red Hot Chili Peppers; *Closer,* by Josh Groban; and *In Time, Best of R.E.M. 1988-2003,* by R.E.M. Releases approximately 200 total packages/year.

Needs Works with freelance art directors, designers, photographers and illustrators on assignment only. Uses freelancers for CD and album tape cover design and illustration; brochure design and illustration; catalog design, illustration and layout; advertising design and illustration; and posters. 100% of freelance work demands knowledge of QuarkXPress, FreeHand, Illustrator or Photoshop.

First Contact & Terms Send query letter with brochure, tearsheets, résumé, slides and photographs. Samples are filed or are returned by SASE if requested by artist. Responds only if interested. Submissions should include roughs, printed samples and b&w and color tearsheets, photographs, slides and transparencies. "Any of these are acceptable." Do not submit original artwork. Pays by the project.

Tips "Send a portfolio—we tend to use artists or illustrators with distinct/stylized workrarely do we call on the illustrators to render likenesses; more often we are looking for someone with a conceptual or humorous approach."

WATCHESGRO MUSIC, BMI—INTERSTATE 40 RECORDS

9208 Spruce Mountain Way, Las Vegas NV 89134. (702)363-8506. **President:** Eddie Lee Carr. Estab. 1975. Produces CDs, tapes and albums rock, country/western and country rock. Releases include *The Baby,* by Blake Shelton; *Three Wooden Crosses,* by Randy Travis; *I Will,* by Chad Simmons; *Jude,* by Judy Willis; *Sonny,* by Sonny Marshall; *Deep in the South,* by Sean O'Brien.

- Watchesgro Music has placed songs in feature films *Waitin' to Live, 8 Mile, Die Another Day, DareDevil 2003.*

Needs Produces 8 solo artists/year. Works with 3 freelancers/year for CD/album/tape cover design and illustration and videos.

First Contact & Terms Send query letter with photographs. Samples are filed or are returned by SASE. Responds

in 1 week only if interested. To show portfolio, mail b&w samples. Pays by the project. Negotiates rights purchased.

[N] WELK MUSIC GROUP

2700 Pennsylvania Ave., Santa Monica CA 90404. (805)498-0197. Fax: (805)498-4297. E-mail: gcartwright@e-znet.com. **Contact:** Georgette Cartwright, creative services manager or Amy Von, director of new artist development. Estab. 1987. Produces CDs, tapes and albums; R&B, jazz, soul, folk, country/western, solo artists. Recent release *Red-Luck,* by Patty Larkin.

● Contact information for Georgette Cartwright listed above; contact information for Amy Von is (310)829-9355; fax (310)315-3006. This label acquired Sugar Hill Records. Sugar Hill will maintain its Durham NC headquarters. Welk Music Group, a division of The Welk Group encompasses Vanguard Records and Ranwood Records.

Needs Produces almost 2 new artists and 2 catalog releases/month. Works with 4 designers/year. Prefers artists with experience in the music industry. Uses artists for CD cover design and illustration, album/tape cover design and illustration; catalog design, illustration and layout; direct mail packages; advertising design. 100% of freelance work demands knowledge of QuarkXPress, Illustrator and Photoshop.

First Contact & Terms Send postcard sample with brochure, photocopies, photographs and tearsheets. Samples are filed. Responds only if interested. To show a portfolio, mail tearsheets and printed samples. Pays for design by the hour, $25-45; by the project, $800-2,000. Pays for illustration by the project, $200-500. Buys all rights.

Tips "We need to have artwork for cover combined with CD booklet format."

[N] WIND-UP ENTERTAINMENT

72 Madison Ave., 8th Floor, New York NY 10016. (212)895-3113. Fax: (212)251-0779. E-mail: mdroescher@wind-uprecords.com. Website: www.wind-up.com. **Creative Director:** Mark Droescher. Estab. 1997. Produces CDs, DVDs, music videos and TV commercials pop, rock by solo artists and groups. Recent releases *Fallen,* by Evanescence; *Disclaimer,* by Seether; *Finger Eleven,* by Finger Eleven.

Needs Produces 12 releases/year. Works with 4-5 freelancers/year. Prefers local freelancers who own Macs. Uses freelancers for album cover design and illustration; CD booklet design and illustration; CD cover design and illustration. 100% of design and 50% of illustration demands knowledge of QuarkXPress, Photoshop.

First Contact & Terms Send query letter with brochure, résumé, transparencies, photocopies, photographs, SASE, tearsheets or website link. Accepts disk submissions compatible with Mac. Samples are filed. Will contact artist for portfolio review if interested. Pays for design by the hour, $25-50. Finds artists through word of mouth, magazines, reps, directories.

Tips "Work should be as personal as possible."

Artists' Reps

Many artists find leaving promotion to a rep allows them more time for the creative process. In exchange for actively promoting an artist's career, the representative receives a percentage of sales (usually 25-30%). Reps focus either on the fine art or commercial markets, rarely both. Very few reps handle designers.

Fine art reps promote the work of fine artists, sculptors, craftspeople and fine art photographers to galleries, museums, corporate art collectors, interior designers and art publishers. Commercial reps help illustrators obtain assignments from advertising agencies, publishers, magazines and other art buyers. Some reps also act as licensing agents.

What reps do

Reps work with you to bring your portfolio up to speed and actively promote your work to clients. Usually a rep will recommend advertising in one of the many creative directories such as *American Showcase* or *Creative Illustration* so that your work will be seen by hundreds of art directors. (Expect to make an initial investment in costs for duplicate portfolios and mailings.) Reps also negotiate contracts, handle billing and collect payments.

Getting representation isn't as easy as you might think. Reps are choosy about who they represent, not just in terms of talent but also in terms of marketability and professionalism. Reps will only take on talent they know will sell.

What to send

Once you've gone through the listings here and compiled a list of art reps who handle your type and style of work, contact them with a brief query letter and nonreturnable copies of your work. Check each listing for specific information.

Learn About Reps

For More Info

The Society of Photographers and Artists Representatives (SPAR) is an organization for professional representatives. SPAR members are required to maintain certain standards and follow a code of ethics. For more information, write to SPAR, 60 E. 42nd St., Suite 1166, New York NY 10165, or visit their Web site www.spar.org.

AREP

P.O. Box 16576, Golden CO 80402. (720)320-4514. Fax: (720)489-3786. E-mail: Christelle@aRep.biz. Website: www.aRep.biz. **Owner:** Christelle Newkirk. Commercial artists representative. Estab. 2000. Represents 1 illustrator, 1 photographer, 1 digital composite artist. aRep is a one-stop small boutique specializing in commerical work. Markets include advertising agencies, corporations/client direct, design firms, editorial/magazines. Artists include Rick Souders. For more names, please see website.

Handles Illustration. "I would be particularly interested in reviewing portfolios of illustrators located in Colorado."

Terms Rep receives 20% commission. Exclusive regional representation is required. Advertising costs are paid by artist. "Must leave a portfolio with me and leave behinds (required for direct mail pieces)."

How to Contact For first contact, send direct query letter with bio, direct mail flier/brochure, tearsheets. Responds in 1 week. After initial contact, call to schedule an appointment or e-mail. Portfolio should include b&w and color finished art, photographs, tearsheets.

N ART SOURCE L.A., INC.

2801 Ocean Park Blvd., PMB 7, Santa Monica CA 90405. (310)452-4411. Fax: (310)452-0300. E-mail: info@artso urcela.com. Website: www.artsourcela.com. **Contact:** Francine Ellman, president. Fine art representative. Estab. 1984. Represents artists in all media in fine art and accessories. Specializes in fine art consulting and curating worldwide. Markets include architects; corporate collections; developers; hospitality public space; interior designers; private collections and government projects.

• Art Source has additional offices in Monterey, CA and Rockville, MD.

Handles Fine art in all media, including works on paper/canvas, giclees, photography, sculpture, and other accessories handmade by American artists. Genres include figurative, florals, landscapes and many others. Artists represented include Boylan and Howe.

Terms Agent receives commission, amount varies; generally 50% commission. Exclusive area representation required in some cases. No geographic restrictions. "We request artists submit a minimum of 20 slides/visuals, résumé and SASE." Advertises in *Art News*; *Artscene*; *Art in America*; *Blue Book*; *Gallery Guide*; *Art Diary*; *Art & Auction*; *Guild*; and *Internet* .

How to Contact For first contact, send résumé, bio, slides or photographs and SASE. Responds in 2 months. After initial contact, "we will call to schedule an appointment" to show portfolio of original art, slides, photographs. Obtains new talent through recommendations, artists' submissions and exhibitions. Finds artists through art exhibitions, art fairs, submissions, referrals by other artists, portfolio reviews and word of mouth.

Tips "Be professional when submitting visuals. Remember—first impressions can be critical! Submit a body of work that is consistent and of the highest quality. Work should be in excellent condition and already photographed for your records. Framing does not enhance the presentation to the client. Please send all submissions to the Southern California Corporate Office."

ARTVISIONS

12117 SE 26th St., Bellevue WA 98005-4118. E-mail: see website. Website: www.artvisions.com. **President:** Neil Miller. Estab. 1993. ArtVisions is a service of avidre, inc. Markets include publishers of limited edition prints, calendars, home decor, stationery, note cards, greeting cards, posters, manufacturers of giftware, home furnishings, textiles, puzzles and games.

Handles Fine art licensing only.

Terms Agent's commission varies. "We produce highly targeted direct marketing programs focused on opportunities to license art. We develop materials, including Web and e-mail, especially for and partially funded by you from your royalty earnings. Requires exclusive worldwide representation for licensing (the artist is free to market original art). Written contract provided.

How to Contact First preference is via e-mail containing a link to a website where your art can be seen. Second preference is via e-mail with a few small samples attached as "JPEGs." Third preference is for slides/photos/tearsheets or brochures via mail, with SASE for return. Always label your materials. "We cannot respond to mail inquiries that do not include examples of your art."

Tips "We do not buy art, we are a licensing agent for artists. Our income is derived from commissions from licensing fees we generate for you, so, we are very careful about selecting artists for our service. To gain an idea of the type of art we seek, please view our website http://www.artvisions.com before submitting. Our way of doing business is very labor intensive and each artist's market plan is unique. Be prepared to invest in yourself. This means being able to provide our licensing clients with either 4×5 transparencies of your artwork or high resolution, professionally made scans on CD."

ARTWORKS ILLUSTRATION

325 W. 38th St., New York NY 10018. (212)239-4946. Fax: (212)239-6106. E-mail: artworksillustration@earthlin k.net. Website: www.artworksillustration.com. **Contact:** Betty Krichman, partner. Commercial illustration rep-

resentative. Estab. 1990. Member of Society of Illustrators. Represents 30 illustrators. Specializes in publishing. Markets include advertising agencies, design firms, paper products/greeting cards, movie studios, publishing/books, sales/promotion firms, corporations/client direct, editorial/magazines. Artists include Dan Brown, Dennis Lyall, Jerry Vanderstelt.

Handles Illustration. Looking for interesting juvenile.

Terms Rep receives 25% commission; 30% for out of town artists (outside tri-state area). Exclusive area representation required. Advertising costs are split 75% paid by artist; 25% paid by rep. Advertises in *American Showcase* and *ISPOT*.

How to Contact For first contact, send e-mail samples. Responds only if interested. After initial contact, drop off or mail portfolio. Portfolio should include slides, tearsheets, transparencies.

☑ CAROL BANCROFT & FRIENDS

4 Old Mill Plain Rd., Danbury CT 06811. (203)730-8270. Fax: (203)730-8275. E-mail: artists@carolbancroft.com. Website: www.carolbancroft.com. **Owner:** Carol Bancroft. Illustration representative for children's publishing. Estab. 1972. Member of SPAR, Society of Illustrators, Graphic Artists Guild, SCBWI. Represents over 40 illustrators. Specializes in representing artists who illustrate for children's publishing—text, trade and any children's-related material. Clients include Scholastic, Holt, HarperCollins, Random House, Penguin USA, Simon & Schuster. Artist list available upon request.

Handles Illustration for children of all ages.

Terms Rep receives 30% commission. Advertising costs are split 75% paid by talent; 25% paid by representative. For promotional purposes, artist should provide "Web address on an e-mail or samples via mail laser copies (not slides), tearsheets, promo pieces, books, good color photocopies, etc.; 6 pieces or more; narrative scenes with children and/or animals interacting." Advertises in *RSVP*; *Picture Book*; *Directory of Illustration.*.

How to Contact Send samples and SASE. "Artists must call no sooner than one month after sending samples."

Tips "We look for artists who can draw animals and people with imagination and energy, depicting engaging characters with action in situational settings."

BERENDSEN & ASSOCIATES, INC.

2233 Kemper Lane, Cincinnati OH 45206. (513)861-1400. Fax: (513)861-6420. E-mail: bob@illustratorsrep.com. Website: www.illustratorsrep.com and www.StockArtRep.com. **Contact:** Bob Berendsen. Commercial illustration, photography, artists' representative. Incorporated 1986. Represents 50 illustrators, 15 photographers. Specializes in "high-visibility consumer accounts." Markets include advertising agencies; corporations/client direct; design firms; editorial/magazines; paper products/greeting cards; publishing/books; sales/promotion firms. Clients include Disney, CNN, Pentagram, F + W Publications. Additional client list available upon request. Represents Jake Ellison, Bill Fox, Frank Ordaz, Wendy Ackison, Marcia Hartsock, Duff Orlemann, Jack Pennington, Dave Reed, Garry Richardson, Ursula Roma, Robert Schuster.

● This rep has four websites—illustratorsrep.com, photographersrep.com, designersrep.com and stockartrep .com. The fast-loading pages are easy for art directors to access—a great promotional tool for their talent.

Handles Illustration, photography. "We are always looking for illustrators who can draw people, product and action well. Also, we look for styles that are metaphoric in content, and it's a plus if the stock rights are available."

Terms Rep receives 30% commission. Charges "mostly for postage but figures not available." No geographic restrictions. Advertising costs are split 70% paid by talent; 30% paid by representative. For promotional purposes, "artist must co-op in our direct mail promotions, and sourcebooks are recommended. Portfolios are updated regularly." Advertises in *RSVP*; *Creative Illustration Book*; *Directory of Illustration* and *American Showcase*.

How to Contact For first contact, send an e-mail with no more than 6 JPEGs attached or send query letter, résumé, and any nonreturnable tearsheets, slides, photographs or photocopies.

Tips Artists should have a "proven style with at least ten samples of that style."

🆖 JOANIE BERNSTEIN, ART REP

756-8 Aves, Naples FL 34102. (239)403-4393. Fax: (239)403-0066. E-mail: joanie@joaniebrep.com. Website: www.joaniebrep.com. **Contact:** Joanie. Commercial illustration representative. Estab. 1984. Represents 8 illustrators. Specializes in illustrations geared towards graphic design, advertising, editorial, books, music and product.

Handles Illustration. Looking for an unusual, problem solving style. Clients include advertising, design, books, music, product merchandising, developers, movie studios, films, private collectors. Artists include Stan Fellows, watercolor; Allen Brewer, folk art; Eric Hanson, refined whimisical; Tom Garrett, collage/line with color; John Kleber, printmaking; Jason Greenberg line with color; Jack Molloy, old world color; Elvis Swift, sophisicated line & color doodle.

Terms Rep receives 25% commission. Exclusive representation required.

How to Contact E-mail samples.

Tips "Make sure you have a website. Advertises in *Workbook* & Web directories."

WOODY COLEMAN PRESENTS, INC.

490 Rockside Rd., Cleveland OH 44131. (216)661-4222. Fax: (216)661-2879. E-mail: woody@portsort.com. Website: www.portsort.com. **Contact:** Laura Ray, CEO. Estab. 1978. Member of Graphic Artists Guild. Specializes in illustration. Markets include advertising agencies; corporations/client direct; design firms; editorial/magazines; paper products/greeting cards; publishing/books; sales/promotion firms; public relations firms. **Handles** Illustration.

Terms Cooperative organization negotiates and invoices all projects and receives 25% commission. Member illustrators receive free placement of 12-image portfolio on Internet Database (see www.portsort.com). For promotional purposes, talent must provide "all 12 or more image portfolios in 4×5 transparencies or high-quality prints, as well as 12-72 dpi scans." Advertises in *American Showcase*, *Black Book*, *The Workbook*, other publications.

How to Contact For member solicitation first contact, send query letter, as well as tearsheets, slides, or SASE. If accepted for membership, portfolio should include tearsheets, 4×5 transparencies.

Tips "Concentrate on developing 12 specific examples of a single style exhibiting work aimed at a particular specialty, such as fantasy, realism, Americana or a particular industry such as food, medical, architecture, transportation, film, etc. Multiple 12-image portfolios allowed."

DANIELE COLLIGNON

200 W. 15th St., New York NY 10011. (212)243-4209. **Contact:** Daniele Collignon. Commercial illustration representative. Estab. 1981. Member of SPAR, Graphic Artists Guild, Art Director's Club. Represents 12 illustrators. Markets include advertising agencies; corporations/client direct; design firms; editorial/magazines; publishing/books.

Handles Illustration.

Terms Rep receives 30% commission. Exclusive area representation is required. No geographic restrictions. Advertising costs are split 75% paid by talent; 25% paid by representative. For promotional purposes, talent must provide 8×10 transparencies (for portfolio) to be mounted, printed samples, professional pieces. Advertises in *American Showcase*, *Black Book*, *The Workbook*.

How to Contact For first contact, send direct mail flier/brochure, tearsheets. Responds in 5 days, only if interested. After initial contact, drop off or mail in appropriate materials for review. Portfolio should include tearsheets, transparencies.

▨ ⧉ CONTACT JUPITER

5 Laurier St., St. Eustache QB J7R 2E5 Canada. Phone/fax: (450)491-3883. E-mail: info@contactjupiter.com. Website: www.contactjupiter.com. **Contact:** Oliver Mielenz, president. Commercial illustration representative. Estab. 1996. Member of Publicity Club of Montreal. Represents 12 illustrators, 6 photographers. Specializes in publishing, children's books, magazine, advertising. Licenses illustrators, photographers. Markets include advertising agencies, paper products/greeting cards, record companies, publishing/books, corporations/client direct, editorial/magazines.

Handles Illustration, multimedia, music, photography, design.

Terms Reps receive 15-25% and rep fee. Promotion, sales services; $3,000-5,000. Advertising costs are split 50% paid by artist; 50% paid by rep. Exclusive representation required. For promotional purposes, talent must provide portfolio pieces (8½×11) and electronic art samples. Advertises in *Illustrators Directory*.

How to Contact Send query letter with photocopies. Responds only if interested. After initial contact, e-mail to set up an interview or portfolio review. Portfolio should include b&w and color tearsheets.

Tips "One specific style is easier to sell. Focus, focus, focus. Initiative, I find, is very important in an artist."

THE DESKTOP GROUP

420 Lexington Ave., Suite 2100, New York NY 10170. (212)916-0824. Fax: (212)867-1759. E-mail: jobs@thedesktopgroup.com. Website: www.thedesktopgroup.com. Estab. 1991. Specializes in recruiting and placing creative talent on a freelance basis. Markets include advertising agencies, design firms, publishers (book and magazine), corporations, and banking/financial firms.

Handles Artists with Macintosh (and Windows) software and multimedia expertise graphic designers, production artists, pre-press technicians, presentation specialists, traffickers, art directors, Web designers, content developers, project managers, copywriters, and proofreaders.

How to Contact For first contact, e-mail résumé, cover letter and work samples.

Tips "Our clients prefer working with talented artists who have flexible, easy-going personalities and who are very professional."

ROBERT GALITZ FINE ART & ACCENT ART

166 Hilltop Court, Sleepy Hollow IL 60118. (847)426-8842. Fax: (847)426-8846. Website: www.galitzfineart.com. **Contact:** Robert Galitz. Fine art representative. Estab. 1985. Represents 100 fine artists (includes 2 sculptors). Specializes in contemporary/abstract corporate art. Markets include architects, corporate collections, galleries, interior decorators, private collections. Represents Roland Poska, Jan Pozzi, Diane Bartz and Louis De Mayo.
Handles Fine art.
Terms Agent receives 25-40% commission. No geographic restrictions; sells mainly in Chicago, Illinois, Wisconsin, Indiana and Kentucky. For promotional purposes talent must provide "good photos and slides." Advertises in monthly art publications and guides.
How to Contact For first contact, send query letter, slides, photographs. Responds in 2 weeks. After initial contact, call for appointment to show portfolio of original art. Obtains new talent through recommendations from others, solicitation, conferences.
Tips "Be confident, persistent. Never give up or quit."

Ⓝ DENNIS GODFREY REPRESENTING ARTISTS

201 W. 21st St., Suite 10G, New York NY 10011. (212)807-0840. E-mail: godfreyreps @aol.com. **Contact:** Dennis Godfrey. Commercial illustration representative. Estab. 1985. Represents 7 illustrators. Specializes in publishing and packaging. Markets include advertising agencies; corporations/client direct; design firms; publishing/ books. Clients include Putnam Berkley, Random House, Scholastic, Landor Design, Lipson Alport Glass just to name a few.
Handles Illustration.
Terms Rep receives 25% commission. Prefers exclusive area representation in NYC/Eastern US. Advertising costs are split 75% paid by talent; 25% paid by representative. For promotional purposes, talent must provide mounted portfolio (at least 20 pieces), as well as promotional pieces. Advertises in *The Workbook*; *American Showcase*.
How to Contact For first contact, send tearsheets. Responds in 2 weeks, only if interested. After initial contact, write for appointment to show portfolio of tearsheets, slides, photographs, photostats.

BARBARA GORDON ASSOCIATES LTD.

165 E. 32nd St., New York NY 10016. (212)686-3514. Fax: (212)532-4302. **Contact:** Barbara Gordon. Commercial illustration and photography representative. Estab. 1969. Member of SPAR, Society of Illustrators, Graphic Artists Guild. Represents 9 illustrators, 1 photographer. "I represent only a small, select group of people and therefore give a great deal of personal time and attention to the people I represent."
Terms No information provided. No geographic restrictions in continental US.
How to Contact For first contact, send direct mail flier/brochure. Responds in 2 weeks. After initial contact, drop off or mail appropriate materials for review. Portfolio should include tearsheets, slides, photographs; "if the talent wants materials or promotion piece returned, include SASE." Obtains new talent through recommendations from others, solicitation, conferences, etc.
Tips "I do not care if an artist or photographer has been published or is experienced. I am essentially interested in people with a good, commercial style. Don't send résumés and don't call to give me a verbal description of your work. Send promotion pieces. *Never* send original art. If you want something back, include a SASE. Always label your slides in case they get separated from your cover letter. And always include a phone number where you can be reached."

Ⓝ ANITA GRIEN—REPRESENTING ARTISTS

155 E. 38th St., New York NY 10016. E-mail: agrien@aol.com. Representative not currently seeking new talent.

▣ CAROL GUENZI AGENTS, INC.

865 Delaware St., Denver CO 80204. (303)820-2599. E-mail: art@artagent.com. Website: www.artagent.com. **Contact:** Carol Guenzi. Commercial illustration, photography, new media and film representative. Estab. 1984. Member of Art Directors Club of Denver. Represents 29 illustrators, 6 photographers and 3 multimedia developers. Specializes in a "wide selection of talent in all areas of visual communications." Markets include advertising agencies; corporations/client direct; design firms; editorial/magazine, paper products/greeting cards, sales/ promotions firms. Clients include Integer, BBDO, DDB Needham, DVC. Partial client list available upon request. Represents Christer Eriksson, Juan Alvarez, Michael Fisher, Kelly Hume, Capstone Studios and more.
Handles Illustration, photography. Looking for "unique style application."
Terms Rep receives 25-30% commission. Exclusive area representative is required. Advertising costs are split 70-75% paid by talent; 25-30% paid by the representation. For promotional purposes, talent must provide "promotional material after six months, some restrictions on portfolios." Advertises in *Black Book*; *Directory of Illustration*; *The Workbook*.

How to Contact For first contact, send PDF's or JPEGs or direct mail flier/brochure. Responds in 3 weeks, only if interested. Call or write for appointment to drop off or mail in appropriate materials for review, depending on artist's location. Portfolio should include tearsheets, slides, photographs. Obtains new talent through solicitation, art directors' referrals, an active pursuit by individual artist.

Tips "Show your strongest style and have at least 12 samples of that style before introducing all your capabilities. Be prepared to add additional work to your portfolio to help round out your style. Have a digital background."

PAT HACKETT/ARTIST REPRESENTATIVE

7014 N. Mercer Way, Mercer Island WA 98040. (206)447-1600. Fax: (206)447-0739. E-mail: pathackett@aol.com. Website: www.pathackett.com. **Contact:** Pat Hackett. Commercial illustration and photography representative. Estab. 1979. Represents 12 illustrators, 1 photographer. Markets include advertising agencies; corporations/client direct; design firms; editorial/magazines.

Handles Illustration.

Terms Rep receives 25-33% commission. Exclusive representation is required. Advertising costs are split 75% paid by talent; 25% paid by representative. For promotional purposes, talent must provide "standardized portfolio, i.e., all pieces within the book are the same format. Reprints are nice, but not absolutely required." Advertises in *Showcase; The Workbook.*

How to Contact For first contact, send direct mail flier/brochure. Responds in 1 week, only if interested. After initial contact, drop off or mail in appropriate materials tearsheets, slides, photographs, photostats, photocopies. Obtains new talent through "recommendations and calls/letters."

Tips Looks for "experience in the *commercial* art world, professional presentation in both portfolio and person, cooperative attitude and enthusiasm."

HK PORTFOLIO

10 E. 29th St., Suite 40G, New York NY 10016. (212)689-7830. Fax: (212)689-7829. E-mail: mela@hkportfolio.com. Website: www.hkportfolio.com. **Contact:** Mela Bolinao. Commercial illustration representative. Estab. 1986. Member of SPAR, Society of Illustrators and Graphic Artists Guild. Represents 44 illustrators. Specializes in illustration for juvenile markets. Markets include advertising agencies; editorial/magazines; publishing/books.

Handles Illustration.

Terms Rep receives 25% commission. No geographic restrictions. Advertising costs are split 75% paid by talent; 25% paid by representative. Advertises in *Picture Book* and *Workbook.*

How to Contact No geographic restrictions. For first contact, send query letter, direct mail flier/brochure, tearsheets, slides, photographs, photostats and SASE. Responds in 1 week. After initial contact, drop off or mail in appropriate materials for review. Portfolio should include tearsheets, slides, photographs, photostats, photocopies.

Tips Leans toward "highly individual personal styles."

IRMEL HOLMBERG

3 Quay Ct., Bay Park NY 11518. (516)887-5348. Fax: (212)202-4356. **Contact:** I. Holmberg. Commercial illustration representative. Estab. 1980. Represents 30 illustrators. Markets include advertising agencies; corporations/client direct; design firms; editorial/magazines; publishing/books.

Terms Rep receives 30% commission. Exclusive area representation is required. Advertising costs are split 70% paid by talent; 30% paid by representative. For promotional purposes, talent must provide versatile portfolio with new fresh work. Advertises in *Dir. of Illustration 2006.*

How to Contact For first contact, send direct mail flier/brochure or e-mail. Responds in 2 weeks only if interested.

SCOTT HULL ASSOCIATES

303 E. Social Row Rd., Dayton OH 45458. (937)433-8383. Fax: (937)433-0434. E-mail: scott@scotthull.com. Website: www.scotthull.com. **Contact:** Scott Hull. Commercial illustration representative. Estab. 1981. Represents 30 plus illustrators.

How to Contact Contact by sending e-mail samples, tearsheets or appropriate materials for review. Follow up with phone call. Responds in 2 weeks.

Tips Looks for "an interesting style and a desire to grow, as well as a marketable portfolio."

VINCENT KAMIN & ASSOCIATES

400 W. Erie St., Chicago IL 60610. (312)787-8834. Fax: (312)787-8172. Website: http//vincekamin.com. Commercial photography, graphic design representative. Estab. 1971. Member of SPAR. Represents 6 illustrators, 6 photographers, 1 designer, 1 fine artist (includes 1 sculptor). Markets include advertising agencies. Represents Steve Bjorkman, Lee Duggan, Andrzej Dudzinski and Gail Randall.

Handles Illustration, photography.

Terms Rep receives 30% commission. Advertising costs are split 90% paid by talent; 10% paid by representative. Advertises in *The Workbook* and *Chicago Directory*.
How to Contact For first contact, send tearsheets. Responds in 10 days. After initial contact, call to schedule an appointment. Portfolio should include tearsheets.

⃞ ELLEN KNABLE & ASSOCIATES, INC.
1158 26th St., #552, Santa Monica CA 90403. (310)829-3269. Fax: (310)453-4053. E-mail: pearl2eka@aol.com. **Contact:** Ellen Knable. Commercial production representative. Markets include advertising agencies; corporations/client direct. Clients include Chiat/Day, BBDO, DDB, Y&R. Client list available upon request.
Terms Rep receives commission. Exclusive West Coast/Southern California representation is required. Advertising costs split varies.
How to Contact For first contact, send query letter, direct mail flier/brochure or websites. Obtains new talent from creatives/artists.
Tips "Have patience and persistence!"

⃞ CLIFF KNECHT—ARTIST REPRESENTATIVE
309 Walnut Rd., Pittsburgh PA 15202. (412)761-5666. Fax: (412)761-4072. E-mail: cliff@artrep1.com. Website: www.artrep1.com. **Contact:** Cliff Knecht. Commercial illustration representative. Estab. 1972. Represents 20 illustrators. Markets include advertising agencies; corporations/client direct; design firms; editorial/magazines; paper products/greeting cards; publishing/books; sales/promotion firms.
Handles Illustration.
Terms Rep receives 25% commission. No geographic restrictions. Advertising costs are split 75% paid by the talent; 25% paid by representative. For promotional purposes, talent must provide a direct mail piece. Advertises in *Graphic Artists Guild Directory of Illustration*.
How to Contact For first contact, send résumé, direct mail flier/brochure, tearsheets, slides. Responds in 1 week. After initial contact, call for appointment to show portfolio of original art, tearsheets, slides, photographs. Obtains new talent directly or through recommendations from others.

ANN KOEFFLER ARTIST REPRESENTATION
1020 W. Riverside Dr., #45, Burbank CA 91506. (818)260-8980. Fax: (818)260-8990. E-mail: annartrep@aol.com. Website: www.annkoeffler.com. **Owner/Operator:** Ann Koeffler. Commercial illustration representative. Estab. 1984. Member of Society of Illustrators. Represents 20 illustrators. Markets include advertising agencies, corporations/client direct, design firms, editorial/magazines, paper products/greeting cards, publishing/books, individual small business owners.
Will Handle Interested in reviewing illustration. Looking for artists who are digitally adept.
Terms Rep receives 25-30% commission. Advertising costs 100% paid by talent. For promotional purposes, talent must provide an initial supply of promotional pieces and a committment to advertise regularly. Advertises in *The Workbook* and *Black Book*.
How to Contact For first contact, send tearsheets or send images digitally. Responds in 1 week. Portfolio should include photocopies, 4×5 chromes.
Tips "I only carry artists who are able to communicate clearly and in an upbeat and professional manner."

SHARON KURLANSKY ASSOCIATES
192 Southville Rd., Southborough MA 01772. (508)460-0037. Fax: (508)480-9221. E-mail: lstock@charter.net. Website: www.laughing-stock.com. **Contact:** Sharon Kurlansky. Commercial illustration representative. Estab. 1978. Represents 9 illustrators. Markets include advertising agencies; corporations/client direct; design firms; editorial/magazines; paper products/greeting cards; publishing/books; sales/promotion firms. Client list available upon request. Represents Tim Lewis, Bruce Hutchison and Blair Thornley. Licenses stock illustration for all markets.
Handles Illustration.
Terms Rep receives 25% commission. Exclusive area representation is required. Advertising costs are split 75% paid by talent; 25% paid by representative. "Will develop promotional materials with talent. Portfolio presentation formated and developed with talent also." Advertises in *American Showcase*; *The Creative Illustration Book*, under artist's name.
How to Contact For first contact, send direct mail flier/brochure, tearsheets, slides and SASE or e-mail with website address/online portfolio. Responds in 1 month if interested. After initial contact, call for appointment to show portfolio of tearsheets, photocopies. Obtains new talent through various means.

LANGLEY CREATIVE
333 N. Michigan Ave., Suite 1322, Chicago IL 60601. (312)782-0244. Fax: (312)782-1535. E-mail: artrepsjl@aol.com and MeganJeanil@aol.com. Website: www.sharonlangley.com and www.theispot.com. **Contact:** Sharon

Langley and/or Megan Langley. Commercial illustration representative. Estab. 1988. Represents illustrators. Markets include advertising agencies; corporations; design firms; editorial/magazines; publishing/books; promotion. Clients include every major player in the United States.

Handles Illustration. "I am receptive to reviewing samples by enthusiastic up-and-coming artists." E-mail samples and/ or your website address.

Terms Rep receives 25% commission. Exclusive area representation is preferred. Advertising costs are split 75% paid by talent; 25% paid by representative. For promotional purposes, talent must provide printed promotional pieces, a well organized, creative portfolio. Advertises in *The Workbook.* "If your book is not ready to show, be willing to invest in a 'zippy' new one."

How to Contact For first contact, send "samples via e-mail or printed materials that do not have to be returned." Responds only if interested. Obtains new talent through recommendations from art directors, referrals and submissions.

Tips "You need to be focused in your direction and style. Be willing to create new samples. Be a 'team player.' The agent and artist form a bond and the goal is success. Don't let your ego get in the way. Be open to constructive criticism and if one agent turns you down, quickly move to the next name on your list."

MAGNET REPS

3450 Vinton Ave., Los Angeles CA 90034. (866)390-5656. E-mail: art@magnetreps.com. Website: http ://magne treps.com. **Contact:** Paolo Rizzi, director. Commercial illustration representative. Estab. 1998. Member of Graphic Artists Guild. Represents 14 illustrators. Markets include advertising agencies, corporations/client direct, design firms, editorial/magazines, movie studios, paper products/greeting cards, publishing/books, record companies, character development. Artists include Ben Shannon, Red Nose Studio, Shawn Barber.

Handles Illustration. Looking for artists with the passion to illustrate every day, an awareness of cultural trends in the world we live in, and a basic understanding of the business of illustration.

Terms Exclusive representation required. Advertising costs are split. For promotional purposes, talent must provide a well-developed, consistent portfolio. Advertises in *Workbook* and others.

How to Contact For first contact, submit a Web link to portfolio, or 2 sample JPEGs for review via e-mail only. Responds in 1 month. We will contact artist via e-mail if we are interested. Portfolio should include color print outs, good quality.

Tips "Be realistic about how your style matches our agency. We do not represent scientific, technical, medical, sci-fi, hyper-realistic, story boarding, landscape, pin-up, cartoon or cutesy styles. We do not represent graphic designers. We will not represent artists that imitate the style of one of our existing artists."

MARLENA AGENCY

145 Witherspoon St., Princeton NJ 08542. (609)252-9405. Fax: (609)252-1949. E-mail: marlena@marlenaagency .com. Website: marlenaagency.com. **Artist Reps:** Marlena Torzecka, Ella Lupo, Greta T'Jonck. Commercial illustration representative. Estab. 1990. Member of Art Directors Club of New York, Society of Illustrators. Represents 28 illustrators from France, Poland, Germany, Hungary, Italy, Spain, Canada and US. Specializes in conceptual illustration. Markets include advertising agencies; corporations/client direct; design firms; editorial/ magazines; publishing/books; theaters. Represents Cyril Cabry, Linda Helton and Gerard DuBois.

• This agency produces promotional materials for artists such as wrapping paper, calendars, brochures.

Handles Illustration, fine art and prints.

Terms Rep receives 30% commission; 35% if translation needed. Costs are shared by all artists. Exclusive area epresentation is required. Advertising costs are split 70% paid by talent; 30% paid by representative. For promotional purposes, talent must provide slides (preferably 8×10 framed); direct mail pieces, 3-4 portfolios. Advertises in *American Showcase, Black Book, Illustrators 35* (New York City), *Workbook, Alternative Pick.* Many of the artists are regularly featured in CA Annuals, The Society of Illustrators Annuals, American Illustration Annuals.

How to Contact For first contact send tearsheets or e-mail low resolution images. Responds in 1 week only if interested. After initial contact, drop off or mail appropriate materials. Portfolio should include tearsheets.

Tips Wants artists with "talent, good concepts—intelligent illustration, promptness in keeping up with projects, deadlines, etc."

Ⓝ MARTHA PRODUCTIONS, INC.

7550 W. 82nd St., Playa Del Rey CA 90293. (310)670-5300. Fax: (310)670-3644. E-mail: marthaprod@earthlink. net. Website: www.marthaproductions.com. **Contact:** Martha Spelman, president. Commercial illustration representative. Estab. 1978. Represents 40 illustrators. Licenses illustrators. Specializes in illustration in various styles and media. Markets include advertising agencies; corporations/client direct; design firms; developers; editorial/magazines; paper products/greeting cards; publishing/books; record companies; sales/promotion firms. Represents Steve Vance, Allen Garns, Bruce Sereta.

Handles Illustration, retro, infographics, character design.

Terms Rep receives 30% commission. Advertising costs are split 70% paid by talent; 30% paid by representative. For promotional purposes, talent must "have existing promotional pieces. Also need to be on our website." Advertises in *The Workbook, Blackbook*.

How to Contact For first contact, send query letter, direct mail flier/brochure and SASE. Can e-mail a few small JPEG files. Responds only if interested. After initial contact, drop off or mail portfolio. Portfolio should include b&w and color tearsheets. Obtains new talent through recommendations and solicitation.

Tips "An artist seeking representation should have a strong portfolio with pieces relevant to advertising, corporate collateral or publishing markets. Check the rep's website or ads to see the other talent they represent to determine whether the artist could be an asset to that rep's group or if there may be a conflict. Reps are looking for new talent that already has a portfolio of salable pieces, some existing promos and hopefully some experience."

MASLOV-WEINBERG

608 York St., San Francisco CA 94110. (415)641-1285. Fax: (415)641-5500. E-mail: larryuu@aol.com. Website: www.maslov.com. **Partner:** Larry Weinberg. Commercial illustration representative. Estab. 1988. Represents 2 fine artists, 15 illustrators. Markets include advertising agencies, corporations/client direct, design firms, editorial/magazines, movie studios, paper products/greeting cards, publishing/books, record companies, sales/promotion firms. Artists include Mark Matcho, Mark Ulriksen, Pamela Hobbs.

Handles Illustration.

Terms Rep receives 25% commission. Exclusive representation required. Advertising costs are split 75% paid by artist; 25% paid by rep. Advertises in *American Showcase*; *Workbook*.

How to Contact For first contact, send query letter with direct mail flier/brochure. Responds only if interested. After initial contact, write to schedule an appointment.

MENDOLA ARTISTS

420 Lexington Ave., New York NY 10170. (212)986-5680. Fax: (212)818-1246. E-mail: mendolaart@aol.com. **Contact:** Tom Mendola. Commercial illustration representative. Estab. 1961. Member of Society of Illustrators, Graphic Artists Guild. Represents 60 or more illustrators. Markets include advertising agencies; corporations/client direct; design firms; editorial/magazines; sales/promotion firms.

Handles Illustration. "We work with the top agencies and publishers. The calibre of talent must be in the top 5%."

Terms Rep receives 25% commission. Exclusive area representation is sometimes required.

How to Contact "Send e-mail with link to website or JPEGs. Alternatively, send printed samples with SASE or items that you do not need returned. We will contact you if interested in seeing additional work."

MHS LICENSING

11100 Wayzata Blvd., Suite 550, Minneapolis MN 55305-5517. (952)544-1377. Fax: (952)544-8663. E-mail: artreviewcommittee@mhslicensing.com. Website: www.mhslicensing.com. **President:** Marty H. Segelbaum. Licensing agency. Estab. 1995. Represents 18 fine artists, 1 photographer, and 4 illustrators or other artists and brands. Markets include paper products/greeting cards, publishing/books and other consumer products including giftware, stationery/paper, tabletop, apparel home fashions, textiles, etc. Artists include Hautman Brothers, Judy Buswell, Erika Oller, Kathy Hatch, Constance Coleman and many others.

• See Insider Report with pet portraitist Constance Coleman in the Gallery section of this book.

Handles Fine art, illustration, photography and brand concepts.

Terms Negotiable with firm.

How to Contact Send query letter with bio, tearsheets, approximately 10 low res JPEGs via e-mail to artreview-committee@mhslicensing.com. See submission guidelines on website. "Keep your submission simple and affordable by leaving all the fancy packaging, wrapping and enclosures in your studio. $8\frac{1}{2} \times 11$ tearsheets (inkjet is fine), biography, and SASE are all that we need for review." Responds in 6 weeks. No appointments scheduled, please no calls. Portfolio should include color tearsheets. Send SASE for return of material.

Tips "Our mutual success is based on providing manufacturers with trend forward artwork. Please don't duplicate what is already on the market but think instead, 'What are consumers going to want to buy in nine months, one year, or two years?' We want to learn how you envision your artwork being applied to a variety of product types. Artists are encouraged to submit their artwork mocked-up into potential product collections ranging from stationery to tabletop to home fashion (kitchen, bed, and bath). Visit your local department store or mass retailer to learn more about the key items in these categories. And, if you have multiple artwork styles, include them with your submission."

MORGAN GAYNIN INC.

194 Third Ave., New York NY 10003. (212)475-0440. Fax: (212)353-8538. E-mail: info@morgangaynin.com. Website: www.morgangaynin.com. **Partners:** Vicki Morgan and Gail Gaynin. Commercial illustration represen-

print

Subscribe and save 66%

Every issue of *PRINT*

- explores the art, influence, power and passion of visual communication

- takes you beyond the beauty and style to the ideas and points of view that drive today's designers

- connects you to the past, present and future of graphic design

Every issue of *PRINT* makes you a better designer

Use the post-paid card below to get a year of *PRINT* for only $37, the <u>lowest</u> <u>rate</u> <u>available</u>.

Send me a year of *PRINT* for only $37.

I'll get 6 issues — including the Regional Design Annual, a $35 newsstand value — at 66% off the newsstand price. ABSOLUTELY NO RISK!

Name_____

Company _____

Address _____

City _____ State_____ ZIP_____

Email _____

❏ You may contact me about my subscription, via email. My email address won't be used for any other purpose.

SEND NO MONEY NOW. WE'LL BILL YOU LATER.

In Canada: you'll be invoiced an additional $15 (includes GST/HST). Outside the U.S. and Canada: add $41 and remit payment in U.S. funds with order. Please allow 4-6 weeks for first-issue delivery. Annual newsstand rate $108.95.

My business is best described as: (choose one)
- ○ Advertising Agency
- ○ Design Studio
- ○ Graphic Arts Vendor
- ○ Company (In-House Design Dept.)
- ○ Educational Institution
- ○ Other (specify)_____

My job title/occupation is: (choose one)
- ○ Owner/Management
- ○ Creative Director
- ○ Art Director/Designer
- ○ Advertising/Marketing Staff
- ○ Instructor
- ○ Student
- ○ Other (specify)_____

J5FAM3

Subscribe now and save 66% off the newsstand price.

You'll get...

PRINT's Regional Design Annual
The most comprehensive yearly profile of graphic design in America, packed with the best, most current work in the country.

PRINT's European Design Annual
A portfolio of the finest work being created across the Continent, with commentary on national styles and international trends.

PRINT's Digital Design Annual
An annual showcase of the most cutting-edge digital art being created in the areas of animation, Web sites, television ads, kiosks and more.

Plus 3 regular issues — a full year of *PRINT* at the introductory rate of just $37. (Annual newsstand rate $108.95.)

tative. Estab. 1974. Markets include advertising agencies; corporations/client direct; design firms; magazines; books; sales/promotion firms.

Handles Illustration.

Terms Rep receives 30% commission. Exclusive area representation is required. No geographic restrictions. Advertising costs are split 70% paid by talent; 30% paid by representative. Advertises in directories, on the Web, direct mail.

How to Contact For first contact, send ''an e-mail with a URL. No drop-off policy.''

LORI NOWICKI AND ASSOCIATES

310 W. 97th St., #24, New York NY 10025. E-mail: lori@lorinowicki.com. Website: www.lorinowicki.com. Estab. 1993. Represents 20 illustrators. Markets include advertising agencies; design firms; editorial/magazines; publishing/books; children's publishing.

Handles Illustration and author/illustrators.

Terms Rep receives 25-30% commission. Cost for direct mail promotional pieces is paid by illustrator. Exclusive area representation is required. Advertising costs are split 75% paid by talent; 25% paid by representative. Advertises in *The Workbook*; *Black Book*; *Showcase*; *Directory of Illustration*.

How to Contact For first contact, send query letter, résumé, nonreturnable tearsheets, or e-mail a link to your website. Samples are not returned. ''Do not phone, do not e-mail attachments, will contact if interested.'' Wants artists with consistent style. ''We are aspiring to build a larger children's publishing division and specifically looking for author/illustrators.''

▣ GERALD & CULLEN RAPP, INC.

420 Lexington Ave., Penthouse, New York NY 10170. (212)889-3337. Fax: (212)889-3341. E-mail: lara@rappart. com. Website: www.theispot.com/rep/rapp. **Contact:** Lara Tomlin. Commercial illustration representative. Estab. 1944. Member of SPAR; Society of Illustrators; Graphic Artists Guild. Represents 50 illustrators. Markets include advertising agencies; corporations/client direct; design firms; editorial/magazines; paper products/greeting cards; publishing/books; sales/promotion firms. Represents Jonathan Carlson, Mark Rosenthal, Seth and James Steinberg.

Handles Illustration.

Terms Rep receives 25-30% commission. Exclusive area representation is required. No geographic restrictions. Split of advertising costs is negotiated. Advertises in *American Showcase*; *The Workbook*; *Graphic Artists Guild Directory* and *CA, Print* magazines. ''Conducts active direct mail program and advertises on the Internet.''

How to Contact For first contact, send query letter, direct mail flier/brochure or e-mail with no more than 1 image attached. Responds in 1 week. Obtains new talent through recommendations from others, solicitations.

REMEN-WILLIS DESIGN GROUP

2964 Colton Road, Pebble Beach CA 93953. (831)655-1407. Fax: (831)655-1408. Website: www.annremenwillis. com. **Art Rep:** Ann Remen-Willis. Children's books only/no advertising. Estab. 1984. Member of SCBWI. Represents 2 fine artists, 15 illustrators. Specializes in children's books trade and text. Markets include design firms, editorial/magazines, paper products/greeting cards, publishing/books. Visit website for artist names.

Handles Illustration.

Terms Rep receives 25% commission. Advertising costs are split 50% paid by artist; 50% paid by rep. Advertises in *Picturebook* and postcard mailings.

How to Contact For first contact, send query letter with tearsheets. Responds in one week. After initial contact, call to schedule an appointment. Portfolio should include b&w and color tearsheets.

Tips ''Fill portfolio with samples of art you want to continue receiving as commissions. Do not include that which is not a true representation of your style and capability.''

▣ RETROREPS (A DIVISION OF MARTHA PRODUCTIONS)

7550 W. 82nd St., Playa Del Rey CA 90293. (310)670-5300. Fax: (310)670-3644. E-mail: marthaprod@earthlink. net. Website: www.retroreps.com. **Contact:** Martha Spelman. Commercial illustration representative. Estab. 1998. Represents 19 illustrators, 1 photographer. Specializes in artists and a photographer working in retro styles from the 1920s through 1970s. Licenses illustrators and photographers. Artists include Bruce Sereta, John Kachik, Tom Nikosey.

• See listing for Martha Productions.

Handles Interested in illustration and photography.

LILLA ROGERS STUDIO

E-mail: info@lillarogers.com. Website: www.lillarogers.com. **Agent:** Lilla Rogers, Ashley Lorenz. Commercial illustration representative. Estab. 1984. Represents 20 illustrators. Markets include advertising agencies, corpo-

rations/client direct, design firms, editorial/magazines, paper products/greeting cards, publishing/books, prints and posters, must companies, sales/promotion firms, children's books, surface design. Artists include Bonnie Dain, Diane Bigda, Jon Cannell.

• Lilla provides mentoring and frequent events for our artists including classes and guest art director lunches.
Handles Illustration.

Terms Rep receives 30% commission. Exclusive representation required. Advertises in *Print Magazine*; *Workbook*; *Showcase* and runs extensive postcard direct mail campaigns..

How to Contact For first contact, e-mail a link to your site, or 3-5 JPEGs. Responds only if interested.

Tips "It's good to check out the agency's website and see if you feel like it's a good fit. Explain in your e-mail why you want an agent and why you think we are a good match."

LIZ SANDERS AGENCY

2415 E. Hangman Creek Lane, Spokane WA 99224. (509)993-6400. Fax: (509)466-5400. E-mail: liz@lizsanders.com. Website: www.lizsanders.com. **Contact:** Liz Sanders, owner. Commercial illustration representative. Estab. 1985. Represents 10 illustrators. Specializes in marketing of individual artists within an ever-evolving illustration world. Markets include advertising agencies, corporations/client direct, design firms, editorial/magazines, juvenile markets, paper products/greeting cards, publishing/books, record companies, sales/promotion firms.

Handles Interested in illustration. Looking for fresh, unique talent committed to long-term careers whereby the agent/talent relationship is mutually respectful, responsive and measurably successful.

Terms Rep receives 25-30% commission. Exclusive representation required. Advertises in *Picturebook*; *American Showcase*; *Workbook*; *Directory of Illustration*; direct mail material; traditional/electronic portfolio for agent's personal presentations; means to advertise if not substantially, then consistently.

How to Contact For first contact, send nonreturnable printed pieces or e-mailed Web address. Responds only if interested. After initial contact, call to schedule an appointment, depending on geographic criteria. Portfolio should include tearsheets, photocopies and digital output.

Tips "Concisely present a single, focused style supported by 8-12 strong samples. Only send a true portfolio upon request."

JOAN SAPIRO ART CONSULTANTS

4750 E. Belleview Ave., Greenwood Village CO 80121. (303)793-0792. Fax: (303)290-9204. E-mail: jsac@qwest.net. **Contact:** Kay Brouillette or Joan Sapiro. Estab. 1980. Specializes in "corporate art with other emphasis on hospitality, health care and art consulting/advising to private collectors."

Handles All mediums of artwork and all prices if applicable for clientele.

Terms Artist must be flexible and willing to ship work on consignment. Also must be able to provide sketches, etc. if commission piece involved. No geographic restrictions.

How to Contact For first contact, send résumé, bio, direct mail flier/brochure, tearsheets, slides, photographs, price list—net (wholesale) and SASE. After initial contact, drop off or mail in appropriate materials for review.

Tips Obtains new talent through recommendations, publications, travel, research, university faculty.

ℕ THE SCHUNA GROUP INC.

1503 Briarknoll Dr., Arden Hills MN 55112. (651)631-8480. Fax: (651)631-8426. E-mail: joanne@schunagroup.com. Website: www.schunagroup.com. **Contact:** JoAnne Schuna, owner. Commercial illustration representative. Represents 15 illustrators. Specializes in illustration. Markets include advertising agencies, corporations/client direct, design firms, editorial/magazines, paper products/greeting cards, publishing/books, record companies, sales/promotion firms. Artists include Cathy Gendron, Jim Dryden.

Handles Interesting in receiving illustration.

Terms Rep receives 25% commission. Exclusive representation required. Advertising costs are split 75% paid by artist; 25% paid by rep. Advertises in *Workbook* and by direct mail.

How to Contact For first contact, send query letter with photocopies, SASE and tearsheets. Responds in 2 weeks. After initial contact, wait for response. Portfolio should include finished art, tearsheets, transparencies.

Tips "Send (either by mail or e-mail) a couple of tearsheets with a brief note initially. If the rep is interested, she will respond and arrange a scenario where she can look at additional work."

ℕ FREDA SCOTT, INC.

200 Brannan St., #411, San Francisco CA 94107. (415)348-9121. Fax: (415)348-9120. E-mail: freda@fredascott.com. Website: www.fredascott.com. **Contact:** Freda Scott. Commercial illustration and photography representative. Estab. 1980. Member of SPAR. Represents 10 illustrators, 15 photographers. Markets include advertising agencies; corporations/client direct; design firms; editorial/magazines; paper products/greeting cards; publishing/books; sales/promotion firms. Clients include J. Walter Thompson, Anderson & Lembke, Oracle Corp., Sun Microsystems. Client list available upon request.

Handles Illustration, photography.

Terms Rep receives 25% commission. No geographic restrictions. Advertising costs are split 75% paid by talent; 25% paid by representative. For promotional purposes, talent must provide "promotion piece and ad in a directory. I also need at least three portfolios." Advertises in *American Showcase*; *Black Book*; *The Workbook*.

How to Contact For first contact, send direct mail flier/brochure, tearsheets and SASE. If you send transparencies, responds in 1 week, if interested. "You need to make follow-up calls." After initial contact, call for appointment to show portfolio of tearsheets, photographs, 4×5 or 8×10.

Tips Obtains new talent sometimes through recommendations, sometimes solicitation. "If you are seriously interested in getting repped, keep sending promos—once every six months or so. Do it yourself a year or two until you know what you need a rep to do."

N SIMPATICO ART & STONE

1221 Demaret Lane, Houston TX 77055-6115. (713)467-7123. **Contact:** Billie Blake Fant. Fine art broker/consultant/exhibitor. Estab. 1973. Specializes in unique fine art, sculpture and Texas domestic stone furniture, carvings, architectural elements. Market includes corporate; institutional and residential clients.

Handles Unique fine art and sculpture not presently represented in Houston, Texas.

Terms Standard commission. Exclusive area representation required.

How to Contact For first contact, send query letter, résumé, slides. Obtains new talent through travel, publications, exhibits and referrals.

SUSAN AND CO.

5002 92nd Ave. SE, Mercer Island WA 98040. (206)232-7873. Fax: (206)232-7908. E-mail: susan@susanandco.com. Website: www.susanandco.com. **Owner:** Susan Trimpe. Commercial illustration, photography representative. Estab. 1979. Member of SPGA. Represents 19 illustrators, 2 photographers. Specializes in commercial illustrators. Markets include advertising agencies; corporations/client direct; design firms; publishing/books. Artists include Bryn Barnard, Linda Ayriss and Larry Jost.

Handles Looks for "current illustration styles."

Terms Rep receives 30% commission. National representation is required. Advertising costs are split 70% paid by talent; 30% paid by representative.

How to Contact For first contact, send query letter and direct mail flier/brochure. Responds in 2 weeks only if interested. After initial contact, call to schedule an appointment. Portfolio should "be representative of unique style."

CHRISTINA A. TUGEAU: ARTIST AGENT

3009 Margaret Jones Lane, Williamsburg VA 23185. E-mail: chris@catugeau.com. Website: www.catugeau.com. **Owner:** Chris Tugeau. Children's publishing market illustration representative (K-12). Estab. 1994. Member of Graphic Artists Guild, SPAR, SCBWI. Represents 35 illustrators. Specializes in children's book publishing and educational market and related areas. Represents Stacey Schuett, Larry Day, Bill Farnsworth, Melissa Iwai, Margie Moore, Keiko Motoyama, Jason Wolff, Jeremy Tugeau, Priscilla Burris, John Kanzler, Ann Barrow, Martha Aviles, Ana Ochoa, Daniel J. Mahoney and others.

Handles Illustration. Must be proficient at illustrating children and animals in a variety of interactive situations, backgrounds, full color/b&w, and with a strong narrative sense.

Terms Rep receives 25% commission. Exclusive USA representation is required. For promotional purposes, talent must provide a direct mail promo piece(s), 8-10 good "back up" samples (multiples), 3 strong portfolio pieces. Advertises in *RSVP*; *GAG Directory of Illustration* and *Picturebook*.

How to Contact For first contact, e-mail a few JPEG samples or send direct mail flier/brochure, tearsheets, photocopies, books, SASE, "No slides! No originals." Responds by 2 weeks.

Tips "You should have a style uniquely and comfortably your own. Cooperative team player and be great with deadlines. Will consider young, new artists to the market with great potential and desire, and of course published, more experienced illustrators. Best to study and learn the market standards and expectations by representing yourself for a while when new to the market."

N JAE WAGONER, ARTIST REPRESENTATIVE

P.O. Box 1259, Alta CA 95701. Website: www.jaewagoner.com. **Contact:** Jae Wagoner. "By mail only—send copies or tear sheets only for us to keep—do not call!" Commercial illustration representative. Estab. 1975. Represents 20 illustrators. Markets include advertising agencies; corporations/client direct; design firms; editorial/magazines; paper products/greeting cards; publishing/books; sales/promotion firms.

• This rep's street address is 33885 Nary Red Rd., Alta CA 95701. However, all mail should go to the P.O. Box.

Handles Illustration.

Terms Agent receives 30% commission. Exclusive area representation required. Advertising costs depend. For

promotional purposes talent must advertise once a year in major promotional book (ex Workbook) exclusively with us. "Specifications and details are handled privately." Advertises in *The Workbook*.

How to Contact When making first contact, send query letter (with other reps mentioned), photocopies ("examples to keep only. No unsolicited work returned.") Responds in weeks only if interested. After initial contact, talent should wait to hear from us.

Tips "We select first from submitted samples we can keep, that are mailed to us. The actual work determines our interest, not verbal recommendation or résumés. Sometimes we search for style we are lacking. It is *not* a good idea to call a rep out of the blue. You are just another voice on the phone. What is important is your work, *not* who you know, where you went to school, etc. Unsolicited work that needs to be returned creates a negative situation for the agent. It can get lost, and the volume can get horrendous. Also—do your homework— do not call and expect to be given the address by phone. It's a waste of the rep's time and shows a lack of effort. Be brief and professional." Sometimes, even if an artist can't be represented, Jae Wagoner provides portfolio reviews, career counseling and advice for an hourly fee (with a 5 hour minimum fee). If you are interested in this service, please request this in your cover letter.

GWEN WALTERS

1801 S. Flagler Dr. #1202, West Palm Beach FL 33401. (561)805-7739. Fax: (561)805-5751. E-mail: Artincgw@aol.com. Website: www.GwenWaltersartrep.com. Commercial illustration representative. Estab. 1976. Member of Graphic Artists Guild. Represents 17 illustrators. "I lean more toward book publishing." Markets include: advertising agencies; corporations/client direct; editorial/magazines; paper products/greeting cards; publishing/books; sales/promotion firms. Represents: Gerardo Suzan, Fabricio Vanden Broeck, Resario Valderrama, Lave Gregory, Susan Spellman, Sally Schaedler, Judith Pfeiffer, Yvonne Gilbert, Gary Torrisi, Larry Johnson, Pat Davis and Linda Pierce.

Handles Illustration.

Terms Rep receives 30% commission. Charges for color photocopies. Advertising costs are split; 50% paid by talent; 50% paid by representative. For promotional purposes, talent must provide direct mail pieces. Advertises in *RSVP*, *Directory of Illustration* and *Picture Book*.

How to Contact For first contact, send résumé, bio, direct mail flier/brochure. After initial contact, representative will call. Portfolio should include "as much as possible."

Tips "You need to pound the pavement for a couple of years to get some experience under your belt. Don't forget to sign all artwork. So many artists forget to stamp their samples."

WASHINGTON-ARTISTS' REPRESENTATIVE INC.

22727 Cielo Vista #2, San Antonio TX 78255-9501. (210)698-1409. E-mail: artrep@sbcglobal.net. Website: www.theispot.com. **Contact:** Dick Washington. Commercial illustration representative. Estab. 1983. Represents 12 illustrators.

Terms No information provided.

How to Contact For first contact, send tearsheets or E-mail: website or images. Responds in 2 weeks, only if interested. After initial contact, call for appointment to show portfolio of original art, tearsheets, slides. Usually obtains new talent through recommendations and solicitation.

Tips "Make sure that you are ready for a real commitment and relationship. It's an important step for an artist, and it should be taken seriously."

DEBORAH WOLFE LTD.

731 N. 24th St., Philadelphia PA 19130. (215)232-6666. Fax: (215)232-6585. E-mail: inquiry@illustrationOnLine.com. Website: www.illustrationOnLine.com. **Contact:** Deborah Wolfe. Commercial illustration representative. Estab. 1978. Represents 25 illustrators. Markets include advertising agencies; corporations/client direct; design firms; editorial/magazines; publishing/books.

Handles Illustration.

Terms Rep receives 25% commission. Advertises in *Black Book*; *The Workbook*; *Directory of Illustration* and *Picturebook*.

How to Contact For first contact, send direct mail flier/brochure, tearsheets, slides or e-mail. Responds in 3 weeks.

Organizations, Publications & Websites

There are literally millions of artist- and designer-related Web sites out there. Here are just a few that we at *Artist's & Graphic Designer's Market* think are particularly useful.

BUSINESS

Arts Business Exchange: www.artsbusiness.com.
Sign up for the free e-mail newsletter and get updates on trends, Canadian art news, sales data and art law and policy.

Starving Artists Law: www.starvingartistslaw.com.
Start here for answers to your legal questions.

Tera's Wish: wwww.teras-wish.com/marketing.htm.
Tera Leigh, author of *How to Be Creative If You Never Thought You Could* (North Light Books), shares tips and ideas for marketing, promotion, P.R. and more.

ILLUSTRATORS

Altpick.com: The Source for Creative Talent & Imagination: www.altpick.com.
News, competition deadlines, artist listings and much more. Check out the wealth of information listed.

Association of Medical Illustrators: www.ami.org.
A must-visit for anyone interested in the highly specialized niche of medical illustration.

The Association of Science Fiction and Fantasy Artists: www.asfa-art.org.
Home of the Chesley Awards, this site is essential for anyone connected to the visual arts of science fiction, fantasy, mythology and related topics.

Canadian Association of Photographers and Illustrators in Communications (CAPIC): www.capic.org.
There's a ton of copyright and industry news and articles on this site, also help with insurance, lawyers, etc.

Canadian Society of Children's Authors, Illustrators and Performers: www.canscaip.org.
This organization promotes all aspects of Children's writing, illustration and performance.

THE DRAWING BOARD: members.aol.com/thedrawing.
Get everything here—from pricing guidelines to events, tips to technique.

Greeting Card Association: www.greetingcard.org.
A great place for learning about and networking in the greeting card industry.

Magatopia: www.magatopia.com.
Online magazine articles, Web searches for art jobs, weekly columns on freelancing. . . . there's a lot to explore at this site.

Magazines A-Z: www.magazinesatoz.com.
This is a straightforward listing of all kinds of magazines.

The Medical Illustrators' Home Page: www.medartist.com.
A site for medical illustrators who want to post their work for stock imagery or view others' work.

Society of Children's Book Writers and Illustrators: www.scbwi.org.
With chapters all over the world, SCBWI is the premier organization for professionals in children's publishing.

The Society of Illustrators: www.societyillustrators.org.
Since 1901, this organization has been working to promote the interest of professional illustrators. Information on exhibitions, career advice and many other links provided.

Theispot.com: www.theispot.com.
An online resource for illustrators and art directors which showcases illustrators' work and serves as a meeting place where illustrators can discuss their profession and share ideas.

Writers Write: Greeting Cards: www.writerswrite.com/greetingcards.
This site has links to greeting card companies and their submission information.

© Michele Amatrula

This illustration by Michele Amatrula is one of several she has posted to the online resource theispot.com. It was originally used as a promotional piece, intended to attract art directors for publishers of YA (Young Adult) titles. It was a very successful promotion. Amatrula specifically targets markets by tailoring her artwork to each market. She's busy with a client list that includes Harper Collins, Avalon Books, *Psychology Today*, Random House, *Essence* magazine, *Scholastic* and Danbury Mint.

FINE ART

American Artist Registry: www.artistregistry.com.
A registry where you can post art, get updates on calls for entries throughout the United States and much more.

Art Deadlines List: www.artdeadlineslist.com.
The e-mail version of this list is free. It's a great source for deadlines for calls for entries, competitions, scholarships, festivals and more.

Art Dealers Association of America: www.artdealers.org.
Opportunities and information on marketing your work, galleries and dealers.

Artdeadline.com: artdeadline.com.
Called the "Art Professional's Resource," this site lists information for funding, grants, commissions for art in public places, representation. . . . the list goes on and on.

Artist Help Network: www.artisthelpnetwork.com.
Find career, legal and financial advice along with multiple regional, national and international resources.

Artist Resource: www.artistresource.org.
Growing online art organization offering career development information for artists from Northern California and beyond.

The Artist's Network: www.artistsnetwork.com.
Get articles, excerpts and tips from *The Artist Magazine*, *Watercolor Magic*, and *Decorative Artist's Workbook*.

Artline: www.artline.com.
Artline is comprised of 7 dealer associations: Art Dealers Association of America, Art Dealers Association of Greater Washington, Association of International Photography Art Dealers, Chicago Art Dealers Association, International Fine Print Dealers Association, San Francisco Art Dealers Association, and Society of London Art Dealers. The Web site has information about exhibits and artists worldwide.

New York Foundation for the Arts: www.nyfa.org.
With news, a searchable database of opportunities for artists, links to other useful sites such as databases of galleries and the Artist's Community Federal Credit Union, this site is loaded!

CARTOONS & COMIC BOOK ART

The Comic Book Legal Defense Fund: www.cbldf.org.
"Defending the comic industry's first amendment rights since 1986."

Friends of Lulu: www.friends-lulu.org.
This national nonprofit organization's purpose is to "promote and encourage female readership and participation in the comic book industry."

National Cartoonists Society: www.reuben.org.
Home and birthplace of the famed Reuben Awards, this organization holds something for cartoonists interested in everything from caricature to animation.

TalkAboutComics.com: www.talkaboutcomics.com.
"Free community resource for small press and Web comics creators and fans."

Resources

The Nose: www.the-nose.com.
"Online caricature artist index."

ADVERTISING, DESIGN & GRAPHIC ART

Advertising Age: www.adage.com.
This site is a database of advertising agencies.

American Institute of Graphic Arts: www.aiga.org.
Whether or not you join the organization, this site is a must for designers! From inspiration to insurance the AIGA is the designer's spot.

The Art Directors Club: www.adcglobal.org.
Founded in 1920, this international not-for-profit organization features job listings, educational opportunities and annual awards in advertising, graphic design, new media and illustration.

Association Typographique Internationale (ATYPI): www.atypi.org.
Dedicated entirely to typography and type, if fonts are your specialty, make sure this site is on your favorites list.

Graphic Artists Guild: www.gag.org.
The art and design industry standard.

HOW **Magazine:** www.howdesign.com.
One of the premier publications dedicated to design, the website features jobs, business resources, inspiration and news, as well as conference information.

Society of Graphic Designers of Canada: www.gdc.net.
Great site for Canadian designers that offers industry news, job postings and forums.

Type Directors Club: www.tdc.org.
Events, news, awards and scholarships are all here for "those interested in excellence in typography."

OTHER USEFUL SITES

Animation World Network: www.awn.com.
Animation industry database, job postings, resume database, education resources, discussion forums, links, newsletters and a host of other resources cover everything animation.

Art Schools: www.artschools.com.
A free online directory with a searchable database of art schools all over the world. They also have information on financial aid, majors and lots more.

Artbusiness.com: www.artbusiness.com.
Contains art-business-related articles, reviews business-of-art books and sells classes on marketing for artists.

The Artist's Magazine: www.artistsmagazine.com.
Archives of articles covering everything from the newest type of colored pencil to techniques in waterolors.

Artlex Art Dictionary: www.artlex.com.
Art dictionary with more than 3,200 terms.

Communication Arts Magazine: www.commarts.com.
Publication and Web site covering all aspects of design from print to digital.

Creative Latitude: www.creativelatitude.com.
Lots of great information to help your freelance creative business. Great articles and profiles of designers and illustrators.

Fresh Lists Mailing Lists: www.freshlists.com.
Contact management system for freelancers.

Illustrators Partnership: www.illustratorspartnership.org.
Forums and resources; copyright new; competition announcements; gallery.

Imagesite: www.imagesite.com.
Lists searchable databases of advertising agencies, art reps, competitions, galleries and printers.

International Animation Association: asifa.net.
ASIFA or Association Internationale du Film d'Animation is an international group dedicated to the art of animation. They list worldwide news and information on chapters of the group, as well as conferences, contests and workshops.

Music Connection: www.musicconnection.com.
If you're working hard to get your art on CD covers, you'll want to keep up with the ever-changing world of the music industry.

Portfolios.com: www.portfolios.com.
Serving both artists and clients looking for artists, portfolios.com offers a variety of services for everyone. This is a really nice site; you can post up to a five-image portfolio for free.

Glossary

Acceptance (payment on). An artist is paid for his work as soon as a buyer decides to use it.

Adobe Illustrator®. Drawing and painting computer software.

Adobe InDesign. Revised, retooled version of Adobe Illustrator.

Adobe PageMaker®. Page-layout design software (formerly Aldus PageMaker). Product relaunched as InDesign.

Adobe Photoshop®. Photo manipulation computer program.

Advance. Amount paid to an artist before beginning work on an assigned project. Often paid to cover preliminary expenses.

Airbrush. Small pencil-shaped pressure gun used to spray ink, paint or dye to obtain gradated tonal effects.

Aldus FreeHand. Illustration software (see Macromedia FreeHand).

Aldus PageMaker. Page layout software (see Adobe PageMaker).

Anime. Japanese word for animation.

Art director. In commercial markets, the person responsible for choosing and purchasing artwork and supervising the design process.

Biannually. Occurring twice a year.

Biennially. Occurring once every two years.

Bimonthly. Occurring once every two months.

Biweekly. Occurring once every two weeks.

Book. Another term for a portfolio.

Buy-out. The sale of all reproduction rights (and sometimes the original work) by the artist; also subcontracted portions of a job resold at a cost or profit to the end client by the artist.

Calligraphy. The art of fine handwriting.

Camera-ready. Art that is completely prepared for copy camera platemaking.

Capabilities brochure. A brochure, similar to an annual report, outlining for prospective clients the nature of a company's business and the range of products or services it provides.

Caption. See gagline.

Carriage trade. Wealthy clients or customers of a business.

CD-ROM. Compact disc read-only memory; nonerasable electronic medium used for digitized image and document storage and retrieval on computers.

Collateral. Accompanying or auxiliary pieces, such as brochures, especially used in advertising.

Color separation. Photographic process of separating any multi-color image into its primary component parts (cyan, magenta, yellow and black) for printing.

Commission. 1) Percentage of retail price taken by a sponsor/salesman on artwork sold. 2) Assignment given to an artist.

Comprehensive. Complete sketch of layout showing how a finished illustration will look when printed; also called a comp.

Copyright. The exclusive legal right to reproduce, publish and sell the matter and form of a literary or artistic work.

Consignment. Arrangement by which items are sent by an artist to a sales agent (gallery, shop, sales rep, etc.) for sale with the understanding the artist will not receive payment until work is sold. A commission is almost always charged for this service.

Direct-mail package. Sales or promotional material that is distributed by mail. Usually consists of an outer envelope, a cover letter, brochure or flier, SASE, and postpaid reply card, or order form with business reply envelope.

Dummy. A rough model of a book or multi-page piece, created as a preliminary step in determining page layout and length. Also, a rough model of a card with an unusual fold or die cut.

Edition. The total number of prints published of one piece of art.

Elhi. Abbreviation for elementary/high school used by publishers to describe young audiences.

Environmental graphic design (EGD). The planning, designing and specifying of graphic elements in the built and natural environment; signage.

EPS files. Encapsulated PostScript—a computer format used for saving or creating graphics.

Estimate. A ballpark figure given to a client by a designer anticipating the final cost of a project.

Etching. A print made by the intaglio process, creating a design in the surface of a metal or other plate with a needle and using a mordant to bite out the design.

Exclusive area representation. Requirement that an artist's work appear in only one outlet within a defined geographical area.

Finished art. A completed illustration, mechanical, photo or combination of the three that is ready to go to the printer. Also called camera-ready art.

Gagline. The words printed with a cartoon (usually directly beneath); also called a caption.

Giclée Method of creating limited and unlimited edition prints using computer technology in place of traditional methods of reproducing artwork. Original artwork or transparency is digitally scanned and the stored information is manipulated on screen using computer software (usually Photoshop). Once the image is refined on screen, it is printed on an Iris printer, a specialized ink-jet printer designed for making giclée prints.

Gouache. Opaque watercolor with definite, appreciable film thickness and an actual paint layer.

Halftone. Reproduction of a continuous tone illustration with the image formed by dots produced by a camera lens screen.

Informational graphics. Information, especially numerical data, visually represented with illustration and text; charts/graphs.

IRC. International Reply Coupon; purchased at the post office to enclose with artwork sent to a foreign buyer to cover his postage cost when replying.

Iris print. Limited and unlimited edition print or giclée output on an Iris or ink-jet printer (named after Iris Graphics of Bedford, Massachusetts, a leading supplier of ink-jet printers).

JPEG files. Joint Photographic Experts Group—a computer format used for saving or creating graphics.

Keyline. Identification of the positions of illustrations and copy for the printer.

Kill fee. Portion of an agreed-upon payment an artist receives for a job that was assigned, started, but then canceled.

Layout. Arrangement of photographs, illustrations, text and headlines for printed material.

Licensing. The process whereby an artist who owns the rights to his or her artwork permits (through a written contract) another party to use the artwork for a specific purpose for a specified time in return for a fee and/or royalty.

Lithography. Printing process based on a design made with a greasy substance on a limestone slab or metal plate and chemically treated so image areas take ink and nonimage areas repel ink.

Logo. Name or design of a company or product used as a trademark on letterhead, direct mail packages, in advertising, etc., to establish visual identity.

Mechanicals. Preparation of work for printing.

Multimedia. A generic term used by advertising, public relations and audiovisual firms to describe productions involving animation, video, Web graphics or other visual effects. Also, a term used to reflect the varied in-house capabilities of an agency.

Naif. Native art of such cultures as African, Eskimo, Native American, etc., usually associated with daily life.

Offset. Printing process in which a flat printing plate is treated to be ink-receptive in image areas and ink-repellent in nonimage areas. Ink is transferred from the printing plate to a rubber plate, and then to the paper.

Overlay. Transparent cover over copy, on which instruction, corrections or color location directions are given.

Panel. In cartooning, the boxed-in illustration; can be single panel, double panel or multiple panel.

PMT. Photomechanical transfer; photostat produced without a negative.

P-O-P. Point-of-purchase; in-store marketing display that promotes a product.

Prima facie. Evidence based on the first impression.

Print. An impression pulled from an original plate, stone, block screen or negative; also a positive made from a photographic negative.

Production artist. In the final phases of the design process, the artist responsible for mechanicals and sometimes the overseeing of printing.

QuarkXPress. Page layout computer program.

Query. Letter to an art director or buyer eliciting interest in a work an artist wants to illustrate or sell.

Quotation. Set fee proposed to a client prior to commencing work on a project.

Rendering. A drawn representation of a building, interior, etc., in perspective.

Retail. The sale of goods in small quantities directly to the consumer.

Roughs. Preliminary sketches or drawings.

Royalty. An agreed percentage paid by a publisher to an artist for each copy of a work sold.

SASE. Self-addressed, stamped envelope.

Self-publishing. In this arrangement, an artist coordinates and pays for printing, distribution and marketing of his/her own artwork and in turn keeps all ensuing profits.

Semiannual. Occurring twice a year.

Semimonthly. Occurring twice a month.

Semiweekly. Occurring twice a week.

Serigraph. Silkscreen; method of printing in which a stencil is adhered to a fine mesh cloth stretched over a wooden frame. Paint is forced through the area not blocked by the stencil.

Speculation. Creating artwork with no assurance that a potential buyer will purchase it or reimburse expenses in any way; referred to as work "on spec."

Spot illustration. Small illustration used to decorate a page of type or to serve as a column ending.

Storyboard. Series of panels that illustrate a progressive sequence or graphics and story copy of a TV commercial, film or filmstrip. Serves as a guide for the eventual finished product.

Tabloid. Publication whose format is an ordinary newspaper page turned sideways.

Tearsheet. Page containing an artist's published illustration, cartoon, design or photograph.

Thumbnail. A rough layout in miniature.

TIFF files. Tagged Image File Format—a computer format used for saving or creating graphics.

Transparency. A photographic positive film such as a color slide.

Type spec. Type specification; determination of the size and style of type to be used in a layout.

Velox. Photoprint of a continuous tone subject that has been transformed into line art by means of a halftone screen.

VHS. Video Home System; a standard videotape format for recording consumer-quality videotape, most commonly used in home videocassette recording and portable camcorders.

Video. General category comprised of videocassettes and videotapes.

Wash. Thin application of transparent color or watercolor black for a pastel or gray tonal effect.

Wholesale. The sale of commodities in large quantities usually for resale (as by a retail merchant).

Resources

Enter our drawing for a
free copy of the next edition

Reader Survey:
Tell us about yourself!

1. How often do you purchase *Artist's & Graphic Designer's Market*?

○ every year
○ every other year
○ This is my first edition

2. Describe yourself and your artwork—and how you use *AGDM*.

3. What do you like best about *AGDM*?

4. Would you like to see an online version of *AGDM*?

○ Yes
○ No

Name: _____
Address: _____
City: _____ State: _____ Zip: _____
Phone: _____ e-mail _____
Website: _____

Fax to Mary Cox, (513) 531-2686 or mail to Artist's & Graphic Designer's Market,
4700 East Galbraith Road, Cincinnati, OH 45236, or e-mail artdesign@fwpubs.com.

TRY *THE PASTEL JOURNAL*...ABSOLUTELY FREE!
And Get Pastel Painting Inspiration Delivered To Your Door!

Take a look at *The Pastel Journal*—the leading magazine for pastelists of all skill levels—and discover why artists worldwide enjoy this one-of-a-kind publication packed with awe-inspiring information and inspiration, plus spectacular full-color artwork. Send for your **FREE** trial issue today!

Inside each bi-monthly issue you'll find:

- *in-depth articles featuring expert tips and techniques that inspire your own art style*
- *insightful interviews with renowned pastel artists like Albert Handell, Elizabeth Mowry, Daniel E. Greene, and many more*
- *reproductions of gorgeous artwork from leading artists*
- *extensive listings of workshops and contests*
- *expert advice on how to market your artwork*
- *product reviews to help you choose the best art materials*
- *and much, much more!*

Take advantage of this special trial offer in *Artist's & Graphic Designer's Market* and discover *The Pastel Journal*—absolutely **FREE!**

Return this postage-paid card today!

SEND MY FREE TRIAL ISSUE!

✓**YES!** Send my FREE no-risk trial issue of *The Pastel Journal* and start my introductory subscription. If I like what I see, I'll get 5 more issues (6 in all) for just $27.00 – that's a 36% savings off the $41.94 newsstand price. If not, I'll write "cancel" on the invoice, return it and owe nothing. The **FREE ISSUE** will be mine to keep!

SEND NO MONEY NOW...WE'LL BILL YOU LATER!

Name_____

Address_____

City _____

State_____ ZIP _____

Subscribers in Canada will be charged an additional US$10 (includes GST/HST) and invoiced. Outside the U.S. and Canada, add US$10 and remit in U.S. funds with this order. Please allow 4-6 weeks for first-issue delivery.

The
Pastel Journal

www.pasteljournal.com

J5FAM5

The Pastel Journal

Get a FREE ISSUE of *The Pastel Journal*

Discover **The Pastel Journal** today–absolutely **FREE!** Inside you'll find a wealth of information and inspiration from today's leading pastel artists, as well as spectacular full-color demonstrations of their artwork. You'll also find invaluable advice, priceless creative inspiration, and exciting new painting techniques that take your talent to the next level. Just take a peek inside:

- *You'll learn how an exciting array of artists use pastel in creating breathtaking landscapes, still lifes, portraits, wildlife art, and more.*

- *You'll discover concrete, useful information about methods and materials, such as how to frame your artwork; how to shoot professional slides; and how to build your own Web site.*

- *You'll explore opportunities and resources through regular columns on marketing, comprehensive workshop and exhibition listings, sources for supplies and services, and much more.*

Find out why **The Pastel Journal** is the leading magazine for pastel artists!

Send in the postage-paid card below and request your FREE TRIAL ISSUE today!

PROCESS IMMEDIATELY!

Niche Marketing Index

The following indexes can help you find the most apropriate listings for the kind of artwork you create. Check the individual listings for specific information about submission requirements.

Children's Publications/Products

Collectibles

Fashion

Horror

Humorous Illustration

Informational Graphics

Licensing

Medical Illustration

Mugs

Religious/Spiritual

Science Fiction/Fantasy

Sport Art

Textiles & Wallpaper

T-Shirts

General Index

General Index